METHODS AND MATERIALS OF PAINTING
of the Great Schools and Masters

Two Volumes Bound as One

Sir Charles Lock Eastlake

DOVER PUBLICATIONS, INC.
Mineola, New York

Bibliographical Note

This Dover edition, first published in 2001, is a new, combined edition of *Methods and Materials of Painting of the Great Schools and Masters,* Volumes One and Two, originally published by Dover in 1960. The original Dover volumes were unabridged and unaltered republications of a work published in two volumes by Longman, Brown, Green, and Longmans in 1847 under the title of *Materials for a History of Oil Painting.*

Library of Congress Cataloging-in-Publication Data

Eastlake, Charles Lock, Sir, 1793–1865.
 [Materials for a history of oil painting]
 Methods and materials of painting of the great schools and masters / Sir Charles Lock Eastlake.
 p. cm.
 Originally published: Materials for a history of oil painting. London : Longman, Brown, Green, and Longmans, 1847; previously published in 2 v. by Dover in 1960.
 Includes index.
 ISBN 0-486-41726-3 (pbk.)
 1. Painting—History. I. Title.

ND50 .E2 2001
751.45'09—dc21

00-052303

Manufactured in the United States of America
Dover Publications, Inc., 31 East 2nd Street, Mineola, N.Y. 11501

TO

THE RIGHT HONOURABLE

SIR ROBERT PEEL, BART.

THIS WORK IS INSCRIBED,

AS

A TESTIMONY OF THE AUTHOR'S GRATITUDE

AND RESPECT.

Volume One

PREFACE.

THE following work was undertaken with a view to promote the objects of the Commissioners on the Fine Arts. It professes to trace the recorded practice of oil painting from its invention; and, by a comparison of authentic traditions with existing works, to point out some of the causes of that durability for which the earlier examples of the art are remarkable. It was considered that such an inquiry, if desirable on general grounds, must be especially so at a time when the best efforts of our artists are required for the permanent decoration of a national edifice.

The want of a sufficiently extensive investigation of original authorities relating to the early practice of oil painting has led to various contradictory theories; and the uncertainty which has been the result has too often induced an impression that the excellence of art, in former ages, depended on some technical advantages which have been lost. It

is the object of the present work to supply, as far
as possible, the facts and authorities which have
hitherto been wanting, so as to enable the reader
to form a tolerably accurate notion respecting the
origin and purpose of the methods described, and
to estimate the influence of the early characteris-
tics of the art even on its consummate practice.
Whatever may be the value of the methods in
question considered in themselves, a knowledge of
them cannot fail to be, at least indirectly, useful.
It is hoped that by substituting an approach to
historical evidence for the vagueness of speculation,
and by rendering it possible for modern professors
to place themselves in the situation of their great
predecessors in regard to merely technical circum-
stances, one source of interruption, if not of dis-
couragement, in the study of the more essential
qualities of art, will be removed. At the same
time, the author trusts that details relating to the
careful processes which were familiar in the best
ages of painting will not lead the inexperienced to
mistake the means for the end; but only teach
them not to disdain even the mechanical operations
which have contributed to confer durability on the
productions of the greatest masters.

The author has, for the most part, confined
himself to the description and explanation of the

processes which were adopted at different times in certain schools, without entering into the discussion of their comparative merits. A mere collection of materials, though presented in due order, must, to a certain extent, assume an unconnected form: this will, perhaps, not be objected to by those who are chiefly desirous of verifying statements relating to practical details by documentary evidence. The minuter circumstances and descriptions adduced are to be regarded as connecting links in a chain of evidence which, especially when novel or when differing from received opinions, it was essential to fortify. As regards the interpretation of the various documents which have been brought together, the author has been careful, in all technical points, and indeed in all apparently questionable cases, to give the original passages together with his translations.

The history of oil painting divides itself into two sections; one relating to the Flemish, the other to the Italian system. The Flemish method, the investigation of which forms the subject of the present volume, necessarily precedes the other: the earliest traces of the art are found in the North, and the process which was invented or improved in Flanders was there developed with reference to a peculiar climate. The modifications

which that process underwent in Italy may be the subject of inquiry hereafter.

The original materials to which the author has had access during the prosecution of his task have been numerous: accounts of several are added in the form of notes at the end of some of the chapters, and elsewhere in the work. The National Records have furnished many hitherto unpublished and curious facts; and the author, not forgetting his obligations to the Commissioners on the Fine Arts, who supported his application to obtain extracts from these documents, takes this opportunity of thanking the authorities in the Record Offices for their valuable aid. To the officers in the British Museum, for their no less important assistance, he also begs to express his acknowledgments.

An interesting MS. (the *Mappæ Clavicula*) in the possession of Sir Thomas Phillips, Bart., has been recently published, edited by Mr. Albert Way, the Director of the Society of Antiquaries: it was desirable that the author should see this treatise some months since, before it appeared in print, and its possessor had the goodness to allow him to inspect a copy. The author is indebted to Mr. Lewis Gruner for procuring him a copy of a valuable MS. of the fifteenth century, which is preserved in the Public Library at Strassburg. Mr. Robert

Hendrie, jun., whose translation of Theophilus has just appeared, has been fortunate in bringing to light, from among the treasures of the British Museum, various other MSS. relating to painting, and has, in a very liberal spirit, pointed them out to the writer of this work. The most important is the MS. of Sir Theodore de Mayerne; the extracts which are inserted in the latter part of this volume, numerous as they are, give but an imperfect idea of the value of De Mayerne's notes. Mr. Hendrie has stated that he intends, with the permission of the Trustees of the Museum, to publish the entire work.

The inquiry proposed in regard to the history of Italian painting may hereafter be assisted by a reference to some copies of MSS. which the author owes to the kindness of Colonel Rawdon, M. P. Mrs. Merrifield, to whom the lovers of art and archæology are already indebted for her translation of Cennini and for other works, has, it is understood, succeeded in obtaining copies of several interesting documents preserved in Italian libraries: these will probably, ere long, be published; and it is believed that they will be of great assistance to the author, or to any other person better qualified for the task, in investigating the history of technical processes in Italy.

To Dr. Waagen and Professor Schlessinger of
Berlin, Director Passavant of Frankfort, Mr. An-
drew Wilson of Genoa, Mr. Kirkup of Florence, and
Mr. Penry Williams of Rome, the author begs to
offer his sincere thanks for their ready attention
to his applications.

CONTENTS.

MATERIALS

FOR

A HISTORY OF OIL PAINTING.

CHAPTER I.

INTRODUCTION. — CONNEXION BETWEEN THE EARLY
HISTORY OF PAINTING AND THAT OF MEDICINE.

IT has been justly remarked that the moderns
are indebted to religious confraternities for the
preservation of knowledge during the dark ages.
Science and art derived the elements of their new
existence, in most cases, from the cloister. In such
asylums their written materials, at least, could
survive the rudest times; and practice, however
degenerate, could scarcely fail, in its uniformity,
to preserve some useful traditions.

Among the studies which had never ceased to
be cultivated in monastic establishments, may be
classed Medicine and the Decorative Arts. The
first was of universal interest and utility; the
latter were indispensable for the construction
and embellishment of sacred edifices. For a

considerable period after the sixth century, the knowledge of medicine was almost confined to ecclesiastics, and it was to their exertions that the first schools for its study owed their origin.* Circumstances, resulting from these very facilities, afterwards led to the interference of Councils, in order to preserve the dignity of the Church; and the higher orders of the clergy were forbidden to exercise the art of healing in any form.† But this prohibition was never extended to the monks; and even when secular physicians in abundance rendered such aid superfluous, indeed even in modern times, scarcely a religious community was without its amateur practitioners, whose skill and benevolence were by no means confined to their order.

The convent had generally its dispensary; the furnishing of which involved chemical as well as botanical researches. Those monks who were painters (and during some ages monks were the

* See Sprengel, Geschichte der Arzneykunde, Halle, 1821—1828, and the authorities quoted by him, vol. ii. p. 474. After speaking of the zeal of Theodore of Canterbury, and the subsequent efforts of the English clergy in promoting these studies, he observes: "Les écoles qu'établirent ces ecclésiastiques étoient très fréquentées par les étrangers, et les savans Anglais firent éclore, principalement sous le règne de Charlemagne, les premiers germes des sciences en France et en Allemagne." — Jourdan's translation, vol. ii. p. 347.

† Sprengel, ib. The regulation was infringed without scruple. See, in the same author, the list of distinguished medical practitioners among the higher clergy.

only painters) had thus opportunities of becoming acquainted with the nature and properties of various materials fitted for their art. The empirical knowledge so obtained and recorded was indeed far from being necessarily accompanied with skill in the higher branches of design; the same principle which guaranteed tradition had rather a tendency to check invention: but the practical methods which time and religious appliances had consecrated were, under such circumstances, at least in no danger of being lost. By similar means, even the technical processes which had been at first adopted from classic sources and from the later Pagan artists may have been unintentionally preserved.*

That there should, at all times, be a connexion between medicine and painting might, perhaps, be inferred from the nature of the studies which are, to a certain extent, common to those arts. At all events, such a connexion has ever existed. This will be apparent, in the course of the present inquiry, from various circumstances. Examples of a more direct kind are not wanting. Thus, Hippocrates complained that the writings of some physicians had less relation to medicine than to the arts of design†; apparently alluding to anatomical

* A kind of wax painting, unquestionably derived from the ancient method, however now degenerate, is still practised by the painter monks of Mount Athos. See Didron et Durand, Manuel d'Iconographie Chrétienne, Paris, 1845, p. 44.

† De veteri Medicina, c. 36.; quoted by Eméric David, Recherches sur l'Art statuaire, p. 177.

works which had been too much confined to descriptions of the bones and muscles. Greek writers, speaking of the arts, employ the terms *pharmaka**, *pharmakeia*†, as synonymous either with pigments or with some substances commonly used in painting. The words *medicament*‡ and *venenum*§ are employed by the Latins in the same sense. Pliny remarks that a certain gum (tragacanth) was "useful to painters and physicians;"‖ and, speaking of the colourless Rhodian glue, observes, "painters and physicians employ it."⊥ His thirty-fifth book, in which the subject of the arts is first exclusively treated, is introduced by a short preface beginning thus. "The nature of metals, and of the substances which are produced with them, has been

* Julius Pollux, Onomasticon, l. vii. c. 28. Dion. Halic. De Compos. Verborum, c. 21.

† Plutarch, De Oraculorum Defectu : quoted by Scheffer, Graphice, Norimb. 1669. Suidas, in voc. φάρμακον, among other meanings, states that the word sometimes signified the Persian naphtha, which may have been used in painting; but, in most of the passages above referred to (to which others might be added), the terms are merely synonymous with pigments or colours.

‡ Pliny, l. ix. c. 62.; medicamentum, c. 64. As the chapters in Pliny are differently arranged in different editions, it may be necessary to state that the edition of Lemaire, Paris, 1827 —1832, is referred to in these notes.

§ Virgil, Georg. l. ii. v. 465. Scheffer, ib.

‖ " Sarcocolla ... commis utilissima pictoribus ac medicis." — L. xiii. c. 20.

⊥ " Eoque pictores et medici utuntur." — L. xxvii. c. 71.

described in the immediately preceding book, in order that the immense field of therapeutics and the mysteries of the laboratory might be duly connected with the technical subtleties of sculpture, painting, and dyeing."* The relation is here plainly acknowledged. But there was a still stronger bond of union between medicine and painting in the middle ages, when the pious votaries of those arts believed that their patron St. Luke had practised both. The author of a Byzantine manuscript on painting, after invoking the Virgin, addresses himself to St. Luke as "the learned physician," and as the artist who had wrought "in colours and in mosaic."†

In the practice of the arts of design, as in the few refined pursuits which were cultivated or allowed during the darker ages, the monks were long independent of secular assistance. Not only the pictures, but the stained glass, the gold and silver chalices, the reliquaries, all that belonged to the decoration and service of the church, were designed, and sometimes entirely executed by them‡;

* " Metallorum, quibus opes constant, agnascentiumque eis natura indicata propemodum est; ita connexis rebus, ut immensa medicinæ silva, officinarumque tenebræ, et morosa cælandi pingendique ac tingendi subtilitas simul dicerentur." Lemaire reads "fingendique;" the common reading is here preferred.

† Didron et Durand, Man. d'Icon. p. 3.

‡ See Theophilus, Diversarum Artium Schedula, introduction to the third book.

and it was not till the thirteenth and fourteenth centuries, when the knowledge of the monastery began to be shared by the world at large, that painting in some degree emerged from this fostering though rigid tuition.

The subsequent history of the art shows how close the relation continued to be between the secular painters and the experienced ecclesiastics. The cloister and the church itself were the localities where those painters chiefly worked. Their choicer materials were often prepared by their employers; and fortunate was the artist, if otherwise skilful, whose lot happened to be cast among a community celebrated above others for attainments in chemistry. Such was, for example, the advantage which Pietro Perugino enjoyed when he resided with the monks of S. Giusto alle Mura.* The description which Vasari has left of that convent, in ruins even in his time and now no longer to be traced, may throw some light on the habits of the monks at earlier periods.

"Above the chapter-house was a large room, where those fathers occupied themselves in making glass for the windows, with the furnaces and other

* The Gesuati; not to be confounded with the later Jesuits. The convent in question was demolished, together with other detached buildings near Florence, in 1529, before or during the siege by the Imperialists under Philibert de Chalons, Prince of Orange. Three altar pictures by Perugino were removed in due time, and still exist in Florence; the frescos necessarily perished.

conveniences necessary for such operations; and as Pietro, while he lived, made the cartoons for these, all the works of the monks, produced in his time, were excellent." After speaking of the beauty of the garden, and of the careful manner in which the vines were trained round the cloisters, the historian continues. "In like manner the room where, according to their custom, they distilled odoriferous waters and medicinal preparations, was furnished with every apparatus of the best kind. In short, that convent was among the most complete and best arranged in the Tuscan state; and I have been desirous to leave this memorial of it, because the greater part of the pictures which it contained were by the hand of our Pietro Perugino."*

Raphael, in one of his letters, states that the Pope

* Pietro Perugino has been commonly regarded merely as the feeble precursor of Raphael. As an inventor and designer he would doubtless be eclipsed by a comparison with less distinguished names; but his merits as a colourist, viewed even now in comparison with the master-works of art, are great. It should be remembered that those merits were in a great measure new to the world in the latter half of the fifteenth century. This accounts for the terms in which Vasari speaks of Perugino's and Francia's colouring, "I popoli nel vederla corsero come matti a questa bellezza nuova" (*Vite*, proemio alla terza parte); and explains the admiration which the works of the former excited (when he was in the zenith of his practice) throughout Europe. (Ib. *Vita di P. Perugino.*) The picture in England which is perhaps best calculated to give an idea of this artist's merit as a colourist is the early Raphael at Blenheim. That work was entirely executed under the guidance of Perugino, and, as regards its colour, resembles the best productions of the elder master.

(Leo X.) had appointed an aged friar to assist him in conducting the building of St. Peter's; and intimates that he expected to learn some "secrets" in architecture from his experienced colleague (who was indeed an accomplished professor).* The best artists were well aware of the advantage of receiving technical lessons from such authorities, and it does not appear that the knowledge which was hived in the convent (notwithstanding the term "secret") was jealously withheld. Thus, Cennini, speaking of the mode of preparing a certain colour, says that the receipt could easily be obtained, "especially from the friars."†

It was not merely by oral instruction that technical secrets were communicated: the traditional and practical knowledge of the monks was condensed in short manuscript formulæ, sometimes on the subject of the arts alone, but oftener mixed up with chemical and medicinal receipts. These collections, still more heterogeneous in their contents as they received fresh additions from other hands, were afterwards published by secular physicians, under the title of "Secreti." Several will be referred to in the course of this work. An example

* Passavant, Rafael von Urbino, Leip. 1839, vol. i. p. 533. Vasari, Vita di Frà Giocondo. Baldinucci, ib.

† Trattato della Pittura, c. 40. Written in the first half of the 15th century; first published, with notes by Tambroni, in 1821 ; translated into English, with notes, by Mrs. Merrifield, in 1844.

may here be selected, because it was composed by a friar of that same order above described, with whom Perugino so long resided; it may even have been the work of a personal friend of the artist.

The author is described in the titlepage as a " reverendo padre Gesuato pratico ed eccellente."* The collection of recipes is small, but its character agrees well with the picture which Vasari has drawn of the Gesuati of Florence. Their prior was celebrated, according to the same historian, for the excellence of his ultramarine†; and the mode of preparing that colour, as described in the compendium, bespeaks unusual care. The horticultural taste of the monks is to be recognised in some directions for growing and improving fruit-trees: cosmetic and medicinal secrets are not forgotten. ‡

* These receipts are published at the end of the *Secreti* of the reverendo Don Alessio, Lucca, 1557. The period of publication is by no means to be considered the date of the composition. There is an earlier edition of Alessio (which it has not been possible to see), and that writer states that he was eighty-two years of age before he gave his experience to the world. His book, he observes, was partly made up from earlier collections of the same kind : thus a preservative against the plague is stated to have been successful in England in 1348. The compendium of the Gesuato was probably written at the close of the fifteenth century.

† " Era . . . il detto priore molto eccellente in fare gli azzurri oltramarini."— *Vasari, Vita di Pietro Perugino.*

‡ In Alessio's compendium (and in others of the kind) is to be found the favourite receipt of the Venetian ladies : " a fare i capelli biondi come fila d' oro." Another begins : " Rimedio col quale fu guarita una donna che per farsi la bionda al

The varnishes may be noticed on another occasion; some of them confirm the authority of those published at a later period by Armenini. A mode of purifying linseed oil is important; not on account of its novelty, but because there can be no doubt, from the reputation of the Gesuati, founded on the habits which have been recorded, that it was commonly practised by the best painters in the early part of the sixteenth century. It will be described hereafter.

These earlier manuals serve to show the nature of the researches which were undertaken in the convent for the practical benefit of the arts. Various motives might induce the monks to devote themselves with zeal to such pursuits. It has been seen that their chemical studies were analogous; that their knowledge of the materials fittest for technical purposes — derived as it was from experiments which they had abundant leisure to make — was likely to be of the best kind. Painting was holy in their eyes; and, although the excellence of the work depended on the artist, it was for them to insure its durability.* By a singular combination of circumstances, the employers

sole," &c. The well-known representation in the *Costumes* of Cesare Vecellio is therefore historically correct.

* Occasional examples of the neglect of works of art by the dignitaries of the church are not forgotten; but such examples may be considered rare exceptions, and, in general, belong to the period when art was declining.

of the artists, the purchasers of pictures (for such the fraternities were in the majority of cases), were often the manufacturers of the painters' materials. Here then was another plain and powerful reason for furnishing the best prepared colours and vehicles. The cost of the finer pigments was, in almost every case, charged to the employer*; but economy could be combined with excellence of quality, when the manufacture was undertaken by the inmates of the convent.

Chemistry was still the professed auxiliary of painting, as well as of medicine, from the thirteenth to the seventeenth century. Colours and other materials, when not furnished by monks who retained the ancient habits of the cloister, were provided by the apothecary.† The most valuable

* See a letter from Benozzo Gozzoli to Pietro de' Medici, *Carteggio d' Artisti,* vol. i. p. 192.; another from Titian to the Doge (Loredano) of Venice, Ib. vol. ii. p. 142. See also various contracts in Gualandi's *Memorie originali Italiane.*

† In some accounts relating to the decoration of St. Stephen's Chapel, dated 1274 (2d of Edward I.), various colours are mentioned as having been purchased from " Roberto de Hakeneye *speciario.*" In a similar document, dated 1315, found by Vernazza in the archives of Turin, and published by him in the *Giornale di Pisa,* 1794, we find colours and painting materials " emptis a Toffredo apothecario." In a MS. of the Royal Library at Paris (hereafter to be mentioned more fully), written in 1431, we read that a certain colour " se trouve chez les apothicaires." When Francia, looking at Michael Angelo's statue of Julius II., inadvertently expressed his admiration of the bronze, the great sculptor angrily observed that he had the same obligation to the Pope for the bronze (meaning, as far

treatises on the merely technical department of the art were composed by physicians; and the alliance between medicine and painting was represented, at different times, by the friendship of Leonardo da Vinci and Marcantonio della Torre, Correggio and Giambattista Lombardi, Vandyck and Theodore de Mayerne. *

as the merit of the work was concerned), as Francia had to the apothecaries (speziali) who supplied him with colours. (*Vasari, Vita di Michelagnolo.*)

* See Vasari, Vita di Leonardo da Vinci. Pungileoni, Memorie istoriche di Antonio Allegri, vol. i. p. 19. 37. vol. ii. p. 34. Of De Mayerne hereafter.

CHAP. II.

WHATEVER connexion may have existed between the technical processes of the ancients and the moderns, the general opinion that oil painting belongs exclusively to the latter appears to be well founded. The silence of the historians of classic art on the subject, amidst frequent allusions to other modes of painting, and the absence of all incidental reference to it by the classic writers generally, may be considered conclusive. This is, however, the chief evidence against the antiquity of oil painting. It is by no means certain that the materials necessary for the process were undiscovered even at that early period when the principal artists of Greece flourished. On the contrary, it will appear that oils which are called drying (the manufacture of which must have preceded the practice of oil painting even in the warmest climates) were known certainly before the Christian era, and probably in times of remote antiquity.

Oils of this description may have been even used as the chief ingredients in the composition of varnishes for paintings and other objects. The

movable pictures of the ancients were, for the
most part, on wood, and either in tempera or in
encaustic.* Works executed in either of these
methods were, from an early period, often covered
with a durable hydrofuge varnish, which, if not
indispensable in all cases as a defence against
damp, at least served to protect the painting from
dust, and allowed of its being washed with
safety.† It will be shown, that resins dissolved in
a drying oil had, for many centuries before the
invention of the modern oil painting, been em-
ployed for such purposes; and it is quite con-
ceivable that a practice which was common among
the Byzantine artists might have been derived, as
many of their processes were, from the technical
methods of the best ages of Greece, when varnishes
of some kind were certainly in use. The well-
known description which Pliny has given of the
effect of that employed by Apelles is sufficient to
establish the general fact. The historian, indeed,

* Pliny divides the principal painters whom he enumerates
into two classes. These were, tempera painters and encaustic
painters. Having mentioned the celebrated artists in encaustic,
after the others (whose method he does not specially describe),
he proceeds to name some less prominent masters generally,
observing: " Hactenus indicatis *in genere utroque* proceribus,
non silebuntur et primis proximi." It would hardly have been
necessary to invite attention to this distinction, had not some
writers endeavoured to confine the movable paintings of the
Greeks to encaustic alone.

† The expression of Pliny, " Custodiretque a pulvere et sor-
dibus," may refer to a varnish of this kind. (L. xxxv. c. 36.)

intimates that the preparation or application of that " atramentum " * was peculiar to the great artist: but whether this referred to an improvement in the composition of varnishes, or even to their first invention, it will hardly be supposed that Apelles was the only Greek painter who employed them.

The question respecting the practice of the ancients in painting is, however, but remotely connected with the object of the present inquiry. Not so the fact that the drying oils were known before even the germs of Christian art appeared. The following references will show that the principal materials employed in modern oil painting were at least ready for the artist, and waited only for a Van Eyck, in the age of Ludius and the painters of Pompeii.

Dioscorides, whose works were familiar to medieval writers on medicine, is supposed to have lived in the age of Augustus.† He mentions two drying oils, walnut oil and poppy oil. After describing the mode of expressing the oil of bitter almonds, and after mentioning the oleum balaninum (oil of ben) ‡, he observes: " the sesamine

* It is not necessary to understand the word " atramentum," in all cases, as synonymous with black. In the treatise of Caneparius, *De Atramentis,* a chapter is headed " De Atramentis diversicoloribus." The varnish of the Byzantines was brown, from the resin which they used and from the action of the fire.

† See Kühn's Preface to his edition of Dioscorides.

‡ See Matthioli's Commentary on Dioscorides, Mantua, 1549, p. 30.

(oil) prepared from sesamum, and the caryine prepared from walnuts, are made in the same manner."* The oil of sesamum, though employed as a varnish in Japan†, cannot be called a drying oil in the usual acceptation of the term; but the description of walnut oil is conclusive; and it is to be observed that none of these materials are mentioned by the Greek author as novelties.

Speaking of the juice expressed from the seed of the black poppy, Dioscorides observes that it is easily diluted (forms an emulsion) with water; that when exposed to the sun the oil becomes separated from the mucilage, and then burns in lamps with a very clear flame.‡ Thus, whether applied to any other use than that here indicated

* Ἔλαιον σησάμινον καὶ καρΰϊνον. — Ὁμοίως δὲ σκευάζεται τοῖς προειρημένοις, τό, τε σησάμινον ἐκ τοῦ σησάμου, καὶ τὸ καρΰϊνον ἐκ τῶν βασιλικῶν καρύων συντιθέμενον. "Olea sesaminum et juglandinum. — Eodem quoque, quo antedicta, modo sesaminum oleum e sesamo, et juglandinum e nucibus juglandibus paratur." — *Dios.* l. i. c. 41., ed. curavit Kühn, Lips. 1829-30.

† Kæmpfer, quoted by Thunberg, Flora Japonica, Lips. 1784, p. 254.

‡ Κράτιστος δέ ἐστιν ὀπὸς ὁ πυκνὸς καὶ βαρύοσμος ... εὐχερῶς διειμένος ὕδατι ... ἔν τε τῷ ἡλίῳ τιθεὶς, διαχεόμενος [lectio altera, διαχριόμενος], καὶ πρὸς λύχνον ἐξαπτόμενος, οὐ ζοφώδει φλογί· φυλάσσων τε μετὰ τὸ σβεσθῆναι τὴν ἐν τῇ ὀσμῇ δύναμιν. "Præstantissimus autem est succus qui densus est et graveolens ... in aqua facilis dilutu ... sed soli expositus diffunditur [oleo obducitur], et ad lucernam accensus flamma ardet minime caliginosa: qui denique, postquam extinctus fuerit, suam odoris vim etiamnum servat." — *Dios.* l. iv. c. 65. Compare Pliny (l. xx. c. 76.), who appears to have copied the latter part of this description.

or not, it is evident that poppy oil was known to
the ancients. The same writer mentions the juice
of fresh hempseed, and speaks of decoctions of
linseed; but the oils separable from them are not
distinctly described, as in the former cases. The
use of bruised linseed is more than once recom-
mended among the medicaments of Hippocrates,
and an astringent property is ascribed to it by the
Greek physicians generally.

Galen, who wrote in the second century, observes
(speaking with reference to medicine) that linseed*
and hempseed† are in their nature drying. On the
subject of nut oil he is distinct. He remarks that
" the edible substance of walnuts is oily and light,
and the juice therefore easily expressed : the longer
the fruit is kept, the more readily this is effected.
Hence (pure) oil may be expressed from the sub-
stance when it is old." ‡

It is to be observed that, hitherto, whenever the

* Τὸ δὲ τοῦ λίνου σπέρμα ξηραίνειν (δύναται).—*In Hippocrat.
de acutor. Morbor. Victu*, l. iv. c. 95. ed. curavit Kühn, Lips.
1821—1833.

† Καννάβεως ὁ καρπὸς . . . ξηραντικός. — *De simpl. Medic.*
l. i. c. 5.

‡ Τοῦ καρύου δ' αὐτοῦ τὸ μὲν ἐδώδιμον ἐλαιῶδές τ' ἐστὶ καὶ λεπτο-
μερὲς, ὥστε διὰ τοῦτο καὶ ἐκχυλοῦται ῥᾳδίως, καὶ μᾶλλον, ὅσῳ περ
ἂν ἀποκείμενον χρονίζῃ, τοιοῦτο γίνεται. ἔλαιον γοῦν ἐκθλῖψαι
δυνατόν ἐστιν ἐξ αὐτοῦ παλαιουμένου. "Porro ipsius nucis id
quod edendo est oleosum est et tenue, itaque etiam facile ex-
primitur, et quo diutius reconditum fuerit, magis tale efficitur.
Quamobrem oleum ex eo inveterato exprimere liceat."—*De
simpl. Medic.* l. vii. c. 12.

classic writers on natural history or medicine
speak of oils (including even such as are drying),
it is always with reference to medicinal, cosmetic, or
culinary purposes. The medicinal oils enumerated
by Pliny — who belongs to the writers of the first
century—comprehend walnut oil.* It is also men-
tioned in his chapter on "artificial oil."† He speaks
merely of the juice of linseed. ‡ In his notice of
cosmetic ointments § he states that resins were
added to them to confine their perfume (to give
them body); and elsewhere observes that all resins
may be dissolved in oil ‖ : but the word *oleum*,
alone, is to be understood to mean olive oil; which
never dries. The silence of Pliny on the subject of
pictures, when speaking of resins and drying oils, is
not conclusive against the antiquity of the oil var-
nish. Modern writers on physics, not uninformed

* "[Oleum] e nuce vero juglande, quod caryinum appellavi-
mus." — L. xxiii. c. 36.

† "Fit [oleum] e nucibus juglandibus, quod caryinon vocant."
— L. xv. c. 7. It is not quite clear what the term "oleum facti-
tium," at the commencement of this chapter, means. Some of
the preparations are merely infusions in olive oil, but others are
distinct oils. Pliny infers that such were unknown in Cato's
time (nearly two centuries before the Christian era), because
that writer speaks of olive oil only. (*De Re rustica.*) This
is disproved by the mention of various other oils by Hippo-
crates, and by the ancient manufacture of still different oils
in Egypt. (*Galen, De simpl. Medic.*, l. vi. c. 5.)

‡ L. xx. c. 92.

§ L. xiii. c. 1.

‖ "Resina omnis dissolvitur oleo." — L. xiv. c. 25.

on the subject of painting, sometimes enlarge on the uses of oils without ever alluding to their being employed in the arts of design. The oleum cicinum (Ricinus communis *L.*), one of the Egyptian oils mentioned by Dioscorides * and others, was used by the painters of the twelfth century as a varnish; this is proved by the following passage in the *Mappæ Clavicula.* "To render a Picture water-proof. — Spread the oil called cicinum over the picture in the sun; thus it is fixed so that it can never be effaced." †

The object of the above quotations is to show that drying oils were known at an early period, and that the chief ingredients necessary for the composition of an oil varnish, and even the modes of preparing oleo-resinous mixtures, were familiar. The next step is more important.

Aetius, a medical writer of the fifth and beginning of the sixth century, at length mentions a drying oil in connexion with works of art. After speak-ing of the oleum cicinum, he proceeds to the

* L. i. c. 38.

† "Ut pictura aqua deleri non possit. — Oleo, quod appel-latur cicinum, super picturam ad solem perunge, et ita con-stringitur ut nunquam deleri possit." — Cap. cv. The title *Mappæ Clavicula* appears to mean a "key to drawing." The copy of this interesting MS. in the possession of Sir Thomas Phillipps, Bart., was written in the twelfth century; the method is therefore at least as old as that date. The oil in question (castor oil), according to Brande (*Manual of Chemistry*), when exposed to air, thickens, and at length solidifies; it is, therefore, a drying oil.

description of linseed oil, — now first distinctly
mentioned, — and observes that it is prepared in the
same manner; that its (medicinal) uses are the
same, and that it had superseded the other.*
Almost immediately after this he mentions walnut
oil as follows. " Walnut oil is prepared like that
of almonds, either by pounding or pressing the
nuts, or by throwing them, after they have been
bruised, into boiling water. The (medicinal) uses
are the same : but it has a use besides these, being
employed by gilders or encaustic painters; for it
dries, and preserves gildings and encaustic paint-
ings for a long time."†

This hitherto unnoticed passage is remarkable

* Λινοσπέρμινον ἔλαιον.—Καὶ ἐκ τοῦ λινοσπέρμου δὲ σκευάζεται
ἔλαιον ὡς τόδε προείρηται, καὶ χρῶνται αὐτῷ νῦν ἀντὶ τοῦ κικίνου,
τὸ γὰρ κίκινον οὐκέτι κομίζεται, ἀλλὰ τοῦτο ἀντ᾽ αὐτοῦ κομίζουσιν.
"Oleum Seminis Lini.— Sed et ex lini semine oleum præparatur
quo modo prædictum est ; et usus ejus jam est pro cicino, nam
cicinon non amplius affertur sed hoc pro ipso afferunt." — Aetii
Amideni Libror. medicinal. &c., Gr. Ven. 1534, l. i. voce E.
Per Janum Cornarium Latine, &c. Lugduni, 1549.

† Ἔλαιον καρὑϊνον. — Ὁμοίως τῷ ἀμυγδαλίνῳ καὶ τοῦτο σκευά-
ζεται, ἢ κοπτομένων καὶ πιεζομένων, ἢ εἰς ὕδωρ ζέον ἐμβαλλομένων
μετὰ τὸ κοπῆναι. ἁρμόττει δὲ τοῖς αὐτοῖς. περιττὸν δὲ ἔχει τὸ
χρησιμεύειν τοῖς χρυσοῦσιν ἢ ἐγκαίουσι, ξηραίνει τε γὰρ, καὶ πολὺν
χρόνον συνέχει τὰς χρυσώσεις καὶ ἐγκαύσεις. "Nucis oleum simi-
liter ut amygdalinum præparatur, nucibus aut tusis et expressis,
aut post contusionem in aquam ferventem conjectis. Commodum
est in eosdem quoque usus. Insuperque hoc privatim habet
quod inaurantibus aut inurentibus conducit. Siccat enim, et ad
multum tempus inaurationes ac inustiones continet et adservat."
— Ib.

on many accounts. The Greek writer had mentioned linseed oil in the same page, yet he speaks of nut oil as if it were exclusively employed in the arts. It thus appears that in the fifth century the drying property of linseed oil was either unknown or disregarded: but the passage establishes the fact, that, at that period, oil varnishes were used for gilt ornaments and for pictures. As regards the application on gilt surfaces, the practice is exemplified by a reference to subsequent writers. Mordants for gilding, composed of drying oils and other ingredients, appear to have been somewhat late inventions, and are mentioned by Cennini*: but the treatise on various arts published by Muratori from a manuscript at Lucca†, that of Eraclius‡, that of Theophilus§, and the Byzantine manuscript lately edited by MM. Didron and Durand ‖, all these speak only of glutinous mordants. The nut oil mentioned by Aetius was therefore used *upon* gilt ornaments as a varnish, not underneath the gilt as a mordant. Eraclius is distinct on this point also;

* Trattato della Pittura, c. 91. 151. &c.

† Antiquitates Italicæ medii Ævi, vol. ii. fol. ed.

‡ De Coloribus et Artibus Romanorum. Published by Raspe, in his Critical Essay on Oil Painting. London, 1781.

§ Diversarum Artium Schedula. First published, in part, by Raspe; recently at greater length, with a French translation, by De l'Escalopier, Paris and Leipzig, 1843; and now about to be published entire, from a newly discovered copy, with an English translation and notes, by Mr. Hendrie.

‖ Manuel d'Iconographie Chrétienne. Paris, 1845.

he mentions the application of varnish to gildings.*
It is therefore clear that an oil varnish, composed
either of inspissated nut oil or of nut oil combined
with a dissolved resin, was employed on gilt sur-
faces and pictures, with a view to preserve them,
at least as early as the fifth century. It may
be added, that a writer who could then state, as
if from his own experience, that such varnishes
had the effect of preserving works "for a long
time," can hardly be understood to speak of a new
invention. Leonardo da Vinci, writing a thousand
years after Aetius, recommends, as a varnish, nut
oil thickened in the sun.†

After the sixth century, as before observed, the
practice of medicine, and that of painting also,
remained for a long period almost exclusively in
the hands of the monks. The Lucca manuscript
above referred to, published by Muratori, is placed
by Mabillon in the time of Charlemagne.‡ That
treatise acquires a new interest from the im-
portant passage above quoted from Aetius. The

* " Quomodo vernicietur aurum ne perdat colorem. — Si
aurum super gypsum positum verniciare volueris, non de puro
vernicio, sed de illo colore qui efficitur ad aurumpetrum faci-
endum, mixto tamen cum oleo modico vernicio, ne sit spissum
nimis, vernicietur super aurum." — *Erac. De Col. et Art. Rom.*
Cennini, on the contrary, directs that gilt ornaments are not to
be varnished.

† Trattato, Roma, 1817, p. 256.

‡ The emperor died at the age of seventy-one, in 814. The
" time of Charlemagne " was therefore chiefly in the eighth
century.

monks may be supposed to have had leisure to make experiments with the oils; and, guided perhaps by the strong expressions of the early Greek medical writers on the siccative quality of linseed, they had now ascertained that the oil which it furnished was at least as drying as the customary nut oil. A varnish, composed of linseed oil (lineleon)* and a needless variety of resins, with which gums even appear to be intermixed, is described in the Lucca document†, while nut

* "Lineleon ex semine lini fiet," are the words of the MS.

† The orthography, as given by Muratori, is here preserved. "De Lucide ad lucidas. Super colores quale fieri debet. Lineleon ÷ ᵃ 4 tereventina ÷ 2 galbanum ÷ 2 larice ÷ 3 libanum ÷ 3 murra ÷ 3 mastice ÷ 3 veronice ÷ 1 gumma cerasi ÷ 2 flore puppli ÷ gumma amygdalina ÷ 2 resina sappini ÷ 2 quæ pisande sunt pisa et grilela et cum superius mitte in gabata auricalca. Et mitte in forniculiclo et sine flamma coce ut non exeat foras et post cola cum linteo mundum. Et si radaverint, decoque; et usque dum spissa fiant, et qualibet opera picta aut scarpilata inlucidare super debeas. Et pone ad sole. Desicca illam."

Translation. — "Mixture of transparent substances, forming a varnish to be applied to coloured surfaces. Linseed oil 4 parts, turpentine resin 2, galbanum 2, larch resin 3, frankincense 3, myrrh 3, mastic 3, amber or sandarac 1, cherry-tree gum 2, (?) 1, almond-tree gum 2, fir resin 2. Pound and sift the dry materials, and put the whole, with the oil above mentioned, in a bronze vessel. Place the vessel on a furnace; let the fire be without flame, that the ingredients may not boil over. Afterwards strain through linen. If the composition be too

ᵃ As the sign ÷ is common to all the ingredients, any quantity may be assumed.

oil is nowhere mentioned in it. The age of Charlemagne was an era in the arts; and the addition of linseed oil to the materials of the varnisher and decorator may thus, on the above evidence, be assigned to it.

From this time, and during many ages, the linseed oil varnish, though composed of simpler materials (such as sandarac and mastic resin boiled in the oil) *, alone appears in the recipes hitherto brought to light. An unsuccessful attempt, hereafter to be mentioned more particularly, was made in the fourteenth century, to introduce nut oil in painting; but that vehicle, after having been so long discarded, appears to have been first restored to some share of favour by Van Eyck, in the beginning of the fifteenth century. Thenceforward the (nut or linseed) oil varnish, as distinguished again from varnishes composed of resins dissolved in essential oils, still continued to be exclusively used till the close of the fifteenth, or beginning of the sixteenth, century; when the Italians, who had already adopted a different system from the first improvers of oil painting, began to employ the essential oil varnishes.

thin, boil again till it becomes thickened. This mixture is to be employed as a varnish on any work in painting or sculpture. Place the work, when varnished, in the sun to dry." Even allowing for the effect of the liquid resins, the proportion of oil is so small in this composition that the varnish, after boiling, must have been of the thickest kind.

* Mappæ Clavicula, c. 25.

The treatises of the twelfth and thirteenth centuries have a peculiar interest; since they may be considered to represent the state of the art at the period when Cimabue adopted it from the Greeks : but the same general methods, inherited from Agnolo Gaddi by Cennini, reappear (in the *Trattato della Pittura* of the latter), but little altered, as regards oil painting, in the early part of the fifteenth century.

This slow progression is only to be explained by the traditional estimation in which tempera was held; for, if we place ourselves in the situation of the painters of the fourteenth century, it will appear, from the facts that have been adduced, that a fund of experience, greater than has been generally supposed to exist, was then accessible. The vague impression that prevailed, at the revival of letters, respecting the buried knowledge of antiquity, stimulated inquiries into the writings of classic authors. Van Eyck, according to a contemporary Italian historian*, consulted such authorities with profit; and the friars who studied medicine applied themselves with fresh ardour to the works of Dioscorides, Galen, and their

* Bartolommeo Facio (commonly Latinised into Facius) wrote his work *De Viris illustribus*, in 1456 ; it appears to have been first published in 1745. Speaking of Van Eyck, he observes : "Putaturque ... multa de colorum proprietatibus invenisse, quæ ab antiquis tradita, ex Plinii et aliorum auctorum lectione didicerat."

followers. Some experiments and observations
applicable to the humbler technicalities of painting,
which occur in the works of those writers, may
not have escaped notice at a time when inven-
tion was everywhere on the alert, and when that
spirit was compatible with utmost veneration for
the ancients.

The following directions for rendering oil colour-
less are given by Dioscorides. " Oil is bleached in
this manner. Select it of a light colour, and not
more than a year old; pour about five gallons
into a new earthenware vessel of an open form,
place it in the sun, and daily at noon dip and pour
back the oil with a ladle, beating up its surface till,
by constant agitation, it is thoroughly immixed and
made to foam." The oil is to be thus treated for
several days; the ingredients afterwards added
(macerated Trigonella and resinous pine-wood
shavings) are unimportant; but in conclusion it
is observed, if " the remainder " of the oil (the
aqueous portion being evaporated) " be not
sufficiently bleached, place it again in the sun,
repeating the above operation, till it becomes
colourless." *

* Ἔλαιον λευκόν. — Λευκαίνεται δὲ ἔλαιον οὕτω. λαβὼν τὸ τῇ
χρόᾳ μὲν λευκὸν, τὴν ἡλικίαν δὲ μὴ πλέον ἐνιαυσίου, ἔγχεε εἰς
κεραμοῦν ἀγγεῖον πλατύστομον καινόν, ἔστωσαν δὲ μέτρῳ κοτύλαι
ρ'. εἶτα θεὶς ὑφ' ἥλιον ἀνάχει κόγχῳ καθ' ἑκάστην ἡμέραν κατὰ τὸ
μέσον, ὑψόθεν τῇ καταφορᾷ χρώμενος, ἵνα τῇ συνεχεῖ κινήσει καὶ
πληγῇ μεταβάληται καὶ ἀφρίσῃ. τῇ δὲ ὀγδόῃ ἡμέρᾳ βρέξας τήλεως

It is by no means improbable that the directions in Cennini for bleaching and thickening linseed oil in the sun may have been derived from this source.* Dioscorides is twice mentioned by Vasari as an authority proverbial among the votaries of natural history and the healing art; the biographer even informs us that Antonio Veneziano, who, he observes, was a follower of Agnolo Gaddi (Cennini's master), quitted the practice of painting

καθαρᾶς ⊲ ν΄ ἐν ὕδατι θερμῷ, ἔμβαλε μαλακὴν γενομένην εἰς τὸ προειρημένον ἔλαιον χωρὶς τοῦ σταγγίσαι τὸ ὕδωρ. προσαπόδος δὲ καὶ δαλὸν πιτυΐνης ὡς ὅτι λιπαρώτατον καὶ εἰς λεπτὰ κατεσχισμένον τὰς ἴσας ὁλκὰς καὶ οὕτως ἔασον ἄλλας ὀκτὼ ἡμέρας διελθεῖν. μετὰ δὲ ταύτας ἀνάχει τῷ κόγχῳ τὸ ἔλαιον. τὸ δὲ λοιπόν, εἰ μὲν εἴη τοῦ τέλους τετευχὸς εἰς καινὸν ἀγγεῖον — κατεράσας ἀποτιθέσω. — εἰ δὲ μὴ πάλιν ἐν ἡλίῳ θετέον αὐτό. καὶ ἐργαστέον ἄχρις οὗ λευκὸν γένηται. — *Dios.* l. i. c. 32.

"Oleum candidum.—Candidum redditur oleum sequenti modo. Sumito album colore nec anniculo vetustius, et in fictile novum lati oris infundito centum heminarum mensura. Dein soli expositum quotidie circa meridiem concha refundito, ex alto deturbans, ut continua motitatione et concussione agitatum mutetur et spumescat. Octava die fœnum Græcum purgatum drachmarum quinquaginta pondere aquaque calida maceratum atque adeo remollitum, aqua interim neutiquam expressa, in supradictum oleum conjicito. Insuper addito tædam pineam perquam pinguem et in tenues assulas concisam pari pondere, itaque dies alios octo elabi sinito. His transactis concha oleum denuo confundito. Quod superest, si finem assecutum fuerit, in vas novum — defundito ac recondito. Sin autem nondum (candorem contraxerit) oleum rursus insolandum et opus ipsum repetendum donec candidum evaserit."

* Trattato, c. 92. The passage will be given in another chapter; examples of the same practice in the time of Rubens will also be referred to.

for that of medicine, in consequence of studying Dioscorides.*

The efficacy of certain ingredients in accelerating the drying of oils was also known to the ancients. Information on this subject was open to the early oil painters in the following observations of Galen: " Litharge dries like all the other metallic medicinal preparations†; " and elsewhere, "white lead and litharge are astringent and drying." ‡ A medical writer of the fourth century writes thus. " Place some [olive] oil in a new vessel, and put it over a moderate fire, then add well ground litharge, sprinkling it little by little with the hand; stir constantly till the oil begins to thicken."§ These passages are specimens of many such in ancient medical authors (beginning with Hippocrates) relating to the siccative quality of metallic oxides. It is, therefore, surprising that Theophilus, probably residing in Germany, and representing the

* Vasari, Vita di Antonio Veneziano. This painter appears to have been too old to be a scholar of Agnolo Gaddi (*Lanzi,* v. i. p. 41.), but it is at least certain that he lived about the same time. He was at work in the Campo Santo, at Pisa, in 1387.

† Λιθάργυρος ξηραίνει μὲν ὥσπερ καὶ τᾶλλα πάντα τὰ μεταλλικὰ — φάρμακα. — *De simpl. Med.* l. ix. c. 3. § 17.

‡ Ψιμύθιον γοῦν καὶ λιθάργυρος στύφει καὶ ξηραίνει. — *De Method. medendi,* l. iii. c. 4.

§ "Oleum mittes in ollam novam et calefacies leni flammâ vel potius igne; tunc mittes sed paulatim de manu aspergens lythargyrum bene tritum et assidue spathomela agitabis, quousque oleum — aliquantum spissescat."—*Marcellus, De Medicamentis,* &c. Bâle, 1536.

northern followers of the Byzantine school, should have complained that linseed oil, mixed with the colours, was too long in drying *, when such well-known remedies for the evil were at hand.

* "Diuturnum et tædiosum nimis est."— *Div. Art. Sched.* l. i. c. 27.

CHAP. III.

EARLIEST PRACTICE OF OIL PAINTING.

In the preceding chapter it has been shown that walnut oil (probably thickened in the sun to the consistence of a varnish) was employed in the fifth century to protect paintings and gilt surfaces; and that a varnish, in which linseed oil was a chief ingredient, was used for similar purposes in the eighth century. It has been seen that the linseed oil varnish, improved and simplified in its preparation, was common in the twelfth century, at which time a thickened oil, without resin, was also employed. In neither of the documents whence these notices are taken is there any allusion to the immixture of solid pigments with the oils. The only approach to such a method consisted in tinging the varnish with a transparent yellow and spreading it over tin-foil, to imitate gold. Directions for preparing such a composition are given in two of the earliest sources above referred to, viz. the Lucca treatise, and the *Mappæ Clavicula*.* The process was com-

* The formula relating to the preparation of this lacker, ir the MS. published by Muratori, is headed "De tictio (sic) petalorum;" in the *Mappæ Clavicula*, c. 112. "Tinctio stagneæ petalæ."

mon in the thirteenth and fourteenth centuries, and
appears to have been adopted for some of the
decorations in St. Stephen's chapel at Westminster.

The earliest writers who distinctly describe the
mixture of solid colours with oil for the purposes of
painting are, Eraclius, Theophilus, Peter de St.
Audemar, and the unknown author of a similar
treatise which is preserved in the British Museum.*
To these sources are to be added some authentic
records of the thirteenth and fourteenth centuries,
which prove that the methods described in contem-
porary treatises on art were then occasionally prac-
tised. These materials furnish a criterion for fixing
the original date of certain later references to oil
painting, or rather to its primitive methods; they
show that some of those directions, though written
in the fifteenth century, were merely repetitions
of older formulæ, and consequently had no con-
nexion with the improvements introduced by Van
Eyck.

The precise chronological order of the writers
above mentioned cannot, at present, be determined.
There is also a difficulty in ascertaining whether,
and to what extent, the later copies of such MSS.
may have been interpolated. Both these questions
are, however, unimportant, in reference to the in-
quiry here proposed; inasmuch as the earliest
copies of the documents to be noticed, transcribed

* Sloane MSS. 1754.

in the thirteenth and fourteenth centuries, plainly
describe the method of oil painting.

The age of Charlemagne, it has been observed, was
an epoch in art in which remarkable technical im-
provements or changes may have taken place*; but,
according to our present data, oil painting does not
appear to have been then known. The next great
age of development was the end of the twelfth,
and beginning of the thirteenth century. At that
period oil painting, in all probability then recently
invented, was in a limited manner practised. The
Mappæ Clavicula does not allude to it. The
existing copy of that treatise — apparently the
only copy — was transcribed in the twelfth cen-
tury. The treatise itself, judging from its con-
tents, was probably first compiled at that time. If
so, the invention of oil painting may be dated soon
after, as copies of the treatises of Eraclius and
Theophilus, written in the thirteenth century,
exist in the British Museum. Assuming that
somewhat older transcripts of both these com-

* The varnish, described in the preceding chapter, which
was in use at this time, is inferior to that employed at an earlier
period, and inferior to that of the twelfth century. Nevertheless,
the elements of a sound practice in design, originally imported,
under the auspices of the emperor, from Italy, had taken root ;
and perhaps afterwards contributed to form the schools of the
Lower Rhine. A poet who lived early in the thirteenth century,
Wolfram Von Eschenbach, alludes, as if proverbially, to the
excellent painters of Maestricht and Cologne. Fiorillo, Ge-
schichte der zeichnenden Künste in Deutschland, &c. v. i. p. 419.

pendiums exist, still the close of the twelfth
century is the earliest date that can be assigned to
the authors. Raspe *, indeed, places Eraclius soon
after the time of St. Isidore of Seville, who lived
in the seventh century. For this there are no
sufficient grounds; it is only probable that he
was older than Theophilus, because the copy of
that writer's work in the British Museum, tran-
scribed early in the thirteenth century in Germany,
contains portions which are found in Eraclius.
Some of those portions are metrical; the other
existing copies of Theophilus, with the exception
of seven lines at the commencement, contain none
that are so: the metrical passages in question have
therefore the appearance of being added from a
different and an earlier source.

Two copies of the treatise by Eraclius, *De Coloribus
et Artibus Romanorum*, are familiar to the antiquary.
One, formerly at Cambridge, and now in the British
Museum †, appears to have been transcribed in the
latter half of the thirteenth century; it was pub-
lished, not very accurately, by Raspe. The other,
which is more complete, is in the Royal Library at
Paris; it was transcribed by Jehan Le Begue in
1431, apparently from a copy by an earlier com-
piler, Alcherius, who is to be traced from 1382
to 1411. The treatise, like that of Theophilus,
is divided into three books; the first two are

* A Critical Essay on Oil Painting, London, 1781, p. 35.
† Egerton MSS. 840. A.

metrical, the third is in the form of the usual compendiums of the middle ages, from which collections of " Secreti " were afterwards printed. The notices relating to oil painting are in the third book: they are clearly descriptive of the method in both copies; the earlier MS. is, for the present, followed.

When Eraclius speaks of oil for painting, linseed oil is always to be understood. In the Paris MS. it is distinctly mentioned, "accipe oleum de lini semine factum," and " tritum cum oleo lini." Nut oil is also mentioned; but with reference only to the polishing of marble. The following is his description of the preparation of the surface of stone for painting:—

" If you wish to paint on a column, or on a stone slab, first dry it perfectly in the sun, or by means of fire. Then take white lead, and grind it very finely with oil on a piece of marble. Spread the white with a broad brush two or three times over the column, which is [supposed to be] already quite smooth and even, without any cavities. Afterwards prime with stiff white, applying it with your hand or with a brush, and let it remain awhile. When it is tolerably dry, pass your hand with some pressure over the surface, drawing your hand towards you, and continue to do this till the surface is as smooth as glass. You may then paint upon it with any colours mixed with oil. If you wish to imitate the veins of marble on a general tint (brown, black, or any other colour), you can give the appearance

when the ground so prepared is dry. Afterwards varnish in the sun."*

The preparation of the surface of wood for painting is thus described: —

"First plane the wood perfectly, rubbing the surface at last with shave-grass. If the wood is of such a nature that its roughness cannot be reduced, or if you have reasons for not wishing so to reduce it and at the same time are not desirous to cover it with leather or cloth, grind dry white lead on a slab, but do not grind it so finely as if you were to paint with it. Then melt some wax on the fire; add finely pulverised tile and the white lead already ground; mix together, stirring with a small stick; and suffer the composition to cool. Afterwards, with a hot iron, melt it into the cavities till they are even, and then with a knife scrape away inequalities. And should you be in doubt whether it is advisable to mix the white lead with wax, know

* "Quomodo preparatur columpna ad pingendum. — Si vis aliquam columpnam vel laminam de petra pingere, in primis optime ad solem vel ad ignem siccare permittes. Deinde album accipe et cum oleo super marmorem clarissime teres. Postea illam columpnam, jam bene sine aliqua fossula planam et politam, de illo albo cum lato pincello superlinies duabus vel tribus vicibus. Postea imprimes cum manu vel brussa de albo spisso et ita dimittes paululum. Cum vero modicum siccatum fuerit, cum manu tua album planando fortiter retrahes; hoc tam diu facies donec planum sit quasi vitrum. Tunc vero poteris desuper de omnibus coloribus et cum oleo distemperatis pingere. Si vero marbrire volueris super colorem, vel brunum, vel nigrum, vel alium colorem, cum siccata fuerit [superficies] marbrire poteris. Postea vernicia ad solem."

that the more you mix the harder it will be. The surface being smooth, take more white, finely ground with oil, and spread it thinly, with a brush adapted for the purpose, wherever you wish to paint: then let it dry in the sun. When dry, add another coat of colour as before, rather stiffer, but not so stiff as to make it necessary to load the surface; only let it be less oily than before; for great care is to be taken never to let the second coat be more fat [than the first]. If it were so, and at the same time abundant, the surface would become wrinkled in drying. And now, not to omit anything that belongs to the subject, I return to the first preparation of the surface of the wood. If, then, the panel on which you intend to paint is not even, cover it with leather made of horse-skin, or with parchment." *

The observation respecting the cause, or one of

* " Quomodo aptetur lignum antequam pingatur.—Quicumque aliquid lignum ornare diversis coloribus satagis, audi que dico. In primis ipsum lignum multum rade, equalem et planissimum radendo et ad ultimum fricando cum illa herba que dicitur Asperella. Quod si ligni materies talis fuerit ut non possis equare ejus asperitates, vel non velis propter aliquas occasiones, nec tu cum corio illud velis cooperire vel panno, album plumbum teres super petram siccum sed non tamen quantum si inde impingere velis. Deinde ceram in vase super ignem liquefacies tegulamque tritam subtiliter albumque plumbum quod ante trivisti simul commisces, sepius movendo cum parvo ligno et sic sine refrigerari. Postea aliquod ferrum fac calidum et cum ipso ceram funde in ipsas caverniculas donec equales sint et sic cum cutello desuper abrade ea que sunt scabrosa. Si autem plum-

the causes, of a wrinkled and shriveled surface, is not unimportant. Oil, or an oil varnish, used in abundance with the colours over a perfectly dry preparation, will produce this appearance: the employment of an oil varnish is even supposed to be detected by it.* The immixture of mucilage (as in newly expressed oil) produces the same effect, if the work be allowed to dry slowly; but, in the old process of preparing oil for painting by exposing it to the sun, the aqueous portion was entirely separated or evaporated. As regards the effect itself, the best painters have not been careful to avoid it. Parts of Titian's St. Sebastian (now in the Gallery of the Vatican) are shriveled; the Giorgione in the Louvre is so; the drapery of the figure of Christ in the Duke of Wellington's "Correggio" exhibits the same appearance; a Madonna and Child by Rey-

bum miscere dubitas cum cera, scito quod quantum plus miscueris tanto durius erit. Et sicut dixi jam equale facto habundancius plumbum valde subtilissime tritum cum oleo desuper per totum ubicumque pingere vis tenuissime extendendo cum pincello sic aptato. Deinde ad solem exsiccari bene permitte. Ac cum siccatus fuerit color, iterum superpone sicut prius fecisti de eodem et spissiorem pones sed non ita spissiorem ut habundanciorem colorem superponas sed ut oleum minus habeat. Nam et in hoc multum cavendum est ut nunquam crassiorem colorem superponas, quod si feceris et habunde posueris cum exsiccari ceperit rugæ desuper erunt. Nunc autem ut ea que supersunt simul omnia dicam, superius, quæso, me redire permitte ubi de ligni nuditate loquutus sum; si illud corio vel panno operire volueris. Quod si lignum quod pingere vis non fuerit equale, corio equino vel pergameno operi illud."

* Merimée, De la Peinture à l'Huile, Paris, 1830, p. 31.

nolds, at Petworth, is in a similar state, as are also parts of some pictures by Greuze. It is the reverse of a cracked surface, and is unquestionably the less evil of the two.* The varnishes mentioned by Eraclius will be noticed in another chapter. A yellow lacker (auripetrum or auripentrum), corresponding with the "tinctio petalorum" of the earlier treatises, was, like that, intended as a glazing over metal foils.

The treatise of the monk Theophilus is entitled *Diversarum Artium Schedula.* As before stated, it appears to have been compiled at the close of the twelfth century. Numerous copies exist; the different readings of several have been compared together in the interesting publication of M. de l'Escalopier.† The copy in the British Museum (which was not known to him, having been only recently brought to light) appears to be the most complete, if not the most ancient, transcript extant.‡ The following passages relate to oil painting : —

* The result in question may have been promoted in some instances by first passing a quickly drying medium thinly over the surface to be covered. When this begins to adhere, the oily colour which is spread over it, drying from the bottom, becomes wrinkled on its surface. Glazing on this, as exemplified in some of the examples referred to, has a certain mossy texture. It is, however, hardly to be supposed that such an appearance, though sometimes well calculated to render certain effects, was ever produced systematically or intentionally.

† Théophile, Prêtre et Moine, Essai sur divers Arts, publié par le Cte. Charles de l'Escalopier. Paris, 1843.

‡ This copy is about to be published, with a translation and notes by Mr. Robert Hendrie, jun.

" Take linseed and dry it in a pan, without water, on the fire. Put it in a mortar and pound it to a fine powder ; then, replacing it in the pan and pouring a little water on it, make it quite hot. Afterwards wrap it in a piece of new linen; place it in a press used for extracting the oil of olives, of walnuts, or of the poppy, and express this in the same manner. With this oil grind minium or vermilion, or any other colour you wish, on a stone slab, without water; and with a brush paint over the doors or panels which you wish to redden, and dry them in the sun. Then give another coat, and dry again. At last give a coat of the gluten called vernition, which is thus prepared." The varnish will be described hereafter.*

Tin-foil being stained and varnished to imitate gold (in the mode before noticed) : " Take any colours which you wish to apply, grinding them carefully in linseed oil, without water; and prepare tints for faces and draperies, as you did before

* " Accipe semen lini et exsicca illud in sartagine super ignem sine aqua. Deinde mitte in mortarium et contunde illud pila donec tenuissimus pulvis fiat, rursusque mittens in sartaginem, et infundens modicum aquæ, sic calefacies fortiter. Postea involve illud in pannum novum, et pone in pressatorium in quo solet oleum olivæ, vel nucum, vel papaveris exprimi, et eodem modo etiam istud exprimatur. Cum hoc oleo tere minium sive cenobrium aut quem alium colorem vis super lapidem sine aqua, et cum pincello linies super ostia, vel tabulas quas rubricare volueris, et ad solem siccabis. Deinde iterum linies, et rursum siccabis. Ad ultimum vero superlinies ei gluten quod vernition dicitur, quodque hoc modo conficitur."— L. i. c. 20.

in water colours ; distinguishing, according to your fancy, animals, birds or foliage, with their proper colours." *

" All kinds of colours may be ground in the same kind of oil and applied on wood, but only on such objects as can be dried in the sun. For, having applied one [coat of] colour, you cannot add another until the first be dry, which in images [figures] and other paintings is too long and tiresome." † It is here to be observed, that, if the oil employed by Theophilus was unusually long in drying, the little care which he seems to have taken in expressing it may have been partly the cause. The commonest precaution would suggest that a press used for olive oil must be quite unfit for the preparation of a good drying oil.

" All colours employed on wood, whether ground in oil or in gum [water], should be applied in three successive coats. The painting being thus completed, place it in the sun, and carefully spread over it the gluten vernition. When this begins to flow with the [sun's] warmth, rub it gently with your

* "Accipe colores quos imponere volueris, terens eos diligenter oleo lini sine aqua, et fac mixturas vultuum ac vestimentorum sicut superius aqua feceras, et bestias sive aves aut folia variabis suis coloribus, prout libuerit." — L. i. c. 26.

† " Omnia genera colorum eodem genere olei teri et poni possunt in opere ligneo, in his tantum rebus quæ sole siccari possunt, quia quotiescunque unum colorem imposueris, alterum ei superponere non potes nisi prior exsiccetur, quod in imaginibus et aliis picturis diuturnum et tædiosum nimis est." — L. i. c. 27.

hand. Do this thrice, and then let it remain till it is thoroughly dry." *

" There is also a kind of painting on wood which is called translucid, or, by some, golden; it is produced as follows. Take a sheet of tin-foil, — not varnished nor tinged with yellow, but in its natural state, and carefully polished, — and line with it the surface which you wish to paint. Then, having varnished the foil, grind colours very finely with linseed oil, and spread them extremely thin with the brush; so let the work dry." †

Some of the practices in these primitive directions for oil painting were continued, not without reason, in the best periods of art; particularly the habit of allowing the under painting to dry thoroughly and even in the sun, before finishing, and finally before varnishing. The latter practice was universal. When Vasari observes that Van Eyck placed a varnished picture in the sun to dry " according to

* " Omnes colores sive oleo sive gummi tritos in ligno ter debes ponere, et pictura perfecta et siccata, delato opere ad solem diligenter linies glutine illud vernition et cum defluere cœperit a calore, leniter manu fricabis, atque tertio sic facies, et tunc sine donec penitus exsiccetur." — L. i. c. 28.

† " De Pictura translucida. — Fit etiam pictura in ligno quæ dicitur translucida, et apud quosdam vocatur aureola, quam hoc modo compones. Tolle petulam stagni non linitam glutine nec coloratam croco sed ita simplicem et diligenter politam, et inde cooperies locum quem ita pingere volueris. Deinde vernitiata petula tere colores imponendos diligentissime oleo lini, ac valde tenues trahe eos cum pincello; sicque permitte siccari." — L. i. c. 29.

custom" (come si costuma), it must be acknow-
ledged that he was literally correct; for the process
seems to have been common from the eighth
century.*

It has been supposed that both Eraclius and
Theophilus were of some country north of the
Alps. The latter uses German words to explain
his Latin †, and Cennini (of whom hereafter) ex-
pressly says that oil painting was much practised
by the Germans. It was also known in France at
an early period. This is proved by the MS. of
Peter de St. Audemar, in the Royal Library at
Paris. The document is contained in a volume of
similar treatises (among which are the more com-
plete copy of Eraclius above mentioned, and a
portion of the treatise of Theophilus) transcribed,
as already stated, in 1431, by Jehan Le Begue.‡

Peter de St. Audemar was a Frenchman, and an
ecclesiastic; his treatise has internal evidence of
being nearly coeval with that of Theophilus. The
passages relating to oil painting are numerous; as
the author, after describing various colours, gene-
rally mentions the medium with which they are to
be mixed, according to their applications for illumi-

* Compare the passages relating to this practice, in the pre-
sent chapter, with that before given from the Lucca MS.

† "Deinde habeas ferros graciles et latiores ... qui sint in una
summitate tenues et acuti, in altera obtusi, qui vocantur *meizel*
[Meiſſel, chisel]." — L. iii. c. 71.

‡ Translations of these various MSS. are about to be pub-
lished by Mrs. Merrifield.

nating (on parchment), for painting on wood, or on walls. For example: —

" White [lead], having been first dried, should be ground in, and mixed with, wine for illuminating on parchment; with oil for painting on wood and on walls. In like manner, grind and mix green [verdigris] with oil for wood, but on walls with wine, or if you prefer it, with oil." *

Blue " apply on walls with water and with egg, but on wood with oil." †

Minium " for walls is ground with gum water, never with egg; it may, however, be tempered with egg for parchment; if used on wood it should be mixed with oil." ‡

Black use " on walls with water or with egg, on wood with oil." § The varnishes in this MS. will be noticed elsewhere.

With this treatise may be classed a similar one in the British Museum ‖, written in the fourteenth

* " Sumptum autem et arefactum album teratur et temperetur cum vino et pingetur in pergamenis, et cum oleo in lignis et in maceriis. Similiter virideum cum oleo teres et distemperabis et operaberis in lignis sed in maceria cum vino vel si mavis cum oleo."

† " Hunc colorem [azurum] cum aqua et cum ovo in maceria pones, in ligno vero cum oleo."

‡ " Ponendo ipsum [minium] in maceriis teritur cum aqua gummata nunquam cum ovo. In pergamenis vero poni potest cum ovo distemperatum, sed in lignis cum oleo."

§ " [Nigrum] in maceriis ... vel cum aqua vel cum ovo, et in lignis cum oleo."

‖ Sloane MSS. 1754.

century, but treating of a practice in art as early as that described by Theophilus. It is mixed up, as usual, with medical notes, and is thus introduced: " Incipit Tractatus de Coloribus Illuminatorum seu Pictorum." The early date of the writing, as compared with that of the MS. of St. Audemar, furnishes an additional proof of the antiquity of that treatise ; the formulæ in both frequently resemble each other, for example:—

" Use blue on walls with water or with wine, but on wood with oil." *

" Grind white [lead] with wine for parchment, but with oil for wood and for walls. In like manner grind and temper green [verdigris] with oil for wood, and with wine for walls, or, if you prefer it, with oil. .. But for books do not grind it, but suffer it to dissolve in good and very clear white wine." †

In these and the former examples the rule of Theophilus seems to be kept in view ; when wood is to be painted, oil is recommended for all colours, because movable panels could be dried in the sun; Theophilus even directs that painted doors should be so dried. White lead and verdigris only are

* " Hunc colorem [azorium] in maceria cum aqua et cum vino pones in ligno vero cum oleo."

† " Teres album cum vino et pingetur percamenis, cum oleo vero in lignis et maceriis. Similiter virideum cum oleo teres et distemperabis in lignis, et in maceriis cum vino vel si mavis cum oleo In libris vero non teres sed in vino bono albo et clarissimo ... temperare permittes."

mixed with oil for walls; because such pigments, being themselves dryers, insured desiccation without the aid of the sun's heat. Minium, which generally dries well, appears to be an exception, as it is directed to be used on walls with gum water; its siccative quality is, however, uncertain.* It is also not impossible that the ancient practice may have been retained, of covering walls so painted with a coat of wax, in the mode prescribed by Vitruvius (l. vii. c. 9).

The MS. last quoted contains some portions in French, and probably, like that of St. Audemar, was composed in a French convent. The treatises cannot be placed later than the end of the thirteenth, or beginning of the fourteenth, century. This was the age of Dante, and "the art which was in Paris called illuminating" (limning) is well illustrated by such guides. Several of the MSS. in the collection of Alcherius relate to this art; others on the same subject are in the British Museum and in private libraries. Missal-painting was the occupation most generally followed in convents before the fifteenth century, and it is not surprising that so many directions relating to it should exist.

From what has been stated, it might be inferred

* "La mine, si vous la destrempez sur la palette seulement avec le cousteau, ne seiche que difficilement; mais si vous la broyez sur la pierre avec l'huyle avant que de l'employer, elle seichera assez tost." — *De Mayerne, Sloane MSS.* 2052.

that oil painting of a limited description must have
been practised in Italy at this time. Of this there
is sufficient evidence. Lorenzo Ghiberti states that
Giotto occasionally painted in oil.* Again, accord-
ing to a document found by Vernazza in the
archives of Turin, a Florentine painter, named
Giorgio d'Aquila, contemporary with Giotto, was
employed in 1325, by the Duke of Savoy, to paint
a chapel at Pinarolo.† The artist was furnished
with a large quantity of nut oil for the purpose;
but the oil, from some cause or other, did not
answer, and consequently, as the document states,
was sent into the ducal kitchen.‡ A failure of

* " Costui [Giotto] fu copio in tutte le cose, lavorò in muro,
lavorò a olio, lavorò in tavola, lavorò di musaico," &c. A por-
tion of the MS. of Ghiberti was published by Cicognara (*Storia
della Scultura,* vol. iv.) who gives a description and critique of
it. The MS. itself is now in the Magliabecchian Library at
Florence.

† See a letter, addressed by Baron Vernazza to the Padre
Guglielmo Della Valle, in the *Giornale di Pisa,* 1794.

‡ " Idem libravit in trayta octo raporum oley nucum expenditi
in castro Pinarolii per manus magistri Georgii pinctoris in
pingendo capellam dominy et eciam pro parte in cochina
[coquina] per manus Nicolini de Mancheto et Ansermeti pro
parte per litteras domini de testimonio et confessione datas
die VIII. Augusti MCCCXXV. quas reddit. Et fuit expaidi-
tum dictum oleum inchina [in coquina] pro parte, ut supra per
confessionem prædictorum Nicolini et Ansermeti, quia non
erat sufficiens in pingendo capellam."— Ib. Eight *rubbj* are
equal to 200 lb. The expression " non erat sufficiens " relates
therefore not to the quantity, but the quality, of the oil. It is
worthy of notice that an English sculptor, "Magister Guglielmus
Anglicus," is mentioned in the same documents, as having used

this kind was perhaps an exception, but it partly explains the observation of Theophilus, that oil painting was chiefly applicable to surfaces which could be dried in the sun. In an attempt to paint with ill-prepared nut oil, without siccative ingredients, and probably in a damp chapel, the process of drying may have appeared so hopeless as to induce a not unreasonable prejudice against the method. There were other objections of a different kind (to be noticed hereafter), which must have tended to limit the application of oil painting.

Among Italian documents of this time, in which oil appears together with materials for painting, the particulars relating to the decoration of the chapel of S. Jacopo, at Pistoja (1347), should not be forgotten. We there find the following entries: — "For eleven oz. of linseed oil, soldi I. den. VIII. For one lb. of giallolino, soldi VIIII. For three lb. of linseed oil, soldi V. For four hundred leaves of fine gold, lire XI. soldi VIII. For one lb. of varnish, soldi VI. "* &c. Professor Branchi, who analysed

a large quantity of wax (334 lb.), in executing a whole length model, "pro facienda una ymagine," of the Countess of Savoy. The date is 1356.

* "Pro undecim onciis ᵃ olei lini seminis die s. [supradicta], lib. — s. I. d. VIII. Pro una libra giallolini die s. lib. — s. VIIII. d. —. Pro tribus libris olei lini seminis die s. lib. — s. V. d. —. Pro quadringentis petiis aurei fini die s. lib. XI. s. VIII. d. —. Pro una libra vernicis die s. lib. — s. VI. d. —," &c.— *Ciampi, Notizie inedite della Sagrestia Pistoiese,* Firenze, 1810, p. 146.

ᵃ Oil is still sold in Italy by weight, not by measure.

the remains of the colours taken from the chapel, found no trace of oil in them, but ascertained, on the contrary, that the binding vehicle was glutinous. He therefore concluded that the oil above mentioned had been used for some inferior decoration.*

Whatever may have been the purposes for which it was considered fit, it is clear from the foregoing statements that oil painting was sometimes employed in Germany, France, and Italy, during the fourteenth century, if not before. That it was also practised in England at the same periods, there is abundant proof. The only question, as regards its early use, both in this country and elsewhere, is, to what kinds of decoration it was applied.

Perhaps no public records contain so many notices relating to operations in painting in the thirteenth and fourteenth centuries, as those which are preserved in this country. Many have been published, but it is supposed that as many yet remain to be brought to light. The frequent mention of oil, among the materials for painting, in those records, has led many inquirers hastily to conclude that it was used in all cases for tempering the colours. This by no means follows; it has been seen that oil was certainly employed at a much earlier period in the composition of varnishes. The

* Ib., Append. p. 15.

following general references — though the documents have been consulted with a view to the present object only — will give some idea of the quantity of existing materials relating to the early English practice of art.

In 1239 (23d of Henry III.) oil is mentioned in connexion with painting. Similar notices appear in numerous account-rolls belonging to the reign of Edward I., viz. from 1274 to 1295; and in others dated 1307, the 1st of Edward II. Another series exists in the records of Ely Cathedral, the dates extending from 1325 to 1351. A great number of the same kind are preserved in accounts belonging to the reign of Edward III., and relating to the decoration of St. Stephen's Chapel, from 1352 to 1358. Partial translations (unfortunately without the original text) of some of the last-mentioned records have been published in Smith's *Antiquities of Westminster.** The extracts made by that writer relate to glass-painting, architecture, and decorations generally. Of certain weekly accounts (belonging to the reign of Edward I.), amounting originally to one hundred and forty-two in number, he states that he had found eleven only.†
In the course of a recent investigation, forty-four have been discovered. However interesting in other points of view, these numerous documents throw but little light on the practice of oil paint-

* London, 1837. † Ib., p. 76.

ing. The same materials constantly reappear, but there is no direct allusion to their use, except as regards the process of varnishing. Such passages as the following refer to the commonest operations of this kind : —

"To the same [Stephen Le Joigneur] for varnishing two coffers, 8*d.*;"* and elsewhere, "To Richard de Assheby for preparing with white, covering with ochre, and varnishing the King's Chamber, according to contract, 32 shillings."† A few specimens of the mandates and accounts above adverted to, beginning with those of the thirteenth century, will therefore suffice. The first in order of time is familiar to many, having been originally published by Walpole.

1239. "The King to his treasurer and chamberlains. Pay from our treasury to Odo the goldsmith and Edward his son one hundred and seventeen shillings and ten-pence for oil, varnish, and colours bought, and for pictures executed in the Queen's Chamber at Westminster, from the octaves of the Holy Trinity [May 25th] in the 23d year of our reign, to the feast of St. Barnabas [June 11th] in the same year, namely, for fifteen days." ‡

* "Eidem [Stephanno le Joignur] pro vernicione ii. coffrorum viii. d."

† "Richardo de Assheby pro dealbacione ocriacione et vernacione camere Regis ad tascham xxxii. s."

‡ "Rex thesauriario et camerariis suis salutem. Liberate de thesauro nostro Odoni aurifabro et Edwardo filio suo centum

It is here necessary to remark, in anticipation of the inquiry respecting varnishes, that the word *vernix* or *vernisium*, in the earlier notices of painting, does not mean a fluid composition, but dry sandarac resin, which, when melted and boiled with oil, formed a varnish, in the modern sense of the term. The proofs of this will be given hereafter. It may be sufficient here to observe, that, in the English accounts, the quantity of varnish is always noted by weight, and that of oil by measure. The above passage should be translated " for oil, sandarac resin, and colours." It will be seen, that the order relates to the work of fifteen days only; but it does not follow that the oil varnish was used upon pictures, or operations in painting, then executed. In the portion of time specified some works may have been varnished and others prepared for it. The date of this mandate is a year before the birth of Cimabue.

In 1259, Master William, the painter, with his assistants, received forty-three shillings and ten-pence for painting a Jesse (no doubt the usual genealogical tree of Christ) on the mantel-piece of the King's Chamber (the Painted Chamber), and " for renovating and *washing* the paint-

et septemdecem solidos et decem denarios pro oleo, vernici, et coloribus emptis, et picturis factis in camerâ reginæ nostræ apud Westm. ab octavis Sanctæ Trinitatis anno regni nostri XXIII. usque ad festum Sancti Barnabe apostoli, eodem anno, scilicet per XV. dies."

ings on the walls of the said chamber."* This supposes that these celebrated works, consisting chiefly of subjects from the Old Testament and from the Apocrypha, were varnished. Size paintings, without such a protection, would hardly have been proof against this "ablution." The *tempera*, composed chiefly of yolk of egg, is firmer than size, and becomes very solid in time; but the coloured remains of the Painted Chamber (the varnish probably having become decomposed from damp during the lapse of ages) easily yielded to the sponge when they were examined in 1819.†

In the period from 1274 to 1277 (2d to 5th of Edward I.), an account, apparently relating to the Painted Chamber, contains the following items:— "To Reymund, for seventeen lb. of white lead, II. s. x. d. To the same, for sixteen gallons (?) of oil, XVI. s. To the same, for twenty-four lb. of varnish, XII. s. . . . To Hugo le Vespunt, for eighteen gallons of oil, XXI. s." &c.‡ Again: To Reymund, for a hundred [leaves] of gold, III. s. To the same, for twenty-two lb. of varnish, XI. s.

* "Magistro Willelmo Pictori cum hominibus suis circa Jesse in Mantell. camini Regis depingendum et circa picturam parietum ipsius camere Regis innovandam et abluendam, XLIII. s. x. d."

† See Gage Rokewode's Account of the Painted Chamber, 1842, p. 15.

‡ "Reymundo pro XVIII. li. albi plumbi II. s. x. d. Eidem pro XVI. gal. olei XVI. s. Eidem pro XXIIII. li. verniz XII. s. . . . Hugoni le Vespunt pro XVIII. gal. olei XXI. s."

I. d." * Elsewhere: "To Robert King, for one cartload of charcoal for drying the painting in the King's Chamber, III. s. VIII. d." † The last entry appears to relate to the drying of surfaces painted in oil, but the precaution may also have been necessary before varnishing tempera. The application of heat, even before painting in oil, according to the directions of Eraclius, will here be remembered: "Ad solem vel ad ignem siccare permittes." It can hardly escape observation, that the practice of oil painting taught by Eraclius agrees in many details with that exemplified in the English records; and the circumstance may warrant a supposition that he composed his treatise in this country.

1289 (17th of Edward I.). The following materials are enumerated in an account relating to repairs in the Painted Chamber. "White lead, varnish, green, oil, red lead, tin-foil, size, gold leaf, silver leaf, red ochre, vermilion, indigo, azure, earthen vessels, cloth," &c. ‡

* "Reymundo pro C. auri III. s. Eidem pro XXII. li. verniz XI. s. I. d."

† "Roberto King pro I. carecta carbonis ad picturam in Camera Regis desiccandam III. s. VIII. d."

‡ "In albo plumbo, vernicio, viridi, oleo, plumbo rubeo, stangno albo, cole [Fr. colle], auro, argento, sinople, vermilone, ynde, asura, ollis, panno et aliis minutis emptis ad viridandam novam Cameram de petra et ad emendaciones picture mangne Camere Regis sicut patet per particulas. Summa XII. li. VI. s. VI. d. ob." This extract is given in the work last quoted, but with some inaccuracies; for example, ranno for panno, and in the heading, verniorum for verinorum. There is no punc-

In 1292, oil and varnish are twice mentioned in a similar account.* In 1307, in consequence of a fire (which occurred in 1298), repairs were again undertaken, and similar materials were used.

The records of Ely are more conclusive as to the immixture of oil with the colours; and, as the materials are nearly the same as in the above extracts, it may be inferred that oil painting of some kind was employed at Westminster. Of this, indeed, there are other proofs.

1325. Among the items of an account, three flagons and a half of oil are mentioned " for painting the figures upon the columns."† The term " ymagines," in these and other English records of the time, is used indiscriminately for painted figures and for statues. In the treatise of St. Audemar the latter are distinguished as " ymagines rotunde." There can be little doubt that, in the above passage, painted figures were meant; and, in any case, oil colours were used.

In 1336, in a similar account, oil appears in

tuation in the original account-rolls, but vernicio viridi should not have been connected. It would be unjust to point out these trifling oversights in an important and interesting work, without, at the same time, paying a tribute of respect to the memory of one who so often distinguished himself as an accurate and intelligent investigator.

* "Item in III. quarteronis olei empti. Summa IX. d. In I. lb. vernicio [sic] empt. Summa IIII. d. In ocra, plastro, filo et pelli emptis," &c.

† " In III. lagenis et dimid. olei pro ymaginibus super columnas depingend. III. s. VI. d."

abundance, forty-eight flagons altogether; and this may explain its absence in other entries, where colours and other materials are mentioned without oil. It should also be observed that, if, in mutilated documents, "varnish" appears alone, it may always be inferred that the oil (without which the *vernix*, or sandarac, was of no use) was originally included in the list of materials. In the last-mentioned account columns were to be painted.*

In 1339 and 1341 oil again appears; in the account of the former date "for tempering the colours." †

In 1351 oil is mentioned "for making the painting in the chapel." ‡ In all these documents, when varnish is included in the items, the quantity, as usual, is noted in weight.

The last accounts in the general list before given (1352—1358) relate to St. Stephen's Chapel.

* "Item in $\frac{xx}{vii}$ iv. lib. albi plumbi empt. de eodem xii. s. prec. i. d. In xiii. lagenis olei empt. de Thoma d'Elm x. s. iii. d. ob. prec. lagen. x. d. ob. In vi. lagenis olei empt. de Thoma de Cheyk iv. s. xi. d. prec. lagen. x. d. In xxviii. lagenis et dimid. olei empt. de Nich. de Wickam xxvi. s. i. d. ob. prec. lagen. xi. d. In dimid. lagen. olei empt. v. d. In vas terren, pro oleo imponendo iv. d. quad. In i. longa corda empt. pro le chapital deaurand. et columpn. depingend. viii. d.," &c.

† "In xxxi. lagenis et dimid. olei empt. de quodam nomine de Wickham pro coloribus temperandis xxi. s. prec. lagen. viii. d.," &c.

‡ "In oleo empt. pro pictura facienda in capella x. s.," &c. The above extracts relating to Ely Cathedral will be found in the *Archæologia*, vol. ix.

They are very numerous; but, as already observed, they afford no additional light respecting the particular applications of oil painting. In other respects they are of great interest; and, like those of the time of Edward I., indicate a practice in art corresponding in almost every particular with that described by Cennini.

The large supplies of oil which appear in the Westminster and Ely records, indicate the coarseness of the operations for which oil was required. The quantity supplied to Giorgio d' Aquila, at Pinarolo, has excited the surprise of Italian antiquaries*; but it now appears that contemporary examples, quite as remarkable, are to be found in English documents. Such notices as the following (not the only entries of the kind) at least remove all doubt as to the nature of the oil sometimes used, and the general purposes for which it was provided. The extracts relate to St. Stephen's Chapel. Sept. 19. 1352 (25th of Edward III.):—" For nineteen flagons of painters' oil, bought for the painting of the chapel, at 3s. 4d. the flagon, 43s. 4d." † March 19. 1353: — "To Thomas Drayton, for eight flagons of painters' oil, bought for the painting of

* See a letter from the Padre Guglielmo Della Valle, in the *Giornale di Pisa*, 1794. He endeavours to show, notwithstanding the plain expression, "non erat sufficiens in pingendo," that the oil may have been used for lamps.

† " Die Lune xix. Septembris. In xix. lagenis olei pictorum emptis pro pictura capelle precium lagene iii. s. iiii. d. xliii. s. iiii. d."

the chapel, at 2s. 6d. the flagon, 20s." * May 13, in the same year: — " To John de Hennay, for seventy flagons and a half of painters' oil, bought for the painting of the same chapel, at 20d. the flagon, 117s. 6d." † Contrasting with this lavish use of oil, we find such entries as the following: — " To Gilbert Pokerig, for two flagons of size, bought for the painting of the said chapel, 2d. To the same, for two earthen vessels for heating the size, three halfpence." ‡ Eggs, which afforded the vehicle for the finer work in tempera, are not mentioned: this may, however, be accounted for either by the incompleteness of the records of this period, or by the nature of the work, as the item occurs in earlier documents, hereafter to be noticed, belonging to the reign of Edward I. (1274). It will be observed that the price of the oil used in St. Stephen's Chapel varies, and that sometimes it is more than three times the price of that employed at Ely about the same time. The expression " painters' oil," applied to the former, may explain this. It had been probably purified and deprived of its mucilage by exposure

* " Die Lune xix. die Marcii. Thome Drayton pro viii. lagenis olei pictorum emptis pro pictura capelle precium lagene ii. s. vi. d. xx. s."

† " Die Lune xiii. die Maii. Johanni de Hennaij pro lxx. lagenis et di. olei pictorum emptis pro pictura ejusdem capelle precium lagene xx. d. cxvii. s. vi. d."

‡ " Die Lune xix. die Marcii [1353]. " Gilberto Pokerig pro ii. lagenis de cole emptis pro pictura dicte capelle ii. d. Eidem pro ii. ollis terreis emptis pro cole calefaciendo i. d. ob."

to the sun, in the mode then generally practised
for the preparation of linseed oil which was to serve
for better kinds of painting (on surfaces where it
was desirable to produce a gloss), and for the
composition of varnishes. This appears the more
likely, as the oil was sometimes purchased of the
(then) principal painter, Hugh of St. Alban's. *

In reviewing these various documents, and others
of the kind, it will not be difficult to determine the
modes in which oil was used among the materials
for painting. First, it was employed in the com-
position of varnishes; probably also as a mordant for
gilding; and, further, for a certain kind of glass-
painting, which will be described in the next chapter.
Next, as at Ely and Westminster, and as the direc-
tions of Eraclius and others prove, it was used from
first to last in painting walls, columns, stone, and
wood. Lastly, the proofs of its having been em-
ployed for pictures, in the modern sense of the term,
are less distinct, and are not numerous. The paint-
ing of the chapel at Ely, and the figures (*ymagines*)
on the columns, may have been of this kind. In
referring to the treatises before quoted, it will
be seen that Eraclius, when describing the mode of

* " Die Lune xxv. die Julii [1352]. Eidem [Magistro Hugoni
de Sancto Albano] pro xiii. lagenis olei pictorum emptis pro
pictura dicte capelle precium lagene iii. s. iiii. d. xliii. s. iiii. d."
The same quantity, at the same comparatively high price, is
entered on the 19th of September following. That extract has
been already given.

painting columns, does not distinctly allude to any
designs upon them; on the contrary, in entering
into details, he speaks only of imitations of marble
on the painted surface. So, when he describes the
preparation of the surface of wood for oil painting,
he begins, " if you wish to adorn any panel with
different colours," without the least allusion to any
design.* The only indication of a higher kind of
art is where he recommends fastening leather or
parchment over the panels, as a ground (when duly
prepared) for oil painting. This evinces greater
care than would be necessary for ordinary deco-
ration. Such a parchment preparation, covered
with a gesso or plaster of Paris ground, is some-
times found in English tempera pictures of the
fourteenth century. The darkly varnished Byzan-
tine pictures are frequently painted on leather
glued to the wood. A similar material (pellis) is
mentioned, together with size and gesso, in an

* It is to be remembered that the question here relates to
designs in oil colours, not in tempera. When designs are re-
ferred to in the Westminster accounts, the material with which
they were executed (or to be executed) is not specified; for
example: " Magistris Hugoni de Sancto Albano et Johanni
de Coton pictoribus operantibus ibidem super protractatura
diversarum ymaginum in eadem capelle per IIII.ᵒʳ dies et dimi-
dium infra idem tempus utroque ipsorum capiente per diem
XII. d. IX. s." Elsewhere we read, " Magistro Hugoni de Sancto
Albano pictori operanti ibidem super ordinacione picture
diversarum imaginum per II. dies," &c. The date is July,
1352.

account above given, dated 1292: but such a
preparation is mentioned by Eraclius incidentally,
as a possible, but almost unnecessary, expedient
for securing a smooth surface. On the whole,
therefore, although his observations bespeak more
knowledge of the mere process than is to be met
with in contemporary or immediately succeeding
writers, the evidence contained in his treatise re-
specting the application of that process to painting,
properly so called, may be considered inconclusive.

Theophilus, though by his own confession dis-
satisfied with the method, describes its somewhat
higher applications more clearly, when he speaks
of depicting various objects on an imitation of
a gold ground (tin-foil stained and varnished).
Among the colours to be prepared for the work,
he mentions " tints for faces;" and, as the foil
ground, probably occupying all the panel, was first
varnished, the whole of the superadded painting
must have been in oil. This passage in Theo-
philus — with the important words " mixturas
vultuum,"— and the records of Ely Cathedral, are
the strongest proofs hitherto found of the entire
execution of pictures in oil in the thirteenth and
fourteenth centuries. The arguments that have
been adduced by various writers, in favour of pre-
tended oil pictures belonging to those periods,
may be passed over ; as it has been found impossible,
in some cases, to distinguish between a painting
executed with oil colours and a tempera picture

which may have imbibed the oil varnish. The execution in oil of certain subordinate portions of works in tempera may have been more general, as it was certainly common in Italy. For examples of this practice it will be necessary to consult those authors who, though writing early in the fifteenth century, still recorded the processes of a former age.*

* The claims of different nations to what has been called " antiquity of ignorance " are of little importance ; but it is clear, from the documents which have been adduced in this chapter, that, as regards the mere process, and without reference to its application, oil painting was more generally and successfully employed in England than elsewhere, during the thirteenth and fourteenth centuries. This may be another reason for supposing some connexion to have existed between Eraclius, who appears to be the oldest writer on oil painting, and the country where his directions were most commonly put in practice.

CHAP. IV.

OIL PAINTING DURING THE LATTER PART OF THE FOURTEENTH CENTURY.

THE documents coming under the class above adverted to, and now proposed to be examined, are, the *Trattato della Pittura* of Cennini; a Venetian MS. in the British Museum; and such portions of the Byzantine MS. before mentioned as have internal evidence of antiquity.

With regard to the date of the first, Cennini himself informs us that he had studied for twelve years with Agnolo Gaddi (who died about the year 1387). He further states that the methods which he communicates had been taught him by that painter; he might have added, perhaps with truth, that they were derived, through Taddeo Gaddi, from Giotto. The precise period when Cennini committed his experience to writing is, therefore, of little importance. It is certain that a considerable part of his life belongs to the fourteenth century, and that his treatise professedly describes the practice of a master of that age. According to the copy which was published by Tambroni (a transcript of the eighteenth century), the work was completed in 1437, in the debtors' prison in Florence. This, it has been observed,

is no proof that Cennini's original MS. was not written earlier. The oldest and best copy known, that in the Ricciardi Library at Florence, has no such date.

The "fourth part" of this treatise contains passages relating to oil painting. As an introduction to these, it will be proper to advert to some directions of Eraclius not hitherto noticed. It may have been remarked that that writer does not, like Theophilus, restrict oil painting to such surfaces as could be dried in the sun. On the contrary, he gives directions for the painting of columns, which, it is to be supposed, were in the interior of churches. Indeed he does not complain that the process of drying was in any case "long and tedious." It might, therefore, be concluded that he used a drying oil, in the modern sense of the term: accordingly, in the copy of his treatise in the Le Begue collection, a drying oil is thus described : —

" How to render Oil fit for mixing with colours. —Put a moderate quantity of lime into oil and boil it, skimming occasionally ; add white lead according to the quantity of oil ; place it in the sun for a month or more, stirring often. Know that the longer it remains in the sun the better it will be. Afterwards strain, and keep, and mix the colours with it." *

* " De Oleo quomodo aptatur ad distemperandum colores.— Calcem in oleo mensurate pone et illud despumando coque.

That this passage was not inserted by Le Begue (1431) is evident from his giving a translation of it among some formulæ in French, collected from various sources, at the end of his volume. The question whether it may have been added by Alcherius, towards the end of the fourteenth or beginning of the fifteenth century, may possibly be determined hereafter by a reference to other MSS. of Eraclius, should such exist. An expression in the earlier copy (thirteenth century), now in the British Museum, at least indicates the use of an oil thickened by exposure to the air; " de crasso oleo poteris verniciare." But the use of such a medium is hardly sufficient to account for the application of oil painting, according to his directions, in situations where, it seems, the oil of Theophilus and that of Giorgio d' Aquila would not dry. It is therefore probable that he used a siccative ingredient in preparing his oil; and white lead, the substance mentioned in the Le Begue MS., might first suggest itself, as its effects were constantly witnessed.

The immixture of a small quantity of lime with the oil, as directed in the above receipt, is remarkable, as the same ingredient was employed at Leyden (as will be shown hereafter) in the seven-

Cerosium in eo secundum quod de oleo fuerit pone, et ad solem per mensem vel eo amplius frequenter removendo pone. Scito quod quanto diutius ad solem fuerit tanto melius erit. Postea cola et serva et colores inde distempera."

teenth century, expressly for the purpose of neutralising the oleic acid. It should be observed that, in the older process, the white lead, acting as an alkaline oxide, would render the previous treatment with lime unnecessary.

The Italian system, from first to last, was less complicated; precautions to insure drying being less requisite in a warm climate: but the thickening of the oil, by long exposure to the sun, was an almost universal practice. In the semi-resinous state which the fluid was thus suffered to attain, it had the (desired) effect of producing a gloss on the pigments with which it was mixed. From the same cause, however, it was rendered unfit, as a vehicle, for finer work. This thick consistence of the oil — the result not of accident, but of choice — seems, indeed, to be the chief reason why oil painting was long confined to inferior operations. The consideration of this subject will be resumed.

Cennini thus introduces the subject of oil painting : —

" C. LXXXIX. *How to paint in oil on walls, on panels, on iron, or on whatever surface you please.* — Before I proceed further, I will teach you to paint with oil on walls, or on panels (the method is much employed by the Germans), and also on iron and on stone. First we will speak of walls.*

* " CAP. LXXXIX. *In che modo si lavora a olio in muro, in tavola, in ferro, e dove vuoi.*

" Innanzi che più oltre vada, ti voglio insegnare a lavorare

" C. xc. *Preparation of walls for painting in oil.*
—Spread mortar over the wall as you would for
painting in fresco, except that, whereas you then
covered portions only at a time, you are now to
cover the whole surface intended for your work.
Then draw in your subject with charcoal, and fix
the design with ink or with verdaccio [a dull
green] duly tempered. Then take a little size,
well diluted. A whole egg, beaten in a porringer
with the milky juice of the fig-tree, is still better.
Add to the egg a glassful of clear water. Then,
either with a sponge or with a soft and broad
brush, pass it once over all the surface to be painted,
and leave it to dry at least for one day.*

" C. xci. *How to prepare an oil fit for tempering
colours, and also fit for mordants, by boiling it over
the fire.* — Among the useful things which you
require to know, you should be acquainted with the
mode of preparing this oil, which is used for mor-

d'olio, in muro o in tavola (che l'usano molto i Tedeschi), e, per
lo simile, in ferro e in pietra. Ma prima diremo del muro."

* " CAP. xc. *Per che modo dei cominciare a lavorare in muro
ad olio.*

"Ismalta in muro a modo che lavorassi in fresco : salvo che,
dove tu smalti a poco a poco, qui tu dei smaltare distesamente
tutto il tuo lavoro. Poi disegna con carbone la tua storia, e
fermala o con inchiostro o con verdaccio temperato. Poi abbia
un poco di colla bene inacquata. Ancora è miglior tempera
tutto l'uovo sbattuto con lattificio del fico in una scodella ; e
mettivi in su 'l detto uovo un migliuolo d' acqua chiara. Poi, o
vuoi con ispugna o vuoi col pennello morbido e mozzetto, daine
una volta per tutto 'l campo che hai a lavorare ; e lascialo
asciugare almen per un dì."

dants, and for various purposes. Take, then, a pound (or two, three, or four pounds) of linseed oil, and put it in a new pipkin; if it be a glazed one so much the better. Procure a small furnace with a round aperture, into which the pipkin should be nicely fitted, so that no flame may come up through the opening; for the fire would presently be attracted by the oil, and you would run the risk of burning the house as well. When you have prepared your furnace, put a moderate fire in it; as the more slowly the oil boils the better it will be. Let it boil till it be reduced one half; it will then be duly prepared. But, for mordants, add to it, when it is thus reduced, an ounce of liquid varnish (which should be good of its kind and clear) for every pound of oil. This oil is good for mordants.*

" C. XCII. *How to prepare good and perfect oil, by*

* " CAP. XCI. *Come tu dei fare l' olio buono per tempera, e anche per mordenti, bollito con fuoco.*

"Perchè delle utili cose che a te bisogna sapere, sì per mordenti sì per molte cose che s'adovra, ti conviene saper fare quest' olio; imperò togli una libra, o due o tre o quattro, d'olio di semenza di lino, e mettilo in una pignatta nuova; e s' è invetriata, tanto è migliore. Fa un fornelletto, e fa una buca tonda, che questa pignatta vi sia commessa a punto, che 'l fuoco non possa di sopra; perchè 'l fuoco vi anderebbe volentieri, e metteresti a pericolo l'olio, e anche da bruciare la casa. Quando hai fatto il tuo fornello, e piglia un fuoco temperato: chè quanto il farai bollire più adagio, tanto sarà migliore e più perfetto. E fallo bollire per mezzo, e sta bene. Ma per far mordenti, quando è tornato per mezzo, mettivi per ciascuna libra d'olio un' oncia di vernice liquida, che sia bella e chiara; e questo cotale olio è buono per mordenti."

baking it in the sun.—Oil may be prepared in another mode : it is thus more fit for colouring, nevertheless the fire is indispensable in preparing oil for mordants. Put linseed oil in a bronze or copper vessel, and in July or August keep it in the sun ; and, if you leave it so exposed till it be reduced one half, it will be perfect for colouring [that is, colourless in itself]. In Florence I have found it to be of the best possible quality.*

" C. XCIII. *How to grind colours in oil, and to use them on walls.* — Grind every colour separately, as you did for working in fresco, except that, as you then ground them with water, you now grind them with this oil [that is, the thickened oil which has just been described] ; and, when you have ground the various colours (for every colour can be used in oil except prepared lime), put them in small vessels provided for the purpose, either of tin or lead. If you cannot procure such, use glazed vessels, and in them place the colours which you have ground ; keeping them in a box, that they may remain clean. Then, when you wish to paint a drapery with three gradations of colour in the

* " CAP. XCII. *Come si fa l' olio buono e perfetto, cot.. al sole.*

"Quando tu hai fatto quest' olio, il quale si cuoce ancora per un altro modo (ed è più perfetto da colorire ; ma per mordenti vuol essere pur di fuoco, cioè cotto), abbi il tuo olio di semenza di lino : e di state mettilo in un catino di bronzo o di rame, o in bacino. E quando è il sole lione, tiello al sole ; il quale, se vel tieni tanto che torni per mezzo, è perfettissimo da colorire. E sappi, che a Firenze l' ho trovato il migliore e 'l più gentile che possa essere."

manner before explained, keep the tints separate, and with minever pencils lay them in their places, carefully uniting them; the colour being tolerably solid. Then leave the work for some days; and, resuming it when it is dry, go over the surface again as may be required. Paint flesh in the same manner, and any thing you may wish to represent, mountains, trees, or other objects. Provide a tin or leaden platter about the depth of a finger's breadth, like a lamp; half fill it with [common] oil, and keep your brushes in it, that they may not dry.*

" C. xciv. *How to paint in oil on iron, on panels, and on stone.*—And in the same manner paint on iron, on any stone surface, or on panels; always

* " Cap. xciii. *Siccome dei triare i colori ad olio, e adoperarli in muro.*

" Ritorna a ritriare, o vero macinare, di colore in colore, come facesti a lavorare in fresco; salvo dove triavi con acqua, tria ora con questo olio. E quando li hai triati, cioè d' ogni colore (chè ciascheduno colore riceve l' olio, salvo bianco sangiovanni), abbi vasellini dove mettere i detti colori di piombo o di stagno. E se non ne truovi, togli degl' invetriati, e mettivi dentro i detti colori macinati: ripongli in una cassetta, che stieno nettamente. Poi con pennelli di vajo, quando vuoi fare un vestire di tre ragioni, siccome t'ho detto, compartiscili e mettili ne'luoghi loro: commettendo bene l' un colore con l' altro, ben sodetti i colori. Poi sta alcun dì, e ritorna, e vedi come son coverti, e ricampeggia come fa mistieri. E così fa dello incarnare, e di fare ogni lavoro che vuoi fare: e così montagne, arbori, ed ogni altro lavoro. Poi abbia una piastra di stagno o di piombo, che sia alta d' intorno un dito, siccome sta una lucerna; e tiella mezza d' olio, e quivi tieni i tuoi pennelli in riposo, chè non si secchino."

giving a coat of size first. The same process is to be adopted for painting on glass, or on any other substance." *

It is plain that, as regards the mere methods, there is nothing in the above directions essentially different from those of Eraclius ; and when Cennini remarks that oil painting was much employed by the Germans, he intimates that, at the time he wrote, it was less common in Italy. The terms " Tedeschi" and " Fiamminghi" were often used indiscriminately by the Italians, but the above allusion to the Germans (taken in either sense) can only be understood to refer to their practice in the fourteenth century. Had Cennini been indebted, however indirectly, to Van Eyck, his treatise would have contained some notice of an improved system, instead of a repetition of the formulæ which had been long received. The immixture of liquid varnish in boiled oil, he expressly says, was only intended to prepare it as a mordant. That he should speak of no dryer for the oil to be used in painting (whereas the later copy of Eraclius mentions white lead) may be explained by the difference of climate : and it is to be observed that the immoderate use of such materials, at a later period, in Italy, was confined to those painters who aimed at great

* " CAP. XCIV. *Come dei lavorare ad olio in ferro, in tavola, in pietra.*

" E per lo simile in ferro lavora, e ogni pietra, ogni tavola, incollando sempre prima ; e così in vetro, o dove vuoi lavorare."

expedition. Cennini indeed mentions both white lead and verdigris, but only as ingredients to assist the drying and consolidation of cements and mordants: of the strong siccative power of the latter he was well aware; for example, after describing a composition of boiled oil, varnish, white lead, and verdigris, he adds: " If you wish this mordant to last [that is, to remain adhesive] for a week before gilding, put no verdigris; if you wish it to last four days, put a little verdigris; if you wish the mordant to be good for a day only, put much verdigris." * He remarks that gilding preserved its lustre well upon it; probably because the air was excluded.

It is remarkable that, notwithstanding the general reference to flesh-painting, " e così fa dello incarnare," in Cennini's directions, there are no certain examples of pictures of the fourteenth century, in which the flesh is executed in oil colours. This leads us to inquire what were the ordinary applications of oil painting in Italy at that time. It appears that the method, when adopted at all, was considered to belong to the complemental and merely decorative parts of a picture. It was employed in portions of the work only, on draperies, and over gilding and foils. Cennini describes such operations as follows. " Gild the surface to be occupied by the drapery; draw on it what orna-

* Trattato, c. 152.

ments or patterns you please; glaze the unorna-
mented intervals with verdigris [here used for the
sake of the colour] ground in oil, shading some folds
twice. Then, when this is dry, glaze the same
colour over the whole drapery, both ornaments and
plain portions."* Again: "Cover with silver foil
the portion to be occupied by the drapery; draw
the folds and ornaments after you have burnished
the silver ground (for this burnishing is always
necessary); glaze vermilion, mixed with yolk of
egg, either over the unornamented intervals, or
over the ornaments. Then, when this is dry, glaze
fine lake, ground in oil, once or twice over the
vermilion portions only, thus relieving crimson or-
naments on a silver ground [or vice versa]."†

These operations, together with the gilt field
round the figures, the stucco decorations, and the
carved framework, tabernacle, or *ornamento* itself
of the picture, were completed first: the faces (and
hands), which in Italian pictures of the fourteenth
century were always in tempera, were added after-
wards, or at all events after the draperies and

* " Ad idem, mettere il campo d' oro, disegnarvi il lavoro che
vuoi, campeggiare ne' campi d' un verderame ad olio; due volte
aombrando alcuna piega; poi universalmente a distesa darne
sopra i campi e sopra i lavori gualivamente."—*Trattato*, c. 143.

† " Ad idem, mettere il vestire d' argento; disegnare il tuo
drappo quando hai brunito (chè così s'intende sempre) cam-
peggiare il campo o vero lacci di cinabro temperato pur con
rossume d' uovo. Poi di una lacca fina ad olio ne dà una volta
o due sopra ogni lavorio, siccome laccio in campo." — Ib.

background were finished.* Cennini teaches the
practice of all but the carving. In later times the
work was divided, and the decorator or gilder was
sometimes a more important person than the painter.
Thus some works of an inferior Florentine artist
were ornamented with stuccoes, carving, and gilding,
by the celebrated Donatello, who, in his youth,
practised this art in connexion with sculpture.†
Vasari observed the following inscription under a
picture. "Simone Cini, a Florentine, wrought the
carved work ; Gabriello Saracini executed the gild-
ing ; and Spinello di Luca, of Arezzo, painted the
picture, in the year 1385."‡

Italian pictures belonging to the fourteenth
and first half of the fifteenth century, frequently
exhibit the partial oil painting above described.
It is to be detected by the difference of surface ;
the portions covered with oil colour being more
raised than other parts of the work. The pre-
paration with yolk of egg, as in the last example
quoted, would increase this appearance ; but the
oil alone, from the thickness of its consistence,
causes a sensible inequality.§ The use of the gold

* "Ti conviene sempre lavorare in vestiri e casamenti, prima
che visi." — *Cennini, Trattato,* cap. 145.

† Vasari, Vita di Dello.

‡ Ib., Vita di Spinello.

§ Several specimens of Florentine pictures with orna-
mented draperies, in the possession of Mr. Warner Ottley,
exemplify the directions of Cennini.

and silver ground, in the mode directed, is evidently derived from the *auripetrum* and *pictura translucida* of the medieval writers before cited. Its latest modification appears in the works of Holbein and his contemporaries, and is thus described by De Mayerne. " Prepare a ground of silver-leaf; on this, when rendered perfectly smooth and in a manner burnished, glaze fine lake; when this is dry, add the folds with the same colour, deepened where necessary with a little black. A similar result may be produced with purified verdigris on a silver or gold ground. It is a very good method."*

The Venetian manuscript above-mentioned contains various notices on painting, mixed up, as usual, with medical formulæ. The directions relating to painting may be placed in the same category with those of Cennini; for, though transcribed early in the fifteenth century, the processes do not essentially vary from those of the preceding age†; the original work probably belongs, for the most part, to the beginning of the fourteenth century.

* " Belle façon de satin cramoysy que j'ai vu aux tableaux anciens de Henry VIII., Edouard son fils, et Marie sa fille, rois d'Angleterre (de Holbein, peintre). Couchez argent en feuille, sur laquelle, bien applany et fort egual comme bruny, glacez avec très belle lacque; et sur icelle, seichée, fais les plis avec lacque et enfoncez avec la mesme et un peu de noir. Je croy que le mesme se fera avec vertdegris distillé sur argent ou sur or. C'est un très beau labeur."

† For an account of the manuscript, with some specimens of its contents, see the note at the end of this chapter.

The chief peculiarities of the treatise consist in receipts for the preparation of water colours for painting on cloth; and in directions for painting and gilding on glass. The latter relate to mere varnishing, as distinguished from glass-enamelling by means of fire. Vasari observes that the French and Flemish glass-painters excelled in the latter art; and that it had been formerly the practice to paint the glass thinly with colours mixed in glutinous or other vehicles, which, he observes, offered but a feeble resistance to the air and rain. The following is a specimen of a firmer vehicle: it shows that the preparation of a strong drying oil by means of metallic oxides was not uncommon at the period when this treatise was written. Similar compositions for mordants under gilding, but not for painting, are to be met with in Cennini's treatise.

" To give a coating, in the Saracenic mode, over tin-foil used with glass.*—Take linseed oil; boil it in a well glazed pipkin; then add unground verdigris, in the proportion of half an oz. to a pound of oil; add also a small quantity of stag's horn that has been calcined to whiteness in a furnace, in an iron vessel. Let the oil and its ingredients boil till, if you put a dove's or hen's feather therein, it will curl with the heat. Thus boiled, remove it from the fire and let it settle; and, when you wish to

* The title is obscure; it is perhaps explained by the description, given in the next page, of the specimen from St. Stephen's Chapel. In that instance the coloured varnish was between the foil and the glass.

temper minium or any other colour which you may wish to glaze over glass, spread the tint with the oil above described, and let it dry in the shade. This coating can never be removed by water, nor by any other moisture whatever; and remember to keep your colours, or the coloured glasses, in a well shut press, that the dust may not spoil them."* A varnish elsewhere described in the MS. is the same composition (chiefly sandarac and linseed oil) which is to be found in all the older authorities subsequent to the age of the Lucca document.

In this recipe there are one or two points that may require explanation. The epithet "Saracinesca," in the title, is sometimes varied in the manuscript by "al modo di Damasco;" the ex-

* "A fare copta [coperta] saracinesca sopra lo stagnolo del vedro. — Toy olio di semēte de lino e ponilo a bolire ɪ una pignata bñ vidriata e īcontenēte mitili oz. ÷ de Ϙderamo ītero sele livre una de olio ᵃ e mitili uno pezolo de cōno de osso de cervo bñ coto ɪ lo forno ɪ una pignata de fuoco tanto che sia bñ biancho e lasala tanto bolire lo ℈dēo olio cū le predicte cosse che se tu li poni una pena de colombo o de galina dentro con le penole esse si astriano. E coto levalo dal fuoco e lasalo sorare. E qñ tu vorai tempa lo minio o voy che altro colore te piace dare p copta del vedro cū lo pređto olio o da lo tuo colore e lasalo secare al ombra, e mai nō porai movere la dicta coperta per aqua ne per altra humidita che sia. Et nota tenere li toi coluri o li vidri coloūti ɪ uno armaro bñ ℈rato che la polvere nō teli guasti."— *Sloane MS.* 416.

ᵃ In a printed copy of this receipt in the *Secreti di Don Timotheo Rossello,* Ven. 1575, the corresponding passage is, " una onza di verderamo intiero, se sarà una libra di oglio."

pressions appear to refer to an Oriental mode of painting and gilding on glass by means of drying oils and varnishes. Many of the operations relate to the embellishment, in this mode, of glass pateræ and chalices " piadene e coppe;" but the use of transparent colours, without gilding, was applicable to the method of glass-varnishing for windows, to which Vasari alludes. Another mode, analogous to this Venetian art, was exemplified in some remains of painted glass found in St. Stephen's Chapel at Westr minster. A fragment was examined by an experienced chemist (Haslam), and is thus described by him. " The specimen of painted glass you lately sent me, — a copy of which you have introduced in your work,— consists of verdigris, prepared with varnish, applied to the glass; immediately over which leaf-silver is laid, and upon that a cement to fasten it to the niche wherein it was inlaid. The green colour in this specimen appears fresh and perfect, which is owing to the exclusion of air, in consequence of the varnish employed and the coating of silver-leaf." * And, he might have added, in consequence of the glass itself, for the colour was within it; the silver-leaf merely protecting it from the damp of the wall, and, at the same time, enhancing the splendour of the colour.

* Smith's Antiquities of Westminster, London, 1837, p. 226. The pieces of painted glass above described were inlaid in the compartments of some large stone brackets which supported statues. (Ib., p. 243.)

In this instance the verdigris was used as a colour; but in the recipe above quoted it is introduced merely as a dryer without colouring the oil, since minium was tempered with it. The siccative ingredients ultimately employed in oil painting were originally used in mordants only; in this manuscript we have the intermediate stage. Verdigris, for example, in the sixteenth and seventeenth centuries, was common as a dryer in Italy and in Spain; and to its immoderate use is perhaps to be attributed the blackness of the shadows in some of the Spanish masters and in Tintoret.* The addition of calcined bones in the preparation of a drying oil is another instance of the existence, in very early times, of methods which have been sometimes announced as modern discoveries. A mode of rendering linseed oil clear and drying in twenty-four hours by means of calcined bones, was published in London by Grandi, in 1807, and was approved by the Society for the Encouragement of Arts. The trial of the heat of the oil by the feather is common in modern receipts.†

* The later Spanish painters considered it the best of all dryers. See Palomino, El Museo Pictorico, l. v. p. 56. That writer, aware of the tendency of verdigris to blacken, recommends that it should be restricted to the dark colours, and then used only in small quantity.

† De Mayerne observes that, if the feather curls with the heat, the oil is not duly prepared ; but, if the feather undergoes no change (the heat being undiminished), the oil is sufficiently boiled.

The direction to let the composition " dry in the shade," after its application, occurs in other descriptions to be hereafter noticed. It is equivalent to saying that a dryer was used, and that the sun's heat was therefore unnecessary.

The application of oil painting to ordinary purposes, at the close of the fourteenth century, is exemplified by a document found at Königsberg. It relates to the painting in oil of the cover or door of a diptych; the picture within being probably executed in tempera. "Item, for the cover, over the picture, painted in oil colours, nine *Firdunge**," about 1*l.* 14*s.* 2*d.* The price indicates a work of no very refined art, but yet not of the commonest kind; the dates of the accounts in which this note appears extend from 1399 to 1409.

The Byzantine treatise before-mentioned was originally composed by Dionysius, a Greek monk and painter, of uncertain date. The present inhabitants of Mount Athos suppose that it was written in the tenth or eleventh century: its experienced editor, M. Didron, considers it much more modern.† Many of the directions contained in it are indeed evidently not older than the sixteenth century; but the probability is that the original treatise may have received additions from

* "Item vor dy decke obir dy toffel mit Olfarwe gemalt ix firdunge (etwa 11 Thlr. 9 Sgr. 6 Pf.)." — *S. A. Hagen, Kunst-Blatt*, 1835, p. 440.

† Manuel, &c., Introduction, p. xxxv.

time to time. Some of the records have internal evidence of antiquity. The ancient varnish, for example, is alluded to in the directions for cleaning altar-pieces, and the following mode of preparing oil, in the sun, is as old as Dioscorides. "Put some *péséri** in a copper vessel; expose it to the hot sun for forty days, only take care not to let it solidify too much; for some *péséri* acquires consistence rapidly, other samples more slowly. When it has the consistence of honey it will be duly prepared. If you were to suffer it to get thicker, you would no longer be able to mix it with other substances, or spread it upon images [pictures] without its forming lumps. You should be careful to cover it every evening, or to remove it into the house, for the night dew spoils it. When you find it in the fit state, pass it through linen to clear it from the flue or insects which may have got into it. You will thus have *péséri* baked in the sun."†

* A drying oil of some kind, probably linseed oil.

† " Comment il faut cuire le péséri. Prenez du péséri et mettez-le dans un large bassin de cuivre ; exposez-le à un soleil ardent pendant quarante jours. Faites attention seulement à ne pas le laisser se coaguler trop solidement; car il y a du péséri qui se prépare très vite, et d'autre plus lentement. Lorsqu'il aura la consistance du miel, il sera bon ; si vous le laissiez épaissir davantage, vous ne pourriez plus le mêler à d'autres substances ni l'étendre sur les images sans qu'il fît des grumeaux. Vous aurez soin donc de le couvrir tous les soirs ou de le rentrer à la maison, car la rosée de la nuit le gâte. Lorsque vous le verrez arrivé à un degré convenable, vous le passerez dans un linge pour le purifier des poils et

Examples of this process occur in later treatises: the chronological order which has been observed requires that these should be noticed elsewhere.

Being now arrived at the period when the great improvement in oil painting was effected by the brothers Hubert and John Van Eyck, it will be desirable to review the facts that have been collected relative to the previous history of the method. The "crassum oleum" mentioned in the earliest copy of Eraclius was applied to the same uses, and may have been as thick, as the *péséri* of the Greeks. In the Paris copy of Eraclius it is even observed, that "the longer the oil remains in the sun the better it will be." Such a mode of preparing oil, — reducing it to half its original quantity, as stated by Cennini, or to "the consistence of honey,"—converted it to a varnish of the most substantial kind; resembling those which could only be applied with the hand or with a sponge, as directed by Theophilus and other writers. The process in question, therefore, points to the remote times when oil was used, on works of art, as a varnish only. When we read of its being so used, it is always to be inferred that it had been prepared in the mode described; indeed, it would not otherwise have been fit to protect the surfaces on which

des insectes qui ont pu le salir, et vous aurez alors du péséri cuit au soleil." — *Manuel*, &c., p. 39.

It is to be regretted that the original Romaic is not given by MM. Didron and Durand together with their translation.

it was spread. The nut oil of Aetius, for example, must have been of this description; and it has been seen that the method of thickening and bleaching oil in the sun was known and practised long before his time. The sesamine oil, if employed as a varnish in the East, must be previously reduced to a like consistence, either by long exposure to the air, or by the addition of drying ingredients; as it appears that even olive oil was so thickened by the ancients for medical and other uses. The Egyptian cicinum, described as a varnish in the *Mappæ Clavicula*, and probably used as such anciently, in warm climates, is of similar quality. Such being the necessary consistence of oils when employed as varnishes, it is quite conceivable that, when oil painting was first attempted, the tints would be prepared with the customary inspissated medium. The examples that have been adduced leave no doubt on this point. Transparent lackers had already been applied with thick varnishes at least as early as the eighth century; and in the transition to oil painting, more strictly so called, the appearance and qualities of a varnish were still retained.

Colours ground in such a vehicle were almost unavoidably spread in flat tints only. The surface of the painting was glossy; an appearance which the early oil painters seem to have considered indispensable. The cause of the "sinking in" of colours was soon known and guarded against; for, when the

work was to receive more than one coat, care was taken that the first painting should be quite dry, even by exposure to the sun, before the second was applied. The surface of stone, after being dried in the same way, or by means of fire, was sometimes covered with size, to intercept all internal cause of alteration in the superposed shining liniment. The surface of wood was required to be perfectly free from damp for the same reason; and, this precaution being observed, one coat only of the thickened oil on hard woods (though more were generally given) insured the glossy appearance. St. Audemar, after describing the tinting of box-wood with saffron, used as a water colour, adds: "If you wish the wood to shine, let the yellow colour dry first; then go over the surface with the same colour mixed with oil*;" that is, with inspissated oil. An English painter of the seventeenth century, with different views but with the same experience, observes: "Never temper your colours with fat oyl, for that will make your colouring look greasy."† The passage in St. Audemar shows that the use of oil colours was originally considered sufficient to produce a shining surface, as opposed to the effect of water colours. As regards the result, without at present

* " Si volueris ut ipsum lignum luceat, permitte prius crocum siccari; postea cum oleo eum super illum pone."

† MS. on Painting by John Martin (1699), in Sir J. Soane's Museum.

considering the change of means, the habit was retained by the Van Eycks; and may be said to have always more or less characterised the schools of the Netherlands as distinguished from those of Italy.

Paintings entirely executed with the thickened vehicle, at a time when art was in the very lowest state, and when its votaries were ill qualified to contend with unnecessary difficulties, must have been of the commonest description. Armorial bearings, patterns, and similar works of mechanical decoration, were perhaps as much as could be attempted. Hence it is not to be wondered at that the more important parts of pictures, such as faces, extremities, and undraped portions of figures gene-rally, should be executed in tempera: or that the prejudice against oil painting, from its assumed unfitness for all delicate operations, should have lasted in Italy for some years after the method of Van Eyck had been made known.

The distinct evidences respecting the nature of the medium employed in the infancy of oil paint-ing may explain less direct allusions. The nut oil used, or attempted to be used, by Giorgio d'Aquila was not "sufficiens in pictura." As before shown, this expression could not relate to the quantity; but, if we consider it with reference to the method that prevailed at the time, the passage may be understood to mean that the oil had not sufficient body, and was not sufficiently thickened

and oxygenated by the action of air and light. This is further proved by the circumstance of its having been still fit for culinary purposes, though it was considered ill adapted for painting.

To the general system above described the unsuccessful oil painting of Theophilus is also perhaps to be considered an exception. There is no evidence that the oil employed by him had undergone the usual treatment, and it appears, moreover, to have been ill prepared at first. The tedious drying, which was the result, would have been obviated in a great degree by using the oil in the mode generally practised; a mode to which, with all its inconveniences, the early painters learned to accustom themselves. The " oleum pictorum " mentioned in the Westminster account-rolls was probably a thickened oil.

Was there no endeavour, it may be asked, to dilute this half-resinified substance with an essential oil? Such a resource is indeed indicated in the Byzantine manuscript, but its date is uncertain; and, from the absence of any similar notice in early documents, it is to be inferred that the practice was borrowed from the schools of Central Italy, where it was common, in the sixteenth century. The method consisted in mixing naphtha with the thickened *péséri*, when used with concrete pine resin as a varnish.* The effect of essential

* Manuel, &c., p. 40. 54.

oils, in painting, especially if they are well rectified, is to produce a dull, unshining surface, called by house-painters *flatting;* this is of itself a reason why the early oil painters, with the prejudices they entertained, were not likely to employ such diluents. The thick consistence of the vehicle was not corrected in Cennini's time; he clearly directs the colours to be ground in the sun-baked oil, and speaks of no mode of thinning either the tints or the medium.

These great inconveniences were counterbalanced by some supposed advantages. The glossy surface, when thoroughly dry (and it was always dried, if possible, in the sun), harboured little dust, and was easily cleaned. Viewed in this light, the vehicle possessed at least equal recommendations with a durable lacker for furniture and implements; and, in the Venetian manuscript, such a varnish is described as applicable to " pictures and cross-bows." * Other merits were more real, and the experience acquired was sometimes remembered and applied in the best ages of painting. The half-resinified oil was well calculated to exclude air from the colours, or, in the painter's phrase, to " lock them up." Accordingly, when, in the early treatises, we read that certain colours required to be ground in oil in order to last, it is always to be remembered that the thickened oil is meant. In

* " A fare vñixe da depinture e da balestre."

the Venetian manuscript, for example, we read: " Grind the said colours in water on the stone, and then temper them with yolk of egg well beaten, or, if you please, with [thickened] linseed oil; indeed verdigris requires to be ground with this oil in order to preserve its colour." * Leonardo da Vinci, who used oil, as a medium for pigments, in the thinnest state, observes (apparently on the contrary, but quite consistently) that verdigris is evanescent as a colour unless it be immediately varnished.† The oil used at an earlier period was, as we have seen, itself a varnish. Thus protected, yellow lakes were employed; and, although some of these are more or less affected by light as well as air, the exclusion of the latter at least was beneficial: the tendency of the oil itself to become yellow, rendered the vehicle fittest for those colours which would be least affected by the change.

The oil, when thickened by exposure to the sun's heat, and when duly prepared, had also a greater drying tendency; for the inspissation so induced is a degree of that oxygenating process which ends in the solidification of the oil. This rendered it fit for the darker colours with or without the addition of varnish, according to its consistence.

* " Maxina li diti coluri cū l' aqua suxo la pietra e poi tempali como el torlo de l' ovo bñ sbatuto o voi como olio de señte de lino. Vero e che 'l Ỹderamo vole esŝ maxinato cō questo olio de señte de lino a volere che nō p̃di suo colore."

† Trattato, &c., p. 124.

The dryers, employed from the earliest times in mordants, were added when necessary. Such a thickened or oleo-resinous vehicle was still used by most of the Italian painters (even after the general practice had changed) for dark colours. In Italian oil pictures executed at the close of the fifteenth and beginning of the sixteenth century, the darks are, on this account, frequently more prominent than the thinly painted lights. The correction of the acid which rancid oil contains (and which may have a tendency to check the siccative quality of the oil) was provided for by the process indicated in the later transcript of Eraclius, or by methods similar in their results. The inspissated oil had another advantage, the only one perhaps which has recommended it in modern times: though nearly reduced to the state of a liquid resin or balsam, it was found to preserve its toughness much longer than such vehicles. It was, therefore, used by some of the Flemish and Dutch masters in shadows (for example, in trees); and may be detected in rich darks, which, notwithstanding their substance, exhibit no tendency to crack.

Thus it appears that, about the year 1400, the practice of oil painting, however needlessly troublesome, had been confirmed by the habit of at least two centuries. Its inconveniences were such that tempera was not unreasonably preferred to it for works that required careful design, precision, and completeness. Hence, the Van Eycks and the

painters of their school seem to have made it their first object to overcome the stigma that attached to oil painting, as a process fit only for ordinary purposes and mechanical decorations. With an ambition partly explained by the previous unavoidably coarse applications of the method, they sought to raise the wonder of the beholder by surpassing the finish of tempera with the very material that had long been considered intractable. Mere finish was, however, the least of the excellencies of these reformers. The step was short which sufficed to remove the self-imposed difficulties of the art; but that effort would probably not have been so successful as it was, in overcoming long established prejudices, had it not been accompanied by some of the best qualities which oil painting, as a means of imitating nature, can command. Before entering on this more interesting part of the inquiry, some documents relating to the general practice of art in England and elsewhere, during the fourteenth century, deserve to be noticed.

NOTE

ON A VENETIAN MANUSCRIPT IN THE BRITISH MUSEUM.

Sloane MSS. 416.

THE title, written in the first leaf by a former possessor is as follows. " Receitts and directions in curing diseases, dyeing, making glass, sope, &c., most part in Italian ; medicinæ Roberti Theotonici."

Some receipts are in Latin. The name Robertus, which does not occur in the book, seems to be erroneously copied from the following passage in the manuscript. " Oleū p̄ciosissimū cōtra oīnia contraria hūc nature sec̄ [secundum] frēm Albertū Theotonicū." The designation Theotonicus (Teutonicus), or German, was sometimes applied to Albertus Magnus. That celebrated personage is distinctly mentioned elsewhere in the manuscript as having taught the mode of preparing a certain blue colour. " Lazurū sec̄ dōtñas Alb̄ti Magni ordinis fratrū p̄dichatorum," &c.

Another receipt is thus headed : " Ad faciendū lazurū cum q̃ potēis pinḡe ɪ muris et pictib̄. [pictilibus] secundū fratrem Paulum ordinis fratrū minorū." The ancient altar-piece of St. Mark's, at Venice, was painted by a " Magister Paulus." (*Lanzi, Storia Pittorica,* Fir. 1822, vol. iii. p. 11.) A picture at Vicenza, mentioned by Della Valle (*Lanzi,* ib.) was inscribed, " 1333. Paulus de Veneciis pinxit hoc opus." A monk of this name, and of the order (Minor Franciscans) mentioned in the MS., is also noticed in connexion with early works of art in Venice, in the following extract from a public record at Treviso, dated 1335. The passage is quoted in Guid' Antonio Zanetti's *Nuova Raccolta delle Monete e Zecche d' Italia,** vol. iv. p. 151. " Maestro Marco, a painter who dwells in Venice with the Frati Minori, executed the pictures on cloth in the German method, which are at Treviso in the church of St. Francis, belonging to the Frati Minori ; (similar

* Bologna, 1775. The work is noticed by Lanzi, vol. i. p. 151.

pictures on cloth are in Venice, in the establishment of the Frati of the same order). In the same place are some glass windows by the hand of the said Maestro Marco, which are well executed. For, a certain German friar executed all those works formerly at the convent in Venice, and Maestro Marco copied and sent them to Treviso. The aforesaid Marco has a brother named Paolo, a painter, dwelling in the same convent, who has [executed] drawings of the death of St. Francis and of the glorious Virgin, as they are painted in the German method, on cloth, at the convent of the Frati Minori at Treviso." *

As stated in the foregoing pages, the notices connected with the arts, in the manuscript in question, relate chiefly to the preparation of materials for painting in water colours on cloth; and to glass-painting. To these circumstances are to be added the coincidence of the name " Frater Paulus ordinis fratrum minorum;" and the fact of the manuscript being in the Venetian dialect. But the above extract is important, independently of the object for which it is quoted, as exemplifying the early influence of the Germans on Venetian art. The " frater Theotonicus," whoever he was, is spoken of in 1335, as having *formerly* introduced his methods into Venice: he was therefore at least coeval with Giotto, who died in 1336. In the next chapter some further evidence will be adduced respecting the early use of cloth instead of wood, for painting, in Venice and in the North of Italy.

* " Et nota quod magister Marcus pictor qui moratur Veneciis penes locum fratrum Minorum, fecit panos Theotonicos qui sunt Tarvisii ad sanctum Franciscum Minorum; qui pani sunt picti etiam Veneciis in loco fr̄ Minorum : et sunt ibi fenestre vitree facte manu dicti magistri, et bene facte. Nam quidam Frater Theotonicus fecit omnia ab antiquo ibi in Veneciis, et Maḡr Marcus exemplavit et misit Tarvisium. Et nota quod supradictus Maḡr Marcus pictor, qui moratur penes Sanctam Mariam fratrum Minorum de Veneciis, habet unum fratrem, nomine Paulum, pictorem, qui moratur penes dictam Sanctam Mariam fr̄ Minorum : qui habet in carta designatam mortem Sancti Francisci, et Virginis gloriose, sicut picte sunt ad modum Theotonicum in pano ad locum Minorum in Tarvisio."

To return to the manuscript. The date of the original compendium may, on the above grounds, be placed in the first half of the fourteenth century. The date of the interpolated copy in the British Museum is more easily determined. One portion, unfortunately imperfect, is transcribed in a small neat hand, and appears to be extracted from an older manuscript; other passages, collected from similar sources, or recording original observations, are written by the compiler of the book; apparently an English monk studying at Padua or Venice, as his Italian is always in the Venetian dialect. A large proportion of the receipts are medical and alchemical; and it is to be regretted that a later possessor of the volume, probably a medical student of the 17th century, has defaced it with English titles, some of which might have been spared.

The English compiler was in Ferrara in 1424; in 1454 he left Bologna and proceeded to Milan ; the latest date is 1456. The following is the passage in which the first date occurs. The traveller, like most of the friars of the period, pays particular attention to the art of illuminating ; receipts relating to such details are very numerous. In describing a mode of executing initial letters raised and gilt, he remarks : " The person who first invented this receipt was a Dominican friar called Fra Maso da Urbino, an illuminator. He used no other composition." And, in conclusion: " This receipt was tried by the above-named friar in Ferrara, in the church of S. Domenico, in my presence, on the 12th of June, 1424, and I wrote the description with my own hand. Remember to breathe on the composition before you lay on the gold." * The last sentence is added as a postscript.

Various passages in this manuscript prove that the art of etching was understood and practised long before it occurred

* " questa reçeta el primo homo che la fieçe mai si fo uno frate de Santo Domenigo chiamato p̄ nome Fra Maxo da Orbino et quale frate era aminiadore, ed elo nō adovrava altra sixa se no questa......e questa reçeta fo provada dal dito frate in la çita de ferara in la Giexia di Santo Domenigo siando mi presente a di XII. de zugnio 1424, ed mia mano ppia la schrissi. Rachordate de refiadar con la bocha sopra lo lavoriero avanti che miti l' oro suoxo."

to the monks, or to Maso Finiguerra, to take impressions from plates. For example : " To prepare a powder for engraving on iron.—Take Roman vitriol [sulphate of iron] * 1 oz., corrosive sublimate 1 oz., nitre $\frac{1}{2}$ oz., verdigris $\frac{1}{2}$ oz. ; reduce these to a fine powder ; then take your iron plate and cover it with liquid varnish ; dry it at the fire, and afterwards draw on it what you wish to engrave. Take wax and make a hedge round your drawing ; pour very strong vinegar within it, and then add the before-mentioned powder, leaving it till the desired effect is produced."† Elsewhere the preparation of liquid corrosives, under the name of aqua fortis (but not exactly corresponding with the usual nitric acid), is described, " for engraving on iron."

Other extracts relating to various processes, remaining to be exemplified, will be given elsewhere. A few of the receipts in the manuscript were published at Venice in the sixteenth century, in the *Secreti* of Timotheo Rossello. An example has been already given. This instance shows how ancient the sources were whence such printed collections were derived.

* The term "Roman Vitriol" is commonly applied, in this country, to sulphate of copper ; but an Italian chemist and writer on painting speaks of it as synonymous with sulphate of iron. See Marcucci, Saggio Analitico-chimico sopra i Colori minerali, &c., Roma, 1816, p. 58.

† "A fare polvere da chavare fero.—R. vedriolo romano oz. una, ariento sulima oz. una, salnitro oz. ÷ , verderamo oz. ÷ , e possa pista ogni chossa sotilmente, e poi to el to fero e mitege suxo vernixe liq̃da e poi sechalo al fogo, e quando sera secho desegniage sovra q̃lo che te piaxe de chavare e quando araj desegniato torai dela cira e farage dintorno le sponde a quelo designãito e poi aibi de laxedo ben forte e mitegene suxo e possa sopra laxedo mitege le dite polveri e lassala stare tanto che el te vegniera fato."

CHAP. V.

As long as painting continued to be practised chiefly in the cloister, its methods, if not its style, were in a great measure common to the Christian world; the technical modifications which it underwent being mostly referable to the differences of climate. To this last cause may be attributed the greater prevalence of oil painting in the North, as compared with Italy; a fact established by the observation of Cennini that "the Germans employed it much;" by the early and abundant use of oils and varnishes in England, as recorded in the account-rolls of the thirteenth and fourteenth centuries; and by the important circumstance of the great improvement in oil painting (ultimately leading to its general use) having been first made in Flanders. All which is sufficiently explained by the necessity of counteracting the effects of a humid atmosphere on painted surfaces, by hydrofuge or oleo-resinous preparations. Among other methods, common on this side of the Alps, may be mentioned the cloth-painting of the English and Germans, and their peculiar process in tempera.

English and German Mode of Painting on Linen.

In the Treviso record, preserved by Guid' Antonio Zanetti, mention is made of a German mode of painting (in water colours) on cloth.* This branch of art seems to have been practised on a large scale in England during the fourteenth century, so as to attract the notice of foreigners. The following passages occur in Le Begue's copy of the MSS. of Alcherius. " Item, in the same original it was thus written: ' On Tuesday, the 11th of February, 1410, I caused a copy to be made in Bologna of certain receipts lent to me by Theodoric of Flanders, an embroiderer accustomed to work at Pavia, which receipts the same Theodoric said he had obtained in London, in England, from the artists who used the water colours hereinafter described.'" † The receipts, which are in French and Latin, relate to the preparation of lake, indigo, green, and other tints. Among these we find the violet, " tournesol;" not, in this case, the lichen Roccella tinctoria, but the Croton tinctorium.‡ The

* See the note at the end of the last chapter.

† " Item in eodem exemplari in quodam alio quaterno precedentibus contiguo scribebat sic. 1410 die Martis xi., Februarii feci copiari in Bononia a receptis ibi imprestatis per Theodoricum de Flandria rachamatorem solitum operari in Castro Papie... quas receptas idem Theodoricus dixit habuisse in Londonia in Anglia ab operariis infrascriptarum aquarum."

‡ The preparation of a blue colour from the " torna sole " is described in the Venetian MS., where a rude drawing of the

transcriber resumes: " After the above, it was thus written in the said original: ' The aforesaid Theodoric, from whom I had these receipts, said that in England the painters work with these water colours on closely woven linen saturated with gum water. This, when dry, is stretched on the floor over coarse woollen and frieze cloths; and the artists, walking over the linen with clean feet, proceed to design and colour historical figures and other subjects. And because the linen is laid quite flat on the woollen cloths, the water colours do not flow and spread, but remain where they are placed; the moisture sinking through into the woollen cloths underneath, which absorb it. In like manner, the outlines of the brush remain defined, for the gum in the linen prevents the spreading of such lines. Yet, after this linen is painted, its thinness is no more obscured than if it was not painted at all, as the colours have no body.' " *

plant is given. The writer observes that those portions of the colour which are not suffered to come in contact with lime assume a violet hue. The lichen is mentioned elsewhere in the MS. under the name of *roxello*.

* " Post super dicta, scriptum sic erat in præfato exemplari: Antedictus Theodoricus a quo habui antescriptas receptas præscriptarum aquarum, dixit quod in Anglia operuntur operarii pictores cum ipsis aquis super tellis bene contextis et balneatis cum aqua gummata de gummi arabico, et siccatis et postea extensis super solario per terram super drappis grossis lane et frixie incedentes cum pedibus nitidis ipsi qui operantur intus, inde desuper ipsas telas operando et depingendo super ipsas imagines historicas et alia; quia ipse telle sedent et stant in

It is remarkable that a native of Flanders, not unacquainted with art, should notice this practice in England, and record the process and materials; for the inference is, that the peculiar method which he describes was not practised in his own country at the period in question. In the beginning of the fifteenth century, the ordinary tempera painting on cloth was certainly common in the Netherlands; rooms being then, as Van Mander states, frequently hung with large works of the kind (executed with egg and size colours), instead of tapestry. He remarks this when speaking of Roger of Bruges, a scholar of Van Eyck, and continues: " I have seen such hangings at Bruges, which I am inclined to think were executed by him. Considering the time when they were done, they are surprising productions, since, in large works, drawing, and knowledge (of the figure) are required."*

planitie extense ut dictum est; et super dictis drapis dicte aque colorate pingendo non fluunt se spargentes sed stant ut ponuntur, et humiditas aquea descendit in drapo lanne qui eam bibit. Ac etiam non sparguntur tractus pincellorum facti ex ipsis aquis quod gummacio tele facta ut dictum est, prohibet sparsionem ipsam tractuum pincellorum, et cum tele ipse operate sunt tamen raritas ipsorum non est suspicata nec obfuscata, plus quam si non picte fuissent, quia aquei colores superscripti non habent tantum corpus quod possent suspicare raritatem in tella." The orthography is preserved in the above extracts.

* " In desen tijt had men de maniere te makē groote doecken, met groote beelden in die men ghebruyckte om Camers mede te behangen, als met Tapijtserije, en waren van Ey-verwe oft Lijm-verwe ghedaen. Hier in was hy [Rogier van Brugge] een goet meester : en ick meen wel van hem te

The peculiarity of the English method appears to have been its absolute transparency; and this same quality distinguished a German mode of painting on cloth, even in the beginning of the sixteenth century, from the Italian tempera. A drawing sent by Albert Durer to Raphael, is described by Vasari, as having been painted "in water colours on a fine linen cloth, which showed the transparent lights on both sides, without white; water colours only being added, while the cloth was left for the lights; which thing appeared wonderful to Raphael."*

The Venetian MS., probably derived from the "frater Theotonicus" mentioned in the Treviso record before quoted, contains directions for the preparation of transparent colours for painting on cloth.† The method thus indicated points to the origin of some technical peculiarities observable in the North of Italy. Various works of the Venetian, Paduan, and Milanese artists were executed at a

Brugge einige van dese doecken gesien te hebben, die wonder-lijch (nae den tijt) te achten en te prijsen waren : want soo in 't groot wat te doen, daer moet teyckeninge en verstandt by zijn," &c. — *Carel Van Mander, Het Schilder-Boeck*, &c., Haerlem, 1604, p. 203.

* Vasari, Vita di Raffaello.

† For example: " A fare aqua negra da lavorare ī pano.— Aqua da fare rosso in pano.—Aque rosse da lavorare ī pano biancho.—A fare aqua çala [gialla] da lavorare suxo el biancho," &c. The meaning attached to the word "lavorare," through-out the MS., shows that the operation was distinct from mere dyeing.

later period in thin tempera on fine linen; and, though not quite transparent, had much less body than the tempera pictures on cloth of other Italian schools. The studies of Squarcione* were occasionally made on this material; as were those of Leonardo da Vinci, Luini, and others connected with the Milanese school.† The early predilection of the Venetians for painting on cloth generally, rather than on wood, was, as Vasari observes, an exception to the Italian practice. Jacopo and Gentile Bellini, he remarks, executed their first pictures on cloth.‡ The German (Theotonicus) who introduced the method in Venice early in the fourteenth century, may thus have been the means of familiarising the artists of the neighbourhood, and of the North of Italy, with the use of that material, which, still distinguished by the fineness of its texture, was often employed by them even for their oil pictures.

As regards the English and German paintings on cloth, there can be little doubt that the thinness of execution for which they were remarkable, though it did not preclude gilding, was adopted with a view to durability. Sandrart affirms that the ordinary (more solid) tempera had been found not to last

* Vasari, Vita di Andrea Mantegna.

† Vasari observes of Leonardo, " Si metteva a ritrargli sopra a certe tele sottilissime di rensa o di panni lini adoperati."—*Vita di Lionardo da Vinci.* A work, by Luini, of this description was lately in the possession of Mr. Buchanan.

‡ Ib., Vita di Jacopo, Giovanni, e Gentile Bellini.

in the Netherlands*; meaning that it was affected
by damp. Accordingly, although size painting was
much practised there at a later period, it was em-
ployed either for temporary purposes of decoration,
or for cartoons to be transferred to tapestry.

The Anglo-German method appears, from the
description, to have been in all respects like modern
water colour painting, except that fine cloth, duly
prepared, served instead of paper. On inflexible
materials, on walls, and on wood, the early English
artists, and those of the Rhine, used a more solid
tempera, but which was still different from that
commonly employed in Italy. The priority of
records respecting the vehicle is in favour of Eng-
land; indeed, from a passage in an early manu-
script, it may be inferred that the process, such as
it was, had been borrowed by the Germans from
this country.

ENGLISH AND GERMAN TEMPERA.

Before entering on this subject, it may be neces-
sary to explain the different meanings of the word
tempera, applied to more or less liquid compositions.
First, it is used in the general sense of mixture, in
accordance with the import of the classic expression
"temperare" (thus Pliny, "temperare unguen-
tum"). In this widest application the Italian sub-
stantive "tempera" means any more or less fluid
medium with which pigments may be mixed, in-

* Teutsche Academie, part i. p. 66.

cluding even oil. Hence Vasari says, "l' olio che è la tempera loro." * Secondly, in a less general sense, the term represents a glutinous, as distinguished from an unctuous or oily, medium; and thus comprehends egg, size, and gums; or, in a more general expression, binding substances originally soluble in water. Lastly, in its most restricted and proper acceptation, it means a vehicle in which yolk of egg is a chief ingredient: the varieties being, yolk of egg mixed in equal quantities with the colour; yolk and white of egg beaten together, and diluted with the milky juice expressed from the shoots of the fig-tree; and the yolk alone so diluted.† These last-named vehicles were the most commonly used by the painters of the South of Europe, before the invention and improvement of oil painting. They are described by the chief Italian writers on art, and by those who have followed them. Sandrart intimates that tempera was still employed in his time, but observes that it was only fit for dry situations.‡

Of the antiquity of the egg vehicle for the purposes of painting there can be no doubt, as Pliny speaks of the application of colours tempered with it on walls. § The mixture of yolk of egg with the fig-tree juice is mentioned by the same writer, but with reference to medicinal purposes only. ‖

* Vasari, Introduzione, c. 21.

† Cennini, Trattato, c. 72. cap. 145. Vasari, Introd. c. 20.

‡ Teutsche Acad., part iii. p. 17., part i. p. 66.

§ L. xxxv. c. 26. ‖ L. xxiii. c. 63.

The fig-tree juice is noticed, in combination with other ingredients, by medieval writers on painting; for example, in the Lucca MS. and in later treatises: a mode of procuring it is described in the *Secreti* of Rossello.* Its omission in the Byzantine MS. is probably accidental, as it is used by Greek painters of the present day. Dioscorides and Pliny remark that the juice of the fig-tree is of the nature of vinegar, and that it coagulates milk.† The modern use of vinegar, as a substitute for this juice, to dilute the yolk of egg in painting, is perhaps derived from these authorities. The tempera, composed of egg and fig-milk, or egg alone, used in dry climates, has been found to attain a very firm consistence, so as to withstand ordinary solvents.

Such was the nature of the Italian tempera properly so called. On walls, and for coarser work, warm size was occasionally used; but the egg vehicle, undiluted, was preferred for altar pictures on wood. Thus used, and drying quickly, it was difficult to effect a union of tints in the more delicately "modelled" parts of a work, —for instance, in the flesh, —without covering the surface with lines (tratteggiare ; Anglice, hatching) in the manner of a drawing : Vasari indeed assumes that tempera pictures could not be executed otherwise.

* Della Summa de' Secreti universali, Ven. 1575, vol. i. p. 127.

† Diosc. l. i. c. 183. Plin. l. xxiii. c. 7.

Examples of works, painted with the egg vehicle, being rounded and duly finished without this laborious process, are certainly not common in Italy. The pictures of Gentile da Fabriano and Sandro Botticelli are among the rare exceptions *; an early specimen of Perugino, in the National Gallery, exhibits the dryer method.

The productions of the still older Rhenish painters, on the contrary, are softened and rounded with scarcely any appearance of this hatching : the ancient altar-piece in the cathedral of Cologne, by Meister Stephan, may be cited as an example. It had been long concluded that the painters whose works in tempera exhibit this union of tints must have employed a vehicle which did not dry rapidly, but allowed time to blend the colours at will. Vasari and other writers suggest a mode of securing this union on cloth, by sponging the back of the picture, and thus arresting the drying till sufficient finish is attained†; but they

* A specimen of Gentile da Fabriano in the collection of Mr. Warner Ottley is remarkable for the fusion of the tints. It is also an example of the partial oil painting in drapery, described by Cennini. (See the last chapter.) The patterns are painted with vermilion, and glazed with lake mixed with oil ; the ornaments below are also in oil. The surface of the portions so treated is, consequently, somewhat more raised than that of the rest of the work. A picture by Sandro Botticelli, in the collection of Mr. Solly, executed entirely in tempera, has the same union of tints with much more body.

† Vasari, Introd. c. 25. Armenini, De' veri Precetti della Pittura, Ravenna, 1587, l. ii. c. 8.

do not allude to any expedient for producing the same result on the surface of wood or of walls. It is also evident from the appearance, above described, of most of the Italian tempera pictures, that no such method was commonly practised.

The Italian painters, though attentive to the preparation of materials with a view to the durability of their works, seem to have made it no part of their study to lessen executive difficulties. Their ambition was to overcome such difficulties by superior skill, rather than by mechanical contrivances. Thus fresco, ultimately, was proposed to be executed without retouching. As if on the same principle, the tempera which was found to dry too fast for the less expert designers of the North, was retained by the Italians in a climate where it dried still faster.

The general omission, by transalpine painters, of the juice of the fig-tree in the tempera vehicle (from the difficulty of procuring it, in colder climates, in sufficient quantity) is unimportant, as its use was by no means universal, even with the Italians. The mode in which the German and English artists retarded the drying of their vehicle, appears to have been by means of an ingredient which has re-appeared in our times in the manufacture of water colours; viz., the addition of honey. Vasari speaks of the immixture of honey with gold-leaf ground in gum water*; it is also mentioned in the Venetian

* Vasari, Introd. c. 28.

MS., among the ingredients of mordants for gilding.* This is the only approach to the transalpine practice which is to be met with in the earlier Italian writers. Still, such allusions indicate an acquaintance with the material for the purposes of painting, and may account for the union of tints observable in the excepted cases before noticed. The practice of mixing a small quantity of honey in grounds or primings, to preserve canvasses in a flexible state, is now common in Italy (and is certainly not to be recommended), but does not appear to be very ancient. A similar process is indeed described in the Byzantine MS.; the date, however, must in this instance be considered uncertain. The use of honey, for the object above mentioned, by the Rhenish and English tempera painters is proved by existing documents.

A MS. (on medical and other subjects) in the public library at Strassburg† contains some directions for the preparation of colours and vehicles, among which the ingredient in question is named. The handwriting of the treatise is of the fifteenth century‡; but older authorities are quoted, and the

* " A fare filitj doro ɪ charta to serapin e mitelo amoio ɪ lo axedo forte p̃ una note e mitege dentro alguna cossa de mielle e de biacha p̃ darge alguno corpo," &c.—" To make fine lines of gold on paper, take gum sagapenum, and let it dissolve in strong vinegar for one night, then add a little honey and a little white lead to give it body."

† The MS. is marked A. VI. No. 19.

‡ Such is the opinion of Director Passavant of Frankfort.

practice generally described may belong even to the early part of the fourteenth century. Honey is repeatedly mentioned for uses similar to those indicated in the Venetian MS.; the following passage is distinct as to its employment in painting: —

"I have now honestly, and, to the attentive, amply taught how all colours are to be tempered, according to the Greek practice, with two aqueous vehicles; also, how the colours are to be mixed, and how each colour is to be shadowed: [I have told] the whole truth. I will now teach how all colours may be tempered with size, on wood, on walls, or on cloth; and, in the first place, how the size is to be prepared for the purpose, so that it shall keep without spoiling, and also without an unpleasant smell. Take parchment cuttings, and, after washing them well, boil them in water to a clear size, neither too strong nor too weak. When the size is sufficiently boiled, add to it a basinful of vinegar, and let the whole boil well. Then take it from the fire, strain it through a cloth into a clean earthenware vessel, and let it cool. Thus prepared, it keeps fresh and good for a long time. The size being like a jelly, when you wish to temper any colours, take as much size as you please, and an equal quantity of water; mix the size and water together, and likewise much honey with them. Warm the composition a little, and immix the honey thoroughly with the size. With this

vehicle all colours are to be tempered, neither too thickly nor too thinly, like the other pigments of which I have already spoken. And these colours can all be coated with varnish; thus they become glossy, and no water or rain can then injure them, so as to cause them to lose either their tints or their shining appearance." *

There is evidence to show that this receipt describes the practice of the English artists at a very early period, though that practice is here

* " Nu han ich redelich und merkelichen wol gelert wie man alle varwen t͞pieren sol noch kriegeschem [nach Griechischen] sitten mit zwein wassern und wie man uff iedie varwe schetwen sol die gantze warhheit. Nun wil ich leren wie man alle varwen mit lim t͞pieren sol uff holtz oder uff muren oder uff tüchern. Und zu dem ersten wie man den lim dar zu bereiten sol das er lange wert und nüt ful wirt und ouch nüt übel smekent wirt. Nim bermit schaben und wesche die vorhin schön mit wasser und süde dar under ein lutern lim weder ze stark noch ze krank und wenn der lim ze hant gesotten ist so tu ein schüssel vol essichs darin und las das wol erwallen und tu in denn ab von dem für und sige in durch ein tuch in ein schön geschirr und setz in do er kül habe. So belibet er lang frische und gut. Ist der lim gestanden als ein galrein und was varwen du wilt t͞pier so nim limes als vil du wilt und ouch als vil wassers als des limes si und müsche den lim und das wasser under enander und ouch vil honges dar under und werme das enwenig und zertrib das honig gar wol under den lim und do mit sol man alle varwen t͞pier weder ze dik noch ze dünne als die andren varwen von' den ich vor han geseit und dis varwen mag man ouch alle wol über strichen mit virnis so werdent si glantz und mag ienien niemer kein wasser noch regen schaden das si ir varwe noch ir glantz nüt verlierent."

dignified with the epithet "Greek." * An Eng-
lish document, in which the same ingredient is
mentioned in connexion with materials for paint-
ing, belongs to the latter half of the thirteenth
century. The notice occurs in an account of ex-
penses relating to works executed by "Master
William" at Westminster, and in the Mews at
"La Cherringe" (Charing). The Mews, it is
to be observed, formed a large establishment
where the king's falconers resided; containing,
besides their dwellings, a chapel and other build-
ings. The principal painter, for such Master
William, the monk of Westminster, was†, might
consequently have been employed there on subjects
not unworthy of his abilities; the more ordinary
labours being undertaken by assistants. The ac-
counts from which the following items are ex-
tracted comprehend the period from the second to
the fifth year of the reign of Edward I. (1274—
1277), but many are missing.

"To William the painter, and his associate, for
the painting of twelve mews, 36s. To the same,
for seven score and twelve lb. of green for the

* See the note, with a further description of the MS., at the
end of this chapter.

† See Gage Rokewode's *Account of the Painted Chamber*,
p. 25.; where it is satisfactorily proved (contrary to Walpole's
supposition) that William, the monk of Westminster, was a
distinct person from William of Florence. The difference of
their abilities may be estimated by the fact, that, while the
latter was paid sixpence a day, William of Westminster was
receiving two shillings.

same, 75*s*. 4½*d*. To Stephen Ferron, for twenty lb. of white, 2*s*. To the same, for one gallon of honey, 12*d*. Item: for one gallon of white wine, 3*d*. Item: for small brushes (?) and eggs, 3½*d*. Item: for yellow, 6*d*. Item: for size, 12*d*."* Other accounts relating to operations in the same locality include a variety of materials : but the surest indication that some of the work was of a superior kind is the frequent mention of eggs, the proper tempera vehicle for all finer painting.

The use of wine in diluting glutinous vehicles was common for a long period: in the quotations already given, from St. Audemar and others, it is frequently mentioned. Vasari relates that the facetious Buffalmacco persuaded some nuns, for whom he painted, to supply him with their choicest wine, ostensibly for the purpose of diluting the colours.† The Northern artists were sometimes content to use beer ; the word (cervisia) is to be met with in early treatises on art ; for example, in Eraclius and Theophilus‡: its occurrence may per-

* " Willielmo Pictori et socio suo pro pictura XII. mutarum XXXVI. s. Eidem pro $\frac{\text{XX.}}{\text{VII.}}$ XII. li. de viridi ad idem LXXV. s. IIII. d. ob. Stephano Ferroni pro XX. li. albi II. s. Eidem pro I. gallon mellis XII. d. Item, pro I. gallon vini albi III. d. Item, pro bersīs et ovis III. d. ob. Item, in croco VI. d. Item, pro coli XII. d."

† Vasari, Vita di Buonamico Buffalmacco.

‡ Beer is still commonly used by decorative painters for graining. Its peculiar fitness, as a very weak glutinous medium,

haps be considered an indication of the transalpine origin of a MS., as it never appears in Italian documents. In the accounts relating to works executed in the chapel of S. Jacopo, at Pistoja, in 1347, certain quantities of wine are mentioned as part of the wages of the painters "pro eorum mercede:"* the quantity furnished to William of Westminster is too small to have been allowed for this purpose. The mention of white wine seems to indicate that the vehicle was intended for light colours. The Strassburg MS. directs red wine to be mixed with a violet colour: in the British Museum MS., quoted in a former chapter, "good and very clear white wine" is preferred for green.†

Judging from some existing specimens, it would appear that the early painters of Nuremberg used this honey vehicle. If so, the method, like the cloth-painting of the "frater Theotonicus," might be supposed to have found its way to Venice; but, with the exception of Gentile da Fabriano, who was in Venice for a considerable time, there is seldom any appearance of a more than ordinary fusion of tints in the early works of that school. The tempera pictures of Crivelli are even remarkable for the laboured treatment before mentioned. It would be

for fixing certain preparations before the application of varnish, is well known.

* Ciampi, Notizie inedite della Sagrestia Pistoiese, Firenze, 1810, p. 146.

† Le Begue, again, speaks of "très bon vin blanc" to be used in a mordant for gilding.

desirable to ascertain whether the altar-piece in-
scribed "Johannes de Alamania et Antonius de
Murano, p. 1445.," now in the public gallery in
Venice, exhibits a different execution, as that work
was undoubtedly painted, in part, by a German
artist.

OTHER ENGLISH METHODS OF THE SAME PERIOD.

With the exception of the peculiarities in practice
that have been described, the technical processes in
England during the fourteenth century closely
resembled those of Italy. This is apparent, if we
compare the records of the works executed at West-
minster during that and the preceding age, with
early Italian documents and treatises; the English
methods occasionally indicate even greater precau-
tions, chiefly with a view to intercept damp. Walls
which were to receive paintings of figures appear
to have been prepared with cloth glued over the
surface*: sometimes leaf-tin was found immediately

* Such expressions as "pro veteri panno, panno, canabi,
canevas," and more particularly " Nicholao Chaunfer pro
xv. ulnis de canevace emptis pro coopertura ymaginum re-
gum depingenda VI. s. VIII. d." (1353), seem to refer to this
practice. In the documents relating to the Duomo of Orvieto
we find : " I. libra et III. den. pro pretio quorundam petiorum
panni lini veteris pro angelis impanandis." The date is 1351.
(*Della Valle, Storia del Duomo d' Orvieto*, Roma, 1791, p. 281.)
The method is thus generally alluded to by Sandrart : " As
they feared that the walls might crack, they glued linen over
them, then laid a ground of gypsum, and painted their pictures
in tempera."— *Teutsche Acad.*, part i. p. 66.

next the wall, even under gilt plaster ornaments.*
Wood was generally covered either with parchment,
leather, or linen.† Plaster of Paris, the careful
preparation of which for the purposes of painting is
described by writers earlier than Cennini, was used
for grounds. ‡ The common parchment size was
employed for tempering the gesso or plaster, and as
the ordinary vehicle for painting (with or without
the addition of honey); the egg medium being
reserved for finer work. This agrees with the
practice of wall-painting described by Vasari when
speaking of the ancient Italian methods. His
words are: "Walls, when dry, should receive one
or two coats of warm size, the work being then
executed entirely with colours tempered with it:
and any one wishing to mix the colours with size
will find no difficulty, observing the same general
rules as in painting with yolk of egg; nor will the
paintings be the worse for being so executed."§
The fish-glue, so often mentioned in the Westmin-
ster accounts, was employed for carpentry.∥

* Gage Rokewode's Account, &c. p. 16.

† Pownall found parchment under a tempera picture of the
time of Richard II. (*Archæologia*, v. 9.) "Pellis" is mentioned
in the Westminster account-rolls.

‡ "In cole, plastro Paris," &c.(1347.) A chapter headed "Ad
faciendum gessum subtile" occurs in one of the MSS. of Al-
cherius.

§ Vasari, Introd. c. 20.

∥ "Johanni Lovekyn pro c. greylingsondes emptis pro bordis
conjungendis III. s. (1353)." Compare Smith's Antiq. of West-
minster, p. 183. 200.

Parchment, as well as " royal paper," was used for certain patterns (not worthy to be called cartoons) which served to transfer designs in the decoration of St. Stephen's Chapel.* A mode of preparing them is described in the *Illuminir-Buch* of Boltzen, a work which will be more particularly referred to in the note at the end of this chapter. The uses of parchment, in the operations of the English painters, explain some terms in a record (in the possession of Sir Thomas Phillipps, Bart.) which is quoted in Gage Rokewode's *Account of the Painted Chamber*, p. 12. " \overline{P} skrowys ad inde făc cole ꞇ pronnos [patronos];"† that is, " for parchments to make size and patterns." The word " scrow " is used as synonymous with parchment in an early English manual, called *A very proper Treatise, wherein is breefely set forth the Art of Limning.* ‡

* " Johanni Lambard pro II. quaternis papiri regalis emptis pro patronis pictorum xx. d. — Eidem [Georgio Cosyn] pro I. quaterna papiri regalis empta pro patronis pictarie [sic] inde faciendis x. d. [1353]."

† The date is 1307.

‡ " Imprinted at London by Thomas Purfoot, 1596." At the end of the book ; " Finished Anno Dom. 1573." See, also, in Johnson's *Dictionary*, the derivation of the word " scroll."

The technical term "size" originally meant a solid composition applied as a ground for gilding. It was chiefly used for raised or " ingrossed " letters : the manuals on illuminating abound with receipts for it. The origin of the term is to be found in the MSS. of Alcherius, where it is called " assisium, Gallice assise ; " that is, a layer, or foundation (for gilding). The older Italian and Spanish writers on art employ the word

It is not necessary here to investigate the precise nature of the various colours used in this country, or elsewhere, during the fourteenth century; but the subject is so far important as the materials may be found to have a connexion with the style of the period: a few observations on certain terms that have occasionally been the subject of inquiry may, also, not be out of place. Among the colours used by the English artists, the words "tinctus" and "teint" often occur. They probably represent the inferior lake made from brazil wood, and called in the Strassburg MS. " röselin varw." The directions for preparing it are among the commonest formulæ of the missal-painters. " Bresil" is mentioned, together with the grain dye extracted from crimson cloth, among the English receipts collected by Theodoric of Flanders, and preserved by Alcherius. In another of the MSS. of the latter (*Experimenta de Coloribus*), the word is written berxilium, berxinum, and versinum, thus show-

" sisa" in a like sense (Alessio, *Secreti;* Pacheco, *Arte de Pintura*). The " syze" of the early English writers has the same meaning. The Strassburg MS. speaks of " ein gut assis zu golde :" the form is here perhaps an indication of the early date of that manual, or rather of its original. The author of the *Proper Treatise* uses the expression " to ingross" (applied to raised letters) in the sense of the Italian " sgrossare ; " to reduce or scrape the surface of the " sisa" so as to fit it to receive the gold leaf. Ingrossed letters were thus necessarily gilt letters. At a later period, for example in Shakspeare's time, the term " engrossed" appears to have had reference to the magnitude only of the written character.

ing the origin of the Italian term *verzino*. It is scarcely necessary to remark that the tree must have given its name to the country, not the country its name to the tree; if, as is commonly assumed, there is any connexion between the two. Brazil wood is mentioned in MSS. on painting written some centuries before the discovery of America.* The origin of the term appears to be either the Spanish *brasas* or the Italian *brage* (glowing coals), in reference to the colour. Chaucer, in the " Nonnes Preestes Tale," alludes to it thus : —

> " He looketh as a sparhauk with his eyen,
> Him nedeth not his colour for to dien
> With brazil, ne with grain of Portingale."

The poet could not want illustrations from the sister art, as he was appointed Clerk of the Works at Westminster, by Richard II., in 1389, with the pay, for that and other duties of the kind, of two shillings a day. It will be observed that the colours noticed by him are the same as those described in the English receipts before mentioned.† The insect

* The tree in the eastern hemisphere, which is said to resemble most nearly the American Cæsalpinia Crista or (modern) brazil wood, is the Cæsalpinia Sappan, a native of India. It may have been imported into Europe by the Venetians and the Moors. In an early MS. on painting, once in the Library of Montpelier, now in that of the Sorbonne at Paris, we read : " Lignum brasilium nascitur in partibus Alexandriæ et est rubei coloris."

† The extract of brazil, which fades in oil, was esteemed, not without reason, by the illuminators. There are speci-

called kermes by the Moors furnished the colour
and name of crimson (kermesino, cremesino);
sometimes called grain, from the prepared material.
The grain of Portugal was celebrated from the time
of Pliny to that of Chaucer.*　The word vermi-
culus, the older form for vermilion, also refers to
this insect in the earlier treatises.

In the accounts relating to St. Stephen's Chapel,
in the time of Edward III., madder lake appears
under the names " cynople," " sinopre."　The word
must have been originally intended for " sinopis "
(strictly, a red earth).†　That, in the documents
referred to, it meant lake, is proved by various
circumstances.　In the MSS. of Alcherius we read
that " sinopis is a colour redder than vermilion; it
is also called cinobrium and mellana, and is made

mens of the tint itself in the Venetian MS.　The evidence as to
the identity of the colour is somewhat singular.　The writer,
after describing a mode of preparing a bright red " cholore
de grana " with " braxile overo lo verzino," observes that even
after it is dry in the shell it may be diluted (with a solution of
alum in vinegar); and that then, though paler, it is still good
for writing.　He continues: " the title of this receipt was
written with the tint of the second quality, after the first
infusion was dry."　The title is, " A fare questo cholore
e anchora piu bello che none questo: probatū."　The other
rubrick titles are of a brighter red tint, having, perhaps, been
written with the first infusion.

　　* " Granum ... circa Emeritam Lusitaniæ, in maxima laude
est." — L. ix. c. 65.　" Grana" is noted in a list of colours in
the Montpelier MS.

　　† For a description of its varieties, see John, Die Malerei
der Alten, p. 123.

from madder."* Again; "sinopis is otherwise composed of madder and the lake above described,"† viz. a lake prepared from ivy gum.‡ In the British Museum MS. (fourteenth century) before quoted, sinopis is described as a composition of "lacta" and madder. § In the *Proper Treatise* "synapour lake" is noticed. Lastly, St. Audemar observes that sinopis is "very costly:" accordingly it is the highest-priced colour in the records. The most expensive azure (probably "azurro della Magna") in the accounts now adverted to was ten shillings the lb.; the best cynople was thirty shillings the lb. ‖ The cheaper kind was perhaps mixed with ivy lake. On one occasion Hugh of St. Alban's procured the cynople of Montpelier (the great manufactory and emporium of colours for some centuries)

* "Sinopis est color magis rubeus quam vermiculus, aliter dicitur cinobrium, aliter mellana, et fit de Varancia."

† "Et aliter sinopis fit ex Varancia et lacha superscripta."

‡ Obtained by making incisions in the branches of ivy "in the month of March." —*St. Audemar.*

§ "Si vis facere optimam sinopidem accipe lactam et Waranciam et coque," &c. Elsewhere: "Rubia major, id est, Waranz [Garance]." The Indian lac lake may be referred to in the following passage (MSS. of Alch.): "Item ad faciendam lacham tolle unciam unam lache que est quedam gumma dicta lacha," &c.

‖ "Eidem [Johanni Lightgrave] pro iii. lb. de asure emptis pro eadem pictura precium lb. x. s. xxx. s. Eidem pro i. lb. de cynople empta pro pictura dicte capelle xxx. s. [1353]." In accounts of Edward the First's time (1294) the best azure was twenty-six shillings the lb.

at eight shillings the lb.* A colour called sinopis, which cost four shillings the lb. in the time of Edward I. (1292), may have been of the same inferior quality.

The directions for preparing these and other brilliant reds are not more numerous, in the treatises of the fourteenth century, than the receipts relating to the favourite green, " viride Græcum" (vert de Grèce, verdigris). The term "viride" alone, which also occurs in the Westminster accounts, appears to be intended for it. Green earth is distinguished in the MSS. by the epithet " terrestre," and sap greens by other designations.

The " broun " mentioned in the records was a red earth: the term perhaps comprehended various kinds. The early painters, accustomed to apply the epithet "red" to lake, kermes grain, and vermilion, looked upon red ochres and bole as brown colours: the last-named material was more especially so designated. In a sort of vocabulary prefixed to the MSS. of Alcherius, we read : " Brown I believe to be Armenian bole; the word is elsewhere used for ' dragon's blood,' which is nearly of the colour of bole."* In the *Proper Treatise* before quoted, all

* "Magistro Hugoni de Sancto Albano pro II. lb. de cynopre de Monte Pessalono precium lb. VIII. s. XVI. s. [1353]."

† " Brunus est color quem puto esse bularminium; alibi ponitur pro sanguine drachonis, qui quasi coloris bularminii est." The adhesive nature of bole, as well as its colour, rendered it an eligible ingredient in the composition of grounds for gilding. The Italian term " brunire," to polish, may perhaps be traced

ochres are called browns, and the mixture of " white
with a good quantity of red " (the colour not being
specified) is described as making " a sadde browne."
It is to be remembered that the word " sad," ap-
plied to colours, meant deep or dark; it is used
in this sense by the author last cited: for exam-
ple, " two parts azure and one of cereuse, sadded
with the same azure "; again: take " two parts
synapour and a third of cerius, and lay it on
thy vinets [foliage] *, and when it is dry, sadde
it with good synapour." The equivalent term
is " to enew " (enough), that is, to saturate:
" enewed or sadded with good ochre." These terms
agree with the early practice of art; shadow, with
the medieval painters, was equivalent to the deep-
ening of the local tint. Coarse and monotonous as
the result was, in their hands, such a view of nature
was, by the colourists, sometimes made compatible
with the largest style of imitation.† The brown of

to the burnishing of gold on Armenian bole (or brunus). Com-
pare Vasari, Introduzione, c. 28., and Vita di Margaritone.

* " Trace all thy letters, and set thy vinets or flowers, and
then thy imagery if thou wilt have any." Though written,
as it appears, after the middle of the sixteenth century, this
Treatise frequently describes the practice of a much earlier
age. It was probably copied from an older manual.

† From the examples given it is, at the same time, apparent
that the term " sad " (employed as above) corresponded with
the German " satt " (Latin " sat ") and only resembled the word
" shadow " accidentally. In the Strassburg MS. the two ex-
pressions appear together, the latter being somewhat disguised
by the mode of spelling. " Uff itelm zinober sol man *schetwen*
mit paris rot oder mit *sattem* röselin." " Pure vermilion should

the Westminster artists may have been the Spanish brown, which, if early writers describe it correctly, resembled Indian red.* With this and indigo the darkest shadows were made. " Indebas et broun" sometimes occur together at the end of the list of materials, as if representing the shadow colours. In the Strassburg MS., indigo, broken with other colours, is used for all darks, except in the flesh : in the *Proper Treatise* it is called " an Indian black." It appears frequently in account-rolls of the time of Edward I. and Edward II. ; but rarely in those of the next reign, when St. Stephen's Chapel was rebuilt and splendidly decorated. This can only be explained by the imperfect state of the existing records, as the colour was universally employed in the fourteenth century, and the " London indigo " (no doubt imported directly from the Levant) was celebrated at a much later period.

The synonymes of indigo are curious. In the earlier English accounts relating to operations in painting (1274), this colour is called Indebas; in the MSS. of Alcherius we read, "indicum finum qui cognomine bagadellus vocatur;" a similar term in the same MS. is explained by the observation

be shaded with lake or with deep brazil red." Again : " Müsch dar under enwenig wis weder ze liecht und [noch] ze *satt* und *schetwe* daruff mit *sattem* spangrün." Take green and " mix a little white with it [making a tint] neither too light nor too dark, and shade thereon with deep verdigris."

* See the Art of Painting in Oyl, by John Smith, 1687, p. 21. Haslam found a red oxide of iron among the remains of colours in St. Stephen's Chapel.

"c'est à dire baguedel." The Montpelier MS. speaks of "indicum de bagadeo;" the Venetian MS. calls it "indigo bago;" Cennini mentions it under the name of "indigo baccadeo" (on one occasion, even "maccabeo"). The following note on this colour, in De l'Escalopier's *Theophilus*, sufficiently explains all these corruptions. "The most esteemed of the indigoes was that of Bagdad; it was called 'indigo bagadel.' The tariffs of Marseilles speak of it under that name, as early as the year 1228." *

Azura, lazura, is the blue copper ore called by the Italians Azurro della Magna (d'Allemagna), and often simply Azurro. In the statutes of the Sienese painters (1355), the artists are enjoined to provide the real colours which, in their contracts, they promise to use; and not to substitute "Azurro della Magna for Azurro oltramarino, nor biadetto, nor indigo for Azurro."† Biadetto, in the Venetian MS. called "bladetus de Inde," is the pale mineral blue which was termed cendre d'azur, and la cendrée in the time of Rubens. De Mayerne says, "la cendrée is made of the blue stone which comes from India, and which is found in silver mines." Elsewhere he gives its synonyme, "cendre d'azur, beis."‡ In the Westminster accounts we

* Théophile, &c. p. 298.

† Gaye, Carteggio inedito d' Artisti, Firenze, 1839—1840, vol. ii. p. 7.

‡ Elsewhere, "la bice des Indes" and "la cendrée d'azur

find Azura and Pura azura distinguished from Bis azura or azura debilis*: the term "bisso," in Cennini, may be connected with these designations.

As the pigments called brown were by no means dark, it would appear that the painters of the fourteenth century, who restricted themselves to the materials which have been described, with their imperfect notions of light and shade, had no means of producing strength of effect but by local colours. The light scale of their flesh tints seems, however, in some instances, to have influenced the treatment of the rest of the work. The picture at Cologne, before referred to, is of this pale character; the two interesting altarpieces (formerly in the Chartreuse near Dijon, and now in the Museum of that city,) painted in 1391 for Philip the Bold of Burgundy † have the same delicate tone. Works of this period are rare; but if, as Smith supposed, the wall-paintings of the

dite en Anglois bice." De Mayerne, also, states that a similar colour was found in the Ardennes. Compare Field, Chromatography, 1835, p. 113.

* In accounts belonging to the time of Edward I. (1294), "bis azura" is four and five shillings the lb. The best "azure" (called "fin," "pura," and "optima"), as before stated, being then twenty-six shillings the lb. In 1353 (Edward III.) "azura debilis" is five, and "azura" ten, shillings the lb.

† The prince who, when scarcely fifteen years of age, fought at the side of his father, King John of France, at the battle of Poictiers, and was taken prisoner with him (1356). Those illustrious captives, with many other foreigners of rank, saw the Chapel of St. Stephen in its finished state, and, at that period, could imbibe a love for art in England.

Chapter House at Westminster were executed in the middle of the fourteenth century *, they may be classed among the most interesting specimens of transalpine art of that period extant. The general character of the colouring in these paintings resembles that of the time; but the local tints are forcible, and the execution is not without a feeling for roundness. It would be desirable to compare these remains (for portions only are well preserved) with some works executed at Ghent, Ypres, and Cologne, in the thirteenth and fourteenth centuries.

Certain technical operations, characteristic of the art of the period, which are to be traced in the English decorations, closely correspond with those described in the early writers. The gilding in St. Stephen's Chapel was profuse; the use of leaf-tin, according to the account-rolls, was equally abundant. Leaf-silver, on the contrary, is rarely mentioned in the later records. This is perhaps explained by the following observation of Cennini.

* When some of the presses were removed in 1801, " representations of angels were discovered to have been painted on the walls, which Mr. Smith minutely examined, and found to resemble those in St. Stephen's Chapel, engraven for this work. From a close comparison of the style of colouring, and from the general character of all of them, Mr. Smith is thoroughly persuaded that the paintings in both buildings were executed by the same artists." — *Antiquities of Westminster*, p. 226. note. Other portions of the walls, covered with paintings, have since been visible: the small and ill executed figures in those compartments appear to be later in date. See the note at the end of Chap. VI.

"Above all, remember to use as little silver as possible; because it does not last, but turns black on walls and on wood, especially on walls. Use, in preference, leaves of tin. Beware, also, of gold that is much alloyed, for it quickly turns black." * All the documents before mentioned, from the Lucca MS. downwards, speak of tin-foil, and of its use, by means of a yellow varnish, to imitate gold. Vestiges of this lacker, the auripetrum of Eraclius, were found by Haslam on some fragments from St. Stephen's Chapel, that were submitted to his examination. The gold leaf, he remarks, "was of great purity." †

The impressions of patterns on gilt grounds, and the ornaments in relief, observable in early Italian pictures, are frequently referred to in the English accounts. The directions of Cennini, and the terms employed in those records, mutually explain each other. The Italian describes the operation of partially roughening or indenting (granare) the gilt field by means of a pattern stamp (rosetta). In the Westminster records (1353), we find " stamps for printing the painting with impressions ‡ ;" with other entries of the same kind. Embossed ornaments, sometimes gilt, sometimes covered with leaf-tin lackered or variously coloured, studded many

* Trattato, cap. 95.

† Smith, Antiq. of Westminster, p. 224.

‡ "Pro stupis emptis pro impressionibus picture imprimendis II. d." The origin of "stupis " is, perhaps, to be sought in the German "stupfel," punchion.

parts of the interior of the chapel. Descriptions of similar methods occur in Cennini (c. 102—130.). The mode of preparing the leaf-tin cut into the proper forms, to be applied either on the raised ornaments or alone, is also fully detailed by that writer (c. 97—101.). Numerous passages in the Westminster accounts show that the English practice was the same.* The insertion of gems (or imitations of them), Anglice "nouches," in the raised diadems of saints is not omitted by the Italian (c. 124.), and the process is to be recognised in some items of earlier accounts belonging to the time of Edward I.† Some details respecting the implements described by Cennini, and mentioned in the English records, are given in the note at the end of this chapter.

It is thus evident that, with the exception of such modifications in technical processes as the difference of climate required, the habits of the English painters in the fourteenth century closely resembled those of the followers of Giotto. As already remarked, this is easily explained by the bond of union which existed between religious

* "Pro VI. duodenis foliorum stanni emptis pro preyntes inde faciendis pro pictura dicte capelle VI. s." Similar entries are frequent. "In cotone empta pro preyntes depictis cubandis. . . . Cubantibus aurum tam super dictis parietibus quam super posicione preyntorum super columpnis marmoreis." (1353—1355.)

* "Item in VI. nouchis V. s. . . . In tribus nouchis II. s. VI. d." (1294.)

establishments, the members of which (as has been seen in many instances) were chiefly active in collecting and communicating information on practical points. In all that belonged to the higher elements of art, in all that the dull descriptions of the monks could not convey, the Italians, during this period, commonly surpassed their transalpine rivals; but in mechanical details they were indebted, in their turn, to the artists of the North.

In order to complete the general view of the state of art, technically considered, in the fourteenth century, some particulars respecting the state of fresco painting and wax painting, at that time, are added in the next chapter.

NOTE

ON A GERMAN MANUSCRIPT IN THE PUBLIC LIBRARY
AT STRASSBURG.

(Marked A. VI. No. 19.)

THIS manuscript is stated by competent judges to have been written in the fifteenth century, but the methods which it describes, like those in Cennini, the Venetian MS., and other compendiums of the kind, belong for the most part to an earlier period. This is apparent, not only from internal evidence as regards the methods themselves, but from the circumstance of the manual having been avowedly compiled from other authorities and documents. For example: " This relates to colours [the preparation of] which Meister Heinrich von Lübegge

taught me." Elsewhere; "This Meister Andres von Colmar taught me."* From other expressions it is equally clear that certain portions were transcribed from an older MS.

The receipts for the preparation of colours used in illuminating resemble those in the treatise of St. Audemar, the Venetian and Montpelier MSS. †, and other early authorities. The nature of the materials sometimes employed in this branch of art need not surprise us when their peculiar application is remembered. The colours, though chiefly extracted from flowers and vegetable substances and too evanescent for general use, were found to last in manuscripts, because light and air were excluded from them. This experience was not lost on the painters of larger works executed with more durable materials, such as altar-pieces; the ancient custom of enclosing these in shrines undoubtedly tended to preserve them, and was therefore long retained.

The colours for illuminating were commonly preserved by steeping small pieces of linen in the tinted extracts, sometimes mixed with alkaline solutions. The process is minutely described in this MS.; the dyes so prepared are there called "tüchlein varwen," literally "clothlet colours." The following passage from another compendium, the Venetian MS., gives the result in few words. "When the aforesaid pieces of cloth are dry, put them in a book of cotton paper, and keep the book under your pillow, that it may take no damp; and, when you wish to use the colours, cut off a small portion [of the cloth], and place it in a shell with a little water, the evening before. In the morning the tint will be ready, the colour being extracted from the linen."‡ This practice is alluded to by Cennini when he says : "You can shade with colours, and by means of

* "Dis ist von varwen die mich lert Meister Heinrich von Lübegge."
"Dis lehrt mich Meister Andres von Colmar."
† The latter speaks of "colores qui fiunt de succo herbarum et florum."
‡ "E quando seranno seche le dite peçe mitele ī uno libro de charta bōbaxina e tine lo libro soto lo chavezale aço che nō pia umiditad e quando ne voi adoverar taiane uno puocho e mitelo amoio la sira ī uno chaparaço con uno puocho de aqᵃ la maitina sera fato e lo cholore foro de la peça."

small pieces of cloth, according to the process of the illuminators."*

The German compiler, speaking of the preparation of a blue colour in this mode, says : "If you wish to make a beautiful clothlet blue colour according to the London practice," † &c. : after describing the method of preparing it he adds : " These [pieces of cloth] may be preserved fresh and brilliant, without any change in their tints, for twenty years ; and this colour, in Paris and in London, is called [blue] for missals, and here in this country clothlet blue; it is a beautiful and valuable colour." ‡

The place denominated *Lampten*, mentioned together with *Paris*, can be no other than London. Instances of misspelling, quite as curious, occur in almost every line of this manuscript. But for the clue afforded by this connexion of the two names, representing two prominent schools of missal-painting, the adjective, " lamptschen — lampenschen," (for Londonschen) would have been unintelligible. It occurs thrice. The first instance has been already quoted ; afterwards we read : " If you wish to make a fine violet colour, take London indigo, and twice as much brasil extract," &c. § The third passage is remarkable. " This manual [another of the sources whence the MS. was compiled] teaches how to temper all colours for painting, and also for executing foliage [in illuminating], according to the practice of London ; likewise [treats] of all transparent colours, red, blue, &c. ; and how to make transparent parchment [size] as clear as glass. It teaches also how to prepare three kinds of gold size, and how to compose three kinds of varnish : and in the first place two aqueous vehicles

* " Puoi fare ed ombrare di colori e di pezzuole secondo che i miniatori adoperano." — *Trattato*, cap. 10.

† " Wellent ir schön fin tüchlinblau var machen nach lamptschen sitten," &c.

‡ " Man mag sü 20 jar wol behalten frisch und schön das ir varwe niemer verwankt und dise varwe heisset ze paris und ze lampten vor misal und hie im land tüchlin blau und ist liep und wert."

§ " Wiltu schön violvarw machen so nim lamptschen endich und zwürent als vil prisilien roter varwe," &c.

with which all colours may be tempered, and this is the first of such gum waters." *

After the receipts for these, — consisting of a solution of gums, with and without the addition of honey and vinegar, — the transparent colours are described ; thus agreeing with the order indicated in the prefatory statement. Having given these directions, which are somewhat diffuse, the writer observes (in the words before quoted): " I have now honestly and, to the attentive, amply taught how all colours are to be tempered, according to the Greek practice, with two aqueous vehicles." Whatever may be thought of the ignorance of the compiler, it is apparent that the epithet " Griechische" is here equivalent to the " Londonsche" before used.† The directions which immediately follow relate to the English size and honey vehicle before described. Then follows the preparation of oil for painting and for gold sizes ; lastly, the three varnishes are described ; the catalogue thus strictly agreeing with the previous general statement.

The observation respecting the " London practice " might, according to the strict interpretation of the words, relate only to the "two aqueous vehicles" first described ; but, when it is

* " Dis buchlin lert wie men all varwen tempieren sol ze molen und ouch ze florieren nach lampenschen sitten und ouch von allen durchschinigen varwen rot blau und wie man durschinig bermit sol machen luter als ein glas. Es lert ouch machen drierleige gold grunde und lert ouch drierleige virnis machen und zu dem ersten 2 wasser damit man alle varwe tempiereren mag und ist dis das erst gumi wasser.'
The expression "zu dem ersten," "in the first place," is a form occurri ng repeatedly in the MS. It is here equivalent to a longer phrase. "First, then, to take the subjects which I have enumerated in due order, I begin by describing the processes which I first mentioned : the following are water-colour vehicles for painting and for executing foliage."

† This may be explained by supposing that the epithet " Greek" occurred in the original compendium ; and the German compiler, after saying, in his own person, that the book which he was about to transcribe taught the London practice, may have afterwards copied the language of the original ; the older manual being derived perhaps from a Byzantine source.

found that the methods throughout agree literally with the
"London practice," as far as that is recorded, it seems more
than probable, that the compendium from which these receipts
were borrowed contained a full account of the English methods
which were in use during the fourteenth century. As regards
the directions for oil painting, however, internal evidence
rather warrants the conclusion that they are later than the
other notices. After describing the size vehicle, the writer
thus proceeds : —

"How to temper all oil colours. — Now, I will also here teach
how all colours are to be tempered with oil, better and [more]
masterly than other painters ; and in the first place how the
oil is to be prepared for the purpose, so that it may be limpid
and clear, and that it may dry quickly.

"How to prepare oil for the colours. — Take the oil of linseed,
or of hempseed, or old nut oil, as much as you please, and put
therein bones that have been long kept, calcined to whiteness,
and an equal quantity of pumice stone ; let them boil in the oil,
removing the scum. Then take the oil from the fire, and let it
well cool ; and, if it is in quantity about a quart, add to it an
ounce of white copperas ; this will diffuse itself in the oil, which
will become quite limpid and clear. Afterwards strain the oil
through a clean linen cloth into a clean basin, and place it in
the sun for four days. Thus it will acquire a thick consistence,
and also become as transparent as a fine crystal. And this oil
dries very fast, and makes all colours beautifully clear, and
glossy besides. All painters are not acquainted with it : from
its excellence it is called oleum preciosum, since half an ounce
is well worth a shilling ; and with [this] oil all colours are to
be ground and tempered. All colours should be ground stiffly,
and then tempered to a half-liquid state, which should be
neither too thick nor too thin.

" These are the colours which should be tempered with oil.
Vermilion, minium, lake, brasil red, blue bice, azure, indigo,
and also black, yellow orpiment, red orpiment, ochre, face
brown red, verdigris, green bice, and white lead. These are
the oil colours and no more. Here observe that these colours
are to be well ground in the oil, and at [last] with every
colour mix three [that is, a few] drops of varnish, and then
place every colour by itself in a clean cup, and paint what you

please. — With all the above mentioned colours a small quantity of calcined bone may be mixed, or a little white copperas about the size of a bean, in order to make the colour dry readily and well." *

Then follow rules for the immixture of the colours, and the mode of shading each tint. From the mention of flesh colour,

* " Wie man alle ouli varwen tpierē sol. — Nu wil ich ouch hie leren wie man alle varwen mit oli tpieř sol bas und meisterlich denn ander moler und zu dem ersten wie man das oli dar zu bereiten sol das es luter und clor werde und dester gern bald troken werde. Wie man das oli zu den farwen bereiten sol. — Man sol nemen linsamen oli oder hanfsamen oli oder alt nus oli als vil man wil und leg darin alt gebrent wis bein und ouch als vil bimses und las das in dem oli erwallen und wirf den schum oben abe von dem oli und setz es ab dem füre und las es wol erkülen und ist des olis ein mos so leg zwei lot galicen stein dar in in das oli und so zergat er in dem oli und wirt gar luter und ouch klar und dar nach so sige das oli durch ein rein lin tüchlin in ein rein bekin und setz das bekin mit dem oli an die sunne 4 tag so wirt das oli dik und ouch luter als ein schöner cristall und dis oli das troknet gar bald und macht alle varwe schön luter und ouch glantz und umb dis oli wussent nüt alle moler und von der guti dis olis so heisset es oleum preciosum wand 1 lot ist wol eines schillinges wert und mit olin sol man alle varwen riben und ouch tpieř alle varwen in der diki riben und ouch tpieř als ein halber bri der weder ze dik noch ze dünne si.

" Dis sint die varwen die man mit oli tpierē sol zu dem ersten zinober nimien paris rot röselin rot liech blau lazur endich und ouch swartz opiment gel rüschelicht verger antlit brunrot spangrün endich grün und ouch bliwis.

" Dis sint die oli varwen und nüt me hie merke dis varwen sol man alle gar wol riben mit dem oli und ze . . . ᵃ so sol man under ieglich varwe drie troph virnis riben und tu denn ie die varw sunder in ein rein geschirr und würke do mit was du wilt — under alle dise vorgn. varwe mag man en wenig wises wolgebrentes beines riben oder en wenig wisses galicen steines als gros als ein bone umb das die varwe gern und wol troken werdent."

ᵃ A word is wanting in the copy, the original having been perhaps illegible.

"libvar, libvarw," and the directions for painting faces, hands, and undraped portions, "antlit und hende und do das bild nakent ist," it would appear that oil painting was sometimes employed for figures, when the original manual was written ; at the same time it is to be remarked that the primitive nature of the mode of painting which is described, indicates a very early date.

With respect to the colours above enumerated, *Paris rot* (Paris red), according to the MS. itself, was lake. As before stated, the treatises of the fourteenth century, particularly those written in France, speak of madder lake under the name of Sinopis, the name which it bears in the Westminster records. *Röselin rot* is described as a preparation from brasil wood (presilien holtz). The *liech blau* (licht blau) corresponds with the " azura debilis " of the English records, and both answer to biadetto. *Rüschelich*, sometimes written rüschegel (rauschgelb), is red orpiment or realgar. Orpiment is noted in accounts of the time of Edward I., and appears in the records of Ely. Black * is mentioned among the materials of the Westminster artists, but it seems that it was chiefly used by the glass-painters for drawing their outlines on white boards, which served instead of cartoons. No dryers are named in the accounts ; they may be comprehended in such expressions as " et aliis minutis — coloribus et aliis," &c. The materials may be supposed to have been familiar ; calcined bones, in particular, were used in painting as early as the twelfth century. In the *Mappæ*

* " Geet and Arnement" (1352), that is, jet and ink (atramentum) ; see Halliwell's *Dictionary of Archaic and Provincial Words:* Smith, in the *Antiquities of Westminster*, explains " arnement " improperly as orpiment. Ink (inchiostro) is mentioned by Cennini as the ordinary material for drawing outlines. The term jet perhaps represented coal black, or rather bistre, called " russ " in the Strassburg MS. From some passages in the accounts these blacks or browns appear to have been, at first, solid substances. " Thome Dadyngton et Roberto Yerdesle molantibus geet et arnementum pro pictura vitri." Elsewhere ; " molantibus get pro pictura vitri." The outlines of the wall-paintings were no doubt sometimes drawn with the same materials. Compare Gage Rokewode, Account, &c. p. 15.

Clavicula verdigris is directed to be mixed with a white made of calcined stag's horn (as it cannot be mixed with white lead without changing).* In the British Museum MS. (fourteenth century) before quoted, the following passage occurs. " Grind the white of [calcined] bones like the other colours; it is particularly necessary to painters, because it may be mixed with orpiment, a colour which can be mixed with no other white." †

As some of the receipts in the Venetian MS. were afterwards printed in collections of *Secreti,* so many directions in the Strassburg MS. are to be recognised, though somewhat altered in form, in the *Illuminir-Buch* of Valentine Boltzen.‡ That author states, in the titlepage of his manual, that part of his communications had never before appeared in print; and, in the preface, apologises to his professional brethren for publishing their secrets, observing that no useful knowledge should be concealed. Among the receipts, the immixture of honey with vehicles for illuminating frequently occurs; and hempseed oil is mentioned with the other oils, as in the MS. The mode of preparing and employing the calcined bones, which is more fully described, may be noticed in another chapter. Boltzen appears to consider the drying power of this ingredient quite sufficient, as he omits the white copperas. The omission is to be accounted for in no other way, since that material was the universal dryer in Germany, the Low Countries, and England, from the fifteenth to the eighteenth century. The printed form throws little light on the terms of the MS.; " ouger " (ochre) is more intelligible than its written equivalent " verger ; " on the other hand, " lamptschen endich " is altered to a form which would defy recognition but for the steps to it which can now be

* "Viride Grecum distemperabis cum aceto, incides de nigro matizabis de albo quod fit de cornu cervi." "Mix verdigris with vinegar, shade with black, light up with white made of [calcined] stag's horn."

† "Album de ossibus moles sicut ceteros colores est ideo pictoribus necessarium quod cum auripigmento potest misceri que mixtura de ɑ" alio fieri non potest."

‡ 1566, no place. The second edition, 1589, was published at Frankfort; the third, 1645, at Hamburg.

traced. The writer observes : " I ought to write of various kinds of indigo, but I restrict myself to that particular sort which is called Lampartischen indigo ; it is found in apothecaries' shops." * The word does not occur elsewhere in the treatise, and in three editions it is always the same ; it is only surprising that it did not grow into " Lombardischen."

The question respecting the English origin of the mode of preparing oil above described, is to be viewed in connexion with the facts that have been adduced in the foregoing chapters. The preparation of oil in the sun was peculiar to no country : it has been seen that it was universal. Verdigris and calcined bones were early used in Italy ; the latter of those ingredients, white lead, and, it now appears, white copperas, were employed perhaps at a still earlier period in the North. That the use of these various materials, as siccifics, was familiar in this country, if familiar anywhere, there cannot be a doubt. It has been shown that oil painting was prevalent in England, before it was common elsewhere ; and the habitual use of the method for ordinary purposes, in such a climate, is of itself a proof of the early use of dryers.

The decoration of St. Stephen's Chapel (after it was rebuilt by Edward III.) in the middle of the fourteenth century was an important event in the history of Northern art. If the talents which the execution of that work called forth — represented by Barneby †, Hugh of St. Alban's, Cotton, Maynard, and others — were not further encouraged, in consequence of Edward's prolonged wars, and the disorganised state of the country in the succeeding reign ; still, the extent of the operations in and about the chapel may have influenced the practice of the neighbouring schools ; and the English methods, in oil painting particularly, may have been adopted in countries where a similar

* " Von Endich solt ich vilerley arten schreiben, aber ich wil mich allein zu den gewissen halten den mañ nents [nennt] Lampartischē Endich, den findet mann in den Apoteken."

† The name of John Barneby does not appear in the lists of the artists employed in St. Stephen's Chapel till 1355 ; he received two shillings a day, that is, twice as much as Hugh of St. Albans.

climate required similar remedies. The intercourse between this country, Germany, and Flanders, at that period, is indicated by various circumstances connected with art, to say nothing of political occurrences. The names of the numerous artists employed in the chapel are chiefly English, but we find that glass was furnished by John de Alemayne, gold leaf by William Allemand, and white varnish (mastic) occasionally by Lonyn of Bruges. In the preceding century (1294) Gilectus of Bruges, a painter, received the highest wages next to Master Walter.*

The coincidence between that part of the Strassburg MS. which speaks of the "London practice," and the methods and materials of the English artists as they are recorded in the documents of the time, is not to be overlooked. The size and honey vehicle has been described. The "transparent colours" applicable, as is incidentally stated in the MS., to linen, resemble those which were noted by Theodoric of Flanders, and afterwards communicated by him in Italy. The occurrence of some English names of water colours in the MSS. of Alcherius and elsewhere, further shows that the "London practice," in this respect, had before attracted attention. The directions for preparing oil grounds for gilding, are not less remarkable, and tend even to explain the consumption of oil during the embellishment of St. Stephen's Chapel, profusely decorated as it was with gold. It is important to observe that the dryers mixed with the gold mordant described in the MS. are the same as those before mentioned as entering into the composition of

* Indications of the use of oil painting for common purposes are not wanting in Flanders in the fourteenth century, and it happens that they appear at the time when the decorations of St. Stephen's Chapel were in progress. De Bast (*Messager des Sciences*, &c., Gand, 1824, p. 50.) quotes some accounts, dated 1351–1352 (found in the archives of Bruges), in which a certain painter engages to decorate the chapel of the Stadt-House at Damme with gold and silver and "all manner of oil colours suitable thereto." "Jan van der Leye den schildere, van der capelle te stoffeerne ten Damme in der steden huus van Brügge, van Goute, van Zelver in allen maniere van olye vaerwe dier toe behoorde," &c.

the oil vehicle. In this case the employment of such ingredients in the fourteenth century need not excite surprise; for it has been shown that dryers were used in mordants before they were introduced in oil painting. The more ancient mode of gilding was by means of glutinous mordants; a firmer ground was required in the North; and the date of the oil gold size, whenever it may have been introduced, may be safely assumed to mark the commencement of the use of dryers for purposes connected with painting.* The preparation of the gold size is thus described: —

"Here I will teach how to gild and silver all materials speedily and effectually, so as to produce a splendid effect; and, in the first place, how to make an excellent varnish colour, on which gold and silver [leaf] may be laid; dry, beautiful, delicate, and lustrous; and from which the gilding and silvering can never be removed, neither by water nor by wine, whatever be the surface on which you lay this gold colour, whether it be iron, steel, tin, lead, stone, or ivory, with all metal-work, or cloth, or taffeta, all things soever on which this colour is applied. Take two parts of ochre, the third part of Armenian bole, and the fourth part of minium, and grind them together on a stone with linseed oil. Grind them well, and in consistence neither thicker nor thinner than the other oil colours; and grind also with the colour calcined bone, about the size of half a walnut to a bleeding-cupful† of colour, and as much white copperas as calcined bone. And after all this is well ground, then add [as much as] half a walnut-shellful of varnish, and mix it thoroughly with the colour. Then, removing all the colour from the stone, place it in a clean glazed cup, and take a piece of skin from a bladder and cut it so that it shall fit the cup, and smear one side well with oil; then place the piece of bladder on the colour. You have thus an excellent colour for gilding, on which

* It thus appears that the Northern artists led the way in accelerating the drying of oil and in retarding the drying of tempera. Neither of the remedies employed for these objects was adopted to the same extent in Italy.

† "Las kechelin (Lasbecken);" the expression indicates that the compiler was in some way connected with the healing art.

gold and silver leaf never loses its brilliancy and lustre. The piece of bladder should be placed on the colour so as to touch its surface every where; thus the gold colour will not skin; and all other oil colours should be covered in the same manner. By this contrivance they remain in a fit state for a long time, and do not quickly become hard."*

Even the details relating to the operation of gilding are not without interest, from their coincidence with the early English methods. "Here I teach how to gild on this gold colour. In the first place, if you wish to gild on wood, on cloth, or on taffeta, give two or three coats of fresh size beforehand. When the size is dry on the wood, cloth, or silk, pass the gold colour over the size with a soft hog's hair brush, spreading the colour equally

* "Hie wil ich leren wie man kürtzentlich und ouch gar nützlich alle dinge vergülden und versilbern sol schön und ouch glantz und zu dem ersten wie man sol machen ein edel glas varwe dar uff man gold und silber leit troken schön vin und glantz und das das gold und das silber niemer ab gat weder von wasser noch von win und war uff du dise gold-varwe strichest es sig isen oder stahel oder zin oder bli oder stein oder bein und andre alle gesmide oder tuch oder zendat und sies ander alle dung do man dise varwe uff strichet. Nim zwei teil vergers und das dritteil bol armenici und das vierde teil minien und rib das alles wol under enander uff einen rib stein mit lin öl und rib es ouch gar wol weder ze dik noch ze dünne als die andren oli varwen und rib ouch als gros wisses gebeines das gebrent si dar under als ein halb boum nus und ouch ein las kechelin vol der varwen und ouch als vil galicen steines als des beines ist gesin und wenn dis alles wol geriben ist so rib ze hindrest in die varwe ein halb nuschal vol virnis in die varwe und zertrib den virnis gar wol under die varwe und tu die varwe von dem stein gar in ein rein überlazurt kachlen und nim phlemlin von einer blattern und schnid das phlemlin sinwel das es recht kome über das kechelin und bestrich das phlemlin zu einer sitten gar wol mit oli und das phlemlin leg oben an uff die varwe so hast du ein edel gut gold varwe dar uff man gold und silber leit das es sinen schin und sin glantz niemer verlürt das phlemlin sol man alle wegen under über die varwe legen so wachset kein hut über die gold varwe und also sol tu allen andern oli varwen tun so belibet si lang lind und werdent nüt balde hert."

and thinly : then let it dry, but not too much; touch it with
your finger, and when it is dry and glossy, but still slightly
adhering to the finger, it is in the fit state for gilding. Then
cut your gold or silver leaf, and lay the pieces carefully on, one
next the other, where the colour is, and press the gold gently on
its ground with cotton, till the whole surface is gilt or silvered.
Then rub the surface with cotton to remove the superfluous
gold from the unprimed places ; it will adhere firmly elsewhere.
Here observe that iron, tin, lead, and all metal-work, ivory,
and all hard materials, do not require to be coated with size
first, although wood and cloth require it. But stone surfaces
and walls should be first saturated with oil before the gold colour
is applied. And in the aforesaid manner all materials are to be
gilt."*

The saturating (tränken) of walls with oil before even the
gold size was applied is another instance of an application of
the oil, besides its employment in painting. The foregoing

* " Hie lere ich wie man uff dise goldvarwe vergülden sol
zu dem ersten wiltu uff holtz oder uff tuch oder uff zendat
vergülden so überstrich das holtz vorhin mit frischen lime
zwürent oder dritund das das holtz werde und tu den andern
ouch also und wenn der lim truken wirt uff dem holtz oder uff
dem tuch oder uff dem stein [der seide ?] so strich die gold
varw über den lym mit einem weichen bürste bensel und
strich die varwe glich und dünne uff und las die gold varwe
troken werden und ouch nüt ze gar und griff mit dem finger
uff die varwe und ist die varwe troken und ouch glantz und
hafftet dir der finger enwenig in der varwe so ist si in rechter
mos ze vergülden so schnide din gold oder din silber und
lege das ordenlich uff nach enandern wo die varwe si und
truke das gold senfteklichen wider mit boumwollen uff die
varwe untz das es alles gar verleit wirt mit golde oder mit
silber und dar nach so ribe das gel über all mit wulle so vart
das gold abe wo die varwe nüt enist. Und belibet das golde
vast wo das gold hingestrichen ist. Hie merk isen zin bli und
alle andri herti gesmide und bein und senliche herti ding die
bedarfent nüt das man si vorhin mit lym überstriche wenn
allem holtz und tuch aber uff steinen und uff muren die sol
man vor mit oli trenken eman die golvar uff strichet und zu
glicherwise als hie vor gelert ist also sol man ouch andri ding
übergülden."

particulars represent, in all probability, the practice of the decorators of St. Stephen's Chapel. As regards the materials, the dryers (or, at all events, some dryers) must, for the reasons before given, of necessity have been used. The colours, the oil and the oil varnish, the earthenware cups for the colours, the cotton for the gilding, are all noted in the accounts.* The circumstance of two sets of colour-grinders being sometimes employed (without reference to glass-painting) might suggest the supposition that one class prepared the colours for the painters (either in tempera or in oil), and the other the gold colour only. †

It appears, therefore, that the only difficulty in identifying the formulæ of the MS. with the English practice of the four-teenth century is the application of oil painting to figures. When Vasari, in the second edition of his work, alludes to Cennini's description of oil painting, he indirectly defends his

* "Pro ollis—pro locatione vasorum—pro parvis ollis terreis emptis ad imponendos diversos colores.——Pro cotone empta ad ponendum et cubandum aurum in eadem capella. In i. lb. pili porcorum empta ad pincellas pictorum inde faciendas xii. d. In i. lb. pili porcorum empta pro bruciis pictorum," &c. Besides hog's hair brushes of various forms Cennini (cap. 64. 65.) describes the mode of preparing small brushes (indispensable in gilding) from the tail of the vaio, an animal, according to the *Della Crusca Dictionary*, resembling the squirrel ; the hairs were to be inserted in quills of vultures, common fowls, or doves, according to the work required. The English accounts frequently contain such details as the following : " In xxx. pennis pavonum et cignorum et caudis scurrellorum emptis pro pincellis pictorum ii. d. ob." De Mayerne speaks of brushes " de queue d'escureuil." Cespedes (quoted by Pacheco, *Arte de Pintura*, p. 396.) says that the best pencils are made of the hairs of the " vero [vajo] Belgico." The French equivalents for vaio are, *vair, petit gris* (*menu vair* being apparently the origin of minever). F. Cuvier, in the *Dictionnaire des Sciences Naturelles* (Paris, 1816–1829), remarks that *petit gris* is merely the name of the common squirrel in its winter colour.

† " ii. pictoribus molantibus colores pro dictis operibus utrique ad v. d. per diem. Rogero Wals cum ii. sociis suis molantibus colores—capientibus per diem iiii. d. ob." The entries occur repeatedly together.

own statement respecting the invention of Van Eyck. He remarks that Cennini treated "of grinding colours in oil to make grounds [for draperies], red, blue, green, and in other modes; and [also treated of oil] for gold mordants, *but not for figures.*" * It happens, as already seen, that Cennini does treat of painting figures in oil; but Vasari's statement may be considered to amount to a declaration that he himself knew of no such application of the method having been made before the time of Van Eyck. The historian's opportunities of judging, in regard to this question, in the sixteenth century, were better than ours; time has, however, confirmed his testimony. It is repeated, no undoubted examples of figures painted in oil during the fourteenth century have hitherto come to light; nor is there any distinct record of such works having been then commonly executed. If, therefore, the original of that portion of the Strassburg MS. which treats of oil painting was written before the year 1400, the passages describing the application of the method to figures are to be placed in the same category with the similar notices in Cennini and even in Theophilus; they are to be regarded as directions which were rarely if ever followed.

* " Trattò finalmente de musaici, del macinare i colori a olio per far campi rossi, azzurri, verdi, e d'altre maniere, e dei mordenti per mettere d'oro, ma non già per figure."— *Vita d'Agnolo Gaddi.*

CHAP. VI.

FRESCO PAINTING AND WAX PAINTING DURING THE FOURTEENTH CENTURY.

FRESCO PAINTING.

AMONG other methods employed in the middle ages, wall-painting with lime, and wax painting, are to be noticed. The first would, by its general terms, comprehend fresco painting; but that process, as described by Vasari, and as practised by the great Italian masters, does not appear to have been in use till near the close of the fourteenth century. Fresco painting requires, as is well known, to be executed in portions; the surface of fresh plaster which is laid on when the painter is about to begin his day's work must be covered and completed, as a portion of a picture, before such plaster is dry; and so on, till the whole design is executed. Some ingenuity is necessary to conceal the joinings of the several portions: it is generally contrived that they shall coincide with lines in the composition, or take place in shadows. Their existence is however unavoidable, and these divisions in the patchwork (for such it may be called), of which all works of the kind must consist, are among the tests of fresco painting, properly so called. Whenever the extent of a surface of plaster, without a joining,

is such that it would be impossible to complete the
work contained in it in a day, it may be concluded,
even without other indications, though such are
seldom wanting, that the mode of execution was
not what is called " buon fresco."

Walls decorated by the earlier Italian masters
exhibit no joinings in the plaster having any refer-
ence to the decorations upon them. The paintings
must consequently have been added when the entire
surface was dry ; and must either have been exe-
cuted in tempera, or, if with lime, by means of a
process called "secco," (or sometimes "fresco secco,"
as opposed to "buon fresco,") which is still commonly
practised in Italy and in Munich. The method has
been thus described. The plastering having been
completed, and lime and sand only having been
used for the last coat, the whole is allowed to dry
thoroughly. It is then rubbed with pumice-stone,
and the evening before the painting is to be com-
menced, the surface is well wetted with water in
which a little lime has been mixed. The wall is
again moistened the next morning ; the cartoons
are then fastened up, and the outline is pounced.
The colours are the same as those used in " buon
fresco," and are mixed with water in the same way,
lime being used for the white. "Work done in this
way will bear to be washed as well as real fresco,
and is as durable ; for ornament it is a better method
than real fresco, as in the latter art it is quite
impossible to make the joinings of the plaster at

outlines, owing to the complicated forms of orna-
ments. The work can be quitted and resumed at
any time, as the artist has always the power of
preparing the surface by moistening it, as at first.
But while the method offeis these advantages, and
is particularly useful where ornamental painting
alone is contemplated, it is, in every important
respect, an inferior art to real fresco."*

That this method was practised during and before
the thirteenth century will be evident from the
following passage in Theophilus. "When figures
or other objects are drawn on a dry wall, the sur-
face should be first sprinkled with water, till it is
quite moist. While the wall is in this state, the
colours are to be applied, all the tints being mixed
with lime, and drying as the wall dries, in order
that they may adhere."†

In the notes added by Le Begue (1431) to his
copy of the MSS. of Alcherius, the following pas-
sage occurs. "Portions of walls [intended to be
painted] should be rather moist than otherwise,
because the colours thus unite and adhere better;

* See a Report on Fresco Painting, by Mr. Wilson, Director
of the Government School of Design at Somerset House, in the
Second Report of the Commissioners on the Fine Arts, p. 40.

† "Cum imagines vel aliarum rerum effigies protrahuntur in
muro sicco, statim aspergatur aqua, tam diu donec omnino
madidus sit. Et in eodem humore liniantur omnes colores,
qui supponendi sunt, qui omnes calce misceantur, et cum ipso
muro siccentur ut hæreant." — *Div. Art. Schedula,* l. i. c. 15.
Theophilus nowhere describes the practice of " buon fresco."

and all colours for walls should be mixed with lime."* The passage in Theophilus (from which this may have been copied) is conclusive as to the early use of " secco," in the sense above explained, for wall-painting. The method, like other processes employed in the middle ages, was probably derived from the ancients; and it may be conjectured that the paintings of Pompeii were, to a certain extent at least, thus executed. Two important facts support this view. First, lime is found in nearly all the colours†; and, secondly, in most of the walls two horizontal joinings only in the plaster are to be detected. ‡ The work in either of the three divisions, but especially in the larger middle division, is much more than could be executed in a day. The method therefore could hardly have

* "Et doivent être murs pans plus moiste que aultre chose pour ce que les couleurs se tiennent mieux ensemble et seront plus fermes, et doivent toutes couleurs pour murs être mellez [sic] avec chaux vive."

† " In every colour, whether employed as the general tint of a compartment, or in the painting of figures and ornaments, a drop of diluted sulphuric acid produced an effervescence, indicating the presence of a small, and often invisible, portion of carbonate of lime, even on the surface of the deepest black."
—*Wiegmann, Die Malerei der Alten,* Hannover, 1836, p. 42. The exceptions are where some few portions are executed in tempera ; some colours on walls, vermilion for instance, are protected with a wax varnish (*Vitruv.* l. vii. c. 9.). It was this circumstance which deceived Winkelmann and others, who maintained that the paintings of Pompeii were executed in wax.

‡ Ib. p. 38.

been "buon fresco." The peculiar fitness of "secco" for ornamental work (which abounds in Pompeii) has been already noticed.*

The use of lime "in all the colours," according to the directions of Theophilus and Le Begue, would necessarily occasion a want of force in the shadows. This was remedied by subsequent painting in tempera. Theophilus, immediately after the passage quoted, speaks of the application of colours mixed with yolk of egg, on the previous preparation, when dry.† The next step to fresco painting (perhaps the ordinary lime painting practised by the ancients) consisted in laying in the design immediately after the original plaster was spread on the wall, and while it was moist. This preparation, or

* Besides the conclusive evidence afforded by the presence of the lime, many of the walls exhibit indented outlines, sometimes, as in the " Casa delle Fontane," indicating the process of tracing. Hence Wiegmann inclines to the opinion that the paintings may have been executed even in " buon fresco," and gets over the difficulty of the quantity of work by supposing that the numerous layers of mortar in the wall kept the surface moist for many days. If so, still the method of " secco " (and it appears even tempera occasionally) may have been employed in finishing. The writer here quoted, who is by far the most rational of those who have considered the subject of the Pompeian decorations, might have been assisted in his investigations by a reference to the wall-painting of the middle ages.

† In strict accordance with the description of Pliny : " Pingentes sandyce sublita mox ovo inducentes purpurissum, fulgorem minii faciunt. Si purpuram fecere malunt, cæruleum subliniunt, mox purpurissum ex ovo inducunt."— L. xxxv. c. 26.

dead colour, at least established the forms and masses
of colour; and, when dry, the work could be finished
either in "secco" or in tempera: the moderns pre-
ferred the latter. The method adopted by the fol-
lowers of Giotto in this partial fresco painting was
somewhat singular. The first rougher coat of lime
and sand having been allowed to dry, the painter
sketched his composition upon it with a red colour
in outline, sometimes adding the shadows. The
design was copied from a small drawing, in the
usual mode, by means of squares. Then the into-
naco, or thin coat of lime and sand, on which the
painting itself was to be executed, was added, either
at once, or in greater or less portions (accordingly
as the chief work was intended to be in fresco or
in tempera); and on this intonaco the design was
repeated. Thus the drawing underneath was des-
tined, from the first, to be covered. It was probably
traced before the lime was spread over it, as the
forms could then be reproduced in the same places,
the tracing being fitted by means of the ends of the
squared lines underneath. In thus making a design
which was to be obliterated, the object could only
have been to judge of the effect of the composition
in its place. In the Campo Santo, at Pisa, a half-
decayed fresco, representing the Coronation of the
Virgin (painted in 1391, by Pietro d' Orvieto),
shows, where the intonaco has fallen off, the first
design drawn, and even shaded, on the plaster un-
derneath. Vasari, describing an unfinished work at

Assisi, by Lippo Memmi, states that the outline was drawn with the brush in red, on the first coat of plaster; "which mode of proceeding," he observes, "might be called the cartoon which the early masters prepared before painting a fresco, in order to shorten the work." He adds that several unfinished and decayed wall-paintings exhibited the same preparation.* The method was retained even after the improved system was introduced. It is described by Cennini. (*Trattato*, c. 67.)

The earliest work in "buon fresco" is probably that painted by Pietro d' Orvieto, in the Campo Santo, at Pisa, about 1390, representing some subjects from Genesis.† In this instance the joinings of the plaster are frequent, as compared with earlier wall-paintings, and the amount of work in each portion may have been, and to all appearance was, finished at once. The earlier mode of employing tempera as the complement of fresco was, however, long retained. The works of Pinturicchio, executed at Siena, in 1503, are completed in tempera, and exhibit colours (such as lake) which are incompatible with mere lime painting.‡ The mixed method was even common at a later period in the sixteenth century, if not at Florence, at least

* Vasari, Vita di Simone e Lippo Memmi.

† Ernst Förster, Beiträge zur neuern Kunstgeschichte, Leipzig, 1835, p. 220.

‡ See "Observations on Fresco Painting," by Mr. Dyce, in the Sixth Report of the Commissioners on the Fine Arts, p. 11.

in other Italian schools. Thus Vasari states that Girolamo da Cotignola executed certain works at S. Michele in Bosco, in Bologna, which were laid in in fresco, and finished in tempera." * The same writer speaking of a series of paintings by Ercole da Ferrara, in a chapel at Bologna, says : " It is reported that Ercole employed twelve years on these works, seven in preparing them in fresco, and five in retouching them." † As the seven years may be supposed to comprehend the execution of the designs and cartoons, together with the first painting on the walls, the quantity of work in tempera was at least equal to that in fresco.

It should be remembered that the expression " a secco " is usually employed by Vasari for retouchings in tempera, and it is not to be confounded with the " secco," or lime painting, on dry walls described by Theophilus. The former term is also used by Italian writers in speaking of repainting or glazing on oil pictures when dry. Examples of " secco," or lime painting, perhaps exist in this country, but the rude representations sometimes to be met with on the walls of chapels are commonly retouched in size.

* " A fresco imposte ed a secco lavorate."—*Vasari, Vita di Bartolommeo da Bagnacavallo.*

† " Dicono che Ercole mise nel lavoro di questa opera dodici anni, sette in condurla a fresco e cinque in ritoccarla a secco. —Id., *Vita di Ercole pittore Ferrarese.*

WAX PAINTING.

The art of using colours prepared with wax, and of fixing pictures so executed by the aid of fire, was inherited from the ancients by the early Christian painters. The term " encaustic " which was long appropriated to this method, strictly means " burning in," an expression which, as Caylus remarked, is scarcely applicable to the mere melting of wax colours. The process, according to the words of Pliny, was not originally restricted to wax painting, but comprehended the engraving by means of encaustic, of outlines on ivory and other substances, with a metal point.* In this instance again the expression need not be taken literally ; forms burnt on ivory could not have been very delicate works of art. It may rather be supposed that the outlines first drawn on waxed

* " Encausto pingendi duo fuisse antiquitus genera constat, cera, et in ebore, cestro, id est, viriculo, donec classes pingi cœpere. Hoc tertium accessit, resolutis igni ceris penecillo utendi, quæ pictura in navibus nec sole, nec sale, ventisque corrumpitur." — L. xxxv. c. 41. " Anciently there were two modes of painting in encaustic, [one] with wax, and [the other] on ivory, by means of the cestrum or graver, till ships began to be painted. This was the third mode introduced, in which the brush was used, the wax [colours] being dissolved by fire." The metal instrument was therefore employed in both the first modes. The cestrum (κέστρον a κεντέω) was a pointed graver, but it must have been formed like the stylus, flat at one end and sharp at the other; since designs in wax, executed with the point, could only have resembled the *sgraffiti* on ivory, and there can be no doubt that the early wax pictures were much more finished.

ivory, (for the facility of correcting them where
necessary,) were afterwards engraved in the sub-
stance; and that the finished and shadowed design
was filled in with one or more colours; being ulti-
mately covered with a wax varnish by the aid of
heat.* Works so produced must have resembled
the *nielli*, or, on a small scale, the *sgraffiti* of the
Italians, and were no doubt quite as excellent.
With the later pagan and early Christian painters,
the word " encaustic " was confined to wax painting
(with the brush) by means of fire. The prevalence
of the method at a subsequent period accounts for
the gradual application of the term to all kinds of
painting, an application which, in the later vicis-
situdes of art, may be said to have survived the
process itself. Thus a Greek philologist, writing
at the close of the fifteenth century, explains a term
equivalent to encaustic by the synonyme " painted,
because artists who paint on walls are called

* See the sensible observations of John, Die Malerei der
Alten, Berlin, 1836, p. 206.

An antique specimen of this art, formerly in the possession
of Monsignore Casali, in Rome, is referred to by Haus, *Sulla
Pittura all' Encausto*, p. 76., quoted by Raoul-Rochette, Pein-
tures Inédites, &c., Paris, 1836, p. 378. A description of a
method somewhat similar, and perhaps originally Greek, occurs
in the Venetian MS. After directing the preparation of a blue
tint with tempera, the writer continues : — " Spread it on the
foil, and, when it is dry, draw on the foil with a sharp point
whatever you wish, and afterwards give it a coat of liquid var-
nish. It will have a good effect." "E mitelo sopra el stagnolo
e qū srā secho desegnali como uno steco aguto quelo che voy e
poy dali la vernixe liquida de sopra. Srā vaga cossa."

encautai." * Other modes of painting, and even illuminating, were sometimes included. The purple and vermilion, used for the imperial signatures and in calligraphy, received the name of encaustic.† By degrees the more ordinary material of writing acquired the designation ; the " incaustum " of Theophilus and other medieval writers is, in substance as well as in name, the " inchiostro " of the Italians, and the source of the English " ink."

The more ancient modes of wax painting mentioned by Pliny were of two kinds : one, above described, was a sort of intaglio filled in with tints ; the other more resembled painting, yet rather in its results than in its process. A heated metal instrument was used instead of the brush. The variously coloured wax pigments were rather modelled than painted into shape. The process, in its commencement at least, and before the tints were blended, must have resembled mosaic ; while its elaborate nature confined the artist to small dimensions. The difficulties of the method were, nevertheless, overcome by some celebrated Greek

* Ἐγκεκαυμένη, ἐζωγραφημένη, ἐπεὶ ἐγκαυταὶ [ἐγκαυσταὶ] λέγονται οἱ ζωγράφοι οἱ διαγράφοντες τοὺς τοίχους. " Encausta, picta ; quia Encaustæ dicuntur pictores qui muros pingunt. Etymol. Magnum, voc. Ἐγκεκαυμένη."—*Éméric-David, Discours Historiques sur la Peinture Moderne,* Paris, 1812, p. 180. See also Letronne, Lettres d'un Antiquaire à un Artiste, Paris, 1840, p. 412. The Lexicon here quoted (the work of Caloergos) was edited by Musurus, Venice, 1499.

† See Panciroli, Rerum memorabilium sive deperditarum, &c. Francof. 1660, p. 10.

painters; and, at a later period, the small encaustic
pictures of Pausias, executed in this style, were
proverbially objects of admiration in the eyes of
Roman collectors.*

The peculiarity of the third and later mode,
encaustic painting chiefly so called, which was
practised by the ancients and in the first centuries
of the Christian era, consisted in the regulated
fusion of the surface of the picture by fire, when
the work was completed; the wax with which the
colours had been mixed having been dissolved in
the first instance, so as to render the pigments fit
to be applied with the brush. "To paint with
wax [colours], and to burn in the picture†" when
finished, were the conditions of the art. The
inustion, or burning in, supposes a sufficient quan-
tity of wax (whatever may have been the other
ingredients) to promote the general fusion and to
produce an apparently enamelled surface. The
instrument employed to effect this was called the
cauterium. This, whether a pan of coals (*Vitruv.*
l. vii. c. 9.), a heater, or whatever it may have been,
was the characteristic implement of the encaustic
painter; who, as we have seen, represented, for a
considerable period, the painter generally. Hence
Tertullian, writing against the dissolute heretic

* "Pausiaca torpes, insane, tabella." *Hor. Sat.* ii. 7.
"Parvas pingebat tabulas. . . . Hoc æmuli eum interpretabantur
facere, quoniam tarda picturæ ratio esset illa." — *Plin.* l. xxxv.
c. 40.

† " Ceris pingere ac picturam inurere." — Ib. c. 39

Hermogenes, who happened to be a votary of art, says he was " doubly a perverter of truth, with his cauterium and his stylus*;" an expression equivalent to the modern phrase " with his pencil and his pen."

In the intaglio encaustic the pointed instrument which was used was called *cestrum* or *viriculum* (veruculum); the substances which were engraved and tinted were various.† A female artist, Lala of Cyzicum, is mentioned as having excelled in portraits, sometimes executed in this mode on ivory.‡ In the second style before mentioned, the heated instrument with which the wax tints were blended was called *rhabdion*§: it was probably flat at one end (like one extremity of the stylus); its forms and sizes, indeed, may have been as varied as those of brushes now. The encaustic painter who used the rhabdion or cestrum (for the terms are employed sometimes indiscriminately) was provided with a box with compartments in which the variously tinted cakes or sticks of wax colours were kept.‖ The cauterium was not necessary;

* "Bis falsarius, et cauterio et stylo."— *Tertull. adv. Hermog. Pict.* c. 1. Quoted by Éméric-David, Discours Hist. p. 182.

† Plin. l. ii. c. 45. l. xxxv. c. 41.

‡ " Lala Cyzicena ... et penecillo pinxit, et cestro in ebore, imagines mulierum maxime... suam quoque imaginem ad speculum." — *Plin.* l. xxxv. c. 40.

§ Literally, a small rod ; the term appears to have been also a synonyme for the pencil. See Letronne, Lettres d'un Antiq. p. 388.

‖ "Pausias et cæteri pictores ejusdem generis loculatas magnas

the rhabdion, heated in a small furnace kept at
hand, supplied its place.* The artist painted on
(small) panels. The implements of the encaustic
painter in the third style were, brushes, the cau-
terium, and pots of more or less liquid wax
colours, instead of, or in addition to, wax crayons
or cakes.† The artist painted on wood, and, when

habent arculas, ubi discolores sunt ceræ." — *Varro, De Re Rus-
tica*, l. iii. c. 17.

A mode of applying colours with a similar ingredient, by
means of heat, is exemplified in the Venetian MS. Colours
are directed to be mixed with turpentine resin, first boiled to a
concrete state; sticks of this material, variously tinted, on being
applied to heated glass, melt as required, and the design is thus
coloured. The writer quaintly says : " As soon as they feel the
warmth, they will adhere and melt like wax ; this work is proof
against water, and shows on all sides." " Como sentirano el
caldo se apicarano e desfarasse como cira e questo nō temera
aqua e parera da ogni lato." The receipt is headed : " A fare
stichi da lavorare ī vedro." Among modern methods, the fusion
of paintings or rather drawings executed with wax crayons, as
proposed by Tomaselli (*Della Cerografia*, Verona, 1785), is
somewhat analogous.

* "Il faut distinguer le cauterion d'avec le rabdion; le premier
étoit employé dans l'encaustique-au-pinceau, lc second dans
l'encaustique-au-cestre." — *Éméric-David, Disc. Hist.* p. 174.
note. Compare Letronne, Lettres, &c. p. 493., on a picture
by Philiscus, representing " officinam pictoris, ignem conflanti
puero."

† " Instrumento legato pictoris colores, penecilli, cauteria et
temperandorum colorum vasa debebantur."— *Julius Paulus,
Recept. Sent.* lib. iii. tit. 6. § 63., quoted by Letronne, Lett.
p. 390. "Pictoris instrumento legato, ceræ, colores, similiaque
horum, legato cedunt; item peniculi, cauteria et conchæ."—
Digest. de Fundo instruct. § 17. (Martianus, lib. xvii.), quoted
by Wiegmann, Die Mal. der Alten, p. 165.

the method was more generally adopted, sometimes on walls. Those who painted in the second style generally practised the third also.* As regards the mere process, no difficulty presents itself in the two first modes; in the third, the method is not so clear.

The ancient mode of bleaching wax so as to render it (while in contact with air) unchangeably white and fit to be mixed with all colours, is minutely described by Dioscorides†, and, after him, by Pliny.‡ The material being thus prepared, the important question remains : How was the wax softened and dissolved, so as to fit it as a vehicle for colours applicable with the brush? for wax alone, merely melted by heat (though it may be so used as a varnish with subsequent friction), cools too rapidly for the operations of painting. It is remarkable that, as yet, no passage has been found in a classic author which clearly describes this process. The omission may be allowed to

* " Pausias autem fecit et grandes tabulas." — *Plin.* l. xxxv. c. 40. " Nicias [an encaustic painter] ... fecit et grandes picturas." — Ib. Large works by both masters were to be seen in the Portico of Pompey, at Rome, in Pliny's time. "Lala ... et penecillo pinxit et cestro in ebore." — Ib. " Penecillo pingere" generally meant, to paint in tempera. Pliny uses the expression in this sense, when he speaks of the restoration, undertaken by Pausias, of a picture by Polygnotus. The trial of Pausias was unsuccessful, " quoniam non suo genere certasset."—Ib. This is easily explained by the circumstance of the colour drying much more rapidly in tempera than in the pencil-encaustic.

† L. ii. c. 105. ‡ L. xxi. c. 49.

prove that it was familiar; but the doubt thus existing has been a fruitful source of theories, experiments, and controversies. It has been assumed by many, reasonably enough, that as the moderns, in speaking of oil painting, rarely mention other fluids which are known to be commonly used with the oil; so the wax, which Pliny and others name as the vehicle of the colours in encaustic painting, may have been one only of the ingredients of such vehicle. It was however the chief ingredient; not necessarily in regard to quantity, but inasmuch as it was indispensable to the fusion of the surface in the final inustion.

The possible methods which have been proposed by the moderns may be reduced to three. 1. The solution of wax by a lixivium, or, in more general terms, by any means which will allow of the pigment being mixed with water. 2. The solution by means of heat in a fixed oil. 3. The solution by means of an essential oil.

Requeno states that wax, when melted with mastic resin and immersed in cold water, forms a brittle compound which can be ground with colours in water; and that a picture executed with such colours (having been previously varnished with melted wax) can be blended and fixed by heat.* Astori is said to have mixed wax with

* Saggi sul Ristabilimento dell' antica Arte de' Greci, &c. Parma, 1787, vol. i. p. 288. 292.

honey and gum water with equal success.* But
the mode of softening wax, which, however objec-
tionable, appears to have had the greatest number
of partisans in the last century, was by means of
alkaline reagents; the material being thus con-
verted into a kind of soap.†

The evidence in ancient authors respecting the
solution of wax by a lixivium is scanty and in-
direct. An expression employed by Julius Pollux
(a writer of the second century) has been supposed
to point to the solution of wax by macceration,
rather than to its liquefaction by fire.‡ Columella
observes that the sediment in oil-vessels should
not be cleansed with boiling lie-wash lest the wax
(and resin with which the vessels were lined)
should be dissolved.§ A medical writer of the
second or third century remarks that the lixivium

* Della Pittura colla Cera all' Encausto ; Memoria del Sign.
Giammaria Astori. Venezia, 1786.

For an account of various other writers on this subject and,
of their methods, see Fiorillo, Kleine Schriften artistischen
Inhalts. Göttingen, 1803, vol. ii. p. 153.

† Bachelier, Lorgna, and Walter were the chief advocates of
this system. It was ridiculed, together with the rival methods
of Caylus and Majault, in a satire by Rouquet, entitled, "L'Art
nouveau de la Peinture en Fromage, ou en Ramequin, inventée
pour suivre le louable Projet de trouver graduellement des
Façons de peindre inférieures à celles qui existent." Marolles,
1755.

‡ Κηρὸν τήξασθαι.— *Onomasticon*, l. vii. c. 28. See Grund,
Die Malerey der Griechen, Dresden, 1811, vol. ii. p. 448.

§ De Re Rustica, l. xii. Grund, ib. p. 447.

of wood ashes dissolves wax.* To these notices may now be added the following two descriptions relating to the wax painting of the middle ages. The first is from the Byzantine MS.

" Mode of painting in order to give a shining surface. — Take size, a strong solution of potass, and white wax, in equal quantities; mix together and place them on the fire to dissolve. Add colour to this mixture; dilute the tint well and paint with a brush. Let the colour dry, and then you can give it a polish [by friction]. Gilding, if you use any, will become very brilliant; it is useless to add varnish." †

The direction to use a brush might almost induce a supposition that this is the remains of an ancient formula relating to the *penecillum* encaustic,

* " Tunc lixivia cinis ceras dissolvit." — *Quintus Serenus Sammonicus,* c. 42. Grund, ib. p. 448.

† " Comment il faut faire la peinture pour donner du lustre. —Prenez de la colle, de l'eau forte [a], et de la cire blanche en égale quantité ; mêlez-les ensemble et placez-les sur le feu pour les faire fondre. Ajoutez la couleur dans ce mélange ; délayez-la bien, et peignez ce que vous voudrez avec un pinceau. Laissez d'abord cette couleur sécher, et ensuite vous pourrez la rendre brillante. L'or, si vous en mettez, deviendra très-brillant ; il est inutile de mettre du vernis." — *Didron et Durand, Manuel,* &c. p. 44.

Wax, which yielded to the nail, was found by Branchi under gilding, in one of the paintings ascribed to Buffalmacco, in the Campo Santo, at Pisa. Ciampi, Notizie, &c., Append. p. 19.

[a] In M. Didron's preface, p. 34., it is explained that "l'eau forte n'est pas l'acide nitrique, mais l'eau seconde de potasse."

as opposed to that which was executed with the
cestrum; but the omission of the cauterium, not to
mention the little promise of durability in the
method indicated, betrays the modern character of
this receipt. Thick varnishes were applied with a
sponge or with the hand, and the use of the brush
is here merely opposed to such modes. The ob-
servation respecting the inexpediency of varnish is
just; and perhaps the term "encaustic," applied
by Aetius to pictures which were varnished with
nut oil in his time, is not to be taken in its strict
sense, but as meaning paintings generally, or
rather those which commonly required varnish.
The method above described is still practised by
the monks of Mount Athos.

The other description occurs in the notes ap-
pended by Le Begue to his copy of older MSS.
In those older documents there is no allusion to
wax painting; it may therefore be concluded that
the use of the vehicle in question was confined to
few. The passage is as follows: —

" If you wish to prepare a liquid fit to temper
all colours, take one lb. of lime and twelve of Flanders
[size]. Put them together in hot water and boil
them well. After suffering the mixture to settle,
strain well through a cloth. Take four lb. of this
water and heat it well; take about two oz. of white
wax and let it boil in this water. Then take about
an oz. of isinglass and let it remain in water till it
is softened and almost dissolved: manipulate it till

it becomes like paste. Put it into the water with the wax and boil all together. Then drop a little of this fluid on a knife or on iron, in order to see whether it is sufficiently boiled, and whether it is like glue. [If it have the proper consistence] strain it, while hot or tepid, through a piece of linen into a clean vessel; let it rest and cover it well. With this fluid you can temper all manner of colours." *

The second general process before adverted to, that of the solution of wax in a fixed oil, was so far practised by the ancients that walls were sometimes varnished and polished (by means of heat) with such ingredients; the polish being promoted by again waxing the surface and rubbing it with linen cloths. The oil in this case was olive oil; for, as before observed, whenever the word "oleum"

* " Si vous voulez faire eaue conoscite a destremper toutes couleurs prenez une livre de chaux et douze de Flandres, puis prenez eaue bouillante et mettez tout ensemble et les faites assez bouillir, puis le laissez bien reposer : puis le coulez parmy un drapel, et de cette eaue prenez livres quatre et la faites bien ardoir. Puis prenez cire blanche environ deux onces et la mettez bouillir avec l'eaue, puis prenez cole de poisson environ une once, puis la mettez en eaue et l'y laissez tant qu'elle soit bien amolie et si comme fondue ; puis la maniez tant qu'elle soit comme paste, puis la mettez en l'eaue avec la cire et la faites ensemble bouillir, puis prenez de cette eaue et mettez sur un coustel ou sur fer pour savoir s'il est bien cuit et s'il est comme glue. Puis adonc coulez cette eaue chaude ou tiede parmy un drap linge en un vaissel net et laissez reposer et la couvrez bien ; et de cette eaue pouvez destramper toutes manieres de couleurs."

alone occurs in ancient authors of the classic
period, olive oil is always to be understood. Vi-
truvius, in describing the above process, which, he
observes, was the same as that adopted for polishing
statues, expressly directs that "a little " oil only
should be used. The same ingredients are some-
times employed for polishing furniture now. The
composition was thus merely a cerate, and could
never have been fit for the purposes of paint-
ing : it was applied on coloured walls as an al-
most colourless varnish, the friction with cloths
removing the superfluous oil.* The solution of wax
in a drying oil (proposed and practised by Tau-
benheim and others) is not mentioned by classic
writers, nor in the treatises of the middle ages.†

* Vitruv. 1. vii. c. 9. In all operations connected with art,
where wax was subjected to the action of heat, its application
seems to have been considered a species of "encaustic." Thus
the above mode of polishing walls was denominated *kausis*, and
the varnishers of statues were called *encaustai*. Such methods
were very ancient, but they related to varnishing, and are not
to be confounded with encaustic painting. That art, accord-
ing to Pliny, and judging from the date of the painters who
excelled in it, was not common till the age of Alexander. The
doubt expressed by Pliny as to the antiquity of the method is
to be explained by the ancient use of the somewhat similar
process above described.

† The following is a modern example of this vehicle. "Pre-
pare the clearest raw linseed oil with litharge, in the usual
way, for about six weeks. Add to the oil an equal quantity of
mastic varnish ; add to both a little scraped wax (about an
eighth). Place the ingredients in an oven for a short time, till
the wax is dissolved. A clear and almost colourless meguilp
is the result."

As Vitruvius, in the passage above quoted, speaks of polishing walls " cum candelis linteisque puris," some doubts may exist respecting the use of candles noted in account-rolls of the fourteenth century. On two occasions we find, in the lists of materials used in St. Stephen's Chapel, the entry "in una libra candele albe; " the usual memorandum, " in candelis emptis," is frequent.* The important epithet " cereis " is, however, wanting, and the item may perhaps be explained by a fuller entry in the records of the Duomo of Orvieto : " Item pro x. libr. candelarum sepi pro lumine fiendo pictorib. pingentibus in Tribuna maj̄. Ecclē ii. libras den̄." The date is 1373.†

The third hypothesis, that wax was dissolved by the ancient encaustic painters in an essential oil, has been supposed to be partly proved by chemical investigation. Fabbroni, in analysing the colours of a mummy cloth, found that they had been mixed with pure wax. He concluded that a volatile oil, probably naphtha, had held it in solution.‡ Dioscorides mentions the immixture of wax and naphtha (with other substances) for medicinal purposes.§ The expression " pharmaka," which occurs in a list of the materials of a painter‖, is often used by

 * 1294. 22d Edward I.

 † Della Valle, Storia del Duomo di Orvieto, Roma, 1791, p. 286. note.

 ‡ Antichità, Vantaggi e Metodo della Pittura Encausta, &c. Roma, 1797.

 § L. i. c. 101.

 ‖ Julius Pollux, Onom. l. vii. c. 28.

Greek writers merely as a synonyme for colours : but it may be allowed to comprehend both resins and naphtha, especially as the last is mentioned by Suidas in explaining the various meanings of the word " pharmakon." As regards medieval art, some light is afforded by the experiments of Professor Branchi, who analysed the colours on some fragments of early Pisan and Florentine pictures. His investigations warranted the inference that the wax, which was clearly ascertained to have been used, at least as a varnish, had been dissolved in an essential oil, apparently spirit of turpentine, as a slight resinous residuum was detected. The experienced chemist remarked further, that the earlier works, those for example of the time of Giunta Pisano (who lived in the first half of the thirteenth century), had the plainest evidence of having been executed, or at least varnished, with wax ; and that soon after the middle of the fourteenth century wax ceased to be used by the Tuscan artists for the purposes of painting.* Such is the general nature of the evidence in support of the different opinions that have been expressed on this question.

In the revival of wax painting (with and without the final inustion) which has taken place of late

* Morrona, Pisa Illustrata, Livorno, 1821, vol. ii. p. 165. Morrona, after quoting the report of Branchi, speaking of his own experiments, states that he never detected wax in the substance of the colours ; and that when it was found under the mere surface, it was evident that it had penetrated through the cracks of the picture. Ib. p. 168.

years in France and Germany, the principle of dis-
solving the wax in an essential oil has been adopted;
the vehicle being consolidated by the addition of
resins. Montabert was chiefly instrumental in in-
troducing this art: an account of his theory and
experiments will be found in his voluminous work
on painting.* The process which he recommends
does not appear to have been preferred in reference
to any hypothesis respecting the methods of anti-
quity; in some applications of the ancient encaustic,
however, a resinous ingredient was used. The fol-
lowing details may give some idea of the later
cerography of the Greeks.

A composition of resin and wax was the ordinary
material employed by the ancients to render sur-
faces waterproof. Among other purposes, this
coarse varnish, sometimes in appearance like mere
pitch, was used for ships. It is described, as so
used, by Dioscorides, as follows. " Some give the
name of zopissa to a compound of resin and wax
which is scraped from ships; it is by some called
apochyma, being in its nature solvent, because it
is imbued with salt water. Others give the name
[zopissa] to the pine resin." † The distinction be-

* Traité complet de la Peinture, Paris, 1829, vol. viii.

† Ζώπισσαν δὲ εἶπον οἱ μὲν εἶναι τὴν ἐκ τῶν πλοίων ξυομένην
ῥητίνην μετὰ τοῦ κηροῦ, καλουμένην ὑπ' ἐνίων ἀπόχυμα, οὖσαν
διαχυτικὴν διὰ τὸ ἐν τῇ θαλάσσῃ βρέχεσθαι· οἱ δὲ τὴν πιτυΐνην
ῥητίνην οὕτως ὠνόμασαν. "Zopissam alii dicunt esse resinam
cum cera navibus derasam, a nonnullis apochyma vocatam, quæ
dissipandi vim habet, quia aqua marina est macerata. Alii
pineam resinam sic appellant."— Diosc. ed. cur. Kühn. l. i. c. 98.

tween pitch and (nearly colourless) resin was
familiar to Dioscorides, as he describes both *; and,
from his here using the latter term, it is evident
that the zopissa was not in itself black, though,
when employed for the coarser purposes of ship-
varnishing, it was no doubt made so. The varnish
of wax and resin is alluded to incidentally by Pliny,
in describing the different compositions used by
the bees in constructing their habitations. After
speaking of the first layer he says : " Upon this
comes a cero-picine mixture, in the mode of pitch-
varnishers, being wax in a more diluted form." †
Here again, the substance which the naturalist calls
" pissoceros " is rather a cero-resinous than a cero-
picine composition ; it only acquires a brown colour
by age. That the Greeks did not always connect
the idea of pitch with the word which they strictly
used for it, may be further exemplified by the cir-
cumstance that common resin is still called by the
Italians " Greek pitch " (pece Greca). For the
rest, the expression " picantium modo, ceu dilutior
cera," indicates the mode in which the solution of
wax was effected.

The cero-resinous zopissa of Dioscorides, when
first applied with the brush, was necessarily fluid.
The resinous ingredient may have been either
naturally liquid, or, if concrete, it was probably

* L. i. c. 91. 94. 97. &c.
† " Pissoceros super eam venit, picantium modo, ceu dilutior
cera." — L. xi. c. 6.

dissolved by the addition of that essential oil which
the liquid resins and balsams already contain. In
either case an essential oil could be added to dilute
the composition *; in either case heat would be
necessary to effect or to assist the solution and im-
mixture of the wax, and to render the preparation
more drying. Such was the nature of the coarse
varnish applied to ships: no care was necessary to
prevent the zopissa from becoming black; it was
probably to all appearance a pitch; but the original
ingredient mixed with the wax was, according to
Dioscorides, not a pitch but a resin. We now come
to ship-painting.

Pliny states that wax painting with the brush,
the third or later style of encaustic before described,
was first adopted for ships; that, so employed,
it was " proof against the sun's heat, the salt of the
sea, and the winds." The effect of wax when mixed
with soft resins is to check their tendency to flow
when exposed even to the highest natural tempera-
ture, and to prevent their cracking on the surface.†

* Besides naphtha, the ancients, though ignorant of the
progress of distillation, were acquainted with the essential oil
of turpentine. The mode of collecting it was by spreading
clean fleeces above the open vessels in which pitch was con-
cocted, and then wringing out the volatile oil. See Diosc. l. i.
c. 95., Plin. l. xv. c. 7.

† One of the objections to asphaltum in painting is its
tendency to flow, and to dry only on the surface. The first
defect is remedied by a due admixture of wax; the second can
only be corrected by dryers. Wax itself has no tendency to
crack ; but, as it long remains soft, it is easily *made* to crack if
varnished with quickly drying resins.

The vehicle used for painting had, thus, the same qualities, the same promise of durability, which re-commended the common ship varnish, and was no doubt the identical zopissa, only prepared with more care, so as to be almost colourless.* The application of painting was thus secondary and accidental, and its character, from first to last, must have been humble enough; yet such embel-lishments, among the art-loving Greeks, are not to be estimated by modern works of the kind. Two distinguished painters, Protogenes and Heraclides, began as ship decorators.†

Such being the vehicle, the colours were not mixed for momentary occasions, but, as in modern fresco and tempera, pots of tints were prepared from the first.‡ The final inustion had the effect of

* The term zopissa may have had reference to the supposed medicinal virtues of the coarser substance which was scraped from ships, and which, being used as a medicine, could not, like the painting vehicle, have been previously mixed with colours. But the expression may have originated in the use of the cero-resinous material for painting figures; as the word zophorus (the frieze), in architecture, was appropriated to that part of the entablature where figures ($\zeta \tilde{\omega} a$) were placed.

† "Quidam et naves pinxisse [Protogenem] usque ad annum quinquagesimum [putant]."— *Plin.* l. xxxv. c. 36. "Est nomen et Heraclidi Macedoni. Initio naves pinxit."— Ib. c. 38. They therefore began as wax painters; but the works by which they acquired their fame were chiefly, if not altogether, in tempera. Pliny's expression, before quoted, "till ships began to be painted," may be understood to mean, painted in a very ornate manner; as we read of painted ships in Homer's time.

‡ Pliny always uses the plural form, " ceræ tinguntur," "ceris pingere," whether speaking of the pencil or cestrum encaustic.

producing an apparently vitrified surface; hence the paintings could be cleaned and polished, from time to time, as required.*

A process of painting thus arising from mere utility, and at first employed in the coarsest decorations, was at length admitted among the styles of refined art. The qualities for which it was originally valued, — durability, and resistance to moisture and ordinary heat, to which may be added the facility of cleaning the surface, — were likely to be remembered in its subsequent applications. Accordingly, the first distinguished wax painter, though accustomed to the cestrum encaustic, was also the first to apply the larger style to ceilings †; and, at a later period, the same method was adopted by Agrippa, even for the walls of baths.‡ Its powerful scale of effect, as compared with tempera

* The modern mode of cleaning wax paintings (with a slight change in the materials) may exemplify the process at all times.

" Si (la peinture) est lustrée, on devra l'épousseter d'abord, puis laver la surface avec de l'eau alcoolisée, et y passer de l'eau pure à la suite : on laissera sécher, et l'on rétablira le lustre par un léger frottement. S'il s'agit d'une peinture vernie à la cire, on opérera comme pour la peinture lustrée, en observant que l'on pourroit ajouter une nouvelle couche de cire dans le cas ou l'on jugerait la première insuffisante."—*Durosiez, Manuel du Peintre à la Cire*, Paris, 1844, p. 28. On the effect of the inustion, see a paper by Mr. Linton, in the Sixth Report of the Commissioners on the Fine Arts, p. 24.

† "Idem (Pausias) et lacunaria primus pingere instituit." — *Plin*. l. xxxv. c. 40.

‡ Ib. l. xxxvi. c. 64.

and secco, was a more general recommendation*: it
was employed for pictures on wood, which divided
the palm with the works of the great artists in the
established method. In the first centuries of the
Christian era, it appears to have superseded all
other processes except mosaic; the durability and
brilliancy (and perhaps mechanical nature) of
which recommended it, in its turn, more and more.†
The Lucca MS. (eighth century) treats more fully of
mosaic than of wax painting; of the latter it is
merely observed that colours mixed with wax were
used on walls and on wood. ‡ The art is scarcely
alluded to in the treatises of the twelfth, thir-
teenth, and fourteenth centuries; and the only evi-
dence relating to it (at present known) which can
be said to belong to medieval art, consists of three
notices. Two of these, from the Byzantine MS.,

* The two most celebrated encaustic painters, Pausias and
Nicias, excelled in chiaroscuro. The former contrived to give
relief to black objects even when foreshortened. (See Pliny's
well understood description of the picture by this artist in the
portico of Pompey, l. xxxv. c. 40.) The latter was also re-
markable for gradation and roundness. Ib.

† The mechanical nature of the final inustion in encaustic,
a process which obliterated the unskilful traces of the pencil,
may also have been one of the recommendations of that art in
barbarous times. An expression employed by St. Chrysostom
seems to imply that he amused himself with the practice of
encaustic. Ἐγὼ καὶ τὴν κηρόχυτον γραφὴν ἠγάπησα. " Ego
quidem pictura cera liquenti confecta delectatus sum."—*Eméric-
David, Discours*, &c. p. 182.

‡ "Ita memoramus ... operationes quæ in parietibus, simplice
in ligno, cera commixtis coloribus," &c.

and from that of Le Begue, have been already given, and neither can be said to have much affinity with the ancient method. A third document exists in the records of the Duomo of Orvieto: a wax vehicle or varnish is there mentioned as having been used by Andrea Pisano. In 1345, that painter received a certain sum " for vermilion, white lead, and *cera colla*, for painting." * In 1351, the following entry appears relating to painting and varnishing a marble statue of the Virgin over the principal door in the façade of the cathedral. " Three soldi for eggs to make, with the white, a medium for diluting the colours for [painting] the figure or image of the Virgin Mary. . . . Seven soldi and ten denari to Messer Andrea di Pisa for vermilion, white lead, and *cera colla*. . . . For two oz. of blue at six soldi the oz., a little red lead, and twelve leaves of gold at six denari for each leaf, to adorn the fair marble Majesty." † It should be observed,

* "Pro cenabro biacca et cera colla pro pingendo."— *Della Valle, Storia*, &c. p. 280.

† " Tres solidos pro hovis pro clara fienda pro coloribus lique-faciendis in figura seu imagine V. M. . . . vii. sol. et x. den. M. Andree de Pisis pro cenabro biacca et cera colla pro duabus uncis azzurri ad rat. vi. solidor. pro uncia et pro modico cerusse [ustæ] et pro xii. foliis dauro ad rat. vi. den. pro quolib. folio pro Majestate pulcra de marmore ornanda."—Ib. p. 281. Della Valle, writing at the close of the last century, states that there was scarcely a vestige of colour on this statue ; but on another, which was within the cathedral, the blue (of the drapery) and some other tints yet remained.

The representation of the enthroned Saviour or Virgin Mary was called a " Maestà," as the Virgin weeping over the dead

that the term " colla," in the older documents, has
not always the sense of size or glue; in the *Mappæ
Clavicula* an oil varnish is called " colla Græca,"
and Theophilus gives the name of " gluten " to the
same substance. In this case the " cera colla " was
necessarily of a hydrofuge nature, as the statue was
in the open air; and the colla appears to have been
used as a coloured varnish over tints mixed with
white of egg only. It is remarkable that precisely
the same ingredients should be mentioned, together
with the wax vehicle, on two occasions. The
vermilion and white were evidently mixed with
the wax; the varnish seems to have been employed
for statues only; and such tints must have been
used for the flesh, in accordance with the habits of
the time; the colour of the varnish being varied
for draperies and other surfaces.*

Christ was called a " Pietà." The only existing document
relating to Cimabue shows that he was employed in 1301
(probably the year of his death) on a mosaic " Majesty," in
the tribune of the Duomo at Pisa. One of the entries is as
follows. "Magister Cimabue pictor Magiestatis pro se et famulo
suo pro diebus quatuor quibus laborarunt in dicta opera ad
rationem solid. x. pro die, lib. ii."—*Ciampi, Notizie,* &c. p. 144.
Linseed oil, varnish (vernix), and turpentine appear in these
accounts also; they must have been used in the composition of
the cement for the mosaic. The quantities are considerable:
"Pro pretio librarum lxxvi. olei linseminis ... ad operam
Magiestatis — pro pretio libre viginti novem trementine ... ad
operam Magiestatis — pro pretio centinarorum quatuor olei
linseminis ad operam Magiestatis et aliarum figurarum, &c., pro
libris quadraginta tribus vernicis," &c.

　* The expression, " variata circumlitio" (*Seneca, Epist.* 86.),

The above document may serve to illustrate the
descriptions of the ancient Greek varnish, or " cir-
cumlitio," on statues. Praxiteles is said to have
esteemed those of his works most which had
received a varnish from the hand of Nicias.* A
mere varnish might have been applied by an
assistant ; but the statues of the Greeks were
partially and slightly tinted. The experience and
taste of Nicias were indispensable, in the opinion
of Praxiteles, to produce a harmonious effect on

may refer to this practice in ancient art. Descriptions of
coloured varnishes, used for painting on glass, occur in the
Venetian MS. ; one of these might be called a *cera colla.*
"Take one lb. of fine white turpentine, three oz. of white
mastic if [the work is to be executed] in winter, but if in
summer, two oz. will suffice; it should be well washed, and
should be dried in the air, but not in the sun. Add half an oz.
of new wax and a quarter of an oz. of white wax ; place the
ingredients in a well glazed earthen vessel, to boil on the fire,"
&c. "Toy una libra de fina trementina biancha e oz. III. de
mastixe biancho sele de Iverno ma sele de estate basta oz. II.
bene lavato e asuto alora e nō al caldo, e oz. ÷ de cira nova e
quarto uno de cira biancha e miti ogni cossa Isieme I una pigna-
tela nova bñ ivedriata e fa bolire le predicte cosse al fuoco," &c.
Green (or any other colour) is then added. The composition
is directed to be applied warm, on warm glass, held over a
charcoal fire. The architect Rusconi speaks of a varnish used
in Venice in his time on walls painted with minium, according
to the method of Vitruvius. It must, therefore, have been a
wax varnish. (*Architettura*, Venezia, 1590, l. vii. c. 9.) It
may be remarked that mastic was used as above, for a dryer,
in the eighth century. "Et si aliquid vitium postea habuerit
(lucida) ut se desiccare non poteat, junge mastic quantum vo-
lueris, aut unciam unam aut mediam."—*Lucca MS.*

* Plin. l. xxxv. c. 40.

his statues, with reference to their intended situation ; the varnish employed (perhaps the usual encaustic vehicle above described) contributed, at the same time, to protect the surface.* The application of the coloured " cera colla " of Andrea Pisano may give some idea of the " circumlitio " of Nicias.

Among the qualities of the Greek encaustic, the gloss which it was fitted to receive was not the least of its recommendations with the ancients. The carefully stuccoed walls of their apartments were polished like mirrors.† Their tempera pictures, by means of a varnish (which encaustic did not require), had the same shining surface.‡ The use

* The cerate, which Vitruvius says was used for statues, was chiefly intended (as in its application on walls) to renew their polish, and to protect certain colours. The tinting (βάπτειν) with varnish was a distinct and previous operation. That the coloured varnishes had the effect of preserving the surface of marble is apparent from the fact, that in the Greek temples, for example the Parthenon, although the colour itself is scarcely to be traced, its presence is frequently indicated by the smoothness even of the present surface, corresponding exactly with the forms of the once painted decorations.

† "Non modo fiunt nitentia, sed etiam imagines expressas aspicientibus ex eo opere remittunt."—*Vitruv.* l. vii. c. 3.

‡ Pliny, speaking of the varnish of Apelles, says: "Ut id ipsum repercussum claritates colorum excitaret — veluti per lapidem specularem."— L. xxxv. c. 36. And elsewhere : "Nec pictura in qua nihil circumlinitum est, eminet." — L. viii.; quoted by Soehnée, Recherches nouvelles sur les Procédés de Peinture des Anciens, Paris, 1822, p. 41. " Secco," or lime painting, and perhaps tempera on walls, appear to have been the only kinds of decoration which had not a glossy surface.

of encaustic and mosaic, in the early periods of Christian art, had partly the same object.* The habit is to be traced in the lustrous varnishes (*lucidæ*) of the middle ages; and there can be no doubt that thickened oils were preferred, in the first rude attempts at oil painting, chiefly because such vehicles insured this glossy appearance. The imitation of the ancients, in mere externals, is indeed to be traced in all the mechanical operations of medieval art. Smoothness of surface, on pictures as on marble, was found to resist the more immediate causes of decay; and this may be a reason why the predilection for it continued, after the revival of art, chiefly in those countries where the effects of the atmosphere are most trying.

In any view of the foregoing statements, it must be evident that the wax painting of the ancients was capable of more force, depth, and gradation, than the customary tempera. The latter had, however, the support of the highest names, those of Zeuxis, Parrhasius, Apelles, and others; painters who had established their reputation and that of their process before encaustic had time to develope itself. The practice of the latter prevailed only when art was declining, and hence, as regards the ancients, its resources were perhaps never fully displayed or appreciated. In the thirteenth century, when painting

* "Dans les siècles précédens, au lieu de dire *peindre* une galerie ou une église, on disoit la *faire jouer*, la *brillanter*." — *Eméric-David, Discours*, &c. p. 107.

began to emerge from a barbarous conventionality, the recorded fame of the greatest artists in antiquity could not fail to suggest the imitation of their usual method. Tempera was, even in Cennini's time, the most esteemed of the existing modes of art * ; and, as already observed, it required all the excellence of the Van Eycks to recommend a different process. In endeavouring to dispense with the necessity of varnishing pictures in the sun, it is not impossible that those artists, versed as they were in the writings of the ancients †, may have first turned their thoughts towards the revival of a method which was altogether independent of varnish, while it rivalled its effects. Whatever may have been their experiments, they ended in adopting a process far superior to the obsolete encaustic.

* Cennini's expression, "Il lavorare di tavola è propio da gentiluomo" (c. 145.), may be compared with Pliny's, "Nulla gloria artificum est nisi eorum qui tabulas pinxere." (L. xxxv. c. 37.) The ancient author's words might include encaustic; but, as he is speaking of the art of Apelles, there can be little doubt that he meant tempera.

† See the testimony of Facius, before quoted, respecting John Van Eyck.

NOTE

ON SOME EARLY SPECIMENS OF ENGLISH ART.

As a supplement to the account of technical processes anterior to the improved method of oil painting, a notice is here added respecting some English works of the fourteenth century. They are not the only specimens extant; and it is hoped that, by inviting attention to such remains, other examples may be preserved before it is too late.

Within the south ambulatory, next the choir in Westminster Abbey, there is an elaborate work (measuring about eleven feet in length, and three in height), which appears to have originally formed part of an altar decoration: it is now enclosed under glass, and, being placed among the tombs, may be sometimes mistaken for part of a monument.

The groundwork is oak; over the joinings and on the surface of some mouldings, strips of parchment were glued. On this framework, covered with a gesso ground, various ornamental compartments and architectural enrichments are completed in relief. The larger compartments were adorned with paintings consisting of remarkably well designed and carefully executed single figures and subjects, with a gold mosaic ground. The work is divided into two similar portions; in the centre is a figure which appears to be intended for Christ, holding the globe and in the act of blessing; an angel with a palm branch is on each side. The single figure at the left end of the whole decoration is St. Peter; the figure that should correspond on the right, and all the Scripture subjects on that side, are gone. In the compartments to the left, between the figure of St. Peter and the centre figures, portions of three subjects remain: one represents the Adoration of the Kings; another, apparently, the Raising of Lazarus; the subject of the third is doubtful, though some figures remain: the fourth is destroyed. These single figures and subjects are worthy of a good Italian artist of the fourteenth century. The remaining decorations were splendid and costly: the small compartments in the architectural enrichments are filled with variously coloured pieces of

glass inlaid on tin-foil (according to the process before described), and have still a brilliant effect. The compartments not occupied by figures were adorned with a deep blue glass resembling lapis lazuli, with gold lines of foliage executed on it. The smaller spaces and mouldings were enriched with cameos and gems, some of which still remain. This interesting work of art lay neglected in a chapel near the north transept, till Mr. Blore, with the permission of the Dean and Chapter, had it placed for security in the case in which it is now seen. It is supposed to have originally formed part of the decoration of the high altar. Its date may be fixed at the close of the thirteenth, or commencement of the fourteenth, century. That the work was executed in England there can be little doubt. The use of parchment instead of cloth between the oak framework and gesso ground, and the resemblance of the coloured glass ornaments with those before described, which were found in St. Stephen's Chapel, indicate also a certain connexion with English technical peculiarities. If the artists were English, the execution proves that the painters of this country were sometimes quite equal to those of Italy in the early age to which this specimen belongs.

Another painting, less questionably English, and of more certain date, but now nearly obliterated, is the canopy of the tomb of Richard II. and Anne, his first wife, in the chapel of St. Edward in Westminster Abbey. At each end there are figures of angels supporting shields. Of the other two compartments, that near the head contains a representation of the Almighty enthroned, holding a globe and in the act of blessing : the other represents Christ and the Virgin, both seated ; the Saviour holds a globe and is also in the act of blessing, the hands of the Virgin are crossed on her breast.* The action and expression of this figure, as far as can be judged from its extremely decayed state, indicate the hand of a superior painter : the ground behind all the figures is ornamented with gilt mosaic. Malcolm (*Londinium redivivum*, vol. i. p. 96.) supposes that these paintings

* The composition much resembles that of a painting (13th century) on the ceiling of a room in the hospital called " La Biloque," at Ghent. (*Kunst-Blatt*, 1843, No. 54.)

were by the same artist who executed the principal subjects in St. Stephen's Chapel. A document in the Pell Records, brought to light by Mr. Devon (of the Chapter House Record Office), determines the date of the work ; the following is Mr. Devon's translation. "Michaelmas, 19 Richard II. [1396]. To Master Peter, sacrist of St. Peter's, Westminster : In money paid him by the hands of John Haxey in discharge of [a claim of] £20 for painting the canopy of the tomb of Anne, late queen of England, buried within the said church ; as for the removal of a tomb near the tomb of the said queen ; also for painting the same tomb so removed, and for painting an image to correspond with another of the king placed opposite in the choir of the said church." From a comparison of this with other documents Mr. Devon places the execution of the work in 1394 : the painter, whoever he was, appears to have been commissioned by the sacristan acting for higher authorities.

The Chapter House at Westminster contains wall-paintings of two different periods : the earliest and best appear to have been executed about the middle of the fourteenth century. The edifice itself was completed in the time of Henry III., who began to rebuild the Abbey ; in the fourteenth century it had been long appropriated to the use of the Commons in parliament assembled. In the two last parliaments of Edward III. the Commons were directed to withdraw from the Painted Chamber, " a lour ancienne place en la maison du Chapitre de l'Abbeye de Westm." * The east side of the octagon building contains five niches corresponding with the sedilia usually to be seen in chapter houses, but which here, from their painted subjects, have the appearance of an altar decoration.

In the centre niche or compartment there is, or rather was, a figure of Christ (with a gilt nimbus containing the cross) holding up his pierced hands. A scarlet robe, embroidered with gold borders, is fastened on the centre of the breast by an embossed and gilt fibula, as in Italian pictures of the time : the robe, parting

* Rot. Parl. vol. ii. p. 322–366.

again, shows the wound in the side. Two angels sustain a deep blue diapered drapery behind the figure. The instruments of the Passion are held by other angels now partly obliterated; the reed and sponge, the spear, and the nails are still visible. The face of the principal figure is destroyed, perhaps by violence. The four other compartments are filled with angels: on the right and left niches, a single central figure is prominent, standing about a head lower than the Christ; behind and below, smaller nimbi and some heads indicate the rest. The principal angels are covered with wings having eyes like those in the peacock's tail; the lower extremities of all the figures are destroyed. Among the angels, some with fiery vermilion faces represent the seraphim, in the manner of the early Italian painters. The principal angel in the niche next the centre to the right holds up two gilt crowns. On the wings of the upper angels, and round the heads of those below, is inscribed a sort of tabular view of the Christian virtues, according to the dogmas of the time. "Confessio" ramifies downwards into "simplicitas, humilitas, fidelitas;" "Satisfactio" into "orōnis devocio, eleemosina," and perhaps "jejunium," or an equivalent word now illegible. Under "Mundicia carnis" are ranged the virtues of temperance; under "Puritas mentis," those relating to the command of the will. In the centre above, the half word "... lateria" (latreia?) is visible. The corresponding angel in the niche to the left holds up an embossed crown with the left hand, and what appears to be a rosary with the right. Inscriptions on this figure have either never existed or they have perished. In the second niche to the right the figures are almost entirely obliterated; in that to the left some portions of heads remain. The general subject of this representation, therefore, is Christ surrounded by the Christian virtues: but many particulars correspond with descriptions in the beginning of the book of the Revelation, and, as the history of St. John the Evangelist is represented on other portions of the walls, they may be so interpreted.

With respect to the date of this work, Mr. Devon is of opinion that the writing in the inscriptions belongs to the time of Edward III. This agrees with the opinion expressed by Smith (*Antiquities of Westminster*, p. 226.). He formed his

conclusion from the perfect coincidence of the style and execution with the then existing remains in St. Stephen's Chapel, with which he was certainly well acquainted. The figures are by no common painter ; some of the heads and hands, with all their defects, may bear a comparison with the works of the Italians of the corresponding period. The same may be said of the colouring of the flesh ; the heads of the principal figures are painted with a good surface and body, probably with the peculiar vehicle before described ; pure lake ("cynople"), used in certain parts of the centre subject, is well preserved, as is the gilding of the nimbi. The stone wall is covered with a coating of gesso, but there is no cloth underneath the preparation. The inscriptions, unlike those on the other representations in the building, are painted on the figures, not stuck on.

The following description of the remaining specimens in the Chapter House (which have been hitherto brought to light) is from a notice obligingly communicated by Mr. Devon, by whom they were discovered in 1841 : —

" They relate to St. John the Evangelist. The first picture I found was the vision of the seven candlesticks, strictly following the description in the first chapter of Revelation, v. 13–16. There is also the figure of a 'white horse, and he that sat on him had a bow,' &c., as in the sixth chapter, second verse. St. John is also represented as writing to the seven churches of Asia, which churches are depicted, with an angel standing at each door. On the left of all this there is a representation of his being put into a caldron of boiling oil by order of the Emperor Domitian : the emperor, or rather his proconsul, dressed in ermine, is present, attended by executioners blowing the fire, ladling the oil, &c. The saint, according to the legend, came from the caldron unhurt. Tertullian is, I believe, the only early writer who mentions the circumstance ; he says it took place before the gate called Porta Latina, in Rome. This corresponds with the inscription on the wall, which, copied (as far as legible), runs thus : ' Tunc proconsul secundum Impiale preceptum Beatissimum Johannem Apostolum itum Romani secum adduxit et Cesari Domitiano ejus adventum nunciavit indignatus autem crudelissimus Domici . . . o consuli jussit ut ante portam que Latina dicitur in conspectu senatus

in ferventi doleo Sanctus Johannes deponeret pr flagellis
cederetur quod et factum est unde protegente eum gracia Dei
tam illesus exiit quam minimus a corrupcione ext videns
vero proconsul eum de doleo exisse cinctum non adustum
obstupefactus voluit eum libertati sue restituere. Et fecisset
. missione regie contradire. Hoc autem cum Domitiano
relatum fuisset precepit Sanctum Johannem Apostolum in
exilium insula que Pathmos dicitur in qua et Apocalipsum
que et nomine ejus legitur et vidit et scripsit.'

" Another picture represents St. John landing from a vessel,
probably at this island of Patmos. There are several other
figures of minstrels, dromedaries, stags, dogs, birds, &c., ac-
companied with inscriptions, for the most part not very legible.
They are written on paper stuck on the wall, which paper is
now decaying and peeling off. With respect to the date of
these works, I can be guided only by the handwriting, which
I take to be between the years 1390 and 1470 ; I think not
earlier than Richard II. (who came to the throne in 1377), and
certainly not later than Henry VI."

This date is corroborated by some architectural forms intro-
duced in the paintings; these the late Mr. Gage Rokewode
and others pronounced to be of the fifteenth century. The
great difference between these wretched productions and the
large figures before described, painted in the time of Ed-
ward III., may be attributed to the accident of some unskilled
monk having undertaken the decorations. For, making every
allowance for the neglect of the arts which was the conse-
quence of the distracted state of the country during the wars of
the roses, it is hardly to be supposed that painting could have
sunk so deplorably in so short a time.

CHAP. VII.

VASARI'S ACCOUNT OF THE METHOD OF OIL PAINTING
INTRODUCED BY VAN EYCK.

THE circumstances which have been detailed in the
preceding chapters may now afford the means of
judging of the state of art, practically considered,
before the time of Hubert and John Van Eyck.
The modes in which oil painting had been em-
ployed before the year 1400 have been sufficiently
exemplified, and the preference given to tempera
has been explained. The latter half of the four-
teenth century had already been marked by in-
novations in technical habits. Within that period
may be placed the beginning of fresco, properly so
called, and the end of wax painting; for, although
the limited use of the latter survived, and even
survives to this day in Greece, its vestiges then
ceased to be traceable, in the ordinary practice of
art, throughout the rest of Europe.

Another and a more important change was at
hand. Soon after the first ten years of the fifteenth
century oil painting was not only rendered prac-
ticable, but the process, as such, was carried to a
perfection in many respects not since surpassed.
The art, recommended as it was at the same time

by new and surprising efforts in imitation, could
not fail to attract attention ; yet, as before stated,
many years elapsed before it found general favour
in Italy. There, however, as in Flanders, the first
painters who applied themselves to it earnestly
were not slow in discovering and displaying the
fuller resources of the method as compared with
tempera. Once adapted to Italian taste, subjects,
and dimensions, it was received with enthusiasm ;
the memory of the original inventor, represented
by the younger Van Eyck, was honoured ac-
cordingly ; and the earliest known writers who
eulogised the Flemish artist were Italians of the
fifteenth and sixteenth centuries. It is not sur-
prising that the previous imperfect attempts at oil
painting should have been overlooked, or that
some authors should even have gone so far as to
ascribe the first invention of the oils used in paint-
ing to Van Eyck: but it is to be regretted that
such assumptions, as the sufficient ground for
praise, should have prevented those who were
acquainted with art from informing themselves
(when it would have been more possible to do so)
as to the real nature of the improvement which all
extolled.

The mention of Van Eyck by Facius has been
already noticed. That writer gives an interesting
account of some of the Flemish artist's works,
when they were first seen in Italy ; but, though
eloquent on their general excellence, he is silent

respecting the method of oil painting: his obser-
vations may therefore, for the present, be passed
over. The evidence of Vasari, in all technical
questions, is of great value. His details relating
to the history and works of artists are, also, gene-
rally to be relied on; he is, however, frequently at
fault in dates, and, therefore, before quoting his
account of Van Eyck's invention and of the intro-
duction of oil painting into Italy, it will be neces-
sary to establish, as far as possible, some leading
epochs in the events of which he treats.

At the commencement of the seventeenth cen-
tury, a monument to Hubert Van Eyck existed in
the church of St. John (now St. Bavo, the cathe-
dral,) at Ghent. On a slab inserted in the wall a
figure of death was represented, holding a plate of
copper inscribed with an epitaph in " old Flemish."
Van Mander, who gives these details, has preserved
the inscription, adding that Hubert was born in
1366. The epitaph states that he died in 1426.
There is no reason to question even the former
date; the portrait of the artist, introduced with
that of his brother, in their great work, the altar-
piece of the same cathedral*, represents a man of

* The panel which contains the portraits is now in the Gallery
at Berlin. The altar-piece was completed by John, after the
death of Hubert, and the portrait of the latter appears to have
been a posthumous one. The evidence respecting the like-
nesses rests only on ancient tradition. (See Van Mander,
p. 200. Compare Octave Delepierre, Galerie d'Artistes Bru-

about sixty. The following is the purport of the epitaph : —

" Take warning from me, ye who walk over me. I was as you are, but am now buried dead beneath you. Thus it appears that neither art nor medicine availed me. Art, honour, wisdom, power, affluence, are spared not when death comes. I was called Hubert Van Eyck; I am now food for worms. Formerly known and highly honoured in painting; this all was shortly after turned to nothing. It was in the year of the Lord, one thousand four hundred and twenty-six, on the eighteenth day of September, that I rendered up my soul to God, in sufferings. Pray God for me, ye who love art, that I may attain to His sight.

geois, Bruges, 1840, p. 10.) But it is to be remarked that the same two portraits (with another, supposed to be that of Margaret, the sister of the painters, and herself an artist,) appear in a picture of the crucifixion by John Van Eyck, now in the possession of Count Tatitscheff. (*Passavant, Kunst-Blatt,* 1841, No. 3.) A circumstance connected with this question deserves to be here noticed. The inscription on the picture by John Van Eyck, in the National Gallery, has generally been read, " Johannes de Eyck fecit hic, 1434." The word hitherto supposed to be *fecit* is, unquestionably, *fuit;* " hic " may therefore be translated "this [man] "; and, if so, the portraits are those of John Van Eyck and his wife. There is not much resemblance between the above-mentioned accredited likenesses and the person represented in the picture in the National Gallery; but the difference of costume and the lapse of seven or eight years may perhaps explain this. The question is submitted to those who have given much attention to the history of John Van Eyck.

Flee sin; turn to the best [objects] : for you must
follow me at last." *

The periods of the birth and death of John Van
Eyck were variously and incorrectly stated, from
Vasari downwards, till the researches of De Bast
and others established them with some certainty.†

* Spieghelt u an my, die op my treden,
Ick was als ghy, nu ben beneden
Begraven doot, als is an schijne,
My ne halp raedt, Const, noch medicijne.ᵃ
Conft, eer, wijsheyt, macht, rijckheyt groot
Is onghespaert, als comt de Doot.
Hubrecht van Eyck was ick ghenant,
Nu spiise der wormen, voormaels bekant
In Schilderije seer hooghe gheeert:
Corts na was yet in niete verkeert.

In 't jaer des Herren, des zijt ghewes,
Duysent, vier hondert, twintich en ses,
In de maendt September, achthien baghen viel,
Dat ick met pijnen Godt gaf mijn ziel.
Bidt Godt voor my, die Conft minnen,
Dat ick zijn aensicht moet ghewinnen,
En vliedt zonde, keert u ten beften:
Want ghy my volghen moet ten leften.

† For the communications of De Bast see the Messager des
Sciences et des Arts, Ghent, 1824, p. 49. &c., and the Kunst-
Blatt, 1826, No. 78. &c. For those of Director Passavant see
his Kunstreise durch England und Belgien, p. 369. ; and Kunst-

ᵃ Zich spiegelen, " to look in a mirror," is still idiomatic Dutch
and Flemish for " to take warning." With a slight alteration
in the spelling, als is an schijne might be translated " all is
illusion." My ne halp raedt is ill spelt and obscure.

Medicine, being named together with art, appears here to
represent one of the qualifications of the painter. Chemistry
and medicine were, in the middle ages, often used as synony-
mous terms. Geber, the Arabian (eighth century), calls alche-
my " medicine of the third class."

The result may be shortly given as follows. The portrait of John Van Eyck, above referred to, may represent a man of about thirty-five.* By the concurrent testimony of historians also, he was much younger than his brother. That he died, not at an advanced age, as Vasari and others assert, but in the vigour of life, and about the year 1445, is proved by various circumstances. In a register (preserved in the archives of Bruges) of a lottery which was drawn February 24. 1445, the following memorandum occurs: " the widow of John Van Eyck two pounds." † A picture by the artist,

Blatt, 1841, No. 3. &c., and 1843, No. 54. &c. On the works of the Van Eycks compare Dr. Waagen Ueber Hubert und Johann van Eyck, Breslau, 1822 ; Schnaase, Niederländische Briefe, Stuttgard und Tübingen, 1834 ; Hotho, Geschichte der deutschen und niederländischen Malerei, Berlin, 1842–43, zweiter Band ; and Alfred Michiels, Histoire de la Peinture Flamande et Hollandaise, Bruxelles, 1845—46. The fourth and concluding volume of this work is not yet published.

* The apparent age of this figure is estimated differently, according to the different hypotheses of writers respecting the period of the painter's birth. Hotho, who assumes that John Van Eyck was more than thirty years younger than Hubert, and who, with others, supposes that the portraits were painted in 1427, sees a man of the age of thirty in the figure in question. Michiels, who is desirous that John, and not Hubert, should be considered the inventor of oil painting, places the birth of the former in 1386 (ten years earlier than Hotho). In his eyes, therefore, the portrait must represent a man of about forty. A middle course may be nearer the truth. The claims of Hubert, as the inventor of the improved oil painting, rest on other evidence about to be noticed.

† "De wed Jans van Eyck ij. pont."—*De Bast, Kunst-Blatt.*

originally in the church of St. Martin, at Ypres, was left unfinished in 1444.* Flemish authors who preceded Van Mander state that Van Eyck died " early," † and (with reference to his powers and activity) "young."‡ A passage in his epitaph appears to refer to the same circumstance. Van Mander himself, who in one passage follows the Italian biographer in regard to the painter's age, in another remarks that " Johannes did not live so long, by many years, as Vasari states." § John Van Eyck was probably born within the years

The document gives the above date; but as the year was then reckoned to begin at Easter, this was the beginning of 1446 according to the present style. Passavant (ib. 1843, No. 55.) assumes that John Van Eyck died in July, 1445, on the ground that a mass was said for the painter yearly in July, in the church of St. Donatus, at Bruges, till near the close of the last century.

 * Passavant, Kunstreise, p. 367.

 † " This noble flower departed early from this world." "Van deser weerelt vroegh dees edel bloeme schiedt." This passage occurs in a poem by Lucas de Heere (the painter), and is quoted by his scholar Van Mander (*Schilder-Boeck*, p. 201–2.). The latter, in a marginal note, hesitates to admit the statement; but his objections are founded on Vasari's account.

 ‡ "Johannes died young; could he have lived longer, he would (as is said of Athemon) easily have surpassed all the painters of the world." "Johannus is jonc overleden, ha'dde hy noch mogen leven, hy hadde (alsoomen van Athémon seyde) lichtelyk alle schilders der werelt te boven ghe-gaen." — *Markus van Vaer-newyck, Historie van Belgis*, Ghendt, 1565. De Bast. "Athé-mon" may be intended for the Artemon of Pliny.

 § " En weet oock dat Joannes soo langhe niet en leefde, op veel jaren, als Vasari den tijt stelt." — *Schilder-Boeck*, p. 200.

1390 and 1395.* Supposing the portraits above mentioned to have been painted soon after the death of Hubert (for they are unquestionably by the hand of John), this would make the latter about thirty-five, the apparent age of his own portrait, when they were executed, and about fifty-four at his death. A Latin epitaph on John Van Eyck was once to be seen on a pillar in the church of St. Donatus, at Bruges, where he was buried. The church itself no longer exists; the inscription is given by Van Mander, and is in substance as follows : —

" Here lies Johannes, who was celebrated for his surpassing skill, and whose felicity in painting excited wonder. He painted breathing forms and the earth's surface covered with flowery vegetation, completing each work to the life. Hence Phidias and Apelles must give place to him, and Polycletus be considered his inferior in art. Call, therefore, the Fates most cruel, who have snatched from us such a man. Yet cease to weep, for destiny is immutable; pray only now to God that he may live in heaven." †

It is not to be supposed from the classic hyperboles (conveyed in no very classic form) in this

* Compare Rathgeber, Annalen der Niederländischen Malerei, Gotha, 1844, p. 30.

† " Hic jacet eximia clarus virtute Joannes,
In quo picturæ gratia mira fuit ;
Spirantes formas et humum florentibus herbis
Pinxit, et ad vivum quodlibet egit opus.

inscription, that John Van Eyck was particularly conversant in sculpture: the allusion to his treatment of landscape is more characteristic.

All writers agree that (the improved) oil painting was first introduced about the year 1410. The earliest work extant, painted in the method, is in the possession of Director Passavant, at Frankfort. It is by Peter Christophsen (called by Vasari, Pietro Crista), a scholar of Hubert Van Eyck, and has the date 1417. The invention can, therefore, hardly be placed later than 1410. At that time John Van Eyck, according to the above chronology, was not twenty years old. It would thus appear that Hubert was the real inventor. The great, if not superior, merit of the younger brother, who survived the elder nearly twenty years, and the fact that the works of the former only were known in Italy, account for his having there superseded all other claims.* Antonello

> Quippe illi Phidias et cedere debet Apelles ;
> Arte illi inferior ac Policretus [sic] erat.
> Crudeles igitur, crudeles dicite Parcas,
> Quæ talem nobis eripuere virum.
> Actum sit lachrymis, incommutabile fatum,
> Vivat ut in cœlis jam deprecare Deum."
> > *Van Mander, Schild.* p. 202.

Delepierre (*Gal. d'Art. Brug.* p. 11.) observes that this inscription was destroyed during the wars of the iconoclasts.

* Among the masterworks of Hubert Van Eyck may be mentioned the principal large figures in the Ghent altarpiece. Fuseli, who saw those works while they were in the

da Messina, who communicated the Flemish process to the Italians, had known John Van Eyck only; Hubert he had never seen. Vasari, in the original edition of his work, does not even mention Hubert; the name appears for the first time in the account (inserted in the second edition) of various Flemish artists, — an account which, as the author tells us, was in a great measure supplied by Flemish authorities. The passage in question, taken literally, ascribes the honour to Hubert; but the words are brief, and the older and more important narrative, about to be examined, remained unaltered.*

The opinion that the chief credit of the invention is due to Hubert receives additional confirmation from the fact, that the bones of the arm and hand

Louvre, speaks of them as follows. "The pictures here exhibited as the works of Hemmelinck, Metsis, Lucas of Holland, A. Dürer, and even Holbein, are inferior to those ascribed to Eyck in colour, execution, and taste. The draperies of the three on a gold ground, especially that of the middle figure, could not be improved in simplicity or elegance by the taste of Raphael himself. The three heads . . . are not inferior in roundness, force, or sweetness, to the heads of L. da Vinci, and possess a more positive principle of colour." — *Knowles's Life of Fuseli;* quoted by Sir E. Head, in his notes to the translation of Kugler's Handbook of Painting, vol. ii. p. 60.

* "Lasciando adunque da parte Martino d' Olanda, Giovanni Eick da Bruggia, ed Huberto suo fratello, che nel 1510 [1410] mise in luce l' invenzione e modo di colorire a olio, come altrove s' è detto," &c. "Mise" strictly refers to Hubert alone. The blunder in the date is treated with undue severity by Van Mander, as in this case it could only have been an oversight of the transcriber or printer.

of that painter were still preserved and exhibited
to view, in the sixteenth century, near the church
in which he had been buried†; as if that hand was
regarded as the instrument which had prepared the
way for the excellence and fame of the greatest
artists. The allusion to his skill in medicine
(chemistry) in his sepulchral inscription, if that
passage has been rightly interpreted, is not un-
important. This merit also seems to have been
afterwards transferred to the younger brother.

Among the events in John Van Eyck's life which
can now be recorded on documentary evidence,
may be mentioned his visit to Portugal, for the
purpose of taking the portrait of the Infanta Eliza-
beth, daughter of John I., before her marriage with
Philip the Good, Duke of Burgundy. The embassy,
accompanied by the artist, left Flanders in October,
1428, and returned on Christmas day, 1429, bring-
ing the bride herself, the portrait having preceded
her some months. *

We now come to Antonello da Messina, the artist
who had the good fortune (for his merit was not
otherwise extraordinary) to introduce oil painting
into Italy. Here, again, the chronology of Vasari
requires to be amended, although his account, in

* M. Van Vaernewyck, quoted by Rathgeber, Annalen,
p. 5.

† Gachard, Collection de Documens inédits concernant
l'Histoire de la Belgique, t. ii. p. 63.; quoted by Passavant,
Kunst-Blatt, 1841, No. 3.

the main, may be shown to be historically true. Without anticipating that account in other respects, it is to be observed that the fact of Antonello having studied for a time with John Van Eyck is supported by the peculiar character of his works, which bear a close resemblance to the style of the Netherlands, as distinguished from that of the contemporary Italian painters.* That he was the first to communicate the improved oil painting south of the Alps is sufficiently established by the universal testimony of Italian writers: other circumstances, hereafter to be noticed, are not wanting to confirm the fact. It appears that he remained some years in Flanders after the death of Van Eyck.† On his return to Italy, probably about 1455‡, he made a short stay in Venice, com-

* A portrait in the Berlin Gallery, by this artist, inscribed "Antonellus Messaneus me pinxit, 1445," must have been painted in the Netherlands. His picture of the Crucifixion, formerly in the Ertborn collection, now in the Academy at Antwerp, was at one time the subject of a lively controversy ; not as to its originality (of which there was never any question), but its inscribed date, which was by many read 1445. There can be no doubt that it is now 1475. If it was originally so written (for there is reason to suppose that it was partly effaced in cleaning), the picture must have been painted in Italy, and probably at Venice. The inscription is, " Antonellus Messaneus me o° [oleo] pinxt."

† See an extract from a MS. given by De Bast in his observations before quoted.

‡ Lanzi supposes about 1450 ; but there is no evidence of oil pictures having been painted in Italy (by Italians) till after

municating his secret to a painter who carried it
to Florence. Antonello soon after revisited his
native place (Messina). There, it seems, he re-
mained, not some months, as Vasari states, but
several years. Returning to the North of Italy, he
fixed himself, for a time, at Milan*, but finally
removed to Venice, where he painted several pic-
tures, the date of the earliest being 1474.† He
died in Venice, certainly not before 1493. His
visit to Flanders may have been undertaken when
he was about the age of thirty.‡

Vasari is not the earliest Italian writer who has
spoken in praise of Van Eyck, but he is the first
who has given an account of the invention of oil
painting. The period when he wrote, as compared
with the date of the Flemish artist, and the oppor-
tunities which were available for him in collecting
the information thus communicated, remain to be
considered. Vasari was born in 1512: his cele-
brated work, *The Lives of the Architects, Painters,*

1455. The first works of the kind which attracted attention
were executed in Florence, between that period and 1460.

* "Mediolani quoque fuit percelebris." — *Maurolico, Hist.
Sican.,* quoted by Hackert, Memorie de Pittori Messinesi. Na-
poli, 1792. Compare Lanzi, Storia, vol. ii. p. 242.

† It is a portrait of a young man, and is inscribed "Antonius
Messaneus me pinxit anno 1474." The picture, once in the
Casa Martinengo at Bologna, is now said to be in the collec-
tion of Count Portalis. Passavant, Kunst-Blatt, 1841, No. 5.
Compare Lanzi, Storia Pitt. vol. iii. p. 27.

‡ See Memorie Istorico-critiche di Antonello degli Antonj
Pittore Messinese, compilate dal Cav. Tommaso Puccini.
Firenze, 1809.

and Sculptors, was completed and given to a friar to transcribe in 1547*, and was first published in 1550.† It had occupied him for some years ; but, in any view of the subject, nearly a century from the time of (John) Van Eyck's death must have elapsed, before the Florentine biographer can be supposed to have obtained the account which he has transmitted us respecting that painter.

The sources whence the historian derived his information are adverted to by himself. In the second edition of his work, in which he gives his own life, Vasari states that he had from early youth been in the habit of collecting notes relating to the history of art. He elsewhere observes that he had been personally acquainted with the greater part of the Flemish artists who, in his time, had visited Italy.‡ He mentions, more particularly, that in 1532 he knew Michael Coxcis (who afterwards copied the celebrated altar-piece, before mentioned, by the Van Eycks, at Ghent, when, as Van Mander relates, Titian supplied him with a valuable blue colour for the drapery of the Virgin§); that two

* Descrizione delle Opere di Giorgio Vasari. His own life, inserted in the second edition, is so entitled. On the authorities consulted by Vasari generally, see Fiorillo's Kleine Schriften artistischen Inhalts, vol. i. p. 83.

† Firenze, Lorenzo Torrentino.

‡ An additional notice of the Flemish artists in the second edition is headed " Di Diversi ;" in later republications, " Di diversi Artisti Fiamminghi."

§ Van Mander states that the colour was found in the

celebrated Flemish glass-painters had copied from
his own designs; that he was intimate with John
Calcar (van Kalcker) and others.* The additional
notices on the German and Flemish artists, given
in his second edition, were furnished, he observes,
by Stradanus (Van Straet) of Bruges, who was his
scholar for ten years; by John of Bologna, born
at Douay; and, further, by Lampsonius of Liege
(originally of Bruges), who corresponded with him,
and who says, in a letter quoted by Vasari, that he
had read and re-read the *Lives of the Painters*.†

It is important to observe that the account of
Van Eyck's invention appears in the second edition
of Vasari, nearly in the same form as in the first.
It may hence be inferred that the Flemish friends
of the biographer, who, like Lampsonius, had atten-
tively read the first edition (or at all events the
passages relating to the artists of their own coun-
try), had found but little which their knowledge
enabled them to amend, in the narrative relating to
Van Eyck. At the same time it should be noticed,
that Vasari, in some instances, omitted to make
full use of the corrections with which he was fur-
nished. Thus, when he speaks of oil painting as

mountains of Hungary, and was easily obtained before the
Turks had possession of the country ; but that, at the period
in question, it was extremely dear. It appears to have been
" Azzurro della Magna," not ultramarine.

 * Vasari, Di div. Art.

 † Ib.

the invention of Hubert Van Eyck, he adds, "as is elsewhere related;" thus showing, either that he had intended to correct, in this particular, other passages in his work, or that he fancied his history to be more consistent than it is. Numerous as his correspondents and contributors were, it must also be admitted that they were not all qualified to give him accurate information. Lampsonius, for example, who had written poetical eulogies on the artists of the Netherlands, and who might therefore be supposed to be well versed in their history, is among those who attribute the invention of oil painting, in the literal sense, to John Van Eyck.* The real authorities of the historian must therefore be sought among those who were accessible to him at an earlier period. Lampsonius, Van Straet, and others, (though useful in communicating intelligence respecting the Flemish artists of their own time,) were only known to Vasari after his first edition was published, and therefore were not responsible

* His inscription under the portrait of John Van Eyck (quasi ipse loquens) begins : —

> " Ille ego, qui lætos oleo de semine lini
> Expresso docui princeps miscere colores," &c.

See his Elogia in Effigies Pictorum celebrium Germaniæ inferioris. Antv. 1572. Lampsonius was also the author of a life of Lambert Lombard, painter and architect, of Liege. His general qualifications may be estimated by the fact that he was for some years the companion of Cardinal Pole in England, and afterwards secretary to three successive bishops of Liege.

either for the merits or defects of the original
narrative.

Among the authorities accessible to the historian
at an earlier period, the safest were perhaps to be
met with in Venice. There Antonello da Messina
died, after having freely communicated the result
of his Flemish studies, near the close of the fifteenth
century. Vasari was first in Venice in 1542*, and
may have corresponded with Venetian artists much
earlier. In his address "Agli Artefici ed a' Lettori,"
at the end of the first edition, he states that he had
employed ten years, in various parts of Italy, in
collecting materials for his biographies; and that he
was always careful to consult the oldest artists, and
persons most worthy of credit. It may therefore
be presumed that his journey to Venice, before the
completion of his work, was undertaken partly with
a view to render his intended publication as correct
as possible. In Venice he could converse with
some "oldest artists," who may have heard from
Antonello da Messina himself the narrative of that
painter's journey to Flanders, and the description
of the method which Van Eyck had taught him.

Among other evidences which the biographer
says he had been careful to collect, were sepulchral
inscriptions. Unfortunately, this appears to have
been less for the purpose of establishing facts, than
to preserve the commonplace tributes of praise

* See Vasari's account of his own life and works.

which distinguished artists had received from their fellow-citizens. The epitaph on Antonello is copied by him as usual. It is not clear from Vasari's statement, whether that inscription existed in a church in Venice, or whether it was a temporary mark of respect on the occasion of the Sicilian artist's funeral. It matters not which, provided it was then written; and indeed it cannot be supposed that Vasari would presume to invent such a document, at a time when the fraud could have been so easily detected. The tenour of that inscription corroborates his account of Antonello as the earliest Italian oil painter. Sansovino, without mentioning the epitaph, remarks even that Antonello was the inventor of the process.* This, though untenable in itself, confirms the tradition that he was the first who practised it in Italy. It should not be omitted, that, although Vasari speaks of Italian artists who had made attempts to improve the methods of painting which existed before Van Eyck's time, he acknowledges that they had failed. Subsequent writers have endeavoured to show that painters of almost every Italian school had known and practised oil painting before 1400 (which, in a certain sense, is quite possible); but Vasari, who was sufficiently jealous of the honour of Italy, gives

* Venetia descritta, 1604; quoted by Puccini, Memorie, &c. p. 23. The same assertion appears in two other writers, quoted by Fiorillo, Kleine Schriften, &c. vol. i. p. 196.

the credit of the invention, whatever it was, un-
hesitatingly to Van Eyck. The inference is that
he had satisfactory evidence of the truth of his
statement.

Such are among the grounds on which it appears
reasonable to conclude that Vasari's account of the
method of oil painting, introduced by Van Eyck,
was derived from good authority; and that having
passed through some critical ordeal, and having
been reprinted, after an interval of eighteen years*,
without material change, it was by competent judges
acknowledged to be generally correct. Van Man-
der, who may be considered in some sense the Vasari
of the Netherlands, and who was himself a painter,
in his account of Van Eyck copied almost verbatim
the statement of the Florentine relative to the
invention of oil painting.

A nearer approach to truth on such a question is
still desirable, and is fortunately not unattainable.
Errors in chronology can, in most instances, be
rectified in Vasari's narrative. Certain contradic-
tions and ambiguities will be explained, where
explanation is possible, in due order. It may be
generally observed that the historian's chief diffi-
culty was of his own making. He chose to assume
that Van Eyck's method was that which " all the
painters of the world," to use his own words, had
sought for; and which, once found, had been every

* In Fiorenza, appresso i Giunti, 1568.

where permanently adopted. The incongruities in his statement arise, in a great measure, from this cause. Long before he visited Venice, perhaps even before Antonello had ceased to exist, the great artists who founded the Venetian school had taken the system of oil painting into their own hands, and had modified it considerably. The same degree of change, though of a different kind, had taken place in Florence and in Milan. It is indeed apparent from Vasari's narrative, that he is, as it were unconsciously, describing a method different from any commonly practised in Italy in his time. His occasional attempts to reconcile this contradiction are the chief causes of the ambiguities referred to.

Vasari's most circumstantial account of the invention attributed to Van Eyck is introduced in the life of Antonello da Messina. It will be desirable to give this short history as nearly as possible in the biographer's own words. The investigations which some statements contained in it may suggest, bearing on the general inquiry proposed, will then be resumed.

"LIFE OF ANTONELLO DA MESSINA.

" When I consider the many valuable qualities with which different masters, followers of this second manner*, had enriched the art of painting,

* The "second manner," in the language of Vasari, means the chief direction of Italian art during the fifteenth century; its limits may be defined by the respective dates of Masaccio and

I cannot but acknowledge the importance of their labours, and give them all credit for their zeal and industry; for their sole object was the improvement of the art, in aiming at which they were regardless of trouble or cost, or of their own personal advantage.

" The mode of painting in tempera, which had been adopted by Cimabue from the Greeks about the year 1250*, was followed by Giotto, and those succeeding masters who have hitherto occupied our attention; and it still continued to be the only method in use for paintings on wood and on cloth. The artists were, nevertheless, aware that pictures so executed were deficient in a certain softness, and in vivacity; and felt that, if a proper method could be discovered which would admit of blending the tints with greater facility, their works would be improved both in form and colour; the earlier practice having always been, to produce the requisite union of the tints by hatching with the point of the brush. But, although many had tried ingenious experiments with a view to such improvement, none had invented a satisfactory process; neither by using liquid varnish or other kinds of colours, mixed with the tempera vehicles.†

Luca Signorelli. It is opposed to the manner of the Giotteschi on the one hand, and to that of Leonardo da Vinci on the other.

* According to Vasari himself, Cimabue was born in 1240.

† "Ne usando vernice liquida o altra sorte di colori mescolati nelle tempere."

"Among those who had in vain tried these or similar methods were Alesso Baldovinetti, Pesello, and many others: but no works produced by them possessed the pleasing effect, and improved qualities which they sought; and, even if those artists had succeeded in their immediate object, they would still have been unable to give the same stability to paintings on wood which those executed on walls possessed. They could not, by such methods, render pictures proof against wet, so as to allow of their being washed without danger of removing the colour; nor was the surface so firm as to resist sudden shocks when the works were handled. These matters were often the subject of fruitless discussion when artists met together; and the same objects were proposed by many eminent painters in other countries besides Italy, in France, Spain, Germany, and elsewhere.

"While things were in this state, it happened that Giovanni of Bruges, pursuing the art in Flanders, where he was much esteemed on account of the skill which he had acquired, began to try experiments with different kinds of colours, and, being fond of alchemy [chemistry], to prepare various

First edition. "Ne con vernice liquida, ne con altra sorte di olii mescolati nella tempera." The word "colours," in the later edition, is unmeaning; but Vasari appears to have substituted it for "oils," to suit the views of those, such as Lampsonius, who attributed the actual invention of oil painting to Van Eyck.

oils for the composition of varnishes, and other things*; researches which ingenious men, such as he was, are wont to make. Having on one occasion, among others, taken great pains in executing a picture on panel, and having finished it with especial care, he varnished it, and placed it in the sun to dry†, as is the custom : but, either because the heat was too great, or perhaps because the panel was ill put together, or the wood not sufficiently seasoned, it unfortunately split open at the joinings. Giovanni, seeing the damage which the heat of the sun had occasioned to the picture, determined to have recourse to some expedient or other to prevent the same cause from ever so injuring his works again ; and, being not less dissatisfied with the varnish than with the process of tempera

* " Si mise . . . a provare diverse sorti di colori, e come quello che si dilettava dell' archimia, a far di molti olii, per far vernici, ed altre cose." First edition : "e cercava di trovare diverse sorti di colori, dilettandosi forte della archimia, e stillando continovamente olii per far vernice e varie sorti di cose." The word " stillare " is used by Italian writers in various senses, besides the chief meaning, " to distil ; " but Vasari, either from his own judgment, or at the suggestion of his Flemish friends, removed the expression in his later edition, lest it should be supposed that Van Eyck distilled the (fixed) oils. The practice was not uncommon in Vasari's time, but is quite opposed to that of Van Eyck. The above is the most important of the few corrections which the biographer thought it necessary to make in the reprint of this portion of his work.

† ..." le diede la vernice, e la mise a seccarsi al sole, come si costuma." First edition : ... " le volse dare la vernice al sole, come si costuma alle tavole."

painting, he began to devise means for preparing a kind of varnish which should dry in the shade, so as to avoid [the danger incurred by] placing his pictures in the sun. Having made experiments with many things, both pure and mixed together, he at last found that linseed oil and nut oil, among the many which he had tested, were more drying than all the rest. These, therefore, boiled with other mixtures of his, made him the varnish which he, nay, which all the painters of the world, had long desired. Continuing his experiments with many other things, he saw that the immixture of the colours with these kinds of oils gave them a very firm consistence, which, when dry, was proof against wet ; and, moreover, that the vehicle lit up the colours so powerfully, that it gave a gloss of itself without varnish ; and that which appeared to him still more admirable was, that it allowed of blending [the colours] infinitely better than tempera.*

* " Onde poi che ebbe molte cose sperimentate, e pure, e mescolate insieme, alla fine trovò, che l' Olio di Seme di Lino, e quello delle Noci, fra tanti che n' haveva provati, erano più seccativi di tutti gl' altri. Questi dunque, bolliti con altre sue misture, gli fecero la vernice, che egli, anzi tutti i pittori del mondo havevano lungamente desiderato. Do o fatto sperienza di molte altre cose, vide che il mescolare i colori con queste sorti d' olii dava loro una tempera molto forte ; e che secca non solo non temeva l' acqua altrimenti, ma accendeva il colore tanto forte, che gli dava lustro da per se senza vernice. Et quello che più gli parve mirabile, fu che si univa meglio che la tempera infinitamente."

This well known and remarkable passage is the same in both

Giovanni, rejoicing in this invention, and being a person of discernment, began many works, and filled all the neighbouring provinces with them, giving the greatest satisfaction, and deriving no small benefit from his labours; while, daily assisted by experience, he went on still producing greater and better things.

" The fame of Giovanni's invention being soon after spread, not only in Flanders, but throughout Italy and many other parts of the world, the greatest curiosity prevailed among the artists to know by what means he rendered his productions so perfect. Those artists, however, seeing the works, and not knowing what [materials] he had employed, could only extol his merit, and give him the homage of their praise, while at the same time they were inspired with emulation; the more so, because, for a time, he would suffer no one to see him at work; nor would he consent to teach any person his secret.* But, having become old, he

editions; some slight verbal alterations making none whatever in the sense. The words, "anzi che tutti i pittori del mondo," are an addition and an unimportant one. The statement respecting the experiments with the oils relates only to the testing of their relative drying qualities. Vasari well knew that the varnish which Van Eyck and others had been in the habit of using (and which had been used for centuries) was partly composed of linseed oil. This subject will be further considered in the next chapter. It will be observed that Vasari, in this passage, uses the word tempera first in a general, and then in a particular, sense.

* This statement is incorrect; Hubert Van Eyck must have

made a favour of imparting it at last to Ruggieri [Roger] of Bruges, his scholar. Ruggieri communicated it to Ausse *, who studied under him, and to others who have been mentioned in the introduction, where, in treating of the practice of art generally, oil painting is described.

" Notwithstanding all this, although merchants made these works an object of traffick, and sent them to all parts, for sovereigns and distinguished persons, to their own great profit, the art did not find its way out of Flanders ; and, although the pictures thus sent had that pungent smell which the immixture of colours with the oils gave them, especially when the works were new, so that it appeared possible to detect the ingredients, yet the discovery was not made during many years. But some Florentines, who trafficked in Flanders and in Naples, having sent to Alphonso I. of Naples a picture on panel, with many figures painted by Giovanni in oil, a work which, on account of the

communicated the process freely to his scholars. Among these were Peter Christophsen, Gerard van der Meire, and probably Justus van Ghent (called by Vasari, Giusto da Guanto); the first has been already mentioned as the author of an oil picture, dated 1417. Gerard van der Meire is supposed to have assisted in painting the Ghent altar-piece. (*Kunst-Blatt*, 1826, No. 81. 1833, No. 82—85.) De Bast also quotes some contracts, dated 1419, 1434, in which certain artists engage to repair or execute pictures with " good oil colours." (Ib. 1826, No. 81. ; 1843, No. 55.)

* Ausse was probably a misprint for Ansse, Hans [Memling]; but it is uncorrected in the second edition.

beauty of the figures, and the new invention in colouring, was greatly valued by that monarch*, all the painters of the kingdom went to see it, and it was by all highly extolled.

"At this time, one Antonello of Messina, a person of an intelligent active spirit, and very sagacious, moreover not unskilled in his profession, having studied drawing for many years in Rome, had established himself at first in Palermo (where he had been employed for some time), and ultimately in Messina, his native place; in which city he had,

* Alphonso V. of Arragon (or I. of Naples) expelled Réné of Anjou from Naples, and made himself master of the king-dom in 1442. Three years remain (between that period and the death of Van Eyck) for the picture in question to arrive, and for Antonello da Messina to proceed to Flanders to learn the method of oil painting. De Bast supposes, however, that Vasari may have been misinformed on this point, and that pictures by Van Eyck were more likely to be sent to Réné of Anjou, who himself painted according to the Flemish method, and who might have recommended Antonello to the Flemish artist. In that case the period in which Antonello may have proceeded to Bruges would be within the years 1438 and 1442, the duration of Réné's sovereignty in Naples. (*Kunst-Blatt*, 1826, No. 84.)

Facius, the historian (or rather one of the historians) of Alphonso, describes a picture by Van Eyck, in the possession of that monarch. "Ejus est tabula insignis in penetralibus Alphonsi regis." It was a triptych; the principal subject was the Annunciation, the others St. John the Baptist, and St. Jerome; on the outside were the portraits of Lomellinus and his wife. Lomellinus was probably the merchant for whom the picture was painted. There can be little doubt that this was the work which Antonello da Messina saw. (*Facius de Viris Illustribus*, p. 46.)

by his works, confirmed the good opinion there
entertained of him as to his ability in painting.
This person, happening to go to Naples on some
affairs, heard that the above-mentioned picture
by Giovanni of Bruges had been received from
Flanders by the King Alfonso; that it was painted
in oil, in such a manner that it could be washed
[with safety]; that its surface was in no danger
from any shock; and that it was, besides, a very
perfect work. Antonello, having made interest to
see it, was so struck with the vivacity of the colours
and the beauty and harmony of that painting, that,
putting aside every other avocation and thought,
he at once set out for Flanders. Arrived in Bruges,
he assiduously cultivated the friendship of Giovanni,
presenting many drawings to him executed in the
Italian style, and other things; so that Giovanni,
in return for these attentions, and also because he
found himself already old, was content that Anto-
nello should see the method of his colouring in oil.
The latter, in consequence, did not quit Flanders
till he had thoroughly learned that process — the
great object of his wishes. Giovanni dying soon
after, Antonello left Flanders, to revisit his native
place and to communicate to Italy so valuable a
secret. After remaining a few months in Mes-
sina, he proceeded to Venice, where, being addicted
to pleasure, he determined to reside and end his
days, having found a mode of life which suited his
inclinations. There, resuming his occupation, he

painted several pictures in oil, according to the
method which he had learned in Flanders. These
pictures are spread among the houses of the Vene-
tian nobility, and, from the new mode in which
they were executed, they were much prized.
Many other works of his were sent to various
places. At length, having acquired considerable
reputation in Venice, he was commissioned to paint
a picture (on wood) for S. Cassiano, a parish of
that city.* He executed the work with all the
ability he possessed, sparing no time to render it
complete. When it was finished, it was greatly
commended from the novelty of that style of
colouring and the beauty of the figures, which
were well drawn; and, as it was then understood
that he had been the means of introducing the new
secret to Venice from Flanders, he was esteemed
and treated with attention by the most distin-
guished inhabitants, as long as he lived.

"Among the painters who were then in repute in
Venice, a certain Maestro Domenico was considered
very excellent. On the arrival of Antonello in
Venice, this person treated him with the greatest
attention, such as bespeaks a warm friendship.
Antonello, not willing to be outdone in kindness by

* Morelli (*Notizie d' Opere di Disegno*, Bassano, 1800,
p. 189.) proves that this picture, mentioned by various writers
with praise, was still in the church of S. Cassiano at the close
of the sixteenth century. In Ridolfi's time (1646) it had
disappeared.

Maestro Domenico, after a few months taught him the secret and method of colouring in oil. No courtesy or kindness soever could be more acceptable to Domenico than this; since it was the means, as he had hoped it would be, of establishing his reputation in his native place. And certainly those persons err greatly who are avaricious of that which costs them nothing, while they imagine that, merely for their own sake, they themselves are to be served by every body. The attentions of Maestro Domenico had the effect of winning from Antonello that which he had gained for himself with so much assiduity and labour, and which perhaps he would have given to no other for a large sum of money. But I shall speak of Maestro Domenico in due time, of the works which he executed in Florence, and of him* to whom he liberally imparted what he himself owed to the kindness of another.

" Antonello, after having painted the altar-piece of S. Cassiano, executed many pictures and portraits for various Venetian noblemen; and M. Bernardo Vecchietti, a Florentine, has by him, two very beautiful figures of S. Francesco and S. Domenico, represented in the same picture.† Afterwards, at

* Andrea dal Castagno, who, according to Vasari, murdered Domenico after having gained his secret.

† This picture is now in the possession of Messrs. Woodburn. It contains two heads only, one representing a Franciscan friar, the other a canon of St. John Lateran; it is described by Borghini, *Il Riposo*, Milan, 1807, vol. ii. p. 104. See also the last Florence edition of Vasari, Vita di Ant. da Messina.

the time when the Signoria [Venetian government]
commissioned him to paint some subjects in the
ducal palace—subjects which they had refused to
give to Francesco Monsignore, of Verona* (though
that painter was warmly recommended by the Duke
of Mantua)—Antonello was attacked with a pleurisy,
and died at the age of forty-nine†, before he had
begun the work. The painters evinced their respect
for his memory at his funeral, in consideration of
the gift which he had made to art in the new mode
of colouring, as this epitaph testifies:—

' DEO OPTIMO, MAXIMO.

Antonio the Painter, the chief ornament of his
native Messina, and of all Sicily, is buried in this
spot. He is not only honoured with the lasting
respect of his profession on account of the singular
skill and grace which his pictures exhibit, but also

* Vasari speaks of Monsignore in the Life of Fra Giocondo,
and observes that he first entered the service of the Duke of
Mantua in 1487.

† The ducal palace was partly destroyed by fire in 1483.
The new building was completed in 1493; after which period,
therefore, Antonello must have prepared to execute his com-
mission. His death may have happened in the same year or
later, but not before. Supposing him to have been about thirty
when he first visited Flanders, he would have been about
seventy-nine in 1493. Puccini (*Memorie*, p. 61.) supposes
Vasari's 49 to be a misprint for 79 ; but the Roman numerals
xxxxix. in the first edition render this supposition improbable.
Among the later works of Antonello, Ridolfi (*Le Meraviglie
dell' Arte*, Ven. 1648, vol. i. p.48.) mentions a fresco at Treviso,
painted in 1490.

because he was the first who conferred splendour and durability on Italian painting, by the immixture of colours with oil.' *

" The death of Antonello was regretted by many of his friends, and particularly by Andrea Riccio†, the sculptor, who executed the two statues of Adam and Eve in the court of the Palazzo della Signoria, and which are considered beautiful works. Such was the end of Antonello, to whom certainly our artists are not less indebted for having introduced the mode of colouring in oil into Italy, than to Giovanni of Bruges for having first invented it in Flanders; both having been the means of enriching and benefiting the art: for by means of this invention painters have attained such excellence that

* " D. O. M.

Antonius pictor, præcipuum Messanæ suæ et Siciliæ totius ornamentum, hac humo contegitur. Non solum suis picturis, in quibus singulare artificium et venustas fuit, sed et quod coloribus oleo miscendis splendorem et perpetuitatem primus Italicæ picturæ contulit, summo semper artificum studio celebratus."

 † Andrea Riccio was born in 1470. (*Scardeonio de Antiq. Patav.* l. iii. p. 375., quoted by Puccini.) Vasari may have intended to speak of Antonio Rizzo, whose name is inscribed on the statue of Eve above mentioned ; that artist was living and in full activity in 1496. (*Puccini,* ib.) Thus the supposition that Antonello may have died after 1493 is invalidated by no circumstance. On the contrary, the anonymous author of the *Memorie de' Pittori Messinesi,* Mess. 1821, p. 19., quotes a picture by Antonello, inscribed 1497, and even refers to writers who prolong his life to 1501. Gallo (*Annali di Messina*), with more probability, states that he died in 1496.

they have almost made their figures living. The method deserves to be the more esteemed, in as much as no writer attributes this mode of colouring to the ancients. If it could be ascertained that the process was really unknown to them, that circumstance would of itself give a pre-eminence to the art of this century over the excellence of the antique. But since nothing is said which has not been said before, so perhaps nothing is done which has not been before done.* I therefore leave the question to its own merits, and, always giving highest praise to those who still add some quality to the art besides drawing, I proceed to write of others."

NOTE

ON THE INTRODUCTION OF OIL PAINTING INTO ITALY.

IT has been already stated that the first Italian oil paintings of which we have any distinct notice were executed at Florence between the years 1455 and 1460. The nature of those works, the character of the artists employed, and the traditions of their process, will be considered at large in the second volume of this work. A few circumstances may be noticed here respecting the introduction of oil painting in other parts of Italy, and particularly in Naples. A letter (quoted by Puccini and Lanzi), dated 20th March, 1524, and addressed by a Neapolitan, Sum-

* Lampsonius (perhaps copying Vasari), in his eulogy on John Van Eyck, expresses the same doubt : — "Atque ipsi ignotum quondam *fortassis* Apelli."

monzio, to a Venetian writer, Marcantonio Michele, contains the following passage :—" From that period [1386—1414] we have had no one till the time of Maestro Colantonio, our Neapolitan, with so much inclination for painting ; and, if he had not died young, he might have done great things. It was the fault only of the times in which he lived, that Colantonio did not attain to the perfect drawing which we see in the antique, and which was possessed [in a greater degree] by his scholar, Antonello da Messina, a man who, I understand, is known among you [Venetians]. The taste of Colantonio was, according to the fashion of the time, entirely in favour of Flemish execution and colouring. He was so devoted to that kind of art, that he had thoughts of going to Flanders; but King René induced him to remain here, undertaking himself to show him the method and vehicle employed in the Flemish colouring."
—" Da questo tempo [del Re Ladislao] non havemo havuto fino a Maestro Colantonio nostro Napolitano persona tanto disposta all' arte della pictura, che se non moriva iovene era par fare cose grandi. Costui non arrivò per colpa de' tempi alla perfettione del disegno delle cose antique, si come ci arrivò il suo discepolo Antonello da Messina, homo secondo intendo noto appresso Voi. La professione di Colantonio tutta era si come portava quel tempo in lavoro di Fiandra, e lo colorire di quel paese, al che era tanto dedito che haveva deliberato andarvi. Ma il Re Raniero lo ritenne qui con mostrarli ipso la pratica e la tempera di tal colorito," &c.

The early date of this letter gives it a more than common importance. The assumption that Antonello da Messina was a scholar of Colantonio del Fiore may be passed over, as at once unsupported and inconclusive. On the other hand, it is certain that Colantonio painted latterly in the Flemish taste ; his St. Jerome, now in the Museum at Naples, compared with earlier works attributed to him in S. Maria la Nuova and elsewhere, proves this. (See *Passavant, Kunst-Blatt,* 1843, No. 57.) But, Neapolitan writers excepted, none who have examined that work, have ventured to say that it is painted in oil. If it bears the date 1436, as Dominici (*Vite de' Pittori Napoletani,* vol. i. p. 105.) and Piacenza (*Baldinucci,* vol. v. p. 146.) assert, that circumstance, according to Summonzio's

statement, sufficiently accounts for its not being painted in oil, as King René's arrival in Naples was later by two years. But supposing that these writers were mistaken (as more recent authorities give no such date), or that later works of the same kind by Colantonio exist, painted while René occupied the throne of Naples, the doubtful appearance of such works may, perhaps, be explained by a reference to the pictures of the royal artist.

Several examples are preserved ; the latest and best is in the cathedral at Aix, and all are more or less in the style of the Van Eycks — a taste which René may have acquired during his three years' captivity at Dijon and Bracon, between the years 1431 and 1436.* Passavant (*Kunst-Blatt*, ib.), speaking of one of these examples, at Villeneuve, near Avignon, says that "it is painted in tempera, over which varnish colours are glazed." King René's chief practice was in illuminating, and it seems that his larger pictures are hatched with the point of the brush, in the manner of the early Italian tempera painters. The royal artist's mode of painting was thus an approach only to the improved system of the Van Eycks, and his partial adoption of their process is explained by his being unable to divest himself of the habits of miniature and missal painting.† The communication of such a method to Colantonio, already far advanced in years (according to the chronology of Dominici), was therefore hardly calculated to give an idea of the new process; and the arrival of Van Eyck's picture, whether sent to René or Alphonso, might still have been the immediate cause of Antonello da Messina's visit to Flanders.

Summonzio's allusion to the estimation in which Antonello was held by the Venetians, establishes the truth of Vasari's statement in regard to that point, and there can be little doubt that the Sicilian was the first to communicate the Flemish

* He was allowed to quit his imprisonment on parole, for the settlement of the affairs of his kingdom, between 1432 and 1434.

† See Œuvres complètes du Roi René, avec une biographie et des notices par M. le Comte de Quatrebarbes, et un grand nombre de dessins et ornements d'après les tableaux et manuscrits originaux par M. Hawke. 4 tomes. Angers, 1845–46.

method of oil painting in Italy. But it is not to be overlooked that some Flemish artists, scholars or followers of Van Eyck, were in Italy, and executed pictures there, about the middle of the fifteenth century. Among these were Roger of Bruges *, Memling, and Justus van Ghent. Facius speaks of the first as having seen and admired a work by Gentile da Fabriano, in Rome, during the year of the jubilee (1450 ; see Muratori, *Annali d'Italia*), and mentions several works by the Flemish artist in Genoa, Ferrara, and Naples. The portrait of Roger of Bruges, with the date 1462, and another picture by the same artist, were seen in Venice by the anonymous traveller whose notes were published by Morelli (*Notizie*, &c. p. 78. 81.) ; and Lanzi inclines to the opinion that the altar-piece in Venice, inscribed " sumus Ruggerii manus," was also painted by him during his stay in that city.

Memling's visit to Italy is rendered probable by the introduction of well-known Italian buildings in pictures executed by him after he was settled at Bruges. He appears to have accompanied his master, Roger of Bruges, on the occasion of the jubilee, when, as Muratori states, the concourse of people from all parts of Europe was so great, that the principal roads of Italy resembled fairs. Several works by Memling existed in Venice and Florence in the fifteenth century.

Justus van Ghent entered into a contract (dated 1465) to paint an altar-piece at Urbino (*Passavant, Rafael von Urbino*, vol. i. p. 429.) The picture is still preserved there. A fresco at Genoa, inscribed " Justus de Alemania pinxit, 1451," if by the same artist, would prove that he was in Italy as early as Roger

* Those who have undertaken to correct Vasari and the early historians of art, for confounding (as they have supposed) Roger of Bruges and Roger van der Weyden, are to be corrected in their turn. The researches of M. Wauters (*Messager des Sciences historiques*, 1846, quoted by Michiels, *Histoire de la Peinture Flamande et Hollandaise*, vol. iii. p. 392.), have proved that Van der Weyden was the family name of Van Eyck's scholar. His son, Goswyn, was also a painter. This fact, and the circumstance of the father having called himself Roger of Bruges, may have led Van Mander and others to consider the latter a distinct person from Roger van der Weyden.

of Bruges. On the whole, therefore, it may be concluded that specimens of the Flemish method were not only imported to Italy, but were actually painted there, before the return of Antonello da Messina from Flanders. The inference is, that the Flemish artists who were thus employed contrived to keep the secret of their process. This may be the more readily believed, from the fact that although Justus van Ghent resided for some years at Urbino, and painted works in oil there, the native artists, such as Giovanni Santi (the father of Raphael), continued to paint in tempera, not having been favoured, as it would seem, by a communication of the method in which Justus wrought. Accordingly, Giovanni Santi, taking occasion to mention the distinguished painters of his day, including John Van Eyck and Roger of Bruges, in a poem which is still extant (*Passavant,* ib. vol. i. p. 444.), appears to resent the illiberality of Justus by omitting his name.

While noticing the introduction of Flemish works into the South of Europe, it may be remarked that in consequence of John Van Eyck's visit to Portugal, and the subsequent relations which subsisted between that country and Flanders, the influence of the Flemish style is very apparent in early works executed by Portuguese artists, which are still preserved in the Academy at Lisbon and elsewhere. This influence has been traced and exemplified by an enlightened amateur, in a series of letters, accompanied with documents (*Les Arts en Portugal, par le Comte A. Raczynski,* Paris, 1846). The author remarks that all pictures executed in Portugal till the middle of the sixteenth century (and in the instance of the pictures of Gran Vasco, even later) are painted in this style. "Assurément dans tous ces tableaux c'est l'influence allemande et flamande qui prédomine ; j'ose même dire qu'elle y règne presque exclusivement." (p. 146.) Together with this general style, there can be no doubt that the technical methods of the Flemish school were also adopted. The same may be observed of the Spanish schools, especially that of Seville, which, in the technical habits of its best period, was more allied to the Flemish than to the Italian practice.

CHAP. VIII.

EXAMINATION OF VASARI'S STATEMENTS RESPECTING THE INVENTION OF VAN EYCK.

In the preceding narrative Vasari prepares the reader for the excellence of oil painting, by dwelling on the inconveniences of tempera. He exaggerates the defects of that method, and the disgust of the artists who practised it. He omits to speak of those exceptional cases in which, as before remarked, a satisfactory union of tints was effected * ; and he appears to forget that, after the novel method was

* Examples like those before adduced were less rare after the middle of the fifteenth century. The paintings of Filippo Lippi, at once finished and free, indicate the use of a medium which did not dry rapidly. This requisite in the tempera vehicle may have been secured, not merely by the immixture of honey, according to the early Anglo-German process, but by the combination of wax with glutinous ingredients as exemplified in Le Begue's receipt before quoted. Another mode, in which even the combination of oil with glutinous vehicles was tried by a Florentine artist, will be noticed in this chapter. As regards the addition of wax, there is no direct evidence that it was commonly employed at the period in question; but, at a time when various efforts were made to improve the practice of tempera, it is by no means improbable that the partial use of wax may have been revived.

introduced, the Italian artists, instead of eagerly
adopting it, long remained faithful to their earlier
habits. For it was not till the essential qualities of
oil painting had been in part developed in Florence,
Milan, and Venice, by Perugino, Leonardo da Vinci,
and Giovanni Bellini, that the new art was gene-
rally followed.

Some circumstances connected with its intro-
duction may have operated, in addition to the
causes before noticed, to prejudice a certain class
of the Florentine masters against it. It was repre-
sented in Italy, at first, by Flemish pictures. These,
though not without influence (independently of
the method in which they were executed), from their
fascinating treatment of accessories, appear to
have been more admired by Italian collectors than
by Italian painters. The specimens of Van Eyck,
Hugo van der Goes, Memling, and others, which
the Florentines had seen * , may have appeared, in

* A St. Jerome, by Van Eyck, was in the possession of
Lorenzo de' Medici, and may have been in Italy at an earlier
period. (*Vasari, Introd.* c. 21.) The Bath, with numerous
figures, was, in the time of Facius (1456), in the possession of
Cardinal Ottaviano degl' Ottaviani : this appears to be the
same picture which Vasari (ibid.) mentions as belonging, after-
wards, to the Duke of Urbino. The specimens of Van Eyck,
which were to be seen in Naples, Milan, and Venice, (see
Morelli, Notizie d'Opere di Disegno, p. 14. 45. 116.) may have
been known to many Tuscan painters. Hugo van der Goes
had painted the altar-piece (a triptych) for the Portinari Chapel
in S. Maria Nuova, at Florence. (*Vasari, Introd.* ibid.) The
picture, now divided and not in its original place, is still in

the eyes of some severe judges (for example, those who daily studied the frescoes of Masaccio *), to indicate a certain connexion between oil painting and minuteness, if not always of size, yet of style. The method, by its very finish and the possible completeness of its gradations, must have seemed well calculated to exhibit numerous objects on a small scale. That this was really the impression produced, at a later period, on one who represented the highest style of design, has been lately proved by means of an interesting document in which the opinions of Michael Angelo on the character of Flemish pictures are recorded by a contemporary artist. †

that church. (*Passavant, Kunst-Blatt,* 1841, No. 5.) A work by this artist, executed at the same time, is now in the Pitti Palace. A picture by Memling was also in S. Maria Nuova; another belonged to the Medici. (*Vasari, Introd.* ib.) That Justus van Ghent, Roger of Bruges, and probably Memling, the scholar of the latter, were all in Italy, has been shown in the note appended to the last chapter. The influence of the style of the Flemish painters in Italy, at this time, is acknowledged by Rumohr (*Italienische Forschungen,* vol. ii. p. 263.). Ciriaco d' Ancona, in a fragment of a letter preserved in Colucci's *Antichità Picene,* tom. xv. p. 143. (compare *Lanzi,* vol. i. p. 276.), speaks of a Sienese painter, Angelo Parrasio, whom he had known at Ferrara in 1449, and who, he remarks, had imitated Van Eyck and Roger of Bruges in a picture executed at Ferrara.

* Vasari, Vita di Masaccio.

† Les Arts en Portugal, par le Comte A. Raczynski. Paris, 1846. This work, before noticed, opens with some extracts from a manuscript by " François de Hollande, architecte et

The Italian masters above named succeeded,
however, in adapting oil painting to large dimen-
sions, in many cases with corresponding breadth
of manner; and their immediate followers carried
its practice to perfection. Vasari, to whom exam-

enlumineur." The principal part, which appears to be a con-
fused history of ancient and modern art, was completed at
Lisbon in 1548. Francisco was most employed during the
reign of John III. (1521—1557). The most interesting
part of the MS., translated by the editor, consists of various
conversations, apparently recorded as they occurred in
Rome. The opinion of Michael Angelo on Flemish art was
elicited by the Marchioness of Pescara, Vittoria Colonna, who
observed that the Flemish pictures appeared to her to be
treated with a more devout feeling than the works of the
Italians. The great artist replies: " La peinture flamande
plaira généralement à tout dévôt plus qu'aucune d'Italie.... En
Flandre, on peint de préférence, pour tromper la vue exteri-
eure, ou des objets qui vous charment ou des objets dont vous
ne puissiez dire du mal, tels que des saints et prophètes. D'or-
dinaire ce sont des chiffons, des masures, des champs très verts
ombragés d'arbres, des rivières et des ponts, ce que l'on appelle
paysages, et beaucoup de figures par-ci par-là; quoique cela
fasse bon effet à certains yeux, en vérité il n'y a là ni raison ni
art, point de symétrie, point de proportions, nul soin dans le
choix, nulle grandeur.... Si je dis tant de mal de la peinture fla-
mande, ce n'est pas qu'elle soit entièrement mauvaise, mais elle
veut rendre avec perfection tant de choses, dont une seule
suffirait par son importance, qu'elle n'en fait aucune d'une
manière satisfaisante.... La bonne peinture est noble et dévote
par elle-même, car chez les sages rien n'élève plus l'âme et ne la
porte davantage à la dévotion que la difficulté de la perfection,"
&c. A native of Holland might have had some reluctance in
recording so severe a judgment on the style of the Netherlands,
but Francisco de Ollanda was born in Lisbon; his father, An-
tonio, having settled there.

ples of that perfection were familiar, appears to have contrasted them, in imagination, with the most timid specimens of tempera.

The biographer next proceeds to speak of certain attempts made by Alesso Baldovinetti, and others, before oil painting was introduced (as he appears to assume), to unite richness and depth of effect with fresco, by employing unctuous ingredients in retouching frescoes, and perhaps for painting generally. In the life of Baldovinetti, he describes the vehicle employed by that artist more particularly. It consisted, he says, of " vernice liquida" and yolk of eggs : he adds that, where the colour so mixed was applied too thickly, it cracked and peeled off.

This defect accounts for his dwelling on the superior firmness and consistence of Van Eyck's pictures, the surface of which, he observes, was in no danger of being detached, even by sudden shocks. To painters of the present day, such accidents to newly painted pictures may appear almost impossible ; yet the use of heterogeneous vehicles may, without due care, lead to such results. Northcote, in his life of Reynolds, relates that a newly finished picture by Sir Joshua, having been accidentally overturned, was found on examination to have shaken off " a considerable part of the face and neck. " * So, when Vasari states that Van Eyck's pictures would bear washing, he probably referred,

* Vol. ii. p. 160.

not to tempera, which, when varnished, was proof
against wet, but to such pictures as those of Bal-
dovinetti, the surface of which, if cracked, would
admit the moisture, and might then be easily
detached.

From the manner in which Vasari speaks of the
(supposed) invention of Baldovinetti, it is evident
that he considered his countryman as one who was
foremost in endeavouring to remedy the defects of
tempera. A reference to the date of this Floren-
tine painter (of which the biographer appears to
have been ignorant) will, therefore, not be unim-
portant. He was born about 1425*, and died near
the close of the century. The period when he
began to practice his method was therefore, in all
probability, scarcely anterior even to the introduc-
tion of oil painting into Florence. Moreover, the
composition which Baldovinetti employed, far from
being an invention of his, was used in Venice in
the peculiar glass-painting already described, before
he was born. This is apparent from the follow-
ing passage in the oldest portion of the Venetian
MS.: "Take yolks of eggs and ' vernice liquida,'
equal quantities, incorporate them well, and apply
the mixture, as a coating, with the brush. It is

* See the documents quoted by Gaye, Carteggio ined. d' Ar-
tisti, vol. i. p. 224. Compare the notes to Baldinucci (Milan,
1811), vol. v. p. 317.; and the notes to the last Florence
edition of Vasari (1832—1838), Vita di A. Baldovinetti.

proof against water and every thing else."* Thus used, the ingredients may have been less liable to crack than when mixed with solid colour. But, without staying to examine further the claims of Alesso Baldovinetti, we proceed to a more important question, viz. the nature of " vernice liquida."

Vasari uses the term as an ordinary and familiar one, in his account of the invention of oil painting and in the life of Baldovinetti. The expression frequently occurs in the Venetian MS., in the MSS. of Alcherius, in the compendium of St. Audemar, and in the notes of Le Begue, and is to be met with in all early treatises on painting. Cennini mentions "vernice liquida" no less than nine times†, and speaks of no other varnish. On one or two other occasions, where the epithet "liquida" is omitted, apparently to avoid repetition, it is still clear that the same composition is meant. The process of varnishing, as already shown, generally took place in the sun ; the sun's heat was, at all events, afterwards necessary to dry the surface. Cennini

* " Toy torli de ove e v̄nixe liquida egualmente ē īcorpora molto bñ īsieme ē de questa tale cola darai p cop̱ta como el penelo la qual colla nō teme aqua ne cossa che sia." The yolk of egg contains a small proportion of oil, but not enough to arrest the drying of the substance ; to increase the oily ingredient was therefore an obvious remedy. The method of Baldovinetti was not perhaps the only attempt to combine oily and glutinous materials, so as to render tempera more manageable ; for this, according to Vasari, was the great object.

† Trattato, c. 101—161.

intimates that the practice was not without risk (as panels are apt to warp and split in the sun), but recommends boiling the varnish well when it was intended that the picture should dry in the shade.*

Tambroni, the editor of Cennini, observes, with reference to a passage in the chapter here quoted, that "the silence of Cennini as to the nature of this varnish is truly to be deplored." The commentator estimated the importance of the desired knowledge justly; at the same time it is surprising that he should have made no attempt to clear up this difficulty, or to satisfy himself and others on the point in question. It is plain from Cennini's account (and it will be proved from other sources) that this was the universal varnish for tempera pictures. Van Eyck, in consequence of the splitting of a panel in the sun, proceeded, first, to prepare his varnish so that it might dry in the shade; and, secondly (which was his chief improvement), to mix the colours partly with this drying medium. Tambroni may therefore have supposed, and not without reason, that a description of the varnish, even with its original defects, which was commonly used by the early tempera painters, might throw some light on the Flemish improvement in oil painting.

* " Se volessi che la vernice asciugasse senza sole, cuocila bene in prima; chè la tavola l' ha molto per bene a non essere troppo sforzata dal sole." — Ib. c. 155.

It will be remarked that there is a close coincidence between Cennini's observation respecting the inconvenience of exposing panels in the sun, and the accident which, according to the narrative, actually occurred to Van Eyck. There is a further coincidence between Cennini's recommendation that the varnish should be well boiled if the picture was *not* to be dried in the sun, and the corresponding precaution actually taken by Van Eyck. But this need not suggest the inference, either that Cennini had heard the story afterwards told by Vasari, or that Vasari had contrived his narrative to suit the directions of Cennini. Any writer might have stated that panels warp in the sun; and any painter, at a time when all were acquainted with mechanical processes, might have known that varnishes long boiled become more drying, though at the same time they become darker in colour. But that which was the chief novelty, the immixture of the colours with such a medium (more carefully prepared), is not noticed by Cennini with reference to painting *, and, which is remarkable, the method was already almost obsolete in Italy in Vasari's time; so that the biographer extolled an invention which he and most of his countrymen no longer sanctioned by their practice. This is the strongest proof that Vasari's account was derived from Flem-

* The mixture of " vernice liquida " with colours (for some purposes) was not unknown to Cennini. (*Trattato*, c. 161.)

ish authorities, and, therefore, likely to be, in the main, correct.

The silence of Cennini respecting the customary varnish need not have been " deplored" by Tam-broni. The composition is fully described by many other writers. Two passages, where Cennini men-tions " vernice liquida," employed as a varnish, are first to be examined. Speaking of a mordant, he says: " It would not be proof against wet or mois-ture in churches, where [though] the walls might be faced with brick; but it is fit for the surface of wood or iron, or any substance intended to be var-nished with " vernice liquida."* In c. 145., the chapter to which Tambroni's note is appended, Cennini says: " Take then your ' vernice liquida' as clear and as light in colour as you can procure it."† In this case, the adjective "liquida," without a comparison with other passages in the book, and particularly the last quoted, might be taken for an ordinary epithet like the " clear " and "light" which accompany it, especially as there are two conjunctions.‡ The punctuation, supplied, as it ap-

* " Questo tal mordente non si difenderebbe nè da acqua nè da umido mai in chiese, dove fusse coperti in mura di mattoni ; ma la sua natura è in tavola e in ferro, o dove fusse cosa avessi a vernicare con vernice liquida."—Ib. c. 153.

† "Adunque togli la tua vernice liquida e lucida, e chiara la più che possi trovare."

‡ This Latinism is quite consistent with the genius of the Italian language, and, if the comma were placed after liquida, would give emphasis.

pears, by Tambroni, shows that he thus understood it. The passage would then read: " Take then your ' vernice' as liquid, clear, and light in colour as you can procure it." Cennini, however, proceeds to direct that the varnish should be applied with the hand or with a sponge, thus showing that the composition was thick in consistence. To say that it should be used in as liquid a state as it could be procured would therefore be a contradiction, as it might be of any degree of fluidity. But the ambiguity which Tambroni's punctuation occasions is entirely removed by a reference to the two MSS. of Cennini preserved in the Laurentian and Riccardian libraries in Florence. In the Laurentian MS. the passage is: "Adoncħ togli latua vernicie liquida bella, e chiara la piucħ possi trovare." In the Riccardian MS.: . . . " latua vernicie liquida. ꞇ lucida ecchiara,"&c. In both these examples, and especially in the last, the words " vernice liquida " cannot be separated.

It is therefore apparent that the expression " vernice liquida," in the passage referred to, is the ordinary term used by early writers, to designate the varnish for tempera pictures. It remains to inquire what was the nature of the composition so called. In order to answer this question clearly, and to avoid future digression, it will first be necessary to consider the subject with reference to a remoter period. The evidence respecting the nature of the more ancient varnishes is partly philological;

but the history of terms is, in this case, closely connected with that of technical processes, and, from the light which it affords, is here indispensable.

Eustathius, a writer of the twelfth century, in his commentary on Homer, states that the Greeks of his day called amber (ἤλεκτρον) Veronice (βερονίκη).* Salmasius, quoting from a Greek medical MS. of the same period, writes it Verenice (βερενίκη).† In the Lucca MS. (8th century) the word Veronica more than once occurs among the ingredients of varnishes, and it is remarkable that in the copies of the same recipes in the *Mappæ Clavicula* (12th century) the word is spelt, in the genitive, Verenicis and Vernicis. This is probably the earliest instance of the use of the Latinised word nearly in its modern form; the original nominative vernice being afterwards changed to vernix.

Veronice or Verenice, as a designation for amber, must have been common at an earlier period than the date of the Lucca MS., since it there occurs as a term in ordinary use. It is scarcely necessary to remark that the letter β was sounded v by the medieval Greeks, as it is by their present descendants. Even during the classic ages of Greece β represented φ in certain dialects. The name Berenice or Beronice, borne by more than one daughter of the Ptolemies, would be more cor-

* ἡ δὲ τῶν ἰδιωτῶν γλῶσσα βερονίκην λέγει τὸ ἤλεκτρον. (*Od.* δ.)

† Salmasius, Exercitationes de Homonymis Hyles Iatricæ, Traj. ad Rhen. 1689, c. 101.

rectly written Pherenice or Pheronice. * The literal coincidence of this name and its modifications with the Vernice of the middle ages, might almost warrant the supposition that amber, which by the best ancient authorities was considered a mineral †, may, at an early period, have been distinguished by the name of a constellation, the constellation of Berenice's (golden) hair. ‡ The comparison of golden tresses with amber was not uncommon with the ancients: Nero, who sometimes affected to be a poet, applied the epithet "succineus" to the hair of his empress Poppœa; in consequence of which, observes Pliny, amber-coloured hair became fashionable. § The emperor had been anticipated by Ovid ‖, perhaps by others.

* Literally "bringing victory;" the same materials formed the name Nicephorus. The alteration of φ to β was usual in the Macedonian dialect and its varieties, according to which Philippus was written Bilippus, &c.

† Theophrastus de Lapidibus, § 63.: compare the notes in Hill's translation.

‡ "Devotæ flavi verticis exuviæ."
 Catull. Coma Berenices, lin. 62.
The poem of Catullus is supposed to be a version of that of Callimachus, now lost, on the same subject. Foscolo, in the notes to his Italian translation (Milan, 1803, p. 119.), observes: " Dirò qui della testa bionda di Berenice; in Egitto dovea essere per la sua rarità di maggior merito che in ogni altro paese." Berenice II., the princess thus celebrated by the astronomer Conon, and by the contemporary poet Callimachus, died about 216, or according to others, 221, B. C.

§ L. xxxvii. c. 12.

‖ "Electro similes faciunt auroque capillos."
 Metam. lib. xv. lin. 316.

Whatever may have suggested the application of the name Bernice to amber, it is clear from the authorities quoted, that the word was so appropriated long before the revival of painting in Italy. At the same time, it does not appear that either the physicians or the painters of the middle ages had very accurate notions respecting the substance. The Oriental names, some of which were adopted into the ancient and modern languages of the West, indicate this ambiguity; while the ancient descriptions of the nature and origin of amber would often serve as well for very different substances. The materials with which it was confounded, and which gradually either served as substitutes for it or entirely superseded it, will require to be specially considered.

First, with regard to sandarac: this resin flows from the Thuja articulata (African arbor vitæ), a dwarf tree somewhat resembling the juniper, which abounds in Barbary on the sides of Mount Atlas *, and is also found in various parts of the East. The fluctuating significations of the word sandarac show how generally this resin was confounded with amber, which it resembles in appearance. In the best Persian lexicon (the *Borhâni Kâti*) " sandar " or " sandarah," is explained as " the name of a certain yellow gum resembling amber." † In Shak-

* Dictionnaire des Sciences naturelles, Paris, 1816–29, art. Thuya. Miller's Gardener's and Botanist's Dictionary, 1807, art. Thuja.

† For these and other references of the kind the author is ndebted to an eminent Oriental scholar.

spear's Hindoostanee dictionary, "sandaros" (Arabic and Persian) is " a resin supposed to be produced by the Juniperus communis, but now proved to exude from a species of Thuja." In the Bengali dictionary, amber is rendered by the word " chandarus." In the *Borhâni Kâti* again, " sandarus, the same as sandar," is said to be distinguished from amber by its smell when burnt. The smell is offensive; yet, from the outward resemblance of the resin to frankincense (" thus "), the tree which bears it has the name " thuia." The term " thy-eum" applied by an ancient authority to amber, and the mention of Numidia as the country where amber was found *, point, in like manner, to sandarac. Salmasius, in the treatise before quoted, remarks that the Arabian writers frequently confounded sandarac and amber, and instances Avicenna, who employs almost the same words to describe the qualities of both. For the rest, the Arabic word " ambar," whence our own is derived, appears to have been originally appropriated to ambergris †. The Arabic and Persian term for the real substance is " Karabe."

Next, as regards copal: in Shakspear's dictionary before quoted, copal is rendered " chandaras — a corruption from the Sanskrit." The Sanskrit compound " chanda-rasa " (literally moon-juice) ‡,

* Pliny, l. xxxvii. c. 11.

† " Leo Africanus balænam *hambara* dici scribit ab incolis Marochi et Fez."— *Salmasius, Exercit.* ib.

‡ Conrad Gessner de Rerum fossilium, &c. (p. 50.) observes :

compared with the Bengali word already given, may thus represent either copal or amber, while the mere sound still connects it with sandarac. The researches of a late French writer on varnishes tend to prove that the South-African copal is the finest in quality, and that the best samples, which sometimes reach Europe from India, are originally procured from Africa. * If he is correct, nothing is American, in the choicer specimens of this resin, but the name.

The difference between amber and Oriental (or African) copal, in the ancient receipts, is thus scarcely to be traced; and as both substances, employed in varnishes, have the same recommendations and nearly the same defects, the distinction is of little importance. Local facilities in obtaining one or the other may, however, be worthy of consideration. Thus, amber was always considered the *German* varnish; and, on the other hand, when the Byzantines refer to amber under its Oriental names, they may sometimes mean copal. There is a more palpable difference between sandarac and the other two substances; yet sandarac was, at an early period,

" Succinum quod Græci Electrum vocitant affinitatem quandam habere cum luna putant aliqui." He mentions the affinity, at least in name, of the " lac lunare " or " mondmilch," a species of agate found in the Alps.

* Tripier-Deveaux, Traité théorique et pratique sur l'Art de faire les Vernis, Paris, 1845, p. 40. See also Guibourt (Histoire abregée des Drogues simples, Paris, 1836, vol. ii. p. 526.) on the copal of Madagascar.

commonly substituted for amber. This practice throws considerable light on the ancient receipts for the preparation of varnishes. Those receipts often appear in two forms, and it will be shown that, in general, the one relates to sandarac, the other to amber (or copal) ; the first being an ordinary, the second a superior, varnish.

The test of amber — its attractive power after friction — to judge from some of its names, was as familiar to the ancients as to the moderns. Those names have a remarkable coincidence in meaning. The old Greek designation, Ἤλεκτρον, is supposed to be derived from ἕλκω, traho*, as amber draws or attracts small light objects, such as straws, &c. Pliny observes that it was called " Harpaga " (ἁρπάζω, rapio) for the same reason.† In some compound Sanskrit terms for amber the word straw is introduced, and is first in order, as "Trina-grahin," straw-seizing; "Trina-mani," straw-gem. The Persian equivalent " Kāh-rubā," straw-stealing, is the source of our Karabe. Buttman states that the word Rav or Raf, to seize, is appropriated to this substance in the North of Germany.‡ It remains to observe that the term Sandaracha, with the Greeks and Romans, meant

* Buttman, Mythologus, vol. ii. p. 362.

† . . . " et vocare harpaga, quia folia et paleas, vestiumque fimbrias rapiat."—L. xxxvii. c. 11. The term " tire-paille " is a familiar French synonyme of amber.

‡ Mythologus, ib.

a red pigment (in Dioscorides, red orpiment). In
the Persian dictionary before mentioned we read
" this word (sandarūs) also denotes a red colour,
probably from the resemblance of red to its own
hue;" that is, the colour of the resin, which
deepens with age. In the Westminster accounts
(13th and 14th centuries) the " vernisium ru-
beum," so often mentioned, is unquestionably
sandarac. The early medical writers distinguish
the resin from the pigment by calling the former
the sandarac of the Arabs, meaning the Arabian
physicians.

The greater facility of dissolving sandarac in
oil, and above all its cheapness as compared with
amber, rendered it fitter for ordinary use. It
became, perhaps even with the ancients, the com-
mon representative of the more costly substance ;
in the middle ages the word " vernix " was applied
to both, and, by degrees, to sandarac alone. In
this stage of the philological inquiry the more
modern dictionaries afford full information. They
refer to times when the original application was
lost, and when " vernix " was the equivalent for
sandarac. Pasini's Italian and Latin dictionary
translates vernix, sandaracha, with the common,
but absurd, derivation "quod *verno* tempore fluat."
Littleton's dictionary has the same meaning and
derivation. The Della Crusca gives " sandaracha "
as the Latin equivalent of " vernice," and " san-
daracha illinere " for " vernicare." The word

Verenice (βερενίκη), to use the words of Salmasius, degenerated to vernix, which was again applied to another substance; it was appropriated to the resin of the juniper (read Thuja), on account of the resemblance of that resin to amber.*

Accordingly, in the early Italian and other recipes for varnishes, the word "vernice" is a common synonyme for sandarac resin. Before this is understood, it is somewhat perplexing to find "vernice" among the ingredients for making a varnish. When Walpole triumphantly adduced the mandate of Henry III. respecting oil and varnish, it was not likely to occur to him that the word "vernix" meant a resin only; and that when dissolved in the oil, and not before, it formed a varnish in the modern sense of the word. It has been already shown that whenever the word "vernix" (sometimes written "vernisium" and "verniz") occurs in the English accounts, the quantity is given in weight, showing that it was a dry substance; the oil, in the same accounts, being always noted by measure.

When the "vernix" or dry sandarac was dissolved by heat in linseed oil, it was consistently called liquid vernix, and, by the Italians, "vernice liquida." As this brings us to Cennini, to

* "Ex quo βερενίκης vocabulo iidem barbari *vernicem* suum depravarunt, quod et pro alio genere gummi usurparunt; ita enim vocarunt gummi Juniperi ob similitudinem quam habet cum succino." — *Exercitat.* &c. c. 101.

the varnish of the tempera painters, and to Van Eyck, the statement will require to be confirmed by satisfactory evidence. Authorities are numerous, and a selection only can be made from them; it is to be remembered that the early writers put the juniper for the Thuja articulata.

Cardanus: " The juice which flows from the juniper is called vernix. — From dry vernix and linseed oil, liquid vernix is made : this is calculated to resist all effects of the atmosphere, and therefore is applied to pictures."*

Matthioli: "The juniper produces a resin similar to mastic, called (though improperly) sandarac. — This, when fresh, is light in colour and transparent, but, as it acquires age, it becomes red. — With this resin and linseed oil is prepared the liquid vernix which is used for giving lustre to pictures, and for varnishing iron. The dry vernix, that is, the resin of the juniper . . . " † then follow the medical uses.

* " Juniperi lachryma vernix vocatur. — E sicca vernice et lini oleo fit liquida vernix, ad omnes cœli impetus coercendos aptissima : unde picturis addi solet." — *Hieron. Cardani de Subtilitate,* &c. Basileæ, 1554, lib. viii.

† " Produce il ginepro la gomma simile al mastice e chiamasi questa gomma (ancora che male) sandaraca.—Questa, quando è fresca, è lucida bianca e trasparente, ma invecchiandosi rosseggia.—Fassi di questa e d' olio di seme di lino artificialmente la vernice liquida che s' adopera per far lustre le pitture e per inverniciare il ferro. La secca, cio è la gomma del ginepro conferisce," &c. — *Il Dioscoride dell' eccellente Dottor medico M. P. Andrea Matthioli,* Mantova, 1549, lib. i. c. 84.

Caneparius : "It is prepared from the sandarac of the Arabs (as the juniper resin is termed in laboratories) ; this is called dry vernix. From this and linseed oil is made the dark liquid vernix, so well adapted for giving lustre to pictures and statues ; it even adds splendour to iron and preserves it from rust." Elsewhere : "The sandarac of the Arabs is, then, a juice flowing from the juniper which hardens to a resin. This, while fresh, is white and transparent ; but, as it acquires age, it inclines to a red colour." *

Schröder : "Juniper : its resin is the sandarac of the Arabs ; dry vernix. Liquid vernix is an artificial preparation composed of this sandarac resin dissolved in linseed oil. The sandarac of the Greeks is orpiment.†

Castello : "Vernisium, the same as vernix ;

* "Componitur ex sandaracha Arabum, hæc est gummi juniperi officinis recepta voce, vernix dicitur arida, ex hac igitur, et oleo lini fit vernix liquida atra, quæ tantum præstat ad tabulas depictas illustrandas, atque imagines, cum etiam ferro nitorem inducat et a rubigine ipsum tueatur."

"Sandaracha Arabum igitur est lachryma emanans a junipero, et in gummi concrescit, quod dum recens est album, lucidum, atque transparens, cum veterascit autem ad rufum colorem inclinat." — *Petri Mariæ Caneparii de Atramentis,* Ven. 1619, Quinta Descript. c. 26.

† "Juniperus : gummi (Arab. sandaracha, vernix) truckener firniss. Vernix liquidus factitius est liquor ex gummi hoc i. e. Sandaracha in oleo lini soluta. Sandaracha Græcorum est auripigmentum." — *Pharmacopœia Medico-chymica,* &c., *auct. Joanne Schrödero,* Ulm. Suev. 1685, lib. iv. c. 179.

otherwise called sandarac or juniper resin, and thus dry vernix; also the fluid composition prepared from this resin, then called liquid vernix." *

The term " vernice" alone is frequently used by early Italian writers for "vernice liquida:" the context then shows that the dry resin is not intended. But whenever " gomma di vernice " occurs, it distinctly means dry sandarac resin. The application of the word " vernice " to varnishes generally was more gradual; indeed, it is necessary to bear in mind that, in most early treatises on painting, the wider application was figurative, the strict meaning being sometimes resumed. After the sixteenth century the general meaning connected with the word varnish prevailed, while the restricted application of the term, as a synonyme of sandarac, by degrees became obsolete. For the present it is essential to preserve the associations of an earlier period, and we proceed to consider the double receipts before noticed, relating to sandarac and amber.

In the *Secreti* of Timotheo Rossello the following examples occur : they are not quoted as the most perfect modes of preparing the varnishes, but as descriptions which throw light on obscurer formulæ of the kind.

* " Vernisium, idem quod vernix, Sandaracha alias vocatur, vel gummi Juniperinum et ita vernix siccus; vel liquor ex hoc gummi paratus estque vernix humidus." — *Bartholomæi Castelli Lexicon Medicum,* &c. Genevæ, 1746.

" To make Vernice liquida.—Take one lb. of sandarac resin and four lb. of linseed oil: place [the latter] on the fire to boil: take another vessel [for the resin], adding three oz. of oil, little by little: stir continually with a spatula, and let the oil continue to boil till the whole is transferred to [the vessel containing] the varnish *: keep up a good fire for the said varnish: and, in order to know when the mixture has boiled enough, place a little on a knife, and if it remain thick, and somewhat firm, the varnish is made. Then instantly remove it from the fire and strain through a wet cloth." †

"To make a superior Vernice liquida.—Take three lb. of linseed oil, one lb. of yellow amber, and six oz. of pulverised brick.‡ Make a furnace with two orifices below, each orifice having bellows adapted to it. The fire, which should be of charcoal, requires to be great. Let there be an opening above:

* This passage in the original is not very clear; but another receipt (p. 251.), from the Venetian MS., explains it.

† "A far Vernice liquida — Piglia lib. i. de goma de vernice, e lib. iiii. d' oglio de linosa, e poni al fuoco e fa bollire, e piglia un altro vaso e poni oz. iii. d' oglio a poco a poco, e sempre mescola con una spatula, e sempre farai bollire l' oglio insino che sarà tutto in vernice, e sempre farai fuoco bono alla detta vernice, e se vorrai sapere quando sarà cotta metti della detta vernice un poco sopra un cortello, e se rimanerà viscosa e un poco dura sarà cotta e subito leva detta vernice dal fuoco e cola in un canevaccio bagnato in acqua."— *Della Summa de' Secreti universali, &c. di Don Timotheo Rossello,* in Venetia, 1575, v.ii. p.127.

‡ The pulverised brick was used merely to assist the clarification of the varnish.

in this fit a glazed vessel which is to be luted to the opening so that the fire may not penetrate; for if it were to do so, the ingredients would presently be in a flame. Place your amber in the vessel with as much of the oil as will cover it: then blow with the bellows and make a great fire till the amber dissolves. As there is great danger of fire, have a wooden trencher ready, wrapped round with a wet cloth, and, if the varnish should catch fire, cover the vessel with the trencher. Meanwhile, boil, in another vessel, the remainder of the oil, making a moderate fire with charcoal, but still taking care that the flame does not ascend. Let this oil continue to boil till it be reduced one third. Then, when the amber is dissolved in the small quantity of oil first mixed with it, as above described, throw in the remaining oil which you have heated to ebullition, and mix together for the space of two misereres [about five minutes], so as to incorporate all well. Then remove the vessel from the fire, and throw in the pulverised brick above mentioned. Stir again a little; then cover the vessel; let the contents settle, and the varnish is made." *

* " A far Vernice liquida e gentile. — Piglia libre iii. d' oglio de linosa e lib. i. de ambro giallo, e oz. sei de polvere de quadrello; poi fa un fornelletto che habbia due bocche e ogni bocca habbia il suo mantesetto che soppia come apparerà disotto ed il fuoco sia de carboni e vole essere gran fuoco ed habbia un pertuso dove stia la pignatta che sia vitriata et ben turrata circa il buso del fornello acciò il fuoco non venghi a la pignatta

These receipts present, in juxta-position, the ordinary representative " Vernix," and the original Greek " Berenice." They appear together elsewhere. In the Byzantine MS. " santaloze " and " sandarac " (the latter being stated " not to be the best ") point to this difference. In the treatise of St. Audemar " vernix " in one receipt is opposed to " glassa " in a second.* In the Montpelier MS. the distinction is remarkable: the resinous substance in the first recipe is called " fernix vel grassa ; " in the second, " glassa vel fernix gna [Germana]." Grasa or grassa is the Spanish term for sandarac. Thus Pacheco, in his receipt for the ordinary

imperò che arde volontiera e metti il tuo ambro nella detta pignatta e l'una parte dell' oglio predetto e tanto solo che sia a pena coperto e così con quelli mantesi soffia e fali gran fuoco insino che l' ambro si disfa, e perchè è gran pericolo di fuoco habbi apparecchiato un tagliero el quale sia coperto di panno bagnato e quando vi saltasse il fuoco coprilo con quello tagliero. Ma prima cocerai l' oglio che ti avanza in una pignatta su quel medemo modo e falli lento fuoco de carboni, e guarda nō vada di sopra, e fa che scemi quasi il terzo, e questo serba, e come ho detto disfatto che sia l' ambro con quel poco d' oglio prima gettali dentro quest' altro oglio che hai fatto bollire, e mescola sempre per spatio di dui miserere per ben incorporarlo, dipoi piglialo levandolo dal fuoco e gettali dentro la polvere sopradetta del quadrello, e mescola bene alquanto, dipoi coprilo e lascialo alquanto riposare e sarà fatto."— Ib.

* " Oleum de lini semine et picem [pece Greca] uno pondere mixt. et eamdem mensuram de vernix pone in ollam et fac bullire bene," &c.

" Oleum lineum . . . mitte in ollam novam ac fac bullire super carbones vel claro igne paulatim, deinde munda glassam tuam quantum volueris, et pone in alteram ollam. et aluminis quasi mediam partem," &c.

varnish, says : " Add four oz. of pulverised grassa, which is the juniper resin, called by the Arabs sandarac."* Glessum (glas), according to Tacitus † and Pliny ‡, was the ancient German name for amber. It is by no means improbable, from the fluctuating forms of words meaning similar things, that " grassa " may have been a corruption from it §: but there can be no doubt that the two recipes in the Montpelier MS. refer to the same materials as the more accurate descriptions of Rossello. The often commented two directions of Theophilus are to be explained in the same manner; for if they were intended to be identical in meaning, as is commonly assumed, the name of the vernix need not have been varied. The first of the two receipts in Theophilus clearly relates to sandarac. In the second, the word " glassa " occurs ‖; and, as in Rossello, there are preparations for a greater fire, and more effectual precautions are taken to prevent accidents: the oil is heated sepa-

* " Echale quatro onzas de grassa molida en polvo (que es la goma del enebro que los Arabes llaman Sandaraca)," &c.—*Arte de Pintura su Antiguedad y Grandezas, por Fr. Pancheco*, Sevilla, 1649, p. 410.

† De Moribus Germanorum, c. xlv.

‡ L. xxxvii. c. 11.

§ In the Strassburg MS. common " glas " is synonymous with sandarac. " Zu dem ersten nim des gemeinen virnis glas ein phunt." " In the first place take of common vernix glas one pound." The inference is, that the superior kind of " glas," used as a varnish, was amber.

‖ Theophili Divers. Art. Schedula, l. i. c. 21.

rately ; the consistence of the varnish is tried, and the vessel is covered when the operation is completed ; all circumstances, no matter whether in themselves important or not, which correspond with the clearer directions of the Italian. That Theophilus should appear to identify " glassa " with the " gummi fornis " (fürniss) before mentioned by him, is to be explained by his employing the term in its general sense, and as the equivalent of " varnish." The example of Rossello is, in this point also, quite parallel, as he still calls his amber varnish " vernice liquida," adding only the epithet " gentile." The direction of Theophilus, not to suffer the varnish to boil, is incorrect, even as regards the sandarac, and is therefore of no weight. His recipe is otherwise objectionable; for, as Merimée observes, two parts of oil to one of resin would make much too thick a varnish for ordinary purposes.* It will be observed that Rossello's proportions, though still calculated to make a very thick composition, are better.

That the words " glassa " and " vernix " meant two distinct substances, is further apparent from the mode in which those words are used in the Paris copy of the manuscript of Eraclius. After speaking of linseed oil and other ingredients, the writer says : " Add vernix to them, and heat the composition on a charcoal fire ; but if you have no

* De la Peinture à l'Huile, Paris, 1830, p. 75.

vernix, take glassa," &c.* In the Strassburg MS.
the term " (common) glas " is applied to sandarac ;
and, in the instance now quoted, it would appear
that the two significations are interchanged,
" glassa " meaning the common substance, and
" vernix " (as originally) amber : Le Begue also
uses " glasse " for sandarac. The clue to this
labyrinth is easily supplied : *glessum* and *berenice*
were the Latin and Greek terms appropriated at an
early period to amber. The word berenice (vernix),
even before the thirteenth century, became the
usual designation for sandarac ; and the word gles-
sum (glas) was sometimes, though rarely, also used
to denote that substance. Where both terms ap-
pear together, they mean distinct things ; and the
context can alone show which of the two meanings
each conveys ; but in general *glas* means amber,
and *vernix* sandarac.

The formulæ of Rossello, the terms of which are
not to be mistaken, may be considered good repre-
sentatives of the earliest modes of preparing
sandarac and amber varnishes ; and, whether of
Byzantine or of German origin, they were proba-
bly derived, mediately or immediately, from the
same ancient source whence Theophilus, the author
of the Montpelier MS., and others had drawn their
information.

It does not appear that the amber varnish was

* " Vernix cum eis pones et super carbones calefacies ; si
autem vernix non habueris accipies glassam," &c.

used at an early period in England. The two resins mentioned in the Westminster accounts are sandarac and mastic, or red and white varnish. The two resins mentioned in a receipt for an oil varnish in the *Mappæ Clavicula*, headed " Collam Græcam facere," are sandarac and mastic. There is some ground for supposing that this MS. is of English origin: the circumstance of the English names of plants (whence colours were manufactured) being given, favours this view. The three materials for varnishes mentioned in the Strassburg MS. (the probable connexion of which with English practice has already been considered) are sandarac, mastic, and turpentine resin; the latter was sometimes called " glorie," from the gloss which it produced.* As this turpentine (in a concrete state) was also called white resin in later times †, it is not impossible that the term " vernisium album" in the English records may have comprehended it. From those accounts it appears that, in the 13th century, the red varnish (sandarac) was 3*d.* and 4*d.* the lb.; the white 10*d.* the lb. ‡; the

* It is so named in Boltzen's Illuminir-Buch and in the Mayerne MS. In the Strassburg MS. it is called " gloriat."

† See Dreme, Der Firniss- u. Kittmacher, oder Anleitung zu vortheilhafter Bereitung der besten Lack- u. Oel-Firnisse, ec. Brünn, 1821. The white resin was also called " encens blanc." — *Pomet, Histoire Générale des Drogues*, Paris, 1735, t. ii. p. 65.

‡ " Item in v. lb. rubei vernicii xv. d. In quinque libris de wernys xv. d. In ii. li. vernisii rubei vii. d. In i. lb. rubei

latter was no doubt mastic. In 1353 the red
varnish was 4*d*. the lb. ; at this time, Lonyn of
Bruges provided 6 lb. of white varnish, at 9*d*.
the lb.; while another dealer in such materials
furnished 136 lb. of white varnish at $4\frac{1}{2}d$. the lb.[*]
The altered price in the latter case might be ac-
counted for by the large quantity sold; but if, as
appears more probable, the substance was different,
it may have been concrete turpentine. The par-
tiality of the Northern artists for a glossy surface
would sufficiently explain its abundant use. Mastic
and " the oyle of a firre tree " are also mentioned
together in the *Proper Treatise* before quoted,
in which some early English methods are to be
traced.[†]

This concrete turpentine was sometimes added
to assist the liquefaction of the sandarac ; thus
prepared, the varnish, besides being glossy, was
less dark in colour, being exposed for a shorter

vernicii IIII. d. In una li. vernisii albi x. d. In I. quarterone
albi vernisii II. d. ob." (1294).

[*] " Johanni Lightgrave pro CXXXVI. lb. albi verniz similiter
emptis pro pictura ejusdem capelle precium lb. IIII. d. ob. LI. s.
Eidem pro XVIII. lb. de verniz rubeo precium lb. IIII. d. VI. s.
Lonyn de Bruges pro VI. lb. di. de verniz blank emptis pro pic-
tura dicte capelle precium lb. IX. d. IIII. s."

[†] An English manuscript in the British Museum (Sloane
MSS. 2584.), apparently written in the first half of the fourteenth
century, contains the following receipt. " Take of ꝑbentyne
I. lb., of gume arabyk [here, as in Theophilus, c. 21., put for
sandarac] I. lb., of frankensense I. lb., and melte hē togeders and
put ꝑerto oyle of lynsed also mochel as it nedes," &c.

time to the action of the fire. Accordingly, some receipts for "vernice liquida" include this ingredient, called "pece Greca" and "pegola." The slowness in drying of the unctuous semi-liquid turpentine in its natural state, rendered a previous treatment necessary to fit it for immixture with varnishes. The old mode of preparing the substance, with this view, is given in the Byzantine MS. as follows. "Take fir resin in the quantity required; place it in a copper vessel (which it should only half fill), and set it on the fire. Take care that it does not run over; if you see it rise, remove it from the fire, and blow on it with a reed, or place the vessel in another that is full of cold water; this instantly stops the tumefaction. Replace it on the fire, and repeat the operation several times, till the resin ceases to swell. Thus pegola is prepared. Remove it from the fire, and pour it into a copper vessel full of water, ready for the purpose. Afterwards gather up the pegola and preserve it." *

* "Comment il faut faire la Pégoula.—Prenez de la résine de sapin, autant d'ocques que vous voudrez ; mettez-la dans un vase de cuivre d'une capacité double du poids de la résine, et placez-la sur le feu pour la faire cuire. Ayez soin de l'empêcher de déborder ; si vous la voyez monter, retirez-la du feu et soufflez dessus avec un chalumeau, ou placez la chaudière dans un autre vase rempli d'eau froide, ce qui arrête sur-le-champ le débordement. Remettez-la ensuite sur le feu, et recommencez ainsi à plusieurs reprises, jusqu'à ce que la résine cesse de déborder. C'est ainsi que se prépare la pégoula. Retirez-la du feu et versez-la dans un vase de cuivre plein d'eau, que vous aurez préparé

The most effectual contrivances were no doubt gradually employed to reduce this ingredient to the fit state for mixing with varnishes; the following process, though modern, may be added as one of the best examples of the kind : —

" Place the resin in a glazed vessel which it should only half fill; add a perfectly pure and filtered solution of potass (one part potass in four of water), and boil all together for an hour on a charcoal fire. Then, removing the vessel from the fire, pour in cold water, so as to cause the turpentine to consolidate itself at the bottom of the vessel. The alkaline solution is then to be poured off, and more cold water is to be added to the turpentine. Boil again for an hour. Remove the vessel from the fire, and, by the addition of cold water, reduce the turpentine to a solid state as before. Again pour off the water and add fresh. The operation should be repeated four or five times. The resin is at last to be carefully decanted, free from all sediment, into

pour cela. Recueillez ensuite la pégoula et conservez-la."— *Manuel,* &c. p. 40.

The mode of preparing the varnish composed of this concrete turpentine and inspissated oil is thus described. " Take of *péséri* [a drying oil] which has been baked in the sun four parts, of pegola three parts. Put them in a vessel on the fire to melt them together. Strain this varnish, and, in using it, expose the picture to the sun. Take care to let the first coat be as thin as possible, to avoid bubbles. If the mixture be too thick, so as to be difficult to spread, add naptha or raw péséri. If you have a good stock of mastic, take two parts of pegola and one of mastic [instead of three of pegola]. This mixture will give you a very good brilliant varnish."—Ib.

another vessel. In this mode it is as pure as possible; it has parted with its oleaginous or unctuous elements, and has acquired perfect whiteness." * The resin is said to be permanently colourless in varnishes only when it is prepared in this way.

The following recipes from the Venetian MS. are examples of " vernice liquida" with and without the concrete turpentine. " To make Painters' Varnish.—Take of linseed oil four oz., boil it in a copper vessel, removing the scum as long as it forms any; then take an oz. and half of sandarac in grain, and put it in another vessel, with a little of the aforesaid boiled oil in the bottom. Let it boil, and continue to add the oil, little by little, till you have poured in all. Let the ingredients still boil, for the more they boil the better [the varnish will be]; and take care that the fire does not reach the oil. This is a good varnish for varnishing whatever you please." † In another receipt, pulverised sandarac is added by degrees to the boiled oil; concrete turpentine (pece Greca), in the proportion of two thirds to the quantity of oil, is also

* Dreme, Der Firniss- und Kittmacher, &c. p. 56.

† "A fare la Vernixe de i Depinturi.—To ollio de semte de lino oz. 4 e mitelo a choxē ī una pignata de ramo e schiumalo bn̄ tanto che l nō geti piu schiuma e po toi oz. 1 ÷ de vernixe ī grana e mitelo ī una altra pignata e mitege uno puocho del sovra dito olio choto ī lo fondo e lassala coxere e chusi va azunzendo a pocho a pocho entro p fina tanto che tugai meso dentro el dito olio e lassalo anchora buire e questo piu buie e miore è guardati che el fogo noge intra dentro. Quest' è fina v̄nixe da īv̄ñigr̄e ço che tu voi."

mentioned. A third receipt in the same MS. likewise
includes the turpentine. "To make 'Vernice liquida.
—Take of sandarac not pulverised one lb., linseed oil
three lb., concrete turpentine three lb.; this will
be good for varnishing cross-bows." * The gloss
which the turpentine imparted was especially de-
sired for implements and furniture; and, in the
North, not less so for pictures.

The longer such a composition is suffered to boil,
the thicker, and, in general, the more drying, the
varnish will be; but it acquires, at the same time,
a very dark colour. This the earlier tempera
painters do not seem to have considered an objec-
tion. The old Byzantine varnishes are extremely
dark, and may represent the practice of still re-
moter times, when the word " atramentum,"
applied to such compositions, was understood
literally.† The pale Italian tempera pictures of
the fourteenth century may have been improved
by such brown glazings, and it is not impossible
that the lighter style of colouring introduced by
Giotto may have been intended by him to coun-
teract the effects of this varnish, the appearance of

* "A fare Vernixe liquida.—To vernixe salda lb. 1., olio de se-
mente de lino lb. 3., pece grega lb. 3. ; e sarà bona da ivernicare
balestre."

† Mancini, the author of a MS. history of painting (to which
Lanzi refers), written in the first half of the seventeenth cen-
tury, speaking of the Byzantine pictures, observes that the
varnish upon them was so dark (partly, no doubt, from the effects
of time) as to render the figures almost invisible.

which in the Greek pictures he could not fail to
observe. Another peculiarity in the works of the
painters of the time referred to, particularly those
of the Florentine and Sienese schools, is the greenish
tone of their colouring in the flesh; produced by
the mode in which they often prepared their works,
viz. by a green under-painting. The appearance
was neutralised by the red sandarac varnish, and
pictures executed in the manner described must
have looked better before it was removed. The
later tempera painters ventured to think a paler
varnish desirable. Cennini (c. 155.) directs that it
should be procured as light in colour as possible,
but the expression was relative, as a sandarac oil
varnish can never be very light.

Such then was "vernice liquida," common and
"gentile;" with and without concrete turpentine.
In its most ancient form, it professed to be com-
posed of amber and linseed oil; but it has been
seen that there never was a time when amber and
sandarac, as ingredients of varnishes, were very
clearly distinguished. The ordinary "vernice
liquida" was composed of three parts linseed oil to
one of sandarac. It was sold in Cennini's time
ready prepared; at that period it was still the cus-
tomary varnish for tempera pictures, and served
for various other purposes. When the white resin,
or concrete turpentine, was added, the proportions of
the oil and sandarac were not therefore altered. It
appears that this last varnish was used in Venice,

but not at an early period in Florence ; it was also common in the North: this may be explained by the greater facility with which the material, (turpentine) was procured in the Alps and in the neighbourhood of the Rhine.* The addition of mastic in "vernice liquida" was rare ; it was occasionally used as a substitute for the sandarac, but not often as an ingredient with it.

The traditional estimation in which the sandarac varnish was held by the medieval painters, next leads us to ask, What were its practical recommendations ? It will be remembered that the question can relate only to fixed-oil varnishes; even the Italians, not to speak of the painters of the North, were scarcely acquainted with essential-oil varnishes, as applicable to pictures, till the close of the fifteenth or commencement of the sixteenth century.† The ordinary sandarac varnish, or "vernice liquida," was thick in consistence, dark in colour, and slow in drying. Sandarac, dissolved in spike oil, or in alcohol, is not durable ; but boiled with a fixed oil it is extremely so. All compositions of the kind are, however, affected by the air sooner or later; and

* The "poix blanche de Bourgogne," as prepared at Strassburg, was long in repute. — *Pomet, Histoire Générale des Drogues,* t. ii. p. 67.

† Varnishes composed of resins and essential oils are not to be confounded with the essential oils alone, which appear to have been used for various purposes at a very early period, and, in the improved oil painting, may have been employed as diluents.

most tempera pictures of the fourteenth and fif-
teenth centuries now look as if they had never been
varnished. In Mr. Warner Ottley's interesting col-
lection of early Florentine pictures, the remains of
the red " vernice liquida " are to be seen on a few
only.* The process of the decay which takes place
in the thick oleo-resinous coating is plainly to be
traced. The varnish cracks, in general without af-
fecting the tempera underneath; a proof that the
former had been added when the work was quite
dry and firm †: the spaces between the cracks in-
crease, till, by degrees, the resinous layer is reduced
to islands. In some tempera pictures large spaces
may be observed to be quite free from the brown
varnish, while it remains in detached spots on other
parts. A picture in such a state is generally freed
by the cleaner from the remaining crust (being then
generally re-varnished with an essential-oil var-
nish); but the vestiges of the older coating, if left
to pulverise, would in time disappear, the painting
itself often remaining in a solid and uninjured state.
The amber and copal varnishes, when made with-
out care, are also extremely dark in colour; if unas-
sisted by siccative ingredients, they dry even more

* These pictures were collected by the late William Young
Ottley towards the close of the last century, and are interesting
even in a technical point of view, from the circumstance of
their having never been retouched.

† Cennini (c. 155.) recommends that, if possible, the varnish
should not be applied to (tempera) pictures till some years after
they are painted; at all events, not till after one year.

slowly than the ordinary "vernix" or sandarac, but they are much more durable : hence it may be concluded that brown varnishes of great age, if entire, were composed of one or other of those substances. The ancient varnishes had thus nothing but their durability to recommend them. Their great defects were, the darkness of their colour, and their slowness in drying.

We now return to Vasari and Van Eyck. The varnish which required the sun's heat to dry it, so that the panel split, may be safely pronounced to have been the customary sandarac oil varnish, made no doubt with care, but still defective.* When Van Eyck undertook to prepare a varnish which was to dry in the shade, his first step, according to the narrative, was to ascertain whether the oil which was commonly used was really the most drying. His experiments confirmed the received opinion ; for, although he pronounced both for linseed and nut oil, it does not appear that either was preferred

* Baldinucci (apparently following Pacheco, *Arte de Pintura*, p. 370.) states that before the accident of the splitting of the panel, Van Eyck had improved the varnish for tempera pictures, which is by no means improbable. The historian, however, adds that the varnish was still very slow in drying : "era difficile e pericolosa a seccarsi." (*Notizie de' Professori*, &c. vol. v. p. 94.) These and similar statements may be considered gratuitous, and as inferences only from the main facts recorded by Vasari. They are however important, in as much as they represent the opinions of artists and writers on art at a time when the traditions of an earlier practice were not entirely forgotten.

to the other.* " These, then," says the biographer, " boiled with other ingredients of his, produced the varnish which he, nay, which all the painters of the world, had long desired."

The object so " long desired " was, above all, to make the varnish drying, and at the same time as colourless as possible. There was the greater reason for endeavouring to secure the latter quality, because the picture was no longer to be placed in the sun, and the bleaching action of strong light was now not to be reckoned on. In later times, as will be shown, pictures were again placed in the sun, at intervals, in order to remove yellowness, and to prepare them for varnishing; even panels were, with due precaution, so exposed, and, if the picture happened to be executed on cloth, the practice was quite safe. But, at the period and under the circumstances in question, it was an especial object to avoid so exposing the picture, on account of the accident that had occurred. Cennini (c. 155.) desired precisely what Van Eyck desired : viz. a varnish that would dry in the shade. He knew that boiling it long would render it more drying, but at the same time inconveniently dark

* It has been sometimes assumed that Van Eyck was the first to employ nut oil : this, as the facts before adduced prove, is a mistaken notion. He may, at most, have restored it to favour. His having occasionally used it shows that lightness of colour in a vehicle was an object with him. He may afterwards have found that this oil yellows in time nearly as much as linseed oil.

in colour. The general nature of Van Eyck's varnish is, therefore, explained by his success; it was drying, without being dark.

Among the "other ingredients" there can thus scarcely be a doubt that a dryer was used; for by this means the primary object was attained, without the long boiling which Cennini thought essential. For the rest, the actual state of Van Eyck's pictures becomes an important part of the evidence to be considered. From the appearance of those works competent judges have concluded that a very firm resin was used; and hence it appears probable that the enterprising artist may have gradually perfected the methods of dissolving amber or copal in oil; the improvement consisting in the lighter colour of the solution. The early traditions of the neighbouring schools, which immediately affect this question, will be examined hereafter.

It is to be remembered, that up to a certain stage of his experiments Van Eyck had aimed only at preparing a better varnish for tempera pictures; and the composition, according to custom, was no doubt still thick in consistence. The next step was to mix this varnish with the colours. It is in the description of this process that the words employed by Vasari are ambiguous; as if contrived to suit, on the one hand, the true account of the Flemish method, which he had received; and, on the other, the altered practice of his own school, and the views of those who imagined

that Van Eyck had literally invented the drying oils and oil painting. The biographer says : " Having tried many things, both pure and mixed together, he (Van Eyck) at last found that linseed oil and nut oil, among the many which he had tested, were more drying than all the rest. These, therefore, boiled with other mixtures of his, made him the varnish &c. . . . After having made trial of many other things, he saw that the immixture of the colours with these kinds of oils gave them a very firm consistence (tempera), which when dry was not only proof against water, but lit up the colour so powerfully that it gave a gloss of itself without varnish." *

The expression, " these kinds of oils," strictly refers to the oils boiled with other mixtures or ingredients; but it may also refer to the two " kinds of oils " before mentioned, unmixed with resins. The latter sense would favour the opinions of those who believed that Van Eyck was the first to mix colours with oil. But the sense intended by Vasari (not to lay any undue stress on his syntax) can be best arrived at by ascertaining what he could *not* mean. He speaks of " vernice liquida" as having been employed by Italian painters who sought to remedy the defects of tempera before the Flemish method of oil painting was practised in Italy. As a painter he must have known what other writers of his time, such as Cardanus and Matthioli, knew,

* See the original passage quoted p. 204.

viz. that "vernice liquida" was partly composed
of linseed oil, and that it was the ancient and
customary varnish for tempera pictures. In the
life of Agnolo Gaddi, he says that Cennini taught
the application of oil colours for various purposes,
"but not for figures." It is, therefore, impossible
that Vasari, knowing what he did, could intend to
state either that Van Eyck had invented linseed
oil, or that he was the first to mix oil with colours.

What the biographer really meant is apparent
from the context. He proceeds to state that the
colours mixed with Van Eyck's vehicle were proof
against water. This cannot be said of all colours
mixed with unprepared oil, as every painter knows;
examples of pigments applied with oil, but which
may be easily removed, when dry, by water, are
given by Leonardo da Vinci *, and by a Spanish
writer. † Vasari states further, that the immixture
of the colours with the medium used by Van Eyck
alone sufficed to give them a gloss, so that they
required no varnish. This, too, cannot be said of

* " Il verde fatto dal rame, ancorchè tal colore sia messo a
olio, . . . se egli sarà lavato con una spugna bagnata di sem-
plice acqua comune, si leverà dalla sua tavola, dove è dipinto,
e massimamente se il tempo sarà umido : e questo nasce perchè
tal verderame è fatto per forza di sale, il qual sale con facilità
si risolve ne' tempi piovosi, e massimamente essendo bagnato e
lavato con la predetta spugna."—*Trattato*, Roma, 1817, p. 124.

† " Si se lava un quadro despues de seis años, se ha de ir á
pasear la laca [el carmin]."—*Palomino, El Museo Pictorico*, &c.,
en Madrid, 1715-24, l. v. c. 4.

mere oils, unless they are thickened to a state which
would render them unfit for precision and sharp-
ness of execution. It may here be observed, that
if the word " tempera," as used in the above passage
by Vasari, is to be taken in the sense of "medium"
(which however is not assumed), the expression,
"gave them a very strong tempera," is most applic-
able to an oleo-resinous vehicle. Cennini observes
that " vernice liquida," mixed with colours, "is the
strongest tempera there is." * Again, Baldinucci,
who, as an Italian and a writer on art, may be
considered a competent judge of Vasari's language,
and who, as a biographer of Flemish as well as
other painters, was likely to consult his Flemish
contemporaries on all technical points relating to
their school, paraphrases the passage in question as
follows. " He [Van Eyck] tried and retried many
oils, resins, and other natural and artificial things;
and at last clearly ascertained that linseed oil and
nut oil dried more readily than any other [oils].
With these he boiled other substances till he in·
vented this beautiful and useful method, resisting
water and every shock, which renders the colours
more lively," &c.† Baldinucci thus seems to have

* . . . " vernice liquida, la quale è più forte tempera che sia."
— *Trattato*, c. 161.

† " Provò e riprovò molti olj, rage, et altre naturali e artificiali
cose : e finalmente venne in chiara cognizione che l' olio del lino
e quello delle noci eran quelli che più d' ogni altra cosa da per
se stessi seccavano. Con essi faceva bollire altre materie, finchè
venne a ritrovare questo bello e util modo resistente all' acqua

understood that the drying varnish, not mere oil, was mixed with the colours. A reference to certain technical considerations will perhaps remove all further difficulty on this point. It is to be remarked, that most colours require to be first ground in oils alone (without resinous ingredients), the oleo-resinous varnish being more conveniently added to each tint afterwards. This may afford a satisfactory defence and explanation both of Vasari's words and meaning; since his expression, " the

e a ogni colpo, che rende i colori assai più vivi," &c. — *Notizie*, vol. v. p. 95.

Having rested on Vasari's statement as the earliest, and, indeed, the only, account of Van Eyck's method (for all later descriptions are borrowed from that account), it has been considered essential to adhere to the biographer's words, and endeavour to interpret them correctly. But it may now be added, that the appearance of Van Eyck's pictures led a modern investigator to the same conclusion which has been arrived at in the explanation of the above passage. Merimée, in his treatise *De la Peinture à l'Huile* (p. 7.), observes, speaking of Van Eyck: "L'objet de ses recherches n'eût été qu'imparfaitement rempli, si les couleurs, préparées comme les nôtres, également susceptibles de s'emboire, eussent exigé l'application ultérieure d'un vernis pour en faire ressortir la transparence et l'éclat. Quelque probable que cette supposition paraisse, ce n'est pas sur une pareille base que mon opinion pouvait s'établir : elle est le résultat d'un examen approfondi des anciennes peintures à l'huile. Cet examen, entrepris pour connaître les procédés primitifs, m'a démontré que, dans les tableaux de Van Eyck et des peintres qui suivirent sa méthode, les couleurs n'ont pas été délayées simplement avec une huile plus ou moins siccative ; mais qu'on y mêlait des vernis auxquels on doit attribuer l'étonnante conservation de plusieurs des plus anciennes peintures dont l'éclat surpasse celui de la plupart de celles du siècle dernier."

immixture of the colours with these kinds of oils," embraces both conditions. The method here alluded to will be further explained by some examples of early German or Flemish processes in the next chapter.

The varnish of Van Eyck was, therefore, oleo-resinous; and its immixture with the colours supposes that it was previously rendered nearly colourless. Still, this result, by whatever means effected, may not have been attained at once; the first inventor, Hubert, may have been content with a darker medium, and it has been observed (without reference to this question) that his pictures and those of his scholars are, not unfrequently, really browner in tone than those of John Van Eyck. * The improvement, indeed, is likely to have been gradual in all respects, and Vasari was quite safe in asserting that it was so. For the same reason, the extent to which tempera was employed in the first experiments may have been far greater than in the later works of these painters. The thickness of the vehicle, in its less perfect state, rendered it fit only for flat glazing tints: till that defect was remedied (and it must have been remedied early) pictures executed in the new process could have been little more than tempera preparations, tinted with transparent varnish colours. This method happens to be exem-

* Passavant, Kunst-Blatt, 1833, No. 82. Ib. 1841, No. 5.

plified in a picture before mentioned, by King
René of Anjou, which is now preserved at Ville-
neuve, near Avignon. The imperfect execution, in
this instance, is partly to be explained by the pecu-
liar habits of the royal artist, and his predilection
for missal-painting and illuminating; for, at the
period when he may have corresponded with John
Van Eyck, that painter had attained the zenith of
his practice. But the habits of an individual here
represent those of a period; the adoption of the
oleo-resinous mode of painting by one who com-
monly practised tempera exemplifies the transition
which the first efforts of Hubert Van Eyck must
have exhibited. In the further consideration of
the subject it will be shown that the assumed origin
of the Flemish system of oil painting affords a
satisfactory explanation even of some peculiar me-
thods of the school.

It is, indeed, already apparent that there is nothing
in Vasari's account of Van Eyck's process which is at
variance with the habits of the time and country
where that process was perfected: on the contrary,
the reasons before given for placing faith in the bio-
grapher's statement have rather been confirmed by
the examination of the statement itself. The oc-
casional ambiguities in Vasari's language, and his
errors in dates, leave the main facts unimpaired.
That he was not ignorant of the extent to which
oil painting had been practised before the time
of the Van Eycks is certain; but, as the *art* of

painting in oil, properly so called, really began with them, he may be excused for omitting any notice of earlier and far inferior attempts.

Assuming, then, his account to be generally correct, and viewing it in connexion with the technical details that have been traced, not forgetting the actual appearance of the Flemish artists' works, it may be concluded that Van Eyck's vehicle was composed either of linseed or nut oil, and resinous ingredients of a durable kind; that it was drying; that, being intended to be mixed with the colours, it was essential that it should be, itself, nearly colourless; and, lastly, that it was of a consistence (though no doubt varied in this respect as occasion required) which allowed of the most delicate execution. Thus much is to be deduced from the evidence hitherto examined. The nature of the resinous ingredient, of the dryer, and of the diluent which may have been used, together with the mode of preparing and purifying the oil, will be considered in the next chapters.

It may now be expected that some opinion should be expressed as to Van Eyck's claims to the fame of an inventor. With former writers on the origin of oil painting this has been the favourite question *:

* Those who have set out with the impression that Van Eyck discovered something, and that the "secret" is now lost, have each thought it necessary to advance some hypothesis ; and various absurd conjectures have been the result. Of the writers whose conclusions have been based on facts and the careful examination

it is here comparatively unimportant. The techni-
cal improvements which Van Eyck introduced were
unquestionably great; but the mere materials em-
ployed by him may have differed little, if at all,
from those which had been long familiar. The
application of oil painting to figures and such other
objects as (with rare exceptions) had before been
executed only in tempera, was a consequence of
the improvement in the vehicle. Still, if we ask
in what the chief novelty of his practice consisted,
we shall at once recognise it in an amount of
general excellence before unknown. At all times,
from Van Eyck's day to the present, whenever
nature has been surprisingly well imitated in pic-
tures, the first and last question with the ignorant
has been — What materials did the artist use ? The
superior mechanical secret is always supposed to be
in the hands of the greatest genius, and an early
example of sudden perfection in art, like the fame
of the heroes of antiquity, was likely to monopolise
and represent the claims of many. It is apparent
that much has been attributed to John Van Eyck
which was really the invention of Hubert; and
both may have been indebted to earlier painters for
the elements of their improved process. It would
be useless now to attempt to divide these claims;
and, although some important discoveries of the

of pictures, Merimée may be considered the most rational. His
treatise, already quoted, was translated into English by W. B.
Sarsfield Taylor, 1839.

elder brother may be ascribed to the younger, it may be safely concluded that much was also due to the investigations and intelligence of the latter. The works of John Van Eyck show that he was endowed with an extraordinary capacity for *seeing nature;* thus gifted, and aided by the example and instructions of Hubert, a world was opened to him, which his predecessors had not attempted to represent. The same mind which was capable of receiving such impressions was also likely to devise suitable means to embody them, and to extend the language of imitation. That the most scrupulous operations of the laboratory should be carried on together with the most devoted practice of art, is quite consistent with the habits of the early painters; but with Van Eyck there was a controlling judgment which kept the end steadily in view, and which gave utmost efficacy to well chosen materials by a process which, in every stage, was calculated for brilliancy of effect and durability. This process will be described and exemplified where facts or documents afford the materials for so doing. The traditions respecting the oleo-resinous vehicles used at an early period in Germany and Flanders will require to be first examined.

ADDITIONAL NOTE (see p. 231.).

SOME medical writers quoted by Salmasius (*Exercitat. Plinianæ,* c. lii.) speak of a kind of red nitre called βερνικάριον. He supposes that this substance received its name from the

colour of amber (βερενίκη), as the common amber varnish
had a red hue ; and refuses to admit the conjecture of those who
derive the name from the Egyptian or Ethiopian locality, the
city Berenice, where the nitre may have abounded, or where
it may have been chiefly imported. " Ab ea beronice electro
genus nitri dictum est βερνικάριον, quod esset simile fulvo
succino. Neophytus : βερνικάριον, τὸ πυῤῥὸν νίτρον. Nicomedes :
βερνικάριον, νίτρον ἐρυθρὸν, οἱ δὲ ἤλεκτρον, οἱ δὲ βερονίκην.
Hujus nitri mentio apud Myrepsium, quod perperam ab urbe
Æthiopiæ Berenice dictum autumat Fuchsius. Immo ab
electri colore, ut ne mireris et vernicem inde nominatum."

The great critic does not seem to have been aware that Galen
twice uses the word βερενίκιον as a synonyme for a species of nitre
(*De Methodo medendi*, lib. viii. c. 4. ; *De Composit. Medi-
camentor. per Genera*, lib. iii. c. 11.). If, therefore, the term was
so appropriated from the resemblance of the colour of the said
nitre to amber, it would follow that the word βερενίκη, as a
synonyme for the latter, must have been in use before Galen's
time. The term appears, however, in no writer so ancient.
The probability, therefore, is, that the nitre was named from
the place where it was found.

The date of the word βερενίκη, as a designation for amber,
has not yet been traced beyond the eighth century ; though its
origin is probably much earlier. The supposition (see p. 231.)
that it may have had reference to Berenice's golden hair receives
some confirmation from an opinion expressed by H. Stephanus
(*Thesaurus*, in voc.). In giving two words from Hesychius,
—βερονικίδες, certain sandals worn by women, and βερονίκιον,
a kind of herb,—he observes of the first, " procul dubio a
Beronice regina, cujus πλόκαμον quoque dicit [Hesychius]
inter astra relatum fuisse ; " and of the second, " a Beronice
regina denominatum fuisse verisimile est."

It should be observed that the modern Greek writer Agapius,
quoted by Ducange with reference to the word βερενίκη (as
a synonyme for sandarac), cannot be considered an authority
of weight as regards the early use of the term, since he lived
in the seventeenth century. See Fabricius, Bibl. Græc. Hamb.
1802, vol. viii. p. 24.

CHAP. IX.

THE use of resinous solutions, combined in various proportions with oil, as a medium or *vehicle* for the colours, was an early technical characteristic of the Northern schools, and merits attention here accordingly. An account of the principal materials which have been so employed, from the commencement of the fifteenth century, would be manifestly incomplete without a description of the methods adopted at different periods for purifying and preparing the oil, the chief ingredient in such compositions. Those methods will, therefore, require to be specially considered; but it will be more consistent with the order hitherto followed to begin by examining the nature of the resinous substances which were in use among the early Flemish painters; the modes of purifying the oils having been common both to the Northern and Italian schools.

In the preceding chapter it has been shown that the varnishes which were first employed were far from being light in colour. The early painters, however attentive to use a colourless oil when it was to be mixed with pigments, were by no means

solicitous that the varnish applied to tempera pic-
tures should be equally light. In preferring a
browner hue for the oleo-resinous compound which
they spread over their works, they may not only
have been influenced by the traditional practice of
the Byzantines, but their researches into the ac-
counts of ancient painting may have led them to
conclude that the varnish of the best artists of
Greece was of a similar description.* The ordi-
nary composition of sandarac and linseed oil, as
already stated, inclined to a red colour; and the
medieval painters were so accustomed to this
appearance in varnishes, and considered it so in-
dispensable, that they even supplied the tint when
it did not exist. Thus Cardanus observes that
when white of eggs was used as a varnish, it was
customary to tinge it with red lead.†

This taste had already declined even in Cennini's
time, before the introduction of the Flemish system
of oil painting into Italy ‡; and, as soon as a var-
nish for tempera pictures began to be used as a
vehicle for pigments, the same reasons which had

* Pliny, l. xxxv. c. 36.

† ... "ovi albo ac sandice factitio...utebantur."— *De Sub-
tilitate,* Basiliæ, 1554, p. 271. That Cardanus understood
"sandix" to mean red lead is apparent from the following
passage in the same work: " E cerussa sandix fit coloris ru-
bicundi venustissimi."—Ib. p. 172.

‡ " Adunque togli la tua vernice . . . chiara la più che possi
trovare." — *Tratt.* c. 155.

recommended colourless oils for such a purpose
dictated a corresponding change in the nature of
the varnish, which was now required to be as light
as possible, so as not to alter the tints with which
it was mixed. In order to trace this change, it will
be necessary to remember the habits of the tem-
pera painters during the fourteenth century.

A tempera picture, when it had been kept long
enough after its completion to acquire due hard-
ness of surface, received a brown-red coating of
thick "vernice liquida," which was spread with the
hand or with a sponge; the painting being exposed
to the sun during, or immediately after, the opera-
tion, till the varnish so applied was dry. The
paleness or freshness of the tempera may have
been sometimes calculated for this brown glaz-
ing (for such it was in effect), and when this
was the case, the picture was, strictly speaking,
unfinished without its varnish. It is, therefore,
quite conceivable that a painter, averse to mere
mechanical operations, would, in this final process,
still have an eye to the harmony of his work, and,
seeing that the tint of his varnish was more or less
adapted to display the hues over which it was
spread, would vary that tint, so as to heighten the
effect of the picture. The practice of tinging
varnishes was not even new, as the example given
by Cardanus proves.* The next step to this would

* As the varnish for figures was reddened, so the varnish

be to treat the tempera picture still more as a preparation, and to calculate still further on the varnish, by modifying and adapting its colour to a greater extent. A work so completed must have nearly approached the appearance of an oil picture. This was perhaps the moment when the new method opened itself to the mind of Hubert Van Eyck; and, making allowance for the inexpertness of a far inferior painter, this is the stage of the art which King René's picture at Villeneuve exhibits. The next change necessarily consisted in using opaque as well as transparent colours; the former being applied over the light, the latter over the darker, portions of the picture; while the work in tempera was now reduced to a light chiaroscuro preparation. The ultimate modifications of this practice, as exemplified in some paintings by John

spread over white metals to imitate gold, or sometimes even over gilding itself, was yellow. It is remarkable that this gold lacker, perhaps the most ancient of the tinted varnishes, should also have remained longest in use, not for its original purpose only, but to give richness to certain colours with which it was mixed. The English treatises of the seventeenth century may generally be considered to represent the Dutch or Flemish practice of that period. In *The Art of Painting in Oyl*, published in 1687 under the name of Smith, we find the following passage. "If you steep *Ornoto* (annotto) in clear well sunned linseed oyl, or oyl of wallnuts, it will tinge the oyl of a delicate golden colour; which oyl so tinged exceeds all others for the laying on of vermilion, red lead, orpiment and masticot; to all which colours it gives an excellent lustre." A less fugitive dye may be supposed to have been substituted for annotto in important operations.

Van Eyck and his followers, will be considered in another chapter.

It was now that the hue of the original varnish became an objection, for, as a medium, it required to be itself colourless: but, although a considerable improvement was possible in this respect, perfection was unattainable, and the difficulty was only to be met by adapting the methods of the art to the conditions with which it had to deal. The alteration or yellowing of the colours in oil painting, by means of the vehicle with which they are mixed, is an objection applicable not only to the amber, copal, and sandarac varnishes, but, in a certain degree, to all others. Even the bleached oil prepared according to the directions of Cennini, or according to other more perfect processes, would, without due precautions (to be noticed hereafter), become yellow in a short time.* The mode in which the tint of the varnish adopted by the first oil painters may have been lightened is explained by the operations of later schools. When a speedily

* The advocates of other methods of painting, and especially of the encaustic process, have not failed to point out this unavoidable defect in the chief material of oil painting. Montabert, one of the most enthusiastic eulogists of encaustic, assumes that the ancients were not unacquainted with oil painting, but rejected it for the method which he extols. The same writer, with Rubens's Luxembourg Gallery before his eyes, makes the following observation. " Si l'on eût proposé à Apelle d'essayer les procédés de Van Eyck, Apelle eût souri de pitié." — *Traité complet de la Peinture*, Paris, 1829, vol. ix. p. 5.

drying varnish was employed, it was usual, and indeed on every account advisable, to thin it for the lighter colours, which dried readily without such assistance, and which required the lightest and most unchangeable medium. Cennini remarks that "vernice liquida" is the strongest of all vehicles *, and if the term be supposed to include amber, called by Rossello " vernice liquida gentile," there can be no doubt that it is so. The degree of strength in that varnish, as it was originally prepared, was more than requisite in its new application as a binding medium for colours; it consequently admitted of being diluted, and was thus, at the same time, rendered lighter in colour. The tempera painters had already thinned their varnishes, even while used as such, by increasing the proportion of oil ; they had also sometimes lightened them by the admixture of " white resin " (though this was chiefly intended to produce a greater gloss) ; and, when the " liquid vernix " was used as a vehicle, its quantity in proportion to pure oil, though varied according to the nature of the colours, was still further diminished.

By this economy in the use of the varnish, the yellowing of the lights was, in a great measure, prevented, while the speedy drying and transparency of the dark tints were at the same time secured : the quantity of the resinous medium every-

* Trattato, c. 161.

where used was still sufficient to maintain an equal gloss, so that the work required no additional varnish at last. But besides this mode of gradually diluting the darker varnish, it also appears that the resinous ingredient itself was varied for different purposes ; indeed certain colours, as will hereafter be shown, had their particular vehicles. To whatever uses the mastic oil-varnish, or the weaker turpentine dissolved in oil, was applied, it is clear that both were in demand at an early period, and we find a Flemish painter, Lonyn of Bruges, furnishing the "white varnish" on one occasion to the painters of St. Stephen's Chapel.* These circumstances are not to be overlooked in examining the earliest records of the vehicles used in Flanders subsequently.

Instead, therefore, of supposing that the first oil painters had achieved impossibilities by inventing a permanently colourless varnish, it may rather be concluded that they had the sagacity to adapt their processes to their materials; knowing that the most carefully prepared vehicle (and that which they employed was doubtless of the purest kind) may, without due precautions, still affect the tone of a picture disadvantageously. However simple the Flemish system of oil painting may have been, and however lasting its general tradition, its methods were considerably modi-

* "Lonyn de Bruges pro VI. lb. di. de verniz blank," &c. The passage has been before quoted.

fied even by the first scholars of the Van Eycks;
proving (if any proof be necessary) that what
is called "the secret" was of little use with-
out intelligence to employ it as circumstances
required. Antonello da Messina, to judge from
some of his productions, used a dark, oleo-resinous,
and flowing vehicle too indiscriminately; Peter
Christophsen has the brown shadows of Hubert
Van Eyck; Hugo Van der Goes is sometimes
yellow in his flesh; while Gerard Van der Meire
scarcely overcomes the pale hues of the tempera
painters. The Flemish inheritors of Van Eyck's
method, who may be said to come nearest to his
technical excellencies, are Roger of Bruges and
Memling.

The foregoing observations, founded on the now
well-known habits of the early tempera painters,
furnish an explanation of the peculiar methods of
the first oil painters, by supposing that a com-
position which had been originally used as a
varnish was, as it were imperceptibly, adopted as
a vehicle for the colours; the resinous ingredient
being subsequently reduced in quantity, and even
varied in kind, as required. This explanation
agrees with the account of the method which
Vasari gives (that writer's story of the panel
splitting in the sun — a not improbable accident —
being left to its own merits): it agrees also with
the appearance of existing works by Van Eyck.
It remains to show that it fully coincides with the

evidence to be gathered from the oldest documents relating to the Flemish practice: these are now to be examined.

The scanty but precious traditions which belong to the fifteenth century first invite our attention. The materials as yet found exist in two treatises, or rather collections of receipts, — a manuscript (already noticed) which is in the public library at Strassburg, and a manuscript in the British Museum. In the passage which has been quoted (p. 130.) from the former, describing the preparation of a drying vehicle, the writer states that " all painters were not acquainted with this oil." This expression is to be regarded as part of that internal evidence which, it was observed, rather warrants the inference that the receipt in question is not older than Van Eyck's time. Whatever may have been its original date, it was certainly recorded in its present form within the century when the Flemish system of oil painting was invented; and, in all probability, comprehends the chief improvements which were introduced with that system. It possesses the general requisites which were defined in the last chapter from an examination of Vasari's statements as compared with other evidence; indeed it might serve as the text for Vasari's description: at the same time showing that such conditions may be fulfilled in various modes. Referring to the passage before quoted from the MS. it will be seen that drying ingredients

are first boiled with the oil, not with the varnish; the colours are ground in this oil, and the varnish is subsequently incorporated with them; an additional quantity of the dryer is then mixed with such colours as require it. The passage, wherein the immixture of the varnish with each tint is described, is as follows:—

" Here observe that all these colours are to be well ground in the oil, and, at last, with every colour mix three [that is, a few] drops of varnish, and then place every colour by itself in a clean cup, &c." *

A definite quantity is here put for an indefinite one, which would necessarily vary according to the

* . . . " hic merke dis varwen sol man alle gar wol riben mit dem oli und ze so sol man under ieglich varwe dric troph virnis riben und tu denn ie die varw sunder in ein rein geschirr," &c. The missing word " hindrest" (effaced or illegible in the MS.) fortunately occurs in a parallel passage, before given (p. 137.), describing a gold size : " Und wenn dis alles wol geriben ist so rib ze hindrest in die varwe ein halb nuschal vol virnis," &c.
It appears that this manuscript came originally from a monastery. The compiler, probably a monk, practised the healing art and painting, and, as an amateur designer, was not likely to exceed the dimensions to which the best artists in Germany and Flanders commonly restricted themselves. His figures being small, the quantity of colour and of varnish mixed in each tint would be minute in proportion. In a description of a drying oil communicated to De Mayerne by a Flemish painter (17th century) we read : " Laissez rasseoir et guardez pour en mesler *une goutte ou deux* sur la palette avec vos couleurs broyées." — *MS.* p. 96.

nature as well as the quantity of the colour; the
(oil) varnish, as will be seen, was so thick that it
could only be added in small quantities to some
tints. The resinous materials are sandarac, mastic,
and "gloriat" or turpentine. They are described
as forming, with oil, three separate compositions;
and it may be inferred that each was to be mixed
with the colours according to the lightness or dark-
ness of the colour and the varnish.

" Here I will teach how to make a good varnish
of three materials — a good and superior varnish
out of each of the materials separately. In the
first place take 1 lb. of sandarac or of mastic,
whichever you please, and pulverise it in a clean
mortar. Then take 3 lb. of linseed oil, or hemp-
seed oil, or old nut oil, and boil this in a clean
vessel, skimming it and taking care, above all, that
it does not run over. After it has boiled and has
been skimmed [throw in and] stir the powdered
resin little by little in the boiling oil: thus the
powder dissolves in the oil. When it is quite dis-
solved let the varnish seethe gently with a moderate
heat, stirring it continually that it may not burn;
and when you find that the composition has become
thick, like melted honey, take a drop of the varnish
on a knife, and, after suffering it to cool a little,
touch it and draw your finger slowly off; if the
varnish strings it is well boiled, but if not, boil it
better till it strings. Then take it from the fire
and suffer it to cool; strain it through a strong

piece of linen, wringing it through the cloth into a clean glazed vessel, and keep it well covered for use. Thus you have an excellent and clear varnish of the best kind.

" And if you wish to make another good varnish, as clear and lustrous as crystal, get 1 lb. of ' gloriat' from the apothecaries' shops and [add] twice the quantity of oil. Let them boil together, and prepare this in all respects like the former varnish; as soon as it strings it is sufficiently boiled, and is in the right state." *

* " Hie wil ich leren gut virnis machen von drierley materien do usser ie der materie sonderlich ein gut edler virnis. Zu dem ersten nim des gemeinen virnis glas ein phunt gewegen oder mastik ein lib. und stosse der eins weders du wilt in einen reinen mörsel ze bulver und nim darzu drie phunt lin ölis oder hanf ölis oder alt nus öli und las das siden in einem reinen kesselin und schum das öli und hüt vor allen dingen das es nüt überlouffe und wen das erwallen ist und geschumet ist so rer das virnis bulver langsam nach enander in das heiss öli so zergat das bulver in dem olin und wenn das bulver gar zergangen ist so las den virnis sieden gar senfteklich mit kleiner hitze und rur den virnis ie ze stunt das es nüt anbrünne und wenn du siehest das der virnis gerattet dikelecht werden als zerlassen honig so nim ein troph des virnis uff ein messer und lass den troph einwenig kalt werden und griff mit einem finger uff den troph züch den finger langsam uff und lat der virnis ein federmlin mit dem finger uff ziechen so ist der virnis und ouch wol gesotten und lat er aber des fademes nüt so süde in bas untz er den faden wol gewinnet und sol in von dem füre und las in erkülen und sich denn den virnis dur ein stark linen tuchlin und ringe den virnis gar dur das tuch in ein rein glazürt hafen und behalt den virnis wol bedeket untz man sin bedarfft so hast du guten edelen lutern virnis den besten.

" Wiltu aber ein andren guten virnis machen der luter und

The sandarac resin, which would form the darkest of these varnishes, is here called "gemeiner virnis glas," an expression which was before explained to be equivalent to "common amber," that is, sandarac, the substitute for amber. In another receipt (for a gold lacker) in the same MS. the term "virnis glas" occurs without the epithet "common," and the context shows that amber is meant.

"If you wish to make another gold colour with which silver, tin, or lead, may be [in appearance] gilt, so that the surface on which the composition is applied will look like fine gold, prepare the colour in this mode. In the first place take amber, pulverise and sift it; take also 1 lb. of oil, and having first boiled and skimmed it, stir the powder by degrees in the hot oil; continue stirring them together till the amber is well dissolved; then let it duly seethe at a great heat, and stir it unceasingly that it may not burn. And when it has become thick," &c.* Then

glantz ist als ein cristalle so nim gloriat in der appenteken 1. phunt und zwürent als vil ölis und las das ouch under enander sieden und tu im mit allen dingen als dem ersten und wenne er ouch einen faden gewinnet als der erste so ist er ouch genug gesotten und ist ouch gerecht."

* "Wiltu aber ein ander gold varwe machen domit man mag silber zin bli vergülden wo man si dar über strichet so schinet si als schön fin gold dise varwe mache alsus zu dem ersten nim aber virnis glas und stos das zu bulver und ruters durch ein sib und ein phunt ölis und las das öli vorhin erwallen und schum es und rur das virnis bulver langsam in das heiss öli und rur es under enander untz das virnis glas wol zergangen si und las es denn wol senftekliche siden an grosse hitze und rur es

follow the materials for tinging the varnish (the ancient "auripetrum") with a gold colour. The writer intimates that this composition was very valuable, and concludes: "This colour is to be preserved clean like the varnish, and whatever substance it is spread over, whether silver, tin, or lead, will become of a fine gold colour. It [the metal so varnished] is then to be placed in the sun till it dries: it will thus be beautifully clear and lustrous, and no moisture can injure it." * The greater heat required and the costliness of the varnish show that amber was here meant, and that the omission of the epithet "common" was not accidental. The cost was, no doubt, the chief reason why sandarac was generally used instead; but those who were willing to incur the expense, for the sake of having a choicer and still more durable varnish, would naturally employ the finer material.

The British Museum manuscript†, above mentioned, was written in the latter half of the fifteenth century: a former possessor of the volume mentions De Ketham as the author. The portion on painting is bound up with various other treatises,

je bi der wile das es nüt anbrounne und wenn es gerattet dikelecht werden" &c.

* ... "Und dise varwe sol man rein behalten als den virnis und was man mit diser varwe über strichet es si silber zin oder bli das wirt schön vin gold var das sol man an der sunne lan wol trocken werden so ist es schön clor und ouch glantz und mag in kein wasser nüt geschaden."

† Sloane MSS. 345.

some of which were written about the year 1500.
De Ketham was a physician, known by at least one
published work*; his language, in the MS. in ques-
tion, is Flemish, but in one of his printed treatises
he is styled "Alemannus," a term (like that of
"Tedesco" with the Italians) which often compre-
hended the natives of the Low Countries. It will
be remarked that the now familiar composition
mentioned in the following receipt is described
not as a mere varnish, but as a vehicle for the
colours; thus again corroborating Vasari's state-
ment : —

"To make a composition which serves for all
colours.—Take 1 lb. of linseed oil and boil it one
hour; then take 4 oz. of pulverised amber and put
it into an earthen vessel, and pour on it as much
of the aforesaid linseed oil as will cover it. Let it
boil till the amber is melted, the solution must
then be strained through a cloth and added to the
first oil. Let it boil, and try on a slate whether it
be strong enough. If it be so, add to it 1 lb. of
resin [concrete turpentine], again suffering it to

* Fasciculum Medicinæ et alia quædam scripsit, Venet. 1495,
See Jo. Alb. Fabricius, Bibliotheca Græca, Hamb. 1726,
vol. xiii. p. 259. The *Fasciculus Medicinæ* to which De
Ketham was the chief contributor, was several times re-
printed; the earliest edition bears the date 1491. It is
remarkable as being the first anatomical work with illustra-
tions; the woodcuts appear to be by B. Montagna. Compare
Rudolph Weigel's Kunstlager-Catalog, Leipzig, 1843, 13ten
Abtheilung, p. 26.

boil a little. Then take it off, and it is ready."*
This composition, though "serving for all colours,"
was necessarily mixed in different proportions with
them after they were ground in oil. Some of the
Flemish physician's receipts, as usual in such com-
pendiums, relate to ordinary and mechanical pro-
cesses, such as the preparation of gold sizes, and
the printing of cloth with varnish colours; but,
even in these, the materials and directions indicate
the habits of the time. The chief dryer, as in the
Strassburg MS., is [white] copperas; colours are
first ground in water, and, when perfectly dry, in oil;
the varnish (with which the copperas is sometimes
boiled) is then added; and, when the colours do not
dry readily, more copperas is mixed with them.†

* "Substancie tmaken daer alle w͞ve indiñ.—R. I. lb. lyn olys
end sid̄ een ure end dan nemt VIII. loet bernsteen ghepulvirt end
doen dy yn een erden poot ende ghiten dar op lyn oly di voer
gesad is dat di wynstey̅ bedowē ys myt den oly end laten dat
syden also langhe dat de bernsteen gesmout̄ ys dy bernsteē soe
sal met syghen doer een doeck eñ doent tostē irst̄ oly end latet̄
sid̄ end pruvet op ey̅ leye of het sterck genoch sy. End yst
steerck genoch soe doet dar I. pont spigelhars yn end latent syd̄
een luttel end dan so settet af end dan ys bereyt."

The mode of dissolving the amber in a small quantity of oil,
before the rest is added, is not to be recommended, as the
solution is thus much more deeply coloured in consequence of
the carbonisation of the oil. The solution of the amber alone,
according to the directions of Theophilus (c. xxi. second
receipt), answers better; but neither method is calculated to
prevent the varnish from becoming very dark. The pale
yellow vinous colour of the best amber explains the synonyme
" wynsteyn."

† The following receipt, though relating only to a composi-
tion for printing cloth, throws some light on the general

Thus it appears that, in the early Flemish practice, the stronger kind of varnish, which was mixed

Flemish practice of the fifteenth century. "To temper all colours.—Take one lb. of linseed oil or nut oil, the older the better, half an oz. of mastic, half an oz. of copperas, two drams of frankincense, one oz. of [white] resin, two oz. of pale red lead of 160; [a] these being pulverised, mix all together. The oil should be first placed on the fire and suffered to boil, then the above-mentioned substances are to be added and stirred continually with a stick to which some cloth is affixed; this stirring and boiling should last two hours; and, in order to try the mixture with black or any other colour, take two parts of linseed oil and the third part from the ingredients above mentioned out of the vessel, with or without measure; and if the cloth [to be printed] be old or thin, add more of the composition from the vessel, otherwise the colour would run: but if the cloth be new and thick the proportion indicated is sufficient. You can then fill your prints with it if you think the colour black enough; but if the burnt black [which you have mixed with it] should not be deep enough, you can take vine branches and burn them in a pot till they are charred; then grind them with water and place them on a piece of chalk to dry. Add a sufficient quantity of this to the burnt black to make the impressions distinct. And all other colours, green or red, yellow or blue, are, in like manner, to be first ground with water only and suffered to dry; then they are to be tempered with oil and with the ingredients from the vessel above mentioned. And in winter, when the colour will not dry in well, grind a little copperas with it, then it will dry thoroughly. Item, cloth should be glazed with a glazing stone; all cloth intended to be tinted should be so prepared.

"Alle werven thoe tēperiren.—R. ı. pont lyn oly of noet oly

[a] The word ochre is sometimes used by the early writers as an adjective, in the Greek sense ὠχρὸς, pallidus. Thus Cardanus, in the passage on red lead before quoted, "ochra id est pallida." "Menie oker van CLX." may therefore mean white lead roasted to a certain degree of heat.

with the colours (previously ground in oil), was amber. In the preceding chapter it was explained that this substance was frequently confounded with copal; but, as the former was at all times more easily procured in the North, it may be concluded that in Germany and Flanders, at least, the term was correctly applied.*

hoe ouder hoe beet, i. loet mastic i. loet coperoet, i. wirdel lots wirock al gepulverizirt end ii. loet spiegelhars menie oker van CLX. iiii. loet ghepulverizirt end dit machmen al thoe samē. End men sal den oly irst opt fuer setten dat hy sydende wort. Soe salmen dan dese verscr̄ substanc̄ dar in doen end roret̄ altoes myt eyn stock d'thoe ow loken aen gesteken. End dit roren end dit siden sal duren ii. uren. End alst men pruven wyl myt zuarte of ander alrehande werve, so sel men nemen ii. deel lynsaet oly end dat darden deel wtter wersc̄ substancie wt den pot met der maten of sondermaten. End ys dat cleet olt ofte dünne so doet dar meer hoe wtten pot of het sonde vloyen. Mer is dat cleet nyc end dicke soe en yst gheennoet. Soe magdi dy printe dar mede wullen. Soe dat w dunc̄ dathet zwart genoch is. End ist sache dat het nyt genoch enhevet van gebranden zwarte so machmen nemen wȳrancke end bernen dy yn een pot alte kalen end wriven sy myt water end doen sy op eyn kryt steyn end latent drogen end doent totten gebrande zwarte alsoe wele dat het wel van den printe gaet. End alle ander werve het sy groen of roet gheel of blaeu. End dy machmen yrst werven wrieven mytten water end latense drogen. End temperense myt olye end myt substancie wt der poot versc̄. End wynterdaghes alst nyt weel drogen een so vriv̄ dar wat coperoet yn het sal theet drogē. Item men sal dat laken licken myt een lick steen dat suldi doen allen laken dy ghy werven wilt."

Another receipt directs that a gold size, if too thick, should be diluted with the oil of amber. "End is dy matery tho sterck so nem eȳ weinhg van bernsteen oly end menghet dar mede."

* It is, however, to be remembered, that during the opulent

The employment of these materials has its technical inconveniences: amber, especially, has a tendency to flow, and this may have been partly the reason why it was used in small quantities, and for particular purposes. Another objection to both, perhaps more applicable to copal, is their tendency to yellow. This seems to have been guarded against by using the varnish sparingly and much diluted in the lights; or even by substituting for it, in such cases, a lighter resinous solution. With regard to the methods of preparing the amber varnish, so as to be as light in colour as possible, it may be assumed that the best processes of the kind were known to Van Eyck. On the other hand, it is not to be supposed that modern chemists would have any great difficulty in obtaining results as successful; nor is it imagined that there was any particular secret in the operation which has been lost, or for which, if lost, an equivalent could not be found : but, in order to pursue the subject historically, some account will here be given of the ordinary modes in use, from the earliest to the later ages of oil painting, for preparing the amber varnish. The evidences of the abundance of the substance

days of Bruges almost every Oriental produce sought in Europe found its way to that city, as the central mart of the North. See Beaucourt de Noortvelde, Geschiedenis van den Brugschen Koophandel, quoted by Michiels, Histoire de la Peinture Flamande et Hollandaise.

itself, in the North of Europe, may be first recapitulated.

The best-informed ancient writers considered the North of Germany as the chief country of amber. The word " glessum " (glas, gläs), appropriated to that substance, according to Tacitus and Pliny, by the Germans, had evidently reference to its transparency. In what precise part of the shores of the Baltic we are to look for the Glessarian island of Pliny * we need not stay to inquire: amber is now found on the coast and under the soil of Prussia, and the chief marts for it are Dantzic and Königsberg.† In the Montpelier MS. " glassa " is called the German vernix (fernix gn̄a). A medical writer of the sixteenth century, speaking of amber, says that when it is dissolved in oil it forms the vernix of the Germans, other ingredients being added ‡; and some authors even derive the whole family of words belonging to vernix, not excepting the medieval Greek terms, from the German bernstein (amber, literally " burnstone ").§

* L. xxxvii. c. 11.

† See Hartmann, Succincta Succini Prussici Historia. Frank. 1677. Fernbach, Die Enkaustische Malerei, München, 1845, p. 139.

‡ "Ad magisterium succini pertinet etiam vernix Germanorum quando in oleo solvitur additis nonnullis." — *Andr. Libavii Singularia*, Franc. 1599, pars iii^a, p. 406.

§ Buttman, Mythologus, vol. ii. p. 362. Libavius, Singularia, ib. p. 594.

Pliny states that amber found its way from the North into Italy, chiefly by way of Venice; that it was therefore common in the plains of Lombardy, whence, in his opinion, the origin of the fable that "trees weep amber on the banks of Po." There, he adds, it was very generally worn in the form of necklaces, by women, for its supposed medicinal virtues, as well as for ornament.* The medical authorities of the middle ages inherited most of the prejudices of the ancients, and amber occupied an important place in their materials; its solution, by means of alcohol or volatile oils, in order to obtain what was called the "magisterium succini," was a favourite problem, and such experiments by medical investigators may have indirectly assisted the labours of Hubert Van Eyck. The substance itself was not less important as an accredited specific in the form of amulets: the virtues of the necklace long survived; the light golden colour being, for this use, preferred.† A specimen of such an ornament, as worn by the women of Bruges in the beginning of the fifteenth century, may be seen in the picture by Van Eyck in the National Gallery; it is suspended next the mirror in the background, and, as usual with the

* L. xxxvii. c. 11.

† See Libavius De Medicinis Succini externis, *Singularia*, pars iiiᵃ, p. 649.; and, among various writers on the medicinal virtues of amber, Vesti, Dissert. de Succino physice et medice considerato. Erfordiæ, 1702.

accessories introduced by this artist, is exquisitely painted.*

The amber used by the Romans might have been obtained, in part at least, from Sicily, and even from some localities in Italy; the epithet Falernian seems, however, to have been applied to an admired German species, so called on account of its (pale yellow) vinous colour.†

From the above circumstances it will not appear extraordinary that the use of amber varnishes should have been general in the North at an early period. The facility of procuring the material was not the only reason for this: the requisites calculated to insure durability in a varnish (whether employed to protect furniture or other objects) are, hardness combined with toughness, resistance to humidity, and that lasting smoothness of surface, affording no minute receptacles for dust or moisture, which is indicated by a perfect gloss. The amber varnish (like that of copal), when duly prepared, possesses these recommendations, and a mechanical perfection, as usual in the infancy of art, was at first the chief object proposed. But such qualities were also especially adapted for a

* It is not quite clear whether this is a necklace or a *corona* (beads for counting prayers). On the amber beads, see Libavius De populari Usu Succini, *Singul.* pars iiiᵃ, p. 644. &c.

† "Falernum et chryselectrum eandem speciem esse conjicimus." — Ib. p. 676. " Succinum falernum : Weinklarer Agstein, oder Bornstein."—*Rulandus, Lexicon Alchym.* Franc. 1661, voc. Succinum.

humid climate; and thus the technical characteristics of the early Flemish painters (such characteristics, at least, as were compatible with higher aims in art) became habitual, and are to be recognised even in some of the highest examples of the school.

In the ancient mode of dissolving amber for varnishes, no precautions whatever were taken to prevent the composition from becoming dark. The process sufficed at all times for ordinary purposes, and hence it often reappears with little change. The following example is given by Libavius (sixteenth century). " Take three lb. of linseed oil; of burnt alum, purified turpentine, and garlic, each half an oz. Mix these in the oil and boil it till it ceases to froth. Then take one lb. of amber, place it in a vessel, the cover of which has an opening about the size of the little finger. Pour in a little oil. Melt the amber on a tripod and stir it with an iron rod inserted through the opening in the cover, to assist the liquefaction. When dissolved, mix it with the oil before prepared, and boil to the consistence of a varnish." * The resemblance of

* " Olei lini libras tres, aluminis usti, resinæ depuratæ, allii, singulas semiuncias, misce et coque donec cesset spuma. Cape postea succini libram, pone in ollam cujus operculum habeat foramen amplitudini digiti minoris quem auricularem vocant. Affunde parum olei, coque super tripode et ferreo bacillo per foramen inserto move ut eliquescat. Cum delicuit solutumque est affunde oleo ante præparato ut dictum est et coque ad consistentiam verñicis."—*Libavius, Singularia,* Franc. 1599—1601, pars iiiª, p. 648.

this receipt, in many respects, to that of Theophilus, is sufficiently apparent. The burnt alum, which is clarifying, and the purified turpentine may be considered improvements; garlic and similar ingredients are still sometimes used in the preparation of drying oils, chiefly in order to furnish moisture for evaporation.

The more obvious improvements of which this direct mode of solution is susceptible are indicated in the Strassburg MS.; such as first carefully preparing the oil (on which the clearness and lightness of varnishes much depends), then throwing in the finely pulverised amber by degrees, and stirring the oil unceasingly, while exposed to heat, to prevent its carbonisation. The modes in which the solution was promoted by peculiar agents may be represented by various modern practices, such as steeping the pulverised substance in oil of rosemary before exposing it to the action of the fire; grinding it in alcohol; and then moistening it, when dry, in the oil of turpentine. The oil of amber itself has been employed with effect in the same way.* An effectual but laborious method consists in grinding the substance very finely in Venice turpentine diluted with the oil of turpentine: the amber then dissolves readily with the aid of heat, and is scarcely, if at all, discoloured. But the principal change (for, as originally practised,

* De Mayerne records a successful experiment of his own, by such means. MS. p. 48.

it was scarcely an improvement) which took place in the ancient process was, to dissolve the amber twice; by which means it was not so long exposed to a fierce heat, the second operation being easily accomplished. " Dissolve one lb. of pulverised amber in an earthen vessel on a charcoal fire. As soon as it is melted, pour it on an iron plate, and again reduce it to powder; then place it in an earthen vessel, first adding linseed oil, already boiled and prepared, with litharge; the solution is completed by the addition of oil of turpentine." * Again: "In Germany they first melted the amber, then poured it on iron plates and pulverised it: to this powder, placed in a vessel, linseed oil already prepared with litharge was added: lastly, they poured in oil of turpentine till all was dissolved." †

As the discoloration of the amber (which still takes place in this process) is the consequence of its continued exposure to great heat, various con-

* " R. succini pulverisati lb. i. qua in tegillo fictili convenienti carbonum igne colliquatur et hæc liquida massa in laminam ferream infunditur ; rursus comminuitur in pulverem atque in tegillo fictili addito primum oleo lini quod cum lithargirio prius coctum et præparatum fuit et postea spiritu terebintinæ totum dissolvitur." — *Dissert. de Succino à Michaeli Alberti*, Halæ Magdeburg. 1750, p. 18.

† " In Deutschland schmeltzen sie zuerst den Bernstein gössen ihn also geschmolzen auf eiserne Bleche aus u. denn pülverten sie ihn; dieses Pulver thatten sie in einen Tiegel und hierzu Leinöl so vorher mit Glätte zugerichtet worden, endlich gössen sie auch Terpentin-oel dazu, bis alles aufgelöset sey."—*Zedler, Grosses Vollstand. Lexicon*, art. Verniss.

trivances have at different times been adopted,
by means of which the portions that are first
melted instantly pass off, and are thus not sub-
jected to the action of the fire a moment longer
than necessary; the following is an example.
" Procure a pear-shaped vessel of copper, measuring
about a foot high and six and a half inches in its
widest diameter; the narrow end or neck (occupy-
ing three or four inches of the former dimension)
should be nearly three inches in diameter at its
truncated end. This opening should be furnished
with a movable cover or stopper, pierced with
holes about the size of a pea. The neck should be
perforated here and there in the same manner.
Fill the neck of the vessel with pieces of the
lightest-coloured amber, and fasten the stopper
well. Procure an iron tripod, the pan of which,
being perforated in the centre, admits the inverted
copper vessel, so that the neck only passes below
it. Lute the vessel to the pan. Charcoal already
well ignited is then placed in the pan round the
sides and almost to the top of the vessel; the fire
is kept up with fresh charcoal. The escape of
gases, evolved by the heated amber, through the
orifices of the neck, precedes the solution. The
amber, as it flows down through the openings, is
received in a vessel of water placed underneath.
The drops, consolidating as they fall, are taken
out of the water at once; the portion which flows
from the upper orifices in the neck is the least

discoloured, and the purest drops are afterwards collected. This operation, like most others adopted for the preparation of varnishes and oils by means of fire, is dangerous from the inflammable nature of the gases which escape. If the pan is perforated with holes to create a draft, it is necessary to surround the neck of the copper vessel underneath with a guard of tin, so as in some measure to cut off the communication between the gases and the fire." [*]

The amber thus dissolved is as light in colour as it can be when prepared by means of heat alone. But in this mode, as in the method before described, that of pouring the melted amber on iron plates, the substance is greatly altered by the process: it has become brittle, and when reduced to powder is easily dissolved in the essential oil of turpentine with very little heat; it consequently requires the addition of a fixed oil to restore to it the requisite degree of toughness.

Recent investigators have found that amber and copal pulverised, and exposed to the air in that state for some time, are, in like manner, easy of solution. The change, in this case, being produced, as is supposed, by the effects of oxygen.[†] The easy solution of the substance is an indication that

[*] Fernbach, Die enkaustische Malerei, München, 1845, p. 141. See, also, Tripier-Deveaux, Traité, &c., p. 60. Compare Secrets des Arts et Métiers, Paris, 1790, tom ii. p. 733.; and Bonanni, Trattato sopra la Vernice, Bologna, 1786, p. 51.

[†] See Tripier-Deveaux, Traité, &c. p. 68.

its hardness and tenacity are more or less impaired ; but this may be considered a uniform result of partial decomposition, by whatever means effected. In the ordinary process of dissolving amber in linseed oil, for example, the original substance is reduced to half its weight by the abstraction of the succinic acid, volatile oil, and gases, which are evolved by heat *; and, as in this case a fixed oil is simultaneously supplied, the sufficient tenacity of the varnish is at once secured. But whether the oil be added at first or subsequently, it is evident that the question of alteration can be one of degree only; to prevent it altogether, when heat is the chief agent, is impossible; it may therefore be supposed that the resinous portion of amber alone (the separation of which can be effected by alcohol or by essential oils) will still form, with a fixed oil, a firmer varnish than any prepared with the ordinary resins, and it can thus be made as light in colour.

Such products have some analogy with the " magisterium succini," one of the secrets of the medieval iatro-chemists. Records of this method may perhaps be found in very early writers; it is not even necessary to assume that its use was subsequent to the practice of distillation (the discovery or introduction of which is attributed to Arnaldus de Villa Nova, in the thirteenth century), as the same result may be obtained with naphtha.

* Dreme, Der Virniss- u. Kittmacher, &c.

Baptista Porta, a well known writer of the sixteenth century, describes the magisterium as follows. " 1 here add the method by which I am accustomed to extract it; the followers of Para-celsus either conceal it or are ignorant of it.* Let the amber be finely pulverised, sprinkle the powder gradually into alcohol, to be dissolved. Pour off the [partial] solution, and add more alcohol, till the remainder of the amber is dissolved, leaving the spirit to act for a month at a time. Place the different solutions in one vessel, and dissolve by [moderate] heat in the open air. The heavy oil which remains at the bottom is the magisterium of amber." †

A similar process is recorded in an English

* Libavius (*Singularia*, pars iiiᵃ, p. 587.) remarks that Andernacus (Gonthier) had published this before Porta.

† " Apponimus modum nos quo extrahere soliti sumus; Paracelsici aut celant aut ignorant : quicquid erit ostendimus. Tundatur succinum minutissimè, tusum in aquam vitæ inspergito, ut illud solvat; solutum transfunde et novum injice quousque quod solveri potest solvatur, per mensem immorando: aquis omnibus in vas unum collatis, igni solvantur in auras. In fundo reses oleum magisterium est succini."—*Jo. Bapt. Portæ Neapolitani Magiæ Naturalis*, lib. xx. Neap. 1588, lib. x. c. 14.

Libavius (*Singularia*, pars iiiᵃ, p. 593.) quotes a similar method recorded by the celebrated Tycho de Brahe. " Ex Cameratianis excepimus Tychonis de Brahe modum qui sequitur. Pollinem succini albi in cucurbita perfunde vini spiritu exsiccato. Clauso vase in cineribus calidis per dies quatuor digere moderato calore. Deinde destilla in balneo lento igni ne ascendat materia. In fundo erit liquor melleus suavissimus. Si augere vis, abstractum spiritum novæ materiæ infunde et age ut prius : postea junge utrumque liquorem."

medical MS. in the British Museum, written in the first half of the seventeenth century. " Hang a broad and shallow linen bagg in a great glass body of three or four gallons (whose mouth is not cut off) by three strong threads. Convey into your bagg, after it is spread and hangeth orderly, the finely scraped powder of amber at the mouth of the long pipe. Let the bagg hang almost to the bottom of the glass. Then pour into your glass three pints of well rectified spirit of wine, or as much as will in a manner cover the amber on the outside. Stop your glass well and set it on a dunghill, or in a gentle balneo for seven days and seven nights. Then shall you have a heavy oyle of Balsome that will issue out of the bagg and fall to the bottom of the spirit of wine; and other most clear, and excellent, and light oyle will float on topp of the spirit, which, with the spirit together, you must pour away by declination, leaving the heavy oyle behind. Then, with a fire of small heat, distill the spirit from the oyle; soe you have a most precious and valuable oyle wherewith Sir Walter Rawleigh had cured twelve persons of dead paulseys." *

De Mayerne employs a method similar to that of Porta in preparing a varnish. " Procure the clearest and whitest amber that can be found: the

* Liber N. Birche Pharmacopœi Norwicensis, &c., Sloane MSS. 3505. p. 203.

tincture or soluble portion should be extracted with highly rectified spirit of wine, by several infusions, in a sand bath. Throw the solution into rain-water; let it remain some days; then pour off the clear fluid, or remove it by strips of felt acting as siphons. Dry the powder which remains on white blotting paper or on chalk, and keep it in a dry place. This powder dissolves quite well in spike oil, and in due proportion makes an excellent varnish, which can be easily spread, dries quickly, and shines splendidly. The solution can be effected by means of a ladle or pan, according to the quantity, on a very moderate fire, taking care that the fire does not reach it, and always stirring with a clean iron rod. I added a little linseed oil; it is desirable that the oil should be drying, such as that which is purified in the sun with white lead, or light litharge, or that which is boiled with calcined white copperas : but with the spike oil alone the varnish answers very well." * Elsewhere,

* " Il fault avec du très pur esprit de vin extraire la teincture ou partie dissoluble de l'ambre la plus claire et blanche qu'on pourra trouver, et ce par plusieurs infusions au sable. Précipitez dans l'eau de pluye, ou simple très pure, ou, pour quelques ouvrages de prix, distillée. Laissez rasseoir par quelques jours, versez vostre liqueur claire par inclination ou bien la séparez d'avec l'ambre par des languettes de feultre et laissez seicher la poudre qui restera sur du papier blanc qui boive, ou bien sur la craye et la guardez en lieu sec. Cette poudre se dissoult fort bien en huyle d'aspic et en deue quantité faict un vernix excellent qui s'estend et se couche avec le pinceau, se seiche fort bien et reluit glorieusement. La dissolution se faict dans

however, as will be seen, he observes that the addition of a fixed oil is always to be recommended. He might have added, that the fixed oils thinned by distillation, which were sometimes employed by the Italians, are unfit for the firm compositions required in humid climates. The opinion of Rubens on the imperfections of essential-oil varnishes will be quoted in another place.

As these methods may be traced even in the modern preparation of varnishes, there seems no reason to doubt that they were employed at a time when the study of iatro-chemistry included various processes directly applicable to the arts; and it is thus intelligible how the painters who, for example, could extract the magisterium of amber, were said to study "medicine." A mode of dissolving copal (and the same method is applicable to amber) which is given by one of the best modern writers on varnishes, may be compared with the foregoing receipts. The improvement consists in exposing the substance to the vapours either of the essential oil of turpentine or spirit of

une cueillère ou poelon, selon la quantité, sur un fort petit feu, prenant soigneusement garde que le feu ne s'y mette, et remuant continuellement avec un pilon de fer bien net. J'y ai adjousté un peu d'huyle de lin, et fera fort bien si l'huyle est siccative, comme celle qui est depurée au soleil avec blanc de plomb ou celle de lytharge claire, ou celle qui est cuitte avec couperose blanche calcinée. Mais avec l'huile d'aspic seule le vernix faict fort bien." From a marginal note, it appears that this receipt was obtained from a German. De Mayerne adds, " Feci Londini Sept. 1638." (MS. p. 162.)

wine. The resin, reduced to pieces about the size
of a pea, is placed in a bag of very fine texture.
This is suspended within a long-necked matrass,
so as to be at the distance of about an inch from
the fluid. The mouth of the matrass is closed
with a moist skin perforated in the centre : the
vessel is then exposed to heat in a sand or water-
bath. In this process spirit of wine should not
boil; on the other hand, the essential oil of tur-
pentine will be even more effectual in operation
(and the operation is slow) if heated to ebullition.*

Libavius alludes to methods known to painters
and others, by which amber was entirely dissolved
in the oil of turpentine or in naphtha.† The mode
was probably the same as that which the moderns
have sometimes adopted with success for the solu-
tion of copal. It consists in using well rectified oil
of turpentine which has been kept for at least a
twelvemonth; the fluid has then the power of dis-
solving a considerable quantity of copal at a
moderate heat, and, as the subsequent admixture
of oil at the same temperature is always possible,
the varnish is quite light. ‡

The above are specimens of the various modes of

* Dreme, Der Virniss- u. Kittmacher, &c. p. 65.

† "Resolvitur et totum oleo terebinthinæ albo, quem spi-
ritum vocamus, aut petroleo in vase clauso incoctum; idque
notæ artis est apud scriniarios, pictores, librarios."—Libav.
Singul. pars iiiᵃ, p. 586.

‡ See a paper by Mr. Linton in the Appendix to the Sixth
Report of the Commissioners on the Fine Arts.

dissolving amber (and they are also applicable to copal) from a remote period downwards. A longer list might have been given, but the principal methods are represented by some or other of the above formulæ. They have been detailed, it is repeated, rather to complete a historical view than for the purpose of supplying any important information, as, in these processes, the moderns have generally improved on the traditionary methods.*

From the numerous notes on this subject, chiefly derived from Flemish painters, which appear in the Mayerne MS., there can be no doubt that amber still merited the title of the " Vernix Germana " in the seventeenth century. It has been seen that this varnish was used in the Netherlands at an early period, to a certain extent as a vehicle for the colours ; being thinned with oil as required.† That

* For examples of the best English modes in use for preparing these and other varnishes, see a valuable treatise by J. Wilson Neil, *Transactions of the Society of Arts*, vol. xlix. part ii.

† Amber and copal, however fit as ingredients for vehicles, cannot be recommended for picture varnishes. It was chiefly as a vehicle that one or the other substance was used in the Northern schools. Many persons now living remember Fairfield, a landscape painter who had studied with Jacob van Strij. The latter, as is well known, was a successful imitator of Cuyp, and, though born more than half a century later, he appears to have been well acquainted with that master's technical methods. Fairfield used copal as a vehicle. He derived the practice from Van Strij, who assured him that such had been Cuyp's ordinary medium.

this was rather a Northern than an Italian habit has been already apparent, and it will be more distinctly exemplified hereafter, in treating of the Italian practice. But it is to be remembered that the method had been originally introduced into Italy from Flanders, and it is therefore occasionally to be traced even in the practice of some of the later Italians. De Mayerne states that "the amber varnish of Venice" was that commonly used for lutes and musical instruments. Though prepared in the German mode, by a twofold solution, it seems that it was by no means light in colour: The amber, re-dissolved in a powerful drying oil, was at first turbid, but it could be clarified with pulverised brick (as recommended by Rossello), and, when duly prepared, it was kept in Italy by all vendors of colours.* The same writer observes that a similar drying varnish, thinned with clear oil, was used by Orazio Gentileschi and others; it was sparingly mixed with the colours already ground in oil, causing them to flow more or less, and giving them a remarkable gloss. It was also used

The tradition agrees with the usual hardness of surface for which Cuyp's works are remarkable.

* " Chez touts les vendeurs des couleurs en Italie on vend une huyle espaisse qu'ils appellent Huyle d'ambre de Venise. Elle est fort trouble mais ils ont un artifice ou avec des briques pilées ou avec de la crouste de pain de l'esclaircir et blanchir. Cette huile meslée sur la palette avec les couleurs déjà broyées à l'ordinaire avec l'huile de lin ou de noix les faict couler et empêche qu'elles n'entrent et s'emboyvent et les rend lustres comme verre d'un esclat excellent."—*MS.* p. 147. verso.

to " oil out " a dry surface, thereby greatly pro-
moting the drying of the superadded colours and
giving them the same qualities.*

Gentileschi, when very aged, was invited to the
court of Charles I., and died in England. His
daughter, Artemisia Gentileschi (an artist of whom
Fuseli speaks in terms of high praise), was also much
employed in this country. De Mayerne observes
that she communicated the mode of preparing and

* " M. Gentileschi, excellent peintre Florentin, adjouste sur la
palette une goutte seulement de vernix d'ambre venant de Venise,
dont on vernit les luths, principalement à la charneure, et ce
pour faire estendre le blanc et l'adoucir facilement, et faire aussi
qu'il se seiche plus tost. Par ce moyen il travaille quand il
veult sans attendre que les couleurs seichent tout à fait ; et le
vernix, quoique rouge, ne guaste point le blanc."—*MS*. p. 10.

" Ayant depuis moymesme demandé au dit M. La Nire l'usage
de ce vernix, il m'a dit qu'il fault mesler deux parties d'huyle de
noix fort claire avec un part du dit vernix d'ambre, et les faire
bien incorporer ensemble à une chaleur fort lente ; que pour
s'en servir il fault passer légèrement avec une esponge fort
doulce imbibée du dit vernix sur les couleurs mortes, et inconti-
nent peindre dessus, que cela faict couler les couleurs et faict
qu'elles s'entremeslent parfaitement, de sorte que quand la be-
sogne est seiche en la refrottant du vernix le travail est aisé, à
quelques heures que l'on s'y met. Il dit avoir appris cecy et en
avoir eu la recepte de Signora Artemisia, fille de Gentileschi,
qui peint extrêmement bien, de qui j'ai vu plusieurs grands ta-
bleaux." — Ib. p. 154. Laniere had also communicated the
description of this varnish to Mrs. Carlisle ; from her De Mayerne
first obtained it. According to that receipt three parts of purified
and bleached nut oil were to be added to one of the varnish.
(MS. p. 151. verso.) For a notice of Anne Carlisle see Walpole,
vol. ii. p. 300.

using the varnish to M. Lanire (Laniere) *, from whom the physician received it. The varnish, as above stated, was the ordinary German preparation.

The practice of Gentileschi, considered independently of his style, thus corresponded in a great degree with the early Flemish tradition. But it is not necessary to suppose that this amber varnish, however carefully prepared, was the only material of the kind employed even in the primitive method; and that method was by degrees variously modified in various schools. The Italians of the sixteenth century more commonly used (as an auxiliary medium) the lighter oil varnish prepared from mastic; and some of the later Flemish painters adopted a similar practice.

With respect to the original process, the Strassburg MS. perhaps contains the most satisfactory explanation of the different vehicles employed. The writer or compiler of that treatise first directs that varnish (the particular kind not being named) should be mixed with all the colours: in afterwards treating of varnishes he mentions three kinds, sandarac (or amber), mastic, and purified turpentine, dissolved in hempseed oil, linseed oil, or nut oil. The oils

* De Mayerne speaks of him as an excellent musician as well as a painter. Compare Dallaway's Walpole, vol. ii. p. 270. For an account of the Gentileschi and their paintings in England, see the same work, ib. p. 267.

appear to have been used indiscriminately; but, as regards the varnishes, it may be inferred that the clearest vehicles were mixed with the light colours, and the darker medium (which also imparted the most durable gloss and was thicker in substance) with the transparent shadows. The appearance of existing works of art agrees with these conditions: in most of the specimens of the early Flemish school the shadows are more raised than the lights, indicating the use of a thicker medium with the transparent colours; the lights have not yellowed beyond the point of an agreeable warmth, while the shadows are sometimes embrowned. The indiscriminate use of a varnish which causes the colours to flow is not to be imagined in the case of Van Eyck, as such a vehicle would not be compatible with the sharpness of his execution. At the same time it is to be remembered that the traditional amber varnish, when prepared or afterwards mixed with siccative oils, as in the practice of Gentileschi, was used as a dryer, and that this drying quality corrects in a great measure the tendency to flow.

The mastic oil-varnish, to which purified turpentine was sometimes added, was much employed by the later Flemish painters, and (as usual with their more modern processes) was introduced by them into this country. The necessity of employing the oleo-resinous medium in such climates as those of England and Holland was thus still recognised,

and, as will be shown hereafter, a proportion of
oil was recommended even in varnishes for finished
pictures.

The following receipts exemplify the use of the
oleo-resinous medium during the 17th century.
They appear in a modern manuscript without a
name. The writer states that he copied them
from a collection of memorandums containing
successive accounts of the methods of painters
who had practised in England from the time of
Vandyck to that of Kneller; but as he adds
that he had lost sight of the original MS., and
as the name even of the transcriber himself is
unknown, the description must rest on its own
merits.

" To make Vandyck's drying oil.—Take an
oz. and half, or two oz. is better, of white lead,
and a pint of nut oil; set the oil upon the fire in a
large earthen vessel; put in the lead by degrees,
as the oil simmers very slowly over the fire till the
whole is dissolved [diffused]." The oil was then
clarified by straining and by repose. The writer
adds: " This oil should be used fresh. Vandyck . . .
always had it prepared in his own house, and
never kept it by him more than a month; after
that time it begins to lose its good qualities: it is
believed that Cornelius Jansen, as well as Vandyck,
used this drying oil." The next extract is: " To
make Vandyck's mastic varnish.—Take 1 lb. of
gum mastic, carefully picked; powder it and set

it in an earthen vessel with 2 lb. of spirit of turpentine. Set this in a sand heat, or any other heat that is less than will make the spirit boil: let it remain (shaking it well continually) till the gum is dissolved. Take it from the fire and let it stand till the contents are cold. The varnish is then to be poured out, and separated from any little foulness it may contain. The best way is to make a quantity of this varnish at a time, and keep it in bottles closely stopped, exposed as much as possible to the heat of the sun. This will make it clear, and improve the colours in proportion to the length of time it is kept. Take 1 lb. of this varnish and half a pint of the drying oil; shake them well together; put them, in a bottle, to simmer on the fire for a quarter of an hour, when the mixture will be complete. But if it should curdle as it cooks, it must be set on the fire again, and simmered until, when cooling, it does not curdle, but appears like a white jelly." Elsewhere: " He [Vandyck] kept all his colours dry, except white, which was ground with nut oil, and kept under water. His colours were tempered as he used them with the oil and varnish [above described]." Of Sir Peter Lely it is related that "his colours, like Vandyck's, were ground in water and kept dry, except the white, which was ground first in water, then with nut oil, and kept in water for use." The transcriber further observes: "It was mentioned in the same manuscript that [Daniel] Seghers, the flower-

painter, used the true Strassburg turpentine boiled with nut oil for his vehicle."*

None of the above circumstances, nor any others purporting to be quoted from the lost manuscript, are at all improbable; on the contrary, they are generally borne out by the known practice of the Continental schools during the corresponding period.† De Mayerne frequently records the directions of painters that varnishes were " to be mixed on the palette with the colours." ‡

The numerous Flemish and Dutch painters who crossed the Alps imported from time to time the methods of the Italians, and combined them with their own. As the merit of Van Eyck had recommended his process to all, so the excellence of the great Italian masters led, in turn, to the adoption of theirs. This reaction began early. Luigi Guicciardini (perhaps copying Vasari) remarks that Schoreel had introduced in Antwerp some of the Italian methods. There are, indeed, numerous

* The author obtained the MS. referred to from Mr. H. Bohn, of York Street, who purchased it at a sale at Messrs. Sotheby's in May, 1845.

† A document to be given hereafter differs slightly from the above account in respect to the oil used by Vandyck ; but his predilections in such particulars may have varied at different times.

‡ " Alors vostre vernix sera faict, que guarderez soigneuse-ment ; et pour vernir, et pour mesler sur la palette avec les couleurs."—*MS.* p. 152. The description is headed "Vernix fort blanc de M. Feltz. Decemb. 1641."

examples of Flemish and Dutch pictures which are national only in their taste, since their technical methods correspond with those of some one or other of the Italian schools. It would be a mistake, however, to suppose that the delicate execution of the artists of the Netherlands is incompatible with an oleo-resinous vehicle. Their most minute finish, as such, is not superior to Van Eyck's; and with respect to the possibility of combining the sharpest precision with the employment of such a medium, it is sufficient to remark that Wilkie's Blind Fiddler was painted throughout with *meguilp* (or drying oil and mastic varnish), as many can attest who saw the progress of that perfect production. The works of some living artists who have uniformly painted with copal oil-varnish will likewise be remembered.

The dryer most commonly used in the Flemish school was white copperas. Two documents of the fifteenth century, relating to that school, which have been quoted, are conclusive as to the early use of this ingredient. The following extracts from the Mayerne MS. show that it was still as common in the seventeenth century. " Colours which do not [of themselves] dry, will dry by adding to them verdigris, white copperas, or crystalline glass*, prepared by extinction in cold water and then very

* The use of a certain kind of glass, in a finely pulverised state, as a dryer, was common in Italy. The mode of preparing it will be more fully described in the second volume.

finely ground."* Elsewhere: "Drying oil more siccative than any other.—Burn white copperas on a redhot shovel, till, after being melted, it dries and becomes a powder. To one lb. of linseed oil add two oz. of this calcined copperas. Boil on a slow fire for an hour, always stirring; then strain. Thus prepared, the oil is not so dark as it would be with litharge, and dries in two or three hours."† Again: "Communication from a Flemish painter at Lord Newport's, 16th Sept. 1633. A powerful drying oil.—Dry or half-calcine white copperas on a fire shovel, and put a small quantity of this with linseed oil. Boil, strain, and keep for use. The painter told me that this oil will dry in two hours, and that there is nothing better for drying lake quickly: the colour becomes very brilliant, and does not fade. The same oil may even be mixed with any other colours that are slow of drying." ‡ Else-

* "Les couleurs qui ne seichent point le feront en y adjoustant le vert de gris, ou la couperose blanche, ou du verre chrystalline pulverisé impalpablement, ou calciné par extinction dans l'eau froide, seiché, et broyé en poudre très subtile."—*MS.* p. 18.

† " Huile plus siccative que toutes les aultres. - R. couperose blanche tant que vous voudrez, bruslez-la sur une poisle rouge tant qu'après avoir esté fondue et avoir boulli elle se seiche et se divise en poudre. R. huyle de lin lb. j. couperose ainsi calcinée ʒij. cuisez à lent feu environ une heure remuant tousjours, coulez votre huyle qui n'est pas si noire qu' avec la lytharge et seiche promptement en deux ou trois heures." — Ib. p. 21.

‡ " Discours d'un peintre Flamand chez my Lord Newport, 16 Sept. 1633. Huyle fort siccative. — Faites bouillir du blanc ℗ desseiché ou à demy calciné sur un poesle de feu et d'iceluy mettez une petite quantité dans l'huyle de lin. Faites bouillir et

where : " The oils fit for making varnishes are nut
oil and linseed oil. These are rendered drying
with litharge, or, which is better, with calcined
white copperas," &c.* The use of this material
prepared in the same manner is recommended in
Smith's *Art of Painting in Oyl*, published at a
time (1687)† when Flemish methods were much
adopted in this country. Copperas is rarer in
Italian formulæ, and in the following instance it is
alluded to as a German material. " To render oil
very drying, some are accustomed to boil with it,
together with litharge, a mineral or species of
vitriol found in Germany, called copperas, reduced
to a very fine powder." ‡ It is to be observed,
that the use of lead, in the form of white lead, is
the most ancient of the recorded dryers, since it

coulez ; guardez. . . . Le peintre m'a dit que cette huyle seiche en
deux heures, et que pour faire seicher la lacque vistement il n'y
a rien de meilleur. La couleur se rend plus vive et ne se guaste
nullement. De mesme elle se peult mesler sur la palette avec
toutes les aultres couleurs qui seichent malaisément."—*M S.*p.161.

* " Les huyles propres à faire vernix sont ceulx de noix et de
lin, lesquels, seules rendues siccatives avec le litharge ou (qui
mieux est) avec la couperose blanche calcinée, se seichent sur
la besogne et peuvent endurer quelque eau que ce soit. Si la
dissolution des resines est faicte avec ces huyles les vernix en
seront plus beaux et auront plus de corps."—Ib. p. 47. verso.

† The first edition has the date 1676.

‡ " Per ottenere anche olio molto seccante sogliono alcuni
farvi bollire ridotto in sottilissima polvere insieme con il litar-
girio un minerale o specie di vitriolo che nasce in Germania
chiamato chuperosa," &c. — *L'Epitome Cosmografica del Padre
Vinc. Coronelli*, Colonia, 1693, p. 99.

occurs in a copy of Eraclius transcribed probably
not later than the year 1400. The circumstance of
white copperas being recommended in the Strass-
burg MS., and in that of De Ketham, in the fifteenth
century, therefore renders it probable that the use
of the latter dryer was one of Van Eyck's improve-
ments. This subject will be further illustrated in
another chapter.

The diluents employed with varnishes and vehi-
cles were, naphtha, the essential oil of turpentine,
and spike oil. Each of these has been incidentally
mentioned in the foregoing extracts; their use
immediately after the date of the improved oil
painting, when thick vehicles were still employed, is
perhaps to be inferred from the extreme precision
of execution in the works of Van Eyck and his
followers. There is no approach to this in the
partial oil painting sometimes observable in the
works of the tempera painters : in such examples
the vehicle is undiluted, and the [decorative] forms
executed with it are always blunt at the edges.
The drying property of the essential oils is in pro-
portion to their rectification *; and the lasting
purity of their tint may partly depend on the same

* De Mayerne observes of the essential oil of turpentine :
" tant plus elle est distillée tant plus elle est siccative et claire
comme eau de roche." Dreme suggests that the rectification of
this oil may be tested by mixing it with white already ground
in linseed oil. If, after half an hour, the essential oil rises above
the diluted pigment, it is duly rectified; if it mixes, it is not
sufficiently pure.

circumstance. De Saussure, whose careful experiments with the oils are well known, speaking of their coloration, says : " It is to be observed that oxygen produced two opposite effects ; it deprived the fixed oils of colour and coloured the volatile oils." He states that the oil of turpentine acquired a brown hue after having been long exposed to the air ; and that spike oil began to change even after a few days.* This observation need not create any distrust respecting the useful diluents in question. They have been employed by the best painters ; and evaporating as they do, when well rectified, the greater or less time in which they become discoloured by the absorption of oxygen can be of little consequence. Those, however, who are desirous of employing the purest and most unchangeable essential oil can easily procure rectified naphtha, which happens to have been the earliest in use for the purposes of painting.†

In diluting thick oleo-resinous compositions with essential oils, it is found that the rapid evaporation of the volatile ingredient, when carefully prepared, requires that it should be frequently renewed ; hence the object proposed may have been assisted,

* Annales de Chimie, vol. xlix. p. 231.

† "Le naphte rectifié d'Amiano a sur l'air une action beaucoup plus faible, que toutes les huiles précédentes. . . . Le naphte avait, après l'absorption [au bout de six ans], toute sa transparence et sa blancheur ; mais il avait déposé sur les parois du récipient un léger enduit solide de couleur jaune."—Ib. p. 238.

as the Byzantine MS. directs, by the addition of a purified, but unboiled, fixed oil.

The foregoing details and references may serve to clear up some of the uncertainty which has existed respecting the early practice of oil painting. It cannot be supposed that the records of contemporary methods in Flanders and its neighbourhood were altogether different from those of the scholars and followers of Van Eyck; it may be more reasonably concluded that the practice introduced by them must have been eagerly learned by many, as soon as it was known to a few. Even those writers who (erroneously) assume that the process was long kept secret still admit that it was unreservedly communicated at last; and there must have been a time, before the details of the method were partially changed to suit another climate and other tastes, when the mere materials and general mode were universally familiar. Perhaps various German or Flemish manuscripts on oil painting (belonging to the middle or latter half of the fifteenth century), yet to be brought to light, describe some portion or other of the method of Van Eyck. Two documents only of this kind, from which extracts have been given, have hitherto been found; but, supported as they are by corroborating evidence, they are conclusive as to the chief materials employed, and even as to the leading peculiarities of the process. They sufficiently establish the fact that an oil varnish was mixed in varied proportions with all the colours.

The use of oleo-resinous vehicles by the early Flemish painters having been sufficiently proved by records, by the appearance of the works of those painters, by the testimony of the historians of art, and by the subsequent practice of the school, it was desirable to ascertain what were the principal resinous ingredients employed: (for the question respecting the oils relates less to their varieties, which are very limited, than to the modes of purifying the oils themselves). In consulting any modern treatise on the technical part of painting, the multitude of substances—for example, under the head of resins—which are necessarily brought to view and described, might seem to render it hopeless to determine what materials of the kind were chiefly in use among the Flemish painters. A comparison of documents extending through several centuries enables us, however, to define the principal substances of this description which were employed in oil varnishes by the painters of the North. These substances consisted of amber, and perhaps copal, sandarac (the ordinary representative of both), mastic, and purified turpentine; the latter being sometimes reduced to a brittle state by a process before described. Thus they might still be classed (as some of these materials were, in the English records of the 13th and 14th centuries) under the general designation of " red and white varnish; " the former serving for the dark colours and shadows, the latter for brighter tints.

Purified turpentine — the white resin, properly

so called — was commonly employed both as an auxiliary solvent, and for the purpose of adding gloss to varnishes; but it was also sometimes used as the chief basis of a light oleo-resinous vehicle.

The comparative durability of resinous substances when dissolved in essential oils, is scarcely a criterion of their solidity when those substances are dissolved in a fixed oil. They then acquire a firmness far greater than unprepared oil alone, or a resinous solution in essences can possess, and communicate that firmness to the pigments with which they are, in due proportions, mixed.*

* From the facility with which it is dissolved, the concrete turpentine is considered the weakest of the resins; yet this substance, if well incorporated with a drying oil, is extremely durable, even in the open air. The following account of such a varnish (composed of the ordinary materials for common purposes), in the first edition of Smith's *Art of Painting*, 1676, p. 79., is not exaggerated. " Some improvements in painting, to resist weather and preserve timber or wooden works from rotting.—Take the hardest rosin you can get, clarifie it well, to which rosin add linseed oyl so much as you find by experience to be sufficient. Let them be well melted and incorporated together on the fire. Then take either umber or red lead (these being extraordinary drying colours) first ground fine, which put into the oyl and rosin. This is a most excellent thing to preserve timber; it lyeth like the China varnish, and will endure ten times as long as other painting (if rightly wrought). This is a most excellent way to preserve the border boards in gardens and any other thing that we would have last long in wet and moisture. The best way to make the varnish (or colour) for this purpose is to put no more oyl to the rosin than what shall just serve to toughen it. . . . The best way to lay this colour on is to heat it hot before you work it, which will make it close the firmer to the wood."

The inspissated or half-resinous oil which was described in a former chapter, thinned or not, as required, may also be considered to represent an oleo-resinous vehicle, and is even well adapted for some purposes.*

The principal methods that have been adopted since the time of Van Eyck, for purifying the oils used in painting, will now be described.

* " This fat drying oyl shall not only make your colours dry sooner than plain oyl, but it shall also add a beauty and lustre to the colour ; so that they shall dry with a gloss, as if they had been varnished over."—*Smith, Art of Painting,* 1687, p. 39. It has been before observed, that this thickened oil was sometimes used by the Flemish landscape-painters in shadows.

ADDITIONAL NOTE.

HOFFMAN (*Observationum physico-chymicarum selectiorum Libri III,* Hal. 1722, p. 223.) gives the following description of an experiment with amber. " I put some pulverised amber in a glass vessel, pouring on it two parts of almond oil; I then placed the vessel in a Papin's digester, carefully constructed, which was one third full of water. Having fastened on the cover very closely, I exposed this for an hour and more to a moderate fire. When the digester was cooled I found the amber dissolved to a gelatinous and pellucid mass (in gelatini-formem et pellucidam massam colliquatum), with a little oil floating above it. From this experiment we clearly learn that expressed oils have a peculiar power on the texture and cohesiveness of amber," &c.

The effect of oil, at a certain temperature, in penetrating "the minute pores of the amber" (as Hoffman elsewhere writes), is still more strikingly exemplified in an invention, or perhaps an old method revived, by Christian Porschinen of Königsberg, at the close of the seventeenth century (June, 1691). He succeeded in rendering amber colourless, so as to employ it as a substitute for magnifying glasses. Zedler (*Grosses vollständiges Univ. Lexicon,* art. Bernsteinerner Brenn-Spiegel) describes the process. The manufacturer placed the amber, already formed and polished for the intended use, in linseed oil exposed to a moderate fire, and sufferd it to remain till it had entirely lost its yellow colour, and had become quite clear and transparent. Zedler states that lenses so prepared are more powerful than those made of glass in igniting gunpowder (welche viel schneller in Brennen und Pulver-anzünden sind als die gläsernen).

The same process was afterwards adopted for clarifying amber beads, so as to render them transparent like glass. The method is probably most successful when the substance is not very thick. For a further account of this invention Zedler refers to Hen. von Sanden, *Disp. de Succino Electricorum principe,* Königsberg, 1714. Dreme (*Der Virniss- und Kittmacher*) alludes to similar methods. "Amber boiled in linseed oil is softened so that it may be bent and compressed : opaque or clouded amber by this process becomes light and transparent. The oil should be heated gradually, otherwise the pieces of amber are liable to crack." Such modes of clarifying amber might be employed with effect, preparatory to its solution by some of the means before indicated.

CHAP. X.

PREPARATION OF OILS.

THE perfection of varnishes of the description referred to in the last chapter greatly depends on the preparation of the oils in which the resins are dissolved; and the best oil for a varnish, or for an oleo-resinous vehicle, is also generally the fittest for using alone as a medium for painting. On this account, the line of separation which has been hitherto observed between the Flemish and Italian practice may here be set aside, since the most carefully prepared oils are required in every case. Examples will therefore be taken, as they may appear worthy of notice, from either school. In conformity with the plan hitherto adopted, scientific descriptions will be quoted as little as possible, the chief object being to present a view of the processes which were common in the best periods of art.

The drying oils mentioned in the records of painting during those periods are, linseed, hempseed, walnut, and poppy oils. Hempseed oil appears rarely; and poppy oil, as a vehicle for painting, was introduced latest.

The common mode of expressing linseed oil, after the seed has undergone a certain preparation by heat (in order to obtain a more copious ole· aginous extract), was in use some centuries before the time of Van Eyck*; but in periods of a more refined practice in art the oil was "cold drawn," chiefly with a view to avoid its discoloration.† The extreme care with which nut oil was sometimes extracted is apparent from Leonardo da Vinci's description of his own method: a similar practice seems to have been familiar in the Northern schools during the seventeenth century.

Leonardo observes: " Walnuts are covered with a husk or rind; if you do not remove this when you extract oil from them, [the colouring matter of] this skin becomes separated from the oil and rises to the surface of the picture, and this is what causes the alteration of pictures."‡ It is not

* See Theophilus, l. i. c. 20.

† Birelli (*Secreti*, Firenze, 1601, p. 541.) begins a receipt: "R. Olio di lino (sine igne) una parte," &c. De Mayerne, speaking of nut oil, says: "Si elle est tirée sans feu elle sera beaucoup meilleur." (MS. p. 151. verso.) In the Venetian MS. we read: "R. dello seme de chanapa e fane quantitad e secca al solombra," &c.

‡ "Le noci sono fasciate da una certa bucciolina che tiene della natura del mallo: se tu non le spogli quando ne fai l'olio, quel mallo si parte dall' olio, e viene in sulla superficie della pittura, e questo è quello che la fa cambiare." — *Amoretti, Memorie storiche, &c., di Leonardo da Vinci*, Milano, 1804, p. 149.

necessary to adopt this explanation of the yellowing of oils even from so high an authority, but we have here a plain proof that the first oil painters were by no means indifferent to this defect in the vehicle. Modern writers have sometimes expressed the opinion, that, as the alteration of oils is unavoidable, it is better to use them at first in the coloured state which they must ultimately attain. That this was not the opinion of earlier investigators will be abundantly proved in this chapter. The best painters seem to have left nothing undone to render oils as colourless as possible before they were used, and to prevent their rising in pictures and forming what is called a horny surface. Leonardo da Vinci elsewhere gives directions for preparing nut oil : —

" Select the finest walnuts: take them from their shell; soak them in a glass vessel, in clear water, till you can remove the rind. Then replace the substance of the nut in clear water, changing the latter as often as it becomes turbid, six, or even eight times. After some time the nuts, on being stirred, separate, and become decomposed of themselves, forming a solution like milk. Expose this in plates in the open air ; the oil will float on the the surface. In order to separate it in a perfectly pure state, take cotton wicks," &c. Then follow directions to use these as siphons, in the well known mode. " All oils," he concludes, " are, in

themselves, clear; it is the mode of extraction which alters them." *

The following note occurs in the MS. of De Mayerne. " M. Lanyre [Laniere] has caused some old, but not rancid, walnuts to be freed from their yellow rind with much trouble ; from the nut, so prepared, he has had some very light and clear oil extracted. I believe that by soaking the nuts in tepid or warm water the pellicle could be easily removed," &c.†

* "Scegli le noci più belle, cavale del guscio, mettile a molle nell' acqua limpida in vaso di vetro, sinchè possi levarne la buccia : remettile quindi in acqua pura, e cangiala ogni volta che la vedi intorbidarsi, per sei e anche otto volte. Dopo qualche tempo le noci, movendole, si disfanno e stempransi formando quasi una lattata. Mettile in piatti all' aria aperta ; e vedrai l' olio galleggiare alla superficie. Per cavarlo purissimo e netto prendi stoppini di bambagia´che da un capo stiano nell' olio, e dall' altro pendano fuori del piatto, ed entrino in una caraffa, due dita sotto la superficie dell' olio ch' è nel piatto. A poco a poco l' olio filtrandosi per lo stoppino cadrà limpidissimo nella caraffa, e la feccia resterà nel piatto. Tutti gli olj in se stessi son limpidi, ma gli altera la maniera d' estrarli." — *Amoretti, Memorie,* &c. p. 149. Compare J. B. Venturi, *Essai sur les Ouvrages Physico-Mathématiques de Léonard de Vinci,* Paris, 1797, p. 30.

† " M. Lanyre a faict esplucher des noix vieilles, non rancées pourtant, et en oster toute la peau jaune avec beaucoup de peine, et de la noix a faict exprimer de l'huile très belle, très blanche, et très claire. Je crois qu'en trempant les noix dans de l'eau tiède ou un peu plus, ceste pellicule s'enlevera aisement après quoy seichez les noix au four après le pain osté ou dans l'estuve, et exprimez l'huile."— *MS.* p. 138. verso. The method of peeling is still occasionally practised in Italy.

In Leonardo's method the oil was at once cleansed from extraneous matter, so that scarcely any subsequent treatment was necessary. In general, however, a further purification is required.

No oil is fit for a varnish or for a vehicle, intended to be durably brilliant or durably light, which has not been thoroughly freed from its mucilage. Those who have advocated other methods of painting (such as encaustic painting), on account of the darkening of oils, have hinted that the presence of mucilage (to which that effect is partly attributable) may be essential either to the durability or the siccative quality of the oil.[*] That this is a mistake may be concluded from the fact that painters, from first to last, have been careful to obtain a vehicle effectually purified from such ingredients.

One of the modes in which oil may be deprived of its mucilage is by mere repose; but the complete defecation by this means requires considerable time. The vessel in which the oil is kept should be carefully stopped, to prevent the thickening of the fluid (unless that quality be desired), and the result will be accelerated by moderate warmth. Reynolds looked upon a present of some very old nut oil as a valuable gift.[†] Lodovico Carracci, in thanking a

[*] Montabert, Traité complet, &c. tome ix. p. 96. Compare Fabbroni, Antichità, Vantaggi, &c., della Pittura Encausta. Roma, 1797.

[†] Northcote's Life of Reynolds, vol. i. p. 118.

friend who had sent him some " precious oil,"* probably alluded to the purity which it had acquired by age. De Ketham, in the MS. before quoted, recommends " linseed or nut oil, the older the better." The Strassburg MS. speaks of old nut and hempseed oil. Valentine Boltzen mentions " pure old hempseed oil." De Mayerne, after quoting the somewhat singular opinion of Abraham Latombe, that nut oil dries better than that of linseed, quaintly adds, in a marginal note, "tant plus vieille, tant meilleur;" and Scheffer, speaking of linseed oil, observes, in equivalent words, " quantò vetustius, tantò solet esse melius."†

This effect of time on the quality of oils may be anticipated in a few months, or even weeks. The directions for accomplishing the purification are innumerable, and it will only be possible to refer to them in classes, giving fuller details of those which appear to be the most innocent and effectual.

The quantity of mucilage always abounding in newly expressed oils may vary in different kinds of oils. As regards its effect, it is to be observed, that its presence tends to augment the discoloration of oils when subjected to great heat. Other tests are no less conclusive. If a small quantity of concentrated sulphuric acid be introduced, drop

* Raccolta di Lettere sulla Pitture, &c., Milano, 1822, vol. i. p. 276.

† Graphice, Norimb. 1669, p. 179.

by drop, into a phial of unclarified oil (in the proportion of 2 parts to 100 of oil), the phial being well shaken, the mucilage soon becomes carbonised: the blackish particles subside, and the oil remains perfectly clear and fluid. Warm water shaken with it assists, for some hours, the separation of the heterogeneous particles, and the excess of acid in the oil combines with the water. An oil so purified, though quite unfit for the purposes of painting, is in the best state for burning in lamps. In its natural condition it produces a turbid flame and thick smoke; when deprived of its mucilage it burns clearly and without the least smoke.* Dioscorides (whose writings were familiar to the early painters or to their teachers), in a passage before quoted, observes that poppy oil, when deprived of its mucilage by exposure to the sun, burns with a clear flame. Thus, if it be true that the action of heat, or of violent agents that are equivalent to it, represents the ultimate effects of atmospheric influences, a mucilaginous oil is more likely to become dark than a purified one.†

Of the more direct methods employed by the

* Dreme, Der Virniss- u. Kittmacher, &c. p. 19. Compare Annales des Arts et Manuf. tom. ix. p. 267., tom. vi. p. 68., tom. v. p. 273.

† "It is indeed some sort of criterion of the durability and changes of colour in pigments, that time and fire produce similar effects thereon : thus if fire deepen any colour, so will time," &c. — *Field, Chromatography*, London, 1835, p. 44.

early painters to effect this separation, the most ancient is that of exposing the oil to the sun; the mucilaginous parts, which are more or less aqueous, are thus either precipitated or evaporated, while the oil becomes nearly colourless: examples have been already given. The other modes which have been recorded may be generally classed as follows: washing, filtration, and the admixture of ingredients mechanically and chemically purifying. As these means have often been employed together, it will not be possible to exemplify them in distinct order; nor is this of much importance. The method of washing, which is undoubtedly the best, though the most tedious, is at once the earliest in the history of modern art, and the most approved by recent authorities.

In the first chapter of this work a mode of purifying oil was noticed as having been taught by the Gesuati, the friends of Perugino. In the compendium of the " Padre Gesuato " before quoted, the method is thus described. " Take fine clear linseed oil of a golden colour in the quantity required; put it in a horn or in a horn-shaped [cone-shaped] glass, having an orifice with a stopper at the point below. Add water, and with a stick stir and mix the oil and water effectually; then, after allowing the fluids to settle, unstop the orifice and let the water run off. Add more, and repeat the operation seven or eight times, or till you find that the water, at its exit, is as clear as when

it was poured in: thus the oil is purified. It is then to be kept in glass bottles for use. Observe that, whenever you find oil mentioned, this purified oil is meant."*

This mode of cleansing oil is described by a Portuguese writer. It was shown in a former chapter, that the early Portuguese school of painting was long influenced by that of Flanders, and the process here noticed may have been derived from Flemish authorities. A similar method, it will appear, was in use in the Netherlands in the seventeenth century. As it was taught by the monks at an early period, its adoption in all schools is easily accounted for.

* "Piglia oglio fatto di semelino bello e chiaro del color croceo ciò è color d'oro e quella quantità che a te pare e mettilo in un corno di vetro over di bue, e che habbia un buchetto in fondo, e metteci sopra acqua fresca, e con un legnetto lavalo bene mesticandolo sottosopra; poi lassalo alquanto posare et apri il buco di sotto e lassa andar via l'acqua, e a questo modo farvi per sette o otto volte, overo tante volte che l'acqua venghi fuora chiara si come tu ce la metti, et a questo modo si purifica il detto oglio; poi conservalo in ampolla di vetro alli tuoi bisogni. . . . Nota che quando tu sentirai nominare oglio intendi di questo purificato."— *Segreti aggiunti et non mai posti in luce per fino a quì. havuti da un reverendo Padre Jesuato pratico ed eccellente.* Printed at the end of the *Secreti di Don Alessio.* Lucca, 1557.

In the above operation, several hours are required for the fluids to separate. The oil is directed to be kept in a glass vessel, in order that light and warmth may tend further to bleach it and promote the evaporation of the aqueous particles.

" To purify Linseed Oil for White and Blues. —
Take a vessel having an orifice at the bottom,
which may be stopped and unstopped. Throw in
the oil mixed with spring water, and, after stir-
ring well, let the mixture settle, till the oil re-
mains uppermost: then gently remove the stopper,
letting out the water, and, as soon as the oil begins
to come out, stop the orifice. Do this three or
four times; the oil will be very clear and fit for
use."*

In a recent French work on varnishes a similar
method on a large scale is described, and, without
reference to the old practice, is recommended on
chemical principles. The author observes: "By
thus removing the fermentable particles which the
oil contained, its affinity for oxygen has been
reduced; a longer duration, a longer resistance to
the atmosphere, is secured for it."† The method
adverted to is commonly employed by the manu-
facturers of choice varnishes, but, as it may not be
familiar to painters, a description of a complete

* " Para purificar olio de linhaça pera o Aluayade et Azuis.—
Tomay hum vazo que seja furado por baixo com hum torno
delicado que se possa tapar et destapar, botailhe o olio com agoa
da fonte, et batey isto muito bem et deixay asentar o olio quē
fique por cima como azeite, depois levemente tiray o torno que
saya a agoa, et tanto que comessar a sayr o olio fechay, et isto
fazey tres ou quatro vezes et ficarā o olio muito purificado, et
que se possa uzar muito bem." —*Philippe Nunez, Arte da Pin-
tura,* em Lisboa, anno 1615, p. 58.

† Tripier-Deveaux, Traité, &c. p. 134.

process of the kind is here given from another source.* In this instance again, the writer professes to be guided by chemical principles only; the accidental coincidence with the early practice, therefore, doubly recommends the method.

In this process wooden vessels or churns are used, each having in the centre a vertical axis with paddles: this is made to revolve rapidly. The oil and water, to which a little common salt is added, are thus incorporated. After an hour the mixed fluids are poured into a trough where they are suffered to remain twenty-four hours. The separated oil is then drawn off by an opening in the side; a sufficient quantity of water being always provided in the trough to raise the oil to the proper level. The first mentioned vessel or churn is, meanwhile, cleansed with warm water, which, mixed with the remainder of the oil, is also thrown into the trough, and is to be allowed for as regards the level. The oil, as it is drawn off, is transferred to the churn, when the first operation is repeated with fresh water. A considerable sediment is found in the trough: the small quantity of oil remaining with it is carefully taken up and thrown into the churn. The newly mixed oil and water are again thrown into the clean trough, and, after the same lapse of time as before, the oil is again removed to the churn. The washing is re-

* Dreme, Der Virniss- u. Kittmacher, &c.

peated three or four times; a very impure oil may require to be thus washed six times.

The process on a small scale is thus described by the same writer. Half fill a glass bottle with pure rain water: add half the quantity of oil, some well-washed and sifted sand, and some torrefied common salt. The bottle being stopped, the whole is to be shaken for a quarter of an hour, and then suffered to settle. As soon as the oil is separated from the water the ingredients should be again agitated, and again allowed to separate. This is to be repeated till the oil has entirely lost its dark colour. It should then be separated from the water by means of a siphon or other contrivance, and poured into another bottle. Fresh sand and water, in the same quantities as before, are to be added; the whole being shaken and allowed to settle as before, six times. The oil is then again to be transferred to another bottle. This series of operations should be repeated at least four times. Every time, a quantity of mucilage separates itself, subsiding in the bottle together with the sand. In the separation of the oil from the water during this purification it is not necessary to be very exact, as the oil is to be mixed with water afresh; but in the last operation it requires to be separated more carefully, and the salt should be omitted in the last washing. The author adds: " No method is fitter than this for refining oil. The most turbid oil is thus reduced to the greatest degree of purity; all mucilage is

separated from it, and its colour becomes so light and clear that it is fit for the manufacture of a varnish of the choicest kind."*

Experience shows that the addition of white sand and salt† accelerates the effect here described, but the washing with water alone is sufficient, in due time, to produce the same result. That the method of the Gesuati, practised as it was in various schools, was that of the early oil painters generally, there can hardly be a question : the expression in the receipt before quoted, " whenever you find oil mentioned, this purified oil is meant," may be considered conclusive on this point.

The oil thus prepared is in a perfectly fluid state; its drying quality, far from being impaired, is rather increased by the operation ; and, when entirely freed from water (by exposure to the sun or by other means), it may be used with advantage as a vehicle for painting. But, in order to render it fit for the preparation of a varnish, it is necessary that it should itself acquire, to a certain extent, the nature of a varnish. The following is a description of the careful method practised and recommended by the author before quoted : —

The oil, purified by means of water in the

* Dreme, Der Virniss- u. Kittmacher, &c. p. 23.

† "La solution aqueuse de sel marin est un des moyens les plus anciennement employés ; il agit en donnant à l'eau une gravité qui détermine plus facilement sa separation d'avec l'huile."—*Annales des Arts et Manuf.* tom. ix. p. 267.

manner above explained, was poured into glass
troughs placed in the sun. Each was filled to one
third of its capacity with water; another third was
occupied by the oil; a similar space remained
between the oil and a glass cover, the cover effec-
tually excluding dust but admitting air. Not-
withstanding the previous purification, the clean
water, after a few days, became turbid, and a
sediment again was formed. After a week the oil
was removed, the vessel was cleansed, and the
operation was repeated. The more serene the
weather, the more perceptible was the sediment in
the vessel. The same process was repeated, from
week to week, six times; sometimes longer, accord-
ing to the state of the oil. After the third week it
was generally observed that the oil was gradually
changing to the state of a varnish: the change in
the consistence of the fluid then rapidly increased.
When the oil had attained a certain consistence,
the separation of the mucilage ceased. In removing
the oil from the water for the last time, great care
was taken that no water should be taken up with
it. The oil that remained was separated by sub-
sidence, in bottles; precautions were observed that
no rain should penetrate into the bottles; to pre-
vent this they were protected with funnel-shaped
covers.

 " Thus," says the writer from whom this de-
scription is taken, " I obtained a varnish [a thick-
ened oil] colourless as water, and brighter than

the oils which are boiled. I have also observed that it undergoes no change. I very much doubt," he continues, "whether it is possible, in any other way, to prepare a better varnish, or one that is fitter for the solution of resins ; not only because an oil so prepared communicates no colour to them, but because it is fluid to such a degree, that a varnish composed with it may be easily spread; whereas, with the boiled oils, the resin becomes more or less coloured, and, when spread as a varnish, leaves inequalities which are difficult to remove." *

Such processes are worthy of the patience of the old painters, and, whether recommendable or not in all their refinements, deserve to be recorded. It is stated that the same results were obtained in winter by suspending bottles, filled with the purified (washed) oil, in ovens moderately heated, the bottles being changed and cleansed as before. Such are the oils in which copal and amber should be dissolved; the varnishes will then be as little coloured as possible.

It has been shown that the washing process was familiar at a very early period. In like manner, the ingredients of salt and sand, recommended in the foregoing extracts, also occur in descriptions of processes derived from good authorities in the Flemish school, at the period when that school

* Dreme, p. 71.

was in its most flourishing state. The addition of salt, for example, is mentioned in a receipt obtained by De Mayerne from "M. Soreau, en Allemand Sorg" (probably the scholar of David Teniers).*
Salt might be chemically injurious to some colours, but, as all traces of it may be ultimately removed from the fluid by washing, there appears to be no risk whatever in its use: Sorg, it will be observed, adds other cleansing ingredients.

" *Linseed or nut oil bleached, and well cleansed.* —Take rain water and dissolve salt in it : mix this with your oil, and wash the oil by shaking it for a considerable time, and frequently, during two or three days. A glass bottle with a stopper below is best adapted for the operation. [After the oil is separated from the water] draw off the salt water, and add more; repeating the process five or six times. Afterwards wash the oil three or four times with fresh rain water. In order to cleanse it well, bread crumbs should be added : this ingredient,

* The date of this particular notice in the physician's MS. is August, 1637 : at that time Hendrik Martenz, called Zorgh or Sorg (a surname which he inherited from his father), was but sixteen years old according to the biographers, who place his birth in 1621. Houbraken, who gives his portrait, says it was taken in 1645, when Sorg was thirty-four. But the same writer afterwards states that this painter died in his 61st year, in 1682. Thus, according to the portrait he was born in 1611 ; according to the latter statement in 1621. The portrait represents a man of about thirty-five. The question is so far interesting as the method of purifying oil above described may have been derived from David Teniers.

passing through the oil, forms a sediment, carrying with it whatever impurities may remain. Afterwards separate your oil, and keep it in a well stopped bottle: it will be as clear as water." *

Another Flemish painter, " M. Adam, demeurant à Coolman street," was in the habit of purifying his oil with the last named ingredient and water only. " Procure a wide-mouthed vessel in which put water and linseed oil, the latter being already well clarified by repose. Shake them together, and, when the oil is again separated, take stale bread crumbs well dried, and sprinkle them upon it. The bread passing through the oil carries with it all impurities. Shake together once daily: let the vessel remain in the shade, well covered, on a table in your room, at any season. Within about a month the oil will be bleached, and as clear as water." †

* " Huile de lin ou de noix fort blanche et bien degraissée. — Prenez eau de pluye et faittes y dissoudre du sel. Meslez avec votre huyle et lavez en agitant longuement par plusieurs fois deux ou trois jours. Cela se peult faire dans une bouteille avec un feuilet au bas et la meilleur chose sera en agitant la bouteille de verre, tirez vostre eau salée et y en remettez de nouvelle faisant comme dessus par v. ou vi. fois. Après lavez la trois ou quatre fois avec eau doulce de pluye. Pour la bien desgraisser il y fault adjouster de la mie de pain, que passant par l'huile tombera à fonds et emportera quand y soit toute la crasse. Separez vostre huile et la gardez dans une phiole bien bouchée : elle sera claire comme eau." — *MS.* p. 143.

† "Ayez un vaisseau à gueule assez large dans lequel vous mettez eau et huile de lin bien depurée par residence ; battez

The use of sand, in the mode recommended by Dreme, is at least as old as the time of Rubens. It has sometimes reappeared, like many of the early methods, as a supposed modern discovery. In Meusel's *Miscellaneen*, for example, it is communicated as if for the first time. A painter, Suhrland, having accidentally spilt some poppy oil on white sand, gathered up what he could mixed with the sand, and observed that in a few days the oil became less coloured, and more fluid.* The method is recorded by De Mayerne as a communication from Mytens, painter to Charles I., before the arrival of Vandyck. Coming from such a source, it may be classed among the processes which were familiar to the Flemish and Dutch painters.

" Colourless and thin linseed oil. — Mix the oil with water and white sand in a glass bottle ; shake it three or four times a day till the contents appear like milk, and leave it constantly exposed to the sun in the month of March. In a month the oil will be as clear as water; and every time [after

bien ensemble et laissez revenir l'huile en dessus. Ayez de la mie de pain de froment rassis bien essuyée (le blanc est bon mais M. Adam s'est tousjours servy du bis) repandez le en saupoudrant avec les doigts dessus l'huyle à travers laquelle le pain passant il en emporte toutte la salleté. Battez fort ensemble tous les jours une fois et laissez vostre vaisseau à l'ombre bien couvert sur une tablette en vostre chambre en toutte saison. Dedans un mois ou environ vostre huyle se blanchira et sera aussi claire que de l'eau."— *MS.* 141.

* Meusel's Miscell. 1782, 14ter Heft, s. 116.

the vessel is shaken], the warmth of the sun, sepa-
rating the oil from the water, purifies it, and at
last bleaches it perfectly." *

On the authority of Van Somer, a painter of the
same school, the writer adds: " It is the oil which
causes the alteration of colours, but, when it is
properly prepared, they will remain unchanged by
it. The month of March is preferable, because the
sun is then less powerful; in other [warmer] sea-
sons the oil soon becomes thick, and is good for
nothing." † The following mode of filtering is
also dictated by Van Somer. " Take linseed oil in
the quantity required; procure a vessel pierced at
the bottom with holes, over which place a piece of
linen ; fill the vessel with perfectly dry sand, and
pass your oil through it into a large pan of water,
place this uncovered in the sun, in serene weather,
for three weeks ; leave it exposed day and night;

* " Huile blanche et *tenue* (subtil) ou fort liquide de lin. —
Meslez l'huile avec de l'eau et y adjoustez du sable blanc dans
une phiole (bassin ou terrine) battez la trois ou quatre fois le
jour tant qu'elle deviendra comme laict, et la laissez continu-
ellement au soleil de Mars. Dans un mois elle se fera claire
comme eau et à chaque fois la chaleur du soleil la separant
d'avec l'eau la dépurera et la blanchira à la fin parfaittement.
Le soleil de Mars vault mieux que tout le reste de l'année car
estant temperé il n'espaissit pas."—*MS.* p. 94.

† "Ce qui tue les couleurs c'est l'huyle, laquelle estant bien
preparée chaque couleur que ce soit ne meurt point. Il la fault
faire au mois de Mars lorsque le soleil est moings chaud
aultrement elle s'engraisse incontinent et ne vault rien."—
Ib. p. 95.

the oil will become as clear as water. Remove it before it becomes thick, and keep it for use." *

De Mayerne was also favoured with a receipt from Vandyck for purifying linseed oil. The directions, which are in bad Italian, are afterwards repeated, in a better form (supplied by Adam), in French; the substance of the two is as follows. "To bleach linseed oil in the shade.—Mix the yolks of two eggs in half a pint of aqua vitæ (not spirit of wine as it immediately coagulates yolk of egg); put this mixture with a quart of oil in a glass bottle in the shade. Shake the ingredients often, incorporating them with a quill split in four; then stop the bottle and let the contents settle. The oil becomes bleached in a few days; separate it from the sediment, and keep for use." †

* "R. de l'huile de lin tant que vous voudrez; ayez un pot percé au fonds: mettez un linomps sur les trous. Emplissez de sable bien sec et passez vostre huyle dedans une grande terrine ou bassin ou il y ait de l'eau. Mettez au soleil a descouvert et au serain, jour et nuit, trois semaines ou ung mois: elle s'esclaircira comme de l'eau. Ostez la devant qu'elle s'engraisse et vous en servez."—*MS.* p. 95.

† "Rta. Per inciarire [ischiarire] l' olio di lino del Sᵒʳ. Cavˡ. Antonio Vandyck. — Se piglia di due ova il rosso et se la batte bene una quartạ parte d' un boccale d' aquavita comune mescolandolo con dᵗᵒ. rosso d' ova il che- si mettra int' un fiasco giungendo un boccale d' olio di lino; et movendo dᵗᵒ. olio con l' ingredienti a tanto che il tutto diventi turbido il che si farà con penna squartata. Se cerra [serra] la bocca del fiasco et lasciandole quietare diventi ciarissᵐᵒ. in brevi giorni."—Ib. p. 138.

" Pour blanchir l'huyle de lin à l'ombre.— Meslez de l'eau de

Once purified and bleached (and it will be re-membered that the colourless state is more likely to be durable when the mucilage is abstracted), the next object was to free the oil from the watery particles which may remain after the washing.* Exposure in glass bottles to the sun, or to a mode-

vie avec des jaulnes d'œufs; je dis eau de vie commune, non esprit de vin lequel cuit et endurcit incontinent les noyaux d'œufs et mettez cette mixtion avec vostre huyle dans une phiole à l'ombre agitant souvent vr̄e vaisseau. Laissez jusques à tant que l'huile estant blanchie vous la couliez et la se-pariez du reste pour vous en servir. Adam m'a dit qu'il prend l'eau de vie commune et qu'il ne fault sinon laisser la phiole sur une tablette à l'ombre et que dedans trois semaines ou un mois au plus l'huile se blanchit parfaittement."—*MS.* p. 141.

Two other methods are here added. The first is recorded by De Mayerne, as a communication from Sorg. "Pour blanchir l'huile de lin ou de noix dans un mois.—Battez l'huile fort longtemps avec de l'alum, adjoustez y de l'eau; mettez au soleil et battez tous les jours v̄re dicte huile tant qu'elle blanchisse en battant; puis la remettez au soleil continuant jusqu'à tant qu'elle devienne blanche, claire et transparente." The following method is now occasionally practised. Fill a glass bottle two thirds full of linseed oil; fill up the remaining space with pure sifted snow; cork loosely, but so as to effectually exclude dust. In six months the oil is clarified.

* For the manufacture of bright oil varnishes, it is necessary that every particle of water should be previously abstracted from the oil; and it is scarcely less desirable that oils intended for painting should be equally free from aqueous particles. The tenacious slimy state in which colours are sometimes found is not unfrequently the consequence of their having been ground, and long kept with some portion of water mixed with the oil; in this state they are slow in drying. See Fernbach, Die Oelmalerei, &c., München, 1843, p. 75.

rate artificial warmth, is the usual mode of effecting this. Air should not be entirely excluded during the process; the vessels might be covered with some porous material fit to imbibe the moisture which may be evaporated.* When the oil is freed from water, the bottles should be well stopped, otherwise the action of the air would gradually thicken the fluid, and generate or increase the oleic acid. The oils and varnishes used by the Dutch painters were kept where the warmth of the sun could occasion-ally act upon them, and still promote their clari-fication : various pictures, representing Dutch artists in their painting-rooms, indicate their tech-nical habits in these particulars.

While the oil is in this state of rest, certain in-gredients may be added tending to absorb any aqueous particles that may remain in it. Among such ingredients may be named burnt alum and calcined borax : the first is often mentioned in early receipts, and is even recommended to be intro-duced into varnishes for the purpose of clarifying them. These, or similar substances, may be suffered to remain in the oil for any length of time. †

* Oil is soonest freed from watery particles, and more quickly bleached, by being exposed to the sun in shallow vessels; these should be covered with glass or with gauze, or with prepared bladder, through which the aqueous particles may exude, and which may be contrived to admit air.

† Calcined white copperas, in a perfectly dry state, and sifted to a fine powder, is not only the best and most innocent dryer, as a metallic oxide, but is a powerful absorbent, thus further

Some modes of purifying oil, besides having the effect of removing mucilage, operate as absorbent dryers or as alkaline correctives. Calcined bones, chalk, lime, magnesia, and other substances, either contrived to perform the office of filters in the ordinary mode, or, when mixed with the oil, tending to purify it by subsidence, have been tried with more or less satisfactory results; but exposure to the sun or sufficient rest is still necessary to complete the process.

The modes of rendering oil clear and drying with calcined bones have also been sometimes published as modern inventions. A process similar to the comparatively recent method of Grandi is given by De Mayerne, who, again, appears to copy Boltzen. Calcined bones, as already shown, are mentioned by still earlier writers : they are noticed not only as ingredients in the preparation of a drying oil, and as an occasional substitute for white lead, but, when finely pulverised, as a means of removing grease: thus employed, the powder has been found useful in thoroughly cleansing the surface of a

promoting the siccative tendency and clearness of oils and varnishes. " From its astringent quality it immediately seizes on any aqueous particles, whether from the oil, gum, or turpentine, if a sufficient quantity is used. Such is its astringent and absorbent quality, that if even water were mixed with the varnish the copperas would seize upon and carry it down to the bottom; neither will it ever combine with the oil as calces of lead do."— *J. Wilson Neil on Varnishes: Transactions of the Society of Arts,* vol. xlix. part 2. p. 56.

picture from oily exudations before varnishing it.*
In the treatise of Valentine Boltzen, which cor-
responds in many particulars with the Strassburg
MS., the ingredient in question is described as a
powerful dryer; for example: " If you wish your
varnish to dry quickly, take sheep's bones, place
them in a new earthenware vessel and lute the
cover close. Set this in a strong fire for two hours;
after which remove it and let it cool. Pound the
bones like fine flour; sift the powder through a
hair sieve, and stir a portion about the size of a
walnut in the boiling varnish; the fluid will then
dry readily on any surface. If you cannot procure
linseed oil, take, instead, old nut oil or hempseed
oil of the clearest and best kind."†

* The Venetian MS. contains a receipt for the removal of
grease by means of finely pulverised calcined bones with the
aid of heat, in the ordinary way. The early Italian painters
prepared drawing-tablets and drawing-paper with calcined
bones of fowls reduced to a very fine powder. It was on this
paper that they drew with a silver point —" la ponta d' argento
supra la mistura d'osso brusato." (*Carteggio d' Artisti*, tom. iii.
p. 175.) Cennini (c. 7.) observes that the bones might be col-
lected from " under the table." The Spanish painters, to this
day, preserve bones after their meals for the preparation of
ivory black (negro de hueso).

† " Hie merck allwegen, wenn du den Virniss haben wilt,
dass es bald truckne, so nim schaf beyn, thue die in einn
neuwen hafen, und verkleybe mit leymen den deckel oben gar
wol, setzs in einstarck fewer ii. stundt, darnach thu den hafen
herab, lass es erkalten. Nimm des beyns ūn stoss es wie reyn
meel, dž er gar nit rauch sey. Beutels durch ein har sib, und
rür es einer nuss gross in dem heissen firniss, dž es darmit

The use of pumice stone, together with calcined bones (as in the Strassburg MS.), is also recommended by Boltzen . " Take old and clear hempseed oil, place it in a vessel on the fire, carefully skimming it as it boils. Take white pumice stone and calcined sheep's bones, pound them well and sift the powder : stir this gradually in the hot oil. Should the oil froth again, skim as before and let it boil well. Then take it from the fire, and place it for two days in the warm sun. If you wish to make it strong, take two ounces of mastic, pound it very fine, and stir it gradually in the oil while it is hot." * This preparation with mastic, it will

erwallet, so truckenet es gar baldt warauff du in streichest. Magst du nit allwegen ankommen Leinsatöle so nim dafür alt nüssöl, oder hanfföl das gar lauter un̄ schön sey, allwegen in dem gewicht oder mensur wie obstehet." —*Illuminir-Buch, künstlich alle Farben zu machen, &c., durch Valentinum Boltzen von Rufach,* 1566, p. 4.

* "Nimm alt lauter hanfföl thû es inn ein Kesselein, machs heiss und schaums sauber, nimm weissen Bimsteyn und gebran̄t Schaffbeyn das stoss und beutels gar reyn, rür es gar sittiglich under das heyss öle. Schaumet es dann wider, so schaume es ab, und lass es einn gûten wall thûn. Darnach hebe es ab, und stells zwey tag an die warm Son̄. Wiltu nun starcken haben, so nim̄ vier loth Mastix, stoss es zu reinem pulver, und rür es in das heiss öl sittiglichen."— *Illuminir-Buch,* p. 5.

In an extract from the Strassburg MS. before given (p. 131.), it will be seen that the powder of calcined bones was also mixed with the colours as a dryer. With reference to the use of this material and of pumice stone by the early painters, it may here be stated, that in 1844, Mr. W. Marris Dinsdale, at the author's request, undertook to analyse a fragment of a picture by Cariani of Bergamo (a contemporary and scholar or imitator of Gior-

be observed, is not dissimilar from the vehicle ascribed to Vandyck in a receipt before quoted.

Of the above mentioned materials, some would have the effect of freeing oil from its acid as well as from its aqueous particles. The earliest known mode of the kind appears in the Paris copy of Eraclius ; a small quantity of lime is there directed to be added to the oil, together with white lead. The painters of the seventeenth century sometimes purified their oil in this way ; for example : "Linseed oil becomes bleached in a very few days, if to a pound of the oil you add one quarter [?] of lime in powder, in a long-necked bottle. Shake daily ; the oil becomes bleached, and does not thicken."* This

gione). Mr. Dinsdale observes of the gesso ground, that it was "interspersed by grains resembling pumice." Speaking of the pigments, he adds : " Crude white of lead, with calcareous matter, very general throughout the picture : with ochres, and I believe, cinnabar. No trace of animal or vegetable matter, save resin, with a general tendency to blacken by heat, which the use of pumice or a sulphuret would account for. Inclined to run, but doubtfully, before the blowpipe, with the exception of one portion which ran fairly into the vitrified state. Hypothetically, I should say, had burned bones in it. Crude carbonate of copper very conspicuous in the drapery round one arm." &c. Octob. 12th, 1844.

Mr. Dinsdale at the same time observed : "Every colour mixed with phosphate of lime (calcined bones) vitrifies when exposed to strong heat ; as Venetian pigments vitrify, might not phosphate of lime have been used as a dryer."

* " L'huile de lin se blanchit dans fort peu de jours si à une livre d'iceluy vous adjoustez un quarteron de chaux vive mise en poudre subtile, dedans un matras ou phiole a col long ;

receipt, given by De Mayerne, appears under the name of Sorg; a similar process is noted elsewhere in the same MS. It appears to have been not uncommon in Holland. An English student in the university of Leyden, in the seventeenth century, records a method there taught for preparing dry-ing oils, whence it appears that lime and chalk were introduced while the oil was on the fire, for the purpose of "neutralising its acid." * Wood ashes have also been used. " To make a thick but clear and very drying oil, fit to mix with colours that have no body, and serving to sustain them so that they shall not sink in the oil.—Take clean warm oak ashes, in quantity about a fourth part of the oil to be used: pour on them a pint of nut oil; leave it for week or fortnight; you will obtain your object." †

agitez assez longtemps touts les jours. L'huile blanchit et ne s'espaissit pas."—*MS.* p. 148.

* "Præparatio ol. lini et cæt^m. aliorum oleorum pro ver-nicibus. — R. ol. lini q. s. coquatur super ignem. Dein injice frustum panis ut illico fermentationem seu effervescentiam quandam faciet, exhalantibus particulis aquosis. Deinde injici-atur aliquod alcali, ut creta, calx, et diversæ calces plumbi ut acidum ejus infringatur. Oleum illud postquam pulveres subsiderint per subsidentiam vel per decantionem clarificetur. Huic ita præparato et denuo igni exposito injiciantur pulveres convenientes scilicet succini præparati, aspalathi, sandarachæ," &c. — *Collectanea Chymica Leydensia.* *Christophorus Love Morley, M.D. Anglus.* Lugd. Batav. 1680.

† "Pour faire une huile espaisse, claire pourtant, fort siccative, propre à mesler les couleurs qui manquent de corps

In these last methods (though it appears they were not uncommon at a period when much attention was paid to materials) there is some danger of saponifying the oil by the immixture of the strong alkaline ingredients: the use of magnesia, which answers the chief end proposed, may be considered less objectionable. Place the oil on the fire, and suffer it to boil gently for three or four hours; remove the scum as long as it forms any. Then add, by degrees, calcined magnesia, in the proportion of a quarter of an ounce to a gallon of oil. Boil well for another hour. When removed from the fire, the covered vessel should be left undisturbed for three months. The magnesia, subsiding, absorbs all acid and mucilage, leaving the oil light and transparent.*

Among the approved modes of freeing oil from its acid, and otherwise purifying it, may be mentioned the use of spirit of wine. Pacheco, a Spanish writer, recommends 3 oz. to be mixed with a lb. of linseed oil (other ingredients which he names are unimportant): the bottle should be placed in the sun for a month, and shaken three times a day. Pacheco observes that the oil so purified may be

afin de leur en donner, pour ne tomber à fonds de l'huile. — R. cendres de chesne nettes, chaudes, une poignée, revenant à la quatrieheme partie de la quantité de l'huile. Versez dessus une pinte d'huile de noix. Laissez ensemble 8 ou 14 jours: vous aurez vostre intention." — *MS.* p. 16.

* J. Wilson Neil on the Manufacture of Varnishes: Trans. of Soc. of Arts, vol. xlix. part 2. p. 43.

safely used with blues, whites, and flesh-tints.* A modern writer gives a similar receipt, " A simple process for rendering oil light and pure is, to mix two oz. of poppy oil with an oz. and half of spirit of wine, placing the bottle in the sun or in a moderately warm oven. In about a fortnight the oil will be clear and nearly colourless."†

The ordinary modes of rendering oil drying by means of metallic oxides remain to be considered. In this instance, again, the methods of the fifteenth century — methods probably introduced by Van Eyck — happen to correspond with those which have been most approved by modern writers. The use of white copperas, as recommended from first to last in the Flemish school, has been already noticed. Another mode of employing this ingredient is here added from a modern writer. " Into four pints of pure soft water put two oz. of foreign [German] white copperas; warm the water in a clean copper pan or glazed earthen jar, until the copperas is dissolved; pour the mixture into a clean glass or stone bottle, large enough to contain three gallons; then add to the solution of copperas one gallon and a half of poppy oil; cork and agitate

* Arte de Pintura, &c. p. 398.

† Fernbach, Die Oelmalerei, &c. p. 70. With regard to the oleic acid, it may be observed that the ingredient, even in excess, can only affect some delicate vegetable colours; thus, it reddens vegetables blues. (See Brande, *Manual of Chemistry*, p. 1128.) Other remedies for this supposed evil are therefore omitted.

the bottle regularly and smartly for at least two hours; then pour out the contents into a wide earthenware dish ; leave it at rest for eight days, when the oil will be clear and brilliant on the surface, and may be taken off with a spoon or flat skimmer, and put up in a glass bottle and exposed to the light, which, in a few weeks, renders the oil exceedingly limpid and colourless."* On the whole, perhaps, no better method of preparing a drying oil can be recommended than that described in the Strassburg MS., if the oil be not suffered to become too thick. White copperas being unquestionably the safest metallic dryer, it may appear useless to give any accounts of other materials and methods; but, as it is certain that preparations of lead were early in use, and that they were also common in the Flemish school during the time of Rubens, they cannot be passed over in a history of processes.†

* J. Wilson Neil, Trans. of Soc. of Arts, vol. 1. p. 34. The operation may be performed with the aid of heat as follows. "Dissolve an oz. of white copperas in three lb. of pure water ; add two lb. of poppy or other oil, and place the whole on the fire. When the water is reduced about a half or two thirds, pour the remaining contents into a glazed earthenware vessel, and let them remain till the oil has become clear. It is then to be separated from the water, and allowed to remain undisturbed for a few weeks longer ; it then becomes as clear as water." — *Fernbach, Die Oelmalerei,* &c. p. 7.

† It is to be remembered, that white copperas requires to be well dried, if not calcined, before it is used; its immixture in oils without this precaution would be injurious. (See J. Wilson Neil, *Transactions,* &c. vol. xlix. part 2. p. 56).

Sugar of lead, also, requires to be dried. "All sugar of

With regard to the exaggerated objections to this ingredient, it should first be observed, that the quantity of lead which oils can dissolve, without the aid of heat, cannot possibly affect colours so much as the immixture of white lead, which, as a pigment, enters largely into the solid portions of every picture. To avoid combinations of lead with the oil which is necessarily mixed with white lead, therefore appears to be a useless precaution. On the other hand, it is to be remembered that the colours which would be injured by the immixture of white lead would also be affected by oils prepared with that mineral in any form. This appears to be the chief ground of the caution often given with respect to drying oils. The use of acetate or sugar of lead is further dangerous, on account of its tendency to re-crystallise, thereby rendering the transparent colours dull ; the extreme case of its visible efflorescence can only occur when it is used in unnecessary abundance. The objections to drying oils on account of their darkness need not exist, as the oils can be rendered nearly colourless in the modes before described.

lead contains about 14·2 per cent of the water of crystallisation, so that to use it in that state is very injurious to the varnish, as its water prevents that complete union of the particles of gum, oil, and lead, which ought to combine and form a whole." (Ib. p. 55.) This substance, if mixed with colours, should be dried only, not calcined ; as, in the latter state, its opaque whiteness destroys the transparency of the dark colours.

Among the early examples of drying oils pre-
pared with white lead, the method recorded in the
Paris copy of Eraclius (perhaps anterior to the time
of Van Eyck) is not to be forgotten. Minium, as
has been shown, occurs more than once in receipts
of the fifteenth century, and both ingredients re-
appear in the succeeding age. A peculiar kind of
Venetian glass, used, when pulverised, as a dryer,
contained a considerable portion of lead; and, if it
acted chemically, may have derived its siccative
quality from that ingredient. The following are
examples of the use of lead in the beginning of the
seventeenth century.

Sorg. "Put linseed or nut oil on the fire in a
glazed earthenware vessel. Suffer it not to boil,
but when it simmers remove it, and throw in
litharge which has been previously well washed
and dried: stir with a spatula or stick, afterwards
cover the vessel and let it remain fifteen or twenty
days. The oil will become colourless and very
drying."*

Mytens. "Boil linseed oil with litharge and
minium on a slow fire, without suffering the fluid

* "Huile de lytharge fort claire et blanche. — Mettez vostre
huile de lin ou de noix sur le feu dans un pot de terre neuf
vernissé faittes la chauffer non qu'elle bouille mais qu'elle com-
mence à fremir. Tirez la du feu et jettez dedans vostre lytharge
bien lavée et bien seichée remuant assez longtemps avec un
spatule ou baston. Couvrez vostre pot et laissez reposer quinze
ou vingt jours. Vostre huile se blanchira en perfection et sera
fort siccative."— *MS.* p. 143.

to foam over; it will become like a syrup. Place it in the sun, in the month of March, in bottles. Leave it till it becomes clear, and in appearance like Canary wine."*

" *Dieterich Keuss*, a painter of Hamburg, bleaches oil in two modes. 1. Put white lead well ground in oil in a wide-mouthed vessel; pour purified linseed oil on it. Place it on the fire and heat it well for about an hour without suffering it to boil; stir with an iron or silver spatula; take it from the fire and let it settle. The following day your oil will be nearly colourless. 2. Pieces or shavings of a certain porous white wood are to be obtained in Germany which serve as tinder for guns: place your oil on pieces of this touchwood in a proper vessel and leave it for a considerable time. The wood attracts all the colouring ingredients of the oil and bleaches it."†

* " 18. Septemb. 1629. M. Mitens peintre trèsexcellent. Huile siccative.—Faittes bouillir l'huile de lin avec de la lytharge et de la mine et ce à lent feu sans qu'il esponde; il deviendra comme un syrop. Mettez la au soleil de Mars dans diverses phioles [De Mayerne inserts "voyez en vaisseau ouvert"] et la laissez jusqu'à tant qu'il esclaircisse et demeure aussi beau que du vin de Canarie." The writer adds: "Possible fault il plus long soleil que celuy de Mars; essayez. Mais tant plus l'huile a de chaleur tant plus elle s'espaissit." — *MS.* p. 94. verso.

† " Dieterich Keuss, peintre de Hambourg, blanchit l'huile de lin en deux façons. 1. En un vaisseau large mettez du blanc de plomb bien broyé avec huyle et versez vostre huyle, bien dépurée par residence, dessus. Mettez sur le feu et faittez chauffer à

Van Somer. "Pour nut oil on well pulverised litharge: place the vessel on the fire and stir constantly. When it begins to boil, remove it; the ebullition past, place it again on the fire; repeat this five or six times. Let it settle, and keep for use. A drop or two should be mixed with the colours, already ground, on the palette: this oil becomes clear and colourless."*

In all these instances, where the oil is exposed to heat, it is to be supposed that it had been previously washed; and it will be observed that great care is taken to prevent its carbonisation. A modern writer, before quoted, recommends drying oil to be prepared thus. "A glass bottle containing the purified (washed) oil is placed in a water-bath, which is heated to ebullition. The bottle should have a wide opening, in order that a considerable surface of oil may be exposed to the action of the air. If

bon escient environ une heure sans que vostre huile bouille, remuant avec une spatule de fer ou d'argent. Ostez de dessus le feu et laissez reposer. Des le lendemain vostre huyle est blanche. 2. En Allemagne on a des couperons ou rabotteures d'un bois blanc dont on se sert pour amorce de fusil ; mettez sur iceulx vostre huile dans un tonnelet, et laissez longtemps. Le bois attire toute la jaulneure de l'huyle et la blanchit." — *MS.* p. 137. verso.

* "R. lytharge d'or, silberglette, bien pulverisée ; mettez de l'huyle de noix dessus ou de lin, et remuez sur le feu ; quand il commencera à bouillir l'ostez du feu et le bouillon passé remettez sur le feu et ce cinq ou six fois. Laissez rasseoir et guardez pour en mesler une goutte ou deux sur la palette avec vos couleurs broyées. Ceste huile s'esclaircit très bien et devient blanche." — Ib. p. 96.

metallic oxides, such as litharge, white lead, or white copperas, are used, they are first enclosed in a small bag, and are suspended in the oil from the mouth of the bottle. White lead alone may be used in the proportion of 1 oz. to 4, 5, or 6 oz. of oil, according as the oil is to be more or less drying. The oxide of zinc or calcined white copperas (which makes a lighter drying oil) may be used in greater quantity. The boiling in the water-bath should continue at least sixteen hours. After twelve hours, the contents of the bag are mixed with the oil. The oil should afterwards remain for a week or fortnight, either exposed to the sun or placed near an oven; the drying materials subside entirely, leaving the oil clear."* Thus prepared, it retains its natural colour. as white lead does not leave it ultimately turbid, so red lead and litharge subside in time, scarcely tinging the oil if it has been previously freed from its mucilage. In large operations the water-bath is not used, but the same result is obtained by placing in the vessel a quantity of water equal to half the quantity of the oil: the contents are then less likely to become carbonised.†

* Dreme, Der Virniss- u. Kittmacher, &c. p. 30.

† A portion of water may be added, even when the process is conducted on a small scale. An eminent painter, lately deceased, was in the habit of boiling two quarts of linseed oil with a quarter of a pint of water together with white lead and litharge, for one hour, according to a Flemish receipt. He states that the oil he used was twenty-eight years old.

Other metallic oxides have been sometimes employed ; of these, verdigris, though among the earliest, cannot be recommended. The following modern receipt is less objectionable. " To a lb. of poppy oil, from two to three oz. of red precipitate (oxide of mercury) were added. The vessel was placed in the sun. After a time—from four to six weeks — a slimy sediment of a grey colour was formed. The mercury had parted with its oxygen, the oil being thereby rendered thicker, more resinous and drying; while the metal remained in its original state in small grains." *

Lead, in its natural state, was not unfrequently used for the same purpose in the seventeenth century. The more modern practice has been to throw small shot or lead filings into the oil.† Some writers have supposed that this ingredient promotes the deposit of mucilage, as a considerable whitish sediment soon appears.‡ This seems to be an erroneous view : on examining the shot afterwards, it will be found that they have lost their polish and have been slightly decomposed. The sediment,

* Fernbach, Die Oelmalerei, &c. p. 69.

† From the following receipt in the Venetian MS. it may be inferred that this ingredient, although, in the instance quoted, serving to thicken common oil, may have been used in the fifteenth century as a dryer for the oils employed in painting, " A conservare le armi lugenti. — R. piombo limato e mitelo ī lolio p spaçio de 9 zorni e poi di questa roba unzi le armi."

‡ See Verri, Saggio elementare sul Disegno, &c., Milano, 1814, p. 110.

therefore, more probably consists of lead combined with the acid of the oil: the fluid is undoubtedly rendered clearer as well as more drying by the process.

In the older method, the oil was placed in small lead troughs and exposed to the air; thus treated, it soon becomes drying and nearly colourless, and, if such a result were desired, it would, in process of time, thickening more and more, attain its maximum of solidification. Cennini (c. 92.) speaks of exposing oil to the sun in "a bronze or copper vessel, or in a basin:" by the latter, he may have meant the pewter basins, such as are still in common use instead of earthenware, for washing, in remote districts in Italy. The following observation is derived from Mytens. "Poppy oil bleaches and becomes more drying, if exposed to the sun for three or four days in a shallow pewter plate covered with a plate or basin of glass."* Another Flemish authority describes a still more effectual mode. "Grind white lead in pure water; make pastilles with it and dry them on chalk in the sun, or on a clean tile. Put your pastilles in a [shallow] leaden vessel, and pour nut oil on them, so that it may cover them. Place the vessel in the sun, and leave it till the oil acquires

* "L'huile de pavot se blanchit et se rend plus siccatif si on la met dans un plat d'estain couvert d'une lame ou bassin de verre au soleil tr̀eschaut par trois ou quatre jours au plus."—*Mayerne MS*. p. 20. verso.

the consistence you wish, and becomes as clear as
water. You may render it so thick, by leaving it
long thus exposed, that it will rope, or may even
be cut."* The solidification of drying oils, as is
well known, may take place without the aid of
metallic oxides, and solely by combination with
oxygen derived from the air; the experiments of
De Saussure on this subject are familiar.† Bou-
vier found that poppy oil became slightly thickened
only while it was kept on water in a well-stopped
bottle; but a portion being separated from the

* " R. du blanc de plomb; broyez le très bien avec l'eau pure,
puis en faites des pastilles que ferez seicher sur la craye et au
soleil, ou sur une tuile bien nette. Arrangez vos pastilles sur
un bacquet de plomb et versez dessus de l'huyle de noix tant
qu'il surnage; mettez au soleil et l'y laissez jusques à tant qu'il
espaissit autant que voudrez et qu'il esclaircisse comme eau.
Vous la pouvez rendre si espaisse en la laissant fort long temps
au soleil qu'elle file et se coupe."—*MS.* p. 20.

Mr. Andrew Wilson, who, during his long residence in Italy,
has been enabled to detect remains of the older technical
processes, has communicated a similar experiment; the white
lead only is omitted. " The leaden trough being placed in the
sun, the oil [in this case, linseed or nut oil, as the Italians
never appear to have used poppy oil] should be occasionally
stirred, till this can be no longer done, from its becoming like a
piece of India rubber. It may be cut out of the trough with a
knife. In this state it is put into an earthen pot, and dissolved
in spirit of turpentine over a moderate fire, taking care that
the varnish does not become brown. Afterwards strain and
closely stop." The lead trough is also mentioned in the *Ency-
clopédie Méthodique, Beaux Arts,* tom. ii. p. 656.

† See Annales de Chimie, tom. xlix. p. 231.

water (in a bottle which admitted air) solidified in a few days.*

It was observed that poppy oil, as a medium for painting, was introduced latest. The observations respecting it in the Mayerne MS. show that its general qualities were still a matter of speculation in the beginning of the 17th century. The following statement appears under the name of Mytens. " Mancop oly † is a very white oil which is used by the painters of the Netherlands, who execute delicate works requiring lively colours, such as the vases of flowers of De Ghein‡ and similar productions. This oil does not dry of itself easily, but it is usually ground with Venetian glass, and then exposed to the sun in a glass bottle. This should be shaken every four days, for three or four weeks; it should then be carefully decanted for use, leaving the sediment

* Manuel des jeunes Artistes et Amateurs, seconde édition, à Paris, 1832, p. 185. Bouvier remarks in a note: "This fact proves that oil thus washed not only becomes very white, but acquires at the same time a drying quality." It had derived oxygen from the water.

† Maancop olie. Maancop (moon-head) the poppy. Van Mander, perhaps the earliest writer who mentions poppy oil with reference to painting, calls it Heulsaeds oly : both terms are still in use.

‡ Jacob de Gheyn, the elder, was born in 1565, and died in 1615. His son had the same name. Both appear to have painted flowers and fruit, and both were also engravers. The portrait of the elder De Gheyn, with a vase of flowers and a bottle of oil among the accessories introduced, is engraved by Hondius; the date is 1610.

with the glass."* The mode of rendering it dry-
ing, by exposing it to the sun in a pewter vessel,
has been already described. De Mayerne adds:
" M. Vannegre, a Walloon painter, states that the
oil thus prepared dries sufficiently well." De
Mayerne himself, speaking of different oils, ob-
serves : "If these oils (linseed and nut oil)
cannot be procured, hempseed oil may be used,
although it rather inclines to a green colour ; or
if you happen to be in a convenient district, for
example, in the neighbourhood of Orleans, the
oil expressed from the seed of the white poppy
is very excellent and very drying [and may be
used accordingly]."† He, however, adds, in a mar-
ginal note : " It is not drying, unless it is rendered
so by artificial means." Elsewhere he again ob-

* " Mancop oly est une huyle fort blanche dont se servent
aux Pays-Bas les peintres qui travaillent en ouvrages delicats
qui requierent des couleurs vives comme aux pots de fleurs de
Ghein et semblables. Ceste huyle ne se seiche pas aisement
d'elle mesme mais on la broye avec du verre de Venise et puis
on les met ensemble au soleil dans une phiole qui doibt estre
agitée de quatre en quatre jours par quelque trois ou quatre
semaines. Fault verser le clair par inclination quand on s'en
voudra servir et laisser le reste sur le verre." — *MS.* p. 21.

† " Au deffault de ces huyles en cas de necessité on peult
user de l'huile de la graine de chanvre encore qu'elle ait quelque
verdeur ; ou si on est en lieu commode, comme au pays de
Gatinois, l'huyle de pavot blanc est très excellente et très
siccative estant faicte de la semence par expression.

" Elle n'est pas siccative si vous ne la rendez telle par artifice."
—Ib. p. 47. verso.

serves: "The oil expressed from the seed of the white poppy is very light and drying; it forms a skin [in drying]. A painter caused a considerable quantity to be prepared for M. Laniere, and said that it did not injure the colours. Nut oil is better than linseed oil."* Again: "To prepare oil for painting white, blue, and similar colours, so that they shall not yellow. Take the grain of the poppy, extract the oil, and mix this with the colours."† In another place he also recommends it for air-tints and blue. At the same time, he remarks that pictures painted with linseed oil bleach better in the sun than those which are executed either with nut or poppy oil.‡ The experience of the moderns in regard to this question is rather in favour of poppy oil, which is said to bleach in ordinary light.

* "L'huile de semence de pavot blanc est fort claire et siccative, puis elle faict une peau au dessus. Un peintre en faisoit faire beaucoup à [pour] M. Lanyre et disoit qu'elle ne gaste point les couleurs. L'huile de noix vault mieux que celle de lin." — *MS.* p. 97.

† "Pour faire huile à peindre sur le blanc, azur et toute aultre sorte de couleur qui ne jaunit point. — R. la graine de pavot blanche et en tirez l'huile et la meslez avec vos couleurs." — Ib. p. 113.

‡ "La meilleure [huile] est l'huyle de lin laquelle si en la peinture devient jaulne en mettant le tableau au soleil les couleurs se vont toujours esclaircissant, ce qui n'arrive pas en l'huyle de noix ni en celuy de semence de pavot. N. (aultres preférent l'huyle de noix.) L'huyle de pavot est bon pour le bleu, quand on fait le ciel, l'air," &c. — Ib. p. 7.

That the Dutch painters gradually preferred poppy oil for some purposes may be gathered from the treatise of Willem Beurs (the scholar of Drillenburg), who lived in the latter half of the seventeenth century.* He observes: " When they [certain materials for white pigments] are dry enough, they are ground in the very best poppy oil, which is better than nut oil, linseed oil, or other known oils." Elsewhere he directs that various colours are to be ground in linseed oil, " the whiter the better." Later writers noticing the practice of the Northern schools, and deriving their receipts from Flemish and Dutch authorities, commonly recommend that delicate colours should be ground in poppy oil.†

The Spanish and Portuguese writers, on the other

* De groote Waerelt in 't kleen geschildert. Amsterd. 1692. (See Houbraken, iii. Deel, p. 355.) In the German translation (Amsterd. 1693), the passages quoted occur in p. 9. 16. Houbraken was himself a scholar of Drillenburg.

† " Il y a des peintres qui ont employé de l'huile tirée de la graine de pavots blancs, parcequ'elle est beaucoup plus blanche et plus claire que l'huile de noix, et qu'elle a d'ailleurs la même qualité d'être siccative : mais ce raffinement n'est bon que pour de très-petits ouvrages où l'on recherche tout ce qui peut contribuer à la beauté et à la vivacité des couleurs." — *De Piles, E'lémens de Peinture,* Paris, 1776, p. 138. He also recommends the zinc dryer : " la couperose blanche fondue et séchée sur une platine de fer." On the subject of poppy oil compare the *Encyclopédie Méthodique* (*Beaux Arts,* 1791, tom. ii. p. 437. art. Huile) ; Bardwell, *Practice of Painting,* &c. 1756, p. 7, &c.

hand, do not mention it, and some even recommend
the use of linseed oil, their ordinary vehicle, for all
colours. Pacheco boasts that some Italians sup-
posed he had used ultramarine when he had em-
ployed a common blue; and states, as a subject of
greater wonder, that his blues and whites were
never painted with the universally extolled nut oil
(which, he says, he was not in the habit of using),
but with that of linseed; " although," he adds,
" some say that blue and white should never see
this oil."* His method of employing it will be
noticed hereafter. Nunez also proposes modes of
using linseed oil, so as to render it a substitute for
nut oil.† Palomino does not speak of poppy oil,
but mentions the oil extracted from the seed of the
pine tree as fit, like nut oil, for white and blues.‡

* " I en esta parte algunos Italianos que an visto mis Azules
se an persuadido que son ultramarinos procurando ver con que
secreto los gastava: i lo que mas admira, que no ven mis Azules
ni mis blancos, el Azeite de nuezes, tan riverenciado de todos,
porque nūca lo uso, ó mui pocas vezes. El de linaza no
me quele mal; aunque ai quien diga que no a de ver el Azul
ni el blanco este Azeite." — *Arte de Pintura,* Sevilla, 1649,
p. 392.

† " Quando quizerdes fazer Aluyalde que se possa uzar como
com olio de nozes, moieo Aluyalde na pedra muito bem com agoa
et depois che botay o olio de Linhaça, et vereis, que indo
moendo, a agoa se vay saindo para fora, et fica Aluyalde só
com o olio que parece purificado." — *Arte de Pintura,* em
Lisboa, anno 1615, p. 50.

‡ " Otro aceyte hay en vez del de nueces para azules y blancos,
que es el de piñones, dexandolos enranciar algun tiempo despues
de quebrantados y descascarados," &c. — *El Museo Pictorico,*
tomo segundo (1724), p. 55.

It will have been seen that De Mayerne omitted no opportunity of consulting persons of practical knowledge on the subject of oils and pigments ; and it seems that he was equally ready to communicate the result of his own experience to those who needed his assistance. An interesting letter written by Joseph Petitot of Geneva, the brother of the celebrated enameller, is bound up with the physician's notes.* The writer gives an account of his mode of rendering cloth waterproof; and, in thanking De Mayerne for his former instructions, submits further questions to him. He states that he had tried the calcined bones and pumice stone to make a siccative oil, but found that umber, his ordinary dryer, was quite as effectual. It will be remembered that, for the object intended, the colour of the oil was unimportant; it was even reduced to a thick consistence by being burnt. Another manufacturer of such materials (Wolffen) states that, having tried litharge and minium, he found that the oil, with the latter ingredient especially, dried hard, and that the stuff on which it was spread was consequently apt to crack. He found that burning the oil for a time, without any siccative ingredient, rendered it sufficiently drying. On the oils, generally, he observes: " The two best oils are linseed and nut oil. There is this difference between them: linseed oil dries at first on its surface and forms a skin; what is underneath is

* It is dated Geneva, 14th January, 1644.

long in drying, though it dries at last ; but nut oil dries entirely and [throughout its substance] in a shorter time, for example, in three or four days ; much better in the air and sun than in the shade."*

De Mayerne suggests that the oil, without being set on fire, might, by long boiling, be thickened sufficiently for the purpose required, and, at the same time, be rendered drying. The mere boiling of oils in this way, with a view to obviate the use of metallic oxides, is recommended by the anonymous author of a useful treatise quoted in the *Encyclopédie Méthodique ;* he suggests that nut oil should be boiled in a water-bath for an hour. †

* " Les deux meilleures huiles sont celle de lin et de noix : avec ceste différence, que celle de lin seiche prémièrement en sa superficie et faict une peau, le reste estant plus long à seicher encor qu'il la face à la longueur. Mais celle de noix se seiche entièrement et en moins de temps, come en trois ou quatre jours, beaucoup mieux à l'air et au soleil qu'à l'ombre." The date of this memorandum is 2. January, 1640. De Mayerne adds in the margin : " Ex ipsius ore."

† " Le moyen d'avoir une huile qui sèche bien, c'est de faire concentrer un peu celle de noix, en la faisant bouillir une heure au bain-marie. On peut encore en essayer d'autres. Je me contenterai d'indiquer celle de copahu : nette, limpide, odoriférante, cette huile m'a paru sècher très-vîte, même avec les couleurs les moins siccatives ; on pourroit y mêler un peu d'huile de noix ou de lin."— *Encycl. Méthod., Beaux Arts,* tom. ii. p. 437. The treatise here referred to, and which is often quoted in the same work, is entitled : " Traité de la Peinture au Pastel, &c. par M. P. R. de C. C. à P. de L. Paris, chez Defer de Maisonneuve, 1788." The writer is mistaken

An eminent foreign professor, writing to the author of the present work on the subject of oils, observes: " The rapid drying of the oil seems to me to be a chief condition, not only for the hardness and compactness of pigments, but also for their purity and durability. Cennini, in his 91st chapter, says ' the more slowly you allow it to boil, the better it will be.' Pure linseed oil, without any addition of sugar of lead or litharge, acquires, by prolonged and gentle boiling [langsames kochen], the power of drying in a night, and renders the linseed oil varnish and all such siccatives unnecessary. It remains long unchanged in consistence and thinly flowing : at this time [1845] I am using an oil of the kind, which I prepared in 1838."

The opinion of Vandyck on the relative fitness of the oils used in painting will be given in another chapter.

in objecting to white copperas because it contains sulphuric acid. Sulphate of zinc (purified by being dissolved and re-crystallised), when calcined, loses the sulphuric acid, and is converted to the oxide of zinc.

ADDITIONAL NOTES.

THE usual mode of increasing the siccative quality of oils, while exposed to strong heat, by the addition of metallic oxides, may afford a test of the relative fitness of the dryers so

used. The following remarks by practical writers are worthy
of notice : —

"The oil quickly absorbs the oxygen of the metallic sub-
stance, which latter is then partly soluble in the fluid.
Linseed oil [with the aid of heat] can disolve the fourth part of
its weight of litharge, and the mixture when cold solidifies in a
mass similar to caoutchouc. This substance, again dissolved and
applied with the brush, forms an elastic varnish impermeable
to water, and which, in many cases [but better on inflexible
surfaces], may be used as a substitute for caoutchouc. The
oxides of iron are, in like manner, easily dissolved in oil.
The oxides of zinc, on the contrary, are difficult of solution in
oil, even with the aid of heat ; nevertheless, they yield a con-
siderable quantity of oxygen." — *Dreme, Der Virniss- u. Kitt-
macher*, &c. p. 15. The same writer elsewhere remarks :
"The oil acquires a resinous quality by means of the oxide
of zinc sooner than with the other metallic substances above
mentioned, since the former parts with its oxygen, during the
boiling, in greater quantity." — Ib. p. 26.

The following experiments, by another investigator, on the
relative solubility, in oil, of zinc and lead dryers, corroborate
the above observations : —

"Experiment 8. That [white]copperas does not combine with
varnish, but only hardens it. — Three lb. of very fine African
copal, one gallon of clarified oil, and two oz. of dried copperas
were mixed off with two gallons of [essential oil of] turpentine,
which, after being strained, had been put by in an open-
mouthed jar for eight months. I then poured off all the varnish,
not quite to the bottoms. I afterwards well washed the sedi-
ment left at the bottom of the jar with two quarts of warm
turpentine, which I filtered through some very fine cambric
muslin, and afterwards dried the copperas in the sun ; it still
weighed two oz. and appeared like what it nearly was, powder
of zinc.

"Experiment 9. That sugar of lead does combine with
varnish. — With the same quantity and quality of gum, oil, and
turpentine, I made three gallons of copal varnish, introducing
two oz. of dried sugar of lead during the boiling. I put it in
a jar for eight months. I then poured off all the varnish, and

washed out the sediment with half a gallon of warm turpentine, filtered as before. I dried the residuum left on the muslin, which only weighed seven drachms, and appeared of a pearly lead colour; so that the varnish had abstracted the remainder." — *J. Wilson Neil, on the Manfacture of Varnishes: Transactions of the Society of Arts,* vol. xlix. part ii. p. 76.

These statements acquire a new interest from the fact (established by documents which have been adduced), that the method which such experiments warrant was really adopted in Flanders in the fifteenth century. As the use of oxides of lead, for dryers, was then familiar, there can be little doubt that the preference given to (dried or calcined) white copperas was not accidental, but rather the result of accurate experiments, such as Hubert van Eyck was qualified to undertake.

It is unnecessary to enter into the questions, on the one hand, whether such preference was a needless refinement ; or, on the other, whether any siccative ingredient is necessary : it is sufficient to have shown that the least objectionable metallic oxide was used as a dryer by the earliest oil painters.

It has been stated on the authority of a modern writer[*], and experience confirms the observation, that oil colours, if intimately mixed with aqueous particles, are slow in drying. The early oil painters did not put their colours in water ; and the later Flemish artists kept white lead only in this way, finding that its colour was improved by it, and that it was slow to imbibe moisture. In such habits climate, no doubt, had its influence. The aqueous particles quickly evaporate in a warm atmosphere, when not thoroughly incorporated with the oil.[†] Nunez, indeed, recommends grinding white lead with

[*] Fernbach, Die Oelmalerei, p. 74.

[†] It has been seen that, under certain circumstances, water may be brought in contact with boiling oil with good results. In some cases the water is decomposed in the operation. Thus, when it is desired to give the oil a resinous quality as soon as possible during the boiling, it is not unusual to sprinkle hot water (which is more divisible and lighter than cold) on the heated fluid. The water coming in contact

linseed oil and water together, chiefly with a view to bleach
the oil : the passage has been already quoted (p. 362.). The
Italian and Spanish painters commonly kept their colours
under water. In the Treviso document before quoted we
read of "small cups and a large vessel for the painters." *
Cespedes explains the use of the latter.† Palomino, on the
other hand, mentions four colours only — white, ochres, light
red, and umber — which should be placed in water. The others,
he remarks, "abhor water, as they part with oil and become
hard in it;" (he might have included the ochres in the pro-
hibited list, as they easily imbibe moisture). He recommends
that such colours should be kept in small cups, covered with
oiled paper; as was the practice with the Flemish painters in
the fifteenth century.‡ The Bolognese painters were not so
particular; they even placed their palettes with the colours on
them under water. Malvasia relates that Alessandro Tiarini,
having permitted a scholar to put his palette and colours into
the same vessel of water with his own, was not a little provoked
at finding that the tints had become mixed.§

with the boiling oil in minute quantities becomes instantly
decomposed; its oxygen combining with the oil, thereby
rendering it more resinous, its hydrogen burning with a
bright flame.

* "Per scudellini per li depentori, L. 1. s. 16. Per un cadin
per depentori, L. 1. s."

† " Un ancho vaso de metal sonoro,
 De frescas ondas transparentes lleno ;
 Do molidos á olio en blando frio
 Del calor los defienda i del estio."

Quoted by Pacheco, Arte de Pintura, p. 396.

‡ El Museo Pictorico, tomo segundo, p. 54. Compare the
passage before quoted from the Strassburg MS.

§ Felsina Pittrice, Bologna, 1678, vol. ii. p. 209.

CHAP. XI.

METHODS OF THE FLEMISH SCHOOL CONSIDERED
GENERALLY.

THE habits of the Flemish painters in regard to the choice and preparation of *vehicles* having been traced in the two preceding chapters by means of numerous records, it is now proposed, with the aid of similar evidence, to describe the ordinary practice of the school in other particulars. The principal points which remain to be considered are: the nature of the ground or substratum on which the picture was executed; the order of operations in the commencement of the picture itself; and such modes of preparing the colours as were, originally at least, peculiar to the artists of Flanders and Holland.

Perhaps the only technical process which has survived without change from remote antiquity is, the method of preparing grounds, on wood or other surfaces, for painting. The layer of chalk and size which is found under the colours of the Egyptian mummy-cases is nearly, if not precisely, the same as that employed by the painters of the middle

ages, and which is often used at the present day.*
This preparation, whether the solid ingredient con-
sist of washed chalk (whitening), or plaster of
Paris † prepared in water and finely ground
(called by the Italians " gesso marcio " ‡), is fittest
for an inflexible surface, as it becomes brittle
with age.

The Venetians, who from the first preferred
cloth of fine texture as a groundwork for pictures,
generally took the precaution of spreading the
composition of size and gesso as thinly as possible,
so as to avoid the danger of its cracking when the
picture was rolled.§ Their practice in this parti-

* See Raspe, A critical Essay on Oil Painting, &c. p. 22. 25.

† Vasari, in his Life of Luca della Robbia, speaking of the
stucco works by that sculptor at " Madri" near Paris, observes
that the plaster of Paris is superior to that made from the
gypsum of Volterra, "because it is soft when worked, but in
time becomes hard." *Madri* probably means the palace
built by Francis the First in the Bois de Boulogne, and which
he called *Madrid.* See the *Lettere Pittoriche* (1757), vol. iv.
p. 338.

‡ Gesso marcio, or marcito, is plaster of Paris first stirred
well with water till it loses the power to *set,* and then kept and
daily stirred for a month. (See Cennini, cap. 116.) A more
exact receipt "ad faciendum gessum subtile" appears in the
MSS. of Alcherius, copied from an Italian MS. of the 14th
century. According to that description the gesso was at first
sifted into the water, and the water was changed daily.

§ Van Mander relates that the elder Pourbus painted a land-
scape on a large cloth prepared with the white size-ground of
the usual kind. The picture required to be frequently rolled
and unrolled, probably while the artist was at work ; the con-
sequence was that the painted surface scaled off.

cular will be further described and exemplified in treating of the Italian methods.

It has been often asserted that Van Eyck painted on wood only: there is, indeed, but one recorded instance of his having used cloth.* Rubens inherited in this respect the predilections of the early Flemish masters: in one of his letters to Sir Dudley Carleton he observes that, for small works, wood is fittest.†

The mode of preparing the ground of panels was so uniform, that the directions of Cennini may be considered applicable to all contemporary schools. The habits of the Northern artists differed from those of the Italians in some few points only. The wood commonly employed by the latter was the white poplar‡: the Flemish painters used oak. Cennini (c. 113.) observes that, when the dimensions of the panel permit such an operation, the surest means of preventing its splitting is to boil it first. Time has shown that in larger works, composed of several pieces, the precautions adopted were seldom sufficient to guard against this accident, or to prevent warping: the mode of protecting the wood by battens, for example, is not always successful.§ The cement which was used by the early

* Morelli, Notizia d'Opere di Disegno, &c. p. 14.
† Carpenter, Pictorial Notices, &c. p. 161.
‡ Cennini, cap. 113. Compare Vasari, Vita di Jacopo, Giovanni, e Gentile Bellini.
§ See the note at the end of this chapter.

painters for their large panels, or *tavole*, was of the strongest kind, consisting of the insoluble part of cheese, ground with quicklime: the mode of preparing this glue, as described by Theophilus and others, has been often published.*

The archives of the Duomo at Treviso contain some curious documents relating to the principal altar-piece of that church — a picture once attributed to Sebastian del Piombo, but now known to be the work of Frà Marco Pensabene. The following items in the account have reference to the subject now under consideration: —

" 7. March, 1520. To Mistro Benetto Marangon at the Duomo, for planks of good wood to make the panel for the figures of the great altar piece, 14 soldi.

" To Mistro Lio, who made the panel, to buy cheese to make the glue for fastening the planks of the same, 1 soldo."

" 13. October, 1521. To Mistro Zan, the gilder, (part of his account) for having laid the gesso ground on the altar-piece, 3 soldi." †

* Take soft cheese, cut it into small bits; pound and wash in a mortar with hot water till all the soluble parts are removed, and till the water, which requires to be frequently changed, remains clear. The cheese, thus prepared, will crumble like bread when dry, and may be kept in that state for any length of time. The substance itself is not soluble in water, but it becomes so by the addition of quicklime: on pounding it with this a viscous cream is formed, which may be thinned with water. It dries quickly, and once dry cannot be again dissolved.

† " Marzo 1520, a dì 7. Dati a Mistro Benetto Marangon

In large altar-pieces, necessarily composed of many pieces, it may be often remarked that each separate plank has become slightly convex in front: this is particularly observable in the picture of the Transfiguration by Raphael.* The heat of candles on altars is supposed to have been the cause of this not uncommon defect†; but heat, if con-

sta al Domo per tavole de talpon [toppo] per far tavolado per le figure della pala dell' altar grando, L. 14. s.

"Dati a Mistro Lio che facea la pala per comprar formajo per far la cola da incolar le tavole de dita pala, L. 1. s."

"A dì, 13. Ottobre. Item dati a Mistro Zan indorador per parte per aver inzesà [ingessato] la pala dell' altar grando, L. 3. s." — *Federigi, Memorie Trevigiane,* Venezia, 1803, vol. i. p. 130. Vasari relates that Paolo Uccello quitted a convent where he had been at work, because the monks fed him with nothing but cheese. He fled if he saw his employers in the streets, but being at last caught by two friars, who outran him, and being questioned as to the cause of his deserting them, he confessed that he was tired of their diet, adding, that he was afraid of being metamorphosed into cement. The expression proves how generally the glue above described was then in use. (*Vita de Paolo Uccello.*)

* The *tavola* on which this picture is painted is composed of five planks three or four inches thick. Richardson, who saw it in S. Pietro in Montorio, says that it is painted "on board or rather on timber, being, as I remember, at least a foot thick." (Vol. ii. p. 313.) He was perhaps deceived by the frame. It is remarkable, that in Titian's St. Sebastian, now in the Vatican, the planks of which the tavola is composed are placed horizontally, or parallel with the shorter sides of the picture; in consequence of which the joinings are numerous. The upper and lower portions of this work are treated as distinct compositions, which may account for this arrangement.

† Richardson, speaking of the St. Cecilia of Raphael, says

siderable, would rather produce the contrary appearance. It would seem that the layer of paint, with its substratum, slightly operates to prevent the wood from contracting or becoming concave, on that side; it might therefore be concluded that a similar protection at the back, by equalising the conditions, would tend to keep the wood flat. The oak panel on which the picture by Van Eyck in the National Gallery is painted is protected at the back by a composition of gesso, size, and tow, over which a coat of black oil-paint was passed. This, whether added when the picture was executed or subsequently, has tended to preserve the wood (which is not at all wormeaten), and perhaps to prevent its warping.*

The judicious practice here noticed was almost the only precaution which the Italians overlooked: in other respects, the directions of Cennini relating to the preparation of panels evince extreme care. He first remarks that, if there should be any appearance of grease on the surface, there is no remedy but to entirely plane away the stained parts. A wood like that of the fir, which might throw out unctuous exudations, was on this account an unsafe material. Instances in which it has been used are sometimes to be met with in early English speci-

that the surface of the picture, opposite the flame of the candles on the altar, was " perfectly fried." (Vol. ii. p. 34.)

* When this expedient is adopted, it is necessary that the coating should not be too firm, but of such a nature as to expand or contract with the wood.

mens, and the ground has become detached in consequence. The Florentine writer recommends that any traces of iron nails in the wood should be covered with small plates of tin-foil, to cut off all communication from the rust. The surface of the panel was not to be too smooth: it was prepared for the gesso ground by two or three coats of size; the first being thinner than the others, in order the more effectually to adhere to the wood.*

The panel was now covered with " gesso grosso," mixed with the stronger parchment size. The gesso was first washed and sifted, but not with the extreme care required for the preparation of the material in its second application: it was therefore called " grosso." This first coat was spread on the plane panel with a *stecca* (a wooden or horn scraper, such as is now used), and on the relieved or ornamented parts with a brush. When this was dry, and when the surface was reduced to sufficient smoothness by instruments adapted for the purpose, the finer gesso, mixed with the same size, was passed over the first preparation with a soft brush. Eight layers at least of this finer composition were applied, each successive layer being spread in a direction contrary to that of the previous one. Cennini observes that relieved ornaments did not require so thick a coat, but that in the plane por-

* Trattato, cap. 113. The strength of the size is also described with sufficient exactness.

tions of the panel (constituting the ground of the picture properly so called) the gesso could hardly be too thick.*

A ground so prepared, however safe while in dry situations, is obviously liable to be softened by moisture; and this is another reason why it is less fit for cloth, which without due precautions may be accessible to damp at the back. Even on wood, a ground of this description, though covered (on one side) with colours mixed with oil, was not always safe; and the porous nature of the white poplar, as compared with oak or chestnut, may partly account for this. Vasari relates that an altar-piece by Ridolfo Ghirlandajo having been placed in a room full of bundles of green broom (prepared for fascines during the siege of Florence), the damp occasioned by them softened the gesso ground, and the surface becoming detached the artist had to repaint the picture.† Another, by Perino del Vaga, formerly in the church of S. Maria sopra Minerva in Rome, having been for a time half under water during an inundation of the Tiber, suffered in the same manner. In the latter

* Trattato, cap. 117. There is either a misprint or an error of the transcriber in this chapter of Cennini; it occurs more than once. "In fogliami e altri rilievi si passa di meno; ma in panni non se ne può dare troppo." He is not speaking of draperies (panni), but of plane surfaces (piani), as opposed to the relieved ornaments. In cap. 115. the parallel passage is correct: "ne' piani non se ne può dare troppo."

† Vita di Ridolfo, David, e Benedetto Grillandai.

case, Vasari remarks that the wood had swollen.*
The same writer gives, as a report only (e' dicono),
the story of Raphael's Spasimo di Sicilia having
floated from a wrecked vessel into the harbour of
Genoa†; but, if the account be true, it is to be
assumed that the edges and back of the picture
were well protected by a hydrofuge coating of some
kind. The wood, which is always thick in Raphael's
altar-pieces, was probably chestnut: the picture,
now in the Madrid Gallery, has been transferred
to cloth.

There can be no doubt, that, when rendered inac-
cessible to damp on all sides, this ground would be
durable under any circumstances: even cloth (not
intended to be rolled), if covered with wax at the
back, might be safely prepared with a size and
gesso ground. Without such a protection, especially
if the ground were thick, the ruin of the picture in
a humid situation would be inevitable. De Mayerne
states that a picture on cloth, by Abraham Latombe,
having hung for several years against the damp
wall of a church, the colour entirely separated, "à
cause de la colle." He consequently recommends a
priming with drying oil. It might indeed be in-
ferred that if panels require to be protected at the

* Vita di Perino del Vaga. The picture (on wood) of Venus
Anadyomene, by Apelles, preserved in Rome, in Pliny's time,
was irreparably injured in the lower half; possibly from a si-
milar cause. Plin. l. xxxv. c. 36.

† Vita di Raffaello. The picture was found "illesa e senza
macchia o difetto alcuno."

back, cloth must need such a safeguard much more. The preservation of the cloth itself by means of tan may be also recommended, as its good results have been tested by long experience.*

It should be remembered, that a picture on cloth is more liable to change if it be thinly painted; as, under such circumstances, it is exposed to the action of air, damp, and even dust, on both sides. In old pictures executed in this manner, and which have not been lined, it may even be remarked, that, where the bars of the stretching-frame behind afford a greater protection to the cloth, the colours are in a fresher state; the difference, which is sometimes very marked, corresponding exactly with the form of the woodwork. So, when such a picture is varnished, the narrow portions of the surface thus protected bear out, while the rest of the picture soon presents a different appearance. Thus, supposing thin painting to be preferred (as it very generally was in the early Flemish school), pictures so executed were calculated to retain their freshness much longer on panel than on cloth.

To return to the preparation of the ground: when the coats of finer gesso were perfectly dry, the surface was again carefully scraped, till, to use the words of Cennini, it was as white as milk and as smooth as ivory. Upon this surface the design

* See, in the Sixth Report of the Commissioners on the Fine Arts, a communication from Mr. Hamlet Millett respecting a mode of rendering canvass durable by means of tan.

was traced from a drawing or cartoon*; the forms
being afterwards fixed with a brownish ink, and
shaded like a drawing. This was the mode of
commencing a tempera picture; but the same pro-
cess was followed without change, or rather with
greater care, by the first oil painters. The follow-
ing details, relating to the habits of the early
Flemish and German masters, are recorded by Van
Mander in his *Elements of Painting.*†

"Our predecessors [he afterwards names Van
Eyck, Albert Durer, Lucas van Leyden, and
(Peter) Brueghel] were in the habit of spreading
the white ground over panels more thickly than we
do: they then scraped the surface as smooth as pos-
sible. They also used cartoons, which they laid on
the smooth fair white ground, and then sat down
and traced them, first rubbing any dark [powder]

* Cennini does not speak of a cartoon; but recommends that
the drawing should be first sketched on the white ground in
charcoal, and then outlined in ink with a minever pencil; the
shadows were washed in afterwards. Cap. 122.

† Den Grondt der Edel vry Schilder-Konst. Perhaps the
two earliest poems on painting — this by Van Mander, and
another by a Spanish writer, Cespedes — are for practical pur-
poses the best. The Flemish author has repelled most readers
by his antiquated language; and unfortunately the third
edition of his *Lives of the Painters,* a somewhat free transla-
tion in modern Dutch, does not contain the work here referred
to. Extracts only from the poem of Cespedes are printed
in Pacheco's *Arte de Pintura:* the MS. probably exists at
Cordova. On the merits of the work, see Cean Bermudez,
Diccionario, &c.

over the back of the drawing. They then drew in
the design, beautifully, with black chalk or pencil.
But an excellent method, which some adopted, was
to grind coal black finely in water; with this they
drew in and shaded their designs with all possible
care. They then delicately spread over the out-
line a thin priming through which every form was
seen, the operation being calculated accordingly;
and this priming was flesh-coloured."* The mar-
ginal heading to this passage is: "They drew
their designs on the white ground, and then passed
an oil-priming over them." †

A picture by Giovanni Bellini, in the Florence

* " Ons moderne Voorders voor henen plochten
 Hun penneelen dicker als wy te witten,
 En schaefdens' alsoo glat als sy wel mochten,
 Ghebruyckten oock cartoenen, die sy brochten
 Op dit effen schoon wit, en ginghen sitten
 Dit doortrecken soo met eenich besmitten,
 Van achter ghewreven, en trockent moykens
 Daer nae met swarte krijkens oft potloykens.

 " Maer t' fraeyste was dit, dat sommighe namen
 Eenich sme-kool swart, al fijntgens ghewreven
 Met water, jae trocken en diepten t' samen
 Hun dinghen seer vlijtich naer het betamen :
 Dan hebbenser aerdich over ghegheven
 Een dunne primuersel, alwaer men even
 Wel alles mocht doorsien, ghestelt voordachtich :
 End' het primuersel was carnatiachtich."

Het Schilder-Boeck (1604), p. 47. verso.

† "Trocken hun dinghen op het wit, en primuerden daer
olyachtich over."

Gallery, is thus drawn and shaded on a white ground, preparatory to its completion in oil colours. A Van Eyck, now in the Academy at Antwerp, representing St. Barbara, is in the same state; the sky only being coloured. Various unfinished pictures by Leonardo da Vinci, Frà Bartolommeo, and others, clearly exhibit the same process. A picture, so prepared, was in a certain sense a finished work; and this may account for so many examples of the kind having been preserved. Cennini's words, in reference to such productions, are remarkable: " E così ti rimarrà un disegno vago, che farai innamorato ogni uomo de' fatti tuoi." *

It is thus evident, as might indeed be reasonably inferred, that, in the first practice of oil painting, the habits of the Italian and Transalpine painters closely corresponded: but, while the Italians, as already noticed, gradually modified the process first adopted, the Flemish artists remained more constant to their traditional methods. The perfection of Van Eyck's technical system is even appa·rent in the works of Rubens, notwithstanding the vast difference of style between the two painters.

It has been seen that a transparent warm tint in oil (that is, an oleo-resinous medium†) was spread

* Cap. 122.

† It is to be remembered that in the early Flemish practice the medium, or vehicle, was always more or less oleo-resinous. The method partly survived in some Italian schools. Armenini

over the outline and white ground. The important question now arises: Was the ground absorbent or not? All writers on the technical processes of painting who have touched on this subject have followed each other in extolling the chalk or gesso grounds of the early painters; because such grounds, they assume, by absorbing the oil, removed in some degree the cause of yellowness in the colours, and thus insured the durability and freshness of the tints. This opinion, as regards the nature of the ground, is erroneous. It is true that the Venetians, when they painted on cloth, generally (but not always) spread so thin a coat of the white ground that the oil penetrated to the back of the picture. In proof of this it may be observed, before such pictures are lined, that the cloth is often embrowned as if it had undergone a slow combustion, and the principal forms and masses of the composition have stained through it. But in many cases even on cloth, and universally on wood, the early masters purposely prevented the absorption of the oil. The strength of the size mixed with the gesso was not of itself sufficient to prevent this; it was not desirable to have too firm a ground, since it was then liable to crack. When Vasari, speaking of a

recommends a flesh-coloured priming mixed with a certain proportion of common (sandarac) varnish ; but, according to his directions, this priming was not transparent but solid, the outline being traced upon it. (*De' veri Precetti della Pittura,* in Ravenna, 1587, lib. ii. p. 125.)

picture on wood by Giovan Francesco Caroto, says that the gesso cracked " per essere mal stemperato," he probably means that the size was too firm.*

The question, whether the ground was absorbent or not, can be determined with certainty by the examination of pictures; but documentary evidence also is not wanting. The older oil pictures on wood have been subject to so many vicissitudes that it is very rare to find a surface which, either from the warping of the panel or from other accidents, is not more or less cracked; in consequence of which, small laminæ of paint sometimes become entirely detached from the ground. In all such cases, and however thin the painted film may be, the ground so exposed will be found perfectly white. Had it been absorbent it would have been yellow, if not brown, with oil.

But there is a still more decisive mode of settling this question by a sort of " experimentum crucis." Pictures are sometimes transferred from panel to cloth. The front being secured by smooth paper or linen, the picture is laid on its face and the wood is gradually planed and scraped away. At last the ground appears; first, the " gesso grosso," then, next the painted surface, the " gesso sottile." On scraping this it is found that it is whitest immediately next the colours; for on the inner side it may sometimes have received slight stains from the wood, if

* Vita di Frà Giocondo ed altri.

the latter was not first sized. When a picture which happens to be much cracked has been oiled or varnished, the fluid will sometimes penetrate through the cracks into the ground, which in such parts had become accessible. In that case the white ground is stained in lines only, corresponding in their direction with the cracks of the picture. This last circumstance also proves that the ground was not sufficiently hard in itself to prevent the absorption of oil.

Accordingly, it required to be rendered non-absorbent by a coating of size; and this was passed *over* the outline, before the oil-priming was applied. Cennini, speaking of painting in oil on walls, says: "Draw your subject with charcoal, and fix the design either with ink or with verdaccio [a dull green] duly tempered. Then take a little size well diluted . . . and, either with a sponge or with a soft and broad brush, pass it once over all the surface to be painted; and leave it to dry at least for a day."* Elsewhere: " How to paint in oil on iron, on panel, or on stone. And in the same manner paint on iron, or every stone surface, every panel; always giving a coat of size first."†

* "Poi disegna con carbone la tua storia, e fermala o con inchiostro o con verdaccio temperato. Poi abbia un poco di colla bene inacquata. Poi, o vuoi con ispugna o vuoi col pennello morbido e mozzetto, daine una volta per tutto 'l campo che hai a lavorare; e lascialo asciugare almen per un dì." — Cap. 90.

† "Come dei lavorare ad olio in ferro, in tavola, in pietra.

Vasari is equally conclusive, although his directions relate to a more modern, and in some respects, a degenerate practice. He says : " Having covered the panels with a gesso ground, they scrape the surface, and, having given four or five coats of very thin size with a sponge, they proceed to grind their colours with nut or linseed oil (although nut oil is better, because it ,yellows less)." * He then directs that a dusky mixture of colours (not to be recommended) should be spread over this sized ground. We have here an instance of a traditional process surviving the motive which gave rise to it. There was obviously no reason for protecting the white ground in this case, as it was to be entirely shut out by the thick priming. The absorption of the oil was effectually, and it would seem needlessly, prevented; but Vasari, in describing this process, unconsciously records the earlier method. The outline, he proceeds to say, might be drawn either with charcoal or with white chalk on the dark priming.

Palomino, who notices the mode in which the early masters prepared their panels, is no less clear on the point in question. After describing the

E per lo simile in ferro lavora, e ogni pietra, ogni tavola, incollando sempre prima; " &c. — Cap. 94.

* " Ingessato che hanno le tavole o quadri, gli radono, e, datovi di dolcissima colla quattro o cinque mani con una spugna, vanno poi macinando i colori con olio di noce o di seme di lino (benchè il noce è meglio, perchè ingialla meno)," &c. — *Introduzione*, cap. 21.

application of the two kinds of gesso (" yeso pardo" and "yeso mate") he says : " At last, having made the surface very smooth, they gave it a coat of size, and, after that, one or two of the oil-priming." *

Van Mander, in the description above quoted, omits to mention the size (not only as applied over the outline, but over the wood before the gesso was spread); but he indirectly alludes to it in another passage, where he speaks of the difficulty of using smalt. The effect of this colour is much injured by its sinking in the oil, and various contrivances have been resorted to, in all schools, to remove the superfluous fluid. Some of these contrivances are enumerated by the Flemish writer. He observes : " On this account some prick the panel with needles; some blow blotting paper close upon the surface, suffering it to remain for a time, so as to absorb the oil; some paint with poppy oil, and others, for the same purpose, use prepared [bleached] oils."†

* " Y últimamente lixandola despues con lixa muy suave y usada, darle una mano de cola de retazo, y despues de ella, una ó dos de imprimacion á el olio."—*El Museo Pictorico*, tomo segundo, p. 49.

† 　" De Smalten behoeven wel in te schieten,
　　Hierom eenighe prickelen met naelden
　　Dicht hun penneelen, om sulx te ghenieten,
　　Sommighe bliesen cladtpapier, en lieten
　　Die daer op ligghen, waer mede sy haelden
　　D' oly daer uyt, en eenigh' ander maelden
　　Met Heulsaeds oly, ander van ghelijcken
　　Ghebruycken oly ghemaeckt met practijcken."
　　　　　　　　　Het Schilder-Boeck, p. 50.

The object was to prevent the alteration of the smalt, either by removing the superfluous oil or by using it in as colourless a state as possible. The first remedy noticed, that of pricking the ground, shows, first, that the surface was, in its ordinary state, impermeable to the oil, and, secondly, that when that surface was perforated the ground within could absorb the fluid. The ground was, therefore, coated with size.

Thus the warm transparent oil priming, which Van Mander says was spread over the outline, left the sized white ground unstained. Had the ground been absorbent, it would have ceased to be white. It was an object with the early Flemish masters to preserve its splendour unimpaired. Many of them, like the Van Eycks, were glass-painters* : they knew the value of light behind colours. Not only in stained glass, but in the " translucid painting " of the middle ages (in which method colours derived effect from being glazed over sheets of metal foil), they were accustomed to the brilliant effect of internal light. The method of these inventors of the art, as regards the gesso preparation and its use, was still followed by Rubens and the painters of his time, when (as was generally the case) they

* See in Houbraken (*De Groote Schouburgh der Nederlantsche Konstschilders*, Amsterdam, 1718, vol. i. p. 15.) a list of painters of this school who were also glass-painters, from Lucas van Leyden to the father of Vandyck.

employed white grounds. The picture of the
Judgment of Paris, by Rubens, in the National
Gallery, is an example; it is painted on a per-
fectly white gesso ground, which must have been
first sized, for there are sufficient indications that
its brightness was unstained with oil. The thin
painting of the early Flemish masters (a system
preserved even by their successors in the treatment
of shadows) was thus calculated on the effect of
the white ground within it; and such a system
being once adopted, the solidity of wood was essen-
tial to the durability of their tints.

It will now be apparent, that, if any portion of a
picture, begun in the mode described, was executed
in tempera, it must have been so prepared before
the oil priming was applied. It is indeed very
probable, that the reddish (carnatiachtich) priming
with an oleo-resinous vehicle, which was passed over
the finished design, was a vestige of the old practice
of covering tempera pictures with a varnish of a
similar tint*, the difference being that the tempera
was now a light chiaroscuro painting only, which
was still to receive its rich shadows and colours, and
to be completed with an oleo-resinous vehicle. The

* The indirect evidence afforded by Armenini (lib. ii.)
on this point is remarkable. Speaking of a priming for oil
pictures, he observes that it was a flesh-tint inclining to flame
colour in consequence of the immixture of (common) varnish
with it. The warm tint of the customary sandarac varnish has
been before noticed.

Flemish historian naturally records these operations as original methods; but, in comparing them with the history of the art which has now been traced, they will appear only as connecting links with a previous practice. Descamps observes that the pictures by Memling in the Hospital of St. John at Bruges are in tempera.* This was, perhaps, a gratuitous assertion, as it is unsupported by any known authority; but, if it have any foundation, it is to be assumed that the design, which, according to custom, was completed before the oil-priming was added, was carried further than usual, so as to amount to a tempera preparation.

The light warm tint which Van Mander assumes to have been generally used in the oil-priming was sometimes omitted, as unfinished pictures prove. Under such circumstances, the picture may have been executed at once on the sized outline. In the works of Lucas van Leyden, and sometimes in those of Albert Durer, the thin yet brilliant lights exhibit a still brighter ground underneath. Again, in a later practice, the colour of the preparation was by no means restricted to a flesh-tint.

The priming being quite dry (for, if it was not, the superadded colours would sink in), the shadows were painted in with a rich transparent brown mixed with a somewhat thick oleo-resinous vehicle of the firmer kind before described. The outlines

* La Vie des Peintres Flamands, &c., tome i. p. 14, 15.

of the lighter parts were not necessarily repeated, since the drawing underneath exhibited all the forms: the minuter darks, though executed with a thinner vehicle, still had the effect of rendering such shades more prominent than the lights. The painters of the sixteenth century often followed the process of the earlier masters in this respect.*

Those of the later artists who drew in their composition (without the previous sketch underneath) on the oil priming, diluted the brown outline colour accordingly. Van Mander observes: "There are others who, having with great pains and study collected sketches and drawings in abundance, combine them in their work, and produce a clean and distinct outline from such materials, according to the design which they have conceived. They either make this outline on the priming, with a single colour, thinly tempered, which can flow readily, or draw it with a dry point, leaving it in a clean state." †
The original method was, perhaps, never entirely

* Compare Van Mander, Het Schilder-Boeck, p. 254. 298.

† "Ander zijnder, die met veel moeyten swaerlijck
　　Wt schetsen oft teyckeninghen met hoopen
　　Hun dinghen te samen rapen eenpaerlijck,
　　En teyckenen daer nae suyver en claerli ck,
　　Volcoomlijck wat sy in den sin beknoopen,
　　Op t' primuersel, met een verwe, die loopen
　　Can, dunne ghetempert, oft treckent netlijck
　　Met Potloot, en vaghent reyn onbesmetlijck."

Het Schilder-Boeck, p. 47.

laid aside: a light sketch, under the size, would serve as a guide for the brown outline, which was freely drawn upon the priming.

When the transparent brown shadows were added throughout the work, in the mode described, the half-tints being also more or less indicated by the same means, the work was tolerably complete as to its chiaroscuro. Examples of pictures in this state are common; but, according to the earlier and often-revived process, as the solid or opaque portions of the work were executed at once, and consequently in parts, so the shadows, though always painted first, were, in like manner, inserted as the work proceeded. Care was taken not to disturb the transparency of the darker shadows by the unnecessary immixture of opaque pigments, and the bright ground was preserved under the lights by not loading them. The vehicle for the light pigments was thinner than that used for the shadows. This, it is repeated, is evident from the fact, that the shadows, in the early Flemish works, are uniformly more raised than the lights.*

The habits of the first oil painters were in many circumstances influenced by the practice of tempera. It has been stated that portions were finished at a time, the ground being left untouched elsewhere.

* Michiels (*Histoire de la Peinture Flamande,* &c., vol. ii. p. 145.) speaks of a picture by Margaret Van Eyck, " où les carnations ayant été peintes très légèrement, les autres parties du tableau forment saillie."

That this was partly derived from the older habit may appear from the observation of Cennini, who, speaking of tempera, directs that the heads should be finished last. Such portions thus remained, for a time, light spots, while the rest of the picture was completed. Whatever parts were first begun by the oil painters (and it appears that they did not reserve the flesh for the last), the ground was, in this manner, left untouched in many places, while other portions were completed. Thus the unfinished Leonardo da Vinci in the Gallery at Milan has some parts — among others the head of the Virgin — nearly completed, while a mass of drapery, the lamb, and some of the background, remain carefully outlined (apparently traced) on a white ground.

The process of the early Flemish oil painters was, in this respect, the same. Van Mander writes : " When this [the priming] was dry, they saw their design distinctly through it, already half-completed. Upon this they proceeded carefully to lay all [the shadows and tints], executing the work with extraordinary care and attention. They did not load the colour, but used it thin and sparingly, in order that the tints might be clear and glowing [by showing the light ground through them]."* The marginal heading to this passage is : " They mostly finished their works at

* " Als dit nu droogh was, saghen sy hun dinghen
 Schier daer half geschildert voor ooghen claerlijck,

once."* In another such heading we read : " Each colour, in order not to fade, is to be put in its place at once."†

In his account of Jeronimus Bos (a later painter, who, perhaps from often treating fantastic subjects, had a freer hand), the same writer says: " He had a firm, rapid, and very agreeable execution, often finishing his works at the first painting; yet those works have stood perfectly well, and without changing. Like other old masters he had a mode of drawing and tracing his subjects on the white panel; he then passed a transparent flesh-coloured priming over the design, often suffering the ground to contribute to the effect of his work." ‡ In his account of Jan de Hollander, a painter of the six-

> Waer op sy alles net aenlegghen ginghen,
> En ten eersten op doen, met sonderlinghen
> Arbeydt en vlijt, en de verwe niet swaerlijck
> Daer op verladende, maer dun en spaerlijck,
> Seer edelijck gheleyt, gloeyend' en reyntgens,
> Met wit hayrkens aerdich ghetrocken cleyntgens."
>
> *Het Schilder Boeck,* p. 48.

* " Deden hun dinghen veel ten eerstē op." — Ib.

† " Elcke verwe van eerst op haer plaets legghen, om niet verstervē." — Ib. p. 47.

‡ " Hy hadde een vaste en seer verdighe en aerdighe handelinghe, doende veel zijn dinghen ten eersten op, het welck nochtans sonder veranderen seer schoon blijft. Hy hadde oock als meer ander oude Meesters de maniere zijn dinghen te teeckenen en trecken op het wit der Penneelen, en daer over een doorschijnigh carnatiachtigh primuersel te legghen, en liet oock dickwils de gronden mede werckē." — Ib. p. 216. verso.

teenth century, the biographer remarks: " He was in the habit of making the ground of his panel or cloth tell, by painting loosely over it; a method which [Peter] Breughel imitated in a peculiar manner."* Again, speaking of an elaborate altar-piece, by Peter Aartsen, which was destroyed by the iconoclasts, Van Mander says: " The cartoon — as large as the painting itself—is still at Amsterdam. This [altar-piece] was an excellent work, handled in a masterly and manly style; the flesh, as well as some other parts, being mostly finished at once on the outline; and the whole was so judiciously executed that at a distance (whence the work required to be viewed) the effect was extremely powerful." *

These passages are sufficient to show that the

* " Veel had hy oock de manier van al swadderende op de Penneelen oft doecken de gronden mede te laten spelen, het welck Brueghel seer eyghentlijck nae volghde." — *Het Schilder-Boeck*, p. 215.

† " Van de Tafel is noch den Carton, so groot als t' werck is geweest, tot Amsterdam: het is geweest een uytgenomen heerlijck werck, meesterlijck en manlijck aenghetast, de naeckten en anders veel ten eersten op de teyckeninghe opgedaen wesende, en soo aendachtig, dat het van verre (ghelijck het uyt der ooghe most staen) hadde eenen uytnemenden grooten welstandt." — Ib. p. 244.

Van Mander mentions other works by this painter which were destroyed by the Protestant iconoclasts; and the editor of the third edition of the *Schilder-Boeck* adds that a large altar-piece by Aartsen, originally at Warmenhuizen in North Holland, representing the Crucifixion, was, in 1566, " hewn in pieces with axes by the senseless peasants," though a lady of Alkmaar offered a large sum to save it.

practice of finishing at once on the prepared out-
line was by no means uncommon even with the
earlier masters. When, therefore, Van Mander
speaks of the dead colour (dootverwe) of Van
Eyck, he probably means the chiaroscuro prepara-
tion, which, whether a shaded drawing on the
white ground or a tempera painting, was executed
on the panel before the size and priming were
added. He observes: " His [Van Eyck's] dead
colourings were cleaner and sharper than the
finished works of other painters, and I remember
to have seen, in the house of my master Lucas de
Heere, at Ghent, a portrait of a female, with a land-
scape behind, which was dead-coloured only, but yet
very neatly and evenly executed."* As regards the
subject, this description nearly corresponds with
the chiaroscuro picture of St. Barbara above men-
tioned, in the Antwerp Gallery. There can be no
doubt that the term " dead colour " was afterwards
applied, as it now is, to pictures prepared, indeed,
with colours, but without their full vivacity; at an
earlier period, however, it seems that the expres-
sion was understood more literally, and that it was
applied to works executed almost in chiaroscuro.

* " Sijn dootverwe was veel suyverder en scherper gedaen
als ander Meesters opghedaen dinghen wesen mochten, alsoo
my wel voorstaet dat ick een cleen conterfeytselken van een
Vrouw-mensch van hem hebbe ghesien, met een Landtschapken
achter, dat maer gedootverwet was, en nochtans seer uytnemende
net en glat, en was ten huyse van mijn meester, Lucas de
Heere, te Gent." — *Het Schilder-Boeck*, p. 202.

For the rest, the above extracts, corroborated as they are by other accounts and by existing works, establish with certainty the preparatory methods of the early Flemish painters. The claims of Van Mander himself, as a competent judge of art, are not to be overlooked. The biographer was born at Meulbeek in 1548, and died in 1606 at Amsterdam, having settled in Holland to avoid the troubles in his own country.* His work was published in 1604. He studied painting first under Lucas de Heere, and then under Peter Vlieric, whom he quitted in 1569 : he afterwards visited Italy, where he remained nearly three years. His professional life and experience thus belong to the sixteenth century. He was evidently well acquainted with the works of those whose merit he records, and his evidence on the technical processes which he describes is unquestionably valuable. That evidence strictly relates to the early Flemish school. He had ceased to live before the younger Teniers was born, and he appears to have known nothing of Rubens, since he makes no mention of the great painter in the biography of Otho Venius, nor in a short notice of Adam van Oort, with both of whom Rubens studied.† His

* See his romantic history at the end of the second edition of the *Schilder-Boeck*, Amsterdam, 1618. The principal events are detailed in Johanna Schopenhauer's *Johann Van Eyck und seine Nachfolger*, Frankfurt a. M. 1822, vol. ii. p. 180.

† Rubens was twenty-seven when Van Mander's work was

testimony respecting the methods of the Nether-
lands school is therefore quite independent of the
authority which those methods derived from the
works and influence of Rubens.

In reviewing the statements of this important
witness, and in further consulting his biographies,
it is impossible not to be struck with the great
attention to drawing which the Flemish process
required. When the habit of making cartoons for
oil pictures was nearly obsolete in Italy, it was
still considered indispensable in Flanders and Hol-
land. Peter Aartsen, a painter before mentioned
among those who often finished their works at
once, left twenty-five cartoons, from which many
altar-pieces had been executed.* Van Mander's
frequent mention of designs, some of which were
on a large scale, shows that the early practice of
deciding every thing before the picture was begun
was still common in his time. The mannerism
which prevailed in the latter part of the sixteenth
century did not affect the technical habits of the
school. Spranger and (Henry) Goltzius made
finished drawings as preparations for pictures, and
the biographer observes that those designers were

published ; his absence in Italy may account for the silence of
the biographer. It would seem, however, that at the age of
twenty-three, when he quitted Flanders on his travels, he had
made no great impression.

* Het Schilder-Boeck, p. 244.

unsurpassed in the management of the pen.* The precision required in smaller works had recommended that instrument to the earlier masters, and the transition to etching and engraving, as in the instance of Lucas van Leyden and others, is thus explained. De Bie, in a general description of the preparatory studies of the Flemish painters, alludes to the use of the pen in drawing, as no less familiar than that of the portcrayon.†

It thus appears that the method proposed by the inventors of oil painting, of preserving light within the colours, involved a certain order of processes. The principal conditions were: first, that the outline should be completed on the panel before the painting, properly so called, was begun. The object, in thus defining the forms, was to avoid alterations and repaintings, which might ultimately render the ground useless without supplying its place. Another condition was to avoid loading the opaque colours. This limitation was not essential with regard to the transparent colours, as such could hardly exclude the bright ground: their prominence in comparison with the lights was,

* Het Schilder-Boeck, p. 273. verso, p. 285. Van Mander remarks that Goltzius used the pen even on cloths primed for oil painting.

† "Leert reuselen met cryt, leert mette penne trecken."—*Het Gulden Cabinet,* tot Lier, 1661, p. 29. Compare p. 195. Hoogstraten also observes that, for giving precision and force to drawings, the pen is the fittest instrument. (*Inleyding tot de Hooge Schoole der Schilderkonst,* tot Rotterdam, 1678, p. 31.)

however, partly the consequence of their being applied with a thick but lucid vehicle. Another consequence of this process was, that tints were mixed to the local hues required. This method (which is indispensable in fresco and tempera painting) may have been continued partly from mere habit.* Cennini gives the same directions for mixing tints in oil as in tempera.†

The practice of using compound tints has not been approved by colourists ‡; the method, as introduced by the early masters, was adapted to certain conditions, but, like many of their processes, was afterwards misapplied. Vasari informs us that Lorenzo di Credi, whose exaggerated nicety in technical details almost equalled that of Gerard Dow, was in the habit of mixing about thirty tints before he began to work.§ The opposite extreme

* Van Mander takes occasion to remark that the practice of fresco painters in mixing tints is no less convenient for oil painters. (*Het Schilder-Boeck*, p. 31.) The marginal heading to the passage referred to is: "The mixing of tints is no loss of time but is very useful." "'T' verwen tēperen is geen tijdt-verlies maer is seer voorderlijck."

† Trattato, cap. 113.

‡ Compare Reynolds, notes on Du Fresnoy's *Art of Painting*, note xxxvii. Wilson, happening to pay a visit to George Lambert, the landscape-painter, noticed the manner in which that artist's palette was prepared; he afterwards observed to a friend, that the cow and the hay to be eaten by the animal were already visible among Lambert's prepared tints. The anecdote was related by Sir George Beaumont.

§ Vita di Lorenzo di Credi.

is perhaps no less objectionable.* Much may depend on the skilful use of the ground. The purest colour in an opaque state and superficially light only, is less brilliant than the foulest mixture through which light shines. Hence, as long as the white ground was visible within the tints, the habit of matching colours from nature (no matter by what complication of hues, provided the ingredients were not chemically injurious to each other) was likely to combine the truth of negative hues with clearness. Such a method would succeed best where the local colour, however neutral, was but little diversified; as in draperies and similar substances. But in flesh, which, strictly speaking, has no local colour, this mode of matching the hues of nature is less possible: it is still more difficult as regards the shadows. Accordingly, it is in delicate carnations that Van Eyck is least successful; the shadows especially are not always true: but in the imitation of darker complexions and the colours of inanimate objects, a vivid reality was often attained by such means.

Inquiries respecting the implements used by the early painters can, generally, possess little interest except for the antiquary; there are cases, however, where such investigations may illustrate the habits of those painters with regard to their style of

* " But if you imagine you can make a pallett of the picture, to make mixtures theare, you will make madd work." — *Harleian MS.* No. 2337. supposed to be written by Riley.

colouring. Strange as it must now seem, all evidence hitherto brought to light tends to prove that the painter's palette was not in use in the beginning of the fifteenth century. Cennini, who is most minute in his descriptions, does not mention it; nor does there appear to be any allusion to it in medieval writers. But if it was not in use in its present form, it may still be supposed that a tablet was at hand which answered the same purpose, or on which the colours were tried.*

The tints required for the portion of work in hand were placed in small cups. The ancient artists in encaustic used shells for this purpose†,

* It would appear, from a passage in Van Mander, that fresco painters still used "tablets and boards" when oil painters used "palettes."

> "In sulcker manier, als op seker Wetten,
> Bereyden haer tavelotsen, oft borden,
> Die op't natte calck haer te wercken setten,
> Ende d' olyverwers op haer palletten."
>
> *Het Schilder-Boeck*, p. 31.

Palomino remarks that the larger palettes (for oil painting) were not held in the hand, but were fastened on stools beside the painter. (*El Museo*, &c. tom. ii. p. 40.) De Mayerne (*MS.* p. 145. verso) uses the expression, "palette à poignée," thus distinguishing the smaller implement.

Vasari's word, *tavolella* (palette), it will be remembered, is the diminutive of *tavola ;* and *paleta* (a word used by the Venetians for a small altar-piece) stands in the same relation to *pala*.

† "Pictoris instrumento legato, ceræ, colores, similiaque horum legato cedunt : item periculi, cauteria, et conchæ." — *Martianus,* lib. xvii. ; quoted by Wiegman, *Die Malerei der Alten.*

and the Byzantine painters continued the practice. A copy of a drawing, supposed to be of the ninth century, representing St. Luke painting the Virgin, is published in Ottley's *Italian School of Design.* The artist holds a brush in one hand and a small shell in the other. In the MSS. of Alcherius colours are mixed in shells. In the Venetian manuscript *caparoze* (shells) are repeatedly mentioned in reference to the same purpose. They were commonly used by the Spanish oil painters*, and were employed in miniature-painting in the seventeenth century †: the practice in that art is, even now, not altogether obsolete.‡ The more liquid colours of the fresco and tempera painters

* Cespedes, in his poem before mentioned, says :

> " Sea argentada concha, do el tesoro,
> Crecio del mar, en el extremo seno,
> La que guarde el carmin, i guarde el oro,
> El verde, el blanco, i el azul sereno."
> Quoted by Pacheco, *Arte de Pintura*, p. 369.

† De Mayerne alludes to this habit in speaking of Huskins (Hoskins) the miniature-painter. He also mentions "pots ou coquilles," in which the colours of tempera painters were kept.

‡ In oil painting the tradition does not appear to have survived the 17th century. Norgate, in a MS. (to be hereafter noticed) on " Limning " and oil painting, written about the year 1634, observes, in his directions for the latter : " You must have shells allsoe to put your colours in after they be grownd, with tinfoil to cover them," &c. Wilson had probably no intention of imitating the ancients, when he mixed his *meguilp* in an oyster shell. See Wright, Some Account of the Life of Richard Wilson, Esq. R. A., London, 1824, p. 20.

required less shallow vessels: these are called *vaselli*, *vasellini*, and *alberelli*, by Cennini and Vasari; and *scudellini* by other writers. The contrivances for keeping them at hand were sometimes curious. Vasari, speaking of Aspertini of Bologna, ridicules his habit of painting with a girdle round him stuck with small pots of colour.*

Those who are curious to trace the history of painters' implements, and particularly of the palette, might compare the numerous representations of St. Luke painting the Virgin. In Van Eyck's picture of this scene, the patron of the art is making a drawing only; he has no colours at hand. Such was the mode in which the Flemish artist himself would study a portrait intended to be painted. Raphael, in treating the same subject, has placed a vasellino in the Saint's left hand: he may have done so from a desire to follow the older representations: the circumstance cannot, in this instance, be considered as evidence that the painters of the time (and the picture is not an early work of the master) did not use the palette. In the "Hortulus Anime," printed at Nuremberg in 1519, St. Luke holds the modern implement. In later

* "Ma quello che era più bello e da ridere si è, che stando cinto, aveva intorno intorno piena la correggia di pignatti pieni di colori temperati, di modo che pareva il diavolo di S. Macario con quelle sue tante ampolle; e quando lavorava con gli occhiali al naso, arebbe fatto ridere i sassi." — *Vita di Bagnacavallo.*

representations of the sixteenth century, the only remarkable circumstance is the diminutive size of the palette. This is no less striking in some of the portraits of artists accompanying the eulogies of Lampsonius.* The habit is perhaps to be traced to the practice of finishing portions of a picture at once (for which few tints would be required), a practice which, as above shown, was at first common: it also indicates a previous preparation of the tints. Later painters, who adopted a freer system, appear to have had no resource but either to use several palettes, and, like Guido, to change them often, or to keep the larger implement, described by Palomino, beside them.†

For a considerable period after the introduction of the improved oil painting, colours were kept in a dry state, and were mixed with the vehicle, in the quantity required, immediately before they were used. They were ground, as has been seen, in a

* Elogia in Effigies Pictorum celebrium Germaniæ inferioris. Antw., 1572.

† Malvasia, Felsina Pittrice, vol. ii. p. 64. Ridolfi (*Le Maraviglie dell' Arte*, vol. i. p. 49.), in gratuitously stating that Antonello da Messina was observed by Giovanni Bellini to dip his brush occasionally in linseed oil, at least described the habit of his own time. Others employed an essential oil for the same purpose. In the latter practice (which was common in the 16th and 17th centuries) the earlier masters may have thought that there was a danger of diluting the pigments unequally, and of not preserving a homogeneous surface. Their tints were prepared in the precise state in which they were to be applied.

pure drying oil; afterwards, a few drops of varnish were added to each tint, the quality of the varnish being varied according to the nature of the colour. The earliest notices of oil colours being kept in bladders occur in English treatises. It would seem that the frequent visits of Dutch and Flemish painters to this country suggested the mode of carrying prepared pigments in a convenient form: itinerant portrait-painters, especially, could, by such a contrivance, be more quickly prepared when their services were required.* The modern practice of keeping colours in this state has been necessarily influenced by views altogether different from those which would guide painters. The colour merchant prepared such materials so that they should not spoil on his hands; in other

* " I remember I had a parcel of colours given me in the year 1661, by a neighbouring yeoman, that were, as he said, left at his house by a trooper that quartered there in the time of the wars, about the year 1644. This man was by profession a picture-drawer, and his colours were all tyed up in bladders according to the method before prescribed," &c. — *Smith's Art of Painting in Oyl*, (5th edition, 1723) p. 4.

Palomino, whose *Museo Pictorico* was first published in 1715, communicates the method of tying colours in bladders as a new discovery. " Modo curioso de conservar los colores molidos á el olio," &c. vol. ii. p. 54. The necessity of moistening the pieces of bladder in water before the colour is placed in them may be mentioned among the objections to this practice. Metal tubes, although they may partially affect some tints, are on the whole preferable. See a paper by Mr. Linton in the *Sixth Report of the Commissioners on the Fine Arts*, p. 24. note.

words, so that they should not easily dry. The early painters, on the contrary, ground or mixed their colours in vehicles of different drying tendencies according to the nature of the pigment; and as the small quantity required was prepared for the occasion only, or was to last but a short time, the spoiling even of a certain portion would be of no consequence. The habits of the older masters, in the preparation of colours and in the mode of using certain pigments, will be further illustrated in the next Chapter.

The leading methods which have been described differ in many respects from those of the Italian, and, in some, from those of the later Flemish masters. Painters of all schools have, indeed, recognised the principle that colours derive brilliancy from light within them; but it was soon found that this object could be attained by various means. It matters not, for example, whether the internal brightness reside in the light ground, or whether it be reproduced at any stage of the work. A preparation of the latter description, answering the same end as the white panel, may consist in a light but very solid painting, by means of which the composition may be defined; and, when such a preparation is thickly painted, the colour of the ground underneath it is obviously unimportant. This conviction may have led to the introduction of dusky grounds; but the indispensable condition of a solid and lighter covering upon such a priming

was gradually overlooked: some later Italian pictures exhibit the thin painting of the older Flemish masters on grounds requiring a contrary treatment, and premature decay has been uniformly the consequence. The opposite precaution, though apparently needless, is to be recommended; viz. that of employing a light ground, even when the picture is intended to be solidly painted. This was often Rembrandt's practice: it indicates his having reckoned on the possibility, at least, of leaving his ground; accordingly it is sometimes apparent even in those of his pictures which are (partially) loaded with colour.

It is evident that if cloth be employed instead of wood, and if the ground or preparation be thin, the colours constituting the picture or its substratum require to be applied in considerable body, in order to exclude air or damp from the back. The bad consequences of a neglect of this have been already noticed. There is thus a plain reason for solid painting on cloth, which is not applicable to panels; and, as the Venetian oil painters happened to prefer cloth from the first, their whole process was soon influenced by this circumstance, and differed widely in its means, though not in its end, from that of the Flemish masters.

When Rubens remarked that wood was preferable for small pictures, he may, therefore, have meant that the solidity which is indispensable for works executed on cloth may be too apparent,

since small pictures can only be seen near. This and other principles of the kind, founded on a not unreasonable attention to the impressions of the ordinary spectator, were, however, set at nought by those who, like Rembrandt, considered art as an acknowledged convention, and who thought it at least unnecessary to conceal its means. It is also to be remembered, that, if a certain smoothness of surface be desired at last, the substance required may be furnished by a sufficiently thick ground (such as Armenini describes); the solidity of the picture, properly so called, is then not so essential.

It was observed that the system of colouring adopted by the Van Eycks may have been influenced by the practice of glass-painting. They appear, in their first efforts at least, to have considered the white panel as representing light behind a coloured and transparent medium, and aimed at giving brilliancy to their tints by allowing the white ground to shine through them. If those painters and their followers erred, it was in sometimes too literally carrying out this principle. Their lights are always transparent (mere white excepted) and their shadows sometimes want depth. This is in accordance with the effect of glass-staining, in which transparency may cease with darkness but never with light. The superior method of Rubens consisted in preserving transparency chiefly in his darks, and in contrasting their lucid

depth with solid lights. Shadows produced in the
mode of Rubens and Teniers are already, strictly
speaking, glazed, a transparent colour being passed
over a light ground to produce them. The ultimate
glazings of the Italian schools were, therefore, less
necessary in the Flemish process, and, accordingly,
were seldom employed. They could, indeed, only
be required for the lights; and Rubens, in many
instances, seems to have calculated on the effects
of time, as sufficient for this object. He may have
thought that the quality of depth, though desirable
throughout a picture, should at all times be most
apparent in shadows; and that this, their distin-
guishing attribute, would be less effective if the
lights were treated on the same principle. The
crudeness of bright pigments may undoubtedly be
toned, to a certain extent, by the film which ac-
cumulates with age, to say nothing of the effect of
varnishes; but, where transparency (no matter how
produced) is wanting, in any degree, in shadows,
time rather increases the defect.*

* The proverb of the Italians, " il Tempo dipinge," is to
be understood chiefly of the tone which solid lights may
acquire. A critic of the last century, dwelling on the qualities
which time cannot confer, observes : " Ricordatevi almeno, che
se il Tempo dipinge, non ha mai disegnato." — *Lettere Pittoriche*
(Milano, 1822), vol. vii. p. 339.

The good effects of time on pictures may be said to belong to
the painter's intention, and should be respected accordingly.
In cases where it might even be historically certain that a
picture had not been originally glazed, yet, as the painter

It is unnecessary to advert to the more striking imperfections commonly noticed in the works of Van Eyck; the meagreness in some of his forms, his occasional hardness, and his want of reflections: they were obviated in a great measure in his latter works, and perhaps, as regards the execution, there does not exist a finer specimen of his powers than the picture by him in the National Gallery. One defect, however, he avoided (and the same may be said of the minutest finishers among the Dutch painters), a defect from which modern artists of all schools are by no means free. When Vasari, in dwelling on the advantages of oil painting, observed that tempera was executed with the point of the brush, he meant to stigmatise the greatest defect of the latter process, viz. the hatched and stippled appearance which betrays the labour of the hand, and reduces painting (in respect to its execution) to a seemingly mechanical operation. If this was looked upon as a defect in tempera, it was likely to be considered unpardonable in oil painting. At all events, it is never to be detected in the smallest and most highly finished works of the Flemish and Dutch painters.*　Either the

probably calculated on the effects of time for producing the requisite tone, it must often be a question whether the *patina* so acquired may represent the intended change or may have overpassed it.

* Van Gool remarks that Karel de Moor latterly adopted a stippled manner in finishing, his earlier works being quite

handling is free, as in Jeronimus Bos or his great successor Teniers; or the surface is produced, apparently at least, at one flow, without any indications of touch. The latter mode is that of Van Eyck, and afterwards of Mieris and others. But in none is the line or point (the *tratteggiare, punteggiare* of the tempera painters) visible: the system was even banished from the later works in tempera, and survived only in what Fuseli calls " the elaborate anguish of missal-painting." When it is remembered that Van Eyck himself sometimes wrought as an illuminator, and when it is remembered how minute the execution of some of the early painters was in their engravings and pen drawings, it is not a little surprising that they should have been enabled, in any degree, to forget their habitual methods when they had to deal with oil painting.

It remains to observe that the qualities in colour which, notwithstanding his occasional dryness, Van Eyck attained deserve to be classed among the essential excellences of the new method, and opened up its resourses. The leading attribute of the material of oil painting, as distinguished from those of

free from it. "In zynen laetsten tyt deet hy de laetste overschildering al stippelende maer voor myn keur zou ik de eerste manier de beste houden."—*De nieuwe Schouburg der Nederlantsche Kunstschilders,* &c., in 's Gravenhage, 1750, vol. ii. p. 432. Perhaps no instance occurs in the earlier Dutch or Flemish writers where such a manner is even mentioned.

tempera and fresco, viz. its power to transmit the light of an internal surface through superposed substances more or less diaphanous, was recognised and expressed. It is true, the early miniature-painting, when not restricted (as it sometimes was) to body colours, exhibited the effect of a light ground under the tints; but this impression was far more complete when the coloured medium, like glass or like a glassy varnish, had, as it were, a distinct existence, and was sensibly interposed between the light ground and the spectator. The important attribute of *depth* was thus proved to be greatly within the power of the new art; and it is the more probable that Van Eyck founded much of his style on the principle of glass-painting, because the characteristics of inward brightness and extreme force were sooner and more fully attained by him than the quality of roundness. His feeling for depth was, however, shown to be nearly allied to that of gradation, by his singular fondness for representing the effects of distance on form. His knowledge of perspective far surpassed that of Pietro della Francesca, Paolo Uccello, and his other Italian contemporaries. Vasari extols perspective designs executed for the first time, as he appears to think, at the close of the fifteenth century, which are not to be compared with some works of the kind by Van Eyck. Again, in Paolo Uccello (the chief early representative of the science in Italy) the love of perspective is to be traced to a

dependence on its mathematical rules, without the slightest feeling for it as a measure of space.* Van Eyck, on the contrary, while he shrunk from no labour which the mere science imposed, seems to have considered its most elaborate results only as a means of representing depth, and of contributing to the pleasing illusion of atmosphere and distance. With such aims it is not surprising that he should substitute, for the customary gilt field behind the principal figures, the cheerful openness of sky and background, and all the indications of inward, as opposed to superficial, extent.† He may have felt that the triumph was even more conspicuous in small dimensions. Facius, in describing the picture of the Bath (in Vasari's time in the possession of the Duke of Urbino), speaks of " horses and men of minute size [reduced by perspective], mountains, forests, villages, castles, wrought with such art that one would suppose them spread over a space of fifty miles." ‡ Giorgione was thought to have added to

* " Fece i campi azzurri, le città di color rosso, e gli edificj variati secondo che gli parvè; ed in questo mancò," &c. — *Vasari, Vita di Paolo Uccello.* Compare Dr. Waagen, Ueber Hubert und Johann Van Eyck, Breslau, 1822, p. 131.

† See the just observations of Dr. Waagen (ib. p. 132.) on this subject. Among the rare instances of an open background in tempera pictures, before Van Eyck's time, may be mentioned a Madonna and Child by the elder Bizzamano. (See *Peintres Primitifs*, par M. Le Chevalier Artaud de Montor, Paris, 1843, pl. iii.)

‡ " Et item equi, hominesque perbrevi statura, montes, ne-

the resources of painting by exhibiting the back of
a figure (whose front only was turned to the spec-
tator) in a mirror. It is not impossible that he
may have borrowed the idea from this same picture
by Van Eyck. The writer above quoted, in another
part of his description, says: " One of the females
shows only her face and bosom, but a mirror which
is on the other side, reflects her back, so that she
is seen in that view as well as in front."* A mirror
is introduced in the picture by Van Eyck in the
National Gallery ; it is a remarkable example of
the feeling of the painter for depth, since it (ap-
parently) extends the limits of the space repre-
sented. In this work too, as in most of his interiors,
he does not omit to give a glimpse of the bright
sky through the open window. In the chiaroscuro
picture of St. Barbara, before mentioned, the only
portion coloured is the blue sky, as if the painter's
first object had been to remind himself of the idea
of space.

mora, pagi, castella tanto artificio elaborata, ut alia ab aliis
quinquaginta millibus passuum distare credas." — *Facius De
Viris Illustribus,* quoted by Morelli, *Notizia d'Opere di Disegno,*
&c. p. 117.

* " E quîs unius os tantummodo pectusque demonstrans
posteriores corporis partes per speculum pictum lateri opposi-
tum ita expressit, ut et terga, quemadmodum pectus videas."
— Ib.

NOTE

ON THE MODES OF STRENGTHENING PANELS BY LEDGES OR BATTENS.

PANELS on which fine pictures have been executed are often injured by the misapplication of parquetting. It would, therefore, appear that the method of safely strengthening wood by ledges, however familiar to cabinet-makers, is not so generally understood as could be wished, by those who undertake operations of far greater importance than the construction of the most costly furniture. A reference to some elementary facts connected with this subject may, therefore, not be without its use.

The fibres of a plank of wood, sawn in the usual way, run lengthwise. The expansion or contraction which can take place acts chiefly, if not solely, at right angles to the direction of those fibres. When this action is equal on both surfaces of the plank, the wood preserves its plane, although it may be altered in lateral extent. When the action is greater on one surface of the plank than on the other, whether from a difference of temperature or from any other unequal conditions, the wood is not only altered in lateral extent, but ceases to be flat, and is said to wind or warp. In this partial alteration, concavity indicates the shrinking of the surface; such shrinking being generally the consequence of the evaporation or destruction of the sap. If a thin piece of wood be exposed to heat till it begins to be charred, it will become concave on the side next the fire. The expansion or contraction of wood, under ordinary circumstances, is attributable to the presence or absence of moisture. A coat of paint, in as much as it protects the surface of wood from moisture and prevents evaporation, is to be considered as tending to produce warping, if confined to one side, or if its effect be not otherwise counteracted.

The warping of wood may be guarded against by forcible means; but the application of such means with a view to

prevent its splitting will generally accelerate the evil it is intended to obviate.

The wood being assumed to be well seasoned, the surest way to prevent its splitting is to leave it free to expand or contract according to the changes of temperature. If this free action be restrained in any point, the substance will sooner or later, in all probability, rend somewhere.

The first principle to observe, therefore, is, never to glue or in any way immovably fasten to the wood a ledge or batten in a direction contrary to that of the fibres. But, as ledges may require to be placed in that direction to prevent the warping of the panel, they should be attached in such a manner as, in answering that end, to allow of the lateral expansion or contraction. The general principle thus proposed may be carried out in various ways. The usual and effectual mode adopted in carpentry is to sink dovetailed ledges in corresponding grooves at the back of the panel. The ledges are not glued or even tightly fitted, but their keyed form prevents their falling out ; and when used in a vertical direction, as in dadoes, they rest on the floor. They may or may not be flush with the surface of the wood, according to its thickness ; in general they project above it.

Another mode which has been adopted with success for picture panels* (which are sometimes too thin to admit of sinking grooves in them with safety) is to glue battens, formed of a wood not firmer than that of the panel, in a direction parallel to that of the fibres. The ordinary glue, thus applied on a narrow extent only of surface, will always expand as much as the wood of the panel; so will the battens. Thus, no force is applied sufficient to restrain the free action proposed. Each of the battens is grooved at corresponding intervals on its under side, next the panel; and through these grooves flat cross pieces, touching the panel, are passed. These, which are at right angles to the battens, and consequently at right angles also to the direction of the fibres of the panel, are not only not

* Particularly by Mr. Francis Leedham, whose skill in lining pictures, and in transferring them from wood to cloth, is well known and appreciated.

glued, but are not even tightly fitted. They are secured at each end, so as not to slip out, by not passing through the two last battens, which are, consequently, fastened on afterwards.

In either of the above methods the edges of the panel should not be confined by a strong frame, but merely by slips sufficient to protect the edges of the picture from chipping. Whatever substance be employed for this purpose, and in whatever mode the slips are attached, they should offer no force which the expanding or contracting action of the panel cannot easily overcome.

As regards the glue employed to fasten the planks of a panel together, it is to be observed that, if not used in undue quantity, it merely represents one of the harder fibres of the wood (the intervals between which chiefly undergo alteration); its strength therefore does not, in this case, appear to be objectionable. But the glue used to fasten the ledges or battens, in the mode described, should on no account be so strong as not to obey the dilatation or contraction of the wood. When the panel is sufficiently thick, the planks of which it is composed may not only be glued but grooved (midway in their substance) across the joint, and feather-tongued.

With respect to the seasoning of wood, the action of the air is generally considered sufficient. Steam has, however, been applied with effect to destroy or consolidate the sap ; and thus the propriety of Cennini's recommendation to boil the wood, whenever its dimensions admit of the operation, is indirectly recognised in modern practice. All such methods are, however, partial only in their effect. It is found, for example, that planks which may have served for flooring even for a century or more, if planed, become again liable to all the changes which new wood would undergo.*

* "Wood in general, if exposed to drought, continues to shrink permanently more or less, especially in the lateral direction, or across its fibres, so long as it lasts ; and, when alternately exposed to the expanding and contracting influences of moisture and drought, the permanent contraction is upon the whole accelerated and increased." — *Encycl. Britannica*, art. Hygrometry.

CHAP. XII.

THE practice of oil painting before the fifteenth century, however limited in its application, afforded ample means of testing the durability of colours mixed with the half-resinified vehicle. In this respect the inventors of the new method may be said to have inherited a long experience. The decorators, who had employed oil painting, had noted much that was calculated to be of service in a more refined exercise of the art; while, in all that related to the purification of the materials used for pigments, the tempera painters, and especially the illuminators, had set the example of the most scrupulous care.

With regard to the materials themselves, it does not appear that any colours of importance, used by the Flemish painters, are now unknown : on the other hand, some valuable pigments have been discovered by the moderns, of which those painters were ignorant. In investigating the practice of the early masters, it is therefore chiefly of consequence to inquire what process the substances finally underwent before they were used as pigments; and by

what contrivances colours which, under ordinary circumstances, were fugitive or changeable, were rendered durable.

Brilliancy, and purity from noxious ingredients, were proposed by the operations of grinding and washing. The perfect levigation of colours by such means was indispensable in the art of illuminating; indeed, far more so than in oil painting: but the Van Eycks, who themselves practised the former method, were not likely to abandon their habitual precautions in undertaking a new process. The finest trituration of certain substances was considered no less essential in tempera. Cennini, who enters fully into this subject, observes: " This colour [white lead] is the better the more it is ground."* Again: "Grind this black for half an hour or an hour, or as much as you please; but know that if you were to grind it for a year it would be blacker and better in tint."† Of sinopia (here meaning a red earth) he says: "The longer it is ground the finer [in tint] it becomes." ‡ Of vermilion: "If you were to grind it for twenty years it would still be better." § Ochre, in like manner, " still becomes more perfect " by grinding‖; and orpiment, "if you were to grind it for ten years, would still be improved."⌡ In general,

* Trattato, c. 59. † Ib. c. 36.
‡ Ib. c. 38. § Ib. c. 40.
‖ Ib. c. 45. ⌡ Ib. c. 47.

it is found that colours are more vivid in proportion as they are finely comminuted; but this is by no means universally the case. Cennini himself remarks that some substances are to be ground but little; he mentions the green and blue carbonates of copper and Naples yellow (giallorino) as pigments which are injured in tint by much grinding.*

The habits of the missal-painters were inherited by the illuminators (limners) of the 16th and 17th centuries, a class of artists who were celebrated in England at those periods. As regards the careful preparation of pigments, the recorded methods of these later painters agree with those of their predecessors, and, in the history of technical processes, may be considered of equal authority. They divided colours into four classes, viz. those which required to be washed and ground, those which were to be washed only, those which were to be ground only, and those which required neither operation. The liquid vegetable extracts, for example, could be neither washed nor ground; ivory and blue blacks, and some other colours, were ground only; white lead was washed and ground; minium, massicot, bice, ultramarine, smalt, and some other substances, were washed only.†

* Trattato, c. 35. 46. 52.

† Norgate, The Art of Limning ether by yᵉ Life, Landscip, or Histories, MS. Compare Sanderson, Graphice, London, 1658, p. 55.; Brown, Ars Pictoria, London, 1675, p. 78. It

Norgate, referring to the last-named class, observes: "If you thincke to make them fine by much grinding, they instantly loose their beauty, becomeing starved and dead." He then minutely describes the process now called "washing over" or elutriation (a method commonly practised, not only in the manufacture of colours, but for other purposes), by which the substance was reduced to an impalpable state. The process is as follows. The colour, for example red lead, is first moistened to render it easily miscible; it is then placed in a basin, which is nearly filled with pure water. Being stirred and allowed to settle, the first scum, together with the fluid, is thrown away. After being well stirred in fresh water, the grosser parts only are allowed to settle, and the coloured water, in which the finer particles are still floating, is poured off into another basin. Water being added to the second basin, the colour is again stirred, and, as soon as the coarser parts have subsided, the rest is again poured off into a third basin. The operation is repeated six or seven times, the colour be-

appears that several copies of Norgate's treatise are extant. Dallaway, in his notes to Walpole (vol. ii. p. 43.), speaks of one in the Bodleian Library, dated 1654, which commences thus: "There are now more than twenty years past, since, at the request of that learned physician, Sir Theodore Mayerne, I wrote the ensuing discourse." Another transcript is in the possession of Sir Henry Bunbury, Bart.; and a third, from which the above extracts are taken, is the property of the author of the present work.

coming finer with each washing. According to the
old process, the various sediments were then again
washed with pure water, and any greasy scum
floating on the surface was thrown away. " And
if," observes Norgate, " you perceive a scum still
to rise upon the water, pour it off again and
again till the colour be clear. The scum is chalk
and other filth in the colour [red lead], which you
are to wash off as long as it doth arise." In the
example of the process (on a very moderate scale)
here quoted, large shells are used instead of basins.
The writer continues: " The colour left in the first
two shells is dross, but the colours in the other
shells are for limning, and the colour in the fourth
shell is finer and fairer than the colour in the third
shell," and so on. The now pure water being abs-
tracted, the shells with their sediments of colour
are placed in the sun to dry. " This done, put your
colour into several boxes or papers, reserveing the
finest for your best use; your rest or courser sorts
you may keep for your ordinary work."*

The small scale of the operation excepted, there

* In his ' Art of Painting in Oyl by yᵉ Life," forming an
appendix to his *Art of Limning,* Norgate gives the following
directions for washing. " Your readiest way for red lead is
to put it into a fine cloth, and when it is tyed up (gathering
the edges of the cloth together), shake and slubber it in a basin
of fair water untill all the finest of it be washed out of the
cloth. Try allsoe whether this way of washing will doe
well for masticote, bise, verditure, and smalt, for I never proved
it."

is no difference between the process here noticed and the modern "washing over" in the manufacture of very fine colours. There can be no doubt that the first oil painters, inheriting the methods of the illuminators, had the patience to prepare their choicer materials in this way. The older practice, though quite as minute, was in some respects less clumsy than that of the limners of the 17th century. Instead of shells, which were employed chiefly as receptacles for the colours in painting, the missal-painters used a cone-shaped glass (cornu pictoris)*; this was better adapted for collecting the sediment and pouring off the turbid and coloured water containing the finer particles. The ultimate operation described by Norgate, viz. washing, as distinguished from elutriation, is also commonly referred to in the ancient receipts.

In general, all foreign matter of the coarser kind subsides sooner than the pigment; the mere wash-

* "Ad purificandum azurium.—R. lazurū sive de alamania sive ultra marinū et fortiter duchatur sup lapidem sine mistione aque . . . postea ipsū accipias et ponatur I chornu pictoris et ponatur sechū de aqua clara et bene duchatur cum bachullo," &c. —*Venetian MS., Sloane MSS.* 416.

" Vermiculum molendum est cum aqua et in cornu deinde mittendum et postquam in cornu positum fuerit implendum est cornu totum aqua," &c.— *Sloane MS.* 1754.

The " cornu pictoris," when perforated, as in the mode of washing oil before described, might serve as a filter, fine cloth being placed within it.

ing process had therefore only the effect of freeing the colour from lighter impurities, and particularly from soluble ingredients. The following example occurs in the Venetian MS. "To purify vermilion. — Take vermilion in the lump and grind it on the stone, first dry, and afterwards with pure water. Then put it in a shell and place it on warm ashes, that the moisture may be evaporated. When it is dry put it in a horn of glass, and throw in strong gum water; stir it with a stick, and then let it settle; throw away the first water, and repeat the operation two or three times. Thus your vermilion is purified."*

* "A purgare lo cinapō. — Toy locinapō ɪtiegro e maxinalo sopra la pietra a seco e poy cū aqua chiara e poy lamiti ī uno caparaço e mitilo sopra lacenē calda aço che la humidita vada via eqñ sra seco mitilo ɪ uno cornicelo de vedro e toy aqua de goma forte ebutagela dentᵒ che stage amoglio emescolalo como uno steco e poy lasalo riposare ebuta via laprima e fa cussi due volte overo tre esrā purgato el tuo cenapō."

A modern writer on oil painting considers it "above all important to invite the attention of the artist to the necessity of subjecting the colours, especially the ordinary pigments which are chemically prepared, to a cleansing process before they are mixed with oil. After showing the importance of this in the instance of white lead, he adds the following example: —

"Grind rose madder lake in water and suffer it to dry on the stone. The colour will soon exhibit a number of needle-like crystals and a white saline efflorescence; both of which have an extremely bitter and pungent taste. When placed in the filter, the water from this colour quickly exhibits the evidence of the saline ingredient; so much so, that twenty or thirty washings are often necessary to free the colour from it. The

It has been seen that, in washing minium, a scum which floated quite on the surface was thrown away, either because it was supposed to be a foreign substance, or from its otherwise tending to injure the tint; but the minuter particles of the colour itself were reserved as the purest and best portion. The painters of the 14th century had observed that such particles are sometimes lighter in colour than the rest.* It would appear from a passage in the MSS. of Alcherius, that a common term was appropriated to this " extract" in all colours. " Bisetus, or the Biseth of folium, is less red in colour than folium itself, and is taken from that portion which floats on the surface. I believe that this term is applicable, in the same sense, to the lighter tint of any colour when tempered in shells for painting, [such lighter tint rising to the surface] after the colour has settled a little."†

efflorescence and crystals in question are alum, which thus exists in excess in the colour, and without a previous cleansing would be introduced into the substance of the picture." The same writer remarks that the effects of the filter on Prussian blue are no less convincing ; and repeats that, in all these cases, the injurious consequences would not be confined to the impure colours themselves, but would affect other tints with which they might be brought in contact." — *Fernbach, Die Oelmalerei,* p. 58.

* Ultramarine is an exception ; the minutest particles floating near the surface of the water are the purest and darkest in colour.

† " Bisetus vel Biseth folii est color minus rubens quam folium, et de eodem folio cum supernatat acceptus. Et credo per hoc

The first tint of certain substances was sometimes thrown away. De Mayerne gives an example*; but he refers to elutriation as follows. " All colours may be varied in quality in washing. The first particles which become diffused equally in the water form the finest [tint] ; the last, the coarsest. Grind white lead first in water, then wash and suffer it to settle awhile; pour off the still turbid fluid, and let it rest. The sediment which it will form will be very pure, and more durable than the dregs [in the first vessel]." †

etiam potest intelligi qualiter clarescens color supernatans cuilibet ex coloribus cum in conchillis temperati sunt ad pingendum et aliquantulum quieverunt."

The colour " folium," described by Theophilus and all the early writers, appears to be the English woad, sometimes confounded with the " folium Indicum." Besides its ordinary blue tint, the substance, it seems, furnished a purple and a red colour.

* The following memorandum appears in the Mayerne MS. under the name of Norgate. " Pour faire bonne cendrée d'azur avec la bice des Indes.—Il le fault mettre en poudre très subtile sur un porphyre, non en métal, parcequ'il noircit et entre aultres le ♃ [tin]. La pierre, quoiqu'elle soit noire, estant lavée, elle devient bleu. Pilez, broyez, lavez avec vinaigre. La poudre au commencement est verte. Ce vert s'en va avec le vinaigre ; le bleu reste au fonds."—*MS.* p. 22.

† " Toutes couleurs, en se lavant, se peuvent diversifier. Les premières qui se meslent exactement parmy l'eau sont les plus fines, les dernières plus grossières. Le blanc de plomb broyé premièrement avec l'eau puis lavé et laissé rasseoir en décantant l'eau trouble faict une résidue qui est très belle et meurt moings que le fonds."—Ib. p. 97. This washing may sometimes require to be repeated several times in the instance of white lead. (See Fernbach, *Die Oelmalerei,* p. 58.)

This finer portion, like the "Bisetus" of the medieval painters, is, in some instances, a change in the tint itself, as well as in its depth. Thus the lighter tint of vermilion, obtained in the mode described, inclines to orange, as compared with the colour from which it is separated.*

The perfect levigation of colours was of great importance to the oil painters on another account, besides the improvement of the tint. De Mayerne frequently remarks that the fading, offuscation, or, as it was called, the "death" of colours, is the consequence of their sinking in the oil. The alteration too often observable in colours which are themselves permanent may undoubtedly be so produced. The formation of a thick and more or less yellow skin of oil above delicate blues and greys, if not literally equivalent to their "death," may at least be said to entomb them. "The death of colours," observes De Mayerne, "is [that appearance which takes place] when the supernatant oil in drying forms a skin, which darkens by [long] exposure to the air. There are some colours, such as the smalts, which are not easily miscible with oil, but always subside without combining with it. They thus easily fade and become darkened."*

* Field's well-known "extract of vermilion." Fernbach probably means another substance, when he says that "the colour called purified vermilion blackens in a very short time if exposed to the sun."—*Die Oelmalerei*, p. 51.

† "La mort des couleurs est quand l'huyle, nageant au dessus,

Smalt, on account of its vitreous nature, cannot be very finely ground without losing much of its tint. The sinking of the colour would thus appear to be partly the consequence of the magnitude of its particles. Various contrivances, resorted to by the Flemish painters in Van Mander's time, to obviate the consequences of this, have been already noticed. They consisted in providing for the absorption of the oil, or in using a bleached oil of the purest kind.

The example which smalt affords of the sinking of the colouring substance (or, as it is sometimes called, the rising of the oil), and the modes of preventing it, throw some light on the practice of the early masters in regard to the preparation both of pigments and vehicles. To obviate the defect in question it might be proposed that the colour should be impalpable; that its vehicle should not only be as colourless as possible, but should possess as much firmness as is consistent with sharpness of execution. Accordingly, all these conditions were attended to in the first practice of oil painting. The expedient of thickening the vehicle with the view here indicated is alluded to by De Mayerne; a receipt for a clear but half-resinified oil (before given) is thus headed: " To make a thick

se seiche et faict une peau qui noircit à l'air. Il y a quelques couleurs, et les esmaulx entre aultres, qui ne se meslent pas aisément avec l'huyle, mais vont tousjours à fonds sans se lier, et ainsi meurent facilement et noircissent." — *MS.* p. 9. verso.

yet clear and very drying oil, fit to mix with colours which want body, in order to sustain them and prevent their sinking in oil."* The superior method of Rubens in meeting the particular difficulty which smalt presents will be noticed in the next chapter.

The other obvious method, which, for the reasons before given, was not possible or advisable in the instance of smalt and in a few other cases, was to reduce the colouring substance to the most impalpable state, so as to insure its admixture with (or suspension in) the vehicle. The minute particles of white lead, or of any other colour, which float long near the surface of water during the operation of washing, are not likely to sink in a much thicker fluid. The heaviness of the substance in a compact state was thus of little consequence, provided the particles were infinitely comminuted. The colour was effectually dried after washing, to prevent, as far as possible, the tendency to cake, especially since it was not always possible to attain

* " Pour faire une huile espaisse fort siccative, propre à mesler les couleurs qui manquent de corps, afin de leur en donner, pour ne tomber à fonds de l'huile."—*MS.* p. 16. Smalt, inasmuch as it will not bear much grinding, is said to have no body. In another sense, its particles being coarse, it might be said to have more substance than other colours. But in any view of this point smalt would be included in the colours referred to by the physician, because it is especially liable to sink in (unprepared) oil.

the requisite fineness by subsequent grinding con-
sistently with perfection of hue.

If, therefore, the tempera painters reduced most
of their pigments to an impalpable state, because,
as Cennini remarks, the tint was thus greatly im-
proved, and if the illuminators spared no pains for
the attainment of the same object, the oil painters
may be said to have had even additional reasons
for following the established practice. Colours so
prepared, when thinly spread over a white ground,
not only exhibited that ground, and consequently
their own hues in greater brilliancy, but were in
less danger of sinking in the vehicle; while the
oleo-resinous vehicle itself was of a nature to sus-
tain the finely comminuted particles. Under these
circumstances the colouring substance was as near
the surface, and as little covered with the pure
medium with which it was combined, as was con-
sistent with its protection from the air; for these
two causes of change, the effects of a humid atmo-
sphere and the undue thickness of the pellicle of
oil, both required to be guarded against, and the
endeavour to fulfil these conditions appears to have
gradually defined the method of the early Flemish
oil painters.*

* To carry this principle to its utmost extent, it only remained
to scatter the pigment in dust on the surface, before such surface
was dry. This, as will be seen, was literally done in some
cases.

Another contrivance to keep the colour above the oil, which was adopted by some later masters of the school, rather belonged to the Italian, and strictly to the Venetian, practice. It consisted in mixing an essential oil with all colours which were more especially injured in their effect by the supernatant vehicle. White, blues, and all delicate tints, including flesh tints, were thus treated. Scheffer, in his short, but not unimportant, observations on the different vehicles for colours, says that white should be tempered with spike oil (in addition to the ordinary medium).* Pacheco boasts that he used linseed oil with blues without fear. His method was to dip his brush occasionally in spike oil, thus causing the linseed oil to subside, and producing the effect which is called (improperly as applied to the pigment) "sinking in."† De Mayerne observes: "If, in using blue, a little spike oil be added to the cendre d'azur it does not fade."‡ Elsewhere, after speaking of the "death" of colours, in consequence of their subsiding in the oil, he again remarks : " Nota. The addition of spike oil to white or blue effectually prevents their fading ;

* "Cerussam spicæ oleo temperare melius putatur."— *Graphice*, Norimb. 1669, p. 179.

† "I no tengo por malo mojar el pincel en el [azeite] de Espliego cuando se va pintando, porque ayuda a rebeverse."—*Arte de Pintura*, &c. p. 392.

‡ "Quand on travaille avec bleu, si on ajouste à la cendre d'azur un peu d'huyle d'aspic, la couleur ne meurt pas."—*MS.* p. 5.

I repeat this because it is a great secret." * The
same recommendation appears under the name of
Latombe. " With regard to blue, two or three
drops of spike oil should be added to it ; thus the
colour sinks in, does not shine, and, having no oily
skin on its surface, never fades, but remains
bright."† According to another authority, " green
does not fade, if, before applying it, a few drops of
naphtha, or spike oil, or well rectified spirit of tur-
pentine, be added to it on the palette ; this causes
the colour to sink in, and whatever sinks in does
not fade."‡ The following communication from
Mytens is dated September 18. 1629. " The way
to make all kinds of colours sink in and look dull,
and to prevent their shining, is to temper them on
the palette with linseed or nut oil, to a pound of
which a quarter of an ounce of spike oil has been
added."§ The editor of De Piles, who was well

* " N. L'addition de l'huyle d'aspic au blanc et au bleu, qui
fait qu'ils ne mourront jamais, ce que je repète parceque c'est un
grand secret."—*MS.* p. 10.

† " Pour le bleu fault adjouster un peu d'huile d'aspic, deux ou
trois gouttes, ainsi la couleur pénètre, ne reluit point, et, n'ayant
point de peau huileuse à la superficie, ne meurt jamais, mais de-
meure belle."—Ib. p. 11.

‡ " Un peintre François. Le vert ne meurt pas, si, quand on
le met en œuvre, on adjouste sur la palette quelques gouttes de
pétrole ou d'huyle d'aspic ou de therebenthine fort clair. Cela
faict emboire la couleur, et ce qui s'emboit ne meurt point."—
Ib. p. 9.

§ " M. Mitens, peintre très excellent. 18 Septembre, 1629
Le moyen de faire emboire toutes sortes de couleurs, les rendre

acquainted with the methods of his time, records a similar process*: Félibien † and Dupuy du Grez ‡ also recommend it, and the authors of the *Encyclopédie Méthodique*§ repeat the same advice. De Mayerne does not omit to remark that, when the surface of an unfinished picture shines, the oil of a superadded layer of colour readily combines with that of the inner, leaving the external face without gloss : but (he might have added), if the inner surface be quite dry, this effect will not take place. By whatever means the inner surface attracts or absorbs the oil the outer will look dull : on the other hand, mere polish (as in the instance of glass) does not of itself produce the appearance which is called " sinking in." ‖

mattes, et empescher qu'elles ne reluisent, est de les destremper sur la palette avec de l'huile de lin ou de noix, à une livre de laquelle on ait adjousté seulement un quart d'once d'huile d'aspic."—Ib. p. 95.

* E'lémens de Peinture Pratique, Paris, 1776, p. 139. The original edition of this work (1684) is extremely scarce, and in the " édition entièrement refondue et augmentée " of Jombert, which has superseded it, it is difficult to say what portion belongs to De Piles. The French writers on art of the 17th century, and their followers, evidently borrowed their technical details from Flemish authorities ; their testimony is valuable accordingly.

† Des Principes de l'Architecture, de la Sculpture, de la Peinture, &c., Paris, 1697, p. 298.

‡ Traité sur la Peinture, Paris, 1700, p. 245. 252.

§ Encyc. Méthod. Beaux Arts, tome ii. p. 652. 657.

‖ See Franchi, La Teorica della Pittura, &c., Lucca, 1739, p. 169.

The use of an essential oil with the colours was
not, in all cases, intended to produce a dull sur-
face ; that effect depends on the quantity em-
ployed, and also on the nature of the original
vehicle. A certain proportion, serving only to
dilute a thick oleo-resinous medium, was compati-
ble with the glossy surface, which was an especial
object with the early Flemish masters, and which
superseded a final varnish. It has been seen that
works so executed were frequently completed at
once. But when, in a later practice, the picture
was laid in, or, in the modern sense of the term,
dead-coloured, it was desirable that the surface,
which was to be again painted upon, should not
shine. The Venetians, who covered their pictures
repeatedly, took every precaution to prevent the
colours from shining ; and, as this system was pur-
sued more or less to the end of the work, they gene-
rally found it necessary to add a varnish at last.

The varnish so applied was by no means thick :
pictures retain their brilliancy in a dry climate
with the least possible protection of their surface.
A Spanish writer, after prohibiting the use of ver-
digris, red lead, the green carbonate of copper, and
orpiment, adds, that in (the dry air of) Andalusia
these colours will last.* It is well known that the
causes of change in pigments are, in many in-
stances, doubly active, or only active when assisted
by humidity. Thus, if a strip of paper coloured

* Palomino, El Museo Pictorico, tomo i. p. 56.

with red lead be introduced into a volume of sul-
phuretted hydrogen, it remains unchanged for a
considerable time while dry; but, if it be moistened,
the discoloration is almost instantaneous. White
lead, treated in the same manner, blackens quite
as rapidly.* A protection of some sort was
thus indispensable for the preservation of pictures
in the damp climate of the Netherlands; the
colours required, to use the painter's phrase, to be
" locked up:" but this was accomplished not so
much by an adventitious coating, which if removed
would leave the surface almost exposed, as by inti-
mately combining the substance of the pigment,
and, as it were, clothing its atoms with the firm,
drying, and colourless vehicle which has been before
described.

With respect to other causes of change, the pro-

* "Although in England the whites of lead cannot be employed,
except with oil or varnish, they are, as is commonly known,
used in Italy as distemper pigments, and, under the influence of
a dry and pure atmosphere, remain for a very long time un-
changed, locked up by size only. When brought to this country,
the distemper paintings executed with lead-whites are very
quickly discoloured. If it were possible to keep them perfectly
free from moisture, impure air would not so readily attack them:
moisture greatly facilitates the combination of the lead-whites
with sulphuretted hydrogen, the chief agent in the changes that
take place. The prevalence and general diffusion of this agent
in our large cities, assisted by the penetrating influence of our
humid climate, which cannot by any known means be with cer-
tainty guarded against, subject lead-whites to the changes which
render them unavailable as water-colour pigments."— *Commu-
nication from Mr. Winsor (of the firm of Winsor and Newton).*

tection from light would seem to be more needed in the South; yet the custom of enclosing pictures in shrines was retained much longer on this side the Alps than in Italy: there, a silken curtain sufficed to protect the work from the solar rays, or from the action of strong light.* The Northern practice may, therefore, still be traced to the necessity of protecting pictures, not indeed from damp itself (which cannot be effectually excluded by the means adverted to), but from dust and smoke, and the impurities which more readily adhere to a moist surface.

The permanence of colours was, for the above reasons, an object of especial attention in the schools of the Netherlands; and perhaps the very experience which was the result may have led to an undue confidence: instances, at least, are not wanting, in which pigments of known instability were used by the best artists in those schools during the 17th century.

The principal colouring substances employed at various times in Flanders and Holland will now be enumerated, together with some of the recorded expedients for insuring the durability of the tints.

* The use of curtains before pictures, to protect them from strong light, is discussed and recommended by Mancini in his *Trattato sopra le Pitture antiche.* This work (referred to by Lanzi in treating of the Sienese school) exists in manuscript only; it contains no information of importance.

On the use of triptychs in Italy and in Flanders, see a note at the end of this chapter.

White. — Among the resources of the Flemish painters for correcting the lowering tendency of the "vehicle," may be mentioned their habit of painting quite up to the brightness and force of nature. The observance of this principle is scarcely less apparent in the masters of the 15th century than in Rubens. The saying of an early Italian writer, "that it would be well for art if white paint were as dear as gems*," was often repeated in Flanders; yet it was an especial object to obtain white of the purest quality. The frequent observations of De Mayerne, on supposed discoveries of brilliant whites by the painters of his time, show how much attention was then given to this subject. All such novelties gave place, however, to the customary white lead† : this was refined and purified by washing, in the mode before described. When ground in oil it was kept in water, and was considered to be still further improved in tint by being

* Leon Battista Alberti, Della Pittura e della Statua, lib. ii.

† The "schelp-wit" mentioned by Hoogstraten (*Inleyding*, &c. p. 220.) and the "schulp-weiss" of Sandrart (*Teutsche Acad.* 1er theil, p. 87.), literally "shell-white," mean only a lead-white prepared, according to the last-named author, in England during the seventeenth century. But Beurs, if his German translator is correct, speaks of the white prepared from (oyster) shells as preferable, for delicate works, to white lead. (*Die grosse Welt*, &c. p. 8.) The pearl-white, which is of this kind, is extremely brilliant, but has not body enough for oil.

exposed in this state to the sun.* The white of calcined hartshorn, according to a writer of the 14th century before quoted, is the only substance which can be safely mixed with orpiment to lighten it.

Yellow. — Van Mander, referring to the tradition respecting the use, by some painters of antiquity, of four colours only, remarks that the Flemish artists had a fuller scale in yellows alone; for, he observes, "besides ochre, we have massicot, yellow lake, and two orpiments."† " The yellows which we use," says Hoogstraten, "are light and brown Roman ochre, massicot, and yellow lake. Orpiment may also be sometimes employed in brilliant draperies."‡ De Bie enumerates massi-

* " Blanc de plomb soit premièrement broyé avec l'eau, puis estant sec, avec l'huyle. Vous le mettez deux ou trois fois au soleil, couvert d'eau; il devient beaucoup plus blanc."—*Mayerne MS.* p. 6. " Toutes couleurs se peuvent garder broyées avec eau et seichées, et se destremper seulement avec l'huile, quand on en veult user, sur la palette, hormis le blanc de plomb, qui, estant dans l'eau, devient toujours plus beau."— Ib. p. 86.

† " Maer wy hebben nu wel al vier verscheyden
 Ghelen boven ten Oker in ons tenten,
 Masticot, schiet-gheel, en twee Oprementen."
 Het Schilder-Boeck, p. 53. verso.

‡ " 't Gheel, dat wy gebruiken, is lichten en bruinen Roomschen oker, mastekotten en schietgeelen. Men kan het opriment in schoone kleederen ook somtijts te pas brengen."— *Inleyding tot de Hooge Schoole der Schilderkonst,* &c., Rotterdam, 1678, p. 220.

cot, ochre, and yellow lake*; Beurs mentions
king's yellow (yellow orpiment), light and brown
ochre, massicot, red orpiment, and light and dark
yellow lake.† He remarks that massicot blackens
in time‡; and Van Mander, speaking of the same
colour, recommends that it should not be used in
flesh, as it turns to a heavy tint, and, moreover,
dries so rapidly as to be inconvenient to use; very
fine light ochre, he observes, is to be preferred.§
It is remarkable that in none of these writers, or
their contemporaries of the same school, is any
substance mentioned which can be considered as
intended to represent Naples yellow, a colour then
common in Italy, and which is supposed to have
been used by Rubens. On the other hand, no
colour is more frequently named than yellow lake.

As the ochres were chiefly relied on for flesh, it
must have been an object to obtain them of the
lightest and purest tint; the browner kinds were
more easily procured. Among the deeper yellows,

* Het Gulden Cabinet, tot Lier, 1661, p. 209.

† Die grosse Welt ins klein abgemahlet, zu Amsterdam,
1693, p. 6.

‡ Ib. p. 14.

§ " Ick meen den Masticot meuchdy wel swichten,
 En ghebruycken hier toe seer schoonen lichten
 Oker, als voorseyt is, t' is meer gheraden,
 Dan zijn Carnaty te gaen overladen
 Met dees swaer verwe, verstervich in 't hooghen,
 En quaet te verwercken door 't haestich drooghen."
 Het Schilder-Boeck, p. 50.

the colours produced by the rust of iron (Mars yellow) are sometimes mentioned. One of De Mayerne's authorities appears to consider " ochre de rut " and " ochre de rouille " as synonymous.*
An English writer of the seventeenth century includes " the best rust " in a list of colours.†

Massicot, though generally condemned, and failing most when mixed with white, is often incidentally mentioned by the above writers as the light yellow which was chiefly in use.

The colours coming under the head of yellow lake are numerous. Transparent tints of this kind, prepared from different vegetable substances, are described in the earliest records of painting. The extracts were originally applied as lackers, but, at a later period, most of the pigments of this description were reduced to a substantial form by impregnating white earths with the juice. Mytens, quoted by De Mayerne, classed the ordinary yellow lake among the earths, on account of the chalk which served to give it body.‡ The ancient lackers were applied with the thickened oil, or with oleo-resinous mixtures ; and, thus protected,

* MS. p. 123. Compare the Encyclopédie Méthodique, art. Ochre.

† Brown, Ars Pictoria, appendix, p. 5.

‡ " *Mytens.* Pour le jaulne l'ocre jaulne l'ocre brune qui donne un roux fort beau le schitgeel ou pinke peult aussi passer entre les terres parceque son corps est de craye quoique la teinture vient de l'herbe Isatis [read Reseda Luteola] laquelle est précipitée avec l'alum puis paytrie avec la craye." — *MS.* p. 123.

may have appeared to later observers as very durable colours. The blue plants, and blue ivy leaves, sometimes conspicuous in Dutch pictures, and now deprived of their complemental yellow, show that the transparent tints of the latter were not always employed with due caution.

The yellow lakes which were familiar in the seventeenth century differed but little from those now employed. The " graines d'Avignon " (Rhamnus infectorius), weld (Reseda Luteola), broom (Genista tinctoria) *, and numerous other vegetable substances, including curcuma, saffron, aloes, and the inner rinds of various trees, are all occasionally mentioned; but none can be considered equal to the quercitron bark, from which the best specimens of this colour are at present prepared.† There was however one substance, viz. gamboge, now undeservedly fallen into disuse in oil painting, which is superior to most, if not to all, of those above named. The colouring matter united with its resinous portion, which renders it more durable in oil painting, may be easily freed from mere gum.‡ De Mayerne, it would seem on good

* The yellow lake called scudegrün, according to a receipt quoted by De Mayerne, was prepared from the "fleurs de genestes." (*MS.* p. 172.)

† For an account of this colour by its inventor, see Bancroft, *Experimental Researches concerning the Philosophy of permanent Colours*, London, 1813, vol. ii. p. 112.

‡ One method is to dissolve the gamboge in alcohol, and then precipitate the colour, united with the resinous portion,

grounds, pronounces in its favour; and his speculations respecting the best mode of using it are confirmed by modern authorities. " Gamboge," he observes, " furnishes a beautiful yellow, constant, unfading, and that works freely." * Again: " There are two kinds of gamboge; one, which is pure and very clean, now (1640) sells for eight shillings the lb.; the other, dirtier, redder, and which, when ground, approaches an orange tint, only costs half that price. . . . The coarser kind answers best, and gives the splendour of gold perfectly, used alone." † He then describes his having mixed it with his amber varnish diluted with spirit of turpentine. He proceeds: " Portman thinks that the gilt leathers of Amsterdam, which are so beautiful, are varnished with this gum.‡ He is of opinion that by boiling

by means of water. Another, and perhaps a better, mode is to dissolve the substance in ether; the gum and impurities subside, leaving a yellow fluid. This is easily separated from the dregs; and, when the ether is evaporated, the colouring matter, combined with a small quantity of resin, remains pure.

* " Un beau jaune, constant et qui ne meurt point et qui s'estend excellemment, est le Gutta Gummi. Je croy qu'avec le bleu on en peult faire un verd excellent." — *MS.* p. 23.

† " Il y a deux sortes de Gutta Gummi ou Gambouja, l'une est pure et fort nette, dont la livre se vend 1640 pour huit shill., l'aultre plus sale, plus rousse, et qui broyée approche de l'aurangé, ne coustant que la moitié du prix de la susditte. . . . La plus grossiere faict beaucoup mieux et donne l'esclat de l'or parfaitement, toute seule." — Ib. p. 74. verso.

‡ The physician, who omits no particulars, remarks that the colour was spread by the leather-varnishers " en battant avec

it in oil it would dissolve better, and might be spread more easily. For myself, I do not think this necessary: I would grind it in very clear spirit of turpentine, and keep this preparation, of the consistence of honey, in a glass. To make use of it, I would temper it with my [amber] varnish, or any other of the kind which would render the colour sufficiently liquid, so as to be able to spread it with the brush."* He suggests that a very little clear drying oil might be added.

le doigt," by tapping with the finger. Glazing-colours, which have no body, can only be applied by some such operation. Armenini directs that a pad or ball should be used, formed of cotton wrapped in a piece of linen; "un piumazzolo di bambase coperto di tela lina." (*I veri Precetti*, p. 127.)

* "Portman croit que les cuirs dorés d'Amsterdam qui sont si beaux se dorent avec cette gomme. Il croit qu'en la cuisant dans l'huile elle se dissoudra mieux, et se couchera plus également. Moy je croy qu'il n'en est pas besoing. Je voudrois broyer la dicte gomme avec huyle de therebentine fort blanche . . . et guarder ceste mixture dans un vaisseau de verre, estant reduite a consistence de miel. Pour m'en servir je voudrois la destremper avec mon vernix magistral ou un aultre equivalent, et luy donner la consistence assez liquide pour pouvoir le coucher avec le pinceaul." — *MS.* p. 75.

A description (in the Strassburg MS.) of a yellow varnish, prepared with amber and drying oil, was noticed in a former chapter. Among the yellow dyes which are mentioned, either of which might be employed to tinge it, the expression "pic. goct." (picis Gokathu) appears to mean gamboge. "The natives of the coast of Coromandel call the tree from which it is principally obtained Gokathu, which grows also in Ceylon and Siam." — *Field, Chromatography*, London, 1841, p. 155.

If the above reading be correct, there can be little doubt that

Gamboge, freed from its gum and dissolved in
spirit of turpentine, easily combines with unctuous
vehicles, but, in order to last, it requires to be
effectually "locked up." Mr. George Barker, well
known for his skill as a picture-restorer, is in pos-
session of a canvass covered by Sir Joshua Rey-
nolds with patches of colours mixed with different
vehicles. The names of the substances used, and
the dates of the principal experiments, are written
next them. The following are examples of tints
which have stood perfectly well. " Yellow lake,
cera, and drying oil. Gamboge and lake with
Venice turpentine. Gamboge with turpentine,
March 6. 1772. Prepared gamboge with cera.
Verditer, varnish alone. Gamboge with Venice
turpentine, June 3. 1772." Contrasting with these
unfaded colours, "gamboge with oil" is to be
traced only by its name. All the above experi-
ments appear to have been made in 1772.

De Mayerne may have known that the amber
varnish which he recommends was used in Holland
with transparent yellows: some examples are here
added, as they confirm the evidence before ad-
duced respecting the employment of this varnish
as a medium for colours. " Take half an oz. of
aloes, half an oz. of amber, pulverise both, and set

gamboge was used by the early Flemish painters. Scheffer
(*Graphice*, p. 168.) asserts, perhaps erroneously, that it had
been recently introduced into Europe in the 17th century.

them on hot coals in a glazed earthen vessel. The
heat at first should not be too great. As soon as the
amber is dissolved, throw in boiling oil, stirring well
with a wooden spatula. Let it cool; strain through
a cloth." * Again : " Take linseed oil, in the quan-
tity required, which has been previously boiled and
skimmed ; add to it amber and aloes, of each equal
quantities; pulverise well, and stir them in the
oil on the fire till the composition is thick enough,"
&c. †

It was before shown that a transparent yellow
was sometimes mixed with certain colours to enrich
them. The painters whom De Mayerne consulted
even recommended the immixture of a yellow of
this kind with vermilion, as a substitute for
minium.‡ A transparent golden or orange colour

* " Neempt een loot aloe, een loot amber, stootet beyde wel
onder een. Settet op heete colen in eenen verloyden pot, int
eerste niet al te heet, alst nu wel tsamen gesmolten is, so giet
siedende olie daer op, roeret wel door een, met een houten
spatula, latet coudt worden eñ sijget door een doeck." — *Secreet-
Boeck waer en vele diversche Secreten ... ghebracht zijn*, tot
Dordrecht, 1601, p. 180.

† " Neemt so veel Lijnolie alst u belieft, die te voren opt vyer
afgeschuymt geweest is, doet daer in amber eñ Aloe, van elckx
even veel, stootet wel onder een, ende menghelet wel opt vyer
onder de Olie tot dattet dichte genoech is, nemet alsdans van
den vyere eñ settet dichte toegestopft under der aerden dry
daghen lanck, ende al wat ghy hier mede op Tin strijct dat
crijcht een Gout verwe." — Ib. p. 182.

‡ " La mine meurt, et n'est pas bonne a l'huile. Pour faire
aurangé fault mesler vermillion et schitgeel ensemble." — *M S.*
p. 5.

appears to have served a more important purpose
in the hands of Rubens. The peculiar glow of
his deep browns is hardly to be accounted for by
any accidental varieties in the earths of Cassel,
which may have been common in his time; nor
does even asphaltum, alone, present the appearance
in question. It may rather be concluded that the
practice of occasionally mixing a warm transparent
yellow with various pigments was applied by the
great colourist to correct the redness of some of
the darker browns; by this means the utmost
richness of tint was produced in shadows, through
which a light ground was often visible.

Among the permanent transparent yellows, that
prepared from madder is not to be forgotten. This
colour is generally considered of difficult manu-
facture ; in modern times, and perhaps formerly,
it has been chiefly prepared in the Netherlands:
its tendency to become slightly orange is no ob-
jection to it for the use above adverted to.*

The gold field behind the principal figures, as
noticed in the last chapter, was discarded by John
Van Eyck. A gold ground was, however, occa-
sionally used at a later period under the colours:
a picture of the Last Judgment, by Bernard Van
Orley, which is still preserved at Antwerp †, was

* Mr. Field (the author of *Chromatography*) often prepared
this colour for Sir Thomas Lawrence.

† In its original place, the Aalmoeseniers-Kapel.

executed, according to Van Mander*, entirely on a gold ground. The customary white panel would perhaps have answered better; but, in some cases (examples occur in early German pictures), a gilt background toned with brown till it ceases to shine is to be classed among the richest effects of yellow.

Orpiment was commonly used in draperies. (Cornelius) Jansen's mode of employing it, inserted under his name in the Mayerne MS., is probably in his own handwriting. As Vandyck's method will be quoted in the next chapter, the remarks of his predecessor need not be given at length ; after describing the two kinds of orpiment, Jansen continues : " It must be ground in water, and, when it is dry, it will easily temper with oyl, either on a pallett or stone, as one uses quantity, but it will never grind fayre in oyl. . . . Orpiment will ly fayre on any culler except verdigris, but no culler can ly fayre on him; he kills them all † : either being wrought upon by other cullers, or mingled with other cullers, except yellow oker or such like

* Het Schilder-Boeck, p. 211.

† The Flemish writers are careful to distinguish the colours which cannot be safely used *under* other colours. One of De Mayerne's correspondents writes : " Il fault toutesfois notter et estre adverty que la dicte myne, le vert de gris, le noir de fumée ou de lampe, sont comme des poisons et que font mauvaises ces couleurs qu'on y met dessus, et pour ce fault les eviter en imprimant," &c.— *MS.* p. 100. verso. Umber is also included, by some authorities, among the colours which should not be used too freely in grounds.

culler to break it for shadows; but shadows are
best made of other cullers, and then orpiment use
for hightnings." * De Mayerne does not omit to
add that orpiment should not be touched with an
iron knife.

Red.—Vermilion, minium, lake, and " face brown
red," are mentioned in the Strassburg MS. The
use of vermilion by Rubens, in flesh, has been
sometimes supposed to be one of the great painter's
bold peculiarities, but there never was a time when
it was not so employed by the Flemish painters.
The carnation tints of the single figures, by Hubert
Van Eyck, in the upper part of the Ghent altar-
piece, are evidently painted with vermilion. Van
Mander, whose precepts, as before remarked, are
antecedent to the influence of Rubens, thus recom-
mends its use. " Let not your flesh colour freeze;
let it not be too cold or purple, for a carnation
which approaches the whiteness of linen cannot
bloom with the signs of life. But vermilion makes
it glow with a more fleshy hue. Endeavour to
produce this warmth. . . . In painting peasants,
shepherds, and mariners, spare not yellow ochre
with your vermilion. . . . Be careful not to light up
the flesh tints in either sex with too much white;
no pure white is visible in the living subject." †

* MS. p. 153.
† " Nu aengaende t'verwen, laet niet vervriesen
U blos, noch soo cout oft purperich laten:
Want sulck een lacke wittigh' incarnaten,

In his account of Jacques de Backer, and the early works of Joos van Cleef, he commends those painters for having avoided the defects here alluded to.*

> Carnaty en can niet lijfverwigh bloeyen,
> Maer vermillioen doet al vleeschigher gloeyen.
>
> Om wel doen gloeyen hebt u speculaty. . .
>
> Aen Boeren, Herders, en aen die daer varen
> Door wilde golven, mit stormen bestreden,
> Daer salmen den ghelen oker niet sparen
> Onder t' vermillioen.
>
> Hooght so niet met wit Mans naecten noch Vrouwen,
> Geen puer wit in 't leven blijckt in 't aenschouwen."
>
> *Het Schilder-Boeck*, p. 49.

* Het Schilder-Boeck, p.232, 227. Of De Backer the biographer remarks : " He was one of the best colourists Antwerp has produced; he had a fleshy manner of painting, not lighting up his carnation with mere white, but with the flesh tint."

On the durability of vermilion, when not adulterated with red lead, and on the means of detecting the latter, see the *Encyc. Méthodique,* art. Cinnabre. The most valuable observations on colours, in the work here quoted, are extracted from the anonymous *Traité de la Peinture au Pastel,* Paris, 1788.

The following anecdote is related by Northcote in his *Life of Reynolds:* "I once humbly endeavoured to persuade Sir Joshua to abandon those fleeting colours, lake and carmine, which it was his practice to use in painting the flesh, and to adopt vermilion in their stead, as infinitely more durable ; although not, perhaps, so exactly true to nature as the former. I remember he looked on his hand and said, ' I can see no vermilion in flesh.' I replied, 'But did not Sir Godfrey Kneller always use vermilion in his flesh colour?' when Sir Joshua answered rather sharply, ' What signifies what a man used who could not colour? But you may use it if you will.' It is to be observed, however, that Sir Joshua made use of vermilion himself in all

The use of vermilion was still more confirmed after it had received the sanction of Rubens. Beurs, who, in his chapter " on the colours of the living model," undertakes to describe a palette for painting flesh, employs vermilion and lake as the only reds for the light masses.* In the earlier part of the 17th century, great attention seems to have been paid to the manufacture of this colour, so as to obtain it in the most brilliant state. " A man at Antwerp," observes De Mayerne, " makes vermilion three times as red as the average colour;" the price at which it was sold was, for the time, enormous.†

" We use," says Hoogstraten, " Indian red, and brown red, vermilion, and minium." ‡ Elsewhere : " With us, lakes are in use, not only the purple, but the blue, green, and brown, or tints of yellow lake." §

his latter works ; finding by experience the ill effects of lake and carmine in his early productions."— Vol. ii. p. 18. The lakes, it may be added, were very inferior to those now in use.

* Die grosse Welt, &c. p. 183.

† MS. p. 95. After speaking of the brilliancy of the colour, the physician speculates on its cause : " An iterata sublimatione, an per additionem sulphuris," &c. Another brilliant red is mentioned by him as follows : " Sircome, Sericon, couleur rouge comme cynabre qui dure au feu et ne meurt point : semble un mercure precipité de fort haulte couleur ; mis sur la lamine ne s'esvapore point ; s'allie facilement avec toutes sortes de couleurs."—Ib. p. 96.

‡ " Wy gebruiken Indiaens en bruin-root, vermelioen en meny." — Inleyding, &c. p. 220.

§ " By ons zijn de lakken in gebruik, niet alleen de paersse,

The " blue lakes " may be passed over ; the green will be briefly noticed in speaking of that colour. These vegetable preparations were no doubt introduced by the illuminators; and, as they are for the most part evanescent colours, their use, at the best period of the Dutch and Flemish schools, can only be accounted for by the confidence with which painters then reckoned on the method of " locking up " tints with protecting vehicles. The experiments of Reynolds, before quoted, exemplify the effects of this expedient.

As regards red lake, the painters of the Netherlands obtained it in perfection. The cultivation of Zealand madder was greatly encouraged by the Emperor Charles V., and for a long period Holland monopolised the sale of the material.* The lac lake of India was no less familiar† ; but whether the modern methods of extracting the purest colouring matter from this substance were known and practised is by no means so certain.‡

maer ook de Blaeuwe, Groene, en Bruine of schietgeelverwige."
—*Inleyding,* &c. p. 222.

* Bancroft, Experimental Researches, &c. vol. ii. p. 221. De Mayerne observes : " La lacque pour glacer doit estre meslée avec peu d'huyle et estre broyée aussi espaisse que du beurre, de sorte qu'elle se puisse couper, aultrement elle n'a point de corps et ne vault rien." — *MS.* p. 87.

† " La lacque qui vient des Indes orientales est une excellente couleur. . . Icelle bruslée en creuset couvert jusques à noirceur seulement faict un noir aussi beau qui celui d'yvoire et qui a plus de corps."— Ib. p. 29.

‡ In a Dutch publication before noticed it is called " a light

The "brown reds" included many kinds of red earths, and the varieties produced by burning the ochres.* "Indian red" may have comprehended, as now, the colcothars of vitriol, formerly called "caput mortuum."

Minium is found to have been generally used alone by the early masters: this accounts for its lasting as a colour, and may also explain the occasional flatness of its tint in draperies. When mixed with white lead and some other colours, it is liable to change. The miniature-painters, who contrived to use it in flesh with white lead, preferred it to vermilion. The oil painters, on the contrary, while they rarely complained of the latter, not unfrequently recorded their objections to minium. Van Mander includes it with verdigris and orpiment, recommending that all those colours should be generally avoided.† De Mayerne observes that "minium fades, and is not good in oil." He then adds: "If you extract the salt from minium with

brown colour." "Gummi Lacca is een wonderbarelick gomme alsmen die, cleyn gestoot en in clare water heet maeckt, so maecktmen daer van een lichte bruyne verwe."— *Secreet-Boeck,* tot Dordrecht, 1601, p. 227.

* The Dutch painters rendered the colour of light red (burnt yellow ochre) brighter by quenching it in wine or in vinegar. "Alsmen hem brant dat hy gloyende wort, eñ met wijn of met azijn blusschet so wort hy vael root, hy is goet om daer mede opt bloote lijf te strijckē."— Ib. p. 246.

† "Meny en Spaens groen wilt oock vry versaken,
En Orpimenten, giftich van natueren."
Het Schilder-Boeck, p. 50.

distilled vinegar, the remainder does not fade, and dries very well." *

Blue. — "For our blues," says Hoogstraten, "we have English, German, and Haarlem ashes, smalts, blue lakes, indigo, and the invaluable ultramarine." † The "ashes," so often mentioned by writers of the seventeenth century, never mean ultramarine ashes, but light blues derived either from silver (the " Indian bice"), from carbonates of copper, or from smalt.‡ The later Dutch painters found that some of these colours little deserved their reputation. Weyerman remarks that the monotonous grey observable in Van Goyen's works, "was not altogether his fault; but in his time a colour was in fashion called Haarlem blue," which, being very perishable was the cause

* " N.B. Si vous otez le sel de la mine avec vinaigre distillé, ce qui reste ne meurt point et seiche fort bien." — *MS.* p. 5. St. Audemar, one of the medieval writers quoted in a former chapter, directs minium to be washed in the " cornu" with wine and water.

† " Wy hebben tot ons blaeuw, Engelsche, Duitsche, en Haerlemse Assen, Smalten, blaeuwe Lakken, Indigo, en den onwaerdeerlijken ultramarijn." — *Inleyding,* &c. p. 221.

‡ The method of preparing blue from silver is often described in early receipts. Boyle and others observe that the tint is derived from the copper which is commonly intermixed with the finer metal. The best quality of the colour called bice, according to De Mayerne, was obtained from some silver mines in India. (*MS.* p. 16.) The German azure (" azurro de la Magna"), much used by the early painters, was not cobalt, but a native carbonate of copper.

of this defect.* Indigo is generally condemned by
the professional authorities whom De Mayerne
quotes, but, according to one of these (Elias Feltz
of Constance), the colour may be rendered safe by
steeping it in vinegar, and exposing it to the sun
for two or three days; the vinegar is then to be
poured off, and the paste when dry may be ground
in oil.† Under the name of Feltz, the following
note also appears. "An excellent mode for ren-
dering indigo, yellow lake, and lake permanent in
oil. Calcine 'roche' alum in a clean crucible, so
as to render it very white in colour and light.
Grind some of this powder with the above-men-
tioned colours in nut oil, on the stone or on the
palette. The colours are thus much more vivid,
and, having been exposed to the sun, rain, and wind,
they have not faded. They generally fade, and
even in a few hours, in the sun."‡ In the margin
is written: "June 19. [1642], Feltz expertus est
et valde probat."

* De Levens-Beschryvingen der Nederlandsche Konst-
Schilders, &c., in 's Gravenhage, 1729, 1e deel, p. 395.

† MS. p. 145.

‡ "Excellent moyen pour fixer l'Indigo, le Sciidegrun et la
Lacque à huyle. Calcinez de l'alum de roche dans un creuset
bien net, de sorte qu'il soit très blanc et leger. Broyez de cette
poudre avec les couleurs susdittes avec huyle de noix, soit sur
la pierre, soit sur la palette à poignée. Les couleurs sont
beaucoup plus orientales et ayant esté exposées au soleil, à la
pluye, et au vent, ne sont point mortes, ce qu'elles sont ordi-
nairement et dans peu d'heures au soleil." —MS. p. 145. verso.

It seems to have been an especial object with the Flemish painters, to protect blues from the alteration commonly occasioned by the yellowing of the oil. Extraordinary methods were adopted for this purpose. Sometimes the blue was painted in size; and, in order to make it adhere effectually to a dry oil ground, the surface was first rubbed with the juice of garlic; the colour afterwards received a coat of "thin and very drying varnish; thus," adds De Mayerne, "your blue will never fade."* He also notes the following method. "After having painted a drapery with a smalt and white lead . . . while the colour is still fresh, powder ultramarine over it, and then, with a very soft feather, brush off the superfluous colour."† Portman, a Flemish painter before mentioned, gives a similar receipt. "Spread a coat of white lead ground in oil; on this, while quite fresh, powder your azure, or coarse smalt, but chiefly a good bice. Let it dry, and by blowing on it, or by means of a hare's foot, remove the powder which has not adhered. Pass over the surface some white of egg or isinglass or size. Let this dry, and then cover it with a very

* "Notez. Le bleu peult estre couché à destrempe avec colle sur vostre imprimeure à huyle (frottée avec suc d'ail), puis, estant sec, appliquez un bon vernis subtil et fort siccatif. Ainsi vostre bleu ne meurt jamais." — *MS.* p. 11.

† "Après avoir faict toute une draperie d'esmail et blanc de plomb . . . quand tout est frais, saulpoudrez d'ultramarin, et avec une plume fort delicate emportez le superflu." — Ib. p. 96.

drying varnish."* According to Malvasia, Lodo-·vico Carracci attempted this in fresco: "In executing the sky, he scattered or blew dry smalt on the fresh colour."† De Mayerne observes that blue (or, he might have added, any colour) may be thus powdered on various objects, such as carved figures or ornaments in relief. "After having given a coat of white lead, the colour is powdered upon it, and the superfluous dust removed; it never fades, and has a very good effect."‡

A bright orange colour was spread in the same manner, but without the admixture of oil in the preparation, on ornamental boxes manufactured in Italy; the method is thus described in the Vene-tian MS. "Take of minium two oz., orpiment half an oz., Naples yellow half an oz.; reduce them all to powder and mix them. First colour the box with saffron, tempered with a lixivium, and suffer it not to dry; powder the colour on it, and after-

* " Couchez sur votre labeur du blanc de plomb broyé à l'huyle, sur lequel, tout frais, poudrez d'azur ou de gros esmail, mais principalement de belle cendrée d'azur. Laissez seicher, et en soufflant, ou avec le pied de lievre, abbattez tout ce qui n'est pas adherent. Passez par dessus du blanc d'œuf ou de l'ycthyocolle, ou quelqu'une de nos colles susdites. Laissez seicher et puis couvrez d'un vernix fort siccatif." — *MS.* p. 151. The use of white of egg under varnish is to be condemned, as it frequently becomes opaque, and is very difficult to remove.

† Felsina Pittrice, tomo i. p. 447.

‡ " Ayant donné la ceruse puis jettant les poudres dessus et soufflant le superflu, jamais ne se guaste et est très beau."

wards [when it is dry], give it a wax varnish, and polish it with a tooth."*

The original object in this practice, as already shown, was to avoid the immixture of blue with oil (that colour being especially liable to change under such circumstances); but the agreeable effect which was the result may have led to the application of the process in other cases. The sparkling appearance of some green and yellow draperies, in Venetian pictures, may have been sometimes produced by thus powdering the bright dry pigments on a ground fitted to retain them. Such a preparation, reduced to a surface by subsequent operations, might then be toned or varnished.

Green. — Hoogstraten regrets that a good green was not so easily to be obtained as other pigments. "Terra verde," he observes, "is too weak, verdigris too crude, and green bice is not durable."† Beurs remarks that greens were usually compounded; it is in such mixtures that the yellow lake has sometimes ill served the intentions of the Dutch painters. De Mayerne frequently notices

* "A fare cholore suoxo a le busole to minio oz. ii., orpimento oz. ᵻ, zanolino oz. ᵻ, e fa spolverizare ogni chossa ĩsieme ĩprima tinze la busola de zafrano destepado con lorina e nō la lassare asugare e possa miti la polvere sovra dite e possa ge da la zira biancha de sovra, e possa la lissa con el dente de porco."

† "Maer ik wenschte wel, dat wy zoo wel het groen, als het Rood of Geel, tot onzen wil hadden. Terra verde is te zwak, en spaens groen te wrced, en d'assen t'onbestandig." — *Inleyding,* &c. p. 221.

the composition of greens with yellow lake, massicot, and bice. The "verd de vessie" (bladder green, sap green,) is correctly described by him as the juice of berries of the cervispina (Rhamnus catharticus, buckthorn); he supposed that some painters contrived to use it in oil, by means of firm vehicles. The Liliengrün, much used in the 17th century, was made from the purple flowers of the Iris germanica.*

The "distilled verdigris," so often mentioned by early writers, is the salt produced by the solution of common verdigris in distilled vinegar; the crystals thus formed furnish the colour in the most brilliant state. Pacheco recommends that it should be ground in vinegar, and then, when dry, in oil; varnish being added at last.† Leonardo da Vinci remarks that verdigris, though ground in oil, can only last when it is varnished immediately after it is dry; otherwise "it not only fades," he observes, "but may be removed by a wet sponge, especially in humid weather. This is because of its saline nature; it becomes deliquescent in a moist atmosphere."‡

* Scheffer, Graphice, p. 177. Compare Lindley's Vegetable Kingdom, p. 161.

† Arte de Pintura, p. 389.

‡ "Il verde fatto dal rame, ancorchè tal color sia messo a olio, se ne va in fumo . . . s' egli non è subito inverniciato: e non solamente se ne va in fumo, ma s' egli sarà lavato con una spugna bagnata di semplice acqua comune, si leverà dalla sua tavola, dove è dipinto, e massimamente se il tempo sarà umido:

These were the cases in which the resources of the Flemish painters, under the disadvantages of a humid climate, were most needed. The mode of "locking up" verdigris may exemplify the means by which all colours liable to be affected by damp, can be rendered durable. The colour was mixed either with a strong oleo-resinous vehicle (it may be supposed without any admixture of lead), or with varnish only. Modern painters, who find that verdigris and some other colours are not durable when mixed with oil, probably use the vehicle prepared with lead, or in too thin a state. It is, however, quite possible to dispense with oil. The traditional practice of the Netherlands is to mix the colour with a balsam * ; in more modern times the balsam of copaiba was used. Bouvier, who recommends an equal quantity of the finest mastic varnish with this ingredient, admits that the colour, thus applied, dries with inconvenient rapidity† ; the copaiba, indeed, answers quite well alone. As the early painters were un-

e questo nasce perchè tal verderame è fatto per forza di sale, il qual sale con facilità si risolve ne' tempi piovosi," &c. — *Trattato*, &c., Roma, 1817, p. 124.

* The term balsam was formerly, and is still often, applied to the liquid resins generally. The modern French chemists, however, restrict the word "baume" to those resins, whether liquid or solid, which contain benzoic acid. See Guibourt, Histoire abregée des Drogues simples, Paris, 1836, tome ii. p. 568. 585,

† Manuel des jeunes Artistes, &c. p. 77.

acquainted with this (American) produce, they may have used the purest turpentine resin, the Cyprus balsam, or a resin dissolved in an essential oil. The solid preparation on which the colour was glazed necessarily inclined to yellow: it was required to be perfectly dry, and the communication between it and the verdigris might even be intercepted by a thin coat of varnish. The colour, then applied with a balsam, lasts perfectly *; and this is an example of the superior method of mixing or clothing the particles with a hydrofuge vehicle calculated to defend them, as opposed to the mode of covering the surface only. The latter practice suffices in many cases, but not infallibly with verdigris. It is also thus intelligible how a colour can be durable, and yet require no superficial varnish.

One consequence of applying verdigris mixed ith a vehicle of the above description would be, that the surface, in process of time, would become more or less cracked; yet not necessarily to such a degree as to injure the appearance, or affect the

* An eminent foreign professor writes : " Twenty-five years since, when at ——, on the Rhine, I heard of a tradition preserved in the Netherlands, viz. that copaiba balsam mixed with verdigris, instead of oil, preserves the colour in its purity; whereas, if the colour is ground in oil, it soon becomes dark and almost black. I know these results from actual experience; on this account I value the balsam much as a vehicle." The Canada balsam, called the English balm of Gilead, would probably answer as well.

durability, of the work. In the well preserved Van Eyck, in the National Gallery, the green drapery is more cracked than any other part of the picture. *

De Mayerne, who, even in his professional capacity, seems to have missed no opportunity of collecting information on his favourite subject, has recorded a similar method applied to commoner purposes. " Bouffault, a very excellent workman, gave me these secrets on his deathbed. A beautiful green. Take of Venice turpentine two ounces, spirit of turpentine an ounce and a half, mix them, add two ounces of verdigris, reduced to small fragments. Place these ingredients on hot ashes, and let them gently dissolve. Try the colour on glass. Pass it through linen."† Another composition of the kind contained yellow lake, the vehicle being

* The fluid resins, or balsams (which are resins originally held in solution by an essential oil), are more unctuous than resins artificially so dissolved, and, in most cases, are less liable to crack. To correct this tendency, however, a small quantity of wax might be added to them. This ingredient has been recommended, in the instance of Copaiba balsam (to check its tendency to flow), by Lucanus in his *Vollständige Anleitung zur Erhaltung, &c., der Gemälde*, Halberstadt, 1842, p. 12. Compare Knirim, Die Harzmalerei der Alten, Leipzig, 1839, p. 174.

† " Bouffault très excellent ouvrier m'a donné ces secrets siens en mourant. Beau vert. R. Therebenthine de Venise 2 oz., huile de Therebenthine 1 oz. et demie ; meslez, adjoustez vert de gris mis en morceaux 2 oz., mettez sur cendres chaudes et faittes bouillir doulcement. Essayez sur un verre si la couleur vous plait. Passez par un linge."—*MS.* p. 31.

the same. The physician remarks that all transparent colours might be applied (as lackers) in the same way.*

Browns. — Van Mander, taking occasion to condemn the use of lampblack, which, he observes (on the authority of Vasari), produced such bad effects in certain parts of Raphael's picture of the Transfiguration, recommends for the shadows of flesh, terra verde, umber, Cologne earth, and asphaltum.† Hoogstraten speaks only of the browner yellow lakes (brown pink). De Bie mentions umber and asphaltum‡; Beurs, umber and Cologne

* Among the receipts of Bouffault two essential-oil varnishes appear : one, composed of spike oil, sandarac, and mastic, was to be used for red and various colours ; the other, consisting of turpentine and the spirit of turpentine, was reserved for greens. This explains the use of the "red and white varnish" mentioned in the early English records (a fixed oil being substituted for an essential oil). The green, which was so much in favour for interior decorations in the 13th and 14th centuries, was no doubt applied with the white varnish, composed either of turpentine or mastic, or both ; as the red tint of the sandarac would vitiate its colour.

† "Laet u in 't ghebruyck neffens umbre werden
 Aspalten, Ceulsch' eerden, en terreverden."
 Het Schilder-Boeck, p. 49. verso.

‡ " Take on your palette the various colours, both choice and ordinary (but such as never fade), tempered with oil ; as red or vermilion, some umber, massicot, some ochre, grateful green, lake, yellow lake and ceruse, ultramarine and smalt, azure and minium, white lead and asphaltum."

 " Nempt op u plat Palet van alderhande verwen
 Goet en gheringh, van aert die nimmermeer vesterven,

earth.* Under the latter term (now appropriated
to a distinct colour) may have been included the
Cassel or Vandyck brown.†

There can be no doubt that asphaltum was much
used by the Flemish painters; it was even pre-
pared in the modern manner. "Asphaltum," says
De Mayerne, "is not ground, but a drying oil is
prepared with litharge, and the pulverised asphal-
tum mixed with this oil is placed in a glass vessel,
suspended by a thread [in a water bath]. Thus
exposed to the fire it melts like butter; when it
begins to boil it is instantly removed. It is an ex-
cellent colour for shadows, and may be glazed like
lake; it lasts well."‡ There are no complaints, in
any of the writers above quoted, of the flowing or

Met olie ghemenght, als root oft fermilioen,
Wat omber, masticot, wat oker, heylsaem groen;
Lack, schetgheel en seruys, oulter marin en smalten,
Asuer en menie, loot-wit en oock aspalten."
Het Gulden Cabinet, &c. p. 208.

* Die grosse Welt, &c. p. 183, 186.
† Compare Field, Chromatography (1841). The following
passage in this work has reference to the subject now under
consideration. "Rubens Brown. — The pigment still in use in
the Netherlands under this appellation is an earth of a lighter
colour and more ochreous texture than the Vandyke brown of
the London shops: it is also of a warmer or more tawny
hue than the latter pigment, and is a beautiful and durable
brown, which works well both in water and oils and which
resembles the brown used by Teniers." — p. 281.
‡ "La spalte ne se broye point : mais on faict une huile sic-
cative avec la lytharge silberglette, et on met la spalte pul-

the cracking of this substance. The painters were
perhaps careful to obtain the best specimens of the
native bitumen.* An English painter of the last
century, who seems to have given much attention
to the manufacture of colours, gives the following
receipt for the preparation of asphaltum: —

"Antwerp Brown. This brown, I believe, is
not to be had in the shops at present, but may be
thus prepared; it is a valuable colour from its
great depth of tone, has great body, and will un-
doubtedly stand well. Put some good asphaltum
into an iron ladle, set it over a slow fire, taking
care that it does not boil over; keep it there till it
will boil no more, and it becomes nearly a cinder.
When cold, put to it the proportion of half an
ounce of sugar of lead to half a pound of the calx;
grind it in the strongest drying oil. It will work
free and dry well."† This treatment, probably,
suffices to prevent its flowing, and may also render
it less liable to crack. To obviate the former de-

verisée dans cest huile dans une conserve de verre ou pot à
pommade pendu à un filet. On le met sur le feu et le tout
se fond comme beurre. Quand il commence à bouillir on l'enleve
vistement. C'est une excellente couleur pour ombrager et se
glace comme la lacque : ne meurt point."

* Compare Field, Chromatography (1841), p. 283. De May-
erne speaking of brown colours for the shadows of flesh, ob-
serves : "Item avec le spalt ou asphaltum qui doit estre choisi
pur, très noir et friable."—*MS.* p. 94.

† Williams, An Essay on the Mechanic of Oil Colours, &c.
Bath, 1787, p. 43.

fect, the French painters of the school of David added wax to the bitumen, when dissolved in the ordinary way. The practice of enriching browns with transparent yellows is alluded to by the writer above quoted; after objecting to brown pink he observes: "a better colour, and more certain, may be made from No. 9. and No. 18. [the 'Antwerp brown,' and yellow lake]."*

Mummy is noticed in a Dutch work (of the age of Van Mander) which has been already referred to. The colour is described as being fit for " hair and drapery," and as being generally useful.†

A colour which was unknown in the best ages of art (having been discovered in the last century), viz. Prussian blue, furnishes, when burnt, a very fine and durable brown. It requires much filtering to free it from salts. ‡

* Williams, Mech. of Oil Colours, p. 46.

† " Men vint de mommie nergens als in de Apteke, het is een Menschenvleesch, dat constich is ghedroocht eñ bereyt. Sy geeft ooc fijne Haerverwe, en cleedinge, eñ is nut tot veel dingen."— *Secreet-Boeck*, p. 253. The writer is here speaking of water colours.

‡ See Bouvier, Manuel, &c. p. 49. Compare Montabert, Traité complet de la Peinture, tome ix. p. 364. Messrs. Winsor and Newton, having made some experiments in preparing this colour, report as follows : " The best mode of obtaining Prussian brown is by reducing Prussian blue to a fine powder and burning or rather roasting it in a shallow pan on a clear fire. A common iron pan does very well for this purpose. While roasting, the powder should be well stirred and shaken, and, as soon as the desired tint is obtained, thrown into water and repeatedly washed, to free it from a

Blacks. — Ivory and bone black are now scarcely distinguished; but the finer substance undoubtedly yields the best black. The Dutch painters substituted the teeth of the walrus for the Oriental ivory, and were so much in the habit of considering the materials identical in all respects, that Hoogstraten, speaking of the invention of this colour by the ancients, observes : " It is said that the ivory, or walrus, black was invented by Apel· les."* Like other writers of the time, he does not omit to condemn lampblack. Under the head of bone, or ivory black, may be mentioned carbonised hartshorn: a collection of specimens of tints (in water colours) is inserted in the Mayerne MS., and among these the " cornu cervium" black is very intense. Among other materials for black pigments may be mentioned black chalk, which, when ground in oil, according to De Mayerne, "dries easily, is unctuous, and spreads well; for painting satins and similar things it is superior to the ordinary [vine] charcoal black, of which blue black is made. It should be kept in water."† Common

quantity of soluble salt which it now contains (some potass, not previously soluble, being set free by the burning). The powder, after being washed, is thrown upon a filter and dried. A variety of tints may be obtained according to degree of burning, and according to the nature of the blue, some samples giving a much warmer tint than others."

* " Men ook zegt dat het yvoir of Walrus zwart van Apelles gevonden is."—*Inleyding,* &c. p. 221.

† " Terre noire ou crayon noir, Black chalke, qui facilement

coal, called by Van Mander "sme-kool" (forge coal), was not only used in water colours, but in oil: it furnishes a brownish tint. De Mayerne observes: " The shadows of flesh are well rendered by pit-coal, which should not be burnt.* This substance is included among dark pigments by other writers of the time. Norgate, whose directions for oil painting correspond in all outward particulars with the Flemish methods, says: " Small cole or charcole [carbonised vine stalks] is a blew black and sea-cole makes a red black and soe called." † The early Flemish illuminators, for example, Gerard of Bruges, also used the warm black prepared from common coal (schmiedekohlenschwartz).‡

Such were the principal colours employed by the painters of the Netherlands. The modes of purifying the materials by washing; their preparation, in certain cases, with peculiar ingredients to insure

se seiche, est gras et s'estend fort bien, et vault mieux que le charbon commun dont on fait le bleu noir ou noir bleu, pour peindre satin et semblables choses; se doit guarder dans l'eau." — *MS.* p. 1.

* " Les ombrages se font excellens pour charneures avec le charbon de pierre qui ne doit point estre bruslé."—Ib. p. 94. Compare Beurs, Die grosse Welt, &c. p. 6. 183.

† Norgate MS.

‡ The treatise of " Gerhard zur Brügge " was published by Willhelm Goeree, and afterwards translated into German, under the title Illuminir- oder Erleuchterey-Kunst, &c., Hamburg, 1678. For the list of colours see p. 3. 5. The yellows include gamboge.

their durability; and the methods of applying them, having been briefly noticed, the more general means adopted to protect them, or "lock them up," will now be described.

The effect of moisture on verdigris, even when the colour is mixed with oil, as noticed by Leonardo da Vinci, shows that such a vehicle, unless it be half-resinified, affords no durable protection to some colours in humid climates; and the efficacy of resinous solutions, as hydrofuges, is at once exemplified by the fact that they answer the end which (unprepared) oil alone is insufficient to accomplish. Colours which are easily affected by humidity require to be protected according to the extent of the evil. Whatever precaution of this kind was requisite in Italy was doubly needed in Flanders. The superficial varnish which sufficed in the extreme case referred to by Leonardo was incorporated with the colour by the oil painters of the North. So, in proportion as the Flemish painters adopted a thinner vehicle, the protecting varnish was applied on colours which the Italians could safely leave exposed, at all events till a general varnish was spread over the work. It will be remembered that this last method was unnecessary in the original Flemish process, according to which the colours, being more or less mixed with varnish and being painted at once, remained glossy, and needed no additional defence.

The following examples of the later practice in

Flanders occur in De Mayerne's notes. After describing the mode of rendering colours dull, and causing the oil to remain undermost by the addition of spike oil, the physician adds: " As soon as the colour is dry, pass the varnish immediately over it."* He elsewhere remarks: " Indigo is used in oil, but it fades without the varnish. It makes a green with dark yellow lake; upon this also the varnish should be spread; the colour then lasts." † Speaking elsewhere of verdigris glazed over other tints, he repeats: " Forget not to add the varnish." ‡ Lastly, after describing the composition of a preservative of this kind, he adds: " The varnish answers very well spread over the whole surface of a picture ; thus the colours are protected, and do not fade." § This observation would have appeared a truism in Italy ; but, coming from a writer who was conversant in the technical habits of the Northern schools, it is well worthy of notice. It shows that the practice of varnishing pictures was not universal in those schools, even in De Mayerne's time. The use of the

* " Quand on travaille du bleu il fault . . . y mesler un peu de huile d'aspic ou de petrole et aussi tost qu'il est sec passer incontinent le vernix par dessus."— *MS.* p. 97. verso.

† " Indigo s'use à huile mais il meurt sans le vernix, on en faict . . . un vert avec schitgeel obscur sur quoy fault passer le vernix et il dure. "— Ib. 95.

‡ Ib. p. 9.

§ " Le vernix fait fort bien passé par dessus tout un tableau ainsi les couleurs se conservent et ne meurent point."— Ib. p. 59. verso.

original Flemish vehicle, or an equivalent to it, still rendered such an addition, in many cases, unnecessary.

The essential-oil varnish, the composition above alluded to, was probably of Italian origin; it was an almost necessary protection to pictures painted with a diluted vehicle, yet a thin coat of the resinous solution was found to be sufficient for this purpose in a dry climate. The period when this composition was introduced in the North is unimportant; but, if adopted when the oleo-resinous vehicle was no longer generally employed, it would be used in a thicker state than in Italy, or, which is the same thing, several layers would be applied: the chief object being to protect the colours, by a hydrofuge coating, from the effects of moisture and air. Hence, as might be expected, the Italian system of varnishing, when once adopted on this side the Alps, was not unfrequently abused. We find Venetians, in the seventeenth century, ridiculing the extreme polish of some "foreign pictures."* One cause of this excess was the difficulty of preserving such compositions from chilling, and even from speedy decay, in a humid climate. The remedies for this, such as they were, will be noticed in due order.

The Italian varnish consisted of an essential oil and a balsam: to these a resin was sometimes added.

* Boschini, La Carta del Navegar Pitoresco, Venezia, 1660, p. 338.

Such compositions, serving to protect the colours and to make them bear out, last perfectly well in Italy when they are carefully prepared.

Armenini describes the essential-oil varnish which was used by Correggio and Parmigiano. His authorities, he informs us, for so designating it were the immediate scholars of those masters ; and he states that he had himself witnessed its general use throughout Lombardy by the best painters. His description is as follows. " Some took clear fir turpentine, and dissolved it in a pipkin on a very moderate fire ; when it was dissolved, they added an equal quantity of petroleum (naptha), throwing it in immediately on removing the liquefied turpentine. Then stirring the composition with the hand, they spread it, while warm, over the picture, which had been previously placed in the sun and was somewhat warmed. They were thus enabled to spread the varnish over every part of the surface equally. This varnish is considered the thinnest, and [at the same time] the most glossy, that is made."*

* " Alcuni dunque pigliavano del oglio d' abezzo chiaro, e lo facevano disfare in un pignattino à lento fuoco, e disfatto bene, li ponevano tanto altro oglio di sasso, gettandovelo dentro subito che essi lo levavano dal fuoco, e mesticando con la mano così caldo lo stendevano sopra il lavoro prima posto al sole, e alquanto caldo, si che toccavano con quella da per tutto egualmente, e questa vernice è tenuta la più sutile, e più lustra d' ogni altra che si faccia ; io ho veduto usarla così per tutta Lombardia da i più valenti, e mi fu detto che così era quella adoprata dal Correggio e dal Parmigiano nelle sue opere, se

The turpentine resin here mentioned is the pro-
duce of the silver fir (Abies pectinata or taxifolia) [*];
it is obtained in perfection on the Italian side
of the Tyrolese Alps. It is perfectly clear and
colourless, which is not the case with Venetian
turpentine (the produce of the larch)[†]; the latter
may, however, be purified in the modes before de-
scribed. Venetian turpentine, perhaps from the
influence of its name, seems to have been chiefly
used by the Flemish painters. It was selected as
light in colour as possible, and, when mixed by heat
with the essential oil of turpentine, care was taken
not to allow the latter to evaporate; for, when this
happened, the varnish was thick and less drying.
The following are examples : —

" Incomparable Varnish. — Take the clearest
Venice turpentine and colourless essential oil of tur-
pentine, equal quantities. Place them in a vessel on

egli si può credere à quelli che li furono discepoli."—*De' veri
Precetti della Pittura*, in Ravenna, 1587, p. 128. For the
best mode of preparing this varnish see the second note at the
end of this chapter.

 [*] Lindley, Vegetable Kingdom, p. 229. Compare Guibourt,
Histoire abrégée des Drogues simples, Paris, 1836, tome ii.
p. 576. This is the "nobilior lachryma abietis" mentioned
by Cardanus (*De Subtil.* lib. viii.), and so described by him as
compared with the inferior turpentine of the larch and of the
"picea" or Abies excelsa. Linnæus, it is to be observed, calls
the Abies pectinata, Pinus Picea; and the Abies excelsa, Pinus
Abies. (*Guibourt*, ib. p. 577.)

 [†] Guibourt, p. 575. Lindley, p. 229. The Strassburg tur-
pentine, also the produce of the Abies pectinata, is not so pure
and colourless as that obtained on the Italian side of the Alps.

a very moderate fire; and, as soon as you see bubbles form round the surface, withdraw it quickly from the fire : the varnish will boil of itself. When cold, keep it in a phial. This varnish may be spread on all colours, particularly on verdigris, on face tints, and all others. It preserves all colours ; they thus never fade, not being liable to be altered by the air. It dries in three hours, and the advantage of it is, that it is possible to work and paint on it afterwards." *

De Mayerne, who records this receipt, probably obtained it from his friend Vandyck, as another contemporary authority thus describes it : " Sir Nathaniel Bacon's vernish for oyl pictures. Allsoe it was the vernish of Sr Anthony Vandike, which he used when he did work over a face again the second time all over, otherwise it will hardly dry. Take two parts of oyle of turpentine and one part of Venice turpentine ; put it in a pipkin and set it over the coles, on a still fire, untill it begin to buble up : or let them boyl very easily, and stop it close

* " Vernix incomparable.—R. Therebentine de Venise très claire, huile de Therebentine blanche, an. mettez en un pot sur un petit feu et quand vous verrez que des bulles se feront à la circonference tirez vistement du feu le vernix bouillera de soi mesme. Estant refroidy guardez le dans une fiole. Le vernix se peult coucher sur toutes couleurs specialement sur le verd de gris sur les visaiges et tout aultre. Il conserve toutes couleurs qui ne meurent jamais ne pouvant estre alterées de l'air. Il seiche dans trois heures et le bon est que par après on peult travailler et peindre dessus." — *Mayerne MS.* p. 95.

with a wett woollen cloth untill it be cold. Then keep it for your use; and when you will use it, lay it but warm, and it will dry."* The damp cloth was evidently intended to prevent the evaporation of the essential oil. Vansomer also gives the following directions. " In preparing the ordinary painter's varnish (which is made with the colourless oil of the clearest Venice turpentine and the turpentine itself, in a water-bath), take care that the spirit does not evaporate in any way, for otherwise the varnish does not dry well nor so quickly. The evaporation may be easily prevented by using a circulating vessel, or a matrass with a very long neck."† A description of the same varnish appears under the name of Van Belcamp, a painter who was employed in copying pictures for Charles I. " An excellent Varnish.—Make the common painter's varnish with very clear Venice turpentine (or, at all events, the least yellow that can be found) and the rectified essential oil of turpentine. It should be made in a sand-bath, without allowing the spirit to evaporate much, for fear the varnish should become

* Norgate MS.

† " En la preparation du vernix ordinaire des peintres (qui se faict avec l'huile blanche de la plus claire Therebentine de Venise et la Therebentine mesme dans le B. M.) il fault adviser que l'esprit de Therebentine ne s'exhale en aulcune façon, aultrement le vernix ne se seiche pas bien ni si tost. Cela se fera facilement ou dans un vaisseau de rencontre ou dans un matras dont le col soit fort long." — *Mayerne MS.* p. 154. verso.

too thick."* De Mayerne, in some general observations on varnishes, remarks: " The most usual [ingredients] for delicate varnishes are, the essential oil of turpentine, spike oil, or petroleum, with turpentine itself, which, although unctuous and slow in drying, dries at last and prevents the varnish from cracking. Nota: very little is necessary; the tenth or twelfth part."† This would indeed be a " delicate," but not very durable, composition. It was,

* " Vernix excellent.—Faittes le vernix commun des peintres avec Therebenthine de Venise très blanche ou au moings la moings jaulne que pourrez trouver et l'huile blanche de Therebenthine redistillée pour mieux faire, ou tirée la premiere fois avec eau. Cecy se doibt faire sur la sable sans souffrir longtemps l'exhalaison de l'esprit de peur que le vernix ne s'espaississe par trop."— *MS.* p. 143. verso. The defect here alluded to, which involved slow and imperfect drying, is corrected by De Piles (or perhaps his editor, Jombert) by the addition of some clear lac varnish. The proportions are, one oz. of turpentine, two oz. of spirit of turpentine, and half an oz. of the lac resin; to be dissolved in a water-bath.

† " Les plus ordinaires pour les vernix delicats sont les huyles de therebenthine, d'aspic et le petroleum avec la therebenthine mesme qui, quoyque grasse et lente se seiche à la parfin et empesche le vernix de s'escailler. Jl y en fault fort peu la 10ieme ou 12ieme partie." — Ib. p. 47. verso. Van Mander relates that Ioos van Cleef, who, in his youth, was one of the best colourists of his time, when he became deranged " varnished his clothes, his hood, and cap with turpentine varnish, and went in this state shining through the streets." " Hy vernistede met Terbentijn vernis zijn cleeren, zijn cappe en zijn bonnet, en gingh soo al glimmende achter straet." — *Het Schilder-Boeck*, p. 226. verso. The anecdote is a proof that turpentine was, originally, the chief substance used in the composition of essential-oil varnishes. Van Cleef died about 1556.

however, a varnish of this kind, or but little stronger, which, when passed over a dry picture before repainting, answered all the end of " oiling out," without its inconveniences, viz. the probability of yellowing. The thin resinous film, if left in any part of the work, undergoes no alteration: though drying rapidly, it leaves a comparatively fresh surface which takes the colour easily; and, having scarcely any body, does not affect the superadded tints. The application of such a varnish by Vandyck, in this way, has been already noticed.

In the Netherlands, the painters were in the habit of increasing the body of this composition by the addition of mastic. The " peintre Flamand" quoted in a former chapter, whom De Mayerne met at " Lord Newport's," said that he commonly used for his picture varnish, " very light turpentine, very clear spirit of turpentine, and mastic." * The physician elsewhere gives the following description. " Very good Varnish used by M. Adam, clear as water, and drying in three hours.—Take of very clear Venice turpentine an oz. and half (this is the best proportion, although sometimes he takes as much as an oz. and three quarters). Place it in a glass vessel, in a basin of hot water, on a small furnace. The turpentine being melted and warm, have ready half an oz. of well cleansed mastic tears

* " Son verny ordinaire pour tableaux est faict avec therebenthine fort blanche huile de therebenthine fort claire et mastic."— *MS.* p. 161.

reduced to a fine powder; throw this into the turpentine, stirring till the mastic is dissolved. Have ready in another vessel four oz. of very light and very clear spirit of turpentine; warm this also, covering the vessel with a glass cover. Throw it into the melted turpentine and mastic, mix duly, and take the vessel from the fire. To apply this, your picture, well cleansed, should be placed in the sun till it gets warm. Spread your varnish upon it warm; let it dry [in the sun]."* De Mayerne has added in a marginal note, " Vidi, optimum."

Hoogstraten also describes a similar composition. " Our varnish, consisting of turpentine, spirit of turpentine, and pulverised mastic dissolved, is sufficiently convenient for our works."† The varnish

* " Vernix très bon de M. Adam, clair comme eau et siccatif en trois heures.—R. therebenthine de Venise fort claire une oz. et demie (qui est la meilleure proportion encor que quelque fois il en prenne jusqu'à une once et trois quarts). Mettez la dans une conserve de verre dans un bassin d'eau chaude sur un petit fourneau et la therebenthine estant fondue et chaude ayez demy once de mastic en larmes bien purgé mis en poudre subtille laquelle jetterez dans la therebenthine remuant tousjours tant que le mastic soit fondu. Ayez en une autre conserve quatre oz. d'huile de therebenthine très blanche et très claire et la faictes pareillement chauffer, le vaisseau couvert d'un couvercle de verre. Versez la avec la therebenthine et le mastic fondu reduites a bon escient et ostez de la chaleur. Pour l'appliquer vostre tableau bien net soit mis au soleil tant qu'il s'eschauffera couchez vostre vernix sur icelui chaud, laissez seicher." — *MS.* p. 141.

† " Onzen vernis van Terpentijn, terpentijn oly, en gestooten mastix gesmolten, is bequaem genoeg tot onze werken." — *Inleyding,* &c. p. 223.

last noticed, under the name of Adam, gives the usual proportions of the ingredients here named. The testimony of Hoogstraten on this and other points is important, because he was the scholar of Rembrandt.*

* "Rembrandt, after the death of my father Theodore, my second master." — *Inleyding*, p. 257.

"On one occasion when I was troublesome to my master Rembrandt, by asking him too many questions respecting the causes of things, he replied very judiciously : 'Try to put well in practice what you already know ; in so doing you will, in good time, discover the hidden things which you now inquire about.' " — Ib. p. 13

NOTE

ON THE USE OF TRIPTYCHS, ETC.

THE practice of enclosing pictures in cases with doors, called diptychs, triptychs, or polyptychs, accordingly as they had one two, or many leaves, is to be traced to the use of portable altar-pieces. The above terms were originally applied to books (libelli) composed of a few tablets or leaves, generally of ivory. The more ornamented kinds were called simply diptychs, because they consisted of ivory covers only, in which leaves of the same substance or of vellum might be inserted. An inscription published by Gruter speaks of " pugillares membranaceos operculis eboreis." The consular diptychs, for example, were nothing more than ivory covers in which the book or libellus itself might be enclosed. They were presents distributed by the consul on his entering office, and generally exhibited the portrait and titles of the new dignitary on one side, and a mythological subject on the other. The covers were carved on the outside, and were plain within.

At a very early period in the Christian era similar diptychs of a larger size were employed in the service of the church. They sometimes contained the figures of saints and martyrs on the inside (probably as a means of concealing them in times of persecution), and were subsequently exhibited on the altar open. The circumstance of the principal representation being on the inside, instead of the outside, constitutes the distinction between the sacred and the consular diptychs.

Such was the origin of the medieval altar-piece, the size of which long remained small as compared with later decorations of the kind. The Roman diptychs are generally rectangular, but sometimes (as in the instance of that representing the apotheosis of Romulus, a work probably of the fourth or fifth century) the upper edge is finished in an ornamental form approaching that of a tympanum. This enrichment, as a matter

of course always followed the architectural taste of the period :
Byzantine diptychs have often circular tops; but those of
later Italian and German origin commonly finish in various
forms of Gothic; the early decorated style occurring most
frequently.

With regard to the number of doors, the most ancient form,
consisting of two leaves, or one door, is now the least common :
the triptych, or centre picture with two doors, the most so.
The Ghent altar-piece by the Van Eycks is a polyptych : it
originally consisted of two tiers of leaves, seven above and
five below. Of the seven, three were fixed, and the portions
closing upon them were divided on each side into two subjects.
Of the five, one large centre subject was fixed, and two leaves
(one on each side) closed upon it. The outside of the doors was,
almost universally, painted in chiaroscuro, probably from a
traditional imitation of the ancient sculptured back of the
original diptych.

When the case was spread open it generally exhibited (at
least in older examples) a centre subject and single figures of
saints on the doors. In Italy the doors appear to have been left
permanently open at an early period, since various altar-pieces
exist, executed in the fourteenth or first half of the fifteenth
century, which, though representing a centre with doors, really
consist of immovable panels, the hinges being omitted. In
Flanders, on the contrary, even to the time of Rubens, the
doors were real, and could be closed upon the principal picture.
The form being at length still more simplified in Italian altar-
pieces, the single figures of saints were no longer separated by
compartments; but were brought into the centre picture, which
generally represented a "Majesty," or enthroned Madonna.
This seems to have been the origin of the groups of saints,
belonging to different periods, which are often introduced
together in altar-pieces. (See Buonarruoti, *Osservazioni sopra
alcuni Frammenti di Vasi antichi di Vetro, &c.*, Firenze, 1716,
p. 231, 257.)

NOTE

ON THE VARNISH PREPARED FROM THE OLIO D'ABEZZO.

An Italian writer of the present century, who had given great attention, during a long series of years, to the technical part of painting, being convinced of the correctness of Armenini's statement respecting this varnish, endeavoured to prepare and use it. He at first failed, from some defect in the materials; he thus describes his more successful experiments. " I thought it possible that the liquid fir resin (olio d' abezzo) might not have been good of its kind, or that it might have been mixed with [Venetian] turpentine or some similar substance ; I therefore, by means of a friend, procured from the Valtellina some olio d' abezzo which was pure, limpid, and of the finest quality. Not satisfied with this, I caused some clear petroleum to be rectified by a chemist, so as to be limpid, transparent, and fluid as water. With these I composed the varnish. I employed it on some old paintings, and on some studies then recently executed by myself: the following is the result of my trials."

The writer states that he applied the varnish to four old pictures which were in an arid state ; he proceeds: " After an interval of more than thirty years these pictures have not only retained their freshness, but it seems that the colours, and especially the whites, have become more agreeable to the eye ; exhibiting, not indeed the lustre of glass, but a clearness like that of a recently painted picture, and without yellowing in the least. I also applied the varnish on a head of an academy figure painted by me about five and twenty years since. On the rest of the figure I made experiments with other varnishes and glazings. This head surpasses all the other portions in a very striking manner ; it appears freshly painted and still moist with oil, retaining its tints perfectly. The coat of varnish is extremely thin, yet on gently washing the surface it

has not suffered. The lustre is uniform ; it is not the gloss of
enamel or glass, but precisely that degree of shine which is
most desirable in a picture."

He then attributes the preservation of Correggio's pictures,
and the clearness of the tints, in a great measure to the use of
this varnish. He continues : " Such results are not surprising,
when the nature of the ingredients in question is considered.
The fir resin is transparent and lustrous ; mastic is not to be
compared to it in these qualities, being naturally opaque. The
rectified petroleum, again, is extremely thin; it evaporates
easily and dissolves the resin perfectly. The varnish, when
spread on a picture, thus dries almost instantaneously, so that
no dust can attach itself to the surface. The mode of spread-
ing the varnish contributes also to its perfect effect ; it should
be applied warm, and the picture should also be warmed,
either in the sun or at the fire. By attending to this, the com-
position may be applied in the thinnest and most transparent
state. The fir resin " he adds, " should be dissolved by a very
slow and gentle heat; warm [wood] ashes almost suffice for
this purpose. It is then taken from the fire and the rectified
petroleum is poured on it, being stirred well with a clean stick.
With respect to the proportions, experience will teach this : it
is always better to put more essential oil than resin, because by
this means the varnish may be spread very thinly, and it may
be always repeated if necessary. Thus the essential oil
quickly evaporates, and the resin remains spread in a fine
transparent and uniform film. Experience proves that the
ingredients thus applied do not yellow, nor does the surface
grow dull ; while the colours are preserved more perfectly than
by any other varnish." — *C. Verri, Saggio elementare sul
Disegno, &c., con alcune Avvertenze sull' Uso de' Colori ad
Olio*, Milano, 1814, p. 138.

CHAP. XIII.

PRACTICE OF LATER MASTERS.

THE characteristics of the early Flemish practice in oil painting, induced by an attention to the effects of the climate in which it arose, are still to be recognised in some of the best productions of the school during the seventeenth century, notwithstanding the influence of Italian examples. The chief peculiarities in the original process, which then survived, may be recapitulated as follows:—

Those who adhered to the early system generally determined the entire composition of their subject before the picture itself was begun; for this purpose they made numerous sketches and studies. They preferred a white ground, which was rendered non-absorbent in a mode before described; and, having completed the outline upon it, they allowed portions of the finished work to exhibit that ground underneath. A general tint — pale flesh-colour, brown, or even grey*—which was sometimes passed

* Many of the sketches, and not unfrequently the finished works, of Rubens are painted on a light grey preparation, through which the white priming is visible.

over the ground, was intended only to assist the middle tints of the picture, and never excluded the still lighter priming. The above process was more especially followed when the picture was executed on wood (a material which the Flemish masters commonly employed), the defence of an impervious substratum allowing of a thinner application of the colour. The shadows, unmixed with opaque colours, were always inserted first. The painting was executed as much as possible at once, and therefore, occasionally, in portions at a time. This last system was, by degrees, so far departed from, that the design, especially when of large dimensions, was dead-coloured from a finished sketch, so as to avoid alterations in the more complete work.

Later painters, instead of the original white ground, employed a dusky priming, serving as a middle tint for the shadows rather than the lights, and not exhibiting a light preparation within it. An "Imprimeur Wallon," residing in London in De Mayerne's time, prepared cloths with a tint composed of white lead, black, red ochre, and a little umber*: the same ground (the umber excepted) is described in Jombert's De Piles.† A preparation of this kind is frequently observable in pictures by the Dutch masters; Teniers is, however, an exception; he still preferred the white ground, over which he passed a light brown trans-

* MS. p. 5. † E'lémens, &c. p. 129.

parent tint. In this use of the light priming, as in many other points, he followed the example of Rubens.*

With regard to vehicles, the same ingredients and processes which were common in the earliest days of the Flemish and German oil painting had survived, and were still adopted by many at the period now under consideration. The mode of rendering oil clear and drying by means of calcined bones (to mention one of the original expedients) is to be traced from the Strassburg MS. in the fifteenth century, through the treatise of Boltzen in the sixteenth, to the *Secreet-Boeck* published at Dort at the commencement of the seventeenth†; and the

* In small works, both of the Italian and Flemish schools, one coat of fine gesso sufficed. Pictures on wood by Teniers, when transferred to cloth or veneered, exhibit a perfectly white ground, unstained with oil.

† After speaking of a varnish composed of one lb. of pulverised mastic added to three lb. of linseed oil, the writer continues : " Here observe, if you wish the varnish to dry quickly take calcined sheep's bones, pound them to powder as fine as dust, sift this through a hair sieve, and then stir a little, about the size of a walnut, into the varnish ; let it boil once with this ingredient, it will then dry quickly on whatever surface you apply it." " Ghy sult al hier noteren dat soe verre als ghy den Vernis wilt hebben dat hy strack drooghe, soe neempt witte gebrande Schaepsbeenders, stootse tot poeder so cleyn als stof, buydelt hem door eenen haeyren sift, ende roert daer van onder den Vernis ontrent soo veel als een note groot, ende laet hem daer mede eens opsieden soo sal sy haestich drooghen, tsy waer op ghy hem strijcht." — *Secreet-Boeck*, tot Dordrecht, 1601, p. 223.

process is again recommended by De Mayerne in the age of Rubens and Rembrandt. So with regard to amber: its employment as a vehicle for colours is noticed in De Ketham's MS., by various German writers of the sixteenth century, and in the Dort publication above referred to; while the modes of dissolving the substance, and of using it in painting, are repeatedly and amply discussed by De Mayerne.

The use of oleo-resinous vehicles, the effect of which rendered a final varnish, at least for many years, needless, was still common in Flanders in the seventeenth century. The pigments, consolidated by the addition of the resinous ingredient, were diluted when necessary with an essential oil, but not (in the original method) to such an extent as to render the surface dull. The consistence of the vehicle itself, except when employed for rich shadows, was at all times such as to be compatible with the sharpest execution. Its drying tendency was sometimes assisted by the addition of metallic oxides; thus securing the colours as soon as possible from the effects of moisture and dust; and the desiccation was completed by exposing the picture, with due precautions, to the action of air and the warmth of the sun.

When a thinner vehicle was used, the essential-oil varnish of the Italians was, almost necessarily, adopted. This consisted, as has been seen, of a liquid resin or balsam dissolved or diluted in spirit

of turpentine or other volatile oil; to this composition, which, it seems, was too thin for a northern climate, mastic was afterwards added; till, at last, as modern experience shows, the latter ingredient entirely superseded the original fir or larch resin.

The oleo-resinous medium had been gradually confined, in Italy, to colours which had little substance, or, when it was used throughout the work, to pictures in exposed or humid situations. In proportion as the authority of the Italian methods prevailed on this side the Alps, the same restrictions were observed in the use of such vehicles; thus superseding the early practice (of Northern origin) from which the Italian painters had found it possible and convenient to depart. The editor of De Piles states that colours ground in a composition of linseed oil and mastic are durable in the open air.* This, which is scarcely to be affirmed with regard to a southern climate, is certainly not true in reference to a northern one.

* " Huile à broyer les couleurs pour résister aux injures de l'air. — Prenez deux onces de mastic en larmes bien claires et broyez les avec de l'huile de lin. Versez ce mélange dans un pot vernissé que vous mettez sur le feu : vous y ferez fondre peu à peu le mastic, remuant toujours la matiere ; puis vous laisserez refroidir cette huile et regarderez si le mastic est fondu et bien incorporé avec l'huile. Alors vous vous en servirez pour broyer vos couleurs, lesquelles résisteront à l'air, et vous en peindrez les ouvrages qui doivent être exposés à l'injure du tems." — *E'lémens*, &c. p. 143.

The method proposed is an instance of the change which the original process, or rather its applications, had undergone : the contrivances to render oil painting proof against damp, which may have been adopted only in extreme cases in Italy, were, at first, ordinary expedients in Flanders; it will be remembered that the composition in question, or an equivalent to it, was a usual vehicle in the early German and Flemish practice.

With respect to the pigments in use, the omission of Naples yellow by the Flemish and Dutch writers on art, even during the seventeenth century, may be considered sufficient evidence that it was not then commonly employed in the Netherlands. A less durable yellow of the lighter kind, viz. massicot, was familiar; but the finest varieties of ochre were recommended in preference. Transparent yellows were very generally, and sometimes too fearlessly, employed. Vermilion and lake were, from first to last, admitted as the chief materials for imitating the florid complexions of the North; and, among the colours peculiar to the later painters, may be mentioned a rich brown, which, whether an earth or mineral alone, or a substance of the kind enriched by the addition of a transparent yellow or orange, is not an unimportant element of the glowing colouring which is remarkable in examples of the school. Such a colour, by artificial combinations at least, is easily supplied; and it is repeated, that, in general, the materials now in use are quite as

good as those which the Flemish masters had at their command.

But it is no less certain that the final preparation of these and other materials for oil painting was more carefully attended to by painters themselves, or their immediate assistants, at the period referred to than at the present day. The examples which have been given in the preceding chapters, and which were copiously selected partly with the view of affording some insight into the ordinary habits of the older masters of the art, sufficiently prove that those masters disdained not to superintend operations which were calculated to insure the durability of their productions. They appear to have been indebted to the colour-merchant for genuine materials only, and they spared no pains to obtain such of the best quality, knowing that the fit preparation of them for the palette was in their own power.* Van Mander recommends that

* Northcote observes: "It was of advantage to the old school of Italian painters that they were under the necessity of making most of their colours themselves, or at least under the inspection of such as possessed chemical knowledge, which excluded all possibility of those adulterations to which the moderns are exposed. The same was also the case in England, till the time of Sir Godfrey Kneller, who, when he came to this country, brought over a servant with him whose sole employment was to prepare all his colours and materials for his work. Kneller afterwards set him up as a colour-maker for artists ; and this man's success, he being the first that kept a colour shop in London, occasioned the practice of it as a trade.

"Sir Joshua was ever careful about procuring unadulterated

choice colours should be laid up in store ; intimating that the opportunities of procuring them were to be seized when they occurred.* At the same time, the range of pigments remained limited; the object was rather to obtain the usual materials good than to encourage the introduction of novelties.

Among the technical improvements on the older process may be especially mentioned the preservation of transparency chiefly in the darker masses, the lights being loaded as required. The system of exhibiting the bright ground through the shadows still involved an adherence to the original method of defining the composition at first; and the solid painting of the lights opened the door to that freedom of execution which the works of the early masters wanted.

That the general principles and, to a great extent, the methods above described were followed in

articles of every sort, and has often desired me to inform the colour-man that he should not regard any price that might be demanded, provided the colours were genuine." — *The Life of Sir Joshua Reynolds*, &c. vol. ii. p. 21.

Some incidental remarks in De Mayerne's notes tend to show that there were persons exclusively employed in the manufacture of painters' materials, in London, before the time of Kneller.

* ———— " En indient u mach ghebeuren,
Wilt u van langher handt van schoon coleuren
Passen te voorsien, en by houden leeren,
Als die de Const houdt in weerden en eeren."
Het Schilder-Boeck, p. 50

the school of the Van Eycks has been established by abundant evidence: the directions of Van Mander and others, which have also been quoted, prove that those methods were still common in Flanders at the commencement of the seventeenth century. It remains to show that Rubens, the highest authority in that school, still sanctioned the same process by his example; while, in adopting those elements of the Italian practice which were compatible with it, he formed a more perfect manner than that which the painters of his own country had generally followed, and carried the principles of the early Flemish masters to a higher perfection.

It has never been ascertained from what source Descamps derived the "maxims" which he attributes to Rubens *; but the practice inculcated by them is so entirely borne out by the evidence of the master's works that there can be no doubt of their authenticity. The same observation is applicable to the account of the method of Teniers given by the same writer. Of Rubens he observes:

" The pictures of his scholars, which were re-touched [by the master], are easily recognised. They want the transparent depths which this great painter turned to such good account. . . . In the pictures of Rubens the obscurer masses have

* It may be conjectured that the authority was Largilière (the master of Descamps), a painter devoted to the principles and methods of the Flemish masters.

scarcely any substance of colour : this was one of the grounds of criticism with his enemies, who objected that his pictures were not painted with sufficient solidity, that they were little more than a tinted varnish, calculated to last no longer than the painter. We now find that this criticism had no just foundation. Every thing at first, under the pencil of Rubens, had the appearance of a glaze only ; but although he often produced tones by means of the [light] priming of the cloth [or panel] that priming was, at least, entirely covered with colour. . . . One of the leading maxims respecting colouring, which he repeated oftenest in his school, was, that it was very dangerous to use white and black. ' Begin,' he was accustomed to say, ' by painting your shadows thinly : be careful not to let white insinuate itself into them ; it is the poison of a picture except in the lights : if white be once allowed to dull the perfect transparency and golden warmth of your shadows, your colouring will no longer be glowing, but heavy and grey.' After having given this very necessary caution respecting the shadows, and having pointed out the colours which can injure their effect, he continues thus : ' The case is different in regard to the lights ; in them the colours may be loaded as much as may be thought requisite. They have substance : it is necessary, however, to keep them pure. This is effected by laying each tint in its place, and the various tints next each other, so that, by a slight

blending with the brush, they may be softened by passing one into the other without stirring them much. Afterwards you may return to this preparation, and give to it those decided touches which are always the distinctive marks of great masters."*

* "Les tableaux de ses Elèves qui ont été retouchés, sont aisés à reconnoître ; on n'y trouve pas les transparents dont ce grand Peintre tiroit si bien parti : . . . Il semble que dans les tableaux de Rubens les masses privées de lumière ne soient presque point chargées de coleur : c'étoit une des critiques de ses ennemis, qui prétendoient que ses Tableaux n'étoient point assez empâtés, et n'étoient presque qu'un vernis colorié, aussi peu durable que l'Artiste. On voit à present que cette prédiction étoit très-mal fondée. Tout n'avoit d'abord, sous le pinceau de Rubens, que l'apparence d'un glacis ; mais quoiqu'il tira souvent des tons de l'impression de sa toile, elle étoit cependant entièrement couverte de couleur : Une des maximes principales qu'il répétoit le plus souvent dans son Ecole, sur le coloris, étoit, qu'il étoit très-dangereux de se servir du blanc et du noir. ' Commencez,' disoit-il, 'à peindre légèrement vos ombres ; gardez-vous d'y laisser glisser du blanc, c'est le poison d'un tableau, excepté dans les lumières ; si le blanc émousse une fois cette pointe brillante et dorée, votre couleur ne sera plus chaude, mais lourde et grise.' Après avoir demontré cette précaution si necessaire pour les ombres, et avoir désigné les couleurs qui peuvent y nuire, il continue ainsi : ' Il n'en est pas de même dans les lumières, on peut charger ses couleurs tant que l'on le juge à propos : Elles ont du corps : il faut cependant les tenir pures : On y reussit en plaçant chaque teinte dans sa place, et près l'une de l'autre, ensorte que d'un leger mêlange fait avec la brosse ou le pinceau, on parvienne à les fondre en les passant l'une dans l'autre sans les tourmenter, et alors on peut retourner sur cette préparation et y donner des touches décidées qui sont toujours les marques distinctives des grands maitres.' " — *Les Vies des Peintres Flamands*, &c., Paris, 1753, tome i. p. 310.

Mansaert, speaking of Rubens's picture of the Elevation of the

It is unnecessary to enumerate the particulars in which such a method agrees, in principle, with that of the early Flemish masters ; one circumstance, however, should not be overlooked. It is well known that Rubens, with all his facility, rarely omitted to decide his composition, and prepare a coloured sketch of the effect before the picture itself was begun.* This method was still more requisite when his scholars were entrusted with the preparation of large works from his finished designs. His drawings and studies are innumerable ; and one of the objects which he proposed, in thus arresting the forms, was to be enabled to insert the shadows on the light ground at once, and to avoid alterations. It is not to be supposed that a painter of such exuberant invention and consummate dexterity would at all times abstain from changes ; his works are by no means free from them : but, in general, such corrections have been made in the lighter masses, where the exclusion of the ground was unimportant. This solidity in the lights is one of the points in which the Italian

Cross, in the Church of St. Walburge at Antwerp, observes : " Dans plusieurs endroits elles [les couleurs] y sont employées fort épaisses et fort grossières, et dans d'autres fort legères, de sorte qu'on y voit à travers le fond du panneau, principalement dans les grandes parties d'ombre." — *Le Peintre amateur et curieux*, p. 250.

* " Nous avous plusieurs esquisses de lui, faites pour le même Tableau. On en connoit trois en France du Tableau d'Autel des Augustins d'Anvers." — *Descamps, Peintres Flamands*, p. 313.

system was blended by Rubens with the early Flemish method.

The caution, in the above passage, respecting the use of white and black, has evidently reference to the warm transparent shades only. Blackness and a leaden opacity in shadows are the dangers to which the observation points. A (dry) white preparation underneath the rich darks is by no means prohibited; indeed it existed in the white ground. On the same principle it might be used in a more or less solid preparation of the shadows, with a view to glazing, as was often the practice of the Italians. Again, not only white, but any light opaque colour, would be injurious, if mixed with the transparent darks, so as to exclude the light within or altogether sully their clearness. On the other hand, in light reflexions Rubens himself could not, and did not, dispense with white. The above precept is therefore to be understood as referring to a particular method, and is not without exceptions even in its application to that method.

In the Italian system, pictures ultimately wrought to the highest degree of warmth were sometimes begun in white and black.* Tintoret,

* Northcote gives the following extracts from some notes by Reynolds. "The Leda, in the Colonna Palace, by Correggio, is dead coloured white, and black or ultramarine in the shadows; and over that is scumbled, thinly and smooth, a warmer tint, I believe caput mortuum [colcothar of vitriol].
. . . The Adonis of Titian, in the Colonna Palace, is dead

being once asked which were the most beautiful colours, answered, "white and black." * By their means the gradation of light and dark in a picture can be, in a great degree, defined. The Flemish masters (including Rubens himself), as is evident from existing specimens, commonly used Cologne earth instead of, or in addition to, black in their chiaroscuro oil sketches ; and some of the Venetian masters employed a warmer brown. Even when confining themselves to such simple materials they were careful to preserve transparency as much as possible in the darks; for, whatever be the nature of the colour, internal light still exhibits its maximum of warmth.

It may here be remarked that those masters who, either from want of skill in drawing or from an impatience of restricting themselves to a fixed design, painted and repainted the shadows, were compelled to use the warmest colours, enriching them further with ultimate glazings, to represent the effect of transparency, and to avoid that leaden

coloured white . . . the shadows in the light parts of a faint purple hue. That purple seems to be occasioned by blackish shadows under, and the colour scumbled over them." Again : " Dead colour with white and black only ; at the second sitting carnation. (To wit, the Barocci in the Palace Albani, and Correggio in the Pamphili.)" — *The Life of Sir Joshua Reynolds*, &c. vol. i. p. 36, 37.

* " Dimandato quali fossero i più belli colori, disse, il nero ed il bianco : perche l' uno dava forza alle figure profondando le ombre, l' altro il rilievo." — *Ridolfi, Le Meraviglie dell' Arte*, &c., 1648, vol. ii. p. 59.

hue which Rubens so justly condemned. The effect of powerful brightness behind colours, however neutral and even seemingly opaque in themselves, may be easily tried by holding up a not uniformly solid painting on cloth between the eye and the light. Wherever the ray penetrates, the dullest pigments are kindled to a flame; to imitate which with solid colours, the most glowing materials must of necessity be used. Reynolds, who scarcely ever left a light ground in the manner of Rubens, supplied its warmth, where he felt it to be desirable, with such colours.

The warm shadows observable in some of the works of Rubens might at first seem to be incompatible with "the negative nature of shade" so often recommended, and of which Correggio has been considered the chief representative. It will, however, be remembered that warmth on a very low scale can never be positive, and that its effect is more rapidly diminished by distance than the glow of brighter colours. The most daring examples of this system, in Rubens and in the Venetians, are to be found in works which required to be seen at a considerable distance*; and, when the Flemish master partially adopted this method in smaller

* " Songez aussi que les tableaux ou autres ouvrages en Peinture, qui sont vus d'une distance éloignée, doivent être plus colorés et rougeâtres dans les parties d'ombres et de lumière que ceux qui sont vus de près."— *Mansaert, Le Peintre amateur et curieux*, p. 282.

pictures, a more than ordinary freshness in the half tints restores the balance which the eye requires, giving the combined effect the utmost vivacity. The transparency of the deeper shades thus prevented the uniform blackness sometimes observable in otherwise fine works of the Italian schools; and as regards another quality in shadows, much and justly insisted on by the critics of the last century and among others by Reynolds*, viz. a uniformity of tone, a

> —— " simple unity of shade,
> As all were from one single palette spread,"†

this attribute is secured by the process in question; a general, and more or less transparent, shade tint being left for the darks, varied in degrees of force rather than in hue.

To return to Descamps: speaking of the younger Teniers, he observes that the objections made to that painter's works (as to those of Rubens), on account of their being so thinly painted in certain parts, were, unfortunately, at one time listened to by the artist. He painted some of his pictures

* "For the sake of harmony, the colours, however distinguished in their light, should be nearly the same in their shadows." — *Reynolds, Notes to Du Fresnoy's Art of Painting*, note XLIII. Cochin (*Voyage d'Italie*, 1758, p. 199.) observes: "[L'artifice] consiste à faire toutes les ombres de son tableau, en quelque façon, du même ton de couleur. . . . Dans les ombres même des étoffes blanches, ce ton y entre assez pour les accorder avec le reste." Cochin was a scholar of Largilière.

† Mason's translation of Du Fresnoy's Art of Painting.

more thickly throughout; but they had neither the lightness nor the warmth of his earlier productions. Rubens, who had persevered in his method, induced Teniers to return to his original practice. " He advised him to load his lights as much as he pleased, but, in painting the shadows, never to omit to keep them transparent, so as to show the priming of the cloth or panel through them; for otherwise the colour of that priming would be of no consequence."*
The biographer takes care to add in a note, that this ground, or priming, was always white, or approaching to it. Rubens, observes De Piles, always made use of white grounds. " I have seen pictures by the hand of this great man, executed at once [on such grounds], and which had a marvellous vivacity."†

One of the objects of the Van Eycks and their followers in keeping the colour thin, besides the

* " Rubens, à qui on avoit fait le même reproche, ramena Teniers à sa première manière. Il lui conseilla de charger les lumières autant qu'il le jugeroit à propos, mais de ne jamais manquer en peignant les ombres, de conserver les transparents de l'impression de la toile ou du panneau; autrement la couleur de cette impression seroit indifférente." — *La Vie des Peintres Flamands*, &c. tome ii. p. 160.

† " Une autre maxime c'étoit de se servir de fonds blancs, sur lesquels ils peignoient, et souvent même au premier coup, sans rien retoucher. . . . Rubens s'en servoit toujours; et j'ay vû des Tableaux de la main de ce grand homme faits au premier coup, qui avoient une vivacité merveilleuse." — *De Piles, Remarques sur l'Art de la Peinture [par Du Fresnoy]*, ver. 382.

chief aim of showing the ground through the tints, seems to have been to preserve a surface which should harbour no dust, and which might be easily cleaned. It is not to be imagined that such a condition, if really proposed, could long fetter the hands of succeeding painters; yet it may be remarked that the works of Rubens, however freely executed, and often thickly painted in the lights, exhibit a surface which may be called smooth as compared with that of many other masters. Hoogstraten, who was accustomed to the practice of Rembrandt, may have had Rubens in his view, when he admitted that a picture with an even surface has the advantage of not being easily soiled. * Whether the Flemish master aimed at producing this appearance from an unconscious adherence to the traditional practice, or from a supposition that it would really contribute to the preservation of his works, it is needless to inquire; but it may be remarked that the method, described by Descamps, of slightly blending the colours of the preparation (which necessarily produced a certain smoothness, not materially altered by the final retouching), was habitual in the school. † That this evenness of surface was

* " Een wel deurwrochte en gladde Schildery heeft vooreerst die deugt, datze minst van stof en vuilnis beschaedicht wort." — *Inleyding*, &c. p. 241.

† Compare Houbraken's account of the method of Frank Hals (a scholar of Van Mander), *De Groote Schouburgh*, &c. vol. i. p. 92. In an earlier age, the works of Rijckaert Aertsz

by no means essential to the preservation of pictures is sufficiently evident from many a well preserved work by Rembrandt, executed certainly with no attention to such a condition. The latter practice of this great painter, so opposite to that of his early years, may perhaps be considered as the direct expression of his opinion on this point, at a time when the style of Rubens had degenerated in the hands of numerous imitators, who, as usual, copied the external characteristics only of their original.*

Hoogstraten, in another passage, expresses an opinion more consonant to the lessons which he had received from Rembrandt. He says: " It is above all desirable that you should accustom yourself to a lively mode of handling, so as to smartly express

ceased to please when, in consequence of the failing of his sight, he left his colours rough. See Van Mander, Het Schilder-Boeck, p. 247. verso.

* On the difference of Rembrandt's manner from that of the celebrated painters of his time, Houbraken makes the following observation. "The peculiarity of his execution (although in many respects not to be commended) leads me to suspect that he adopted it intentionally ; for, if he had taken up a manner of painting like that of others, or if he had proposed to imitate any of the celebrated Italians or other great painters, the world would, by a comparison of his style with that of his models, have been enabled to define his [subordinate] merit ; whereas now, by taking the contrary course, he has superseded all such tests. He has done that which Tacitus says Tiberius intended when he avoided all which could give occasion to the people to institute a comparison between him and Augustus, whose memory, he saw, was cherished by all."— *De Groote Schouburgh*, vol. i. p. 273. The allusion to Rubens is not to be mistaken.

the different planes or surfaces [of the object represented]; giving the drawing due emphasis, and the colouring, when it admits of it, a playful freedom, without ever proceeding to polishing or blending: for this annihilates feeling, supplying nothing in its stead but a sleepy constraint, through which the legitimate breaking of the colours is sacrificed. It is better to aim at softness with a well-nourished brush, and, as Jordaens used to express it, ' gaily lay on the colour,' caring little for the even surface produced by blending; for, paint as thickly as you please, smoothness will, by subsequent operations, creep in of itself." *

As the practice of Rubens was, not to blend the colour much with the tint that was next it, so the method of Rembrandt was, not to mix the superadded pigment with what was underneath it, except in final operations, when, to conceal the art, the brush was allowed here and there to plough deeply.

* "„Dies is allermeest te prijzen, datmen zich tot een wakkere pinseelstreek gewoon maeke, die de plaetsen, die van andere iets verschillen, dapperlijk aenwijze, gevende de teykening zijn behoorlijke toedrukkingen, en de koloreeringen, daer 't lijden kan, een speelende zwaddering : zonder ooit tot lekken of verdrijven te komen; want dit verdrijft de deugt, en geeft niets anders als een droomige stijvicheit, tot verlies van d' oprechte breekinge der verwen. Beter is 't de zachticheyt met een vol pinseel te zoeken, en, gelijk het Jordaens plach te noemen, lustich toe te zabberen, weynich act gevende op de gladde in een smelting : dewijl de zelve, hoe stout gy ook zult toetasten, door 't veel doorschilderen wel van zelfs zal inkruipen." — *Inleyding,* &c. p. 233.

Mansaert remarks that " he [Rembrandt] rarely blended his colours, laying one on the other without mixing them." * Northcote records the following similar observation by Reynolds. " To preserve the colours fresh and clean in painting, it must be done by laying on more colour, and not by rubbing them in when they are once laid ; and, if it can be done, they should be laid just in their proper places at first, and not any more be touched, because the freshness of the colours is tarnished and lost in mixing," &c.† The direction here given, it will be remembered, refers to solid painting, in which the effect of the colours is not calculated on the light ground underneath. The sharpness which is so remarkable in well preserved Venetian pictures of the best time is of a still different quality from that alluded to by Hoogstraten, and is altogether incompatible with the employment of a thick vehicle. Even the

* " Les tableaux de Rymbrant sont chargés de couleurs principalement aux belles lumières ; il fondoit rarement ses teintes, les couchant les unes sur les autres sans les marier ensemble : façon de travailler particulière à ce grand maître." — *Le Peintre amateur et curieux, &c. par G. P. Mansaert, Peintre,* Bruxelles, 1763, 2^{nde} partie, p. 142.

† The Life of Sir Joshua Reynolds, vol. i. p. 78. This observation, extracted from some notes in the handwriting of Sir Joshua, and supposed by Northcote to be original, is a translation from a passage in the annotations of De Piles on Du Fresnoy's poem. " Pour conserver les couleurs fraîches, il faut peindre en mettant toujours les couleurs et non pas en frottant après les avoir couchées sur la toile ; et s'il se pouvoit," &c. — *Remarques sur l'Art de la Peinture,* ver. 382.

distinctness of Rembrandt's touch, produced by a rapidly drying varnish, has not the peculiar crispness of the Venetians.

Descamps, in alluding to the practice of Rubens, in the passage above quoted, speaks of "a tinted varnish." This expression, used by the critics of the painter, was not likely to be accidental; it is indeed literally applicable to the vehicle of the earlier masters, and the employment of such a medium by Rubens was almost a necessary consequence of his adopting the original method of showing the ground through the deep colours; for, in proportion as the pigment is thin, the vehicle requires to be substantial. But the durability which the oleo-resinous medium insured, and the possibility of dispensing with a final varnish by its means, appear to have recommended it to Rubens in the execution of his work generally. Its consistence was no doubt varied as required, as in Flemish pictures of the fifteenth and sixteenth centuries; and he was certainly not less careful than the early painters to use it in as colourless a state as possible for his brightest lights. In some of his works it is impossible to mistake the semi-resinous nature of the medium universally employed. Merimée detected the presence of varnish in the ridges of liquid colour with which the sketches of Rubens are outlined*, and Reynolds, whose peculiar prac-

* " A great number of sketches by this master are preserved, in which his process may be distinctly seen. The figures,

tice well qualified him to give an opinion on such matters, remarks that the picture of the Battle of the Amazons, formerly in the Dusseldorf Gallery and now at Munich, is " painted in varnish."* De Piles, a warm advocate of the style and methods of Rubens, recommends the use of varnish, in finishing at once, in order that the colours may " set" in working.†

The firmness of a semi-resinous medium recom-

drawn at first with black lead [probably before the size was added], are then retraced [on the oleo-resinous priming] with the hair pencil, and the effect of light and dark is produced by a brown colour thinly applied. The lines, formed by the pencil, are very delicate, yet at the same time full of colour. Their continuity proves that the pencil flowed freely on the surface of the panel. The ridges formed by the brush are not effaced, and the thick touches of transparent colours have remained where they were placed, notwithstanding their extremely liquid state."—*De la Peinture à l'Huile*, p. 19. Merimée is quite correct in concluding that the appearance in question indicates the presence of a resin ; the brown outlines, if drawn with oil alone, would not have remained sharp. The correspondence of the process here described with Van Mander's account of the method of the earlier painters will not fail to be remarked.

* Journey to Flanders and Holland. Reynolds further observes : " This appears to be painted at the same time of his life that he painted the Fall of the Angels, which is in his best manner."

† " Si l'on veut faire un portrait au premier coup il faut . . . faire en sorte qu'il y ait peu d'huile dans les couleurs ; et si l'on y vouloit mêler en peignant un peu de vernis avec la pointe du pinceau, cela donneroit un moyen facile de mettre couleurs sur couleurs, et de les mêler en peignant sans les emporter. " — *Cours de Peinture*, p. 290.

mended it to painters who adopted a much more
solid execution.* The glossy effect which it pro-
duced, and which rather fits it for works executed
at once, may have been reduced by the admixture
of a larger proportion of well rectified essential oil;
or, in repainting, a wash of the latter (lightly
applied for fear of disturbing the surface) would
diminish this effect, and prepare the work for the
ulterior operations. According to some notes
which have been preserved relating to the ever-
varying practice of Reynolds, it is evident that he
did not object to the occasional use of varnish, even
in the commencement of his pictures.† Rembrandt,
who was likely to adopt the semi-resinous vehicle,
not only from the traditional favour in which it was
held in the Netherlands, but from its assisting the
texture which he aimed at producing, was not
always careful to use the medium in the most
colourless state. A writer well acquainted with
the methods of the Flemish and Dutch schools,
speaking of a picture by this master which had ac-
quired a russet tone, observes that, although this
was partly the effect of time, it was also a con-

* "Jordaens had not begun to study painting under Rubens,
and he was not accustomed, like that master, to prepare his
pictures with thin washes ; but the brilliancy and transparency
of his colour are such, independently of all contrast, that it is
not to be doubted that it contains varnish."— *Merimée, De la
Peinture à l'Huile*, p. 22.

† See some extracts from the notes here referred to at the
end of this chapter.

sequence of Rembrandt's habit of painting with varnish.* The essential-oil varnish commonly employed at the time, and which a scholar of Rembrandt has described, was chiefly composed of Venice turpentine, a material which, when not carefully purified, is very apt to grow yellow. But this ingredient is hardly sufficient to account for the uniform tawny colour sometimes observable in pictures by Rembrandt. The ordinary (red) sandarac oil varnish, the ancient "vernice liquida," was still commonly used in the seventeenth century by cabinetmakers, and was rendered very drying by means of spike oil, in addition to the ordinary ingredients.† The amber varnish had been adopted in its stead

* "Un jour que je montrois une fort belle pièce de cet auteur à un particulier, il me demanda s'il mêloit de la suie dans ses couleurs, puisqu'elles lui paroissoient si roussâtres. . . J'avoue que le vrai coloris étoit changé par la longueur du tems, d'autant plus que Rymbrant étoit accoutumé à peindre au vernis."—*Mansaert, Le Peintre Amateur*, &c., 2nde Partie, p. 142.

† "Vernix est le vernix commun qui se met en œuvre par les menuisiers et marqueteurs duquel se servent les peintres qui font des lambris et peignent les boutiques et boestes des apotiquaires, auquel pour le rendre plus tost siccatif ils adjoustent deux oz. d'aspic pour livre. Cela se seiche en fort peu d'heures et a fort beau lustre." De Mayerne explains that this "vernix" is sandarac dissolved in oil. The date of the memorandum is "24. Feb. 1634."

The celebrated Ruisdael was the son of a cabinet-maker at Amsterdam. The preservation of ancient methods and materials in the commoner handicrafts, after they have become obsolete in the arts which are subject to the taste or caprice of professors, has been already adverted to.

by the early Flemish painters, and, though often represented by copal, had never been entirely laid aside; it had even returned to the North from Italy, in the hands of Gentileschi. Rembrandt, from motives of economy, may have employed the scarcely less durable common "vernix," or sandarac oil varnish; and, for certain effects, may have reckoned on its tint. Either this, or the rapidly drying Venice amber before described, was, in all probability, used by him freely.

In the practice of oil painting, from the first, the darkness of the vehicle had been allowed to increase with the darkness of the colour employed; and, on the same principle, when, from whatever cause, such a medium has been used throughout the work, large masses of shadow and extreme force have been commonly resorted to, in order to give comparative freshness to the yellow lights. Painters who have not been careful to use a colourless vehicle are the most remarkable, and consistently so, for the depth of their effects and their scarcity of light. It is not necessary, in this instance, to inquire which circumstance influenced or led to the other; it is sufficient to remark that they are correlative. The influence of the colour of the vehicle on the quantity and depth of shadow is, indeed, plainly to be traced in the general style of oil painting, as compared with tempera and other methods.* It may be added, that the lighter

* Sandrart (*Teutsche Acad.* p. 336.) relates, it is to be hoped

treatment has rarely been successful without a modification of the vehicle itself. The low tone to which the lights subside, even when the most carefully prepared medium is employed, suggested to the first Flemish and Italian masters of the art — to the Van Eycks and Leonardo da Vinci — the necessity of that extreme force which is remarkable in their productions. To appreciate this merit in the Van Eycks, it is necessary to remember the pale character of the works executed immediately before their time, for example, the altarpieces of Cologne and Dijon.

Some precautions adopted in all schools, to guard against or remedy the general defect here alluded to, remain to be considered. From the first introduction of oil painting, the yellowing of the vehicle was looked upon as its chief objection. Light within the colours, and force round them, were among the resources adopted by the Van Eycks to disguise this evil. The more direct expedients consisted in clarifying the oils to the last degree of purity; in rendering them drying, so as to present without delay a barrier to the action of air and moisture; and in fortifying them with resins, which had also the effect of checking the

on no good authority, that Rubens induced Jordaens to paint some works in tempera for tapestries, in the hope that his rival, by being accustomed to the light style of colouring suitable to tempera, might lose his characteristic force in oil; the biographer even adds that the scheme answered.

accumulation of the thinner ingredient on the surface. The suppression of the oil was found to be promoted by the addition of a certain proportion of a highly rectified essential oil; but this adjunct, if used at all in the earlier ages of the Flemish school, was not intended, as it afterwards was, to do away altogether with the gloss of the vehicle; for, had this been the case, the work would have required a varnish at last; and one of the recorded peculiarities of the early Flemish pictures was, that the surface bore out without varnish.

A superficial film, however thin, of the oleo-resinous vehicle, which invariably remained, thus superseded varnish; and to this surface the lighter and evaporable exudations of the oil would rise.[*] Leonardo da Vinci, as before shown, had noticed this effect; and the question with him, as with all oil painters, was, how this superficial yellowing was to be prevented or removed. In the subsequent Italian practice, when the whole picture was frequently laid in with an almost equal body of colour, which was to be again covered, it was allowable to cleanse the surface fearlessly; for example, by washing with alkaline detergents, and even by scraping and abrading the oily film.[†] But this was not

[*] " The drying of oils takes place partly from the evaporation of a portion of the fluid oil, partly from their combination with oxygen derived from the air." — *Dreme, Der Virniss- und Kittmacher*, p. 18.

[†] Fine sand, pulverised Flanders brick, or cuttle-fish, may

possible with finished works; a remedy was required which should remove the superficial discolouration without otherwise affecting the substance of the picture. The early painters could not long be in doubt as to the fittest expedient. They were familiar with the bleaching action of the sun on oils, and they knew from that experience that the same process, duly regulated, would remove the yellowness objected to, would harden the binding vehicle, and, by almost reducing the superficial film to its resinous ingredient only, would anticipate in some measure the enamel of time.* When the surface was thus freed from the evaporable portion of the oil, and was no longer in danger of undergoing change by exclusion from the light, the enclosure of the picture in its altar shrine undoubtedly tended to preserve the freshness of the colours.

The artists of the Netherlands, who at first

be used with good effect in this way, when it is not important to preserve the surface of the picture. Armenini (*I veri Precetti*, p. 126.) even recommends scraping with a knife ; but this can only be advisable when the surface is not very rough.

* The same process, by accelerating the evaporation of aqueous particles and insuring the free action of air, tends to resinify the oil itself. "According to Thénard and Gay-Lussac (olive) oil consists of 77·21 parts of carbon, 9·43 of oxygen, and 13·36 of hydrogen : resin, of 75·94 parts of carbon, 13·34 of oxygen, and 10·72 of hydrogen. Hence, as the oil acquires oxygen and loses hydrogen it approaches the nature of a resin."— *Dreme, Der Virniss- und Kittmacher*, p. 19. note.

painted chiefly on wood, were not deterred by the story of Van Eyck's accident from placing their pictures in the sun. They continued the practice; not as originally, merely to dry the surface, but to bleach and remove the superficial oil. They even suffered occasionally from the use of this remedy, precisely as Van Eyck was said to have suffered. Van Mander relates that Peter Vlieric (his second master) having placed an unfinished picture on wood in the sun, the panel split, " so that it required to be again glued and planed." * The practice in question was familiar in Italy in Cennini's time, and was not likely to be discontinued after the introduction of oil painting, as there was then an additional reason for it. It is, therefore, by no means improbable that the Venetians, who took every possible means to prevent the rising and yellowing of the oil, and who needed not Cennini's caution † to be reminded of the danger of exposing panels to the sun, may have found in the necessity of the practice itself a new motive for painting on cloth.

The Venetian painters of the present day commonly place their pictures in the sun, not merely

* "Dese maeckte hy te Cortrijck, was een redelijck groot Penneel, t'welck ghedootverwet zijnde, is in de Son gheborsten, dat het herlijmt en gheschaeft zijn most." — *Het Schilder-Boeck*, p. 251. verso.

† "La tavola l' ha molto per bene a non essere troppo sforzata dal sole." — *Trattato*, c. 155.

before varnishing, but at different stages of the work. In the expeditious days of the school, the rapid drying of the colours was often promoted by such means. Ridolfi states that Maffeo Verona was accustomed, in summer, to prepare a picture in the morning, and, after drying it in the sun, to finish it before night.* The fierce heat of the Italian sun limited the process in the warmer season to a very short interval, at least for finished pictures. A Genoese painter, writing to a friend in the month of July, requests that a newly painted picture on cloth may be exposed "for a quarter of an hour " † to the sun. The story of Titian placing his portrait of Paul III. in the sun, previously to its being varnished, is well known : the anecdote is preserved by Vasari only from the circumstance of the passers by mistaking the representation for the pope himself. ‡ It is not unlikely that Rembrandt may have placed the

* Le Meraviglie dell' Arte, vol. ii. p. 148.

† " Sarà bene che il quadro che ho fatto quando sarà messo sopra al suo telaro, lo facciate stare un quarto d' ora al sole. Genova, 6. Luglio, 1704." — *Lettere Pittoriche* (1822), vol. iv. p. 61.

‡ " Essendo [il ritratto di papa Paolo di Tiziano] messo a una finestra al sole alto per verniciare, tutti quelli che passavano, credendolo vivo, gli facevan di capo." — *Le Opere de Giorgio Vasari*, Firenze, 1832–1838, Parte 2nda, p. 1450. In the copy of the same letter of Vasari in the *Lettere Pittoriche*, it is stated that the picture was placed " in su un terrazzo :" the illusion produced would have been more possible supposing the figure to be seen at a window, as in the passage quoted.

portrait of his servant at his window merely to expose it to the light, but the story is recorded because of the illusion which the picture produced.*

The practice was, at all events, common in the Netherlands during the seventeenth century. De Mayerne, whose information was chiefly derived from painters of that school, observes, in a passage already noticed, that, when the picture is placed in the sun, linseed oil bleaches better than the other oils: the process was, therefore, customary in all cases. Adam, a Flemish painter frequently named by the physician, remarks that certain colours (massicot and indigo) are liable to change, if the picture is exposed to the sun.† Norgate, in the MS. before quoted, gives the following receipt. " To refresh oyl pictures, whose colours are faded " (the expression " faded " here meaning the alteration produced by a film of oil on the surface). — " Wash the picture clean with water, and set it in a hott sunshine to dry the space of three or four hours, soe the colours will be refreshed, and, if it be but a litle faded, it will recover it again." The next receipt begins, " If your picture be old," &c.;

* De Piles, Cours de Peinture, &c., Paris, 1708, p. 10. This writer states that he afterwards purchased the picture in question, " que je trouvai d'un beau pinceau et d'une grande force."

† " M. Adam, Peintre Flamand. — Le massicot et indico à huyle s'esvanouissent et se tirent dehors, si le tableau est exposé au soleil; ce sont couleurs dont il fault fort peu user." —MS. p. 123.

thus showing that, in the case referred to, he alludes to recently painted pictures.

The Spanish painters adopted the same method. Palomino, after speaking of the necessity of assisting the desiccation of most colours, observes : " This [drying] is promoted by the state of the weather in summer, and by the sun in winter ; the pictures being placed where they can receive the solar rays. It is, indeed, always important that an oil picture should be exposed to the air and sun for a while, in order to remove the oily exudation, which deadens the colours, especially the blues and whites; and the more so if the picture has been for a time turned to the wall. Care must, however, be taken in regard to indigo, for the sun, if powerful, will cause it to fade."*

The habits of Rubens, in this respect, may be gathered from various letters of his, in which he alludes to the same practice. In one addressed to Sustermans, at Florence, to whom his "Allegory of War," now in the Pitti Palace, was consigned, he expresses his fears that the flesh tints and whites

* "Y para esto ayudan tambien mucho el tiempo, si es verano, y el sol, si es invierno, poniendo las pinturas donde le puedan gozar ; y siempre es importante á una pintura á el olio que goce á el descubierto de los ayres y del sol algun tanto para que se le quite lo abutagado que suele mortificar los colores, especialmente en azules y blancos, y mas si ha estado algun tiempo vuelta á la pared ; pero con cuidado si tiene añil, porque si es mucho el sol, se lo llevará." — *El Museo Pictorico*, tomo 2ndo, p. 57.

may have become a little yellow in consequence of the picture having been packed up while it was fresh; and requests that, should such be the case, it may be exposed to the sun, at intervals, to remedy the defect.* In his letters to Sir Dudley Carleton, he repeatedly adverts to his having placed certain pictures, then freshly retouched, in the sun to dry. There is, however, no evidence that these, or any other of his works, were so exposed in order to be varnished : on the contrary, the pictures referred to were sent away, rolled, within a very few days after he had worked upon them. The circumstances under which they were completed tend further to show that the vehicle used, while it superseded the necessity of an ultimate varnish, must have dried hard in a very short time, to admit of their being packed in the mode described.†

* "Io temo che stando tanto tempo una pittura fresca incollata ed incassata, ben potrebbono smarrire un poco gli colori, e particolarmente le carnagioni e le bianche ingiallirsi qualche poco ; che però, sendo V. S. si grand' uomo nella nostra professione, vi rimedierà facilmente con esporlo al sole, lasciandolo per intervalli ; e quando fusse necessario, ben potrà V. S. con mia permissione metterci la sua mano, e ritoccarlo dove sarà di bisogno, o per disgrazia, o per mia dappocaggine." — *Lettere Pittoriche* (1822), vol. iii. p. 528. The date of this letter is "12. Marzo, 1638."

† All the pictures, nine in number, were more or less retouched by Rubens in the month of May, 1618 : two or three required considerable repainting. On the 26th of May he writes that for some time he had not given a single stroke of the brush, "alcuna pennellata," except on these pictures ; and

Another letter from Rubens to Peiresc is no less important, as it contains the great painter's opinion, founded on his experience, of the remedy in question. He says: "If I knew that my portrait was still at Antwerp, I would cause it to be detained, and the case to be opened, in order to see if it is not spoiled after having been so long shut up without air ; and whether, as commonly happens to fresh colours [under such circumstances], it has not turned yellow, so as to be no longer in appearance what it was at first. The remedy, however, if it should happen to be in so bad a state, will be to place it several times in the sun, as the sun can dissipate the superfluity of oil which causes this alteration. And, if at any time it should again become brown, it should again be exposed to the sun's rays, which are the only antidote for this disease of the heart." *

reckons on completing all by the 28th. By the end of the month the pictures were all packed in their cases, for on the 1st of June he writes: "I quadri tutti ben conditionati et incassiti con diligenza ho consigniati," &c. He speaks of them as freshly retouched, "frescamente rittochi;" always alluding to painting, and not to varnishing. See the letters in Carpenter's *Pictorial Notices*, &c. p. 153. 165. It is hardly to be conceived that, in entering into all these details, the application of varnish would have been omitted, if it had taken place: the inference is, that the vehicle which he used rendered such an addition unnecessary, being itself partly composed of varnish.

* " Se io sapessi che il mio ritratto fosse ancora in Anversa, io lo farei ritenere per aprir la cassa, e vedere se sendo stato rinchiuso tanto tempo in una cassa senza veder l' aria, non sia guasto e, siccome suole accadere agli colori freschi, ingialdito,

The recommendation in this letter, and in that to Sustermans, to place the picture in the sun " at intervals," and " several times," is not an unnecessary caution, even when the work is executed on cloth. Besides the danger, already adverted to, of some colours fading (especially if not defended by a firm vehicle), it is to be remarked that pigments thinly spread on a dry ground, in expanding with the heat, may become partially detached and rise in blisters. This is more likely to take place in pictures painted on panel, because the wood contracts (on the heated side), while the paint has a contrary tendency. Accidents of this kind are avoided by not exposing the picture to a fierce heat for any continuous length of time ; in warm and dry weather it is safer to place it in the open air, without exposing it to the direct rays of the sun.*

The repetition of this process, as Rubens intimates, will at last entirely exhaust the exudations

di maniera che non parirà più quello che fu. Il remedio però, se arrivarà [d' essere] così mal trattato, sarà di metterlo più volte al sole, che sa macerare questa ridundanza del oglio che causa questa mutanza ; e se per intervalli torna ad imbrunirsi, bisogna di novo esporlo ai raggi solari, che sono l' unico antidoto contro questo morbo cardiaco." — *Gachet, Lettres inédites de Pierre Paul Rubens*, 1840, p. 234.

* Sebastian Resta, speaking of some pictures which had darkened in tone, recommends that they should be placed for some days in the open air : " Gli tenga qualche giorno all' aria che si rischiariranno un poco più."— *Lettere Pittoriche* (1822), vol. ii. p. 114.

which cause the yellowing of the surface; and, when a picture is thus as safe as it can be from further change, the same cause which would injure it while in a fresh state, viz. its being screened from the action of light, will now be beneficial, and will tend to maintain the vivacity and force of the colours. The age of triptychs is past; the habit of reserving fine pictures for occasional inspection only is now almost obsolete; but their protection from the sun's rays, when there is no longer any " superfluity of oil" to dissipate, is essential to their preservation.*

Painters who are accustomed to a climate where the sun is not always to be had when wanted may find in the example of the Dutch and Flemish artists, who had no better sky than our own, a sufficient inducement to revive the practice above described. Rubens, as appears from one of his letters to Sir Dudley Carleton, required serene as well as sunny weather, because the wind " stirring up the dust is injurious to newly painted pictures." He had thus all the disadvantages to contend with which the painters of this country can experience.

The hints obtained by De Mayerne from Rubens and Vandyck relate to various subjects, and occur

* The celebrated Pietà, by Perugino, now in the Pitti Palace at Florence, suffered from long exposure to the sun while in its original situation in the Church of S. Chiara. See the notes to the Florence edition of Vasari (1832–1838), vol. i. p. 124.

in different parts of the physician's MS.; but, as it may be desirable to compare the remarks so recorded, they are here inserted together; with the exception of Vandyck's receipt for clarifying oil, which has been already given.

The physician, in noting some methods for preparing essential-oil varnishes, adds the following receipt, which, it will be seen, corresponds with that of Armenini, called the varnish of Correggio. "Another method, which is considered better. — Melt 1 oz. of very fine turpentine in 2 oz. of petroleum in a water-bath, taking care that nothing boils. This varnish never cracks, does not become white [opaque], and displays your work perfectly." * Immediately after, he inserts Rubens's opinion on this varnish.

"M. Rubens. N.B. Turpentine in time becomes arid (as the essential oil of turpentine or the petroleum evaporates), and is not proof against water. The best varnish, resisting water, is made with drying oil, much thickened in the sun on litharge, without boiling at all." †

* "Aultre façon qu'on tient meilleure. — R. Térébenthine très belle une oz., pétrole deux oz., fondus ensemble dans eau chaude, et guardez que rien ne bouille. Ce vernix ne s'escaille jamais, ne blanchit point, et vous monstre exactement tout vostre ouvrage." — *MS.* p. 7. verso.

† "La térébenthine avec le temps se seiche, l'huile de térébenthine ou le pétrole s'esvanouissant, et ne peut endurer l'eau. Le meilleur vernis résistant à l'eau se faict avec l'huile siccative fort espaissie au soleil sur la lytharge (voyez sur la céruse) sans aulcunement bouillir." — Ib. p 8. The observation in

The first point which is clear from this memorandum is, that Rubens disapproved of essential-oil varnishes as final coatings for pictures. The varnish first described, as already shown, was held in great estimation by the Italians, and is frequently noticed in the physician's MS.; but, in more than one instance, he takes occasion to say, on the authority of various Flemish painters, that, without some admixture of oil, it is not durable in a humid climate. For example: " M. Portman, a Flemish painter, thinks that any varnish, whether composed of mastic, sandarac, or other resins, which cannot bear moisture without becoming white, and thereby being spoiled, will bear it without injury if you add to your varnish a little drying oil bleached in the sun, in the mode before explained. This oil should be thinned (so as to be easily spread) with spike oil, which presently evaporates; thus the drying oil will preserve all the rest." *

After describing one of the essential-oil varnishes of Van Belcamp, De Mayerne observes : " The addi-

the parenthesis is by De Mayerne. In the margin is written, "M. Rubens. N. B."

* " Vernix résistant à l'eau. — M. Portman, peintre Flamand, croit que tout vernix, soit de mastic, sandarach, ou aultres gommes resineuses, qui ne peuvent souffrir l'eaue sans blanchir et se gaster, la souffriront sans préjudice si à vostre vernix vous adjoustez un peu d'huyle grasse blanchie au soleil, ut a. s., laquelle soit délayée et rendue extensible avec huile d'aspic qui s'évapore facilement ; ainsi l'huile seichant conservera tout le reste." — MS. p. 151.

tion of some very drying linseed or nut oil, in the proportion of half an oz. to a lb., will render this varnish, and any other which whitens or cracks in the air, very hard and firm."* Elsewhere, after noticing some similar compositions, he says : " To all these varnishes add a little nut or linseed oil bleached in the sun ; this prevents their cracking, and causes them to resist moisture and air." † On the authority of Mytens, he gives the following direction : " To render it [the varnish] constant and unalterable by moisture, add to it, when it is prepared, an eighth part of drying linseed oil, bleached in the sun." ‡ A remedy for the chilling of ordinary varnishes is also suggested by Mytens. " Observe that a bloom appears on the surface of varnish as if one had breathed on it; this takes place especially in a damp situation. It is easily wiped away with a piece of linen; but it will not happen at all, if the picture, when varnished, is placed and left for some hours in the sun ; or [and] if a second coat of the same varnish be applied." §

* " L'addition de ℥ ss sur lb. 1. d'huile de lin ou de noix fort siccative rendra ce vernis, et tout aultre qui se blanchit ou s'ecaille à l'air, très dur et resistant." — *MS.* p. 163.

† " A` tous ces vernis ajoustez un peu d'huile de noix ou de lin blanchie au soleil : cela empesche qu'ils ne se fendent et les faict resister à l'eau et à l'air." — Ib. p. 112.

‡ " Pour le rendre constant et inalterable à l'eau quand le vernix est faict adjoustez une huictiesme partie d'huyle de lin blanchie au soleil, siccative."

§ " (Mitens) Notez que sur le vernix, principalement en lieu

The sunned drying oil, of which Rubens speaks, may either have been an ingredient in an oleo-resinous varnish, or, being half-resinified, may have formed a varnish by itself. As it was " much thickened," it required, in either case, to be diluted; and it will be seen that (at least in painting) he employed an essential oil for this purpose.

Leonardo da Vinci alludes to a varnish consisting of nut oil alone, thickened in the sun (rassodato al sole) * ; and a Flemish authority quoted by De Mayerne, after describing the usual essential-oil varnish, adds: " nut oil alone answers very well also." † If the opinion of Rubens above cited is to be taken literally, his authority may be added to those who recommended such a varnish : but this remains to be examined.

It is to be supposed that, whenever this method was adopted, the oil had the consistence and nature of a varnish ; having been thickened and bleached by exposure to the sun, and having been rendered drying, either by the same means, or by the addition of metallic oxides. In some cases it was even allowed to attain its maximum of solidification, and was then dissolved by gentle heat with spirit of

ou à l'air humide, se faict un ternissement bleuastre, comme si on avoit soufflé dessus, qui s'essuye facilement avec un linge, mais qui ne viendra point si le tableau verny est mis et laissé pour quelques heures au soleil, ou si on donne une seconde couche du dit vernix." — *MS.* p. 149.

 * Trattato della Pittura, Roma, 1817, p. 256.

 † MS. p. 154. verso.

turpentine.* The addition of an essential oil
would, indeed, be required in most cases, in order
that the varnish might be easily spread, and in order
to reduce its substance when applied on the picture.
But it would evidently have been a misapplication
of the method, to use thin unprepared oils. They
have not sufficient body to protect the surface, and,
as they become incorporated with the colours, have
only the effect of yellowing without defending them.
Van Gool relates that Robert Du Val, who was
employed by William III. to take charge of the
cartoons, and to repair other works at Hampton
Court, had adopted the system here objected to.
" He had," observes the biographer, " quite a mis-
taken notion on this subject, as I know from having
often conversed with him; I found that instead of
good varnish, he used nut oil to bring out the
colours, maintaining that this was the best mode
of keeping pictures in a good state. On this point
I could never agree with him; for it is impossible
to rub the oil so thinly and sparingly on the sur-
face as to prevent it, before it is dry, from running
down. Besides which, no oil is known which does
not become yellow in time, thus spoiling the effect
of the picture; it is, also, not to be removed without
caustic materials, the application of which is ex-
tremely dangerous : whereas, when the ordinary

* See the description before given of a varnish of this kind,
p. 357.

varnish has become yellow, it is easily removed by any one who understands the operation."*

Du Val appears to have used the nut oil in its thin unprepared state, thus rendering the method doubly objectionable. When thickened and bleached in the sun, and again diluted with a quickly evaporating essential oil, it would undoubtedly form a sufficient defence for pictures, and would, perhaps, be less likely to turn yellow, though this last defect, as Van Gool remarks, is hardly to be avoided. The addition of a small quantity only of bleached oil to the ordinary " Italian " varnish, in the mode recommended by De Mayerne and his Flemish authorities, would form a more brilliant and

* " Op order van Koning Willem den derden, monarch van Groot Brittanje, stak Du Val naer Engelant over, om het geen beschadigt of vuil was in order te brengen en schoon te laeten maken ; hoewel hy van dit laetste een heel verkeert begrip had, daer ik wel meer als eens met hem over in gesprek ben geweest, en verstont van hem, dat hy, in plaets van goede Vernis, Nooten-Olie gebruikte om uit te halen ; voorgevende, dat zulks het beste middel was om de Schildereyen in goeden staet te houden ; het geen ik geenzints met hem eens was ; want daer is niemand in staet, om 'er den Olie zo dor en schrael op te vryven, of, eer hy droog is, loopt 'er dezelve by neer ; waer noch by komt, dat 'er geen Olie bekent is die niet geel wordt door den tyt, en de Schildereyen bederft ; ook is 'er dezelve nooit af te krygen als met bytende middelen, het geen ten uiterste gevaerlyk is. Daer men in tegendeel Vernis, die geel geworden is, op een heele makkelyke manier, voor jemant die de behandeling weet, daer weder kan afdoen." — De Nieuwe Schouburg der Nederlantsche Kunstschilders, &c., in 'Sgravenhage, 1750, vol. i. p. 85.

scarcely less durable composition, and there can be little doubt that this was what Rubens meant. The expression "le meilleur vernis se faict *avec*," &c., bears this interpretation. But if he gave his opinion in favour of such a varnish, as compared with the more perishable applications in use, it still does not follow that he commonly employed it.

As already remarked, it may, at least, be inferred from the above passage, that he did not varnish his works with an essential-oil varnish; and if, as there seems ground to conclude, he used an oleo-resinous vehicle with his colours, his pictures, when first executed, could not require varnish at all. It is not likely that a painter who took such precautions to remove the yellowness occasioned by the rising of the oil, and who describes that effect as a "disease of the heart," would increase the evil he complained of by the addition of oil on the surface; nor could he consistently have explained such an effect in the words just cited, if the rising of the oil had been checked by a superadded varnish of any kind. Rubens appears to have considered that the essential-oil varnish, although answering very well in Italy, is not fit for a humid climate; and that the best substitute for such a composition is a vehicle which leaves a sufficient gloss on the colours, thereby superseding the necessity of any further addition. It may also have been his opinion, that those who consider a

varnish indispensable might employ, as such, this same medium diluted with an essential oil.

After all, the gloss on pictures executed with an oleo-resinous vehicle, though it may supersede varnish for many years, disappears at last, and requires to be supplied by other means. Specimens of pictures by the immediate followers of the Van Eycks are sometimes to be seen in their original state. They have now the dryness of tempera; the gloss, which at the time of their completion rendered varnish unnecessary, has entirely disappeared. Two portions of the triptych by Hugo van der Goes in S. Maria Nuova, at Florence, are* in this condition, and contrast strongly with the third (one of the wings) which has been recently varnished.

It remains to observe, in reference to the above opinion of Rubens, that he evidently did not object to a drying oil prepared with litharge, provided the oil was not boiled with that substance. The next memorandum is as follows:—

" M. Rubens. N.B. To make your colours spread easily, and consequently unite well, and even retain their freshness — as in the case of blues and indeed all colours—dip your brush lightly, from time to time while you paint, in clear essential oil of Venice turpentine, distilled in a water-bath; then, with the same brush, mix your colours on the

* April, 1846.

palette."* De Mayerne, in a marginal note, ex-
plains the oil of turpentine by the term "aqua di
raggia" (the present Italian appellation of spirit of
turpentine). The word "vidi" is also added, inti-
mating that the physician had seen Rubens put his
recommendation in practice.

The direction here given is a necessary conse-
quence of using a somewhat thickened drying oil.
If the oil itself be thinned with the spirit, the latter,
when well rectified, evaporates so quickly, and so
soon separates from the oil by rising above it, that
the method proposed by Rubens is perhaps the
least inconvenient. The same mode was adopted
(probably to a greater extent) by Paul Veronese,
as will be shown hereafter. Painters are aware
that a considerable quantity of essential oil may be
used with an oleo-resinous vehicle, without impair-
ing its gloss. It has been shown that some Flemish
painters, adopting the Italian practice, were in the
habit of using so much spirit with certain colours,
as purposely to render them dull; but it is evident
that, had Rubens done this, he must have varnished
his pictures at last, and this does not appear to

* " M. Rubens. N.B. Pour faire que vos couleurs s'esten-
dent facilement, et par conséquent se meslent bien, et mesme ne
meurent pas, comme pour les azurs, mais généralement en
toutes couleurs, en peignant trempez légèrement de fois à aultre
votre pinceau dans de l'huile blanche de térébenthine de Venise
extraite au baing m., puis avec le dit pinceau meslez vos
couleurs sur la palette." — *MS.* p. 10.

have been his ordinary practice. De Mayerne, in another part of his MS., writes:

" Sir Peter Paul Rubens said that all colours should be ready ground, employing for this purpose spirit of turpentine, which is better than spike oil, and not so strong."*

If colours are ground in an essential oil, it is to be supposed that the fluid has been perfectly rectified, otherwise the resinous portion would cause the colours to cake. Spirit of wine is, for this reason, generally preferred. Rubens had probably experienced the inconvenience of using colours ground in water, from the difficulty of drying them thoroughly; the mischief of aqueous particles in oils, varnishes, or pigments, has been already noticed. The expression " fiera," applied to spike oil, may have had reference to its pungent odour. The colours being perfectly ground, and kept in that state, could then be mixed with the drying vehicle for immediate use, according to the early Flemish practice. He proceeds :

* " Il Cavaliere Pietro Paulo Rubens. Il Signor Cavaliere Rubens a detto che bisogna che tutti i colori siano presto macinati operando con acqua di raggia che è migliore e non tanta fiera come l' oglio di spica."— MS. p. 151. The physician explains " acqua di raggia" as follows : " i. cum oleo extracto ex pice molli et alba quæ colligitur ex arbore picea, est boni odoris et distillatur in aqua instar olei albi Terebinthinæ." Rubens appears to have sometimes conversed, as he commonly wrote, in Italian ; but not always in the purest and most intelligible language. The word " presto" is probably here used in the sense of the French "prêt."

"To use smalt so that it shall be beautiful and light, it is necessary to temper it quickly with varnish; then to lay it on gently, without caring to stir it much while the colour is wet, because this stirring spoils it : but when dry it may be worked upon as you please. The same mode may be adopted for blue bice. Ultramarine and ultramarine ashes are excellent for finishing the distance."*

The varnish here alluded to was no doubt the essential-oil varnish before mentioned, composed of fir resin and petroleum ; the recommendation to mix the colour with it quickly (from its rapid drying) would hardly be applicable to an oil varnish. The ultramarine was evidently used in the second painting, perhaps over a preparation with the "cendre d'azur." The next remarks relate to Vandyck.

"Sir Anthony Vandyck, Knight, a very excellent painter. London, 30th December, 1632. N.B. Oil is the principal thing which painters should be choice in, endeavouring to have it good, colourless, fluid ; for otherwise, if it be too thick, it alters all the finest colours, especially the blues and whatever is made with them, as the greens."

* "Per far la smalta bella e chiara bisogna temperarla con vernice tosto e metterla piano e non affaticarsi a mescolar troppo mentre il colore e umido, perchè questa agitatione guasta il colore. Ma essendo il lavoro secco si puo lavorare di sopra come vi piace.

"Così si puo far con la cenere— cendre d'azur. L'oltramarino e la cenere di oltramarino sono bellissime per finire la lontananza."— *MS.* p. 151.

" Linseed oil is the best of all the oils ; it even surpasses nut oil, which is more fat, and that of the poppy seed, which becomes so and easily thickens."*

It is evident from these passages that the practice of Rubens and Vandyck differed in regard to the vehicle. Vandyck is, however, quite consistent : as he was accustomed to a thin and fluid medium, he objected, as will be seen, to the amber varnish. The firm vehicle which Rubens appears to have used, diluting it as required, was, for the same reason, not to his taste. On the other hand, the oleo-resinous medium, described as Vandyck's in a former chapter, and which, according to that account, he always preferred in a fresh state, before it had become inspissated, possessed the quality which he here approves. The physician continues :

" Having suggested to him that those colours — blue and green — when applied with gum water or isinglass in distemper, and then varnished, are as good as colours applied with oil, he told me that he very often laid in those colours in his pictures with gum water, and when they were

* " S^r Antony Van Deik chevalier, peintre très excellent. Londres 30. X^{bris} 1632. N.B. L'huyle est la principale chose que les peintres doivent rechercher, taschant de l'avoir bonne, blanche, liquide ; car aultrement, si elle est trop grasse, elle tue toutes les plus belles couleurs, comme les azurs principalement et tout ce qui se faict avec iceulx, comme les verds.

" L'huyle de lin est la meilleure de toutes, mesme elle surpasse celle de noix, qui est plus grasse, et celle de semence de pavot, qui le devient et s'espaissit facilement." — *MS.* p. 154.

dry passed his varnish over them : but that the secret consists in making colours in distemper take and adhere to a priming in oil. This is accomplished certainly and permanently if the juice of onion or garlic be passed over the priming : the juice, when dry, receives and retains colours mixed with water.

" This conversation arose in consequence of his telling me that Signor Gentileschi, a Florentine painter of merit, has a very excellent green, prepared from an herb, which he makes use of in his oil pictures, possibly in the mode above described."* De Mayerne adds : " See above, among the observations on green colours, the preparation of bladder green with tartar; see also the notes on gamboge, a colour which does not fade."

In the process here recorded, which was common

* " Lui ayant proposé que les couleurs susdites, l'azur et le verd, estant couchées avec eau gommée ou colle de poisson à détrempe, puis vernissées, sont esquivalents à celles qui sont mises à huile, il m'a dit que bien souvent il couche en ses tableaux lesdites couleurs avec eau gommée, et puis, estant seiches, passe son vernix par dessus. Mais que le secret consiste à faire que les couleurs à détrempe prennent et s'attachent sur l'imprimeure qui est à huile. Ce qui se fera certainement et fidellement, si on passe par dessus l'imprimeure le suc d'oignon (ou d'ail) lequel estant sec reçoit et garde les couleurs à eau. Ce discours est venu sur ce qu'il m'a dit que S^r. Gentileschi, bon peintre Florentin, a un très excellent verd fait avec une herbe, duquel il se sert à ses tableaux à huile, possiblement de façon susdite. [Voyez ici devant entre les verds la préparation du verd de vessie avec le tartre et le Gambouya qui ne meurt point.]" — *MS.* p. 154.

with some Venetian painters, it was necessáry to cover the portion painted in tempera with varnish, so as to render the colour proof against water. This precaution was sometimes imperfectly attended to, or the varnish may have decayed; the consequence has been (particularly in some Venetian examples), that such portions have been sometimes partly disturbed by washing. The varnish of Vandyck, fortunately recorded by Norgate, has been already given.

The use of the medium above described, as a mordant for gilding, is very ancient; it occurs in most of the early treatises, and, among others, in the Byzantine and Venetian MSS. before quoted.* It may have been employed at an early period in oil painting, in the mode recommended by Vandyck; it was afterwards used in the Northern schools, as a means of assisting the adherence of oil colours on any smooth surface. The editor of De Piles, after describing the preparation of an oil ground on copper, adds that the metal may be painted on at once, without any ground, if it be previously rubbed with the juice of garlic.† The authors of the *Encyclopédie Méthodique* even state that glass may be prepared for painting in the

* The glutinous mordants described in the latter are, gum arabic (rendered less liable to crack by the addition of honey or sugar), ox-gall, the milky juice of the fig tree, gum sagapenum, and the juice of garlic.

† E'lémens, &c. p. 138.

same way.* The adherence to an oil ground is complete, apparently in consequence of the presence of an essential oil in the juice. De Mayerne continues:

"Treatment of Yellow. He [Vandyck] makes use of orpiment, which is the finest yellow that is to be found; but it dries very slowly, and, when mixed with other colours, it destroys them. In order to make it dry, a little ground glass should be added to it. In making use of it, it should be applied by itself; the drapery (for which alone it is fit) having been prepared with other yellows. Upon these, when dry, the lights should be painted with orpiment: your work will then be in the highest degree beautiful.

" He spoke to me of an exquisite white, compared with which the finest white lead appears grey, which, he says, is known to M. Rubens.

" Also of a man who dissolved amber without carbonising it, so that the solution was pale, yellow, transparent.†

The above communications from Vandyck are

* Beaux Arts, vol. ii., art. Impression, p. 661.

† "Labeur de Jaune. Il se sert de l'orpiment, qui est le plus beau jaune que l'on sçauroit avoir ; mais il seiche fort tardivement, et meslé avec toutes autres couleurs il les tue. Pour la faire seicher il y fault adjouter un peu de verre broyé. Et pour s'en servir il le faut appliquer seul, ayant fait la draperie (pour laquelle seule il est très bon) avec autres couleurs jaunes, et sur icelles bien seiches fault rehausser sur le jour avec orpiment. Ainsi votre labeur sera beau par excellence.

" Il m'a parlé d'un blanc exquis au prix [auprès] duquel le

inserted towards the end of the physician's MS. The following extracts occur before it, but they have been here placed in the order of their dates.

" London, 20th May, 1633. The ground, or priming, for pictures is of great consequence. Sir Antonio Vandyck has made the experiment of priming with isinglass; but he told me that what is painted upon it cracks, and that this glue causes the colours to fade in a very few days. Thus it is good for nothing.

" Having given him some of my good [amber] varnish to work with the colours, by mixing it with them on the palette in the same mode as the varnish of Gentileschi is used, he told me that it thickened too much, and that the colours, in consequence, became less flowing. Having replied that the addition of a little spirit of turpentine, or other fluid which evaporates, would remedy this, he answered that it would not: but that remains to be tried. See whether the oil of white poppy, spike oil, or other will answer."*

blanc de plomb le plus beau semble gris, qu'il dit estre cogneu par M. Rubens.

" Item d'un homme qui dissolvoit l'ambre sans le brusler, de sorte que la dissolution estoit blanche, jaune, transparent." — *MS*. p. 155.

* " 20. May, 1633, à Londres. L'imprimeure est de très grande conséquence. Sʳ. Antonio Van Deik a essayé d'imprimer avec la colle de poisson ; mais il m'a dit que le labeur s'escaille, et que cette colle dans fort peu de jours tue les couleurs. Partant elle ne vaut rien.

" Lui ayant donné de mon bon vernix pour travailler avec les

De Mayerne had made the amber varnish too thick and too drying; the latter defect, instead of being corrected, would rather be increased by the addition of an essential oil. The proposed poppy oil was a fitter remedy. The author of the Byzantine MS. directs a thick vehicle to be diluted either with an essential oil, or with a raw (unprepared) fixed oil. The physician proceeds:

" He [Vandyck] has tried the white of Bismuth with oil, and says that the white prepared from lead—the material commonly used — provided it be well washed, is much whiter than that of Bismuth. The latter has not body enough, and is only good for the miniature-painter." *

" Mytens having tried the white of tin [or Bismuth] told me that it blackened on exposure to the sun, and that if mixed with white lead it spoils the latter. Thus it is good for nothing in oil, nor even in tempera if you expose it to the air: in a book it would do for illuminating." †

couleurs, les meslant sur la palette à la façon de celui de Gentileschi, il m'a dit qu'il s'espaissit trop, et que les couleurs se rendent par là moins coulantes. Lui ayant repliqué que d'y adjouster un peu d'huile de térébenthine, ou aultre qui s'evapore, cela peult servir pour remède, il m'a répondu que non. Cela gist à l'essai. Voyez si l'huile de pavot blanc, l'huile d'aspic ou aultre pourra servir." — *MS.* p. 10. verso.

 * " Il a essayé le blanc de ♃ Bismuth à huile, et dit que celui de blanc de plomb, qui est l'ordinaire, pourvu qu'il soit bien lavé, est beaucoup plus blanc ; que celui de ♃ n'a pas assez de corps, et ne vault rien que pour l'enlumineur." — *MS.* ib.

 † " Mitens, ayant essayé le blanc de ♃, m'a dit qu'exposé au

It seems that tin (♃) and bismuth were not very clearly distinguished at the period when the physician wrote. The allusion to the washing of white lead shows that Vandyck, like other painters of his time, did not neglect this mode of improving the colour. The trial by exposure to the sun also exemplifies the habits before noticed.

The technical processes of the Flemish school long survived, not only in England but in France. De Piles and his immediate followers were the eulogists of Rubens. At a later period Descamps undertook to write the lives and record the practice of the painters of the Netherlands; while Largilière, Descamps's teacher, ceased not to exhort his countrymen to study the works of those masters to whom he was himself indebted for the skill or knowledge which he possessed. The principles of Largilière were embodied by his scholar, Oudry, in some valuable observations "On the manner of studying colour."* The homage paid by the French school to that of Flanders, during the seventeenth and first half of the eighteenth century, accounts for the resemblance which is often to be traced

soleil il se noircit, et si vous le meslez avec blanc de plomb il le gaste : partant il ne vault rien à l'huile, ny mesme à destrempe si vous l'exposez à l'air. En un livre il est bon pour enluminer." —*MS.* p. 10. verso.

* Réflexions sur la Manière d'étudier la Couleur, en comparant les Objets les uns aux autres. Printed originally in Watelet's Dictionnaire des Arts de Peinture, Sculture, &c., Paris, 1792, vol. i. p. 366.

between the directions contained in French manuals of those periods, and the methods which have now been brought to light from MSS. written during the lifetime of Rubens and Vandyck. The same may be said of the scattered records of art in this country; and, to whatever extent the English painters of the last age may have professed to imitate Italian examples, their technical habits still leaned to the traditions of the Flemish school.

EXTRACTS

FROM NOTES BY SIR JOSHUA REYNOLDS.

THE notes which Sir Joshua Reynolds kept of the materials employed, and the order of the processes adopted by him, in the execution of many of his works, are important links in the technical history of painting. On a comparison of these interesting records with various circumstances that have been detailed in the foregoing pages, it will now appear that his experiments were not, as has been sometimes supposed, entirely novel. His methods often coincided with the Flemish practice, and were probably derived from its traditions. His use of wax was, however, an exception. The credit which that medium suddenly acquired in the latter part of the eighteenth century was the result of Caylus's attempts to restore the ancient encaustic painting. The original purpose failed, but the chief material which had been the object of experiment in the attempted revival, was adopted, with no very good results, by the oil painters, and especially by Reynolds.

Most of the notes from which the following specimens are extracted (and of which other copies exist) have already

appeared in print; they are not all equally interesting, and some, from the obscure form in which the memoranda were entered, are unintelligible. Sir Joshua may have adopted this mode to conceal his methods from his immediate attendants. It may be satisfactory to know that there can be no doubt of the authenticity of these records; the author is enabled to give his testimony on this point, having seen the original MSS. in the handwriting of Reynolds.

" Mr. Pelham, painted with lake and white and black and blue, varnished with gum mastic dissolved in oil with sal Saturni and rock alum. Yellow lake and Naples and black mixed with the varnish. July 7th, 1766."

This portrait was therefore laid in with white and black and blue, as Sir Joshua supposed Correggio's Leda, and some other pictures which he saw in Rome, were begun.* Lake was the only red admitted in this preparation, over which was passed a yellow varnish. The varnish itself, with the exception of the dryer (sugar of lead), corresponds with one described by Armenini.†

" Lord Villers, given to Dr. Barnard. Painted with vernice fatta di cera and Venice Turp. mischiato con gli colori macinati in olio. Carmine in vece di Lacca. Lady Wray, do."

The abbreviated form, "cera vern.," which sometimes occurs in these notes, is explained by this passage. It was a varnish consisting of wax dissolved in Venice turpentine : a portion of this was mixed with the colours previously ground in oil.

" Oct. 1767. Lord Townsend prima con magᴾ., poi olio, poi magᴾ. senza olio. Lacca, poi verniciato con vermilion."

This appears to mean that the colours, in the first and last sitting were mixed or ground with meguilp alone ; but, as that composition consists of oil and mastic varnish, the expression " senza olio" is not literally correct. Lake was employed as the red in the first painting, and was varnished with vermilion.

* Northcote's Life of Reynolds, vol. i. p. 36.
† I veri Precetti, &c. (1587), p. 129.

"The Speaker, the face colori in olio mischiato con magilp. poi verniciato."

Colours ground in oil were mixed with meguilp, then varnished.

"Solo magilp e poi tutto verniciato con colori in polvere senza olio e magilp."

The colours in the first paintings were ground in meguilp alone ; the colours used with the (mastic) varnish may have been spread in a dry state, mingling with the varnish in the process of working : or, "colori in polvere" may only mean that the colours were not previously ground in oil.

"Master Buck, finito con ver. senza olio o cera, carmine.

(Mastic) varnish alone used with the colours in finishing.

"Duchess of Ancaster, prima magilp, seconda olio, terza olio."

The colours were mixed in the first sitting with meguilp only, in the second and third with oil.

"Lady Almeria Carpenter, Mrs. Cholmondeley, con magilp, terza olio."

The colours were mixed in the first two sittings with meguilp, in the third with oil.

"Mio proprio, given to Mrs. Burke, con cera finito quasi, poi con mastic var. finito interamente, poi cerata senza colori."

His own portrait, almost finished with wax, completed with mastic varnish, then covered with a wax varnish. This order of processes, the final wax varnish excepted, was well calculated to produce cracking. The wax must have been dissolved in spirit of turpentine and then mixed with colours ground in oil, as colours ground in the dissolved wax alone would have been unmanageable.

"Offe's picture painted with cera and cap. solo, cinabro."

Painted with wax and copaiba, vermilion for the red. The anonymous author of the *Traité de la Peinture au Pastel* (1788) suggests that copaiba should be generally used instead of, or slightly diluted with, oil. The use of this or some similar "balsam," with certain colours, by the painters of the Netherlands, has been already adverted to. Colours ground in

wax dissolved in a liquid resin would be scarcely manageable without some addition of oil, as an essential oil (with which they might be diluted) evaporates too rapidly.

"April 3. 1769. Per gli colori Cinabro e Lacca e ultramarine e nero, senza giallo. Prima in olio, ultima con vernice solo e giallo."

The colours first named (without yellow) were mixed with oil for the first sitting ; yellow afterwards added with (mastic) varnish alone.

" May 17. 1769. On a grey ground. First sitting vermilion, lake, white, black Second, ditto. Third, ditto. ultramarine. Last, senza olio, yellow ochre, black, lake, vermilion, touched upon with white."

" Senza olio" is equivalent to " with varnish only."

"July 10. 1769. My own picture painted first with oil, aft. glazed without white, with capvi [copaiba], yellow ochre, and lake, no varn."

Part of this is struck through with the pen, and the memorandum continues : " painted with lake, yellow ochre, blue and black, capi. and cera vern."

From the correction it appears that the wax varnish before described was used together with copaiba.

" Dr. Johnson and Goldsmith, 1st olio, after capivi with colours but without white ; the hand of Goldsmith capivi and white.

" Mrs. Horton, con capivi senza giallo, giallo quando era finito."

" Jan. 22. 1770. Sono stabilito in maniera di dipingere, primo e secondo o con olio o capivi, gli colori solo nero, ultram. e biacca, secondo medesimo, ultimo con giallo okero e lacca e nero e ultram. senza biacca, ritoccato con poca biacca e gli altri colori. My own given to Mrs. Burke."

This picture has been already mentioned ; it was painted with a different vehicle, but the memorandum here appears to mean that the colours and order of the processes corresponded with those now described.

"Feb. 6. 1770. Primo olio biacca e nero, secondo olio biacca e lacca, terzo capivi lacca e giallo e nero senza biacca."

"May, 1770. My own picture, canvas unprimed, cera, finito con vernice."

"The Nysæan nymph with Bacchus principiato con cera sola, finito con cera e capivi, per causa it crak'd. Do. Dr. John. Offe fatto interamente con cap. e cera. Testa sopra un fondo preparato con olio e biacca."

When wax alone was used underneath, a more resinous medium being employed above, the surface was liable to crack. With this example " Offe's picture," already described, appears to be contrasted; that work having been painted with wax and copaiba from the first.

FROM ANOTHER MEMORANDUM-BOOK.

" Oct. 1779. Hope, cera solamente. La milior maniera con cera mischiata con Turp. di Venetia. Justicia, ma li panni cera sol."

Having before used the solution of wax in Venice turpentine (as appears from instances already quoted), his approval of it here may be considered the result of experience.

" Strawberry Girl, cera sol.

" Dr. Barnard, 1st black and white, 2. Verm. and white dry, 3. varnished and retouched."

"Oct. 2. 1772. Miss Kirkman. gum dr. et whiting, poi cerata, poi ovata, poi verniciata e retouched. Cracks."

A picture begun with whitening· and gum tragacanth, then covered successively with wax, white of egg, and varnish, could hardly escape cracking and separating. Compare the anecdote quoted p. 221.

" Aug. 15. 1774. White, blue, asphaltum, verm. senza nero. Miss Foley, Sir R. Fletcher, Mr. Hare."

" Aug. 26. 1774. White, asphal. verm. minio principalm. e giallo di Napoli, ni nero ni turchino. Ragazzo con sorella, glaze con asphaltum e lacca.

" Sir R. Fletcher. Biacca, nero, ultramarine, verm. sed principalmente minio senza giallo. Ultima volta oiled out and

painted all over. Do. Mr. Hare, except glazed with varnish and giallo di Napoli finito quasi con asphaltum, minio e verm. poi con poco di ultramarine qua e là, senza giallo."

"Mr. Whiteford, Asphal. verm. minio principalmente senza giallo."

Another portrait, in the description of which some unintelligible contractions appear, was painted at first with "bruciata e non bruciata umbra e biacca, poco di olio."

Of another (or perhaps the same) he writes: "umbra, verm., biacca, thick, occasionally thinned with [spirit of] turpentine. Prima, nero, cinabro, minio e azurro, thick."

"Lord Henry and Lady Charlotte Spencer, first olio, e poi colori con cera senza olio. Mr. Weyland do. Miss N. do. Mrs. Mordaunt do. Mrs. Morris do. Tyrconnel do.

"My own, Florence, upon raw cloth, cera solamente."

"Mrs. Sheridan, the face in olio, poi cerato. Panni in olio poi con cera senza olio, poi olio e cera."

Even in this case "cera senza olio" cannot be supposed to mean that the colours were ground in dissolved wax only, but that wax was mixed with the colours previously ground in oil.

"My Lord Altorp minio e nero sol. poi giallo e verm. senza biacca, olio.

"Mrs. Montagu, olio poi cerata e ritoccata con biacca."

"Samuel, V. red [Venetian red?] glazed with gamboge and verm. Drapery gam. and lake, sky retouched with orp."

Another copy reads "retouched with turp." The gamboge and lake, quoted with other experiments in page 444., is extremely brilliant, having lasted perfectly well with Venice turpentine.

"St. Joseph, dipinto con verm. e nero velato con gamboge e lacca e asphaltum, poco di turchino nella barba. Panni, turchino e lacca."

"My own picture sent to Plympton, cera poi verniciato senza olio; colori, Cologne earth, vermilion. The cloth varnished first with copal varnish, white and blue, on a raw cloth."

The word "blue" is struck through with the pen.

" Miss Molesworth, drapery painted with oil colour first, after cera alone. Miss Ridge do. Lady Granby do.

" Præsepe [nativity] on a raw cloth senza olio. Venice turp. e cera."

" Aug. 1779. Hope, my own copy, first oil, then Venice T. [turpentine] cera, verm. white and black, poi varnished with Venice [turpentine] and cera. Light red and black thickly varnished."

" 1781. Manner. Colours to be used Indian red, light red, blue and black, finished with varnish senza olio, poi ritocc. con giallo."

The few unquestionable defects in the practice thus exemplified may be enumerated as follows : —

1. Heterogeneous mixtures, as in the instance of Miss Kirkman's portrait.

2. The use of soft materials under others of a less dilatable nature; as in the instance of the picture of Bacchus and the Nymph ; this is one of the ordinary causes of cracking. Merimée observes : " Cracks take place whenever the inner colours of the painting remain soft when the external layer is dry. Let drying oil, for example, be thickly spread on a canvass ; it will be very soon dry on its surface. Let white lead be painted upon this ; the colour will sink in, and will dry the sooner because a portion of the oil which it contained quits it to combine with the drying oil of the inner layer. In this state of things, if the atmosphere be warm enough for the materials to expand, the layer of white will crack."* The expansive tendency of the oil underneath is greater than that of the white. When these conditions are reversed, when the softer layer is uppermost, it will, if it contain much oil, become wrinkled or shriveled on the surface.

3. The use of colours of uncertain stability, such as lake (probably not of the best kind), yellow lake, and minium. The

* De la Peinture à l'Huile, p. 102.

mention of orpiment (orp.) is doubtful, but Northcote, who gives some extracts similar to those above copied, quotes the following passage. "For painting the flesh, black, blue black, white, lake, carmine, orpiment, yellow ochre, ultramarine, and varnish. To lay the pallett; first lay carmine and white in different degrees; second, lay orpiment and white, ditto; third, lay blue black and white, ditto." * The date of this memorandum is early, Dec. 6. 1755. Carmine, orpiment, and blue black were at this time the representatives of red, yellow, and blue on Sir Joshua's palette. The immixture of orpiment with white, it is scarcely necessary to say, was sure to change. The directions of Cornelius Jansen and Vandyck point out the true mode of using this colour: its poisonous nature may, however, be added to other reasons for avoiding it. Another colour which Reynolds, in his latter practice, used too profusely, was asphaltum. When mixed with the colours, without due precautions in its preparation, it causes them to remain long soft, and is easily torn by drying varnishes.

With the above exceptions, not forgetting the use of wax (which, whether advisable or not, is unsanctioned by the example of the early masters), the practice of Reynolds, as exhibited in the above memoranda, is by no means dissimilar from that of the Flemish school. The use of liquid resins and varnishes with the colours, in addition to and even without oil, agrees with some methods occasionally adopted by Rubens and Rembrandt, as well as with the habits of the earliest oil painters. The object in this practice seems to have been to combine apparent substance with transparency, a characteristic which, as before observed, is especially attainable in oil painting as compared with other methods. The depth and richness of texture which Reynolds sought, and for which his finest works are remarkable, are qualities peculiar to the art in which he excelled. Although he never seems to have reckoned on the light priming of his canvass, as Rubens did, yet his system of painting at first in white and black, and with cool reds only, was equivalent to that process. Over this preparation his

* Life of Reynolds, vol. i. p. 78.

warmer, yellower colours, generally applied with varnishes only, had the richest effect: the picture in this state was sometimes retouched with tints mixed with white; but was finished quite as often, it seems, even in the lights, with the warmer colours alone.

The method of Reynolds, therefore, presents a judicious and generally successful union of the Italian and Flemish practice; inclining, on the whole, to the latter.

NOTE

ON THE MAYERNE MANUSCRIPT IN THE BRITISH MUSEUM.

(*Sloane MSS.*, No. 2052.)

THEODORE DE MAYERNE, the author of the MS. in question, was born in 1573 at Geneva, where his father, Louis, had distinguished himself by various literary productions. Theodore selected the medical profession; and, after studying at Montpelier and at Paris, accompanied Henri Duc de Rohan to Germany and Italy. On his return he opened a school, in which he delivered lectures to students in surgery and medicine. This proceeding, and the innovation, as it then appears to have been, of employing mineral specifics in the healing art, excited a spirit of opposition which led to a public resolution, emanating from the faculty at Paris, in which his practice was condemned. His reputation rapidly increased from this period. He had before been appointed one of the physicians in ordinary to Henry IV.: in 1611, James I. invited him to England, and appointed him his first physician. De Mayerne enjoyed the same title under Charles I.: he died at Chelsea, leaving a large fortune, in 1655.

The name of Theodore de Mayerne appears with honour in the history of chemistry: Brande observes that the writings of

Paracelsus "are deficient in the acumen and knowledge displayed by his immediate successors, especially by Theodore de Mayerne and Du Chesne." * His knowledge of painting, and remarkable predilection for investigating its technical processes and materials, were of great service to the artists with whom he was in communication. Dallaway, in his annotations on Walpole, after noticing the influence of De Mayerne's medical practice on the modern pharmacopœia, remarks that " his application of chemistry to the composition of pigments, and which he liberally communicated to the painters who enjoyed the royal patronage, to Rubens, Vandyck, and Petitot, tended most essentially to the promotion of the art. From his experiments were discovered the principal colours to be used for enamelling, and the means of vitrifying them. Rubens painted his portrait ; certainly one of the finest now extant. It originally ornamented the Arundel collection ; was then at Dr. Mead's ; Lord Besborough's ; and is now [1826] at Cleveland House." †

A monarch who was so fond of painting as Charles I. was fortunate in having the assistance of a person who combined a love of art with a scientific knowledge applicable to its mechanical operations. It is not surprising that such an amateur as De Mayerne should enjoy the confidence of the first painters of his time ; or that, in return for the useful hints which he was sometimes enabled to give them, they should freely open to him the results of their practical knowledge. Such communications, registered at the time by an intelligent observer, throw considerable light on the state of painting at one of its most brilliant periods, and tend especially to illustrate the habits of the Flemish and Dutch schools.

The manuscript in question is entitled " Pictoria, Sculptoria, Tinctoria, et quæ subalternarum Artium spectantia in Lingua Latina, Gallica, Italica, Germanica conscripta, a Petro

* Manual of Chemistry, p. 23.

† Walpole's Anecdotes, edited by the Rev. James Dallaway, vol. ii. p. 302. note.

Paulo Rubens, Van Dyke, Somers, Greenberry, Jansen, &c. Fol. No. xix. A. D. 1620. T. de Mayerne."

The signature is evidently that of De Mayerne. The same autograph occurs in the MS., p. 148. : "Artifice pour raviver tableaux à destrempe et les rendre equivalents à ceux qui sont à huyle. T. de Mayerne Invent. 1632." The signature and the passage which precedes it are, in this instance, written, currente calamo, by the same person ; and from this specimen it appears that the greater part of the book is written by the physician himself. Communications consisting of autograph letters from various persons, and even short treatises, are also bound up with the work. In one or two letters the superscription is preserved : one in particular, from Joseph Petitot (brother it seems of the celebrated John Petitot), which is dated "de Genève ce 14 Janvier, 1644," is addressed, "A Monsieur Monsieur le Chevalier de Mayerne, Baron d'Aubonne, et Premier Medecin du Roi, et demeut. en St. Martin's Lane, à Londres." The barony of Aubonne descended to him from his ancestors. In a letter dated 1631, from another correspondent, he is styled "Monsieur de Maierne, Premier Medecin de leurs Majestés."

The identity of the compiler of this MS. with the celebrated physician and chemist of the same name is thus clearly established, as well as the fact that the greater part of the book is in his own handwriting. Various circumstances to which it refers corroborate its authenticity, and connect it with the age of Charles I. As the work will be published entire by Mr. Hendrie, its contents need not be further anticipated here.

ADDITIONS AND CORRECTIONS.

Page 4.

THE assumed identity of the sarcocolla of Pliny with gum tragacanth rests on the authority of Dr. John, Die Malerei der Alten, Berlin, 1836, p. 210.

Page 63. lines 2, 3.

For " The oldest and best copy known, that in the Ricciardi," read " The best copy known, that in the Riccardi."

Page 83.

Size under oil paint is not limited by Cennini to the surface of stone, but is directed to be applied in all cases. (*Trattato*, c. 94.) Earlier writers only recommend that the surface to be painted should be thoroughly dry.

Page 98.

Mabuse occasionally adopted the method, here described, of painting in water colours on cloth, as appears from the following passage in Van Mander. " There is also . . . at Amsterdam a large work representing the beheading of St. James, executed in chiaroscuro entirely without [body] colours, being tinted only; so that the whole cloth may be folded, pressed, and crushed without injury."

" Daer is oock . . . t' Amsterdam een groot stuck, wesende een onthoofdinge Jacobi, van wit en swart, ghedaen schier sonder verwe, als sapachtigh, datmen den heelen doeck mach vouwen, douwen, en kroken, sonder dat hem hinderen mach." — *Het Schilder-Boeck*, p. 225. verso.

Page 100.

Sandrart observes that the ordinary tempera was only fit for dry situations. The method of tinting linen, as opposed to solid tempera, was no doubt suggested by the effects of damp on body colours. Van Mander, speaking of some subjects in tempera on cloth, by Lucas van Leyden, observes: "It is to be lamented that these works are much injured by time, and in consequence of the damp of the walls — a great evil in these Netherlands."

" . . . het is te jammeren datse ten tijdt en de oudtheyt so by den tanden hebben ghehabt en verdorven, door de vochticheyt der muren, daer in dese Nederlanden veel ghebrecks van is." — *Het Schilder-Boeck*, p. 214.

Page 111. Note.

The passage, "pro coopertura ymaginum regum depingenda," may perhaps be better explained by the following mandate of Henry III.: —

" Rex Thesaurario, &c., Liberate de thesauro nostro Willielmo de Sancto Paulo, xxviii. d. ad emendam telam ad cooperiendum altare in capella nostra Sancti Stephani apud Westmonasterium. Teste Rege apud Westmon. xix. die Maii." (21 Hen. III. 1237.)

Page 116.

The first number of the *Archæological Journal* (March, 1844) contains some receipts for colours, written early in the fourteenth century. The explanation of " cynople " there given only shows that there were inferior colours of the name, as well as the costly preparation described in the passage above referred to. The " gaudegrene " was probably prepared from weld (gaude).

Page 121.

The statutes of the Sienese painters (1355) might be compared with those of the English Painters' Guild, written more than half a century earlier (1283). The following passage is quoted by Sir Francis Palgrave, in his *Merchant and Friar*, page 9. : —

" Pourveu est, que nul ne mette fors (hormis) bonnes et fines couleurs sur or ou sur argent. C'est à savoir, bon azur, bon sinople, bon vert, bon vermillon, ou des autres bonnes couleurs destrempes d'huile, e nient de brasil, ne de inde de Baldas, ne de nul autre mauveise couleur."

The finer lake, which had received the name of sinople, is here clearly distinguished from brasil (from which it is prepared in one of the receipts printed in the *Archæological Journal*, above quoted). For the explanation of " Inde de Baldas," see p. 121. of the present work. It is to be observed that no mention of oil colours occurs in the Sienese document.

Page 171. Note.

A " Majesty," like that represented by Cimabue, is referred to in the following order dated the seventeenth of Henry III., before Cimabue was born : —

" Mandatum est custodi domorum Regis de Wudestok quod in rotunda capella Regis de Wudestok bonis coloribus depingi faciat Majestatem Domini et quatuor Evangelistas, et imaginem Sancti Edmundi ex una parte et imaginem Sancti Edwardi ex alia parte. Teste P. Winton. Episcopo apud Westmon. xxiiii. die Januarii (1233)." — *Liberate Rolls.*

Page 343. Note, line 11.

For " ivory black " read " bone black."

SCRIPTURAL AND HISTORICAL SUBJECTS

PAINTED IN ENGLAND

DURING THE REIGN OF HENRY III.

THE following documents throw considerable light on the state of painting in this country during the first half of the thirteenth century; they are selected from a greater number, some of those already published having been omitted.* A few notices are included (as specimens of many similar directions) relating to sculpture and also to mere decoration. The taste for painting rooms in green, "viridi colore depingi et auro scintillari," has been already adverted to, as partly tending to explain the occasional use of the "white" instead of the "red" varnish.

"Rex custodi Manerii de Kenington salutem. Præcipimus tibi quod caminum cameræ nostræ de Kenington de novo fieri facias et ea quæ reparanda sunt in aliis domibus nostris ibidem reparari et capellam nostram de camera nostra depingi historiis ita quod campus sit de viridi colore estencelatus stellis aureis... Teste Rege apud Kenington, XVII. die Martii (1233)." — *Liberate Rolls.*

"Mandatum est Vicecomiti Oxon. quod picturas quæ restant faciendæ in magno talamo Regis apud Wudestok fieri facias, et depingi in magna capella imaginem Crucefixi et imagines Beatæ Mariæ et Beati Johannis. . . . Teste Rege apud Wudestok, XXIIII. die Junii (1233)." — Ib.

* See Gage Rokewode's Account of the Painted Chamber, Brayley and Britton's History of the Ancient Palace at Westminster, and Smith's Antiquities of Westminster.

"Rex Vicecomiti Suthamptou. salutem. Præcipimus tibi quod . . . cameram Reginæ nostræ ibidem [Winton.] depingi et picturam in camera nostra ubi necesse fuerit renovari . . . et Majestatem quandam in capella Sancti Thomæ depingi. T. R. ap. Merleberg. xxvi. die Mart. (1238)." — *Liberate Rolls.*

"Mandatum est Vicecomiti Suthampton. quod . . . lambruschuram cameræ ibidem [Winton.] colorari viridi colore et stellari auro et circulos fieri in eadem lambruschura in quibus depingantur historiæ Veteris et Novi Testamenti. T. R. apud Wherewell xxvii. die Decemb. (1238)." — Ib.

"Henricus Dei gratia Rex Angliæ &c. Vicecomiti Southampton. salutem. Præcipimus tibi quod . . . fieri etiam facias quandam Mariolam cum quodam magno tabernaculo ad capellam prædictæ Reginæ nostræ et quandam tabulam depictam ante altare ejusdem capellæ. T. R. ap. Wudestok xiiii. die Novembris (1239)." — Ib.

"Rex Vicecomiti Kantiæ salutem. Præcipimus tibi quod parietes capellæ nostræ infra castrum Roffense de novo plastrari et dealbari et capellam ipsam intus depingi et Majestatem loco quo prius depicta fuit renovari. T. R. ap. Roff. x. die Febr. (1239)." — Ib.

"Rex custodibus operationis Turris Lond. salutem. Præcipimus vobis quod . . . fieri faciatis in eadem capella [S. Johannis Evangelistæ] tres fenestras vitreas unam scilicet ex parte Boreali cum quadam Mariola tenente puerum suum, reliquam in parte Australi de Trinitate, et tertiam de Sancto Johanne Apostolo et Evangelista in eadem parte Australi . . . et depingi duas imagines pulchras ubi melius et decentius fieri possint in eadem capella, unam de Sancto Edwardo tenentem anulum et donantem et tendentem Sancto Johanni Evangelistæ. . . T. R. ap. Windlesoram. x. die Decemb. (1241)." — Ib.

"Rex custodibus operationis Turris Lond. salutem. Præcipimus vobis quod . . . et Mariolam cum suo tabernaculo et imagines beatorum Petri, Nicholai, et Katarinæ et trabem ultra altare beati Petri et parvum patibulum cum suis imaginibus de novo colari [sic] et bonis coloribus refriscari ; et fieri faciatis quandam imaginem de beata Virgine ultra altare beati Petri versus Austrum, et alteram imaginem de beato Petro in solemni apparatu Archiepiscopali in parte Boreali ultra dictum

altare, et de optimis coloribus depingi, et quandam imaginem de Sancto Christoforo tenentem et portantem Ihesum ubi melius et decentius fieri potest et depingi in prædicta ecclesia. Et fieri faciatis duas tabulas pulchras et de optimis coloribus et de historiis beatorum Nicholai et Katerinæ depingi ante altaria dictorum sanctorum in eadem ecclesia et duos Scherumbinos stantes a dextris et sinistris magni patibuli pulchros fieri faciatis in prædicta ecclesia cum hilari vultu et jocoso. Teste ut supra (1241)." — *Liberate Rolls.*

" Mandatum est Ballivis Wudestok. quod . . . in capella Regis [apud Wudestok.] super tabulam altaris imagines Crucefixi, Beatæ Mariæ, Sancti Johannis Evangelistæ et duorum angelorum in modum Cherubim et Seraphim confectorum fieri . . . faciant. T. R. ap. Wudestok. xix. die Febr. (1244)." — Ib.

" Mandatum est Vicecomiti Suthampton. quod . . . Majestatem et imagines circa ipsum [in capella Sancti Thomæ, Winton.] fieri et deaurari faciat, et ultra hostium illius cameræ [Reginæ] quandam civitatem depingi. T. R. ap. Lutegareshull. iii. die Mart. (1246)." — Ib.

" Mandatum est R. de Mucegros custodi manerii de Lutegareshull. quod . . . depingi etiam [faciat] postes ejusdem [aleæ] colore marmoreo et historiam de Divite et Lazaro in gabulo ex opposito deisii. T. R. ap. Westmon. xvii. die Mart. (1246)." — Ib.

" Mandatum est eidem [Vicecomiti Kantiæ] quod fieri faciat in ecclesia Castri Dovoriæ tria altaria, unum in honore Sancti Edmundi, et aliud in honore Sancti Adriani et tertium Sancti Edwardi et tres imagines prædictorum trium Sanctorum et unam de Sancto Johanne Evangelista. T. R. ap. Wingeham. xv. die Mart. (1247)." — Ib.

" Rex Vicecomiti Suthampton. salutem. Præcipimus tibi quod fieri facias unam trabem in capella Reginæ nostræ in castro nostro Winton. et desuper unam crucem cum Maria et Johanne superpositis. T. R. ap. Clarendon. xviii. die Decemb. (1248)." — Ib.

" Rex Vicecomiti Suthampton. salutem. Præcipimus tibi quod in eadem capella [Winton.] depingi [facias] imaginem Beatæ Mariæ ultra altare et versus Austrum in eadem

capella imaginem Dei et Matris suæ. T. R. ap. Winton. XXVIII. die Decemb. (1248)." — *Liberate Rolls.*

" Rex Vicecomiti Suthampton. salutem. Præcipimus tibi quod... depingi facias in capella dilectæ Reginæ nostræ apud Winton. super gabulum versus Occidentem imaginem Sancti Christofori qui, sicut alibi depingitur, in ulnis suis deferat Christum, et imaginem Beati Edwardi Regis qualiter anulum suum cuidam peregrino [donet] cujus imago similiter depingatur. T. R. ap. Windlesor. II. die Maii (1248)." — Ib.

" Rex Ballivo suo de Wodestok. salutem. Præcipimus tibi quod... imagines Crucefixi et Beatæ Mariæ et Beati Johannis Evangelistæ in tabulis et muris juxta sedem nostram in superiori capella depingi facias. T. R. ap. Wodestok. xx. die Junii (1250)." — Ib.

"Rex Constabulario suo de Merļeberg. salutem. Præcipimus tibi quod in castro nostro de Merleberg. fieri facias... in capella Reginæ nostræ ibidem unum Crucefixum cum Maria et Johanne et unam Mariam cum puero... Et in castro nostro de Lutegarshul.... unum Crucefixum cum Maria et Johanne et imaginem Beatæ Mariæ cum puero in capella nostra. T. R. ap. Winton. VIII. die Julii (1250)." — Ib.

"Rex Godefrido de Lyston. salutem. Præcipimus tibi quod in aula castri nostri de Windesora.... fieri facias regalem sedem in qua depingi facias imaginem Regis sceptrum in manu tenentis provisurus quod sedes illa pictura aurea decenter ornetur. T. R. ap. Clarendon XIX. die Julii (1250)."— Ib.

" Rex Vicecomiti Wiltes. salutem. Præcipimus tibi quod in capella nostra Omnium Sanctorum in manerio nostro de Clarendon. fieri facias.... unum Crucefixum cum duabus imaginibus ex utraque parte de ligno et imaginem Beatæ Mariæ cum puero.... In camera Fratrum minorum fiant imagines Sanctæ Trinitatis et Beatæ Mariæ. T. R. ap. Gillingham. xxx. die Julii (1250)." — Ib.

"Rex Vicecomiti Wiltes. salutem. Præcipimus tibi quod in camera Reginæ nostræ unam fenestram vitream et in eadem fenestra unam Mariolam cum puero et unam Reginam ad pedes ipsius Mariolæ junctis manibus tenentem in manu sua Ave Maria fieri facias. T. R. ap. Clarendon. VII. die Decemb. (1251)." — Ib.

" Rex Vicecomiti Suthampton. salutem. Præcipimus tibi quod novam capellam nostram in castro nostro Winton. de historia Josep depingi et . . . tabulam juxta lectum nostrum de imaginibus custodum lecti Salomonis depingi facias. T. R. ap. Winton. xx. die Decemb. (1251)." — *Liberate Rolls.*

"Rex Johanni de Haneberg. salutem. Præcipimus tibi quod . . . picturam beatæ Mariæ Virginis [in capella Reginæ apud Wodestok.] melius depingi facias. T. R. ap. Wodestok. iii. die Feb. (1251)." — Ib.

" Henricus Dei Gratia Rex Angliæ &c. Vicecomiti Essex. salutem. Præcipimus tibi quod . . . imaginem ejusdem Beati Edwardi ex parte orientali inferioris partis ostii [in capella S. Johannis Evan. in cimeterio de Clavering] cum anulo porrigendo imagini Beati Johannis Evangelistæ ex parte superiore ostii ejusdem capellæ depingi facias. T. R. ap. Waleden. xii. die Mart. (1251)." — Ib.

"Rex Vicecomiti Suthampton. salutem. Præcipimus tibi quod . . . pingi facias cameram Rosamundæ in eodem castro [Winton.] historiam Antiochæ. T. R. ap. Wherewell. vi. die Junii (1251)." — Ib.

" Rex Vicecomiti Wiltes. salutem. Præcipimus tibi quod . . . in eadem camera [Clarendon.] historiam Antiochæ et duellum Regis Ricardi depingi et lambruscariam illam depingi viridi colore cum scintillis aureis . . Imagines autem Beatæ Mariæ, Beati Edwardi et Cherubin fieri facias et poni in capella nostra. T. R. ap. Merleberg. ii. die Julii (1251)." — Ib.

" Rex Ballivo suo de Havering. salutem. Præcipimus tibi quod apud Havering. . . . in capella ejusdem Reginæ unam Mariolam cum puero fieri et Annunciationem Beatæ Mariæ in eadem depingi . . . et in camera dictæ Reginæ quatuor Evangelistas depingi cum aliis picturis in eadem . . . facias. T. R. ap. Wantham. xxvi. die Augusti (1251)." — Ib.

" Rex Vicecomiti Surr. et Sussex. salutem. Præcipimus tibi quod apud Guldeford. . . . in capella Beatæ Katherinæ ejusdem imaginem et ejusdem historiam ultra altare absque auro et azuro honeste depingi . . facias. T. R. ap. Windesor. xx. die Septemb. (1251)." — Ib.

" Rex Vicecomiti Notingham. salutem. Præcipimus tibi quod ante altare in capella nostra [apud Noting.] quan-

dam tabulam de historia Sancti Willielmi et super idem altare aliam tabulam de historia Sancti Edwardi depingi facias . . . et in capella Sanctæ Katerinæ ante altare unam tabulam et super altare aliam cum historia ejusdem virginis et in gabulo ejusdem capellæ tremendum judicium depingi. T. R. ap. Notingham. xii. die Decemb. (1252)."—*Liberate Rolls.*

"Rex Vicecomiti Notingham. salutem. Præcipimus tibi quod . . . in fronte albæ capellæ ejusdem castri [Notingh.] depingi [facias] imaginem Sancti Edwardi ex una parte et ex alia parte imaginem Beati Johannis Evangelistæ et in medio imaginem Beatæ Virginis cum puero. . . . T. R. ap. Notingham. xiii. die Januarii (1252)."—Ib.

"Rex Vicecomiti Notingham. salutem. Præcipimus tibi quod in camera Reginæ nostræ apud Notingham. depingi facias historiam Alexandri circumquaque. T. R. ap. Noting. xv. die Januar. (1252)."—Ib.

"Rex Vicecomiti Notingham. salutem. Præcipimus tibi quod . . . quandam magnam verinam extra ostium ejusdem cameræ cum imagine Sancti Martini pallium pauperi extendentis fieri facias. T. ut supra.

"Rex Vicecomiti Northampton. salutem. Præcipimus tibi quod . . . in castro nostro Northampton. . . . fieri facias fenestras de albo vitro et in eisdem historiam Lazari et Divitis depingi. T. R. ap. Noting. xv. die Januar. (1252)."—Ib.

"Rex Johanni de Henneberg. et Petro de Leg. custodibus operationum suarum de Wodestok. salutem. Præcipimus vobis quod apud Wodestok. . . . una verinam cum imagine Beatæ Mariæ in nova capella et imaginem Angelicam ultra sacrarium ejusdem capellæ et . . . veterem capellam historia de muliere adulterio condempnata et qualiter Dominus scripsit in terra, et qualiter Dominus dedit Alapham Sancto Paulo et aliquid de Sancto Paulo depingi, et in superiore parte ejusdem capellæ historiam Evangelistarum similiter depingi faciatis. T. R. ap. Wodestok. iiii. die Febr. (1252)."—Ib.

"Rex Vicecomiti Suthampton. salutem. Præcipimus tibi quod . . . fieri facias duas tabulas ad duo altaria et duo superaltaria ponenda in capella nostra Sancti Thomæ et capella nostra juxta lectum nostrum in Castro [Winton.] et in eadem capella fieri facias unam Crucem cum Maria et Johanne et aliam Mariam

cum filio suo. T. R. ap. Winton. xxvii. die Junii (1252)."—
Liberate Rolls.

"Rex Johanni de Hanneberg. et Petro de Legh. custodibus manerii sui de Wudestock. salutem. Præcipimus vobis quod . . . duas tabulas depictas cum imaginibus duorum Episcoporum in magna capella nostra ibidem poni et unam tabulam depictam cum imagine Beatæ Mariæ in capella Beati Edwardi . . faciatis. T. R. ap. Wudestok. xix. die August. (1252)."—Ib.

"Rex Odæ Wymer Ballivo suo de Gillingham. salutem. Præcipimus tibi quod . . . in fenestris vitreis depingi [facias] tres imagines videlicet Beatæ Mariæ Beati Edwardi Regis et Confessoris et Beati Eustachii . . &c. T. R. ap. Gillingham. x. die Decemb. (1253)."—Ib.

"Rex Vicecomiti Suthampton. salutem. Præcipimus tibi quod in fronte capellæ Sancti Thomæ in castro nostro Winton. imaginem Beatæ Mariæ cum puero suo fieri ; warderobam Reginæ nostræ viridi pictura et stellis aureis depingi et quendam angelum ex altera parte prædictæ capellæ fieri et imagines Prophetarum in circuitu ejusdem capellæ depingi et in fenestra vitrea in eadem capella imaginem Beati Edwardi cum anulo fieri . . . facias. T. R. ap. Winton. xxviii. die Decemb. (1253)." — Ib.

"Rex Vicecomiti Northampton. salutem. Præcipimus tibi quod . . . quandam fenestram vitream in aula nostra Northampton. cum imaginibus Lazari et Divitis in ea depictis ex opposito desci nostri . . facias. T. R. ap. Merton. viii. die Januar.(1253)." —Ib.

"Rex Ballivo suo de Havering. salutem. Præcipimus tibi quod superiorem capellam nostram de Havering. lambruscari et quandam imaginem Beatæ Mariæ Virginis in inferiori capella et duas fenestras vitreas cum scutis Provinciæ . . . facias. T. R. ap. Havering. viii. die Aprilis (1253)."— Ib.

"Rex Vicecomiti Sussex. salutem. Præcipimus tibi quod . . . habere facias Ricardo Constabulario et Elyæ Maunsell. custodibus operationum nostrarum de Guldeford. centum libras ad ad depingendum in aula nostra ibidem ex opposito sedis nostræ historiam de Divite et Lazaro . . &c. T. R. ap. Guldeford. iii. die Januar. (1256)." — Ib.

"Rex Vicecomiti Suthampton. salutem. Præcipimus tibi quod

. . . in capella Sancti Thomæ [in castro Winton.] unam fene-
stram vitream cum imagine de Majestate et sub Majestate
imaginem Sancti Edwardi tenentem in manibus quendam
Regem Majestati oblatum, et imaginem Sancti Georgii super
parietem in introitu aulæ . . . facias. T. R. ap. Winton. xxx.
die Junii (1256)."—*Liberate Rolls.*

"Rex Vicecomiti Surr. salutem. Præcipimus tibi quod . . .
imaginem Sancti Edwardi et imaginem Sancti Johannis tenen-
tem anulum in sua manu ibidem depingi et easdem imagines
super murum juxta sedem nostram in capella nostra de Gulde-
ford. similiter depingi facias, et quandam imaginem Beatæ
Mariæ fieri facias et poni in capella Reginæ nostræ ibidem.
T. R. ap. Turrim Lond. xiii. die Februar. (1261)."—Ib.

"Rex dilecto et fideli suo Roberto de Sancto Johanne Con-
stabulario Castri sui Winton. salutem. Mandamus vobis quod
. . . quandam fenestram albam de vitro fieri et Nativitatem
Beatæ Mariæ in ea depingi faciatis. T. R. ap. Westmon. xi.
die Februar. (1266)."— Ib.

"Rex Vicecomiti Wiltes. salutem. Præcipimus tibi quod . . .
quatuor Evangelistas in fenestris vitreis aulæ nostræ [apud
Clarendon] fieri facias. T. R. ap. Clarendon. xvii. die Decem.
(1268)."—Ib.

"Rex Vicecomiti Suthampton. salutem. Præcipimus tibi
quod . . . [apud Winton.] unam imaginem Beati Edwardi incidi
et depingi . . . et picturas frontellorum coram altaribus in
capella nostra et omnes alias picturas domorum nostrarum et
capellarum ibidem innovari . . . facias. T. R. ap. Westmon.
xxvi. die Julii (1268.)" — Ib.

The mandates that follow are extracted from the Close
Rolls.

"Mandatum est W. Karliolensi Episcopo quod capellas Regis
Sancti Stephani et Sancti Johannis Westmonasterii celare faciat
ultra altaria et quatuor tabulas fieri, videlicet duas ponendas
ante eadem altaria et duas strictiores ponendas super eadem
altaria, in quibus tabulis depingi faciat quod melius et com-
petentius viderit depingendum, dum tamen in tabulis stric-
tioribus depingantur sanctorum Stephani et Johannis [imagines]
. . . ita quod pro posse suo ea parata inveniat Rex in adventu

suo London. T. R. ap. Otteford. iiii. die Decemb. (16 Hen. III. 1232)." — *Close Rolls.*

" Mandatum est R. Passelewe quod fieri faciat vel emi si prompte inveniantur duas imagines pulchras et bene depictas, unam ad similitudinem Beati Johannis Evangelistæ et aliam ad similitudinem Beati Stephani Martyris quales conveniunt præ- dictorum Sanctorum figuris ; ita quod Rex imagines prædictas promptas et decenter provisas inveniat in capellis suis West- monasterii in primo adventu suo London, et quod inde possit commendari (1233)." — Ib.

" Mandatum est H. de Patheshull . . . quod . . . borduram a tergo sedis regis in capella Sancti Stephani apud Westmonas- terium et borduram a tergo sedis Reginæ ex alia parte ejusdem capellæ interius et exterius depingi faciat de viridi colore juxta sedem ipsius Reginæ depingi faciat qnandam Crucem cum Maria et Johanne ex opposito Crucis Regis quæ juxta sedem Regis depicta est. T. R. ap. Winton. vii. die Febr. (1236)." — Ib.

" Mandatum est H. de Pateshull. Thesaurario quod . . . in capella Sancti Stephani apud Westmonasterium . . . a tergo ultra sedem Regis faciat depingi historiam Joseph. T. R. ap. Westmon. x. die Februarii (1238)." — Ib.

" Mandatum est custodibus operationum de Windlesora quod in capella Regis depingi faciant vetus testamentum et novum. T. R. ap. Burdegal. x. die April. (1243)." — Ib.

" Mandatum est Edwardo filio Odonis quod in exteriori parte sedis Regis in capella Sancti Stephani Westmonasterii . . . bene depingi faciat pulchram et decentem imaginem Sanctæ Mariæ et ex alia parte cancelli versus ostium gardini imagines Regis et Reginæ ita quod paratæ sint et bene depictæ in proximo adventu Regis ibidem. T. R. ap. Clarendon. viii. die Febr. (1245)." — Ib.

" Mandatum est Edwardo de Westmonasterio quod in capella Beati Stephani depingi faciat imagines apostolorum in circuitu ejusdem capellæ et judicium in occidentali parte ejusdem et iconiam Beatæ Mariæ Virginis in quadam tabula similiter pingi faciat, ita quod parata sint in adventu Regis. T. R. ap. Bruges- water. xiii. die August. (1250)." — Ib.

" Mandatum est Edwardo de Westmonasterio . . . quod . . .

magnam etiam Crucem collocari faciat in navi ecclesiæ West-
monasterii et emat duos angelos in modum Cherubym ex utra-
que parte illius crucis collocandos. T. R. ap. Wodestok. IIII.
die Febr. (1251)." — *Close Rolls.*

" Mandatum est Edwardo de Westmonasterio quod in novo
opere fabricæ feretri Beati Edwardi apud Westmonasterium
fieri faciat unam capellam ubi commodius fieri possit . . . et
depingatur in eadem capella historia Sancti Edwardi et bassam
cameram lambruscari faciat in qua depingatur historia Sancti
Eustachii et in fenestra gabali historia Salomonis et Marculphi.
T. R. ap. Gillingham. IX. die Decemb. (1253)." — Ib.

THE END.

Volume Two

PREFACE

BY

LADY EASTLAKE.

In submitting to the public the chapters destined for the second volume of the *Materials for a History of Oil Painting*, which Sir Charles Eastlake left in a state of preparation, Lady Eastlake is anxious to state how far she has presumed to exercise the office of editor in the revision of them. It will not be necessary to assure those readers already acquainted with Sir Charles's habits of conscientious accuracy and patient research that such habits are as vividly impressed on these chapters as on all that have gone before. Owing, however, to the labours of Signor Cavalcaselle,* which were greatly assisted and promoted by Sir Charles, in-

* A new History of Painting in Italy, by J. A. Crowe and G. B. Cavalcaselle (1864), authors of the Early Flemish Painters.

formation has been brought to light proving the falsity of certain long-admitted passages in the history of Oil Painting, without, for the present, substituting any certain facts in their place. This information affects the first only of the chapters now presented—a portion of which has, accordingly, been suppressed. The contents of this chapter especially turned upon the formerly accepted statement that a chapel in S. Maria Nuova at Florence, which belonged to a wealthy family of the name of Portinari, had served as a kind of nursery of the art of oil painting in central Italy. It is known, namely, that a picture by Memling, and a triptych by Hugo Van der Goes—both in oil—were painted for this Portinari chapel (also called the chapel of S. Egidio and the Cappella Maggiore); the triptych by Hugo Van der Goes being still in its place. Vasari also states that Andrea dal Castagno and Domenico Veneziano executed certain paintings on the walls of the same chapel *in oil*. These paintings, which, according to Vasari, illustrated the Life of the Madonna, have long since disappeared, and, with them, all certain evidence of the method of their execution; from the light now obtained, however, it has become doubtful, perhaps more than doubtful, whether any of the series were executed by the process implied by the modern term " oil paint-

ing." The records of the Hospital of S. Maria Nuova, it is true, show that linseed oil was abundantly furnished to Domenico Veneziano during the period of his labours; but this proves nothing more than a use of that vehicle which Sir Charles Eastlake, in his first volume—chapters iii. and iv. especially—has shown to have been, long before the invention of oil painting, common in processes of wall-painting. And this doubt gains further strength from the fact that Signor Cavalcaselle's researches furnish so complete a contradiction to some of Vasari's statements regarding Domenico Veneziano and Andrea dal Castagno, as, in great measure, to invalidate all of them. Not only does it appear that Domenico Veneziano could not have learned the secret of oil painting at Venice from Antonello da Messina, as circumstantially asserted by Vasari (even granting that he ever was in Venice, or ever learnt the secret at all), but it is proved that the crowning act of the romance, which has so long outraged the feelings of Vasari's readers, and of which the possession of this secret is given as the plausible motive, is as untrue as all the rest. It is now known, by incontrovertible documents, that Andrea dal Castagno died in 1457, some years before the alleged murder of his supposed friend and benefactor, and that Domenico

Veneziano survived him four years. The state-
ment also of the rivalry of these two painters—as
far, at least, as their supposed simultaneous opera-
tions in the Portinari chapel gave it the colour of
truth—is equally overturned by Signor Cavalca-
selle, who quotes from the records of the hospital
attached to S. Maria Nuova, that Domenico ter-
minated his six years' labours in the chapel in
1445, and that Andrea only commenced his in
1451. For all trustworthy information regarding
these two painters the reader is referred to Signor
Cavalcaselle's work, vol. ii. pp. 302–318.

As regards therefore the importance of Domenico
Veneziano and Andrea dal Castagno as links in the
generations of oil painters, they may be dismissed
from the scene. Still, it is justice to Sir Charles
Eastlake to state that his personal observations
and complete possession of all other sources of
information perpetually led him into modest anta-
gonism with one who, both in style of painting
and habits of mind, was perhaps a character as
strongly opposed to his own as history could fur-
nish. Many parts of the first volume of the
Materials bear witness to Sir Charles's convic-
tion of some of Vasari's errors, and to his suspicion
of others. As regards Vasari's statement that
Antonello da Messina was the first to communicate

the Flemish method of oil painting in Italy, the reader is referred to p. 217 of the first volume, in which Sir Charles shows that many Flemish artists — scholars or followers of Van Eyck—were in Italy and executed works there, about the middle of the fifteenth century. In such portions also of this first chapter of the second volume as Lady Eastlake has ventured to suppress, the difficulty of reconciling Vasari's most circumstantial and positively asserted tale with Sir Charles's own accurate knowledge is throughout apparent. It did not escape Sir Charles's observation that while Domenico Vene- ziano was asserted by Vasari to be the chief practiser of the new art in Florence, the only two works re- maining by his hand, there or elsewhere, are neither of them in oil. The one, the Virgin and Child enthroned, with the figure of the First Person of the Trinity above,* and two heads of saints below,† which till lately occupied the Canto de' Carnesecchi at Florence, is in fresco: the other, an altar-piece in S. Lucia de' Bardi in Florence, signed by the painter, and which Sir Charles, on more than one occasion, closely inspected, is in tempera.‡ He

* This portion is now in the possession of Prince Pio at Florence.

† These two heads have passed from the collection of Sir Charles Eastlake into the National Gallery.

‡ The picture is engraved in Rosini, No. 42.

thus describes it from notes taken on the spot:—
"The picture is in the church of S. Lucia de'
Bardi, and represents the Madonna and Child
enthroned under Italian-Gothic architecture; two
saints stand on each side. On the first step of the
throne is the inscription 'Opus Dominici de Vene-
tiis. Ho Mater Dei, miserere mei. Datum
est.' Of this work Rumohr observes that the
expression of the female saint is not unworthy of
Angelico da Fiesole.* The Madonna and Child
are very agreeably composed, the coloured pave-
ment and architecture are in the Venetian taste, and
from the effect of modern varnishings the picture
has a warm tone which gives it a resemblance (but
it is only a resemblance) to a work in oil."†

But though the part assigned to these two
painters in the first chapter by Sir Charles—and
always with the utmost difficulty in reconciling
facts which he knew to be true, with others which
he had then no grounds to dismiss as false—is thus
necessarily set aside, yet Sir Charles's great interest
in the Portinari family as patrons of the new art
does not, on that account, lack due foundation. In
the mercantile transactions of the Portinari in the

* Italiänische Forschungen, vol. ii. p. 262.

† E. Förster (Kunst-Blatt, p. 67, 1830) calls it an oil pic-
ture; it is now universally acknowledged to be in tempera.

fifteenth century, as partners of the Medici, and agents for them in foreign parts, which probably led to their taste for the newly-practised Northern art—in their employment of Memling and Hugo Van der Goes for the decorations of the family chapel—and in the possible influence of those pictures in Florence at that period—Lady Eastlake has seen sufficient grounds for retaining a page of family history which is interwoven with the palmiest days of Florentine art and prosperity.

With the exception of the omission, thus explained, of part of the first chapter, no alteration has been required in the portion now presented to the public.

It may be added that the edition of Vasari referred to throughout is that of Florence, 1832–8.

December 1868.

CONTENTS.

CHAPTER I.

CHAP. II.

CHAP. III.

CHAP. IV.

CHAP. V.

CHAP. VI.

PROFESSIONAL ESSAYS.

xiv CONTENTS.

MATERIALS

A HISTORY OF OIL PAINTING.

CHAPTER I.

FOLCO PORTINARI AND HIS DESCENDANTS—HOSPITAL OF S.
MARIA NUOVA—ANCIENT FLORENTINE ACADEMY OF PAINT-
ERS—ANTONELLO DA MESSINA—THE POLLAIUOLI.

THE name of Portinari is connected both with the
history of Italian poetry and Italian art. About
the year 1285, Folco Portinari, the father of Dante's
Beatrice, founded the hospital of S. Maria Nuova
in Florence, and employed Cimabue to paint a
Madonna for its chapel.* More than a century
and a half later a member of the same family, Folco
di Adoardo Portinari †, commissioned Domenico

* Richa, Notizie Istoriche delle Chiese Fiorentine. Firenze,
1754–1762, vol. viii. pp. 175, 190. The hospital of S. Maria
Nuova is not to be confounded with the church and convent
of S. Maria Novella.

† The elder line of the Portinari, from the end of the thir-
teenth to the beginning of the sixteenth century, is as fol-
lows:—Folco di Ricovero, founder of the hospital, died in 1289;

Manetto; Giovanni; Adoardo; Folco $\begin{cases} \text{Pigello ; Folco.} \\ \text{Tommaso ; Antonio.} \end{cases}$

Veneziano and Andrea dal Castagno to decorate the Portinari chapel in the church of S. Maria Nuova, and to these works were added some Flemish examples of the new art of oil painting, among which are especially mentioned a small picture by Memling and a triptych by Hugo Van der Goes.*

The ancient Florentine Academy of Painters, dating from the time of Giotto, held its first sittings in S. Maria Nuova—an event commemorated in the sixteenth century by the presentation, on the part of the Academy, to the same chapel, of an altar-piece by Alessandro Allori.† The early connection of the painters with this institution is partly accounted for by their having been at first included in the same " arte " or guild with the physicians.‡ About the year 1420 the original chapel of the hospital was enlarged by Lorenzo di Bicci, who, painter as well as architect, adorned the façade with two frescoes representing the consecration of

* Vasari, *Introduzione*, c. 21 ; and his notice, *Di diversi Artisti Fiamminghi.* It may be necessary to repeat that Ausse, or Hausse, is Vasari's misprint for Hansse, or Hans (Memling), whom he clearly designates as the scholar of Roger of Bruges. Vasari, *Vita di Antonello da Messina* ; compare Baldinucci, vol. v. p. 411 ; De Bast, in the *Kunst-Blatt*, 1826, p. 321, note ; and Passavant, *ib.* 1843, p. 257. On the works of Memling and Hugo Van der Goes for the Portinari, see Passavant, *ib.* 1841, pp. 18, 33, 251 ; and 1843, p. 258.

† Richa, Notizie, &c., vol. viii. p. 191.

‡ See the Florence edition of Vasari, 1832–1838, p. 316, note 13.

the new edifice by Pope Martin V.* Of other paintings executed in various parts of the vast establishment, some may be noticed hereafter.

The pious and charitable intentions of the founder were carried out by his descendants with equal zeal, and the excellent management of the institution recommended it far and near. When Martin V. entered the cemetery where the bones were exhibited to view piled around, he knelt at the threshold, and, taking up a handful of dust, pronounced the promise of as many indulgences as there were atoms of mortality in his grasp to all who should there pray for the souls of the departed, and to all who might die within the precincts of the asylum.† The last benediction had a powerful influence on the prosperity of the institution. To superannuated painters were now added persons of rank from various parts of Italy and Europe, till S. Maria Nuova almost became to Christendom what the Valley of Jehoshaphat still is to the Hebrew world. The fame of a hospital which was long considered a model for general imitation attracted the attention of Henry VIII. of England, for whom a full description of the institution and its regulations was prepared in 1524 by a Francesco Portinari, who, it appears, was about this

* Richa, Notizie, &c.; ib. p. 197. Vasari, Vita di Lorenzo di Bicci. One of the frescoes is engraved in the Etruria Pittrice, Pl. XV.

† Ib. p. 194.

time ambassador from the republic of Florence to the English monarch.* It remains to observe that the accidental connection which existed between this foundation and the revival and perfection of painting was confirmed by important advantages affecting the practice of that art. Attached to a chapel where the dead were first deposited was a hall for the study of anatomy, to which was subsequently added a theatre for lectures. The chemical department, again, comprehended an ample dispensary, underneath which, in extensive vaults, distillations and other operations requiring the use of fire were carried on; the whole being under the superintendence of experienced professors.†

Such was S. Maria Nuova. The Pollaiuoli, Leonardo da Vinci, and Michael Angelo may there have become familiar with dissections and with the structure of the skeleton; there the Florentine painters could trace back the traditions of Italian art from the time when Byzantine trammels were first cast aside; and there they could procure certain materials essential to the practice of the new art prepared in the best manner by chemists who took an interest in their pursuit.

If the institution which has been described might thus, for many reasons, be called the cradle of Italian art, it was also, in a more literal sense, the

* Richa, Notizie, &c., pp. 184, 218. The ambassador is also called Pier Francesco Portinari.

† Ib. pp. 208, 209.

chosen place of rest of the artists. Many an aged professor sought peace within its walls, to quit them no more; and many a convalescent left its precincts with reluctance. Vasari relates that when the friends of Nanni Grosso, a sculptor, visited him in S. Maria Nuova after his recovery, and inquired after his health, he replied, " I am not well. I am in want of a little fever; I should then have an excuse for remaining where I have had every comfort." An example is afterwards given of the kind of comfort which this artist required. During his last illness, when he was again an inmate of the hospital, an ill-formed crucifix was brought to him; the dying sculptor turned from it with pain, and entreated that a better work of the kind by Donatello might be placed before his eyes.[*]

With regard to the early oil paintings with which the principal chapel was decorated, it is not known whether the picture by Memling was painted in Italy (which the artist may have visited with his master, Roger of Bruges, in 1450), or whether it was afterwards transmitted from Flanders: that it was painted for the Portinari there is no doubt. The triptych by Hugo Van der Goes, or, as Vasari calls him, Ugo d' Anversa, was probably painted about twenty years later. That work, which is still in the chapel, may be at once described.

The main picture, now separated from the wings, hangs on the wall left of the door on entering: the

* Vasari, Vita di Andrea Verrocchio.

two wings hang on the opposite side. The subject
of the principal picture is the Nativity : angels
hover over the scene, and one of them, in shadow,
is lighted by the splendour from the Infant; so
early was this idea—often supposed to be an inven-
tion of Correggio—customary in the treatment of
the subject.* Other angels stand around, singing
the " Sanctus," which is inscribed on the hem of
the robes of two who are kneeling. The adoring
shepherds are remarkable for their vivid indivi-
duality and the earnestness of their expression. In
the foreground is a vase of flowers, in the taste of
Van Eyck. Of the wings or doors, one exhibits a
member of the Portinari family and his two sons,
for whom St. Anthony and an Apostle—either
St. Matthias or St. Thomas (as he holds a lance)—
intercede ; the other wing represents the wife of
Portinari and her daughter, introduced by St.
Margaret and Mary Magdalene.†

* The apocryphal sources appear to have been the Protevan-
gelion and the Evang. Infantiæ.

† A portrait, by some writers supposed to represent Folco
Portinari, but which bears the arms of the Bandini family,
was a few years since in the Pitti Gallery (Passavant, *Kunst-
Blatt*, 1841, p. 18 ; Reumont, *ib*. 172) ; it is now in the
Gallery of the Uffizj. On the back, painted in chiaroscuro, is
the Angel of the Annunciation. The companion portrait of
the wife certainly resembles the lady in the altar-piece of Hugo
Van der Goes above described, except that there she is repre-
sented younger; on the back is seen a chiaroscuro Madonna,
completing the subject of the Annunciation. This work has
been attributed to Van der Goes ; but the portraits, which

Various writers, including Richa, have ascribed these pictures sometimes to Domenico Veneziano, sometimes to Andrea dal Castagno, forgetting (to say nothing of the internal evidence of the art) that those artists painted on the walls of the chapel, and that their works there have long since perished. In consequence of this mistake, the subject has been wrongly described, and the personages who, according to Vasari, were introduced in the wall-pictures, have been transferred to these. Even some modern critics, who have been well aware that the existing work is by Hugo Van der Goes, " che fe' la tavola di S. Maria Nuova,"[*] have inadvertently followed the remaining part of Richa's blunder by assuming that the figure of the donor represents Folco Portinari. It will appear, as we proceed, that the portrait is much more probably that of Tommaso de' Portinari, a son of Folco, who was more than once in Bruges in the latter half of the fifteenth century, and whose name may be referred to by the introduction of St. Thomas the Apostle. The portraits all appear to be taken from the life, but whether the work was executed in Italy or in Flanders is uncertain.

The small picture by Memling above noticed is twice mentioned by Vasari, who intimates that subsequently to its being placed in the Portinari chapel it became the property of Cosmo de' Medici; he also

are strikingly defective in proportion, are inferior to the generality of his productions.

[*] Vasari, Introduzione, c. 21, p. 42.

informs us that it represented the Passion.* Such
a subject often comprehended various scenes, and
hence it is not improbable that a picture by Mem-
ling answering this description, and which is now
in the Gallery at Turin, is the identical work exe-
cuted for the Portinari.† No subject of the kind,
by the artist, is known to exist in Florence.

The commercial enterprises of the Portinari are
not to be overlooked in noticing their encourage-
ment of painters who followed or adopted the
method of Van Eyck. A manuscript chronicle
compiled by a descendant of the family about the
year 1700 is preserved in the Riccardian library at
Florence. From these records it appears that
during the fifteenth century the Portinari were
first the partners, then the agents, of the Medici
in various parts of Italy and in other countries.
For example, commercial transactions were con-
ducted in Venice by a Giovanni Portinari and a
Giovanni de' Medici (probably the father of Cosmo)
so early as 1406. In 1448 Pigello, the son of Folco
d' Adoardo Portinari, superintended, with his part-
ners, the affairs of Cosmo de' Medici in that city,
and appears to have resided there some years.

Ten years later we find the same Pigello acting,
apparently alone, in a similar capacity at Milan,
where he ultimately settled with his family, and

* Vasari, Introduzione, and the notice, Di diversi Artisti
Fiamminghi.

† Passavant, Kunst-Blatt, 1843, p. 258.

where he died in 1468. In 1470 and later, others of the house trafficked in Flanders and the North.*

* The writer of the Chronicle containing these details was Folco Antonio Maria Portinari, a priest. The MS. is numbered 1884 in the Riccardian library ; it was first noticed by Mr. Seymour Kirkup, to whom the author is indebted for the following extracts :—

"1406. Giovanni Portinari faceva negozio in Venezia con Matteo Tanagli e Giovanni de' Medici.

"1448. Pigello di Folco d'Adoardo Portinari con Alessandro Martelli e Francesco di Daviti regenti in Venezia la compagnia de' Medici," &c.

"1458. Il sudetto Pigello governava il banco e la ragione in Milano di Cosimo de' Medici." (Vasari, in his life of Michelozzi, a Florentine sculptor and architect, speaks of the palace at Milan, which Francesco Sforza presented to Cosmo de' Medici, and adds : "It appears that the sums which Cosmo spent in the restoration of this palace were furnished by Pigello Portinari, a citizen of Florence, who at that time was at the head of the bank and commercial establishment of Cosmo in Milan, and who himself dwelt in the said palace." Respecting the chapel which Pigello built at Milan at his own cost, see Richa, Notizie, &c., vol. viii. p. 185.)

"1460. Giovanni d' Adoardo Portinari fece negozio in Milano con Piero di Giovanni di Cosimo de' Medici.

"1470. Folco di Pigello di Folco Portinari con Tommaso di Folco Portinari, descritti mercanti famosi e segnalati, negoziavano a Lione in Francia, e la ragione diceva ancora colla famiglia dell' Antella e Ghicci, e tenevano p factori Matteo Ghicci, uno dell' Antella, uno de' Boni, e Zanobi da Scarperia; nel quale anno pure negoziavano p la Fiandra, Inghilterra, Olanda, Zelanda, e Scozia, Giovanni d' Adoardo Portinari e Benedetto Portinari.

"1480. Tommaso di Folco Portinari fece negozio in Bruggia di Fiandra con Lorenzo de' Medici.

"1480. Tommaso di Folco Portinari fece negozio in Londra con Alessandro d' Adoardo Portinari e Tommaso Guidotti.

"Bernardo d' Adoardo Portinari fece negozio di pannini et altro nella città di Lione in Francia.

These data are not unimportant, as serving to explain the introduction of oil painting into Florence. Pigello Portinari must have been in Venice when Antonello da Messina dwelt for a time in that city on his return from Flanders.

Again, we find that Antonello, during his long absence from Venice, dwelt for a time in Milan. Whatever may have led him to visit that city (perhaps the accident merely of its being in his road from Venice to Genoa, the most convenient port whence he could embark for Messina), it is highly probable that he owed to Pigello Portinari the attentions which he received there, and which induced him to prolong his stay.* Lastly, the sub-

"1484. Detto negoziava pure in Bruggia.

"1488. Folco [di Pigello di Folco] Portinari fece negozio di pannini et altro in Bruggia di Fiandra con Tommaso di Folco Portinari."

From other passages it also appears that the Medici and Portinari had still a joint establishment in Venice late in the fifteenth century.

* According to Vasari, in his *Vita d'Antonio Filarete*, quoting from a MS. by that sculptor and architect, which is now in the Magliabechian library at Florence, Pigello Portinari decorated the palace at Milan, mentioned in a former note, with various paintings, including portraits. The artists, with the exception of Michelozzi and Vincenzo Foppa, are not named ; but this edifice, together with Pigello's sumptuous chapel of S. Pietro Martire at S. Eustorgio, and the Albergo de' Poveri, built by Francesco Sforza, all which were adorned with paintings and altar-pieces, offered abundant opportunities for the employment of the artists then at Milan. The following passage in Filarete's MS. relating to the palace justifies Vasari's general statement :—" Ancora l' entrata d' essa è degnissima, et

sequent employment of Hugo Van der Goes on a
work to be placed in the Portinari chapel at Florence
may be explained by the commercial relations of
this same family, chiefly represented by Tommaso
de' Portinari, with Flanders, about the time when
Van der Goes was in the zenith of his reputation.

The earliest Italian oil painters now invite our
attention.

Respecting their first teacher, Antonello da Mes-
sina, there is little to add to the account already
given. Since the publication of the first volume of
this work, however, an important date has come to
light. It is now certain that John Van Eyck died
in 1441:* at that time Antonello was probably
about twenty-seven years of age, and the period

maggiormente quando sarà dipinta nel modo che già ragionammo
insieme con Pigello Portinari, huomo degnio et dabene, el
quale ivi reggia e guida tutto el traffico che anno a Milano ;
col quale ebbi ragionamento di quello che dipingere s' aveva."
See the note at the end of this chapter.

* See the interesting documents in the pamphlet entitled
Les trois Frères Van Eyck, par l'Abbé Carton. Bruges, 1848.
On the Abbé's mistake respecting the date of Antonello da
Messina's birth, see Dr. Waagen, *Kunst-Blatt*, 1849, p. 62.
With reference to the date of Van Eyck's death, it is to be
observed that as Alphonso of Arragon expelled René of Anjou
from Naples in 1442, it follows that the picture by Van Eyck,
which, according to Vasari, induced Antonello to visit Flan-
ders, must have been seen by him before Alphonso possessed
it ; and hence the conjecture of De Bast (*Kunst-Blatt*, 1826,
p. 333, note) that the painting in question was originally sent
to King René, and was seen by Antonello while it was in that
monarch's possession, is well founded.

of his visit to Flanders is, in some measure, defined. A portrait by him, in the Berlin Gallery, has the date 1445; and as there is some reason to believe that it was painted in Italy, the artist may have quitted Flanders for Venice in 1444. As yet there is no ground, save the questionable evidence of this portrait, to conclude that Antonello returned to Italy so early;* but assuming such to be the case, his first residence in Venice must have been of long duration. There is nothing improbable in this, as he must have passed a considerable number of years either in Venice during his first stay there, or in Milan. That during those years he was occupied with his art we cannot doubt, but it is remarkable that, except the portrait referred to, no picture by Antonello has been hitherto noticed with an earlier date than 1470†: according to a Sicilian writer, an Ecce Homo, formerly at Palermo, was so inscribed.‡ The compiler of the " Memorie de' Pittori Messinesi,"

* The doubtful evidence alluded to is the fact that the portrait is painted on chestnut-wood, a material not commonly used for such purposes in the North : the authenticity of the picture has never been called in question. According to a Flemish MS., quoted by De Bast (*Kunst-Blatt*, 1826, p. 339), Antonello remained some years in Flanders after Van Eyck's death.

† The date on Antonello's picture of the Crucifixion, in the Gallery at Antwerp, is now universally acknowledged to be 1476.

‡ Vincenzo Auria, quoted by the author of the *Memorie de' Pittori Messinesi.* In Messina, 1821, p. 16.

published also the "Guida per la Città di Mes-
sina." * In that compendium, when speaking of
the church of S. Gregorio at Messina, the writer
describes a picture of the Virgin and Child by
Antonello inscribed with the artist's name and
the date 1473 :† hence he infers that Antonello
remained in Sicily till that year. Antonello's resi-
dence in Milan must therefore have preceded his
visit to Sicily, where, accordingly, his biographer
supposes him to arrive shortly before (*verso*) 1465.
Circumstances are not wanting to support this con-
jecture; for it is by no means unlikely that his
success in Milan was regarded by his competitors
there with extreme jealousy : though protected, as
we assume, by the Portinari, Antonello appeared
among the Milanese artists as a stranger, prac-
tising a mode of painting to them unknown, and
which had obtained favour with the wealthy.‡ We
are also led to conclude that Antonello returned to
Venice in 1473, immediately after the completion
of the picture in S. Gregorio at Messina. In cor-
roboration of this view, it is to be observed that

* Siracusa, 1826.

† Memorie de' Pittori Messinesi, p. 20. According to the
same author, four other pictures, originally forming part of
the altar-piece, are now in the sacristy of S. Gregorio. The
inscription on the latter is given in the *Memorie*, p. 15, as fol-
lows :—" Anno Dei MᵒCCCCᵒ septuagesimo tertio Antonellus
Messanensis me pinxit."

‡ The expression " Mediolani quoque fuit percelebris " (see
Materials, vol. i. p. 194, note) is sufficiently conclusive on this
point.

Zanetti, on grounds irrespective of the above evidence, fixes 1473 as the date of the first oil picture painted by a Venetian artist.* Antonello, knowing that the process was gradually becoming public, would, on his reappearance, naturally be anxious to assert his claim to be considered the earliest teacher of the art in Italy: accordingly, he seems to have lost not a moment, after arriving in Venice, to impart the knowledge he possessed,† and the work by Bartolommeo Vivarini, formerly in S. Giovanni e Paolo, may have been the first, though as yet the very imperfect, fruits of the Sicilian artist's teaching. Whether Zanetti was right or not in judging that this picture was executed in oil we have now no means of ascertaining, as it has disappeared; certain, however, it is that the earliest date, as yet known, on any picture painted by Antonello after his return to Venice is 1474. The Sicilian lived to see himself surpassed even in the use of the method which he had taught; but at the period now referred to,

* Della Pintura Veneziana. In Venezia, 1771, p. 24.

† Ridolfi's story (*Le Meraviglie dell' Arte*, vol. i. p. 48) respecting a stratagem employed by Giovanni Bellini to possess himself of Antonello's secret, need not be rejected ; it would only prove that Giovanni had no personal acquaintance with the Sicilian, and that he sought to obtain, unobserved, a better knowledge of the method than, as a stranger, he was likely to obtain. Antonello's free communication of his process would probably be first made to those painters whom he had known during his former residence in Venice.

his works, in depth and richness of colour at least, were far superior to those of his Venetian followers. The portrait in the collection of Count Pourtalès,* inscribed "1474. Antonellus Messaneus me pinxit," is an excellent specimen of the artist: in force, warmth, and clearness it would bear a comparison with the best Flemish examples; while, although minutely finished (as in the eyes, eyebrows, and beard), it is not without a certain Italian breadth.† Before quitting this painter it may be remarked that after having once acquired the art of oil painting he seems never to have laid it aside for any other method; whereas many of those who adopted the Flemish process wanted inclination or perseverance to practise it on all occasions. We proceed to trace the progress of his earlier successors in the art at Florence.

It does not appear that the Italian artists had as yet any means of acquiring a knowledge of oil painting from foreign professors. The Flemish painters who visited Italy seem to have kept their secret jealously. Justus van Ghent, who was employed by Federigo da Montefeltro at Urbino, and one of whose works in oil, completed there in 1474, still exists, contrived to conceal his method from the painters of the Umbrian school.‡ Antonello da

* Now in the Gallery of the Louvre.—*Ed.*

† This appears to be the portrait which, according to Lanzi (vol. ii. p. 27), was formerly in the Casa Martinengo at Venice.

‡ Sir Charles Eastlake subsequently, on a visit to Urbino,

Messina, while residing at Milan, must have been equally cautious; for not a single specimen or record has come to light to show that the art was taught by him in the north of Italy till 1473, when he was again in Venice. A celebrated work, painted in oil by Antonio Pollaiuolo, was completed, after much study and many previous essays, in 1475; and we find that this artist long wrought as a goldsmith before he learnt the art of oil painting from Piero, his younger brother.

The productions of the Pollaiuoli comprehend the earliest unquestionable examples of Italian oil painting now extant. The two brothers at first worked together, but Antonio, who was the more accomplished designer, by degrees asserted his superiority. Vasari notices but one occasion, an early one, in which Piero painted some works alone. The remains are still to be seen: they consist of some single figures of angels and prophets, and an Annunciation, painted on the walls in the church of S. Miniato al Monte. The single figures are

Sept. 1858, examined the work by Justus van Ghent here alluded to, and formed a very low opinion of it, which he thus summed up in notes taken at the time:—" The painter was utterly unworthy to be admitted among those in Urbino who must have been his cotemporaries, and, assuming that this picture represents his ability and the extent of his qualities, there is not a single particular, not even architecture or still life, in which he can be said to have influenced the Italians." To this cause, perhaps, rather than to any secrecy, may be assigned the fact that the method of Justus van Ghent found no followers in Urbino.—*Ed.*

nearly effaced, and are, moreover, high on the wall; the Annunciation is better preserved and more accessible. The deep colours of the Madonna's dress and certain peculiarities in the surface, hereafter to be noticed, indicate the material with which these figures are painted; the appearance of the work agrees, in short, with the statement of Vasari, who expressly says that Piero executed it in oil. In the same church the brothers painted an altar-piece on wood, and, as Vasari again states, in oil; it represented three saints— St. James, St. Eustace, and St. Vincent. This picture has been removed to the Gallery of the Uffizj, where it now is. Puccini,* who had an opportunity of observing it narrowly, asserts that it is in tempera. The technical question must be left in this case undecided, for even supposing the brothers to have produced works in oil before the date of this picture, there would be nothing extraordinary in their subsequently painting an altar-piece in tempera. With respect to the general merits of the work, it is evident that two hands were concerned in it; the St. Vincent and the St. James are far superior to the St. Eustace: that figure is consequently to be assigned to Piero. Vasari speaks of a work by the Pollaiuoli executed in oil on cloth, in the church of S. Michele in Orto. Some single figures of Virtues, also painted in oil, and which

* Memorie di Antonello degli Antonj, Firenze, 1809, p. 65.

VOL. II.

were originally in the Mercatanzia (a tribunal so called), are now in a corridor annexed to the Uffizj; they are interesting in a technical point of view, and will be noticed as we proceed. The two pictures by Antonio in the same gallery, representing the Labours of Hercules, appear to be repetitions on a reduced scale of two out of three works of the kind painted for Lorenzo de' Medici; they are chiefly remarkable for their boldness of design.

The celebrated picture of St. Sebastian, originally in the chapel of S. Sebastiano a' Servi, afterwards in the Palazzo Pucci*, was completed in 1475. It is painted on wood, and unquestionably in oil; it has been engraved in the *Etruria Pittrice* and elsewhere. The date, which Vasari, in reference to the general merits of the work, records as an era in art, its technical qualities, and its excellent preservation, render this picture especially worthy of attention. This was the first great example of the application of the new art to altar-pieces. Oil painting was thus at last recommended to the Florentines by a true son of the school. The enterprising genius of Antonio Pollaiuolo displayed itself in works remarkable for vigour of drawing, while the hardness and anatomical precision which even his oil pictures exhibit would scarcely be looked upon as a defect at the period when he lived. Soon after the completion of the St. Sebastian, he was employed to

* Now in the National Gallery.—*Ed.*

paint a figure of St. Christopher on the external wall of the church of S. Miniato fra le Torri. The representations of this saint were always gigantic, not only in accordance with the legend, but because the sight of the picture was supposed to act as a charm in renovating the strength of the labourer and in preventing accidents; hence it was desirable that it should be conspicuous from afar as well as near.[*] The St. Christopher of Antonio Pollaiuolo was nearly twenty feet high: according to Baldinucci, in whose time it was still visible, there was a tradition that Michael Angelo in his youth was in the habit of making drawings from it by way of study.

The foreground figures in the St. Sebastian are not only as large as life, but their style of design is full, in the taste afterwards carried to its extreme by Michael Angelo, and is thus directly opposed to the meagreness of the early Flemish school. The peculiarities of the execution will be described hereafter.

But notwithstanding the great abilities of Antonio Pollaiuolo, most of the Florentine artists, like Michael Angelo himself at a later period, could appreciate the efforts of their countryman in design without extending their approbation to the method of oil painting which he had adopted. The elder painters, such as Cosimo Rosselli, Sandro Botticelli,

[*] See L' Osservatore Fiorentino, vol. i. p. 113. Compare Maniago, Storia delle Belle Arti Friulane, 1823, p. 193. For the legend, see Mrs. Jameson's Sacred and Legendary Art, vol. ii. p. 48.

and others, were too much wedded to their early
habits to venture much on the novel practice.
Even Domenico Ghirlandajo, who was young when
Antonio's masterpieces were produced, showed to
the last a disinclination for the change. He was
in the habit of saying that painting consists in
drawing, and that the only method which promised
unlimited durability was mosaic—expressions which
appear to have had reference to the opinions of
others in favour of the new system.

Two pictures ascribed to Ghirlandajo, in the
Berlin Gallery, are remarkable for being painted
partly in tempera and partly in oil. In one, repre-
senting the Madonna in glory adored by saints
below, the two kneeling figures of St. Jerome and
St. Francis are in oil; all the rest of the work is in
tempera. The figures in oil are supposed to be by
Francesco Granacci, one of Ghirlandajo's scholars,
and the inference is that the picture was left un-
finished by the master. In the other—a single
figure of St. Anthony—the saint is painted in oil,
and the background in tempera. The companion
picture, representing S. Vincenzo Ferreri, is en-
tirely in tempera. In the case of the St. Anthony
it may be supposed that the figure was completed
after the death of Ghirlandajo by his brother David,
or by Bastiano Mainardi, both of whom could
imitate his manner closely. Vasari does not men-
tion a single oil picture by Domenico Ghirlandajo.
It is, however, quite possible that such works by

him may exist. As rare examples, they would merely prove the hesitation and reluctance with which some of the best artists, followers of the earlier methods, made attempts in the novel process.

The opinions or prejudices of Ghirlandajo with regard to a question then so much discussed must have had a powerful influence on his great scholar Michael Angelo—the latest representative of the opponents of oil painting.

NOTE

ON TWO COPIES OF AN INEDITED MANUSCRIPT
BY ANTONIO FILARETE.

THE MS. referred to is a treatise on architecture in twenty-five chapters. Various copies in Italian and various Latin translations exist, but the work has never been deemed worthy to be printed. Two Italian copies are in Florence; one in the Palatine, the other in the Magliabechian Library. Morelli (*Notizia d'Opere di Disegno*, pp. 160, 168) describes a Latin version in the library of St. Mark, at Venice, and enumerates other copies, in both languages, existing elsewhere. Of the two MSS. in Florence, that in the Palatine Library is addressed to Francesco Sforza (who died in 1466); many names are not filled in, some chapters or books towards the end are wanting, and the MS. is written in at least two different hands. From these circumstances, as well as from the absence of sufficient decoration, it is evident that this could not be the presentation copy to Sforza. The Magliabechian copy is dedicated to Pietro de' Medici, and was once in the possession of Cosimo, the first Grand Duke: this fact, added to the beauty and regularity of the execution, is a sufficient proof that the volume was really presented to Pietro. Vasari (*Vita di Filarete*) states that it was completed and dedicated

in 1464, and there is internal evidence to show that it was not finished before the autumn of that year. Morelli (*Notizia*, p. 169) and Zani (*Enciclopedia*, vol. ii. p. 336) appear to be wrong in supposing that the Palatine MS., addressed to Sforza, was written in 1460. According to Gaye (*Carteggio d'Artisti*, vol. i. p. 202), that date occurs in both MSS., but only with reference to certain edifices to mark the year when they were built : the same writer concludes that both copies were written about the same time. He remarks that both allude throughout to Cosmo de' Medici as living, but in this he is mistaken; the Magliabechian copy speaks, towards the end, of the "degnia memoria di Cosimo." Cosmo (Pater Patriæ) died August 1st, 1464.* There is also a passage alluding to the death of a younger son of Cosmo, Giovanni de' Medici, who died in 1463. From the difficulty of making a careful inspection of the Palatine MS. when these researches were first undertaken, the author is not prepared to say whether any evidences of so late a date exist in that copy or not; the following facts are, however, not unimportant :—The Palatine MS. speaks at length of the Albergo de' Poveri (built by the writer of the treatise), at Milan, as a completed work, and, according to a medal quoted by Vasari, the first stone was laid by Francesco Sforza in 1457. After that, as appears from both MSS., as well as from other authorities, Filarete planned and partly built the Cathedral of Bergamo, and during the progress of that and other works, as he himself tells us, composed his voluminous treatise.† These labours may fairly be allowed to extend from 1457 to 1464. In the absence of more special evidence, we therefore conclude with Gaye that both copies were written about the same time. The Magliabechian

* Gaye, by an oversight, speaks of April, 1464, as the date of Cosmo's death.

† " e [fece] nella città di Milano il glorioso albergho de poveri di Dio sotto Francesco Sforza duca quarto di Milano el quale colla sua mano la prima pietra nel fondamento colloco et altre cose pme inessa [città furono] hordinate, la chiesa maggiore di Bergamo anchora hordinai et inquesto tempo quando aveva alquanto divacazione queste conaltre hoperette compuosi," &c.— *Magliab. MS.*

MS. contains a remarkable description of the process of oil painting (to be noticed hereafter) which is wanting in the other, and which was overlooked by Gaye. The passage, occurring towards the end in both MSS., in which Domenico Veneziano is mentioned, has reference to the proposed decoration of a palace at Milan which had been presented to Cosmo de' Medici by Francesco Sforza. The discussions often assume the form of a dialogue, although the interlocutors must be supposed :—

[*Principe.*] " So, in my opinion, it should be done ; it is for you therefore to find the master, and to make arrangements for these undertakings."

[*Filarete.*] " I fear, Signore, we must wait ; as there is a dearth of good masters. The proposed works should by all means be executed satisfactorily ; but, from whatever cause, good masters are not to be found. Several who were formerly in Florence, and who would have come at our call, are dead ; one called Masaccio, another called Masolino ; one who was a friar, called Fra Giovanni. Lately, also, among other good painters, died Domenico da Venezia ; another called Francesco di Pesello, who was a good master for animals ; another, called Berto, who died at Lyons on the Rhone ; another, again, who was very learned and skilful in painting, called Andreino degl' Impiccati : so that I fear there may be some difficulty. We will, however, do the best we can with those who are to be had ; we will see whether any good painter can be found in the North—one there was who was most excellent, called Giovanni da Bruggia ; he too is dead. I think there is one Maestro Ruggieri [Roger of Bruges], who is celebrated, and also one Giachetto, a Frenchman [or Fleming] if indeed he still lives. He is a clever artist, especially in portraits ; at Rome he painted Pope Eugenius [IV.] with two of his attendants next him, looking absolutely alive. Those likenesses are painted on cloth, and the picture was placed in the sacristy of the church della Minerva. I speak of this work because the artist painted the portraits in my time.* We will therefore

* Vasari, in his Life of Filarete, and probably quoting from the MS. here described, speaks of a portrait of Eugenius IV. in

see whether we can have these painters, and if we cannot, we must employ those who are on the spot."*

Some of the above allusions by Filarete to defunct painters are by no means complimentary to the existing or rising talents of his day ; at all events, in regretting that so many good

the Minerva by Giovanni Focchora or (first edition) Fochetta[1]—intended perhaps for the "Giachetto Francoso" of Filarete. The portrait may have been executed about 1440.

[[1] It is suggested that "Fochetta" may have been the corruption of Fouquet—Jehan Fouquet de Tours—painter to Louis XI. of France, and known by his portraits of royal personages.—*Ed.*]

* The original passage, as written in the Magliabechian copy, is as follows :—

"A me pare checosi sidebba fare siche avoi sta trova il maestro a chesidia hordine afar fare queste cose. Io dubito Signiore abisognera aspettare pche cie carestia dimaestri chesien buoni pche queste cose vogliono stare bene aogni modo voglio stieno bene manon situovano maestri buoni non so pche nemorti una sorte che erano afirenze chesarebbono venuti iquali erano buoni maestri tutti cioè uno chiamato Masaccio unaltro chiamato Masolino uno chera frate chiamato fra Giovanni poi ancora nuovamente ne sono morti tra altri buoni uno chiamato Domenico davenegia unaltro chiamato Francesco dipesello il quale pesello fu grande maestro danimali unaltro sichiamava Berto ilquale mori alione sopra Rodano unaltro ancora ilquale era nella pittura molto dotto e perito ilquale sichiamava Andreino deglimpicchati siche dubito sara dificolta averne. Bene faremo conquegli che potremo avere ilmeglio si potra sivorrebbe vedere senelle parti oltramonti ne fusse nessuno buono dove nera uno valentissimo ilquale sichiamava Giovanni dabruggia e lui ancora emorto parmi cisia uno maestro Ruggiera che e vantaggiato ancora uno giachetto francoso ancora se vive e buono maestro maximo aritrarre del naturale ilquale fe aroma papa Eugenio e due altri desuoi appresso dilui cheveramente parevano vivi proprio iquali dipinse insu uno panno ilquale fu collocato nella sagrestia della Minerva. Io dico cosi pche amio tempo glidipinse siche vedremo seglipossiamo avere senon faremo conquesti checisono."

The passage in both MSS., in which the date 1460 occurs in anagrams, and which gave rise to Zani's supposition that the treatise was completed at that period, is here given literatim from the Palatine copy, as the transcript professed to be taken from that MS. by Zani's correspondent is incorrect in some particulars :—

painters were dead, about the year 1464, it was superfluous to name Masaccio, who died twenty years earlier. Still less necessary was it to allude to Masolino (if the same as Masolino da Panicale), since, according to Baldinucci, he died in 1415. Of the recently deceased, at the head of whom appears Domenico Veneziano, Francesco Pesello died, according to the same authority, in 1457. Probably, the expression "nuovamente" in Filarete's loose style, refers chiefly to Domenico, for, even in speaking of the then certainly recent deaths of Giovanni and Cosmo de' Medici (1463, 1464), he uses no such term.

It is remarkable that, in Filarete's judgment, two Northern painters—Roger of Bruges and "Giachetto Francoso"—were after all the fittest to execute the proposed works at Milan. The unknown "Giachetto," * like Roger of Bruges, was probably an oil painter, and this is not the only instance in which the architects of that time, aiming at durability in decorations, and persuaded of the superior recommendations of oil painting in that respect, showed a preference for the new method. The omission of Antonello da Messina's name in Filarete's capricious list may be explained by that painter having, in all probability, quitted Milan for Sicily when the passage was written. Vincenzo Foppa, a native of Lombardy, and the artist ultimately employed †, is also unnoticed.

"Disse allhora il figliolo del Signore alinterpreto per nostra fe chiariteci un poco quello dicono le lettere. Io vi chiariro quello io nintendo di queste pche cie alcuna non ne intendo bene pche sono lettere in modo intromesse che no sintendono le quali sono queste—Re zogalea gliofi D. FR. SF. [Re Galeazo figlio di Francesco Sforza] i quali hanno p loro magnanimita questo porto con tutti questi altri edifitii e la terra insieme constituita e fondata questo a chi passera fia noto e p lo architecto nostro ordinati il quale onitoan nolihaver [Antonio Haverlino] chiamato p patria notirenflo [Florentino] nel lemi troqua tocen tasanse [mile quatro cento sesanta]. Questo non ne intendo altrimenti. Ben basta noi faremo scrivere il nome el tempo di chi ha fatto fare e fatto si quando sara forniti questi deficii che restano a fare."

* See p. 24, note by Ed.

† Vasari, Vita di Michelozzo Michelozzi, and Vita di Filarete.

CHAP. II.

RECAPITULATION OF CHARACTERISTICS OF EARLY FLEMISH
SCHOOL—THE VARNISH OF TEMPERA PICTURES—IMPROVE-
MENTS BY VAN EYCK—MIXTURE OF VARNISH WITH COLOURS
—METHODS OF PAINTING.

BEFORE we proceed to inquire into the Italian practice of oil painting, it will be desirable to recapitulate the chief characteristics of the early Flemish school, since to that school Italian oil painting owed its origin.

The details contained in the first volume of this work render it now possible to confine our attention to the conclusions derived from them, without going into the evidence on which such conclusions rest : it will be sufficient to refer to the documents there adduced, occasionally noticing some others which have since come to light, and which either corroborate or correct the former statements.

Tempera pictures, executed before and after the time of Van Eyck, were coated with a varnish composed of sandarac dissolved in linseed oil, generally in the proportion of three parts of oil to one of resin.* This varnish was extremely durable,

* Vol. i. pp. 241, 251, 253. Compare Mrs. Merrifield's Original Treatises, dating from the twelfth to the eighteenth

but it was a substitute for a firmer composition of
the kind, still more ancient in date, and in which
amber was used instead of sandarac. The word
Vernice, or Bernice, was originally appropriated
first to amber and then to sandarac, as dry sub-
stances.* The sandarac varnish was known in
Italy by the name of " vernice liquida ;" the amber

centuries, on the arts of Painting, &c., 1849, Introduction,
p. cclxi.

* Vol. i. pp. 230, 237, note. The authority of Eustathius
on the early application of the word Bernice is alone conclu-
sive ; others will, however, be found in the treatises of
Libavius, Salmasius, Butman, and the authors quoted by them.
Butman's derivation of Bernice from Bernstein, a northern
appellation of amber, is probably correct (*Mythologus,* vol. ii.
p. 362). The antiquity of the trade with the North for this
substance is established by the following passages from another
high authority :—" The amber trade, which was probably
first directed to the West Cimbrian coasts, and only subse-
quently to the Baltic and the country of the Esthonians, owes
its first origin to the boldness and perseverance of Phœnician
coast navigators. In its subsequent extension it offers a re-
markable instance of the influence which may be exerted by a
predilection for even one single foreign production in opening
an inland trade between nations, and in making known large
tracts of country. In the same way that the Phocæan Mas-
silians brought the British tin across France to the Rhone, the
amber was conveyed from people to people through Germany,
and by the Celts on either declivity of the Alps to the Po."
Again :—" A not inconsiderable inland trade with the remote
amber countries was carried on by them (the Etruscans),
passing through Northern Italy and across the Alps."—Hum-
boldt, *Cosmos,* vol. ii. pp. 128, 134, Sabine's translation.
Among the works quoted in support of these statements is
Ukert's memoir "Ueber das Electrum, in der Zeitschrift für
Alterthumswissenschaft," Jahr. 1838, No. 52–55.

varnish by that of " vernice d' ambra," or "vernice liquida gentile." * Both, in consequence of the great heat required in their preparation, were dark in colour, the amber varnish most so. Both inclined to a warm reddish hue, not merely from the effects of partial carbonisation, but, in the case of the sandarac especially, because the dry substance acquires a russet hue from age. In English account-rolls of the thirteenth and fourteenth centuries, the term " vernisium rubrum" distinguishes the sandarac resin.†

Not only tempera pictures, but painted walls and even implements and armour, were, in the middle ages, commonly varnished with vernice liquida.‡ For ordinary purposes the varnish was less carefully prepared; common resin (" pece Greca," or " pegola") was sometimes mixed with the sandarac, sometimes superseded it; such compositions were called "vernice grossa," and " vernice comune."§

* Vol. i. pp. 238, 241.

† Ib. p. 247.

‡ Ib. pp. 238, 239, 252. Marciana MS., Mrs. Merrifield's Original Treatises, p. 636.

§ Fioraventi, *Compendio dei Secreti Rationali.* Venezia, 1597, p. 116. Marciana MS., 637. The epithet " comune " necessarily changed its application accordingly as any given varnish became common ; the term " grossa " is equally vague. Originally there can be no doubt that the "vernice liquida" was called " comune ; " that the " gemeiner virnis " of the Strassburg MS. was sandarac, as opposed to amber, and even so late as the seventeenth century an English writer (Salmon, *Polygraphices*, l. ii. c. 5) speaks of " common liquid varnish " com-

The warm reddish tint of the sandarac varnish rendered it unfit, in nice operations, for covering greens and blues, and indeed any delicate colours which might be vitiated by its hue. For such purposes a lighter varnish, called by the Italians "vernice chiara," was used, composed of mastic or of bleached fir resin, or sometimes of both, and nut oil* (the commoner kind consisting of the ordinary fir resin and linseed oil). In English records of the thirteenth and following century the "white" as well as the "red" varnish frequently occurs; the white varnish being generally mentioned together

posed of "linseed oil and gum sandarack." Italians of the sixteenth century, however, understood by "vernice comune" a compound of linseed oil and common resin. Even this, according to Bonanni (*Trattato sopra la Vernice, &c.*, in Bologna, 1786, p. 42), was improperly called "vernice di ambra;" again, Giambattista Volpata, in a MS. possessed by the author, speaks of "vernice grossa o d'ambra." The red and white varnishes had probably their common substitutes, and in comparing many authorities it appears that in general "vernice grossa" meant a cheap substitute for amber or for sandarac, probably resembling those varnishes in tint, while "vernice comune" was the lighter coarse kind. According to De Mayerne (see Vol. i. pp. 303, 304), the so-called "huile d'ambre de Venise," or "Vernix d'ambre de Venise," sold in the shops in Italy in his time, and no doubt the same as that mentioned by Volpato, inclined, like sandarac, to a red tint. For the rest, the application of the term "amber varnish" to the most ordinary oleo-resinous compounds proves the estimation in which the real medium was held.

* Armenini, De' veri Precetti della Pittura (in Ravenna, 1587, p. 129). Vol. i. pp. 247, 462, note, 552. Marciana MS., Mrs. Merrifield, Original Treatises, p. 632.

with materials for painting surfaces in green or in
blue. For example, in the fabric-rolls of Exeter
Cathedral, under the date 1320, verdigris, azure,
indigo, and white varnish are included in the same
entry:* in that document, the white varnish is one
shilling the pound ; the red was always cheaper.†

The English records, not to 'mention various
other documents before quoted, also show that at
the periods referred to (before 1400), colours
mixed with linseed oil were used for common pur-
poses of decoration. In such cases the painted
surface, if coated with "vernice liquida," would be
very durable: it was, however, durable of itself
and from another cause: the details of Cennini, ‡
the Byzantine MS.,§ and other authorities prove
that the oil so used with colours was thickened, by
exposure to the air and sun, to the consistence of
honey. These descriptions of the medium agree
with the appearance of certain portions—such as
ornamental patterns and other details—executed
in oil in early tempera pictures. The edges of the
parts so painted are blunt, and the surface is not
merely raised (as tempera itself often is), but the

* " 1320. 1 libra de azura empta London per Dominum
Episcopum Walterum de Stapeldon, 1 libra de Ynde bandas,
18d.; 4 lib. de verdigris, 2s. 4d. ; 4 lib. de vermilloun ; 5 lib.
de verniz alb. 5s.; ¾ de Sinople, 4s. 9d. .. In 16 lagenis olei pro
pictura, 21s. 6d."

† Vol. i. pp. 247, 248.
‡ Ib. pp. 65-9.
§ Ib. p. 79.

substance is transparent.* The thickened oil was found, from experience, to be much more durable than oil in a fresher state; when so prepared it is, in fact, half resinified, it acquires the nature of a varnish, and, to use a technical term, "locks up" colours more effectually.†

Both the oil and the varnishes used were thus calculated for durability. The perfect gloss which resulted from their semi-resinous state indicated a compactness of the particles which secured the surface from damp and rendered it possible to preserve the work in a clean state, if necessary, even by occasional ablution.‡ But the thick consistence of the oil rendered it unmanageable for finer painting; hence, such portions as required very delicate

* Vol. i. pp. 71, 73. Cicognara (*Storia della Scultura,* Prato, 1823, vol. iii. p. 158) describes a tempera picture by the early Venetian painter Lorenzo, dated 1369. It not only retained the original varnish, but certain portions were executed in oil. "The colour employed in the ornaments and gems on the gold ground, in the nimbus, and on the drapery of the Christ, is not tempera, but appears as if crystallized with another diaphanous and thick substance, strongly adhering to the gold ground, with which tempera would not bind. The tints used in these ornaments were evidently ground and prepared with the same oil or varnish which was spread over the whole work."

† Vol. i. p. 511, note.

‡ Vasari's expressions, "il modo di poterle lavare," and, speaking of Van Eyck's vehicle "secca non temeva l' acqua" (*Vita di Antonello da Messina*), may be compared with Pliny's "custodiretque a pulvere et sordibus," when speaking of an ancient varnish. Vol. i. p. 14.

modelling—for example, the heads and undraped
portions of figures in altar-pieces—were executed
in tempera.* We are not called upon to explain
the reason why oil painting—generally known and
practised as it was, for ordinary purposes, before
the year 1400—should have been so long despised
for works of price and skill. Nothing, apparently,
prevented the painters of those days from employ-
ing the oil in a thinner state, since, even admitting
its more perishable nature in that state, it could
always have been protected, like a work in tempera,
by the customary varnish. Of the fact of the un-
willingness of the painters, and of their persevering
to practise tempera for ages after the immixture of
colours with oil was known, there is, however, no
doubt whatever. It is even certain that long after
excellent oil pictures had been produced, such as
to excite an admiration which has lasted to our
day, some of the best Italian masters still looked
upon the art with distrust and dislike.

But, at all events, the practice of decorators in
the application of colours with oil, and the long
experience of tempera painters in the use of var-
nishes, before the commencement of the fifteenth
century, enable us to form some idea of the nature
of the improvements introduced by Hubert Van
Eyck.† He was in the habit, like others, of coating

* Vol. i. pp. 72, 175.

† The claims of Hubert Van Eyck as the original inventor
of the new method are now universally acknowledged. See

his tempera pictures with " vernice liquida;" like others, he must also have been acquainted with the "white varnish." (We find that in 1353 Lonyn of Bruges furnished some pounds of the substance so called for the use of the painters of St. Stephen's Chapel.*) For a time his habits may have been in all respects those of the painters who had preceded him. Painted and varnished walls in interiors were sometimes dried by means of fire:† the varnished tempera picture, being movable, was always placed in the sun, precisely according to the directions of Eraclius and Theophilus.‡ There is therefore nothing improbable in Vasari's story, that a work of Van Eyck's painted on wood (the material then almost universally employed), when so exposed by him, split from the heat, and induced the artist to think of preparing his "vernice" so that it should dry without the aid of the sun's heat. A similar accident happened to a Flemish painter at a later period §, and may have happened to many. To an Italian, accustomed to the practice of so exposing pictures, and aware of the danger attending it ‖, the explanation would seem quite satisfactory. A northern painter might only suggest that the tediousness of drying, with or without the sun, in a humid climate, might have been a

Carton, *Les trois Frères Van Eyck*, p. 32 ; compare Passavant, *Kunst-Blatt*, 1850, p. 14. * Vol. i. p. 248, note.
 † Ib. p. 53. ‡ Ib. pp. 35, 40. § Ib. 512.
 ‖ Cennini, Trattato, c. 155.

sufficient reason for devising some means to accelerate the process of desiccation. Yet no sufficient means for this purpose, we may be assured, had been adopted before Hubert Van Eyck's time.

The primary object of Van Eyck, according to Vasari, was thus to make the customary varnish more drying.* His first experiments were with the oils. He found no reason to conclude that linseed oil—the vehicle then generally used—was inferior to any other known oils as regards its siccative quality; but he seems to have revived the use of walnut (nut) oil†, and, as that oil has been supposed to become less yellow than the other with time, he may have employed it for certain colours, and may have appropriated it to the preparation of the "white varnish." We find that, at all events, this practice afterwards obtained.

The chief dryer which he used in preparing the oils or varnishes appears to have been white copperas—a material common in Germany, and which was certainly used in Flanders for the purpose in question in the fifteenth century. The reasons which may have induced Van Eyck to prefer this dryer to lead have been explained in the preceding volume.‡ The records of the time and country

* Vol. i. p. 205; compare Morelli, Notizia, &c., p. 116.

† It had been used as a varnish in, if not before, the fifth century, and had been tried, though without success, apparently as a medium for colours, in the fourteenth. Vol. i. pp. 19, 46.

‡ See Vol. i. pp. 130, 131, 285, the extracts from the Strass-

further show that the oils were then purified and rendered more drying by means of calcined bones.*

In searching for choicer resinous materials, and such as promised the utmost durability, Van Eyck could hardly fail to give a preference to amber. The darkness of the ordinary (and perhaps very ancient) solutions of amber was an objection to them as varnishes, and this appearance he may have corrected, as it is corrected now, by great care in the preparation.† Another substance, often, like sandarac, confounded with amber in the middle

burg MS., and from that of De Ketham, also p. 366. It should be further observed that white copperas is perfectly safe as a dryer when boiled with oil or varnishes, since it only parts with its sulphuric acid at a much higher temperature than in such boiling it can be subjected to. When calcined, it is also harmless, having then parted with its sulphuric acid; but in this state it is a white pigment merely (flowers of zinc), and as such is unfit for the darks, and superfluous (as a dryer) in the lights. Mixed with colours when it is dried only, not calcined, it may be sometimes injurious, "on account of the extreme tendency of the vitriolic acid to become dark." On this defect see the *Traité de la Peinture au Pastel.* Paris, 1788, p. 69.

* Vol. i. pp. 130, 143.

† See the description of Lewis's method in his *Commercium Philosophico-Technicum.* London, 1763, p. 366. It is quoted in Mrs. Merrifield's *Ancient Treatises,* &c., Introduction, p. cclxxiv., note. Lewis's solution of amber was "in linseed oil, gold coloured; in oil of poppy-seeds, yellowish red; in oil of nuts, deeper coloured." From these experiments it would appear that the ancient medium, linseed oil, is fittest for the amber varnish.

ages *, may also have invited the Flemish artists'
attention; this was copal, which forms a varnish
quite as eligible for painting †, and which can be pre-

* Vol. i. p. 233.

† See the interesting account of Sheldrake's experiments
with amber and copal, *Transactions of the Society of Arts*,
1801, vol. xix. "These colours (mixed with amber) were not
acted upon," he observes, "by spirit of wine and spirit of
turpentine united. They were washed with spirit of sal am-
moniac and solutions of potash for a longer time than would
destroy common oil-colours, without being injured." The
result of his experiments with copal was the same, "except
that with copal the colours were something brighter than with
amber." He concludes :—"If my experiments have not mis-
led me, I am entitled to draw the following conclusions from
them :—Wherever a picture was found possessing evidently
superior brilliancy of colour, independent of what is produced
by the painter's skill in colouring, that brilliancy is derived
from the admixture of some resinous substance in the vehicle.
If it does not yield on the application of spirit of turpentine
and spirit of wine, separately or together, nor to such alkalies
as are known to dissolve oils in the same time, it is to be pre-
sumed that vehicle contains amber or copal, because they are
the only substances known to resist those menstrua."

With regard to the superior brilliancy of the tints mixed
with copal, this, it seems, is only the case at first. Dreme
(*Der Firniss- und Kittmacher*, Brünn, 1821, p. 129) observes,
that when the two compounds are employed in coach-varnish-
ing, the copal is the more brilliant for a time only, but that in
the end, and after long exposure to sun and rain, the amber is
far superior. For the purposes which we are now considering,
the difference in the relative durability of the two substances
is unimportant. The tendency of copal to become yellow, and
the darker hue of the amber varnish, are no objections to
painters who are not afraid of depth. The never-failing force
of the early oil pictures is among the proofs that the vehicles
then used were not light in colour. Intensity, either in chiar-

pared less coloured even than that of sandarac. In an historical point of view, in which we profess chiefly to consider these questions, it is, however, more probable that Van Eyck used amber than copal, because, as we have seen, the former substance was certainly employed in Flanders in the fifteenth century, and because it was at hand. The oriental or African copal could, doubtless, have been imported in the North, just as amber found its way, in the remotest times, from the Baltic to the Mediterranean; but there is no documentary evidence to prove that it was used in painting so early. These doubts are of little consequence, as both materials possess nearly the same recommendations; we shall even find that most Italian painters were satisfied with the sandarac varnish. The great point is, that the early painters used resins dissolved in fixed oils, not in essential oils; and it appears that even the weakest of the former class of varnishes—the compound of linseed oil and common resin—was considered adapted to protect surfaces in the open air.*

It was before observed that the early practice of using the red or white varnish, according to the colours over which they were passed, or according to the transparent colours with which they were

oscuro or in local hues, was considered indispensable, and implies a more or less tinted medium.

* Smith, Art of Painting in Oil, 1687, p. 86. Salmon, Polygraphices, l. ii. c. 5.

mixed, may have given Van Eyck the first idea of
assisting the effect of tempera with variously tinted
oleo-resinous lackers—compositions which had been
used for certain ornamental purposes for centuries
before his time.* Whether this was the inter-
mediate step or not is of little importance, a great
improvement gradually arose out of his first ex-
periments. The design being carefully drawn and
shaded, he ground the colours in clarified, but not
thickened oil† (using, we may presume, the lighter
coloured oil with the more delicate tints), and then
adding to each tint a certain quantity of the red or
white varnish, in greater or less proportions, and
also according to the tint.‡ The shadows, darks,
and warm tints generally might be safely fortified
with the amber varnish; but the sky, and certain

* Vol. i. pp. 38, 263, 264, 272. It has been seen (Vol. i.
p. 270) that the early painters were so accustomed to the reddish
hue of the sandarac varnish that other compositions intended to
represent it were sometimes tinged with a red colour. The
following extracts confirm this. In a Venetian MS., dated 1466,
in the possession of Mr. Seymour Kirkup, we read :—" Da
fare la sustantia si pone ī luogo dela V̄nixe liquida, quando
quella nō si trovasse." The ingredients are " oleo de semente
de lino, mastexe, *minio*, incenso " and " pegola biancha." In a
Bolognese MS., also of the fifteenth century, published by Mrs.
Merrifield (*Original Treatises*, p. 489), we find the following
receipt:—" A fare vernice liquida per altro modo. Recipe
libre 1 de olio de seme de lino . . . poi tolli mezo quarto de
alume de rocho spolverizato et altratanto *minio* o *cinabrio*."
The yellow and green varnishes were no less common.

† See Vol. i. pp. 130, 278, the extracts from the Strassburg
MS.　　　　　　　　　　　‡ Ib. p. 279.

colours—such as greens and blues—would, precisely according to the earlier practice of the decorators, require to be mixed with the white varnish. The work executed with such materials was already sufficiently protected; the final varnish, in search of which all the experiments had been undertaken, was now no longer necessary. The materials intended to be used for that purpose had been incorporated, to a sufficient extent, with the colours, and left them glossy, transparent, and firm.*

Meanwhile the tempera picture had been gradually reduced to a carefully shaded drawing, or, at most, to a very light chiaroscuro painting, as, on the other hand, what might be compared to the former ultimate varnishing had become a complicated work, in which opaque as well as transparent colours were used.

As this system had been gradually developed from the previous mode of varnishing, so, however long the process might be, it was a single and final operation. The work was essentially executed at once†, or, as the Italians express it, " alla prima." This system is quite compatible with utmost care and precision. It supposes the design to be perfectly settled, and the drawing to be finished beforehand, and enables the painter to leave his ground (that is, the tint of the priming) when and where he pleases—a power of which the later

* Vol. i. p. 205. † Ib. pp. 393, 394.

Flemish painters took great advantage. A recent example in our own school may here be quoted: Wilkie's celebrated picture of the " Preaching of John Knox," though long in hand, was executed in the sense explained, at once, on the white ground, patches of which were to be seen next finished portions of the work till the whole was completed. This general characteristic of the early Flemish painters (the exceptions and modifications we need not stay to consider) was adhered to and carried to perfection by Rubens, who arrested his design in finished sketches, in order that the picture itself might be executed as much as possible " alla prima." * We shall find, in the course of our investigations, that the Italian, and especially the Venetian practice differed essentially in this respect from the practice of the Flemish school.

To return to the earlier methods. The varnishes that have been described were thick in consistence. Experience taught that the resinous ingredient, on which their compactness and their hydrofuge quality mainly depended, should be as copious as was compatible with the toughness of the composition. Such a consistence in the red varnish, which was freely used with transparent darks, not only insured (at least for a considerable time) an effect of

* Vol. i. pp. 492, 429. Latterly, as is well known, Rubens' sketches were partly intended to enable his scholars to prepare his pictures.

depth by its lucid clearness*—a quality more or less common to all these preparations,—but was further necessary on the principle that in proportion as the pigment has less body the vehicle requires to be substantial. The white varnishes were even thicker, but for other reasons: they were employed with the paler fugitive colours, such as yellow lakes, which, if unprotected, soon disappear ;† with verdigris, which, in order to remain unchanged, requires to be well guarded from damp by a medium which, though abundant, cannot vitiate its tint. ‡ Lastly, they were employed especially with blues, which, consisting chiefly of carbonates of copper, were found to become partially green and otherwise altered in time, if not effectually "locked up." § An Italian writer accordingly intimates that blue requires more gum than any other colour.‖ The "vernice liquida," whether prepared with sandarac or amber, was com-

* Compare the passage from Cicognara before quoted (p. 31.)

† On the superior effect of resinous compounds, as compared with mere oils, in preserving fugitive colours, see the experiments quoted in Vol. i. p. 444.

‡ Ib. pp. 458, 468.

§ The colour called " azurro della Magna " (d' Allemagna) was, with the exception of ultramarine, almost the only blue used by the early painters. See the observations of Petrini, in the Antologia (Firenze), August, 1821.

‖ " Fa bisogno a voler temperar bene i colori d' osservar che l' azurro da campo vuole assai gomma, in discrezione ; il verde . . . a bel modo, ma la biacca ne vuol puochissima."—Birelli, *Opere.* In Fiorenza, 1601, p. 346.

posed, as already stated, of three parts of linseed oil to one of resin; the quantity of oil being necessarily reduced in the preparation by fire. But the white varnish, when composed of fir resin and nut oil, consisted of two parts only of oil to one of resin.* The light varnish of mastic and nut oil was at least as thick, for Armenini directs that the resin should be merely well covered with oil in the vessel in which it was to be dissolved.† The safe proportion, combining toughness, by means of the oil, with the lustre and firmness which the resin imparted, was, in these lighter varnishes especially, sometimes overpassed. Accordingly, in the early oil pictures, the white varnishes have, in most cases, become more extensively cracked than the dark ones, although the latter, from another cause, often exhibit a rougher appearance. The white and red varnishes are easily distinguished in pictures, not only by the colours to which they were respectively appropriated, but by their effects. The cracks of the sandarac varnish or ordinary " vernice liquida," when that compound has been used moderately, are short, and sooner or later become abraded at the edges. When used in quantity, the substance acquires in time, and especially if exposed to the sun's rays, a corroded and

* Boltzen, Illumirbuch, 1566, p. 5. Strassburg MS., quoted Vol. i. p. 278. Fioravanti, *Compendio*, &c., p. 116, gives even three parts of resin to one of oil.

† De' veri Precetti, &c., p. 129.

blistered appearance. The white varnish, on the other hand, has long continuous cracks, and yet retains a smoother surface. The characteristics of the two may be seen together in the portrait of Julius II., ascribed to Raphael, in the National Gallery. The green colour is protected by the usual white varnish, the "vernice liquida" being used elsewhere in the picture. A specimen of the excessive corroded appearance which the latter varnish sometimes presents is to be seen in the shadows of the drapery of the St. Peter in the picture by Annibale Carracci, No. 9 in the same collection. This apparently blistered effect is the never-failing mark of sandarac as distinguished also from the amber varnish, which never exhibits such extreme results; although, like copal, it cracks (if at all) in the same short manner. The long glassy crack distinguishes mastic and fir resin when they are used abundantly.*

* The oil varnishes, which afforded, and which often still afford, such effectual protection to the paintings of the early masters, require to be themselves protected after the lapse of years. For this purpose the essential-oil varnishes (which were first used by the Italians) are quite sufficient. Had these been applied in time, so as merely to exclude the air from the surface of the painting—the action of the sun's rays being always supposed to be guarded against—the cracked and corroded appearances above described might have been arrested.

If, on the one hand, the effects of time may be prevented by these expedients, they may, on the other, be accelerated (for the sake of experiment) by exposing varnished surfaces in the open air. A good copal varnish (somewhat diluted, however,

There were some apparent exceptions to the system above described in the treatment both of lights and darks. All dark shadows, those even of blues and greens, inasmuch as such darks are comparatively colourless, were commonly inserted with the " vernice liquida." When, in the early oil pictures, blues which have retained their colour are not prominent, that is, when they are not protected by a superabundance of (the white) varnish,, it may be inferred that the colour used was ultramarine. Opaque colours of whatever tint, especially if durable, required to be mixed with no more varnish than was requisite to give them a gloss like the rest of the work. Black, for example, was so treated; it was thus distinguished, as a local colour, from mere darkness, and had less transparency than the shadows: moreover, it required no especial protection from the atmosphere, since, as a colour, it is not affected by the ordinary causes of change. On the same principle, and still more obviously, white, as well as all solid, light, permanent colours, required less vehicle: their apparent substance would have become inconveniently prominent (as compared with the ordinary surface

according to the modern system, with spirit of turpentine), after being so exposed for two years, has become minutely cracked like (thin) sandarac, and threatens further decay. With regard to the complicated effects of certain ingredients, such as wax, asphaltum, glass, &c., in varnishes, no attempt will be here made to trace or explain them.

preferred by the early masters) if a varnish, of the consistence above described, had been mixed with them in great quantity: but they do not even require such protection, and on this account also they were applied with less of the fortifying vehicle. In the early oil pictures the most solid painting, on a comparatively large scale, and chiefly produced by the thickness of the pigment, occurs in light skies. Even these contain a proportion of varnish; for it was necessary that a sufficient quantity of it should be mixed with *all* the colours to insure a uniform gloss, and to render a final varnish superfluous, at least for many years. The presence of the oleo-resinous medium even in the opaque colours is to be detected, among other indications, by the prominence of small ornaments and of all details where the touch was unavoidably minute. In such portions, where it was impossible to spread the colour, the substance which it derives from the varnish gives it an embossed appearance.

It is to be remembered that there were no other ingredients in these varnishes than fixed oils, resins, and dryers, such as have been described.* No essential oils entered into their composition. We find that in the seventeenth century the cabinet-makers of Amsterdam introduced spike oil into the

* The ingredients sometimes introduced for absorbing the aqueous particles and for mechanically clarifying the composition, are of course excepted.

"vernice liquida," to render it more drying without impairing its clearness.* There are evidences of a similar practice in Italy at the close of the sixteenth century; but we meet with nothing of the kind in the earliest records of the Flemish method. According to that method, when, in the course of painting, the varnishes or the tints mixed with them were found to be too thick, they were diluted not with an essential oil but with a fixed oil—with the same fluid in which the resin was dissolved.† There may thus, after all, be some truth in Ridolfi's statement that Antonello da Messina was seen to dilute his tints from time to time as he worked, with linseed oil.‡ In the original process, the admixture of essential oils would hardly have been compatible with durability; the strength even of the amber varnish is impaired if the composition be diluted with an evaporable ingredient; the compactness of the substance is thus necessarily diminished, and the result is apparent, in extreme cases, by the dulness of the surface. In the later Italian practice, on the other hand, the colours, often copiously diluted with an essential oil, and mixed only in certain cases with varnish, required to be coated with a protecting varnish as soon as the work was completed. It is

* Vol. i. p. 507, note.

† An indication of this practice will be found in an early Dutch or Flemish MS. quoted Vol. i. p. 286, note.

‡ Le Meraviglie dell' Arte. In Venezia, 1648. Vol. i. p. 49.

unnecessary to decide between the two methods; the choice, in either case, was first dictated by the experience of climate.*

The practice of the early Flemish masters in preparing the ground, and in carefully drawing the design upon it, has been described at length in the preceding volume. It may only be necessary to add, in reference to that subject, that the shading of the design (to be painted upon) was carried so far, with the point, or with a tint in water-colour, that the light ground was in a great measure excluded by it, and, consequently, more excluded in the darks than in the lights of the picture. This was one of the defects of the original Flemish process; it was remedied by subsequent painters, and more especially by Rubens, who was careful to preserve brightness within the transparent shadows, while his solid lights exclude the ground.† The older Flemish painters kept their lights thin, and as the opaque colours had less of the varnish mixed with them, their surface is generally but little raised, while that of the shadows, and of those colours which required much vehicle, projects beyond the surface of the lights.

Various Flemish pictures of the fifteenth century

* Vol. i. p. 434. In Vol. i. p. 313, it is conjectured that the sharpness of execution observable in some works of the early oil painters indicates the admixture of essential oils: the same precision is however quite attainable with fixed oils, even when somewhat thickened by a resinous ingredient.

† Ib. pp. 492, 499.

might be referred to in illustration of the general
practice which has been described, the system
being, of course, more apparent in large works.
The following are among the technical character-
istics which will generally be recognised:—The sur-
face of the flesh tints is seldom prominent; black
is little prominent; rich shadows, and, above all,
greens and blues, are, in a manner, embossed, and,
for the reasons before given, are often more cracked
than the rest of the work. Two pictures by
Mabuse at Hampton Court—No. 509, representing
James IV. of Scotland, with other figures, and No.
510, his Queen—are remarkable examples. On
looking at the mere surface of the first (which may
be best contrived by viewing it from an angle with
the light in which it shines), it will be seen that the
face and the black cap of the principal figure are
quite embedded within the prominent green drapery
round it; the blue is in like manner prominent, and
the shadows, even when small in quantity, are gene-
rally more raised than the lights. This is one of
innumerable examples of the kind, and the observer
who is interested in such particulars may easily
detect the same system in smaller works of the
school: the green drapery, for example, in the Van
Eyck in the National Gallery, is more prominent
and more cracked than any other part of the
picture; the blue, which is less thick than usual,
is probably in this case ultramarine. By such
observation it will also become apparent that the

methods of the Flemish painters were in many respects allied to the habits of preceding ages, and the humble records of the decoration of St. Stephen's Chapel, and of English cathedrals, verified and explained as those records are by later documents, throw no inconsiderable light on the original practice of oil painting.

The leading peculiarities above described are to be traced in the early Italian oil pictures, proving the Flemish origin of the mode in which they were executed; the effects of time on some of these works tend further to show what was the nature and consistence of the varnishes used. In some half-decayed pictures, the darks, where the " vernice liquida " has been copiously employed, are frequently blistered in the mode before described; the greens and blues, in which the white varnish has been freely used, causing their surface to be prominent, are cracked only, but to a great extent; the blacks, the flesh tints, and the sky (though the latter is often painted with considerable body) are cracked least.*

Such appear to have been the vehicles of the early oil painters. Those who are interested in such investigations will perhaps be curious to

* In the practice of oil painting here considered, the tendency to crack is generally in proportion to the quantity or quality of the resinous ingredient employed. Some of the later Flemish painters seem to have used thickened oil only in their rich shadows to obviate the defect.

know whether such materials can now be satis-
factorily prepared. The " vernice liquida," and
the amber varnish, after having become obsolete
in practice, and after their very designations had,
unaccountably enough, become a mystery, have
been lately revived in consequence of these re-
searches; and we are now enabled to verify the
descriptions of the oldest writers on art from actual
observation and experiment. The solution of the
light resins in the fixed oils (forming the " white
varnish ") is easily accomplished: the solution of
sandarac and amber in those oils is, on the other
hand, difficult and dangerous, as the operation, to
be successful, requires to be undertaken on a large
scale. The English varnish-makers, who are sur-
passed by none, were at first reluctant to make
these solutions with so small a quantity in propor-
tion to the " gums," as the old formulæ prescribe,
and without the usual ingredient of an essential
oil, which latter not only thins the composition,
but renders it more drying. It was, however, con-
sidered of importance, with a view to making the
experiment fairly, that the ancient method should
be strictly followed. The employment of a per-
fectly purified linseed oil was by no means a new
condition: the prescribed quantity of oil in pro-
portion to the resin, the use of copperas as a dryer,
and the omission of spirit of turpentine were, by
degrees, attended to. The " vernice liquida " and
the amber varnish have thus been made, resembling

the vehicles which the painters of the fifteenth century used. A copal varnish was prepared in the same way. The "vernice liquida," or sandarac varnish, corresponds in tint with the descriptions of Italian and other writers: the amber varnish is darker, but either may be mixed with good results even with light tints; greens and blues perhaps excepted. De Mayerne observes that the amber varnish used by Gentileschi, though coloured, did not spoil white.*

He might have added, that the first effect of the vehicle, which is slightly to warm the tints with which it is mixed, is permanent, and does not degenerate to what painters call a horny surface. Such effects agree with the result of Sheldrake's experiments; he remarks that "colours mixed with amber, after having been shut up in a drawer for several years, lost nothing of their original brilliancy. The same colours tempered with oils, and excluded from the air, were so much altered that they could scarcely be recognised."† The oil varnishes generally, when well prepared, and with sufficient body, have all more or less this preserving

* Vol. i. p. 304, note. The effect of materials of all kinds may be counteracted by a peculiar taste and practice. Gentileschi was no colourist, and none would imagine, from the coldness of his works, that he was in the habit of using a coloured vehicle. In the general appearance of his pictures we have at least a proof that the amber varnish does not necessarily produce either a "foxy" colouring or a horny surface.

† Transactions of the Society of Arts, before quoted, (p. 36.)

quality: the different effects of such vehicles, as
compared with those of the common drying oils
(which some of them certainly resemble in colour),
seem to be that the thick consistence of the former,
in consequence of the resinous ingredient, when
once dry, tends to fix the particles so that they
undergo no further change; whereas the ordinary
thin oils long continue to rise to the surface.

The colours with which these varnishes are, in
greater or less proportions, incorporated, should be
first well ground in the oils before described, using
the clarified drying oil when necessary ; but, in
order to reduce the quantity of the oil before
adding the varnish, it is advisable to place the
colour on compact blotting-paper, or on a smooth
piece of plaster-cast; the superfluous oil is thus
absorbed, and the varnish may then be mixed with
the tint in the proportions required. The colours
may occasionally be ground at once in the varnish,
but the thickness of the medium renders the opera-
tion troublesome.

It is not pretended that there is much of novelty
in these materials. All who are acquainted with
the nature of an oil varnish can judge of the pro-
perties of the more substantial compounds above
described, and will also be aware of the incon-
veniences attending their use. To those less fa-
miliar with preparations of the kind it may be
necessary to remark that such materials are adapted
to a particular practice, and that they were em-

ployed by the early painters in final operations
only. Their effect is to produce a glossy surface,
which, as painters well know, is ill calculated for a
second operation. Yet certain effects in Rem-
brandt's works were probably the result of skilfully-
repeated applications of such thick and transparent
vehicles on a surface not too smooth.

All oil varnishes have a tendency to flow. In
marking forms with the brush in transparent darks
laid in with a copious admixture of amber, san-
darac, or copal varnish, it is found that such forms
soon become indistinct, and flow more or less into
a mass. The defect is best remedied by inserting
or repeating the markings when the surface begins
to dry; they then keep their due sharpness. The
tendency to flow is more easily counteracted in the
lights where the substance of the pigment tends to
arrest and fix the vehicle; indeed, the sharpest pen-
cilling remains distinct after a very short time if
the colour be used in sufficient body. It has been
seen that the early oil painters applied their lights
thinly, and in this case the colours would of them-
selves for a longer time easily flow and blend
together. This may account for the general ab-
sence of "hatching" (or working with lines, as in
a drawing) which is characteristic of the older
Flemish masters even in small works. It is not
so generally avoided in early Italian oil pictures—
a circumstance which will be considered as we
proceed. What would now be considered an

inconvenience must have been looked upon as an advantage by painters who were accustomed to tempera, in which, according to Vasari *, hatching with the point of the brush was the ordinary mode of finishing. The extreme facility of blending the mere substance of the pigments, even when thin, in the new method, appears to be alluded to by the same writer when, in describing the Flemish vehicle, he says, " what appeared to him most admirable was that the varnish had the effect of blending the colours," &c. †

The tendency to flow which is peculiar to oil varnishes (and which, after all, is an evidence of their homogeneous consistence) cannot be conveniently corrected by ground glass—a material which was used with certain colours by the Italians—for that ingredient, when finely pulverised, is equivalent to a white pigment, and would altogether destroy the transparency of the darks, for which the vehicle is chiefly required. The immixture of wax answers better, but this ingredient has the effect of rendering the varnish comparatively dull, and, to say nothing of the consequent necessity of a final varnish, diminishes to a certain extent, perhaps permanently, the lucid depths of the shadows. In order to correct the inconvenience adverted to, it is advisable to use

* Vita di Antonello da Messina. Also Vita di Andrea Mantegna, vol. i. p. 401 ; Vita di Niccolo Soggi, vol. ii. p. 754.
† Ib.

the pigment itself in due quantity in proportion to the varnish: the tendency is arrested by incipient desiccation, and the glassy smoothness of the surface which would be the result of leaving the work to itself may be prevented, without impairing its gloss.* As one of Van Eyck's principal improvements was the drying property of his varnish, this remedy must have been everywhere rendered effectual according to the exigencies of climate: accordingly we find that the oil varnishes used in Italy were employed partly to assist the drying of the dark colours.†

The defect above pointed out was certainly corrected by the Italian painters: it is very rare that the *drop*, indicating the tendency to *flow*, is to be detected in their works. In a picture of St. Paul

* It appears from the directions of Cennini (*Trattato*, c. 155), and also from the Romaic MS. (Didron et Durand, *Manuel d'Iconographie chrétienne*, Paris, 1845, p. 42), that the tempera painters were in the habit of laying their pictures flat when they applied the " vernice liquida." This certainly prevents the varnish from flowing down, but the surface becomes like glass—an appearance which, however desirable in a final varnish, is not so agreeable in glazings. It may be obviated after such an operation in two modes: either by exposing the picture in a horizontal position to the sun, or, more certainly and infallibly, by passing an essential oil over the smooth surface: this has the effect of *shrivelling* the oleo-resinous coat. (See Vol. i. p. 37.) This appearance in a varnish is a defect, but the artifice may have been resorted to by painters with a view to certain effects in glazing: the result in pictures will be again noticed hereafter.

† Vol. i. p. 304. Armenini, De' veri Precetti, pp. 124, 129.

by Perugino (No. 1355 in the Gallery of the
Louvre) it is slightly apparent where the green
drapery meets the red, and on the under side of
the right arm. Some indications of the kind are
also to be seen in portions of the blue drapery in
Raphael's " Belle Jardinière" (No. 1185 in the same
collection). On the other hand, in pictures where
the shadows are painted with much vehicle, the
marks of the brush are sometimes visible in the
transparent mass.

It is only possible, we repeat, to leave such
traces in an oil varnish, however thick (if un-
mixed with wax), when the surface is nearly dry.
Whether the older painters had any other special
means of arresting the flow of the colour in the
cases referred to may be a question: the advantage
of *meguilp* in this respect will always render it a
favourite vehicle, notwithstanding its defects; but
there is no evidence whatever that the old masters
used it.*

Whatever limitations may have been observed
in the immixture, with certain colours, of what was

* The most remarkable instance of the copious use of me-
guilp, with which the author is acquainted, is Wilkie's picture
of the "Preaching of John Knox." The effect of the ordinary
mastic varnish on pictures so painted is well known ; see
Cunningham's *Life of Sir David Wilkie,* 1834, vol. iii.
p. 298. A middle course between the old and the modern
practice, which artists might now adopt, would be, after using
meguilp freely, to secure it, in finishing the picture, with an oil
varnish.

called the red varnish, that varnish was by no
means excluded from the flesh tints; on the con-
trary, the early painters evidently considered that
the glow which it could impart to such tints was
not among the least of its recommendations: its
presence in any colour to which its tint is not
directly opposed may, in fact, be said to be equiva-
lent to sunshine. This, again, may explain an
expression in Vasari's description of the Flemish
method—a description which, though apparently
misunderstood by that writer himself, must have
been furnished by a good authority—when he says
that the varnish which Van Eyck mixed with the
tints not only gave them a firm consistence, but
" kindled the colour to such a degree that it had a
lustre of its own without the addition of 'vernice.' "*
Armenini, after recommending that a little " ver-
nice comune " should be mixed with a light reddish
ground-tint which he proposes, says that the in-
gredient gives the tint " a certain flame-coloured
appearance." †

* Vita di Antonello da Messina.

† De' veri Precetti, p. 125. When Armenini, shortly be-
fore, directs that verdigris should be fortified with " vernice
comune," we are to understand the substance properly so called
in his time—a compound of linseed oil and common resin.
This varnish was evidently a mellow golden colour, otherwise
it could scarcely give to the light reddish ground " a flame-
coloured appearance ;" such a tint would by no means render it
unfit for greens. For the blues, however, Armenini prescribes
the whiter varnish of mastic and clear nut oil. Ib. p. 129.

If, as we have had reason to conclude, Van Eyck used a durable varnish with his flesh tints, this may account for a greater apparent thickness in such portions of his work than perhaps they really possess. It is seldom possible to see the outline under his lights—a circumstance which may be explained by the fact that the amber varnish preserves the surface from the effects of the atmosphere far more effectually than any other vehicle. Cennini calls " vernice liquida " the firmest of vehicles*, and this would be more literally true if he had intended to speak of the amber varnish (" vernice liquida gentile "). The apparent solidity of the lights in Van Eyck's pictures appears to be referable to the power of this last medium. Experience has long shown that white lead, when not sufficiently protected, has a tendency to become semi-transparent. If painted even thickly over darks, such darks will, after a time—sometimes after a few months only—become visible through it, giving the once white external colour a grey hue. The experiment may be easily made by painting over a chess-board uniformly with white: at first nothing is visible through the pigment, but sooner or later the black squares will reappear, showing, in the superior brilliancy of the colour occupying the white squares, the advantage of a light ground. Such experiments exemplify the changes that take

* Trattato, c. 161.

place in pictures when lights are painted with insufficient body over darks, as in making corrections known by the name of " pentimenti." In the usual language of painters, the darks are said to " come up," or, as the French express it, " pousser." There may be cases where such effects really take place*, but the usual cause is that above noticed— the tendency of the white lead to become transparent.

When, therefore, white and the tints which partake of it are not applied in great body, more especially when there is a ground at all darker underneath them, such tints are more likely to retain their solidity when duly protected by a resinous medium. As an example of another practice, the St. Catherine by Raphael, in the National Gallery, may be referred to. On examining the neck of that figure the lines of the first drawing on the white ground will be easily perceived. It is not to be supposed that the flesh tint was originally painted so thin as not to exclude those lines, it is far more probable that it has gradually become transparent in consequence of being painted with a vehicle not sufficiently binding.

The material or mechanical advantages of Van Eyck's medium as described by Vasari †—the drying property of the varnish, its perfectly hydrofuge surface, the firm consistence which its immixture

* Vol. i. p. 447, note.　　† Vita di Antonello da Messina.

with the pigments insured, its effect in kindling the colours, its permanent lustre, its tendency to promote the fusion of the tints—are all applicable to the amber varnish, and, in various degrees, to the oil-varnishes generally when duly prepared; but, in most of the above respects, to no medium without either a resinous ingredient or a resinous principle. The vehicle was the vehicle of a colourist, and in the hands of the Flemish artist and his best followers it produced warmth, force, and transparency. The chief peculiarity of the method which it involved was that the picture, properly so called, required to be executed " alla prima;" the colours which needed no varnish at last were themselves equivalent to a varnish; and the painting, however gradually and exquisitely wrought, was only a final process applied to a carefully finished design, prepared like a drawing, or, when dead coloured, in little more than chiaroscuro.*

Making every allowance for the facilities which Van Eyck's system afforded to painters even moderately gifted as colourists, it would be absurd to suppose that all were qualified to take advantage of that system. Of the painters who first adopted the method, many saw in it only the recommendation of durability, or a novelty which had attracted the attention of the rich. Antonello da Messina, though constant to the method, himself compre-

* Vol. i. pp. 380, 381, 395.

hended but little of its power; and the allusion, in his epitaph, to the "splendour as well as durability" which he had been the means of imparting to Italian painting, rather points him out as the cause than the example of the excellence which followed.

We now resume the history of the method, and of the modifications which it underwent in Italy.

Resistance to humidity was the original recommendation of oil painting in its rudest form, and dictated its applications.* The method, both in its early state and with the improvements which Van Eyck had introduced, was employed in Italy, from first to last, and at first exclusively, for standards carried in religious processions in the open air; for canopies (*baldacchini*), also so used; for caparisons (*barde*) of horses; and for similar purposes.† For a long period after the new pro-

* A receipt for protecting (tempera) painting with thickened oil "ut aqua deleri non possit," occurs in a MS. of the 12th century. See Vol. i. p. 19.

† The instances in Vasari are numerous. See the Lives of Luca Signorelli, Domenico Pecori, Girolamo Genga, &c. It was reserved for the biographer to assert that oil pictures are spared by the lightning. At a time when amber (elektron) entered into the materials of painting, he might have carried his theory farther. The following passage occurs in his Life of Raffaellino del Garbo : "una saetta cascò vicino a questa tavola, la quale per essere lavorato a olio, non offese niente, ma dove ella passò accanto all' ornamento messo d' oro, lo consumò quel vapore, lasciando il semplice bolo senza oro. Mi è parso scrivere questo a proposito del dipignere a olio,

cess was known, the higher aims of art found their expression chiefly in tempera—a method which, however defective in some respects, was at least not open to objection, south of the Alps, on account of its liability to decay. In Flanders, on the contrary, tempera was soon acted on by damp; * and hence oil painting, for fine works of art as well as for common purposes, was there the result of necessity. These different conditions of climate explain both the earlier demand for oil painting in the North, and the long indifference of the Italians even to the improved method of Van Eyck, when it was proposed to apply it to purposes for which it was not absolutely necessary.

It might, at that time, be concluded that a method of painting which was proof against external damp would be best adapted for walls; at all events, it was at once resolved to try it in that mode. There were sufficient grounds, as we have seen, for not, at first, employing it for movable pictures on wood; it must have appeared injudicious, in the state of opinion at the time, to attempt to introduce it for such purposes: the customary method adopted for altar-pieces—that of tempera—was not only found to be sufficiently durable, but was perhaps better fitted for the partial

acciò si veda quanto importi sapere difendersi da simile ingiuria; e non solo a questa opera l' ha fatto, ma a molte altre."

* Vol. i. p. 550.

gilding sometimes added to such works. The decay of paintings on walls was, on the other hand, much more common[*], and hence any method which promised a greater durability on such surfaces would, it might be presumed, be welcomed at once. There were reasons—then not suspected, and indeed, as will hereafter appear, not rightly understood even by the later Italians—why oil paintings on solid walls could not preserve the brilliancy of their tints for any length of time, though the works themselves might last for ages; but if this had been noticed in examples of the coarse oil painting before practised, it might still be supposed that the new method would be free from such defects.

Among the different methods employed by the Flemish painters in beginning their works on panel, and which have already been described at length, the most usual was that corresponding with the process recommended by Cennini in commencing wall paintings in oil. The design being carefully completed on the ground, a coat of size (and afterwards, generally, a thin warm tint in oil which did not conceal the outline) was passed over it.[†] Another mode was to apply an oil priming first, and to draw in the subject upon it.[‡]

The opinion of Leon Battista Alberti respecting

[*] Vasari, Vita di Simone e Lippo Memmi; Vita di Tommaso detto Il Giottino; Vita di Antonio Veneziano, &c.

[†] Vol. i. pp. 384, 386. [‡] Ib. p. 390.

oil painting on walls may have been recorded about this time; he died in 1472. His words are :—" There is a new invention, in which all kinds of colours applied with linseed oil are proof against all effects of the atmosphere; provided the wall on which they are spread be dry and perfectly free from moisture [within]." * This notice, imperfect as it is, of a then recently practised method (for Alberti cannot allude to the common oil painting which had been in use for centuries) is important.

Another contemporary writer already quoted— Antonio Filarete, sculptor and architect—gives a more detailed account of the new method. His manuscript treatise was completed, as we have had reason to conclude, in 1464.

After briefly noticing the process of fresco and the mode of rounding forms by light and shade, he thus proceeds:—" And you are to follow the same system in tempera; in oil, also, all these colours may be applied, but this is a different labour and a different process—a process which is certainly beautiful in the hands of those who dare to practise it. In Germany they work well in this method: Maestro Giovanni [Van Eyck] of Bruges especially [excelled in it], and Maestro Ruggieri;

* " Novum inventum oleo linaceo colores quos velis inducere contra omnes aëris et cœli injurias eternos: modo siccus et minime uliginosus sit paries ubi inducantur."—Leonis Baptistæ Alberti Florentini, *Libri de re ædificatoria decem.*—Parrhisiis, 1512, l. b. c. 9.

(Rogier van der Weyde) both of whom employed these colours admirably. *Q.* Tell me in what mode painters work with this oil, and what oil they use: if that of linseed, is it not very dark for the purpose? *A.* Yes; but the dark colour may be removed. I am not acquainted with the mode, unless it be to place the oil in a vase, and suffer it to remain undisturbed a long time; it thus becomes lighter in tint: some, indeed, say there is a quicker mode. *Q.* Let that pass; what is the mode of working? *A.* The gesso with which your panel is prepared, or the mortar (if you work on a wall) being dry, you give a coat of colour ground in oil. White answers for this purpose, and if any other tint [be mixed with it] it is of no importance what colour is used. This ground being prepared, draw your design upon it with very fine lines and in the manner which I before described, and then paint the sky upon it.* Then, with white, paint everything which you have to represent with a sort of shade of white, whether you have to represent figures, buildings, animals, or trees, whatever you have to execute, express its form with this white. It should be well ground (indeed all colours should be well ground; and every time let them dry well, in order that each [layer] may incorporate well with the other).

* The painting of the sky, apparently in its own colour, while the rest was to be prepared in chiaroscuro, reminds us of the unfinished Van Eyck—the St. Barbara—in the museum at Antwerp. Vol. i. p. 414.

And thus, having with this white defined all the
forms for what is to come upon them, prepare the
shadows with the tint you prefer, and then when
all is dry give a thin coat of the colour which is to
clothe the preparation, and round the forms more
completely, heightening with white or with any
other tint that will harmonise with that which you
have given to the object ; and thus you will
treat all the objects which you wish to represent.
And on walls also you must proceed in this same
manner." *

* " . . . et cosi sea afare a tempa et anche aoglio sipossono
mettere tutti questi colori ma questa e altra fatica et altro
modo il quale e bello chi losa fare. Nellamagna silavora bene
inquesta forma maxime dacquello maestro giovanni dabruggia
et Maestro Ruggieri iquali anno adopato optimamente questi
colori aolio. dimi inche modo silavora con questo olio e che
olio e questo olio sie diseme dilino none egli molto obscuro. si
maseglitoglie ilmodo nonso senon mettilo intro una amoretta
et lasciarvelo stare uno buono tempo eglisischiarisce vero e
che dice chece elmodo affare piu presto. lasciamo andare il
lavorare come sifa. prima sulatua tavola ingessata overamente
imuro che sia lacalcina vuole essere seccha et poi una mano
di colore macinato aolio sella biaccha e buona et anche fosse
altro colore non monta niente che colore sisia et fatto questo
disegnia il tuo piano colinie sottilissime e conquelmodo chedi-
nanzi tidissi poi fa laere insuquesto poi colbianco dituttо quello
che vuoi fare da come dire una ombra dibianco cioe che tu o
figure ocasamenti o animali o arbori o qualche cosa chetu abbi
afare da laforma con questa biaccha et chesia bene macinata
et cosi tutti glialtri colori sieno bene macinati et ogni volta
glilascia ben secchare pche sincorpori bene luno collaltro et
cosi data questa mano dibiaccha alle forme di tutto quello
chevuoi fare suvi et tu conquegli colori conche tu vuoi fare

There can be little doubt that this account was derived from a personal examination of the first oil paintings executed by Italians, according to the improved method, in Florence. The passage occurs in book xxiv. (consequently very near the end) of the Magliabechian copy of the MS., and is not in the Palatine copy. The completion of the former in the autumn of 1464 appears to be a sufficient ground for fixing the date of the memorandum in that year.

The only other hypothesis at all admissible is, that Filarete, who had been employed as an architect at Milan, may there have become acquainted with Antonello da Messina, and may have obtained some imperfect information from him. This, however, is not very probable, as the writer (as we have seen, p. 23) omits to mention that painter in a list of the worthies of his day who were known to him. At all events, this is the earliest Italian description of oil painting which can be supposed to have any reference to Van Eyck's method.

l' ombra * poi conuna mano sotile di quello colore che tu lai avestire dagliene una coperta sottile quando latua ombra e seccha et tu poi lameni rilevando colbianco o conaltro colore chesiconfaccia conquello che dato ai alla tua figura et cosi farai atutte letue cose chedipingere insuquesto vuoi et anche insulmuro acquesto medesimo modo bisognia fare."

* In order to give a passable construction to this passage, it is necessary either to read "fane" or "farai" for "fare," or, without altering anything, to consider "ombra" as the imperative of *ombrare*: "l' ombra" for *ombralo*.

The reason, in this instance, for *painting* as well as *drawing* the chiaroscuro design has been already explained. Such an under-painting (representing the finished and shaded drawing then commonly preferred on panels) required to be executed with a thin vehicle, and, if possible, without gloss, the more fitly to receive the oil varnishes with which the colours, properly so called, were applied.

Filarete was evidently ignorant of the nature of the vehicles employed in the final process; but the information which he wanted is supplied in a description of wall painting which is given by Vasari, and repeated by Borghini. The former says:— "When it is proposed to paint in oil on the dry wall, two modes [of preparing the wall may be adopted]. One is as follows:—If the wall has been whitened, either in fresco or in any other mode, it is scraped; or if, being covered with mortar only, it have a smooth surface, boiled oil is passed over it two or three times, or till it will absorb no more. When this is dry, a priming should be spread over the surface, as explained in the preceding chapter. This being dry, the design may be either traced or drawn upon it; after which the work may be completed as in painting on wood, always using a little 'vernice' mixed with the tints, because by this means there is no necessity for varnishing the work at last." *

* "Quando gli artefici vogliono lavorare a olio in sul muro secco, due maniere possono tenere : una con fare che il muro,

The description of the other mode of preparing the wall is here unimportant.

Borghini's directions are nearly the same. He merely observes, as Vasari does elsewhere, that the colours had better be ground in nut oil, as it yellows less than that of linseed. He then directs that a little "vernice" should be mixed with the tints.*

Thus, in and after the middle of the sixteenth century (the date of the two writers last quoted), the Flemish process survived at Florence in the application of oil painting to peculiar purposes only. Had those writers left no details of the method of painting on wood or on cloth, it might be inferred from the passages cited that the oil varnish was also commonly employed in works of that kind; but, in descriptions of such applications of oil painting, they say nothing whatever of mix-

se vi è dato su il bianco o a fresco o in altro modo, si raschi, o, se egli è restato liscio senza bianco ma intonacato, vi si dia su due o tre mani di olio bollito e cotto, continuando a ridarvelo su, sino a tanto che non voglia più bere ; e poi secco, se gli da di mestica o imprimitura, come si disse nel capitolo avanti a questo. Ciò fatto e secco, possono gli artefici calcare o disegnare, e tale opera come la tavola condurre al fine, tenendo mescolato continuo nei colori un poco di vernice, perchè facendo questo non accade poi verniciarla."— *Introduzione*, c. xxii.

* "Dando i colori, temperato con olio di noce o di linseme (ma meglio fia di noce, perchè è più sottile, e non ingialla i colori, ne' quali fia bene mescolare un poco di vernice), conducerte con diligenza a fine l' opera vostra, laquale non accaderà verniciarla."—*Il Reposo*, Milano, 1807, vol. i. p. 202. The first edition is dated 1584.

ing varnish with the colours.* It appears, there-
fore, that the Florentine contemporaries of Vasari,
looking merely at the quality of durability, had by
degrees considered such a use of varnish to be un-
necessary, except when, as in the case specified,
the work was exposed to damp. In this gradual
restriction, in Florence, of the Flemish method
(when employed on the higher objects of art) to
wall painting, we recognise a proof of the general
fitness of that method for a severer climate. Under
circumstances which, in certain seasons, approxi-
mated to the conditions of a northern atmosphere,
the art of the North was retained without change.
It is only remarkable that the origin and intention
of its technical peculiarities were so far lost sight
of at the period referred to, that Vasari explains
the admixture of varnish with the colours merely
by observing that it rendered a final varnish un-
necessary. Meanwhile, the advantages of the pro-
cess in a higher sense—the richness of shadows
and low tones, the general glow which it could
impart, and the force which it at once compelled
and assisted—were in danger of being forgotten.

Though accepted at first by few, the art began
with a fairer promise. The original method ap-
pears to have been implicitly followed in Florence

* Borghini expressly prohibits any vehicles in addition to
nut oil :—" Chi volesse dipingere a olio in tavola . . . colorisca
co' colori temperati con olio di noce, senza più."—*Il Reposo*,
vol. i. p. 203.

and the neighbouring schools for a considerable time by several painters. The first whom we have to notice is Antonio Pollaiuolo; of his surviving works the picture which most invites attention is the celebrated St. Sebastian, of which we have spoken (p. 18). This early specimen of Florentine oil painting is still in excellent preservation. Its surface has, at some not very recent period, been indented but scarcely perforated, by what appear to be small shot-marks. These, with the usual warping of the planks of which the " tavola " is composed, and a few scratches, are the only injuries. The minute pits or bruises have here and there been filled up, but the picture exhibits little appearance of repainting.

It is quite evident that this work was painted at once on a warm light ground. There was no solid chiaroscuro preparation, and there is no indication of a dead colour. With the exception of a slight change in an outline, no part appears to have been retouched. There is no appearance of "hatching;" the generally thin substance of the pigments is blended, the tints fused. Certain portions are, however, painted with great precision, as, for example, the wrinkles on the older figures, and even the grain of the skin on the back of one of their hands. The darks are, almost without exception, more prominent than the lights, and, from the effects of time, are now rough and blistered. Even the dark trees in the distant landscape are all, as it were,

embossed, in consequence of being painted with a
thick medium. The lights have remained smooth,
and free from cracks; the minuter lights only are
raised; the minute darks have the same appear-
ance; the drops of blood, for instance, on the
martyr have the relief of real drops.

The " Virtues " by Pollaiuolo, before mentioned
(p. 17), are inferior specimens of the master, but
they have the same general characteristics. The
darks are prominent and are now corroded. The
flesh is thinly painted : this last peculiarity is almost
universal in the early Italian as in the early Flemish
pictures, and indicates the careful completion of
such portions, at once, on the light ground. Light
skies are often more loaded; in them the thicker
" vernice chiara " was commonly used, which in-
creased their apparent body; they appear, however,
to have been really painted with more substance
to insure their luminous effect, and this must have
been more necessary when the ground was tinted.
In the flesh, on the contrary, the tint which was
sometimes used for the ground was calculated to
assist the colour *, while the warmer and somewhat
thinner varnish was used. In the two pictures
by Pollaiuolo representing the " Acts of Hercules,"
the flesh is as usual thin, while the light sky and.
all the darks are raised.

The examples that have been adduced are suf-
ficient to show that the earliest specimens of oil

* Vol. i. p. 393.

painting produced in Florence were executed strictly according to the Flemish process, and, if not in every case with the same vehicle, with a nearly equivalent one, employed partly from choice and certainly on the same principles. Those principles contained the germ of the best practice: the thin painting of the flesh may be reckoned among the defects; but even this habit was partly a consequence of looking upon such portions of the work as belonging to the class of low tones, and requiring, like all such tones, to be more or less transparent. The defect was sooner remedied in Italy than in the North: there, we seldom find the lighter flesh-tints solidly painted till the age of Rubens and Rembrandt. Another occasional defect, before adverted to, common to the early Flemish masters and their Italian followers, was that of shading the preparatory drawing to the exclusion of the light ground where it was wanted most: but this is a question of degree; a shade tint which is sufficient to indicate the chiaroscuro of a work, before the actual painting is begun, may still be light enough to give value to the transparent shadows afterwards inserted.* In other

* Internal light in the obscurer portions of a picture, by whatever means that transparency is obtained or represented, is indispensable to richness of effect. Without it, force degenerates to blackness, and darkness is no longer equivalent to depth. Vasari justly remarks that no ultimate varnish could give depth to the black shadows of Giulio Romano :—" Questo nero fa perdere e smarrire la maggior parte delle fatiche che

respects Antonio Pollaiuolo followed with advantage the Flemish system, and transmitted it unimpaired to the great artists who succeeded him.

One great peculiarity of the system, and of which he felt the value, was the abundant use of the thick yet lucid vehicle in the darks: while these retained their surface and gloss they must have given to his works a richness then new in the art.* The appearances of this kind above noticed in his works now enable us to pronounce that an oil varnish of the ordinary kind (sandarac and linseed oil, called

vi sono dentro, conciossiachè il nero, ancorchè sia verniciato, fa perdere il buono," &c.— *Vita di Giulio Romano.*

* The early oil painters saw in the method the qualities opposed to tempera; when portions executed in oil had been introduced in tempera pictures (ornaments, gems, &c.), the quality aimed at and attained in those portions was that of depth—depth, in the positive and real sense of seeing colour or light in and through a lustrous, transparent, but thick substance, for the oils and varnishes then used had an almost honey-like body. This actual representation of depth (as distinguished from the imitation of atmosphere, distance, and roundness) is the essential and original characteristic of oil painting. By later masters it was applied to assist the expression of space, as in shadow, but it was also used to give the charm of depth to all colours, to flesh, and even to stone and to wood. Among the masters who felt this most, so as sometimes to carry it to excess, may be named Correggio, Rembrandt, and Reynolds (the latter here named with reference solely to this quality, and irrespective of any merits or defects of other kinds). The " Annunciation " by Pollaiuolo at Berlin, with all its defects, has the richness and depth of the most consummate oil painters : not from the expression of distance and space, for in this perhaps it fails, but from the mechanical real effect of a transparent vehicle used over light with all the colours.

"vernice liquida") was used probably in all the colours except the sky, but especially in the darks. Had the firmer amber varnish been employed, the surface of the raised shadows would not have been affected in the mode described; or at least not to that extent. The known durability even of the "vernice liquida" appears to have given it an almost equal reputation in the eyes of the Italians, and a Florentine had pronounced it to be "the strongest vehicle there is." For works not likely to be exposed to any extraordinary trials—such trials as being kept at all seasons and for ages within churches—this sandarac oil varnish (greatly to be recommended for its tint and lustre) may be considered an all-sufficient vehicle; but as regards the question of actual durability, there is no doubt that the amber varnish is unsurpassed. With regard to the estimation in which its rival was held in Italy it must be remembered that while used only as a varnish for tempera pictures it was not applied in much body; and when, as must have happened in the lapse of time or from unusual exposure to the vicissitudes of heat and cold, the oleo-resinous coating cracked, such a result produced no serious change in the effect of the work, which, in extreme cases, could be cleaned and then varnished afresh.* In the course of our investigations we shall, however, have abundant proof,

* Didron et Durand, Manuel, &c., p. 43. The words translated "eau forte" are explained (Introduction, p. xxxiv.) to mean the "eau seconde de potasse."

from the decay that has taken place in the rich shadows of excellent pictures, that the Italians placed too much confidence in this favourite vehicle: the lavish use of a semi-resinous medium where, certainly, it was most required—in the transparent darks, and, in another form, to protect certain colours—was ill calculated to resist the Italian summer atmosphere, still less the occasional action of the sun's rays.* The question of the influence of climate on the technical peculiarities of the arts would lead to deeper inquiries than we can here indulge in; thus much, however, may be confidently affirmed, that the richness of texture

* Such effects of the sun's rays are not confined to Italy; the fine picture of Rubens with his wife and child at Blenheim is remarkable for the quantity of vehicle with which the mass of shade in the drapery is painted. This portion is now *riddled* with cracks, in consequence of the picture having been formerly in a situation where it was partially exposed to the sun.

The influence of heat on resinous compounds is too often exemplified in church pictures by the effect of the altar candles on portions of the work that have been nearest to them. The lower portion of Titian's picture of the Assumption, formerly in the Frari at Venice, was seriously injured in the centre from this cause, and the figure seated on the sarcophagus required to be in a great measure repainted in consequence. Richardson (*Works*, vol. ii. p. 34) says that Raphael's St. Cecilia was "fried" in the parts nearest to the candles. Vasari informs us that the doors painted by Liberale Veronese to protect an early picture of the Madonna in S. Maria della Scala, at Verona, were injured from the same cause, and the triptych was placed in the sacristy for safety. Lastly, a work by Granacci was burnt by the candles inadvertently left on an altar.—*Vita di Fra Giocondo; Vita di Francesco Granacci.*

which, as a result of firm yet transparent vehicles, a Rembrandt could produce with safety, and even, in a material sense, with advantage, in the climate of the Netherlands, often led to premature decay in the works of some of the best Italian colourists. Undoubtedly, the evil might have been arrested by ordinary care on the part of those to whom the conservation of such works was entrusted; and as this is, or should be, an easy condition, we conclude that the later Italian painters had no just ground, in the experience of their climate and its effects, for abandoning the technical characteristics of the Flemish method. Such objectors, nevertheless, there were: not only was oil painting denuded of its best attributes by those later Florentines who suggested or adopted the precepts of Borghini, but examples were not wanting of painters who altogether condemned and abandoned the method. At a period in the sixteenth century, when the finest examples of oil painting had been produced, Domenico Beccafumi returned to tempera, from a persuasion that the more modern process was not durable.*

* " E perchè aveva Domenico opinione che le cose colorite a tempera si mantenessero meglio chè quelle colorite a olio, dicendo che gli pareva, che più fussero invecchiate le cose di Luca da Cortona, de' Pollaiuolo, e degli altri maestri che in quel tempo lavorarono a olio, che quelle di Fra Filippo, di Benozzo, e degli altri che colorirono a tempera innanzi a questi, per questo, dico, si risolvè, avendo a fare una tavola per la compagnia di S. Bernardino in su la piazza di S. Francesco, di farla a tempera."—Vasari, *Vita di Domenico Beccafumi.*

CHAP. III.

LORENZO DI CREDI—LEONARDO DA VINCI—PIETRO PERUGINO— FRANCESCO FRANCIA.

THE works of Antonio Pollaiuolo, considered as oil paintings, and independently of their merit in design, were far from exciting universal admiration among the artists of Florence, or of the neighbouring schools, but there were some of the then rising generation who looked at these works with deeper interest, and who were at once attracted by the new method.

About the year 1475, when the St. Sebastian by Pollaiuolo was completed, three young men, afterwards celebrated, were studying with Andrea Verocchio. These were Pietro Perugino (born about 1446)*, Leonardo da Vinci (born 1452), and

* Vasari's statement that Perugino studied for a time with Verocchio has been doubted by some modern historians, partly on account of the very little resemblance to be traced between the style and aim of the two artists; but the authority of an interesting contemporary writer—Giovanni Sanzio, the father of Raphael—may be considered a corroboration of Vasari's assertion. In a poem on the Acts of Federigo da Montefeltro,

Lorenzo di Credi (born 1453). The first-named was then twenty-nine years of age; Leonardo da Vinci was twenty-three, and Lorenzo di Credi was a year younger than Leonardo. Their instructor, Andrea Verocchio, was a sculptor, who handled the brush only occasionally, and not even very successfully; in other respects, and especially as a designer, his influence on the subsequent direction of the Florentine school was both marked and beneficial. His well-studied contours for a battle, in which the combatants were naked, probably suggested the idea of the celebrated cartoon by Michael Angelo of the " Bathing Soldiers " suddenly called to the field. Verocchio is said to have been one of the first who took casts from nature, and the practice indicates a desire to master the difficulties of modelling. He was, in short, well qualified to teach the knowledge of form and anatomy—studies no less essential to a painter than to those of his own profession. To all appearance the first ardent admirers and successful cultivators of the new art of oil painting were thus, at the time when their predilections were manifested, qualifying themselves to be skilful designers; but their subsequent practice does not altogether confirm this. Of the three

which is preserved in the Vatican Library, Giovanni alludes to the friendship between Leonardo da Vinci and Perugino when young men, and, as we may conclude, fellow-students in Florence :—" Due giovin par d' etate e par d' amori, Leonardo da Vinci e 'l Perusino, Pier della Pieve, che son divin pittori."

painters above named, Leonardo was the only one who, partly by Verocchio's instructions and example, had acquired a thorough knowledge of the human figure and great skill in modelling. If he equalled his teacher in these respects, he soon surpassed him as a painter. An altar-piece in which, while yet a youth, he assisted Verocchio, is preserved in the gallery of the Academy at Florence, and it is related that the figure of an attendant angel, added by the scholar, was considered so superior to the rest of the work, that Andrea, in his mortification, determined to abandon the pencil for ever.

It is, indeed, on many grounds probable that whatever Perugino and Lorenzo di Credi learnt of painting while they were in the school of Verocchio was chiefly derived from Leonardo. As regards Lorenzo especially, this is confirmed by the character of his works. At an early period he copied a picture by Leonardo so closely that the original could not be distinguished; the predilection was lasting, and his style, from first to last, was formed on that of his fellow-student. The friendship of Leonardo and Perugino during their youth has been already adverted to (see note, p. 78), but the elder artist seems to have borrowed little from Leonardo except a more refined taste in expression. The secret of the intimacy is however sufficiently explained by their common study of oil painting at a time when that method had been adopted by few.

Lorenzo di Credi's style and practice, in imitation of Leonardo, must have been formed previous to 1480, about which time Leonardo quitted Florence for Milan, where he remained till near the close of the century. The eight or ten years immediately preceding 1480, therefore, define the period when the Flemish method of oil painting was first studied by the scholars of Verocchio. The process was gradually modified by each of them, but, as will appear, most so by Leonardo. That enterprising spirit, far from looking coldly on the new art, eagerly and early adopted it; and it was apparently through his example that his companions forgot their prejudices, and became warmly interested in the pursuit. Each, however, according to his character and views, recognised in it peculiar advantages. In the eyes of Leonardo the method had two great recommendations—that of enabling him to correct his forms and expressions to the last degree of accuracy and truth, and that of furnishing the means of closely imitating the relief and force of nature. Lorenzo di Credi, if attracted also by these qualities, was still more smitten with the fusion of tints and the finish which the method promised; while Perugino was more alive than either to the transparency and warmth which it could command. The tradition of the mere art could no longer be a secret; Antonio Pollaiuolo had many disciples, and the process was now in the hands of too many to continue to be monopolised.

Lorenzo di Credi, who, in the practice of painting, could have felt little in common with Verocchio, was, nevertheless, sincerely attached to him; he remained with him assisting in the direction of his affairs after the departure of Leonardo and Perugino, and when Verocchio died in Venice in 1488, from the fatigue he underwent in casting his equestrian statue of Bartolommeo da Bergamo, Lorenzo hastened thither, and brought back his remains to Florence.

Though the occasion of his short stay in Venice must have allowed but little opportunity for observation, Lorenzo could not, as a painter, be insensible to the interest of the place. At that time Antonello da Messina was in full employment there, and had produced his masterwork—the altar-piece of S. Cassiano. The very year (1488) of Lorenzo's visit was marked by the completion of two celebrated works (hereafter to be described) by Giovanni Bellini, in which the first promise was given of that powerful and glowing colour afterwards carried to perfection in the works of Giorgione—then only eleven years of age. Lorenzo's practice was formed, and it does not appear that it was essentially altered in consequence of this experience, but the enthusiasm which now began to prevail in Venice for the new method must have confirmed his predilection for it.

The early pictures in tempera by Lorenzo di Credi are seldom interesting; he was an example

of those to whom Vasari may be supposed to allude
in his general notice of the introduction of oil paint-
ing—tempera painters who longed for a method
which should supersede the necessity of finishing
with the point, and which, with the requisite preci-
sion, should command an imperceptible blending
of the tints. The qualities which recommended
the new process to Lorenzo may be said to charac-
terise all his oil pictures. One of the best, repre-
senting St. Julian and St. Nicholas standing beside
the enthroned Madonna, is now in the Louvre; and
of this Vasari says, " Whoever would be convinced
that careful processes in oil painting are essential
to the durability of the work, should look at this
picture." Two excellent specimens, both repre-
senting the Nativity, are in the gallery of the
Uffizj at Florence. All these works have the same
technical characteristics: there is no " hatching "
in any part; the flesh tints, though quite as smooth
as those of the earlier masters, are much more
solid, but notwithstanding this solidity the darks
are more raised than the lights. In the Louvre
picture above mentioned (the only specimen of the
master in the collection), the blues and greens are,
as usual, prominent; the left hand of St. Nicholas,
for example, is quite embedded in the blue cover
of the book he holds. In some cases the prominent
shadows, like those in Pollaiuolo's St. Sebastian,
and in his single figures of " Virtues," are blistered
and corroded, and consequently rough.

Lorenzo's system of dead colouring, as distinguished from the original Flemish practice, may be inferred from the appearance of his pictures, in which the ground is almost entirely excluded, and from the fact of his having left many half-finished works at his death. A certain conscientious feeling, agreeing with his character in other respects (for he was among the followers of Savonarola), influenced even his practice in art; and his love of finish was rather encouraged than checked by Leonardo da Vinci, though that great artist, in his own elaborate works, was fastidious with a higher aim. The extreme care and delicacy of Lorenzo's execution are, however, not to be regarded as an imitation of the earlier Italian examples of oil painting which he had seen. The works of Antonio Pollaiuolo are so far bold and decided that, even when of large dimensions, they are painted at once and without retouching; the pictures of Lorenzo were the result of repeated and slow processes.

With this explanation the remarkable description of this painter's habits which Vasari has left may not be uninteresting:—" He was so finished and delicate in his works," says that writer, " that every other picture compared with his will always appear a sketch, and coarsely executed. . . . He was not desirous of undertaking many large works, as he took infinite pains in bringing such to completion. The colours which he employed were ground to the

last degree of fineness; he purified and distilled his oils, prepared from walnuts; the tints on his palette were very numerous, so much so that they extended through all gradations from the first light tint to the deepest dark with a needless regularity: the consequence was that sometimes he had five and twenty or thirty tints on a palette, and for each tint he kept a different pencil. When he was at work he would not suffer the least movement which could stir any dust. Such an extreme nicety is no more to be commended," gravely adds the biographer, " than an extreme negligence."

In his preference of nut oil to the exclusion, it seems, of that of linseed, Lorenzo di Credi resembled Leonardo: the expression "he distilled" ("stillava") may only relate to the process of filtering, which was not uncommon; but as Leonardo certainly distilled the oils, including even the fixed oil he used, by means of fire, the word is perhaps in the above passage to be taken in its literal sense. It is scarcely necessary to observe that, as regards the fixed oils, it was a useless refinement. But wherever modifications of the Flemish process may have been introduced or adopted by Lorenzo di Credi, he preserved one peculiarity unaltered: this was the abundant use of the "vernice" in his darks. As already observed, the common "vernice liquida" was considered by the Italians extremely durable, and no less so than the amber varnish (though this was certainly a mistake). This can

alone account for the circumstance that so scrupulous a workman did not on all occasions prefer the latter.

As the more innovating technical habits of Lorenzo di Credi appear to have been derived from his fellow-scholar, it is to be regretted that so few certain works by Leonardo da Vinci, belonging to the period of his first residence in Florence, should be preserved. The earliest example is the angel before mentioned in Verocchio's altar-piece, representing the Baptism of Christ, now in the gallery of the Florentine Academy. But for the addition by the scholar, it would not be easy to determine whether the work is in tempera or in oil, as portions only exhibit the peculiarities of the latter method. The figure of Leonardo's angel has, however, more body than the rest of the picture, and is free from "hatching," while the portions executed by Verocchio frequently betray the use of the point. In the figure in question, again, the darks are prominent, and some blue drapery is, as usual, more raised than any other part. This picture long remained forgotten in a church near Vallombrosa, and was only brought to light in 1812: it has therefore suffered considerably.

The celebrated Medusa's head in the gallery of the Uffizj has been doubted by a writer of no

ordinary authority*, but his opinion has not been confirmed by that of any other connoisseur. Technically considered, the work corresponds sufficiently with the accredited specimens of the master, and is painted with an equal body of colour. In the same gallery, and underneath the Medusa, is a portrait of a young man also attributed, but hardly on sufficient grounds, to Leonardo. It is solid, like the works of Lorenzo di Credi, yet there is evidence of its being painted on a light ground. The darks are, as usual, much more raised than the lights, and the green background is more prominent than the black cap which it surrounds, precisely as those colours are treated in the early Flemish pictures. Leonardo's portrait of himself (belonging to a different period), in the same gallery, has the same general characteristics; solid throughout, but with the darks most raised, in consequence of the greater proportion of thick varnish used with them.

The editors of one of the earlier works on the Florence Gallery† are of opinion that Leonardo's unfinished picture of the Adoration of the Magi belongs to his second residence in Florence (1499–1513), and adduce some not unimportant reasons for their conclusions; Vasari, on the other hand, includes it among the master's earlier works.

* Rumohr, Italiänische Forschungen, vol. ii. p. 307.
† Reale Galleria di Firenze.

Whenever it was executed, it is plain that the artist got into difficulty with it, and he may have thrown it aside in consequence. The work exhibits two different stages, or rather experiments: in one portion the composition is laid in, in chiaroscuro, on a cream-coloured ground; the very pale outlines and shadows of this preparation are greenish. A second process is apparent upon this in the remaining portion; the shadows are inserted without care, so as to encroach in many places on the outline, and are sometimes violently dark. The fainter greenish shades have, at a distance, the appearance of white scumbled over the intenser darks, but on near inspection this is found not to be the case, although some white was used. All this cannot be said to belong to any regular system, but some other circumstances merit attention. The chiaroscuro preparation agrees in principle with Filarete's description of the method of oil painting. The greenish shadows correspond with the practice of the earlier tempera and fresco painters, and, as we shall see, were an exception to Leonardo's general method. The darker shadows were evidently inserted with " vernice," and though often prominent, are not blistered or corroded like those of some specimens before noticed.

A small picture of St. Jerome, by Leonardo, which was sold with the Fesch collection, is another and a more careful example of this chiaroscuro preparation. In this instance no white is added;

the ground is left for the lights, and a brown colour, varying in depth, but never intensely dark, is alone employed to define the masses and round the forms. The head of the saint is highly finished in this mode ; the rest of the work is not carried so far. To the two last-mentioned specimens may be added various studies of heads in chiaroscuro, which are sometimes to be met with in public and private collections; one is in the gallery at Parma, another, a study for the head of the " Vierge aux Rochers," was once in the possession of Messrs. Woodburn.

The manner in which these preparations are executed shows that Leonardo did not follow the original Flemish method in this stage of his work so closely as Giovanni Bellini and other early Italian oil painters. The Florentine, it may be gathered, both from his writings and his works, seems to have thought that each process of art, as well as each quality in nature, has its characteristic and corresponding means of expression. While employed in drawing, for example, he aimed at the last degree of exquisite precision, as if accuracy of mere form were, by means of a pointed instrument, the proper object of imitation. But when he dealt with light and shade—and especially by means of the brush —his attention was directed to the attainment of roundness by imperceptible gradations, and the softer instrument was employed to express, by such gradations, the thorough *modelling* of the object. In unfinished works by Van Eyck and Giovanni

Bellini, on the contrary, the light and shade of the future picture is expressed with the point; the work is finished as a drawing, although all was to be covered and obliterated by more or less solid painting. The later Flemish painters adopted the Leonardesque process: the earlier method was that of the tempera painters, who always completed their compositions as drawings before they began to paint. The preparation with the brush instead of the point (after the outline was defined) may be considered one of Leonardo's improvements on the older system, and the practice seems to have been adopted by him as much from the capabilities of the instrument and materials of oil painting as from a desire to combine breadth with finish in the treatment of shade.

Various pictures which are described as early works of the master exhibit his characteristic merits too imperfectly to be considered really his. The so-called " Monaca," in the Pitti Gallery, appears to belong to another school and period. The Madonna with the vase of flowers, in the Borghese Gallery at Rome, corresponds in its subject and accessories with a picture described by Vasari, but is hardly equal to Leonardo's reputation.

The later and more consummate productions of the master may be classed according to his places of residence. At the head of his works executed at Milan stands the celebrated Last Supper: of his movable pictures, probably done at the same

period (1480–1499), some are preserved in the
Louvre. Among them is the portrait called " La
Belle Ferronière," but supposed to be that of
Lucrezia Crivelli. The St. John and the Bacchus
in the same gallery, may perhaps belong to Leo-
nardo's second residence in Florence; on this point
it is difficult, and not very important, to decide.
The " Vierge aux Balances " has been considered the
work of Oggione, and is certainly not by Leonardo.
The " Vierge aux Rochers " is also by a scholar: the
original is in the possession of the Earl of Suffolk at
Charlton Park. The picture was once in the chapel
" della Concezione " in the church of S. Francesco
at Milan: two angels, originally forming the side
pictures or doors to the work, are still in the col-
lection of Duke Melzi in that city. To these speci-
mens are to be added the portraits of Lodovico
Sforza and his consort, and the head of St. John in
the Ambrosian Library at Milan; the Holy Family,
now in the possession of the Countess of Warwick
at Gatton Park; and the Holy Family in the gallery
of the Hermitage at Petersburg. The unfinished
picture in the Brera at Milan, the Virgin and Child
with a lamb, is supposed to be the production of a
scholar: some critics see in it the work of two
hands. The finished portions are executed at
once on the light ground, as in the early Flemish
system, and as in Pollaiuolo's St. Sebastian : the
process is more apparent in this specimen, as con-
siderable portions of the white ground are still

untouched. Admitting this to be the work of a less practised hand than Leonardo's, or, at all events, to be not entirely by himself, it is to be remembered that he was ever making experiments, and that he may sometimes have returned to the earlier practice, which must have been first familiar to him.

To the period of Leonardo's second residence in Florence (1499–1513) belong the Battle of Anghiara, commonly called, from the portion of the composition which has been copied and preserved, the Battle of the Standard; the celebrated portrait of Mona Lisa in the Louvre; a young man's head in the Belvedere Gallery at Vienna; and the cartoon in the Royal Academy in London. To this period may also belong some Madonnas which are perhaps to be found among the pictures ascribed to Leonardo in Spain.*

No work of importance can with certainty be referred to as marking Leonardo's short stay in Rome. The Madonna and the portrait mentioned by Vasari are not to be traced. The fresco in S. Onofrio either proves that the method induced the artist to alter his style, or, as Rumohr supposes,

* Of the three pictures, so called, by Leonardo da Vinci, since seen by Sir Charles Eastlake in the Madrid Gallery, he describes No. 666, Retrato de Mona Lisa, as a "poor copy;" No. 778, Sacra Familia, as "a Luini—rather blackened;" and No. 917, Jesus, Santa Ana y la Virgen, as "an indifferent picture."—*Ed.*

that he painted it during an earlier visit to Rome. The picture called Modesty and Vanity, in the Sciarra Palace, is now generally acknowledged to be a work by Luini, as is also the Christ and the Doctors in the National Gallery in London.

Between the date of Leonardo's last departure from Florence to reside in France (1516) to 1519, when he died, the only works which can with probability be ascribed to him are, the unfinished Holy Family (a picture in which the Madonna sits on the lap of St. Anna) in the Louvre; and the Flora, or Diane de Poictiers, called when in the Orleans Gallery "La Colombine," afterwards at the Hague.*

Many other pictures which formerly passed for Leonardo's productions, executed before as well as during his residence in France, have, with increased knowledge of the manner of his imitators, and a more accurate acquaintance with his own style and method, been attributed to his scholars. The Pomona in the Berlin Gallery is, on good grounds, assigned in the catalogue of that museum to Francesco Melzi; the Judith at Vienna is by Cesare da Sesto; the Leda (miscalled a Charity), formerly at Cassel and since at the Hague, is also a school picture. The Christ with the Globe in the Miles collection, the Magdalen in that of Hofrath Adamo-

* Now in the Gallery of the Hermitage, Petersburg. See *Gemälde-Sammlung in der Kaiserlichen Ermitage zu St. Petersburg*, von Dr. G. F. Waagen, 1864.

vitsch in Vienna, the Daughter of Herodias in the Tribune at Florence, and the St. Catherine at Copenhagen—pictures of which there are numerous repetitions—are by, or after, Luini. The Christ bearing his Cross, a half-figure, at Vienna, is also of Leonardo's school. It will not be necessary to consider all even of the genuine works of the master above enumerated; a few will be sufficient to illustrate his technical peculiarities and the changes which he introduced in the Flemish system of oil painting.

Leonardo's refined taste and fastidious habits may be traced in opposite effects—in untiring labour, and in apparently causeless dissatisfaction. From a real love of excellence, and by no means from indolence, he was averse to methods which require decision and dispatch, and this temper of mind may be supposed to have influenced his adoption of a process which left improvement always in his power. This cannot be literally said of the Flemish system of oil painting, in which, when once the design was completed on the ground of the intended picture, that design was looked upon as nearly as unalterable as an outlined fresco. To what extent Leonardo used and abused the facilities which he found the new process afforded may be gathered from the state of the unfinished picture in the Brera, above noticed, p. 87, of the Adoration of the Magi. But the more judicious employment of the controllable means of oil painting is to be recog-

nised in many of his works, in successive opera-
tions, in the most exquisite "modelling," and in
the preservation, notwithstanding such repainting,
of a uniform surface. This power of still making
corrections, and superadding refinements in form,
expression, and effect, was analogous to the advan-
tage which he possessed as a sculptor. It appears
that the model for the equestrian statue of Fran-
cesco Sforza was kept in the clay for sixteen years;
during the greater part of that time Leonardo was
also employed on his noblest work, the Last Supper,
in S. Maria delle Grazie, and a contemporary
writer gives the following account of his habits in
Milan :—

"He was wont to go early in the morning—I
have often seen and watched him—and ascend the
scaffolding (for the picture of the Last Supper is
somewhat high from the ground); he would con-
tinue painting there from sunrise to twilight, for-
getting his meals and never laying aside his pencil.
Then, perhaps, for two, three, or four days he would
not touch the work; yet he sometimes stood for an
hour or two in the day, merely looking at it, and
as if passing judgment on his figures. I have also
seen him (as caprice or impulse moved him) set
out at noon, under a July sun, from the Corte
Vecchia, where he was modelling that stupendous
horse in clay, and hasten to the Madonna delle
Grazie; there, having ascended the scaffolding, he
would take his pencil, and, after giving one or two

touches to a figure, he would all at once quit the convent." *

The habit, here so clearly indicated, of yielding to impulses, and taking advantage of the facilities which oil painting afforded, without the necessity (at least at the moment) of cumbrous mechanical preparations, implies a certain simplicity in the materials employed, and agrees with the system of the artist as exhibited in his pictures—the system of carrying his work nearly to completion with very few colours, in order to confine his attention at first to form and light and shade. The portrait of Mona Lisa was, according to Vasari, a labour of four years, though declared unfinished at last: this is quite intelligible if we suppose it to have been taken up occasionally in the mode above described.

The first characteristic, therefore, which we notice as distinguishing the finished works of Leonardo from the contemporary or earlier examples of Flemish oil painting, is the solidity of the work, generally produced by frequent repaintings. This practice involved a certain modification of the materials. A thick semi-resinous vehicle is fitted for final *sealing* operations only; it is quite possible, by means of preparatory sketches and a completed design, to reduce this final work to one "alla prima" painting, as was often the practice of the

* Novelle del Bandello, Parte 1, p. 363.

Flemish masters; but it is hardly practicable, at all events, it is not convenient or agreeable, to cover a work repeatedly with such a medium—producing a shining surface, and rendering it difficult, after frequent operations, to express the minuter forms with precision. In order to return again and again to the work, as was the practice of Leonardo, a less glossy and a less substantial vehicle was necessary: the changes thus induced gradually defined the Italian, as distinguished from the Flemish, method of oil painting.

With all his sense of the advantages of the new process, Leonardo participated in the dread of oil which was so common among the Florentines. He preferred nut oil, as less coloured than that of linseed, and took infinite pains to extract it in the purest state. He appears at one time to have believed that not only this but all the fixed oils could be rendered perfectly colourless; but he must have found that, after all such precautions, time ultimately deepened their hue. He distilled these oils in the hope of obtaining a less changeable vehicle, with no greater success. With better promise of attaining his object, he confined himself to certain colours in the earlier stages of his pictures, with a view to counteract the subsequent yellowing of the oil. He prepared, and even completed them (their final glazings excepted), in a purplish tone, and thus provided by anticipation a remedy for the evil which he dreaded. With the exception of the

Adoration of the Magi, in which the fainter shadows are greenish, there is scarcely a picture by Leonardo, whatever stage of completion it may have reached, which does not exhibit this more or less solid purplish preparation, varying from an ink-colour scarcely removed from grey—as in the Mona Lisa, as in the "Vierge aux Rochers" at Charlton, and as in an unfinished head in the gallery at Parma —to the almost violet hue of the Holy Family in the gallery of the Hermitage at Petersburg. De Piles remarks that the carnations of Leonardo incline for the most part to the colour of wine-lees, and that a violet colour predominates in his pictures; Rumohr notices the same tints in the head of Ludovico Sforza in the Ambrosian Library at Milan, and in other examples. Leonardo himself, describing a mode of painting with gum-water, recommends the use of lake and black among the colours for painting the shadows of flesh, the darker shades being strengthened with lake and ink.

It appears, both from the unfinished Adoration of the Magi, and from Leonardo's writings, that he preferred a yellowish ground or priming. This was the opposite hue to his dead colour, as his dead colour was again the opposite to the mellow tone which glazing and time would give. On the same principle the tempera painters dead-coloured their flesh green, that the carnations might look fresher, and the Venetians prepared a sky with cream colour as a ground for blue.

The importance which Leonardo attached to the purity and whiteness of the oils in the preparation of his pictures led to other changes in the vehicle. The yellow film which, notwithstanding all his precautions, gathered upon the surface of his work, often long in hand, was still an objection. It was remedied by the partial use of the essential oils; he distilled these himself, and, not impossibly, may have been the first who employed them in painting. A remedy, applicable at least to pictures in an unfinished state, was thus at length found, and, as we shall hereafter have occasion to refer to this strictly Italian practice, its general conditions and results may be at once described.

When the colours are ground in a purified fixed oil, diluted with an essential oil, they dry partly by evaporation, they are covered with no skin, and, if the essential oil be properly rectified, have no gloss on the surface. A picture so painted, even if turned to the wall and left for months deprived of light and almost of air, undergoes scarcely any change. The experiment may be easily made by covering one portion of the surface with white, ground with a fixed oil, and another next it with white, ground with less of the fixed oil (or from which much of the oil has been extracted), and diluted with an essential oil: the latter mode of mixing and applying the colour corresponds with the well-known process termed by the house-painters

" flatting," because the surface is free from shine.*
A picture executed with tints thus prepared may
be retouched and repainted to any extent without
turning immoderately yellow; and when to this pre-
caution, as adopted by Leonardo, was added that
of painting the work throughout in a purplish tone,
the apprehended evil was as far as possible prevented
or neutralised.

The essential oil which Leonardo employed ap-
pears to have been that known by the name of spike
oil. Here the practice of the Milanese school in
the sixteenth century throws light on an incidental
expression in Vasari. The biographer states that
while Leonardo was in Rome, having been com-
missioned by Leo X. to paint a picture, he imme-
diately began to distil oils and herbs for the purpose
of making varnishes, upon which the Pope observed,
" Alas! this man will do nothing, for he is thinking
of the end before the beginning of the work."
" The herbs" which the artist placed in the alembic
could be no other than lavender, from which spike
oil, afterwards so commonly used in painting, is
extracted. The Milanese writer, Lomazzo, in his
Idea del Tempio della Pittura, says, " The colours
are ground with the oil of walnuts, of lavender, and

* In painting with gum-water, Leonardo was also careful to
prevent a glossy surface:—" Sfumato che tu hai, lascia sec-
care, poi ritocca a secca con lacca e gomma, stata assai tempo
con l' acqua gommata insieme liquida, che è migliore, perchè
fa l' uffizio suo senza lustrare."— *Trattato della Pittura*, p. 256.

of other things." The other essential oils used by the Italian painters were spirit of turpentine, and petroleum ("oglio di sasso") or naphtha—the first common in the neighbourhood of Venice, the latter abounding in the territory of Parma; but Lomazzo, true to the practice of Leonardo, lays the greatest stress on nut oil and spike oil. The Florentines seem to have inherited the same predilections. A Spanish writer, born in Florence in the sixteenth century[*], thus describes the vehicles used in painting:— "The colours for painting in oil are employed and ground with nut oil, spike oil, petroleum, linseed oil, and spirit of turpentine." It was before shown that some Spanish painters were contented with linseed oil, and rather ridiculed the preference given by some Italians to nut oil; the prominent place which the latter occupies in Carducho's list may tend to prove that, though he left Florence when young, his technical instructions were derived from Italian rather than from Spanish authorities. Pacheco boasts of being able to use linseed even with blues and whites, his secret to prevent its yellowing being still the oil of lavender. According to the words of Vasari, if taken literally, both the essential oil and the (distilled) fixed oil were intended by Leonardo for the composition of varnishes: this is quite possible; but the prepara-

[*] Carducho, Dialogo de la Pintura, su defensa, origen, essencia, definicion, modos y diferencias. 4to. Madrid, 1633.

tion of the essential oil at all sufficiently implies its use as a diluent in painting, and the testimony of Lomazzo, confirmed by that of Carducho, is conclusive on this point.

The appearance of the surface in Leonardo's well-preserved pictures and in those of his followers, corroborates the evidence which is to be gathered from the above writers. The solid light parts (with which thin vehicles are most fitly used) are covered with innumerable fine cracks, not at all disturbing the effect: these indicate the use of a medium not very binding, yet not capable of violent contraction, inasmuch as the particles of colour subside in a thin medium into their most compact form; on the other hand the evaporation being checked, to a certain extent, by the presence of a fixed oil and a slight resinous ingredient, is not so complete as to occasion any considerable contraction and consequent disruption. When the latter results take place in pictures so executed, it is to be presumed that the essential oil was too abundantly used.* These effects may be easily proved by experiment; for which purpose the painted surface should be exposed to the changes of temperature in the open air.†

* In examining the surface of pictures painted on panel, it is necessary to distinguish between the cracks on the painting which follow the fibres of the wood from those which arise from the state of the pigment, or the nature of the vehicles used.

† Under such circumstances white lead, applied in body,

To return to Leonardo, a solid painting was now prepared, calculated by the vehicles which had been employed to undergo little change of tint, and fitted to counteract even that change by a purposed tendency to the opposite hue. All this was, however, only a preparation. When all was done, the painter had conducted his work to a stage corresponding with the shaded outline, without body, of the early Flemish masters. The chief difference, besides the solidity of the preparation, was that the delicate gradations of light and shade were carried much farther in Leonardo's process, and that, therefore, in this respect, little remained to be done in the process of colouring. Some other peculiarities in the treatment of the shadows (which rarely exhibited the ground through them) will be presently considered. Such being the under-painting, the remaining part of the work was necessarily modified accordingly ; the tinting of the lights might now be accomplished with the thinnest applications of warm, opaque colours, and the whole of this final operation required a treatment more approaching to glazing (that is, the employment of literally transparent colours) than was practised in the Flemish school. This thinner use of the opaque

remains longest without cracks when used with oil alone ; with the ordinary semi-resinous vehicles, now commonly used, it becomes cracked in long lines ; with a due admixture of essential oil the cracks are finer and shorter, or with inspissated oil the surface, instead of cracking, becomes shrivelled.

colours was still more requisite in the half lights, the varieties of which in chiaroscuro had been already expressed in the grey or purple preparation with the utmost nicety: on these, therefore, the scumbling colours, tending to harmonise the subdued lights with the rest of the work, were spread with a sparing hand, softening still more the finer markings and rounding the forms by almost imperceptible gradations, or, as Lomazzo expresses, " with tinted film upon film." This treatment is what the Italians distinguished by the term " sfumato."

The perfection of the system was afterwards attained in the Lombard and Venetian schools, for Leonardo, though its worthy inventor, was far from succeeding in it uniformly. His preparation was in one sense too perfect. The scumbling which he could venture to pass over his exquisite " dead colour " sometimes wanted power to neutralise its exaggerated inky hue. Sometimes, again, the completeness and beauty of the preparation, in all but colour, tempted him to dispense entirely with that last glow, for which, after all, the previous work had been calculated. Vasari states that the Mona Lisa was left unfinished: modern critics have often assumed that its present grey, though in other respects perfect, state, is a consequence of cleaning; but the hands have the full carnation tone, and, as a proof that the picture is not materially different from its original hue (in whatever

other respects it may have suffered), it may be mentioned that very old copies have the same appearance.*

There was another reason why, in Leonardo's process, a nearer approach to the Flemish system in his ultimate operations was impossible. From an ambition to produce on a flat surface the apparent relief and roundness of sculpture, he was in the habit of gradually painting the shadows of his preparation, or dead colour, to their strongest effect. His fine feeling for light and shade had been cultivated to the prejudice, as is often the case, of colour. He saw in darkness its force rather than its depth; in light its brilliancy rather than its warmth; in half light the delicacy of gradations rather than the breadth of local tint. His precepts agree with his practice: he considered light and shade the essence of painting, and more difficult of attainment than drawing. His position, that shade destroys colour, betrayed him, while he aimed at strength, into blackness. On one occasion he observes that, as greens become dark they become bluer, and perhaps there is no instance in his works of a transparent brown shadow to green. This force, or rather blackness of his shadows in pictures merely prepared for glazing, rendered the warming effect of those glazings powerless, for it is essential to such operations that the superadded colour

* See Leonardo da Vinci-Album, von G. F. Waagen. Berlin.

should always be the darker. Vasari speaks of
Leonardo's endeavours to approach the force of
nature in the following terms:—" It is curious to
trace the efforts of this extraordinary genius in his
desire to give utmost relief to the objects which he
painted. In trying to increase the intensity of
shade by darkness within darkness, he sought for
blacks deeper than other blacks, in order that the
light should, by opposition, be more brilliant. The
result, however, was that scarcely any light re-
mained in the picture; such effects rather resem-
bling night scenes than a gradually mitigated
daylight. But all this was in consequence of his
aiming at utmost relief, and indicated an ambition
to attain the end and perfection of imitation." The
biographer afterwards again refers to this love of
intense shade:—" This painter added a certain
obscurity to the art of colouring in oil, in con-
sequence of which the moderns have given great
force and relief to their figures." Succeeding
colourists may have adopted a greater force in
consequence of this practice, but certainly not in
exact imitation of it, for the darker shadows of
Leonardo are for the most part opaque. The St.
John in the Louvre is one of many examples: in
that work the darks, while they exclude every
vestige of the internal light ground, must have
been too intense themselves to be a fit preparation
for subsequent glazings. In the directions which
Leonardo has left for painting (in gum-water) the

shadows of flesh, he recommends that the first colour, composed of blacks and reds, should be retouched with lake alone. The same system appears to have been followed in his oil painting (for which indeed the method he describes may have been sometimes a preparation), but the inky shadows were in many instances too dark to be corrected by lake or by transparent browns.

The painting executed in the mode described, with thinned oils, required not only the warmth which the ultimate glazings could give, but the protection which the more substantial vehicle used with these glazings insured. The "flatting" process in common painting is unfit, as is well known, for the open air. The absence of gloss indicates a more or less porous surface, which is too readily susceptible of damp, before it hardens, to last, when so exposed, even for a short period; a picture somewhat thinly executed with drying oil disappeared entirely, under such circumstances, in a few months. Without supposing extraordinary trials, experience shows that the alternating effects of moisture and aridity are soon destructive to pictures when the substance or surface of the work is imperfectly defended. In Italy the protection, as such, which a hydrofuge coating can give was indeed less essential than in the North, and carefully kept small works, in which it was omitted, do not appear to have suffered much in a mechanical sense, except as regards the fine and minute cracks

before mentioned, with which the surface of Leonardo's best works is covered: the Mona Lisa is a remarkable example.

Leonardo, like other painters, had his dark and light oil varnish: the first was composed of amber and nut oil, the nut oil being sometimes distilled; the light varnish consisted of nut oil thickened in the sun. Whether the solution of amber with nut oil instead of the customary linseed oil was a needless refinement or not, his mention of an amber oil varnish shows that the choicer composition prepared in the North ("vernix Germanorum") was now employed in Italy. On one occasion, when Leonardo speaks of varnish, the lighter of the above vehicles is perhaps to be understood; he observes that verdigris, " even if applied with oil, will soon disappear unless it be immediately varnished." A half resinified fixed oil is quite as efficacious as the " white varnish" in locking up this colour, and certainly more so than an essential-oil varnish: the effect of balsams employed for the same purpose has been before adverted to.*

In the passages which have been quoted Leonardo speaks of oil varnishes only, but the same reasons which made him reluctant to cover his highly-wrought "dead colour" with mellower tints which would have rendered further alteration in-

* See Vol. i. p. 459. Also Sir Joshua Reynolds's experiment, ibid. pp. 540, 541.

convenient, induced him to seek for thinner compositions to protect his work. Vasari observes that "he undertook extraordinary experiments in seeking for oils to paint with, and varnishes to preserve the finished pictures." Such a varnish, the result of "extraordinary experiments," could not have been the well-known oil varnishes, and if Leo X. found him "distilling herbs for the purpose of making varnishes," an essential-oil varnish must have been in that instance proposed.

Next in estimation to amber, the customary resinous ingredient in the oil varnishes was sandarac. The latter can be dissolved in no essential oil except spike oil, and this composition, which in Italy lasts for a considerable time, appears to have been the thinner varnish of Leonardo. Its employment by him is the more probable since we find it in use in the Florentine school in the sixteenth century, and its introduction agrees with the prevailing tendency of that school to shun the fixed oils as much as possible, using them sparingly in painting, and rarely in varnishing. Borghini thus describes a composition for the latter purpose, intended to dry in the shade—a precaution again corresponding with Leonardo's habits:—"Take an ounce of spike oil and an ounce of sandarac in powder; these being mixed together are to be boiled in a new glazed pipkin, and if the varnish is required to be more lustrous, more sandarac should be added. It should be well stirrèd in boiling;

when the solution is completed the varnish should be removed from the fire—it should be carefully applied while tepid to the picture, and this varnish is very delicate and of an agreeable smell." Leonardo's experience must have convinced him that no varnish is durable: this may be gathered from his proposing what he calls "an eternal varnish," consisting of a very thin sheet of glass, which was to be attached to the surface of the picture.* On the whole, perhaps, the composition called the varnish of Correggio is, in an Italian atmosphere, the least objectionable of the thinner varnishes.

Among Leonardo's "extraordinary experiments" with oils may be reckoned his method, noticed by Lomazzo, of reducing the substance of the fixed oils by distillation. As the practice was condemned even by his immediate followers (represented by that writer), and as we find no trace of the employment of such oils in painting, except by Lorenzo di Credi, it may be concluded that the invention was short-lived. From the records of Florentine investigators, it appears not unlikely that Leonardo made use of the same oil in the composition of his amber varnish; at all events, we find such a preparation described by the Padre Gesuato, whose " Secreti " were appended to an edition of Alexius published at Lucca in the middle of the sixteenth

* Trattato della Pittura, p. 255.

century. The receipt was copied by later writers, but the process itself, if introduced by Leonardo, appears after his time to have survived only in description.

The equal substance with which most of the works of Leonardo are painted; the force, approaching to blackness, in the shadows of some of his preparations; and his reluctance to adopt the thick rich glazings which, according to the practice of his time, precluded all further retouching, sufficiently account for the want of that prominence of surface in the darks which is characteristic of the early oil pictures. Leonardo's flesh tints are generally as solid as any other portion: in the picture in the Louvre in which the Virgin is sitting on the lap of St. Anna, the flesh is unusually thin—a circumstance explained by the unfinished state of the work. A slight prominence in the dark is only partially to be traced in that picture, in the St. John, in the Bacchus, and in some other examples, which will be noticed as we proceed. Leonardo's greens and blues are, in like manner, scarcely more raised than the surface of the other colours; the use of ultramarine, which, unlike the "Azzurro della Magna," requires no thick vehicle to protect it, would partly explain this, and the changes which have sometimes taken place where transparent tints were not sufficiently "locked up," not only as regards greens but other colours, prove that the artist's deviations from the traditional practice were not always improvements.

Leonardo seems to have been averse to expose his pictures to the sun; the use of an evaporable ingredient (spike oil) might undoubtedly render the surface so exposed too arid, and too liable to crack. On one occasion he directs a painting, prepared for varnishing, to be dried in a dark oven: * he nowhere mentions dryers.

The dryers used at an early period in Italy are to be detected in descriptions of mordants for gildings. Cennini directs linseed oil to be slowly boiled till it be reduced one half; this drying oil, he observes, is good for painting, and when further thickened with a certain proportion of " vernice liquida " is fit for mordants. Elsewhere he speaks of white lead and verdigris mixed with oil and " vernice " for mordants. The later Florentine preparations of this kind were fitter for occasional use in painting, and the best was evidently of northern origin. A composition which must have resembled japanners' gold-size in colour and siccative power is described by Borghini: it consisted of umber, massicot, minium, calcined bones, and calcined vitriol; these materials being finely ground were boiled in linseed or nut oil, and the preparation was used as a mordant when cold—that is, in a clarified state. Borghini, after directing how the vitriol was to be calcined, observes:—" This vitriol makes all slow-drying colours dry, but it spots

* Trattato della Pittura, p. 256.

them." There can be little doubt that white cop-
peras or sulphate of zinc is here meant, since no
other "vitriol" is known to have been used as a
dryer; as already explained (p. 35 note), it is per-
fectly harmless when boiled with oils according to
the Flemish method, and when calcined would also
be harmless if mixed in substance with the colours,
but being then opaque, it would be unfit to mix
with darks. The composition described by Borghini
might perhaps be improved for the uses of painting
by omitting the preparations of lead, which are
more or less soluble in oil, while the sulphate of
zinc is not so. Another mordant described by the
same writer, and which is applicable as a siccific,
was composed of the remains of colours which had
dried with a pellicle. These were boiled in nut
oil till they were dissolved; the preparation was
then strained and clarified.

The paintings which Leonardo executed in oil
on walls were ill calculated for durability. Three
works of the kind were undertaken by him: the
celebrated Last Supper in the refectory of S.
Maria delle Grazie at Milan; the portraits of Lodo-
vico and Beatrice Sforza in the same hall, opposite
the Last Supper and next the Crucifixion in fresco,
by Giovanni Donato Montorfani; and the Battle
of Anghiara (called, from the portion which is
known from copies, the Battle of the Standard) in
the council-chamber at Florence. The Madonna
and Child in the convent of S. Onofrio at Rome,

painted, according to Titi and others, in oil, is certainly in fresco.*

In preparing to paint on the walls of the refectory in S. Maria delle Grazie, it is evident that, mindful perhaps of the suggestion before quoted of Leon Battista Alberti, he proposed to take additional precautions at the outset of the work. The portraits of Lodovico Sforza and his consort were painted on the smooth intonaco corresponding with that on which Montorfani's fresco was executed, the surface having been perhaps prepared with size for Leonardo's oil pictures : parts of the white wall are now exposed, and the portions of those pictures which remain are so blackened that the forms are scarcely distinguishable. These works are, however, comparatively unimportant, and the artist is said to have undertaken them with reluctance. But the wall on which the Last Supper was painted was first covered with a mixture of common resin, mastic, gesso, and other materials. This coating, however, proved insufficient for an unusually damp wall, which, in consequence of the low site of the building, was exposed even to the effects of inundations. The wall of the council-chamber at Florence was defended by a similar composition, apparently including linseed oil; in this case an evil of a different kind occurred—the hydrofuge coating began to flow down, and after Leonardo

* See Bunsen, Beschreibung der Stadt Rom, vol. iii. Part III. p. 585.

had abandoned the painting the surface required to be supported with woodwork.

With the exception of the hydrofuge preparation, Leonardo appears to have made no change in his system of painting on walls as compared with his ordinary process: he reckoned on his first and last operations (the last having been unfortunately omitted) for the preservation of the work. In the painting itself his chief object was to reserve the power of retouching till he was satisfied, and, keeping this in view, to prevent a glossy surface and the yellowing of the oil. Paolo Giovio, a contemporary of Leonardo, and perhaps personally known to him, says that the Battle of Anghiara was painted with nut oil, and Lomazzo attributes the early decay of the Last Supper to the artist having used it thinned by distillation; but neither the practice nor the further dilution of the vehicle with spike oil would have been injurious had these paintings been completed with oil varnishes. Leonardo's deviation from the Flemish process is especially evident in his mode of painting upon walls: we have seen that the Florentine artists who succeeded him retained, in that case only, the Flemish method of using varnish with all the colours. Leonardo undoubtedly contemplated the ultimate toning, and, which was no less important, the protection of the surface by means of substantial vehicles; but in this as in many other instances the final operation was for ever postponed.

That the protection of the surface of the wall
from internal damp is essential to the preservation
of pictures executed upon that surface there can be
no question, but one cause of the blackening of oil
pictures on walls has been generally overlooked.
Vasari remarks that Andrea dal Castagno, the Pol-
laiuoli, and others, had never been able to prevent
their oil paintings on walls from turning black; he
then expresses his conviction that the difficulty
had been entirely surmounted by Sebastian del
Piombo, who, not content with a hydrofuge pre-
paration as a ground for the picture, mixed the
very mortar with resin, and spread the first rough
coat with a hot iron, "in consequence of which,"
continues the biographer, "his paintings on walls
have effectually resisted moisture, and have pre-
served their colours without the slightest change."
He instances the picture by Sebastian of the Flagel-
lation of Christ, in S. Pietro in Montorio at Rome.
When Vasari wrote, that picture might have re-
tained its freshness, but now, from its blackened
surface, it is scarcely visible. Such is, indeed, a
common if not a universal defect of wall paintings
in oil.

The cause of this change is not merely internal.
Borghini, though he expresses himself incorrectly,
hints at another source of the evil: "Whoever,"
he observes, "wishes their oil painting on walls to
last long, should paint on walls of brick, and not
on walls of stone; for the latter, in humid weather,

give forth moisture and stain the picture, whereas bricks are less susceptible of damp." The colder the surface, the more the moisture of the atmosphere will be condensed upon it, and when a painting is executed on stone, its surface will necessarily be wet in damp weather. The decay of the picture, if executed with thin oil alone, would be the speedy result: even if it were painted with firm vehicles, as was usually the practice, still the moist surface would attract dust and smoke, and gradually become blackened. On the same principle an oil painting would retain its original appearance longer on plaster upon laths than on the colder surface of plaster upon bricks. The same conditions affect fresco painting to a certain extent, but much less so, from the constant tendency of lime to a redisintegration, from the surface inwards, of the original carbonate ; that process requires moisture, and thus, for a considerable time at least, prevents its accumulation in damp weather on the mere surface.

The epitaph on Leonardo which appears in the first edition of Vasari's *Lives*, might be understood to attribute to him the invention of oil painting, thus pointing to the many changes which he introduced in the process: if the eulogy is exaggerated in this respect, it is no less so in alluding to his "transparent shadows." The writer, having assumed that Leonardo was the first who practised oil painting, ascribes to him,

without further enquiry, the characteristic excellence of the method.

Two interesting specimens of the master, further illustrating his technical predilections and his versatility, may be noticed in conclusion. The picture called the "Vierge aux Rochers," in the possession of the Earl of Suffolk, was probably one of the first works painted by Leonardo in Milan. The shades and obscurer colours are now become intensely dark, and this peculiarity is observable in the two pictures of angels, originally forming part of the altar-piece, which are still at Milan. The system adopted in this picture may have been the same, carried farther, as that of the unfinished Adoration of the Magi in Florence; the brown darks appear to have been inserted at first, time having rendered them more opaque. The flesh tints are painted with the usual purplish greyish tint, but not with so much body as in some of his later works. As the picture was long in a church, it is hardly to be supposed that it was left unfinished; the more probable conclusion is that the present colourless state of the flesh is in consequence of the glazings having disappeared. The surface of the darks, though rarely prominent, is here and there cracked, and in a mode which indicates the use of sandarac.

The Holy Family in the possession of the Countess of Warwick at Gatton Park, is an exception, in a technical point of view, to the usual system of Leonardo. The excellence of the com-

position, and the thoroughly studied drawing and modelling of the heads and hands, are sufficient evidences of the master, while the remarkable preservation of the picture gives it a more than common interest and value. The peculiarities of the execution, as compared with Leonardo's other works, are to be considered as proofs of his studious and investigating character, and perhaps in this case admit of more direct explanation. Lomazzo's statement that no work of the master is to be considered finished can hardly apply to this example, which is completed in every part. The colouring of the flesh is warm, and although there is evidence here and there—for example, in the children—of a cool preparation in the lower half-tints and lighter shadows, that preparation was so far calculated for the mellower tones with which it is clothed that no unpleasant grey or inky colour predominates. The heads and hands of the Joseph and Zacharias are even golden in tone. The flesh, though as usual free from "hatching," is thinner than in most works of the master; and the shadows, especially the darker parts of the blue drapery, decidedly prominent in comparison with the portions in which white was used. Some dark green drapery behind the heads of the Madonna and Joseph, and elsewhere, is cracked in a manner which shows that the ordinary "white varnish" was used, but the raised shadows generally are not cracked at all, and their perfect preservation, notwithstanding the quantity of

vehicle used in them, indicates the use of the amber varnish. No essential oil appears to have been employed in this picture; the cracks in the flesh are not numerous (as in the portrait of Lucrezia Crivelli, that of Mona Lisa, and the St. John), and are apparently the consequence of a slight expansion in the fibres of the wood, the grain of which they generally follow. On minute inspection, a light ground is to be detected through the shadows of the flesh.

All the above peculiarities—the prominence of the shadows as compared with the light, the firmness of the vehicle both in lights and darks, the use of the white varnish in the deeper greens, the general warmth of tone, and the comparative transparency of the shadows of the flesh—are characteristic of the early Flemish system, and there is perhaps no other work of Leonardo's in which that system is so closely followed. The picture belongs to the middle period of the master's practice, and may have been executed in Milan. The probability is that Leonardo may there have studied some specimens of the Flemish process: none were more likely to come under his observation, from their novelty and celebrity at the time, than the works of Antonello da Messina. That painter had returned to Venice; but, as we have seen, he had resided for some years in Milan, and must have left numerous pictures there—perhaps chiefly portraits. Whatever may have been the cause of Leonardo's adoption of the Flemish method during

part of his stay in Milan, his fastidious and pro-
crastinating habits (apparent at that time in the
prosecution of his great work in S. Maria delle
Grazie) ultimately determined his executive me-
thod, and the style which is more peculiarly his
own is best represented by a subsequent work at
Florence—the portrait of Mona Lisa.

The foregoing description of Leonardo's works
and method has been purposely minute, because
he is to be regarded as the founder, strictly speak-
ing, of the Italian process of oil painting. The more
important characteristics of his mere practice may
be shortly defined as follows. The system of re-
touching to any extent the preparation or *abbozzo*
may be said to date from him; and the technical ex-
pedients and materials which rendered this system
possible and convenient were also his invention.
In securing the means of painting and repainting
without prematurely coating the surface with semi-
resinous and glossy vehicles, his object seems to
have been to retain the power of improving his
works in form and expression, and of imitating
with completeness the roundness and relief of
natural objects. The application of mellower tints
and glazings with substantial varnishes was re-
served for final operations, or till the artist was
satisfied. In this respect Leonardo differed not, in
principle, from the Flemish masters: they too,
though using varnish (in greater or less propor-
tions) with all the colours, may be said to have

employed it only in final operations; but their final painting was, in many cases, the only painting—the work being executed, like a fresco or tempera picture, from finished sketches, portion by portion. The progress of the art from tempera was indeed gradual and consistent: the tempera picture was varnished; the first oil painters, in the course of experiments to improve this varnish, ended by mixing it with the colours, and assuming or finding that the application of tints with so glossy a vehicle could not conveniently be repeated, they thoroughly drew and shaded their design before the colours were applied, and then often painted " alla prima." A literally unchangeable design and the decision of the subsequent operations were not to Leonardo's taste. In order to reserve the power of correcting his work he invented a mode of painting with diluted oil, calculated to prevent gloss on the surface, postponing the use of thick varnishes, at least in the lights, till his picture was all but completed. That picture, purposely kept cool and grey in colour, but with every form, half-tint, and shadow defined, was equivalent to the Flemish painter's finished drawing, since, in both cases, a single operation only with varnish-colours was required to complete the work, or, at all events, the portion so treated. One consequence of Leonardo's repaintings, perhaps not at first contemplated by him, was a greater solidity or body of colour (*impasto*) than had previously been attempted, or than was by

some contemporary artists thought desirable. It will be seen as we proceed, that, with the exception of Lorenzo di Credi, the immediate followers of Leonardo preferred a thinner substance in the lights, and especially in the flesh tints, and thus adhered more closely to the Flemish system. The solid preparation was, however, subsequently adopted by many (especially when painting on cloth instead of wood), as a means of preserving the work, and was gradually considered indispensable in larger pictures as forming a needful substratum for the semi-transparent and transparent tintings called scumbling and glazing. The judicious use, by the Venetian painters, of these various methods, including a lighter preparation of the shadows, soon opened the way to excellences never contemplated by Leonardo.

In enumerating the actual changes which this inventive and fastidious painter introduced, and which were sooner or later adopted, not only in Italy, but, by a natural reaction, sometimes in the schools of the North, we may thus reckon:—1. The exclusion of the light ground by a solid prepara tory painting. 2. The use of essential oils together with nut oil in that preparation. 3. The practice of thinly painting and ultimately scumbling and glazing over the carefully prepared dead colour, as opposed to the simpler and more decided processes, or sometimes the single "alla prima" operation of the Flemish masters. 4. The reservation of thick

resinous vehicles (when employed to cover the lights) for final operations, so as to avoid as much as possible a glossy surface during the earlier stages of the work. 5. The use of essential oil varnishes.

The defects into which Leonardo was often betrayed—on the one hand by his exclusive study of chiaroscuro, and, on the other, by his endeavours to guard against the yellowing of oil—were, want of transparency in his shadows, and want of warmth in his flesh tints. The chief practice, characteristic of the school of Van Eyck, which he retained, was the use of the amber varnish, substituting nut oil (sometimes even distilled) for the customary linseed oil. Instead of the " white varnish," composed of nut oil and mastic, or nut oil and fir resin, he, at least occasionally, used the thickened nut oil alone.

We now come to the third member of the trium-virate before mentioned—Pietro Vanucci, called Perugino. Some of the writers who have traced the progress of this painter are unwilling, as already stated, to believe that with his habits in a great measure formed at Perugia, and probably no longer a youth when he first visited Florence, he could have entered the school of Verocchio as a student. But in Italy, and at that time, such a circumstance would excite no surprise; the thirst for knowledge was the great stimulus—the readiest means of ac-

quiring it the chief consideration. In any view of this question, the early friendship of Perugino and Leonardo, whether as fellow-students or not, is established on the safest authority.

Supposing Perugino to have arrived at Florence at the age of twenty-five (1471)—to allow time for his previous studies at Perugia with his first master, Bonfigli, and for some works of his own there—it is plain that the improved method of oil painting must have been then unknown to him. He could only acquire that knowledge in Florence, and probably not till a year or two later. One of his early pictures—the Adoration of the Magi*, formerly in the Chiesa de' Servi (formerly called S. Maria Nuova) at Perugia†—is, according to Mezzanotte, painted in oil. The style of this picture indicates little influence of Florentine studies; but if, as Rumohr on good grounds supposes, the work was executed in 1475, it may, quite possibly, be an attempt in the new method. It matters little

* Cavalcaselle attributes this picture to Fiorenzo di Lorenzo. It is now in the Perugia Gallery, No. 39, under the name of Dom. Ghirlandajo! See Cavalcaselle, vol. iii. p. 158, and note.—*Ed.*

† A picture of the Transfiguration, once in the same church, now in the gallery at Perugia, is placed by Orsini (*Vita, Elogio e Memorie di Pietro Perugino*, p. 20) among the early works of the master. It has, however, suffered so much, and is so repainted, that it will hardly be safe to draw any conclusions from it. The altar-piece in S. Simone at Perugia, which Orsini (p. 24) inclines to place among the early works of Pietro Perugino, indicates rather the weakness of age.

whether this work was painted in Florence or
in Perugia; Florence may be considered the head-
quarters of the artist about that time, and 1475
is the date of Antonio Pollaiuolo's St. Sebastian.
The earliest work which Perugino is known to
have executed in Florence is a fresco formerly in
S. Piero Maggiore, and which, on the demolition of
that church, was removed to the Palazzo Albizzi,
where it now is.* From a document obligingly
communicated by the present inheritor of the pic-
ture, it appears that the artist received a hundred
gold crowns for it from Luca degl' Albizzi. That
individual, having been concerned in the conspiracy
of the Pazzi, was exiled in 1478, and did not return
to Florence till after twenty-five years. The work
in question may have been executed about 1476–7.
A fresco by Perugino at Cerqueto, near his native
city, had the date 1478. In 1480 Perugino left
Florence for Rome†, where he was employed by
Sixtus IV., and, after that pontiff's death, by
others for some years, occasionally visiting Perugia.
Leonardo quitted Tuscany for Milan about the
same time: it is therefore sufficiently evident that, if
Perugino gave his attention to oil painting in com-
pany with Leonardo and Lorenzo di Credi, the time

* Vasari (vol. i. p. 420) speaks of the resistance of this
fresco to rain and wind. See also Bocchi, Bellezze di Firenze,
p. 176, quoted in Orsini, p. 120.

† According to Orsini (p. 137, note), Perugino was in Pe-
rugia in 1483.

when such studies were prosecuted must have been anterior to 1480. In the absence of dates on many of Perugino's works it is not possible to determine what pictures by him, now extant, were painted before that period. Many circumstances concur to prove that he had then attained great practice in the method; and perhaps a writer before quoted is correct in assigning the works executed for the Gesuati in the church of S. Giusto alle Mura to the period of the artist's first residence in Florence. The church, with its frescoes by Pietro, was destroyed in 1529 during the siege of Florence, but the three altar-pieces in oil by him were removed, and are still preserved: in one of them (a Crucifixion, with the Magdalen), now in the church of S. Giovanni della Calza, some critics have traced an imitation of Luca Signorelli; if they are correct *, this is an additional reason for concluding that the picture, and consequently its companions, were executed about the time above supposed. Signorelli painted several pictures in Florence for Lorenzo de' Medici, some of which are now in the Uffizj. Perugino again met Signorelli, and must have seen a fresco by him (afterwards destroyed) in Rome; but there is no trace of the imitation above alluded to after Pietro's first residence in Florence.

In Rome Perugino found few disposed to employ

* See Passavant's Life of Raphael (German), p. 489. Also Borghini, Il Riposo, vol. ii. p. 150, note, and Baldinucci, vol. v. p. 491.

him as an oil painter: his works in the Sistine
Chapel, as well as those begun in the Vatican, were
necessarily in fresco. A round picture, formerly
in the Corsini Palace, and lately in the Royal
Gallery at the Hague, is a beautiful example of
tempera.* Another work in tempera, with the
date 1491, probably executed at Perugia for a
Roman employer, is now in the Albani Palace at
Rome. The altar-piece formerly in the church of
St. Mark in Rome has disappeared.†

Soon after 1490 the artist was again in Perugia
and Florence; his time was divided between those
and other cities (including Rome, which he more
than once revisited) till about 1515‡, when he
retired to Perugia, chiefly on account of the severity
with which the followers of Michael Angelo in
Florence treated his latter works. He died at
Frontignano, between Città della Pieve and Perugia,
at the age of seventy-eight, in 1524.

The best works of Perugino were executed be-
tween 1490 and 1505. The following are among
the most celebrated:—The altar-piece painted for
the church of S. Domenico at Fiesole, and dated
1493, representing the Madonna and Child en-

* Now in the Louvre.

† Bunsen (vol. iii. Part III. p. 536) mentions a picture of
St. Mark ascribed to Perugino, but more like a Venetian picture.

‡ As he purchased a burial-place in the Servi at Florence
in July, 1515, he can hardly have abandoned the idea of
ending his days in that city until after that date. See Vasari,
note 50 to *Life*.

throned, with St. John the Baptist and St. Sebastian standing beside them, is now in the gallery of the Uffizj. This picture is remarkable for a very refined character and expression in the Madonna. Another, with the same date, somewhat similar in subject, is in the Belvedere Gallery at Vienna. A picture of the Madonna with two saints, SS. Augustin and James, dated 1494, is in the church of S. Agostino at Cremona.* Four excellent works of the master were painted, or completed, in the following year (1495): the Dead Christ mourned by the Marys and Disciples, originally in the church of S. Chiara, and now in the Pitti Gallery at Florence; the enthroned Madonna and Child surrounded by the patron saints of Perugia, painted for and formerly in the Cappella del Magistrato at Perugia, and now in the gallery of the Vatican ;† the Ascension, painted

* This picture was among those taken to Paris.

† Mariotti gives a curious and amusing history of this picture. In 1479 a painter of Perugia, Pietro di Maestro Galeotto, was commissioned to paint an altar-piece for the Cappella del Magistrato within the space of two years. The picture was to represent the Madonna and Child with the four patron saints of Perugia — SS. Lorenzo, Ludovico, Ercolano, and Costanzo. Galeotto was not a man of punctual habits. Three years elapsed, and the work was not complete ; and, for fear of the plague, which was increasing in Perugia, he obtained another year's grace. In that year he died, leaving the picture unfinished. Then the magistracy applied to their fellow-townsman, Pietro Perugino, and a contract was drawn up with him, stipulating that the picture should be completed in four months' time from that date, November, 1483. "But,"

for S. Pietro Maggiore at Perugia, and now in the
gallery at Lyons; and the Sposalizio, or Marriage
of the Virgin, once in the Duomo at Perugia, and
now at the Museum of Caen, in Normandy. A
picture of the Nativity, originally in the church
of S. Antonio Abbate in Perugia, is now in the
Louvre; it was painted about 1497. An altar-
piece with the same date, representing the enthroned
Madonna and Child surrounded by six saints, is in
the church of S. Maria Nuova at Fano. The pic-
ture of the Madonna and Child, round whom kneel
six figures while angels hover above, painted in
1498 for the confraternity " Della Consolazione,"

says the author, "what availed the promises of the old
painters?" Within a few days of the signing of the contract
Perugino was on his way elsewhere, and the picture remained
in statu quo. The magistracy waited for his return till the
December of the same year, 1483, and then they signed an
agreement with another painter and fellow-townsman, Santi
di Apollonio, binding him to complete the work within one
year. But the third labourer in this field was as little con-
scientious as the two first. Seven years passed away, and
he never set a stroke. All this while the picture remained at
the house of Galeotto's father, who, tired of keeping it, con-
signed it, in 1791, along with some unused colours, to the
magistracy. Four years longer the unfinished work sent up
its mute protest. Then the magistracy bethought themselves
again of Pietro Perugino, whose growing fame wiped out his
past delinquencies; and in March, 1495, a fresh contract
bound the painter to complete this and other labours within
six months. Whether he was more punctual this time is not
known, but Mariotti adds: "il quadro però noi lo vediam
fatto."—*Lettere pittoriche Perugine*, pp. 146-152. This picture
was among those taken to Paris.

in Perugia, is in the church of S. Domenico in
that city. About the same time was painted the
altar-piece called the Family of St. Anna, formerly
in the church of S. Maria de' Fossi at Perugia, and
now in the museum at Marseilles. Two children
(St. James Major and St. James Minor*) in the
picture were copied by Raphael in tempera on a
gold ground: (this, perhaps the earliest existing
work of Perugino's distinguished scholar, is pre-
served in the sacristy of S. Pietro Maggiore at
Perugia). The Assumption of the Virgin, painted
for the convent of Vallombrosa in 1500, is now in
the gallery of the Academy at Florence. The
great work of Perugino—the series of frescoes in
the " Sala del Cambio " at Perugia—was executed
about 1500 : these paintings bear the same relation to
the artist's fame as those of the Vatican do to that of
Raphael. The picture of the Resurrection, painted
in 1502 for the church of S. Francesco at Perugia,
is now in the gallery of the Vatican : in this work
the assistance of Raphael is apparent. To the years
1504–1505 belong the wall paintings at Città della
Pieve (Perugino's birthplace) and at Panicale ; the
first representing the Adoration of the Kings, the
latter the Martyrdom of St. Sebastian. These
works are interesting in a technical point of view,

* Passavant describes the children as the Infant Christ and
St. John, but in the original picture the name of each is
inscribed in the nimbus.

having been apparently painted on the dry wall, in the method called "secco." * An altar-piece representing the Virgin and Child enthroned surrounded by saints, painted in 1507 for Montone, near Città di Castello, was, in the last century and probably still is, in a private collection at Ascoli: it differs in one respect from the generality of Pietro's works, as the upper part consists of a gold ground on which some figures of angels are relieved.

Some excellent pictures of the master which are preserved in various galleries are here omitted, as they are of uncertain dates. The later works of Perugino are generally inferior to those that have been named: intent latterly, as it appears, on amassing wealth, he often adapted his former compositions to new subjects, and, while his powers of invention declined, his colouring, which constitutes so great a part of the merit of his best productions, also became weak. This is observable in an altar decoration of considerable extent, painted (probably in 1512) for the church of S. Agostino in Perugia. The insulated altar exhibited a picture on each side, besides smaller accessory subjects; the two principal portions are still in the church, though not in their original place. Perugino's last works were wall paintings: a Nativity and some other subjects at Frontignano (between Città della Pieve and Perugia) were

* See Vol. i. p. 142.

painted in and after 1522. These, like some earlier specimens of the kind, are executed on the dry wall.

Many of the altar-pieces here enumerated were adorned with other pictures. The principal subject was commonly surmounted by another, forming an apex to the decoration: the upper and smaller picture was often of the lunette form (like the Francia of that shape in the National Gallery); the pilasters or lateral portions of the frame were sometimes filled with single figures or half-figures of saints, and a narrow compartment below (the predella) was occupied with small Scripture subjects, and sometimes with figures of saints as well. Most of such smaller figures by Perugino, originally belonging to larger works, are now scattered in galleries, and are not unfrequently attributed to Raphael. The three predella pictures of the altarpiece of the Ascension, now at Lyons, which are in the museum at Rouen, are examples. At the period when these works were executed, Raphael was but twelve years old. One of the works of the master in which the hand of the scholar is really apparent is (as we have said) in the picture of the Resurrection in the Vatican Gallery (1502). Another in the same gallery, representing the Nativity, appears to have been chiefly the work of Perugino's scholars, and the head of Joseph is, on good grounds, ascribed to Raphael. On the other hand, predella pictures, or larger subjects executed

in the manner of Perugino, and which belong to a later date than 1505, cannot be the work of the great scholar, who about that period began to emancipate himself from the style of his master.

The three altar-pieces painted for S. Giusto alle Mura, and which are all preserved in Florence, merit especial attention, not only because they appear to be among the earlier works of the master, but because Vasari has undertaken to describe the mode in which they were painted. His words are: " These three pictures have suffered much, and are cracked throughout the darks and in the shadows; this happens when the first coat of colour which is laid on the priming is not quite dry (for three layers of colour are applied one over the other). Hence, these, as they gradually dry, contract in consequence of their thickness, and have force enough to cause these cracks—an effect which Pietro could not foresee, since it was only in his time that painters began to colour well in oil."

It is true that these works have suffered partially in the mode described, but not more so than other pictures of the time. It is remarkable that Vasari should notice the cracks as existing only in the darks and in the shadows, for this at once contradicts his explanation; it was in those parts that the oleo-resinous vehicle was used in greatest abundance, and the somewhat premature effects above noticed, taking place perhaps fifty years after the pictures were executed, may have been occasioned

by using the vehicle with too great a proportion of
resin, or by the insufficient protection of the works
from the sun's rays, or from the heat. Had the
thickness of the pigment and the circumstance of
the under layer not being dry been the sole cause
of the defects in question, the light portions would
have been cracked as well as the dark. In Peru-
gino's works the flesh tint is generally thin, and
sometimes extremely so. Vasari's explanation is
thus inconsistent with the master's practice. In
other respects his observation is just; when a
picture is repeatedly covered it is important that
the under layer, if thick, should be quite dry before
another is superadded. This precaution appears
even in the directions of Eraclius, and that it was
observed by the first oil painters in the improved
method is apparent from the passage before given
from the manuscript of Filarete. For the rest the
methodical application of three successive layers
belongs rather to the practice of Vasari's time than
to that of Perugino. In his life of Fra Barto-
lommeo, the biographer, in speaking of similar
defects in one of that painter's works, again alludes
to those altar-pieces by Perugino, and attributes
the evil in both cases to the application of " fresh
colours to a fresh size " (the size and gesso
priming). The precaution of painting on a per-
fectly dry priming is also important, but it was not
necessary to assign such a cause for the cracks in
transparent darks.

Of the three altar-pieces referred to, that in the church " della Calza " is a very fine specimen of the master; it represents the Crucifixion, with the Magdalen, St. John, St. Jerome, and St. Colombino (founder of the Gesuati).* The picture is not in bad preservation, but has been neglected, and much needs a coat of varnish, having now almost the appearance of a fresco. On nearer inspection, the darks, which are more or less cracked and blistered throughout, are found to be thicker than the lights, which, however, appear to have lost none of their original body; minute darks, such as the foliage even of distant trees, are, as it were, embossed; both flesh and draperies, here and there, exhibit hatching. The surface of the green drapery of the Magdalen is remarkably prominent; the shadows of the crimson drapery are also thick, and are much cracked and corroded; some parts of this drapery, and others that have chipped, show the white ground underneath. The other two pictures, the Pietà and the Gethsemane†, are in the gallery of the Florentine Academy. In the latter the shadows are raised, even those

* The likeness of this picture to Luca Signorelli has, as we have seen (p. 127), been suggested. Cavalcaselle (vol. iii. p. 247) says : " It is difficult to ascribe this piece either to Perugino or Signorelli."—*Ed.*

† Of this picture Sir Charles Eastlake says in a note, dated 1856 :—" Colour of dead Christ and of standing figure behind St. John—yellow and brown—like an approach to Signorelli; none of the heads *quite* like Perugino, perhaps the Christ and Nicodemus most."—*Ed.*

under the features; the darks of the draperies are also prominent, and are now blistered and roughened. The flesh, on the contrary, is thinly painted, so as to show the light ground within it. In the Pietà the flesh is somewhat more solid, but in this picture also the darks are thick, cracked, and corroded.

The altar-piece painted in 1493 for St. Domenico at Fiesole, and now in the tribune of the Uffizj, has the same general peculiarities; the darks especially are thick, and have suffered to a certain extent in the usual way.

The once beautiful S. Chiara picture, now in the Pitti Gallery, is said to have suffered from the sun's rays in its original situation; it is now in a very ruined state, and has been much repaired. It is, however, to be observed that the darks are all raised, and the greens and blues especially so: the cracks in these colours indicate the use of the white varnish; the shadows of red drapery, rough and blistered, indicate that of sandarac. The flesh, though not without body, is so relatively thin as to be often embedded in the surrounding darks, and in some places it exhibits hatching.

The enthroned Madonna and Child surrounded by the patron saints of Perugia, now in the Vatican, is a fine and well-preserved specimen of the master. The usual prominence of the darks, and the usual difference in substance between the flesh and the draperies, are again observable. The blue drapery

of the Madonna, and the green of the saint reading, are both thick — the blue extremely so. The surface has suffered but little from cracks, but where they appear the varieties follow the conditions before noticed. The minute cracks of the lake drapery of the bishop with the crozier show the white ground within, now varnished to a cream colour. The substantial shadows of the blue drapery show marks of the brush, not to be confounded with hatching.

Some other pictures of the master in the same gallery (the Vatican) may be here noticed. A Nativity (from Spinola, near Todi), painted about 1500, exhibits the same qualities. The hands of the Madonna are embedded in the surrounding draperies; the blue is extremely thick and cracked, but has been much restored; the red drapery is hatched in the shadows. The flesh is so thin as sometimes to show the outline underneath—a dark single line; the shadows of the flesh are a little hatched; this is also observable in the head of Joseph ascribed to Raphael.

In the picture of the Resurrection (1502) in the Vatican the flesh is very thinly painted, the boundaries of the surrounding colours, of whatever kind, being much more prominent; the flesh is in this case free from hatching.

The celebrated Ascension, now at Lyons, has been transferred from wood to cloth. After a picture has undergone this process, however safe that pro-

cess may sometimes be, the finer inequalities of the original surface, the relative prominence of darks and lights, are less distinguishable. In this case either the operation or the subsequent cleaning has considerably injured the effect of this once finely-coloured work; still, the peculiarities already noticed are plainly to be traced. The surface of three predella pictures which are in the public gallery at Rouen (and there erroneously ascribed to Raphael) is sufficiently well preserved. They represent the Adoration of the Magi, the Baptism, and the Resurrection: of these the Baptism is the best. In the Adoration of the Magi a figure occurs on the left (with the drapery hanging from the shoulders behind, free of the figure), which is repeated in the Città della Pieve wall painting, and appears to have suggested the St. John in Raphael's picture at Blenheim.* In these predella pictures the flesh is thinly painted, and, as in the former specimens described, is embedded in the surrounding colours—the darks, and especially the blues and greens, having the usual relative thickness. The sky is somewhat more solidly painted than the flesh, the substance of the trees, whether blue or green, relieved on the sky, is prominent.

Of the figures of saints which also adorned the

* Two small pictures, replicas by Raphael of the Baptism and Resurrection, in the possession of the King of Bavaria, are copies from the corresponding subjects at Rouen.

altar-piece of the Ascension, six returned to Pe-
rugia, and three are in the Vatican Gallery. In
the latter more or less hatching is observable ; the
shadows only in the flesh of the S. Benedetto are
cracked, the lights not being at all so. This last
peculiarity is indeed almost universally the case in
Perugino's works, and is a consequence of the thin-
ness with which the flesh was painted. The hands
of the aged S. Placido show white lights like a
chalk drawing, and the flesh of the S. Flavia is
hatched throughout. The backgrounds of these
heads appear to be repainted, for in Orsini's time
they were all, according to him, of the colour of
indigo.*

The interesting picture of the Sposalizio, which
was followed so closely by Raphael in his celebrated
small picture of that subject, is now the chief orna-
ment of the museum at Caen, in Normandy. The
picture had suffered in the last century by over-
cleaning, and the original thinness of the flesh is
here so much reduced that the white ground is in
some places scarcely covered ; the flesh does not
appear to be hatched. The blues, even of distant
figures, and the green drapery of the high priest,
are prominent ; the glazing colour in the green
drapery above the hand of Joseph which the high
priest holds, has accumulated there, indicating the

* Orsini, Vita di P. Perugino, p. 160. These pictures, with
others now in Perugia, were copied by Sassoferrato.—*Ib.*,
p. 160, and note.

flow or drop of the vehicle. The darks in the blue
drapery of the Virgin are blistered and rough. A
small picture of St. Jerome by Perugino, in the
same gallery (Caen), probably part of an altar
decoration, is thinly painted, and here and there
exhibits hatching.

The picture of the Nativity painted for S.
Antonio Abbate at Perugia, and now in the Louvre,
is in excellent preservation, and clearly exhibits
the peculiarities of the master's practice. The
kings or magi are represented arriving in the
middle distance. All the darks, in distant as well
as in near objects, are more prominent than the
lights. The blues and greens, the former especially,
have the greatest apparent body; minute darks,
such as stems of trees, appear embossed. The flesh
is throughout embedded in the surrounding colours,
but is blended and free from hatching. This pic-
ture was not numbered in the catalogue of the
contents of the Louvre in 1815. A Holy Family
by the master, No. 1161, exhibits partial hatch-
ings, the raised darks have in this case suffered
more; the thick vehicle used with the shadow is
betrayed by the minute darks, such as the divisions
of fingers, where they appear as projecting ridges
opposed to the thin flesh. In a figure of St. Paul,
by Perugino, No. 1355, the transparent colour in
the green drapery appears to have flowed where
the green meets the red, and again on the under
side of the right arm.

A picture of the Assumption painted in 1500 for the monks of Vallombrosa, and now in the gallery of the Florentine Academy, exhibits the same general qualities as the former specimens described. In this and in some other pictures by the master, the thick vehicle with which the glazing colours were applied is sometimes grained by the hairs of a larger brush. The flesh is thin, and in this instance both flesh and draperies are hatched. A small Madonna in the Pitti Gallery may close this sufficiently numerous list of examples; in it all the darks are raised, those even in the features and extremities, as in the dark line of separation, before noticed, between the fingers. The flesh is thin, and, as well as other portions, is partially hatched.

Referring to the Vallombrosa picture (the date of which is unquestionable) and to other examples, it thus appears that the system of hatching in oil pictures was more or less retained by Perugino in the best period of his practice. As this mode of execution was not derived from his fellow-students, the scholars of Verocchio, nor from the best examples of the Flemish process, it is only to be explained by his habits in tempera painting—a process which he practised to the last, and which may have influenced his hand. In the Città della Pieve wall painting (1504), and in the single figures in fresco in S. Severo at Perugia (1521), Gaye*

* See contribution to the *Kunst-Blatt*, 1837, p. 271, by this writer.

remarks an excess of this hatching, and a want of due finish in consequence. It is seldom employed to excess or so as to impair the effect of his oil paintings, and in some of them is hardly introduced at all. Such a system, designs being ready, was favourable to the rapidity with which Perugino's later works were executed, but in those later works it was mechanical rapidity only, and no longer accompanied by vigour or depth. It is remarkable that with such a feeling for force and richness of colour as his best works exhibit—qualities in which he surpassed most of his contemporaries—he should in many cases retain a mode of execution not only not required in oil painting, but which its means enabled the artist to dispense with. Whatever may be said in favour of such a method, it must be admitted that it is not characteristic of oil painters, and that it is not to be found as a systematic mode of execution in the works of the best masters.

With such powers as a colourist in oil as the Vatican picture, the Ascension, and other specimens exhibit, it is not to be supposed that Perugino leaned rather to tempera than to the new method; but it has been sometimes a question whether certain of his works—not, it is true, the most celebrated—are in tempera or in oil. It is known that the Italian painters towards the close of the fifteenth century, in their transition from the one method to the other, frequently completed tempera pictures with oleo-resinous colours. A Madonna

by Ingegno, a few years since in the Metzger collection in Florence, may be cited as an example.* Long before the introduction of the Flemish method, portions of tempera pictures, as we have seen, were covered with transparent oleo-resinous glazings, and as the whole work was finally varnished with "vernice liquida," such partial tintings were not inharmonious. In the more extensive subsequent use of this system, the flesh and sky were always covered least, and many a work in which the process now seems ambiguous has more or less the qualities of an oil painting throughout, except in those parts, which are sometimes only slightly toned by the final general varnish. When the oleoresinous tinting is carried still farther, the work is to all intents an oil picture.

The practice of the Italians, at first reluctant to quit tempera for the new mode, and adopting half measures, explains the origin of oil painting and the peculiarities of its early process; the use of tinted oil varnishes being of very ancient date. Even in the Venetian school early works of Bellini, assumed to be in oil, have been sometimes discovered, too late, to be in tempera—the surface, after the removal of the varnish, having yielded to the application of moisture.†

As the apparently capricious treatment of pic-

* See Passavant, vol. i. p. 503.

† See Zanetti, Della Pittura Veneziana, pp. 47–48.

tures, in regard to their subjects, has been some-
times traced to the will of the employer rather than
to that of the painter, so the method or process to
be adopted was not always decided by the latter;
but, however this may be, the occasional union of
tempera and oil painting by Perugino may be con-
sidered an attempt on his part to introduce the
new mode rather than to cling to the old.

From the examples adduced it appears that the
practice of Perugino as an oil painter differed from
that of Leonardo and Lorenzo di Credi chiefly in
the treatment of the flesh. In Perugino it is almost
invariably thin, and not unfrequently exhibits the
white ground underneath. In the works of his
two fellow-students this indication of want of body
is scarcely ever to be remarked, and tracings of
hatching are equally rare. As a colourist, Perugino
in his best time was superior to both. In the
tinting of his pictures, he fearlessly employed the
rich varnishes of the Flemish masters, and his use
of them appears, with few exceptions, to have been
according to the original methods before described.
His blues and greens are thickly protected with the
" white varnish;" his flesh tints, transparent reds,
and glowing colours are applied with the warmer
sandarac varnish, which is profusely used in the
shadows and deeper local colours. In the use of
this—the " red varnish"—Perugino seems to have
contented himself with the " vernice liquida" (san-

darac and linseed oil); his shadows, if painted with the firmer amber varnish, would hardly have exhibited the cracked appearance which Vasari noticed so soon after the date of the artist, and which is still apparent. For a considerable time, if not exposed to violent changes of temperature, the sandarac oil varnish, as already observed, is quite equal in its effects to the finer composition, and is unsurpassed in gloss. The parsimonious habits which were attributed to Perugino may explain his preference of the least costly materials, and may account for his common use in draperies of the "azurro della Magna"—indicated by the abundant protecting varnish which ultramarine did not require. In some cases—for example, in the Montone altar-piece—according to Orsini, he used smalt in tempera on a black preparation.* In fresco painting, in which ultramarine is indispensable, he however employed it freely; and Vasari records an anecdote of his dealings with the Prior of the Gesuati at S. Giusto alle Mura, from whom the painter obtained this colour.† It is supposed, and not unreasonably, that Perugino learnt much relating to pigments from the friars of that convent, who were excellent chemists. The "Secreti" of a Gesuato, including various recipes for preparing

* The practice, according to some, of using smalt in tempera was sometimes resorted to by Paul Veronese. See Orsini, *Descrizione della Pittura, &c., della Città di Ascoli*, 1790, p. 73.

† Vasari, vol. i. p. 420.

colours, and one for purifying linseed oil*, were
published at Lucca about thirty years after Peru-
gino's death. If the three oil pictures above noticed,
originally painted for S. Giusto alle Mura, were,
as we have supposed, executed before 1480, then
the honour of being the first in Italy to display the
resources of the Flemish system, as a means of
insuring warmth and transparency, may be awarded
to Perugino, as Giovanni Bellini cannot be said to
have approached those qualities in oil painting till
1488. The first works of Perugino, as a colourist,
were executed about 1495, and of these the altar-
piece in the Vatican, representing the Madonna and
Child, surrounded by the patron saints of Perugia,
is a remarkable example. The sunny glow, con-
sidered apart from a certain dryness in the forms,
and certain mannerisms which the painter never
entirely got rid of, may stand beside the richest
works of the Venetians. This is the least important
picture, as to subject and dimensions, which bears
that date†, but neither of the others—neither the
Pitti altar-piece, once in S. Chiara, nor the Sposa-
lizio at Caen, nor the Ascension at Lyons—are so
well preserved.

* Vol. i. p. 321, note.

† The date generally indicates that the picture was com-
pleted in the year inscribed, but when begun is not always so
certain. It is hardly to be supposed that the three or four
large altar-pieces, with the date 1495, were the labour of one
year only.

The name and works of Francesco Francia are readily associated in the memory with those of Perugino. In point of time the Bolognese artist cannot indeed be classed with the earliest oil painters, his first known work being dated 1490. Little is known of his education in art; originally a die-engraver, he is said to have first practised painting at nearly the age of forty. It has been supposed that the works of Perugino, three of which adorned churches in Bologna, first inspired him with a love of oil painting. His practice, like his general taste, has a close affinity with that of the Umbrian master, but a comparison of the works of both shows that they differed even in some technical respects. The best of the altar-pieces which Perugino sent to Bologna—that of S. Giovanni in Monte—is now in the Bolognese Gallery, where it may be compared with several examples of Francia.

The occasional fondness of the Bolognese painter for heightening certain portions of his pictures— not only ornaments and rays, but the lights of distant trees — with gold, can hardly have been derived from Perugino. With the exception of the gold ground of the Montone altar-piece one instance only is cited in the works of Perugino— an early picture of the Transfiguration in the Chiesa de' Servi at Perugia, in which gilded rays were introduced.* In the treatment of the darker

* The gold rays in question were effaced by an inexpert cleaner even in Orsini's time.—See Vita di P. Perugino, p. 21, note.

colours and deep shadows Francia closely followed
the then customary methods. Such portions are
inserted with a thick oleo-resinous vehicle, but, as
the extreme darks seldom exhibit the corroded
appearance which is so common in the oil pictures
of Perugino, it is to be presumed that the material
used was not always the sandarac varnish. In the
lighter vehicles (white varnishes) employed with
blues and greens there was less choice, and accord-
ingly, in them (in the blues especially) the effects
of time betray themselves in the works of Francia,
as in other oil pictures of the period. But the chief
difference in the practice of this painter, as compared
with that of Perugino, is the greater solidity and
the fusion of his flesh tints. In his first known
work, dated 1490, above noted; in that represent-
ing the Angel of the Annunciation appearing to the
Virgin in the presence of St. John the Baptist and
St. Jerome ; and in that of the Nativity—all in the
gallery at Bologna—the flesh, though in every case
less prominent in surface than the darks, has con-
siderable substance, and frequently exhibits the
fine hair cracks common in Leonardo's works, but
scarcely ever to be seen in those of Perugino.
These general peculiarities will be recognised in the
Francias in the National Gallery, and in a picture
of the Baptism by the same master at Hampton
Court. In these examples, besides the common
characteristics of apparent substance in the trans-
parent colours and darks, and of greater prominence

in the blues, and occasionally in the greens, it will be seen that the more solid parts of the flesh are here and there minutely cracked. Another attribute of Francia, again differing from Perugino, is the blended surface of his flesh, which never exhibits hatching, or, if ever, only in the fainter shadows. It is doubtful even whether such appearances may not be the hatching of the drawing underneath, seen through the thinnest portions of the flesh tint. The gallery of the Louvre has no specimen of Francia.* In the collection of Count Pourtalés in Paris† there are two specimens; in both, the flesh, though less prominent than the surrounding colours, is solid and fused, and exhibits (in the larger specimen chiefly) the fine hair cracks before described.

It has been sometimes said that the manner of Francia holds a middle place between that of Perugino and Giovanni Bellini. This is hardly correct. The practice of Francia is rather composed of the manner of Leonardo, Lorenzo di Credi, and Perugino. The superior solidity of his flesh is attained at the cost of some of Perugino's glow, and there is scarcely a particular, except perhaps the taste of his backgrounds, in which he can be said to approach the

* At the time this was written there was no Francia in the Louvre ; now that gallery possesses a rather inferior specimen. It is remarkable that no specimen of this great painter was carried off from Italy by the French.—*Ed.*

† Sold in 1865.—*Ed.*

Venetians more nearly than the Umbrian master. Vasari classes the two masters together, and appears to consider them the first who, in Central Italy, displayed the resources and the charm of oil painting. He tells us that " people crowded with enthusiasm to see this new and more real perfection, deeming absolutely that nothing could ever surpass it." Part of the attraction was, or deserved to be, the unaffected religious feeling which pervaded their works; these merits, at all events, are such as still to command the homage of a large section of the tasteful world. Still, looking at their claims in relation to their own age, it must be admitted that, in technical respects, this almost exclusive attention to the novel excellence which they recommended, rendered them inattentive to the rapid progress which others around them were then making in design. Michael Angelo, who had no partiality for oil painting, ridiculed them both; and Vasari, after the above eulogy, intimates that the ampler style of Leonardo da Vinci (the type of which, he might have added, was the Last Supper, at Milan) again enlarged the boundaries of the art beyond all anticipations, and gave a new direction to the public taste.

CHAP. IV.

RAPHAEL—FRA BARTOLOMMEO—MARIOTTO ALBERTINELLI—RIDOLFO
GHIRLANDAJO—GRANACCI—BUGIARDINI—ANDREA DEL SARTO.

In pursuing an enquiry into the Italian practice of oil painting, it will often be necessary to refer to pictures remarkable for their invention and expression. That the mere technical peculiarities of such works should hitherto have been scarcely noticed can excite no surprise. The impressions which such productions excite so entirely supersede the consideration of the mere art, that we seldom feel disposed to enquire what are even their merits in the mechanical parts of painting. For the present, however, our attention is professedly confined to those outward qualities, and while the subordinate nature of such researches is admitted, it must be evident that examples which are well known, and which are remarkable for their preservation and general excellence, must be the fittest for our purpose. The apology here offered may require to be remembered throughout these volumes, but it appears to be more especially necessary in approaching the consideration of works which, from

their chiefly addressing the feelings and imagination, generally compel us to overlook their mechanical and material conditions.

In all technical particulars the early works of Raphael, as might be expected, closely resemble those of Perugino. His first style was even confirmed for a time in Florence by the example of Fra Bartolommeo, who, it will appear, in many points closely adhered to the original method of oil painting. It was not till the year 1508, and immediately before he removed to Rome, that the great painter began to adopt the more solid manner of Leonardo da Vinci and his followers. In Rome that manner was still preferred by him, and if, in his later works, some characteristics of the older method are to be recognised, this is rather to be attributed to certain of his scholars who prepared his pictures than to any further change in his own practice.

The method of hatching which the earlier pictures of Raphael exhibit is rarely apparent in his more mature works. His first essays were probably in tempera, like the copy by him, still at Perugia, of the two children in the picture by Perugino at Marseilles, before mentioned.* The two predella pictures of the Baptism and Resurrection in the possession of the King of Bavaria, which appear to be copied from those by

* See p. 131.

Perugino now at Rouen, are either in tempera or, if in oil, are hatched according to the habits of a tempera painter. Some of the earliest examples of Raphael's execution—pictures by Perugino in which he assisted—are now in the gallery of the Vatican. The picture of the Resurrection has been already noticed among the works of Perugino. A Nativity, called "Il Presepe della Spineta," from the church near Todi whence it came, is supposed to have been partly painted by Raphael at a very early age. This is corroborated by the existence of a study by him in black chalk, now in the British Museum, for the head of Joseph—the portion of the picture (otherwise weak) which is most worthy of him. In some parts of that figure hatchings are observable in the shadows of the flesh; the flesh throughout is very thin, and shows the delicate outline like a pencil line through it: the blue drapery next the hands of the Madonna forms a thick raised boundary round them; the red drapery is hatched in the shadows.

The first altar-piece, and the only Crucifixion known to have been painted by Raphael, is now in England, in the possession of Earl Dudley. It was painted for the church of S. Domenico at Città di Castello, whence it was removed during the French occupation of Italy at the close of the last century; it afterwards formed part of the collection of Cardinal Fesch. This interesting work appears to have been completed about the year 1500, when

Raphael was only seventeen years of age; in its general treatment, and in certain peculiarities of form and action, it closely resembles the style of his master, and Vasari remarks that if the name of the artist were not inscribed on it, it would be supposed to be by the hand of Perugino. It has been observed that the expression of the head, and particularly that of the Magdalen, already evince the finer feeling of Raphael; indeed Vasari, even on another ground, is hardly correct in the observation referred to, since Perugino was at the zenith of his practice at the period when this altar-piece was executed, and, as regards mere completeness of execution and richness of colouring, would undoubtedly have produced a very different work. Still, the picture, which is remarkably well preserved, affords the clearest evidence of the adoption of Perugino's practice. The outline, which is often visible through the thinner portions of the work, is drawn on a white ground. The flesh is thin, so much so that the hands and other portions appear less prominent than the surrounding darker colours of draperies; both flesh and draperies are sometimes hatched. The darks in general are raised; this is even apparent in the minute darks of the features, showing that a very thick vehicle was used with the transparent browns; it is also remarkable in the shadows of the blue drapery, and in the greens generally. The sky is, as usual, somewhat more solid than the flesh, and, like some other

portions, has the appearance of having been painted in tempera, but this is a question always difficult to determine.

That the light parts should be almost free from cracks is partly explained, as in Perugino's works, by the thinness of the pigment; yet the darks, often prominent with a rich vehicle, are nearly as sound. When it is considered that this altar-piece remained for nearly three hundred years in the church for which it was painted, its fine state of preservation, as compared with that of pictures which have, under similar circumstances, gone to decay, appears to indicate the use of the firmer medium then employed, namely, the amber varnish. With respect to the prominence of the minute darks, it has already been explained that such portions, executed with a thick oil varnish, remained of necessity more raised than larger surfaces so covered, simply because there was less room to spread the tint. The same peculiarity is often observable in early Italian, as well as Flemish oil pictures, in minute lights, such as embossed ornaments. These are prominent, not so much by the thickness of the colour as by that of the vehicle. In such instances, the edges of the touch are blunt, and are easily distinguished from the dry crisp touch of the solid pigment (with the least possible quantity of vehicle), observable in the works of some Venetian masters.

The prominence of the transparent colours gene-

rally, and of the minuter darks in the features, is to be regarded as a test of the good preservation of an early oil picture. The inequality of surface is less observable on such pictures when painted on cloth, as the artists appear to have taken the precaution not to load the semi-resinous vehicle so abundantly on a flexible material, for fear of its cracking; but the smoother appearance in question is sometimes to be attributed to the operation of lining, in which, in order to secure the adhesion of the additional cloth at the back, the picture is submitted to great pressure. The same flattening result is also likely to take place when pictures are transferred from wood to cloth. Raphael's Coronation of the Virgin, painted in 1502 for the church of S. Francesco in Perugia, and now in the Vatican, was, in consequence of the decay of the wood, necessarily thus treated in Paris, whither it was conveyed in 1797 from its original place. The operation appears to have been better performed than that of restoration, the effects of which are traceable here and there in darkened spots. The flesh, in this work, is extremely thin, appearing, as usual, embedded in the surrounding colours; the outlines, as in the feet of the Apostles, are visible here and there through the pigment. The blue drapery of the Madonna is corroded, and has a dull surface in consequence of that gritty appearance of the colour before described; a similar appearance is observable in the darks. The brilliant green

drapery is extremely thick, and is now covered
with horizontal, slightly projecting ridges (pro-
bably following the fibres of the wood, and occa-
sioned by its contraction); it is cracked in the
shadows, where the vehicle is still more abundant.
The corroded effect in some darks is here to be
attributed to the use of the sandarac oil varnish
("vernice liquida"), while the mastic oil varnish
("vernice chiara") is clearly indicated in the green.

The three predella pictures belonging to this
altar-piece are also in the Vatican Gallery; the
subjects are, on the left, the Annunciation; on the
right, the Presentation in the Temple; in the
centre, the Adoration of the Kings. The same
general peculiarities as regards execution and
materials are here observable: the angels' dark
wings in the Annunciation are very prominent in
surface; the flesh, which is remarkably thin, is not
at all hatched (the figures being small), but is
highly finished and fused—its surface is very per-
ceptibly lower than that of the surrounding colours.
A portion of the blue distance in the centre picture
is more raised than any other part; the darks of
the lake draperies are also very prominent. In the
third picture, the Presentation, the shadows of the
yellow drapery are hatched; a green drapery has
much less vehicle than usual, and has faded in
consequence: the effects of the protecting "vernice
chiara," and of the want of it, may here be com-
pared in the same altar-piece, the greens in the

large picture being remarkably fresh. The gesso ground of these predella pictures is visible at the edge, showing that it is as thick as in the early Flemish pictures.

The Vision of a Knight, in the National Gallery, is placed by Passavant in chronological order after the last: it may have been painted about the year 1503. The finish of the flesh in this small work resembles that of the predella pictures last described; here, too, the minuteness of the size renders the thinness of the flesh less remarkable, but its relative thinness as compared with the darks is immediately observable. The purplish dress of the figure with the sword, the greens and blues, are all much raised; the lakes, as usual, more in the shadows: the minute darks, as in the nearer tree, and the small tree in the landscape also project. The sky has considerable body, but not more than the distant mountains: the most prominent portions of the picture are, as usual, the darks. The gesso ground is visible at the edges; some indications of gilding on the ground next the border are probably derived from the frame.

The same general appearances are to be traced in the celebrated Sposalizio at Milan, painted in 1504. In that work the opaque colours are sometimes so thin that the outlines, especially of the architecture, are visible through them; the darks, some of which appear to have increased, are, as usual, prominent.

From 1505 to 1508 the gradual influence of Florentine examples is to be traced in the works of Raphael; yet less, for a time, in modes of execution than in general taste. The smaller picture of a Madonna and Child, in the possession of Earl Cowper at Panshanger, belongs to the earlier date, and, from its excellent preservation, is a remarkable example of the methods hitherto described. The flesh is extremely thin, and is highly hatched here and there in the half-shadows; the sky is somewhat thicker; the darks are prominent, especially the green and blue draperies: the blue drapery is so thick, that where the colour is inserted between the fingers of the Madonna's hand it has the appearance of a solid wedge. In this instance the "vernice chiara," or mastic oil varnish, must have been used: the cracks are large or continuous, having the usual appearance of mastic cracks. The varnish was probably made extremely thick, to correct its tendency to flow; it has also answered the intended effect of preserving the "azurro della Magna."

The Ansidei altar-piece, now at Blenheim, has the date 1505—or 1506.* The picture is in excellent preservation: the broader shadows in most of the heads and necks are a little hatched; the Madonna's head is more thinly painted than the rest, but the flesh is nowhere cracked; the sky is

* Mr. Gruner, the well-known engraver, reads 1506 ; Passavant, 1505.

more solid, but still is not so prominent as the darks, immediately next it, of the baldachin or throne behind the Madonna: the darks are always prominent, the edges often appearing in ridges. The green drapery of St. Nicholas, which has the same peculiarity, is rough, as if painted with ill-ground colour; the blue drapery of the Madonna is much raised in the shadows, and is roughened by cracks of the "vernice chiara." The lights on the blue drapery are hatched; the red drapery of St. John was prepared for glazing by a more solid preparation than usual; the shadows are, however, still comparatively raised. Some lines, as in the architecture of the Sposalizio, are indented; the cross held by St. Nicholas has this appearance. The ground was white; it is seen through some rubbed parts, as in the left leg of the child. The comparative solidity of the lights in this picture may be an additional reason for reading the date 1506 rather than 1505; at the same time it is certain that other works by Raphael, executed at a somewhat later period in Florence, are again thinner in the opaque colours, as if the artist fluctuated between the influence of Fra Bartolommeo and Leonardo da Vinci. The rapidity with which some of these works were executed, when once the design was completed, may, however, sufficiently account for such apparent varieties.

To the same period (about 1506) belongs the St. Catherine in the National Gallery. Various

studies for this figure exist, and the cartoon of the size of the picture is in the Louvre. In the flesh, the painting is so thin that the hatched outline on the white ground—for example, in the neck—is distinctly seen through the colour. The sky, though still thin, is somewhat more raised than the flesh. The darks are all prominent, even to the shadows of the features. The hands are embedded in the darks immediately round them. The toned green of the sleeve, glazed over a light preparation, is, as usual, prominent. The lake drapery appears to have been prepared with bright lights; still the comparative prominence of the shadows is apparent; the same peculiarity is observable in the trees and near leaves in the landscape. The picture is in excellent preservation; the lights are free from cracks, and there is only a slight tendency to the corroded effect, so often described, of the sandarac varnish in some unimportant parts of the lake drapery.

The picture of the Entombment of Christ, now in the Borghese Gallery at Rome, has the date 1507. The outlines on the white ground are, in this instance, much thicker than usual, as if inserted with a brush; they are visible in many parts of the figure carrying the body (at the head), in the left arm of the opposite supporting figure (at the feet), and in the Madonna's head. The flesh in the figure of the Christ is much more finished than in the others; it is more solid, and,

except in some shadows, is free from hatching. In other portions—as in the Madonna's head, in the hands of the female clasped round her, and in those of the other holding her up—hatching is very perceptible. The hair of the supporting figure at the feet of the Christ is also expressed by lines, as is the yellow hair of the kneeling female. Notwithstanding the comparative solidity of the figure of the Christ, the whole mass with its accompanying drapery is embedded in the surrounding darks. This is the appearance of the flesh throughout, with the single exception of the profile of the man holding the legs, the surface of which is somewhat more raised than the dark landscape background on which it is relieved. The green and blue draperies are much the thickest parts of the picture, the green being uniformly raised, the blue most in the shadows. Both are cracked; the green indicating the use of the "vernice chiara," and exhibiting cracks and ridges following the fibre of the wood (in this case placed vertically). Some cracks in the light portions are traceable to the same cause, as distinguished from cracks in the pigment itself. These latter are nowhere apparent.

Of the last works executed by Raphael in Florence, it will be sufficient to mention two—the larger Madonna at Panshanger, which has the date 1508, and the "Belle Jardinière" in the Louvre, supposed, on good grounds, to be the picture which Raphael left with the blue drapery

unfinished, and which, in that portion, was completed by Ridolfo Ghirlandajo. The picture at Panshanger can be conveniently compared with the earlier work, before described (p. 160), in the same collection. In the later work the flesh has more body, so that the surface has here and there fine hair-like cracks, like those already noticed in Leonardo da Vinci. The green and blue portions of the drapery are much raised, the darks are universally so, and the blue sky is more prominent than the heads.

In the "Belle Jardinière," although the sky is thicker than the flesh, the latter has considerable body in the lights, while in the thinner faint shadows hatching is here and there apparent. The more solid parts of the flesh have the same hair-like cracks as the specimen last described. The darks throughout are prominent, the blue drapery is especially so, and appears to have been painted with much vehicle. The work of the brush is visible in the semi-solid colour.

These examples have been selected from among many others, partly because their dates are more accurately determinable. In comparing the technical qualities, to which our attention is, for the present, confined, with those before noticed in the first Florentine oil painters and in Leonardo da Vinci, it will now be apparent that Raphael, especially in his more elaborate and studied works, gradually adopted the system of painting the flesh

with substance. In the absence of unfinished pictures of his later time, it may be inferred that this more solid execution was the result, as in Leonardo's case, of repeated operations. This method afforded the means of revising the forms; but it is remarkable that this advantage was never abused by Raphael. To the last his preparatory outline was definite, and his corrections rarely differed much from the design which, after numerous sketches and studies, was fixed as the groundwork of the picture. Examples of a very opposite practice by some of the colourists will hereafter be noticed. There can be no doubt that habits of decision and of mental activity are best cultivated by determining the design at first, while the opposite practice of relying on the facility with which alterations may be made in oil painting tends at least to procrastinate the needful exertion. It is curious to compare, in this respect, the *pentimenti* (after-thoughts or corrections) of Raphael with those of Leonardo da Vinci. The Adoration of the Magi, before described, by Leonardo, shows how soon the artist's experience of the possibility of correcting an oil painting by repeated operations led him, in the instance quoted at least, to capricious changes and apparent indecision. At a later period, painters accustomed to a very different practice would have easily remedied the mere outward defects thus occasioned; but Leonardo, fastidious in regard to the process as well as the design,

appears to have thrown aside the sketch, which perhaps he felt he had marred, in disgust.

As before explained, Leonardo appears to have gradually adopted (perhaps invented) the system of repainting, in order to reserve the power of improving his forms and expressions. It will now appear that Raphael, in following that method, may have been influenced by a conviction that the work was likely to be more durable by being solidly executed. It is true he found another advantage in departing from the "alla prima" method of the early oil painters. As occupation crowded upon him, he must have soon looked forward to the employment of assistants, and it seems that, even in Florence, he sometimes availed himself of such means of gaining time. In such a system repeated operations are indispensable. The *abbozzo*, or under-painting, however thinly executed by an assistant on the outline (perhaps traced by the scholar, and afterwards corrected by the master), would, in most cases, be entirely covered again by the master's work, and thus a certain thickness of the colour would be unavoidable. The question is so far interesting, inasmuch as all pictures executed so thinly as to indicate one operation only, must, if exhibiting other sufficient evidence of their authenticity, have been painted by the master alone. But the proof that Raphael aimed at solidity in his later works, from a belief that such a mode of execution insured their durability, is to be found

in his later portraits—works in which the heads at least must have been executed by his own hand. The portrait of Julius II. in the Pitti Palace, of which there are numerous repetitions, is thus solidly painted; that of Leo X. in the same gallery, that of Count Castiglione in the Louvre, that of the Violin Player in the Sicarra Palace at Rome, with many others, have the same quality, as distinguished from the more thinly painted portraits of the Florentine period, such as those of Agnolo and Maddelena Doni, and others.

On Raphael's arrival in Rome in 1508, he was soon engaged in preparing designs for the Vatican frescoes, and during the pontificate of Julius, who died in 1513, his oil pictures are not numerous. Among them may be mentioned the " Vierge au Diadème " (called also " Le Sommeil de Jésus "), now in the Louvre; the Madonna and Child in the Stafford Gallery; and the Madonna di Foligno. In these and other oil pictures of the same period by the great artist, although the co-operation of assistants is in some cases to be supposed, the work may have been entirely covered by the master's hand. The three pictures referred to all exhibit, together with the prominent darks of the old practice, a thicker *impasto* in the flesh. In the first named—the " Vierge au Diadème "—the flesh in the sleeping infant exhibits the fine cracks so perceptible in the works of Leonardo. In other technical respects the habits of the early oil painters

are apparent; the darks are raised, and the blue drapery on which the infant sleeps is extremely thick. In the graceful Madonna and Child in the Bridgewater Gallery the flesh has the usual cracks, and the blue drapery is extremely prominent, so as to make the flesh near it appear embedded. The Madonna di Foligno, in the Vatican Gallery, was transferred from wood to cloth in Paris, and, for the reasons before given (p. 139), perhaps the original varieties in the surface may have been somewhat obliterated in the process. Still, the greater prominence of the darks is here and there to be observed, as, for instance, in the green background next the boy standing below. The flesh is, however, much more solid throughout than in the early works of the master: the most prominent darks are the shadows in the grey dress of St. Francis.

During the remainder of his laborious life, from 1513 to 1520, the number of Raphael's undertakings rendered it necessary for him to depend more than ever on the assistance of his now numerous scholars. All the oil pictures of this period are remarkable for the thicker painting of the flesh; in some which have been transferred from wood to cloth, the difference between the surface of the flesh and that of the darks is scarcely perceptible. This is the case in the large Holy Family, now in the Louvre, painted for Francis I. (1518), in which the hand and colouring of Giulio Romano are apparent, agreeing with Vasari's statement respecting

that painter's assistance in the work. The large
St. Michael, in the Louvre, also transferred from
wood to cloth, is in the same state; but the thicker
impasto of the flesh is here not to be mistaken. In
the Madonna della Sedia in the Pitti Palace, the flesh
has again much substance; but in this instance all
the darks are raised, and the green drapery is espe-
cially thick. Lastly, in the Transfiguration, which
is still on its original wood, although the flesh has
considerable body, the darks are all raised round
it, and the blues and greens remarkably so. The
shadows of the blue drapery of the woman kneeling
in the foreground are loaded with vehicle, which
has cracked widely. The sky is, as usual, more
raised than the flesh, which is evident where they
come in contact—as in the undraped portions of
the figure of Christ. The heads and extremities of
the figures kneeling on the left, though thickly
painted, are embedded in the surrounding darker
colours.

These examples are sufficient to prove that the
process of transferring large pictures from wood to
cloth tends to efface the varieties of surface, thus
obliterating indications which throw great light on
the early history of oil painting. It is not to be
supposed that the difference which has been pointed
out in the larger pictures so transferred, as com-
pared with better preserved specimens, is to be ex-
plained by the different habits and practice of
Raphael's scholars. One of the altar-pieces which

he had early engaged to paint was, in consequence of his increasing occupations, so long deferred that the design only appears to have been ready at his death. The subject of this work, originally in the convent of Monte Luce, near Perugia, and now in the Vatican, is the Coronation of the Virgin. Four years after Raphael's decease his two principal scholars and executors—Giulio Romano and Francesco Penni—undertook to complete the work; Giulio painting the upper portion, and Francesco the lower (the picture, executed on wood, being composed of two separate parts). In this work the treatment of the flesh, as compared with that of the darks in regard to surface, corresponds with Raphael's later manner. We find the same system in a Nativity by Giulio Romano in the Louvre. In this instance, while the flesh is comparatively solid, the blue drapery of the Madonna and the green dress of St. John the Evangelist are, as usual, prominent, from the quantity of varnish used with them.

The foregoing observations show that the method of Raphael and his scholars ultimately approached that of Leonardo. The main characteristic, as distinguished from the earlier practice, and from that of Perugino, being that the flesh and light portions of the work acquired a certain solidity—the result of repeated operations after the outline was completed—so that the intermediate process, preparatory painting, or *abbozzo*, could be entrusted to a

scholar. The authority of two such masters was more than sufficient to establish this method in the Florentine and Roman schools, and we shall now see that the words of Vasari, in his *Introduction*, where he treats of the first Italian practice of oil painting, have a peculiar and just meaning. After speaking of the Flemish inventors of the method, and of Antonello da Messina's residence in Venice, he adds:—" it continued to be improved till the time of Pietro Perugino, Leonardo da Vinci, and Raphael; so that, through their means, it has been brought to the perfection which our artists have since imparted to it." It is quite excusable in Vasari to suppose that the new art had attained perfection in Tuscany. Perhaps the example he had in his view at the time he wrote was Andrea del Sarto—a consummate painter as well as designer, and who inherited the technical ability, though not all the higher qualifications, of the two great masters above named. In the " Proemio," or preface, to the third part of his work, Vasari still gives the first place to Raphael, and, after describing his various excellences, adds:—" Andrea del Sarto followed in the same style; that is, only was more delicate and less robust (*gagliardo*) in colouring."* The last epithet, applied to Raphael's colouring, is borne out chiefly by his frescoes of the

* " Seguì in questa maniera, ma più dolce di colorito, e non tanta gagliarda."—Vasari, *Proemio alla terza Parte,* p. 442.

Mass of Bolsena and the Heliodorus. It is also applicable to some of his oil pictures, in which, probably emulating Sebastian del Piombo, he aims for a time at greater warmth in the flesh. His pictures of this class are, however, rather fiery than golden, and the manner cannot be considered characteristic. It was adopted, and sometimes carried to excess, by one of his scholars, Perino del Vaga, who, again, in assisting Raphael, may have imparted it somewhat too largely to the works' in which he co-operated.

Among the early Florentine oil painters none comprehended the resources of the new art better than Baccio della Porta, afterwards, when he became a Dominican monk, called Fra Bartolommeo. He was born in 1475, and having, in the last years of the century, become a zealous follower of Savonarola, he was so deeply affected by that reformer's fate that he quitted the world for the cloister in 1500. Among those united with him by a religious aim in art, and by attachment to the preacher, was Lorenzo di Credi, whose predilection for oil painting has been already noticed, and who, from his ripe age and experience, was well qualified to instruct Bartolommeo in the mysteries of the new art. Another circumstance may also have had its influence: the younger artist was commissioned to paint a fresco of the Last Judg-

ment in the chapel of the cemetery in S. Maria
Nuova. While employed on that work Barto-
lommeo must have had daily opportunities of
making his observations on the chapel of the hos-
pital, which, as we have seen, exhibited specimens
of Flemish oil paintings. On these examples his
practice in the new art, considered without re-
ference to his general taste, appears to have been
formed. On his change of life, Fra Bartolommeo,
stricken in spirit, for a time abandoned the pencil:
the fresco above mentioned was left half finished,
and was completed by his fellow-student and fol-
lower, Mariotto Albertinelli. The remains of this
fresco have been removed from the chapel of the
cemetery to a neighbouring *cortile*.

Fra Bartolommeo, or, as he is commonly called
by way of distinction, the Frate, may, on the
whole, be considered the best colourist of the Flo-
rentine school. His adherence to the Flemish
method of oil painting is apparent in the thinness
of his flesh tints, as compared with the works of
Lorenzo di Credi, Leonardo da Vinci, and the
later pictures of Raphael. In this peculiarity, in-
deed, he sometimes, like Perugino, went beyond
the inventors of the art, and perhaps there are no
Flemish masters so thin in the lights (especially
when we consider the dimensions of his works) as
Fra Bartolommeo. The softness of his gradations
is to be traced to Leonardo, but in emulating the
force and roundness of that painter, he at one time

fell into the defect of blackness; and as, according
to Vasari, he used lampblack, the evil has, in the
cases alluded to, since increased. His best pictures
are quite free from this opacity in the darks, and,
with equal force, have a luminous transparency
and depth in the lower tones; exhibiting, in large
dimensions, the vivid clearness of the Flemish
manner combined with greater softness and far
nobler forms.

Of the Madonnas painted by Fra Bartolommeo
in his youth, and which are alluded to by Vasari,
none can with certainty be pointed out. A smaller
work, belonging to the same period, is a shrine
which served to enclose a small statue of the Virgin,
by Donatello. On the inner sides of the doors
are represented the Nativity and the Presentation
in the Temple; on the outer, in chiaroscuro, the
Annunciation. These delicately executed oil paint-
ings, but a few inches high, are now in the gallery
of the Uffizj. In a miniature size even a painter
accustomed to a thin execution unavoidably treats
the flesh tints and lights with more body than in
his larger works—as is observable in Raphael's
" Vision of a Knight," as compared with larger
specimens of the master corresponding with it in
date. It is not, however, unlikely that, during
Bartolommeo's intercourse with Lorenzo di Credi,
his works may have partaken more of the solidity
of that painter's manner. Still, in these minute
works, the darks are more prominent than the flesh;

but not the blue, which, in this case, may well be supposed to be ultramarine.

The four years which, according to Vasari, Bartolommeo passed without exercising his art are to be reckoned, not from his taking the vows, but from the troublous period which ended in the execution of Savonarola in 1498. The first work executed by him afterwards (in the beginning of the following century) was the altar-piece representing the Vision of St. Bernard, formerly in the Badia di Firenze, and now in the Florentine Academy. This picture has been much injured and repainted, and perhaps in consequence of its various cleanings and restorations, now presents little variety of surface. The flesh is thinly painted, but has sufficient substance to conceal in most places the dark outline: an original correction is apparent in the St. John's foot, where a second outline appears above the first painting. In this, as in various pictures of the time, the ruled lines of architecture are indented in the gesso ground. The Holy Family, with the Infant St. John, painted for the favourite chapel of Agnolo Doni, is now in the Corsini Palace in Rome. This picture exhibits, in an extreme degree, the peculiar transparent system of the Frate. Whatever care may have been taken with the design, it is difficult to suppose any under-painting, properly so called, in a work which has so little body. The white or yellowish ground is everywhere visible underneath the lights, and as

these, in the fairer carnations, are not very broken in tone, the flesh has a bright, but almost too clean an appearance at a distance, as in the fine specimen of the master at Panshanger. This approach to crudeness is sometimes, doubtless, the result of injudicious cleaning, but it is partly to be explained, as we shall hereafter see, from other causes. Even the hair of St. John shows the ground through the lights, and the only parts of the flesh which have any approach to body are the lighter portions of the Infant Christ. The brown outline on the ground is frequently apparent, especially round the limbs of the children; the flesh, which is not at all cracked, is blended or fused, and free from hatching. Some of the draperies are intensely deep and rich, the darker colours, and especially their shadows, being applied with a thick vehicle. The shadowed portion of the red drapery of St. Joseph projects in a ridge next the face of the Madonna; the whole surface of this drapery is covered with the minute cracks of the red " vernice liquida." The only colour which has much substance in the light is the blue drapery of the Madonna—a substance in this case not produced by the vehicle, but by solid painting, afterwards slightly glazed; the brown transparent shadows, on the contrary, are extremely thick with the oleo-resinous varnish, and form a projecting surface round the Infant's legs.

Vasari, in the commencement of his Life of Fra

Bartolommeo, after speaking of his first studies with Cosimo Rosselli (from whom he could learn nothing of oil painting), immediately proceeds to tell us that he studied with great interest the works of Leonardo da Vinci. Leonardo had quitted Florence after his first residence there when Bartolommeo was about twelve years old. The works which he left in Tuscany may, undoubtedly, have had their influence, but it was after his return in 1500 that an imitation of his works by the Frate is to be observed. The St. Bernard, above mentioned, though painted after that date, has, however, no approach to the intense force and soft gradation which the younger artist admired in the works of Leonardo. In these qualities alone is the imitation in question to be at any time traced in the Frate; for the general thinness of the opaque colours, even in his mature works, differed widely from the practice of Leonardo, and from that of his own early companion, Lorenzo di Credi.

A picture representing the marriage of St. Catherine, painted for St. Mark's (the convent of the Frate), and presented it appears in Vasari's time to the King of France, is now in the Louvre. The flesh, which is thin and free from cracks, is embedded in the surrounding colours, the darks, blues, and greens being treated in the usual way. The red (lake) draperies of Fra Bartolommeo are sometimes executed at once with the transparent colour on the light ground; in this instance the

outlines on the ground are seen through it: the sandarac vehicle used in the shadows has here and there become corroded; in the green lining of the Madonna's blue drapery the cracks indicate the use of the white varnish. Another picture of this kind, dated 1515, which the Frate painted to replace the first, is now in the Pitti Gallery, where it is called the "Madonna del Baldacchino." This is one of those works in which the artist, in aiming at force, is betrayed into blackness: although the flesh is thin, the whole has an opaque, cold effect. Vasari speaks of the great relief for which this picture was remarkable, adding, that the artist in this instance imitated Leonardo's system, "especially in the darks, in which he employed lamp-black and ivory-black; in consequence of the use of these materials," the picture, he continues, "is now much darker than it was when it was painted, the shadows having constantly increased in obscurity." Here, as in other instances, the outline is sometimes visible through the flesh in the light portions; the intense and opaque shadows—not improved by the effect of time, in the centuries that have intervened since Vasari's observation—allow of no such inspection: the outlines of the architecture are, as usual, indented.* A third picture of this class, executed soon afterwards, is still in the convent church; it represents the Madonna

* A copy of this picture, by Gabbiani, is in the convent of S. Marco.—Vasari, *Life of Fra Bartolommeo*, note 15.

and Child, six saints, and two angels. This is also in a very blackened state, and the face of the Madonna is badly repainted; the Infant Christ is, however, well preserved, and is so fine as to justify the mistake of Pietro da Cortona, who, according to Bottari, believed the work to be Raphael's. The flesh appears to have been originally thin, for in some places—for example, in the Infant's right arm —the outline is visible through the colour: the indented outlines of the architecture are apparent in the steps, but are almost filled up with repainting.

The Pietà formerly in S. Jacopo fra Fossi, now in the Pitti Gallery, was left unfinished*, and was completed, Vasari says, by Bugiardini. It is now in a very ruined state; the boards of the panel on which it is painted are much warped, and the whole surface (the ground being partially detached) is more or less blistered. The background is entirely repainted, and the two figures of St. John and St. Paul, which, it seems, were added by Bugiardini, were thus obliterated. The only conclusions to be drawn from the present state of this once grand picture are that the flesh was thinly painted, and that the darks generally had the usual

* In Life of Bugiardini (vol. ii. p. 801), Vasari says it was merely outlined. The Rape of Dinah, copied by Bugiardini, was also left unfinished. See note to Vasari's Life of Fra Bartolommeo, note 24.

apparent substance in consequence of the profuse employment with them of a thick vehicle.

The picture of the " Salvator Mundi," once in the Annunziata, and now in the Pitti Gallery, with rather more body than some of the works described, has the same general characteristics. The two figures of prophets, Job and Isaiah *, now in the tribune of the Uffizj, appear to have originally belonged to this picture, and are fine specimens of the master. These also have somewhat more substance in the lights, and are very powerful from the intense and rich darks which, in this instance, have not the effect of blackness. With these may be classed a half-figure of S. Vincenzo, once in St. Mark's and now in the Florentine Academy. This is the picture which Vasari observes was much cracked (in the shadows), in consequence, as he thought, of being painted without allowing time for the size and gesso ground and for the first colours to dry—as in the case, according to him, of Perugino's altar-pieces at S. Giusto alle Mura. The picture is placed too high to allow of any minute inspection. The cracks appear to have been filled up, and although by no means in a good state, the work is striking from the richness of its effect. In this case again the flesh is somewhat less thin than in the generality of the Frate's works.

The celebrated St. Mark, painted for the con-

* See note to Vasari's Life of Fra Bartolommeo.

vent, and now in the Pitti Gallery, has also suffered from cleanings and restorations. It is a specimen of the transparent, forcible, and rich manner of the painter; the lake drapery consists of little more than a glazing on what appears to have been a yellowish ground, which is seen through the lights. The extremely warm, lighter shades in the flesh are well calculated for the almost colossal size of the figure, and produce their just effect at a due distance. The darks in the eyes have unfortunately become, or have been made, too intense, so as to give them the effect of spots; the green tunic has lost its tone, and is now become almost blue.

A small Holy Family in the same gallery has the same brilliant and transparent character; the colours of the draperies—especially of a green—are here, as usual, more prominent than the flesh, which, however, is not deficient in body. With these specimens, considered with reference to their technical characteristics, may be classed a Holy Family in the possession of Earl Cowper at Panshanger. The flesh is thin, and is exceeded in apparent substance by the other colours; the outlines on the light ground are seen through the wrist of the Child, in the extremities of both children, and round the eyes of the Madonna. A slight appearance of hatching in the fainter shades is probably the first drawing seen through the colour—as in the leg of the St. John. The darks throughout

are prominent; the thick vehicle, which was profusely used in the shadows of the blue drapery, is now cracked and corroded, presenting a dull appearance where the utmost lucid force was intended. Notwithstanding this and other imperfections, the picture has a powerful glowing effect —intensely forcible without blackness—and is only somewhat too fresh and clean in the lighter carnations.

In the former part of this work it was stated that a thinner and less durable vehicle was used by the early oil painters with the opaque than with the transparent colours. The proof of this may be found in the fact, that the cleanings to which pictures like those of the Frate have been subjected have sometimes stirred the lights, but have not affected the darks. The latter have been more or less injured by time, but, at all events, their relative prominence is a proof that they have not been rubbed away : on the other hand, the occasional crudeness of the flesh tints, and perhaps the undue display of the outlines underneath them, may be partly attributed to the effect of cleanings.

Three of the Frate's works are in churches in Lucca. Of two that are in S. Romano, the smaller, on cloth, has the date 1509; the larger, also on cloth, is dated 1515. The third, in S. Martino, of moderate size, on wood, is also dated 1509. The large picture—the " Madonna della Misericordia " —has been much restored, and now appears

scarcely worthy of its great reputation. Both the others are superior to it; but that in S. Martino (the cathedral)—representing the Madonna with St. Stephen and St. John and an exquisite angel seated on the steps of the throne playing a lute— is to be classed among the finest examples of the master. The smaller picture in S. Romano, representing the Magdalen and St. Catherine of Siena (or, according to some, the two St. Catherines), with a glory of angels above, has also great beauty and harmony. In all these pictures, with an exception presently to be noticed, the flesh is thin relatively to the other colours; the outline is distinguishable through the lighter shades and half-tints, and through the middle tints of the lake drapery. All the darks are more prominent than the flesh. With regard to the colours, the greatest apparent thickness is observable in the greens, somewhat less in the blues, and least in the reds. Wherever the vehicle has been thickly used, cracks or a corroded surface are more or less observable.

It would appear that Raphael furnished the design for the upper part of this picture, as a drawing for it by him exists in the gallery of the Uffizj at Florence. Rumohr even supposes that the angels in the picture are also partly by the great artist's hand : his reasons are that the shadows of the flesh tints are painted with considerable body—a system, as he justly remarks, corresponding with Raphael's method, but quite

opposed to that of the Frate.* The date, 1509, does not render this co-operation improbable, as the upper part may have been finished before Raphael's departure from Rome in the preceding year.

A desire to see the works of Michael Angelo and Raphael—the motive assigned by Vasari for Fra Bartolommeo's journey to Rome—would be but an imperfect guide to the date of his visit, had not the biographer also informed us that he was entertained there by Mariano Fetti, called the Frate " del Piombo," from his holding that office, to which, in the time of Clement VII., Sebastiano Luciano succeeded. Mariano's predecessor in the office was Bramante the architect, who died in 1514; it was therefore, in all probability, after that date that Fra Bartolommeo visited Rome.†There he began two figures of St. Peter and St. Paul for Fra Mariano. His stay, Vasari tells

* Rumohr, Italiänische Forschungen, vol. iii. pp. 71, 72, and 134.

† The works of Sebastiano Luciano which are most known, including the Raising of Lazarus, in the National Gallery, were painted some years before he obtained the office " del Piombo," and before he assumed with it the habit and designation of " Frate." The same title may therefore, not impossibly, have been applied to Mariano Fetti, without reference to the precise year when he was appointed to the office. Still, the date 1514 may, on many accounts, be considered as that of Bartolommeo's visit. The then recent promotion of Mariano may have been the immediate cause, and his employing Bartolommeo indicates that he was possessed of some authority.

us, was short; he appears to have been oppressed with the excellence of the works he saw, and probably finding the place unsuited to his habits and his health, he departed without even finishing the work on which he was employed, and praying Raphael to complete it. This the great painter found time to do, and the figure of St. Peter is chiefly by his hand. These works, which are on wood and well preserved, exhibit therefore the best possible means of comparing the methods of the two painters. In renewing his communication with Raphael, and in observing the changes which that master's style as an oil painter had undergone since they had studied together in Florence, Fra Bartolommeo could not fail to remark a greater solidity of execution as compared with works painted by the younger artist at a former period, and partly perhaps under his own guidance. But if he acknowledged the advantages of the subsequent method, recommended, as it now was, by so celebrated a painter, there is but slender evidence to show that his own practice was influenced by the example. Of the two Apostles above mentioned, the head and hands of the St. Peter are evidently by Raphael; and those portions are much more solid than the flesh tints in the St. Paul. The surface in the latter exhibits no marked change from the well-known manner of the Frate; the left hand, for example, is embedded in the surrounding drapery: it is also to be observed that the colour is more glowing

and transparent than in the companion picture. Raphael, who must have found it difficult, in the midst of his associations, to fulfil his promise to his friend, evidently executed his task in haste; but, far from being disadvantageous, this has afforded a striking proof of the mastery of the great painter in the management of oil colours. The picture is remarkably well preserved, and, though the flesh is painted with considerable body, free from cracks. The traces of the full brush are everywhere observable; the colour is sometimes left in solid touches, and the execution is as bold as that of the later Venetians. Had Raphael oftener executed oil paintings entirely with his own hand in his later time we should, no doubt, have seen a more evident result of that dexterity which his practice in fresco, and knowledge of form, must have given him. In adhering to his own method, the great artist has emulated in this case the warmth of his friend's colour, but as his work is solid, with scarcely any glazing, the head of St. Peter, noble as it is, is rather red than glowing.* The St. Paul by the Frate is perhaps the finer of the two in expression, as well as in transparent warmth; it is only inferior in substance and execution. The union of solidity with that richness which glazing can best give was reserved for the Venetians.

An unfinished Madonna and Child by Fra Bar-

* See anecdote in Cortegiano, book ii. p. 213.

tolommeo, more solidly painted in the flesh than the generality of his works, was exhibited at the British Institution in 1841 under the name of Raphael : if that picture was begun in Rome—which the circumstance of its being half finished renders not improbable—it might be supposed that its greater substance was a consequence of the painter's then new impressions. But, whatever may have been the Frate's experiments in Rome, it is certain that his latest finished oil picture, painted after his return to Florence, and in the year before his death (died October 1517), exhibits all the extreme peculiarities of his technical style. The picture here alluded to is the Presentation, in the Belvedere Gallery at Vienna, formerly the altarpiece of a chapel in St. Mark's at Florence.* The colouring is, as usual, vivid and clear, the consequence of the transparent system of the painting—a system carried so far in this instance that the outlines are visible through the flesh tints. The picture bears the inscription, " Orate pro pictore olim sacelli hujus novitio 1516."† A small picture of the Annunciation, now in the Louvre, in which the Madonna is accompanied by various saints, has the date 1515. In this instance again the flesh is

* The tradition repeated at Vienna that Rubens formed his style from this particular work, can have little weight when it is recollected that the picture migrated from Florence to Vienna so late as 1782. See Wilkie's remarks on its ruined state.

† The repetition in the Uffizj is inferior.

thin, and without cracks, while the darks and the
usual colours are prominent; the inscription is,
" F. Bart°. FLOREN. or^{is} pre ("ordinis predicato-
rum") 1515."

A large picture by the Frate representing the
patron saints of Florence was left unfinished at
his death, and is now in the gallery of the Uffizj.
This work, Vasari tells us, was a commission from
the Gonfaloniere Soderini, and was intended for
the same council-chamber where Michael Angélo
and Leonardo da Vinci had been employed; but
by a singular fatality neither of the three masters
completed the work allotted to him. An engraving
of Fra Bartolommeo's composition may be seen in
the small edition of the Florence Gallery. The
white ground of the picture appears to have been
covered with a semi-opaque yellowish tint: this
tells for the lights; the shadows are laid in with
brown, which, in the darkest touches, appears
almost black. The effect of the whole is like an
immense bistre drawing on wood. The forms are
drawn with a clean, very dark outline, which
appears thin and wiry for so large a scale : the
outlines of the architecture and steps, and even of
some books, are ruled and indented. Vasari inti-
mates that Fra Bartolommeo was employed on this
composition immediately before his decease, but
the banishment of Soderini in 1512 was no doubt
the cause of the suspension of the undertaking. The
Gonfaloniere quitted Florence in that year, never

to return, and unless we suppose that Ottaviano de' Medici, ultimately the possessor of the work, commissioned the Frate to proceed with it (which does not appear), it must have been left incomplete some years before the painter's death.[*]

This picture, together with Vasari's description of the Frate's method, and the evidence of his more finished works already described, gives the fullest insight into his general process. The yellowish ground seems to have been adopted by Fra Bartolommeo in other instances—for example, in the gigantic St. Mark now in the Pitti Gallery. Occasionally, as is evident from an uncovered portion of the small Holy Family before described, which is now in England, the ground was white. The large work above referred to, however, shows that at the best period of his practice the Frate preferred the yellowish tinted ground, due allowance being made for the yellowing and darkening of the varnish with which the surface of the unfinished picture in question is now covered. The habit was probably derived from Leonardo : that master, as we have seen, apparently with a view to correct the yellowing of the oil, painted his flesh of a purple hue, sometimes even exaggerating this tint. Such being his practice, he would consistently select a ground tint (yellowish) which was again the opposite of the purple preparation, in order to give it value. On

* Vasari, Life of Fra Bartolommeo, notes 43 and 44.

the same principle the tempera painters prepared their carnations with a green tint; with the same view Titian prepared his blue skies with a light brown inclining to orange; while Rubens and Vandyck often painted their flesh tints on a grey ground. The Adoration of the Magi, by Leonardo, exhibits the yellowish ground, and is only not carried far enough to exemplify the purple preparation.

It is not easy to determine to what extent the extreme thinness in the flesh tints which some of the pictures of the Frate now exhibit may be the effect of time and cleanings; but as the thinness, in greater or less degree, was undoubtedly one of the original characteristics of his works, it is not to be supposed that he would ever make the ground so dark as to mar the brilliancy and warmth of the superadded carnations. The internal light which they actually display, and the brightness which they acquire from their transparency, are conclusive on this point. The cold effect of a thin light over relative darkness is apparent wherever the outlines are seen underneath the semi-opaque light colour, a bluish tint being necessarily the result. The general principle, independent of any authority, is not to be mistaken. As Descamps (quoting Rubens) observes, the ground tint is of no importance if it be entirely and thickly covered: when thinly covered, it will, if darker than the superadded colour, impart a coldness to it; if

lighter, it will enhance the warmth. The bright and glowing carnations of Fra Bartolommeo, thinly painted as they are, or have been, suppose, therefore, a ground which, when yellowish, was still of a very light tint. A partial coldness may be sometimes intentionally produced, on the principle just adverted to, for the sake of the pearliness of the tone, as colours of all kinds are never so clear, never so unlike pigment, as when they are seen through each other without an atomic mixture: only it is necessary to bear in mind that white lead has a tendency to become transparent by age, especially when not fortified by a firm vehicle, and that therefore cool tints which are produced by thin lights over a darker preparation will become colder in time, even though that tendency be somewhat counteracted by the gradual mellowing both of colours and varnishes.

With the exception of the occasional use of this light yellow tint for the ground, the method of Fra Bartolommeo was nearly in accordance with that of the Flemish masters. The defined outline, the insertion of the shadows upon it—the ground being left for the lights—the comparatively thin flesh tints (thinner than the Flemish*), the darks lucid and prominent with a thick vehicle, all correspond with the principles and practice of the first oil painters. Vasari observes that the Frate was in

* This system was imitated by the later Flemish painters.

the habit of preparing his pictures as if they were cartoons—that is, merely with reference to the composition, forms, and light and dark—using (printer's) ink or asphaltum for the outlines and shadows. This general system, he remarks, is evident from many unfinished works left by the artist. The use of lampblack is to be recognised, not only in the outlines of some of his pictures (as, for example, in the St. Bernard), but in the shadows of some of his finished works, where it has not unfrequently done mischief: the use of asphaltum was, it seems, no less common. The chief objection of the moderns to this pigment—its tendency to crack—was counteracted, at least for a considerable time, by using it with the oil varnishes. It is also consistent with the habits of the early painters to suppose that it was first thoroughly washed, after being well ground, so as to free it from greasy particles, and thus to render it more drying. Still, as its tendency to crack and blacken was not quite overcome, the corroded appearance of the darks in many pictures of the sixteenth century of various schools, is no doubt partly to be attributed to its use. The S. Vincenzo of Fra Bartolommeo was, according to Vasari, cracked in all directions in his time, and, unless the picture had been exposed to the sun's rays in its original situation, this effect may have been accelerated by the use of the colour in question.

The Frate's habit of studying the chiaroscuro of

his compositions, independently of the effect of colours, led him occasionally to complete works in this style. A picture of St. George and the Dragon, and a head of Christ, are enumerated among his productions in chiaroscuro, and to this practice the force and delicacy of his gradations are partly to be attributed. Fra Bartolommeo, observes Vasari, was in the habit of working from nature, and in order to copy draperies, armour, and articles of dress, he made use of a wooden lay figure the size of life, contrived, like those now in use, to bend at the joints. From the manner in which the biographer speaks of this circumstance, and from his having, as he informs us, possessed himself of the identical wormeaten mannequin as a memorial of the painter, it would appear that the Frate was the inventor of this useful auxiliary. Later writers, and among them Baldinucci, have accordingly assumed this to be the case. It seems that the artist was also accustomed to use clay models, probably in order to study the effects of light and shade in groups.

We now proceed to consider Mariotto Albertinelli, the early friend and companion of Fra Bartolommeo, whose studies were directed to the same outward qualities in painting, though they were not always informed by so pure a feeling. The circumstances which induced the Frate to become

a monk had the effect of driving Mariotto into the world and into opposite habits, while his attachment to his art chiefly showed itself in the pursuit of technical methods to attain perfection in relief— a taste which had been introduced, together with better things, by Leonardo da Vinci.

It will not be necessary to follow the practice of this painter so closely as that of Fra Bartolommeo, since the technical qualities are nearly the same. The masterwork of Mariotto—the Visitation, in the gallery of the Uffizj—has the outward peculiarities that have been noticed in the works of the Frate. The flesh is thinly painted in comparison with the darks, as is evident from the appearance of the head of Elizabeth, surrounded by the thicker blue drapery of the Virgin. All the darks are raised and have suffered much, but the cracks and inequalities have been here and there filled up by the restorer. The altar-piece formerly at S. Trinità at Florence, and now in the Louvre, representing the Madonna and Child with St. Jerome and St. Zenobius, has the same peculiarities: the flesh is embedded and the darks are substantial with vehicle; it has the date 1506. In this picture, as in the works of the Frate and others of the time, the red (lake) drapery has less body than the blue and green, except in the shadows—an indication, perhaps, that a durable colour was used, which did not require to be so effectually "locked up" as the " azurro della Magna," " giallo santo," and other tints. The Assumption, formerly in the Casa Acciauoli at Florence, is now

in the Berlin Gallery. Lanzi* attributes the lower part of this work (consisting of various saints) to Mariotto, and the upper part to the Frate; Dr. Waagen reverses the masters, and his judgment is probably correct.† If the upper part is by Mariotto, the thinness of the flesh exceeds even his ordinary want of substance; the darks, on the contrary, are thick with vehicle. The same general characteristics are observable in the lower portion, and it is only by a comparison of the two works in other qualities that the respective masters are to be recognised.

Vasari is sufficiently clear in his explanation of Mariotto's efforts to secure relief, although the present appearance of the painter's works, from the effects of time, does not always correspond with the biographer's description of their merits. This is the case with the picture of the Annunciation, painted for the Compagnia di S. Zanobi, and now in the Florentine Academy. It is a forcible and expressive work, and has the usual characteristics of the master, but it can hardly be regarded as an illustration of the principles and objects which, if Vasari be correct, the artist had in view. Mariotto, he informs us, worked on this picture in the place which it was to occupy, and had even contrived additional windows so as to regulate the light for the upper portions. " He was of opinion," con-

* Storia pittorica d' Italia. Epoca seconda, p. 129.
† See Catalogue of Berlin Gallery.

tinues the biographer, " that such pictures were only to be valued which combine force and relief with tenderness (in the shadows). He was aware that relief could only be attained by shadow, while at the same time, if the obscurity be too great, indistinctness is the necessary consequence. On the other hand, if the tenderness be indiscriminate, relief is sacrificed. His object, therefore, was to unite with delicacy of shade a certain system of effect, which, he considered, had not before been attempted. An opportunity seemed to present itself in this work, on which he bestowed infinite study. This is apparent in the figure of the Almighty and in some infant angels, which are strongly relieved against a dark background, consisting of the perspective of a waggon roof, the arches of which, duly diminishing, recede so as to produce illusion. There are also some angels in the air, scattering flowers. This work was painted and repainted by Mariotto before he could satisfy himself; he changed the effect repeatedly, now making it lighter, now daiker, sometimes increasing, and again reducing the vivacity of the tints. He was fastidious to the last, feeling that his hand could not realise his intention. He would willingly have found a white more brilliant than white lead, and therefore tried to purify the colour, in order to add still brighter lights to the illumined portions." Compelled to content himself in the end, his work was highly extolled by the artists of

the day, and when a difference arose between him and his employers respecting the remuneration, the case was referred to Pietro Perugino, then aged, Ridolfo Ghirlandajo, and Francesco Granacci, who pronounced a satisfactory decision.

The opinion of Mariotto that the desired union of force and delicacy had not been sufficiently attained by preceding painters, may have been directed, and not unjustly, against the darker works of Leonardo da Vinci. The judicious system which he proposed, whether really his, or supposed to be so by Vasari, cannot, however, be said to have been fully exemplified till the best Venetian painters solved the difficulty. The principle is admirably explained by Zanetti, not only in describing Titian's colouring, but in other parts of his work. The example which best illustrates the (assumed) aim of Mariotto is perhaps Pordenone. Zanetti observes that one of that great painter's peculiarities was his love of foreshortening, the results of which, like those of perspective generally, tend to get rid of the flat surface ; another peculiarity was to employ half-shadows chiefly in the flesh, with a very sparing proportion of extreme darks, reserving greater force in large masses for the background of the figures ; or, when the (draped) figures admitted of dark masses, relieving them by an expanse of light in the background. The system of breadth of light relieved on breadth of shade was aimed at by Mariotto in the upper part of the Annunciation ;

the opposite principle is more successfully carried out in the Visitation. The addition of the effects of perspective in the background of the Annunciation is analogous to that love of foreshortening which all these painters have exhibited whose attention has been especially directed to the study of gradation.

To some it may appear that the above comparison between the efforts of a Florentine and the best Venetian practice is inadmissible; and assuredly it would have occurred to none to hint at such a comparison, but for Vasari's remarks. But the history of art, at all times, is full of examples of a clearly understood principle failing in its effect from not being carried far enough, and from not being assisted by such other executive means as can convey the intended impression distinctly and powerfully to the eye. It is for this reason that the best theories of art, and the best descriptions of methods, can never convey their full meaning so as to be available with certainty in practice. The same words may be applicable to very different *degrees* of the effect proposed—to degrees so imperfect and so little expressive of the intention, except to the imagination of the artist, that the result may, to his astonishment, be criticised for a want of the very qualities to which his attention may seem to himself to have been especially directed. This shows the great use (amidst some unavoidable evils) of modern exhibitions: they may be said

to supply the place of that competition in churches and public buildings from which the painters of Italy reaped so much advantage. They had the additional advantage of first displaying their works to the public in the situations they were ultimately to occupy, and of studying their effect under such circumstances accordingly. While a work of art is seen alone, aided perhaps by the descriptions of the artist and his eulogists, every merit, in some unassignable degree, may be ascribed to it. It is the same with schools and periods while they are studied apart. It is quite conceivable that the Annunciation of Mariotto and a masterwork by Titian, considered solely with regard to the relief attained on the above principles, and avoiding allusions to the peculiarities of the masters, might be described in the same terms; so powerless is language to represent the relations of light and colour —to represent proportion.

Of the other early Florentine oil painters— Ridolfo Ghirlandajo, Granacci, Bugiardini, and their contemporaries or immediate followers—none were so uniformly thin in the flesh tints as the Frate and Mariotto, although in their works generally the darks are more prominent than the lights. In Ridolfo's funeral of St. Zenobius, in the Uffizj, the flesh has a moderate substance, while the darks, and especially the blues, are thick with vehicle. In the other picture, in which the saint raises a

dead boy to life, the same peculiarities are observable: the thickness of the greens is especially visible. Granacci's technical manner may be traced in the two pictures of angels in the Florentine Academy, though these are now in a ruined condition, and badly restored : the darks are cracked and corroded throughout, but it is evident that they had the usual prominence as compared with the flesh. His picture in the Uffizj of the Madonna dropping her girdle to St. Thomas is also in a very injured state, and is placed too high to admit of accurate inspection; the details that are visible confirm, however, the above general statement. A Madonna attributed to him in the Pitti Gallery agrees in the same qualities ; the flesh has a good body, but is, still, less raised than the darks. A Madonna by Bugiardini resembles it in the comparative solidity of the flesh. Several of these painters and their companions studied for a time either with the Frate or with Mariotto Albertinelli, yet the extreme thinness in the flesh tints which those painters' works exhibit does not often occur in the same degree.

Andrea del Sarto (1478–1530) first appears as an oil painter in company with Franciabigio, a scholar of Mariotto. The two artists worked for a time together, both gradually adopting a somewhat more solid texture in the flesh than the works of Albertinelli exhibited. In less finished paintings

by Andrea the transparent system prevails; for example, in some small but well-designed pictures from the history of Joseph, originally painted on some furniture for Pier Francesco Borgherini, two of which are in the Pitti Gallery, and three, apparently from the same series, at Panshanger.* In all these the system of the early Florentine oil painters of the Peruginesque school (as distinguished from that of Leonardo, Lorenzo di Credi, and Raphael in his later works) is clearly exemplified: the flesh is thin, the darks all prominent, the blues and greens most protected with vehicle, the lakes less so, except in shadows. Part of the

* The history of these pictures is as follows:—Four painters, Andrea del Sarto, Ubertini, called Il Bachiacca, Francesco Granacci, and Pontormo, were employed to ornament the wedding-chamber of a young couple (Pier Francesco Borgherini and Margherita Acciauoli) with pictures adapted to the *cassoni* and other furniture. The history of Joseph was chosen as the subject. At the siege of Florence (1529), when the citizens hastened to propitiate Francis I., Pier Francesco retired to Lucca, leaving his wife in the house. During his absence the Gonfaloniere and Council decided that the pictures of the Borgherini wedding-chamber would be an acceptable present to the King of France. A certain Giovan Battista della Palla, who had already prepared other peace-offerings for the enemy, was foremost in desiring to add these pictures to the number, and undertook to obtain them from the lady. His reception by Margherita, who responded to his errand by the "maggior villania che mai fusse detta ad altro uomo," will be found in Vasari's *Life of Pontormo*, vol. ii. p. 821. The fate of the pictures by Il Bachiacca and Granacci is not known. For other allusions to these works see Vasari, vol. i. pp. 572, 670-672.

series was painted by Granacci and others; two by
Pontormo are in the gallery of the Uffizj. Such
works were probably executed " alla prima," but
Andrea soon adopted the system of preparing his
pictures with a dead colour: an unfinished painting
by him in the Guadagni Palace at Florence exhibits
his process; the subject is the Adoration of the
Magi; the black outline, drawn apparently with a
reed pen on a light (perhaps originally white)
ground, is seen everywhere, but the features and
minuter forms are not defined, and sometimes are
very roughly indicated. The sky and background
only are finished ; the flesh, draperies, and adjuncts
are all true in tone, although laid in with so little
colour. This exemplifies the process, consisting of
several operations, which Vasari (in speaking of
some damaged pictures by Perugino) assumes to
have been common to all oil painters, but which
perhaps was first reduced to a system by Andrea,
with whom Vasari himself for a time studied. The
method of covering a work repeatedly with more or
less of opaque colour would soon suggest the possi-
bility of corrections in the forms and composition.
In a Holy Family by Andrea, now in the Louvre,
a hand of St. Elizabeth has been introduced across
the arm of the youthful St. John after that figure
was completed, and, not having been painted with
sufficient body, now shows the shadow underneath
it, thus reducing the superadded flesh tint in that
part to a grey. Andrea's method, though more

solid than that of the Peruginesque school gene-
rally, was not sufficiently so to permit his painting
light over dark without ultimate injury to the
brilliancy of his colour. That he could, however,
paint solidly when he pleased, the copy of Raphael's
Leo X. (which deceived Giulio Romano) may be
considered a sufficient proof.

This semi-solid system—a middle process be-
tween that exhibited in the substantial works of
Leonardo (such as the Mona Lisa) and of the
followers of Raphael, on the one hand, and the
transparent method of the Frate and those who
resembled him on the other—continued to charac-
terise the succeeding Florentine painters, till the
period of what is called the reformation of art in
Tuscany, by Cigoli, Jacopo da Empoli, Cristofano
Allori, and their contemporaries, who appear to have
aimed, to a certain extent, at the solidity of Cor-
reggio.* Less change is, however, apparent in the
treatment of the darks, which, in the works of the
later painters, are often remarkable for a profusion
of vehicle; but rather, it would appear, with a view
to preserve certain colours than, as at first, to give
depth to the intenser shadows.

On the whole, it appears that Perugino, Fra
Bartolommeo, and Mariotto Albertinelli carried the
transparent system in the lights farther than the
early Flemish oil painters, while they retained, and

* See Lanzi, Storia pittorica d' Italia, pp. 189–90.

sometimes exaggerated the use of rich and lucid
vehicles in the darks. If this latter practice on the
part of the Italians may be accounted for by the
increased dimensions of their works, as compared
with those of the Northern districts, it must still
be obvious that the light portions in their pictures
might, on the same principle, have been more sub-
stantial. It may be a question, as before remarked,
whether the greater apparent solidity of the flesh
tints and illumined parts in the works of the Van
Eycks, and some of their scholars, may not have
been the consequence of using a firmer vehicle,
which has prevented the white lead from becoming
transparent : from whatever cause, those painters
are certainly more solid than the Italians above
named. It is also worthy of notice that the produc-
tions of some later Flemish painters (for example,
Lucas Van Leyden and his contemporaries) have
less body than those of their predecessors, and this
is not improbably to be attributed, directly or indi-
rectly, to a Florentine influence. At a still later
period the rich and transparent shadows of Rubens
were, as some have conjectured, derived from the
manner of Fra Bartolommeo.* The followers of
Raphael carried with them throughout Italy, some-
times to the Netherlands, the more solid system,
and the example of Leonardo was the means of

* It has been seen that the author repudiates the tradition
regarding a particular work by Fra Bartolommeo, which Rubens
was supposed to have seen at Vienna. See p. 187, note.—*Ed.*

establishing it in Lombardy. The early Sienese oil painters fluctuated for a time between the Peruginesque and the opposite method, but, on the whole, inclined to the latter.

Having noticed the points on which the practice of Fra Bartolommeo and his followers differed from that of Leonardo da Vinci, it remains to speak of those qualities which were common to the two masters. Among the technical methods and peculiarities which the Frate adopted from Leonardo, as distinguished from the Flemish method, we first find that he laid in the shadows with the brush on the ground instead of hatching them: the use of a yellowish ground, perhaps suggested by the occasional practice of Leonardo, has been already noticed. In more important particulars the improvement attempted, rather than attained, by the Frate was a transparent system opposed to the solid purplish lights, and often inky shadows, of Leonardo in his carnations. The depth and brilliancy which Fra Bartolommeo sometimes attained in this way (exemplified by the picture at Panshanger) approach, however, a glassy unsubstantial appearance, when such specimens are contrasted with more solidly painted works. The Annunciation of Mariotto Albertinelli, before mentioned, is, with all its force, a remarkable example of the defect here alluded to. The succeeding painters of Tuscany corrected this thinness in the lights imperfectly, without retaining the extreme force and

richness in the shades which characterise the Frate.
Another quality which was adopted from Leonardo,
and of which the Florentines were especially en-
amoured, was the 'sfumato' system — the imper-
ceptible softening of the transitions in half-tints
and shadows. The want of substance which long
characterised the school is ill adapted for this soft-
ness in the passages from light to shade. The
'sfumato' applied to a thin preparation seems to
add to the glassiness and poverty of the surface,
and gives a look both of labour and incompleteness.
It is more agreeable in small works, where a mode-
rate thinness may assist the delicacy of the execu-
tion. A picture by Ubertini, called il Bachiacca,
once in the gallery at Dresden, and now in that
of Berlin, is a good example of the Florentine
'sfumato' on a small scale.*

On the whole, it must appear that the method of
the Frate, though recommended by extreme force
and transparency, as well as by a noble style, had
an unfortunate influence on the Florentine school
as regards one important quality—solidity. It
was in fact a retrograde step as compared with the
Van Eycks, and was the means of introducing an

* This is one of two pictures painted originally for Gio-
vanni Maria Benintendi of Florence, and afterwards sold to
the Elector of Saxony. See last Florentine edition of Vasari,
(1832–38), Vita di Franciabigio, vol. i. p. 627, notes 15 and
16 ; Vita di Bastiano di S. Gallo, vol. ii. pp. 868–9 ; see also
vol. i. p. 427, note 62.

executive imperfection, which was never quite re-
trieved by the Tuscan painters. It suited a school
of designers. The mode in which such a school
would endeavour to compass the excellences of
oil painting without sacrificing form would natu-
rally be by a transparent tinting, in the application
of which the outline was covered with reluctance,
and in such a mode as always to be recovered.
The terms employed to describe the operations of
such a school have thus sometimes only a relative
application as compared with their ordinary mean-
ing. When, for example, Vasari says that Mariotto
Albertinelli frequently altered the colouring and
effect of his picture of the Annunciation before
described, repainting it more than once, we are
not to suppose that the result was a thickly painted
picture—a reasonable conclusion in any other case
—for the work (which exists to attest that it is
not so) proves that these changes were made with-
out destroying the characteristic thinness of the
artist's execution. Such changes suppose that
both lights and shadows were washed out with an
essential oil, and again inserted on the ground,
not that the work was loaded again and again, as in
modern cases of *pentimenti*.*

* Sir Joshua Reynolds is reported to have said of his pic-
ture of the Infant Hercules, now at St. Petersburg, " There
are several pictures under it, some better, some worse." The
pictures of the colourists frequently tell the same tale, as their
pentimenti come to light.

Hence the lesson which the more established Florentine practice teaches is, that while there may be no necessity for deviating from the original design—supposed to be decided in sketches and in the preparation—the powers of oil painting are but half displayed unless the preparation be either immediately or gradually wrought up to solidity. The gradual mode of attaining substance, on Leonardo's most finished system, considered irrespectively of his colouring, is undoubtedly the safest, as it admits of correcting the forms; but it is by no means assumed that even this practice can ever supersede the necessity of enriching operations at last. There have been no colourists, painting the size of nature, without solidity in the lights.

CHAP. V.

CORREGGIO.

HITHERTO the progress and vicissitudes of oil painting in the hands of individual masters have been partly traceable to distinct influences, and have not failed of due illustration by a reference to existing works in their chronological order; but we have now to examine the technical style of a painter of the highest rank—Antonio Allegri da Correggio—whose early history and education are wrapt in obscurity, and whose authentic productions cannot, in the majority of cases, be referred with certainty to dates. An easy explanation of the originality and excellence of this painter might be found in his transcendent genius; yet, could we follow his steps from the commencement of his career, we should probably find in his case, as in Raphael's, that he at first adopted much from others, and that his style received a bias from circumstances of time and place as yet imperfectly known to us.

The best life of Correggio is that by Pungileoni:[*]
though needlessly diffuse, and written in a con-
fused and desultory style, the more important state-
ments it contains are supported by documentary
evidence, and the author shows no disposition to
adopt without examination the vague stories of
former biographers. Many of these stories, though
not supported by sufficient authority, need not be
rejected merely on account of their improbability;
but it may be observed, once for all, that Vasari's
remarks on the artist's poverty, and the absurd
account of his death in consequence of carrying a
load of copper money from Parma to Correggio,
have not the remotest foundation beyond the mere
assertion of that writer, while they are contradicted
by the clearest facts. The great painter, though
not wealthy, was in easy circumstances, and was
sufficiently well paid, as appears by existing con-
tracts and receipts, for the works he undertook. The
works themselves—among others, the cupolas of
two churches—would not have been confided to an
indigent professor; and, as Lanzi[†] and others justly
remark, the artist himself spared no time, study, or
expense in the execution of the important com-
missions he received, and grudged no outlay in
the materials of his pictures. Documents further
prove that purchases of land were the result of his

[*] Memorie istoriche di Antonio Allegri. 1818.
[†] Storia pittorica d' Italia, vol. iv. pp. 55–57.

increasing fortune, and that his family inherited from him a considerable property.

Enough has been therefore ascertained to prove the worldly prosperity, the public estimation, and the liberal spirit of Correggio: what is wanted is a more accurate knowledge of his professional career, especially at its commencement. The zeal with which the history of art at any given period is investigated necessarily depends on the interest with which the productions of that period are regarded: none will regret that the activity of modern research has hitherto been directed to the early Italian and Flemish schools, since the facts arrived at form, in every view, a proper foundation for further enquiry. But it is to be feared, from the almost exclusive predilection for those schools on the part of writers the most competent to treat such subjects, that the history of the great painters of Venice and Parma is not likely to be undertaken with equal love. The aim of Correggio, especially, is so opposite, in many respects, to the spirit of the fifteenth century; his peculiarities find so little favour at present with the admirers of that tendency and of its consummation in the best works of Raphael, that we cannot as yet look for an investigation of his life and progress in art at their hands.

A critic of the last century—Raphael Mengs— to whom we are indebted for a careful analysis, at least, of the great artist's external qualities, is not

unjustly looked upon by his own countrymen as the latest important representative of that effete imitation of the old masters and of the antique statues which the modern German school, at its commencement, especially sought to avoid. While Mengs devoted his life to the study and illustration of his favourite painter's works, a representative of the new German tendency dates the moral decline of art from " the effeminate Correggio :" the epithet must, however, be understood to relate to the taste rather than the practice of a great painter whose colossal foreshortenings on a curved surface in fresco, might have excited the wonder of Michael Angelo himself. The judgment, of which the above is a specimen, is partly the consequence of the exclusive admiration with which even the peculiarities of the great artist were regarded in the last century; for it is to be remarked that while the writers of that period enlarge on the technical merits of Correggio, they scarcely allude to the total change which his altar-pieces exhibit, as compared, in their impression on the mind, with the similar works of earlier masters. Mengs, Reynolds, and others, in the midst of enlightened criticism on the qualities of the mere painter, and while extolling his playful grace, have little to say on the absence of all solemnity, all devotional feeling, from his church pictures, in which, except where the subject is essentially pathetic, a joyous and even humorous feeling may be said to prevail.

The most extraordinary instance of the trivial and childish treatment of a sacred subject, as regards invention and composition, is perhaps the St. Sebastian at Dresden, in which the actions of some of the infant angels and of other figures border, and intentionally so, on the ridiculous. This playful feeling, though still utterly unfit for an altar-piece, is kept within more discreet limits in the St. Jerome at Parma and the St. George at Dresden; but even in these the misapplied conceits, graceful as they sometimes are, and safe from caricature by the accompaniment of beauty, would be felt to be irreverent on a comparison of such works with corresponding subjects by Raphael, Lorenzo di Credi, and many an earlier painter.

Correggio's power of seeing and rendering certain qualities in nature which constitute the essence of painting as an art, also interfered, to a certain extent, with the customary forms of representation. Painting, in its infancy, aimed only at intelligible appearances on a flat surface; and, in afterwards recognising the importance of grand lines and masses, still kept those lines and masses in a great measure parallel with the plane of the picture. For colossal works, intended to be seen at a distance, and under circumstances which do not admit of the discrimination of the delicate varieties of light and shade, this flatter treatment is probably the best, since it must, under such circumstances, be the most easily intelligible; but when the distance at which

the work is to be viewed admits of a full perception of the finer gradations of light, then the qualities in which Correggio excelled come legitimately into operation—legitimately at least in reference to such physical conditions; and it would be difficult to suppose that a painter possessed of the requisite skill would, from a regard to certain questionable principles, exercise such self-denial as to suppress the resources of art which he felt to be at his command. The qualities here alluded to are, however, many of them, opposed to the real and permanent attributes which the earlier painters aimed at: they consist in foreshortening, a term commonly restricted to figures; in the alteration of forms generally by perspective; in depth, or the representation of space; and in gradations of light as well as of magnitude. All these directly tend to get rid of the flat surface, and are, consequently, characteristic excellences of the art of painting. Accordingly, in Correggio's system, figures are generally placed at some angle with the plane of the picture, and are seldom quite parallel with it; the consequence is that his masses of light are often composed of many objects. This has been called a broken assemblage of shapes, and, if reduced to outline, it would sometimes undoubtedly appear so, the objects being (to use an exaggerated expression for the sake of clearness) placed *endwise* towards the spectator; but when connected by a magic harmony of light and shade, the result, far from being

scattered, is "a plenitude of effect" seldom to be found in other painters, and more satisfactory than when that mass is cheaply attained by broad flat surfaces. But this picturesque style of composition is ill adapted to the solemn repose which devotional subjects require, especially as Correggio is seldom happy in the arrangement and forms of his drapery; while, as regards the application of chiaroscuro (as he used it) to such subjects, it must again be evident that the charm thus imparted, and without which his composition would have appeared incomplete and unsatisfactory, was sometimes calculated to supersede the consideration of the subject as such, and to become itself the chief source of interest.

The censure of the modern critics before referred to is more especially and justly directed against Correggio's selection and treatment of certain mythological subjects, such as the fables of Leda, Danae, and Io. The effect of soft and harmonious transitions of light and shade—a characteristic excellence of the master—is of itself allied to the voluptuous: the principle was oftener applied by Correggio to subjects of pathos and solemnity; these, assisted by the soothing spell of his chiaroscuro and by forms of beauty, excite a calm and pleasing impression, by no means foreign to the end proposed; but the application was, unfortunately, not less successful when he united beauty and mystery in subjects addressed to very different feelings. Yet, although it may be admitted that the tendency of

Correggio's feeling and fancy, as well as the fascination of his light and shade, found, as it were, a natural application in subjects of the above description, it ought not to be supposed that he alone, among his contemporaries, ventured on such themes. The taste was encouraged by the age; nor were the painters of severer schools free from the infection, though their designs wanted the dangerous attraction which Correggio's style could impart.

In the application of (fresco) painting to architecture, the practice of Correggio differed again widely from that of preceding masters: his innovations in this department may be exemplified by comparing his cupolas with the ceiling of the Sistine Chapel by Michael Angelo. That great painter, though a master of foreshortening, has not, in the instance referred to, supposed his figures to be *above* the eye, but *opposite* to it, so that they are still intelligible when seen in any other situation, as, for example, in an engraving; Correggio, on the other hand, in his cupolas, always aimed at producing the perspective appearance of figures above the eye; and the violent foreshortening which is the consequence renders his figures unsatisfactory except in their original situation and when seen from below, where their effect must at first have been marvellous. Mengs himself was astonished at their apparent distortion when he inspected them near. Yet we have reason to believe that, when aided by light and shade, and in their

uninjured state, their effect was precisely what the painter intended. But, after all, if the object of art be to meet the impressions of nature by corresponding representation, it is evident that foreshortening on ceilings or cupolas, as it necessarily presents the human figure and all objects in a mode absolutely foreign to our experience, must more or less depart from the plain end of imitation, and can only excite wonder at the artist's skill. It remains to observe that the foreshortenings which Correggio has introduced in his cupolas are, in most cases, incompatible with all but a general expression in the features, as the heads are almost always represented as if seen from below. All nobler objects were thus overlooked in the pursuit of a favourite excellence, and Correggio ever sought the attributes of perspective as opposed to qualities of the mere surface: his management of all the elements of gradation, by which he secured space and depth, is (thus) less allied to that perspicuity of representation which distinguishes the formative arts from poetry, than to the specific excellences which distinguish painting from sculpture. To pierce in appearance the surface of a cupola with ascending figures, notwithstanding the amazing difficulty of the undertaking, was an enterprise quite to his taste.

In such attempts to express space no attention was paid to the form of the architecture; the dome was apparently annihilated, and the real and unreal were confounded. In the subsequent abuse of this

system the architectural forms were sometimes literally altered, as in the ceiling of the Jesuits' Church in Rome, where clouds and figures descend here and there below the real cornice, and appear to cast their shadows across it: a surface adapted for painting being inserted in place of the actual entablature where it is supposed to be covered with clouds. The absurdity of such caprices requires no comment; but where the actual mouldings are not interfered with it seems at first a more doubtful question whether the painter has not a right to give the same idea of extent upwards as he aims at in all pictures in the horizontal sense. It appears, however, from the example of Michael Angelo and Raphael, that those masters considered painting on walls and ceilings wholly subservient to the architecture; they seem, at all events, to have considered that no attempt should be made to deceive the spectator respecting surfaces which it may be the architect's purpose to preserve, either for the unity of his design or as essential to construction.

It has been seen that Correggio, in his frescoes, far from sacrificing his favourite qualities in order to make forms more intelligible at that distance from which they were chiefly to be viewed, seized the opportunity of attempting the most daring foreshortenings—such as, indeed, never occur in his oil pictures, where, with every aid from completeness of execution and the power on the part of the spec-

tator of selecting the best point of view and the fittest light, perspective appearances in general might be more clearly expressed. The obvious precaution of greatly enlarging the dimensions of his figures in the cupolas was, however, duly observed, and it must be admitted that, in this respect, he calculated the proportions for the distance better than Michael Angelo, who, in the ceiling of the Sistine Chapel, began his compositions on too small a scale. As regards colour, Correggio seems to have fully comprehended the style fit for pictures requiring to be viewed chiefly from a distance. The peculiarity of his frescoes in this particular, as distinguished from his oil pictures, is the extreme warmth of the shadows in the flesh: the effect of this, as seen from below, is quite satisfactory, although the exaggeration is found to be violent on near inspection. The cooling effect of interposed atmosphere reduces the excessive warmth to the truth of nature, and prevents the opaque and leaden effect which would otherwise be the result. On the colour of Correggio's frescoes Wilkie thus expresses himself:—" Here, I observe, hot shadows prevail: this he has to a fault, making parts of his figures look like red chalk drawings, but the sunny and dazzling effect of the whole may be attributed to this artifice." Again:—" This great work of Correggio (the cupola of the cathedral) has all the harmonious colour of his oil pictures, but is notwithstanding conducted upon a plan quite different

—lightness and freshness being the leading principles. . . . The flesh tint, though never warmer than nature in the lights, is in the shadows hot to foxiness, giving much of it the appearance of a red chalk drawing. The effect of the whole is, however, extremely varied by different coloured lights and shadows, producing the utmost zest and harmony, and, in point of colour, the most rich and beautiful fresco I have seen."

In this treatment of fresco, considered with reference to the important department of colour, Correggio, probably without having seen any similar examples, adopted the same principle which other great painters found, under such conditions, to be indispensable. The remains of Giorgione's works of the kind, the frescoes of Titian and Pordenone, more especially when in the open air, Raphael's Mass of Bolsena, as well as oil pictures by the Venetians and by Rubens, originally intended to be viewed from some distance, are remarkable for this warmth in the shadows. Indeed, in comparing Correggio with these masters, it will be found that while he ventured to the utmost limits in the warmth of shadows in fresco, he is in oil pictures much more neutral and negative in his shadows than the great Flemish and Venetian masters.

It will be unnecessary to dwell on other qualities which can be better exemplified in describing the great painter's practice in oil painting, and which evince the most comprehensive view both of the

appearances of nature and of the modes of attaining their equivalents in art.

Antonio Allegri was born at Correggio, a town afterwards comprehended in the Duchy of Modena, in 1494; he died at the age of forty, thus resembling Raphael and Giorgione in the shortness of his career no less than in the extent of his fame. Little is known of the state of painting in Parma and its neighbourhood at the beginning of the sixteenth century. The influence of Francia, by means of his scholar Lodovico da Parma, and of Bellini by means of Cristoforo Caselli, are slender evidences of the style that may have prevailed there. Correggio is supposed to have learned the rudiments of his art from his uncle Lorenzo Allegri, and from Antonio Bartoletti. If Vedriani is correct in saying that he studied under Francesco Bianchi, called Il Frari, at Modena, this could only have been for a short period, as that painter died in 1510 after a lingering illness, when the scholar was but sixteen years old. A picture by Francesco Bianchi, representing the Virgin and Child enthroned, St. Benedict, St. Quentin, and two angels, is in the gallery of the Louvre; in the general arrangement and in some particulars, even to the coloured bas-relief on the throne, this example has certainly a striking resemblance to an early work by Correggio—the St. Francis in the gallery at Dresden; in execution, however, it has little in common with the style of the great painter except

in the softness of the gradations. In other respects it has the characteristics of most oil pictures of the period; the flesh is thinly painted, while the surface of the darks—of those in the blue drapery particularly—is comparatively raised.

In 1511, in consequence of a plague, Manfredo, then Lord of Correggio, removed for a time to Mantua; and there is good reason to suppose that the young painter, then seventeen years of age, took refuge in that city from the same cause, probably accompanying the court. Of the supposed journeys of Correggio to various parts of Italy, none can be more safely assumed than his visit to Mantua. The communication between the cities of Lombardy, on each side the level course of the Po, presented indeed no difficulty; but the intervening Apennines are perhaps to be regarded among the obstructions which, added to political jealousies, may then have rendered a journey to Florence somewhat formidable. At all events, there is no evidence to show that Correggio was ever in Tuscany, still less that he made a pilgrimage to Rome. Had he even proceeded so far as Lucca, he might there have seen works by Fra Bartolommeo—two of which were painted in 1509—and in that case the sight of these pictures, remarkable as they are, both for force and for delicacy of light and shade, might not unreasonably have been supposed to have influenced in some respect the style of Correggio. The great painter's presence in Bologna rests on an apocryphal story first promul

gated, it seems, by Padre Resta. Correggio is here represented as standing before Raphael's St. Cecilia, the fame of which rendered it an acknowledged type of excellence; but the conclusion which it forced on the mind of the painter of the "Notte" is said to have found utterance in the words, "Son pittore anch' io."

The supposition that Milan was among the places Correggio visited receives some support from the connection which is to be traced between the works of Leonardo and his own. That connection, more or less distinct, but never very positive, consists in a sweetness of expression, in the love of roundness, in softness of transitions, in solidity of surface, and in the use of certain materials. But, as before observed, it is in Mantua that we must look for the most unquestionable sources of those influences which may have contributed to form the style of Correggio.

The works of Andrea Mantegna, from the originality of power which they displayed, and from the great reputation of the master, must there have made a strong impression on the mind of a young artist seeing them for the first time. The historians of art have traced a resemblance between the earliest altar-piece of Correggio — the St. Francis now at Dresden, and the Madonna della Vittoria by Mantegna,—particularly in the action and drapery of the Madonna, to which we shall presently allude; but the quality which was likely to attract the young painter most, and which

he could see nowhere carried so far, was that of foreshortening on ceilings. Andrea Mantegna died in 1506 ;* consequently, it must have been from his works, and not from his personal instruction, as some have supposed, that Correggio could have derived any improvement. A room in the " Castello" at Mantua, called the " Camera dei Sposi," and which still exists, was completed by Mantegna as early as 1474;† the ceiling of this room is a remarkable example of that species of foreshortening, before described, in which the objects and figures are represented as if seen from below, or " di sotto in sù." Round a supposed open space in the centre of the ceiling, through which the blue sky appears, a balustrade is painted, over which Genii look down into the room; the whole being foreshortened as objects would be if really so placed.

The only other work of this kind which, as far as we know, had then appeared in Italy, was a fresco of the Ascension of Christ in the semi-dome of the tribune in the church of the SS. Apostoli in Rome (now in the Quirinal), by Melozzo da Forlì,

* This appears from a letter to the Marchese Francesco Gonzaga, written September 5, 1506, by a son of Mantegna, announcing the death of the great painter as having taken place on the previous Sunday. See *Memorie biografiche dei Pittori, Scultori, Architetti e Incisori Mantovani, del fu Dottore Pasquale-Coddi*, p. 102. The letter is given in appendix.

† See Ib., inscription in the Camera dei Sposi, by Mantegna, p. 101.

originally a fellow-scholar of Mantegna with Squarcione at Padua. Melozzo's work is supposed, on good grounds, to have been executed about 1472; it could therefore hardly have been earlier than the ceiling of Mantegna, which, as it required to be finished before the walls were painted, may well be supposed to have been executed a year or two before 1474—the date of the completion of the whole room. The " sposi " from whom this room received its name were Lodovico Gonzaga and Barbara of Brandenburgh, daughter of the Elector John I. A lady of the same family, Frances of Brandenburgh, the wife of Borso, Count of Correggio, built a palace in 1506 at Correggio.* The rooms were decorated by a painter whose name has not been preserved, and on the ceiling of one of them was repeated, though in a far less skilful manner, the foreshortened design of Andrea Mantegna at Mantua. The sight of this ceiling, and still more that of the original, may have first awakened in Correggio the desire to attempt a similar work, and to this early impression the cupolas of Parma probably owed their existence.

Yet it does not appear that Correggio ever aimed at producing elaborate architectural effects of perspective. It was chiefly the foreshortening of the human figure which he sought to represent with

* See Pungileoni, Memorie istoriche di Antonio Allegri, 1818, vol. ii. pp. 30–31.

truth. To do this he must either have modelled figures himself, in order to copy from them when suspended above the eye, or he must have been assisted by some sculptor. As an excellent modeller, Antonio Begarelli of Modena, was at hand, and as the tradition existed in the seventeenth century that Correggio availed himself of that artist's skill for the purpose in question, it may fairly be supposed that such was the fact; nor is it any derogation, as some writers have insisted, from the great painter's genius, to assume that after having completed his design he would call in the assistance of a sculptor to enable him to prepare clay models of such figures as he could not possibly see, suspended as was required, in nature. At all events, it is certain that Correggio could not have drawn some of the figures in his cupolas except by the aid of models prepared either by himself or by others.

Among the earliest works attributed to Correggio, but of uncertain date, may be mentioned a picture the Betrayal of Christ, in which the incident of the young man escaping naked (Mark xiv. 52) is introduced. Copies are sometimes met with, and two exist with the obviously false dates of 1505 and 1506 ; the original appears to be lost.* A small picture representing the Virgin and Child with St. John, the authenticity of which had been attested,

* Opere di Mengs, p. 188, and note ; and Lanzi, vol. iv. p. 65

in the beginning of the present century by various professors of Parma, was sold in London, at Christie's, with the collection of the late General Sir John Murray, in 1851. The well-known and better authenticated sketch of the Muleteers, in the possession of the Duke of Sutherland, is also placed by most writers among the master's early productions; but, however slight, it betrays no want of experience or of freedom. The three pictures above noticed are supposed, perhaps erroneously, to have been executed before Correggio's visit to Mantua in 1511. His return to his native place is fixed in 1513, and the following year is the date of the St. Francis now at Dresden, as appears by the documents and accounts of expenses relating to it, published by Pungileoni. The undoubted authenticity of this work and its certain date render it a safe criterion for the earlier practice of the painter. It has a certain hardness in the outlines from which the two last pictures above named are exempt, proving that at the age of twenty Correggio had not attained that richness and plenitude of manner which, soon after, characterised his works.

With regard to the influence of particular painters or particular works to be traced in the St. Francis, it would be difficult to believe that Correggio had not somewhere seen examples of the expression of Leonardo da Vinci; the imitation of another master is still less questionable. It is evident

that the Madonna, though not the infant Christ,
in this picture, dedicated to St. Francis, is taken
directly from Andrea Mantegna's Madonna della
Vittoria, an altar-piece which Correggio must have
seen at Mantua. The coincidence is so complete,
that it would alone suffice to prove the previous
acquaintance of Correggio with the works of An-
drea. In justice to the earlier master, it should be
noted that the extended hand of the Madonna is
more successful in his work than in that of Cor-
reggio. Setting aside this defect, the graceful,
free, and picturesque treatment of hands for which
Correggio was distinguished (occasionally carrying
it to mannerism) is already apparent in its best
form in the picture now under consideration; as,
for example, in the hands of the St. Catherine, the
hand of the St. John holding the cross, and the lower
hand of the St. Francis. That tendency in Cor-
reggio to make the composition subservient to the
expression of space is apparent even in this pro-
duction, the arrangement of which might be called
severe in comparison with his later works. The
tendency referred to appears to have dictated a
certain sway of the figures by which their parallelism
with the plane of the picture is avoided, while the
movements are agreeably contrasted with each
other. The circumstance of the two infant angels
above (two only are seen as entire figures) being
nearly similar in action though in opposite views,
may evidence the practice, common no doubt in the

school of Mantegna and his followers, of using clay models for similar foreshortenings.

If the St. Francis may be said to foreshadow the characteristics of the painter in the qualities hitherto considered, the resemblance is still more complete as regards the method of oil painting which it exhibits. It was probably in Mantua, during a residence of two years, that Correggio adopted that solid, full manner of painting which is more or less apparent in his earliest known works; the system of using a thick, rich vehicle for shadows was common, as we have seen, to most painters of the time, but the smooth solidity of his lights was new, and may be said still to remain peculiar to him. The technical conditions of this surface will be considered hereafter; its early adoption by Correggio may perhaps be traced to the method of some painters of the Mantuan school but little known, and with whom it may have been an accidental attribute. The remaining works of Leonbruno[*], for example, sometimes exhibit a fulness of "impasto" which, if adopted sufficiently early (and he was five years older than Correggio), may have influenced the style of the master.

The flesh throughout the picture of St. Francis is smooth yet solid, nowhere so thin as to show an outline underneath, and nowhere hatched. The

[*] Notizie storiche spettanti la Vita e le Opere di Leonbruno, da Gir. Prandi. Mantova, 1825.

flow and fusion of the substance in the flesh tints, without apparent handling, indicates the use either of a half-resinified oil or of an oil varnish—probably the finest amber varnish of the Flemish masters. Where the vehicle abounds, for example, in lucid darks, as is generally the case in Correggio's works, the surface has frequently that blistered, roughened appearance so often before described as the effect of time on the " vernice liquida." To account for this, we must either suppose that the commoner vehicle (sandarac oil varnish) was used with the darks, or that a lavish use even of the amber varnish is subject to the same effects after a long lapse of time—effects consisting, apparently, in the gradual separation and desiccation of the oleaginous portion, and the concretion and agglomeration of the resinous particles. In the works of the Van Eycks and their immediate followers, the more moderate use of the oil varnish has had no worse consequences than to produce small, reticulated, uniform cracks, the substance of the vehicle having been too inconsiderable to cause the change above mentioned; but the large scale on which the Italian masters painted soon led to a copious employment of the oil varnish, and when we occasionally find the same change in the darks of Titian and of Rubens, we must either conclude that they all made use of the sandarac oil varnish in such portions, or that the firmer amber varnish, when so abundantly used, is liable to the same consequences.

To return to the St. Francis. In the masses of shade and in the darks generally in which the vehicle was abundantly used, the surface has now that rugged, more or less agglomerated appearance before alluded to, producing the very opposite effect to that intended by the painter: the effect is especially remarkable in the shadows of the grey dress of the St. Francis, and in those of the red drapery of the St. John; in the latter, especially in the shadow between the legs. The other peculiarities are such as we should expect from the use of the materials often before described; the blue drapery of the Madonna has the usual prominence, while the red is not more raised than the general surface; the flesh, as before remarked, is comparatively solid and smooth, and rarely exhibits cracks: the left foot of the St. Francis has, however, the fine and numerous cracks so often occurring in the works of Leonardo da Vinci. The picture is on wood.

It will now be desirable to take a rapid glance at the works of Correggio, as far as possible in their chronological order, indicating peculiarities of execution where they occur, but reserving any further remarks on his technical methods and materials till his principal works shall have been noticed.

A picture painted for a church at Carpi, and which has been confounded by Lanzi and others with the St. Francis, probably represented a Pietà,

being described as " Maria Vergine con Gesù Cristo nel grembo."

The portrait of a Physician in the Dresden Gallery belongs to the same period: reasons for supposing it to represent Giambattista Lombardi rather than any other person, are given by Pungileoni. Hirt remarks that it might pass for the work of a Venetian master, but for the peculiar solidity of the colour which distinguishes Correggio. Mengs also remarks that it has even more "impasto" than Giorgione. It is on wood, and is generally free from cracks. Lombardi was at once the physician, the friend, and the instructor of the artist; he was godfather to Correggio's first-born child in 1521. In the close intimacy which subsisted between them, he assisted the painter not only in his anatomical studies, but in such chemical researches as were calculated to aid him in the practice of oil painting.

A " Riposo," formerly in the church of the Franciscans at Correggio, representing the Virgin and Child, St. Francis and St. Joseph, has disappeared. The pretended original is in the tribune of the Uffizj at Florence ; but, notwithstanding some historical circumstances in its favour, it has not sufficient internal evidence to warrant its being classed among the genuine works of the master. Among other lost works may be named three pictures, originally forming an altar-piece in three

parts, representing a figure of the Almighty in the centre, on one side St. John the Baptist, on the other St. Bartholomew. The picture of Christ, seated on a rainbow, with some angels above, formerly in the Marescalchi Gallery at Bologna, is now in the Vatican; it is by many not considered genuine. A picture of the daughter of Herodias with the head of St. John, and another, a shepherd playing on a flute, are among the works of the master at present known only by copies.

The picture called S. Marta (more properly Margarita), containing figures of St. Peter, the Magdalen, and S. Leonardo, is now in the possession of Lord Ashburton. This work, attributed by high authorities to the master, has, with some evidences of inexperience, the solidity of the flesh peculiar to Correggio, but the dark shadows have no longer the transparency nor the superficial indications of a rich vehicle. This may be partly the result of its having been lined (if not transferred from wood to cloth)—a process which has always the effect of flattening and equalising the surface of the colour. The blue drapery of St. Peter has, however, the usual relative prominence, as may be seen in the portion above the yellow drapery. It seems that this picture was at one time, while at Correggio, purposely covered with a dark varnish to prevent its being taken away, and probably the removal of this, whenever the

operation took place, may have removed also some of the original surface, and may have rendered considerable retouchings necessary.

An altar-piece of the same quality and period was painted for a church in the village of Albinea, near Scandiano. The composition, to judge from an ordinary engraving, was but indifferent. The original cannot at present be traced; a copy by Boulanger was substituted for it in the seventeenth century.

Of Correggio's frescoes in the convent of S. Paolo at Parma, painted about 1518, it is unnecessary here to speak. A fresco of the Assumption of St. Benedict, painted about the same time on the ceiling of the dormitory of S. Giovanni, at Parma, is now known only from descriptions.

While on the subject of Correggio's frescoes, his more important works of that kind, though some were executed later, may be here enumerated. The cupola of the church of S. Giovanni at Parma represented the Ascension witnessed by the Apostles: the figures of the latter are colossal. In the tribune of the same church Correggio painted the Coronation of the Virgin amid an assembly of saints and angels. This latter work was destroyed in 1588, in order to enlarge the choir. The largest fragment which was saved—part of the main subject— is now preserved in the Library at Parma; other portions are sometimes to be met with in private collections. Before the demolition, portions were copied by the Carracci, and the two pictures of

groups of heads and portions of angels in the National Gallery are probably by Annibale Carracci; other portions so copied are in the gallery at Naples. The design of the whole fresco was repainted in the tribune of the enlarged choir by Cesare Aretusi, from a copy made by him in oil. These frescoes in S. Giovanni were completed by Correggio in or before 1524.* Vestiges of another (fresco) representing some infants, in a garden niche in the precincts of the Benedictine convent in the same city (Parma), may still remain. Other less important works in fresco attributed to this period may be passed over. Some remains, removed from their original places, are preserved in the church of the Circumcision, and in the Academy at Parma.†

In 1519, the marriage of his sister Catherine to Vicenzo Mariani is supposed to have suggested the picture of the Marriage of St. Catherine, now in the Louvre, as a present to the bride. The small picture of the same subject in the Naples Gallery

* The first payment on account of the cupola of the Duomo at Parma is dated 1526. The work was suspended occasionally, but was completed in 1531. The subject is the Assumption of the Virgin. Both cupolas—that of the Duomo and that of S. Giovanni, with other works of the master—are engraved in an admirable manner by and under the direction of the Cav. Toschi.

† For an account of some minor works in the church of St. John Evangelist, over the door of the chapter-house, see Pungileoni, pp. 145-146.

is different in composition, and was probably painted later; there is also in the same gallery a copy of the Louvre picture. That picture exhibits the perfectly formed technical manner of Correggio, while the peculiar golden tone of the flesh may indicate the use of a mellowing vehicle: the solidity of the surface is of the fullest kind, and the lights are almost free from cracks; the darks are comparatively raised, and in some few parts are slightly corroded in the manner so often described; the blue, both in the drapery and in the distance, is very prominent. The Naples picture has that shrivelled surface which indicates a profuse liquid medium, probably an oil varnish; the surface is also minutely cracked; the sky is more thickly painted than the flesh, and the blue drapery, now darkened, has the cracks which indicate the use of the " white varnish."

Some writers place the small picture of Christ in the Garden, now in the possession of the Duke of Wellington, about this period of the master's practice; if they are correct it is plain that, soon after the age of twenty-five—when the Marriage of St. Catherine may have been painted—he had attained the perfection of that taste in chiaroscuro which distinguishes his finest works. The use of an oil varnish, or of a copious vehicle of some kind, with the colour, is apparent in the shrivelled surface of the blue drapery.

In 1520, at the age of twenty-six, Correggio

married Girolama Merlini, and there appears no reason to doubt the common opinion, that, after the birth of his son Pomponio, in the following year, the picture of the mother with the sleeping child, called La Zingarella, in the Naples Gallery, that of the Virgin adoring the Child, in the Tribune at Florence, and, at a somewhat later period, that of the Virgin dressing the Child, in the National Gallery, may have been suggested by domestic scenes. The Zingarella appears, from some slightly injured portions of the picture, to have been painted on a light warm ground; the background is more thickly painted than the flesh; the light portions of the flesh are shrivelled, but the cracks are probably in the ground or priming. The intense blues and greens have the usual prominence of surface.*

The Madonna, with the infant lying before her, in the Tribune at Florence, with all its grace, borders so nearly on affectation and quaintness that it is doubted by some; in all technical respects it is worthy of the master. The substance is, as usual, considerable throughout; still the darks are thickest, and are more cracked than the lights. Mengs remarks that a " Noli me tangere,"

* Of this picture Wilkie says :—" The Virgin and Child with the Rabbit is a first-rate specimen. The white is of a rich cream colour, the flesh like Rembrandt's, the blue drapery toned into complete harmony, the green (some fresh colours) glazed into great depth, and the leaves of the trees behind the Virgin's head like the deepest emerald."

by Correggio (formerly in the Escurial, now in the Madrid Gallery) is similar in style to this picture. The Madonna dressing the Child, in the National Gallery, is, as regards the painting, a perfect specimen of the master; in this instance again, although the flesh is remarkably solid, the darks are still more prominent. Mengs noticed several " pentimenti " in this picture; they are apparent in the changes of the action of the Madonna, and also of the Infant.*

The graceful Cupid making his bow, while two Amorini, in the lower part of the picture, laugh and weep, is well known by repetitions; on the authority of Vasari, it is commonly ascribed to Parmigianino; the invention is, however, probably due to Correggio alone, as it is essentially his in conception and feeling. The example in the Belvedere Gallery at Vienna is perhaps the original, but even its warmest admirers acknowledge that it has suffered considerably; the picture is on wood; there is, or was, a good copy in the same gallery by Heinz. The repetition in the Stafford Gallery, formerly in the Orleans collection, and long ascribed to Correggio, is now more justly attributed to Parmigianino.

The " Ecce Homo " in the National Gallery, a picture of Correggio's best time, is also one of the best examples of his treatment of sacred and grave

* Mengs, Opere, p. 312.

subjects.* It has been justly observed that the painter, distinguished as he was for a graceful sentimentality and an exuberance of feeling, sought, in undertaking such subjects, rather to express the passion of grief than the profound sense of sorrow or resignation. This work is an instance: the expression, even of the Christ, may be said rather to excite sympathy than to inspire awe, while those of the Madonna and the Magdalen embody the intenseness of grief. As this picture is on wood, the relative prominence of the colours is sufficiently apparent; the blue of the Madonna is much raised; the richly varnished deeper shadows also indicate the use of a copious vehicle; the cracks in general appear to be those of the panel, or of the ground only; but behind the figure of Pilate the peculiar cracks of the " vernice liquida" are apparent. The head of the Magdalen appears to have been an afterthought, or " pentimento," as the blue drapery was originally completed underneath it.

The Mercury teaching Cupid to read, in the National Gallery, is not in so good a state as the other two pictures by the master in the collection; to say nothing of its retouchings, the operation of lining has had the usual effect of flattening the colour, so that there are now few indications of the appearance which the surface of the shadows may once have exhibited.

* Reynolds' Life, by Northcote, vol. i. p. 36.

The Jupiter and Antiope, now in the Louvre, though in better preservation, has the same equality of surface from the same cause: the cracks in the substance of the solid colour are such as are found in canvas that has been rolled; a darkened varnish which has penetrated some of the cracks conveys the impression of the picture having been painted on a dark ground, but a careful examination shows that such was not the case. With the exception of these slight defects, the picture is an excellent example of the best style and period of the master. The preparation, or under-painting, of the now warm and golden flesh must have been cool; a rich brown is glazed round the outlines, in shadows, and round the herbage and other objects.

The Deposition from the Cross and the Martyrdom of S. Placido and S. Flavia, two pictures originally painted for a chapel in the church of S. Giovanni at Parma, are now in the gallery of that city. Both are on cloth, and, from the cause before mentioned, exhibit but little indication of the original delicacies of execution. In the Deposition both the blue and lake draperies of the Virgin are covered with the minute cracks of the "vernice liquida" moderately used. In the subject of the Martyrs*, the shrivelled surface of the darks indicates the more copious employment of an oil varnish; the same appearance is observable in

* This picture was among the Correggios taken to Paris.

the blue and orange draperies of the S. Flavia. Both pictures are tolerably free from cracks in the solid lights. Repetitions are in the Madrid Gallery.

The St. Sebastian, now at Dresden, was painted about 1525, for the confraternity of St. Sebastian at Modena. It was one of the six Correggios which migrated from the gallery of Modena to the Saxon capital.* It was repaired in the seventeenth century by Flaminio Torre, a Bolognese painter; in the hands of another renovator it is said to have been placed in the sun, and to have suffered in consequence. Its last restorer was the celebrated Palmeroli. It is, however, not in so ruined a state as was supposed. The flesh is as usual smooth and solidly painted; the shadows only exhibit a corroded appearance, the use of a rich vehicle desiccated and contracted in the mode before described. This is observable in some shadowed portions of the flesh—for example, in the left leg and arm of the St. Sebastian, and in parts of the body, and still more in the shadows of draperies, as in those of the yellow ecclesiastical garment of the S. Geminiano. The surface of the blue draperies of the St. Rock and of the Madonna is more raised in comparison with the other parts. The picture is on wood.

* Ninety-nine pictures, selected from the gallery of Francis II., Duke of Modena, were purchased in 1745 by Frederick Augustus III., Elector of Saxony and King of Poland, for the sum of 30,000 gold sequins, which, as is supposed were coined in Venice for the occasion.

The "Madonna della Scodella," now in the gallery at Parma, may have been painted in 1528; the date on its frame when in its original place—the church of S. Sepolcro at Parma—was "1530, 19 Giugno." Some accounts of its having been early maltreated are contradicted by Mengs; but its present state, probably from the partial removal of glazings, does not exhibit that general harmony so remarkable in most of the master's works. The shadows have the short cracks and an approach to the corroded appearance of the usual oil varnish. The surface is partially cracked and blistered in the lights, as in the lower angel. The blue drapery of the Madonna and the subdued green drapery of St. Joseph have the raised appearance so often noticed on wood. Wilkie writes thus from Parma in 1826 :*
—" The Holy Family, Madonna della Scodella, is here, but has suffered much—blues rubbed to the bone. The trees behind the Virgin are most rich and lucid, scarcely anything but asphaltum; the whole picture more thin and transparent than is his wont. The drapery about Joseph is of the brightest chrome and orange; and though parts of the picture are out of harmony, it is still most captivating in its effect."

The celebrated St. Jerome, also in the gallery at Parma, must have been completed in 1527–1528,

* Life of Sir David Wilkie, by Allan Cunningham, vol. ii. p. 279.

for a chapel in S. Antonio at Parma. The com-
mission, given some years earlier, was from Donna
Briscide Colla; the price was four hundred gold
" lire imperiali," and the lady, to show her satisfac-
tion, when the work was finished, sent to the artist
among other acceptable presents from her farm a
well-fattened pig.* According to another record,
the monks of S. Antonio were the givers: in
either case an allusion was probably intended to St.
Anthony, for although that saint is not introduced
in the picture, his church was benefited by the
addition of such a work to its internal decorations.
The inequality of the surface in this picture is at
once a proof of its good preservation and an illus-
tration of the practice of the master. The substance
or " impasto " of the flesh and of the lighter objects
generally, however solid, appear embedded next the
darks, and next the blue draperies. This is very
apparent in the shoulder of the infant next the
blue on the Madonna's left shoulder, in the right
arm of the St. Jerome, and in the roll of paper he
holds, as compared with the raised surface of his
greenish blue drapery. The leg of St. Jerome
clearly shows, with the surrounding colours, the
practice so often illustrated; the upper portion
next his blue drapery is much embedded as com-
pared with that drapery; next the lake drapery it

* The story is also told of other pictures, with circum-
stances intended to prove the poverty of Correggio. See Pun-
gileoni, vol. i. p. 196.

is less so; while the knee, and the red drapery of the Virgin, on which the knee is relieved, are level. The red lining of the drapery of St. Jerome is in like manner embedded in the blue next it. The same appearance is observable in the relative surfaces of the shoulder of the Magdalen and the dark background, the latter being much more prominent. The portions most cracked are the blue drapery of the Virgin (which, in its nearer portions, exhibits a cream-coloured ground through the cracks) and the darker parts of the blue drapery of St. Jerome, especially behind the arm. The continuous cracks in the blue of the Madonna and elsewhere indicate the white varnish; the lake draperies and some of the more thinly glazed darks exhibit the short reticulated cracks of the firmer varnish. The solid smooth lights are as usual less affected in this way; the portion which is most cracked is the white drapery under the left hand of the Madonna, and the appearance indicates a more copious use of the varnish.

Wilkie observes of this picture:—* " The famous St. Jerome (or the Day) takes the lead; this, for force, richness, beauty, and expression, makes everything give way. Hundreds of copies have been made, but all poor compared with the fearless glazings, the impasted bituminous shadows of this picture." Again: " The famous picture of the Holy

* Life of Sir David Wilkie, by Allan Cunningham, vol. ii. p. 279.

Family and St. Jerome, of which there are so many
poor and black copies, though it is rich and bril-
liant beyond description. This, compared with all
about it, has a power quite extraordinary; the
lights, particularly of the flesh, are mellow and
rich, the shadows transparent and clear, and some
of them deep as midnight. The Magdalen, for
character, colour, and expression, is the perfec-
tion not only of Correggio but of painting, and the
head and body of Christ have that luminous rich-
ness that forms one of the greatest delights and one
of the greatest difficulties of the art. In looking
closely into this picture, I find the lights generally
the least loaded; the blues extremely loaded both
in light and shade, and the thickest paint of all is
that in the deepest shadows in the centre of the
picture, where the colour appears both to float and
to crack from the impasted colour and vehicle neces-
sary to the strength of his effect.* . . . His red on
St. Jerome's drapery is of the most intense kind
that vermilion, glazed, will produce; but if I
do take an exception, it is to the quality of his
brightest blues, being, in comparison with what I
have seen in his other works, too intense and too
cold for the harmony of the rest of the picture.
The usual excuse in pictures of this kind is the
ravages of the picture-cleaner; but in a work so
carefully preserved this will not serve. The ap-

* Life of Sir David Wilkie, by Allan Cunningham, vol. ii.
pp. 289–90.

pearance in the blues of rubbing is not obvious; indeed their being painted in a thicker body than the rest of the picture would seem to show an intention that they should tell strong. Their effect almost amounts to harshness; but to question Correggio's harmony is like cavilling at Sacred Writ. In his Madonna (the Zingarella) at Naples the blue is softened down to a greenish hue like Rembrandt." On wood.

The celebrated picture of the Nativity, called "La Notte," as the St. Jerome, by way of contrast, is distinguished as "Il Giorno," was painted for the Pratoneri family in Reggio, and was placed in the church of S. Prospero in that city in 1530. Correggio received the commission in 1522, but the picture does not appear to have been painted till 1529. It was removed to Modena in 1640, and passed from the Ducal Gallery of that city to Dresden in 1745. It is unnecessary for our present purpose to dwell on the higher qualities for which this work is renowned. Its technical excellence was originally as remarkable as its invention, but it is one of those works which have suffered from time and cleaning. The present relative smoothness both of lights and darks is to be attributed to the operations of restorers; the blue drapery of the Virgin—the usual test of the preservation of a picture of the time—is still, in a slight degree, more raised than the surrounding colours, but the shadows generally have no longer the rich sub-

stance derived from a substantial vehicle, which, in all probability, they once possessed.

" The Notte of Correggio," says Wilkie, writing in 1826, " is no longer what it was—*it is a rubbed-out picture.* The glazings upon the lights having been taken off, they are left white and raw, and can no longer be judged of as the art of that great master."* Elsewhere: " Correggio did not, like Rembrandt, in these effects attempt to give the colour of lamplight; the phosphorescent quality of light was more his aim, as in his Christ in the Garden. But here the light on the Virgin and Child is white, chalky, and thin; Still, however, the beauty of the Mother and Child, the matchless group of angels overhead, the daybreak in the sky, and the whole arrangement of light and shadow, give it the right to be considered, in conception at least, the greatest of his works."† The picture is on wood.

The picture called S. Giorgio was painted for the church of S. Pietro Martire in Modena, about 1531–2; from the Ducal Gallery, to which it was afterwards removed, it migrated with the flower of that collection to Dresden in the last century. The solidity of the lights in this picture is unimpaired and is very remarkable, but the rich glazings have

* Life of Sir David Wilkie, by Allan Cunningham, vol. ii. p. 327.

† Ib. vol. ii. p. 337.

been disturbed, so as to obliterate in a great measure the inequalities of the surface. On wood.

The well-known recumbent Magdalen reading was one of the six works of the master which, with other fine works in the gallery of Modena, enriched, or rather formed, the Dresden Gallery. The precise date of this picture is uncertain, but it may be safely concluded that it was the result of the consummate experience of the artist. The description which Sir D. Wilkie has given of this picture is sufficiently applicable to the purpose of these notes. " To those," he says, " who like pictures in their pristine condition, the Magdalen will be highly satisfactory. This is perfect, almost as left by the master, without even varnish. The neck, head, and arms, are beautiful; the face and right arm one of the finest pieces of painting I have ever witnessed. The shadows of this picture are extremely loaded—the lights, though painted flat and floating, are, compared with them, thin and smooth. The book and left hand are finished with a softness and detail resembling Gerard Dow, or Van der Werf. The background and darks of this picture, even the blue drapery, want richness and transparency."*

Elsewhere: " The small Magdalen, though it is very small, is in the most perfect condition; the head and arms most highly finished, and in a most

* Life of Sir David Wilkie, by Allan Cunningham, vol. ii. p. 327.

creamy, floating manner of painting, but the background and blue drapery want richness."* This picture is on copper.

The Io, the Leda, and the Ganymede have been so much injured and repaired that a description of them would be of little use. The best example of the first-named is in the gallery at Berlin, where the Leda is also preserved. The Ganymede and a repetition of the Io are in the Belvedere Gallery at Vienna. All are on cloth. The Danae, formerly in England, in the collection of Walsh Potter, is now in the Borghese Gallery in Rome; this is also on cloth, and, like the pictures last noticed, is covered with cracks: although better preserved than those specimens it exhibits little inequality of surface: a dark blue, part of the couch, has the usual appearance in consequence of the thick vehicle used with it.

The two allegorical pictures of the Triumph of Virtue, and the Bondage of Vice, described by Mengs as forming part of the Royal Gallery of France, are now in that part of the gallery of the Louvre which is devoted to drawings. Both are in tempera, and on cloth. A repetition of the Triumph of Virtue in the Doria Gallery in Rome is interesting from being unfinished, clearly showing the process—or, at least, one of the processes— of Correggio, not only in tempera but in oil. The

* Life of Sir David Wilkie, by Allan Cunningham, vol. ii. p. 338.

cloth, which, as usual in tempera painting, is not primed, has a warm brown tint by way of ground. In the upper part of the picture there is a portion, consisting of infant genii amid some clouds, which is outlined only, with a red (painted) outline. The figure of Virtue is prepared with white and a brownish black only; the high lights in this figure are cracked in very small cracks. The winged figure of Glory is partly coloured, apparently on a similar preparation, the flesh colour having warm shadows. One of the infant genii above is begun in a cold black and white, slightly tinted in the face and in the pale golden hair. The head of a figure seated near the figure of Virtue is finished very carefully, and in full colour. There is some doubt whether this final work is tempera or oil; it is more probably the former. In consequence, perhaps, of the rolling of the cloth, or other careless treatment, the colour has scaled off in a few parts, and sometimes in lines, as if the cloth had been folded. The sky and green ground appear to have been painted at once in their present colour. Mengs, who also describes the Doria picture, does not hint at any part of it being in oil. He says: " In this work we see one portion prepared only in black and white, very thinly, but at the same time with the grace and intelligence of his finished works. Other portions are executed in colour, scarcely tinted, yet giving the perfect effect of nature. Above all, it is wonderful to observe the great intelligence of foreshortening,

especially in those parts where the prominence of muscles or the fulness of forms partly conceals the forms beyond, producing that intricacy of modelling which is so difficult to express satisfactorily. On the whole, I should say," continues Mengs, "that there are many pictures of the master more beautiful than this, but in none of the finished examples is the greatness of Correggio more apparent." *

Other pictures by Correggio in tempera were once in the Farnese collection at Parma, as appears from Barri's notices, and from portions of a MS. catalogue of that collection published by Pungileoni.

Having now enumerated the greater part of Correggio's existing works, and having described their appearance so far as is requisite for the present enquiry, it remains to compare the evidence so furnished with other circumstances tending to throw light on the technical method of this consummate master.

Every method was familiar to Correggio; the drawings and studies for his frescoes, which are preserved in various collections, are generally executed, or at least completed, in red chalk †, and exhibit the most profound knowledge of foreshortening, the most delicate feeling for roundness, and a thoroughly practised hand. His love of gradation and of the imperceptible union of half-tints led

* Opere di Mengs, p. 187.

† Drawings of this class were in the collection of Vasari. See Pungileoni, vol. i. p. 144.

him to use the "stump" or some similar mechanical means.* Among other materials he appears sometimes to have employed coloured crayons, or, at all events, to have produced drawings similar to crayon drawings. Bellori and Baldinucci mention the circumstance of Baroccio having been first induced to emulate Correggio by seeing some studies by that master in crayons. As regards Correggio's practice in modelling, it must be evident to every painter that he used clay models for the drawing of some of his foreshortened figures, and for light and shade generally. Mengs remarks that the infant angels standing behind the figure of St. George (playing with the helmet of that saint), in the picture called the "S. Giorgio," show, by the peculiar effects of cast shadows upon them, that those effects must have been copied from clay models.† The practice of modelling, as an auxiliary to foreshortening, may have been first learnt by Correggio at Mantua among the followers of Mantegna. In Mantua also he may have studied from specimens of the antique (which some writers send him to Rome to see), and in the same city he probably acquired that solidity in oil painting which neither his Modenese instructors nor the older artists of Parma had approached. The practice of tempera might have been acquired anywhere, but

* Waagen, Kunstwerke und Künstler in England, vol. i. p. 126.
† Opere di Mengs, p. 179.

the examples of Mantegna's Triumphs, at Mantua, painted as they are on cloth, were more allied to Correggio's freedom of hand than the laboured productions of the earlier masters who practised that method on wood. The advantage of painting in tempera on cloth, when delicate modelling is required, is that the work (otherwise rapidly drying) can be kept moist by wetting the back of the picture. This method is noticed by Vasari and by Armenini.* The few existing tempera pictures by Correggio are all on cloth; whether they were intended as preparations for oil pictures, and whether all his oil pictures on cloth were originally prepared in tempera, it is impossible to say. The tendency of size colours to crack renders it advisable to use them very thinly; but, even if thickly used, a layer of oil colour, applied with a firm vehicle, sufficiently fixes the more fragile substratum. The chief use of a light tempera preparation is to arrest the forms and masses of light and shade before the application of oil; but the same end may be answered by using essential oils mixed in a large proportion with the fixed oil, according to the method before described of Leonardo da Vinci. Whatever may have been Correggio's object in occasionally painting in tempera, it is not probable that the fear of oil, which we have seen operated so strongly with some of the Florentines, was among his reasons. At the

* Dei veri Precetti della Pittura, vol. i.

same time it is evident, from the unfinished portions of the Doria picture, and from many of his pictures which have, to a certain extent, lost their glazings, that he began his flesh colour on a comparatively colourless, and sometimes even cold scale, as compared with the glow of his finished works. It is not difficult to trace this fresh and cool preparation even in some of his warmest pictures, as, for example, in the Jupiter and Antiope in the Louvre. Others, again, like the St. George at Dresden, and the beautiful Madonna and Child in the National Gallery, are probably in a cruder state than when they were first completed, and tend to throw light on the artist's process. Sir Joshua Reynolds was of opinion that Correggio began his pictures with cool colours. He says: " The Leda in the Colonna Palace, by Correggio, is dead-coloured white, and black or ultramarine in the shadows; and over that is scumbled, thinly and smooth, a warmer tint—I believe caput mortuum [colcothar of vitriol]. The lights are mellow, the shadows bluish, but mellow. The picture is painted on panel, in a broad and large manner, but finished like an enamel; the shadows harmonise and are lost in the ground."* The following observation also occurs: " Dead colour with white and black only; at the second sitting carnation; to wit, the Baroccio in the Palace Albani, and the Correggio in

* Northcote's Life of Reynolds, vol. i. p. 36.

the Pamphili (Doria)." He further observes: " The
Adonis of Titian, in the Colonna Palace, is dead-
coloured white, with the muscles marked bold: the
second painting, he scumbled a light colour over
it: the lights, a mellow flesh colour; the shadows
in the light parts of a faint purple hue—at least so
they were at first. That purple hue seems to be
occasioned by blackish shadows under, and the
colour scumbled over them. I copied the Titian
in the Colonna collection with white, umber,
minium, cinnabar, black; the shadows thin of
colour. In respect to painting the flesh tint, after
it has been finished with very strong (crude)
colours, such as ultramarine and carmine, pass
white over it, very, very thin with oil. I believe
it will have a wonderful effect. Or paint carnation
too red, and then scumble it over with white and
black."*

The above remarks were made by Reynolds at
the age of twenty-seven, but his unfinished or
damaged pictures at a very late period of his prac-
tice exhibit a similar principle. Not long before
his death, some pictures, which he was in the habit
of lending for students to copy, were prepared with
indian red, black, white, and umber, and purposely
left in that unfinished state. His biographer
(Northcote) remarks: " It was always Reynolds'
advice to his scholars to use as few colours as

* Northcote's Life of Reynolds, vol. i. p. 37.

possible, as the only means of being secure from becoming dirty or heavy in colouring."* With regard to the use of black, it is to be remembered that a preparation of shadows with white and black requires to be very light, for, if painted with much force, no glazings, however warm, can overcome the greyness, and the result will be heavy and opaque. The practice of Reynolds and of Correggio (in part of the Doria picture most clearly) shows that the use of black and white in the preparation is compatible with extreme warmth at last; but many colourists—and the late Mr. Etty may be quoted as an example—either avoid black altogether in flesh, or use it very sparingly, preferring raw umber. Mr. Etty used black (with white) in his light tempera preparations only. When questioned about this by the author, to whom he once showed a beginning in tempera, he replied: " I use black in this stage of the work, but never afterwards."

The use of a warmer and colder chiaroscuro preparation in the same work, is observable in the works of many colourists—in the Doria Correggio, in Vandyck's chiaroscuro pictures and sketches, and in those of Rembrandt. The later system of Reynolds—the use of white, black, indian red, and raw umber—may be safely recommended, inasmuch as these materials comprehend representatives (however negative) of the three primary colours; black

* Northcote's Life of Reynolds, vol. i. p. 40, note.

representing blue, colcothar red, and umber yellow. In his copy of the Colonna Titian, it appears Sir Joshua used vermilion instead of indian red. Such colours, while they are too few and simple to become heavy by immixture, and while they thus invite freedom and solidity, may also be used at last as scumbling colours, (the black excepted) by which the qualities of warmth and transparency, if not that of force, may to a great extent be rendered.

When the simple materials above named, or others equivalent to them, have done their utmost in arresting form, roundness, expression, solidity, and, as far as possible, warmth and depth, the work is duly prepared for rich shadows—applied with a lucid but very substantial vehicle—and, for corresponding half-tints and lights, toned by semi-transparent and transparent colours, and always applied with a rich vehicle.

It is here that the great difference—after all more apparent than real—between the Italian and Flemish system is to be remarked. The advice of the earliest oil painters, and of Rubens, was to begin with the shadows. In the methods above noticed, the darkest shadows are first inserted after the work is far advanced. This seeming contradiction is easily reconciled: in the preparation, the rule of Rubens may, and had better be strictly followed; and when the preparation is complete and the work thoroughly dry, the new operation is

only a repetition of the same order of processes on a more transparent scale: the painter again begins with the shadows—this time carefully avoiding any admixture of opaque tints with the dark transparent colours, and keeping the thinly applied (in their nature opaque) scumbling colours from mixing with the shadows. In short, the *last* operation of the Italian practice is, strictly speaking, the *only* operation of the Flemish practice.

The first stage of the Italian process—the solid and well-modelled preparation—as has been already stated, was first reduced to a system by Leonardo da Vinci; but it was perfected, and sometimes perhaps abused, by Correggio and the Venetians. The confidence which a painter acquires when he is confined to a few colours, and the feeling with which he works when solidity is made an object, render him indifferent to alterations, and the works of the Lombard and Venetian colourists consequently often abound with *pentimenti*. The history of *pentimenti*—literally repentances, or afterthoughts—throws some light on the progressive practice of art. Doubtless the early painters abstained from such changes partly from timidity; but their method also had its influence. The fresco painters were compelled, from the nature of the process, to complete their design before beginning to paint; the tempera painters, partly from the habit of fresco and partly from the peculiar conditions of tempera, as it was then practised for

altar-pieces, considered a finished design as a pre-
paration for the picture indispensable. The same
may be said of the early Flemish and of some
Italian oil painters. In all these cases it is plain
that any experiments or changes in the composition
must have been made in separate drawings and
sketches. Some of the Italian masters who adopted
the Flemish practice deviated so far from this sys-
tem that they occasionally made considerable altera-
tions in the design on which the picture itself was
to be painted, but, in general, none in the picture
properly so called. Fra Bartolommeo, for example,
sometimes painted on outlines on which the original
sketch and the subsequent (and final) composition
existed together, the picture itself being altered
no more. Lastly, *pentimenti* in the picture itself
suppose solidity, and hence they occur chiefly in
the works of the habitually solid painters, such as
the Lombards, the Venetians, and their followers.

The brightness of the ground is of less im-
portance when that ground is everywhere thickly
covered; still, as a measure of precaution, it is
always desirable to use a light ground, as it is
always convenient to paint on one slightly tinted.
Correggio's tempera work in the Doria is on a warm
brown ground; his oil pictures appear to have
been painted on a lighter warm tint. *Penti-
menti* sometimes, as the case may happen, are
painted on the worst possible ground; thus the

alteration in the face and neck of the Madonna, and the introduction of the hand of the Magdalen in the "Ecce Homo" of Correggio in the National Gallery, involved the necessity in both cases of painting flesh on a very dark blue. It has before been explained that the tendency of the white to become transparent sooner or later renders the dark colour underneath visible, even when the super-added pigment is unusually thick. On this account it is advisable to remove very dark colours, and to lay bare the light ground before repainting.

Black, white, and red were, in the opinion of Reynolds, sufficient to prepare a picture for the colouring of Correggio. In speaking of the Venetian painters we shall hereafter have occasion to quote a still higher authority recommending the same materials. Black, white, and red are sufficient not only to prepare a picture, but to imitate nature in many important qualities closely; and when no approach to completeness is attainable with such means, the addition of a multiplicity of colours would not really finish the work more, but, on the contrary, would rather multiply its defects. The extreme of force is obviously not within the compass of such colours, especially as blackness is to be avoided; for while black itself has not the depth of some intense and transparent browns, the necessity of always largely qualifying it with red, and in most cases even with white, leaves the extreme depths unexpressed. The last glow of

warmth is also clearly unattainable with such means. But, with these exceptions, most of the attributes of the skilful painter can be expressed with the simple materials in question.

Solidity of execution, with the vivacity and graces of handling; the elasticity of surface, which depends on the due balance of sharpness and softness; the vigorous touch and the delicate marking —all subservient to truth of modelling—are qualities admired in good pictures as if colours in all their variety were essential to produce them; but the material conditions on which such qualities depend are literally confined to solid white paint and any representative of darkness which can serve to measure the gradations of light.

The skilful application of a relatively dark colour on a light ground—often so admirable to painters' eyes in the backgrounds and obscurer portions of Rembrandt, Rubens, and Teniers—the depth that is expressed by an irregular veil of comparative darkness swept over the light ground, while that light is seen more or less in unequal intensities and shapes, as glimpses of it appear through the mazy network of the large brush-marks, or disappear in more cloudy patches—this expression of depth, measured still further by more or less solid work above it, and by thinner darks above all—this mastery, by which the flat surface is transformed into space, so fascinating in the judicious unfinish of a consummate workman—depends not on

colours, but solely on the dexterous use of dark and light materials.

Again, the plain definition of transparency is the appearance of one thing through another; the irregular, dragged application of a solid and opaque material, by allowing the under-tint to appear at intervals, at once conveys the impression and constitutes the fact of transparency, and, as in the former case, the result depends on the hand and eye, and on paint of any kind, not on colours as such.

Lastly, all colours—even the opaque, even the cold—acquire warmth by being so thinly applied as to allow a brighter tint within to reflect light through them. Colours so applied may be either unsubstantial or transparent in their nature, or, though naturally solid, they may be applied in so thin a film that the under-tint shall be visible through them. The application of colours that are in their nature transparent is called *glazing*. The thin and transparent application of solid and opaque colours is called *scumbling*. When the superadded thin tint is darker than the ground on which it is spread, the result is warmth; when the thin film or tint is lighter than the ground, the result is coldness. The Italians have but one term for glazing and scumbling; for both operations they have always used the word "velare," to veil. As final "veilings" were always applied by the old masters with a thick and glossy vehicle,

the term glazing, as it seems to imply a shining glassy surface, may perhaps owe its origin to the old practice and vehicles.

The warmth which is attainable even with black, white, and red, is therefore not to be estimated by the mere atomic and clayey mixture of the materials. The same may be observed of the degree and kind of coldness that may be expressed. The blueness that is produced by " veiling " black with white, or red with white (both being cases in which the under colour is the darker), is incalculably more pearly and ethereal than any mere admixture of black and white. Leonardo da Vinci did not omit to remark that the blueness of distant objects is in proportion to their darkness and to the purity of the intervening (white) atmosphere.* The opposite effects of warmth when the superadded tint is the darker may be observed by holding the commonest object that is thin enough to transmit light between the eye and the light. The ordinary, nameless colour of the material becomes kindled to gold and flame, ranging in brilliancy and glow according to the varying thinness of the texture or substance. Every curtain and window-blind and every stained glass window exemplifies this effect of a diaphanous colour—no matter whether the medium be actually transparent, like glass, or relatively so, like any light-transmitting material—interposed between

* Trattato della Pittura di Leo. da Vinci, pp. 22, 36.

the eye and a light ground. Every such appearance exemplifies the effect of glazing, while a white gauze suspended before a dark opening represents the operation and result of scumbling—viz., light over a dark ground.

It is therefore plain that the qualities most admired in finely coloured pictures are not the consequence of the variety of materials, but of the skilful use of very few simple colours. But, while laying a stress on the power of such materials, it is to be remembered that the picture conducted to the utmost possible completion by such means is still deficient in (absolute) warmth and force, and still more obviously in variety of colour. With regard to the variety of colours in accessories, it is indeed evident, from the example of the Doria picture, that Correggio's chiaroscuro preparation was confined to the flesh, and that other objects were painted in at first—not indeed with their full force, nor, of necessity, in their full warmth and tone, but in their local colours. Other painters, both Italian and Flemish, were sometimes in the habit of preparing the entire picture in chiaroscuro, but even when that system is adopted, it appears advisable to tint the accessories to some approach to the actual colour before so treating the flesh. By Correggio's method, as exemplified in the instance of the picture referred to, and perhaps in others which may come to light, the want of warmth and vigour in the flesh would be more apparent, and

the first toning operations would be at once nearer
to nature. Without, however, comparing the rela-
tive merit and utility of the two methods, it is
sufficient to advert to the fact that the system of
tinting the accessories at first, while the flesh was
comparatively colourless, was in all probability the
ordinary practice of Correggio.

The peculiar finish of the flesh, and the softness
of its gradations in light and shade, which are
remarkable in Correggio's works, may have been
partly the result of the completeness of the pre-
paratory state, or under-painting. A picture pre-
pared for scumbling and glazing was generally
painted sharper and harder in the forms and
markings than it was ultimately intended to be,
because the general operations of thin coatings,
scumblings, and glazings, tend to soften such
markings. The under-painting of Correggio's flesh
has, however, already in a great degree the requi-
site softness, and hence, when it received the final
operations, the gradations were still more delicate;
a certain amount of sharpness in forcible markings
being attainable with dark transparent colours in
finishing. The softness of the preparation does
not, however, extend to draperies and objects that
are rugged, crisp, and sharp in their nature: it is
apparent even in the finished works of Correggio
that such substances were prepared very differently
from the flesh.

A work arrived at the stage we have supposed

may be thus described. The flesh is solidly painted
on a light scale, either in a neutral colour or in a
purplish colour, which in the shadows and half-
lights does not approach to the black or the inky.
The deepest shadows and the darks of the hair still
do not give the impression of blackness, but by the
sufficient admixture of red have a purplish brown
appearance. The lights are very nearly pure white,
and if small in quantity are literally white; the half-
tints are still purplish, being rarely composed of
white and black only. The effects of light and
shade, the finer gradations in the half-tints, and the
place of the red tints, though not in their full force,
are all closely rendered; and the work, wanting
only the last degree of force and warmth, has
already a finished appearance. The last operations
in this preparatory work have been scumblings of
light over dark or over red to produce pearliness
and roundness; or, if red tints scarcely darker than
the under-painting have been so used, it has been
to increase warmth by transparency, and at the
same time add to relief. The draperies and other
objects, whether begun with the same neutral ma-
terials or not, are carried to the same degree of
relief with their local colours, the lights being much
lighter, and the shadows less forcible than they are
ultimately to appear.

The whole work has been hitherto painted either
with linseed oil alone, or with linseed oil diluted
with an essential oil. The essential oil used by

Correggio was probably petroleum, (also known as naphtha, or olio di sasso), which was common in the schools of Parma and Bologna. Petroleum is found in abundance in the territory of Parma and Modena, and according to a modern authority*, the city of Parma is lighted with it. But whether petroleum, or spirit of turpentine, or spike oil (the diluent of Leonardo) be used, it should be perfectly well rectified first; the linseed oil should also be of the purest kind.

The picture so painted, and in the state that has been described, will probably be free from a glossy surface, and will appear, from that circumstance, to be much less finished than it really is. The dull unglossy surface, it is to be remembered, is as desirable in a picture prepared for toning as it is prejudicial to the effect of the completed work, and the vehicle used for toning was for this reason of a lustrous and substantial kind. The prepared or dead-coloured work should be left in this state till the surface is perfectly dry, and if alterations are required they had better be made before the next operations are begun. It is difficult to say whether the *pentimenti* of Correggio were made while the work was in this state, or after it had been partially toned, or even quite finished; there can be no doubt, however, that they had better be made before the toning takes place.

* Ure's Dictionary of Arts and Manufactures, p. 879.

The mechanical treatment of pictures, before toning, can be better illustrated by the more known practice of the Venetian and other schools. A picture painted with a due proportion of essential oil mixed with linseed oil may be turned to the wall without fear of discoloration, but it is safer to place the work so that it should receive sufficient light and air. It should at least be well washed and cleaned before it is again painted upon.

It has been before observed that the final operation of the Italians was the only operation, as regards painting and tinting, of the Flemish masters and of their first Italian followers. While the Flemish masters generally endeavoured to show the light ground (on which the design was carefully drawn and shaded) through the colour, so as to give brilliancy and warmth to the superadded thin lights and rich shadows which alone constituted the picture, using a thick but lucid vehicle with the transparent or transparently used colours, the Italians in their final operation worked in precisely the same way and with the same or a similar vehicle, allowing the bright under-painting to tell through the thin substance of the toning colours.

The picture being quite clean and free from all superficial greasiness, the portion to be coloured and enriched should first be oiled out, and this had better be done with the same thick vehicle with which the tints are to be applied. The advice of Rubens is then quite applicable: begin by inserting

your shadows, and take care that no opaque colour, especially white, insinuate itself into their lucid depths. The half-tints will then by degrees be floated in with tints composed more or less with white; the lights, though already warmed by the oil varnish, should be tinted in like manner. The whole surface having been thus, to a certain extent, toned and coloured, the shadows should be gone over again, and should by degrees receive the last degree of warmth; the lights should be revised and tinted in like manner; the same operation with transparent and semi-transparent colours, always applied with the same vehicle, may be repeated till the depth and warmth of nature is approached. It is quite possible now to insert (partially) more solid lights, cool touches, and points of warmth in the flowing mass of vehicle and transparent colour. Such operations, and indeed the application on the lights of opaque pigments in a semi-transparent state, entirely conceal the process, and give the work the appearance of having been painted at once. The draperies and accessories should be treated in the same way; the shadows being inserted with transparent colours and applied with an abundance of vehicle; the lights toned either with transparent or semi-transparent colour; but as the tint is supposed to be nearly attained in the preparation, transparent colours alone may suffice in this case.

When fugitive or changeable colours are em-

ployed in the accessories, they require to be locked
up with a more than usually copious vehicle; and
in such cases the preserving medium appears to
have been used with the more or less solid colour
before the final toning. Thus the oil varnish
abounds most in the deepest shades, whatever may
be the colour; and in colours it abounds most in
blues and greens—the first, as before explained,
having been often painted with the carbonate of
copper, and the latter with verdigris, and subse-
quently with yellow lake.

With respect to the vehicle, there is no room to
suppose that the adoption of the Flemish method
was not as common to the painters of Parma as to
all other early Italian schools of oil painting. The
careful execution of Correggio would probably lead
him to prefer the finest and firmest of the ancient
oil varnishes—the amber varnish. It is remarkable
that Pliny should explain the fable that " trees
weep amber on the banks of Po " by the fact
that amber ornaments were very commonly worn
in the plains of Lombardy, while he distinctly states
that it found its way to Italy from the North over
the Rhætian Alps. A modern might have remarked
the great use of amber as a varnish by the Cre-
monese manufacturers of musical instruments; and
the painter Gentileschi tells us that in his time all
the colour-vendors in Italy sold the amber varnish
used by the varnishers of lutes. The Flemish
method once known, there would hardly be a more

convenient place than Mantua, "vicino Cremona," for obtaining amber varnish of good quality; and Correggio might have been indebted to his friend Lombardi for preparing it in the most transparent state. With regard to the supply of amber, it was not even necessary to depend on the North, for it was, and is actually, found in the neighbourhood of Parma. It being thus probable that Correggio used the amber varnish in his final operations, it only remained to prove this by means of his existing works. The late Professor Moreni of Parma is said to have analysed a portion of a damaged picture by Correggio, and to have detected amber where the traces of the vehicle were most abundant. Signor Moreni was hopelessly ill when the author sought to obtain some information from him on this point; but his researches were known to many, and Cav. Toschi, the celebrated engraver of the works of Correggio, has distinctly certified* that his deceased colleague had found amber in the analysis of a fragment of the "Procession to Calvary" in the gallery at Parma—a picture supposed to be an early work of Correggio, though, according to others, the production of his friend Anselmi.

* In a letter to the author, dated July 6, 1847.—*Ed.*

CHAP. VI.

VENETIAN METHODS.

IN approaching the consideration of the methods of oil painting practised by the great masters of Venice, the first step to a right understanding and appreciation of those methods is to forget for a time many associations and reminiscences of the Flemish practice, even in its highest examples. The leading diversities of the two methods may be briefly stated thus. In the Flemish mode the composition, previously determined, being outlined on a white or on a light ground and the chiaroscuro slightly indicated, the picture was painted *alla prima*—that is, though the work might be long in hand, each part was finished as much as possible, and often literally, at once. The transparent darks in these portions were inserted frequently in their full force at first; the greatest care was taken not to dull their brilliancy and depth by any admixture of white, or by any light opaque colour ; the half-tints were only moderately solid, the lights alone were sometimes loaded. The ground was thus seen through the darks and deeper half-tints, and often through other portions. In every part more

or less oil varnish was used with the colours, but especially in the darks. The picture thus painted required no varnish at last. Such, making due allowance for occasional variations in practice, were the prevailing characteristics of the Flemish system.

In the Venetian method, though the composition was in a great measure and sometimes quite determined at first, alterations were admissible, and the first outline was not always adhered to. The darks were in most cases painted much lighter than they were ultimately to be, and white might be used in any part : although roughness in the shadows was avoided, solidity was not restricted to the lights. The ground was not often seen through any portion of the work. No part was finished at once, and, far from desiring to give a glossy surface while the picture was in progress, the contrary appearance was aimed at till the whole was completed. The vehicles, therefore, were thinner at first.

Thus, supposing the system to be always regular, the Venetian *abbozzo* or preparation, when quite completed, resembled the Flemish chiaroscuro design—the final processes of the Venetian and the only processes of the Flemish artist were, in a great measure, the same. But as the Venetian process was rarely so methodical as here supposed, it is only in the early works of the school that even this resemblance is to be recognised.

The great object proposed by the Venetian masters was the perfection of colouring, and, in

aiming at this, they subdivided the processes of painting so as to make the result more certain, but certainly demanding less immediate and constant exercise of all the powers than was required in the Flemish process, which, in a certain degree, was more allied to fresco. Of all the merits and advantages of the Venetian and Italian method, the moderns have clung most to the indolent, or what may be made the indolent, habit of postponing the exercise of necessary decision, because of the continued possibility of alteration. Where this method of the *abbozzo* is not made use of in order to aim at a peculiar perfection in colouring, the *alla prima*, neck or nothing, irrevocable Flemish method is a far more manly and more difficult practice. But whoever wishes to enjoy the luxury and delight of painting, should settle his design and composition as unalterably as Rubens did in his coloured sketches for great works, and then proceed with the picture according to the Venetian system.

The most important difference, however, between the two methods remains to be noticed. In the Flemish mode, the ground being supposed to be, as it often was, white, it follows that every superadded tint will be darker than the ground. Darkness over light, provided the light be apparent through, produces warmth, and this was one of the sources of that glow which the thin shadows of the Flemish colourists exhibit. For the same reason that every tint (as distinguished from mere white) was darker

than the ground, the cool tints of these colour-
ists could never be produced by passing light
over darkness ; they therefore sometimes admitted
the most delicate azure in their flesh, and rarely
suffered black to come near it. The Venetians, on
the contrary, banished blue from their flesh, be-
cause they could produce tints of equivalent and
even greater tenderness by passing light pigments
very thinly over relative darks.

The aim of the colourist is first to produce a
pleasing balance and a constant and even minute
interchange between cold and warm hues. His
next object is that the nature of these warm and
cold colours shall be of the last degree of refine-
ment and delicacy. The system of glazing—pass-
ing a relatively dark colour in a diaphanous state
over a lighter colour—is a mode of insuring deli-
cacy in the warm tones. And to attain an equiva-
lent delicacy in the cool tints the expedient presents
itself of passing a relatively light colour, or even
white, in a diaphanous state over a darker hue.
This method of producing the cool tones constitutes
the essential difference between the Venetian and the
Flemish practice. Both agree in attaining the acme
of warmth by passing relative darkness over light,
but the practice of the reverse as a means of obtain-
ing coolness was not even compatible with the Fle-
mish system, and cannot consistently form a part of it.

In glazing to produce warmth, all colours, even
the coldest, when light is seen through them, be-

come relatively warmer and more vivid ; but the increased warmth is a difference of degree only, and as such does not materially affect the nature of the hue ; but, in thinly passing white over any colour, or over darkness, to produce coolness, an actual change of tint takes place. Leonardo da Vinci remarked the production of blue by this means in nature, when thin colourless vapour is interposed between the eye and darkness or depth beyond, as (he instances) in the blue of the sky, and in the blueness of distant dark objects (see p. 263). So it may be observed that smoke when seen against a dark object appears blue, but seen against a light object or a light sky looks brown.

The effect also of a film of white spread over differing and sufficiently warm dark colours is far more powerful and varied in its result than that of the opposite process with a film of darkness. Not that the changes produced by a thin pigment can equal the effects of vapour in nature, but the approach to these effects thus attainable is of the utmost value to the colourist—for the blueness which may be produced in a picture, as in nature, by the interposition of a light medium before darkness, especially if the darkness be warm, will be of the finest kind. Thus, in the Venetian practice, degrees both of warm and cool tints could be obtained *dynamically** as opposed to a clayey or *atomic*

* "*Dynamics*: The science of the motion of bodies that mutually act on one another." Crabb's Technological Dict.—*Ed.*

mixture of the colours. In the Flemish practice
the cool tints could only be produced by actual
colour; accordingly the finest azures, as we have
said, were admitted by the Flemish masters into
delicate flesh from which black was invariably ex-
cluded. The Venetians, on the other hand, not
only banished all blue colour from flesh, but ad-
mitted black in the fairest carnations ; not as a
colour, for as such it never appeared, but as
sufficing, when mixed with red, to give that
amount of darkness which in its turn produced the
pearl when seen through the lighter tints passed
over it. To imitate this delicate effect, Rubens,
when copying or freely reproducing the works of
Titian, introduced azure tints where the Venetians
had obtained as fine a coolness without them.

An objection may be raised to this system on
the ground of its possible want of durability. It
may be urged that, as pictures painted even with
solid colours on a dark ground are always liable
to grow colder by the tendency of the white pig-
ment to become transparent, so this evil effect may
be the more speedily and decidedly apprehended
where only a slight film has been laid on. It may
be replied, that the ground in the cases referred to
was always decidedly dark, whereas the cool tints
we have described are only passed over what we
have defined as *relative* darkness—viz., over hues
often but slightly darker than themselves. But,
even supposing a really dark ground, it is to be

remembered that the cool tints so brought forth are always preparations for glazing, and that such glazings effectually lock them up. On the other hand, such is the ultimate warmth and glow of Venetian pictures, that if it were possible for the locked-up " dynamic " greys to become cooler by growing more transparent, the result would be rather advantageous than not. Indeed, the thinner the superadded light becomes, the finer will be the tint. But, we repeat, such tints are always comparatively internal, and glazings must disappear before their existence can be endangered.

Another and more general objection may be made against the refinements of scumbling and glazing. They may be accused of being too exclusively subservient to colour, and of involving a certain effeminacy of execution. But without contending for the highest place in the scale of art, either for the Venetian school or for that perfection of colouring which it attained, it is not possible, in the presence of the master-works of Titian, Tintoret, or Paul Veronese, to feel that any charge of effeminacy can be brought against it; and this leads us to consider the counteracting principle which at once ennobled and concealed the consummate refinement of practice which these masters have bequeathed.

The system of producing warmth and richness by means of comparative darkness over light, whether by transparent or opaque colours thinly applied, had been practised and carried to great

perfection by Giovanni Bellini and by others; but there is no evidence of their having known the opposite process—namely, the effects of light colours over dark. That great master and his cotemporaries had all been instructed in the Flemish method, and it must have been long before an expedient so opposed to its conditions could have been entertained.

Giorgione appears to have been the first painter who, aiming at all that could combine freshness with that fiery glow which his finished works display, adopted a mode of preserving coolness which could be regulated to any extent, and introduced with safety and purity in any stage of the work. Assuming this to be the case, he would at the same time see the danger of the extreme softness and obliteration of form to be apprehended from this treatment, and therefore the necessity of a proportionate boldness and solidity as its basis. Without the substance and ruggedness of the rock, the superadded cloud, still more softened by glazing, would have wanted contrast of texture and truth of imitation. While therefore adopting contrivances which insured the softest transitions, the most perfect roundness, and the largest breadth, it was impossible for a painter of energetic character like Giorgione not to feel that the utmost vigour and apparent contempt of labour were requisite in the earlier stages of a work in order to conceal the delicate operations reserved for its completion. His

follower, Sebastian del Piombo, however resolute of
hand in preparing the *abbozzo*, could not conceal
from M. Angelo the extreme delicacy of the sub-
sequent operations; and it was of Sebastian's system
he spoke when in an angry moment he told that
master that oil painting was an employment fit for
women and children.

The energetic Tintoret was intent on avoiding
another danger of his school—the neglect of draw-
ing. His studies to this end, with M. Angelo's
works as his guide, are well known; and although
he could at times compass all the delicacies of his
cotemporaries, his practice was so forcible and
powerful, and his rapidity so great, that M. Angelo
might possibly have retracted his hasty sentence,
had he witnessed the prowess of such a workman.

But to return to Giorgione. Without this clue
to his style, Venetian writers who had seen his
best works in their best state must appear to con-
tradict themselves in speaking of his characteristics.
According to some, one of his chief merits con-
sisted in inventing that daring and contemptuous
execution which forms so decided a line of separa-
tion between him and Bellini; at the same time it
is stated that his outlines and forms are soft, and
one writer (Ludovico Dolce) observes, that the
delicacy of his transitions in masses of light and
shade is such, that it seemed as if there was no
shadow at all. Others refer in like manner to the
consummate refinement with which such passages

are blended—to his " sfumato " and extreme ten-
derness—and then again extol his rapidity, his bold-
ness, and his solid touch. In short, softness and
freedom ("*morbidezza e franchezza* ") are the attri-
butes most frequently cited as characteristics of this
master. All this, however seemingly incompatible,
is perfectly true, and supplies the best eulogy on
Giorgione.

Whoever, therefore, aims at Venetian delicacy of
colour cannot do justice either to the system or to
himself unless a foundation of the firmest execu-
tion be prepared for it. It is also of the nature of
solidity and freedom of hand to attract more atten-
tion than those more indefinite processes we have
been describing; and it is pleasing to find spectators
extolling the boldness and apparent carelessness of
works which in their more subtle treatment are
examples of the highest refinement and most ex-
quisite delicacy.

In this respect our country has reason to be
proud that the finer works of Turner are a very
intelligible introduction to one, and that not the
least, of the excellencies of Venetian colouring.
He depended quite as much on his scumblings with
white as on his glazings, but the softness induced
by both was counteracted by a substructure of the
most abrupt and rugged kind. The subsequent
scumbling, toned again in its turn, was the source
of one of the many fascinations of this extraordi-
nary painter, who gives us solid and crisp lights

surrounded and beautifully contrasting with etherial nothingness, or with the semitransparent depth of alabaster.

With respect to the ultimate richness of the Venetians and the influence of what has been termed the dynamic grey underneath, it is undoubtedly true that there is more power in the freshness produced by light over dark than in that of a solid cool tint; just as there is more real warmth in a glazed colour than in what professes to be its equivalent in an atomic mixture. But all such refinements and remedies are not calculated for description. The cases are endless in which partial deviations even from the fittest recognised means may serve a special purpose. All that can be attempted in a mere outline of this kind is to describe the leading principle, leaving its infinite modifications to the varieties of ability and feeling.

To turn now to matters of practice. Before applying this system to flesh painting it is better to test its capabilities on subordinate subjects. A picture or sketch will probably be at hand, with rocks, broken ground or similar objects of negative colour, on which the painter may make the experiment, and it will interest him to find how the preciousness of colour may be thus imparted even to mere stone or clay. It is necessary that there should be some indications of light and shade, but no shadow of any extent should be intensely dark; while it matters little, for the purposes proposed,

what the forms may be, nor even, provided it be not absolutely false and violent, what the colour may be. A picture, therefore, having been selected for the experiment, the whole surface should be covered so thinly with white that the forms and the light and shade may be seen through it. The film of white should then be equalized and flattened; in glazing, when the dark colour sinks into the inequalities of the surface the effect may be agreeable, but in spreading an opaque colour over a more or less rough surface no particles of the white should be allowed to collect round the prominent points. The readiest mode of flattening the colour is by beating or stabbing (*botteggiando*) with a large brush adapted for the purpose. The white should at last be so delicately spread that it shall look like a grey preparation, retaining all the forms slightly blunted, and being equally diffused over lights and shades. Where the points of shadows were very dark the tint will be bluest; where there was any tendency to warmth of colour the grey will incline to violet or lilac. Should it be desired to increase this violet tendency—the tint being exquisite of its kind—it will be remembered for another experiment that a previous glaze of some warm colour, first allowed to dry, will insure it.

For the next process of glazing, the surface may be oiled out. A warm brown is the only colour required, but its warmth may be sometimes in-

creased with effect. The object is to kill the cold colour, and the whole surface may or may not be first slightly tinted with this general glaze. Then the bluish shadows should be neutralized —afterwards the lower purple half-tints—till gradually the whole surface is warmed. The predominant colour will long be grey, but at last, though this colour is not and perhaps cannot be quite suppressed, it assumes a general warmth tempered by freshness and presenting points of contrast between cool and glowing hues of infinite variety.

This experiment is purposely proposed in the simplest form, but it contains the principles of the whole system. The elements of harmony here are two-fold, the cause of the coolness being universal, while the coolness itself is infinitely varied in degree. For it will be seen that the scale of colour thus produced is not in inverse ratio with that of the original picture. The varieties of coolness in the film are far greater than those of warmth in the substructure. The film of white thus added will, as we have said, produce blue, and in proportion to the warmth underneath, that tendency to red which includes various tender shades of the violet and purple, but it cannot generate yellow, orange, or green. These hues will be the result of the brown glazing (suppose asphaltum) which, passed over the bluest parts, gives rise to olive tints, or an approach to green—over the redder, tends to orange, and in the high lights borders on yellow. Thus, while

there are abundant elements of harmony and gradation, there are infinite materials of contrast —and this constitutes fine colouring.

This system of scumbling may be said to double the fascinations of ordinary glazing—indeed neither can be completed without the other—for as the one supplies warmth dynamically, so the opposite provides coolness in the same way. With such harmonies as these unmixing surfaces produce, the mere palette has nothing to do, although the palette is especially required to do its work efficiently at first.

Let the same method be adopted for architecture. Suppose a portion of a building carefully executed as to light and shade, with all its members defined, and its surface solid, and here and there crisp. It may be painted in black and white with a slight admixture of indian red—or in any neutral colour. Cover the surface with white, and equalize it perfectly as before, till the whole looks like a very delicate grey preparation, the light and shade and every form being sufficiently apparent. When dry, glaze as before, opposing warm lines to the pearly middle tints, and defining the minute mouldings with the same brown. Patches of extreme cold should be neutralized, and the general warmth regulated as desired. By way of focusing the browns, a stain or two, or perhaps a brown weed, will have a pleasing effect. So simple a process as this will banish all ideas of the palette, and,

evident as the brush-work may be, and ought to be, will transform the mere paint into silver and gold.

In this, as in the former experiment, purely dynamic conditions are purposely preserved, but the modelling or rounding of objects may be assisted or completed, even in this stage, by middle tints used transparently over lighter portions :—they can hardly require to be used over darker portions, for the white alone suffices in such cases. A middle tint of grey, composed of black, white, and Indian red, if used transparently and as a preparation for fresh glazing, will sufficiently match the dynamic grey. But if required to be used solidly (which is not here supposed) a much more elaborate compound of tints would be necessary. To imitate, and that imperfectly, this nameless dynamic coolness in solid colour we recommend the following method. Place a touch of white on a somewhat dark-coloured palette—such as rosewood—spread a portion of it in various degrees of thinness, and various tints of grey, bluish, and violet will be the result. Beside these etherial tones make up an atomic mixture matching one or more of them. Such tints will represent as nearly as solid painting can the depth of white, and will serve to prepare its shadows.

The above mode of finding the neutral depth of a tint may be applied to all colours that are lighter than the rosewood palette, for when very thinly spread they present their dynamic combination in the cool sense with darkness.

In the cases hitherto supposed, the groundwork being nearly neutral, the grey has partaken of that character. But when the light film of white is passed over a positive colour a more or less considerable modification of that colour is the result. Thus a vermilion drapery is changed to a pronounced lilac; on that preparation when dry the shadows may be inserted with lake, the original colour being more excluded from the lights, and the half-tints assisted with a tint (applied as usual in a transparent state) of black, white, and much lake. To correct the lilac further and to mitigate the lake a final glazing of asphaltum, or even of semi-transparent yellow would be adopted.

Again, the dynamic coolness may be sufficiently given to rich yellows by means of a film of Naples yellow instead of white, the darks being afterwards restored, and the cool tints neutralized with a deeper yellow. There are still more complicated modes of producing refined colours in draperies on the dynamic principle, but the examples given may suffice.

Blue, being itself the result of a light film over darkness, can gain nothing by being treated like the warm colours, as the grey produced would only be a degree of its own hue and would involve no contrast to it. A better mode of giving it value, for example in a sky, is to prepare the space it is to occupy with a very light warm transparent brown, gradually varied in depth according to the

natural appearances. On this a tint of blue and
white graduated in the same proportion should be
so thinly passed as to show the warm colour
through, till, at the horizon, the scarcely percep-
tible blue is lost in the warm light of the ground.
The clouds, if any, are in this process "left."
The same system may be adopted in blue draperies
—the folds and light and shade being entirely de-
fined with a transparent brown. The blue is then
painted upon it so thinly that the warm lights of
the ground shine through it, while the deepest
warm shades may be left almost untouched.

It remains to speak of the application of the
system to flesh. The black, white, and red recom-
mended by the actual precepts or by the obvious
practice of all colourists from Titian to Reynolds, as
the fittest materials for light and shade, modelling
and solidity, in the preparation of flesh (see p. 260),
can be varied in two only of the ingredients,—in the
black and the red. For the first the Venetians com-
monly used "nero di Verona"—a black earth still
to be found at Venice, and, no doubt, at Verona and
in its neighbourhood. It is warmer than ivory or
bone-black, or lamp-black, and perhaps warmer
than common coal. But the coal, when mixed
with white, is sufficiently identical with it. The
red was generally light red, and warm reds of the
same kind, but, no doubt, the colour called "Indian
red" was also used. This warm red and warm
black were quite sufficient on the one hand, when

used transparently, to produce a rich brown, and, on the other, when mixed with white (with less of the red), and used in the same way, represented cool half-tints. The first operations consisted, however, in solid modelling and bold execution with these colours, which being thus few and simple may be fearlessly intermixed without fear of muddiness. Those who object to black may substitute the " terra verde." A swarthy complexion may be first supposed. The whole tone is low, and the first object as usual is to preserve the masses of light and shade. The forms are then blended in the shadows, and the masses simplified and partly lost by the scumbling process; in which case pure white is not the medium to employ, but a middle tint consisting always of the same black, white and red. (In this manner were probably produced those low-toned preparations, without blackness, which we sometimes see in over-cleaned Venetian pictures, when their state enables us to judge of the first painting.) The masses of light may require to be treated in the same way, the tint used for the purpose being much lighter, though still far from white. The shadowed portion may now be considered sufficiently prepared, and may be left in the broad state just described. Not so the light: upon the broad scumbling which does not quite conceal the previous modelling, that modelling should now be renewed with tints (produced still with the same colours) applied in a

diaphanous state. By degrees, even with mere red and black (or the brownest and warmest shades of burnt " terra verde," still mixed with Indian red), the flesh acquires richness and roundness. The point to stop is where sufficient force cannot be attained without blackness. The next operation is glazing only with browns and reds.

The same colours are fitted to prepare the fairest carnation, of course in very different proportions. When sufficient solidity is attained the whole may be scumbled with white. The shadows should then be restored, the extreme coolness being duly corrected with a tint composed from the same common materials, while in the light portions the modelling and warmth should be most delicately renewed on the same principle. The intention of the scumbling is, in all cases, to produce extreme purity in the cool tints, and breadth in the whole: great care consequently should be taken not to destroy the tenderness of the one or the largeness of the other. The desired roundness and gradation being attained, more delicate tints (in the fair complexion) may be added, such as vermilion and lake in some places.

The hair, of whatever shade, may be prepared with the same tints that are used for the flesh, with less, or sometimes no white. The principle of avoiding blackness does not even apply here, for a thin black, to represent the colour black, may, judiciously used, answer, or partly answer, the end proposed.

An important observation should not be omitted in reference to the scumbling process applied to delicate carnations. The film of white passed over an already light surface will undoubtedly give it greater breadth, by rendering fainter the middle tints which are afterwards, at least partially, delicately warmed again. But a result quite as important or more so is the production of that exquisite cool tint we have so often described. Care therefore should be taken not to destroy or diminish that relative warmth or darkness on which the existence of the cool overlaid tint depends. If therefore the flesh, in consequence of repeated general lightenings, be found not to have sufficient elements of contrast left, the remedy is to glaze it entirely with a warm tint, in order to provide a fresh general foundation for the dynamic coolness. On this again the warm partial glazings may be applied in the manner before described.

We have alluded to the semi-opaque scumbling necessary for a dark complexion. The opposite practice in glazing may be said to meet it half way. For the " sfumato " of the Venetians was not produced by common glazing, as understood of a perfectly transparent medium over light, but by colours of a semi-transparent kind. All the half opaque reds—light red, Indian red, perhaps even vermilion, brown reds, and burnt sienna, &c.—may be used for warm lights, and for all but the deepest shades. Even these colours are too transparent,

and may receive both tone and body from a slight admixture of thick darks, or half darks—such as umber, burnt green earth, &c. In some cases white even may be necessary, or Naples yellow, but all yellows in glazing, or rather " nel sfumare " are powerful, and give even a *too* golden colour. The transparent yellows are only fit for the extreme darks—they jaundice the lights.

In describing a system which thus presents all the effect of blending without the appearance of handling we have perhaps given the impression— very difficult to avoid in treating such subjects— of an over regular and definable process. The youthful artist will soon discover that there are no mechanical recipes for an art which depends on the subtlest decisions of the eye and mind. The experience and observation of another may be given as far as possible in words; the actual meaning of those words can only be determined by years of practice. The efficacy of the process we have dwelt on will be perhaps soonest apparent when applied, with modifications, as a remedy where more positive aids are fruitless. When a piece of drapery—suppose vermilion and white—white for the lights, pure vermilion in reflexions, black and white in half-tints and shadows forced with lake, toned afterwards with brown (sienna)—when such a piece of drapery has been painted in strongly, and with too unbroken a colour, a white film, diluted with a thick oleo-resinous vehicle, will restore variety, cool-

ness, and what is called " sweetness " as opposed to rankness. The white film in spreading in the vehicle will settle into an apparently granulated (though really smooth surface) with points and vermicular forms, giving at once texture and sparkle. The colour so produced will be of the lilac kind. The white, before it settles and begins to dry, may be so wrought and adapted to the folds as to assist the relief. When dry, the too red shadows may be killed with umber and white, and others strengthened with lake and rich tones. The cool half lights and masses should be assisted with blue, black and white, all thin, and the lights further modelled by thin applications of white. When dry, all may be glazed with raw sienna. Thus will be produced a rose colour tint of that nameless, negative kind seen in Venetian draperies—abounding in delicate half-tints, yet ultimately warm. A head also, which has become too unbroken and rank in colour, may be treated in the same way.

Again, we cannot too often repeat, the best corrective for the only danger of such processes—viz., the excess of the " sfumato "—is to observe a rough and brisk handling in the first preparation. It is not impossible however to renew broken and rugged touches, which, by the addition of such helps as wax, ground resin, or ground glass, may be applied with substance and without colour. At all events, the crispness, whether given first or last, *must* be present in various degrees, preserved distinct from

the evanescent softness of the scumbling. This kind of contrast is of the most precious kind, and nothing contributes more to express the thinness of the skin and the seeming depth within it.

A further class of scumbling must here be alluded to. However frequently the operations of thin light over dark and transparent dark over light may be repeated, it will at all events generally be found desirable when the darker glazing is getting dry to drag thin light here and there upon it again. Such delicate, dragged retouches which may be either conspicuous as such, or of more than gossamer thinness, have many uses. They modify the light where requisite, they freshen the colour, and, by not stirring the surface of the glazing while they cling to it—by being suspended as opaque particles on a glassy medium—they instantly distinguish the surface from what it covers, and express the depth within. Representations of depth, depending on the fine distinction of the alternately superposed colours, are peculiar to oil painting and are worthy of attention as thus exhibiting the capabilities of the method. The most perfect expression of the relation between substance and space is that of an irregular, crisp and insulated light, suspended, as it were, on the depth and nothingness of formless transparency. When the crisp touch is underneath it becomes more or less blunted by repeated scumblings over it, and it is sometimes desirable, when all is done, to raise such islands again from the

depth. An effect precisely equivalent to this occurs in fresco painting, when the work is nearly dry. A touch of light no sooner meets the *intonaco* than all its moisture is greedily absorbed, and the impinged particles remain precisely as if a rock were suddenly left dry by the retiring of the sea. The contrast does not, however, remain thus complete ; for, in fresco, when the whole is dry the last touches appear to unite more with the surface on which they are placed. The operation in oil painting resembles this in so far that the light is added when the surface is nearly dry. The surface not being stirred, the light remains distinct upon it. In oil, however, the appearance has the advantage of being lasting. It may be sometimes observed in the works of Paul Veronese.

The particulars described may be regarded by some as needless refinements, but this objection once admitted would strike at the root of all the finer effects of colour and transparency. There is another mode of looking at such studies, which is to regard them as a language to be learnt, the command of which will enable and induce the artist to attempt the imitation of certain exquisitely delicate appearances in nature which he would otherwise consider as beyond the reach of material pigments. The production of various degrees of transparency and of the whole range of warm and cool tints by judicious alternations of scumbling and glazing, is a world which may be said to be at the painter's

command. The art of producing such results may
be studied at first merely as an art, and without di-
rect reference to nature. The processes in fact are
in a degree precisely those of nature, and therefore
can never fail to open up a universe of colour un-
approachable by any other means. It need not
therefore be dissembled that the dynamic method,
considered with reference to the effect of colour
only, involves completeness in itself, and is so far
independent of nature as it is an application of
nature's own means. But the power and capabili-
ties of the system being felt, its possible refine-
ments, with all its accidents, and all its assistance
from vehicles and from substance—such as the re-
peated interposition of colourless media (for which
the Italian varnish is adapted) and the production
of internal sparkle by brilliant colours half ground,
or even by the veiled glitter of metallic particles—
all these capabilities being felt, with many more
aids from that " cunning " which he has acquired
at home, the painter goes to Nature and compares
her world with his own. He finds that infinite as
the Great Artist is, he too has in his possession a
miniature scale of processes which, in the conjuring
up of magical effects, is analogous to those which
Nature herself puts into requisition, and he at once
selects and delights in the most difficult of those
problems in light and colour which the external
world presents to him.

NOTE BY EDITOR.

WITH this last short chapter on Venetian methods, the manuscript of the second volume of "Materials for a History of Oil Painting" stops short. The work being thus incomplete, Lady Eastlake has felt it advisable to add a selection from a number of, what may be termed, professional essays and memoranda which Sir Charles had designed for ultimate publication, though deterred by ever increasing occupation from fulfilling that intention. Lady Eastlake has had the advantage of submitting this selection to competent judges, and is encouraged by them to present it to the public, with a view to its usefulness to the student of art.

PROFESSIONAL ESSAYS.

COLOUR, LIGHT, SHADE, CORREGGIO, &c.

THE agreeable impressions of Nature as address-
ing themselves principally to the senses are those
which are most apparent, and the colours of ob-
jects, which seem to have no other use than to
mark their differences, are thus intimately allied to
the principle of beauty. The variety of colours,
whether abruptly or imperceptibly expressed, is
therefore their leading characteristic, and their
office is to distinguish. The absence of colour,
whether in light or shade, is, on the contrary, a
common quality, its office is obviously to unite.
That degree of light which represents the reflexion
of its source is never admitted in the works of the
colourists, except in polished or liquid surfaces ;
the office of light being to display the colours of
objects, and not itself, such shining spots would
not only be so much deducted from the real colour
of the object, but, as they might occur in different
substances, they would prevent their necessary
distinction. The degree of light which is imitated
in art is therefore that which displays the local

hues of objects, that is, their differences, and thus the common and uniting quality is mainly reduced to shade alone.* The highest style of colour will thus be that which expresses most fully, consistent with possible nature, the general local hues of objects. The office of shade is directly opposed to that of colour; in aiding those representations of general Nature in which beauty resides, its end will be to display the forms of objects without unnecessarily concealing their hues. This may be considered its most abstract character, as freest from accident, but, as a vehicle of mystery in subjects which aim at sublimity or principally address the imagination, it is most independent and effective. The idea of the Sublime is, however, an exception to the general impression of Nature, and shade will be more accidental as it ceases to display form, or unduly conceals colour. The accidental effects of light and shade which do not convey ideas connected with the sublime, belong therefore to the

* Although the best colourists never suffer the high lights to reflect the source of the light so strongly as to differ decidedly from the hue of the object, yet it is not consistent with nature or the practice of those colourists to reduce " the common quality to shade alone." The highest light on objects, without being a mirror of the source of light, is *composed* of the *colour of the light* and the *colour of the object*. The consequence of this will generally be that cold colours will have their lights warmer than the general hue, and warm colours will have their lights cooler. This approaches a common quality in the lights.

lowest style. These accidental effects are infinite,
and are all more or less opposed to the display
of form and colour. Yet this very display is a
relative term, and forms and hues are only ap-
parent because others with which they are com-
pared are less so. An unpleasant and untrue
equality and want of gradation would be the
consequence of neglecting this truth, and it follows
that there is a point beyond which the display of
local colour and the rejection of the accidents of
light and shade would be untrue to the general
impression of nature.

It was the opinion of Sir Joshua Reynolds that,
had the fine pictures of the Greeks been preserved
to us, we should find them as well drawn as the
Laocoon, and probably coloured like Titian; but he
soon after concluded on good grounds that the
same works would perhaps be deficient in the skilful
management of the masses of chiaroscuro. The
general character of ancient art seems to have been
to dwell on the permanent qualities of things in
preference to their temporary and variable appear-
ances, and hence the constant nature of the local
hues of objects would be considered more worthy
of imitation than the mutable effects of light and
shade. The ancient paintings which have been
preserved exhibit the excess of this system, and
the want of gradation is among their prominent
imperfections. The Venetians, the great modern
examples of colour, may be considered to have

made the nearest approach to the theory of the ancients without falling into their defects, or violating the characteristic imitation of nature. Yet the Venetian school has not escaped the charge of deficiency in chiaroscuro, and although the example of Giorgione was followed by other men of eminence, the prevailing character of the school was local colour as opposed to light and shade. These rival qualities are admitted by the testimony of ages to have been united in Titian in such proportions as are most compatible with the perfection of art, and in him chiaroscuro is the subordinate quality. It would thus appear that the style in which colour predominates is the fittest for the display of beauty, and that the uncertainty of shade is adapted to ideas connected with the sublime. The quantity of shade employed by different schools seems at first sight to depend on the difference of climate, yet, in the works of Correggio, who formed his style under the same sun of Italy, both the colour and the forms are much less defined than in the works of the Venetians. His manner is in fact formed from the nature of shade; in his hands it is deprived of all its less pleasing attributes, and he has applied it almost uniformly to subjects of beauty. The extraordinary union of beauty with mystery, so contrary to the general idea of nature, is still true to some of her most important facts, to which indeed all ideas of beauty tend; and it is curious to observe that the same feeling which led

Correggio to make beauty indistinct, also led him sometimes to treat a class of subjects which he alone could treat adequately. In considering beauty and love, or a feeling which resembles the latter, as cause and effect,* it appears that the definite nature of the first diminishes as the feeling (or blindness) of love or admiration to which it tends, increases, till the abstract idea of love dwells solely in the imagination, and is no longer measured by its cause. To produce an adequate object for this internal sense of beauty is the great end of the fine arts, and its triumphs consist in meeting it by definite representation. The style of Correggio, which is one of the wonders of human invention, owes its charm to the union of the cause and effect above mentioned. The palpable representation of beauty by him is more or less united with the indistinctness of view which characterises the feeling it tends to create. The voluptuous impression produced by this union is doubly reprehensible in subjects of a certain description, but in scenes of a purer nature it produces a charm no other means can approach, and which no painter has embodied in an equal degree with Correggio.

The above remarks are necessary to show that although this great artist's style belongs, strictly speaking, neither to the definite idea of beauty, nor

* Burke says, " By beauty I understand a quality in things which creates the sentiment of love, or some feeling which resembles it."

to the feeling of awe and fear which more or less
accompanies the idea of the sublime, it is still true
to very general ideas of nature, and if it were not
so it would not be so fascinating as it is. The
great distinction between the offices of colour and
of shade admits in the nature of things of no other
exception; the other great masters who have at-
tempted to unite them, rather than to make shade
the rule, differ widely from Correggio, and their
styles are true to that view of nature which admits
a certain quantity of accident. Such is the cha-
racter of the Spanish, Flemish, and Dutch colour-
ists; their styles are all to be ranged under the
two great heads of agreeable or solemn impressions;
they are often beautiful and often sublime, but the
union of beauty and mystery occurs nowhere but
in the works of Correggio. In the works of
Rembrandt the very opposite *motive* appears; the
effects of that great painter, even in ordinary
subjects, approach the sublime, his shade is thus
legitimately employed to conceal unpleasant forms
or to excite ideas of solemnity and grandeur. His
colour, which is equal to Titian, is, from the abun-
dance of shade, less in quantity, but, in strict con-
sonance with the nature of both, the accidental
effects of shade are accompanied with proportionate
ideas of solemnity, and his colour fascinates the
eye with its richness and beauty. Thus, if the
value which the scarcity of his light acquires is
untrue to the general impression of nature in which

beauty consists, the degree in which he departs
from this idea never fails to bring him nearer the
nature of the sublime.

It must always be remembered that the sublime
is more or less accidental or uncommon, and any
degree of accident which tends to produce, or is
even excused by grandeur of effect, must not be
censured because it departs from beauty. The
lowest styles of art are those which admit the
greatest quantity of accident without approaching
the sublime; they are to be considered as lesser, or
rather as the least degrees of beauty. It may be
added that the works of art which belong to this
class are not very numerous. The Dutch schools,
however individual in form and conception, are
abstract and large in colour and light and shade.
Even where a work is deficient in most other
general ideas, composition, and arrangement either
of forms or light are always observable, so that a
purely accidental or literally imitative work of art
is hardly to be quoted. It seems indeed a contra-
diction to the nature of the arts.

As usual, it will be necessary to attempt to
define the highest style in colour and chiaroscuro
in order to avoid the multiplicity of exceptions
which would attend any other mode of inquiry; it
must only be remembered that the principles thus
arrived at are not the only principles because they
are the most abstract; on the contrary, the use of
a good rule in any part of the art is to have some-

thing to depart from; some point by which the admission of accident may be measured.

The colours in nature are so infinitely varied that even on comparing objects apparently similar in hue together, a slight difference will generally be perceptible. Hence, however slightly marked the tints of substances may be, whether in the light style of Guido, or in the sombre and almost colourless effects of Ludovico Carracci, their relative differences must still be in some measure expressed. The office of colour is to distinguish.

The differences of objects are invariably conveyed by their general effect, their component varieties may be, and frequently are, similar in some particulars, but it is obvious that the abstract nature of colour will be most attained by suppressing the accidental similarities in different objects, and dwelling only on the points of opposition. The skill of Titian was particularly shown in distinguishing objects that apparently differ but slightly in colour; by exaggerating the characteristic hues to which they respectively tend, and by suppressing their common qualities. Thus Mengs and Fuseli justly observe that he took the predominant quality in a colour for the only quality, by painting flesh which abounded in ruddy or warm tints entirely in such tints, and by depriving of all such tints a carnation which was inclined to paleness. This would be chiefly done if two such complexions were in immediate comparison, for it

is evident the qualities to be suppressed or dwelt
on must always depend on the surrounding rela-
tions. The same practice is observable, particularly
in the Venetian school, in all other qualities; soft-
ness and hardness, transparency and opacity are
always more or less opposed to each other. It
may be observed, once for all, as a general fact,
that every quality in Nature is *relative*, and that the
comparisons which exhibit the mutual differences
of things are as essential as shade is to the display
of light.

It has been already said that the degree of light
which represents the reflexion of its source is sup-
pressed or sparingly admitted by the colourists,
except where such effects are constant. In shining
surfaces light is a common quality, for the degree
of brightness which represents it may recur in
similar objects. In all other cases it is the colour
of the object, however mixed, as we have said, with
the light, which is reflected to our sight, and it
will hence be always slightly different. The shin-
ing lights on skin are particularly suppressed by
the masters of colour when the flesh happens to
be near a brilliant surface, and on the same prin-
ciples the softness of flesh or hair is more than
ever dwelt on when opposed to a hard substance;
the light in the eye even is not shown if near very
white linen; the qualities would be similar, and in
nature they are different. The *degrees* of these
differences are not always possible or advisable in

art, and Sir Joshua Reynolds objects to the prac-
tice of Rembrandt in painting flesh as much below
the shine of armour as it is in nature; a difference
to *some* extent is, however, indispensable in all
cases where it is observable in nature, for a very
small portion of absolute similarity, if it is visible
as such, is enough to destroy relief. The relative
effect of objects requires the expression of such
only of their component details as assist, or, at
least, do not weaken their general mutual differ-
ence ; in other words the intrinsic qualities are
to be expressed in subordination to their relative
effect, and where the difference in the whole effect
of objects is strong, the expression of their re-
spective intrinsic qualities is least of all necessary.
In opposition to the practice of the great colourists,
the modern continental schools (German renaissance
at Rome and elsewhere), however, hold that the
relief and detail of black objects, such as hair,
drapery, &c., should be as equally apparent as in
lighter substances. If this could be done without
destroying the relative character of the object, art
would do too much, and dark hair, so executed,
would attract our attention before the face; but in
general the relative character (or value) is de-
stroyed in the attempt, and complete failure in the
real end of imitation (the impression of a whole)
is the consequence of endeavouring to surpass the
economy of nature. Whenever the characteristic
quality of an object is that of strong opposition to

everything near it, its whole effect appears to be more than ever necessary in imitation. Its chief impression is its relative effect; a property evidently in danger of being impaired by introducing too many of its own intrinsic qualities. It follows that in all such cases (where intrinsic qualities are introduced) the surface or colour so treated will be least like the object considered abstractedly. The effects of light on black substances are different from the colour of the mass, and thus materially weaken its relative effect. It will be found that in the works of the Venetian, Spanish, and Flemish colourists the gloss of black hair is in a great measure suppressed. In any other colour the practice is less necessary, because the effects of light are not necessarily so different from the local hue of the object. The intrinsic or proper qualities of objects in detail thus appear admissible in proportion as their relative effect is weak. An object absolutely isolated would require to be absolutely imitated in all its parts, but as long as a comparison of any kind exists, the points of difference are the essential requisites.*

For the above reasons it appears (and the standards of excellence in this part of art justify the conclusion) that it would be false to correct an

* On the same principle, Sir Joshua Reynolds observes that no single figure can properly make part of a group, nor any figure of a group stand alone ; also elsewhere that a single figure requires contrast and details in its parts.

exaggeration of the qualities of an object (if nature had been at all kept in view) by adding more of the same quality near it. The contrary practice of giving it character by opposition will be attended with better success. If flesh, for instance, is never more glowing than when opposed to blue, never more pearly than when compared with red, never ruddier than in the neighbourhood of green, never fairer than when contrasted with black, nor richer or deeper than when opposed to white ; these are obviously the contrasts such exaggerations respectively require, because they are the truest modes of accounting for them. To correct redness by red, or paleness by white is the opposite, and, as it would appear, the narrower and less effective method.*

It has been observed that shade is the common and uniting quality, for by whatever means the extreme degrees of it are represented, these appearances will occur, however varied in quantity, in every object seen at the same distance. With reflexion, the region of light and colours again begins, but the uniting principle of shade will of necessity soften the differences of hues in this case, and it is a well-known precept that the colours of

* It may be observed that any cold colour in the neighbourhood of flesh must be in its mass darker than the flesh. Red may be either darker or lighter—the latter if the flesh is dark and cold. Flesh is best treated as a dark in the neighbourhood of yellow, the yellow can only be treated as a dark when the flesh is very glowing indeed.

objects, however different in the lights, should be of the same or nearly the same colour in the shades.* It follows from the foregoing observations that it would be false to the general and largest view of nature to unite by colour and to distinguish by light and shade. Both these truths, however, have their modifications. In all cases where distinction by colour is no longer sufficient, distinction by accidents of light and shade may be necessary. This happens in such distances where the colours, even of large masses, cannot be much distinguished; in which case the accidents of light and shade are employed with success. It is very common to see these effects in the backgrounds of Venetian pictures, although they are jealously excluded from the nearer objects.† In the background they remind us of the *presence* of light, which thus exhibits *itself*, while in the foreground it is only used to display, as usual, *the objects of nature.* It may be remarked that we are only reminded of the source and operation of the light when its effects are accidental and somewhat extraordinary; for, although light reflects itself in shining or liquid surfaces, those appearances are permanent in nature, and thus may belong to the highest style

* Sir Joshua—notes on Du Fresnoy. The Venetians exhibit more of the differences of colour in shade than any other school.

† Such, at least, is the general character of the school. Tintoret is an exception, but the Bassans, however dark in their effects, are seldom accidental.

of imitation. Again, according to high authorities, the difference between near and distant objects is often expressed by accidental shades on one or the other ; the distinction of near objects from each other by accidents of light and shade is the most direct infringement, and most needs circumspection. In large compositions where variety must necessarily accompany quantity and numbers, it can hardly be avoided, or rather it would be false to avoid it, but it is opposed to the most abstract interpretation of nature.

The Venetians never seem to admit union by colour till the differences of hues are lost (as we have said) in distance, and accident necessarily begins, but other schools, such as the Dutch and Flemish, break and diffuse the local colours some- times till they may be almost said to lose their locality and become common qualities. Sir Joshua Reynolds instances the Bolognese school and Ludo- vico Carracci in particular as the strongest example of this; in his works the colours are almost reduced to chiaroscuro, and lose, as it were, their nature. Such effects can be fit only for a particular class of subjects, and must be considered exceptions to that general idea of nature in which beauty resides, but the more moderate degree in which the Dutch and Flemish practised this system does not destroy joy- ous impressions, but only serves to mitigate the too pronounced integrity of the colours. In this ques- tion, perhaps much of the difficulty is to be solved

by the influence of climate, yet even the northern
critics acknowledge the pre-eminence of the Vene-
tian school, and Rubens, one of the chief authorities
for the *union* or breaking of colours, borrowed his
style from the Venetians themselves, the great ex-
amples of the relative *difference* of hues.

The difference between the Venetian and Flemish
schools is, after all, less than it appears, even in the
point under consideration. It must be remembered
that the brightest tints we see (in the brightest
scarlet stuffs for instance) are never pure, and it is
as impossible to separate one colour from a ray of
light by a dye which shall absorb all colours but
that one, as it is to mix the whole seven into white,
by artificial or material means. Yet these im-
perfect tints, for such they are, of the brightest
draperies are far too splendid for the purposes of
art, and need to be sparingly introduced, so that a
picture may be insufferably crude and gaudy, and
yet be composed of impure colours. It is known
that the brightest and apparently the purest colour
reflects a portion of many, if not of all the others,
nor is there a tint used in Painting, however bright,
which is not in some degree broken by all the hues
of the Prism. Nature is thus the remote as well
as the immediate authority for this breaking and
harmonising system. We are accustomed to attach
ideas of splendour and brilliancy to the Venetian
school, yet their pictures exhibit a low, solemn
harmony compared to many a work that might be

instanced belonging to modern schools. It is need-less to observe that this depth and harmony is greatly attributable to a certain breaking and toning of the colours; for the integrity and purity of the tints which are remarked as charac-teristic of the Venetian school are relative terms, and mean anything but unbroken colours. The difficulty of lowering, breaking, and warming the colours so as still to *appear* pure is precisely in what the difficulty of colouring consists, but it is indispensable to a just imitation of nature. It is perhaps impossible to determine, except by the testimony of that accumulated experience which settles the various claims of talent, to what degree the union of colours should be carried. That decision has been pronounced in favour of the Venetians as the highest in style, and the bad imitations of that school prove that it is very hazardous to attempt the integrity of colours further than they have done. The opposite system is undoubtedly safer, for the Flemish painters by breaking and repeating the colours still more than the Venetians, succeeded in forming a pleasing and harmonious, though a less elevated style. A still greater union such as we find in the Bolognese school, in Murillo, and in many of the Dutch painters has always been found to be agreeable, and has, in many cases, entitled the artist to the reputation of a colourist. It must not however be forgotten, that, to whatever degree this harmonising system is carried, and however mingled

the materials appear on a close inspection, a differ-ence of some kind is absolutely necessary when the work is seen at its due distance. This is not diffi-cult, for it is hardly possible (even if the artist in-tended it) to make two colours exactly alike on the breaking system. In like manner the repetition of colours which is so often recommended, does not mean an absolute repetition of the *same* tint; a slight variety of it is more pleasing, and is quite sufficient to appear a repetition. Thus in every school that pretends to colour it will be found that the great office of distinguishing and the great characteristic of variety always accompany the management of the colours ; whatever may be the degree in which the principle is attended to.

NECESSITY FOR DEFINITIONS.

DEFINITIONS are arrived at by ascertaining what a thing is not. This is not so endless an enquiry as might at first be supposed : it would obviously be unnecessary to compare an object or quality with others totally and evidently dissimilar to it. In order to arrive at something like precision, the range of comparison must be narrower; it suffices to distinguish the object or quality from those with which it might by possibility be confounded, or which, at all events, are most nearly allied to it.

Definitions are arrived at by ascertaining what a thing is not. This, which is true of mental perception, is also true of outward vision. The immediate and indispensable cause of our perceiving an object, so as to be aware of its nature, is its difference from what is next it. Its essential character consists in those points in which it differs from *every* thing else.

Such being the cause of visible distinctness, the first step in painting, to produce a just imitation of nature, is to define and apply the principles of negation. The negative element sought may be either general or specific. For example, the expression of substance will be assisted by the opposition of space; but the representation of a specific substance or object will be assisted by a comparison with other objects calculated to define its particular character.

To proceed in due order: it is necessary to begin with general negations; general distinctness, which is their aim, being of primary importance. For it is not enough that the specific character of an object should be accurately expressed, it is first, and above all, necessary that the mere substance should be distinct. The positive elements are form, light, and colour: the negative elements are therefore obscurity, or space, and neutrality.

With regard to form, which always supposes variety, the comparative negation is the straight line; the absolute negation the absence of all lines.

With regard to light, the comparative negation is diminished brightness, the positive negation absolute darkness. With regard to colour, the comparative negation is reduced vivacity, the positive negation neutrality.

In each of these cases, the negation is the real cause of effect, and the attention should be chiefly directed to its due employment and not to the quality to be displayed, except only as it may be an exponent of the other. Diminished brightness, neutrality, and the absence of form are then the chief elements of effect, and they are to be considered as the foundation of all visible distinctness, vivacity, and character.

It is the same with other qualities; a spirited touch is desirable, but the touch itself is not to be thought of till a bed is prepared for it, which, by its more or less *sfumato* nothingness, shall give the touch value.

NEGATIVE LIGHTS AND SHADES.

THE negative shade of every colour is best prepared by a hue exactly opposite to its light. The negative light of each colour may be obtained by a mechanical means. A colour placed on one side of a semi-diaphanous substance, thin ivory for instance, will give its negative light on the opposite side—that is, the medium of warm white through

which it is seen makes the real colour appear
lighter and cooler in a just proportion. Intense
orange yellow, (deep chrome) seen through this
transparent medium, gives for its light a warm,
light rose colour; vermilion gives a cold light rose
colour; lake, a very cold light rose or purple colour;
light red, a light purplish; burnt sienna, a light
purplish grey; brown, a light grey; or, all these
light colours being given, the other colours are
their depths or multiples. Blue gives a compara-
tively warm light grey, light green a light greenish
grey.

These colours are generally found together in
nature. Thus when the sky is nearest to blue (for
when the clouds are coloured it is no longer a
pure blue), the clouds, with their warmish light
grey, represent the same harmony which the above
experiment gives, and which would be agreeable in
a drapery. Green leaves give their negative light
in their under colourless parts, and give as they
change their tints also the colours that harmonise
with green, such as brown, warm and cool, light
yellowish brown, &c. A rose gives a cool light
like the warm colours above mentioned, being most
coloured in its reflexions, where the colour is mul-
tiplied into its real strength.

These things are easily arrived at with the more
positive colours, but the colourist is shown most in
balancing and adjusting with equal nicety those
which are the most nameless. Any common colour,

such as the tone of the ground or rock, a tree, &c., has its true negative light and its true shade. A picture that is full of exquisite harmonies of this kind, even to the most undefined subdivisions of the colours, is highly finished; and this is one of the highest excellences of oil painting, because it is an excellence peculiar to this art.

NATURAL HARMONIES.

The imitation of nature teaches the artist to apprehend, or at least to have some glimpse of the mystery of the *relations* of harmony; but the real power of the arts is not acknowledged or arrived at till the artist can supply the relations which cannot be got directly from nature. This creative power is necessary even in the lowest departments of art, for, unless an entire scene is copied from nature, something of arrangement, composition and harmony is supplied by the artist. Now the science derived from the imitation of nature teaches what follows from certain data, and although the rules which regulate it may be, strictly speaking, useless to one who has not found them for himself, still the grander principles which influence those rules are intelligible and applicable from the beginning, and comprehend in their just application all the minutest cases which demand solution. There can be no doubt that the Greeks had reduced the arts

to this certainty, and made them as sure in their results, although apparently imitative, as in the more creative arts of architecture, and the invention of the forms of vases, furniture, &c. The uniform and pervading excellence of all they did is not to be explained by any other means.

The dependence of every portion, every atom of nature on what it comes in contact with, is its *life*, its excellence, its beauty. A work of art is therefore not even imitative which does not represent this chain of mutual dependence. It is like the principle of the wedge, the smallest or the largest portion represents the same power; and so, in a fine work of art, the relation of the smallest portion, which is thought worth admitting, to its neighbour, is as true as that of the grander contrasts which first command attention. On the other hand a portion of an imitative work which is not allied to and does not present an epitome of the whole is dead and false.

Again, a work of art which is true to itself in these great principles of nature is more really imitative than a collection of facsimiles of the peculiarities and accidents of nature, which, it will generally be found, have no connection with each other. We admire a Greek temple or a Greek vase, and if any one should observe that there is nothing like them in nature, we might wonder (admitting the remark) that we could admire them; but a little reflexion would teach us that we only admire *because*

they are true to the principles of nature, although not imitative, or imitative only in the largest and truest sense. The Greeks were not at a loss in thus apparently creating, because their whole practice of the arts, even in those more apparently imitative, was equally intellectual,—equally removed from blind copying. However startling this assertion may be, it will cease to appear strange when it is remembered that the modern imitative arts are equally creative wherever they command permanent admiration. The *choice* of forms and attitudes, or, when these are less necessary, the choice of colours and their exquisite dependence on each other, and above all the indispensable requisite of that general effect in painting which is calculated to attract, partake of this creative power, being imitative of nature only in her spirit. The theory of the fine arts therefore which are addressed to the eye may be defined to be *the science of the relations of nature*, or the power of combining as nature combines without nature, for nature can only assist the artist in his actual operations by giving him the materials. We can thus understand it to be possible that Claude, who, his biographer relates, spent whole days in observing the appearances of the outer world and in forming a mind equal to all cases, yet never painted a study from nature, although he necessarily reverted to her for the details of forms.

NATURAL CONTRASTS.

As long as things are compared together their beauty will be identified with the points on which they differ, but the sum of these differences will be found to be their characteristic qualities. Hence the great principle of imitative art that contrast is as character, importance, and beauty, and hence the spell which rivets the attention on the points of interest, and regulates the gradations of interest in the spectator. The contrasts in nature by which the eye is principally informed, viz. those of forms and colours, are differences of *kind*; the contrasts of light and dark, hard and soft are differences of *degree*. These, we may suppose, comprehend the chief contrasts in imitative art, but it is scarcely necessary to observe that there is no quality which is perceptible to the senses which can be a quality at all but as differing from that which it is not. The qualities of transparency, solidity, smoothness, proximity, &c., can only strike us to be such by a comparison with some approach to opacity, lightness, roughness, distance, and so forth. The vast field of observation which is spread before the painter accounts at once both for the rarity and also for the variety of excellence in this art, and shows how natural it is for a nation, a school, or an individual to select such portions of this translation of nature as the authority of custom, accident, or inclination may direct. Thus we find

the Venetian school delighted in the vivacity which
results from contrast of colours; while the Flemish
and Dutch schools dwelt rather on gradations
of light and shade, and hardness and softness;
excellences but imperfectly practised by the Vene-
tians. Each school had its exceptions. In Italy,
Leonardo da Vinci, Giorgione, and Correggio tem-
pered more or less the display of colour with the
gradations of chiaroscuro, while Rubens, Rembrandt,
and Reynolds added the colour of Italy to the
fascinations of the Northern schools. The quantity
of distinctness, and the greater or less rapidity of
gradation in what relates to the conduct of a
picture are the points in which schools fluctuate
most. On the hazardous question " which is to be
preferred?" we do not hesitate to assert that the
representation which offers the greatest sum of
such contrasts as agree with the general, remem-
bered, or permanent impressions of nature is to be
preferred to the truth with which a particular or
extraordinary appearance is rendered. The works
of art which a now immutable decision has placed
in the first class exhibit in their several depart-
ments the largest facts or appearances of nature
which were the object of study in that department.
The excellence of such works in one or more
qualities is often accompanied with very slender
pretensions in others; hence the mistake often
arising in the criticism of the arts, and the dif-
ference of opinion even among artists who see

nothing but their darling excellence. In a word, the excellence of imitative representation may be defined to be its conformity to the style of the arts —to the style of the particular art—and to its fitness to address human beings; in other words, its general means, its specific means, and its only end.

FINISH.

FINISH in an imitative work implies the accurate and true relation of each quality to its neighbour. In painting, the finish which is at once most in the style of the art and most difficult is the nice calculation of each hue on that next to it. This is called *fineness* of colouring, but it is in fact nothing more or less than that truth which the art proposes.

SPACE.

THE flat surface is got rid of by composition, aided by linear and aerial perspective; by roundness and gradation; by colour; by execution; and by the nature of the vehicle.

As respects composition, it is got rid of by varying the places of objects and their parts in depth, as opposed to superficial, basrelief composition. Every object should mark a different degree of distance. If there are but few objects, still, they should never occupy precisely the same plane; and one object should, as often as possible, be

placed obliquely with the plane of the picture, by which means every point of its extent marks a different distance from that plane. With regard to different objects, the same rule in composition which, in basrelief, dictates their not being placed horizontally or perpendicularly in a line with each other, requires that they should not be equidistant from the plane of the picture. When their position in depth is thus varied, their apparently superficial parallelism, either horizontally or vertically, is of less importance; but the same variety should be observed in every direction; in the horizontal and in the perpendicular direction, and in the direction at right angles with the plane of the picture—that is, in depth.

Architectural lines and surfaces are frequently parallel with the plane of the picture: the commonest case is a flat wall, or portion of one, directly opposite the eye. This is a case where the other modes of variety, above enumerated, are especially required, and where the flatness of the wall, which is unavoidable, should be shown to be quite distinct, and more or less distant, from the flat plane of the picture. To these modes of variety we shall return.

The representation of space is the abstract expression of that receding distance from the plane of the picture which should be marked by objects, when objects are introduced. In their absence much depends on gradation, colour, execution, and vehicle; and this is one of the instances where the

effect of nature may be approached by means entirely belonging to the materials of art. The best example of this peculiar skill is Rembrandt. Gradation is applicable to a flat surface, and is therefore not in itself sufficient to produce the desired effect of space; gradation, in the case of the varied light and tones on a wall, does not alter its flatness; it would falsify the object if it did: all that it does is to show that the flat surface, so represented, is, as a whole, more or less *within* and distant from the surface of the picture. It is quite allowable to give a greater impression of transparency and depth to the substance or texture of the wall than it really possesses, but not to falsify its general character. This character is easily maintained by a line of architecture across it, a cast shadow across it, an object suspended upon it, or any contrivance which expresses and defines its actual flatness, even though the execution should convey the impression, to a certain extent, of depth.

But, in the expression of actual depth, the gradation, which is more or less regular on a wall, is not necessarily so in space. Here the appearance which, on a solid surface, would give the effect of undulation rather than flatness is admissible to any extent, subject only to the effect of chiaroscuro required in representing space. The *in-and-in* look which Rembrandt expresses so well might doubtless be regular, like a quiet evening sky, but he rarely, if ever, represented such unbroken effects. His depth

is contrived on the same principle as its expression by accidentally placed objects would be conveyed —that is, its indications are irregular, undulating, and not in unbroken succession and order. The most distant point (if it be permitted so to distinguish such vague measures of distance), whether expressed by darkness, by inward light, by retiring colour, or by execution—by the mutual relation of semi-superposed pigment, or by lucid vehicle marking *real* depth—that most distant point or place represents what, in composition, would be the most distant object, and so of nearer points or places.

EFFECT.

WHAT is called *effect* in painting consists in sacrificing many things for a few. The Italian word "*despotare*" is a very strong one applied to the art of making the principal object tell. Effect is, however, incomplete till the objects or points in these objects (for the system may be for ever subdivided) surpass what is round them in all the requisites of effect. Perhaps the most essential course is to have no lines equally cutting in the immediate neighbourhood. Nothing gives relief more, for it corresponds with the effect produced in nature; when we fix our attention on a particular object all round it is mist and indistinctness.

CHIAROSCURO PREPARATIONS.

THEIR EFFECT, DULY MANAGED, OF PRODUCING DEPTH AND RICHNESS.

In the system of thin painting, adopted by some Flemish masters, and perhaps carried farthest (on a large scale) by Fra Bartolommeo among the Italians, much depends on the chiaroscuro preparation. The light ground is left for the lights, but, by the time the half-lights (as well as the shadows) are inserted, very little of the white ground remains. The transparent preparation or chiaroscuro (formed by a brown only, with lights left) being *quite dry*, the local colour is thinly painted over it. Light over dark is cold; and, in order to preserve the requisite warmth, the tint (suppose light red and white) spread over the preparation, still deepens in colour as the half-lights deepen: if this were not attended to the half-lights would still be too cold—and the darkest would be the most leaden. But by still proportioning the depth of the warm flesh tint to the depth of the half-tint, a sufficient coolness (more or less as required) may always be preserved; the deepest shades should be retouched, if retouching is at all required, with transparent darks only, and will consequently be very warm. In this system the cool tints are produced in various degrees by passing light over dark, and no positive cool colour need

be introduced anywhere, except, if required, in the
highest lights,—for there, the ground being pure
and bright, nothing lighter (consistent with truth
of tint) can be passed over it; consequently cool
tints cannot be produced *dynamically*, that is by
seeing dark, or any degree of it, through light.
In such cases actual cool tints may therefore be
introduced if necessary, and the slightest tintings,
whether of extreme warmth (as in vermilion
touches) or coolness, which may be required to
complete the work or to prevent monotony, will
effectually conceal the artifice of the process. No
other process so well secures depth and clearness,
and combines richness of transparency with appa-
rent solidity. To conceal the process still more,
the high lights may be freely impinged with ap-
parent substance (and some actual substance) by
the aid of a thick, but not flowing vehicle, (drying
cerate with " vernice liquida,") and the whole may
be finally glazed to a still warmer, deeper tone.
The whole circle of operations might then be re-
peated—scumbling and glazing to any extent; but
probably without adding to the original qualities
in colour and real depth, although other improve-
ments (in expression, &c.) might be the result.
If, in the chiaroscuro preparation, white is used
to insure greater completeness in form and ex-
pression, the whole system becomes more com-
plicated, and care is requisite, perhaps with re-
peated operations, to preserve transparency in the

shadows equivalent to that produced by leaving the ground. Heads, in unfinished pictures by Titian, are examples of this method. Solid chiaroscuro under-paintings, but by means of glazing brought into much the same state as a preparation with the ground left, should be first laid in; over such work, the thin, warm, flesh tints, leaving the deepest shadows for still richer tonings, would have the best effect.

In thus tinting a sky, prepared with a gradation of brown on a light ground (which should be quite dry), it is essential to clearness and depth that the blue and white superadded tint should be darker than the brown transparent preparation. When not so, the blue has a cold opaque look—on the contrary, it has always a toned warm effect when thinly painted over a ground lighter than itself. Care should therefore be taken not to make the brown preparation too dark, especially as the blue can always be toned by glazings and so rendered darker. In this system of sky painting, if there is any solid work it can only be in the preparation, ultimately toned and embrowned in the mode before described for flesh, before the thin blue is superadded. In order to get the blue flat (the preparation being quite dry) it should be laid in with a slow drying vehicle—mere oil—to which a little spike oil may be added to prevent needless yellowing. The same principle (that the superadded tint should always be darker) applies to all

cold colours—green, grey, &c., but warm colours may be sometimes lighter than the brown ground, even when they are transparent, in order to produce cool tints.

CHIAROSCURO PREPARATIONS.

TRANSPARENT BROWN.

RAW umber and white may be made a very pleasing colour by the light over dark, and dark over light system;—cool, silvery, tender tints are produced by the former process, and (by contrast) a great amount of richness by the latter. The softness which is the result of the scumbling and "flattening" system, with large brushes, can be agreeably contrasted with pressed, abrupt, crisp touches in lights and in *sillons lumineux* with the same brushes—as well as by occasional sharpness in shades.

When umber alone has been used in darkest broad shades, and proves to be too opaque a preparation for ultimate deepest shades, it will be found possible to lighten and warm them a little by introducing vermilion and other very warm tints in minute quantity, and without stirring much, in the midst of a quantity of vehicle. This can be finally glazed with a very rich brown, and with more vehicle. In the Rubens system of laying in the deepest shades with a dark transparent brown only, much vehicle should also be used with

the colour—if not at first, at last. This system is difficult unless the whole be laid in with the same brown, for otherwise chalky solid lights continue long out of harmony with the rich, brown, diaphanous shades—the eye only tolerates the latter when the lights are rich.

For an ordinary brown preparation, not too *glazy*, raw umber, warmed with a tint composed of Cap. brown, and burnt sienna, will do. This is convenient because of its quick drying before the dust adheres to it, but any brown, not too neutral (sufficiently warm) and not too oily and glazy for the lighter parts, will do.

The thick glossy vehicle used at last (and which is useful for protecting and sealing the work) is not desirable at first, and as a surface to paint upon, for many reasons. Above all, because the colour does not adhere to such a glossy surface, and there is the danger of portions becoming afterwards detached. To obviate this, when painting on such a surface is unavoidable, it is advisable to soften it as much as possible beforehand, with a strong essential oil. The Venetian principle of using nothing glossy in the preparation and first paintings, is the safe principle. But they feared not a thick glossy vehicle at last, and especially for depth.

DEPTH OF LIGHT TINTS.

As the " depth of white" is found by spreading white very thinly over a dark (warm) ground, and imitating by a solid mixed tint the pearly depth so produced, (see p. 286) so the (cool) depth of flesh, or of any warm light colour may be found in the same way. All such depths being more or less negations of the colour, or opposites to it, must consist of the three colours in some form or other, and in varied proportions—the union of the three being the characteristic and condition of negation. The purplish greys which are the result may be sometimes composed of blue and a warm red (the warm red being strictly speaking of the nature of orange). Thus ultramarine and light red will produce a purplish grey fit to represent the cool depth of some warm lights ; black, blue, lake and umber, and a hundred other combinations come to the same general result of neutrality, but more or less *fineness* and delicacy of tone is arrived at by imitating and matching, as nearly as possible, the ethereal tint produced by thin warm light over dark, when a flesh tint or other warm light tint is very thinly spread over a warm dark ground. As the light of this neutral coolness is warm, so the darkness opposed to it requires to be of the same warmth in an intense degree. A mellow, warm light, (which, strictly speaking, is always some degree or kind of

orange) is, in its darkest state, the richest possible brown—the warmth and richness required may be heightened by transparency, by showing a light ground through the warm darkness, and by rendering the browns more lucid by a transparent but substantial vehicle.

WARM SHADOWS.

THE colourists of all schools treat the deepest shades as intense and, more or less, transparent browns. This brown could undoubtedly be produced by glazing over a not too dark grey (rather over a light grey—as was the practice, in consequence of his ground, of Rubens); but such a system could express no force of light and shade, and in Rubens' case, although the ground was often a light grey, the brown dark was inserted at first in its deepest power. There is, therefore, in this respect, no essential difference between the Italian and the Flemish practice; intense brown, no matter how produced, is common to all the colourists in dark shadows.

The system of expressing almost all degrees of chiaroscuro by grey, as the lower depth of white, led some great painters, and, to a certain extent, even Correggio, to adopt too blue a preparation for their darker shades. Neutrality, by dint of glazing, may doubtless be attained in such shade, but generally at the expense of clearness and warmth.

Zanetti, in eulogising Giorgione, says that his shadows were not " bigie " or " ferrigne " like those of some other painters. The Lombard painters generally, including many followers of Leonardo da Vinci, have this defect, this iron coldness in the shadows; but even they employ deepest brown, and brown only, in the intensest darks.

With this precaution, either avoiding very dark bluish greys in the lowest half-lights, or gradually warming them as they pass the ordinary force of light middle tints (where this coldness is desirable) the system of modelling with a grey that is really neutral cannot be too much recommended. The utility and the charm of this neutral tint are most felt when, after the preparation is dry, the middle tints are allowed to imbibe degrees of warmth— for the nature of the grey is such, from its absolute neutrality, that the slightest tinge of colour upon it is precious and harmonious.

TREATMENT OF GREEN AND BLUE.

1. A NEUTRAL grey preparation being duly lighted up and modelled, without bluish low tones, and with brown only, or a preparation for it, in the darker shades—vivid green tints, not, however, of the bluish kind, are passed thinly over the half-tints, the lights being left. The modelling may be assisted by darkening or lightening the green middle tint, but the higher lights are, more or less, untouched.

When dry, the whole is glazed with a rich brown
—the precise kind, (whether semi-opaque, or dark
orange-like, *ut scis*, or perfectly transparent of the
same or of a browner tint) depending on experiment.

2. The only difference in the second mode is to
slightly glaze the whole grey preparation with a
warm brown at first, and, either at once, or better,
when this glazing is dry, to insert the green middle
tints in the mode above described. The vehicle
for such rich operations had better be the usual
Italian glazing vehicle.

The question now is whether blues, light or
intense, might not be prepared in the same way.
In the first place the method, No. 2, above no-
ticed, is the only one that would answer in such
a case. The grey, well modelled, and somewhat
sharp preparation, with brisk lights, very brilliant
or not, according to the colour required, with half-
tints not too bluish, and with brown in the in-
tensest darks—this grey preparation, when dry,
is first glazed with a rich orange-like brown.
When dry, (and here this is essential) the blue
middle tints are inserted in various degrees of
strength, so as to assist the modelling. The lights
are as yet left, and may be altogether left in
certain blues—in which case they present, by
contrast, a broken, mellow, dusky orange-tint to
the blue middle tints—a rich deep brown succeed-
ing in the intensest shades, and sometimes (as

there are examples in Titian) in reflexions. The crudeness of the blue, if striking, may be ultimately modified by glazing.

But, if the blue be required to be very deep, the preparation corresponding, the lights are entirely covered with the blue tints (though not the deepest shades, which are supposed to be, partially at least, as dark as possible). In this operation, therefore, much depends on showing enough of the glazed and warm preparation through the blue, especially in the lights and in the lower tones, for, in the middle tints, the blue may be most powerful. In this again a final toning may be required.

In repeated operations, such as those above described, it is not necessary to oil out when the dry surface is dull—as in glazing a brown over the solid preparation (which preparation, if properly executed, will present a perfectly dull surface), previous sponging being all that is required. But, after it has received the brown glazing, the surface will probably be more or less glossy, and, in inserting the blue on that surface after it is dry, it will be better to oil out—taking care to remove the oil afterwards with a linen rag till it scarcely leaves a trace on the cloth.

If this treatment of blue for draperies should prove satisfactory (as it certainly answers in greens), it would also be found that skies, and blue mountains, and distances might be treated in the same way, and thus the same system would be

used throughout. The forms of the sky being modelled, and the place of the blue, or portions of the blue, being indicated by a light grey (but not bluish) middle tint—the whole, when dry, may be lightly glazed with a warm brown, the portions which are to be blue being well warmed. When dry, oil out as above, and insert the blue, allowing the ground to be partially seen through in the places intended for it ; varying its depth of course as required, and as already indicated in the preparation, and toning finally, if necessary.

In landscape, generally, the forms may be defined and the lights impinged with the grey middle tint lightened with white ; still avoiding too bluish a grey in the lower tones. When dry, glaze first with brown, and then insert (the surface being dry) the local broken colours—masses of green, of brownish, yellowish, greyish, &c.—leaving the warm ground under and amidst the cold colours, and occasionally reviving and increasing the grey under-tint in the midst of warm colours. The whole are toned at last, more especially the greens and blues—the only tints which, in a landscape, are in danger of being crude.

With regard to reviving the grey preparation, this was evidently a frequent resource with the colourists ; the only difference being that the grey produced over a more or less finished and warmed surface may be a dynamic grey—that is, a cool tint produced by scumbling thinly a light tint over

a dark. Still, the same grey may be employed,
only it should be spread more thinly. Occasionally,
however, it may be solidly touched over the finished
portion and toned again as required.

This system is also observable in the practice of
the colourists in flesh painting. It is not a regu-
larly calculated system, or rather, the system, how-
ever well calculated, rarely " runs smooth " through
all the operations ; remedies are resorted to, and
they consist in restoring comparative light and cool-
ness where required, to be again toned and har-
monised with the rest of the work.

The darkest shadows, or, at all events, very
forcible shadows, may be improved in tint, when
required, by the same means : the grey then used
is not a violently light colour, nor does it really
border on blueness; that it will appear light and
cold, when so applied, is however certain, and it
should be so contrived that the patched portion is
not violently offensive even before it is glazed.

Untrue half-tints and depths may be rectified
in the same way : they should be first scumbled
(*botteggiando*) with a neutral grey, duly removed
from blueness. If the passage to be rectified be
sufficiently light, it may then be toned so as to
harmonise with the rest of the work.

As the depth of light golden, or warm-coloured
hair is prepared with this grey, so the same grey
may also be used as the preparation for the depth
of gold; for, when warmed by the right glazing

colour, (no matter whether semi-opaque or trans-
parent,—better semi-opaque at first) it expresses
the true depth of gold. In some pictures the
lights appear to have been at first indicated by
white, or a tint slightly removed from it, such
lights being covered with opaque (that is, semi-
opaque because thin) light yellow at last. Other
painters have taken a shorter course, but, in the
works of all colourists, a balance of warm and cold
has been by some means or other preserved in the
minutest, as well as in the largest portions.

In repeated operations the principle, therefore,
seems to be neutrality upon colour, and colour
upon neutrality. The only exceptions are blue and
green, which require to be inserted on a surface
apparently the opposite colour. Lastly, purple is
the representative and index of opacity; when
treated as a transparent colour it is most agree-
able when it has more lake than blue. A deep
transparent violet is found in works of the Ferra-
rese and Milanese painters, but never in those of the
Venetians. The purples or lilacs of the Venetians
are always opaque, and appear as half-lights, never
as transparent intense darks, and never as high
lights.

OILING OUT.

In painting the human figure, the refinements of
expression and the perfect anatomical modelling
of parts in subordination to general roundness, sup-

pose, at least in some stage of the work, great nicety of execution and great delicacy of manipulation. Whether this can be accompanied with evident freedom or not, there should, at least, be no appearance of labour. If the touch cannot be light and varied, it should not be apparent at all. There is no danger of extreme minuteness in the solid painting, nor in the transparent shades. In the first, the bright preparation may consist of few and simple colours, and as there can be no fear of sullying such colours, even in the lowest half-tints, there can be no temptation to a timid handling. In the shades also, if inserted once for all in a transparent state, on the Flemish system, any approach to minuteness of touch (except where mere lines are required) can be obviated by sweeping lightly over such touches with a broad soft brush; and if, on the other hand, the shades are painted more solidly, to be afterwards glazed, the method presents no more difficulty than that adopted in the lights, answering to that produced by the Italian " *sfumino*." The degree of minuteness lies rather in the final retouchings and scumblings with a view to truth of modelling and tinting, and the evil is best obviated by glazing, or at least oiling out (and removing the superfluous oil) before beginning these more delicate operations. For if such operations are attempted on a dry surface, the scale of the work being small, a greater or less amount of stippling is the almost unavoidable consequence. No spreading and soften-

ing with the "*sfumino*" overcomes this quite, because many minute (hollow) portions of the surface remain dry, and present an untoned contrast with the rest. The previous glazing or oiling out may therefore be considered indispensable, before the more delicate work in question is commenced. The method is indeed recommended by Armenini, and was no doubt adopted by the Italian painters generally. The retouchings on a dry surface, which the Venetians perhaps almost exclusively employed, were always bold, and are not to be confounded with the final scumblings and glazings above referred to. The system of impinging sparkling lights, and even insulated darks, was rather a completion of the abrupt, crisp preparation before the finer union of the parts was attended to. That finer union, with the Venetians, as with all other painters, Italian or Flemish, was, and can only be duly accomplished, so as to avoid the appearance of labour on the one hand or spottiness on the other, by working on a moistened surface with finely ground tints. It rests with the artist to use, in this stage of the work, an ordinary thin vehicle or an oil varnish with his tints; for such literally alternate operations the Italians, and even the Venetians, frequently used the oil varnish. This, when employed profusely, as in Titian's St. Sebastian (Vatican), no doubt superseded the necessity of a final varnish, at least for many years. It appears probable that the oil varnish was then used abun-

dantly in the last general glazings and scumblings in large altar pictures, which were to be sometimes exposed to damp, and at all events to great varieties of temperature in churches; while, for works of less extent and intended for other situations, the surface, being less protected, (in consequence of a less robust vehicle having been used), immediately required the essential-oil varnish, which served to protect, as well as to bring out the colours.

VEHICLE FOR SHADOWS.

In painting it is safe to assume that till the darkness reaches the intensest degree, transparency increases with darkness. Warmth, therefore, increases with darkness, at least as long as any inward light is visible; and, to avoid blackness in the deepest shades—to be " deep yet clear," it is still desirable that here and there points of warm reflected light, varying in extent of depth, should be visible. The transparency of deep shades is greatly assisted by the rich consistence of the vehicle; light being then reflected not from the lucid surface, but, however faintly, from within it. For rich darks it is always desirable to have a thick vehicle. This vehicle should be clear, but it need not be colourless. It should not be liable to crack. It should be also quick drying; because, if slow, the dust which unavoidably adheres to the surface may affect the transparency of the

shadows, and is, at all events, difficult to re-
move. Thickened, or half-resinified oil, is well
adapted for this purpose, but an oil already inspis-
sated with a resin is, perhaps, preferable, as the
paleness of the oil is, for the purpose in question,
not so essential. The oil and sandarac varnish,
"vernice liquida," if made according to the old
receipts (3 parts oil to 1 of resin) is sufficiently
thick. In order that the richness and lustre in the
vehicle should be permanent, it is safer to use
such an oil varnish instead of resins dissolved in
essential oils only. The latter, useful as they are
for some purposes, and however brilliant at first,
have not the lasting clearness which is desirable
in deep shadows. The defect of the oil varnishes,
even when much thickened with resins, is their
tendency to flow, but this, if less compatible with
extreme sharpness of execution, is of less conse-
quence in shadows and may be corrected in a great
measure by the dryer.

The internal light represented by a light ground,
over which transparent colours are passed, may be
renewed and reproduced (and can only be repro-
duced) by the hottest orange-red colours. The
"rouge de Mars," sometimes lightened by the scar-
let Mars, together with the vermilions, and similar
colours, is well adapted for this purpose, but it is
essential that the colour should be impinged in its
brightness and not smeared or rubbed, for, when
so passed over a darker tint it will only make a

heavy and even greyish colour. The best mode of securing its sparkle and brilliancy and, at the same time, of producing that partial broken effect only of transparency which is so agreeable, is to apply it carefully with an (ivory) palette knife, the shape of which may be even adapted for minute as well as for large operations. The more solid, cooler, umber-like hues of the shadows will thus acquire great effect, and still produce a balance of warm and cold tones.

Some of Rembrandt's portrait backgrounds, though treated with scarcely any attention to form, and from the lowness of their tones presenting only an harmonious mass, are found, on inspection, to be full of a variety of hues; the warmth, as usual, increasing with darkness and with light, the cool colours pervading the half-tints. Besides this variety of tones, there is a fascinating variety of another kind, produced by the various apparent depths which a thick diaphanous vehicle insures. Here and there the lighter portions are loaded, but, being again overlaid with the semi-liquid lucid medium, broken with transparent tints, the surface is sufficiently filled up. The absence of positive form which generally accompanies this harmonious obscurity in Rembrandt has the effect of increasing the impression of depth. The result, for the particular end proposed, is perhaps more complete than in the works of any other painter, not excepting Correggio, although in his case the same principle

and method are, to a great extent, observable. The peculiar practice of Rembrandt here alluded to has also the great recommendation of being a distinctive attribute of oil painting, and of ranking among those qualities which successfully imitate nature by means proper to one art and one method alone.

Numerous examples might be selected from the works of Rembrandt where this most satisfactory union of truth and consummate art is attained. One of the most remarkable is in a portrait of an old lady exhibited at the British Institution in 1848, (the property of Mr. Jones Lloyd, now Lord Overstone). The general tone of the low background harmonises perfectly with the head—at a moderate distance its depth appears to be nothingness—on a nearer inspection it is found to be full of vague forms, and a multitude of hues; golden reflexions and even crimson points are relieved by varied tints of umber and toned greys. The surface is equally diversified, sometimes rougher and more solid, sometimes evanescent—the degrees of depth seem infinite. The mysterious forms look like the stalactites of a grotto, but whether intended for them, for the fringe of draperies, or for the indistinct forms of architecture, it is impossible to say.

The richer portions of this picture are probably painted with such a vehicle as the " vernice liquida" in all its original thickness, rendered sufficiently drying. There is scarcely any sharpness in any part of the work, yet a gradation in this respect is preserved.

The quantity of vehicle used by such a painter as Rembrandt in such effects is scarcely conceivable by modern artists; but it is plain, from an inspection of many of Reynolds' works, that the founder of the English school very commonly aimed at this method. He sought to give the requisite body, combined with more or less transparency, by means of wax very copiously used, and with what unfortunate results his pictures often tell.

It does not appear likely that Rembrandt used wax. His scholar, Hoogstraten, who describes the technical habits of the time so fully, would probably have noticed this had it been common.

To return to the portrait referred to: it is plain, from the sharp, arrested, unmixing touch in the head, that the flowing vehicle was exchanged in this case for an essential-oil varnish, mixed in due quantity with the colours ground in oil.* No other vehicle of the oleaginous kind produces this unmixing, abrupt, unflowing appearance more completely. But the flowing quality can be no objection to a glazing vehicle, and it is therefore probable that, except where a rapidly drying surface was wanted, the transparent glazings were in all cases applied with an oleo-resinous, and more or less thick medium. For the lights, the purest bleached oil, with mastic or even with fir-resin, would be preferable to the dark " vernice liquida," and the dryer might

* See Mansaert; compare De Piles.

be sugar of lead, in moderate quantity, instead of gold size.

The preparation of the lights in Rembrandt's heads appears to have been often cool, and the quick-drying, broken, and arrested masses and touches that are applied on it, leave the cool tints of various degrees of darkness half visible at edges and uncovered dragged portions, as it were, through them.

It was important to cover the whole surface as much as possible at one painting, so as to insure sufficient union of the tints with all their occasional abruptness; when the surface was quite dry a slight application of thin and quick-drying varnish would answer the same end if covered at the right moment.

The flowing of the touch in consequence of using the oleo-resinous vehicle in the shadows may be corrected by implanting the last dark, sharper lines and touches when the thick transparent lucid shades are nearly dry; the touch then remains in its place.

As in the rich shadows the warm ground may be reproduced or represented at any stage, so the cool under-painting in the lights may be renewed at pleasure with a view to superadding warmer tints upon it. The transparent tintings last added, as in the more vivid hues of the flesh, had still better be introduced on a surface not quite dry: a thin application of varnish is one mode of contriving this, but such touches may also be added in the

final glaze or even before, on a dry surface, provided it is not too glossy to receive them.

It remains to observe that, as warmth increases with transparency and consequently with darkness, a picture may be richly coloured without any positive colours (since the richest hues on a low scale do not tell as such). Gilbert S. Newton, who had a fine eye for colour, was remarkable for selecting neutral colours for his dresses, while, like Gains, borough, he gave an impression of richness by avoiding coldness, blackness, and opacity in all his darks—even in dark blue skies. The shadows of trees may thus be warm; the shadows even of white or grey architecture are painted by Rubens and Vandyck with the richest transparent browns. The colourists took care of the darks, and left the lights to take care of themselves.

One consequence of this system, however, is, that the lights can never consist of " sickly white "—they must be toned, though comparatively colourless. Another consequence is that the picture can never be " poor." Depth of shadows supposes richness of vehicle, and the quality of the lights must sustain this. There is, however, a difference between the richness and depth of the two. The character of Rembrandt's lights is that transparency is attained not by thin paintings, but by half seeing what is beneath, between, or beside solid touches: sharpness and brokenness of touch is attained by a rapidly drying vehicle (mixing a portion of *essen-*

tial-oil varnish with the tints). The transparency of his shadows is quite different—the diaphanous effect is more simple; that is, tints are seen as if through a glass, and the operation of glazing is more general—the use of a thick *oil* varnish is also not compatible with much sharpness.

As Corelli and other musicians are said to have composed their bass first, so the Flemish and Dutch colourists painted their rich shadows first: a flesh-coloured ground being supposed, the outline defined (whether upon or underneath it matters little), and the glowing and brown shadows inserted, it is impossible for the lights to be crude, though they may be comparatively neutral—it is also probable that they will be boldly impasted and freely handled. When the lights are inserted first, (before the shadows), they are almost sure to be too light, and the consequence is that the *key* is always changing as the darks become increased. It is therefore on every account better to establish the maximum of darkness and richness at once *somewhere*, as a guide to the eye.

TRANSPARENT PAINTING.

WHEN many colours are mixed together, their effect can only be clear by being so thinly spread as to show the light ground through them; but, if a thick system of painting be adopted, it is a great object to avoid a clayey mixture of the colours. This has been attained by colourists in various

ways. One mode is to use few colours at a time, because then they may be mixed without restraint. This mode was often adopted by the early Italian masters, and by Reynolds—it consisted in painting at first chiefly for form and chiaroscuro, with a hint only at the ultimate colour. The work might be of any degree of solidity, but, even in this process, the shadows can, if desired, be left without body, so as to show the ground through them. The more ordinary process was, however, to paint lights and shadows with an almost equal body, the shadows being kept light, comparatively cool, and clear. This preparation, when dry, was then rendered fit for a new application of colour, by a very thin rapidly drying varnish—a spirit alone, or (as some preferred) a thin coat of oil, which was carefully wiped off again, leaving the surface scarcely moist. The warm colours, still few in number, were then freely used; transparent and rich tints being alone used in some shadows. Lastly, when again dry, the whole might be glazed, and not necessarily with one tint only. The harmony of the whole work would probably require a variety of tints—these, however, being transparent, would (with common precautions) no more affect the mere transparency of the work than the mixture of tints in water colour. The essential condition in glazing is that the superadded colour should always be darker, or, at least, quite as dark as the under-colour; if not, a leaden opacity will be the result.

Another method. Thick painting, with prepared tints, both warm and cold in great variety, but each mixed at first on the palette with a rapidly drying medium, so as to insure the comparative isolation of each touch, if desired. This is the method of Rembrandt in some of his finest works: in many, so painted, the shadows are still kept transparent, in others, their richness is insured by repeated but independent, and more or less *un-mixing* operations. One most agreeable consequence of this method is that tints, representing a cool depth on which the superadded warm colours are impinged and which may be partially reproduced at any time, dry soon enough and sufficiently to prevent the clayey immixture of the impinged tints; and not only is this effect produced, but the superadded touch does not melt into the tint underneath, but finishes abruptly with a more or less broken, ragged edge, which, by a contrast of mere texture, independent of the difference of hue, is thus sharply distinguished from the bed on which it is impinged, and, aided by the difference of hue (the under-colour being generally of a retiring nature) seems suspended in air, and conveys the idea of depth—the *in-and-in* look—which is the great charm of the master-works of oil painting, in the liveliest manner. Sir George Beaumont, whose precepts and taste were chiefly derived from Reynolds, used to say that " transparency does not necessarily mean effects produced by literally transparent

colours, but generally by seeing one thing within or partly within another."

In Rembrandt's works of the class referred to, the mere material application of the tints—(so distinct that the order of their application by the partial exhibition of what is underneath or behind them may be seen)—expresses the quality of depth, and closely resembles the peculiar semi-transparent effect of some stones—such as the agate—a comparison which Sir David Wilkie often made. There can be no doubt that these effects in pictures, when seen near, are more transparent than flesh, but, at a due distance, the imitation is perfect. In this finest of all exaggerations, the principle is the same as that of the extreme richness of colouring, and especially of the shadows, adopted (more especially in large pictures) by the great masters; the effect of air and the imperfection of vision soon reduce the darker glowing tints to the just truth of nature; whereas, when the truth is only literally rendered in a near view, the shadows appear opaque and black at a very moderate distance.

As regards the vehicles which may be used to insure this rapid drying, the first condition is that after extracting from the colours the excess of oil in which they were ground, the drying and more or less resinous vehicle should be mixed in due, and (as regards the darks) in varying proportions with *all* the tints.

DEPTH.

THE principle of depth, which is peculiar to oil painting, depends, in a great measure, on our being aware of a transparent medium. Colour may be seen through colour in the thinnest oil painting, or in water-colour painting, and great beauty of combined, yet unmixed, hues may be the result.

But the impression of depth here dwelt on, is that which we experience in looking at a gem set on a bright ground. Its colour is not only enhanced by the light shining through it from within, but the eye is conscious of the existence of the transparent medium—is conscious that its outer and inner surfaces are distinct. We have this impression even when the medium is colourless, as in looking at any object under crystal, or under clear water; however pure the medium there is always enough to mark its presence, and the objects seen through it have, more or less, the quality of depth.

Perhaps the word *tone* (so often confounded with *tint*) might be partly defined as the appearance of one hue within another, when the medium is also appreciable. The higher qualities of tone reside in the harmonious relation of hues in depth—an effect greatly attainable even where the medium is not distinctly visible—but the perfection of such qualities undoubtedly depends on that positive and

actual measure of the " within and without " which
a rich medium affords.

COOL LIGHTS ON RED.

THE shine (suppose of ordinary daylight) on red
morocco, appears to be the colour of the light only,
without any admixture of that of the object—the
cool, whitish, silver lights form an exquisite con-
trast to the toned, red lake depths, and would be
agreeable in separate objects placed next each other
(the same perhaps is true of all *shines* as contrasted
with the local colour on which they appear). The
whitish light which, on polished surfaces, is merely
the image of the light, had better be produced (not
merely by white, but) by the depth of white, (found,
ut scis) on a very light scale—that is, heightened
with white. It will thus always partake more or
less of a purplish hue on yellow, brown, and black
objects; of a purely neutral, silvery tint on bright
red objects, and of a relatively warm mellow colour
on blue, and green, and purple objects.

The tendency of the shine to a purplish hue is
very apparent on warm objects, (for instance, on
old polished or varnished oak) not in the highest
lights, but where the shine is scarcely perceptible—
at the edge or subsidence of such lights—as where
they die away on polished mouldings ; in such cases
the more delicate the light, the purpler it becomes
—as if the object were very thinly scumbled with
semi-opaque light.

OIL PAINTING.

OIL PAINTING as a distinct method cannot be said to exist till the medium used produces that *in-and-in* look which is unattainable in any other mode or material. The quality of depth is to be sought even in solid, light, opaque objects, and can only be expressed in them (as in the darks) by exhibiting varieties of tone and light, suspended, as it were, in the substance or thickness of the vehicle. The difference between the treatment of the lights and darks, in this system of lucid, but substantial vehicles, is, that in the lights the surface may always be more or less marked, whereas in the darks the surface should never be visible. This has nothing to do with the *actual* surface or projection of vehicle, (which may be considerable without being visible, in a proper light,) but with the apparent surface—that which is intended to be seen when the picture is in a proper light.

MACCHIA.*

A MAN's head of the ordinary complexion seen at a certain distance in the unpronounced light and shade of the open air, or of a room with more than one window, or with a diffused light, exhibits that appearance which Leonardo da Vinci somewhere describes, and which is common in Venetian pictures. The effect of the minuter shades or dark

* The blocking out of the masses of light and shade.—*Ed.*

colours (of eyes, brows, beard, &c.) is, as Leonardo
observes, to colour the whole mass—to make it
darker and warmer. The darker side of the face
(the light being assumed to predominate on one
side) has, seen at such a distance and under such
circumstances, a browner hue only, and is hardly
distinguishable from dark local colour on the light
side. Barry (the painter) somewhere describes
the shadow of Titian's flesh as "flesh colour dark-
ened and embrowned only." There is, however, a
fine gradation both in light and dark, (more per-
haps in light); the retiring parts of the face, as
for instance the side of the cheek and temple,
without losing their broad warmth of colour, are
less illumined than the cheekbone, and the fore-
head is often the same ; the nose again, even in fair
subjects, looks darker, partly because surrounded
with darks, and partly because its minute lights (at
the point and on the bridge) become invisible, as
Leonardo truly observes, at a little distance. There
is also no shine on dark hair at a certain distance.

This distant, broad, shadowy effect is most agree-
able when the surface in painting is not too trans-
parent and glossy, but rather mealy. This effect
is produced by using, where possible, semi-opaque
colours (always darker than the colour on which they
are scumbled) in tinting, toning, and darkening.
The same appearance is to be aimed at in golden
complexions; they should not look too glassy and
glossy, but have a due opacity. This may be ex-

tended even to half-shadows. In this is seen one great difference between the Venetian and Flemish masters ; the Flemish painters can never have too much transparency, and they certainly manage it well; but the Venetians with equal, or with scarcely less splendour, have more solidity, and yet their system, in its shadowy breadth, agrees more with ideal and somewhat distantly seen forms.

VENETIAN PROCESS.

THE Venetian process was divided into the blotting of the masses, solid painting, sharp touching, (*colpeggiare*), scumbling, and glazing. The chief requisite in this system—indeed in oil painting generally—is to restrict the *touch* to solid painting or to minute shadows, and never to show a small handling in scumbling, that is, when the paint is thin. Minute work with solid paint soon cures itself; the touch soon becomes bold and varied, but it is not so easily avoided with thin paint. Such thin scumbling should always be swept in masses, otherwise it will degenerate to stippling. (See pictures by Buonvicino (Moretto) as an example of the touch—small yet solid, sparkling and vivid.)

The bright minute touches of an unglazed Venetian picture must have appeared quite raw, and almost snow tipped—glazing was indispensable to lower and harmonise the work. Looking, however, to such a final process, the bright touches might

be most sparkling. It is a mistake to aim at this harmony too soon ; the attempt leads to want of vigour in handling, want of light, and ultimate flatness and dullness. Boschini observes that Titian's pictures were *gemmed* all over during the work, and no doubt just before they were completed by glazing.

BELLINI THINNED HIS VEHICLE WITH LINSEED OIL.

IF Bellini used the amber varnish, (or its substitute, " vernice liquida") with the colours, as this is apt to clog them, it is quite reasonable to suppose that he would, like painters now using the same material, dilute the pigments, so thickened, with oil. Hence the story of Ridolfi, though told with another and a mistaken view—viz., in the belief that oil was only then recently introduced in painting—may, after all, be a true tradition.

It is to be remembered that, with the early oil painters, essential oils had no place *together* with fixed-oil varnishes ; the two might be used separately—the essential oils were perhaps used by Leonardo da Vinci in his solid preparations, but never to thin the oil varnishes. Their diluent was necessarily a *fixed* oil.

Ridolfi's account of Schiavone's preparing his tints some days before they were used, is interesting, and agrees with the fat, cloggy look of his

colour. His touch seems brisk by dint of force and firm brushes. It is, however, not impossible that he may have used amber varnish or its equivalent, in the manner of Correggio, only without blending the tints. He studied and used the designs of Parmigianino, and hence a possible connection with a Correggiesque practice.

It is very probable from the appearance of Baroccio's surface and handling, that he used the amber varnish.

The circumstance of Gentileschi, at a later period, inheriting this practice may be traced to a connection with the schools of Parma.

WARM OUTLINES AND SHADOWS.

ZANETTI marks the improvement of the early Venetian school in colour, by the observation 'fece più rosseggiare il contorno.' The outlines of the earliest painters were black. The effect of a warm outline to indicate flesh, even though the rest be white, is visible in some ancient mosaics in the vestibule of St. Mark's at Venice. The next step, or an extension of the principle, was the warming of the shadows, especially when small in quantity—the use of the blood tint. The reverse of these methods would be to make the centre of the flesh the warmest, and to allow it to grow colder towards the outlines and shades. The finer, broader principle consisted in kindling

the form at its boundaries and in its depths, and letting the centre take care of itself—for it would necessarily be cooler than the darker parts.

When the system of preparing a cool under-painting was introduced, (by the Bellini and their followers,) the warm glazings began in the darks, then toned the half-lights, and, lastly, tinted the lights. But, when all was tinted, the breadth of colour was sustained by keeping the focus in the darks. One consequence of this system was that the cheeks could not be much coloured—a general glow was rather attempted, for the colour being given in the shadow, contrast required that it should be less strong in the light. Ludovico Dolce, noticing this as the practice of Titian, gives a reason for it in his own way. It might be observed that the Venetians in adopting this system only copied the nature which they saw: if so, it must be concluded that Nature in Italy suggests a higher style of colour than elsewhere. The warm glazings (always semi-opaque in the *lights* and half-lights, though perfectly transparent in deepest shades) were even suppressed in a great measure by some Venetians in the lights; the effect was to give a certain effect of transparency, as if the skin were thin. (For, if we suppose a column of glass, we shall see the colour crowded towards the edges, and less strong in the centre; the colour is, as it were, accumulated in the foreshortened parts.) This effect had also, in heads, its use in expression.

Zanetti speaks of "certi lividi," introduced by Basaiti. These "lividi" were merely parts less covered with the warm tintings, such warmth being suffered rather to accumulate in the darker, and less prominent portions. The coloured (not reddened) features, and paler cheeks of Basaiti's saints give them a look of passion and emotion, not to be rendered in an engraving.

The system easily degenerates into foxiness. Paduanino is often an instance of the abuse. The warm *brown* shadows (as opposed to Paduanino's red) in Titian—for example, in hands and feet—contrast agreeably with cool lights and middle tints.

NEUTRAL TINTS IN WHITE AND OTHER DRAPERIES.

In the grey depth of white, the yellow ingredient (represented, we suppose, by raw umber,) requires to be very sparingly used, especially when the tint is employed in scumbling over a light, since all colours are warmer in effect when light is within them.

For the blue element, black is sometimes not sufficiently delicate ; a blue, however small in quantity, is requisite, and the colour should even be fine of its kind—the French ultramarine would be preferable to common blues. It is quite possible to do without black, in which case, of course, the

yellow and red ingredients must be increased to neutralise the blue. For the red, Indian red is commonly used and may suffice, but the purple reds, either of iron or madder, may be employed with advantage. For the lights, the yellow element should slightly predominate, and the deeper shades should be brown—so, in black objects, the deepest parts may sometimes be brown.

The effect of lightening a shadow by scumbling or dragging a lighter tint over it, is to make it colder as well as less dark (light over dark is cold). As every colour contains all the colours, on the principles before explained, and as the *blue* tendency is in excess in the case supposed, the tint employed to correct it should have as much of the *orange* as the nature of the ingredients (used in the local colour) permits. If again the bluish tint (suppose in a rose drapery) has been glazed with lake, as it will evidently be too purple for the local colour, the correcting (and perhaps lightening) tint should then incline to yellow. Once neutralised and harmonised, the usual cool half-tints, and coloured depths can again be inserted if required.

TONING, TO MITIGATE PARTIAL OR GENERAL CRUDENESS.

ALL vivid warm colours, and spots of any such colour in a larger mass, when toned, and reduced by brown, are not only more harmonious and

agreeable, but appear to have their actual hues deepened. The reason may be that such toning partakes of the nature of shade, and the colour is not so much altered as deepened—though slightly neutralised.

Cold colours that are too crude, are, when toned with brown, equally true and deep. In this case the colour would seem to be *opposed* by the toning—but the effect is quite as satisfactory, perhaps more so than in the case of warm crude colours that are toned.

All colours that are crude from whiteness, or lightness, are improved in like manner by a toning brown.

The silvery depths of white even are made more telling by a golden browning, near, and more or less upon them. [The sparkling quality is indispensable in white and in flesh, and, in general, in all light objects—the delicate half-tints are revealed and multiplied by such treatment, which, however, is not to be confounded with the imitation of shine. The sparkling quality depends on (relative) brightness, sharpness and crispness, and ultimate tone, for such a quality is more precious and is even increased really by the glazing, as the points of brightness are less obscured than some of the surrounding portions.]

The toning brown should be used everywhere to mitigate crudeness, even in partial tints (that may be too vivid) and spots—for where, on a very light

scale, the toning is proportioned—not only in draperies, skies, landscape and inanimate objects, but even in flesh.

The general distribution of light and dark, and the modelling in all details should, however, be completed before, as very little modelling can be safely effected by toning—the attempt may end in rankness.

TEXTURE.—CONTRAST OF SURFACE IN SCUMBLING.

THE contrast between the delicacy of scumbling—a delicacy consisting in extreme fineness of tint (by means of semi-transparency) as well as in extreme softness—the contrast between this, and the crisp roughness of lights, against which it stops—is of a most agreeable kind. Suddenness of form, texture, or colour in nature, is best imitated by such means. A rough (roughly painted) isolated small cloud, (light or dark) in the midst of a formless space— formless, but full of gradation of light and tint, and without apparent substance—expresses this peculiar contrast; like a rock in smooth water. The same effect may be sometimes seen in Titian's flesh; smooth, or apparently smooth depths of half-light lie round a rugged crisp light. The beauty of scumbling is not displayed unless it floats round such sharp, rugged substance. The roughness and brokenness of such points and touches may be

assisted by ground glass used as a pigment—it is always *short*, even when used (not too liquid) with an oil varnish, or wax medium. The roughness may also be assisted, where required, by the pulverised colour itself, (dry on an adhesive surface) or by ground glass, or ground resin, or even by ashes, so applied.

SCUMBLING AND RETOUCHING.

A MOISTENED surface is almost indispensable for delicate and partial scumblings, but modellings produced by comparatively abrupt retouchings may be added at any time on a dry surface. The two methods are most convenient in finishing. Under the first are comprehended the accidents produced not only by dark over light, but by light over dark; the latter producing pearly tints not to be attained by solid painting. The other mode (the retouching) is more akin to solid painting, and may be a means of regaining sharpness and abruptness, which the scumbling system has, of course, a tendency to destroy. In beginning a work, solidity and freedom should be especial objects, as they cannot be so well attained after the work is completed. In order not to get too white, the whole should be scumbled, and re-scumbled from time to time with the local tint, or with the warm or cool corrections which may be required (white being generally sufficient for the latter). Then the modelling may

recommence, and be gradually carried to the delicacies of form. In order to secure apparent freedom and sharpness, those passages should be looked for which admit of an abrupt insertion of light—for in half-lights this abruptness is not so agreeable. Cast shadows may also be abrupt and free. Again, in most other objects, (besides the flesh) this abruptness and solidity may be easily secured.

Thin scumblings with a vehicle (or with the mere colour) much diluted with spike oil or other essential oil, will not become horny, but, on the other hand, they may easily be washed off, and therefore require to be *fixed* with a varnish of some sort. An oil varnish, or mere half-resinified oil, may be used in this case—an essential-oil varnish is in danger of removing the tints unless the surface be first protected with a thin glutinous film. For example, a wash of *beer* fixes the surface sufficiently to bear a varnish. A thicker glutinous medium is not advisable, as it is apt to become white with the varnish. On the whole, perhaps, an oil varnish is safest for recently painted pictures.

CRISPNESS AND SHARPNESS BEFORE TONING.

For the " sfumato " system, and the production of pearly tints by light over dark, a crisp and solid under-painting is indispensable. It is undoubtedly possible to give this appearance (as the Venetians,

according to Boschini, sometimes seem to have done, even after a solid beginning) at last, or when the work is advanced, and everything is in its place; but there is danger of some reluctance at that stage to disturb the effect, and to risk losing what has been attained in expression. But anything is better than ivory smoothness; sufficient crispness and ruggedness for glazing can, at all events, be secured; only remembering that what is soft, will be still softer by glazing.

Reynolds says that Titian's chief care was "to express the local colour, to preserve the masses of light and shade, and to give, by contrast, the idea of that solidity which is inseparable from natural objects." The preservation of masses of light and shade is one of the merits of the Venetian colourists, and it is difficult to understand how such a school can be said to be deficient in chiaroscuro. The suppression, or slight indication of markings in the light, gradually led to the suppression of dark shades in the flesh altogether, and, as if this was not enough, we frequently find a very light blond hair added. (The features, however, always tell.) The whole is then relieved by a strong and broad contrast of dark and sometimes cold masses, according to the tint of the flesh and drapery; the light, golden flesh is also sometimes accompanied by a white dress, and then the whole figure (with a few points of dark) is relieved against the equally massed ground.*

* Compare Zanetti, p. 218.

It is in securing, (before toning,) the breadth of light in the flesh, that the scumbling system, or alternate scumbling and modelling, may beget too much smoothness, softness, and finish; all which will be still more undecided when glazing is added. It is therefore very necessary to keep, or renew, crisp lights; taking care to have as many *abrupt* passages as possible—(abrupt, that is, as to texture). These should be carefully kept, as softness will take care of itself. The equality, or unbrokenness of intermediate passages of half-light, which may look unpleasantly finished in surface, will be sure to receive accidents from glazing. The point is to secure sufficient sharpness where sharpness should be.

This variety of mere surface can be greatly assisted by the vehicle, which of itself supplies substance, and does not obstruct crispness. A sparkling quality is one of the sources of brilliancy, and delicate modelling, in fine Venetian pictures. This is sometimes produced by beating, or stabbing, with the brush with white—(what is called in the Venetian dialect " botizar ")—and the same process, over a solid preparation, helps to give that equally granulated and mossy texture which is often observable both in flesh and draperies. But, it should always be remembered that such processes are only agreeable when superadded to a rougher, and more " colpeggiato " (touched) preparation. With regard to the more delicate sparkle which assists the

finest modelling and the niceties of expression, its effect may be first tried by irregularly dotting, with white chalk, on the points or surfaces where its effect is desired. This same effect, when agreeable, can be produced by inserting—no matter whether accidentally or with intention, (provided the result be irregular) the same sparkle with points of white. An old worn brush is useful for the purpose. In such cases it is important that the points, or minute touches of white, should be solid. Their too great brilliancy can be obviated either by tinting upon them to a certain extent when dry; or by using much stiff vehicle, and counteracting its yellowing, as usual, by the purplish hue of the superadded light—but pure white may be used in this way also, and tinted afterwards. *Thin*, partial, and minute tintings of white, though useful in equalising and solidifying, and in distributing minute greys (as they are always employed to stop out relative darks) are not calculated for the sparkling process; *that* can only be produced by solid, diamond-like, but irregular, and irregularly placed points and touches.

The " botizar " system is almost indispensable for producing breadth, without too much sacrificing modelling. Its equality, union, and finish, and its imperceptible gradations require to be sufficiently broken, either by the abruptness of the preparation, or by superadded sharpness, crispness, and definite sparkle. One mode of breaking its soft transitions,

is by spottiness of local colour; for it should be remembered that whatever reason there may be, (in young subjects) for unbroken roundness, there is no such reason for softening colour, as in the cheeks or elsewhere: the more patchy and abrupt this can be, consistently with truth and the appearance of health, the better will it contrast with the soft gradations of the lights and half-tints. This is one of the points in which Titian is superior to Palma Vecchio. Paul Veronese never fails in it, nor in anything that belongs to briskness, or vivacity of execution.

GLAZING SYSTEM.

To give full effect to the glazing system (especially with the old substantial vehicle) it is necessary that the preparation should be more or less solid, and *freely* handled. In Bassan the lights on flesh and other objects were sometimes impinged with much of the local colour in an advanced state of the work, and after all had been laid in in chiaroscuro and glazed. In this way it is always possible to prevent a woolly effect, and to restore something of a sparkling appearance by inserting bright rough touches, and toning them afterwards. Schiavone is a great master in all that relates to colour, brilliancy, and vivacity of execution.

The glazing system (the thick vehicle being always understood to be used) has various condi-

tions, some relating to colour, some to surface and texture, some to chiaroscuro.

In colour the first principle of the glazing system is warmth, and the second broken hues.

The neutrality which the latter seems to involve (as distinguished from positive and gaudy colouring) is still made compatible with warmth by contriving that the cold colours shall be neutralised by warm ones, and the (too) warm and positive by *cool* or neutral, rather than by *cold* hues.

In this system of neutralising and breaking, the application of the exactly opposite (transparent) tints is to be attended to, and as the preparation does not consist of one uniform tint but of cool half-lights of reddish, greenish, bluish, purplish, &c., so the superadded tonings should be varied constantly to antagonise the under-painting. We thus find in draperies of Venetian pictures a nameless colour produced, although we might easily call it red, rose-colour, &c.—the bluest tints are toned with orange, the greenish with lake, the violently red not with a positive green but with an olive, umbry colour; orange the same, the olive inclining more to grey. Blue is toned with rich brown (dark orange) slightly, and has the same warm colour both for its intense darks and, on a light scale, for its lights.

In general, the colour which should be used to neutralise another, is that of the high light and shadow of the colour to be neutralised. Thus

a vivid, crude blue is toned by its opposite, a rich brown, (the depth or darkness of the brown depending of course on the tint of the blue which it duly balances); a rich transparent brown might be the shadow of this blue, and white, a little embrowned or gilded, would be the true light. A vivid and crude green is toned by a reddish brown—that same colour in its deep transparent state is the fit shadow for the green, and white, embrowned or reddened, would be the true light. The bluer the green the more the light would incline to orange, but it is to be remembered that *two* positive or strong colours can hardly come together—when the green is strong, the light is comparatively colourless. The opposite of orange is strictly blue, but, on the same principle, as the orange is strong and positive the opposite should be comparatively neutral, a dusky, greyish, umbry tint is the fittest depth for orange. Blue is strictly a half-tint, not a shade-tint, the opposite, of course, is therefore to be recognised in its half-tints, which are sometimes in Venetian pictures of the neutral character above described. The reflex shadows of *all* colours are warm; and the lights of orange are not its opposite, but only lesser degrees of orange—that is, yellow.

So with regard to yellow—its opposite, purple, belongs neither to the shade nor to the light, but only to the half-light, and *there* requires not to be positive, but rather to be a greyish depth. Its lights are only lesser degrees of yellow.

So with regard to red—its opposite, green, belongs neither to the shade nor to the light, but only to the half-light. The neutral half-light of red is as usual not positive, but is rather an umbry depth.

The opposite of a positive colour is a negative one, but which is still opposite in the quality of tint also.

The opposite of bright red is pearl colour ⎫
 „ „ „ bright orange is grey ⎬ neutral grey, black.
 „ „ „ bright yellow is purplish grey ⎭

 „ „ „ bright green is reddish brown ⎫
 „ „ „ purple is yellow brown ⎬ brown, warmish white.
 „ „ „ blue is orange brown ⎭

The opposite of the warm colours is in their half-lights.
 „ „ „ „ cold colours is in their shadows and lights.

The lights and shadows of warm colours differ from those colours only in degree.

LIFE IN INANIMATE THINGS.

THE surface of the living figure is the most noble object of imitation, and it is this which chiefly limits sculpture to the naked. Life being the fittest aim of representation, it becomes so also, in some form or mode, in inanimate objects. In sculpture, where colour is wanting, the drapery for example is often made to cling to the forms, in order that it may derive from them an interest which the mere expression of folds cannot possess intrinsically. Besides this, drapery, even when not showing so distinctly the forms of the nude, may assist com-

position, and may be grand or beautiful in itself from the arrangement of its lines. But it is in painting, and when the charm of colour is added, that an attribute allied to life may be given to drapery, and to all inanimate objects, independently of their forms. The contrasts of warmth and coolness, of transparency and opacity, of pure and negative hues—contrasts, in short, of all kinds which the eye can appreciate, besides those connected with mere form—these form the *life* of nature, and give interest and beauty to objects that would be otherwise passed over. As painting cannot do without such objects, and as they make up a large portion of every picture—from skies and clouds to trees, rocks, and foreground; from draperies and architecture to all kinds of artificial productions and implements—these inanimate portions of a picture should receive the especial attention of the artist to endow them with life. Light, gradation, and contrast are the means by which this may be effected, but within these words lies the whole soul of refined imitation. The infinite modes in which inanimate objects are rendered charming to the eye, by the means here indicated, can only be studied in well-coloured pictures. Contrast of colour is the chief agent: gradation is, strictly speaking, only a subdivision of contrast, for, as the object of contrast is variety, so no contrasts should be repeated; and this suggests degrees of intensity —varieties in degree as well as in kind.

PALETTE KNIFE.

THE expression of alternate sharpness and softness
in the boundaries of forms, (whether forms of sub-
stance, of light, or of colour,) is indispensable to
truth of imitation in painting, and by whatever
mode this peculiar contrast is attained, it can hardly
fail to insure a picturesque and apparently free
execution. An enlightened friend of Reynolds,
Sir George Beaumont, often heard that great
colourist say that accidental appearances in nature
had better be produced by accidental operations.
The same amateur was of opinion that the success
of water-colour painters in skies was greatly owing
to the unavoidable rapidity and uncontrolled free-
dom with which the forms of their clouds were
produced. Be this as it may, there can be no
doubt that not only certain forms of material things,
but the fantastic shapes of masses and accidents of
light, the capricious patches and breakings of colour
on various surfaces, and the gemlike and irregular
crispness of brilliant lights are all better rendered
by methods which may be said to be, at least partly,
accidental; and it is indeed only when accident is
thus called in to imitate accident, that the infinite
variety of nature can be said to be approached.

At the same time all depends on a right use of
this principle. Nothing can be more seemingly at
variance with such a proposed mode of imitation
than the scientific studies and careful practice which

aim at distinct appearances and immutable facts. The knowledge of anatomy and of beauty of form in the human figure and in animals, for instance, are referable to fixed laws; and the artist in such studies professes to define the types of excellence. It is one of the difficulties and privileges of painting that the most apparently opposite aims may, and must at different times, regulate its practice; the unprejudiced artist has, in short, to know and feel when the precision of science is to be his guide, and when that precision would endanger the very truth of imitation which he proposes.

Without entering further into the question what should, and what should not be the objects of precision, (the living form being admitted to stand pre-eminent among the recognised and definite objects,) it is to be remarked that whatever may be the degree of precision which the boundaries of some objects require — and they can never require undeviating hardness or softness — an irregular crispness in the lights is never out of place, whether in flesh, armour, drapery, or sky. The question what degree of softness is necessary to balance that crispness has been variously answered, according to the taste of painters, and it must also depend on the distance at which the work is to be seen. All such questions of degree must necessarily be left undetermined. We have here only to speak of the operations or methods. Much may depend on mechanical contrivances, and

on varying and contrasting the operations. For example, although the brush may, in a bold hand, be employed to produce a sharp, crisp and irregular handling, and although it must be considered an indispensable instrument to assist even this kind of execution, yet it is not so entirely independent of the will as a harder instrument. In the peculiar practice here referred to, the brush may be considered the instrument of softness, the palette knife of crispness and sharpness. The first may represent imperceptible gradation, the other the abrupt edge and point of a crystal sharpness; the one typifies the cloud, the other the gem. By the palette knife is to be understood a very flexible ivory blade; several such, varying in the breadth of their extremity from an inch to almost a point, may be used. Their flexibility at the point of course increases with use, by degrees the point wears away and becomes less regular, and is not the worse for being so.

In all pictures there must be a scheme of light and dark, warm and cold. It is plain, therefore, that the will of the artist should be most exercised in the largest scale, and least so in the smallest details. The same may be observed of forms; their general proportions and true relation of masses are more important than the accuracy of minute parts. In the latter, freedom can do no harm.

THE GEM-LIKE QUALITY.

In general it may be safe to assert that it is a defect for anything in a picture to be capable of being *likened* to another. Nothing is so charming as when things have their *own* quality, and are like nothing but themselves : always remembering that of the many qualities of which one object may be composed or partake, such only will be most prominent which are forced into notice from existing comparisons. It may be observed, however, that in description things can only be presented to the mind's eye by resemblances, and, in this case, when the object is to exalt the particular thing, exaggeration is allowable and necessary. Thus cheeks are like roses, clouds like gold, flesh like snow and vermilion, &c. In imitative art, where these substances are addressed to the actual eye, they require to be *distinguished* from each other. Still, in the various modes in which nature may be rendered (according as the letter or the spirit is most aimed at, and above all according to the comparison or contrast of the moment), there will always be a resemblance between a painted imitation as an effect, and some general quality in nature independent of, and in addition to, the particular imitation aimed at. The truth of this is admitted by the terms of praise, and still more by those of dispraise, used to characterize pictures. A picture, for instance, is said to be golden, to be silvery, to

be gem-like—to be mossy, to be woolly, to be
wooden, to be tinny, &c. Now if we consider the
laudatory comparisons which relate either to the
colour or some collateral quality, we find that no
quality comprehends such absolute and universal
excellence as the *gem-like*. It comprehends the
golden and the silvery, only adding the quality
of transparency ; the pearly, the sparkling, the
velvetty, the glittering, the pure, the definite, are
all comprehended in the *gem-like*. What is or
may be wanting is the solid which borders on the
opaque, the soft which borders on the misty, the
flexible or undulating, &c. The qualities which
more particularly constitute the gem, and which
may be aimed at in painting, are precision of
leading forms, and sharpness soon lost in softness
which may always insure a sufficient approach to
the flexible ; this may be translated into precision of
touch rather than of *general form*. The lights are
the minimum of the colour, the deepest shades the
maximum ; reflexions are infinite and bright, but
only sparkling in points. The shades are trans-
parent, but all is transparent ; and the character of
the gem certainly is to be most lucid and clear in
the lightest parts. This is Tintoret's system : his
deep shades are often opaque and too black, but
they are lighted up by sparks of brilliancy which,
originally no doubt, gave transparency to the whole
mass. Any colour, whether trunk of tree, rock,
earth, or what not, may thus partake of the gem.

The greatest care should be to make the reflexions sparkling and brilliant, for the lights will take care of themselves. A transparent substance exhibits its own colour, and reflects but little of others. To avoid too much monotony in a drapery, for instance, the hue may be varied ad infinitum if necessary by glazing variously, but still it will present but a series of gems, and not give the idea of an opaque substance reflecting foreign hues. Violent orange, vermilion, and all colours whose light is their maximum are not gem-like, but they give great value to those that are so. White can hardly be gem-like, unless the lights are treated with precision. Its cool shade is generally surrounded with a warm outline, for everything beyond it is probably warmer than itself. This warm outline is agreeable even when coming on blue. Black is most gem-like when glazed on white, so as to have none but *internal* lights, and if any are on the surface, still precise and definite. Hair has a silken quality of its own which does not partake of the gem; it reflects the light (does not drink it like a jewel), but with as much of its own colour as possible. The purple lights on black hair give it a very opaque look.

The same sort of resemblance in this good sense of the word (that is, a resemblance to something most perfect of its kind) may be aimed at in the choice of colours : various reds, for instance, are beautiful when they resemble the rose, the blood,

the flame, the ruby : the colour of wine in a transparent glass is the same as the gem. (The Venetians loved to place it on a silvery white tablecloth.) Yellow, the golden, the gem-like; blue, the sapphire : the last is the most difficult colour to make brilliant, yet Titian does it.

FACILITY OF EXECUTION.

THE spontaneous and effortless freedom of some painters, no doubt, belonged to their general character. The " mocking at toil," the " sprezzatura" of Giorgione—the "judicious strokes that supersede labour," are the surest test of genius and of the fit temperament for a painter; for such a power necessarily supposes the comprehension of a whole, a habit of viewing things in their largest relations. The idea of power is always conveyed when we have an impression that the actor, whatever he may be doing, can or could do more than he actually does—that the strength shown is only a part of the strength that might be shown. This is true, even literally, in the wielding of the brush; the line should be a part of a larger line; the direction and impetus of the hand should not be limited to the form or touch actually produced, but should have a larger sway. There can be no doubt that the evidence of this liberty and range of hand, eye, and mind (for all go together in legitimate freedom) is charming to the spectator. And this is not all, it

is really more imitative; the cramped and bounded is not nature.

The rules of art can go far to correct that spiritless stiffness which arises from equality of shapes and masses, from parallelism of lines and monotony of hues, indeed, if it were not so, tolerable works of art would be much rarer than they are. The question here proposed is how far mere freedom of hand, which is often a source of variety, especially in surface and in sharpness and softness, can be, and has sometimes been, assisted by judicious methods, and attainable in short by study.

In painting, as in writing, it is undoubtedly true that the appearance of facility itself may be the result of labour. In writing, indeed, it is scarcely an object of ambition to have it believed that the work cost little time and trouble. Few writers are seen to compose their works; the labour of months may be read in an hour, and may yet appear to have been produced by some powerful mind in as short a time. But when Addison was gently reproved for writing a long answer to a letter, he replied, " I had not time to write a short one." The appearance of power and facility would have cost him more trouble. To a greater extent it is the same in painting. It is the condition of the art to require a certain method.

Let us examine the ordinary process of Rubens —one of the greatest masters of facility the world has seen. In order to secure the possibility of exe-

cuting his work with apparent rapidity, and without torturing the colours as it is called, he defined everything in a coloured sketch, from which, as is well-known, his scholars " got in" the large picture. If it be asked what preceded his masterly sketch, it is replied designs on paper, studies from nature, and a careful outline rarely departed from, even in that sketch. There was nothing of what is called Invention in his large picture. Not only the composition, but the masses of light and dark and colour were all determined, and the details of the drapery, architecture, &c., all sufficiently defined. There remained literally little but execution to think of : the labour of covering the canvas with colours fitted for his ultimate effects was performed by others ; he was thus set free from the necessity of labour partly by the assistance of others, but chiefly by his own well directed previous labour. If there was genius in such a man, it must be admitted that there was also admirable judgment, and that his judgment was shown in making the fairest occasions and freest scope for the display of his genius. " Divide, et impera," the motto of the Hero of the Nile, was exemplified in every picture by his hand. To invent, compose, draw, give gradations of light, and clothe with true colours, all at once, might have been done, if by any man, by Rubens. He adopted, however, the more cautious mode of giving his energies to each in turn, though each was prophetically viewed in

relation to its neighbour quality. The whole effect was indeed already planned and embodied—gradually even then—in the sketch. Nothing remained for the last operation, but to think of beauties of execution and harmony. Had he laboured his work after all the previous steps (it matters not whether we consider the freest operations of the picture or the freest of the sketch, for both were results), there would have been no consistent principle in his processes : the object of the first labour was that there might be a finer labour—rather delight— in the completion. Without this evidence of liberty and joy the plant which had crept to its fullness by the successive aid of every ministering energy would have been without its "consummate flower." " Quem mulcent auræ, firmat sol, educat imber."

Facility is therefore secured by labour. It is quite conceivable, and experience constantly shows that what is first done in careful and laborious succession may at last be done by a strong effort of attention at once. The previous labour here resides in the previous life. The well-known answer of Reynolds to one who complained that his price was high for the work of an hour is here applicable.

But the sense here intended by the expression " facility is secured by labour" requires, for the purpose in view, to be explained. It is understood with reference to the efficacy of the processes which precede the exercise of freedom. That ultimate freedom may be called another kind of

labour, for most certainly it is not to be exercised carelessly, though sometimes apparently so. The lesson which Rubens gives, in short, may be useful in an humbler form for those who, from whatever cause, are wont to take refuge in labour of a mechanical kind, instead of doing everything with apparent will. The greater the timidity or the less the amount of that instinctive energy which gives soul to trifles, the more the workman requires to calculate his previous labour so as to enable him to attain the desired facility at last; to place it, in short, as completely in his power as possible. Van Mander says of Van Eyck that his dead colouring, or preparations, were more careful than the finished works of other painters. This is quite possible, and may have been the case even with Rubens' pictures as prepared by his scholars or even by himself. The preparations of the Florentine painters, Fra Bartolommeo and Andrea del Sarto especially, were also more careful than their finished works. A judicious economy would on every account suggest this; the appearance of freedom is, we have assumed, an excellence—it is specious, winning, fascinating—it is not the quality to bury under subsequent and more laboured operations; it should be the consequence and not the forerunner of labour.

What is called dead colouring is any stage of a picture short of its ultimate vivacity and intended completeness. The appearance of freedom after

most careful study might be given in the very last
stage. The preparation, however advanced, should
be calculated accordingly. If, for instance, a cut-
ting edge of ploughed pigment next a form be
intended, it would be necessary to keep the pre-
vious surface flat and thin; to *repeat* a ridge of
paint or a raised touch is an evidence of failure.
Sometimes this cannot be avoided, but it is best
avoided by care in the previous preparation, and by
a fixed intention which is supposed to be justified
by the effect of the sketch.

The preparation of the groundwork, in every
sense of the term, which is to receive the free
painting, has been hitherto dwelt on, that stage
which precedes the thin washes and glazings that
complete and harmonise a picture. The pre-
paration of the pigment itself for the final work, is
equally essential. It by no means follows that the
apparently brisk execution of fine pictures was
really done in haste ; a false colour in a light is a
greater defect than a wrong direction of its form,
(for the outline at least may be correct). Not
only the tint as such, but in sufficient quantity,
should be duly prepared; there can be no facility
without abundance of colour: the brush even re-
quires to be loaded with care, and not at random—
then the " sprezzatura " or " bravura " of the hand
will accomplish its task without hesitation. In
some cases a single touch is absolutely requisite,
and therefore requires to be in all respects right,

but "right" does not mean formal, nor even neat; an accidental "abandon" is the (apparent) quality to aim at, the object still being to conceal labour. In other cases touches may be repeated, but only for the sake of more *impasto*, for better modelling. In such instances all that is requisite is that the last and most visible work should be quite free.

The preparation of the tints in due quantity leads to the consideration of the sometimes disputed general question respecting mixing tints. Sir George Beaumont used to tell a story of Wilson, who, after visiting the landscape painter, George Lambert, complained that he could see on Lambert's palette "the cow, and the grass she was going to eat." Some portrait painters (see *Bouvier's Manual*) mix an infinity of tints for flesh. All this has been condemned, but the opposite extreme is equally unadvisable. Time, labour, and attention, are dissipated in constantly mixing tints with the brush from the pure colours on the palette; brushes are used soft, there are unequal proportions of oil in the colours, and the palette may be said to receive more attention than the picture. The tints, a few at least, should therefore be prepared for the work of the moment. This is more especially necessary (though not at first seen to be so) in the final retouchings. There should be colour enough and to spare, and each tint, whether for high lights or anything else, should be accurately prepared. The

advanced work easily furnishes a key for the tones, and trials, to make all sure, are quite possible, for as the surface is assumed to be dry a tint may be tried and wiped off again.

Finally, it may be repeated, the appearance of dexterity and rapidity, the sweep of the brush, the sparkle of the touch are not only graces but necessities in painting. When a work lacks these, it should rather be carefully hard than carefully soft, for hardness, however objectionable, is allied to determination and exertion, softness to weakness and indolence.

REMEDIES.

It has been elsewhere observed that the best pictures are but blunders dexterously remedied, and as, in inventing a picture, the necessity of certain picturesque arrangements suggests the introduction of incidents that often add greatly to the moral or imaginative interest of the subject, so the remedies above alluded to may be the means of giving new character and zest to a subject. It is in this way that length is sometimes added to lines or extent to masses of light, shade, or colour, and both advantageously so, where such would not have been thought of but from the necessity of remedying a defect. The result of accident in this way brings the art nearer to nature, for where pictures are the result of so much pondering and design (all which tends to neutralise character), any arrange-

ment independent of the painter's *will*, if at all compatible with the subject, should be carefully preserved.

The great principle of lessening the effect of a form, or mass, or arrangement which is unpleasant to the eye is to *divert the attention from it*. Sometimes very little will do this, but, to do it effectually, to apply the proper remedy, the nature of the defects should be clearly understood. It will not then always be found that some *opposite* attraction will annihilate it, for this, on the contrary, may sometimes make the objectionable feature still more conspicuous. It is obvious that no mere rules (as such) can be intelligible or applicable in these cases, but the general principle of diverting the attention is always safe, for it even includes putting the defective object in shade, which certainly diverts the attention from it by making it less conspicuous. But the other mode is by making some other object *more* conspicuous, and it is precisely in this sort of remedy that the new object or attraction may be the means, never thought of before, of eking out a composition, or mass, or line, which adds much to the general effect. It is obvious that in introducing a remedy, care should be taken to make a *virtue of necessity*, and to make the remedy serve some positive as well as negative purpose; at any rate when accident has thus suggested an improvement it should be followed up to completion.

HOW TO COMPOSE AND PAINT A SINGLE HEAD.

To give grace, nature, ease, and all that which makes a picture attractive, to a single head (without hands), is one of the difficulties with which portrait painters, and even painters who are not tied to a likeness, have to contend; and it is worth enquiring what are among the causes which contribute to success in this particular.

Extraordinary beauty, or an expression which seems to speak volumes, and with which we can converse, are the first and highest qualities in a single head. For it is obvious that when so little of a figure is seen, the only excuse for representing it doing nothing, is because it is very worthy to be looked at. A particular dress is often considered a sufficient reason, but it will never be admired if put on an unattractive person. In the next place all the powers of fascination which painting possesses are necessary, even with a beautiful and expressive countenance, to make so *abridged* a representation truly effective, and equivalent to pictures which contain more. It may be observed that every picture, no matter what it contains or represents, should be calculated for effect in a gallery of excellent works. We find for instance that a single head by Rembrandt will bear down before it large masses of figures by inferior colourists; so

that it is not because it is a part of a figure or a
small picture that a head must necessarily be with-
out much interest. The fascinating effect which is
produced by the powers of colour, light, and shade,
requires the hand, science, and experience of a
master, and to attempt to show in what that fasci-
nation consists would be to unveil, were it possible,
all the resources of the art. But in minor things
there are some observations to be made on the
general practice of painters.

The placing the head high in the canvas is
always to be observed; the contrary proceeding
gives the idea of a short person, or the impression
that we might have seen more of the figure. The
next thing to attend to (and not so easily done), is
to avoid a truncated appearance at the lower edge
of the picture where the arms and body are cut off
by the frame. When the bend of the arms can be
shown they look less glued to the sides of the
figure, but even a very graceful action of the arms
when cut off a little above the elbow may produce
a very unpleasant and awkward effect. The action
itself has, however, something to do with this, and
it is better to let the portions of the arms take the
direction which is least unpleasant, without think-
ing what becomes of them afterwards, than to ima-
gine a complete action, which may not, as above
observed, be pleasing, seen piecemeal. The safest
way, however, to get over this truncated appear-
ance is either to lose the lower part in drapery, or

to merge the outlines, if seen, in shadow or light, in short, to do away with the idea of division and cutting off, by hiding the intersection.

The opposite to this principle would be to make the part of the figure cut off by the frame the most conspicuous, when we immediately feel that there is more of the figure which we do not see. On the contrary when the head is most conspicuous, and the lower part left in uncertainty, we are not so much reminded that it is a half figure.

The making the head conspicuous is indeed the sine quâ non of this branch of art, and would only be neglected by an artist who had theorised himself out of the first and obvious requisites of a picture; viz., *that the greatest attention must be paid to, or at least attracted by the parts which are most important.**

The grace and ease which are sometimes eminently pleasing in pictures of only head and shoulders, depend on truth of drawing and proportion. To render a common and natural action well, seems, in so small a portion of the figure, a matter of little difficulty, but if it were not really extremely difficult we should see it oftener well done. The cause of failure generally is the fitting on of a neck and shoulders to a face without sufficiently

* In a small part of a figure, as in a three-quarter canvas, *any* sort of background with detail and lights and darks is dangerous. It is *supposed* that the head only is worth exhibiting, otherwise so small a canvas would not be chosen— all else must, therefore, be nothing in comparison.

studying the harmony of the action as well as of
the proportions from nature. The face is gene-
rally advanced considerably before much is done
to the rest. It is not necessary perhaps that all
should be carried on together, but a drawing of
the *whole* is necessary (either on the canvas or on
a separate paper) from the model. The forms and
proportions may be afterwards improved.

The more the representation is confined to the
head, the more the head should not only be effec-
tive and attractive, but the more it should have in
it an expression and appearance which in nature
would force us to forget the rest of the figure. A
mere head perhaps is always best represented
looking at the spectator, and if it has a depth
of expression and something uncommon which
realises or accords with some unuttered thought,
in addition to all the charms of colour and effect,
it will rivet the spectator as much as an historical
picture.

But it is much better in fancy subjects, where
an artist is not tied to size, to introduce the hands.
The difficulty of getting over the truncated effect
is greatly diminished, and, what is of more impor-
tance still, a definite and motived expression and
action can be given throughout what we see of the
figure. It is true some difficulties are increased,
such as the skilful management of the light, now
rendered complicated by the spots of light formed
by the hands, the paramount necessity of making

the general masses take pleasing shapes, &c. The hands, when thus introduced, should only serve to increase the expression of the head and the general beauty of the picture, but a more positive part they should not play. The actions and the feelings of a figure in a portrait or fancy subject of this kind are sufficiently limited if we reduce them to those truly interesting. We must always remember that the picture is supposed to exhibit the particular *mind* of the human being represented. A man with his hand extended, as if speaking to or about to receive one who addresses him, may be excused in a portrait as a mode of identifying the individual, but it is worth nothing as a means of affecting or impressing the spectator. To do this the person represented must do something or look something which exhibits him in his essential and peculiar, not in an accidental and common character. A deviation from such a principle is less pardonable in fancy subjects because the character there is left to the painter's own choosing, and a work of this kind with no particular *meaning* (always remembering that it is the face which should mean most) is even less interesting than a portrait.

In ideal subjects it is obviously safest to let the character and expression agree with the age and sex of the person. A lovely woman for instance will be more attractive (because more generally natural) with an expression of deep tenderness,

melancholy, innocence, hope, devotion, or benevolence, than with a look of profound meditation or grief; which latter supposes a remote cause of which we are left in ignorance, and also destroys beauty. But of all expressions in the head of a beautiful woman that of innocent, confiding, and devoted love is what will best *tell* in a picture.

Next to the expression, *par excellence*, should be considered all that contributes to heighten the effect of this union of the physical and moral character. Titian makes his female heads really *women* by the flow of soft luxurious hair, golden and waving, with part loose on the shoulders. The Greeks represented women *round* in outline and in relief, the bones suppressed, the angles of the shoulders softened. Titian had the same penetration in catching what is truly nature; his half-tints are composed of imperceptible gradations on the cheeks, forehead, neck, and bosom, and thus the features tell with power. The greatest contrasts in the figure have been placed by nature in the head, where the shadow of the hair gives value to the face, and in the face (where all the features should tell more than any accidental shade) the eye has more contrast, from its lightness, darkness and sparkle, than any other feature.

The most ordinary colour of flesh and that which we find imitated in the works of the Italian masters, even including the Venetians, is a hue much lower than white and very different from any positive

colour; yet it may be warm or cool and still be comparatively neutral, and if warm it will either verge towards *red, yellow* or *orange*. A negative colour of the latter kind, and more or less lower than warm white linen, is the predominant hue of Titian's fairest flesh colour. If such a colour is supposed, it may be well to examine what ground will give it most value. It is first evident that a delicate colour of any kind * will betray the mixed nature of the flesh, the neutrality of which will become muddiness. But a positive colour of a vigorous kind will exhibit its neutrality without impairing its brightness, and if warmth and glow can also be exhibited we shall have many characteristics of flesh. The rest, such as transparency, gradation, &c., being intrinsic qualities, are less dependent on opposition, though still greatly dependent. Various tones of blue and green of the deepest kind will therefore give *warmth* and comparative *neutrality* to flesh of the mixed and low kind, while the darkness of these colours will prevent even their purest parts from making the flesh look muddy. But any positive colour, very light indeed, near flesh which is composed of many broken colours, will make the latter muddy. Ridolfi relates that Titian preferred red

* Hence the purity of white linen is not only unpleasant from its boldness, as Sir Joshua Reynolds remarks, but also because where flesh is truly rendered, it may betray its mixed nature. White, "tinged with the rays of the setting sun," may be as *mixed* a colour as the flesh, only more colourless, it will thus differ in *degree*, not in *kind*, and therefore harmonise.

and blue as grounds to flesh, because, he says, they never injure the colour. A red ground to flesh will exhibit its pearliness and its neutrality, and should therefore be used where the flesh is neutral on the *cool* side—blue or green will best exhibit a flesh when that is neutral in the *warm* key; but the *sort* of red we sometimes see in finely coloured pictures as a ground to flesh supposes a total sacrifice of the flesh as to brightness; or, if its purity be also preserved, it supposes a very high key for the flesh and not so literal an imitation as the Venetians generally adopt. In Bonifazio we have rose-coloured draperies like gems and with bright lights, but the flesh next it no longer pretends to brightness, it is a low, pearly middle tint. In a portrait this would be too great a sacrifice, for the drapery may be said to be principal in such a case.

Again, in Palma Vecchio we have sometimes gem-like lake draperies with bright lights, but the flesh is painted in the purest and highest key, and still has a superior brightness without losing its neutrality. Lastly, in Titian, we have the safer practice of deep, warm lake draperies next to flesh true in tone (neutral in a warm key) which give it brightness by their depth, and pearliness by their redness, and neutrality by their positiveness. Titian seems to have aimed at giving the transparency of flesh, not by surrounding it with muddy colours (because his flesh is itself too mixed and broken) but by colouring it in such a mode as

characterises a transparent body—viz., by making the shadows, at least at their beginning, very warm (the dark shadows will of necessity be warm). If we make the experiment of looking at a coloured drapery—a curtain, for instance—between us and the light, we shall find the colour deepened in the shades instead of becoming weaker, and we shall also observe that the colour of the object is, as it were, multiplied. This rich and pleasing effect is aimed at by all the Venetian painters in their draperies, and by Titian very much in the flesh. To avoid a glassy and unsubstantial appearance this great master used draperies coloured still more in this system, while his flesh, which we know from Boschini,* was composed of the commonest earths, does not appear to have been finally glazed like his draperies with an absolutely transparent colour, but with one composed of semi-transparent washes; thus acquiring a comparative solidity and earthiness compared to lighter substances.

On the other hand a muddy background may be used with effect next to flesh which is remarkable for its positiveness and which abounds in unbroken tints. Such a practice is the reverse of Titian's general method, but the principle of contrast is the same, and beautiful effects have been sometimes thus produced. This method gives flesh *every* agreeable quality and consequently at

* *Carta del Navigar,* v. 5.

the expense of general truth, but in a half figure
with little accompaniment this may be safely done
if we have no means of detecting the artifice.
That flesh should be warm, sufficiently neutral, and
bright, is an object compatible with general imita-
tion, but that it should be more transparent than
any other substance, and lighter than any other
substance, can only happen (to be true) when no
other substances are visible. It follows that in a
head, or (what is called) three quarters, where flesh
is absolutely principal and alone, it may be prin-
cipal in every way without losing its character.
But after all, it must be remembered that Titian
(and Giorgione perhaps) seldom availed themselves
of this artifice, but always aimed at the general and
true character of flesh, whether in a confined or ex-
tended subject.

We have thus considered how *warmth*, compara-
tive *neutrality*, *brightness*, and *transparency*—four
great qualities of flesh—are to be approached. The
imperceptible gradations of its half-lights are best
heightened by visible sharpness upon or near them ;
ornaments, such as black or gold necklaces, or gems,
or dark cutting strings, and similar things, are in-
troduced by the Venetians with the utmost hard-
ness on flesh so softly graduated that we cannot
arrest the division of the half-tints. Lastly, not
only the edges of shadows are soft, but all *shadows*
which are constant and do not express a hollow are
lightened up with reflexions so as to keep the flesh

free from large portions of darkness,* and hence the darks of the features and leading points tell with double meaning and vivacity.

Of all these qualities that which admits of the greater *variety of scale* is the quality of brightness. Flesh may be made much whiter than it is and yet appear true if we have no white or any superior brightness near it. Where gems, gold, or silver are introduced the true scale of nature can only be given by painting flesh as low as it is. It is remarkable that Titian did this, and yet disdained to use the brightness in his power by making gems and metal sparkle. His flesh probably was always lower than nature, and richer and warmer, so that had he chosen to give the brightness of gems he might have done so, but we remark in his female portraits that he dwells rather on the colour than on the polish of gold—he dwells on its reflexions where its own colour is multiplied and enriched— but not on the direct shine of the light which naturally destroys the colour of the object. The same may be observed in his mode of painting the eye, the sparkle of white, powerful as it is in giving speculation to the eye, is not to the taste of a colourist; the liquid appearance of the eye partakes of and enriches its colour and transparency, but the direct light robs it of its colour, and, if a

* That is to say, the general idea of the colour should be preserved unimpaired by light and shade, as far as is compatible with truth.

considerable touch, produces undue and inharmonious contrasts. These direct touches of light are greatly suppressed in Titian when they come on the dark of the eye. But his method is quite different when large masses of polished substance are to be treated. The colour of the object is here nothing, its character is to *reflect*, and it reflects all things. The beaming look of armour opposed to flesh, *in which all polish is carefully suppressed*, gives great beauty to both. A polish on flesh is to be suppressed generally, as the light would differ from the colour, but more especially when metals, silks, or any glossy things are near.

ON SUBJECTS FOR PAINTING.

It is a common error with unpractised artists, especially if their minds are cultivated, to consider those subjects fittest for painting which excite the most important historical recollections, and in which the actors are interesting, at least from their names. The real interest of such pictures would be best tried by submitting them to spectators ignorant of the persons represented (as most spectators probably would be unless their names were written under the figures). In description it is of the first consequence that the actors, whatever they are doing, should be morally interesting. It is not *what* they are doing but *who* are doing which is the great source of interest ; for no one act, not

even the greatest in a man's life, is equivalent to
the impression produced by the sum of his acts
and the world's opinion—in short, by his *fame*—
which makes the individual interesting *whatever* he
may be doing. In painting, on the contrary, it is
not who is doing but what is being done, as pre-
sented to our sight, which is the first as well as
the last and longest source of interest. Great, or
well-known names, in addition to this *sine quâ non*,
undoubtedly add to the effect.

There are many persons so unconscious of the
difference between the best and the worst pictures
that to them the association is all in all; this exists
with all spectators more or less, and is only in
danger of being totally unfelt by that class of
artists who make the impression on the eye alone
the only rule for choice of subject, composition,
costume, &c. When once this becomes the sole
guide (and it is admitted in all cases to be a very
principal one), no absurdities in a moral, historical,
or chronological point of view check the artist.
His object (he says) is to produce a powerful and
pleasing impression on the sense, and he not un-
justly argues that those who criticise him for errors
in costume, or for liberties taken with his subject,
would have the right to find still greater fault with
him if he produced an insipid picture. He works
with his own materials, as the writer does with his,
and the art of representation can only pretend to
independence and, in short, to *style* when its prin-

ciples and practice are regulated by its proper and
distinct end. This view which contains much
truth, but which easily admits of exaggeration,
explains the extraordinary liberties which artists
took at a time when the *art* was in its most perfect
development. These licenses form a singular con-
trast with the fidelity to costume and the insipid
propriety of modern pictures. A very little re-
flexion is sufficient to convince us that the master-
works of art would never have received the sanction
of universal and enduring approbation but for the
truest and the largest reasons—that the world's
approbation has been given them because they
unite as much of the end of art with as much of
the means as is compatible, and that the defects
above alluded to may often be necessary to, and
even the chief cause of their excellence.

A habit of contemplating works of art merely
with reference to those qualities which are common
to description and general learning is the cause of
the quantity of false criticism which has so often
fallen from the pens of cultivated men. Nothing
in short is easier than to find the greatest defects
as to history, situation &c. in the finest works, and
nothing can be a greater mistake (in most cases,
we do not say in all) than to suppose that the
remedying of these defects would improve the *work
of art*. Let the Laocoon be clothed (as he should
be) in his sacerdotal robes, and the coldest of these
critics would acknowledge that no drapery nor

ornament, especially in the monotony of marble, would be so beautiful or so impressive as his fine and convulsed form. Here then is an instance of the translation which is necessary when a subject is changed from one language to another—from description to representation. The first object of the artist who works in marble is to overcome its *lifelessness,* and no representation of drapery or any inanimate substance as a principal object ever does this. Drapery was therefore treated generally as an accessory by the ancient sculptors, and, when entire figures were clothed, as the marble could not be turned into a surface of animated life, its hardness and rigidity were converted, in the form of drapery, into an illusion of softness and flexibility; but such qualities were inferior to the expression of voluntary action, in short, of life, and, above all, of human life.

In painting too, nothing is so beautiful as the colour of the flesh, and we must not be surprised to find that the greatest colourists not only sought every opportunity of unclothing their figures but introduced all sorts of contrasts near them, whether warranted or not, in order to give them value. Michael Angelo's love of nude figures was of another, perhaps of a higher kind; he aimed at expressing grand ideas of nature, and with the feeling of a sculptor he disdained to waste his powers in painting cloth instead of human forms. The excesses to which Michael Angelo and the

colourists carried this feeling, though for different reasons, are well known. Raphael, with the highest forms, was fortunate in having no particular passion either for colour, or for anatomy, and was therefore enabled to unite more of general propriety with the claims of art than any other painter. But let it not be supposed that even he will stand the test of the false criticism above alluded to. No painter is fuller of anachronisms. Like all the other great artists, he aims at satisfying the feelings and the eye, but not the *learning* of the spectator. Lastly, even Poussin—the classic, correct, and pure—is full of errors in costume, while he gives a general impression of the chaste and simple principles of composition so admired in the ancients.

But if errors to this extent are to be found in the purest schools and examples what shall we say of those artists who confined themselves entirely to the ends of the art, and how can we account for the admiration bestowed upon them? Many of the mere colourists may be censured for having occupied themselves with an important part of the style, but not with the whole of the style of their art. Rembrandt, for instance, in compositions which did not require beauty, may be said to have attained perfection by satisfying the eye and the imagination and deeply interesting the feelings, and yet with every conceivable error of costume. The colourists of the Venetian school (always excepting Titian) atone for the want of interest often visible in their

works, by a certain refinement of elegance which we always associate with splendour of colour, and which, in Paul Veronese, is often accompanied with a vivacity in the air and attitude, which although soon tiring, is addressed to the imagination and allied to ideas of beauty. Rubens, again, has not even this quality; he seldom approaches the idea of beauty in his forms or attitudes, yet he is always great in the particular beauty (that of colour) which constitutes the essence of painting, and every part of his works is evidence of his deep feeling for all that constitutes the style of this art as distinguished from any other.

When intelligent spectators (who have not paid particular attention to art) are sincere in their opinions on such works, they judge them merely as expressive of a subject, and fasten immediately on anything that shocks their notions of propriety as to invention, costume, &c. Those again who are less severe endeavour to make up the sum of praise, which they know it is usual to bestow, by supposing excellences which come within their sphere of comprehension. It is to be lamented that sensible men should think it necessary on these occasions to assume a virtue which they have not. Dr. Beattie, after sitting to Reynolds, declares that, whatever might be thought of his colouring, he was a great designer. This was altogether affectation, because he could judge as little of the one as of the other; but it is not uncommon for intelligent people to

praise a picture for that which it has not, merely because they know that something ought to be praised.

It is an undeniable fact that there are certain requisites in a work of art which are more necessary than any others. *That which addresses the sense must delight the sense before it can reach the mind.* Again, there is a difference in the interest of objects, and another difference in their sort of interest. It may be assumed first, that nothing is so interesting to human beings as human beings; and secondly, that the exhibition of female beauty will always first attract the eye. But although interest in the object and beauty in colouring may be thus secured, a picture may still need some moral interest—that is, the feelings must be interested—and, lastly, the intellect may be addressed by as much attention to costume or history as can be kept subordinate to more proper claims.

MEANS AND END OF ART.

[Fragment from a Journal Book of 1828.]

ONE thing is certain, that whatever the *end* of art may be, whatever feelings in men it may address, its *means* must be ever the same. These are not measured by the temper of society in any age, but by the nature of the art itself, which is immutable. If it is not *itself* it will be surpassed by something else, either by Sculpture or by Poetry. There

can be no question or no difficulty in settling the
question as to what the strength and character and
beauty of painting consist in—as a means. But
what end these means shall serve,—in short what
feeling in man should be addressed, is the question.
It would at first appear that as the senses must
necessarily be addressed and pleased, some feeling
connected with the mere enjoyment of nature
ought to constitute the strongest impression made
by the arts. This would, however, at once involve
the necessity (in theory) of suppressing them al-
together. It is evident, therefore, that they can
be only fitted for the refined enjoyment of human
beings when they correct the indispensable appeal
to the senses by a pure moral impression.

This is almost what the Memlings and Van
Eycks do; their notion of colour is of the largest
kind (making some allowance for the general in-
fancy of art), the true character of things is every-
where expressed (black is never lighted—flesh is
always transparent—white is always brilliant), and
while the sense is charmed with this large and
true view of nature, which might give tenfold in-
terest to a subject of more beauty, the end all this
serves is of the most solemn, pure, innocent and
noble kind. The beauties of nature and all the
pleasures of sense may be presented in the same
way, for we know it is quite possible for human
beings to love Nature in her most attractive forms,
without sensual associations, and if it were not so,

our reason would be useless to us. By attractive forms are not meant voluptuous ones, for these are in their nature unfit for imitation; but there is no more reason why a pure subject should not be connected with the whole attractions of art in colour, &c., than that the beauties of nature should not be compatible with an innocent feeling. It is the privilege of reasonable beings to unite the two: united they must ever be, more or less, for the attempt to suppress the attractions of sense in life, is only as absurd as to attempt to reject colour from Painting. It comes then to this that, as the method or language of Painting is one, immutable, and indispensable, the great object is to take care that the *end* be noble, human, refined; for the means will take care of themselves. The end is defined by the nature of the feelings excited, and no matter what the subject is (if always sufficiently beautiful to the eye) so long as the feelings excited are noble and elevated. If they excite human sympathy in its pleasing degrees, all that is permanently graceful or refined, all that is rational and intellectual in joy, and all that is dignified in sorrow—all in short that is human and religious—the end of art may be safely said to be accomplished in any age, for the human and Christian character is as certain in its definition as the character of the art. It appears then that the *means* are determined by examining the nature of the art itself,—as it were blindly, impli-

citly, with a docile and passive spirit of enquiry—
independently of any other consideration, and from
this determination there is no appeal. The *end*, on
the other hand, is measured by the general feeling in
the human spectator to be addressed, and as the
senses *must* be sensual, the end cannot be too high
and pure, provided it be within our sympathies, and
sufficiently analogous to human sensibilities. This
is using the imitation of nature as wise men tell us
to use nature itself—viz., in subordination to our
immortal and *not natural* being. The union of the
two in Painting is extremely pleasing, because the
very means by which the sense is delighted (as is
elsewhere shown) make the ruling impression more
strong. The more perfect the appeal to the sense
in the *means*, the more impressive will be the *end*.
The Greeks seem to have contented themselves
with clearly defining the nature of the means, and
the means and end were one with them. Nature
only existed to be enjoyed; there was no moral
monitor to check the indulgence of what nature
offered; but let it not be supposed that their art is
therefore more consistent and perfect; it was more
easily *made* consistent, it is true, with the then ex-
isting state of things. Still, there is no more im-
possibility, as before said, in uniting a pure end
with the indispensable means of art, than there
is for a man to live for the health of body and
mind, and not for his appetites: and, moreover, if
accomplished, such a style of art would be more

strictly human and characteristic of our nature,—
more fitted for beings made of body and soul to-
gether. If brutes could draw and model they
would minister to earthly objects only; but beings
who confess immortal aspirations must distinguish
even their abstract ideas of Nature from such
as mere mortals would arrive at. The Greeks
defined the object of the hopes of mere mortals to
consist in the enjoyment of nature—they defined
them consistently, accurately, perfectly, as ad-
dressed to the senses and the imagination. They
defined too the feelings of the natural man to which
their works were addressed—his pride, his dignity,
his courage, his love, his taste—but his soul-felt
trust, his peace, his faith, his humility, his contri-
tion, they could not address, because they knew
them not. They could represent the joys of
nature, and the feelings of the natural man har-
monized then with those joys as they do now: but
evil in any shape was without solace to them:
without resignation, without comprehension, with-
out submission, the exhibition of evil in art appeals
to human sympathies as if there were none else to
help. Thus evil or pain if represented in antique
sculpture either underwent modifications suited to
the art, or was a means only to exhibit the
human form in finer action.

INDEX.

THE END.

A CATALOG OF SELECTED
DOVER BOOKS
IN ALL FIELDS OF INTEREST

A CATALOG OF SELECTED DOVER
BOOKS IN ALL FIELDS OF INTEREST

CONCERNING THE SPIRITUAL IN ART, Wassily Kandinsky. Pioneering work by father of abstract art. Thoughts on color theory, nature of art. Analysis of earlier masters. 12 illustrations. 80pp. of text. 5⅜ x 8½. 23411-8 Pa. $4.95

ANIMALS: 1,419 Copyright-Free Illustrations of Mammals, Birds, Fish, Insects, etc., Jim Harter (ed.). Clear wood engravings present, in extremely lifelike poses, over 1,000 species of animals. One of the most extensive pictorial sourcebooks of its kind. Captions. Index. 284pp. 9 x 12. 23766-4 Pa. $14.95

CELTIC ART: The Methods of Construction, George Bain. Simple geometric techniques for making Celtic interlacements, spirals, Kells-type initials, animals, humans, etc. Over 500 illustrations. 160pp. 9 x 12. (Available in U.S. only.) 22923-8 Pa. $9.95

AN ATLAS OF ANATOMY FOR ARTISTS, Fritz Schider. Most thorough reference work on art anatomy in the world. Hundreds of illustrations, including selections from works by Vesalius, Leonardo, Goya, Ingres, Michelangelo, others. 593 illustrations. 192pp. 7⅛ x 10¼. 20241-0 Pa. $9.95

CELTIC HAND STROKE-BY-STROKE (Irish Half-Uncial from "The Book of Kells"): An Arthur Baker Calligraphy Manual, Arthur Baker. Complete guide to creating each letter of the alphabet in distinctive Celtic manner. Covers hand position, strokes, pens, inks, paper, more. Illustrated. 48pp. 8¼ x 11. 24336-2 Pa. $3.95

EASY ORIGAMI, John Montroll. Charming collection of 32 projects (hat, cup, pelican, piano, swan, many more) specially designed for the novice origami hobbyist. Clearly illustrated easy-to-follow instructions insure that even beginning papercrafters will achieve successful results. 48pp. 8¼ x 11. 27298-2 Pa. $3.50

THE COMPLETE BOOK OF BIRDHOUSE CONSTRUCTION FOR WOOD-WORKERS, Scott D. Campbell. Detailed instructions, illustrations, tables. Also data on bird habitat and instinct patterns. Bibliography. 3 tables. 63 illustrations in 15 figures. 48pp. 5¼ x 8½. 24407-5 Pa. $2.50

BLOOMINGDALE'S ILLUSTRATED 1886 CATALOG: Fashions, Dry Goods and Housewares, Bloomingdale Brothers. Famed merchants' extremely rare catalog depicting about 1,700 products: clothing, housewares, firearms, dry goods, jewelry, more. Invaluable for dating, identifying vintage items. Also, copyright-free graphics for artists, designers. Co-published with Henry Ford Museum & Greenfield Village. 160pp. 8¼ x 11. 25780-0 Pa. $10.95

HISTORIC COSTUME IN PICTURES, Braun & Schneider. Over 1,450 costumed figures in clearly detailed engravings–from dawn of civilization to end of 19th century. Captions. Many folk costumes. 256pp. 8⅜ x 11¾. 23150-X Pa. $12.95

STICKLEY CRAFTSMAN FURNITURE CATALOGS, Gustav Stickley and L. & J. G. Stickley. Beautiful, functional furniture in two authentic catalogs from 1910. 594 illustrations, including 277 photos, show settles, rockers, armchairs, reclining chairs, bookcases, desks, tables. 183pp. 6½ x 9¼. 23838-5 Pa. $11.95

AMERICAN LOCOMOTIVES IN HISTORIC PHOTOGRAPHS: 1858 to 1949, Ron Ziel (ed.). A rare collection of 126 meticulously detailed official photographs, called "builder portraits," of American locomotives that majestically chronicle the rise of steam locomotive power in America. Introduction. Detailed captions. xi+ 129pp. 9 x 12. 27393-8 Pa. $13.95

AMERICA'S LIGHTHOUSES: An Illustrated History, Francis Ross Holland, Jr. Delightfully written, profusely illustrated fact-filled survey of over 200 American lighthouses since 1716. History, anecdotes, technological advances, more. 240pp. 8 x 10¾.
25576-X Pa. $12.95

TOWARDS A NEW ARCHITECTURE, Le Corbusier. Pioneering manifesto by founder of "International School." Technical and aesthetic theories, views of industry, economics, relation of form to function, "mass-production split" and much more. Profusely illustrated. 320pp. 6⅛ x 9¼. (Available in U.S. only.) 25023-7 Pa. $10.95

HOW THE OTHER HALF LIVES, Jacob Riis. Famous journalistic record, exposing poverty and degradation of New York slums around 1900, by major social reformer. 100 striking and influential photographs. 233pp. 10 x 7⅞.
22012-5 Pa. $11.95

FRUIT KEY AND TWIG KEY TO TREES AND SHRUBS, William M. Harlow. One of the handiest and most widely used identification aids. Fruit key covers 120 deciduous and evergreen species; twig key 160 deciduous species. Easily used. Over 300 photographs. 126pp. 5⅜ x 8½. 20511-8 Pa. $3.95

COMMON BIRD SONGS, Dr. Donald J. Borror. Songs of 60 most common U.S. birds: robins, sparrows, cardinals, bluejays, finches, more–arranged in order of increasing complexity. Up to 9 variations of songs of each species.
Cassette and manual 99911-4 $8.95

ORCHIDS AS HOUSE PLANTS, Rebecca Tyson Northen. Grow cattleyas and many other kinds of orchids–in a window, in a case, or under artificial light. 63 illustrations. 148pp. 5⅜ x 8½. 23261-1 Pa. $7.95

MONSTER MAZES, Dave Phillips. Masterful mazes at four levels of difficulty. Avoid deadly perils and evil creatures to find magical treasures. Solutions for all 32 exciting illustrated puzzles. 48pp. 8¼ x 11. 26005-4 Pa. $2.95

MOZART'S DON GIOVANNI (DOVER OPERA LIBRETTO SERIES), Wolfgang Amadeus Mozart. Introduced and translated by Ellen H. Bleiler. Standard Italian libretto, with complete English translation. Convenient and thoroughly portable–an ideal companion for reading along with a recording or the performance itself. Introduction. List of characters. Plot summary. 121pp. 5¼ x 8½.
24944-1 Pa. $3.95

TECHNICAL MANUAL AND DICTIONARY OF CLASSICAL BALLET, Gail Grant. Defines, explains, comments on steps, movements, poses and concepts. 15-page pictorial section. Basic book for student, viewer. 127pp. 5⅜ x 8½.
21843-0 Pa. $4.95

THE CLARINET AND CLARINET PLAYING, David Pino. Lively, comprehensive work features suggestions about technique, musicianship, and musical interpretation, as well as guidelines for teaching, making your own reeds, and preparing for public performance. Includes an intriguing look at clarinet history. "A godsend," *The Clarinet,* Journal of the International Clarinet Society. Appendixes. 7 illus. 320pp. 5⅜ x 8½. 40270-3 Pa. $9.95

HOLLYWOOD GLAMOR PORTRAITS, John Kobal (ed.). 145 photos from 1926-49. Harlow, Gable, Bogart, Bacall; 94 stars in all. Full background on photographers, technical aspects. 160pp. 8⅜ x 11¼. 23352-9 Pa. $12.95

THE ANNOTATED CASEY AT THE BAT: A Collection of Ballads about the Mighty Casey/Third, Revised Edition, Martin Gardner (ed.). Amusing sequels and parodies of one of America's best-loved poems: Casey's Revenge, Why Casey Whiffed, Casey's Sister at the Bat, others. 256pp. 5⅜ x 8½. 28598-7 Pa. $8.95

THE RAVEN AND OTHER FAVORITE POEMS, Edgar Allan Poe. Over 40 of the author's most memorable poems: "The Bells," "Ulalume," "Israfel," "To Helen," "The Conqueror Worm," "Eldorado," "Annabel Lee," many more. Alphabetic lists of titles and first lines. 64pp. 5⁵⁄₁₆ x 8¼. 26685-0 Pa. $1.00

PERSONAL MEMOIRS OF U. S. GRANT, Ulysses Simpson Grant. Intelligent, deeply moving firsthand account of Civil War campaigns, considered by many the finest military memoirs ever written. Includes letters, historic photographs, maps and more. 528pp. 6⅛ x 9¼. 28587-1 Pa. $12.95

ANCIENT EGYPTIAN MATERIALS AND INDUSTRIES, A. Lucas and J. Harris. Fascinating, comprehensive, thoroughly documented text describes this ancient civilization's vast resources and the processes that incorporated them in daily life, including the use of animal products, building materials, cosmetics, perfumes and incense, fibers, glazed ware, glass and its manufacture, materials used in the mummification process, and much more. 544pp. 6⅛ x 9¼. (Available in U.S. only.) 40446-3 Pa. $16.95

RUSSIAN STORIES/PYCCKNE PACCKA3bl: A Dual-Language Book, edited by Gleb Struve. Twelve tales by such masters as Chekhov, Tolstoy, Dostoevsky, Pushkin, others. Excellent word-for-word English translations on facing pages, plus teaching and study aids, Russian/English vocabulary, biographical/critical introductions, more. 416pp. 5⅜ x 8½. 26244-8 Pa. $9.95

PHILADELPHIA THEN AND NOW: 60 Sites Photographed in the Past and Present, Kenneth Finkel and Susan Oyama. Rare photographs of City Hall, Logan Square, Independence Hall, Betsy Ross House, other landmarks juxtaposed with contemporary views. Captures changing face of historic city. Introduction. Captions. 128pp. 8¼ x 11. 25790-8 Pa. $9.95

AIA ARCHITECTURAL GUIDE TO NASSAU AND SUFFOLK COUNTIES, LONG ISLAND, The American Institute of Architects, Long Island Chapter, and the Society for the Preservation of Long Island Antiquities. Comprehensive, well-researched and generously illustrated volume brings to life over three centuries of Long Island's great architectural heritage. More than 240 photographs with authoritative, extensively detailed captions. 176pp. 8¼ x 11. 26946-9 Pa. $14.95

NORTH AMERICAN INDIAN LIFE: Customs and Traditions of 23 Tribes, Elsie Clews Parsons (ed.). 27 fictionalized essays by noted anthropologists examine religion, customs, government, additional facets of life among the Winnebago, Crow, Zuni, Eskimo, other tribes. 480pp. 6⅛ x 9¼. 27377-6 Pa. $10.95

FRANK LLOYD WRIGHT'S DANA HOUSE, Donald Hoffmann. Pictorial essay of residential masterpiece with over 160 interior and exterior photos, plans, elevations, sketches and studies. 128pp. 9¼ x 10¾. 29120-0 Pa. $14.95

THE MALE AND FEMALE FIGURE IN MOTION: 60 Classic Photographic Sequences, Eadweard Muybridge. 60 true-action photographs of men and women walking, running, climbing, bending, turning, etc., reproduced from rare 19th-century masterpiece. vi + 121pp. 9 x 12. 24745-7 Pa. $12.95

1001 QUESTIONS ANSWERED ABOUT THE SEASHORE, N. J. Berrill and Jacquelyn Berrill. Queries answered about dolphins, sea snails, sponges, starfish, fishes, shore birds, many others. Covers appearance, breeding, growth, feeding, much more. 305pp. 5¼ x 8¼. 23366-9 Pa. $9.95

ATTRACTING BIRDS TO YOUR YARD, William J. Weber. Easy-to-follow guide offers advice on how to attract the greatest diversity of birds: birdhouses, feeders, water and waterers, much more. 96pp. 5³⁄₁₆ x 8¼. 28927-3 Pa. $2.50

MEDICINAL AND OTHER USES OF NORTH AMERICAN PLANTS: A Historical Survey with Special Reference to the Eastern Indian Tribes, Charlotte Erichsen-Brown. Chronological historical citations document 500 years of usage of plants, trees, shrubs native to eastern Canada, northeastern U.S. Also complete identifying information. 343 illustrations. 544pp. 6½ x 9¼. 25951-X Pa. $12.95

STORYBOOK MAZES, Dave Phillips. 23 stories and mazes on two-page spreads: Wizard of Oz, Treasure Island, Robin Hood, etc. Solutions. 64pp. 8¼ x 11. 23628-5 Pa. $2.95

AMERICAN NEGRO SONGS: 230 Folk Songs and Spirituals, Religious and Secular, John W. Work. This authoritative study traces the African influences of songs sung and played by black Americans at work, in church, and as entertainment. The author discusses the lyric significance of such songs as "Swing Low, Sweet Chariot," "John Henry," and others and offers the words and music for 230 songs. Bibliography. Index of Song Titles. 272pp. 6½ x 9¼. 40271-1 Pa. $9.95

MOVIE-STAR PORTRAITS OF THE FORTIES, John Kobal (ed.). 163 glamor, studio photos of 106 stars of the 1940s: Rita Hayworth, Ava Gardner, Marlon Brando, Clark Gable, many more. 176pp. 8⅜ x 11¼. 23546-7 Pa. $14.95

BENCHLEY LOST AND FOUND, Robert Benchley. Finest humor from early 30s, about pet peeves, child psychologists, post office and others. Mostly unavailable elsewhere. 73 illustrations by Peter Arno and others. 183pp. 5⅜ x 8½. 22410-4 Pa. $6.95

YEKL and THE IMPORTED BRIDEGROOM AND OTHER STORIES OF YIDDISH NEW YORK, Abraham Cahan. Film Hester Street based on *Yekl* (1896). Novel, other stories among first about Jewish immigrants on N.Y.'s East Side. 240pp. 5⅜ x 8½. 22427-9 Pa. $7.95

SELECTED POEMS, Walt Whitman. Generous sampling from *Leaves of Grass.* Twenty-four poems include "I Hear America Singing," "Song of the Open Road," "I Sing the Body Electric," "When Lilacs Last in the Dooryard Bloom'd," "O Captain! My Captain!"–all reprinted from an authoritative edition. Lists of titles and first lines. 128pp. 5³⁄₁₆ x 8¼. 26878-0 Pa. $1.00

THE BEST TALES OF HOFFMANN, E. T. A. Hoffmann. 10 of Hoffmann's most important stories: "Nutcracker and the King of Mice," "The Golden Flowerpot," etc. 458pp. 5⅜ x 8½. 21793-0 Pa. $9.95

FROM FETISH TO GOD IN ANCIENT EGYPT, E. A. Wallis Budge. Rich detailed survey of Egyptian conception of "God" and gods, magic, cult of animals, Osiris, more. Also, superb English translations of hymns and legends. 240 illustrations. 545pp. 5⅜ x 8½. 25803-3 Pa. $13.95

FRENCH STORIES/CONTES FRANÇAIS: A Dual-Language Book, Wallace Fowlie. Ten stories by French masters, Voltaire to Camus: "Micromegas" by Voltaire; "The Atheist's Mass" by Balzac; "Minuet" by de Maupassant; "The Guest" by Camus, six more. Excellent English translations on facing pages. Also French-English vocabulary list, exercises, more. 352pp. 5⅜ x 8½. 26443-2 Pa. $9.95

CHICAGO AT THE TURN OF THE CENTURY IN PHOTOGRAPHS: 122 Historic Views from the Collections of the Chicago Historical Society, Larry A. Viskochil. Rare large-format prints offer detailed views of City Hall, State Street, the Loop, Hull House, Union Station, many other landmarks, circa 1904-1913. Introduction. Captions. Maps. 144pp. 9⅜ x 12¼. 24656-6 Pa. $12.95

OLD BROOKLYN IN EARLY PHOTOGRAPHS, 1865-1929, William Lee Younger. Luna Park, Gravesend race track, construction of Grand Army Plaza, moving of Hotel Brighton, etc. 157 previously unpublished photographs. 165pp. 8⅞ x 11¾.
23587-4 Pa. $13.95

THE MYTHS OF THE NORTH AMERICAN INDIANS, Lewis Spence. Rich anthology of the myths and legends of the Algonquins, Iroquois, Pawnees and Sioux, prefaced by an extensive historical and ethnological commentary. 36 illustrations. 480pp. 5⅜ x 8½. 25967-6 Pa. $10.95

AN ENCYCLOPEDIA OF BATTLES: Accounts of Over 1,560 Battles from 1479 B.C. to the Present, David Eggenberger. Essential details of every major battle in recorded history from the first battle of Megiddo in 1479 B.C. to Grenada in 1984. List of Battle Maps. New Appendix covering the years 1967-1984. Index. 99 illustrations. 544pp. 6½ x 9¼. 24913-1 Pa. $16.95

SAILING ALONE AROUND THE WORLD, Captain Joshua Slocum. First man to sail around the world, alone, in small boat. One of great feats of seamanship told in delightful manner. 67 illustrations. 294pp. 5⅜ x 8½. 20326-3 Pa. $6.95

ANARCHISM AND OTHER ESSAYS, Emma Goldman. Powerful, penetrating, prophetic essays on direct action, role of minorities, prison reform, puritan hypocrisy, violence, etc. 271pp. 5⅜ x 8½. 22484-8 Pa. $8.95

MYTHS OF THE HINDUS AND BUDDHISTS, Ananda K. Coomaraswamy and Sister Nivedita. Great stories of the epics; deeds of Krishna, Shiva, taken from puranas, Vedas, folk tales; etc. 32 illustrations. 400pp. 5⅜ x 8½. 21759-0 Pa. $12.95

THE TRAUMA OF BIRTH, Otto Rank. Rank's controversial thesis that anxiety neurosis is caused by profound psychological trauma which occurs at birth. 256pp. 5⅜ x 8½. 27974-X Pa. $7.95

A THEOLOGICO-POLITICAL TREATISE, Benedict Spinoza. Also contains unfinished Political Treatise. Great classic on religious liberty, theory of government on common consent. R. Elwes translation. Total of 421pp. 5⅜ x 8½. 20249-6 Pa. $10.95

MY BONDAGE AND MY FREEDOM, Frederick Douglass. Born a slave, Douglass became outspoken force in antislavery movement. The best of Douglass' autobiographies. Graphic description of slave life. 464pp. 5⅜ x 8½. 22457-0 Pa. $8.95

FOLLOWING THE EQUATOR: A Journey Around the World, Mark Twain. Fascinating humorous account of 1897 voyage to Hawaii, Australia, India, New Zealand, etc. Ironic, bemused reports on peoples, customs, climate, flora and fauna, politics, much more. 197 illustrations. 720pp. 5⅜ x 8½. 26113-1 Pa. $15.95

THE PEOPLE CALLED SHAKERS, Edward D. Andrews. Definitive study of Shakers: origins, beliefs, practices, dances, social organization, furniture and crafts, etc. 33 illustrations. 351pp. 5⅜ x 8½. 21081-2 Pa. $12.95

THE MYTHS OF GREECE AND ROME, H. A. Guerber. A classic of mythology, generously illustrated, long prized for its simple, graphic, accurate retelling of the principal myths of Greece and Rome, and for its commentary on their origins and significance. With 64 illustrations by Michelangelo, Raphael, Titian, Rubens, Canova, Bernini and others. 480pp. 5⅜ x 8½. 27584-1 Pa. $10.95

PSYCHOLOGY OF MUSIC, Carl E. Seashore. Classic work discusses music as a medium from psychological viewpoint. Clear treatment of physical acoustics, auditory apparatus, sound perception, development of musical skills, nature of musical feeling, host of other topics. 88 figures. 408pp. 5⅜ x 8½. 21851-1 Pa. $11.95

THE PHILOSOPHY OF HISTORY, Georg W. Hegel. Great classic of Western thought develops concept that history is not chance but rational process, the evolution of freedom. 457pp. 5⅜ x 8½. 20112-0 Pa. $9.95

THE BOOK OF TEA, Kakuzo Okakura. Minor classic of the Orient: entertaining, charming explanation, interpretation of traditional Japanese culture in terms of tea ceremony. 94pp. 5⅜ x 8½. 20070-1 Pa. $3.95

LIFE IN ANCIENT EGYPT, Adolf Erman. Fullest, most thorough, detailed older account with much not in more recent books, domestic life, religion, magic, medicine, commerce, much more. Many illustrations reproduce tomb paintings, carvings, hieroglyphs, etc. 597pp. 5⅜ x 8½. 22632-8 Pa. $12.95

SUNDIALS, Their Theory and Construction, Albert Waugh. Far and away the best, most thorough coverage of ideas, mathematics concerned, types, construction, adjusting anywhere. Simple, nontechnical treatment allows even children to build several of these dials. Over 100 illustrations. 230pp. 5⅜ x 8½. 22947-5 Pa. $8.95

THEORETICAL HYDRODYNAMICS, L. M. Milne-Thomson. Classic exposition of the mathematical theory of fluid motion, applicable to both hydrodynamics and aerodynamics. Over 600 exercises. 768pp. 6⅛ x 9¼. 68970-0 Pa. $20.95

SONGS OF EXPERIENCE: Facsimile Reproduction with 26 Plates in Full Color, William Blake. 26 full-color plates from a rare 1826 edition. Includes "TheTyger," "London," "Holy Thursday," and other poems. Printed text of poems. 48pp. 5¼ x 7.
24636-1 Pa. $4.95

OLD-TIME VIGNETTES IN FULL COLOR, Carol Belanger Grafton (ed.). Over 390 charming, often sentimental illustrations, selected from archives of Victorian graphics—pretty women posing, children playing, food, flowers, kittens and puppies, smiling cherubs, birds and butterflies, much more. All copyright-free. 48pp. 9¼ x 12¼.
27269-9 Pa. $7.95

PERSPECTIVE FOR ARTISTS, Rex Vicat Cole. Depth, perspective of sky and sea, shadows, much more, not usually covered. 391 diagrams, 81 reproductions of drawings and paintings. 279pp. 5⅛ x 8½. 22487-2 Pa. $9.95

DRAWING THE LIVING FIGURE, Joseph Sheppard. Innovative approach to artistic anatomy focuses on specifics of surface anatomy, rather than muscles and bones. Over 170 drawings of live models in front, back and side views, and in widely varying poses. Accompanying diagrams. 177 illustrations. Introduction. Index. 144pp. 8⅜ x11¼. 26723-7 Pa. $9.95

GOTHIC AND OLD ENGLISH ALPHABETS: 100 Complete Fonts, Dan X. Solo. Add power, elegance to posters, signs, other graphics with 100 stunning copyright-free alphabets: Blackstone, Dolbey, Germania, 97 more—including many lower-case, numerals, punctuation marks. 104pp. 8⅛ x 11. 24695-7 Pa. $9.95

HOW TO DO BEADWORK, Mary White. Fundamental book on craft from simple projects to five-bead chains and woven works. 106 illustrations. 142pp. 5⅜ x 8. 20697-1 Pa. $5.95

THE BOOK OF WOOD CARVING, Charles Marshall Sayers. Finest book for beginners discusses fundamentals and offers 34 designs. "Absolutely first rate . . . well thought out and well executed."–E. J. Tangerman. 118pp. 7¾ x 10⅜. 23654-4 Pa. $7.95

ILLUSTRATED CATALOG OF CIVIL WAR MILITARY GOODS: Union Army Weapons, Insignia, Uniform Accessories, and Other Equipment, Schuyler, Hartley, and Graham. Rare, profusely illustrated 1846 catalog includes Union Army uniform and dress regulations, arms and ammunition, coats, insignia, flags, swords, rifles, etc. 226 illustrations. 160pp. 9 x 12. 24939-5 Pa. $12.95

WOMEN'S FASHIONS OF THE EARLY 1900s: An Unabridged Republication of "New York Fashions, 1909," National Cloak & Suit Co. Rare catalog of mail-order fashions documents women's and children's clothing styles shortly after the turn of the century. Captions offer full descriptions, prices. Invaluable resource for fashion, costume historians. Approximately 725 illustrations. 128pp. 8⅜ x 11¼. 27276-1 Pa. $12.95

THE 1912 AND 1915 GUSTAV STICKLEY FURNITURE CATALOGS, Gustav Stickley. With over 200 detailed illustrations and descriptions, these two catalogs are essential reading and reference materials and identification guides for Stickley furniture. Captions cite materials, dimensions and prices. 112pp. 6½ x 9¼. 26676-1 Pa. $9.95

EARLY AMERICAN LOCOMOTIVES, John H. White, Jr. Finest locomotive engravings from early 19th century: historical (1804–74), main-line (after 1870), special, foreign, etc. 147 plates. 142pp. 11⅜ x 8¼. 22772-3 Pa. $12.95

THE TALL SHIPS OF TODAY IN PHOTOGRAPHS, Frank O. Braynard. Lavishly illustrated tribute to nearly 100 majestic contemporary sailing vessels: Amerigo Vespucci, Clearwater, Constitution, Eagle, Mayflower, Sea Cloud, Victory, many more. Authoritative captions provide statistics, background on each ship. 190 black-and-white photographs and illustrations. Introduction. 128pp. 8⅞ x 11¾. 27163-3 Pa. $14.95

LITTLE BOOK OF EARLY AMERICAN CRAFTS AND TRADES, Peter Stockham (ed.). 1807 children's book explains crafts and trades: baker, hatter, cooper, potter, and many others. 23 copperplate illustrations. 140pp. 4⅝ x 6.
23336-7 Pa. $4.95

VICTORIAN FASHIONS AND COSTUMES FROM HARPER'S BAZAR, 1867–1898, Stella Blum (ed.). Day costumes, evening wear, sports clothes, shoes, hats, other accessories in over 1,000 detailed engravings. 320pp. 9⅜ x 12¼.
22990-4 Pa. $16.95

GUSTAV STICKLEY, THE CRAFTSMAN, Mary Ann Smith. Superb study surveys broad scope of Stickley's achievement, especially in architecture. Design philosophy, rise and fall of the Craftsman empire, descriptions and floor plans for many Craftsman houses, more. 86 black-and-white halftones. 31 line illustrations. Introduction 208pp. 6½ x 9¼.
27210-9 Pa. $9.95

THE LONG ISLAND RAIL ROAD IN EARLY PHOTOGRAPHS, Ron Ziel. Over 220 rare photos, informative text document origin (1844) and development of rail service on Long Island. Vintage views of early trains, locomotives, stations, passengers, crews, much more. Captions. 8⅜ x 11¾.
26301-0 Pa. $14.95

VOYAGE OF THE LIBERDADE, Joshua Slocum. Great 19th-century mariner's thrilling, first-hand account of the wreck of his ship off South America, the 35-foot boat he built from the wreckage, and its remarkable voyage home. 128pp. 5⅜ x 8½.
40022-0 Pa. $5.95

TEN BOOKS ON ARCHITECTURE, Vitruvius. The most important book ever written on architecture. Early Roman aesthetics, technology, classical orders, site selection, all other aspects. Morgan translation. 331pp. 5⅜ x 8½. 20645-9 Pa. $9.95

THE HUMAN FIGURE IN MOTION, Eadweard Muybridge. More than 4,500 stopped-action photos, in action series, showing undraped men, women, children jumping, lying down, throwing, sitting, wrestling, carrying, etc. 390pp. 7⅞ x 10⅝.
20204-6 Clothbd. $29.95

TREES OF THE EASTERN AND CENTRAL UNITED STATES AND CANADA, William M. Harlow. Best one-volume guide to 140 trees. Full descriptions, woodlore, range, etc. Over 600 illustrations. Handy size. 288pp. 4½ x 6⅜.
20395-6 Pa. $6.95

SONGS OF WESTERN BIRDS, Dr. Donald J. Borror. Complete song and call repertoire of 60 western species, including flycatchers, juncoes, cactus wrens, many more–includes fully illustrated booklet. Cassette and manual 99913-0 $8.95

GROWING AND USING HERBS AND SPICES, Milo Miloradovich. Versatile handbook provides all the information needed for cultivation and use of all the herbs and spices available in North America. 4 illustrations. Index. Glossary. 236pp. 5⅜ x 8½.
25058-X Pa. $7.95

BIG BOOK OF MAZES AND LABYRINTHS, Walter Shepherd. 50 mazes and labyrinths in all–classical, solid, ripple, and more–in one great volume. Perfect inexpensive puzzler for clever youngsters. Full solutions. 112pp. 8⅜ x 11.
22951-3 Pa. $5.95

PIANO TUNING, J. Cree Fischer. Clearest, best book for beginner, amateur. Simple repairs, raising dropped notes, tuning by easy method of flattened fifths. No previous skills needed. 4 illustrations. 201pp. 5⅜ x 8½. 23267-0 Pa. $6.95

HINTS TO SINGERS, Lillian Nordica. Selecting the right teacher, developing confidence, overcoming stage fright, and many other important skills receive thoughtful discussion in this indispensible guide, written by a world-famous diva of four decades' experience. 96pp. 5³/₈ x 8¹/₂. 40094-8 Pa. $4.95

THE COMPLETE NONSENSE OF EDWARD LEAR, Edward Lear. All nonsense limericks, zany alphabets, Owl and Pussycat, songs, nonsense botany, etc., illustrated by Lear. Total of 320pp. 5⅜ x 8½. (Available in U.S. only.) 20167-8 Pa. $7.95

VICTORIAN PARLOUR POETRY: An Annotated Anthology, Michael R. Turner. 117 gems by Longfellow, Tennyson, Browning, many lesser-known poets. "The Village Blacksmith," "Curfew Must Not Ring Tonight," "Only a Baby Small," dozens more, often difficult to find elsewhere. Index of poets, titles, first lines. xxiii + 325pp. 5⅜ x 8¼. 27044-0 Pa. $12.95

DUBLINERS, James Joyce. Fifteen stories offer vivid, tightly focused observations of the lives of Dublin's poorer classes. At least one, "The Dead," is considered a masterpiece. Reprinted complete and unabridged from standard edition. 160pp. 5³/₁₆ x 8¼. 26870-5 Pa. $1.50

GREAT WEIRD TALES: 14 Stories by Lovecraft, Blackwood, Machen and Others, S. T. Joshi (ed.). 14 spellbinding tales, including "The Sin Eater," by Fiona McLeod, "The Eye Above the Mantel," by Frank Belknap Long, as well as renowned works by R. H. Barlow, Lord Dunsany, Arthur Machen, W. C. Morrow and eight other masters of the genre. 256pp. 5⅜ x 8½. (Available in U.S. only.) 40436-6 Pa. $8.95

THE BOOK OF THE SACRED MAGIC OF ABRAMELIN THE MAGE, translated by S. MacGregor Mathers. Medieval manuscript of ceremonial magic. Basic document in Aleister Crowley, Golden Dawn groups. 268pp. 5⅜ x 8½. 23211-5 Pa. $9.95

NEW RUSSIAN-ENGLISH AND ENGLISH-RUSSIAN DICTIONARY, M. A. O'Brien. This is a remarkably handy Russian dictionary, containing a surprising amount of information, including over 70,000 entries. 366pp. 4½ x 6⅛. 20208-9 Pa. $10.95

HISTORIC HOMES OF THE AMERICAN PRESIDENTS, Second, Revised Edition, Irvin Haas. A traveler's guide to American Presidential homes, most open to the public, depicting and describing homes occupied by every American President from George Washington to George Bush. With visiting hours, admission charges, travel routes. 175 photographs. Index. 160pp. 8¼ x 11. 26751-2 Pa. $13.95

NEW YORK IN THE FORTIES, Andreas Feininger. 162 brilliant photographs by the well-known photographer, formerly with *Life* magazine. Commuters, shoppers, Times Square at night, much else from city at its peak. Captions by John von Hartz. 181pp. 9¼ x 10¾. 23585-8 Pa. $13.95

INDIAN SIGN LANGUAGE, William Tomkins. Over 525 signs developed by Sioux and other tribes. Written instructions and diagrams. Also 290 pictographs. 111pp. 6⅛ x 9¼. 22029-X Pa. $3.95

ANATOMY: A Complete Guide for Artists, Joseph Sheppard. A master of figure drawing shows artists how to render human anatomy convincingly. Over 460 illustrations. 224pp. 8⅜ x 11¼. 27279-6 Pa. $11.95

MEDIEVAL CALLIGRAPHY: Its History and Technique, Marc Drogin. Spirited history, comprehensive instruction manual covers 13 styles (ca. 4th century through 15th). Excellent photographs; directions for duplicating medieval techniques with modern tools. 224pp. 8⅜ x 11¼. 26142-5 Pa. $12.95

DRIED FLOWERS: How to Prepare Them, Sarah Whitlock and Martha Rankin. Complete instructions on how to use silica gel, meal and borax, perlite aggregate, sand and borax, glycerine and water to create attractive permanent flower arrangements. 12 illustrations. 32pp. 5⅜ x 8½. 21802-3 Pa. $1.00

EASY-TO-MAKE BIRD FEEDERS FOR WOODWORKERS, Scott D. Campbell. Detailed, simple-to-use guide for designing, constructing, caring for and using feeders. Text, illustrations for 12 classic and contemporary designs. 96pp. 5⅜ x 8½.
25847-5 Pa. $3.95

SCOTTISH WONDER TALES FROM MYTH AND LEGEND, Donald A. Mackenzie. 16 lively tales tell of giants rumbling down mountainsides, of a magic wand that turns stone pillars into warriors, of gods and goddesses, evil hags, powerful forces and more. 240pp. 5⅜ x 8½. 29677-6 Pa. $6.95

THE HISTORY OF UNDERCLOTHES, C. Willett Cunnington and Phyllis Cunnington. Fascinating, well-documented survey covering six centuries of English undergarments, enhanced with over 100 illustrations: 12th-century laced-up bodice, footed long drawers (1795), 19th-century bustles, 19th-century corsets for men, Victorian "bust improvers," much more. 272pp. 5⅜ x 8¼. 27124-2 Pa. $9.95

ARTS AND CRAFTS FURNITURE: The Complete Brooks Catalog of 1912, Brooks Manufacturing Co. Photos and detailed descriptions of more than 150 now very collectible furniture designs from the Arts and Crafts movement depict davenports, settees, buffets, desks, tables, chairs, bedsteads, dressers and more, all built of solid, quarter-sawed oak. Invaluable for students and enthusiasts of antiques, Americana and the decorative arts. 80pp. 6½ x 9¾. 27471-3 Pa. $8.95

WILBUR AND ORVILLE: A Biography of the Wright Brothers, Fred Howard. Definitive, crisply written study tells the full story of the brothers' lives and work. A vividly written biography, unparalleled in scope and color, that also captures the spirit of an extraordinary era. 560pp. 6⅛ x 9¼. 40297-5 Pa. $17.95

THE ARTS OF THE SAILOR: Knotting, Splicing and Ropework, Hervey Garrett Smith. Indispensable shipboard reference covers tools, basic knots and useful hitches; handsewing and canvas work, more. Over 100 illustrations. Delightful reading for sea lovers. 256pp. 5⅜ x 8½. 26440-8 Pa. $8.95

FRANK LLOYD WRIGHT'S FALLINGWATER: The House and Its History, Second, Revised Edition, Donald Hoffmann. A total revision—both in text and illustrations—of the standard document on Fallingwater, the boldest, most personal architectural statement of Wright's mature years, updated with valuable new material from the recently opened Frank Lloyd Wright Archives. "Fascinating"–*The New York Times*. 116 illustrations. 128pp. 9¼ x 10¾. 27430-6 Pa. $12.95

PHOTOGRAPHIC SKETCHBOOK OF THE CIVIL WAR, Alexander Gardner. 100 photos taken on field during the Civil War. Famous shots of Manassas Harper's Ferry, Lincoln, Richmond, slave pens, etc. 244pp. 10⅛ x 8¼. 22731-6 Pa. $10.95

FIVE ACRES AND INDEPENDENCE, Maurice G. Kains. Great back-to-the-land classic explains basics of self-sufficient farming. The one book to get. 95 illustrations. 397pp. 5⅜ x 8½. 20974-1 Pa. $7.95

SONGS OF EASTERN BIRDS, Dr. Donald J. Borror. Songs and calls of 60 species most common to eastern U.S.: warblers, woodpeckers, flycatchers, thrushes, larks, many more in high-quality recording. Cassette and manual 99912-2 $9.95

A MODERN HERBAL, Margaret Grieve. Much the fullest, most exact, most useful compilation of herbal material. Gigantic alphabetical encyclopedia, from aconite to zedoary, gives botanical information, medical properties, folklore, economic uses, much else. Indispensable to serious reader. 161 illustrations. 888pp. 6½ x 9¼. 2-vol. set. (Available in U.S. only.) Vol. I: 22798-7 Pa. $10.95
Vol. II: 22799-5 Pa. $10.95

HIDDEN TREASURE MAZE BOOK, Dave Phillips. Solve 34 challenging mazes accompanied by heroic tales of adventure. Evil dragons, people-eating plants, blood-thirsty giants, many more dangerous adversaries lurk at every twist and turn. 34 mazes, stories, solutions. 48pp. 8¼ x 11. 24566-7 Pa. $2.95

LETTERS OF W. A. MOZART, Wolfgang A. Mozart. Remarkable letters show bawdy wit, humor, imagination, musical insights, contemporary musical world; includes some letters from Leopold Mozart. 276pp. 5⅜ x 8½. 22859-2 Pa. $9.95

BASIC PRINCIPLES OF CLASSICAL BALLET, Agrippina Vaganova. Great Russian theoretician, teacher explains methods for teaching classical ballet. 118 illustrations. 175pp. 5⅜ x 8½. 22036-2 Pa. $6.95

THE JUMPING FROG, Mark Twain. Revenge edition. The original story of The Celebrated Jumping Frog of Calaveras County, a hapless French translation, and Twain's hilarious "retranslation" from the French. 12 illustrations. 66pp. 5⅜ x 8½. 22686-7 Pa. $4.95

BEST REMEMBERED POEMS, Martin Gardner (ed.). The 126 poems in this superb collection of 19th- and 20th-century British and American verse range from Shelley's "To a Skylark" to the impassioned "Renascence" of Edna St. Vincent Millay and to Edward Lear's whimsical "The Owl and the Pussycat." 224pp. 5⅜ x 8½. 27165-X Pa. $5.95

COMPLETE SONNETS, William Shakespeare. Over 150 exquisite poems deal with love, friendship, the tyranny of time, beauty's evanescence, death and other themes in language of remarkable power, precision and beauty. Glossary of archaic terms. 80pp. 5³⁄₁₆ x 8¼. 26686-9 Pa. $1.00

THE BATTLES THAT CHANGED HISTORY, Fletcher Pratt. Eminent historian profiles 16 crucial conflicts, ancient to modern, that changed the course of civilization. 352pp. 5⅜ x 8½. 41129-X Pa. $9.95

THE WIT AND HUMOR OF OSCAR WILDE, Alvin Redman (ed.). More than 1,000 ripostes, paradoxes, wisecracks: Work is the curse of the drinking classes; I can resist everything except temptation; etc. 258pp. 5⅜ x 8½. 20602-5 Pa. $6.95

SHAKESPEARE LEXICON AND QUOTATION DICTIONARY, Alexander Schmidt. Full definitions, locations, shades of meaning in every word in plays and poems. More than 50,000 exact quotations. 1,485pp. 6½ x 9¼. 2-vol. set.

Vol. 1: 22726-X Pa. $17.95
Vol. 2: 22727-8 Pa. $17.95

SELECTED POEMS, Emily Dickinson. Over 100 best-known, best-loved poems by one of America's foremost poets, reprinted from authoritative early editions. No comparable edition at this price. Index of first lines. 64pp. 5³⁄₁₆ x 8¼.

26466-1 Pa. $1.00

THE INSIDIOUS DR. FU-MANCHU, Sax Rohmer. The first of the popular mystery series introduces a pair of English detectives to their archnemesis, the diabolical Dr. Fu-Manchu. Flavorful atmosphere, fast-paced action, and colorful characters enliven this classic of the genre. 208pp. 5³⁄₁₆ x 8¼. 29898-1 Pa. $2.00

THE MALLEUS MALEFICARUM OF KRAMER AND SPRENGER, translated by Montague Summers. Full text of most important witchhunter's "bible," used by both Catholics and Protestants. 278pp. 6⅝ x 10. 22802-9 Pa. $12.95

SPANISH STORIES/CUENTOS ESPAÑOLES: A Dual-Language Book, Angel Flores (ed.). Unique format offers 13 great stories in Spanish by Cervantes, Borges, others. Faithful English translations on facing pages. 352pp. 5⅜ x 8½.

25399-6 Pa. $8.95

GARDEN CITY, LONG ISLAND, IN EARLY PHOTOGRAPHS, 1869–1919, Mildred H. Smith. Handsome treasury of 118 vintage pictures, accompanied by carefully researched captions, document the Garden City Hotel fire (1899), the Vanderbilt Cup Race (1908), the first airmail flight departing from the Nassau Boulevard Aerodrome (1911), and much more. 96pp. 8⅞ x 11¾. 40669-5 Pa. $12.95

OLD QUEENS, N.Y., IN EARLY PHOTOGRAPHS, Vincent F. Seyfried and William Asadorian. Over 160 rare photographs of Maspeth, Jamaica, Jackson Heights, and other areas. Vintage views of DeWitt Clinton mansion, 1939 World's Fair and more. Captions. 192pp. 8⅞ x 11. 26358-4 Pa. $14.95

CAPTURED BY THE INDIANS: 15 Firsthand Accounts, 1750-1870, Frederick Drimmer. Astounding true historical accounts of grisly torture, bloody conflicts, relentless pursuits, miraculous escapes and more, by people who lived to tell the tale. 384pp. 5⅜ x 8½. 24901-8 Pa. $9.95

THE WORLD'S GREAT SPEECHES (Fourth Enlarged Edition), Lewis Copeland, Lawrence W. Lamm, and Stephen J. McKenna. Nearly 300 speeches provide public speakers with a wealth of updated quotes and inspiration–from Pericles' funeral oration and William Jennings Bryan's "Cross of Gold Speech" to Malcolm X's powerful words on the Black Revolution and Earl of Spenser's tribute to his sister, Diana, Princess of Wales. 944pp. 5⅜ x 8⅜. 40903-1 Pa. $15.95

THE BOOK OF THE SWORD, Sir Richard F. Burton. Great Victorian scholar/adventurer's eloquent, erudite history of the "queen of weapons"–from prehistory to early Roman Empire. Evolution and development of early swords, variations (sabre, broadsword, cutlass, scimitar, etc.), much more. 336pp. 6⅛ x 9¼.

25434-8 Pa. $9.95

AUTOBIOGRAPHY: The Story of My Experiments with Truth, Mohandas K. Gandhi. Boyhood, legal studies, purification, the growth of the Satyagraha (nonviolent protest) movement. Critical, inspiring work of the man responsible for the freedom of India. 480pp. 5⅜ x 8½. (Available in U.S. only.) 24593-4 Pa. $9.95

CELTIC MYTHS AND LEGENDS, T. W. Rolleston. Masterful retelling of Irish and Welsh stories and tales. Cuchulain, King Arthur, Deirdre, the Grail, many more. First paperback edition. 58 full-page illustrations. 512pp. 5⅜ x 8½. 26507-2 Pa. $9.95

THE PRINCIPLES OF PSYCHOLOGY, William James. Famous long course complete, unabridged. Stream of thought, time perception, memory, experimental methods; great work decades ahead of its time. 94 figures. 1,391pp. 5⅜ x 8½. 2-vol. set.
Vol. I: 20381-6 Pa. $14.95
Vol. II: 20382-4 Pa. $14.95

THE WORLD AS WILL AND REPRESENTATION, Arthur Schopenhauer. Definitive English translation of Schopenhauer's life work, correcting more than 1,000 errors, omissions in earlier translations. Translated by E. F. J. Payne. Total of 1,269pp. 5⅜ x 8½. 2-vol. set.
Vol. 1: 21761-2 Pa. $12.95
Vol. 2: 21762-0 Pa. $12.95

MAGIC AND MYSTERY IN TIBET, Madame Alexandra David-Neel. Experiences among lamas, magicians, sages, sorcerers, Bonpa wizards. A true psychic discovery. 32 illustrations. 321pp. 5⅜ x 8½. (Available in U.S. only.) 22682-4 Pa. $9.95

THE EGYPTIAN BOOK OF THE DEAD, E. A. Wallis Budge. Complete reproduction of Ani's papyrus, finest ever found. Full hieroglyphic text, interlinear transliteration, word-for-word translation, smooth translation. 533pp. 6½ x 9¼.
21866-X Pa. $12.95

MATHEMATICS FOR THE NONMATHEMATICIAN, Morris Kline. Detailed, college-level treatment of mathematics in cultural and historical context, with numerous exercises. Recommended Reading Lists. Tables. Numerous figures. 641pp. 5⅜ x 8½.
24823-2 Pa. $11.95

PROBABILISTIC METHODS IN THE THEORY OF STRUCTURES, Isaac Elishakoff. Well-written introduction covers the elements of the theory of probability from two or more random variables, the reliability of such multivariable structures, the theory of random function, Monte Carlo methods of treating problems incapable of exact solution, and more. Examples. 502pp. 5³/₈ x 8¹/₂. 40691-1 Pa. $16.95

THE RIME OF THE ANCIENT MARINER, Gustave Doré, S. T. Coleridge. Doré's finest work; 34 plates capture moods, subtleties of poem. Flawless full-size reproductions printed on facing pages with authoritative text of poem. "Beautiful. Simply beautiful."–Publisher's Weekly. 77pp. 9¼ x 12. 22305-1 Pa. $7.95

NORTH AMERICAN INDIAN DESIGNS FOR ARTISTS AND CRAFTSPEOPLE, Eva Wilson. Over 360 authentic copyright-free designs adapted from Navajo blankets, Hopi pottery, Sioux buffalo hides, more. Geometrics, symbolic figures, plant and animal motifs, etc. 128pp. 8⅜ x 11. (Not for sale in the United Kingdom.) 25341-4 Pa. $9.95

SCULPTURE: Principles and Practice, Louis Slobodkin. Step-by-step approach to clay, plaster, metals, stone; classical and modern. 253 drawings, photos. 255pp. 8⅜ x 11.
22960-2 Pa. $11.95

THE INFLUENCE OF SEA POWER UPON HISTORY, 1660–1783, A. T. Mahan. Influential classic of naval history and tactics still used as text in war colleges. First paperback edition. 4 maps. 24 battle plans. 640pp. 5⅜ x 8½. 25509-3 Pa. $14.95

THE STORY OF THE TITANIC AS TOLD BY ITS SURVIVORS, Jack Winocour (ed.). What it was really like. Panic, despair, shocking inefficiency, and a little heroism. More thrilling than any fictional account. 26 illustrations. 320pp. 5⅜ x 8½. 20610-6 Pa. $8.95

FAIRY AND FOLK TALES OF THE IRISH PEASANTRY, William Butler Yeats (ed.). Treasury of 64 tales from the twilight world of Celtic myth and legend: "The Soul Cages," "The Kildare Pooka," "King O'Toole and his Goose," many more. Introduction and Notes by W. B. Yeats. 352pp. 5⅜ x 8½. 26941-8 Pa. $8.95

BUDDHIST MAHAYANA TEXTS, E. B. Cowell and others (eds.). Superb, accurate translations of basic documents in Mahayana Buddhism, highly important in history of religions. The Buddha-karita of Asvaghosha, Larger Sukhavativyuha, more. 448pp. 5⅜ x 8½. 25552-2 Pa. $12.95

ONE TWO THREE . . . INFINITY: Facts and Speculations of Science, George Gamow. Great physicist's fascinating, readable overview of contemporary science: number theory, relativity, fourth dimension, entropy, genes, atomic structure, much more. 128 illustrations. Index. 352pp. 5⅜ x 8½. 25664-2 Pa. $9.95

EXPERIMENTATION AND MEASUREMENT, W. J. Youden. Introductory manual explains laws of measurement in simple terms and offers tips for achieving accuracy and minimizing errors. Mathematics of measurement, use of instruments, experimenting with machines. 1994 edition. Foreword. Preface. Introduction. Epilogue. Selected Readings. Glossary. Index. Tables and figures. 128pp. $5^3/_8$ x $8^1/_2$. 40451-X Pa. $6.95

DALÍ ON MODERN ART: The Cuckolds of Antiquated Modern Art, Salvador Dalí. Influential painter skewers modern art and its practitioners. Outrageous evaluations of Picasso, Cézanne, Turner, more. 15 renderings of paintings discussed. 44 calligraphic decorations by Dalí. 96pp. 5⅜ x 8½. (Available in U.S. only.) 29220-7 Pa. $5.95

ANTIQUE PLAYING CARDS: A Pictorial History, Henry René D'Allemagne. Over 900 elaborate, decorative images from rare playing cards (14th–20th centuries): Bacchus, death, dancing dogs, hunting scenes, royal coats of arms, players cheating, much more. 96pp. 9¼ x 12¼. 29265-7 Pa. $12.95

MAKING FURNITURE MASTERPIECES: 30 Projects with Measured Drawings, Franklin H. Gottshall. Step-by-step instructions, illustrations for constructing handsome, useful pieces, among them a Sheraton desk, Chippendale chair, Spanish desk, Queen Anne table and a William and Mary dressing mirror. 224pp. 8⅛ x 11¼. 29338-6 Pa. $13.95

THE FOSSIL BOOK: A Record of Prehistoric Life, Patricia V. Rich et al. Profusely illustrated definitive guide covers everything from single-celled organisms and dinosaurs to birds and mammals and the interplay between climate and man. Over 1,500 illustrations. 760pp. 7½ x 10⅛. 29371-8 Pa. $29.95

Prices subject to change without notice.

Available at your book dealer or write for free catalog to Dept. GI, Dover Publications, Inc., 31 East 2nd St., Mineola, N.Y. 11501. Dover publishes more than 500 books each year on science, elementary and advanced mathematics, biology, music, art, literary history, social sciences and other areas.

BATTLES
OF THE
AMERICAN
CIVIL WAR
1861 ~ 1865

BATTLES
OF THE
AMERICAN
CIVIL WAR
1861 ~ 1865

FROM FORT SUMTER TO PETERSBURG

KEVIN J. DOUGHERTY MARTIN J. DOUGHERTY PARKER HILLS CHRIS McNAB MICHAEL F. PAVKOVIC

amber
BOOKS

First published in 2007 by Amber Books Ltd
Bradley's Close
74–77 White Lion Street
London N1 9PF
United Kingdom
www.amberbooks.co.uk

ISBN: 978-1-905704-93-4

Project Editor: Michael Spilling
Design: Jerry Williams
Picture Research: Terry Foreshaw
Illustrations: Julian Baker

Printed in Dubai

CONTENTS

INTRODUCTION

FROM 1861 TO 1865, THE CIVIL WAR RAVAGED THE UNITED STATES. IT WAS A WAR SOME HAVE CALLED 'THE SECOND AMERICAN REVOLUTION', AND INDEED THERE WAS MUCH THAT WAS REVOLUTIONARY ABOUT IT. NEW WEAPONS MADE THE WAR MORE LETHAL. NEW ATTITUDES CHANGED THE WAR'S IMPACT ON CIVILIANS. NEW OBJECTIVES TRANSFORMED THE WAR'S PURPOSE. NEW TECHNOLOGY MADE TRANSPORTATION AND COMMUNICATIONS ELEMENTS OF BATTLEFIELD STRATEGY AS NEVER BEFORE. NEW ARMIES WERE LARGER THAN ANY THAT AMERICA HAD PREVIOUSLY EXPERIENCED. THE END RESULT WAS A TOTAL WAR IN WHICH THE UNION AND THE CONFEDERACY FOUGHT FOR THEIR VERY SURVIVAL.

In the early years of the war, the Federal cavalry was no match for its Confederate counterpart. Confederate cavalryman Major-General JEB 'Jeb' Stuart (1833–64) would be especially active, riding all the way around George B McClellan's (1826–85) army on the Virginia Peninsula.

Although a variety of factors triggered the Civil War, slavery, and more specifically the expansion of slavery, was the principal cause. By the mid-nineteenth century, slavery had become the South's bedrock institution. Its impact had grown beyond providing the labour force for the South's agricultural economy. Slavery had become the basic assumption by which white Southerners defined relations between the white and black races, and the slaveholding planter class had come to dominate politics in the South.

The North also benefited from slavery thanks to the economic synergy of the triangular trade between Europe, Africa and the Americas. Nonetheless, the Northern economy was based more on industry than agriculture, and slavery never took root in the North. Instead, many Northerners

turned against slavery and a vocal minority became ardent abolitionists.

The result was that sectional differences resulting from slavery came to dominate American politics. The balance of power between slave and free states was a tenuous one and all national political decisions reflected its importance. For example, whenever a territory applied for statehood, its status as a free or slave state had to be considered. In this way the Missouri Compromise of 1820 allowed Maine to enter the Union as a free state, and Missouri to enter as a slave state in order to maintain the balance. However, the compromise specified that no other slave states from the unorganized Louisiana Purchase territory would be allowed north of Missouri's southern boundary.

Another crisis was avoided in 1832 over a protective tariff that increased the price of imported manufactured goods. Many Southerners felt this legislation unfairly benefited the North, and South Carolina's rice industry found it especially objectionable. In response to the tariff, South Carolina declared that a state had the right to void any act of Congress that the state considered illegal. This 'Nullification Crisis' highlighted the growing sectional economical differences, while also giving voice to the political concept of states' rights. President Andrew Jackson (1767–1845) sent naval vessels to Charleston as a Federal show of force, while elder statesman Henry Clay (1777–1852) ultimately crafted a compromise tariff to resolve the crisis. Nonetheless, South Carolina's position as a flashpoint in challenging the Federal government was established.

In 1846, the United States went to war with Mexico, an act that would, seemingly, be devoid of slavery implications, but many Northerners saw the war as an attempt by the South to gain more territory for slavery. Indeed, Congressman David Wilmot (1814–68) of Pennsylvania introduced a resolution that would have prevented any land gained in the war from becoming slave territory. This 'Wilmot Proviso' failed, but it served to demonstrate the role slavery had come to play in national politics.

Another compromise was needed in 1850 when territories gained from Mexico prepared to enter the Union. California was admitted as a free state and it was decided that slavery in New Mexico and Utah would be decided by popular sovereignty. In addition, the slave trade was prohibited in the District of Columbia and a more stringent fugitive slave law was passed that required all US citizens to assist in the return of runaway slaves. The Compromise of 1850, partly Clay's work once again, was yet another attempt to meet the competing demands of the free and slave states.

The Kansas–Nebraska Act of 1854 declared that the slavery issue in Kansas and Nebraska would be decided by popular sovereignty. Because this act specifically repealed the Missouri Compromise of 1820, it drew the ire of many abolitionists. Zealots like John Brown (1800–59) made the territory 'Bleeding Kansas' as they fought to sway attitudes.

With this experience under his belt, Brown went east to Harpers Ferry, Virginia, where he raided an arsenal in an attempt to lead an armed slave revolt. Forces commanded by Lieutenant-Colonel Robert E Lee (1807–70) crushed the revolt, but it highlighted a deep-seated Southern fear of slave rebellion and resulted in a crackdown on slave behaviour throughout the South.

SECESSION
While all these incidents helped exacerbate sectional differences, the event that actually

Cap badges of the Union miltary: infantry, artillery and cavalry. Civil War soldiers depicted their branches by wearing unique insignia. The Corps of Engineers was considered the elite branch. During the war, Federal Brigadier-General Philip Kearny (1815–62) also introduced the practice of designated unit affiliation by a distinctive patch.

led to secession was the election of President Abraham Lincoln (1809–65) on 6 November 1860. Many Southerners interpreted Lincoln's election as sounding the death knell for their way of life and on 20 December, South Carolina voted to secede. The Deep South states of Mississippi, Alabama, Louisiana, Georgia, Florida and Texas followed.

As the Southern states seceded, they usually took with them the Federal garrisons within their borders. One notable exception was Fort Sumter, South Carolina, where a brave band of soldiers led by Major Robert Anderson (1805–71) refused to surrender. Fort Sumter became the epicentre of the growing sectional crisis. The Confederate government could no more tolerate this presence of 'foreign' military on its soil than the Federal government could legitimize secession by abandoning the fort. A tense standoff continued for several weeks. Then, on 12 April 1861, Confederate artillery under the command of General PGT Beauregard (1818–93) began bombarding Fort Sumter. Anderson, isolated and running low on provisions, had little choice but to surrender on 14 April.

In the aftermath of this attack on the US flag, President Lincoln called for 75,000 three-month volunteers to suppress the rebellion. This action forced the states of the upper South to decide between two alternatives: fight against their brother Southerners or leave the Union. Virginia, Arkansas, North Carolina and Tennessee all chose the latter course, bringing to 11 the total number of states that had seceded.

Of critical importance to both sides were the border states of Missouri, Kentucky and Maryland. These were slave states with strong connections to the South. Although

Enlisted soldiers in the Civil War wore straight, 'stove pipe' trousers that were cut fairly full. Creasing was not practised and trousers were pressed round, if at all. US Army issue trousers were made of sky blue kersey, and Confederate soldiers wore grey or butternut.

Opposite: Though having only a very limited military background, Abraham Lincoln proved to be a highly effective wartime president. In many cases he grasped broad strategic concepts before his generals did.

there was considerable pro-Confederacy sentiment in these states, they stopped short of secession. They would become a battleground, especially early in war, as the North sought to secure them for the Union, and the South sought to win them over to the Confederacy. Of critical importance was Maryland because of its proximity to Washington DC, the Federal capital.

THE SIDES COMPARED

As both the North and the South prepared for war, the North enjoyed a remarkable advantage in almost every measurable statistic. The North had a population of 20 million compared to 9 million in the South, of whom only 5.5 million were white. The North had over 110,000 manufacturing establishments while the South had just 18,000. The North had 35,400km (22,000 miles) of railroad to the South's 13,680 (8500). Even in agriculture the North outperformed the South, holding 75 per cent of the nation's farm acreage, producing 60 per cent of its livestock, 67 per cent of its corn and 81 per cent of its wheat. In sum, the North controlled 75 per cent of the nation's total wealth. Militarily, the North had 16,000 men in its army and 90 warships in its navy. In establishing itself as a nation, the fledgling Confederacy would be starting from scratch in many areas.

Nonetheless, the Confederacy had several key advantages. Most notable was what it would take to win the war. The South merely had to defend itself long enough to make the North grow tired of fighting. The North, on the other hand, had the more difficult task of going on the offensive and wresting back the Southern territory. The Confederacy also had high hopes for foreign intervention based on the assumption that European demand for cotton would not tolerate interruption. Finally, the South had the benefit of interior lines: the military principle that a force able to exploit its central position relative to the enemy has the advantage.

INTRODUCTION

The Civil War was the first great railroad war. Railroads were used to move troops and equipment and became critical in keeping supplies flowing to armies in the field.

Both sides formulated their strategies amid these advantages and disadvantages. The initial plan for the Federals was the Anaconda Plan, developed by the aging Mexican War (1846–48) hero, Lieutenant-General Winfield Scott (1786–1866). Scott's plan was to raise a huge army, blockade the Confederate coast with the superior Federal Navy, secure the Mississippi River, thereby cutting the South in two, and then wait. It was a well-thought-out plan that, ultimately, would reflect much of how the Federals fought the war; but in 1861, it was rejected as taking too long. Most Northerners expected a quick end to the war and President Lincoln knew that time was on the Confederacy's side. Thus, Scott's Anaconda Plan was rejected in favour of an immediate offensive against the Confederate capital of Richmond.

The South soon realized that it could not defend its entire vast frontier, although President Jefferson Davis (1808–89) was under huge political pressure from state governors to do so. Instead, Davis adopted an 'offensive-defensive' strategy by which the Confederacy would allow a Federal thrust to develop, determine its main axis of advance and then, at the advantageous moment, concentrate and counterattack to cut it off. The strategy was recognition of the North's resource advantage.

LEADERSHIP

On paper, Jefferson Davis looked much better suited than Abraham Lincoln to the role of wartime president. Davis had graduated from West Point, been a hero in the Mexican War and been an outstanding Secretary of War. Lincoln, on the other hand, had no military experience, save as a captain in the militia during the Black Hawk War. There, Lincoln joked, he had only fought mosquitoes.

In fact, Lincoln proved to be an excellent commander-in-chief, grasping the changing nature of war and its broad strategic implications before many of his generals. His was willing to push his presidential powers and suppress some civil liberties, such as suspending habeas corpus and censoring newspapers, to meet the emergencies of war. Most importantly, Lincoln understood that the policy of conciliation was not going to work. Lincoln knew that the South would have to be forced, rather than coaxed, back into the Union. Nonetheless, Lincoln would have to cycle through the likes of Irvin McDowell (1818–85), George B McClellan, John Pope (1822–92), McClellan again, Ambrose Burnside (1824–81), Joseph Hooker (1814–79) and George G Meade (1815–72) before finally finding in Ulysses S Grant (1822–85) a commanding general who shared his strategic vision.

What Grant brought to the Federal high command was a grand strategy that would press the Confederacy from all sides. Additionally, Grant understood that the tremendous manpower and resource advantage enjoyed by the Federals would allow him to continue to engage the Confederates, even if he suffered high casualties in the process.

Opposite: Jefferson Davis had impressive military experience as a graduate of West Point, a hero in the Mexican War of 1846–48 and an outstanding Secretary of War. As President of the Confederacy he would face many challenges in trying to build a new nation in time of war.

Used primarily by cavalry on both sides, the carbine came into its own in the Civil War. Above is a selection of single-shot carbines. From the top: the Warner, the Maynard, the Palmer, the Gallager, the Wesson, the Burnside, the Perry Navy carbine and the Merrill.

War had learned their trade as junior officers during the Mexican War. Among those Mexican War veterans who led the Confederate armies were Lee, Thomas 'Stonewall' Jackson (1824–63), Joseph E Johnston (1807–91), James Longstreet (1821–1904), Braxton Bragg (1817–76), AP Hill (1825–65) and Beauregard. Grant, McClellan, Pope, Winfield Scott Hancock (1824–86), Hooker, Meade and George H Thomas (1816–70) had seen Mexican War service for the Federals. Because of this the Mexican War has been called 'a dress rehearsal for the Civil War', although certainly not all its lessons were transferable to the latter conflict.

Another important proving ground for the Civil War generalship was West Point. In one list of 60 major Civil War battles, West Point graduates commanded on both sides in 55 of them. In the remaining five battles, a West Point graduate commanded on one of the two sides. At West Point, these officers were exposed to the military theories of Antoine-Henri Jomini (1779–1869) and his geometrical approach to war, which emphasized interior lines. The end result, according to one observer, was that 'many a Civil War general went into battle with a sword in one hand and Jomini's *Summary of the Art of War* in the other'.

A major challenge for the Civil War officer was the unprecedented size of the armies. In the Mexican War, Winfield Scott's entire army had totalled fewer than 13,000 men. Such a number would hardly make a respectable corps in the Civil War. McClellan, for example, had 104,300 men available at the beginning of the Seven Days' Battles.

Lee led some 70,000 men into Pennsylvania for his Gettysburg Campaign. At the Wilderness, Grant attacked Lee with more than 100,000. These enormous armies would stretch Civil War command and control to the utmost, especially given the limited means of communications and the fact that many of the soldiers were independent-thinking and relatively inexperienced volunteers.

WEAPONS AND TACTICS
In 1853, the US Army had adopted the rifled infantry musket. By this time, a

Davis, on the other hand, tended to micromanage his generals and use his military expertise to immerse himself in details at the expense of greater strategic considerations. Furthermore, the strong individual sentiment and resistance to centralized government among most Southerners prevented Davis from exercising expanded wartime powers as Lincoln did. Davis was fortunate in quickly finding a trusted military commander in Lee, but, unlike Grant on the Union side, Lee was reluctant to exert his authority beyond his own theatre of operations. Moreover, the Confederacy's finite pool of manpower made Confederate casualties irreplaceable and limited Lee's options.

In many cases the men who led the Federal and Confederate forces in the Civil

French Army captain named Claude E Minie (1804–79) had developed a way to load a rifled musket as easily as a smoothbore. The 'Minie ball' was a cylindro-conoidal bullet that was slightly smaller in diameter than the barrel and, thus, could be easily dropped down the barrel. One end, however, was hollow, so, when the rifle was fired, expanding gas widened the sides of the hollow end, causing the bullet to grip the rifling and create the spinning effect needed for accuracy. To take advantage of this technology, the United States adapted the Model 1855 Springfield rifle to take .58 calibre Minie ammunition. The difference was significant. The smoothbore musket had a range of 91–182m (100–200 yards). The new rifle was effective from 366–549m (400–600 yards).

However, this change in technology was not accompanied by a drastic change in tactics. Civil War formations remained fixed in the Napoleonic style, with men standing shoulder to shoulder, and small intervals between units. The lines were maintained rigidly parallel to allow for a massed or uniform volley at the halt, and to maximize the shock effect. Commanders knew such a formation presented a vulnerable target, but they felt that an attack coming in successive waves would eventually overwhelm the defenders and carry the field.

In actuality, this increased range combined with the tactic of fighting behind heavy breastworks greatly increased the power of the defence. Frontal attacks such as Fredericksburg, Pickett's Charge and Kennesaw proved deadly to the attackers. To avoid attacking into the teeth of the enemy's defences, many Civil War generals began using turning movements and envelopments to strike the less-protected flanks. The battles of Second Manassas and Chancellorsville are excellent examples.

Union Colonel Strong Vincent steadies the 16th Michigan as they defend Little Roundtop at the Battle of Gettysburg, 2 July 1863.

The Confederacy faced a serious disadvantage in terms of available manpower. The North had a population of 20 million compared to just 9 million in the South. Of that 9 million, only 5.5 million were white.

One result of this increased power of the defence was that battles took longer to fight and the ability to achieve a decisive result became increasingly elusive. Lee's ability to disengage after his defeat at Gettysburg is a good example.

Other important technological advances that had an impact on the Civil War were the telegraph and the railroad. The telegraph allowed both operational and strategic communications. Operators could hook insulated wire into existing trunk lines to reach into the civilian telegraph network and extend communications from the battlefield to the rear areas. For example, during the Peninsula Campaign, Thaddeus Sobieski Constantine Lowe (1831–1913) would ascend above the battlefield in a balloon and telegraph his observations to eagerly awaiting Federal commanders. The telegraph also allowed the administrations and War Departments in Washington and Richmond to communicate directly with their commanders in the field.

The Civil War was the 'first great railroad war'. The Jominian influence of interior lines made railroads an attractive means of moving troops rapidly across great distances. Although the geography appeared to give the Confederacy an advantage in interior lines, the superior Federal rail system often proved an effective counter. The rail movement of 25,000 Federal soldiers, travelling 1931km (1200 miles) from Virginia to the Chattanooga front, in late 1863 is a good example.

THE BATTLES

The history of the Civil War contains many interesting facets. Entire volumes cover its economic, diplomatic, social and other aspects. The focus of this particular study is military engagement as seen through the 20 most important battles of the war.

According to the Civil War Sites Advisory Commission there were 10,500 armed conflicts in the Civil War, ranging from major battles to minor skirmishes. Of these, the commission identified 384 or 3.7 per cent of the total as having military

significance. Obviously whittling this list down to the 20 most important is no easy task. The battles selected for this book were ones that markedly contributed to how the war was fought or how it turned out. Therefore some famous battles such as Fredericksburg did not make the list because they did not alter the overall strategic situation and some decisive Federal victories such as Fort Fisher were omitted because they occurred so late that the war's outcome was already inevitable.

Also conspicuously absent is Sherman's March to the Sea and subsequent Carolinas Campaign. While this campaign was among the most important in the war, the weak Confederate resistance and Sherman's tactic of avoiding Confederate armies resulted in few pitched battles that were on a scale with others covered in this book. The campaign, however, is mentioned in the discussion of Kennesaw and the Atlanta Campaign which made the March to the Sea possible. A brief explanation of why the particular battles were selected for this book follows.

1861

The opening battle of Fort Sumter ensured that the sectional differences would not be settled peacefully. First Manassas showed both sides that the war was going to be a long one. It was also a demonstration of the important part that railroads would play in the war.

1862

Fort Donelson was the first major Federal victory, reversing a string of debacles and opening up the way to Nashville. The Shenandoah Valley Campaign included several battles, but Kernstown is highlighted here because it was after this defeat that Federal forces were first withheld from joining Major-General George McClellan on the Virginia Peninsula. The Valley Campaign is also an excellent example of the adroit use of Jomini's concept of interior lines. Shiloh ensured Federal control of western and middle Tennessee. New Orleans cost the South its largest city and part of the Mississippi River. The Peninsula Campaign comprised several battles, to include the Seven Days' Battles, but Gaines' Mill is highlighted here because it was this defeat that led McClellan to announce his plan to withdraw. The Peninsula Campaign is also important because it marked General Robert E Lee's assumption of command of the Army of Northern Virginia.

Second Manassas was the Confederate victory that facilitated the invasion of Maryland. Antietam was the Federal victory that repulsed that invasion and gave

Between the Potomac and the Rio Grande, the Confederate coast stretched across 5711km (3549 miles) of shoreline with 189 harbour and river openings. Many coastal battles would occur at places like Fort Sumter and New Orleans.

President Lincoln the victory he needed to announce the Emancipation Proclamation. The Emancipation Proclamation expanded the Federal objective of the war beyond merely restoring the Union to include, also, the ending of slavery. As such, it changed the very nature of the war. Corinth ended the Confederate hopes of major operations in Tennessee and allowed Major-General Ulysses S Grant to concentrate on Vicksburg. The Federal victory at Perryville halted the Confederate drive into Kentucky, an important border state.

1863

Chancellorsville encouraged Lee to launch his second invasion into Northern territory, but it also cost him his trusted subordinate Lieutenant-General 'Stonewall' Jackson. The Vicksburg Campaign gave the Federals control of the Mississippi River and split the Confederacy in two. It included many battles, but Champion Hill is highlighted here because it was this defeat that forced Lieutenant-General John Pemberton (1814–81) to withdraw to Vicksburg, where Grant subjected him to a siege. Gettysburg thwarted Lee's second invasion of the North and also cost Lee enough men to preclude future offensives. Chattanooga and Chickamauga opened the Deep South to Federal invasion.

1864

The Wilderness and Spotsylvania Courthouse showed that Grant, unlike his predecessors, would not retreat, but instead would continue to apply the relentless pressure that would ultimately lead to Federal victory. The Atlanta Campaign ensured Lincoln's re-election, which meant there would be no peaceful settlement to the war. It included many battles, but Kennesaw is highlighted here because it was the only instance in which Major-General William Tecumseh Sherman (1820–91) deviated from his pattern of flank manoeuvres and engaged in a costly frontal attack. Mobile Bay represented the loss of the South's last

The first black soldiers went into battle in 1863. By the end of the war, 10 percent of the Federal Army, a total of 180,000 men, would be black soldiers.

major port on the Gulf of Mexico and, along with Atlanta, helped ensure that Lincoln would be re-elected. While Sherman was embarking on his March to the Sea after the Atlanta Campaign, Confederate Lieutenant General John Bell Hood launched a desperate move into Tennessee to attempt to cut off Sherman from the north. The Federal victories at Franklin and Nashville virtually eliminated Hood's Army of Tennessee and left Lee's Army of Northern Virginia as the Confederacy's only substantial military force.

1865

Finally, the siege of Petersburg, culminating in the Federal victory at Five Forks, ended Lee's opportunity for manoeuvre and thus sealed the fate of the Army of Northern Virginia and, with it, the Confederacy. Of course, Civil War historians and buffs may be able to make a case for replacing one battle from our list with another, but, given our criteria, we are fairly confident this list represents the 20 most militarily significant battles in the war.

BEYOND THE CIVIL WAR

The Federal victory in the Civil War resulted in the continuance of the United States as a politically united nation with strengthened federal authority. As such it was the pivotal experience in American history. That is not to say, however, that with the surrender at Appomattox everything took care of itself. The legacy of the Civil War continues in the United States today, and some of the conflict's issues remain unresolved.

With the end of the Civil War, the United States faced the difficult task of re-establishing a nation that had been disrupted by four years of civil strife. Lincoln had envisioned a quick restoration, establishing civilian governments in the former Confederate states as quickly as practicable. However, after Lincoln's assassination, the Radical Republicans in Congress, who had long been pressing Lincoln for a stricter prosecution of the war, dismissed Lincoln's plan. The new president, Andrew Johnson (1808–75), tried to implement a plan that was in many ways slightly harsher than Lincoln's but, in so

doing, Johnson was attacked fiercely by the Radical Republicans. The end result was Congressional control of Reconstruction, the process by which the defeated Confederate states would progress to re-entering the Union.

Reconstruction was a tumultuous period in American history that saw the military occupation of the ex-Confederacy, the impeachment of President Johnson, the sometimes painful transition of the slaves to freemen, the influx of carpetbaggers who often exploited the new political situation in the South and the rise of the Ku Klux Klan as an organization of white Southerners dedicated to maintaining the old social order. Reconstruction finally ended with the Compromise of 1877, in which contested voter returns in South Carolina, Florida and Louisiana were resolved in favour of Rutherford B Hayes (1822–93). Hayes became President of the United States and in exchange he promised to withdraw all remaining Federal troops from the South, ending Reconstruction and permitting white Southerners to reassert control. With this transfer of power the Southern states began to pass Jim Crow laws and other policies that reversed the gains made by black people.

In spite of the imperfections of Reconstruction, the Civil War resulted in the emancipation of some 3.5 million slaves within the Confederacy, and the Thirteenth Amendment (1865) ultimately ended slavery in the United States. To be sure, the end of slavery did not equate to immediate equality among the races in the United States. It remained for the slow and steady progress of the civil rights movement, a movement that continues today, to bring about genuine change.

Even now, more than 140 years after Appomattox, signs of the Civil War still permeate the American landscape. Confederate memorials grace many Southern towns. Controversies over the Confederate battle flag excite various emotions. Civil War re-enactors establish camps and refight battles. Many US Army posts are named after Civil War generals. Both documentaries and dramas about the Civil War win awards. Battlefield parks such as Gettysburg draw millions of visitors each year, while preservationists and developers battle over the relative merits of urban sprawl.

Clearly, the Civil War is indelibly etched in the American consciousness. Even this book is a small part of preserving its memory.

Ships land supplies in a Federal river port on the eastern seaboard. The Union Army had a massive advantage in men and materiel over their Confederate counterparts, and it is this that influenced the outcome of the war more than any other factor.

FORT SUMTER
APRIL 1861

THE BATTLE OF FORT SUMTER IN APRIL 1861 WAS SMALL IN SCALE BUT EPIC IN IMPORT. THE ISOLATED FORT OFF THE SOUTH CAROLINA COASTLINE BECAME THE FOCUS OF GROWING ANTAGONISM BETWEEN THE FEDERAL NORTH AND THE SECESSIONIST SOUTH. THE RESULTING TWO-DAY ACTION SAW THE FIRST SHOTS FIRED IN WHAT WOULD BECOME THE AMERICAN CIVIL WAR.

WHY DID IT HAPPEN?

WHO A small Union garrison occupied Fort Sumter. Sumter was effectively besieged, then bombarded, by surrounding Confederate batteries.

WHAT The battle was an artillery duel, the Confederates deploying nearly 50 heavy-calibre guns and mortars. Union troops had 60 guns, but not all could be used and many had limited range and ammunition.

WHERE The waters of Charleston harbour, between Morris Island and James Island to the south, and Sullivan's Island to the north.

WHEN April 1861.

WHY South Carolina's secessionist government sought to take possession of the forts within the state, while the US government declared them Federal property.

OUTCOME A 36-hour Confederate bombardment forced the Union garrison to surrender Fort Sumter. The action began the American Civil War.

By early 1861, the United States was in a state of political and social crisis. Antagonism between the US Federal government and the Southern states over issues such as slavery and states' rights reached a crescendo with the election of President Abraham Lincoln (1809–65) in November 1860 (he was sworn in on 4 March 1861). Lincoln, a constitutionalist, argued that any secession from the Union was illegal, although defiance quickly stirred in several rebel states. By the end of January 1861 seven states had declared secession, and together formed the Confederate States of America on 4 February, with its own president, Jefferson Davis (1808–89), elected on 9 February.

One of the early actions of the breakaway states was to take over Federal forts and bases within their territories, well aware that the new South needed to make preparations for possible hostilities. However, Federal garrisons remained in place at many locations – potential power kegs in the pressure cooker of secession. The tension was particularly high in South Carolina, the first state to secede, around the harbour at Charleston.

The approach to the harbour was a broad waterway framed by two landmasses that formed entrance waters of roughly 2.4km (1.5 miles) across. At the southern end of the gap was Morris Island, which drove a long rocky promontory out into the bay

In 1860 President James Buchanan (1791–1868) struggled to cope with the growing political crisis. It was made worse by the men of the Covode Committee (pictured right), who investigated the president for possible impeachment.

known as Cummings Point. To the west of Morris Island, further inland, was James Island. (Morris and James islands are here described as separate features, but they effectively formed one river-slashed landmass running into Charleston harbour.) On the other side of the bay was Sullivan's Island and mainland Mount Pleasant. The city of Charleston lay protected by these northern and southern arms of the South Carolina coastline, at the confluence of the Cooper and Ashley rivers.

The whole approach to Charleston was framed with fortifications and coastal guns. On Morris Island were batteries on Cummings Point and, moving south, Fort Wagner and Fort Shaw. Fort Johnson sat on the northernmost tip of James Island, while Sullivan's Island guarded the northern entrance to the harbour with Fort Moultrie and a floating battery off the west tip of the island, an iron-coated raft containing two 43-pounder and two 32-pounder guns. Other batteries were found along the edge of Mount Pleasant, and another fort, Castle Pinkney, sat well back on an island at the mouth of the Cooper River.

There remained one other fort in the area – Fort Sumter. Fort Sumter sat on an island of its own between Morris Island and Sullivan's Island, dominating the entrance to Charleston harbour and sitting on its own specially constructed sand bar. The fort was a solid five-sided structure, built after the war of 1812. At its longest point it was 57.9m (190ft) in length, and it was capable of taking up to 135 guns of various calibres (although it never reached this complement of weaponry). The fortress walls were 1.5m (5ft) thick. Sumter was a powerful emplacement, the centrepiece of the Charleston defences, with control over all shipping wanting to enter the harbour waters. It was this fort that would spark the American Civil War.

ANTAGONISM

With South Carolina's official secession declared on 20 December 1860, there remained the issue of ownership of all the harbour fortresses and batteries. These were considered as Federal possessions by the US government, but the state governor, Francis W Pickens (1805–69), argued that

all property within state borders should become state-owned. While Fort Sumter was not occupied, Fort Moultrie was held by a small US Army force of two companies of the First US Artillery, commanded by Major Robert Anderson (1805–71). Anderson was a talented and well-connected officer. He had graduated from West Point in 1825 and had served with distinction in the Second Seminole War (1835–42) and the Mexican War (1846–48); during the former conflict he served on General Winfield Scott's (1786–1866) staff. He was appointed to the command of the First US Artillery on 5 October 1857. Because Anderson was competent while also loyal to the Union (despite his having been

LOCATION

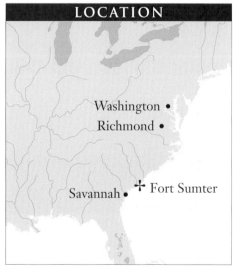

Washington •
Richmond •

Savannah • ✝ Fort Sumter

The forts along the eastern seaboard had a critical importance during the Civil War. Whoever controlled the coast would have greater logistical control, and therefore could dominate the coastal cities in the east.

FORT SUMTER

Major-General Abner Doubleday (1819–93) was second-in-command to Robert Anderson at Fort Sumter (he was at the time a captain). He rose to fame by personally aiming the cannon that fired the first Union shot from Sumter.

THE OPPOSED FORCES

FEDERAL
A small garrison of US Army troops confined in Fort Sumter.

CONFEDERATE
Various South Carolina militia units and artillery batteries, gathered around Charleston harbour.

born in Louisville, Kentucky), he was soon appointed to the Charleston command. With secession declared, the status of his Federal troops was uncertain, hence three commissioners from the South Carolina Convention – Robert W Barnwell (1801–82), James H Adams (1812–61) and James L Orr (1822–73) – were sent to Washington DC to negotiate for the non-violent transfer of Moultrie to the state. The conditions of the negotiations were that no side should engage the other while talks were taking place, nor should the disposition of forces at the harbour change.

On 26 December 1860, Anderson broke these conditions. In a secret night-time manoeuvre, he transferred his troops over to Fort Sumter and took up positions. Anderson's manoeuvre may have been politically inflammatory, but it made some military sense. Fort Moultrie was a powerful fortress, but its gun defences were designed to deliver fire out to sea. Against a land attack – the likeliest assault route should South Carolina decide to take the fort by force – it was badly configured. (During subsequent negotiations Anderson stated that he specifically feared a landing of state troops on the sand hills north of the fort.) Fort Sumter gave Anderson 360-degree protection from assault.

The state authorities soon dispatched representation to Anderson. A cordial meeting between Anderson and Colonel Johnston Pettigrew (1828–63) of the First South Carolina Rifles on 27 December saw no resolution – Anderson reasserted his right to command over all the harbour defences, despite Pettigrew emphasizing that if the situation was not resolved, then violence would be the likely outcome. Anderson also said that he knew of no conditional arrangements between South Carolina and Washington DC, and that he had to make his own decisions in the absence of guidance from the Federal government. Pettigrew returned from the meeting without satisfaction. Anderson, meanwhile, hoisted the Union flag over the fort and initiated intensive efforts to prepare its defences for action.

Despite the increase in tension, Governor Pickens and his authorities were hesitant about the use of force, as was the

Confederate government headed by Jefferson Davis. Nevertheless, on 9 January 1861, the US steamer *The Star of the West* attempted a resupply run to Fort Sumter, but was met with fire from the batteries along Morris Island plus some shots from Fort Moultrie. The ship was not damaged, but it was forced to turn about. Anderson declared the action unjustifiable, adding that if an apology was not forthcoming, he might turn his own guns on Charleston's shipping. Although a truce of sorts was

declared, both sides expedited their preparations for war.

OPENING SHOTS

By the beginning of March 1861, Fort Sumter was effectively under siege, and its supplies were beginning to run low. Its position was also looking increasingly vulnerable. All surrounding forts had been occupied by Confederate troops, and had been deliberately up-gunned. At Fort Moultrie, for example, the artillery commander Lieutenant-Colonel RS Ripley (1823–87) positioned a total of 26 artillery pieces, ranging from 24-pounders through to 25cm (10in) mortars, to fire on Fort Sumter if necessary. At Cummings Point were six 25cm (10in) mortars and six direct-fire guns. Fort Johnson contained four mortars and a 24-pounder gun. Add in the capability of the floating and other batteries, and in total there would be more than 40 guns of various different calibres capable of firing on Fort Sumter by the time hostilities broke out in April. (A Union estimate of the Confederate artillery firing on Fort Sumter during the action was 30 guns and 17 mortars.) Furthermore, 500 troops from various state militias were made ready to form assault parties.

A vivid depiction of the Confederate bombardment of Fort Sumter. The Confederate batteries were able to deliver almost 360-degree direct or indirect fire, using a mix of solid shot and explosive-filled shells.

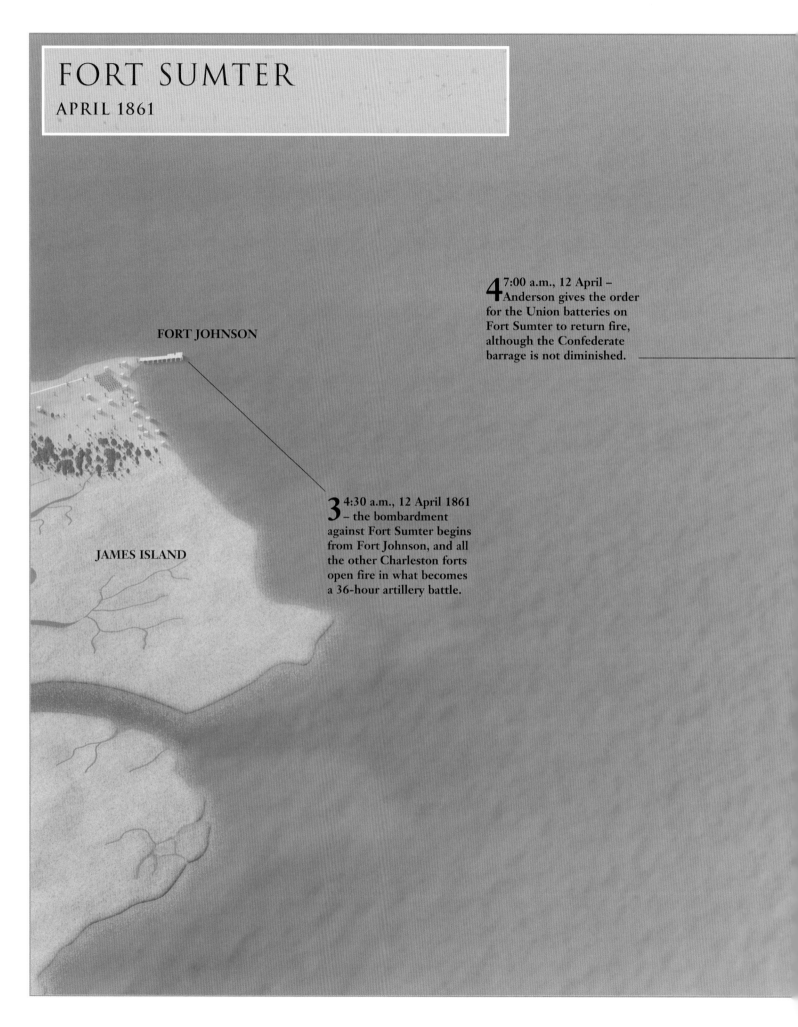

FORT SUMTER
APRIL 1861

FORT JOHNSON

JAMES ISLAND

4 7:00 a.m., 12 April – Anderson gives the order for the Union batteries on Fort Sumter to return fire, although the Confederate barrage is not diminished.

3 4:30 a.m., 12 April 1861 – the bombardment against Fort Sumter begins from Fort Johnson, and all the other Charleston forts open fire in what becomes a 36-hour artillery battle.

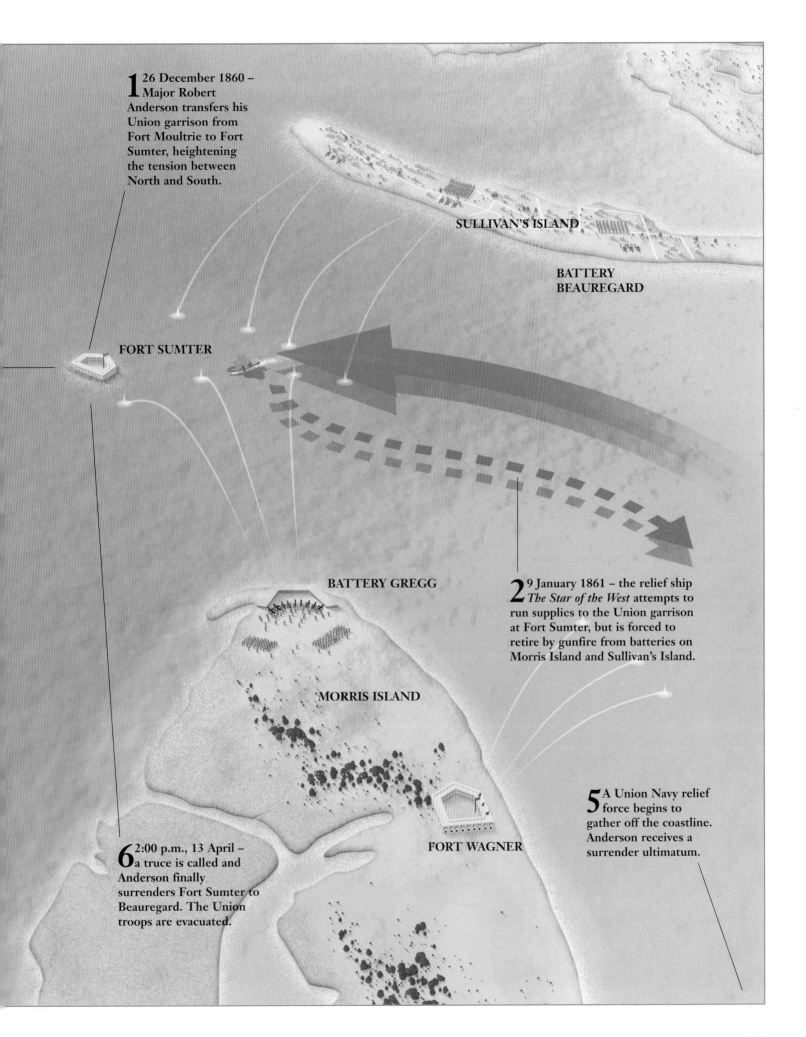

1 26 December 1860 – Major Robert Anderson transfers his Union garrison from Fort Moultrie to Fort Sumter, heightening the tension between North and South.

SULLIVAN'S ISLAND

BATTERY BEAUREGARD

FORT SUMTER

BATTERY GREGG

2 9 January 1861 – the relief ship *The Star of the West* attempts to run supplies to the Union garrison at Fort Sumter, but is forced to retire by gunfire from batteries on Morris Island and Sullivan's Island.

MORRIS ISLAND

5 A Union Navy relief force begins to gather off the coastline. Anderson receives a surrender ultimatum.

FORT WAGNER

6 2:00 p.m., 13 April – a truce is called and Anderson finally surrenders Fort Sumter to Beauregard. The Union troops are evacuated.

The rebel troops surrounding Fort Sumter also received a new overall commander. On 27 February, PGT Beauregard (1818–93), who would become one of the great commanders of the Civil War, was appointed a brigadier-general in the new Confederate Army. On 1 March, he took command over all the forces around Charleston. With supreme irony, Anderson had actually been Beauregard's artillery instructor at West Point, and Beauregard had also served as Anderson's assistant. Such a relationship ensured a high degree of civility and respect between the two men, but preparations for war continued.

Left: A photograph of Fort Sumter taken after the battle clearly shows the 1.5m (5ft) thick walls that were the fort's greatest defence. The wheeled gun that sits at the top would have a limited range for the inter-fort engagement.

Below: A depiction of the action on board the Confederate floating battery in Charleston harbour. The battery had four heavy artillery pieces.

Beauregard made sure that all troops were well trained, particularly in the use of artillery. On Fort Sumter, meanwhile, supplies were running critically short.

Events took a new turn on 4 April. Lincoln was becoming increasingly concerned about the fate of the Fort Sumter garrison, and ordered a naval relief expedition to be dispatched. His note to Pickens informed the governor that 'an attempt will be made to supply Fort Sumter with provisions only, and that if such attempt be not resisted, no effort to throw in men, arms, or ammunition will be made without further notice, [except] in case of an attack on the fort.'

A violent debate amongst the Southern governments now followed, but the decision was made to bombard and take Fort Sumter before the relief fleet could replenish it. Beauregard received his instructions about Fort Sumter from the Secretary of War: 'You will at once demand its evacuation, and if this is refused proceed, in such a manner you may determine, to reduce it.'

On 11 April, Beauregard issued an instruction to Anderson saying that the Union troops had to abandon the fort or it would be taken by force. Anderson's response was brief and to the point:

'General: I have the honor to acknowledge the receipt of your communication demanding the evacuation of this fort, and to say, in reply thereto, that it is a demand with which I regret that my sense of honor, and of my obligations to my government, prevent my compliance. Thanking you for the fair, manly and courteous terms proposed, and for the high compliment paid me, I am, General, very respectfully, your obedient servant, ROBERT ANDERSON, Major, First Artillery, Commanding.'

Subsequent communications did not ease the gathering tension, particularly as the US relief force was already gathering for its run in to Fort Sumter. Then, at 3:20 a.m. on 12

Robert Anderson. Despite the loss of Fort Sumter, Anderson was feted as a hero in the North. He was promoted to brigadier-general, but retired from the Army in 1863 because of ill health.

The 1861 battle was far from the end of Fort Sumter's travails. Between 1863 and 1865 the fort was under regular, intense Union bombardment. Here Union Parrott guns prepare to fire upon the much abused fort at the end of 1863.

April, Beauregard told Anderson that in one hour's time the first shots would be fired.

He was true to his word. At 4:30 a.m. a mortar was fired from Fort Johnson, whereupon a 36-hour bombardment of the fort began. The fire was incredibly intense – Fort Moultrie alone fired 2490 projectiles into the fort structure. In terms of defence, Anderson was faced with a problem. His firepower within Fort Sumter was not inconsiderable. Captain JG Foster (1823–74) of the Corps of Engineers, US Army, who served in Fort Sumter, listed the fort's defences as follows:

'Barbette tier: *Right flank, one 10-inch columbiad, four 8-inch columbiads, four 42-pounders. Right face, none. Left face, three 8-inch sea-coast howitzers, one 32-pounder. Left flank, one 10-inch columbiad, two 8-inch columbiads, two 42-pounders. Gorge, one 8-inch sea-coast howitzer, two 32-pounders, six 24-pounders. Total in barbette, 27 guns.*

Casemate tier: *Right flank, one 42-pounder, four 32-pounders. Right face, three 42-pounders. Left face, ten 32-pounders. Left flank, five 32-pounders. Gorge, two 32-pounders. Total in casemate, 21 guns. Total available in both tiers, 48 guns.*

Besides the above, there were arranged on the parade, to serve mortars, one 10-inch columbiad to throw shells into Charleston and four 8-inch columbiads to throw shells into the batteries on Cummings Point.'

Despite such a contingent of firepower, Foster admits that the casemate guns were the only ones used. The guns on the uppermost level were too exposed to enemy fire, while those below often had

The Coehorn mortar was named after its inventor, the Dutch officer Baron van Coehorn (1641–1704). It had a relatively fixed trajectory and a calibre ranging from 114mm (4.5in) to more than 250mm (10in). Such mortars were used in the Charleston batteries.

insufficient elevation to fire over the walls. Nonetheless, Anderson did order fire to commence at 7:00 a.m., but it had little effect in lessening the onslaught. The many small-calibre guns did not have the range or penetration to do serious damage to the enemy fort structures. Once the Fort Sumter garrison began firing, another problem facing Anderson's men (of whom 16 were musicians, not frontline troops) was a rapid depletion of ammunition – the garrison had only 700 rounds to begin with. By the middle of 12 April, only six guns were still able to fire.

Within Fort Sumter, by contrast, the Confederate fire delivered steady destruction. The main barracks caught fire

Preparations for the Union flag-raising over Fort Sumter on 14 April 1865. Robert Anderson himself performed the flag-raising, having come out of retirement two months earlier.

three times and the fires had to be extinguished by hand. Foster noted that: 'The direction of the enemy's shells being from the northeast, north, southwest, and southeast, sought every part of the work, and the fuses being well graduated, exploded in most instances just within the line of parapet.' Numerous Union guns were put out of action, and the tiered walls collapsed at many points. The fort's main gates were also blown open.

SURRENDER

As day broke on 13 April, the last rice supplies were served to the Union troops – a small amount of pork was the only food left. More significantly, hot shot had ignited an uncontrollable fire around the fort's magazine. Only 50 barrels of powder were saved before the magazine had to be sealed with earth and ominously left to burn. Fire also spread to the barracks, pushing the defenders out to the fort's walls. Loose

barrels of powder and explosive munitions began to detonate in the heat. It was clear to Anderson that Fort Sumter's resistance was unsustainable. At 2:00 p.m. on 13 April, a truce was finally agreed and the firing stopped. Negotiations for surrender of the fort were undertaken, the Union troops agreeing to make a transfer at 2:30 p.m. on 14 April. The US ships off the coast would take the men back north. Ironically, although the destruction within Fort Sumter was intense, the only fatality incurred was when Union troops, by agreement with Beauregard, fired a salute to the US flag, during which a gun and a pile of cartridges exploded.

Fort Sumter became a Confederate possession on 14 April, but few imagined the conflict the battle would begin. Lincoln called for a volunteer force to retake the forts. Lincoln did indeed take back Sumter, but that day did not come until 14 April 1865, after four years of bloody war.

FIRST MANASSAS
21 JULY 1861

BY THE END OF 1860, THE UNITED STATES FACED A CRISIS THAT THREATENED TO DISMEMBER THE UNION. IN DECEMBER OF THAT YEAR, SOUTH CAROLINA WAS THE FIRST STATE TO SECEDE AND WAS SOON JOINED BY OTHERS WHO TOGETHER FORMED THE CONFEDERACY. BY APRIL 1861, THE ONLY RECOURSE WAS THE USE OF FORCE. THE FIRST SALVO WAS FIRED BY THE CONFEDERATES AS THEY BOMBARDED FORT SUMTER AT CHARLESTON ON 12–13 APRIL. THE WAR HAD BEGUN.

WHY DID IT HAPPEN?

WHO The Union Army of Northeastern Virginia (35,000) under Brigadier-General Irvin McDowell (1818–85) attacked the Confederate Army of the Potomac (22,000) under Brigadier-General PGT Beauregard (1818–93), later reinforced by some 12,000 troops under Brigadier-General Joseph E Johnston (1807–91).

WHAT McDowell's forces launched a series of attacks against the Confederates defending the Bull Run stream.

WHERE Along the Bull Run stream north of Manassas Junction, some 40km (25 miles) southwest of Washington DC.

WHEN 21 July 1861.

WHY The Union forces executed a number of poorly coordinated attacks. While enjoying initial success, the Union army was ultimately thrown back in confusion.

OUTCOME The Union troops were routed back to Washington and ceased to exist as a viable fighting force.

As a result of the bombardment of Fort Sumter, President Abraham Lincoln (1809–65), who had only been in office for a month, faced a war for which the Union was ill-prepared. The US Army at the time numbered only 16,000 men, its main purpose to serve as a constabulary force, in particular against the various Native American tribes along the western frontier. As a result, the great majority of the US regulars were deployed west of the Mississippi River. The remaining troops were used to guard the various government installations in the east, including arsenals

Joe Johnston was a West Point graduate who had served in the US Army prior to the war. He had reached the position of Quartermaster-General before the war's outbreak, but, hailing from Virginia, he joined the forces of the Confederacy.

and coastal fortifications, such as Fort Sumter; or they were deployed in small outposts along the border with Canada. Given these duties, most Army regiments rarely served together as units but were instead parcelled out as company-sized garrisons, so the troops were not prepared for the kind of large-scale manoeuvres that would be necessary for the imminent hostilities. To exacerbate matters, some 1200 of these troops stationed in Texas were unable to extricate themselves from Confederate territory before hostilities commenced, and were made prisoners of war.

Like their troops, the officer corps of the US Army was ill-prepared for the looming hostilities. The senior officers were an aged group led by Brevet Lieutenant-General Winfield Scott (1786–1866). Scott was a veteran of both the War of 1812 and the Mexican War (1846–48) but, by 1861, at the age of 75, he was so old and infirm that he could neither ride a horse nor command an army in the field, even though he was the only Union officer who had any experience

of commanding large bodies of troops in battle. The other senior officers were mostly in their mid-60s. Two of the three general officers of the line were over 70, and the third was 60.

In the case of the junior- and field-grade officers, the men were perhaps better prepared physically for the war, but they too had a problem to overcome, namely a lack of experience in fighting large-scale conventional war. Most of these officers had never commanded more than a company-sized garrison in action on account of the Army's role at that time and the way in which it was deployed. When the Civil War began, these officers had only theoretical knowledge of how larger units such as battalions or regiments functioned, based primarily on their drill manuals, and knew virtually nothing at all about higher military formations such as brigades and divisions.

Since the Army regulars were too few and ill-prepared for the war that now faced the Union, President Lincoln was forced to rely on other sources of military manpower.

The First Battle of Manassas took place in the 161km (100-mile) corridor between the two capitals, Richmond and Washington. This area was the central theatre of the entire war, where many of the best-known battles of the conflict took place.

NEW YORK STATE MILITIA

One of the more famous units of the Civil War was the 'Fighting' 69th New York State Militia which fought as part of William T Sherman's (1820–91) brigade at the First Battle of Manassas under Colonel Michael Corcoran (1827–63). The regiment was composed of Irish immigrants and was one of the first units of 90-day volunteers to enlist for the war. The regiment was sent to defend Washington and spent much of its time in garrison drilling under the watchful eyes of its officers and was soon recognized as a competently trained unit. After sweeping over Matthews Hill, the 69th was hotly engaged in a firefight with the Louisiana Tigers, a Zouave regiment, and after two volleys drove the Tigers back. After this, the 69th re-formed and repeatedly attacked Confederate positions on Henry House Hill, having discarded their knapsacks, some even charging in bare-chested, but were repulsed. After four attacks, Sherman's brigade was forced to retreat and the 69th helped cover the retreat, even forming a square against pursuing cavalry.

FIRST MANASSAS

*This Model 1841 field piece could fire a 2.7kg (6lb)
round more than 1550m (1700 yards). It was used
extensively during the Mexican War (1846–48), but
by the time of the Civil War it was considered obsolete.
Nevertheless, Confederate batteries made extensive use
of the six-pounder at Manassas.*

In theory, there was a large militia that
could be called up to support the Army in
such a crisis, but the militia had not been
closely regulated in recent years.

As a result, many of the militia rolls were
hopelessly out of date and many militia
units did not perform any form of regular
muster or drill. Although there were some
quality militia units, these were divided
between the Union and the Confederacy.
Nonetheless, on 15 April, Lincoln issued a
call for 75,000 militiamen from those states
still loyal to the Union, and his request was
not only met but exceeded. These troops
were to be enrolled for a period of three
months as required under the various
Militia Acts. It quickly became clear that
this force would not be adequate for the task
at hand, so Lincoln unilaterally decided to
approve the addition of some 20,000 troops
(10 regiments) to the US Army.
Additionally, he called on the states to
provide more than 40,000 volunteers whose
regiments would be enlisted for three years.

The Confederacy faced similar problems.
It had no regular troops at its disposal, and
although the Confederate Congress did
approve the creation of a standing army, it
never really materialized.

There was, however, a cadre of
experienced officers, as some 20 per cent of
the 1100 officers of the US Army resigned
their commissions and took up arms for the
Confederacy. President Jefferson Davis
(1808–89), like Lincoln, was therefore forced
to rely on militiamen and volunteers. In
March 1861, Davis was authorized to call up

the state militias for a period of 60 days and
to enlist an additional 100,000 volunteers for
the cause.

THE CAMPAIGN

In the months following the outbreak of
hostilities, both sides hurriedly collected,
trained, and deployed their forces. Given
that a mere 161km (100 miles) separated the
two capitals of Washington and Richmond,
this area in between would clearly become
an important theatre of operations. Federal
troops gathered in Washington and soon
crossed the Potomac River in order to
occupy Alexandria, Virginia. At the same
time, troops began the task of erecting a
significant complex of fortifications to
defend the city and to protect the troops
organizing and training there.

As the Union forces mustered, it became
necessary to appoint a commander since
Winfield Scott was incapable of taking the
field himself. Scott had a couple of
candidates from the Army's senior
leadership in mind, but political pressure
from a member of President Lincoln's
cabinet forced him to appoint a younger
officer, Brevet Major Irvin McDowell, to
command the troops who would form the
Union's main field force. McDowell, a 42-
year-old who had graduated from West
Point, was therefore promoted to brigadier-
general and given command of the Army of
Northeastern Virginia numbering more
than 35,000 men. A smaller force of 18,000
troops was placed under the command of
Major-General Robert Patterson (1792–

1881), a 69-year-old veteran who had served with Scott in Mexico and been one of Scott's choices for McDowell's command. Patterson had previously been given command of Union troops but had not shown himself to be an energetic leader.

At the same time, the Confederates formed their forces in the theatre. The main force was to be commanded by 43-year-old Brigadier-General PGT Beauregard, a classmate of McDowell's who had led the attack on Fort Sumter. Beauregard commanded 22,000 men stationed around Manassas Junction, an important rail point that also sat astride two important roads that led from Washington and Richmond. There was a second large concentration of 11,000 Confederate troops at Harpers Ferry to the northwest under Brigadier-General Joseph E Johnston.

By June, the Union forces were under both political and military pressure to prepare an offensive strategy. Many Northern leaders assumed the rebellion would collapse if the Union Army could seek and win a single, decisive battle. The Northern press began to echo these sentiments with stories that began with the mantra 'Forward to Richmond'. Moreover, although Scott understood that Union troops were still forming and training, there was a serious danger associated with delaying the attack, namely that many of the militia units who formed a significant portion of the Union Army were nearing the end of their enlistments, and if action were not imminent, these troops would simply go home. As a result, by the end of June, Scott asked McDowell and his staff to prepare a campaign plan to move against the Confederate troops located south of Washington DC.

McDowell's plan centred on his army advancing in three prongs against Beauregard at Manassas, while Patterson and his troops moved on Harpers Ferry, pinning Johnston and his forces and preventing the two Confederate armies

During the Civil War, both Union and Confederate armies possessed units of Zouaves who wore uniforms based upon those of France's North African units which had fought in the Crimean War (1854–56). Their bright uniforms and exotic look made them a popular motif for militia units. Here Zouaves are shown fighting off a cavalry attack, a relatively rare occurrence during the conflict.

FIRST MANASSAS

FIRST MANASSAS

21 JULY 1861

1 Union troops, supported by two batteries of artillery, push forward against Henry House Hill and the Confederate brigades that have reformed there.

5 Union troops remain in place at the Stone Bridge, which the Confederates have left unguarded, and never enter the fray.

STONE BRIDGE

HENRY HOUSE HILL

3 Stuart's cavalry help drive Union infantry from Henry House Hill, exposing their batteries and later taking part in the pursuit of the shattered Union army.

2 Having been pushed off Matthews Hill, Confederate troops rally, inspired by the stand of Thomas 'Stonewall' Jackson's Virginians on the plateau of Henry House Hill.

6 Some Confederate troops, such as regiments from Edmund Kirby Smith's Brigade, arrive at Manassas from Harper's Ferry.

CENTREVILLE

BULL RUN RIVER

4 Brigades from the Confederate right flank begin to move to into action like Jubal Early's Brigade which helps hasten the Union route

FIRST MANASSAS

William T Sherman on his horse 'Duke' outside Atlanta in 1864. At the First Battle of Manassas, Sherman commanded the Third Brigade of Tyler's division which launched an attack against the Confederate flank, driving them from Matthews Hill. Although Sherman was wounded, he was one of the few Union officers to distinguish himself.

from joining forces. Scott approved the plan and ordered McDowell to move on 8 July, while Patterson was to move against Johnston on 2 July. But things did not go according to plan. It took McDowell until 16 July to get his inexperienced troops organized, supplied and on the move. In the meantime, Patterson crossed the Potomac, but advanced in such a way that Johnston, who had withdrawn to Winchester, was still able to support Beauregard.

On 16 July, McDowell's army was on the move. It was organized into five divisions – four of these divisions (the First, Second, Third and Fifth) advanced towards Manassas Junction, while the remaining division (the Fourth), consisting of eight regiments of volunteers and militia primarily from New Jersey, was left in Arlington as a reserve. The march was a difficult one for the green Union troops, who were unaccustomed to marching long distances loaded with their equipment and supplies. Many soldiers fell out of the column, often stopping to pick berries along the side of the road, forcing McDowell to halt his columns in order to allow stragglers to rejoin the ranks. The next day, he called

a halt at Fairfax Courthouse at noon to rest his troops and to restore communications with one of his divisions.

McDowell's slow advance and the delay at Fairfax Courthouse gave Beauregard time to redeploy and request reinforcement. Initially, Beauregard had deployed his forces on both sides of the Bull Run stream, but now he was able to pull all of his forces south of the stream and place them to cover key crossing points. Moreover, on 17 July, he was able to contact the government in Richmond, informing President Davis of this major Union offensive. Davis responded by ordering a few scattered units to join Beauregard, and ordered Joe Johnston to quit his position at Winchester and use the railroad to move his army to Manassas in support.

DISPOSITION OF FORCES

McDowell decided on a new plan of attack now that his forces were concentrated. This plan was to use one of his divisions, the First, to pin the main force of Confederates deployed along the Bull Run stream, while the remainder of his forces made a flanking manoeuvre to the east, turning the enemy's right flank. On 18 July, McDowell ordered the First Division under the command of Brigadier-General Daniel Tyler (1797–1882) to Centreville in preparation for the attack. Tyler was to occupy the town but avoid engaging the enemy.

McDowell, meanwhile, reconnoitred the roads and terrain in preparation for his flanking manoeuvre. From the beginning, things went wrong. McDowell discovered that neither the roads nor the terrain would allow him easily to turn the Confederate right, so he ordered the remaining divisions to follow Tyler to Centreville. As it happens, Tyler exceeded his orders and dispatched a brigade beyond Centreville to seize Blackburn's Ford, where Brigadier-General James Longstreet's (1821–1904) Virginians and Colonel Jubal Early's (1816–94) brigade soon engaged them. The Union troops were pushed back, causing considerable dismay among the other troops of Tyler's division.

Confused and frustrated, McDowell spent the next two days reorganizing his forces and drawing up another battle plan.

He decided to use Tyler's First Division, less the brigade that had been engaged on 18 July, for an advance against the Confederate forces along the Bull Run, focusing on the troops that held Stone Bridge. This was not to be the main attack, but rather a feint to hold the enemy's attention.

The main attack was to be a large flank march by Colonel David Hunter's (1802–86) Second Division and Colonel Samuel P Heintzelman's (1805–80) Third Division. They were to march to the northwest and appear on the Confederate left, crossing the Bull Run at Sudley Springs Ford and Poplar Ford.

Having crossed the Bull Run stream, they would then have been in a position to roll up the enemy's positions. The Fifth Division under Colonel Dixon Stansbury Miles (1804–62) was to serve as the attacking forces' reserve. McDowell's plan was sound but required a level of coordination more appropriate to the well-trained, disciplined troops of a Frederick

the Great or a Napoleon, not the green troops under his command.

While McDowell was planning, Beauregard began receiving his much-needed reinforcements. On 18 July, Johnston began marching his troops, screened by Colonel JEB 'Jeb' Stuart's (1833–64) cavalry regiment, to Piedmont, where they would embark on trains and then proceed to Manassas Junction. Unfortunately, a lack of railroad capacity meant that these troops would arrive over the course of three days. On 19 July, Brigadier-General Thomas Jackson (1824–63) and his five regiments of Virginians arrived, along with two regiments from Georgia under Brigadier-General Francis Bartow (1816–61). On the following day, three regiments from Brigadier-General Barnard Elliott Bee's (1824–61) brigade arrived along with Brigadier-General Johnston. Also on 19 July, Jeb Stuart's cavalry and the Confederate artillery arrived, after having

STUART'S CAVALRY

JEB Stuart earned the reputation as one of the most dashing cavalry commanders of the Civil War. But despite this reputation, gone were the days of the massed cavalry charges of the Napoleonic era. The reasons behind this were the relatively low ratio of cavalry serving in Civil War armies and the growing lethality of infantry firearms and artillery. The Manassas campaign shows how Stuart would use his cavalry throughout the war. He commanded all of the Confederate horsemen. These troopers screened the movement of General Johnston's troops as they disengaged in the Shenandoah Valley and moved to Manassas. During the battle itself, they made a charge on Henry House Hill to drive away Union infantry, thus exposing two Union batteries. After the battle, some of Stuart's cavalry were involved in pursuing the fleeing Union forces. The massing of Confederate cavalry under Stuart would allow him to make his famous raids later in the war, although his detachment sometimes worked against the Confederacy such as at the Battle of Gettysburg where he was effectively out of the battle.

marched from Winchester. A fourth brigade under Brigadier-General Edmund Kirby Smith (1824–93) would not arrive until the afternoon of 21 July, after battle had already been joined. Most of the reinforcements were initially posted on the Confederate right, where McDowell had intended to launch his earlier flanking attack.

THE BATTLE

In order for McDowell's plan to work, Tyler needed to begin moving his troops well before dawn, since his troops needed to move forward before the other divisions could move down the road for their flank march. Tyler was to have started at 2:30 a.m., but, perhaps overly cautious as a result of the affair at Blackburn's Ford, he moved more slowly, not getting under way until after 3:30 a.m. and not reaching his position near the Stone Bridge until nearly 6:00 a.m. This resulted in delaying the movements of Hunter's and Heintzelman's divisions.

As Tyler's troops reached the Stone Bridge, they skirmished with a small Confederate force under the command of Colonel Nathan George Evans (1824–68). Evans was suspicious that this large Union force did not press the attack when he learned from some of his troops posted as pickets, and from an officer stationed in the Signal Corps tower at Manassas Junction, that a large force of Union troops was moving to his left and preparing to cross the Bull Run at Sudley Springs Ford. Evans acted with initiative and, leaving a small force at the Stone Bridge, moved the majority of his troops, a regiment of South Carolinians and a battalion from Louisiana, to meet the new threat. Fortunately for Evans, the Union troops did not cross at 7:00 a.m. as planned, but nearly two hours later as a result of the delay from earlier that morning. Evans occupied a small hill, Matthews Hill, and vigorously engaged the Union troops of Hunter's division in a lengthy firefight, while the latter formed their battle lines. In the course of this engagement, Hunter, who had joined a regiment of Rhode Islanders, was wounded.

This allowed Beauregard, who saw how the Union attack was developing, to send reinforcements to the Confederate left, including the troops of Bee and Bartow, although they became more heavily engaged than was planned. These troops fought a desperate action for much of the morning, but the weight of numbers that favoured the Union forces began to tell and by midday the Confederates were compelled to retreat.

Fortunately, the Union forces did not press the attack, which allowed Jackson's troops, supported by artillery and, later, other units to occupy a new defensive position on Henry House Hill. This allowed the remnants of the troops from Matthews Hill to regroup. It was at this point that Bee, trying to rally his troops, pointed at the Virginians and told his men 'There stands Jackson like a stone wall', leading to the general's famous sobriquet of 'Stonewall' Jackson.

At about 1:30 p.m., the Union forces were finally able to begin their attack on Henry House Hill. It was a bloody affair, with both sides sending in reinforcements. Both sides were engaged in a fierce firefight and the Union used artillery at close range, although it would cost them two batteries as a result. The fight over the plateau had drawn virtually all of the troops from the Stone Bridge but Tyler never pressed the attack, contenting himself with occupying the

The First Battle of Manassas cost the Union nearly 2500 killed and wounded while the Confederacy suffered close to 2000 casualties. After such a battle, the field would have been a bleak place, with both the damage caused by the fighting and the bodies strewn about.

northern bank of the Bull Run. By mid-afternoon, the Union forces were in a position to use their superior numbers and turn the Confederate left when the last of the troops from Winchester arrived by train and marched directly into the fight. This prevented the Union flanking manoeuvre and when, at about 4:00 p.m., forces from the Confederate right joined them, the Union troops had finally had enough and broke. Once the retreat began, there was no hope of rallying the inexperienced Union regiments. The troops fled towards Washington, sweeping up picnickers who had stopped to watch the battle. An artillery round from a Confederate gun overturned a wagon on the bridge at Cubs Ford, leading to the abandonment of a number of Union artillery

pieces and wagons. Although, by now, there was virtually no organized resistance left, eight companies of US regulars were able to serve as a rearguard. In the event, it turned out that this was not really necessary. Although the Confederate forces had won the battle, they too were inexperienced and exhausted, and a pursuit would have been, most likely, a disaster for them. The First Battle of Manassas (also known as the First Battle of Bull Run) had been won because the Confederate commanders were better able to coordinate the movements of their troops than were their Union counterparts. While McDowell was plagued by delays and uncoordinated attacks, Beauregard and Johnston were able to move troops where they were needed at critical moments.

Monuments to fallen comrades quickly appeared on Civil War battlefields. The first monument raised at Manassas went up only six weeks after the battle. The monument depicted was erected after the war on 11 June 1865 at Henry House Hill and is ornamented with artillery shells. The inscription reads, 'In memory of the patriots who fell'.

FORT DONELSON
12–16 FEBRUARY 1862

CONTROL OF THE MAJOR RIVERS WAS AN IMPORTANT STRATEGIC OBJECTIVE IN THE CIVIL WAR. FORTS EQUIPPED WITH POWERFUL ARTILLERY COMMANDED THE RIVER PASSAGES AND HAD TO BE REMOVED BEFORE OPPOSITION FORCES COULD MAKE USE OF THE WATERWAY. MANY MAJOR OPERATIONS REVOLVED AROUND THESE FORTRESSES.

WHY DID IT HAPPEN?

WHO 27,000 Union troops under Brigadier-General Ulysses S Grant (1822–85) vs. 21,000 Confederates under Brigadier-General John B Floyd (1806–63).

WHAT Union forces surrounded the fort and probed the defences, prompting a Confederate breakout attempt.

WHERE Fort Donelson, on the Cumberland River in Tennessee.

WHEN 12–16 February 1862.

WHY Forts Donelson and Henry commanded the Cumberland and Tennessee Rivers, and provided the Confederacy with a secure base from which to threaten Kentucky. Union operations were launched to remove the Confederate presence.

OUTCOME The breakout was unsuccessful and the trapped Confederates were forced to surrender.

At the outset of the Civil War, not all states declared for either the Union or the Confederacy. One that remained undecided was Kentucky. Kentucky had the third-largest population of all the slave-owning states and held much in common with both sides. The state refused to furnish troops to assist the Union in putting down the Confederacy, but neither would it join the rebellion.

Internal politics were rather vigorous, with various parts of the state aligned with the two factions. Kentucky at first proclaimed strict neutrality, which was eminently acceptable to the Union. Lincoln (1809–65) himself believed that Kentucky would in time come over to the Union side. Whatever happened, he knew, Kentucky must not join the Confederacy.

Both sides thus courted Kentucky, and eventually matters came to a head. The state government declared for the Union, but large elements of the state forces went south to fight for the Confederacy. The state was contested by regular and irregular military forces and divided in its loyalty.

Confederate sympathizers formed their own provisional state government in December 1861, which then declared secession and was welcomed into the

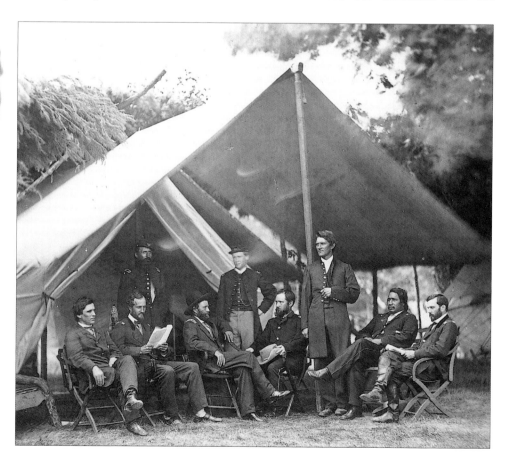

Rather than a professional military staff, General Grant gathered a select group of men he knew and trusted from civilian life. None had military experience but they worked well together and served Grant admirably.

Confederate States of America. The Union could not tolerate this situation. Kentucky was necessary to both sides and might swing either way. The obvious answer was to demonstrate control of the state by chasing the Confederate field armies out, so in the winter of 1861–62 the Union advanced through Kentucky and pushed the rebels southwards.

By the beginning of 1862, the main Confederate threat to Kentucky was represented by Fort Donelson and Fort Henry, on the Cumberland and Tennessee rivers respectively. These forts would provide a base for rebel forces advancing to renew the campaign for Kentucky and in addition commanded their respective waterways. Union strategy called for an advance down the Mississippi to split the Confederacy in two, but the tributaries had to be cleared first – including the Cumberland and Tennessee.

Thus the elimination of the Confederate presence at Henry and Donelson served two purposes: political and strategic. The job was given to a commander who was relatively unknown at the time – Brigadier-General Ulysses S Grant.

On 6 February 1862, General Grant attacked Fort Henry. His plan was to advance with two divisions overland while gunboats under Flag Officer Andrew H Foote (1806–63) covered the attack by bombarding the fort.

In the event, things went better than Grant could have hoped. The Tennessee River was rising, and the fort turned out to be badly sited. As the floodwaters inundated the fort and the gunboats approached, the fort commander, Brigadier-General Lloyd Tilghman (1816–63), was forced to surrender. Thus Grant took possession of the first fort without his army having to fire a shot. He would not have it so easy at Fort Donelson, however.

GRANT ADVANCES

As Grant marched overland towards Fort Donelson, the Confederate position was not good. The fort was a strategic asset but in order to defend it, it would be necessary

to funnel in more troops than could be spared. If the Confederate Army was defeated at Fort Donelson, it might mean the loss of central Tennessee, including the armament factories at Nashville.

Nevertheless, the decision was made to fight for the fort. Twelve thousand troops marched quickly up to reinforce the 5000 already there, and additional forces deployed in Kentucky were pulled back to bring the force at Fort Donelson up to about 21,000. Command was offered to Lieutenant-General PGT Beauregard (1818–93), who had taken charge of the operation against Port Sumter. Beauregard was ill at the time, so Brigadier-General John B Floyd was appointed instead.

UNION SOLDIER

As a rule, Federal troops were better and more uniformly equipped than their Confederate adversaries. However, everybody empowered to raise troops was permitted to equip them as it saw fit. Uniforms and even armament varied considerably according to fashion, availability and opinion as to what was best. As a result, some Union troops wore grey and some Confederate units went to war in blue.

Many soldiers privately obtained extra equipment, such as revolvers, hand weapons, extra clothing and even a form of primitive body armour. Most of this extraneous gear was discarded early in the unit's first march, and a measure of uniformity was quickly established out of necessity. Experienced troops carried only what they needed – rifle, ammunition and bayonet, plus a basic mess kit, blanket and a few personal items.

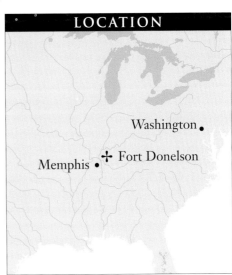

LOCATION

In the vast North American interior, rivers provided a route for resupply and troop movement. Many of the battles of the Civil War were fought over control of a river. The Battle of Fort Donelson was no exception.

39

FORT DONELSON

Floyd was a politician rather than a career officer, as were many commanders on both sides. Despite having just come from a less than inspiring stint with the Army of Northern Virginia, he was senior, so command passed to him. There were serious doubts in the Confederate command as to whether Donelson was defensible, especially after the disaster at Fort Henry.

There were also doubts on the Union side. Major-General Henry Halleck (1815–72), the theatre commander, considered Grant to be something of a loose cannon and was unsure as to whether Fort Donelson could be taken. The clash of personalities played a part in the campaign; Grant was determined to achieve as much as he could before Halleck lost his nerve, which Grant thought was likely if he took too long or suffered any real setbacks.

Grant initially thought that he could reach and capture Fort Donelson, then return to Fort Henry, all by 8 February. With only 18km (12 miles) between the two, it seemed feasible. However, bad weather slowed the operation down. Grant was not ready to commence hostilities against Donelson until 12 February.

On the eve of battle, Grant held a council of war, as was fashionable at the time. All but one of his generals agreed with the plan, and Grant was determined to press ahead. Such councils were most common when a commander was unsure of his own judgment, and it is significant that this was the last one that Grant held.

THE FIRST DAY

Grant had about 15,000 men under his command at this point, with reinforcements coming up. In addition to the two divisions deployed at Fort Henry, Grant was forming a third as the units to create it came in. He also had eight batteries of artillery and two regiments of cavalry available.

Opposite Grant's force, the Confederates had created a semicircular defensive position with Fort Donelson and the town of Dover at the corners. The position backed onto the Cumberland River. The Confederate forces included nine batteries of field artillery and a heavy artillery battery that commanded the river. There were also

Union naval officer Andrew H Foote later in life. Foote was highly commended for his brave and successful attack on Fort Henry, in the run-up to the encounter at Fort Donelson.

three cavalry regiments under Colonel Nathan Bedford Forrest (1821–77).

The Confederate position was fairly strong, with the fort situated some 30m (100ft) above the level of the river and the infantry entrenched on a ridge, with their position improved by obstacles placed to impede an assault.

Much of the first day was spent by the Union force in reaching the field and getting into position. Forrest's cavalry

brigade harassed the deployment, causing delay. The Southern cavalry were highly skilled in the traditional screening role, and carried it out well. All the signs were that Floyd was going to make an aggressive defence of the fort. The first of the Union gunboats arrived during the day and exchanged fire with Fort Donelson for a time before withdrawing. Grant himself established his headquarters and assessed the situation, laying his plans for the

coming battle, which by now, he knew, would not be a walkover like Fort Henry.

THE SECOND DAY

Grant wanted detailed reconnaissance of the enemy positions and, contrary to his reckless reputation, gave orders for probing attacks only. No general engagement was to be initiated. The first probe was to be made by two brigades on the Union left. After some skirmishing, this attack stalled, degenerating

In this painting, Confederate cavalry under the command of Colonel Nathan Bedford Forrest gallop through woods near Fort Donelson.

FORT DONELSON

A recent invention, the Parrott gun was a rifled muzzle-loader. The commonest version was a 10-pounder with superior range and accuracy to the smoothbore 12-pound 'Napoleon'. Heavier guns were also built.

into a steady exchange of fire between troops remaining carefully under cover.

However, on the Union right, Brigadier-General John A McClernand (1812–1900), the only one of Grant's commanders to disagree about the attack, launched his own assault without orders. This was aimed at removing an artillery battery that was irritating McClernand's force. The attack was a confused affair involving three regiments from two different brigades, and it was not made clear to the officers involved who was in overall command.

The resulting chaos robbed the attack of any chance it might have had, and the three regiments were halted well short of their objective by intense fire. Casualties were heavy, and many of the wounded who might otherwise have survived perished when the grass they lay in caught fire.

The second day ended with a blizzard. Many of Grant's troops lacked coats or blankets due to supply issues on the march, and campfires could not be built as they highlighted soldiers for enemy marksmen.

THE THIRD DAY

During the bitter night of 13/14 February, Floyd held his own council of war, which came to the consensus that the fort could not be held. The forces trapped within the defensive line were vital to the defence of Tennessee, and in particular Nashville, and must be preserved. The only option was to break out and escape.

Brigadier-General Gideon J Pillow (1806–78) was given the task of leading the breakout from Donelson. An aggressive

fighting commander, Pillow was a good choice but the operation was delayed when a Union sharpshooter killed one of Pillow's aides close to him. Pillow may or may not have panicked, but in any case he concluded that the enemy was aware of the imminent operation, ensuring its failure. He postponed the breakout, to Floyd's annoyance.

The day dawned and the pattern of sniping and probing continued until midday, when another Union brigade arrived overland. Shortly afterwards, more gunboats came up, along with several thousand more Union soldiers aboard steamers. This was precisely the sort of development that the riverine forts were supposed to prevent.

Foote's gunboats went in to attack the fort at about 3:00 p.m. This time, however, things were different from how they had been at Fort Henry. Heavy artillery including 10 32-pounder smoothbores and two rifled cannon opened up at a range of about 480m (525 yards), pounding the Union gunboats. The fight was short, with the four Union boats taking about 170 hits between them. Two were disabled and all were damaged. There were three more boats available but these were 'timberclads', armoured more lightly (with thick timbers rather than iron) and even less able to withstand the devastating fire from the fort.

Grant realized that the naval assault was not going to work this time, and weighing up the odds he concluded that a land attack was not guaranteed to succeed either. He informed his superior, Halleck, that a siege might be necessary.

Armies have always foraged on the march, and here Grant's men appear to have located furniture rather than food. It seems likely that these benches were 'borrowed' from a small town's church or school.

THE OPPOSED FORCES

FEDERAL
 riverine force comprising:
 – 4 ironclads
 – 3 timberclad gunboats
 Total: **27,000**

CONFEDERATE
 fortress artillery and troops
 Total: **21,000**

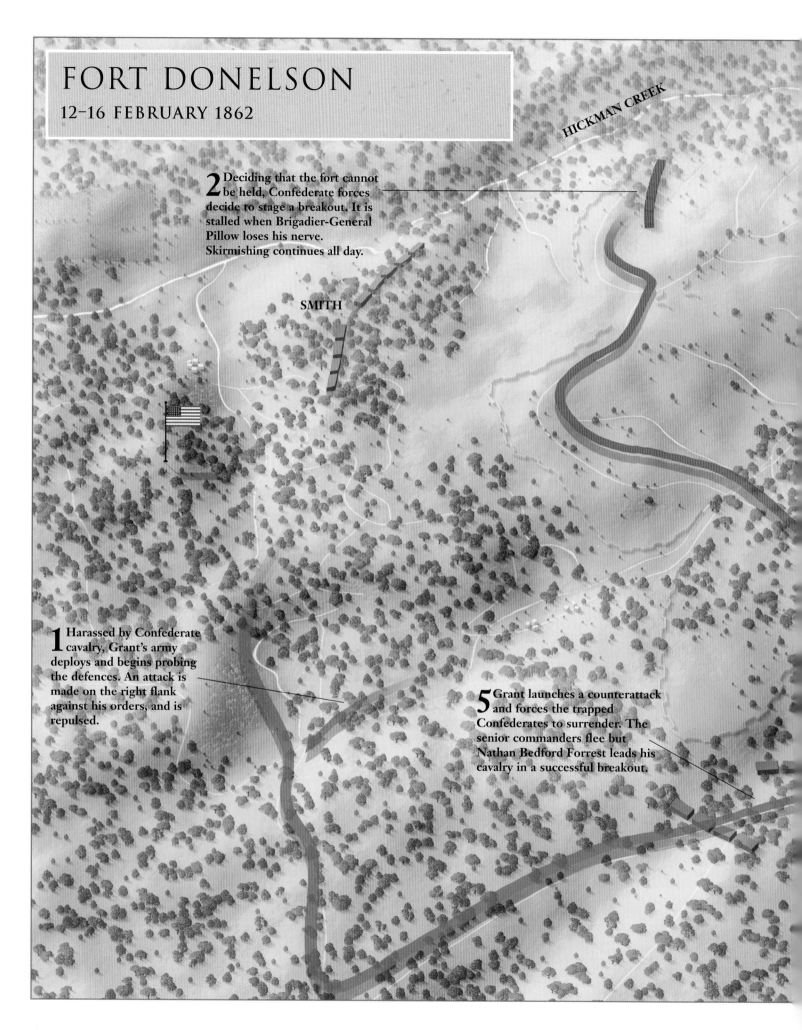

FORT DONELSON
12–16 FEBRUARY 1862

HICKMAN CREEK

2 Deciding that the fort cannot be held, Confederate forces decide to stage a breakout. It is stalled when Brigadier-General Pillow loses his nerve. Skirmishing continues all day.

SMITH

1 Harassed by Confederate cavalry, Grant's army deploys and begins probing the defences. An attack is made on the right flank against his orders, and is repulsed.

5 Grant launches a counterattack and forces the trapped Confederates to surrender. The senior commanders flee but Nathan Bedford Forrest leads his cavalry in a successful breakout.

FORT DONELSON

INDIAN CREEK

CUMBERLAND RIVER

DOVER

BUCKNER

PILLOW

WALLACE

3 A second breakout is launched, led by Pillow and supported by the cavalry. Catching the Union commanders off guard it is successful at first.

4 Union reinforcements trying to plug the gap are initially driven off but the breakout is gradually fought to a standstill. Although an escape route now exists the Confederates pull back to regroup.

45

This illustration shows a typical entrenchment of the period. Well-prepared entrenchments would include such features as a headlog resting on top of blocks, with a firing slit beneath, a firing step, and supported trench walls.

THE FOURTH DAY

After another council of war, Floyd decided that his breakout plan was still the only viable option. Pillow was again detailed to lead it, and this time the assault went ahead.

At first light on 15 February, the Confederates came storming out of their positions and fell on McClernand's division at the right-hand end of the Union line. The foul weather actually worked to the Union troops' advantage; it was so cold that many men were awake trying to keep warm. Thus rather than a few sleepy sentries, Pillow's men were opposed by a larger number of wakeful, if chilled, troops.

Grant himself was caught off guard. Not expecting any real activity among the defenders, he had gone to visit the naval commander and, as the attack opened, was aboard Foote's flagship.

The Confederate attack achieved considerable success in the first two hours. Supported by Forrest's cavalry, who fought dismounted as often as not, Pillow's division pushed McClernand's back and aside, opening up a gap to escape through. The Union forces fell back in reasonably good order but they were under severe pressure.

McClernand knew he was in trouble and sent for help. But Grant had failed to delegate command to anyone in his absence and, without his authority, Brigadier-General Lew Wallace (1827–1905), commanding the newly formed Third Division, was reluctant to respond.

Things became steadily worse for the right flank. Ready ammunition was running out, and there was no resupply available. The previously orderly fighting retreat was beginning to crumble. McClernand sent a second messenger to Wallace, with a desperate entreaty for help, any sort of help – and soon. Wallace finally responded, shifting two brigades across to bolster the right. However, they were quickly flanked and forced back.

The Confederates were also suffering command problems. Seeing the Union flank turned, Forrest pushed for a headlong general assault, but all he got was a measured advance. Meanwhile, Pillow had realized that Brigadier-General Simon Bolivar Buckner's (1823–1914) division was not attacking. He demanded support, which

In this stylized illustration, Union troops attempt to storm a heavily defended Confederate redoubt at the Battle of Fort Donelson.

resulted in an exchange of hot words before Buckner finally got moving.

Buckner's division joined Pillow's and drove the Federal troops back, but the advance was slowing. McClernand's division was in disarray but enough of Wallace's men were engaged that a defensive line of sorts could be formed, and this bought McClernand some time to re-form his units. After three assaults on the Union line, the Confederates pulled back somewhat to regroup. This was about 12:30 p.m. The trap had been forced open, however. It was now possible to break out and escape.

About 30 minutes later Grant reached Wallace's headquarters, having been summoned from his conference with Foote. His command was in chaos, but Grant quickly took charge. First he sent a messenger to Foote, ordering him to advance with his gunboats and make as much noise as possible. Grant hoped the sounds of naval gunfire would encourage his wavering men. The Union commander also learned that some of the Confederate troops were carrying knapsacks, and correctly deduced that this was a breakout attempt rather than an attempt to win the battle. He began planning an attack, and the opposition obliged by handing him a splendid opportunity.

Despite the fact that he had opened the way for a breakout, Pillow did not exploit it. Instead, he was determined to regroup his force and bring up supplies before marching out. For some reason he concluded that this was best done in his original positions, and withdrew his division to their trenches. Floyd, in overall command of the Confederate force, decided to pull his entire command back in.

Grant ordered Brigadier-General Charles F Smith (1807–62), commanding the Union Second Division, unengaged on the left flank, to make the decisive attack. His orders were to do no less than take Fort Donelson, and Smith began an advance with two brigades. A lone regiment of Tennessee infantry attempted to resist the assault but was pushed out of its positions. Smith consolidated his gains and beat off several counterattacks late in the day.

Meanwhile, Wallace had managed to re-form some units and, with three brigades (one from each division), he began to advance. Wallace's force was able to advance back to more or less where McClernand had started the day.

THE FINAL DAY

The night of 15/16 February was marked by another snowstorm, which killed many of the wounded. Although Grant had not actually plugged the gap that Pillow had made in his lines and the way was open for

Brigadier-General Lew Wallace commanded the newly formed Third Division at the Battle of Fort Donelson.

a Confederate breakout, he had decided to attack again in the morning. Meanwhile, Pillow and Floyd were congratulating one another and sending telegraphs to Nashville with news of a victory.

Sanity returned to the Confederate camp, assisted by Buckner, who gloomily informed Floyd that he could not hope to stop a renewed assault for even an hour. Sanity was then quickly displaced by defeatism, and Floyd turned over command

to Pillow. Floyd was wanted in the Union for corruption and supporting secession, and so feared capture.

UNCONDITIONAL SURRENDER

Pillow did not like the prospect of capture any better than his superior. Turning over command to Buckner, he escaped across the river in a small boat. Floyd's departure was a little more honourable, in that he left aboard a steamer with two regiments of

Union troops advance against prepared Confederate positions dimly seen through the smoke of battle. Casualties in an assault were always high, even before the attacking troops reached the enemy line.

troops and could, at least, pretend to have been trying to salvage something from the defeat rather than blatantly fleeing. Colonel Forrest was unimpressed by these less than heroic gestures and led his surviving cavalry in a successful breakout.

Buckner sent a note to Grant asking for surrender terms. The two had served together in happier times, but Grant was not inclined to be merciful. He demanded full surrender, and thus gained his nickname of 'Unconditional Surrender' Grant. Buckner knew he had no option. Smith was established within the Confederate position and ready to make an assault that Buckner knew he could not stop. Able to do nothing more than protest Grant's hard line, Buckner surrendered his command, ending the Battle of Fort Donelson.

AFTERMATH

The Battle of Fort Donelson cost Grant almost 3000 casualties. The Confederates lost 2000 killed and wounded. However, the defeat at Donelson was particularly costly to the Confederacy, as the Confederate Army was not merely routed; more than 12,000 men became prisoners and were lost to the war effort. This led to an inability to defend Tennessee properly and a retreat southwards that would eventually lead to the bloody clash at Shiloh. Nashville, with its arms factories and transport hub, was abandoned at the end of the month.

The Union could now begin the long drive down the Mississippi but, more importantly, the Confederate threat to Kentucky was gone and most of Tennessee would soon be under Federal control.

As the Civil War went on, procedures for locating casualties and bringing them to aid stations were implemented. Were this grisly but necessary task not undertaken, men who might well fight again would often die on the battlefield, sometimes days after the fighting ended.

KERNSTOWN
23 MARCH 1862

VIRGINIA'S SHENANDOAH VALLEY WAS CRITICAL TO THE CONFEDERACY BOTH AS AN AGRICULTURAL BREADBASKET AND AS A POTENTIAL INVASION ROUTE INTO THE NORTH. IN THE SPRING OF 1862, MAJOR-GENERAL THOMAS 'STONEWALL' JACKSON CONDUCTED A BRILLIANT CAMPAIGN THERE, USING SUPERIOR STRATEGY AND HARD MARCHING TO DEFEAT A MUCH LARGER FEDERAL FOE.

WHY DID IT HAPPEN?

WHO Confederate forces under Major-General Thomas 'Stonewall' Jackson (1824–63) battled the much larger Federal forces of Major-Generals Banks, Shields and Fremont.

WHAT Jackson defeated the Federals in a series of battles, including Kernstown (23 March), McDowell (8 May), Front Royal (23 May), Cross Keys (8 June) and Port Republic (9 June).

WHERE The Shenandoah Valley, Virginia.

WHEN March to June 1862.

WHY Jackson used interior lines and hard marching to defeat the uncoordinated Federal armies.

OUTCOME Jackson's success caused President Lincoln (1809–65) such concern for the safety of Washington that he withheld troops earmarked for Major-General George B McClellan's (1826–85) Peninsula Campaign.

From the very beginning of McClellan's planning for an operation on the Virginia Peninsula, events in the Shenandoah Valley had been of great importance. Terminating on the Potomac River just 48km (30 miles) northwest of Washington, the Valley represented a potential Confederate avenue of approach into the Federal capital.

President Abraham Lincoln had demanded that McClellan leave an adequate force behind to guarantee Washington's safety. Pursuant to this requirement, McClellan issued instructions to Major-General Nathaniel Banks (1816–94) on 16 March 1862, ordering him to 'open your communications with the valley of the Shenandoah. As soon as the Manassas Gap Railway is in running order, intrench a

brigade of infantry, say four regiments, with two batteries, at or near the point where the railway crosses the Shenandoah. Something like two regiments of cavalry should be left in the vicinity to occupy Winchester and thoroughly scour the country south of the railway and up the Shenandoah Valley. The general object is to cover the line of the Potomac and Washington.'

In reality, the defensive-minded General Joseph E Johnston (1807–91) was certainly not contemplating a Confederate offensive against Washington. He was beginning to feel very vulnerable with his position at Manassas, especially since the coming warm spring weather would dry the roads and make it possible for McClellan to attack with superior numbers. Johnston had no intention of waiting around long enough for

Few locations saw more of the Civil War than the Shenandoah Valley town of Winchester, Virginia. Three battles were fought there and formal possession of the town went back and forth between Federals and Confederates 14 times.

this to happen. On 7 March, he ordered all of his troops east of the Blue Ridge Mountains, some 42,000 effectives, to withdraw to the Rappahannock River, nearly half the distance to Richmond. Only Jackson's 5400 men would remain in the Shenandoah Valley to threaten the right flank of any Federal advance.

Unaware of McClellan's plans for an amphibious turning movement, Johnston expected the Federals to march directly south to Richmond. Accordingly, he ordered Jackson's Valley Army to fall back in line with the main army, protect its flank, secure the Blue Ridge passes and slow or stop enemy progress up the Shenandoah. Of greatest importance was the fact that Johnston needed Jackson to prevent Banks from reinforcing McClellan. Johnston could not have expected much from Jackson's small Valley Army. As it turned out, the Shenandoah Valley Campaign would be nothing short of a masterpiece.

KERNSTOWN

When McClellan learned of Johnston's withdrawal, he ordered his armies to push forward on all fronts. Cautiously, Banks and his 38,000 men moved up the Valley and occupied Winchester on 12 March, only to find that Jackson had departed the previous day. Jackson had fallen back to Mount Jackson, 56km (35 miles) to the south, where he learned from Colonel Turner Ashby's (1828–62) cavalry reports that part of Banks's army was preparing to head east to reinforce McClellan as he prepared to embark on his Peninsula Campaign. Indeed, on 20 March, Brigadier-General Alpheus Williams (1810–78) and his 7000 men had started for Manassas and Brigadier-General James Shields's (1810–79) 9000-man division had dropped back from Strasburg and was prepared to follow.

Jackson's mission was to hold Banks in place, so the Confederate began hurrying his forces north. In the meantime, Ashby's troopers clashed with Shields's pickets just south of Winchester on 22 March. Shields was wounded in the fighting, but he developed a solid plan before he left the

field. He ordered part of his division to move south of Winchester during the night, and another brigade to march north, to give the appearance of abandoning Winchester. However, that brigade would then halt and remain ready to return when Jackson approached. That same night, Confederate loyalists from Winchester mistakenly told Ashby that Shields had left only a four-regiment rearguard and even these were under orders to depart for Harpers Ferry the next day.

At about 2:00 p.m. on 23 March, Jackson rode into Kernstown, 6km (4 miles) south of Winchester, where Ashby told him the good news. Jackson was faced with a dilemma. His men were tired from marching 40km (25 miles) on 22 March and a further 26km (16 miles) on 23 March. Already some 1500 stragglers trailed behind. Even more

LAMAR RIFLES

The spirit of volunteerism ran high in the early days of the Civil War, especially as both Federals and Confederates anticipated a short war. As part of this initial surge of fervour, the 11th Mississippi Regiment was formed at Corinth on 4 May. It consisted of 10 companies from the northern portion of Mississippi, including the University of Mississippi. University Chancellor FAP Barnard (1809–89), with the endorsement of Confederate President Jefferson Davis (1808–89), pleaded with the parents of his students not to send them into military service, but to no avail. Students from the University of Mississippi comprised most of the 11th Mississippi's Company A, the University Greys, and part of Company G, the Lamar Rifles. This loss of students and faculty to the war effort forced the University of Mississippi to close.

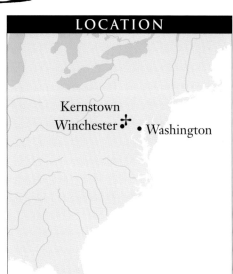

LOCATION

Kernstown

Winchester ✛ • Washington

Geography gave the Shenandoah Valley great military significance. Its southwest to northeast direction made it an ideal Confederate invasion avenue into the Federal capital in Washington.

Between March and June 1862, Major-General Thomas 'Stonewall' Jackson led his 'foot cavalry' to victory over numerically superior but uncoordinated Federal armies in several battles.

THE OPPOSED FORCES

FEDERAL
Total: 60,000

CONFEDERATE
Total: 16,000
(under Jackson)

distressing to Jackson was the fact it was a Sunday. Traditionally, the pious Jackson rigorously adhered to the Sabbath – even considering government mail delivery on Sunday to be a violation of Divine Law and urging Congress to end such activity.

On the other hand, Jackson had a fleeting opportunity to defeat an isolated part of the Federal Army. He could not wait a day and still accomplish his mission of holding Banks in place. Although the decision distressed him, Jackson attacked Shields at Kernstown on Sunday, 23 March. He explained to his wife, Anna, who was also troubled by the action: 'You appear much concerned at my attacking on Sunday. I was greatly concerned too, but I felt it my duty to do it, in consideration of the ruinous effects that might result from postponing the battle until morning. So far as I can see, my course was a wise one; the best that I could do under the circumstances, though very distasteful to my feelings; and I hope and pray to our Heavenly Father that I may never again be circumstanced on that day.'

In fact, Kernstown was a tactical defeat for Jackson in which he suffered 718 casualties compared to 568 Federal losses. Against far superior numbers, the Confederates ultimately ran low on ammunition and were forced to withdraw 7km (4.5 miles) south to Newtown.

Strategically, however, Kernstown was a huge Confederate victory. Jackson's presence and aggressive action caused the Federal authorities to halt plans to shift forces to McClellan. Instead, Banks was held in place, Brigadier-General Louis Blenker's (1812–63) division was withdrawn from McClellan and sent to oppose Jackson, and Major-General Irvin McDowell's (1818–85) First Corps was withheld from McClellan. The Federals then established three separate and independent commands: the Department of the Rappahannock, under McDowell; the Department of the Shenandoah, under Banks; and the Mountain Department, under Major-General John Fremont (1813–90). These three commanders reported directly to

Washington, and no general on the scene was charged with synchronizing their operations. This uncoordinated command structure would ultimately contribute to Jackson's success.

GREATER POSSIBILITIES

In April, Major-General Richard S Ewell (1817–72) arrived to reinforce Jackson with 8500 men. Jackson also received permission to use Brigadier-General Edward 'Allegheny' Johnson's (1816–73) small division, which brought Jackson's total strength to 17,000. Jackson left Ewell to hold Banks in place, while Jackson, keeping his own plans secret even from his subordinates, went on the move.

As President Jefferson Davis' military advisor, General Robert E Lee (1807–70) had already seen an opportunity to use Jackson in the Valley to threaten McClellan's plans for the Peninsula. On 21 April, Lee wrote to Jackson: 'I have no doubt an attempt will be made to occupy Fredericksburg and use it as a base of

Brigadier-General Alpheus Williams commanded a division under Major-General Nathaniel Banks, whose brief was to safeguard Washington during Major-General George B McClellan's Peninsula Campaign of 1862.

operations against Richmond. Our present force there is very small.… If you can use General Ewell's division in an attack on General Banks and drive him back, it will prove a great relief to the pressure on Fredericksburg.' While Lee was trying to buy time to concentrate forces on the

Peninsula, the immediate Confederate response to McClellan's Peninsula Campaign was actually Jackson's effort in the Valley.

Banks thought Jackson was headed for Richmond, but on 8 May Jackson suddenly appeared at McDowell, 51.5km (32 miles) west of Stanton. There, he defeated the 6000 Federals commanded by Fremont. Jackson knew Fremont's army was closing in from the Allegheny Mountains, west of the Shenandoah Valley, and a junction between Fremont and Banks would have been disastrous to Jackson. Instead, the victory secured Jackson's left flank, and he then hurried back into the Valley to join Ewell for a concentrated effort against Banks.

By mid-May, part of Banks's army was again preparing to depart to join McClellan

In 1857 the United States Army fielded a new 12-pounder gun-howitzer. This multipurpose piece was designed to replace existing guns and howitzers. It could fire canister and shell like the 12-pounder howitzer and solid shot at an effective range of 1535m (1680 yards) like the 12-pounder gun.

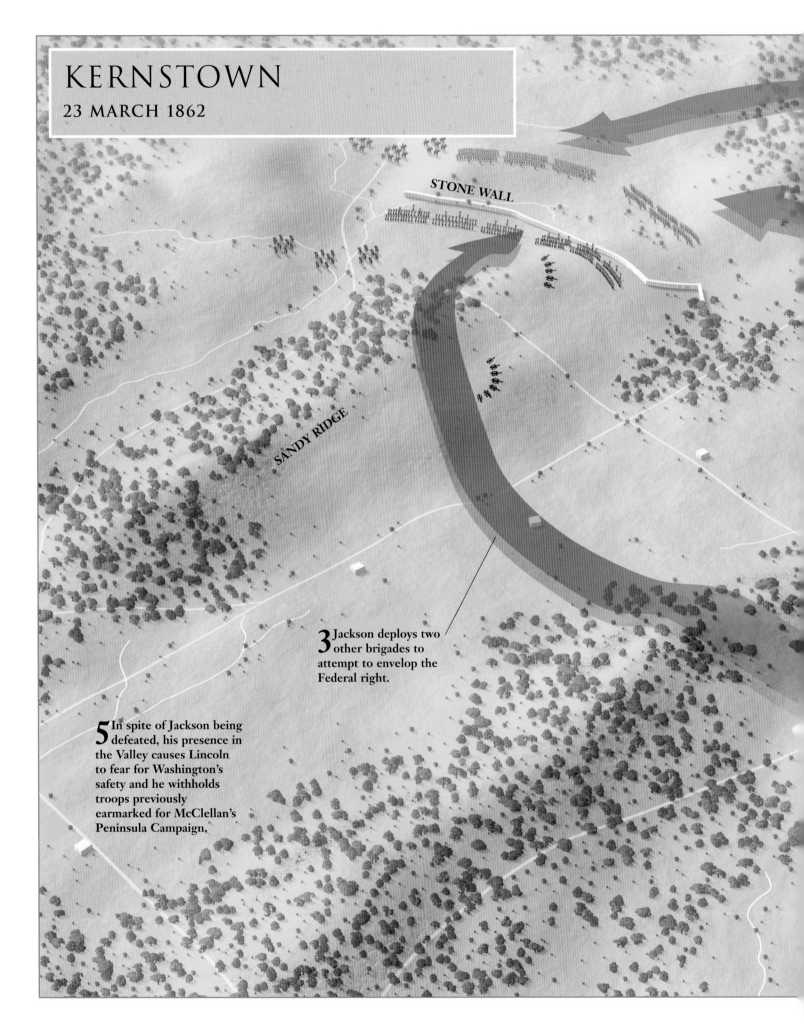

KERNSTOWN

23 MARCH 1862

STONE WALL

SANDY RIDGE

3 Jackson deploys two other brigades to attempt to envelop the Federal right.

5 In spite of Jackson being defeated, his presence in the Valley causes Lincoln to fear for Washington's safety and he withholds troops previously earmarked for McClellan's Peninsula Campaign.

4 The Federals counter Jackson's attempted envelopment and hand the Confederates a tactical defeat.

1 On 22 March Confederate cavalry clash with Shields's pickets just south of Winchester. Shields orders part of his division to move south of Winchester during the night and another brigade to move north to Kernstown to give the appearance of abandoning Winchester.

KERNSTOWN

2 On 23 March at 2:00 p.m., Jackson rides into Kernstown and meets Ashby. Jackson reinforces Ashby with one brigade.

KERNSTOWN

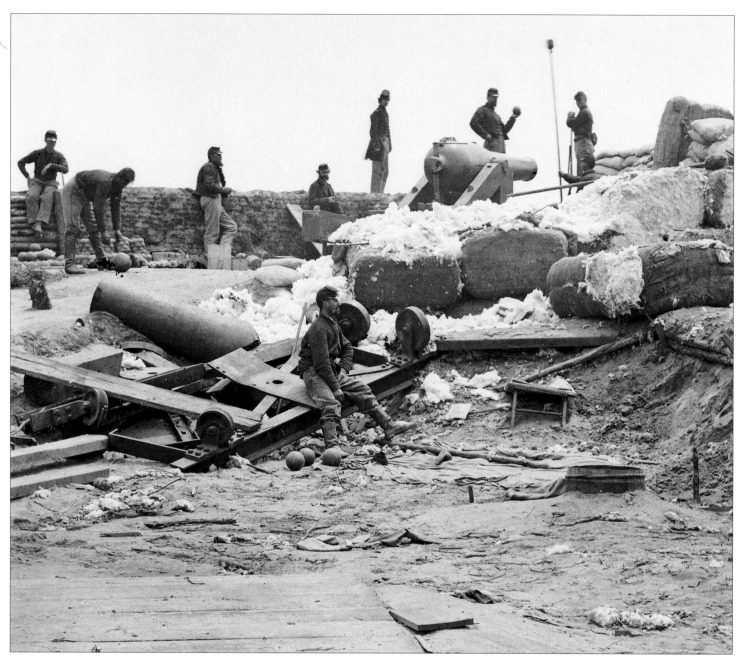

Yorktown before the evacuation. Brilliant in its own right, the larger significance of Jackson's Shenandoah Valley Campaign lay in the effect it had on diverting resources from McClellan's Peninsula Campaign.

outside Richmond. Jackson used a cavalry screen to make Banks think Jackson was headed toward Strasburg. Instead, the Confederate general turned unexpectedly across the Massanuttens, joined with Ewell at Luray, and with their combined 16,000 men struck the unsuspecting 1000 Federals at Front Royal on 23 May. Jackson tore through the town and the Federals fled towards Strasburg. Then Banks and Jackson began a race to Winchester. On 25 May, the two armies collided in what became another victory for Jackson.

EFFECT ON THE PENINSULA

These events were occurring right as General McClellan's efforts were beginning

to bear fruit on the Peninsula, with the Confederates evacuating Yorktown on 3 May, withdrawing towards Richmond and, in the process, abandoning Norfolk. On 18 May, McClellan had received a telegram from Secretary of War Edwin Stanton (1814–69) announcing that McDowell's First Corps would be marching from Fredericksburg, where it had been held previously for fear of Washington's safety, and would soon join him. But Jackson's success in the Valley was beginning to have a much broader impact. President Lincoln, who had never been comfortable with McClellan's provisions for Washington's safety, was now seriously worried. On 24 May, Lincoln telegraphed

KERNSTOWN

McClellan: 'In consequence of Gen. Banks' critical position I have been compelled to suspend Gen. McDowell's movement to join you.'

McClellan complained that 'the object of Jackson's movement was probably to prevent reinforcements being sent to me' rather than to attack Washington. McDowell agreed, stating that 'It is impossible that Jackson can have been largely reinforced. He is merely creating a diversion and the surest way to bring him from the lower valley is for me to move rapidly on Richmond.' Such arguments failed to convince Lincoln, and the order stood. Disgustedly, McDowell lamented: 'If the enemy can succeed so readily in disconcerting all our plans by alarming us first at one point then at another, he will paralyze a larger force with a very small one.' This is exactly what Jackson had succeeded in doing.

At first Jackson's operations had caught the authorities in Washington off guard. Now Lincoln and Stanton became obsessed with the idea of trapping Jackson. They ordered McDowell and his 40,000-man corps to join Fremont's at Strasburg. At the beginning of June, Banks, Fremont and Shields began converging on Jackson from the west, north and east in the hopes of bagging him at Strasburg.

To take full advantage of his central position in the Shenandoah Valley, Jackson had developed an excellent routine for his marches. His men would march for 50

In the Shenandoah Valley, 'Stonewall' Jackson faced vastly superior Federal armies commanded by Nathaniel Banks (shown here), Irvin McDowell and John Fremont. Each of these three officers operated independently, which hindered Federal unity of effort.

minutes, halt for a 10-minute rest, and then resume the march. At midday, they would have an hour for lunch. The role of the chain of command was clearly articulated: 'Brigade commanders will see that the foregoing rules are strictly adhered to, and for this purpose will, from time to time, allow his command to move by him, so as to verify its condition. He will also designate one of his staff officers to do the same at such times as he may deem necessary.' This strict regime and the accompanying results caused Jackson's command to become known as the 'foot cavalry'.

Now Jackson employed these techniques to march his men 80.5km (50 miles) in two days to escape the Federal trap closing in on Strasburg and then fell back to Harrisonburg. Fremont and Shields pursued on parallel roads that would eventually meet at Port Republic. Jackson positioned Ewell 6km (4 miles) to the northwest at Cross Keys and stationed his own men on the rolling hills of Port Republic.

Ewell selected a line astride the Port Republic Road on a high, wooded ridge. At 9:00 a.m. on 8 June, Fremont's men, advancing down Port Republic Road, met Ewell's pickets. Fremont launched a weak

Although a tactical defeat for the Confederates, Kernstown was a strategic victory because Jackson's presence and aggressive action caused Lincoln to fear for the security of Washington.

attack against Ewell's right flank, but was easily repulsed. Casualties on both sides were light, with Ewell losing 288 and Fremont 684, but Fremont withdrew from the field. Ewell left a few men to watch Fremont and then withdrew during the night to assist Jackson at Port Republic.

There, Jackson was in a close fight with Shields, but Ewell arrived just in time to turn the tide. Fremont could hear the fighting and took up the pursuit, but Ewell's rearguard had burned the bridge that Fremont needed to cross. Fremont could only watch as Jackson and Ewell defeated Shields and forced him to withdraw.

Jackson's victory at Port Republic was the climax of the Valley Campaign. He had defeated portions of four Federal armies totalling over 60,000 men. In the process he was changing events on the Peninsula as well. When Lee replaced Johnston, the new commander of the Army of Northern Virginia took advantage of the opportunity created by Jackson's success in the Valley. On 8 June, Lee wrote to Jackson: 'Should there be nothing requiring your attention in the valley so as to prevent your leaving it for a few days, and you can make arrangements

Opposite: Surrounded by his staff, Thomas 'Stonewall' Jackson is saluted by his men during the Shenandoah Valley campaign. Jackson had previously served with distinction in the Mexican War (1846–48).

to deceive the enemy and impress him with the idea of your presence, please let me know, that you may unite at the decisive movement with the army near Richmond.'

Three days later, Lee further explained that Jackson would 'sweep down between the Chickahominy and Pamunkey, cutting up the enemy's communications, etc., while this army attacks General McClellan in front. He will thus, I think, be forced to come out of his intrenchments where he is strongly posted on the Chickahominy and preparing to move by gradual approaches on Richmond.'

'The sooner you unite with this army the better,' Lee told Jackson on 16 June. Jackson's Valley Campaign had been the Confederates' first response to McClellan's offensive by diverting Federal resources from the Peninsula. Now Jackson's success would allow him to join Lee, giving him the numbers he needed to go on the offensive.

Until the advent of breech-loading rifles, loading from the prone was a slow and difficult process. Early breech-loaders were technically unsatisfactory because gas and flame escaped from the breech. Eventually, however, a good breech-loader, the Sharps, was developed at Harpers Ferry.

SHILOH
6–7 APRIL 1862

GENERAL ALBERT SIDNEY JOHNSTON'S ATTACK AT SHILOH WAS A CHANCE TO CRUSH A UNION FORCE BEFORE THE ARMIES OF THE OHIO AND TENNESSEE COULD EFFECT A JUNCTION. ONCE THESE FORCES COMBINED, THE REBELS WOULD BE AT A SIGNIFICANT NUMERICAL DISADVANTAGE. FAILURE TO WIN AT SHILOH RESULTED IN THIS HAPPENING ANYWAY AND, THEREAFTER, THE CONFEDERACY WAS ON THE DEFENSIVE IN THE WEST

WHY DID IT HAPPEN?

WHO Union Army of the Tennessee under Major-General Ulysses S Grant (1822–85) and Union Army of the Ohio under Brigadier-General Don Carlos Buell (1818–98), making a total of 62,000 vs. Confederate Army of Mississippi under General Albert Sidney Johnston (1803–62) totalling 44,000.

WHAT The Confederates attacked and pushed Grant's army back all day on 6 April, but were driven off the following day after Union reinforcements arrived.

WHERE 40km (25 miles) north of Corinth, Mississippi, at Shiloh on the Tennessee River.

WHEN 6–7 April 1862.

WHY The Confederate Army launched a surprise attack against Grant's command, hoping to destroy it before it was reinforced by Buell's force. This was necessary to prevent a concentration and thereby to protect the rail junction at Corinth.

OUTCOME After a day of hard-won successes in which Johnston was killed and replaced by Lieutenant-General PGT Beauregard (1818–93), the Confederates were forced to retire and ultimately to evacuate Corinth.

In the first months of the Civil War, both sides were convinced that the matter could be settled fairly quickly, and neither the Union nor the Confederacy was ready for a long war. The slaughter at Shiloh was an early indication that the struggle would be long and bitter.

Although towns and forts changed hands, many of the strategic objectives of the war, which led to eventual victory for the Union, were important as hubs or conduits of transportation rather than having political significance. Railway junctions and rivers, permitting rapid movement of supplies and forces, were of critical importance. One

such was the rail junction at Corinth, Mississippi, which linked the east–west Memphis and Charleston Railroad with the north–south Mobile & Ohio Railroad. If the Confederacy could be deprived of Corinth, its logistics capabilities would be dealt a serious blow.

The highly motivated but poorly trained forces on both sides had clashed to the north of Corinth over the winter of 1861–62, and the Confederates had come off worst. With the loss of Forts Henry and Donelson, the Rebel army under Johnston had been pushed out of southern Kentucky and most of Tennessee. Johnston pulled

William Tecumseh Sherman with his staff. Wars in Europe had demonstrated the value of a well-trained, trusted and reliable staff to support a general officer. Good staff work tended to be the exception rather than the rule in the inexperienced armies of 1862.

further back and established a new line to protect the vital railroads, which linked Richmond to Memphis and allowed forces to be brought forward from the far south.

Johnston's army was a little more experienced and better trained now, and he decided that he must strike rather than awaiting a Union move. Using the railroad to marshal supplies and men at Corinth, Johnston marched out on 2 April 1862. His plan was to fall on Grant's Army of the Tennessee and destroy it before reinforcements in the form of Buell's Army of the Ohio could arrive. Despite reorganization and some training, the Confederate Army was still inexperienced and this, combined with very bad roads, slowed the march down.

GRANT SITS TIGHT

On the Union side, Grant was not expecting any serious Confederate activity. While Buell was moving his force up to make contact, Grant's army was drilling in camp near Shiloh. Despite a certain amount of sickness (mainly diarrhoea), morale was good in the Union camp, partly due to the successes of the previous few months.

Grant asked his superior, Major-General Henry Halleck (1815–72), for instructions and was told that once Buell arrived, he was to advance on Corinth, but in the meantime he was to 'sit tight'. Grant's sub-commanders, including William Tecumseh Sherman (1820–91), were certain that there was not a 'Reb' nearer to the Union army than Corinth. They were still certain of this on the night of 5 April, despite the fact that 44,000 Confederate soldiers were camped just a few kilometres away.

That night, Beauregard, Johnston's second-in-command, feared that the Union army had been alerted. With the element of surprise lost, Beauregard thought the Federal army too numerous. He asked his commander to call off the operation, but Johnston disagreed, stating that he would fight even if the enemy turned out to have a million men ranged against him.

OPENING MOVES

The Confederate force was in position on 6 April when Union pickets stumbled on its massed brigades. They fled back in the

direction of their camps and Johnston's army rolled after them, moving quickly through the wooded terrain and achieving almost total surprise. Brutal close-range firefights broke out as the Rebels stormed through one stunned Union unit after another. Many were caught in camp and totally unready to fight.

Stumbling half-dressed from their tents and bivouacs, Federal troops grabbed for their weapons and tried to make sense of the chaos. Officers were not always nearby, and many of them had no real idea what was

JEFF DAVIS RIFLES

The raising of volunteer units was common practice in the United and the Confederate States. Jefferson Davis (1808–89), President of the Confederacy, had raised and led his own well-trained and highly effective battalion for service in the Mexican War.

For the Civil War, a company-sized unit named for the president was raised in Marshall County, Mississippi. The Jeff Davis Rifles, as this unit was known, was incorporated as Company D of the 9th Mississippi Infantry. The 9th was described by General Braxton Bragg (1817–76) as an 'admirable regiment' and gave excellent service throughout the campaign.

The colonel of the 9th, James R Chalmers (1831–98), was promoted to brigadier-general of what became known as the High Pressure Brigade, and led it to distinction at Shiloh, where the 9th MS Infantry was instrumental in the great attack and in holding off pursuit during the retreat.

LOCATION

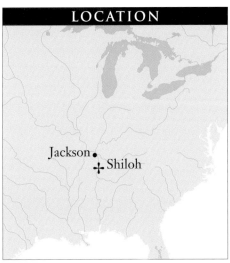

Jackson • ✝ Shiloh

The Battle of Shiloh was instigated by the Confederates in an attempt to defeat the larger Union army in detail. The location was not especially significant; what mattered was bringing the enemy swiftly to battle and defeating him.

More representative than accurate, this painting nevertheless gives some idea of the extreme close-quarters fighting that took place at Shiloh. Heavy casualties were inevitable at such short ranges.

THE OPPOSED FORCES

FEDERAL
Army of West Tennessee	**48,894**
Army of the Ohio	**17,918**

CONFEDERATE
Army of Mississippi	**44,699**

going on, either. There were problems with ammunition, which had not been issued in any quantity, as nobody was expecting action. Nor were the camps fortified; the need had not been perceived.

Lack of physical preparation was one thing but even worse was the psychological effect of being attacked out of nowhere. The first positions fell quickly, and for many units further back the only warning of the assault was the arrival of frightened comrades pursued by mobs of Rebel troops.

By mid-morning, it seemed that the Army of the Tennessee was about to be chased into the river. The Union army seemed to be dissolving rapidly under the assault but this was only partially true. Here and there, units rallied more or less intact, and small groups fought back as best they

could. The attack was also becoming disorganized, and on the Federal right something resembling a defensive line was being established.

STAND AND FIGHT

Around Shiloh church, the Federals made a stand. For the entire day this force, composed of a mix of formed units and men who had rallied and fallen in with their comrades, was subjected to a steady hammering by the inexperienced but determined Confederates. With little idea what was happening elsewhere, the Union troops clung on, with heavy casualties on both sides.

The stubborn fight around Shiloh Church stalled Johnston's left flank and, while the Confederates gradually pushed

them back, the Union force was still fighting at the end of the day.

Meanwhile, on the Confederate right, the assault had been brought to a standstill by a force under the command of Brigadier-General Benjamin Prentiss (1819–1901), who had gathered every man he could find and was clinging grimly to a sunken road in front of an oak thicket that became known as the Hornet's Nest because of the sound bullets made passing through the leaves and branches. This position linked to a peach orchard to the south, where more Federals were making a fight of it.

Word came to Prentiss from Grant: 'Hold the sunken road at all costs', and for the next six hours, his thrown-together command tried its best to do just that.

AT THE HORNET'S NEST

The Confederate army was now in as much confusion as its Union foes, but it was slowly gaining ground. Recognizing the Hornet's Nest as the key to the Federal position, the Rebels threw in 11 attacks, each one repulsed with heavy casualties on each side.

The Union line was bent back in places and pierced now and then, but the situation was restored each time, and as the day went on Prentiss obeyed Grant's urgent instructions to hold out. Finally, Johnston found a way to break the Union line. Assembling 62 cannon, the largest 'grand battery' deployed in the war, he ordered a massive bombardment that tore through the oak thicket. Under the cover of the cannon fire, Johnston led the final attack in person.

Johnston's assault finally succeeded, but only at great cost. Even as the remnant of Prentiss' force scattered or surrendered, leaving the exhausted Confederate infantry in possession of the sunken road, Johnston was seen to be swaying in the saddle. His clothing was shot through and he was bleeding from a major leg wound. Before his personal surgeon could arrive – he had been sent off to look after wounded men from both sides – Johnston succumbed.

THE FIRST DAY ENDS

General Johnston's death left Beauregard in command of a chaotic but very nearly victorious Confederate army. Grant's force had been squashed into a small area around Pittsburg Landing, with its back to the river, and the army was badly shaken. A final hard blow might have settled the matter, but the Confederates were exhausted as well, and badly disorganized.

General Albert Sidney Johnston was an experienced professional officer and a good choice for army command. His compassion in sending off his personal surgeon to treat wounded proved his downfall when he bled to death from an easily treatable leg wound.

Although more advanced guns were available, the smoothbore 12-pound 'Napoleon' was still the mainstay of field artillery. At close range, firing canister, it was more effective than a rifled gun as the smooth bore produced a more even cone-shaped area of effect.

SHILOH
6–7 APRIL 1862

3 Elements of the Federal army make a determined stand around Shiloh Church. Although battered, they manage to hold on all day.

4 Ordered to hold the sunken road at all costs, Union troops put up a tremendous fight at what became known as the Hornet's Nest. Confederate General Johnston is killed leading an attack to clear it.

OWL CREEK

SHILOH CHURCH

SHERMAN

McCLERNAND

HARDEE

1 Union pickets stumble on the Confederate force, triggering the start of the attack. The nearest Federal units are totally surprised and unable to resist.

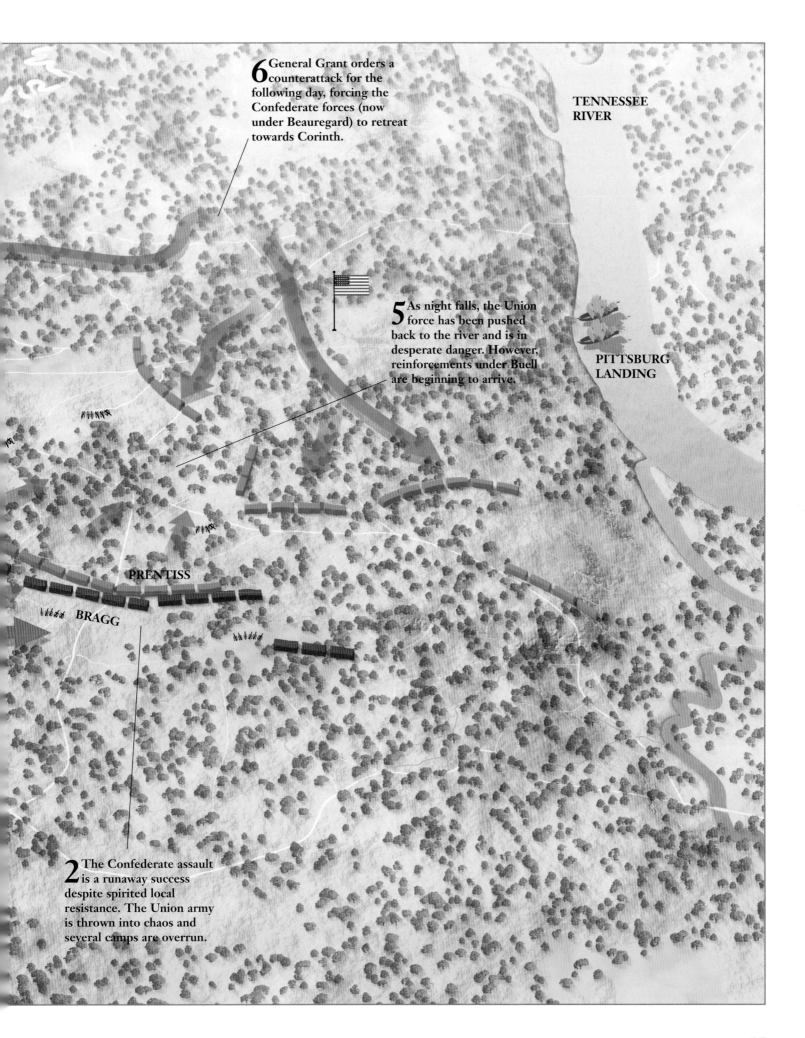

6 General Grant orders a counterattack for the following day, forcing the Confederate forces (now under Beauregard) to retreat towards Corinth.

TENNESSEE RIVER

5 As night falls, the Union force has been pushed back to the river and is in desperate danger. However, reinforcements under Buell are beginning to arrive.

PITTSBURG LANDING

PRENTISS

BRAGG

2 The Confederate assault is a runaway success despite spirited local resistance. The Union army is thrown into chaos and several camps are overrun.

Opposite: William Tecumseh Sherman was a graduate of West Point who was superintendent of the Louisiana Military Academy at the outbreak of war. Although the state seceded, Sherman decided to fight for the Union and waged his own version of total war against the South.

Right: Officers direct their companies to their positions on the firing line, struggling to maintain cohesion and control despite enemy fire and casualties on the ground. Once a unit became disorganized it was very difficult to re-form under fire.

Beauregard put in a somewhat half-hearted attack on the final Union position, but Grant had by now managed to establish a solid defensive line. He was supported by two gunboats operating on the river and by a powerful artillery battery. Even better, he had heard that Buell, who up to that point had not been hurrying, was coming up fast and was about to begin ferrying his troops across the Tennessee River.

Beauregard thought he had won, and telegraphed Richmond to that effect. He had good reason to think so: the army he had just inherited now occupied all but one of the Union camps. Johnston's promise that the Confederates would sleep in the enemy's camp that night had come true. The Union force had its back to the river and could be annihilated in the morning.

THE NIGHT

After a day of desperate defence that left the battlefield carpeted with dead and wounded, Grant decided to strike back when morning came. His own forces were reinforced by Buell's men, and had gained a further advantage.

Major-General Lew Wallace (1827–1905), out on the Union right, had been too far away to take part in the first day's fighting but arrived during the night. His force was

Mounted raiders could range far and wide, causing damage to the enemy and distracting his attention from more major campaigns. Many raids were made by regular cavalry units while others were little more than excuses for banditry.

Amidst the closely wooded terrain of the Tennessee River, General Albert Sidney Johnston rallies the 13th Arkansas Regiment at the battle of Shiloh.

organized, relatively fresh and in a position to open hostilities.

The two gunboats shelled suspected Confederate positions during the night as Buell's men came ashore, and a heavy rainstorm added to the general misery. There was no system in place to collect the wounded from the battlefield, so they were left where they were. Many died of their wounds in the cold and wet.

GRANT COUNTERATTACKS

In the grey dawn of 7 April, Wallace's force attacked the Confederate left and caused the sort of confusion that had beset the Union camps the day before. The Rebels were still scattered and badly disorganized, and as the fighting spread along the length of the line, Beauregard managed to rally about 30,000 men and begin fighting back.

However, Grant had over 20,000 fresh reinforcements plus the survivors of the previous day's fighting. The numerical advantage, plus the psychological blow dealt when the troops who were expecting to attack on their own terms were themselves assaulted, was too much for the Rebels, who were gradually pushed back.

THE CONFEDERATE RETREAT

Beauregard realized that he was beaten and ordered a retreat towards Corinth, which was partially covered (and partially hindered) by a storm. Along the way, Beauregard organized a rearguard of about 12,000 men under Brigadier-General John C Breckinridge (1821–75).

Grant's army pursued as best it could, and inflicted about 3000 casualties on the rearguard, but it was not able to turn the retreat into a rout and thereby win a strategic victory. The Federal army was too shaken, tired and disorganized for an effective pursuit, so it retired to the shattered camps it had previously occupied and began dealing with the dead and wounded.

AFTERMATH

The sudden assault and near-disaster had shocked the Union army, and gave rise to the realization that the war was going to be long and hard, with colossal numbers of dead on both sides. About 13,000 Union troops were dead and missing, and the Confederates had lost about 10,500. This appalling death toll was equivalent to the Battle of Waterloo. Unlike Waterloo, however, it was not the cataclysmic end to an era of war, but merely the first of many such slaughters.

However, despite the vast casualty figures, nothing had really changed. Both armies were still 'in being' and the overall strategic situation was not greatly altered. That alone made Shiloh a decisive moment in the course of the war. The Confederacy needed a victory to protect the rail links and to keep the Union forces off balance, and it had failed to achieve one. The long-term prospects were not good, and the operation had been conceived to address that situation. There would not be another chance, and of course the able General Albert Sidney Johnston had been killed, making him the highest-ranking officer on either side to be killed in action.

Now Corinth and the rail links were in danger, and after Corinth the Union would be able to push on to Memphis and Vicksburg. Grant began preparations to advance on Beauregard's army and capture Corinth, but the operation was delayed by the arrival of Halleck, who outranked Grant and therefore assumed overall command. This short pause was enough for the Confederate army to ready itself for further combat, and led to a more protracted campaign. However, in due course, the Rebels were forced to abandon Corinth.

The fall of Corinth stemmed directly from the failure to win at Shiloh, and robbed the South of the only all-weather rail link from Richmond to Memphis. In time, Vicksburg too would fall, opening up the Mississippi to the Union and effectively splitting the Confederacy in half. It was such losses, as much as defeats in great battles like Gettysburg, that spelled the doom of the Confederacy.

With only a fraction of the industry and manpower available to the Northern (Union) states, the Confederacy was always at a strategic disadvantage. From Shiloh onwards, it was on the defensive in the west and that could only end one way. The North could afford to grind its enemy down but the South needed decisive victories. Shiloh was almost, but not quite, the masterstroke that gave the South a fighting chance at victory in the west.

John C Breckinridge had experience commanding volunteers in the Mexican War (1846–48) and had served as Vice-President of the United States. He was unsuccessful in running for president in 1860 but served the Confederacy well in both military and political capacities.

NEW ORLEANS
APRIL–MAY 1862

NEW ORLEANS WAS IMPORTANT TO THE SOUTH AS A PORT, A SHIPBUILDING CENTRE, AND A KEY CITY ON THE MISSISSIPPI RIVER. AS SUCH, IT WAS A PRIME TARGET FOR THE FEDERAL BLOCKADE. THE CITY SURRENDERED ON 25 APRIL 1862 AFTER ADMIRAL DAVID FARRAGUT CONDUCTED A DARING RUN PAST THE TWO FORTS THAT WERE SUPPOSED TO SAFEGUARD IT.

WHY DID IT HAPPEN?

WHO Confederate forces under Major-General Mansfield Lovell (1822–84) defended New Orleans, a key Confederate port, shipbuilding centre and wealthy Mississippi River city, against a Federal naval force led by Flag Officer David Farragut (1801–70).

WHAT Farragut ran his fleet past the powerful Forts Jackson and St Philip, compelling New Orleans to surrender, and then army troops under Major-General Benjamin Franklin Butler (1818–93) moved forward to occupy the city.

WHERE New Orleans, Louisiana.

WHEN 25 April to 1 May 1862.

WHY The Confederate defences were plagued by a low priority, a lack of unified effort and a mistaken assumption of the direction of the true threat. Farragut's bold plan to run past the forts was made possible by the presence of Butler's army troops to isolate the forts from New Orleans as Farragut proceeded to the city.

OUTCOME The South lost its most populated city and a key port, but the Federals were unable to seize the advantage and take Vicksburg.

By 1861, every shipyard in New Orleans was busy building, converting or repairing some type of vessel connected to the war effort. It was a largely decentralized enterprise with few of the ships actually earmarked for the fledgling Confederate Navy, but three ironclads were under construction. The *Manassas* was a private venture built to be a profit-making privateer. The *Louisiana* and the *Mississippi* were being built under separate contracts authorized by Confederate Secretary of the Navy Stephen Mallory (1813–73). It was, in most cases, a confused and competing effort that did not efficiently use the scarce Confederate resources. Nonetheless, New Orleans was a hubbub of shipbuilding activity and rumours of Confederate ironclads there raised concerns in the Federal Navy office.

The Confederate first in charge of the New Orleans defences was Major-General David Twiggs (1790–1862), who arrived in the city on 31 May. Twiggs's hopes rested on Fort Jackson and Fort St Philip, which guarded the Mississippi River approaches 121km (75 miles) south of New Orleans. Fort St Philip was a citadel built by the Spanish in the 1790s and expanded two decades later. Fort Jackson, on the other hand, was a more modern and powerful structure built in a pentagonal design. These strongholds gave the Confederates an exaggerated feeling of security.

David Porter, shown in the centre of this photograph, commanded 19 mortar boats as part of his foster brother Flag Officer David Farragut's naval assault on New Orleans. Porter fired 2997 shells at Fort Jackson but was unable to compel the fort to surrender by his bombardment alone.

FAULTY ASSUMPTION

Early in the war, the Confederacy was most concerned with an attack on New Orleans from the south, but soon a competing point of view gained ascendancy. Faith in Forts Jackson and St Philip, as well as the broad inland bayous and a string of fortifications known as the New Orleans' Chalmette defence line, led local observers like George Cable (1844–1925) to believe that 'Nothing afloat could pass the forts. Nothing that walked could get through the swamps.' Instead, Federal ironclad construction upriver at places such as Cincinnati, Carondelet (near St Louis) and Mound City caused many to think the real threat would be from the north.

As for the southern approach, Twiggs anticipated the Federal Navy would use only wooden warships there and that Forts Jackson and St Philip were capable of defending against such a threat.

Indeed, in the first naval encounter below New Orleans, the Confederates had reason to believe the Federal Navy was not very powerful at all. As progress towards building the ironclads proceeded at a frustratingly slow pace, Confederate Commander George Hollins (1799–1878) finally lost his patience. He commandeered the *Manassas*, and, along with six lightly armed riverboats he already had, struck the remarkably complacent Federal fleet at Head of the Passes, where the main stem of the Mississippi River branches off into three distinct directions at its mouth in the Gulf, in the early morning hours of 12 October. Federal Captain John Pope (1798–1876) was thoroughly surprised and routed. The fiasco was derisively dubbed 'Pope's Run', but while the Confederate 'victory' embarrassed the Federals and boosted Confederate morale, it did no permanent damage other than to Pope's career.

Not long before, Twiggs would have been on solid ground in thinking that wooden ships were no match for heavy fortifications, but recent events at Port Royal Sound, South Carolina, had proven otherwise. There Captain Samuel DuPont (1803–65) had used steam power and superior weaponry to defeat two Rebel forts. If Twiggs had missed this lesson, Commander David Dixon Porter (1813–91)

had not. He saw no reason to believe that he could not do on the Lower Mississippi what DuPont had done at Port Royal.

Porter obtained an audience with Secretary of the Navy Gideon Welles (1802–78) and briefed him on his plan to precede the proposed attack with a 48-hour mortar bombardment of Forts Jackson and St Philip. By mounting these mortars on modified schooners, there would be no need for a large cooperating land force. In fact, with the Navy providing most of the firepower, the only support required from the Army would be a few thousand soldiers to garrison the captured forts and occupy

PETTY OFFICER, US NAVY

The Federals enjoyed a huge naval advantage over the Confederates, possessing over 90 warships at the outbreak of the Civil War. In contrast the fledgling Confederate Navy inherited just five vessels from the seceded states. Secretary of the Navy Gideon Welles and Assistant Secretary of the Navy Gustavus Fox (1821–83) provided very effective administrative leadership of the Federal Navy and seasoned sailors such as David Farragut, Samuel DuPont, Louis Goldsborough (1805–77) and Andrew Foote (1806–63), the first rear-admirals in the US Navy's history, provided solid command at sea. The Federals' naval superiority allowed them not just to mount an effective blockade of Confederate commerce but also to conduct amphibious operations with the Army along the Confederate coast at places such as Fort Fisher, North Carolina, and to project power up rivers to reach places such as Vicksburg, Mississippi.

NEW ORLEANS

David Twiggs, the Confederate general first responsible for the defences of New Orleans, was a senior military officer with service dating back to the War of 1812. By the time of the Civil War, however, he was past his prime and soon relinquished his command to Mansfield Lovell.

THE OPPOSED FORCES

FEDERAL
Navy: **24 wooden vessels**
19 mortar boats
Army: **15,000**

CONFEDERATE
Navy: **8 vessels**
(River Defense Fleet and Louisiana State Navy)
6 vessels
(Confederate Navy, including the ironclads *Louisiana* and *Manassas*)
Army: **4000**

the city. Welles was convinced and, together with Porter, he obtained President Abraham Lincoln's (1809–65) approval. To lead the operation, Welles employed Captain David Farragut. On 9 January 1862, Welles gave Farragut command of the newly constituted West Gulf Blockading Squadron and on 19 March, the Senate confirmed Farragut's appointment to flag officer.

While the Federal plans and command arrangements were solidifying, those of the Confederates were falling apart. By this time the prevalent opinion in the Confederate high command was that an attack would come from upriver. Thus,

Secretary Mallory sent Hollins and his small fleet upriver to join in the Confederate defence of Columbus, Kentucky. The move left New Orleans without naval protection. To add to the turmoil, on 5 October, Twiggs asked to be relieved of his command.

LOVELL ARRIVES

Even before Twiggs had tendered his resignation, the War Department had dispatched Mansfield Lovell to New Orleans to serve as Twiggs's assistant. When Lovell arrived on 17 October, he learned he was the new commander and had been promoted to major-general. Before Lovell

Samuel Colt (1814–62) was the most prolific manufacturer of handguns during the Civil War. His .36 calibre Navy model (pictured here) was especially popular in the South.

left Richmond for New Orleans, he spoke with both President Jefferson Davis (1808–89) and Secretary of War Judah P Benjamin (1811–84) and argued that the only proper way to defend New Orleans was to unify the land and naval commands. Davis chose to leave the commands divided, but encouraged Lovell to maintain 'unrestrained intercourse and cordial fraternization' with the Navy. In the end, a lack of unity of effort between the Confederate Army and Navy would plague the defence of New Orleans.

In the meantime, Lovell set out on an inspection tour of his new command and found inferior ammunition, antiquated cannon, manpower shortages, unimpeded river approaches, unfinished lines, incompetent officers and dilapidated fortifications. He worked diligently to correct these deficiencies, including scavenging loose chain and anchors from across the South to strengthen the defensive log boom across the Mississippi River. Lovell now had a barrier securely chained to both banks, held in place by 15 anchors weighing 1134–1814kg (2500–4000lb). Obviously proud, Lovell wrote: 'This raft is a complete obstruction, and has enfilading fire from Fort Jackson and direct fire from Saint Philip.'

But as fast as Lovell could improve things, the War Department seemed to unravel them. Part of the problem was the low priority New Orleans was receiving

from Richmond. Medical supplies, clothing, rifles and even some of the big naval guns were being siphoned off for service in Virginia, South Carolina and Tennessee. Neither Davis nor Benjamin considered New Orleans in imminent danger of attack. Even after Lovell raised and trained a force of 10,000 infantry, the Secretary of War sent half of them to reinforce General Albert Sidney Johnston's (1803–62) Army of Mississippi at Corinth after the loss of Forts Henry and Donelson.

Lovell, however, knew there was a threat much closer to home. He could see the

New Orleans 1862. One of the important characteristics of New Orleans was its status as a shipbuilding centre. Especially threatening to the Federals were the ironclads being built there.

NEW ORLEANS
APRIL–MAY 1862

FORT ST PHILIP

MISSISSIPPI RIVER

5 A motley group of Confederate vessels, including the ironclads *Manassas* and *Louisiana*, as well as the forts, resist the attack, but the passage is never really in doubt.

FORT JACKSON

6 Farragut continues on to New Orleans and the city surrenders. On 1 May the Federal Army occupies the city. The forts surrendered on 27 April.

1 The Confederates place a huge amount of confidence in Forts Jackson and St Philip being able to block any Federal attack from the south.

2 The Confederates build a chain and log barrier to try to block the river.

4 Shortly after midnight on 24 April Farragut attacks with his ships organized into three divisions.

3 On 18 April Porter begins a huge mortar bombardment of the Confederate positions. The shelling continues until 23 April when Farragut realizes that the forts will not succumb to bombardment alone.

MORTAR SCHOONERS

David Farragut was selected by Secretary of the Navy Gideon Welles to command the newly created West Gulf Blockading Squadron. The broad appointment helped conceal the more specific Federal plan to attack New Orleans.

Federal force unloading troops on Ship Island, a narrow stretch of sand some 21km (13 miles) southwest of Biloxi, Mississippi, and a convenient staging location for any operation against New Orleans. With Hollins' fleet still upriver, Lovell had only two small naval vessels operating on Lake Pontchartrain to help defend New Orleans against a landing. Lovell took his concerns

about the lack of naval cooperation to Benjamin, who promptly ordered Lovell to impress 14 specific ships into public service. These became known as the River Defense Fleet, a grandiose name for what was in fact merely another distraction for the already-harried Lovell, who had to divert scarce resources, including his attention, in order to man, arm and clad it. The defence of New Orleans continued to spiral into a confused mess.

On 13 March 1862, Major-General Benjamin Butler arrived at Ship Island with the final instalment of his 15,255 Federal soldiers. In the meantime, Farragut was building his fleet there and preparing for the attack. The *Brooklyn* occupied Head of the Passes, light-draught steamers moved upriver to reconnoitre the forts, and Porter positioned his mortar schooners. The Federals were obviously up to something, but Confederate defensive preparations hardly kept pace. Even Lovell seemed ambivalent. On 15 April, he wrote a letter to the new Secretary of War George W Randolph (1818–67) stating 'no harm done. Twenty-seven vessels in sight from forts.' The defenders of New Orleans continued in their ignorant bliss.

PORTER'S BUMMERS

The vessels Lovell had observed were of Porter's mortar flotilla. On 16 April, Porter towed three schooners to a marker 2743m (3000 yards) from Fort Jackson and lobbed a few shells to test the range. The next day, all 21 of Porter's vessels, derisively called 'bummers' by the 'real' sailors in the fleet, were at anchor in carefully determined positions. Then on 18 April, at 9:00 a.m., Porter began his huge bombardment. For 10 straight hours, each schooner fired a round every 10 minutes for a total of nearly 3000 shells. Porter had predicted his mortars could reduce the forts in two days, and by nightfall he realized that was not going to be the case.

Still, Farragut let Porter continue his efforts until the morning of 20 April, when the former signalled his officers to his flagship to announce his new plan.

Farragut was convinced that mortars alone would not cause the forts to surrender. With Butler and 7000 of his men now across

Farragut ran his fleet past the powerful Confederate forts Jackson and St Philip and pressed on to New Orleans. Once the forts realized New Orleans had been captured, they also surrendered.

the bar, Farragut had other options. Farragut's plan was to destroy the chain barrier, run past the forts with his warships and, once above the forts, land Butler's troops to seize the forts. Porter's mortars, much to their commander's chagrin, would remain in position.

The first part of Farragut's plan began on the night of 20 April, when a force under Captain Henry Bell (1808–68) departed on a mission to break the chain. The Confederates tried to disrupt the operation by launching a fire raft, but Bell and his men were ultimately successful in clearing the obstacle. Still, Farragut allowed Porter to continue his bombardment, but by 23 April the promised results had not yet come. The commander asked for still more time. 'Look

here, David,' Farragut replied, 'We'll demonstrate the practical value of mortar work.' Farragut then ordered his signal officer to wave a red pennant every time a shell landed inside Fort Jackson and a white one for every shell that missed its target. The results spoke for themselves, as time and again the white flag was unfurled. 'There's the score,' Farragut conceded, 'I guess we'll go up the river tonight.'

THE FEDERAL ATTACK

Farragut began his attack shortly after midnight on 24 April. Although the Federal fleet took fire from both the forts and the Confederate ram *Manassas*, the passage never really was in doubt. Farragut had organized his ships into three divisions for the run. Singly or in small groups, they all made it except for the *Varuna*, which was sunk, and three gunboats from the rear division that were forced to turn back.

Farragut now sent word to Porter to demand the surrender of the forts, and to

Butler to bring up the Army transports from Head of the Passes. Farragut then pushed on towards New Orleans and anchored for the night 24km (15 miles) below the city.

Before dawn on 25 April, Farragut was up and moving towards New Orleans. Lovell had torched the levee and retreated from the city, leaving the inhabitants in a state of panic. As Farragut pulled alongside New Orleans, he hammered it with broadsides.

Then Farragut dispatched his marines to take possession of the Federal mint, post office and customs house and replace the Confederate flag with the Stars and Stripes on all public buildings. Captain Theodorus Bailey (1805–77), commander of Farragut's Red Division, worked his way through an angry mob and demanded the city's surrender, but the mayor claimed to be under martial law and without authority. When Farragut threatened a bombardment, the mayor and Common Council declared New Orleans an open city.

The forts had refused Porter's demand to surrender, so he resumed his bombardment. He made a second offer two days later but still the forts refused. Finally, as word drifted downriver of New Orleans' fate, morale broke. At midnight on 27 April, the fort troops mutinied. Brigadier-General Johnson Duncan (1827–62) had no choice but to surrender. Commander John Mitchell (1811–89) held out a little longer aboard the *Louisiana*, but ultimately blew her up and surrendered the remnants of the naval command.

On 1 May, Butler and the Army came up from their landing at Quarantine and began a controversial occupation of New Orleans. A debate would develop between Butler and Porter over their relative contributions to the victory. In fact, while the Navy did do the fighting, the Army's presence was critical to the Navy's success. Without Butler's force to isolate Forts Jackson and St Philip and pacify the hostile New Orleans population, Farragut could have remained in New Orleans just a short time. Instead, Farragut was able to run past the Confederate forts and then land Federal Army troops to cut the defenders off from New Orleans.

UNREALIZED POTENTIAL

New Orleans was indeed a great victory for the Union. One of the South's premier cities and the mouth of the Mississippi River were now under Federal control. Still, it was a limited victory in that this strategic momentum was not maintained. The logical sequence after New Orleans was to move up the Mississippi to capture the river port city of Vicksburg.

Belatedly, Farragut did make minor attempts to do so, but by then the opportunity had been lost. The Federals would not be able to wrest Vicksburg from the Rebels until Major-General Ulysses S Grant (1822–85) did so on 4 July 1863 after a lengthy campaign of manoeuvre and siege.

New Orleans was the greatest single victory of the Civil War for the Federal Navy. Not only was the Confederacy's largest city captured, the Federals now had control of a large stretch of the lower Mississippi River.

GAINES' MILL
27 JUNE 1862

ON 17 MARCH 1862, MAJOR-GENERAL GEORGE MCCLELLAN ADVANCED 90,000 FEDERAL SOLDIERS TOWARDS RICHMOND UP THE VIRGINIA PENINSULA. HOWEVER, WHAT BEGAN AS A BOLD MANOEUVRE QUICKLY LOST ITS MOMENTUM AS MCCLELLAN FELL VICTIM TO HIS OWN OVERCAUTION AND THE SUPERIOR ABILITIES OF GENERAL ROBERT E LEE. IN A SERIES OF HARD-FOUGHT BATTLES COLLECTIVELY KNOWN AS THE SEVEN DAYS, LEE DEFEATED MCCLELLAN AT PLACES SUCH AS GAINES' MILL AND FORCED HIM TO ABANDON THE OFFENSIVE.

WHY DID IT HAPPEN?

WHO Federal forces under Major-General George B McClellan (1826–85) battled Confederates first under General Joseph E Johnston (1807–91) and then General Robert E Lee (1807–70).

WHAT McClellan conducted an amphibious turning movement in an attempt to avoid a frontal assault on Richmond.

WHERE The Virginia Peninsula.

WHEN March to July 1862 with the Battle of Gaines' Mill occurring 27 June.

WHY McClellan was overly cautious and gave Lee a chance to build enough of a force to launch an audacious counteroffensive. In the process, Lee was aided by Major-General 'Stonewall' Jackson's (1824–63) brilliant Shenandoah Valley Campaign, which caused forces earmarked for McClellan to be withheld to help defend Washington.

OUTCOME McClellan was repulsed and withdrew from the Peninsula, while Lee built on his momentum and moved north to attack at Second Manassas.

Against protected defenders, Civil War artillery could not get close enough to have the desired effect with canister without exposing the gunners to the long-range fire of the defenders' rifles. Therefore most artillery battles, such as Malvern Hill during the Seven Days, were defensive.

McClellan's goal was to avoid a frontal assault against General Joe Johnston's entrenched Confederates around Manassas and Centreville. To this end, McClellan proposed a bold, amphibious turning movement from Annapolis, Maryland, through Chesapeake Bay to the mouth of the Rappahannock River. The landing site would be the small hamlet of Urbanna, which lay about 96.5km (60 road miles) northeast of Richmond. From there, McClellan would march on Richmond.

However, Johnston began feeling vulnerable with his position at Manassas, and on 7 March 1862 he ordered all of his troops east of the Blue Ridge Mountains, some 42,000 effectives, to withdraw to the Rappahannock River, nearly half the distance to Richmond. Only Major-General 'Stonewall' Jackson's 5400 men would

remain in the Shenandoah Valley to threaten the right flank of any Federal advance. Johnston's move completely negated the basis of the Urbanna Plan. Instead of turning the Confederates and getting between them and Richmond, McClellan now faced an enemy who had occupied the very area from which he proposed to begin his operation.

By this time, however, McClellan was committed to an amphibious campaign. Instead of Urbanna, he decided on Fort Monroe as a landing site. Fort Monroe guarded the strategic Hampton Roads on the tip of the Virginia Peninsula and had the advantage of being garrisoned by 10,000 Federal troops, but it did not offer the opportunity to cut off the Confederates as the Urbanna Plan would have done. The campaign would now require a slow, toilsome march ending in a toe-to-toe fight at Richmond.

Standing in the way of McClellan's plan was the *Merrimack*, a former US steam frigate that the Federals burned and scuttled and which the Confederates had raised and converted to an ironclad. On 8 March, the *Merrimack*, now rechristened the *Virginia*, sailed down the Elizabeth River into Hampton Roads and made short work of five of the Federal blockade ships lying at anchor. The next day, the Federal ironclad,

the *Monitor*, arrived on the scene. The two ironclads fought to a tactical draw, but the overall result was a strategic Federal victory. Although the *Virginia* was still a threat, anxiety over the vessel's potential to destroy single-handedly the Federal fleet was abated. At least one obstacle had been lessened along the way of McClellan's Peninsula Campaign.

THE PENINSULA CAMPAIGN

The embarkation itself began on 17 March and was fully effected on 5 April. It was a colossal move, eventually totalling 90,000 men and leading one British observer to liken it to 'the stride of a giant'. By 4 April, McClellan felt he had enough forces on the ground and began to advance on Yorktown.

However, after a brief encounter with Major-General John Magruder's (1807–71) Warwick River defensive line, McClellan decided to cease manoeuvre and initiate siege operations. These lasted until 3 May, when the Confederates abandoned Yorktown and withdrew up the Peninsula on their own terms. Major-General James Longstreet (1821–1904) covered the Confederate withdrawal with a sharp delaying action at Williamsburg.

As Johnston traded space for time, Robert E Lee, then serving as President Jefferson Davis' (1808–89) military advisor,

LOCATION

Washington
Richmond — Gaines' Mill

Gaines' Mill lay about 16km (10 miles) northeast of the Confederate capital of Richmond, which was McClellan's objective during the Peninsula Campaign.

FIRING VOLLEYS

Each Civil War soldier carried paper cartridges containing sealed powder and a Minie ball, a cylindro-conoidal bullet. One end of the bullet was hollow, and when the rifle was fired, expanding gas widened the sides of this hollow so that the bullet gripped the rifling and created the spinning effect needed for accuracy.

To load, the soldier poured the powder and ball down the barrel, then wadded the paper and dropped it too down the barrel, using his ramrod to compact the contents. Then he placed a percussion cap over the small nipple at the base of the hammer, cocked the hammer, aimed and fired. A well-drilled soldier could fire three rounds a minute.

Lee's plan for a turning movement at Mechanicsville failed because of the late arrival of 'Stonewall' Jackson. Instead Federal Major-General Fitz John Porter (1822–1901) made good use of the terrain to repulse the Confederate attack.

THE OPPOSED FORCES

FEDERAL
Seven Days	**104,300**
Gaines' Mill	**34,214**

CONFEDERATE
Seven Days	**85,000**
Gaines' Mill	**57,018**

effected a 're-concentration' of forces that would ultimately turn the tables on McClellan's offensive. However, of greater concern to the immediate situation, Johnston's withdrawal up the Peninsula forced the Confederates to abandon Norfolk. This left the *Virginia* without a home port. Her draught of 8m (22ft) was too deep for her to withdraw up the James River and, finally, on 11 May, she was abandoned and blown up.

With the *Virginia* gone, the James was open as an avenue of attack to Richmond. Federal Flag Officer Louis Goldsborough (1805–77) attempted to project a naval force up the river only to be repulsed by Confederates at Drewry's Bluff, less than 13km (8 miles) south of Richmond.

SEVEN PINES

On 28 May, Johnston learned that Jackson's Shenandoah Valley Campaign had caused such concern for the safety of Washington that Abraham Lincoln (1809–65) had withheld Major-General Irvin McDowell's

(1818–85) corps that had been earmarked to join McClellan. This news changed the strategic situation outside of Richmond dramatically. With the threat of McDowell's force removed, the Confederates could act more aggressively.

Reconnaissance informed Johnston that there were two vulnerable Federal corps south of the Chickahominy River. In the Battle of Seven Pines, Johnston tried to isolate and destroy these corps, but he failed. Johnston mismanaged the battle, issuing unclear instructions and failing to synchronize his forces. Over two days of fighting, the Confederates lost 6134 killed, wounded or missing, and the Federals 5031. Johnston accomplished none of his objectives and, after midnight on 2 June, the Confederates retreated to the west. During the fighting, Johnston was wounded and, on 1 June, Lee arrived with orders from President Davis to take command.

Lee quickly took advantage of the opportunity created by Jackson's success in the Valley. On 8 June, he wrote to Jackson,

asking him if he could bring his forces to the Peninsula. Then Major-General JEB 'Jeb' Stuart (1833–64) rode completely around McClellan's army between 12 and 15 June. The cavalryman returned with news that the Federal right flank near Mechanicsville did not extend far enough north to block the roads that Lee planned to use to bring Jackson's troops to the battle. Moreover, the Federals' primary supply line, the Richmond & York River Railroad, was vulnerable. If Lee could turn McClellan's flank, he could threaten the Federal communications at the same time. 'The sooner you unite with this army the better,' Lee told Jackson on 16 June.

The result was the Battle of Mechanicsville, the first of a series of battles known collectively as the Seven Days. At Mechanicsville, Union forces used superior terrain around Beaver Dam Creek to inflict over 1500 dead and wounded, compared to less than 400 Federal casualties. Jackson, no doubt exhausted from the Valley Campaign, was uncharacteristically late, turning Lee's planned flanking manoeuvre into a costly frontal attack. But when McClellan finally ascertained Jackson was advancing, the Federals panicked and decided to retreat. Lee had lost the battle, but, thanks to McClellan's loss of nerve, was on his way to winning the campaign.

GAINES' MILL

When McClellan decided to retreat, crossings over the swampy terrain became of critical importance to him, so he ordered Major-General Fitz John Porter to pull

Federal troops rest near Gaines' Mill, seen in the background. Joe Johnston was wounded at Seven Pines and Robert E Lee assumed command. Lee would go on to become the heart and soul of the Army of Northern Virginia. Johnston himself confessed, 'The shot that struck me down is the very best that has been fired in the Confederate cause yet.'

GAINES' MILL
27 JUNE 1862

5 Pressed hard, Porter requests further reinforcements, but McClellan sends just two brigades. Jackson finally arrives and the Confederates launch an unsophisticated attack that eventually breaks the Federal line.

3 Lee's plan is for 'Stonewall' Jackson to march to Old Cold Harbor and join forces with DH Hill to attack the Federal flank. Jackson is late and Hill is forced to wait.

BUCHANAN

DH HILL

4 AP Hill and Longstreet are supposed to attack the Federal front while DH Hill and Jackson attack the flank. Jackson's slow arrival leads Lee to order AP Hill to advance in a costly frontal attack without Jackson.

2 McClellan orders Porter to pull back to a defendable position covering the Chickahominy River bridge, just south of Gaines's Mill.

McCALL

MORELL

LONGSTREET

AP HILL

POWHITE CREEK

GAINES' MILL

1 Lee's attack at Mechanicsville on 26 June fails to defeat the Federals but causes McClellan to panic and decide to retreat. Lee orders A.P. Hill to move across Beaver Dam Creek to keep pressure on the withdrawing Federals.

OLD COLD HARBOR

Among the technological innovations of the Civil War was the use of observation balloons. Thaddeus Sobieski Constantine Lowe (1831–1913) became the father of the US Balloon Corps and George McClellan made frequent use of Lowe's services during the Peninsula Campaign.

back to a defendable position covering the Chickahominy bridges. The general area was a largely open, oval-shaped plateau, varying in height from 12–24m (40–80ft). The highest elevation was known locally as Turkey Hill, although the battle would be named for Gaines' Mill, around 1.6km (1 mile) away.

Beginning at the northeastern corner of the plateau, and curving around its northern and western sides before emptying into the Chickahominy, was Boatswain's Swamp. Its banks and bottomlands were heavily overgrown and towards its mouth it was steepsided and particularly marshy. Boatswain's Swamp was not the obstacle Beaver Dam Creek was, but it would prove to be rough going for the Confederates.

To the north and west of the plateau, the ground was largely open and sloped down towards the swamp. On the Federals' side, it rose more steeply. Porter placed his corps in a 3km (1.75-mile) crescent facing north and west. Major-General George Morell's (1815–83) division was on the left or western flank, and Brigadier-General George Sykes's (1822–80) was on the right or northern flank. These were arranged in two lines, one near Boatswain's Swamp and the other halfway up the hillside. Major-General George McCall's (1802–68) division constituted a third line, the reserve, at the crest of the plateau. In all, Porter had 27,160 men in position for the Battle of Gaines' Mill. Seventeen Federal batteries, 96 guns in all, were positioned in line, or in reserve, across the plateau. Additionally, three batteries from Major-General William Franklin's (1823–1903) Sixth Corps south of the river could range any assault against Porter's left flank. As at Beaver Dam Creek, Porter had found excellent defensive terrain and used it to his advantage.

MCLELLAN'S RESPONSE

Lee knew that McClellan was defensive-minded, but he did not suspect the magnitude of McClellan's response to Mechanicsville. Rather than completely abandoning the campaign, Lee believed that McClellan would merely reposition to defend his supply line to White House. Thus Lee intended to keep up the pressure, and he ordered Major-General AP Hill (1825–65) to move across Beaver Dam Creek as soon as he learned Porter had abandoned his position. He believed that the Federals would withdraw to Powhite Creek, the next good defensive position.

When Lee finally made contact with Jackson at 10:30 a.m. on 27 June, he formed a plan for an envelopment. Jackson was to march northeast on the Old Cold Harbor Road across the headwaters of Powhite

Creek to Old Cold Harbor, where he would be joined by Major-General DH Hill (1821–89). Hill was already conducting his own wider turning movement over the Old Church Road further north. When joined, Jackson and DH Hill would have 14 of the Army of Northern Virginia's 26 brigades. While AP Hill and Longstreet kept the Federals busy from the front, Jackson and DH Hill would threaten the enemy communications with the Richmond & York River Railroad. Major-General Benjamin Huger (1805–77) and Magruder would be left to defend Richmond.

As it turned out, Lee would face some of the same problems in synchronizing the attack at Gaines' Mill that he had faced at Mechanicsville. DH Hill reached Old Cold Harbor well before Jackson and found himself prematurely joined in battle

between noon and 1:00 p.m. Hill, however, had run into a larger force than he had expected. Furthermore, he appeared to be at the enemy's front rather than its flank. He decided to wait for Jackson. As at Mechanicsville, however, Jackson would be painfully slow in arriving.

While DH Hill was waiting, AP Hill had advanced down Telegraph Road towards Gaines' Mill and New Cold Harbor beyond it. At New Cold Harbor, AP Hill's lead brigade under Brigadier-General Maxcy Gregg (1814–62) encountered a severe Federal artillery barrage. Lee and Hill quickly moved to Gregg's position and learned that the Federals had not made their stand at Powhite Creek but had occupied a considerably stronger position further east. This was at Boatswain's Swamp, a feature that did not appear on Lee's map.

Under McClellan, Federal artillery batteries were assigned to divisions, with each division then relinquishing two batteries to form a corps reserve. Control of the guns under this system was inconsistent. In September 1862, Henry Hunt (1819–89) became the Chief of Artillery for the Army of the Potomac, and within a year, he effected a reorganization of the artillery and centralized its command.

To meet this new situation, Lee ordered the rest of AP Hill's division and that of Longstreet to move up and form a line. Porter could observe these developments from his headquarters on the hilltop and requested reinforcements. In response, Major-General Henry Slocum's (1827–94) division from Sixth Corps was sent forward to cross the Chickahominy River at Alexander's Bridge.

At 2:30 p.m., AP Hill gave the order to advance. Most of his men would have at least 400m (440 yards) of open ground to cross before they reached Boatswain's Swamp. They would be facing three batteries of Federal artillery posted on the lower slopes of the plateau and several higher up on the crest. For nearly two hours, Hill's men struggled against these odds and got nowhere.

In the course of the day Hill would lose 2154 men, and most of these losses would occur right here. For Hill, it was Beaver Dam Creek all over again. He was taking a furious pounding in a frontal assault across open ground into Federal artillery. Moreover, Jackson was nowhere to be found.

WRONG DIRECTION

In fact, Jackson had obtained a guide at Walnut Grove Church and apparently told him only that he wanted to go to Old Cold Harbor. He did not impress upon the guide that he wanted to arrive at Old Cold Harbor by a route that would approach the Federals from the flank. It was not until 5km (3 miles) into the march, just short of Powhite Creek, that the guide discovered Jackson's intent.

At that point, there was no choice but to backtrack to Old Cold Harbor Road. By the time Jackson's lead division under Major-General Richard S Ewell (1817–72) reached Old Cold Harbor, Lee's aide Colonel Walter Taylor (1838–1916) was there to meet him. Lee was concerned by AP Hill's vulnerability to a counterattack and had sent Taylor to direct Jackson's men to the battlefield. Ewell hurried his brigades into action, committing them piecemeal. The Federals defeated each in turn.

By now, Slocum's reinforcements were reaching Porter, and Porter would use them

Brigadier-General George Sykes commanded one of the divisions in Major-General Fitz John Porter's Fifth Corps at Gaines' Mill. While 'Stonewall' Jackson was late in arriving at the battle, Sykes held off a Confederate attack from DH Hill.

Left: Carrying their regimental colours, soldiers from the 28th Massachusetts Volunteers and the Irish Brigade engage with Confederate forces at Gaines' Mill.

Smoothbore muskets had a range of 100–200m (110–220 yards), while rifles were effective from 400–600m (440–660 yards). This new range and accuracy served to strengthen the defence during the Civil War.

Volunteer soldiers formed a critical part of both armies. However, their individualistic nature and lack of formal military training frustrated many professional officers like George McClellan.

to plug gaps in the Federal lines. He was under increasing pressure as Longstreet was now launching diversionary attacks on the right to try to afford some relief for AP Hill. Porter reported to McClellan that 'I am pressed hard, very hard' and, unless reinforced, 'I am afraid I shall be driven from my position.'

McClellan had no plan as to how he might meet this situation. Instead of acting, he non-committally asked his subordinates if they had any troops to spare. In the end, McClellan responded by sending Porter two brigades from Major-General Edwin Sumner's (1797–1863) Second Corps. This was a mere one-tenth of the forces available to McClellan on the south side of the Chickahominy, where he was being paralyzed by nothing more than a demonstration by Magruder.

While McClellan was so parsimoniously reinforcing Porter, Jackson's belated arrival was providing Lee with additional men. Daylight was beginning to fade, and there was time for just one more large-scale attack

before darkness. Both Lee and Jackson had gravitated to the centre of the battlefield and ultimately met on Telegraph Road. 'Ah, General, I am very glad to see you,' Lee said. 'I had hoped to be with you before.' Jackson only nodded at the gentle rebuke.

The result of the meeting was that Jackson would add Major-Generals Chase Whiting's (1824–65) and Charles Winder's (1829–62) divisions to the fight, attacking on Longstreet's left. After combat, ineffective units were removed and two of Winder's brigades and one of Longstreet's were allocated to the reserve. Lee had 32,100 men in 16 brigades to throw against Porter's 34,000 remaining effectives.

CLIMAX

The climax of the Battle of Gaines' Mill was a confused mêlée. DH Hill advanced with his five brigades on the left. To his right was Ewell, then Whiting, then Longstreet. There was no nuance about the attack, but, in the end, Confederate persistence ultimately carried the day. Brigadier-General John Bell Hood's (1831–79) brigade of Whiting's division is traditionally credited with being the first to break the Federal line. Indeed, Lee had earlier sought out Hood. 'This must be done,' he told him, explaining the situation. 'Can you break this line?' 'I will try,' Hood promised. On Whiting's instructions, Hood and Brigadier-General Evander Law (1836–1920) advanced their brigades without pausing to fire, covering the open ground to Boatswain's Swamp as quickly as possible. Hood had split his men, making the charge on both flanks of Law's brigade.

Hood's and Law's brigades suffered staggering casualties. Between them, they lost 1018 men at Gaines' Mill, at least two-thirds of whom were from this charge. Nonetheless, the Federals, able to fire at best three shots a minute, were unable to keep up with the swift pace of the attack. The Federal line broke.

Employing generalship based on audacity and manoeuvre, Lee launched a counteroffensive to McClellan's Peninsula Campaign that removed the Federal threat to Richmond.

It was soon the same everywhere. Almost simultaneously, Porter's defence cracked. There was no choice now but to retreat towards the Chickahominy crossings. Darkness covered the Federal move.

Gaines' Mill would prove to be the largest and most costly battle, not just of the Seven Days but also of the entire Peninsula Campaign. A total of almost 100,000 men had been on the field. In less than nine hours of fighting, Porter had suffered 6837 total casualties and Lee 7993. The Federal failure is best explained by the fact that McClellan did not fight the battle to win. He had left 64,000 men idle on the south side of the Chickahominy while Porter fought alone. Although victorious, the Confederates suffered high casualties, and this too can be explained by an inability to get forces into the fight.

The setback caused McClellan to announce to his lieutenants what he had privately already decided. He would abandon the campaign and shift his base from White House to Harrison's Landing, where he would be under the protection of Flag Officer Goldsborough's Navy gunboats. As McClellan withdrew, there would be sharp fighting at Savage's Station (29 June), White Oak Swamp (30 June) and Malvern Hill (1 July).

Lee had turned the Federals back from Richmond, but he was unable to defeat them decisively. Safe at Harrison's Landing, McClellan consolidated his forces until they were withdrawn to northern Virginia to support Major-General John Pope (1822–92) and the threat he was then facing at Second Manassas. The Peninsula Campaign was over.

SECOND MANASSAS
28–30 AUGUST 1862

THE SECOND BATTLE OF MANASSAS (ALSO KNOWN AS THE SECOND BATTLE OF BULL RUN) WAS THE HIGH POINT FOR THE CONFEDERACY'S ARMIES. GENERAL ROBERT E LEE TOOK AN INCREDIBLE RISK IN DIVIDING HIS FORCES IN THE FACE OF SUPERIOR NUMBERS, BUT WAS ABLE TO GAIN A DECISIVE ADVANTAGE THAT RESULTED IN A TOTAL VICTORY.

WHY DID IT HAPPEN?

WHO Union Army of Virginia (63,000 men) under Major-General John Pope (1822–92) opposed by the Confederate Army of Northern Virginia (55,000 men) under General Robert E Lee (1807–70).

WHAT Pope attacked Major-General Thomas 'Stonewall' Jackson's (1824–63) corps in a disjointed fashion and was unable to defeat it before Lee arrived with the remainder of the Confederate army.

WHERE Near Manassas, Virginia, 42km (26 miles) southwest of Washington DC.

WHEN 28–30 August 1862.

WHY Lee wished to prevent a junction between Pope's army and the Union Army of the Potomac under Major-General George B McClellan (1826–85). He advanced against Pope's supply line and drew the Army of Virginia into a fight on approximately equal terms.

OUTCOME After some initial successes, Pope's force was soundly defeated. Pope was dismissed from army command. Lee's victory opened the way for an invasion of the North.

The ground around Manassas was not auspicious for the Union forces. It was here, in July 1861, that a Union army had broken on the bulwark of Jackson's brigade and thus earned the Southern general his nickname of 'Stonewall'. More recently, three independent Union forces had been unable to defeat a badly outnumbered Jackson in the Shenandoah Valley.

Nonetheless, victory here was necessary. Washington was just 42km (26 miles) away and had to be protected, while the Confederate capital at Richmond was also within striking distance. To bring about this much-needed victory, the Union forces in the region were combined under the command of Major-General John Pope, who managed to antagonize his own side as well the enemy. Even Robert E Lee, a man

not normally given to animosity even towards his enemies, took a personal dislike to the Union commander.

Pope's newly formed Army of Virginia was a serious threat to Lee, who was already outnumbered by the 90,000 strong Army of the Potomac under Major-General George McClellan. If the two Union forces made a junction, Lee was in real trouble. It would have to be prevented.

Lee knew that McClellan was much given to procrastination and was unlikely to make a decisive move any time soon, so he decided to hit Pope hard before McClellan realized what was going on. He sent Jackson north against Pope with just 12,000 men, then ordered Major-General AP Hill (1825–65) to support Jackson, bringing another 24,000 men under Jackson's hand.

Thomas Jonathan Jackson was a strong-willed and eccentric man with deeply held religious beliefs. Although a staunch Christian who disliked fighting on a Sunday, he was also a fearsome battle commander.

The three Union corps that had been formed into the Army of Virginia were still dispersed, and Jackson decided to defeat them in detail by use of a central position from which to lunge against each one in turn. However, Jackson was so concerned with secrecy that he did not fully brief his commanders (including AP Hill) and disorganized his own force in the process.

Jackson's force ran into the Union corps under Major-General Nathaniel Banks (1816–94) at Cedar Mountain and was driven back by a very aggressive assault until Hill's force arrived on the field. Banks had neglected to request reinforcements and could not cope with the setback; his force was soundly defeated.

However, by now McClellan was moving to reinforce Pope. This was a slow business, but Lee knew that his time was limited. He decided to crush Pope as quickly as possible, using Clark's Mountain to conceal his advance until he could launch a decisive attack on Pope's eastern flank. This was more than a tactical flanking movement; if successful, it would drive a wedge between Pope and McClellan, and also knock Pope off his line of retreat to Washington.

Things did not quite go according to plan. Lee's staff was slow to organize the attack, and then his cavalry commander Major-General JEB 'Jeb' Stuart (1833–64) was almost captured when his headquarters was attacked. His adjutant was taken, and in his possession was a copy of Lee's entire battle plan. Stuart struck back with a raid on Pope's headquarters and came back with dire news: in five days McClellan's forces would be in position to aid Pope, bringing the Union army up to 130,000 against Lee's 55,000 or so. Pope already had 75,000 men but if Lee was going to act, it had to be now, before things got any worse.

UNCONVENTIONAL MOVES

Even though he knew that conventional strategy became the norm because it worked, and that those who ignored the rules invited disaster, Lee threw away convention and caution (and, some said, sanity), and split his forces in the face of a superior foe. It may be that he had no choice – it was either this desperate gamble or certain defeat by superior forces.

PRIVATE, IRON BRIGADE

First known as Rufus King's Brigade and later as 'that damn Black Hat Brigade', the formation that became known as the Iron Brigade was composed mainly of units from Wisconsin, plus one from Indiana and, later, one from Michigan. The unit's nickname came from its ability to stand 'like iron' under intense fire – one reason why the formation suffered very high casualties during the war.

Before the Second Battle of Manassas the Iron Brigade was able to muster 2100 men of all ranks. Afterwards, only 1250 answered the roll call. The brigade was recruited back up to just under 1900 in time for Gettysburg but suffered a staggering 1212 casualties there. Some of the units of the brigade took 75–80 per cent casualties.

Whatever the reasoning, Lee sent Jackson's corps, supported by Stuart's cavalry, off on the morning of 25 August. They marched first to Salem (42km/26 miles) and, after covering a remarkable 58km (36 miles) the following day, fell on the Union depot at Manassas on the night of 26 August, destroying the supplies found there.

POPE'S REACTIONS

Pope now found himself in the central position, with 75,000 men available. He could move against Jackson's 24,000 or Major-General James Longstreet's (1821–1904) corps of 30,000, leaving a small force to cover the other. Pope had already

LOCATION

Second Manassas · Washington
· Richmond

Lying just 42km (26 miles) from Washington, about midway between the Union and Confederate capitals, Manassas Junction was a critical point that had already seen heavy fighting earlier in the war.

93

SECOND MANASSAS

THE OPPOSED FORCES

FEDERAL
Total: **63,000**
(troops of all arms)

CONFEDERATE
Total: **55,000**
(troops of all arms)

begun redeploying his forces to counter Jackson's move, and now had a real chance to smash the Confederate corps. However, Jackson was a master of what would come to be known as deception operations. Manoeuvring his forces in a manner designed to mislead and confuse Pope as to his intentions, Jackson moved to Sudley Mountain and reformed his corps on Stony Ridge. His forces were in position by midday on 28 August.

Pope was thoroughly confused by Jackson's movements and did not have adequate reconnaissance information to hand. The captured Confederate battle plan did not help at all. Pope's men reached Manassas too late to catch Jackson and wasted more time in confused movements. Pope then heard that there were Confederates in Centreville and jumped to the conclusion that he had found his enemy.

He sent his entire force racing towards Centreville to engage the enemy. He had been so busy trying to intercept and destroy Jackson that he forgot about Longstreet, permitting the two Confederate forces to make a junction.

ACTION AT GROVETON

Late in the day on 28 August, Jackson's forces attacked Union troops moving down the turnpike towards Centreville. Jackson did not want the Federal forces to take up good defensive positions in Centreville, so

Troops from one of the many New York regiments to fight at Second Manassas pose for the camera. The Civil War was the first conflict to be extensively photographed. Posed images like this one were a novelty at the time, as were the newspapers they appeared in soon after being taken.

The opening of the Second Manassas Campaign came on 9 August in the shadow of Cedar Mountain in northern Virginia, where Brigadier-General Nathaniel Banks's corps fought with Major-General Thomas J. 'Stonewall' Jackson's Second Corps. The battle cost the Federal forces 314 killed, 1445 wounded and 662 missing, totalling 2381 of the 8000 troops engaged. The Confederate forces suffered casualties of 241 killed, 1120 wounded and 4 missing for 1365 of the 16,800 troops employed.

he accepted the risk inherent in making his position known to Pope (who was still groping around for him) and fired on elements of Brigadier-General Rufus King's (1814–76) division as they moved down the Warrenton Turnpike.

Six thousand Confederates attacked about 2300 Union troops under Brigadier-General John Gibbon (1827–96). The Union troops were green but Gibbon was an experienced and determined commander who led his men at the advancing Confederate force. Lines shook out and the firing started. For over two hours the opposing lines stood, in places just 100m (110 yards) apart, and blazed away at one another. There was no attempt at flanking or manoeuvre, just raw firepower poured into the enemy in the hope of breaking them. Gibbon's brigade was reinforced during the battle, bringing his strength up to about half that of the Confederates. At nightfall, the battle petered out, leaving about 1300 casualties on each side. The Confederate force withdrew. Pope misconstrued the action as evidence that Jackson was retreating towards the Shenandoah Valley. He ordered his army to concentrate at Groveton, ready to annihilate Jackson.

SECOND MANASSAS OPENS

Pope was wrong about his opponents' intentions, but Jackson's position was not all that good. He had 20,000 men, who were positioned behind an unfinished railroad line, with the cut as a defensive obstacle. Longstreet was on his way but was still some hours out. Despite his mistakes thus far, Pope had a real chance to pulverize Jackson's force. The first attack went in on the morning of 29 August.

Pope's force advanced against Jackson in a disjointed fashion, making repeated attacks that caused heavy casualties but did not drive Jackson back. About an hour into the fighting, Longstreet's corps came up on Jackson's right and began extending the Confederate line to the south.

On the Union side, Major-General Fitz John Porter's (1822–1901) corps did make a probing attack against what seemed to be Jackson's right flank. In fact, Porter's troops, who were moving up from Manassas Junction, had encountered Longstreet, whose flank was, in turn, held by Stuart's cavalry. After a minor skirmish, Porter withdrew and refused an order to attack, presumably thinking he was unlikely to succeed. He led his force to join the main Union body.

Proving that mistakes were not the sole preserve of the Union army, Longstreet did not attack once he was in position. A dangerous gap had opened up in the Union army, and Longstreet was ideally positioned to exploit it. However, his thinking was defensive at the time and although the Confederates did press forward somewhat as their opponents fell back, there was no

John Pope held general rank more or less from the outset of the war and helped raise some of the earliest volunteer units to be recruited. Although successful in the west, he is mainly remembered for his defeat at Second Manassas and for his arrogant address upon assuming his new command in the east.

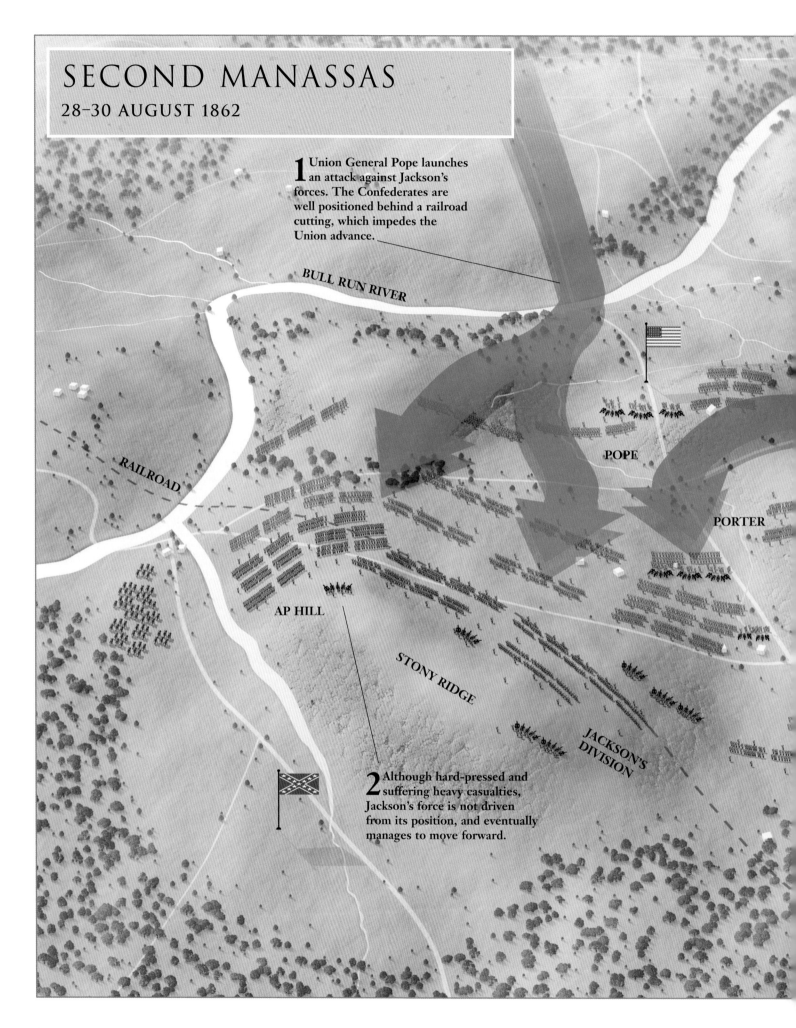

SECOND MANASSAS

28–30 AUGUST 1862

1 Union General Pope launches an attack against Jackson's forces. The Confederates are well positioned behind a railroad cutting, which impedes the Union advance.

BULL RUN RIVER

RAILROAD

POPE

PORTER

AP HILL

STONY RIDGE

JACKSON'S DIVISION

2 Although hard-pressed and suffering heavy casualties, Jackson's force is not driven from its position, and eventually manages to move forward.

3 Porter's troops, coming from Manassas Junction, make a weak attack against the Confederates as Longstreet is getting into position on Jackson's right.

HENRY
HOUSE HILL

5 Pope, believing that the Confederates are beaten, orders a pursuit for the next day. Instead he is hammered by the largest massed attack of the war on 30 August, where Union forces are defeated and driven from the field.

LONGSTREET

4 As Porter is driven off, Longstreet has a perfect opportunity to attack as a gap opens up in the Union line, but allows it to pass.

A Confederate Kentucky cavalryman fires his service revolver. Cavalry were mainly effective as scouts, raiders and skirmishers in the Civil War. Infantry firepower was such that a traditional sabre charge was unlikely to be effective. The cavalryman's combination of mobility and firepower made him an important asset all the same.

pursuit or attempt to exploit the repulse of the Union army. Indeed, Jackson ordered his troops to withdraw from the ground they had taken and resume their previous defensive positions. Pope, as usual, misconstrued the move.

This time, Pope decided that the Confederates were in retreat, and ordered a pursuit for the following day. He still did not know that Longstreet was on the field, nor that Lee was coming up as well.

THE SECOND DAY

The second day opened with Jackson's force returning to its former positions and the Union army beginning a new series of attacks. Pope finally became aware of Longstreet's presence but still thought the Confederates were retreating. Skirmishing went on all day, with casualties mounting on both sides.

In the early afternoon, Pope decided to put in a decisive assault. This began at about 3:00 p.m., and was launched with great determination. Successive lines went forward and fierce close-range firefights broke out all along the Confederate line.

Jackson's corps had a good defensive position and confidence born of the previous day's victory. But the men were tired and the enemy far more numerous. Many battles of the Civil War were decided by raw firepower, with victory going to the side that hung on longest. Would the Rebels be broken first by the hammering they were receiving, or would the Federal troops run out of aggression and fall back? The crisis point had arrived.

THE DECISIVE MOMENT

Porter's force put in an attack, which was met with massed Confederate artillery fire and hurled back. Seeing that the moment had arrived, General Robert E Lee, who

had reached the battlefield with his own force, ordered Longstreet forward against the Union left flank.

Longstreet had 28,000 men under his hand, who had thus far played little part in the battle. They were relatively fresh and were opposed by only weak forces. The advance, which was the largest massed assault of the entire war, smashed into the

weak Union line and flung it back. This endangered the flank of the forces assaulting Jackson, and resulted in a general movement towards the rear. For a time, it appeared that Pope's army was going to be chased from the field and devastated.

Despite the extremely aggressive advance of Longstreet's corps, elements of the Union force were able to rally and make a stand on Henry House Hill, the same place where Jackson's brigade had broken the Union assault at the First Battle of Manassas. Although the rearguard was hard-pressed by determined Confederate attacks, it was able to hold out and prevent the total collapse of the Union Army.

As a result of the rearguard action, Pope's army came off the field at Second Manassas defeated and bloodied but generally intact. It remained a viable fighting force, which was an improvement on the situation after First Manassas.

Below: The Confederate 5th Texas Regiment charge the Federal 5th New York Zouaves at the battle of Second Manassas.

PURSUIT (1 SEPTEMBER)

Following on from this success, Lee continued to attack. He made a second large flanking manoeuvre, hoping to cut off the retreating Union army and obliterate it. However, the going was slow even for Jackson's hard-marching 'foot cavalry'. Jackson's force reached Chantilly and there encountered Union forces under Major-General Isaac Stevens (1818–62) and Major-General Philip Kearny (1815–62) on 1 September.

A sharp fight ensued, in which both Union commanders were killed, but Jackson was unable to complete his flanking movement and the Union line of retreat remained open. Pope was shaken by the string of defeats and retired into the defences of Washington, even though reinforcements were available to him.

AFTERMATH

Lee had not quite managed to destroy Pope's army, mainly due to Longstreet's failure to attack on the first day and the determined rearguard action on Henry House Hill. Pope's decision to send troops north to cover his flank, thus precipitating the inconclusive but important fight at Chantilly, also did much to stop a tactical defeat becoming a strategic disaster. Pope was blamed for the fiasco and relieved of his command. Porter's career was also wrecked by allegations that his refusal to attack Longstreet was calculated to cause Pope's defeat and McClellan's reinstatement as overall commander.

Lee was not able to make an attempt on Washington's defences with the forces he had to hand, and McClellan remained a threat. However, the way was now open for an advance across the Potomac into the North. Lee had shown that he could gamble when he had to and that, overall, the Southern forces were better led than their Northern counterparts.

Victory at Second Manassas was a turning point for the Confederacy. Not long beforehand, Lee was facing certain defeat; now the Union forces were in disarray and there was a real chance of winning the war.

Up until Second Manassas, the Confederacy had been trying to stave off defeat in Virginia, which would mean the loss of the capital and probably the end of the war. Now a new campaign opened, which would lead to Antietam and another turning point.

Thanks to the stand at Henry House Hill, the Federal army was able to cross the Bull Run and withdraw in good order. Thousands of men were funnelled across this narrow bridge.

ANTIETAM
17 SEPTEMBER 1862

THE YEAR 1862 BEGAN WELL FOR THE UNION. IN THE WEST, UNION ARMIES ACHIEVED A NUMBER OF IMPORTANT VICTORIES, INCLUDING GRANT'S SUCCESS AT SHILOH. LIKEWISE, THE UNION NAVY WON SOME SIGNIFICANT GAINS, INCLUDING THE CAPTURE OF NEW ORLEANS AND THE USS *MONITOR'S* FORCING THE CONFEDERATE IRONCLAD *VIRGINIA* (FORMERLY THE UNION FRIGATE USS *MERRIMACK*) TO YIELD HAMPTON ROADS AND THE MOUTH OF THE JAMES RIVER TO FEDERAL CONTROL.

WHY DID IT HAPPEN?

WHO Major-General George B McClellan's (1826–85) Union Army of the Potomac (87,000) confronted General Robert E Lee's (1807–70) Confederate Army of Northern Virginia (45,000).

WHAT McClellan's army attacked while the Confederates were drawn up along Antietam Creek on the Maryland side of the Potomac River, inflicting some 10,300 casualties while losing 12,400 men.

WHERE Sharpsburg, Maryland, some 80.5km (50 miles) northwest of Washington DC.

WHEN 17 September 1862.

WHY McClellan's natural caution, his belief that he was outnumbered, plus poorly coordinated attacks allowed Lee to repulse Union attacks and withdraw to Virginia.

OUTCOME While the Army of Northern Virginia remained a significant force, Southern hopes of Maryland joining the Confederacy were dashed, as was the possibility of foreign intervention on their behalf. Lincoln also had the victory he needed to issue the Emancipation Proclamation.

Despite these successes on other fronts, the Union was unable to make significant progress in the central theatre of the war, that 161km (100-mile) front between the capitals of Washington DC and Richmond. Here, the main Confederate army of 60,000 men under General Joseph E Johnston (1807–91) faced the Union army of more than 100,000 under the command of Major-General George B McClellan. Under pressure from Lincoln (1809–65), McClellan came up with a plan for a grand flanking manoeuvre that required transporting his army to the Virginia Peninsula for an attack on

Richmond. By late March McClellan had concentrated a large army of nearly 100,000 on the Peninsula, but he was slow to act and so missed an opportunity to strike at Richmond from the Peninsula while he was opposed by a force of only 17,000 men. Johnston and his army moved to block McClellan's advance.

At this point, McClellan, noting that with the withdrawal of Johnston to the Peninsula Washington was no longer in danger, requested the release of a corps that had been left to defend Washington. He was thwarted by the advice of Robert E Lee, who suggested that Major-General Thomas

This is the railroad bridge at Harpers Ferry. The town was an important Union garrison and supply centre. The heights in the background were captured by Confederate troops and it is clear from the photograph how these dominate the town.

'Stonewall' Jackson's (1824–63) troops in the Shenandoah Valley make a feint to tie down Union forces. Jackson executed a masterful campaign, not only pinning, and defeating, large numbers of Union forces in and around the Valley, but also convincing Lincoln not to release the corps McClellan had requested.

Although McClellan would advance to within 8km (5 miles) of Richmond, he would be forced to retreat when Robert E Lee assumed command of the Confederate army there after Johnston had been wounded. During June and July, the two armies fought a number of engagements and, although the battles were indecisive and costly to the Confederacy, Lee's skilful manoeuvring forced the Union army to halt its efforts to seize Richmond.

POPE TO THE FORE

In early August, Lincoln decided to concentrate Union forces in northern Virginia under the command of Major-General John Pope (1822–92) as the Army of Virginia. He also ordered McClellan to begin withdrawing his forces from the Peninsula, intending for the two forces to join together and create a huge army to march on Richmond from the north. Lee reacted quickly, ordering a probing attack by Jackson against Pope and moving the bulk of his own forces north in support. At the Second Battle of Manassas (28–30 August), Pope's army was mauled by Jackson and by Longstreet, whom Lee had sent to support him.

Lee had hoped to annihilate the Army of Virginia, but Pope began an orderly retreat to Centreville, and the exhaustion of the Rebel troops, especially those of Jackson's command, a vigorous defence by the Union rearguard and impending arrival of Union reinforcements, made this impossible.

By the end of the summer, Confederate fortunes on the war's central front were on the rise. Lee had turned back a major Union effort against the Rebel capital, Richmond, and, in conjunction with Jackson, had counterattacked and won a significant victory. At the same time, Union forces in the western theatre had become bogged down and lost the initiative. It was at this point that the Confederacy planned a major series of coordinated offensives against the Union forces both in the east and the west.

THE CAMPAIGN

The Union Army was in disarray. Pope and his subordinates blamed one another for the debacle at Manassas. President Lincoln was despondent because he was unable to find a commander who seemed capable of winning the decisive victory he so sorely wanted. In the event, he appointed, once again, George McClellan as the commander of the reinforced Army of the Potomac. Many in the Lincoln administration were against the general's reappointment, including Secretary of War Edwin Stanton (1814–69). Although Lincoln perhaps

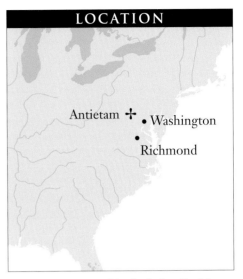

LOCATION

Antietam ✚ •Washington
•Richmond

The battle took place in Maryland where Confederate forces could threaten the capital, Washington, as well as the rich farms and towns of Pennsylvania. It was further hoped that a Confederate army in Maryland would bring that state over to the Confederate cause.

1ST SOUTH CAROLINA REGIMENT OF RIFLES

Also known as Orr's Rifles, the regiment was formed in July 1861 and was engaged in many of the important battles of the war. At Antietam, it was part of Brigadier-General Maxcy Gregg's (1814–62) brigade of AP Hill's (1825–65) Light Division along with four other units of South Carolinians. The unit was involved in Hill's counterattack against Major-General Ambrose Burnside (1824–81). Hill notes that Gregg's brigade was composed of veterans and while engaging in a firefight, poured in 'destructive volleys' against the advancing Union troops. Three Confederate brigades, including Gregg and his South Carolina regiments, numbering only 2000 men, were able to drive off Burnside's corps.

This illustration shows the difficulty that faced the troops of Burnside's corps as it tried to push across the Rohrbach Bridge. Only one unit at a time could cross the bridge and so the Union forces were forced to launch piecemeal attacks rather than coordinated ones.

realized that McClellan's cautious nature made him less than ideal as an aggressive battlefield commander, McClellan had, nonetheless, demonstrated his skills as an excellent military administrator. After the defeat at Second Manassas, it was these skills that were needed to reforge the demoralized Union army.

While the Union forces were regrouping, the Confederacy was planning its coordinated offensives for the autumn of 1862. There were to be three separate campaigns launched. Two western armies under General Braxton Bragg (1817–76) and Major-General Earl Van Dorn (1820–63) were to invade Kentucky and Tennessee respectively. In the meantime, Lee and the Army of Northern Virginia were to move north through Maryland, pushing on to Harrisburg, the capital of Pennsylvania. If successful, the Confederacy would see a number of positive strategic

effects. First, it was hoped that the arrival of a Confederate army in Maryland, which was home to a number of Southern sympathizers, would bring that state within the Confederacy, providing both manpower and resources.

Secondly, Lee's army had suffered from the constant and arduous campaigning earlier in the year and his troops were in desperate need of all manner of supplies. Many of these could be procured in Pennsylvania. Lastly, Harrisburg was an important centre of communications that sat astride road and railroad lines that would allow Lee and his army to threaten a number of important Northern cities, such as Philadelphia, Baltimore and Washington, with either direct attack or by cutting their supply lines.

On 5 September, Lee led his Army of Northern Virginia across the Potomac River into Maryland. Unfortunately, it quickly became apparent to him that, despite the sympathetic leanings of many Marylanders, the state and its population were not actively going to support him or his army. One reason for this may have been the appearance of the Army of Northern Virginia. Although the troops were flushed

with victory and very confident, they hardly looked like a triumphant army. Few units had a uniform appearance and many of the troops' clothing was threadbare and their equipment was worn out.

HARPERS FERRY

Lee continued to move north towards Frederick, which he occupied. While there he learned that the Union forces in and around Harpers Ferry, about 13,000 men, had not retreated even though they were now cut off by his invasion force. Lee decided to have Jackson cross the Potomac with 15,000 men while two other divisions supported Jackson by occupying the heights on the Maryland side of the river. He would take the remainder of the army and move towards Hagerstown.

On 9 September, Lee had orders drawn up, Special Orders 191, outlining his plan, with copies sent to the pertinent commanders. This did not seem to be a particularly risky manoeuvre given McClellan's propensity for caution and his tentative movements. Lee believed that the army would be reunited before it faced a major engagement. Having received its marching orders, the Army of Northern

Virginia divided into four columns and departed the next day.

Unfortunately for Lee, McClellan moved more quickly than usual, perhaps spurred on by the panic that Lee's invasion had caused. On 7 September, the Army of the Potomac left Washington in pursuit of Lee's forces. The army's morale had not improved much since the defeat at Second Manassas a little more than a week before. But as the Union troops marched though western Maryland, a profound change occurred. Unlike Lee, the Union troops were met with great enthusiasm by the local population, who came out in large numbers to cheer them on and provide them with food and drink. For the first time, the Army of the Potomac was on the defensive, fighting on its own soil, and with the outpouring of support morale soared.

On 12–13 September, Confederate troops occupied the heights east of Harpers Ferry, facing only minor resistance, and,

after a brief bombardment, the town and its garrison, less 1500 cavalry who managed to break out, surrendered to Jackson the following day. But while Jackson was enjoying success at Harpers Ferry, fate struck a serious blow to the Army of Northern Virginia.

On 13 September, McClellan's army entered Frederick and received an enthusiastic greeting from the inhabitants. One Union regiment, the 27th Indiana, halted that morning at a farm just outside town. As troops fell out to rest, a corporal in the unit found an envelope containing three cigars wrapped in a sheet of paper. The soldier unwrapped the paper and discovered that it was a copy of Special Orders 191, detailing Lee's campaign plan. The captured document was quickly passed up the chain of command until it reached General McClellan's headquarters. But McClellan was indecisive; although he had the enemy's plans, he believed, as he all too

THE OPPOSED FORCES

FEDERAL
Army of the Potomac,
consisting of 7 army corps **87,000**

CONFEDERATE
Army of Northern Virginia,
consisting of 2 army corps **45,000**

Major-General Ambrose Burnside, seated in the centre with his legs crossed, commanded the Union army's Ninth Corps. He is shown with his staff. Photographs of commanders and their staffs taken either before or after a battle were very popular.

ANTIETAM
17 SEPTEMBER 1862

3 DH Hill defends the sunken road, which came to be known as Bloody Lane, against repeated assaults by Sumner's corps.

1 At dawn, Hooker's corps attacks Jackson on Lee's left flank. Thrust and counterthrust leave the cornfield and the Dunker Church grounds strewn with dead and wounded.

UPPER BRIDGE

SUMNER

HOOKER

DH HILL

DUNKER CHURCH

ANDERSON

STUART

POTOMAC RIVER

2 Mansfield assaults the Confederate left, making only limited progress, while Sedgwick's charging division of Sumner's corps plunges into Jackson's trap and is badly mauled.

5 After three hours, Burnside succeeds in crossing the lower bridge. Sluggish progress towards Sharpsburg threatens to cut off the Confederate line of retreat.

PORTER

MIDDLE BRIDGE

BURNSIDE

LOWER BRIDGE

ANTIETAM CREEK

LONGSTREET

SHARPSBURG

6 At 4:00 p.m., after a 23km (17-mile) forced march from Harpers Ferry, AP Hill's Light Division arrives when needed most to halt Burnside and end the fighting.

4 A misinterpreted order and Colonel Francis Barlow's (1834–96) flanking manoeuvre force a Confederate retreat from Bloody Lane, but McClellan withholds reserves from the breach in Lee's centre.

Above: A soldier of a Zouave unit which formed part of Major-General Ambrose Burnside's Ninth Corps. His regiment had the distinction of being the Union unit which advanced farthest during the battle, attacking the outskirts of Sharpsburg in the afternoon.

often did, that Lee's force was much larger than it actually was. As a result, it took hours for orders to be drafted and the Union forces did not begin moving until the next morning.

Lee, however, received intelligence regarding the impending movement of the Union army. Colonel JEB 'Jeb' Stuart's (1833–64) cavalry scouts had noted the unusual activity among the Union units and a message was received from a Southern sympathizer that McClellan had obtained a copy of his orders. Had McClellan moved quickly on 13 September, he might have taken and held the passes in the South Mountain range. Lee, however, moved more quickly and blocked the three key passes with his available forces, perhaps 16,000 men. On 14 September, these forces were attacked by more than twice their number of Union soldiers. Although the fighting was fierce, the Southern troops were forced to yield the passes to the enemy.

Things looked bleak for Lee on the night of 14 September and he was planning to abandon the campaign and retreat back to Virginia when he received word that Harpers Ferry was about to surrender to Jackson. This strengthened his resolve and so Lee determined to make his stand where

he had received the message – Sharpsburg. This was a strong position, protected by a series of hills and Antietam Creek. At noon on 15 September, Lee received confirmation that Harpers Ferry had in fact surrendered and sent orders to all of his units to converge on Sharpsburg for what could be, if they were victorious, a decisive battle.

DISPOSITIONS

On 15 September, Lee had managed to gather some 18,000 troops at Sharpsburg, but they had not had the time to fully deploy. McClellan's forces began arriving that afternoon as well but, cautious as ever, he did not cross the unguarded Antietam Creek; indeed, he did not even make an effort to reconnoitre the far bank by sending out a cavalry screen. The next day, troops arrived on both sides. Lee's force increased to perhaps 25,000 men while McClellan had some 55,000 men deployed with another 14,000 or so men only a few

Hooker's First Corps launched a sustained attack along the Hagerstown Turnpike on the morning of 17 September and there was heavy fighting stretching the length of the road. The bodies are those of Confederate soldiers killed in the fighting.

kilometres away. But rather than attacking on 16 September, McClellan spent the entire day planning rather than moving. Once again, he assumed that Lee's forces were far stronger than they actually were and so he delayed attacking. This was a missed opportunity for the Union to defeat the Army of Northern Virginia while it was divided. By the time the battle began on the morning of 17 September Lee had gathered most of his available forces at Sharpsburg. Only Major-General AP Hill's division was not present, as it was on the march and expected to arrive later that day.

Lee had deployed his forces to the north and east of Sharpsburg along a ridgeline with both wings protected by water; the left rested on a bend in the Potomac River, while the right was anchored on Antietam Creek. Stuart's cavalry held the extreme left of Lee's line. The main body of the

Confederate left was composed of Jackson's corps, while Longstreet's corps held the Confederate right flank.

McClellan had finally sent troops across the Antietam on the evening of 16 September. He sent Major-General Joseph Hooker (1814–79) and his First Corps, later followed by Major-General Joseph K Mansfield's (1803–62) 12th Corps, as the right wing of his army. On the eastern bank of the Antietam, the remainder of his army was placed, beginning with Major-General William B Franklin (1823–1903) and his Sixth Corps, closely followed by Major-General Edwin Sumner's (1797–1863) Second Corps. Then came the Fifth Corps under Major-General Fitz John Porter (1822–1901) supported by Brigadier-General Alfred Pleasonton's (1824–97) cavalry division and, finally, Major-General Ambrose Burnside's Ninth Corps, which

This painting shows Union troops advancing at the double. Although tactics of the time, such as Hardee's Rifle and Light Infantry Tactics, emphasized firepower, moving forward at the double in order to come to grips with cold steel was seen as a possible counter to the infantry firefight.

ANTIETAM

formed the army's left flank. The plan called for 'Fighting Joe' Hooker supported by Mansfield and Sumner to sweep down the Hagerstown Turnpike and engage the Confederate left flank. Once this had been done and Lee's attention was fixed on his left, Burnside would force his way over the Antietam by the Rohrbach Bridge. The remaining two corps and Pleasonton's cavalry were to be kept in reserve.

THE BATTLE

The battle began at dawn with Hooker's First Corps quickly moving to the attack along the Hagerstown Pike. As the Union troops entered the cornfield that lay to the east of the Pike between two large woods, they became heavily engaged with Jackson's troops. The fighting was intense, with both sides suffering heavy losses. Particularly devastating was the artillery fire. Both sides engaged in stiff counterbattery fire and the Union artillery fired at point-blank range into the cornfield, inflicting massive casualties. For nearly two hours both sides fed divisions into the fray without gaining the advantage. It was not until 7:00 a.m. that troops from the next Union corps, Mansfield's 12th, joined the action. Sadly, this was to be typical for the battle –

McClellan's inability to coordinate attacks that would have allowed him to take advantage of his superiority in numbers. By the time Mansfield engaged the enemy, Hooker's division had been rendered nearly combat ineffective. Moreover, Lee used the time to move additional troops to support his left flank.

Once again, the Union troops of the 12th Corps attacked, but without much support and thus with limited success – when the troops did make a breakthrough they were unsupported. The only support came from one division of Sumner's corps, which, having crossed the cornfield and entered the West Woods without reconnoitring first, was ambushed and badly mauled.

Sumner's remaining two divisions advanced around 9:00 a.m., moving south to engage the centre of Lee's line. Here, the Confederates occupied an 800m (880-yard) stretch of road that had been eroded by years of use and provided a natural trench line for the Confederates holding it. For nearly four hours the Union troops launched attacks against the enemy in 'Bloody Lane' until, finally, they managed to take and hold it.

Once again, a lack of coordination, in this case not committing the troops held in

reserve from the corps of Major-Generals Porter and Franklin, allowed an opportunity to be lost. It is clear that McClellan assumed that he needed to keep these troops in reserve to counter Lee's reserve forces – which did not exist.

While the Union army was hotly engaged in the cornfield, the West Woods, and then at Bloody Lane, Burnside, who was to have engaged in early assault, remained inactive. This allowed Lee to move units facing Burnside to other parts of the battlefield at critical moments. At 10:00 a.m., however, Burnside received direct orders to attack and he now faced a considerably reduced Confederate force. Although he outnumbered the enemy by more than three to one, Burnside was unable to force a crossing of the Antietam for several hours.

His actions at Rohrbach, soon to be evermore known as Burnside's Bridge, were both unimaginative and lethargic. He suffered heavy casualties by sending units to attack across the bridge. It was not until the early afternoon that some of his troops turned the Confederates' position by fording the creek downstream; and it was not until nearly 3:00 p.m. that he was prepared for a more general advance against the Confederate right and began forcing them back towards Sharpsburg, cutting off their line of retreat across the Potomac. But Burnside's lack of initiative proved costly since at 4:00 p.m. AP Hill arrived from Harpers Ferry with badly needed reinforcements and attacked Burnside's left flank, collapsing it.

Although Burnside's left flank was in serious trouble, his right continued to press the Confederates, driving them towards Sharpsburg, but McClellan refused to send in his reserves, assuming himself still to be outnumbered.

As night fell, both sides were exhausted and had suffered horrific casualties. On the morning of 18 September Lee could muster perhaps 30,000 effectives and had no hope of fresh troops. McClellan, meanwhile, had received some 13,000 reinforcements who, together with his uncommitted reserves, gave him more fresh troops than Lee had fit for duty in his entire army. But his belief that Lee had hidden reserves kept him from engaging on 18 September, and so the Army of Northern Virginia was able to slip away unmolested that night.

Although McClellan had missed an opportunity to destroy Lee's army and likely end the war, the strategic effects of the Battle of Antietam were nonetheless significant. The Union had turned back a major Confederate offensive on to their soil and, in so doing, had kept Maryland out of the Confederacy. This also ended any hope of foreign intervention on behalf of the South. Finally, President Lincoln, who did not wish to appear desperate when he issued the Emancipation Proclamation, could now do so in the wake of a major strategic victory.

This photograph shows President Lincoln with Allan Pinkerton (1819–84), head of the Secret Service, and Major-General John McClernand (1812–1900). The victory at Antietam was important to Lincoln since it provided him with a much-needed success before announcing the Emancipation Proclamation.

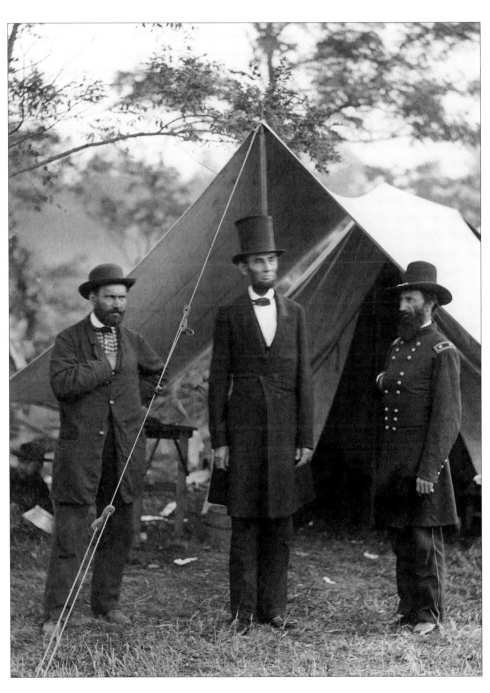

CORINTH
3–4 OCTOBER 1862

RAILROADS AND THEIR ABILITY TO MOVE TROOPS AND EQUIPMENT RAPIDLY OVER GREAT DISTANCES CATAPULTED THE OTHERWISE MODEST TOWN OF CORINTH, MISSISSIPPI, ONTO CENTRE STAGE OF THE CIVIL WAR. BOTH FEDERALS AND CONFEDERATES WANTED THIS STRATEGIC LOCATION AS A MEANS OF INFLUENCING OPERATIONS IN TENNESSEE. TWO BATTLES WERE FOUGHT OVER CORINTH, WITH THE FEDERALS ESTABLISHING PERMANENT CONTROL AFTER THE SECOND BATTLE ON 3–4 OCTOBER 1862.

WHY DID IT HAPPEN?

WHO Confederate and Federal forces sought to control the railroad system in the west in order to influence operations in Tennessee.

WHAT First a pending siege forced the Confederates to abandon Corinth. Then the Federals occupied and fortified the town and defeated a Confederate attack.

WHERE Corinth, Mississippi, where the Memphis and Charleston Railroad met with the Mobile and Ohio Railroad.

WHEN 3–4 October 1862.

WHY The Confederate attack was poorly planned and became progressively weaker as it lengthened while the Federal defences became stronger as they contracted.

OUTCOME The Confederates' ability to reinforce Tennessee was denied and Major-General Ulysses S Grant (1822–85) was then able to turn his attention to Vicksburg.

At the time of the Civil War, Corinth was still a young town. It was settled in 1854 and had a pre-war population of only 1200. Its business district consisted mostly of one- and two-storey, gabled, wood-frame structures. Corinth boasted the typical dry goods stores, blacksmith shops, livery stables, saloons, restaurants, drugstore, bakery, tailor's shop and picture gallery. The Aetna Insurance Company had a local office there, and there were three hotels, including the Tishomingo, renowned for its luxury of serving ice water. It was all relatively routine, save perhaps for the post office, which, rather than the standard whitewash, was painted pink.

What separated Corinth from any of the hundreds of other similar-sized towns throughout the Confederate west was the railroad. Railroads brought with them the important strategic concept of interior lines – the ability of one side to use superior lateral communications to reinforce their separated units faster than the enemy could reinforce theirs. Indeed, the Civil War would become the first great railroad war.

At Corinth, the Memphis and Charleston Railroad met with the Mobile and Ohio Railroad. Control of Corinth meant control of railroads from Columbus and Memphis, as well as those running south into Mississippi and eastwards to connect with Nashville and Chattanooga. Many Federal military and political leaders believed that if the Union could occupy two points in the South, the rebellion would

At Iuka, Major-General Edward Ord (1818–83), standing, centre, was unable to combine with Major-General William Rosecrans (1819–98) to trap the Confederates between two pincers. He would later command the 18th Corps during Grant's Overland Campaign in Virginia.

collapse. Obviously, one point was Richmond. The other was Corinth. Major-General Ulysses S Grant called Corinth 'the great strategic position at the West between the Tennessee and Mississippi Rivers and between Nashville and Vicksburg'. Confederate President Jefferson Davis (1808–89) considered the Memphis and Charleston Railroad the 'vertebrae of the Confederacy'. Corinth itself was known as 'the crossroads of the Confederacy'. It was all sufficiently important to cause Corinth to play a pivotal role in the preliminaries to the Battle of Shiloh, to host two battles itself and to facilitate the launching of the decisive Vicksburg Campaign.

CORINTH AND SHILOH

Grant's victories at Forts Henry and Donelson in February 1862 forced General Albert Sidney Johnston's (1803–62) Army of Mississippi out of Tennessee. Johnston then decided to concentrate his forces at the rail junction at Corinth. At the same time, Grant had assembled some 45,000 men at Pittsburg Landing, about 32km (20 miles) northeast of Corinth, where he would wait for the arrival of Major-General Don Carlos Buell's (1818–98) Army of the Ohio from Nashville. In times of peace, one of the ways goods reached Corinth from the Tennessee River was along a road from the wharf at Pittsburg Landing. Now Pittsburg Landing offered Grant a convenient staging area for a march south to attack Corinth.

Grant was quite sure that Corinth would be the next battlefield and that he would be the one initiating the action. He wrote to one of his generals: 'I am clearly of the opinion that the enemy are gathering strength at Corinth quite as rapidly as we are here, and the sooner we attack, the easier will be the task of taking the place.' Indeed, attack was all Grant had in mind. He failed to prepare any defences himself and responded to suggestions that the Confederates themselves might attack by saying: 'They're all back at Corinth, and, when our transportation arrives, we have got to go there and draw them out, as you would draw a badger out of a hole.'

As a result, Grant was caught completely by surprise on 6 April, when Johnston attacked at Shiloh. The first day of the fighting was a close call for Grant's army, but the Federals recovered the second day and won the battle. In the process, Johnston, who some considered the Confederacy's greatest general at the time, was killed, and General PGT Beauregard (1818–93) assumed command. Beauregard retreated back to Corinth and began building heavy fortifications.

The Federals also experienced a leadership change. In spite of the overall victory, Grant's poor showing on the first day of Shiloh damaged his credibility, and he was replaced by Major-General Henry Halleck (1815–72). Thus it would be Halleck who would lead the Federal

LOCATION

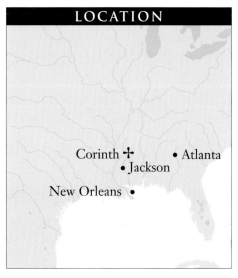

The importance of railroads: Corinth's position at the junction of the Memphis and Charleston Railroad and the Mobile and Ohio Railroad made it 'the crossroads of the Confederacy'.

offensive against Corinth that Grant had been anticipating before General Johnston interrupted his plans.

FIRST BATTLE OF CORINTH

Halleck would eventually provide valuable service to the Union in an administrative capacity as General-in-Chief and then as Grant's chief of staff, but he was not an impressive field commander. His approach march towards Corinth was slow and deliberate. Every night he stopped and had his men dig in. After the horrific losses at

Opposite: Confederate troops charge Union trenches. The Confederates' lack of reserves prevented them from exploiting local successes at the Second Battle of Corinth.

Shiloh, Halleck was in no mood to risk additional heavy combat. As Captain EB Soper described: 'Every advance was made in line of battle preceded by skirmishers. When the popping on the skirmish line became hot, lines were dressed up at favourable positions, every other man holding two rifles, and his file-mate industriously using the shovel or axe, relieving each other every minute or two. A strong line of rifle pits was in this way speedily constructed.'

To make matters worse, Halleck had to corduroy many kilometres of roads (surface them with branches and small tree trunks laid side by side) to give him the dry, dependable and durable surface he needed to transport supplies by wagon. Thus Halleck crept along at a rate of less than

The dashing Pierre Beauregard won early fame in the Civil War as both the hero of Fort Sumter and First Manassas. He assumed command at Shiloh after General Albert Sidney Johnston was killed.

THE OPPOSED FORCES

FEDERAL
Army of the Mississippi **23,000**

CONFEDERATE
Army of Tennessee **22,000**

CORINTH
3–4 OCTOBER 1862

2 On 2 October Rosecrans discovers Van Dorn is advancing on Corinth which threatens to cut Rosecrans off from any potential reinforcements from Grant.

4 On the morning of 3 October Van Dorn attacks Rosecrans' outer defensive line and enjoys initial success.

COLLEGE HILL

6 Van Dorn renews his attack on 4 October but by now Rosecrans is manning a contracted line and has received reinforcements. The Confederate attack is repulsed in heavy fighting before Battery Robinette and Van Dorn is forced to withdraw from the battlefield.

3 The Confederates deploy in an arc to the northwest of Corinth with Major-General Mansfield Lovell on the right and Major-General Sterling Price on the left.

VAN DORN

ROSECRANS

CORINTH

5 Rosecrans' inner defences consist of Batteries Robinette, Williams, Phillips, Tannrath, and Lothrop in the College Hill area. In the wake of Van Dorn's attack on 3 October, the Federals withdraw to these strong defences just before dark.

1 On 30 May the Federals occupy Corinth after it is abandoned by the Confederates and begin improving the defensive positions. By 2 October, Rosecrans has 23,000 men at Corinth.

OLD CONFEDERATE EARTHENWORKS

Opposite: The Federals occupied and improved the already strong positions left behind when the Confederates abandoned Corinth during the night of 29/30 May. By the time of the second battle, the Confederate forces faced successive inner and outer rings of entrenchments.

1.6km (1 mile) per day. The consequence was that Beauregard had plenty of time to prepare his defences and his plan.

The Confederate entrenchments formed an 11km (7-mile) line that covered the northern and eastern approaches to Corinth and extended in an arc about 2.4km (1.5 miles) from town. They were anchored east and west on the Memphis and Charleston Railroad and included rifle pits with battery emplacements at key points. It was a formidable line.

Still Beauregard knew that he was far outnumbered. He had withdrawn to Corinth with 30,000 of the 40,000 Confederates who fought at Shiloh, and later reinforcements brought his strength to 66,000. Halleck had begun his march from Shiloh with 90,000, and his ranks had swollen to 110,000 by the time he reached Corinth. By mid-May, Halleck was astride the Mobile and Ohio Railroad north of Corinth and had cut the Memphis and Charleston Railroad to the east.

Instead of subjecting himself to the lopsided siege that Halleck was planning, Beauregard resorted to a ruse to play on Halleck's cautious nature. As trains rolled into Corinth, Beauregard had his men cheer wildly as if reinforcements were arriving.

Halleck took the bait and proceeded with due caution. In reality, there were no reinforcements, and instead, on the night of 29/30 May, Beauregard loaded his men and equipment onto the trains and withdrew to Tupelo. By the time Halleck finally assaulted Corinth on the morning of 30 May, Beauregard and his army were gone.

Halleck had captured an important location without a fight, but he had let his enemy escape. This was of little concern to Halleck, who had always considered Corinth rather than Beauregard's army to be his true objective. Halleck wrote to his wife that he now possessed 'a most important military point'. Moreover, he had accomplished the feat with very little loss of life. He wrote: 'This to me is the great merit of the whole, although the public will be greatly disappointed that thousands were not killed in a great battle! I have won the victory without the battle! Military history will do me justice.' Grant, who assuredly would have used a more aggressive strategy in attacking Corinth, had a different opinion. 'The possession of Corinth by National troops', he wrote, 'was of strategic importance, but the victory was barren in every other particular.' Nonetheless, Corinth was now in Federal hands, and it would be the Confederates who would be doing the attacking at the next battle there.

IUKA

On 11 July 1862, President Abraham Lincoln (1809–65) ordered General Halleck to Washington, where Halleck finally found his calling as General-in-Chief. Grant

assumed Halleck's command more or less by default and inherited a widely scattered army that lacked the centralized striking force he wanted.

Moreover, Confederate forces in Mississippi under Major-General Earl Van Dorn (1820–63) and Major-General Sterling Price (1809–67) were a threat to General Grant's communications with Federal forces in Tennessee and represented possible reinforcements to the Confederate forces under General Braxton Bragg (1817–76) who were concentrating in Tennessee in preparation for Bragg's invasion of Kentucky.

Grant resolved to act, attacking Price at Iuka on 19 September. Grant had planned to trap Price in a pincer between Major-Generals William Rosecrans and Edward OC Ord, but the two Federal generals failed to act in concert and Price escaped. Price and Van Dorn joined forces near Ripley, southwest of Corinth, on 28 September. For his part, Grant ordered most of his army back to Corinth, which was now 'more than ever the centrepiece and linchpin of the Union position in northern Mississippi and West Tennessee'.

CORINTH AGAIN

Still Grant's army was relatively scattered, and Van Dorn considered Rosecrans' force at Corinth to be isolated enough to be a

Civil War defenders would often use chevaux de frise – sharpened rows of sticks that were especially effective obstacles against cavalry charges.

The strongest Federal defences at Corinth were made up of their artillery batteries in the College Hill area. The key position of Battery Robinette repulsed the main Confederate attack.

vulnerable target. Accordingly, Van Dorn planned to defeat Rosecrans, seize the railroad junction at Corinth, and use it to support a campaign into western Tennessee. It was not a particularly well-thought-out plan as events would demonstrate.

On the morning of 3 October, Van Dorn struck. Rosecrans had greatly improved the already-formidable defences the Rebels had vacated, and the Federal fortifications now consisted of successive outer and inner entrenchments. The sweeping arc of the outer defences stretched the Federals thin, but this initial line served its purpose even if it only delayed the attackers. After a day of hard fighting, the Federals withdrew to their inner defences, just before dark. Now Rosecrans was at his strongest defences, consisting of Batteries Robinette, Williams, Phillips, Tannrath and Lothrop in the College Hill area, just a few hundred metres

outside Corinth. These batteries were connected by breastworks and in some cases protected by abatis – trees that were felled and sharpened to create an obstacle for the enemy. Corporal Charles Wright of the 81st Ohio considered the College Hill line 'a splendid place to make the fight'. It was indeed an advantageous situation for the Federals. While the Confederates had been sapping their strength fighting through Rosecrans' defence in depth, Rosecrans was receiving a steady stream of reinforcements and improving his ability to support mutually his forces in his now contracted line. 'The line of attack was a long one,' Van Dorn noted, 'and as it approached the interior defences of the enemy that line must necessarily become contracted.'

The next day Van Dorn continued his attack, opening up with a pre-dawn bombardment that amounted to 'a real display of fireworks' according to one Federal. Many of the Confederate shells, however, landed long, exploding in Corinth itself and killing civilians and one wounded Federal soldier in the Tishomingo Hotel. Price launched an initial charge at about 10:00 a.m. that showed promise when the Confederates found a weak point in the Federal line and penetrated into Corinth, where house-to-house fighting ensued. Rosecrans himself seemed to have thought the day was lost and began issuing panicky orders to burn various stockpiles of supplies.

This illustration shows the elaborate regulation Confederate Army officers' sleeve design. From left to right: general, colonel, captain and lieutenant.

But Rosecrans need not have worried. In a pitched battle in front of Battery Robinette, the Federal line rallied and pushed back Brigadier-General Dabney Maurey's (1822–1900) division of Van Dorn's army. The Confederates had thrown all they had at the Federals, who had reserves that the Confederates did not. Van Dorn had reached his culminating point and he knew it. To continue the attack risked complete destruction, and that afternoon he began marching away from the battlefield.

Rosecrans was now in a good position to cut off the Confederate retreat, and Grant had high hopes for such a vigorous pursuit, but instead Rosecrans told his men to get some rest and be ready to go after Van Dorn in the morning. Major-Generals Edward OC Ord and Stephen Hurlbut (1815–82) did attempt a pursuit but without Rosecrans to press the Confederates from the southeast, the trap could not be closed. When Rosecrans finally got moving on 5 October, he advanced only 13km (8 miles) and went into camp.

The Second Battle of Corinth was over. It had been a costly affair for both sides. Federal casualties were 3090, while the Confederates suffered 4467. While Grant was disappointed that Van Dorn had not been destroyed, securing Corinth was still a major victory for the Federals.

CORINTH AND VICKSBURG

With Corinth safely in Federal hands, Van Dorn and Price could no longer reinforce Confederate forces in Tennessee. Grant was now free to concern himself with greater ventures. He explained: 'The battle relieved me from any further anxiety for the safety of the territory within my jurisdiction, and soon after receiving reinforcements I suggested to the general-in-chief a forward movement against Vicksburg.' The railroad had made Corinth worth fighting for, but, having won it, Grant was ready to move on.

Grant now held significant portions of the Mobile and Ohio, Mississippi Central, and Memphis and Charleston railroads, but he wanted to get out of the business of guarding railroads and depots and go on the offensive. 'By moving against the enemy,' Grant explained, 'into his unsubdued, or not yet captured, territory, driving their army before us, these lines would nearly hold themselves; thus affording a large force for field operations.' The object of these 'field operations' was to be Vicksburg.

SIGNIFICANCE

Corinth stands as a demonstration of how railroads influenced operations and strategy in the Civil War. It had already brought together the two great armies that clashed at Shiloh. In turn, the Rebels and Federals had defended and attacked it, struggling for its control. Now possession of this small railroad town was about to make possible one of the war's most decisive campaigns. As much as perhaps any other place in the western theatre, Corinth shows why the Civil War was a war of railroad strategy.

General Beauregard used a ruse to trick Halleck into thinking reinforcements were arriving at Corinth. Instead Beauregard withdrew to avoid Halleck's numerical advantage. By the time of the Second Battle of Corinth, Beauregard had been replaced by Braxton Bragg as commander of the Army of Tennessee and had assumed command of coastal defences in Georgia and South Carolina.

PERRYVILLE
8 OCTOBER 1862

PERRYVILLE DEMONSTRATED THE WEAKNESSES OF BOTH SIDES AT THIS STAGE OF THE WAR. THE REBELS WERE SKILLED AND EXPERIENCED BUT TOO FEW IN NUMBER; THE FEDERALS WERE INEXPERIENCED AND BADLY LED. THIS BATTLE WAS THE CIVIL WAR IN MICROCOSM: THE CONFEDERATES OUTFOUGHT THEIR OPPONENTS BUT LOST AT THE STRATEGIC LEVEL DUE TO THE ENEMY'S VASTLY SUPERIOR RESOURCES.

WHY DID IT HAPPEN?

WHO Union Army of the Ohio (37,000 men) under Major-General Don Carlos Buell (1818–98) opposed by the Confederate Army of the Mississippi (16,000 men) under General Braxton Bragg (1817–76).

WHAT A skirmish over water sources developed into a full-scale battle, in which the Confederates were tactical victors. However, the Rebel force was forced to retreat upon discovering that the Federals were much stronger than expected.

WHERE Perryville, Kentucky.

WHEN 8 October 1862.

WHY Confederate forces had invaded Kentucky, hoping to rally support in the state for the Rebel cause.

OUTCOME Although tactical victors, the Confederates were forced to retreat, entirely withdrawing from Kentucky.

Kentucky was important to both sides, and there was considerable support for the Rebel cause in the state even though it had officially declared for the Union. If Kentucky could be induced to switch sides, then the balance of power would shift dramatically. Such a shift was badly needed. After being driven out of Kentucky and most of Tennessee, the Confederacy had lost Nashville and Corinth, and was gradually losing the war in the west.

Major-General Edmund Kirby Smith (1824–93), commanding Confederate forces in eastern Tennessee, believed that the answer was to take the offensive, driving into Kentucky. If successful, the operation might bring the state into the Confederacy, which already recognized it as a member because of the considerable support there for secession.

Even if Kentucky did not change sides, the Union could not afford to risk losing the state and would have to oppose the invasion force, along with whatever local support rallied to it, and this would take pressure off Tennessee. President Jefferson Davis (1808–89) agreed and authorized Smith to

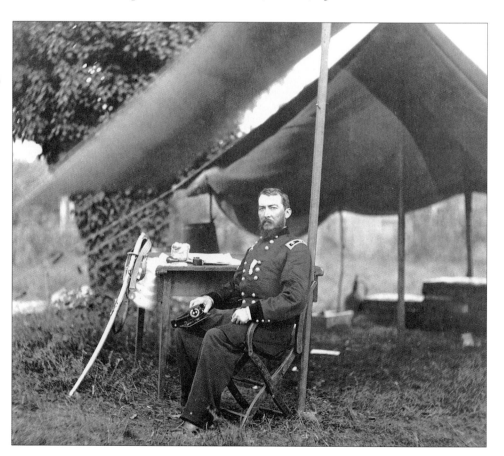

Philip H Sheridan (1831–88) never lacked aggression. He was suspended while at West Point for fighting with another cadet, but went on to become one of the North's most successful fighting commanders.

go ahead. He also confirmed General Braxton Bragg, who had assumed temporary command of the Confederate Army of the Mississippi, as permanent commander of that force.

The plan was for Bragg to move to protect Chattanooga, which was threatened by a large Union army under Major-General Don Carlos Buell, while Smith advanced into Kentucky with his command and some of Bragg's brigades. This operation called for a considerable logistics undertaking, with numerous units moving simultaneously on several different railroads. Critically, neither Bragg nor Smith was in charge of the other. Jefferson Davis himself confirmed Smith as an independent commander, and though there was an understanding that the two would support one another, there was no clear chain of command.

THE PLAN

Throughout the summer, regular and partisan Confederate forces caused chaos in Kentucky, Tennessee and Missouri, distracting the attention of the Federal forces. Meanwhile, Bragg and Smith met to discuss the campaign, drew up a plan of action and set about making it a reality.

Smith commanded about 21,000 men in four infantry divisions and a cavalry brigade, which were to advance and clear the Cumberland Gap of Union forces, opening the way to Kentucky. His force

was then to join Bragg's and move into middle Tennessee, cutting off Buell from Nashville and forcing him to retreat.

Buell was at this time making slow progress in Tennessee. Having advanced into enemy territory, he was reliant on the Memphis and Charleston Railroad for his supply line. First having to repair it, he was now constantly fighting off Confederate cavalry raids to keep the supply line open. Bragg's movement to Chattanooga forced Buell to reassess, and it soon became apparent that capturing Chattanooga was no longer practicable.

Buell decided to move to Murfreesboro, southeast of Nashville, ignoring the advice of Major-General George H Thomas (1816–70). This caused a rift between the two commanders at a time when close cooperation was vital. Buell changed his mind about intercepting Bragg's army and fell back on Nashville to defend it against the expected attack.

However, Bragg instead crossed the Cumberland River and entered Kentucky, where Smith was already operating. Smith had decided to ignore the plan to join up and retake Nashville, and instead marched his force through the Cumberland Gap and into Kentucky. Now his force and that of

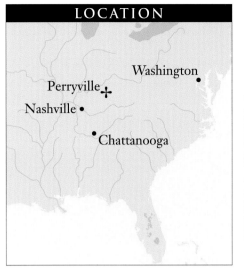

The western theatre is sometimes overshadowed by the great events in the east, but the hotly contested battles for Kentucky and Tennessee were a vital factor in the eventual Federal victory.

MARCHING ORDER

Troops on both sides did a lot more marching than fighting. 'Light Marching Order' was used for a short march with the expectation of picket duty, work or combat at the end. Troops carried their weapon, ammunition, canteen and haversack in light order but left cook pots and such like in camp.

'Heavy Marching Order' was used for changes of position and meant that troops had to carry everything they owned and needed with them. Troops would set out in neat columns of fours but within a kilometre or so this order would dissolve with men walking as they thought best. Straggling was common and many men became lost on a long march.

Bragg were both in Kentucky, forcing Buell to come after them.

CONFEDERATE SUCCESSES

On 30 August, Smith's command met and routed a green Union force of two brigades under Major-General William 'Bull' Nelson (1824–62). About 4300 of the 6500 Union troops fielded were taken prisoner. After resting for a day, Smith then advanced on Lexington and captured it. His cavalry pursued the remnants of the Union force towards Louisville while elements of his infantry moved up to threaten Cincinnati.

Responding to the desperate situation, neighbouring Union states threw together whatever units they could, mostly forming them from raw recruits, and appointed Major-General Horatio Wright (1820–99) to command the scratch force. Panic prevailed in Cincinnati and the frantic Union response eventually resulted in Wright having 70,000 men under his command. These men were very green, however, and many had not even completed basic training.

Smith was unable to achieve much more than he already had, however, mainly due to splitting his force up too much. After some skirmishing, Smith halted and then began to pull back towards Lexington.

Meanwhile, Bragg had positioned his army between Buell and Smith, cutting Buell off from Louisville. His position was good, but he allowed himself to be distracted by a rather bizarre incident. One of Bragg's subordinates attacked a Union bridge garrison under Colonel John Wilder (1830–1917) and was repulsed. Bragg just had to respond and marched his force to surround the garrison.

The newly appointed Colonel Wilder did not know what to do in the face of a demand for his surrender, and asked for advice from – of all people – Confederate Major-General SB Buckner (1823–1914). Buckner showed him the hopelessness of his position and Wilder wisely surrendered.

Bragg then weighed his options and decided to make a junction with Smith, enabling Buell to rush to Louisville. There, 'Bull' Nelson was bickering with a fellow officer, Brigadier-General Jefferson C Davis (1828–79), who ended up being sent to Cincinnati by Nelson and then back to Louisville by Wright. Arriving back in Louisville on 29 September, Davis entered into another argument with Nelson and eventually shot him.

Buell's efforts to reorganize his army and kick the Confederates out of Kentucky were further impeded by an order from the War Department to hand over command to Major-General George H Thomas. The latter resolved the situation by refusing to assume command, allowing Buell to deal with the crisis without the disruption brought about by a change in command.

THE ARMIES CONVERGE

Finally, Buell's Army of the Ohio marched out to confront Bragg on 1 October. It was now formed as three corps. The Third

A military academy graduate and veteran of previous wars, Don Carlos Buell was a stern disciplinarian. His career fell victim as much to political factors as his own actions, which were at times more headstrong than well considered.

Corps included Brigadier-General Philip Sheridan, and was commanded by Major-General Charles C Gilbert (1822–1903) instead of Nelson, who died shortly after being shot by Davis. Thomas went with the army as second-in-command.

Bragg and Smith held a ceremony on 4 October to inaugurate a Confederate governor for the Confederate state of Kentucky, but news that Buell was in the field caused the Confederates to fall back. They reached Perryville on 6 October. Sending out forces to scout for the enemy, Bragg discovered that the Union army was approaching Perryville along three roads.

The day of 7 October was spent preparing defensive positions, while the Union army made its dispositions for battle. Buell set up his headquarters about 8km (5 miles) from Perryville and gave his orders. He was suffering from the effects of a fall from his horse that day and was unable to ride during the battle.

THE BATTLE OPENS

In the early hours of the 8 October, Union forces were preparing to attack, with some units still far from their intended positions. Those that were in place began sending out parties to look for water. Rainfall had been sparse for months, and water was in short supply. The 10th Indiana, sent to set up a picket line on Peter's Hill to secure a water source in Doctor's Creek, were unaware for a time that they were in close to proximity

to the Confederate 7th Arkansas. When Major-General Alexander M McCook (1831–1903) sent a brigade up to reinforce the Indiana men, they ran into the Arkansas regiment instead and fighting broke out, which then spread to neighbouring troops.

Fierce combat took place between Sheridan's division and Brigadier-General St John Liddell's (1815–70) Confederate brigade for possession of Peter's Hill. Throughout this engagement, Sheridan's superior, the newly appointed Gilbert, bombarded him with instructions not to cause a general engagement and to stop wasting artillery ammunition.

THE CONFEDERATES ATTACK

The right wing of the Confederate army, under Major-General Leonidas Polk (1806–64), had been ordered by Bragg to attack the Union forces opposite it. However, Polk decided that, given the size of the force facing him, this was not practicable. He ordered his command to assume a defensive posture.

Bragg himself was convinced that the main Union force was located at Frankfort and that the main action would be fought there, and was thus not present at Perryville when the action opened. He expected to hear Polk's attack begin, and when he did not, he rode to Perryville in person. There, although he did not have accurate reconnaissance information, he ordered Polk's force to attack. A division under

These guns are rifled Parrott 30-pounders, capable of firing solid shot to destroy other guns or fortifications, or explosive fragmentation rounds for anti-personnel work. They were extremely accurate to about 2km (1.2 miles) and capable of hitting a target about three times as far away, with some luck.

THE OPPOSED FORCES

FEDERAL
Army of the Ohio **37,000**

CONFEDERATE
Army of the Mississippi **16,000**

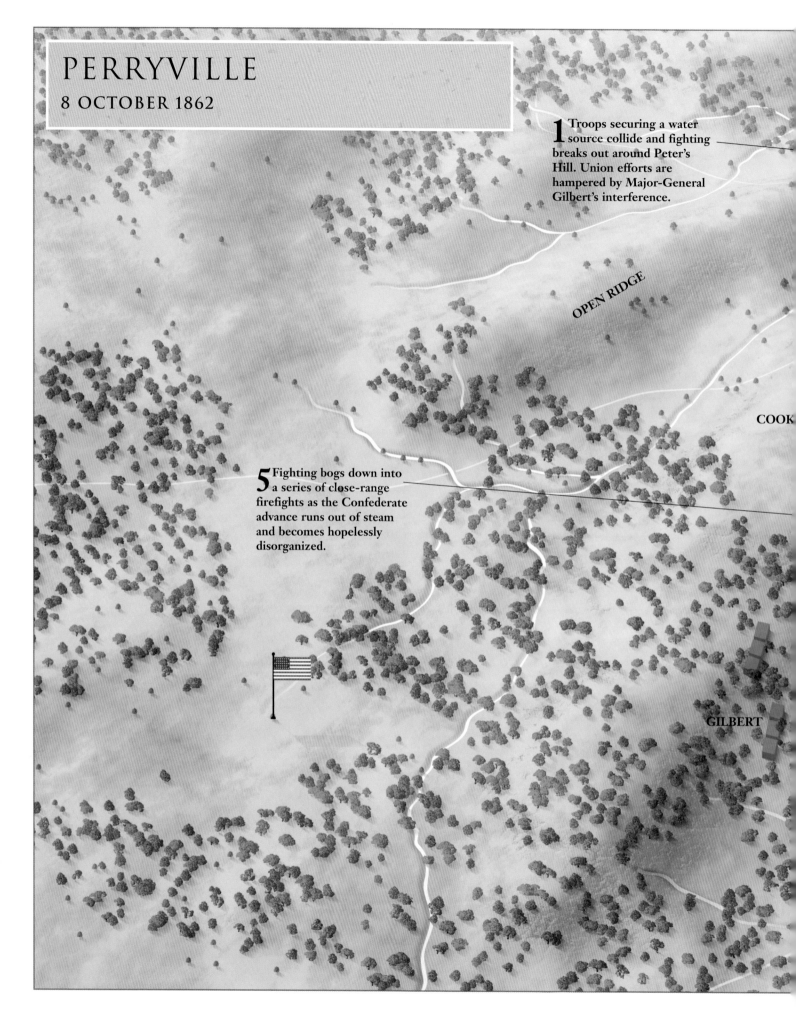

PERRYVILLE
8 OCTOBER 1862

1 Troops securing a water source collide and fighting breaks out around Peter's Hill. Union efforts are hampered by Major-General Gilbert's interference.

OPEN RIDGE

COOK

5 Fighting bogs down into a series of close-range firefights as the Confederate advance runs out of steam and becomes hopelessly disorganized.

GILBERT

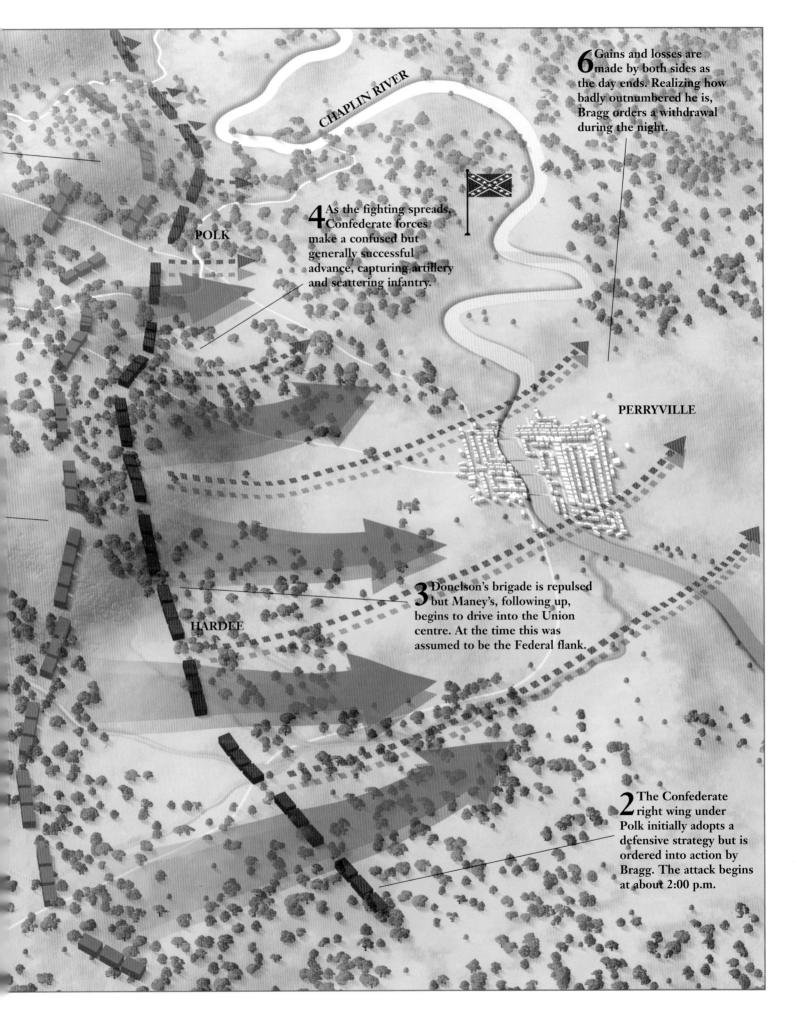

CHAPLIN RIVER

POLK

PERRYVILLE

HARDEE

6 Gains and losses are made by both sides as the day ends. Realizing how badly outnumbered he is, Bragg orders a withdrawal during the night.

4 As the fighting spreads, Confederate forces make a confused but generally successful advance, capturing artillery and scattering infantry.

3 Donelson's brigade is repulsed but Maney's, following up, begins to drive into the Union centre. At the time this was assumed to be the Federal flank.

2 The Confederate right wing under Polk initially adopts a defensive strategy but is ordered into action by Bragg. The attack begins at about 2:00 p.m.

The Colt Army Model 1860 was a state-of-the-art sidearm and popular with officers and cavalrymen on both sides. Although expensive it offered good firepower, reliability and man-stopping performance.

Many of the Union units at Perryville were composed entirely of raw recruits. Not yet used to army life, they were flung into desperate fighting against more experienced Confederate forces and suffered accordingly.

Major-General BF Cheatham (1820–86) began to advance a little after 2:00 p.m., crossing the river and clambering up the slopes beyond to assault what Bragg thought was the Union flank.

In fact, Cheatham's division had gone up against the centre of the Union line. Facing them was General McCook's force of some 22,000 men, and Cheatham's division was enfiladed by artillery batteries.

The first brigade to attack, that of Brigadier-General Daniel S Donelson (1801–63), was halted and driven back. The second, a veteran force from Tennessee under Brigadier-General George E Maney (1826–1901), began pushing the largely raw Federals back. They overran the Union artillery and captured several guns.

About an hour after Cheatham's division moved off, its supports began their own advance. This was a very confused affair due to revised orders that were not properly transmitted. Some formations followed their original orders, while others used the new ones. Amid the ensuing chaos, a protracted firefight broke out between troops using two parallel stone walls as cover, and this went on for some time.

Despite the confused orders, the attack was going well. Cheatham's division continued to advance after overrunning the artillery, scattering the raw 21st Wisconsin that was ordered up to halt it. Meanwhile, Brigadier-General Bushrod Johnson's (1817–80) Confederate brigade, now hopelessly disorganized by terrain, enemy action and its own orders, tried to put in a new attack but was halted by the 3rd Ohio.

Brigadier-General Patrick R Cleburne's (1828–64) brigade was ordered up to replace Johnson's and to allow it to re-form properly. At the same time, Brigadier-General Daniel W Adams' (1821–72) brigade was ordered to pass right across the front of Sheridan's division to take up a flanking position. Under normal conditions this manoeuvre would be shot to pieces, but Adams got lucky; command and control problems existed in the Union army, too.

UNION GENERALS

With Buell sitting in a house a few kilometres away, Thomas was in a position to make a real difference on the battlefield. By rights he should have been commanding this battle anyway but for his decision to leave Buell in charge. He did not make a great job of being second-in-command, however. As well as neglecting to report in person as ordered, he also failed to provide any advice about, or personal observations of, the situation to Buell.

Worse, Gilbert's constant badgering of Sheridan to stop wasting ammunition constrained him from interfering in the redeployment of Adams' brigade, which then fell on the flank of Colonel William Lytle's (1826–63) brigade. Lytle himself was wounded in the head and captured, though since the Confederates thought his wound would be fatal, he was not taken prisoner.

McCook's corps in the centre was under severe pressure, but reinforcements were available. One reason they were not transferred was the rather optimistic attack by Colonel Samuel Powell's brigade on what amounted to most of two corps. Gilbert hesitated to send reinforcements – even a single brigade – to McCook's aid while he was under attack. Buell finally realized that something major was going on late in the afternoon when a messenger

from McCook arrived requesting urgent assistance. By this time, it was rather late.

At the day drew to an end, sporadic attacks took place along the Rebel line. On the right, having driven the Union forces back, the brigades of Maney and Brigadier-General Alexander P Stewart (1821–1908) pulled back, allowing Union troops to retake the heights in front of them. New orders arrived, and the two brigades advanced again, regaining their former positions. Meanwhile, in the centre, a new

William S Rosecrans (1819–98) had served in the regular Army as an engineering officer until 1854, and returned from a successful civil engineering career to join the Union cause. Although overall a good officer, he had a tendency to micromanage his forces.

This photograph taken after the battle shows a lane near Perryville flanked by lines of chevaux-de-frise and wooden palisades. This severely restricted the movement of enemy infantry – breaking up any charges – as well as ensuring enemy cavalry did not carry out flanking manoeuvres.

Union line, with reinforcements coming up from Third Corps, managed to bring the Confederate advance to a standstill. Lack of ammunition was also a problem for the Rebel troops, which then pulled back.

On the Confederate left, Powell's brigade had also failed to make much impression against the vastly superior force it had attacked. As it retired, Union troops

and a half-dozen guns were able to advance into Perryville, presenting the Federals with a real opportunity to cut Bragg's line of retreat. Lack of coordination robbed them of the opportunity, however.

The last action of the day took place at about 6:30 p.m., when a final Confederate attack, in brigade strength, drove back the Union troops facing it. The fall of night prevented further gains from being made, and McCook's battered corps was reinforced by a fresh brigade soon after.

THE CONFEDERATE RETREAT

The Confederates had been on the offensive all day, despite Polk's initial decision to fight a defensive action. They

had delivered a splendid beating to McCook's corps and driven the raw, untried Union troops before them at every opportunity. However, they had also lost 510 killed and about 2900 wounded or missing. Union losses came to some 845 killed and about 3350 wounded or missing.

The day had been a clear victory for the Confederate Army, though only a tactical one. Nothing of strategic significance was gained. More importantly, Bragg became aware of the size of the force ranged against him at last, and ordered a retreat rather than continue the struggle for another day.

At about 1:00 a.m., on 9 October, the Confederate forces began retiring. The last units were pulled out of Perryville at

midday. Buell made no attempt to interfere with the withdrawal, allowing Bragg to meet up with Smith and detached forces under Brigadier-General Humphrey Marshall (1812–72) at Harrodsburg, giving him a force nearly the same size as Buell's command, and far more experienced.

Smith wanted to turn and attack Buell, savaging the Union army, but Bragg decided that he had a good defensive position and preferred to await an attack. However, he soon began to worry that Buell would move to block his line of retreat and ordered his army to fall back. Buell did not so much pursue the retreating Confederate army as shuffle nervously after it. Finding his army once again in proximity to Bragg's new position at Bryantsville, Buell hesitated once more, as he considered undertaking a flanking movement.

Elsewhere, the Confederate Army of Northern Virginia was retreating from Sharpsburg, and other forces had failed to recapture Corinth. They would not now be moving to assist Bragg, and the hoped-for explosion of support for the Rebel cause in Kentucky had not occurred. Bragg thus decided to retire into Tennessee. Buell did nothing to impede the movement.

AFTERMATH

The combined Confederate force dispersed again into two armies under Smith and Bragg, and a smaller force under Marshall. Buell ambled after the retreating Rebels for a while, then headed for Nashville. His army was reconstituted as 14th Army Corps and given to Major-General William S Rosecrans to command. Buell never commanded a major force again.

Bragg was also in trouble with his superiors. Notorious for being 'naturally disputatious', he had upset several of his subordinates and complaints had been made. He was summoned to Richmond to explain himself to President Jefferson Davis (1808–89), but retained his command.

The result at Perryville was more or less a victory by default for the Union, and effectively ended the Confederate threat to Kentucky. The initiative was now firmly with the Union in the western theatre.

This illustration shows Confederate infantry firing volleys into advancing Federal troops. Well-trained troops could fire on average 3–4 rounds per minute, causing devastation at ranges of up to 500m (560 yards). Most engagements between infantry took place at less than 200m (220 yards). Charging infantry were expected to cover 147m (160 yards) per minute, allowing the enemy to fire at least five rounds before engaging in hand-to-hand combat. Consequently, losses amongst charging troops could be staggering.

CHANCELLORSVILLE
1–5 MAY 1863

CHANCELLORSVILLE SEVERELY DENTED THE MORALE OF THE ARMY OF THE POTOMAC. ALTHOUGH POSSESSING SUPERIOR NUMBERS, IT WAS AGAIN DEFEATED BY LEE, WHO USED UNCONVENTIONAL TACTICS OUT OF NECESSITY. BOTH SIDES MADE RISKY MANOEUVRES IN THE HOPE OF GAINING AN ADVANTAGE. THE BATTLE IS CHIEFLY FAMOUS FOR THE DEATH OF 'STONEWALL' JACKSON, WHOSE LOSS WAS BITTERLY FELT.

WHY DID IT HAPPEN?

WHO The Union Army of the Potomac under Major-General Joseph Hooker (1814–79), numbering about 130,000, opposed by the Confederate Army of Northern Virginia under General Robert E Lee (1807–70), numbering about 100,000.

WHAT Although outnumbered, Lee split his force and launched a flanking action, manoeuvring to bring his smaller force to bear at the critical point.

WHERE To the west of Fredericksburg, Virginia.

WHEN 1–5 May 1863.

WHY Newly appointed Union army commander 'Fighting Joe' Hooker launched an operation against Lee, hoping to destroy the Army of Northern Virginia. Although his aim was offensive, his battle plan was entirely defensive.

OUTCOME Lee's outnumbered army inflicted a defeat on the Union force and caused it to retreat. This opened the way for Lee's Second Invasion of the North.

Much has been made of the apparent incompetence and ineptitude shown by both sides at times during the Civil War, but the truth is that mistakes were inevitable. The Civil War was fought by armies that had to be created more or less from scratch, with very small numbers of regulars to provide guidance. It was fought with weapons whose capabilities had not been fully explored.

Moreover, political considerations meant that commanders were sometimes chosen as much for their connections and the support they would garner in their home states as for their military abilities. The necessity of political support, without which the war was lost before a shot was fired, sometimes placed individuals in positions that they were not trained or experienced enough to cope with. Some rose to the occasion; others tried and failed.

The armies and commanders on both sides were essentially learning their trade on the job, so to speak, and new ideas had to be tried. These were not always successful. One such was the system of 'Grand Divisions' in the Union Army, in which divisions were grouped into corps, and those then into Grand Divisions. The result was cumbersome and after the defeat at Fredericksburg the Union Army of the Potomac discarded the idea.

The Army of the Potomac also gained a new commander at this time, with Joseph Hooker replacing Major-General Ambrose Burnside (1824–81) in overall command.

'Jeb' Stuart (left) was a daring and aggressive cavalry commander who liked to be given scope to use his initiative. General Lee made good use of this factor at Chancellorsville, but at Gettysburg the partnership broke down with disastrous consequences.

Hooker reorganized the army, creating an independent cavalry corps, and worked at improving morale before setting out on an operation that would result in the destruction of Lee's Army of Northern Virginia and open the way for a triumphant march into Richmond.

The plan was sound enough, but the Confederacy was fortunate indeed to have gained the services of Robert E Lee and Lieutenant-General Thomas J Jackson (1824–63), better known as 'Stonewall' Jackson.

HOOKER'S PLANS

Hooker's idea was to launch a cavalry raid on Lee's supply line and cut his link to Richmond, forcing the Confederate army to leave its winter camp, where it still resided, and retreat. Hooker would then attack with overwhelming force and destroy the Army of Northern Virginia.

With this plan in mind, Hooker decided to cross the Rappahannock River, which separated the two armies, north of Fredericksburg. The cavalry, over 11,000 men and 22 guns under Major-General George Stoneman (1822–94), was sent off to cross the river and get into Lee's rear. However, Stoneman's crossing was delayed by bad weather for a fortnight, so Hooker decided to force the issue. He sent 60,000 men in three corps (which would previously have constituted a Grand Division) across the Rappahannock.

There were three practicable fords for the crossing. Two of these – Bank's Ford and United States Ford – were guarded, but the force was able to get across at Kelly's Ford, advancing to cross the Rapidan as well. With an additional corps and the cavalry across the rivers, Hooker's plan was beginning to come together.

LEE REACTS

Suspicious already that the Federals were up to something, Lee reacted quickly when word came that Union troops were across the Rappahannock River. He pulled in

Lieutenant-General James Longstreet (1821–1904), who was detached to besiege Suffolk, and sent off units to prepare defensive positions. Critically, two brigades of Major-General Richard H Anderson's (1821–79) division were sent towards Chancellorsville to prepare positions there.

Leaving slightly over 10,000 men under Brigadier-General Jubal Early (1816–94) in defensive positions at Fredericksburg, Lee began concentrating his main force to counter the new threat. He now had a good idea where the Union forces were, and in what numbers. Lee was outnumbered but that was nothing new. There was certainly no question that the Army of Northern Virginia would retreat as Hooker hoped.

THE FIRST DAY (1 MAY)

Marching westwards, the three divisions of the Confederate Second Corps under

1ST SHARPSHOOTERS

While several Union regiments were raised with fanciful titles like Guards, Irrepressibles and Sharpshooters, the 1st Sharpshooters was a deliberate attempt to create a formation composed entirely of excellent shots. The standard infantry rifle was accurate out to a good distance in the hands of a well-trained man, but once the regiment received Sharps breech-loading rifles they became a deadly instrument that inflicted heavy losses on the enemy. Indeed, the regiment gained a reputation as the unit that had inflicted the most casualties on the enemy.

The Sharpshooters fought with distinction at Chancellorsville, Gettysburg, the Wilderness and many other major actions. With their fast-firing rifles they were constantly pushed to the front of the line and consequently suffered heavy casualties – of 2570 men who served with the regiment, some 1300 were killed or wounded in the course of the war.

LOCATION

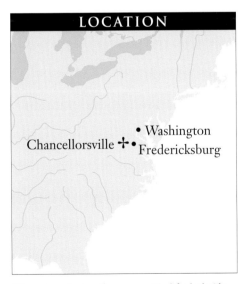

Chancellorsville ✛ • Washington
• Fredericksburg

The eastern theatre of war was critical for both sides as the capitals of both the Union and the Confederacy were located there, and close together. Thus several major actions took place in a relatively small space.

The four Union corps that were supposed to be operating in Lee's rear, and trying to force a retreat, pulled back to Chancellorsville and established positions in the early hours of the morning. Hooker was now hoping that Lee would attack him and smash his army to pieces on the Federal forces in the process, and even proclaimed that the Army of Northern Virginia was now the property of the Army of the Potomac. This was an odd thing to say, having just handed the initiative to Lee, who was not known for acting in accordance with his enemy's wishes.

THE SECOND DAY (2 MAY)

While Lee and Jackson were planning their next move on the evening of 1 May, Lee's cavalry informed him that the Union right flank was 'in the air', in other words, not properly covered or anchored by defensive terrain. The plan they came up with was audacious. Leaving just 15,000 men with Lee (the divisions of Anderson and McLaws), Jackson would take his 30,000 off on a wide flank march and fall on the enemy's rear. Meanwhile, Hooker was ordering up another corps from Fredericksburg to Chancellorsville, which would bring the Union force to 90,000.

At about 9:00 a.m. on 2 May, Hooker received news that Confederate forces had been spotted moving south, and concluded that Lee was retreating. Stoneman's cavalry was in position to attack their likely route, and everything seemed to be going well. Hooker ordered Major-General John Sedgwick (1813–64), who was still in front of Fredericksburg, to attack if the chances seemed good, and later modified this to an order to attack with his entire force.

At 2:00 p.m. or so, Jackson's force became aware of Federal troops ahead of them, and after a careful deployment, Jackson put in a very aggressive attack that began just after 5:00 p.m. Two divisions of

A sergeant from the Confederate 1st Virginia Cavalry. As a rule the Confederate cavalry was better than its Union counterpart, being recruited from country-bred men who could already ride and shoot. The carbine was the most effective of cavalry weapons in the Civil War, though Confederate cavalry still liked to attack with sabre and revolver.

Lieutenant-General 'Stonewall' Jackson and a division under Major-General Lafayette McLaws (1821–97) arrived on the flank of Anderson's brigades. Jackson was in overall command and had orders from Lee to halt the Union advance. Lee's command style was loose, allowing his subordinates to act as they thought best, and as usual Jackson thought it best to attack.

Thus, as elements of Major-General George G Meade's (1815–72) corps came down the Orange Turnpike near Chancellorsville, they ran into a skirmish line from Anderson's division. Breaking through, they were confronted by five divisions of Rebel troops and faced flanking if reinforcements did not come up. They were on their way when Hooker's order to fall back to Chancellorsville came through.

US Army non-commissioned chevrons. From left to right: ordnance sergeant, quartermaster sergeant, sergeant-major, first sergeant, sergeant and corporal.

Union troops were scattered and routed, and confusion spread throughout the Union force. Union Major-General Daniel Sickles (1819–1914) decided to pull his command back as it was in danger of being crushed between Lee and Jackson.

The retreat turned into disaster as Sickles' force became totally disorganized. One division became lost and wandered towards Lee's entrenched force. The other became involved in a three-way running fight and was cut up badly before reaching safety by midnight.

As night fell the Federals were able to regain some control of the situation and established positions facing the new threat. Jackson wanted to launch a night assault against the hasty Union redeployment and take advantage of the confusion that reigned. It was whilst reconnoitring for this attack that he was fired on by his own side's pickets and seriously wounded.

Jackson had been hit three times and was evacuated to a field hospital. His left arm was amputated, but he died several days later of pneumonia. His loss was keenly felt in the Confederate Army. Not only was he a brilliant commander in his own right, but he also worked well as a team with Lee. The rapport and mutual trust they had established was one of the keys to Confederate success, and without it the Army of Northern Virginia was more prone to delays and mistakes than before.

Meanwhile, command passed to Major-General JEB 'Jeb' Stuart (1833–64), the Confederate cavalry commander. While he was establishing control, the Union army managed to re-form somewhat, though Major-General Oliver O Howard's (1830–1909) corps in particular was in a bad way.

THE THIRD DAY (3 MAY)

Lee now decided to recombine his force and inflict a deathblow on Hooker's army. He led his command towards Chancellorsville to meet up with Stuart, who was pressing the Federals. Stuart had placed more than

Sabres drawn, the Federal 8th Pennsylvania Cavalry engage with Confederate forces at Chancellorsville. Cavalry rarely used sabres in the Civil War: revolvers and carbines proved more effective skirmishing weapons.

THE OPPOSED FORCES

FEDERAL
(including detached forces)
Total: 130,000

CONFEDERATE
Total: 60,000

CHANCELLORSVILLE
1–5 MAY 1863

1 After some initial skirmishing, four Union corps take up positions in Chancellorsville in the hope that Lee will attack their defensive positions.

MEADE

HOOKER

JACKSON

4 'Stonewall' Jackson is critically wounded whilst on reconnaissance for a renewed attack. Union forces take up hasty new positions.

3 Jackson deploys on the Union right and throws in a determined assault that routs two entire divisions and inflicts heavy casualties on Union troops in Chancellorsville.

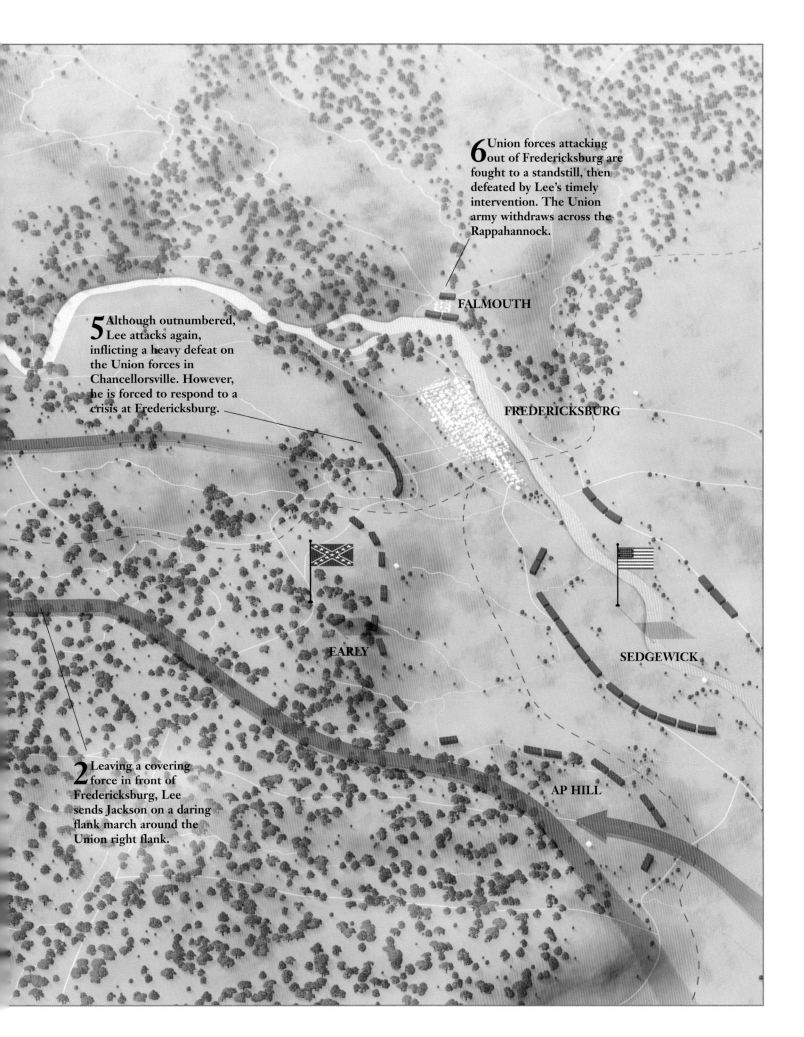

6 Union forces attacking out of Fredericksburg are fought to a standstill, then defeated by Lee's timely intervention. The Union army withdraws across the Rappahannock.

FALMOUTH

5 Although outnumbered, Lee attacks again, inflicting a heavy defeat on the Union forces in Chancellorsville. However, he is forced to respond to a crisis at Fredericksburg.

FREDERICKSBURG

EARLY

SEDGEWICK

2 Leaving a covering force in front of Fredericksburg, Lee sends Jackson on a daring flank march around the Union right flank.

AP HILL

CHANCELLORSVILLE

100 guns to fire into the Union force. This included 70 atop Hazel's Grove, which Sickles abandoned at Hooker's order. Their fire was more than the Federals could stand, and in the face of attacks by Lee and Stuart the Union troops began to break.

The fighting was extremely bloody but victory was nearing when Lee received word from Early, who was in trouble to the east. Sedgwick's assault had broken through his thinned lines and he was being pushed westwards. He had started with about 10,000 men and was outnumbered four to one at least.

Again, Lee reacted decisively. Reasoning that the Union force in front of him was unlikely to take the offensive, Lee sent off McLaws with his division to stop Sedgwick. They arrived just in time; Early's command had been pushed to the south and out of the way of the advancing Union corps. Sedgwick would have been clear to advance into Lee's rear but for the arrival of McLaws at about 4:30 p.m. Despite the disparity in numbers, McLaws was able to stall the Union advance, and Sedgwick set up defensive positions to protect his force in the coming night.

THE FOURTH DAY (4 MAY)

Depending on the observer's point of view, Lee was ether stuck between Sedgwick's hammer and Hooker's anvil, or he had the advantage of a central position between two forces of rather hesitant enemies. Lee took the latter view. Although 'Jeb' Stuart commanded only about 25,000 men to contain Hooker's 80,000 or so around Chancellorsville, Lee correctly gambled that the Union force would not come out to fight. In the event, Hooker was busy setting up defences around United States Ford to ensure he had an escape route; hardly the action of a commander determined to go on the attack.

The combined forces of Generals Anderson, McLaws and Early, under Lee's

Left: 'Fighting Joe' Hooker got his nickname accidentally from a newspaper headline which was supposed to read 'Fighting – Joe Hooker' and led into a story about a minor battle. Instead a misprint trumpeted 'Fighting Joe Hooker' across the nation.

Below: James Ewell Brown ('Jeb') Stuart was an able and aggressive cavalry commander who had already distinguished himself as a junior officer when war broke out. He was mortally wounded in action against cavalry under Philip H Sheridan (1831–88), his Union counterpart.

Opposite: Confederate troops killed at the Battle of Chancellorsville lie in a shallow trench behind the stone wall on Mary's Heights, Fredricksburg. This photograph was taken by Union officer Captain Andrew J Russell.

overall guidance, got into position to attack Sedgwick from three sides, with Early's men retaking positions around Fredericksburg that Sedgwick had not garrisoned. The Confederate attack did not go in until 6:00 p.m., and Sedgwick fought a hard defensive battle before pulling back across the Rappahannock River at Bank's Ford during the night.

THE LAST DAY (5 MAY)

Chancellorsville ended with Hooker accepting that he could not win, although in truth the Union general had been defeated for some time before that, at least in his own mind. He lost his chance to force a victory when he allowed his army to be bottled up in defensive positions by a vastly inferior force. When asked why he allowed this to happen, Hooker confessed to having had a loss of confidence.

Once Sedgwick had withdrawn, Hooker decided that nothing further could be done and began to pull back across the Rappahannock, completing the move by 6 May. He had hoped Sedgwick would be able to hold Bank's Ford and thus allow Hooker's army to pull back across the river, regroup and renew the offensive, but the order was miscommunicated like several others, and the opportunity was lost.

UNION CAVALRY FAILS

The large body of Union cavalry sent out at the very outset of the campaign by Hooker achieved very little. It might have been some use if the Confederate army really had come its way or had retreated as Hooker had hoped. When this did not come to pass, Stoneman's foray proved fruitless. During the week of 1–7 May Stoneman's force did carry out some minor raids but these did not affect the outcome of the campaign in any way. By 7 May, Stoneman had rejoined the main Union army and at this point, with the last of the

This colour illustration depicts the death of Jackson at Chancellorsville. Hearing that Jackson was wounded and in hospital, Lee remarked that Jackson had lost his left arm – but Lee had just lost his right. As subsequent events would show, he was not far wrong.

Union forces back in friendly territory, the operation was over.

AFTERMATH

Hooker's plan may have been basically sound, but it did not take sufficient account of the fact that Robert E Lee was an aggressive and innovative general. Giving him the initiative was unwise, even when Lee was outnumbered. 'Fighting Joe' Hooker displayed a very passive mindset once the fighting started, even though his initial manoeuvring was good. The resulting Union defeat might have been avoided by even the hint that Hooker might come out of his positions around Chancellorsville and attack.

Chancellorsville was important to the course of the war in many ways. The people of the Union were shocked by the defeat of Hooker's army, which had repercussions for the re-election chances of Abraham Lincoln (1809–65). Hooker himself was sacked as army commander a little later, paving the way for Meade to take command just in time to defeat Lee at Gettysburg.

However, the news was not all bad for the Federals. They had taken 17,000 casualties compared to the 13,000 or so taken by the Confederates, not counting the thousands of prisoners taken in the chaos of the second day. However, the Union troops had demonstrated a fighting ability that had previously been somewhat lacking. Up to this point the Rebels could rely on being able to outfight even a superior Union force, but at Chancellorsville many Federal units gave as good as they got. This trend was repeated at Gettysburg.

More seriously, the Confederacy's losses represented nearly 25 per cent of the committed force and could not be replaced as readily as those on the Union side. With the Confederacy having a smaller population base and less industry than the North, casualties had a more serious effect on the Southern side, and even a victory in the field might lead to eventual strategic defeat if the price were too high. At Chancellorsville the Union began to exact that price.

One casualty in particular was keenly felt. The death of 'Stonewall' Jackson was not merely a blow to morale, especially with

the tragic circumstances in which it occurred, but it ended the team that had been so effective for Lee up to that point. Hooker's campaign at Chancellorsville suffered from misunderstandings and subordinates not doing what the commander wanted. Up to now, Lee had not had to contend with this problem to a great extent. That had changed, as would be apparent at Gettysburg.

However, on balance, things looked good for Lee and the Army of Northern Virginia after Chancellorsville. A vastly superior force had been sent packing, and Jackson's last great attack had been an enormous success. The way was now open for a new invasion of the North and the prospect of bringing the war to a successful end.

Several monuments to 'Stonewall' Jackson exist, as is only fitting. He is buried in the Stonewall Jackson Memorial Cemetery at Lexington, Virginia.

CHAMPION HILL

16 MAY 1863

CHAMPION HILL, ONE OF FIVE LAND BATTLES OF THE VICKSBURG CAMPAIGN FOUGHT IN 1863 IN CENTRAL MISSISSIPPI, VIRTUALLY SEALED THE FATE OF THE CONFEDERATE ARMY OF VICKSBURG, AND SUBSEQUENTLY ENSURED NORTHERN CONTROL OF THE LOWER MISSISSIPPI RIVER VALLEY. THAT CONTROL WAS VITAL TO UNION STRATEGY AND, JUST AS IMPORTANTLY, WAS A POLITICAL NECESSITY FOR A BELEAGUERED PRESIDENT LINCOLN.

WHY DID IT HAPPEN?

WHO The Union army commanded by Major-General Ulysses S Grant (1822–85), in order to capture the citadel of Vicksburg, Mississippi, and achieve total control of the Lower Mississippi River Valley, invaded Mississippi and attacked Confederate Lieutenant-General John C Pemberton's (1814–81) divided forces.

WHAT Grant's seven swiftly marching infantry divisions of 32,000 men outmanoeuvred Pemberton's three infantry divisions, totalling 23,000 soldiers, crashing into them on three axes of advance.

WHERE In central Mississippi, between the railroad towns of Edwards and Bolton, along the wooded ridge known as Champion Hill.

WHEN 16 May 1863.

WHY Grant's rapid offensive and multiple axes of advance surprised Pemberton, who was attempting to avoid a general engagement by moving to destroy Grant's line of communications.

OUTCOME Pemberton's army was driven back into the trenches surrounding the port city of Vicksburg and was penned in by Grant's army and Rear-Admiral David Dixon Porter's (1813–91) fleet, compelling the Confederates to surrender after a 47-day siege.

Grant asked Rear-Admiral Porter to run the fleet past the batteries of the Fortress City. Pictured are seven gunboats, a tug, a captured Confederate ram, three transport ships, and coal barges that ran the gauntlet of 37 guns on the night of 16 April 1863.

Just after dusk on 28 January 1863, the steamer *Magnolia* skirted up to the muddy western bank of the Mississippi River at Young's Point, Louisiana. On board was Major-General Ulysses S Grant, who, without fanfare, had journeyed the 759km (410 river miles) south from Memphis to assume field command of his army. That night he wrote to his wife Julia by the lamplight in his cabin and advised her that he would 'not learn anything of the situation of affairs until morning'. The words were tempered with caution as he suggested that he may not return to her until 'the reduction of Vicksburg is attempted'. Five months later, on 1 July, Grant's letter to his wife reflected confidence rather than caution as he wrote: 'You remain where you are … until you know I am in Vicksburg.' On 4 July, Grant triumphantly rode into Vicksburg at the head of his army.

MUD AND MARCHING

In the 156 days since his virtually unnoticed arrival at Young's Point, Grant and his men had slogged and marched over 322km (200 miles), first in fetid swamps and later in choking dust. Their destination had been Vicksburg, a goal that was ironically perched on a bluff across the Mississippi River just 11km (7 miles) to the east of Young's Point. Those momentous days and difficult miles witnessed the transformation

CONFEDERATE BATTLE FLAG

This flag with the St Andrew's cross is commonly identified with the Confederacy, and was designed by William Porcher Miles (1822–99). However, Miles's design was initially rejected by the Confederate Provisional Congress, which selected instead the 'Stars and Bars' (a flag with three horizontal bars – two red and one white in the centre – each bar one-third the width of the flag, and a blue union with a circle of white stars – one star for each Confederate state). At the Battle of First Manassas on 21 July 1861 the similarity of the 'Stars and Bars' of the Confederacy and the 'Stars and Stripes' of the Union created confusion. Subsequently Miles was asked to design a new battle flag. His St Andrew's cross flag was then introduced in Virginia on 28 November 1861, and on 1 May 1863 it replaced the 'Stars and Bars' as the Confederate battle flag.

of Ulysses Grant from a much-criticized general to one of the great figures of military history. In that five-month period Grant prosecuted 'the most brilliant campaign ever fought on American soil', and delivered to the people and the government of the United States a victory that very possibly saved both a presidency and the Union.

When Grant arrived in Louisiana he found his army immersed in a sea of mud and ooze, with a vast and bridgeless Mississippi River between him and his ultimate objective. The army had been deposited there one month earlier when Grant's subordinate, Major-General William Tecumseh Sherman (1820–91), had been ordered to embark on transports at Memphis and steam south to capture Vicksburg in a bold amphibious thrust. Simultaneously, Grant was to march overland to the south from Oxford, Mississippi, towards the capital city of Jackson, 72km (45 miles) east of Vicksburg. Between Grant and Jackson was Confederate Lieutenant-General John C Pemberton's army, which had dug in on the south bank of the Yalobusha River at

Greenwood, Mississippi, to await Grant's attack. The plan seemed simple enough, and if all went well, Sherman would slink in through the back door at Vicksburg while Grant pounded on the front door at Greenwood. But, as Clausewitz wrote, 'in war the simplest thing is difficult'.

REARGUARD ACTION

On 20 December, the same day that Sherman's amphibious force steamed out of Memphis, Pemberton's ad hoc cavalry division, 3500 troopers strong and commanded by the fearless Major-General Earl Van Dorn (1820–63), galloped into Grant's rear echelon and destroyed the Federal supply depot at Holly Springs, Mississippi. While the flames of Van Dorn's men consumed Grant's precious food and ammunition, the Confederate cavalry of

ubiquitous Brigadier-General Nathan Bedford Forrest (1821–77) boldly destroyed Grant's railroad line and supplies in western Tennessee at Jackson, Humboldt, Trenton and Union City, thus ending any hope of replenishment of the Holly Springs depot. With his line of communications in flames, Grant had to bring his landward thrust to an ignominious end. The threat to his front gone, Pemberton quickly transported his men along the railroad to Jackson, then Vicksburg, to confront Sherman.

Sherman's unsuspecting and unlucky soldiers disembarked on the Yazoo River 8km (5 miles) north of Vicksburg and attacked, unsupported, through the bitterly cold swamps of Chickasaw Bayou, only to suffer a bitter repulse on 29 December. The badly mauled Union soldiers then limped back onto the transports to be shipped to the relative safety, if not comfort, of Louisiana. Sherman's acerbic after-action report of 5 January 1863 told the story: 'I reached Vicksburg at the time appointed, landed, assaulted, and failed.'

ACHIEVABLE OBJECTIVES

When Grant arrived at Sherman's miserable Louisiana campground three weeks later, he was acutely aware of the problems that he faced, not only militarily, but also politically. The North had suffered dramatic military losses from mid-December 1862 to early

LOCATION

Memphis

Vicksburg ⊹ Champion Hill

New Orleans

The Mississippi was vital to both North and South. By 1863 Union forces had wrested control of the Lower Mississippi Valley from Cairo IL to Vicksburg and from New Orleans to Port Hudson LA.

Ulysses S Grant, pictured here during the Civil War, reflected in an 1879 interview: 'I don't think there is one of my campaigns with which I have not some fault to find, and which, as I see now, I could not have improved, except perhaps Vicksburg.'

January 1863. Preceding these losses were major political losses in October 1862. The mid-term state elections had been disastrous for President Lincoln (1809–65) and his Republican Party, and five key states that had supported Lincoln in 1860 had abandoned the Republicans and sent Democratic majorities to Congress. The war had dragged on, the losses had dramatically escalated, and the voters had expressed their displeasure with the Lincoln administration.

In the midst of the dire situation for the Northern war effort, Grant, with his army mired in the Louisiana swamps during a rain-filled winter, knew that the correct military move would have been to recall his troops to the dry ground of Memphis and prepare for a springtime offensive – precisely what those closest to him advised. However, Grant correctly sensed that a retrograde action at that time would be viewed as another defeat to a discouraged and angry Northern populace. He recalled that 'There was nothing left to be done but to go forward to a decisive victory.'

As any commander worth his salt would do, Grant immediately established an achievable objective: 'The problem was to secure a footing upon dry ground on the east side of the river from which the troops could operate against Vicksburg.' Thus his men would spend the next three months working to achieve that objective. February, March and April were exacerbating months in which Grant faced opposition not only from the Confederates but also from the Northern press, from members of Congress and from some of his own generals. He was accused of stupidity and drunkenness, and one attempt after another failed to get his army onto dry ground. To make matters worse, Grant was physically plagued by a nasty case of boils and an accidentally discarded set of false teeth.

GRAND GULF

Grant's situation did not improve until his troops were finally ferried across the Mississippi to Bruinsburg, Mississippi, on 29–30 April. The hardships and stress of this period in Louisiana are reflected in Grant's missive to his superior officer, Major-General Henry Halleck (1815–72), written just as Grant's army was crossing the

Mississippi: 'I feel that the battle is more than half won,' he scrawled. One must wonder if Halleck, far away in Washington, truly understood these words.

Fittingly, once across the Mississippi, Grant immediately established a new objective: 'Capture Grand Gulf to use as a base.' On 1 May, at Port Gibson, Grant defeated a much smaller Confederate force that had been belatedly sent to prevent his army from establishing a beachhead. Then, on 3 May, he flanked and captured Grand Gulf on the Mississippi River. Thus, in two days Grant achieved his second objective.

The capture of Grand Gulf provided Grant with a much-needed base from which to operate and, with the help of Rear-Admiral Porter's Navy, by 8 May Grant's logistics officer had gathered two million rations at Grand Gulf. As the Federal columns moved inland, they were followed by ammunition, coffee, hardtack and salt piled into confiscated buggies and wagons.

On the same day that Grand Gulf was captured, Grant's rapidly moving forces seized a critical Confederate boat bridge at Hankinson's Ferry across the Big Black River – the last major water barrier between Grand Gulf and Vicksburg. The road north to Vicksburg seemed to be open. Grant arrived at Hankinson's in the pre-dawn hours on 4 May, and on 5 May he sent a one-day reconnaissance patrol north towards Vicksburg.

The report from this expedition convinced Grant that the road to Vicksburg was not quite as open as it seemed, because Pemberton had dug in on Redbone Ridge – the high ground between the Big Black River and Vicksburg – to await an attack. Grant then surprised everyone, from Pemberton to his bosses in Washington, by refusing to do the obvious.

After evaluating the reconnaissance report at Hankinson's Ferry, Grant established his next objective. He decided to feign an attack across the captured bridge, but would actually swing to the northeast, using the Big Black to protect his left flank. He would then manoeuvre his army into position to sever Pemberton's railroad line of communications connecting Vicksburg to Jackson. Grant had learned a valuable lesson at Holly Springs the previous December –

the vulnerability of a railroad – and he would use this lesson against John Pemberton, the very man who had taught it to him.

THREE-PRONGED ATTACK

By 12 May, Grant had manoeuvred his army into three attacking columns with plans to attack the railroad at three points: Edwards Station, 24km (15 miles) east of Vicksburg; Midway Station, 5km (3 miles) east of Edwards; and Bolton, 5km (3 miles) east of Midway. Meanwhile, Pemberton somehow divined Grant's intentions and eventually sent 23,000 men to dig in on a commanding ridge 3.2km (2 miles) south of Edwards at Mount Moriah. Just as he had done at Yalobusha and Redbone, Pemberton planned to fight a defensive battle on commanding terrain.

Realizing that the left of Grant's army was bounded by the Big Black River, Pemberton decided to send a lone brigade out of Jackson to scout and harass the Federal right flank. Pemberton wrote his orders poorly, however, and his cavalry, which was intended to ride from Jackson to the town of Raymond to scout for this 3000-man brigade, galloped instead to Edwards. Meanwhile, Grant's right column of almost 12,000 men marched towards Raymond, which was on their route to Bolton. At Raymond, 10km (6 miles) southeast of Bolton, an aggressive Confederate brigade commander, with no cavalry and with vague orders from Pemberton, decided to attack on the morning of 12 May. He mistakenly perceived the 12,000-soldier corps on the Union right flank to be a 1500-man brigade. The resulting Battle of Raymond lasted several hours, ending with the greatly outnumbered Confederates retreating back to Jackson.

At his campsite on Dillon's Farm, 10km (6 miles) to the west of Raymond, Grant

heard the reverberations of the guns. He knew then that there were enemy forces on his right flank. He was also cognizant of Pemberton's forces to his front at Mount Moriah, and due to his excellent intelligence-gathering, he knew that General Joseph E Johnston (1807–91) was en route to Jackson with more forces. Grant realized that, despite his successful manoeuvring to strike the railroad, the situation had changed and he must change with it. That night, he ordered a feint on Mount Moriah to hold the Confederate forces there in place while he swung the rest of his army northeast and eastwards to Jackson, to drive Johnston out of the capital city. Major-General John McClernand's (1812–1900) 13th Corps would conduct the

Major-General John A McClernand's 13th Corps led the way through the Louisiana wetlands; provided the vanguard across the Mississippi; fought the battles of Port Gibson and Champion Hill; and penetrated the defences of Vicksburg. Yet, due to his turbulent relationship with Grant, the aggressive McClernand has been unfairly labelled as an incompetent general.

THE OPPOSED FORCES

FEDERAL
Infantry 30,000
Artillery 100 guns
Total: **32,000**

CONFEDERATE
Infantry 22,000
Artillery 66 guns
Total: **23,000**

CHAMPION HILL
16 MAY 1863

1 At dawn, Grant's seven divisions move towards Pemberton on three roads. At 9:00 a.m., Grant's northernmost divisions attack and force Pemberton, whose forces are strung along the Ratliff Road, to defend his left flank.

3 At 2:15 p.m., McClernand, on the Middle Road, receives Grant's 12:35 p.m. order to attack. McClernand moves forward with two divisions and sends orders for his two divisions on the Raymond Road to attack.

MIDDLE ROAD

JACKSON ROAD

2 The improvised Confederate left is too thin to withstand Grant's onslaught, and the Federals overrun Champion Hill. Union troops then advance to the Crossroads, capturing Confederate artillery. Pemberton's army is in peril.

CARR

BAKER'S CREEK

5 Pemberton orders Loring, on the Confederate right, to support Bowen. Threatened by Union forces to his front, Loring delays until it is too late. His lead brigade arrives at the Crossroads at 3:45 p.m.

AJ SMITH

LORING

RATLIFF ROAD

BOWEN

CHAMPION HILL

STEVENSON

OVEY

6 At 4:00 p.m., Pemberton orders a retreat across the Baker's Creek bridge on the Raymond Road. Loring covers the retreat with Brigadier-General Lloyd Tilghman's brigade, while Pemberton retreats to the Big Black River railroad bridge.

4 At 2:30 p.m., Pemberton counterattacks with Bowen's division and recaptures the Crossroads and Champion Hill. Bowen's two-brigade counterattack culminates at 3:00 p.m. when it crashes into Crocker's fresh Union division near Champion House.

A selection of Civil War muskets. From top to bottom: an M1841 'Mississippi' rifle; an M1861 rifle musket; a P1858 British-made file musket, commonly used by Confederate forces; an M1863 rifle musket; and a Whitneyville rifle made under US Navy contract.

feint and remain behind to protect the rear of the army. Meanwhile, Major-General James McPherson's (1828–64) victorious 17th Corps at Raymond would march 13km (8 miles) northeast to Clinton and destroy the railroad at that point. Sherman's 15th Corps would march from Dillon's through Raymond to Mississippi Springs, and then move to attack Jackson in concert with McPherson's force.

Arriving on 13 May at Clinton, McPherson's men destroyed the railroad and telegraph lines that were vital to the Confederates, thus accomplishing Grant's third objective. On 14 May, both he and Sherman marched eastwards on two separate roads and drove Johnston's soldiers out of Jackson. With Johnston retreating to the northeast and Pemberton now virtually isolated to the west, Grant went to his fourth objective – the destruction of Pemberton's army.

On 15 May, Grant ordered McPherson and McClernand to march westwards to strike Pemberton, while Sherman remained in Jackson with two of his three divisions to destroy the railroads and military facilities

In December 1862 Grant learned a hard lesson about the vulnerability of a railroad when the Confederate cavalry destroyed his rail line of communications and doomed his first attempt on Vicksburg.

there. As Sherman's men burned Jackson on 15 May, McPherson's two divisions tramped westwards, following the railroad through Clinton to Bolton, where they encamped before dark. Awaiting McPherson at Bolton was one of McClernand's divisions, which Grant had ordered to Clinton to reinforce McPherson's smaller corps.

McClernand's other three divisions were supplemented by one division of Sherman's corps, which had lately arrived at Raymond after successfully completing its mission of

guarding Grant's supply trains from Grand Gulf. McClernand's four divisions spent the night of 15 May encamped just west of Raymond, and the politician-turned-general astutely placed these divisions along two axes of advance: two on the Raymond–Edwards Road, or the direct road to Edwards; and two on the Middle Road, which paralleled the Raymond–Edwards Road just 3.2km (2 miles) to the north. Just 3.2km (2 miles) further north, on the road that ran from Bolton to Edwards, were McPherson's three divisions. Through expert manoeuvring, Grant's army now occupied a 6.5km (4-mile) front, with seven Union divisions poised to attack along three axes of advance.

While Grant's men were rapidly closing on Pemberton's army on 15 May, Pemberton was himself moving his forces, albeit with much less success. After a contentious council of war at Mount Moriah on 14 May, in which Pemberton's general officers had literally voted on several courses of action, Pemberton compromised and ordered his army to

march the next day in a single column in an attempt to attack Grant's supply line at Dillon's. However, in the hours of 14 May, while the council deliberated, Grant's supply wagons were safely passing through Dillon's on their way to Raymond. So, Pemberton's odyssey of 15 May, in which his men marched, detoured or stood in place the entire day and much of the ensuing night, was a fool's errand accentuated by poor staff preparation and non-existent route reconnaissance.

THE BATTLE

The fateful morning of 16 May 1863 found Pemberton's tired army strung along a dirt farm road after having marched most of the night, with their commanding general facing south to an objective – the enemy supply line – that no longer existed. To make matters worse, Grant's well-rested seven divisions broke camp barely 10km

(6 miles) to the east, marched westwards and attacked the Confederate forces on three separate roads. Pemberton was surprised by Grant's triple-axis attack and, to all intents and purposes, the battle had already been decided.

One of McPherson's three divisions moved around the Confederate left flank, forcing the Southerners to reform their line to form the top of a crude figure '7'. But the grey line was too thin, and Major-General John Alexander Logan's (1826–86) Federals broke through.

To close this gap, Pemberton ordered a counterattack, and the Missourians and Arkansans of Brigadier-General John Bowen's (1830–63) division let loose a Rebel yell and drove the Federals back until the tired Southerners ran out of ammunition. Bowen's men then crashed into massed Federal artillery and were simultaneously struck by a fresh Union division. Exhausted,

In this highly dramatized 1887 chromolithograph, Major-General John Logan (left of centre with hat in hand) leads his 3rd Division of the XVII Corps at Champion Hill to attack the Confederate left flank at 10:30 a.m., 16 May 1863. The railroad connecting Vicksburg to Jackson is in the background. As Logan's division crashed into two brigades from Alabama and Georgia, General Grant, at the nearby Champion House, instructed a staff officer to 'Go down to Logan and tell him he is making history today.'

Opposite: The Eagle of the Eighth. Carrying their live Bald Eagle mascot into battle, the men of the 8th Wisconsin Volunteers lead the assault on Vicksburg, Mississippi.

Siege of Vicksburg. On 18 May 1863 General Sherman's XV Corps drove Confederate sharpshooters from Mrs. Martha Edwards' farmhouse (centre right). The encircled Vicksburg garrison eventually surrendered on 4 July 1863.

outnumbered and bulletless, Bowen's soldiers had no choice but to retire.

Grant had manoeuvred well, and his men not only outnumbered the Confederates but, due to his choice of approach routes, the Northern troops were also in the right places at the right times. Eventually, Pemberton had no choice but to order a retreat towards Vicksburg and, in the process of retreating, Major-General William Loring's (1818-86) Confederate division became separated from the rest of the army.

Loring's discouraged men retreated south, abandoned their artillery in the dark of night, and then trudged eastwards around Grant's army eventually to join General Johnston's forces.

Disgruntled over the way the battle had been managed, Loring did not send Pemberton a message to advise his commander that the division was going away from, not towards, the rest of the army. Consequently, on 17 May, a bewildered Pemberton placed a blocking force at the Big Black River to hold the planked-over railroad bridge so that the errant Loring could cross and rejoin the army. Grant's advancing forces struck this luckless 5000-man force and quickly captured more than 1700 of them, along with 18 cannon.

AFTERMATH: VICKSBURG

The remainder of Pemberton's army fell back into the trenches of Vicksburg, only to be surrounded by Grant's army on land and Porter's fleet on water. It was a foregone conclusion that Pemberton must surrender, which he did on 4 July 1863.

On that day, Grant achieved his fourth and final objective of the Vicksburg Campaign and, blessed with the Union victory at Gettysburg the previous day, President Lincoln could breathe a sigh of relief. Both his war to save the Union and his 1864 re-election campaign were infused with new life. And as Grant later wrote: 'The fate of the Confederacy was sealed when Vicksburg fell.'

GETTYSBURG

1–3 JULY 1863

GETTYSBURG IS OFTEN THOUGHT OF AS THE TURNING POINT OF THE CIVIL WAR, BUT IT WAS NOT IMMEDIATELY DECISIVE. HOWEVER, THE SOUTH NEEDED A MAJOR VICTORY MORE THAN THE NORTH, AND FAILURE TO WIN ONE TIPPED THE BALANCE IN FAVOUR OF THE UNION. IT WAS IN SOME WAYS A BATTLE DECIDED BY MISTAKES, AND, IN THE END, THE UNION ARMY MADE FEWER OF THEM THAN ITS OPPONENTS.

WHY DID IT HAPPEN?

WHO The Union Army of the Potomac under the command of Major-General George G Meade (1815–72) numbering about 95,000, opposed by General Robert E Lee's (1807–70) Confederate Army of Northern Virginia, about 75,000 strong.

WHAT A 'meeting engagement' gradually drew in both armies, developing into a major battle in which the Confederate army generally attacked and the Union force fought from defensive positions atop Cemetery Ridge.

WHERE Gettysburg, Pennsylvania.

WHEN 1–3 July 1863.

WHY The Confederate army was operating in Union territory during Lee's Second Invasion of the North and was foraging for supplies. The location was a matter of chance, though it was inevitable that a clash would occur.

OUTCOME Lee's army was unable to defeat the Union force opposing it, and took casualties that it could not afford. Although the battle was indecisive in immediate military terms it was important politically and strategically.

In the summer of 1863, both sides were facing their own crises. In the North, with presidential elections looming, there was a real danger that a pro-peace president might be elected, who would be willing to let the secession states go in return for an end to the war. In the South, it was becoming increasingly difficult to find supplies, weapons and manpower to maintain the war effort. With Vicksburg under siege, there was a real possibility that the Confederacy might lose the use of the vital Mississippi waterway.

General Robert E Lee's advance into the North was critical for both sides. He might even take Washington and dictate the terms of peace in Napoleonic style, but his mere presence on Union soil was an affront to the prestige of President Lincoln (1809–65), who needed public confidence if he was to win the coming election. Just by having an army 'in being' in enemy territory, Lee was a threat to the Union. But he was also exposing his irreplaceable Army of Northern Virginia to defeat.

The Union Army of the Potomac was shadowing Lee's force, trying to prevent it from moving against Washington. It, too, could not risk defeat or the capital would be open to attack. During this tense period, Lee's army was sending out units to forage across the countryside in search of vital

Arriving during the battle, Meade positioned his headquarters in this farmhouse, sufficiently close to the action that stray artillery rounds narrowly missed the general and his staff during the battle.

supplies, including food and shoes. This further confused the issue as reports of these detached units made it difficult to be sure exactly where Lee was.

Unfortunately, Lee was robbed at this time of his own best reconnaissance asset, the cavalry of Major-General JEB 'Jeb' Stuart (1833–64). Stuart was somewhat in eclipse and wanted to renew his fortunes with attention-grabbing operations. He had taken his command off on a raid, which turned into an attempt to repeat his previous exploit of riding right around the Union army. He caused a certain amount of disruption to the enemy but would have been more use to Lee if he had been available to provide reconnaissance and screening.

The general confusion was increased by the resignation of Union army commander Major-General 'Fighting Joe' Hooker (1814–79) after a dispute with Major-General Henry Halleck (1815–72). His replacement, Major-General George G Meade, would need time to familiarize himself with the situation and his new command, but time was not to be had; events precipitated a major battle whether or not anyone was ready for it.

COLLISION AT GETTYSBURG

The town of Gettysburg, Pennsylvania, was an important road junction and was said to contain a warehouse with large supplies of shoes, something the Confederate army badly needed. A brigade under Brigadier-General James Pettigrew (1828–63) was sent into the town to forage, and was encountered there by a Union cavalry force under Brigadier-General John Buford (1826–63). Buford's cavalry were trained as mobile infantry, fighting in a dismounted skirmish line.

Buford's force was something of an experiment, and among the ideas on trial was the use of repeating rifles. So, when

Pettigrew's brigade began to advance against them, Buford's outnumbered men were able to hold their ground on McPherson Ridge for a time, though they were hard-pressed. The arrival of elements of the Union First Corps turned the tide, and now the Confederate force was pushed back. Other units were coming up as quickly as possible, and the fight began to spread out as units fell in on the flanks of those already engaged.

The situation was chaotic, with units arriving unexpectedly and rushing straight into action. Sometimes, this led to dramatic success and sometimes to disaster. Occasionally, both occurred in rapid succession, as when Brigadier-General James Archer's (1817–64) Confederate brigade made a dramatic attack on McPherson's Woods and captured the area, only to be outflanked by the Union Iron Brigade and captured – almost to a man.

114TH PENNSYLVANIA ZOUAVES

At the time of the Civil War there was a fashion for all things French in America, and several regiments were raised and equipped in the fashion of the Zouaves who fought for the French government. They were among the best light infantry in the world, and were widely copied. The original Zouaves were North African mercenaries but were gradually replaced by Frenchmen, while the distinctive clothing of the original soldiers was retained in its style but altered to French national colours.

The 114th Pennsylvania was raised in late 1862. It was renowned for its excellent drill and fighting ability. The regiment served with the Army of the Potomac at Gettysburg and through the remainder of the war, being appointed to the position of headquarters guard for General Meade in 1864.

LOCATION

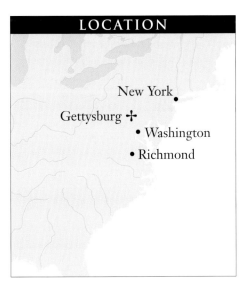

New York

Gettysburg ✝

• Washington

• Richmond

General Lee's Invasion of the North was intended to threaten Washington and other strategic locations, and resulted in a period of countermanoeuvres that culminated in the clash at Gettysburg.

It was during the fight for McPherson's Woods that Major-General John Fulton Reynolds (1820–63), at that point the senior Union officer on the field, was killed. It was also the point at which the true situation began to become clear. Seeing the black hats of the Iron Brigade advancing, a voice in the Confederate ranks was heard to call out: 'Hell, that ain't no milishy, that's the Army of the Potomac!'

The advantage swung one way, then the other. At one point the Rebels outnumbered the Federal troops on the field but were forced to attack across a railroad cut and took heavy casualties. The cut was bitterly contested for hours, and gradually two semi-coherent battle lines began to emerge from the chaos.

John Fulton Reynolds was a career soldier from a military family, who had served with great distinction in the Mexican War. He was one of the best Federal corps commanders and a severe loss to the Union cause.

The Confederates were getting the better of it, and the Federal troops were gradually pushed back into, and through, Gettysburg. Thousands were taken prisoner and whole units were broken, with the survivors rallying on or behind Cemetery Ridge. They were covered by a determined rearguard action fought by the Union First Corps, which reached the ridge battered but in fairly good order.

Meanwhile, a succession of increasingly senior Union officers were reaching the field and assuming command, as each had a right to do. This created more confusion but gradually order asserted itself, with units being sent to defensive positions on the ridge.

This was the best chance Lee had of winning the battle, with the Union army shaken and disorganized. Lee gave orders to the effect that the Confederate army was to advance and push the enemy off the heights, but the attack was delayed too long and the moment passed.

By nightfall on the first day, the Union army was formed in a 'fish-hook' shape along Cemetery Ridge, with the Confederate army in a similar shape along Seminary Ridge and curving around the top of the fish-hook to the north. This gave the Union force the advantage of a shorter line, allowing reinforcements to be moved quickly from one point to another. Lee did have control of the Chambersburg and Hagerstown roads, however, and thus good communications to his rear.

THE SECOND DAY DAWNS

Both the Union and the Confederate armies spent the morning of the second day improving their position and their situation, slotting newly arrived units into their corps and divisional positions, and sorting out the chaos of the previous day's hurried deployments. Skirmishers exchanged fire but there was little major activity.

However, it was obvious that a battle was going to be fought here. Meade knew he had a strong position and was determined to defend it. Lee had the initiative and was equally determined to attack. Lee moved his forces into position and, as noon approached, began to mass troops opposite the southern end of the Union line. Lee had

in fact ordered an attack to be launched at daybreak, but it was delayed, a problem that beset the Confederate army.

Detecting the movement opposite his command, Union Major-General Daniel Sickles (1819–1914) moved his Third Corps forward into a better position to meet the coming attack, occupying a peach orchard and the surrounding terrain. He had already asked for (and not been given) permission to do so, and now acted on his own initiative, leaving a dangerous gap in the Union line.

LEE ATTACKS ON THE LEFT

Lee was becoming increasingly impatient with Lieutenant-General James Longstreet (1821–1904), who was still stalling instead of attacking as ordered. Longstreet was short of one of his divisions, commanded by Major-General George Pickett (1825–75), which was still on the road. He did not want

to 'fight with one boot off', but was finally pushed into action by Lee.

The attack opened with a massive artillery bombardment of the Union troops occupying the Peach Orchard. Then Longstreet's assault finally went in. As a result of his earlier stalling, Longstreet's attack was disjointed but, despite hard resistance from Sickles' Third Corps, the Union forces were pushed back.

During the next four hours, the Union left flank was in severe danger. Six times the Confederates captured the Wheat Field but were driven off, and skirmishers hunted one another through the tumbled rocks of the Devil's Den. First one side, then the other, gained the advantage, but eventually Sickles' corps was pushed back. One Rebel brigade, under Brigadier-General Ambrose R Wright (1826–72), gained Cemetery Ridge but was pushed off again.

The confusion that reigned during the first day of the Battle of Gettysburg prevented either side from realizing the importance of the hill of Little Round Top. The subsequent defence of the hill was one of the decisive moments of the Civil War.

THE OPPOSED FORCES

FEDERAL
 Army of the Potomac
95,000

CONFEDERATE
 Army of Northern Virginia
75,000

A Confederate infantryman of the 1st Texas Brigade lunges forward with his bayonet-tipped musket. Troops of the 1st Texas were heavily engaged in the capture of Devil's Den on 2 July 1863, at Gettysburg.

As the Union line was broken, crisis loomed. On the Union right were two hills: Round Top and Little Round Top. The former was too steep and rocky to be much use. Little Round Top, however, could be used as a position for artillery to enfilade the Union line along Cemetery Ridge, and it was entirely undefended other than by a signals detachment.

FIGHT FOR ROUND TOPS

Meade reacted decisively and quickly to the news that Sickles was in trouble, committing most of his army reserve, and weakening his right flank, to send reinforcements to the embattled left. This was a courageous move: the Union centre

and right were also under attack, but Meade correctly decided that the most serious threat was to his left.

However, they could not have reached the Round Tops in time to prevent them being occupied in strength. Meade needed time, and that time was bought for him on the personal initiative of the Chief Engineer of the Union Army, Brigadier-General Gouverneur K Warren (1830–82).

Realizing the importance of Little Round Top, Warren rushed to the nearest troops – Brigadier-General James Barnes's (1801–69) division of Fifth Corps – and borrowed a brigade under the command of Colonel Strong Vincent (1837–63). These troops reached the crest of Little Round Top just as Confederate troops – elements of Major-General John Bell Hood's (1831–79) division, which had already taken Round Top – were coming up the other side.

For a while the fate of Little Round Top was undecided but, despite being badly outnumbered, Vincent's brigade was able to cling on and then even counterattacked downhill at bayonet point. Although there was still heavy fighting going on, the successful defence of Little Round Top meant that the crisis had passed for the Union army. Reinforcements arrived and the situation was gradually restored.

LEE ATTACKS ON THE RIGHT

Meanwhile, another Confederate attack was going in against the northern end of the fish-hook, with the aim of dislodging the Union army from Culp's Hill and turning its right flank. After an artillery preparation that was met by overwhelming counterfire

from Cemetery Hill, Lieutenant-General Richard S Ewell's (1817–72) corps finally moved forward with Major-General Edward 'Allegheny' Johnson's (1816–73) division in the lead.

Exploiting the weakened Union position (caused by sending brigades south to assist Sickles), Johnson's division was able to take the southern slopes of Culp's Hill and to advance almost as far as the Baltimore Pike. It was chiefly opposed by a single brigade under Brigadier-General George S Greene, (1801–99) which held out long enough to receive reinforcements. Meanwhile, Brigadier-General Jubal Early's (1816–94) command made an attempt on Cemetery Hill but the expected support did not materialize and the attack was beaten off.

As night fell, the Confederates were in possession of important terrain at the right of the Union line, and were within a few hundred metres of the Union supply wagons. However, darkness concealed the situation and the fighting died down.

THE THIRD DAY OPENS

The Union army was still in danger as the third day began. Although there had been no big successes on the Confederate part, they held part of Culp's Hill and some territory around the bases of the Round Tops. They had exerted serious pressure and, arguably, had only failed to win a victory due to lack of coordination.

On the Union side, more reinforcements had arrived in the form of Major-General John Sedgwick's (1813–64) 15,000-strong corps, but the Confederate army had also been reinforced by late arrivals, including that of Stuart's cavalry. On balance, however, it would appear that Lee had missed his chance. He did not have an

objective viewpoint, and things probably looked more favourable from where he stood. He still believed that he could win.

Having attacked heavily on the right and left, and only weakly in the centre, Lee reasoned that the Union centre must have been weakened to meet his thrusts on the second day. Meade correctly predicted this move and reinforced his centre with infantry plus an artillery redeployment to allow massed fire down the hill.

Equally importantly, Meade bolstered the centre psychologically by informing Brigadier-General John Gibbon (1827–96) of Lee's intentions and his preparations to meet them, saying that Gibbon's command would be where the blow was to fall – and be repulsed. Seeing their commander proven correct must have been good for morale among the defending troops.

One other thing was necessary to remedy the Union position: Culp's Hill must be retaken. Twelfth Corps was given the task,

and reinforced accordingly. Some of the troops involved in the assault had an affront to avenge – they had been sent off to reinforce Sickles and had returned to find their positions in enemy hands. This deprived them of food and, they told themselves, a more comfortable night than the one they had just spent in the open.

Johnson's Confederate division wished to widen the penetration it had made into the Union line, and the Federal force wanted to see it off. Johnson's men came out to attack and fighting rapidly spread until about 10:00 a.m., when the Federals finally dislodged Johnson's division from its captured positions. Forced to retreat to the main Confederate line, Johnson's division was shot up badly by Union artillery on the way.

LEE PLANS A DECISIVE BLOW
Although his scouts (and General Longstreet) informed him that it would be possible to manoeuvre around Meade's

This was the terrain so bitterly fought over; hilly and liberally sprinkled with obstacles to break up an infantry advance. The same obstructions provided cover for sharpshooters on both sides.

6 After a two-hour artillery barrage, 15,000 Confederates traverse open ground to assault the Union centre on Cemetery Ridge. The ill-fated Pickett's Charge ends in shattering defeat.

AP HILL

SEMINARY RIDGE

3 Elements of AP Hill's corps strike the Union centre, but determined counterattacks force the Confederates to give up temporary gains.

LONGSTREET

2 Fighting rages in the Wheat Field and Peach Orchard as waves of Confederates smash Sickles' salient. Union artillery fire plugs the gap in Meade's line.

PEACH ORCHARD

LITTLE ROUND TOP

DEVIL'S DEN

SYKES

1 At 4.00 p.m., Longstreet's artillery hits the Union left. Hood's division captures Devil's Den. Warren rushes Union defenders to Little Round Top, saving the key position.

7 Cavalry action prevents any Confederate reinforcements from reaching the fighting, while Kilpatrick's impetuous Union cavalry charge against Longstreet results in slaughter, ending the battle.

GETTYSBURG

4 In gathering darkness, Ewell fails to capture Culp's Hill, while Early gains the summit of Cemetery Hill but, without reinforcements, is compelled to abandon the effort.

5 Ewell vainly renews the assault at Culp's Hill and Spangler's Spring, and Union counterattacks end the threat to the heights on Meade's right.

JOHNSON

HOWARD

CEMETERY HILL

CULP'S HILL

NEWTON

ROCK CREEK

GETTYSBURG
1–3 JULY 1863

army and perhaps force it to attack on ground of his choosing, Lee was determined to end this matter here and now. Pointing to Cemetery Ridge, he stated that 'the enemy is there and I am going to strike him'.

Lee's strike would take the form of 15,000 men advancing en masse to break through the Union centre. Many of his troops had been only peripherally involved the previous day and Lee believed that they were fresh enough and sufficiently determined to carry Cemetery Ridge. Longstreet disagreed, suggesting that 'no fifteen thousand men ever arrayed for battle can take that position'. But Lee was in command, not Longstreet, and the only concession to the latter was some compromise over details of the plan.

PICKETT'S CHARGE

Preparations were made, troops were shifted and the hour approached. Longstreet's misgivings grew, but at about

1:00 p.m., the artillery preparation began. This was not as effective as Lee had hoped for, partly due to lack of ammunition, and partly because the guns were firing upwards and tended to shoot over the ridge rather into the forces arrayed along its crest. A tremendous storm of fire came from the massed Federal artillery in reply.

Finally, Pickett, who had been detailed to lead the assault, asked Longstreet if he should advance. Longstreet was unable to give him an answer but nodded, and Pickett's Charge began. This was one of the great military undertakings of the period – a full 15,000 men advancing with their colours, almost as if on parade. There was a brief lull in the firing, during which the Rebel lines crossed about half the distance to the base of the ridge. Then, the Federal artillery began firing.

The massed Union guns fired ceaselessly as the Confederate infantry struggled forward and began to ascend the hill. Gunners changed from roundshot to shell and finally canister as Pickett's Charge came towards them, but the Rebels just closed ranks and kept coming. More artillery (including some guns positioned, ironically enough, on Little Round Top) enfiladed the lines, and as the range dropped, rifle fire broke out along the crest line.

Gaps were opening up between Confederate units, but the advance continued. However, Union Major-General Winfield Scott Hancock (1824–86) pushed a brigade into the gap and began firing into the flank of the advancing enemy units. They broke up two brigades on the Confederate right and sent the survivors back towards their own lines.

By now the leading elements of the Confederate force were approaching the main Union line. Pickett positioned himself, an inviting target on his black horse, to direct units coming up and remained there within range of enemy

A cavalryman from Rush's Lancers, 6th Pennsylvania Cavalry. The lance was going out of fashion in the 1860s, though some units still carried it. The Union cavalry made better use of their firearms than hand weapons. Note that the revolver is worn in 'reverse cavalry' position.

A section of the Gettysburg Cyclorama, painted in 1883 by French artist Paul Phillippoteaux (1845–1923), depicting Pickett's Charge on the final day of the battle. In many ways this was the last hurrah for the Confederacy. Afterwards, the tide had fully turned in favour of the North.

sharpshooters. He fed in units as they arrived, trying to maintain some kind of organization to the assault.

On the left, Pettigrew's division came under murderous flanking fire and broke up. With both flanks stalled and falling back, the only chance for success lay with Pickett's central units. They came forward, pausing only to shoot, and were within 100 metres (110 yards) of the stone wall behind which Gibbon's men waited with loaded weapons. Just as Meade had predicted, the main thrust was coming straight at Gibbon.

Gibbon gave the command to fire, and within five minutes the determined assault was shot to pieces. A scant 150 Confederate

soldiers reached the stone wall and clambered over it, led by Brigadier-General Lewis Armistead (1817–63). A Union brigade under Brigadier-General AS Webb (1835–1911) broke and ran, and nearby gunners were chased off or shot down.

This was the high watermark, the point where Pickett's Charge crested and began to ebb. Rallied Union troops, assisted by artillery firing point-blank, blasted the intrepid general and his tiny force off the hill. The assault began to thin out and break up as the Union defenders returned to their positions and continued firing. Soon, Confederate regiments began to break and scatter back down the ridge. The charge was over, and Lee's chance of winning the battle was gone with it. Estimates of Southern dead and wounded in the assault range from 7000 to more than 10,000.

ENDGAME

Longstreet did what he could to rally the shattered survivors and form some kind of

battle line in case of a counterattack. It did not come, however. The reason might have been that Meade was thinking defensively and was unable to switch to aggressive operations. It might have been that the Union army was exhausted, and there is also the possibility that Meade did not know that the Confederates were beaten. He may have been expecting another assault from his highly determined enemies.

Lee knew he was beaten, though. Despondently telling Pickett that he and his men had done all that could possibly be asked of them, he accepted the blame for the failure with the simple words: 'This was all my fault.'

The Rebel army was perhaps less despondent. Once out of immediate danger most of the survivors of the charge returned to their units at a walk rather than fleeing into the distance. They knew they had been dealt a beating, but defeat was a new experience for them and, rather than breaking their spirit, it provoked a desire for

revenge. It is perhaps as well for the Army of the Potomac that Meade did not choose to counterattack, given the mood in the Confederate lines at that point.

CAVALRY SKIRMISHES

As Pickett's Charge was going in, a cavalry fight broke out at the southern end of the battlefield. This was an inconclusive but violent business, and went on for some time. Meanwhile, to the north, a rather more serious cavalry action took place. Four Confederate brigades under the legendary 'Jeb' Stuart fought it out with three Union brigades. The prize was control of the roads in the Union army's rear. Lee had hoped that the sudden appearance of Stuart's cavalry in the Union rear would be a factor in breaking the Army of the Potomac, coinciding with Pickett's Charge. In the event the fight, though hard, did not materially affect the result of the battle.

The cavalry fight involved dismounted men fighting as skirmishers and several batteries of artillery as well as the more traditional running fight. In general, the Union cavalry was inferior to that of the Confederacy in terms of horsemanship and dash. As a result, the Rebels liked to get stuck in with sabres and revolvers, while the Union cavalry tended to come off worse in such engagements. However, one brigade on the Union side was only too willing to meet the Confederate *beau sabreurs* on their own terms – headlong at the point of the sword. This brigade was commanded by a man who had been a captain on the staff a few days earlier and had been promoted, with two others, to general rank for lunatic bravery. His name was George Armstrong Custer (1839–76).

Custer's brigade clashed with the advancing Rebels in a violent mutual charge that became a classic cavalry mêlée of charge and countercharge, while a firefight around Rummell House drew in ever-larger numbers of dismounted men. The fight went on for some time before winding

Entitled 'Come on you wolverines!', this modern painting depicts General George Armstrong Custer leading the Michigan Brigade in a charge at the Battle of Gettysburg, 3 July 1863.

Photographer Timothy O'Sullivan (c1840–82) recorded this grisly scene of Union dead in a meadow near the Peach Orchard. These soldiers were probably killed on 2 July 1863, defending the advanced positions of the Union Third Corps.

down somewhat inconclusively. The Confederate cavalry withdrew into the gathering darkness.

One other cavalry action took place that day. While Confederate General James Longstreet was trying to rebuild the battle line, the Union cavalry commander Major-General Hugh Judson Kilpatrick (1836–81) decided to make a cavalry attack. It is possible that he believed that Meade might be about to counterattack and was trying to assist. Whatever the reason, he ordered one of his regiments forward.

Led by the newly promoted Brigadier-General John F Farnsworth (1820–97), 300 Union cavalrymen charged. They punched through the Confederate line and into the rear, then broke through and came back without their commander, who was killed.

LEE RETREATS

As darkness fell on the third day of Gettysburg, there was a real possibility that the fighting would be resumed on 4 July. However, after waiting for a Union attack

and choosing not to launch one of his own, Lee began a withdrawal.

It seems that Meade was not entirely sure that Lee was withdrawing until 5 July, at which point he sent orders to some of his detached troops to impede and harass the retreat. The most effective action against the retreating Confederates was a cavalry attack made at night, which caused a fair amount of damage.

Union cavalry intermittently harassed the withdrawing Army of Northern Virginia and were driven off at times by walking

wounded who had retained their rifles. However, there was no serious attempt at a close pursuit. Heavy rains, which had flooded the Potomac, hampered the retreat and made the going difficult.

However, Meade was reluctant to press the pursuit and, once the river had subsided, Lee was able to get his army across and out of danger.

AFTERMATH

Gettysburg was, in truth, an inconclusive affair, but the Union could afford to fight a struggle of attrition and the Confederacy simply could not. There was a point when Lee might have broken the Army of the Potomac and perhaps even taken the Federal capital of Washington, but that moment had now passed. The odds against the Confederacy were growing ever longer, especially with a victory to shore up Lincoln's bid for re-election.

Gettysburg was, therefore, the point at which the Confederacy lost its best chance to win to war, and from then onwards it was on the road to defeat.

In one of the few photographs taken during the dedication of the Gettysburg National Cemetery on 19 November 1863, President Abraham Lincoln is barely visible seated at the left on the crowded speakers' platform. Lincoln's Gettysburg Address, consisting of slightly more than 200 words, remains one of the principal documents of American freedom.

CHICKAMAUGA
18–20 SEPTEMBER 1863

CHICKAMAUGA WAS ONE OF THE FEW OCCASIONS THAT THE CONFEDERATES ACTUALLY OUTNUMBERED THEIR OPPONENTS. IT WAS THE MOST SERIOUS DEFEAT SUFFERED BY THE UNION IN THE WESTERN THEATRE OF WAR, AND MARKED THE END OF WHAT HAD BEEN UP TO THEN A SUCCESSFUL CAMPAIGN BY GENERAL ROSECRANS.

WHY DID IT HAPPEN?

WHO Union Army of the Cumberland (62,000 men) under Major-General William S Rosecrans (1819–98) opposed by the Confederate Army of Tennessee (65,000 men) under General Braxton Bragg (1817–76).

WHAT The battle was something of a 'meeting engagement', which developed into an all-out brawl in very difficult terrain. Confederate forces were able to exploit a gap in the Union line.

WHERE Near Fort Oglethorpe near Chattanooga, Georgia.

WHEN 18–20 September 1863.

WHY Bragg's objective was to regain control of Chattanooga, an important railroad junction.

OUTCOME Most of the Union army collapsed and scattered, forcing Rosecrans to retreat into Chattanooga. Bragg's army then laid siege to the town.

After his defence of Cincinnati during the Confederate invasion of Kentucky, Rosecrans was given command of the Union armies in the western theatre, replacing the hesitant Brigadier-General Don Carlos Buell (1818–98). He embarked on a successful advance through Tennessee, pushing Bragg's army southwards.

Rosecrans' superiors and President Lincoln (1809–65) were determined that he should capture Chattanooga as soon as possible. The city was critical as it controlled a vital rail junction whose loss would reduce the Confederates' ability to move supplies and troops about, weakening their whole war effort. It would also serve as a base to attack Atlanta and to launch operations into the Deep South.

The Confederates knew how vital the city was, and were prepared to defend it heavily, so Rosecrans decided to dislodge them by manoeuvre rather than assault. His plan was to position his army to the south of the city and cut off its supply lines, and in mid-August, he set out to do just that.

To cover Rosecrans' crossing of the Tennessee River, he ordered diversionary attacks to be made. These included a bombardment of the city's defences. In fact, the bombardment was made by a single battery of light artillery covered by just one brigade of troops, but it reinforced Bragg's preconceived ideas about what Rosecrans would do and so occupied his full attention. Rosecrans was therefore able to carry out the first part of his flanking march more or less unopposed.

Meanwhile, the Confederacy was taking steps to ensure that Chattanooga was properly defended and so pulled in forces

The American Civil War was one of the first conflicts in which large-scale movements of troops and supplies by rail played an important part. Control of rail junctions such as the one at Chattanooga was a vital strategic factor.

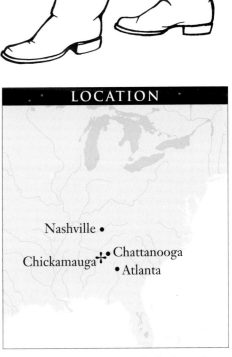

from other regions, including a corps of the Army of Northern Virginia under the command of Lieutenant-General James Longstreet (1821–1904).

Rosecrans was moving through difficult terrain and was obliged to divide his force. His three corps each moved by a different road and became widely separated on the march. Once Bragg learned of the situation, he realized that he had been handed an opportunity to move against each corps in turn and defeat the Union army in detail.

Bragg pulled out of Chattanooga on 8 September and began his move. Rosecrans duly learned of it and decided that Bragg was retreating, perhaps intending to fall back on Atlanta. In part, this belief was due to a successful deception operation on Bragg's part.

Deserters have always been a useful source of information to their opponents, and Bragg made sure that Rosecrans captured some. These men were in fact volunteers carrying false information, deliberately fostering the impression that Bragg was in retreat. In fact, he was encamped at La Fayette, and was ready and willing to fight.

Sending cavalry to cut a railroad supplying Bragg's force, Rosecrans also sent a corps to capture Chattanooga while the rest of the army advanced after Bragg's supposedly retiring force. The 14th Corps, under Major-General George H Thomas (1816–70), was heading for La Fayette, when the lead division ran into resistance. The resulting action became known as the Battle of Davis' Cross Roads or the Battle of Dug Gap.

A Confederate division under Major-General Thomas C Hindman (1828–68) was detailed to attack the lead division of Thomas' corps – commanded by Major-General James S Negley (1826–1901) – in the flank as it moved through Dug Gap, at which point Major-General Patrick Ronayne Cleburne's (1828–64) division would assault it from the front. The plan involved reinforcements that did not arrive in time, so the attack was postponed until

CONFEDERATE RIFLEMAN

Drawn from a smaller population and with less industry available to support them, the armies of the Confederacy were less uniform in appearance than the Federal forces and tended to be equipped with whatever was available. The Confederacy made more use of irregular units than the North, and in this it had an advantage in that a large segment of its population was composed of resourceful backwoodsmen already skilled in fieldcraft and shooting.

This individual is armed with an early sniper rifle. The long optical sight is primitive but under the right conditions his weapon could kill a specific individual – say an officer or a colour-bearer – from a great distance.

the next day, by which time Negley, too, had been reinforced.

The Confederate attack went in against two divisions, whose commanding officers conducted a skilled fighting withdrawal, leapfrogging back to Stevens' Gap to await reinforcement by the rest of the corps. This was accomplished in spite of constant harassment and determined attacks by the Confederate forces.

Perhaps Bragg realized that he had lost his opportunity to defeat Thomas' corps, or perhaps he just changed his mind as he was very prone to do, but in any case he decided to move north and attack 21st Corps under Major-General Thomas Leonidas Crittenden (1819–93) instead.

Bragg ordered Lieutenant-General Leonidas Polk (1806–64) to move with his command against Crittenden's corps. Polk advanced but, finding that Crittenden's division had concentrated, decided not to make the attack. Rosecrans was by now concentrating his three dispersed corps and was no longer vulnerable to defeat in detail.

THE FIRST DAY

Bragg's army began the operation on 18 September, marching northwards back up the La Fayette road. Crittenden's corps was on the northern, left, flank of the Union army, and to get at it the Confederates had

LOCATION

Nashville •

Chickamauga ✛ • Chattanooga
• Atlanta

The Battle of Chickamauga was fought close to the critical rail junction of Chattanooga. The actual location was coincidental – the decisive clash could have occurred at a number of other points.

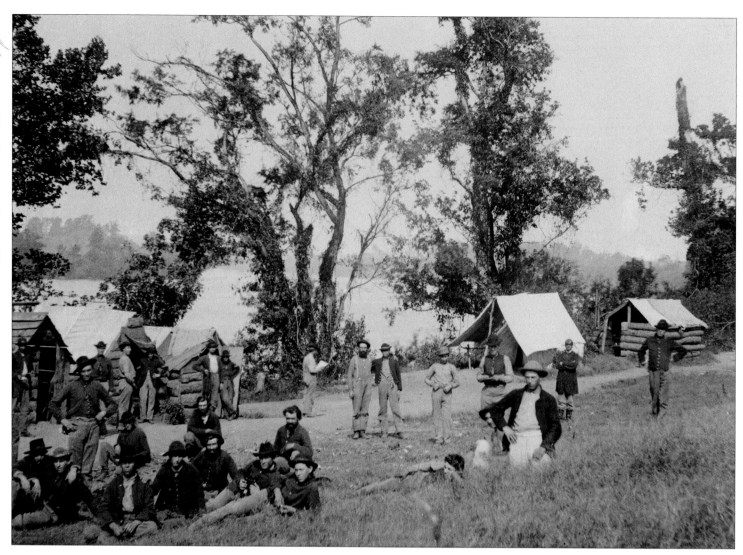

Whenever they halted for any length of time, the troops on both sides would make themselves as comfortable as possible. This peaceful scene is a stark contrast to the savage short-range fighting that would soon erupt.

to cross the Chickamauga Creek. The attempt ran into determined resistance from Union cavalry and mounted infantry.

One of the defending officers, Colonel John T Wilder (1830–1917), had been forced to surrender a river crossing the previous year when badly outnumbered. There was to be no repeat of that incident in 1863. Wilder's cavalry put up a spirited fight, their lack of numbers partially offset by the fact that some of them carried repeating rifles. Wilder's troops inflicted considerable casualties on Brigadier-General St John R Liddell's (1815–70) division and were able to destroy the bridge that the Confederates wanted to use.

Meanwhile, cavalry under Colonel R Minty were eventually pushed back from Reed's Bridge, and the Confederates were able to cross in force. Finally getting into position to attack Crittenden, Polk was to have assaulted frontally after a flanking force consisting of the corps under Major-General Simon B Buckner (1823–1914), Major-General WHT Walker (1816–64) and Brigadier-General Nathan B Forrest (1821–77) moved into position. However, the delay imposed by crossing the creek prevented the flanking operation from taking place and the attack did not develop.

The situation was confused on both sides. Neither Bragg nor Rosecrans knew exactly where his enemy was, nor how many men he commanded. During the night of the 18/19 September, reconnaissance patrols from both forces probed the enemy positions, and as each one reported back, the respective commanders moved units accordingly.

Rosecrans' thinking was defensive at this point. Bragg planned to attack. Each army occupied about 10km (6 miles) of front, in terrain that was entirely unsuitable for a major battle. Dense woods covered most of the ground and it was not possible to see more than 50m (55 yards) or so. Artillery would be no use at all in the coming battle, except in the fields that had been cleared between the stands of trees. Nevertheless, Bragg was determined to fight.

THE SECOND DAY

At dawn on 19 September, Crittenden's corps was no longer the northern flank of the Union position. Thomas' corps was now on its flank. Bragg was unaware of this and still thought Crittenden's corps represented the end of the Union line.

Thomas ordered Brigadier-General John Milton Brannan's (1819–92) division to reconnoitre towards Chickamauga Creek and find out what the Confederates were up

to. Brannan ran into Forrest's cavalry, which was dismounted, and launched an attack that drove the cavalry back. The fighting drew in nearby Confederate infantry and gradually spread until a major engagement was under way.

First Buckner's corps and Major-General BF Cheatham's (1820–86) division joined the action, and Bragg fed in more troops as the scale of the fighting became apparent. By the end of the day all but two of his divisions had been in action and on the Union side the whole of 14th, 20th and 21st corps were engaged.

Bragg launched several assaults, but all were beaten back, and by nightfall no real gains had been made by either side. The fighting had been ferocious, often at very close quarters in difficult terrain. Hand-to-hand combat had occurred in several places, with no overall guidance by senior officers. Chickamauga had turned into a soldier's battle, one that would be decided by the resolve and raw fighting power of the men on both sides.

FURTHER REDEPLOYMENTS

Nevertheless, the two commanders did what they could to influence the outcome, shifting units around during the night of 19/20 September. Bragg may not have known just how severe the fighting had been. He referred to the day's action as 'heavy skirmishing' that had taken place while his command was trying to get into line of battle. However, he did make one very good decision.

Realizing that it was going to be impossible to re-form the army according to its original command structure, Bragg reorganized according to where each unit was at the time, placing Polk in command of the right wing, containing Lieutenant-General DH Hill's (1821–89) corps and the reserve corps, and Longstreet in command of the left wing, which contained Buckner's corps and the one Longstreet himself had brought from Virginia. Out-of-position units were assigned to the nearest high command structure, rather than moved across a wooded battlefield in the dark.

THE OPPOSED FORCES

FEDERAL
Army of the Cumberland **62,000**
(mostly infantry)

CONFEDERATE
Army of Tennessee **65,000**
(mostly infantry)

Confederate Major-General Patrick Cleburne rallies his troops at the battle of Chickamauga. Cleburne's division was involved in the assault on Thomas' Corps.

4 The Union line is shattered, with two entire corps driven off the field, leaving Thomas' corps dangerously exposed.

1 After the fighting of the first two days, the Union army assumes a defensive posture as both commanders try to reorganize their forces.

THOMAS

5 Stubborn resistance by Thomas' corps and some other formations averts total disaster as the Confederate advance is fought to a bloody standstill.

CLEBURNE

SHERIDAN

BR JOHNSON

6 Thomas manages to make an orderly retreat at the end of the day, taking up defensive positions in Chattanooga. The city is besieged by Bragg's army.

2 The northern end of the Confederate line opens the attack. Thomas' Union corps is soon under intense pressure but holds its positions.

3 Confusion in the Union command structure causes a gap to open up in the line just as Longstreet's forces roll forwards.

LONGSTREET

CHICKAMAUGA
18–20 SEPTEMBER 1863

Leonidas Polk was a West Point graduate and an ordained bishop. He was a friend of Jefferson Davis (1808–89), who appointed him a major-general in the Confederate Army. He was not a successful commander but was well liked by his troops.

Meanwhile, the Union Army was on the defensive again, chopping down trees to make breastworks in order to strengthen its positions. This was probably the right decision, as Bragg was planning an assault for the next morning. His plan was to roll forwards in succession from north to south across the entire battlefield. At 9:00 a.m. the following morning, the attack began.

THE FINAL DAY

Major-General John C Breckinridge's (1821–75) division opened the Confederate attack, engaging Thomas' corps. Under serious pressure, Thomas called up Negley's division, which had been placed in reserve – or so the Union commanders thought. In fact, Negley's division was in the line, but he was still able to send troops to help Thomas once Brigadier-General Thomas Wood (18923–1906), whose division was in reserve instead of Negley's, came up to relieve him.

Up to about 11:00 a.m., Thomas' corps was able to fend off the Confederate assault. However, the mismanaged deployment was to have serious consequences for Rosecrans. Misapprehending the location of Wood's

division, Rosecrans ordered Wood to close up and support Major-General Joseph J Reynolds (1822–99). This would have been appropriate if Wood was where Rosecrans thought he was, but in the event the order required Wood to pull back out of the line, move behind Brannan's division and finally close up with Reynolds' right flank, where Rosecrans had thought he was all along.

This unfortunate movement left a gap in the Union line, which Major-General Philip Henry Sheridan (1831–88) and Brigadier-General Jefferson C Davis (1828–79) began moving their divisions to cover. However, they were a little too late. At about 11:30 a.m., Longstreet's wing was rolling forward and hit the Union line while the gap was open. Sheridan's and Davis' divisions were overwhelmed and scattered, and the Union line was compromised.

Thinking that a general collapse was occurring, Rosecrans precipitated one. Along with Major-General Alexander McCook (1831–1903), commanding 20th Corps, and Crittenden (21st Corps commander), he panicked and fled the field, along with most of the units of the two affected corps.

Not everyone fled, and total disaster was averted by the initiative and determination of several Union commanders. As the corps around them disintegrated, Wilder's cavalry again distinguished themselves, advancing to counterattack with their repeating rifles.

Although terribly hard-pressed, Wilder's men were able to slow Longstreet down long enough to save many of the fleeing men, and also bought time for the sole remaining corps commander on the field to realize what was happening and act.

Thomas remained in the field, and with him his corps. He pulled back some of his units to anchor his flanks, but otherwise stayed where he was, determined to make a fight of it. In this, he was nobly assisted by two brigades under Major-General Gordon Granger (1822–76). Granger was supposed to be in the rear, in reserve to cover the rear and flank. Correctly deciding that there were more important tasks at hand, Granger led his force forward and offered his units to Thomas. They were just in time to prevent Thomas' flank being enveloped.

Two factors prevented he total collapse of the Union army. One was the stubborn fight put up by Thomas, who became known as the 'Rock of Chickamauga'. The other was that Bragg had not allowed for a general pursuit and was not able to make the most of his unexpected victory.

Beating off more attacks on his thin line, Thomas was able to hold out for the rest of

This illustration tries to give an impression of the close-quarters fighting that took place all along the line. It is somewhat unlikely that formed units fired into one another from quite such close range, however.

the day and was then able to retire into the defences of Chattanooga, where Rosecrans had taken refuge. The Confederate army then laid siege to the city.

AFTERMATH

Chickamauga was a major defeat for the Union, although it came at great cost to the Confederacy. Around 16,000 Union soldiers were killed or wounded, while the Rebels lost 18,500 or so. Although Bragg won a tactical victory, he was not able to make much of it, due partly to the difficult terrain, partly to Thomas' defiance and partly to his own decision not to create an army reserve capable of conducting a vigorous pursuit.

Rosecrans' career was finished, though Thomas was rightly elevated to high command, and Granger's timely initiative was also rewarded. One other individual distinguished himself: James A Garfield (1831–81), Rosecrans' chief of staff. After accompanying his commander off the field

of battle, Garfield went back to see what help he could be while the general in command of the army fled to Chattanooga. Garfield was eventually elected President of the United States.

On the Confederate side, General Bragg relieved three of his commanders for 'misconduct' during the battle, though his own abrasive nature had played its part in the friction that had beset the command structure of the army.

Bragg did not retake Chattanooga. He besieged the city until November, when a relief force under Major-General William Tecumseh Sherman (1820–91) and Major-General Ulysses S Grant (1822–85) arrived to break the siege. Some months before, President Lincoln (1809–65) had suggested that whoever controlled Chattanooga would win the war. He had said much the same thing about the state of Kentucky, and now the Union had both. Although its army had been beaten in the field, the Union was still winning the war.

After their defeat at Chickamauga, the Union forces were besieged in Chattanooga with the Confederates cutting off their supply lines. A Union offensive to reopen the lines resulted in the Battle of Lookout Mountain on 24 November 1864.

THE WILDERNESS/ SPOTSYLVANIA COURTHOUSE

5–20 MAY 1864

WHEN LIEUTENANT-GENERAL ULYSSES S GRANT BECAME GENERAL-IN-CHIEF ON 12 MARCH 1864, HE BROUGHT A NEW PERSPECTIVE TO THE FEDERAL WAR EFFORT. FOR THE FIRST TIME THE FEDERALS WOULD TREAT THE WAR AS A WHOLE, PRESSING THE CONFEDERATES ON ALL SIDES SIMULTANEOUSLY, RATHER THAN ALLOWING THEM TO REINFORCE FIRST ONE THREATENED AREA, AND THEN ANOTHER.

WHY DID IT HAPPEN?

WHO Federal forces under Lieutenant-General Ulysses S Grant (1822–85) attacked Confederates under General Robert E Lee (1807–70) in the opening battles of what proved to be the war's decisive campaign in Virginia.

WHAT Lee defeated Grant by thwarting the Federal turning movements, but Grant relentlessly maintained the pressure.

WHERE The Wilderness and Spotsylvania Courthouse, Virginia.

WHEN 5–7 May 1864 (The Wilderness) and 7–20 May 1864 (Spotsylvania Courthouse).

WHY At the Wilderness, Lee used restrictive terrain to offset Grant's superior numbers. At Spotsylvania Courthouse, Lee used excellent analysis of intelligence reports to ascertain Grant's intentions and then beat Grant in a race to Spotsylvania Courthouse.

OUTCOME At the Wilderness, Grant sustained 17,000 casualties compared to 10,000 for Lee. At Spotsylvania Courthouse, Grant suffered 18,000 more compared to just 12,000 for Lee. However, at this point in the war Grant knew that he could replace his losses while Lee could not.

Grant devised a cohesive strategy for 1864 to attack the Confederates from all directions. Major-General Franz Sigel (1824–1902) would advance up the Shenandoah Valley. Major-General Benjamin Butler (1818–93) would conduct an amphibious operation against the Richmond-Petersburg area. Major-General Nathaniel Banks (1816–94) would march on Mobile, Alabama, and shut down the Confederacy's last major port on the Gulf of Mexico. Major-General William Tecumseh Sherman (1820–91) would attack the Confederate war-making ability in the Deep South. Major-General George G Meade (1815–72) would focus on Confederate General Robert E Lee. 'Lee's army is your objective point,' Grant told Meade. 'Wherever Lee goes, there you will go also.'

While Meade would command the Army of the Potomac, Grant would accompany it in the field. All these operations were designed to jump off simultaneously in May, and on 4 May Grant crossed the Rapidan River into an area of Virginia appropriately called the Wilderness. It was the beginning

Grant brought a new attitude to the Army of the Potomac, telling one subordinate, 'Oh, I am heartily tired of hearing what Lee is going to do. Some of you always seem to think he is suddenly going to turn a double somersault and land in our rear.... Go back to your command and try to think what we are going to do ourselves, instead of what Lee is going to do.'

of the campaign that would ultimately lead to Lee's surrender at Appomattox on 9 April 1865. Only Grant's persistence and grand strategic vision made this outcome possible, because in the beginning, Lee would use terrain and entrenchments to thwart the Federal forces at the Wilderness and Spotsylvania Courthouse.

DISPOSITIONS

As both sides readied for battle, the odds appeared to favour the Federals. Including his cavalry, Grant had a force of more than 118,000 men while Lee could muster fewer than 62,000. One Federal general on the scene figured that if Grant's force could have been deployed properly, it would have covered a front of 34 km (21 miles), two ranks deep, with one-third of its strength held in reserve. Under the same conditions, Lee could cover a total of only 18km (12 miles). More important than mere size was the composition of the force. In the key areas of firepower and manoeuvrability, Grant had 274 guns manned by 9945 artillerymen as well as Major-General Philip H Sheridan's (1831–88) crack command of 11,839 cavalrymen.

On the other hand, Lee had only 224 guns manned by roughly 4800 artillerymen and Major-General JEB 'Jeb' Stuart's (1833–64) cavalry of some 8000 men. In order to be successful, Lee would have to overcome this discrepancy. He would do this by selecting a battlefield on which restrictive terrain would mitigate his small numbers and negate Grant's firepower advantage.

The virgin timber of the Wilderness had been cut down many years before, and a tangled second growth of stunted pines, vines, scrub brush and creepers had engulfed the region. The few roads in existence often led to dead ends in the middle of nowhere and were inaccurately mapped. The ground itself was broken by irregular ridges and crisscrossed by numerous streams that cut shallow ravines. In many places these streams followed serpentine routes that resulted in brush-covered swamps. Civil War correspondent William Swinton

(1833–92) wrote that it was 'impossible to conceive a field worse adapted to the movements of a grand army'. Historian Bruce Catton (1899–1978) would agree, calling the Wilderness 'the last place on earth for armies to fight'.

Such a place, however, was just what Lee needed. The thick vegetation neutralized the mobility of the Federal cavalry and made observed artillery fire nearly impossible. The dense woods would prevent Grant from massing his superior numbers, and would make command and control difficult. By picking his ground carefully, Lee was able to make the otherwise indifferent terrain work to the advantage of his smaller and lighter force.

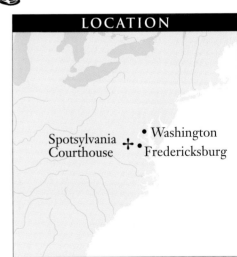

SHERIDAN'S CAVALRY

The cavalry served as the commander's eyes and ears in the Civil War. However, instead of providing Grant with much-needed reconnaissance at Spotsylvania Courthouse, Major-General Phil Sheridan had convinced Grant to dispatch him on a raid towards Richmond. The raid was less successful than Sheridan and Grant had hoped, but it did lead to the death of Major-General 'Jeb' Stuart, Lee's trusted cavalry commander, at Yellow Tavern.

Battlefield communications were a major challenge for Civil War commanders. Line-of-sight systems such as guidons offered communications capability at the tactical level, as did couriers, which were used to deliver messages around the battlefield.

LOCATION

Spotsylvania Courthouse • Washington • Fredericksburg

The area of the Wilderness and Spotsylvania Courthouse was familiar to both armies. It was the same general area that Lee and Hooker had fought over a year earlier. The thickness of the Wilderness favoured the defender.

THE WILDERNESS/SPOTSYLVANIA COURTHOUSE

THE WILDERNESS

After crossing the Rapidan, Grant had hoped to clear the inhospitable Wilderness with the least possible delay, but instead he had to wait for his supply train to catch up. The armies were in close proximity to each other, but neither side knew exactly where the other was. On 5 May, the Federals made contact with Lieutenant-General Richard S Ewell's (1817–72) corps, mistakenly thinking it was a smaller element. At first the Federals drove back Ewell's lead division but then Brigadier-General John B Gordon (1832–1904) launched a counterattack that overwhelmed both flanks of the Federals' attempted frontal assault. Having halted the Federal advance, Ewell dug in and held his

Grant's 1864 campaign in Virginia began with two days of costly fighting in the Wilderness. Many wounded on both sides died horrible deaths when the trees and thick underbrush caught fire.

ground until the corps of Lieutenant-Generals AP Hill (1825–65) and James Longstreet (1821–1904) could arrive.

Both Grant and Lee had offensive plans for 6 May, and the fighting resumed at 5:00 a.m. Again the Federals gained the initial advantage, partially collapsing Hill's line. As the battle wore on, however, the restrictive terrain caused Grant's units to dissolve into smaller and smaller groups. Using an unfinished railroad cut that provided a covered approach to the Federal southern flank, Longstreet was able to stabilize the line with an attack that began at 11:00 a.m. Lee had prepared personally to lead the first counterattacking units, but passionate cries of 'Lee to the rear' dissuaded him. Then, just before dark, Gordon attacked the Federal right, gaining ground but not being able to sustain the advance. During the night, both sides dug new lines.

The heavy fighting during the day had ignited many brush fires in the thick

undergrowth and at several points shooting had stopped by mutual consent as both sides worked together to rescue wounded soldiers from the flames. Cries for help and water pierced the battlefield. Nonetheless, during the night of 7/8 May, some 200 men suffocated or burned to death.

In the end, the Wilderness was a lopsided victory for the Confederates, with Grant suffering 17,000 casualties compared to 10,000 for Lee. But what was most important was what happened next. In the past, after taking such a beating, the Army of the Potomac would have retreated and licked its wounds. Grant, however, was a new type of commander. He chose to keep the pressure on Lee by simply disengaging and continuing the effort to get around Lee's flank. Late on 7 May, Grant rode at the head of his army and approached a road junction in the Wilderness. A left turn would mean the usual withdrawal toward the fords of the Rapidan and Rappahannock

Rivers. To the right was the road to Richmond via Spotsylvania Courthouse. As the blue columns approached, Grant pointed to the right. The soldiers cheered. They knew that things were different now. There would be no turning back. In that sense, the battle of the Wilderness marked the beginning of the end for Lee's Army of Northern Virginia.

THE NEXT MOVE

After the Wilderness, Lee understood Grant had two basic options: to advance or to retreat. Many, like Gordon, believed that after such a sound thrashing, Grant would opt to retreat, but Lee told Gordon, 'Grant is not going to retreat. He will move his army to Spotsylvania.' Surprised, Gordon asked Lee if there was any evidence that the Federals were moving in that direction. 'Not at all, not at all,' Lee said, 'But that is the next point at which the armies will meet. Spotsylvania is now General Grant's best strategic point.'

Lee based this conclusion on reports from Major-General Jubal Early (1816–94) on the extreme left of the Confederate line that the Union troops had abandoned their positions opposite his division and had done the same for part of Brigadier-General Edward 'Allegheny' Johnson's (1816–73) command. Likewise, Ewell had reported that the Federals were dismantling their pontoon bridges at Germanna. From these indicators, Lee concluded that Grant had severed his line of communications via Germanna and would not retreat back across the Rapidan River. With this course of action discounted, Lee had then to determine in which direction Grant would advance. He had two possibilities: either Grant would move eastwards towards Fredericksburg or southeastwards towards Spotsylvania Courthouse.

TERRAIN

As Lee examined these two possibilities in an effort to determine which was more likely, he discovered there was much more to recommend Spotsylvania Courthouse to Grant. First of all, if Grant intended an advance on Richmond, the direct road to Spotsylvania Courthouse was less than half as long as the Fredericksburg route.

Secondly, Spotsylvania Courthouse was key terrain for anyone desiring to control Hanover Junction, where two major railroads met, and if Grant wished to drive Lee back on Richmond by cutting off his supplies, Grant would almost certainly try to seize the junction.

Thus Lee's analysis seemed to recommend Spotsylvania Courthouse as Grant's objective, but reports from the field were conflicting. Cavalry scouts had reported heavy wagon traffic in the Fredericksburg direction, but Stuart was also reporting that a strong Federal force had occupied Todd's Tavern, midway between Grant's present position and Spotsylvania Courthouse.

Here, Lee took the counsel of his analysis and began hedging his bets towards Spotsylvania Courthouse. He sent Brigadier-General William Pendleton (1809–83) to cut a road southwards through the woods from the Plank Road to the highway running from Orange Courthouse to Spotsylvania. This precaution would give the Confederates an inner line in the eventuality of a race to Spotsylvania. Lee also advised Stuart to study the roads in the direction of Spotsylvania.

With these steps in motion, Lee continued his close monitoring of every intelligence report of Grant's probable movements. All day, the cumulative evidence supported a move toward

Although the Wilderness cost Grant 17,000 casualties compared to just 10,000 for Lee, Grant knew he could replace his losses while Lee could not. Rather than being a callous butcher Grant was actually a thoroughly modern general who understood that the only way to end the war was to keep unrelenting pressure on Lee.

THE OPPOSED FORCES

THE WILDERNESS
FEDERAL	101,895
(excluding cavalry)	
CONFEDERATE	61,025

SPOTSYLVANIA COURTHOUSE
FEDERAL	100,000
CONFEDERATE	52,000

SPOTSYLVANIA COURTHOUSE
7–20 MAY 1864

3 On 9 May the Federal Second Corps takes a position to the right of the Federal Fifth Corps.

HANCOCK

WARREN

ANDERSON

MAHONE

HETH

4 On 10 May Confederates under Major-General Henry Heth and Brigadier-General William Mahone attack. The Federals execute a series of piecemeal attacks all along the lines.

5 On 10 May Upton executes an innovative assault against the Confederate Mule Shoe salient. Grant repeats the manoeuvre with the entire Second Corps on 12 May but the Confederates are able to construct a new line across the salient.

1 In spite of heavy losses in the Wilderness on 5–7 May, Grant orders Meade's army to march to Spotsylvania Courthouse and keep the pressure on Lee.

UPTON

EWELL

BURNSIDE

EARLY

SPOTSYLVANIA COURTHOUSE

2 On 9 May the Confederate Third Corps marches along Shady Grove Church Road to the village of Spotsylvania Courthouse.

6 On 20 and 21 May both armies depart Spotsylvania Courthouse headed south. They will meet again at the Battle of North Anna.

Spotsylvania Courthouse, and in the afternoon came the decisive indicator. At 4:00 p.m., a staff officer came down from an observation post in the attic of the deserted house that served as the headquarters of Hill's Third Corps. The observer reported that, with the aid of a powerful marine glass, he had seen a number of heavy artillery pieces, which had previously been held in reserve, now being moved south down the Brock Road, towards the Confederate right and, ultimately, Spotsylvania.

No Federal infantry had yet begun to move, but the artillery indicator was all Lee needed to reach his conclusion and to dispatch his First Corps under Major-General Richard H Anderson (1821–79) along Pendleton's newly cut road. Lee dispatched two of his staff officers with all haste to instruct the cavalry to hold Spotsylvania Courthouse. As they rode, one said to the other, 'How in God's name does the old man know General Grant is moving

to Spotsylvania Courthouse?' The answer lay in Lee's detailed and critical study of intelligence reports that both eliminated certain Federal courses and suggested the likelihood of others. The race to Spotsylvania Courthouse was on, and, thanks to Lee's analysis, the Confederates had a head start.

SPOTSYLVANIA COURTHOUSE

Throughout 8 May, the two armies flowed onto the battlefield and built corresponding lines of earthworks east and west of the Brock Road. The Confederate line ended up including a huge salient, or bulge, pointing north in the direction of the Federals. Its shape gave rise to the salient being dubbed the 'Mule Shoe'. Grant probed both of Lee's flanks on 9 and 10 May, to no avail. Unlike at the Wilderness, where Lee had counterattacked extensively, at Spotsylvania he fought almost entirely from behind entrenchments. Grant viewed this as a confession of weakness, but at the same time found it difficult to crack the Confederate line.

THE MULE SHOE

However, Grant saw a possibility in an imaginative attack on 10 May by just 12 regiments led by Colonel Emory Upton (1839–81). Upton was a visionary, though he was just 24 years old and less than three years out of West Point. Instead of undertaking a broad-front attack in line, Upton advanced in column formation. In order to keep up their momentum, the troops closed without firing en route – an eventuality Upton ensured by having all but his first rank advance with uncapped muskets. The attack enjoyed remarkable initial success. In just 60 seconds, Upton's men closed with a startled brigade of Georgians, seized four guns and a reserve line of works, and almost reached the McCoull House in the centre of the Mule Shoe. There Confederate artillery at the top of the salient halted the advance. Without additional support, Upton was unable to hold his gains and was forced to withdraw.

The new tactic impressed Grant, so he decided to try it again, this time by

Early in the Civil War, the Confederates had enjoyed a vast superiority over the Federals in terms of the quality of their cavalry. By this point, however, the Federal cavalry had developed into an effective arm of the Union Army.

This illustration shows Union Army officers' sleeve design. The greater the number of braids, the higher the rank. From left to right: first lieutenant, captain, major, lieutenant-colonel, colonel and general.

throwing Major-General Winfield Scott Hancock's (1824–86) entire Second Corps against the Mule Shoe. On 12 May at 4:30 a.m., a massed attack of 20,000 Federals advanced, and in just 15 minutes they were pouring through gaps in the Confederate lines. Hancock captured 4000 Confederate prisoners. The contested area became known as the 'Bloody Angle'.

In a desperate attempt to restore the breach, Lee counterattacked and succeeded in completing a new line of entrenchments across the base of the salient. For nearly 20 hours the fighting continued almost unabated in what may have been the most ferociously sustained combat in the entire war. The firing had been so intense that musket balls cut down an oak tree 56cm (22in) in diameter. There was more inconclusive fighting on 18 and 19 May, but the Confederate line held. Federal losses at Spotsylvania Courthouse included Major-General John Sedgwick (1813–64), the popular commander of Sixth Corps and, in a related battle at Yellow Tavern, the famed Confederate cavalryman Major-General JEB 'Jeb' Stuart was killed. Fighting mostly behind the protection of entrenchments, Lee suffered just 12,000 casualties compared to Grant's 18,000.

Having survived this close call, Lee withdrew on 20 May to a new position at Hanover Junction, thwarting another attempted turning movement by Grant.

In a pattern that would foreshadow World War I (1914–18), the defenders had proved able to repair a breach in a fortified line faster than the attackers could exploit it.

THE BIGGER PICTURE

Nonetheless, part of Grant's genius was an ability to look beyond individual battles and see the campaign as a whole. Although battles like the Wilderness and Spotsylvania Courthouse were costly, Grant could afford the losses while Lee and the Confederacy could not. On 11 May, Grant wired Major-General Henry Halleck (1815–72) in Washington that he intended 'to fight it out on this line if it takes all summer'. It would take even longer than that, but Grant had made his point. He would continue the relentless pressure of his Virginia Campaign at Hanover Junction, Cold Harbor and Petersburg, and ultimately lead the Army of the Potomac to victory.

Known as 'Hancock the Superb', Winfield Scott Hancock was one of Grant's most capable commanders. It was Hancock's corps that Grant selected to attack the Mule Shoe using Emory Upton's new tactics.

THE WILDERNESS/SPOTSYLVANIA COURTHOUSE

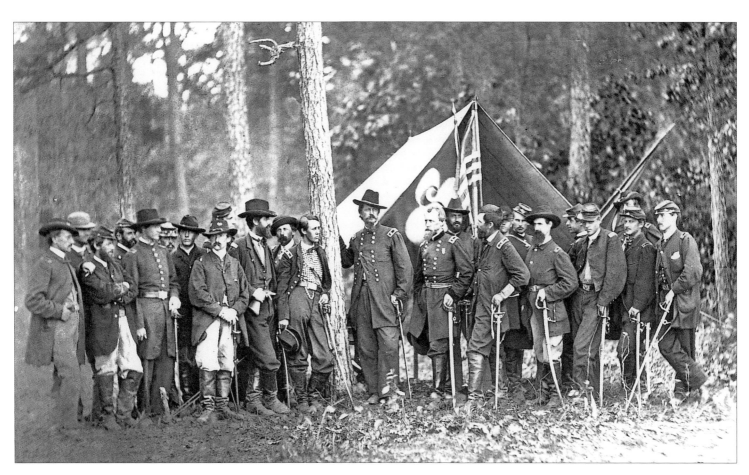

KENNESAW MOUNTAIN
27 JUNE 1864

GRANT'S COORDINATED STRATEGY FOR THE SPRING OF 1864 INVOLVED SIMULTANEOUS ADVANCES DESIGNED TO PRESS THE CONFEDERACY ON ALL FRONTS. THE TWO MOST IMPORTANT OFFENSIVES WERE GRANT'S OWN CAMPAIGN IN VIRGINIA, IN WHICH MEADE WOULD MAINTAIN CONSTANT PRESSURE ON LEE'S ARMY OF NORTHERN VIRGINIA, AND SHERMAN'S ATLANTA CAMPAIGN AGAINST JOHNSTON'S ARMY OF TENNESSEE. THE RESULTS WERE CATASTROPHIC FOR THE FEDERALS, BUT, UNDETERRED, SHERMAN TOOK POSSESSION OF ATLANTA ON 2 SEPTEMBER.

WHY DID IT HAPPEN?

WHO The Atlanta Campaign began with Major-General William T Sherman's (1820–91) Federals fighting Confederates commanded by General Joseph E Johnston (1807–91), who was ultimately replaced by Lieutenant-General John Bell Hood (1831–79).

WHAT Johnston fought a delaying action, withdrawing to successive entrenched positions to thwart Sherman's attempted turning movements. Only at Kennesaw Mountain did Sherman attack.

WHERE From Dalton to Atlanta, Georgia.

WHEN The Atlanta Campaign lasted from 1 May to 8 September 1864. The Battle of Kennesaw Mountain was fought on 27 June.

WHY Many argue that Johnston's defensive tactics were correct, but President Jefferson Davis (1808–89) grew frustrated by the steady withdrawals and replaced Johnston with Hood. Sherman relished the new opportunity to fight 'in open ground'.

OUTCOME Kennesaw Mountain was a resounding Confederate victory. Still Sherman was undeterred in his steady march to Atlanta. The Federal capture of Atlanta deprived the Confederacy of a critical industrial centre. More importantly, it gave the North a much-needed victory.

After his defeat in the Chattanooga Campaign, General Braxton Bragg (1817–76) retreated 40km (25 miles) south to Dalton, Georgia, and dug in his forces. By this time a public outcry had developed for Bragg's removal, and Bragg succumbed to the pressure and asked to be relieved. President Jefferson Davis replaced Bragg with General Joe Johnston, a man with whom Davis had had strained relations since the very beginning of the war. Johnston was a defensive fighter by nature and the fact that he began the campaign with only 62,000 men compared to Sherman's 100,000 reinforced this tendency.

Sherman, on the other, hand thrived on the offensive. By this point in the war he had developed an extremely close relationship with Grant (1822–85), and Sherman fully understood what the new General-in-Chief wanted him to do. Grant's instructions were 'to move against Johnston's army, to break it up, and to get into the interior of the enemy's country as far as you can, inflicting all the damage you can against their war resources'.

With the Confederates forced back into the defenses of Atlanta, Sherman could have used his artillery to mount a lengthy siege. Instead he launched attacks to try to cut Hood's open railroad to the south.

Grant and Sherman were thoroughly modern generals who understood manoeuvre, logistics and the support of the population. Atlanta was a vital supply, manufacturing and communications centre that was second only to Richmond in its industrial importance to the Confederacy. Thus far, it had escaped the ravages of war. By capturing Atlanta, Sherman would not only interrupt supplies that were helping keep General Robert E Lee's (1807–70) Army of Northern Virginia in the field, he would take the war to the Confederate people. But capturing Atlanta would not only dispirit the Confederate population, it would also silence those peace advocates in the North who considered Grant to be hopelessly deadlocked with Lee in Virginia, with no end to the fighting in sight. With President Lincoln (1809–65) facing a tough challenge in the 1864 election from a Democratic peace platform, capturing Atlanta would have as much political importance as it would military.

Sherman began his march on 7 May, just a few days after Lieutenant-General Ulysses S Grant and Major-General George G Meade (1815–72) began their offensive against Lee in Virginia. Sherman found Johnston's Dalton defences too strong, so he sent Major-General James McPherson's (1828–64) Army of the Tennessee to turn the Confederates from the west while Major-General George H Thomas' (1816–70) Army of the Cumberland advanced frontally along the Western & Atlantic Railroad. Fighting took place around Rocky Face Ridge on 5–9 May, but Johnston fell back without becoming decisively engaged.

Throughout the campaign, Johnston withdrew to positions that had previously been reconnoitred by his engineers. By this point in the war, his men had the breastwork construction process down to a science. First, trees were felled and trimmed, and the logs rolled in line to form

a revetment usually 1.2m (4ft) high. The logs were then banked with earth from a ditch dug to their front. The earth formed a sloping parapet about 2–3m (7–10ft) at the top and 1m (3ft) at ground level. On top of the revetment, skids supported a line of head logs interrupted by 8cm (3in) wide horizontal loopholes, through which the men could fire while still being protected. In front of these breastworks the men felled trees and bushes towards the enemy to form elaborate *chevaux-de-frise* and *abatis*. The defences went up so quickly that one Union soldier surmised that the Confederates must carry their breastworks with them. Sherman complained: 'The enemy can build parapets faster than we can march.'

Johnston received reinforcements in the form of Lieutenant-General Leonidas Polk's (1806–64) corps and took up strong defensive positions at Resaca, where fighting occurred on 13–16 May. As Sherman threatened an envelopment from the west, Johnston again withdrew. In this

CONFEDERATE 'BUTTERNUT' FIELD DRESS

The Confederate Quartermaster Department was seldom able to supply the Confederate soldier with all the required items of uniform. Instead soldiers wore whatever became available, and home-dyed butternut jackets and trousers became characteristic items rather than the traditional Confederate grey. One sketch in an 1861 Harper's Weekly *shows 26 variations of the Confederate uniform. At times this lack of standardization caused confusion on the battlefield. At First Manassas, for example, the Federal 11th New York Infantry was dressed in grey and the opposing Confederate 33rd Virginia Infantry was still wearing civilian clothes.*

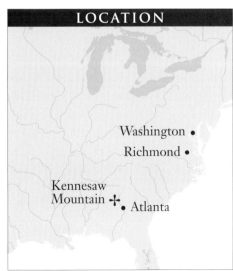

LOCATION

Washington •

Richmond •

Kennesaw
Mountain ✝ • Atlanta

Kennesaw Mountain lay astride the Western & Atlantic Railroad and blocked Sherman's advance from Dalton to Atlanta, Georgia.

now relatively open country, Sherman chose to advance on a broad front. In the process, his forces were not in close supporting distance of each other. This situation gave the usually defensive-minded Johnston an opportunity to go on the offensive at Cassville. Major-General John Schofield's (1831–1906) small Army of the Ohio, augmented by Major-General Joe Hooker's (1814–79) corps, was on the road from Adairsville to Cassville while McPherson's army was marching about 8km (5 miles) west of Adairsville. Most of Thomas' army was on a road that went from Adairsville 16km (10 miles) south to Kingston before veering east to Cassville. Johnston had plans to concentrate his 74,000 men at Cassville and ambush the fewer than 35,000 Federals under Schofield and Hooker. Ideally, the other two Federal armies could then be defeated piecemeal as they rushed to Schofield's aid.

It was a promising opportunity but the normally aggressive Lieutenant-General John Bell Hood mistakenly assumed a small Federal cavalry detachment was a much larger force and faced east as a precaution, rather than west, as the attack plan called for. The ensuing delay foiled Johnston's initial plan and then, on 19 May, Hood and Polk convinced Johnston their lines were too vulnerable to enfilade fire, and Johnston again withdrew. Johnston occupied positions at Allatoona Pass, which Sherman considered too formidable to attack. Instead, Sherman rested his army for three days and then undertook another turning movement at Dallas. Fighting occurred there on 25–27 May, and Johnston retired to Kennesaw Mountain.

KENNESAW MOUNTAIN

Johnston formed a 16km (10-mile) long defensive front that encompassed three mountains: Brush Mountain on the right, Pine Mountain in the middle and Lost Mountain on the left. Behind these three, at a distance of 3.2km (2 miles), stood Kennesaw Mountain, the strongest part of the Confederate line. The peak was nearly 305m (1000ft) above the surrounding landscape, and the Western & Atlantic Railroad skirted its base. Kennesaw Mountain blocked Sherman's approach to

the Chattahoochee, the last broad river north of Atlanta. General Sherman summed up the situation, writing to Washington DC: 'The whole countryside is one vast fort, and Johnston must have at least fifty miles of connected trenches with *abatis* and finished batteries.... Our lines are now in close contact and the fighting incessant, with a good deal of artillery. As fast as we gain one position the enemy has another all

THE OPPOSED FORCES

FEDERAL
Army of the Tennessee
Army of the Cumberland
Army of the Ohio
Total: 100,000

CONFEDERATE

Army of Tennessee
Initially 62,000
After Polk's
reinforcements 74,000

<div style="text-align: right">KENNESAW MOUNTAIN</div>

ready…. Kennesaw … is the key to the whole country.'

On 10 June, Sherman began probing Johnston's position but nearly two weeks of constant rains slowed progress. On 14 June, Polk was killed by an artillery round on Pine Mountain, and the next day, Johnston pulled his troops off of Pine Mountain to avoid being enveloped. On the night of 17/18 June, Johnston withdrew from Lost Mountain and Brush Mountain because of another threatened envelopment and consolidated his position on Kennesaw.

In spite of the strength of the Confederate position, Sherman elected to deviate from his pattern of turning movements and instead attempted a frontal assault. There were a couple reasons behind Sherman's decision. First, he thought he had found a point where the Confederate

Entitled 'Thunder on Little Kennesaw', this modern painting shows Lumsdens' Alabama Battery defending Little Kennesaw Mountain against Sherman's attack, as incendiary devices stream overhead.

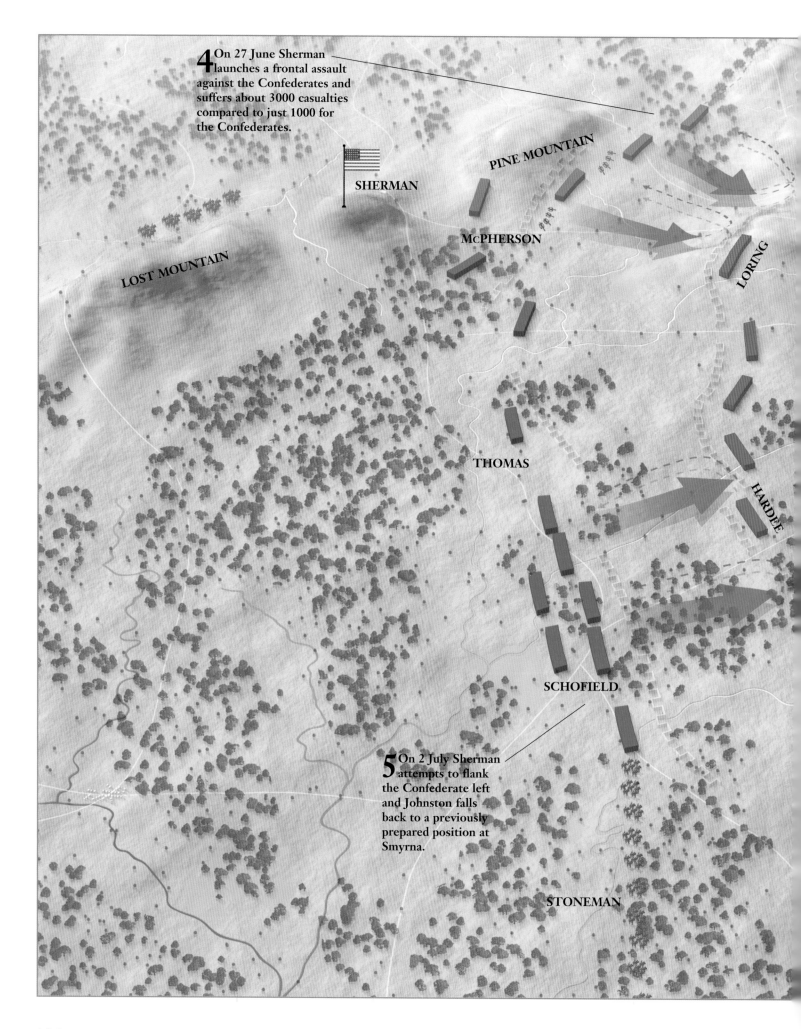

4 On 27 June Sherman launches a frontal assault against the Confederates and suffers about 3000 casualties compared to just 1000 for the Confederates.

PINE MOUNTAIN

SHERMAN

McPHERSON

LORING

LOST MOUNTAIN

THOMAS

HARDEE

SCHOFIELD

5 On 2 July Sherman attempts to flank the Confederate left and Johnston falls back to a previously prepared position at Smyrna.

STONEMAN

WHEELER

KENNESAW MOUNTAIN

2 Major-General
William Loring
occupies the crests
of Big and Little
Kennesaw.

MARIETTA

JOHNSTON

3 Hardee's corps
blocks Federal
approaches to
Marietta from the
west.

1 On 18 June
Johnston falls back
from Pine Mountain
and establishes a new
line along the crest of
Kennesaw Mountain.

HOOD

JACKSON

KENNESAW MOUNTAIN
27 JUNE 1864

Three Federal assaults brought Sherman's men within 27m (90ft) of the Confederate lines at Kennesaw Mountain, but the defence held. His frontal attack thwarted, after Kennesaw Sherman resumed his turning movements.

line was weak and a breakthrough possible. Recent rains had reduced his mobility, adding to his frustration. The only alternative to attacking was to delay, an idea that was anathema to Sherman. Perhaps most importantly, Sherman thought an attack was important to maintaining the offensive spirit of his troops, who, he believed, 'had settled down to the belief that flanking alone was my game.... A fresh furrow in a ploughed field,' Sherman complained, 'will stop a whole column, and all begin to entrench.'

Sherman, therefore, ordered Schofield to extend his right in order to compel Johnston to lengthen and thin his lines. McPherson was instructed to make a feint on his extreme left with his cavalry and one

The seven-shot Spencer carbine was the most effective shoulder arm of the Civil War. A breech-loader rather than a more cumbersome muzzle-loader, the Spencer, it was said, 'could be loaded on Sunday and fired all week'. The shorter stock of the carbine and its rapid firepower made it a popular choice among Union cavalry troops.

division, but to make his main attack at a point southwest of Kennesaw. Thomas would assault the centre of the Confederate position. Schofield would exploit a toehold he had gained on 20 June in fighting south of Olley's Creek. Each column would try to penetrate the defences at a single point, consolidate in the Confederate rear, and be prepared to advance towards Marietta and the Western & Atlantic.

There was little finesse in the attack. At 8:00 a.m. on 27 June, Sherman initiated a

'furious cannonade' of about 200 guns. Some 5500 Federal soldiers advanced through the dense and rugged terrain. Their leaders had little specific information on the lie of the land or the nature of the Confederate positions. In some places the Federals had success against the Confederate outposts, but they could not get close to the main defences before encountering a murderous fire. 'The air seemed filled with bullets,' recalled one survivor. Three separate assaults got nowhere and for the next five days some Federals held their ground within 27m (90ft) of the Confederate positions, but there was no further fighting. The attack on 27 June had cost Sherman about 3000 men compared to less than 1000 for the Confederates. On 2 July, Sherman resumed his efforts to turn Johnston, who withdrew to a previously prepared position at Smyrna.

THE FALL OF ATLANTA

General Joe Johnston's new line was built along the Chattahoochee River, which represented the last major obstacle between Sherman and Atlanta. In fighting on 4–9 July, Sherman again turned the Confederates and Johnston withdrew to Peach Tree Creek. By this time, President Davis was exasperated by Johnston's failure to make a stand. Davis replaced Johnston with Hood, a man with a marked reputation as a fighter. Many observers questioned the decision. Sherman wrote that by this act 'the Confederate Government rendered us most valuable service'.

Grant felt that replacing Johnston was a mistake, believing that 'Johnston [had] acted very wisely: he husbanded his men and saved as much of his territory as he could, without fighting decisive battles in which all might be lost…. I know that both Sherman and I were rejoiced when we heard of the change. Hood was unquestionably a brave, gallant soldier and not destitute of ability; but unfortunately his policy was to fight the enemy wherever he saw him, without thinking much of the consequences of defeat.' Even General Robert E Lee had

Confederate General Joe Johnston fought a skilful delay throughout the Atlanta Campaign. He would withdraw to successive defensive positions that were already reconnoitred and laid out by his engineers.

President Jefferson Davis placed Lieutenant-General John Bell Hood in command of the Confederate forces at Atlanta. The aggressive Hood launched a series of costly attacks, but ultimately was forced to withdraw.

advised Davis: 'Hood is a bold fighter. I am doubtful as to other qualities necessary.'

If Davis wanted offensive action, he was not to be disappointed. As Sherman closed in on Atlanta from the north and east, Hood ordered an attack to begin at 1:00 p.m. on 20 July. The target was Thomas' army, which had secured a shallow bridgehead across Peach Tree Creek and was now unsupported by Sherman's other armies. Thomas had earned the nickname the 'Rock of Chickamauga' for his ability to hold ground even when isolated and he would live up to this reputation at Peach Tree Creek. The Confederates launched a series of assaults until 6:00 p.m., but ultimately were forced to withdraw to the defences of Atlanta. Hood had suffered 2500 casualties, compared to about 1600 for the Federals.

As Hood withdrew, Sherman mistakenly thought the Confederates were abandoning Atlanta and sent Major-General McPherson in pursuit to the south and east. Hood sent his cavalry under Major-General Joseph Wheeler (1836–1906) and Lieutenant-General William J Hardee's (1815–73) corps on a night march to strike McPherson's southern flank. In the fighting on 22 July, the popular and capable McPherson was killed, but the Confederate attack was defeated. When Grant learned of McPherson's death, an observer said Grant's 'mouth twitched and his eyes shut … Then the tears came and one followed the other down his bronzed cheeks as he sat there without a word or comment.' In another lopsided battle, Hood's Confederates suffered 8500 casualties, compared to just 3700 among Sherman's Union forces.

By 25 July Sherman had invested Atlanta from the north and east. Hood still had an open railroad to the south, which Sherman tried unsuccessfully to sever with two raids between 26 and 31 July and the Battle of Ezra Church on 28 July. Hood finally evacuated Atlanta on 1 September and the Federal forces moved in to occupy the city the next morning.

MARCH TO THE SEA AND THE CAROLINAS CAMPAIGN

Having captured Atlanta, Sherman also gained a problem. Freed from having to defend Atlanta, Hood moved into northwest Georgia, where he had secure lines of communication into Alabama. Throughout October, Hood threatened Sherman's vulnerable Western & Atlantic Railroad supply line. Sherman was forced to devote much energy to this new menace from Hood.

To solve the problem, Sherman decided to cut loose from his railroad line of supply, abandon Atlanta, and strike out for a new base on the coast. In the process, Sherman proposed taking the war to a new level of totality. He wrote Grant that 'the utter destruction of [the Confederacy's rail] roads, houses, and people will cripple their military resources… I can make the march, and make Georgia howl!'

Dispatching Thomas to defend Tennessee and deal with Hood, Sherman abandoned Atlanta after destroying anything of value to the Confederate war effort. On November 15 he began a march against almost no opposition, cutting a sixty mile swath through Georgia. On 21 December Confederate Lieutenant General William Hardee abandoned Savannah on the Atlantic coast, and Sherman presented the city to President Lincoln as a Christmas gift. There Sherman received resupplies by sea and plotted his next move. Sherman wrote Chief of Staff Major General Henry Halleck, 'the whole United States, North and South, would rejoice to have this army turned loose on South Carolina to devastate the state in the manner we have done Georgia.' By 20 January, Sherman's army had entered South Carolina and began unleashing vengeful destruction against the very birthplace of secession.

As in Georgia, Confederate resistance was a mere token. As Sherman bore down on the South Carolina capital of Columbia, Confederate Lieutenant General Wade Hampton informed the mayor that resistance would be futile and on 17 February, the mayor approached Sherman with an offer to surrender.

What followed as Sherman's troops entered the city has become a matter of some debate. The end result was that the city was burned and destroyed. How much of the damage was malicious vengeance on the part of the Federals as opposed to an effort by the fleeing Confederates to destroy items of value to the enemy remains a subject of controversy. Whatever the genesis, high winds and inebriated soldiers only made matters worse. By the time Sherman marched out of Columbia on 20 February, he reported the city 'utterly ruined.' Sherman continued his march into North Carolina where Johnston had assembled a force of some 21,000 effectives to try to slow Sherman's 60,000-man juggernaut. Although Sherman was unable to completely destroy Johnston at the battle of Bentonville on 19 March, Johnston knew

the end was at hand. General Robert E. Lee had surrendered to Grant on 9 April. Johnston finally surrendered to Sherman on 26 April.

IMPACT

The combined effects of Sherman's Atlanta Campaign, March to the Sea, and Carolinas Campaign were profound. On September 3, Sherman had telegraphed Washington, 'So Atlanta is ours, and fairly won.' The news could not have come at a better time for President Lincoln, who was facing a stiff challenge from Major General George McClellan in the upcoming presidential election. War weariness had fallen upon the North and Lincoln had gone so far as to require his cabinet members to sign a statement saying, 'This morning, as for some days past, it seems exceedingly probable that this Administration will not be reelected. Then it will be my duty to so co-operate with the President elect, as to save the Union between the election and the inauguration…'

The capture of Atlanta, along with another Federal success at Mobile Bay, completely changed the picture. McClellan

began to distance himself from the Peace Democrats and Lincoln's reelection was assured. While Sherman had defeated a major Confederate army in the field and captured an important industrial city, the main impact of Atlanta was on the political front.

From there Sherman took the war to the Confederate people as his March to the Sea and Carolinas Campaign destroyed the Confederacy's infrastructure and morale. He proved himself to be a master of manoeuvre and logistics and completed the elevation of the Civil War from its limited war beginnings to its total war conclusion.

On 15 November 1864, Sherman destroyed the military resources of Atlanta and began his March to the Sea. On 21 December, Confederate Lieutenant General William Hardee evacuated Savannah and Sherman occupied it. On 17 February Sherman burned the secessionist capital of Columbia, SC. A month later, on 19 March, Sherman defeated Confederate General Joe Johnston at Bentonville, NC. Finally, on 26 April 1865, Johnston surrendered to Sherman at Raleigh.

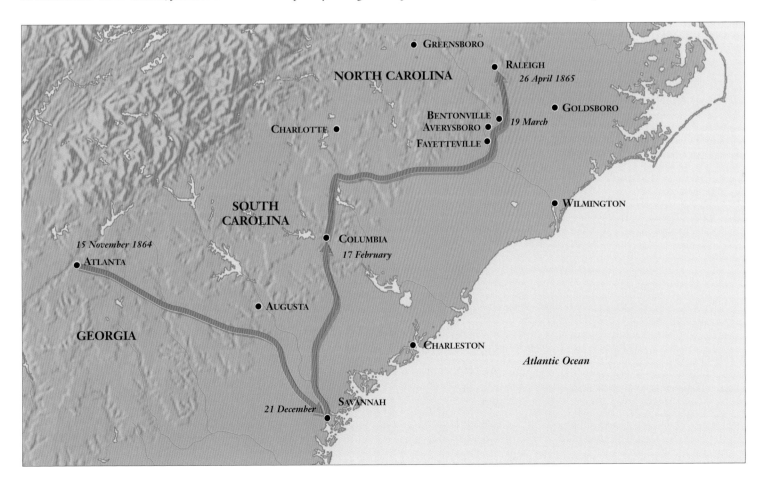

MOBILE BAY
5 AUGUST 1864

ON 5 AUGUST 1864, REAR-ADMIRAL DAVID GLASGOW FARRAGUT GAVE HIS IMMORTAL COMMAND, 'DAMN THE TORPEDOES! FULL SPEED AHEAD,' AND LED HIS FLEET INTO MOBILE BAY, ALABAMA. THE ENSUING FEDERAL VICTORY CLOSED THE CONFEDERACY'S LAST SIGNIFICANT PORT ON THE GULF OF MEXICO AND HELPED ENSURE ABRAHAM LINCOLN'S RE-ELECTION AS PRESIDENT.

WHY DID IT HAPPEN?

WHO Federal forces led by Rear-Admiral David Farragut (1801–70) attacked Confederate naval forces commanded by Admiral Franklin Buchanan (1800–74).

WHAT Farragut defeated Buchanan in a matter of hours, and the Confederate forts defending the bay surrendered shortly thereafter.

WHERE Mobile Bay, Alabama.

WHEN 5 August 1864.

WHY Farragut daringly commanded 'Damn the torpedoes! Full speed ahead,' as he led his fleet past the imposing Fort Morgan and the treacherous minefield in the bay.

OUTCOME The Federal victory closed the last major Confederate port on the Gulf of Mexico to blockade-running and, along with Sherman's capture of Atlanta, helped ensure Lincoln's re-election.

The last two holdouts among the Confederacy's major ports were Wilmington, North Carolina, and Mobile Bay. The Federals wanted to shut down both in order to halt the slow trickle of European supplies that was keeping General Robert E Lee's (1807–70) Army of Northern Virginia alive. Wilmington had survived because the Cape Fear River's two entrances made it difficult to blockade and because it was guarded by the mighty Fort Fisher. Mobile Bay, on the other hand, had been spared because of higher Federal priorities elsewhere. Vicksburg, Charleston and the Red River Campaign all had served to distract attention and resources from Mobile Bay.

In the meantime, blockading in the Gulf of Mexico had proven to be extremely difficult. There were some 966km (600 miles) between Pensacola and the Rio Grande, not counting the Mississippi River Delta. Behind the coast lay a complex network of inland waterways that allowed shallow draft schooners to find exits and inlets not covered by blockaders. Mobile was by far the most important Gulf port used by the Confederate blockade-runners. It was second only to New Orleans as the South's largest cotton-exporting port before the war, and the Federal capture of New Orleans on 25 April 1862 only increased Mobile's importance. During the war, blockade-runners plied their trade between there and Bermuda, Nassau and Havana.

Moreover, Mobile Bay and its port were vital to the Southern war effort. Alabama was second only to Richmond's Tredegar

Because Farragut was born near Knoxville, Tennessee, and had married a woman from Norfolk, Virginia, many people had concerns about his devotion to the Federal cause. In fact, Farragut proved to be a staunch Unionist.

32PDR CARRONADE

Both Federals and Confederates entered the Civil War adhering to the long-held military dictum that coastal forts were superior to ships. In fact, one gun on land was considered to be equal to four on water. The entire coastal defence of the United States had been planned according to this precept. Steam-powered ships and improved ordnance, however, had served to change this equation. In early operations such as Hatteras Inlet, North Carolina, and Port Royal Sound, South Carolina, the Federal Navy had proved that the traditional superiority of the fort was no longer assured. Mobile Bay would be another naval victory.

Iron Works as the Confederacy's centre for manufacturing iron and rolling heavy iron plate. About 209km (130 miles) north of Mobile along the Alabama River was Bassett's Yard in Selma. There, three ironclads were under construction. In all, eight were being built on the Alabama and Tombigbee rivers. Only one, the *Tennessee*, would be completed in time to see action, and the desire to halt further ironclad production made Mobile an even more important target for the Federals.

THE DEFENDERS

Mobile Bay would prove to be a difficult target because, although the bay stretched far inland, its entrance was only 5km (3 miles) wide. There, Fort Gaines guarded the western side from Dauphin Island. Stretching eastwards from the fort, the defenders had placed a series of sunken pilings that reduced the bay's entrance by over half. Beyond these obstructions, shallow water and 'torpedoes' – submerged mines fitted with percussion caps or fulminate of mercury fuses that were rigged to detonate upon contact with a ship's hull – further narrowed the channel. Brigadier-General Gabriel James Rains (1803–81), who had pioneered the use of land mines during the Peninsula Campaign, had been instrumental in laying out the system for Mobile. In all, 180 submerged torpedoes were arranged in three parallel rows. Most, however, had been in the water for some

time and many would prove defective.

On the eastern edge of the minefield was a thin opening stretching some 182m (200 yards) to Mobile Point that provided a passageway for blockade-runners. Mobile Point was a long neck of land that jutted out and controlled the entrance to the bay. There stood the powerful Fort Morgan, a massive pentagon-shaped, three-tiered structure with 47 guns. No ship could negotiate the opening in the minefield without passing underneath Fort Morgan's guns. Completing the defences, a much smaller Fort Powell blocked a narrow inter-coastal passage north of Dauphin Island via the Mississippi Sound. Brigadier-General Richard Page (1807–1901), a nephew of General Robert E Lee, was in charge of these outer defences. Page was well suited to understanding the requirements of a coastal defence. Before the Civil War he had served 37 years in the US Navy.

Behind these forts were the ironclad *Tennessee* and three wooden gunboats under the able command of Admiral Franklin Buchanan. Buchanan had commanded the *Virginia* (ex-*Merrimack*) and, like Farragut, was a seasoned and aggressive fighter. His gunboats were of little consequence, but the *Tennessee* was a force to be reckoned with. She had 15cm (6in) of armour on her casemate, 13cm (5in) on her sides and 5cm

(2in) on her deck. She had six Brooke Rifles, but she was inadequately powered for her weight and therefore hard to manoeuvre. Buchanan was pinning his hopes on the *Tennessee*, and Farragut knew it. He wrote to his son: 'Buchanan has a vessel which he says is superior to the *Merrimack* with which he intends to attack us.... So we are to have no child's play.'

THE FEDERAL NAVY

The Federals knew that the Confederates could mount a spirited defence against wooden vessels, so in January Assistant Secretary of the Navy Gustavas Fox

LOCATION

• Memphis

New Orleans • ✝ Mobile Bay

Mobile Bay was the last major port open to the Confederacy on the Gulf of Mexico. Blockade-runners used it to provide the foreign commerce necessary for the Confederacy's survival.

An 86mm (3.5in) boat carriage gun. Before the Civil War, future Federal Rear-Admiral John A Dahlgren (1809–70) invented the Dahlgren gun, a rifled cannon, and boat howitzers with iron carriages. Dahlgren's boat howitzers were the finest guns of their time in the world and were used by both Federals and Confederates throughout the Civil War.

(15in) Dahlgren guns behind 28cm (11in) of turret armour. They were the most powerful warships then in existence. Complementing them were the *Chickasaw* and the *Winnebago*, twin-turret, quadruple-screwed river monitors with batteries of four 28cm (11in) guns. The *Tecumseh* was the last to arrive, reaching Farragut on 4 August, just in time for the battle. In addition, Farragut had 14 wooden ships and an initial Army contingent of 2000 troops.

THE BATTLE IS JOINED

On 3 August, Major-General Gordon Granger (1822–76) landed his brigade at the west end of Dauphin Island, in the rear of Fort Gaines. Farragut had hoped simultaneously to begin the naval engagement but the *Tecumseh*'s late arrival had made that impossible. As Granger moved to invest Fort Gaines the next day, Farragut retired to his cabin and wrote: 'I am going into Mobile in the morning if God is my leader, as I hope He is, and in Him I place my trust. If He thinks it is the place for me to die, I am ready to submit to His will.'

(1821–83) had asked Farragut how many ironclads he thought he would need to blast his way into Mobile Bay. 'Just as many as you can spare; two would answer me well, more would do better,' Farragut replied. By July the Navy had four monitors on the way to Farragut. The *Manhattan* and the *Tecumseh* were large, improved vessels, mounting a pair of 38cm

Farragut had good reason to be somewhat fatalistic. His plan was as dangerous as it was bold. The four monitors would take the lead, with their shallow

Armed with cannon and manned by infantry, Fort Morgan controlled the entrance to Mobile Bay and covered the minefield that narrowed the passage. The parapets of the fort were 4.3m (15ft) thick.

draught permitting them to hug the shore and avoid the mines, while their low profiles and armour plating would protect them from Fort Morgan's guns. The wooden ships would follow, echeloned slightly to the left of the monitors to use them as a shield.

As a further caution, Farragut would lash each of his smaller gunboats to the port side of one of his larger vessels. This measure would not only protect the smaller ships from Fort Morgan, but if the larger vessel's engines were disabled, the gunboat could also act as a tug to pull the damaged ship to safety. Once the pairs had passed out of range of Fort Morgan, the connecting cables would be cut and each vessel would operate independently.

Farragut was exactly the man for such a hazardous undertaking. He had already succeeded in a similarly daring manoeuvre to capture New Orleans. In terms of personality, Secretary of the Navy Gideon Welles (1802–78) considered Farragut to be 'better fitted to lead an expedition through danger and difficulty than to command an extensive blockade; [he] is a good officer in a great emergency, will more willingly take risks in order to obtain great results than any other officer in high position in either Navy or Army.'

Throughout the night of 4 August, the meticulous Farragut made his final preparations. Any unnecessary spars and rigging was removed to facilitate speed and manoeuvrability. As at New Orleans, chain garlands were hung over the ships' starboard sides and sandbags were piled 'from stem to stern, and from the berth to the spar deck' for added protection. At dawn on 5 August, the Federal fleet drew up in battle formation.

Farragut gave the order to get under way with the monitors leading and the wooden ships behind. A little after 6:30 a.m., the *Tecumseh* fired a ranging shot and the fleet pressed forward, closing its order as it advanced. Fort Morgan opened fire at 7:10 a.m., with the fleet 800m (880 yards) away. The *Brooklyn*, at the head of the Federal

wooden ships, returned fire. 'Soon after this,' Farragut deadpanned, 'the action became lively.'

Buchanan brought the *Tennessee* and the three small ships out from behind Mobile Point and lined them up just behind the minefield, executing the classic naval manoeuvre of crossing Farragut's 'T' and sending a raking fire down the long axis of the Federal line. By this time, the *Brooklyn*, with her superior speed, had drawn level with the rear of the monitors. At this rate, a wooden ship would end up leading the attack. Just then the *Brooklyn* spotted 'a row of suspicious looking buoys … directly

Gordon Granger had performed well at Chickamauga and Chattanooga and now commanded the Federal land forces at Mobile Bay.

THE OPPOSED FORCES

FEDERAL
Navy:	**4 ironclads**
	14 wooden ships
Army:	**5500**

CONFEDERATE
Navy:	**1 ironclad**
	3 wooden gunboats
Army:	**140 at Fort Powell**
	600 at Fort Gaines
	400 at Fort Morgan

MOBILE BAY

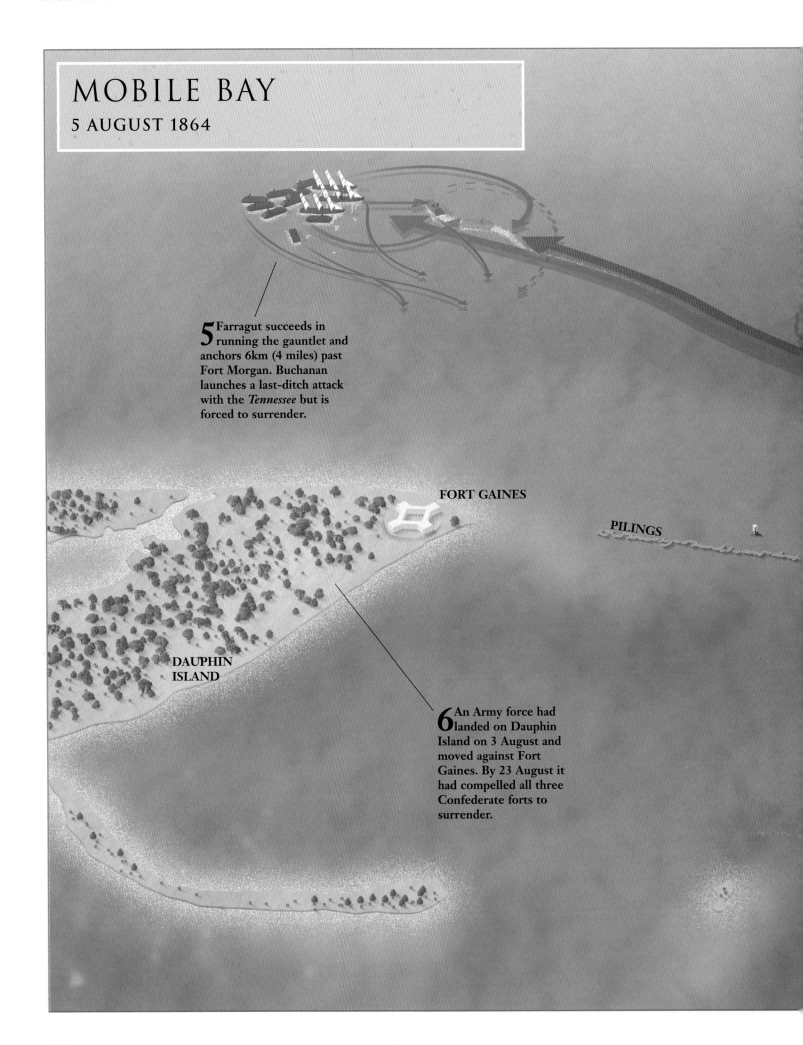

MOBILE BAY

5 AUGUST 1864

5 Farragut succeeds in running the gauntlet and anchors 6km (4 miles) past Fort Morgan. Buchanan launches a last-ditch attack with the *Tennessee* but is forced to surrender.

FORT GAINES

PILINGS

DAUPHIN ISLAND

6 An Army force had landed on Dauphin Island on 3 August and moved against Fort Gaines. By 23 August it had compelled all three Confederate forts to surrender.

3 Buchanan lines the four Confederate vessels including the *Tennessee* up just behind the minefield and begins firing on the advancing Federals.

MOBILE
POINT

FORT
MORGAN

4 The *Tecumseh* hits a mine and sinks but Farragut seizes the initiative and commands, 'I shall lead. Damn the torpedoes! Full speed ahead.'

2 The Confederates have placed pilings and torpedoes to narrow the channel. There is a small gap in the minefield but ships using this passage will have to hazard the guns of Fort Morgan.

1 At dawn on 5 August Farragut begins his attack.

under our bows'. Unsure what to do, Captain James Alden (1810–77) ordered the ship to back engines to clear the hazard. Consequently, the manoeuvre compressed Farragut's entire fleet and exposed it to murderous fire from Fort Morgan. To make matters worse, the *Tecumseh*, at the head of the formation, struck a torpedo and went down swiftly. Remarkably spry for a 63-year-old, Farragut had climbed the rigging of his flagship *Hartford*'s mainmast to ascertain the situation. He knew the battle had reached its crisis point, and he knew what he had to do. 'I shall lead,' he said. 'Damn the torpedoes! Full speed ahead.'

With that, the *Hartford*, with the *Metacomet* lashed alongside, turned sharply to port and sped past the *Brooklyn* directly across the minefield into Mobile Bay. Buchanan continued his raking fire but, from the moment the Federal fleet made its turn, its starboard batteries unloaded on Fort Morgan, driving the Confederate gunners to shelter. However, once the stronger lead ships were past, Fort Morgan was able to return fire against the weaker ones in the rear. The last tandem, the *Oneida* and the *Galena*, were hit badly but limped on.

The main threat now was the *Tennessee*. The Federals delivered repeated broadsides that barely dented the ironclad. A mile into the bay, Farragut gave the order to cut loose the smaller ships and commanded 'Gunboats chase enemy gunboats'. The small Confederate ships were quickly neutralized, but Buchanan readied the *Tennessee* for one last run. With only six hours of coal left, Buchanan knew he had to act. He headed straight for the Federal fleet, which had anchored 6km (4 miles) beyond Fort Morgan and started eating breakfast. Farragut was in a state of disbelief. 'I did not think Old Buck was such a fool,' he said. 'Destroy the enemy's principal ship by ramming her.' The *Monongahela* obeyed the order and struck the *Tennessee* a glancing blow. The *Tennessee* stood its ground but was

The Battle of Mobile Bay *by William H Overend (1851–98). At the pivotal point of the battle, Admiral Farragut rose to the occasion and declared, 'I shall lead. Damn the torpedoes! Full speed ahead.'*

After the loss of Mobile Bay, Fort Fisher, North Carolina, remained one of the few important ports open to Confederate blockade-running.

soon swarmed by the *Manhattan* and then the *Lackawanna* and the *Hartford*. In the midst of the chaos the *Lackawanna*, a sloop-of-war, accidentally rammed the *Hartford*, momentarily endangering Farragut himself. By now the *Tennessee* was barely hanging on. The *Chickasaw* pulled into position and delivered a terrible fire. Buchanan, by now himself suffering from a compound fracture of his leg, turned to Commander James D Johnston (1817–96), captain of the *Tennessee*, and said, 'Well, Johnston, if you cannot do any further damage you had better surrender.' Johnston took one last look from the gun deck, saw the *Ossippe* fast approaching, and decided to lower the Confederate colours and hoist a white flag.

The naval battle had lasted but a couple of hours. Of the 3000 Federals engaged, there were 319 casualties, including 93 who drowned when the *Tecumseh* sank. The number of Confederate naval personnel lost was much higher: 312 out of 470 engaged.

The forts did not hold out much longer. First, the ironclad river monitor *Chickasaw* turned its four guns against the tiny Fort

Powell. The Confederates abandoned the fort on the night of 5 August, blowing it up as they departed. The 600-man garrison at Fort Gaines mustered a faint-hearted show of resistance and then surrendered early on 8 August. Granger took the Confederates prisoner and then moved his entire force of about 5500 against the 400 Confederates at Fort Morgan.

The Federals received a siege train from New Orleans on 17 August and began a heavy land and naval bombardment on 22 August. At the same time General Granger pushed his trenches to within assaulting distance of the fort. The Confederates raised a white flag the next morning and formally surrendered at 2:30 p.m. Losses on both sides were negligible. From all three forts, the Federals captured 1464 prisoners and 104 pieces of artillery.

RESULTS

Farragut considered Mobile Bay 'one of the hardest-earned victories of my life', and Secretary of the Navy Welles proclaimed that it 'sent a thrill of joy through all true

The CSS Tennessee was one of the few ironclads available to the Confederate Navy. Her iron plate was 50x250mm (2x10in) and her armament included six Brooke Rifles (field artillery).

hearts'. However, when Welles brought the news to President Abraham Lincoln (1809–65), he was disappointed by Lincoln's apparent lack of enthusiasm. After three years and four months of fighting, blockade-running on the Gulf of Mexico now virtually ceased altogether, and the only port that remained open to the Rebels was Wilmington. Welles considered this a magnificent accomplishment, but he lamented in his diary: 'It is not appreciated as it should be.'

Without access to the sea, the city of Mobile was of no strategic importance and withered on the vine. It was finally occupied by Federal forces on 12 April 1865.

Like his president, General-in-Chief Lieutenant-General Ulysses S Grant (1822–85) found it hard to get too excited about the victory at Mobile Bay. He had planned for his spring 1864 campaign to include a drive against Mobile that would help support Major-General William T Sherman's (1820–91) Atlanta Campaign. Instead, however, Major-General Nathaniel Banks (1816–94) followed political motivations and marched up the cotton-rich but strategically unimportant Red River Valley. By early April, Banks's campaign was a failure and Grant's hope for a supporting operation in the rear of General Joseph E Johnston's (1807–91) Army of Tennessee was lost. When Mobile finally fell, Grant was unimpressed. In his *Memoirs* he

explained: 'I had tried for more than two years to have an expedition sent against Mobile when its possession by us would have been of great advantage. It finally cost lives to take it when its possession was of no importance....'

Perhaps the greatest significance of Farragut's success was political. When combined with Sherman's capture of Atlanta in September, Mobile Bay provided the Federals with twin victories that indicated the overall war effort was succeeding. Up to that point there was a real possibility that war weariness would cost Lincoln the 1864 election. Had that been the case, the Civil War would have likely ended in some negotiated settlement. Instead, the momentum gained by battlefield victories and the re-election of Lincoln as president ensured the ultimate defeat of the Confederacy.

The Federal fleet at Mobile Bay included four monitors and 14 wooden ships. Opposing them at sea the Confederates had the ironclad Tennessee *and a carefully placed minefield.*

FRANKLIN/NASHVILLE
24–30 NOVEMBER 1864

THE RACE TOWARDS NASHVILLE BETWEEN UNION AND CONFEDERATE FORCES IN THE NOVEMBER OF 1864 WAS CONFEDERATE GENERAL JOHN B HOOD'S LAST CHANCE TO DISTURB MAJOR-GENERAL WILLIAM SHERMAN'S BOLD 'MARCH TO THE SEA'. A SERIES OF CONFEDERATE TACTICAL ERRORS SAW THE UNION ARMY OF THE OHIO SLIP FROM HOOD'S GRASP.

WHY DID IT HAPPEN?

WHO The Union Army of the Ohio, commanded by Major-General John M Schofield (1831–1906), and General John Bell Hood's (1831–79) Confederate Army of Tennessee.

WHAT Schofield makes an advance through Tennessee towards Nashville, while Hood attempts to sever the advance by getting ahead of the Union troops, first at Columbia, then at Spring Hill.

WHERE The state of Tennessee, between Pulaski and Spring Hill.

WHEN 24–30 November 1864.

WHY Hood planned to destroy the Army of the Ohio and take Nashville, thus making Major-General William Tecumseh Sherman (1820–91) abandon his March to the Sea further east.

OUTCOME The Confederates allowed Schofield's forces to escape their trap, leading to major Confederate losses at the subsequent Battle of Franklin and a defeat at the Battle of Nashville.

On 1 September 1864, the Union forces of Major-General William Tecumseh Sherman took the city of Atlanta, Georgia – a cruel body blow for the Confederate strategists. The Confederate Army of Tennessee was unable to hold the city, despite a change of command from the cautious General Joseph E Johnston (1807–91) to the impetuous General John Bell Hood, and Sherman now planned his next move.

What Sherman conceived was his now-famous March to the Sea. He would take four corps of troops (around 60,000 men) and make a two-wing advance from Atlanta through Georgia to the Atlantic coast (aiming for Savannah, to the south of Charleston), crushing the Confederates' Georgian defence and, ultimately, opening the way for a swing northwards into the Carolinas. The plan was high-risk for two principal reasons. First, the march would be conducted through the very centre of hostile territory, with the accompanying danger that constant low-level actions, as well as set-piece battles, would steadily lead to the collapse of the march before it reached its objective. The second concern was Hood. His 40,000 Rebels remained to Sherman's rear, so could drag his march to a halt by making the Union forces fight constant rearguard and flanking actions.

A scene at the earthwork Fort McAllister, Georgia. The fort fell to Sherman on 13 December 1864 as Union forces invested Savannah. With the fort gone, the Union took control of the river and Savannah was doomed to fall.

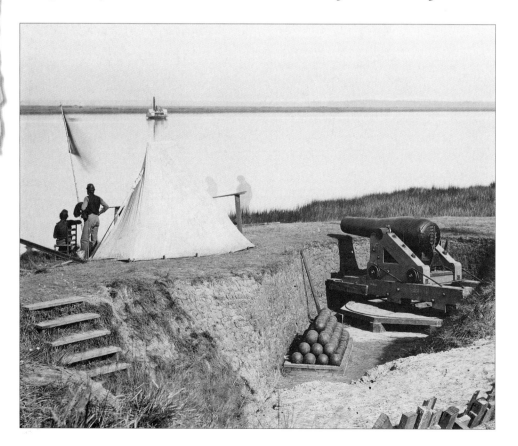

Sherman was confident that his men could handle the former concern, and on 21 September the problem of Hood partially resolved itself. Hood transferred his army west to Palmetto, with the intention of attacking the Union supply lines into Atlanta. Sherman had to take this threat seriously, as he correctly deduced that Hood's ultimate goal might be to take Nashville. (Nashville was an extremely important supply hub for the Union Army, delivering thousands of horses, wagons and items of uniform to Sherman's men.) For the next month, Hood and Sherman played out a cat-and-mouse series of battles. Hood managed to destroy many supply depots, but also suffered heavy losses at Allatoona Pass on 5 October. It soon became apparent to Hood's men that they did not have the strength to crush Sherman. Sherman recognized this also, and decided to turn his back on Hood and focus once more on his March to the Sea, for which Lieutenant-General Ulysses S Grant (1822–85) gave his approval on 7 November.

To ensure Nashville's safety, Sherman sent Fourth Corps under Major-General David S Stanley (1828–1902), 23rd Corps under Major-General John M Schofield, who was in overall command of the two corps, and a large force of cavalry under Major-General James H Wilson (1837–1925) to reinforce the troops of Major-General George H Thomas (1816–70) that were garrisoning Nashville. Also earmarked for the city's defence was 26th Corps, under Major-General Andrew J Smith (1815–97), which would not arrive in Nashville until the end of November. The journey of these Union forces – collectively known as the Army of the Ohio – through Tennessee set the scene for a frantic race and a series of bloody engagements.

IN PURSUIT

The Union and Confederate forces in Tennessee ranked roughly equal in crude terms of manpower. The Fourth and 23rd corps together totalled around 30,000 men, with the cavalry, the Post of Nashville and other units making the Union numbers up to around 46,000. The Confederate Army of Tennessee had some 40,000 men, having lost 15,000 troops in the Atlanta Campaign

after Hood took over. The Rebel forces were divided into three corps, under the command of Lieutenant-General Stephen D Lee (1833–1908), Major-General Benjamin F Cheatham (1820–86) and Lieutenant-General Alexander P Stewart (1821–1908). In addition, Hood could rely on the 6000 elite horsemen under the great cavalry commander Major-General Nathan Bedford Forrest (1821–77).

The big difference between the two sides lay most acutely in the issue of morale. By this stage in the conflict, the Federal soldiers were motivated and confident, and had much belief in hard, intelligent

LOCATION

Raleigh
Nashville
✛ Franklin
Atlanta
Savannah

Had Hood succeeded in his offensive towards Nashville, Sherman might have been forced to break off his March to the Sea from Atlanta to Savannah.

UNION HUSSAR

This Union soldier mixes old and modern traditions in his dress. While many cavalry wore the black felt campaign hat, with one side turned up, this soldier wears a less ostentatious Union cap, featuring crossed swords. The jacket harks back to Hungarian hussar uniform, with ornate cord loop fastenings rather than normal buttonholes. A cavalry sabre with ornamental tassel hangs from the left side of his belt, but the soldier also has a musket set in a bolster. The type of gun is unclear, but it is likely a carbine, of which some 50 different varieties were manufactured during the Civil War. With its shorter length, the carbine offered greater ease of use from horseback and easier storage. The soldier also has a pistol holster on his belt.

THE OPPOSED FORCES

FEDERAL
Army of the Ohio
Total: 46,000

CONFEDERATE
Three corps of the
Army of Tennessee
Total: 40,000

commanders such as Sherman. The Army of Tennessee, by contrast, had suffered a string of withering defeats, and morale was uncertain. For example, when Hood redeployed his troops to La Fayette after the Battle of Allatoona Pass, he discovered that not a single corps commander believed that they could defeat Sherman in open battle. In addition, the Army of Tennessee's previous commander, Joe Johnston, had been known for his caution with his men's lives, whereas Hood had a tendency to launch into bloody battles with sketchy advanced planning.

The consequent bloodshed did not inspire in the Confederate ranks great confidence in their leadership. Morale was

just kept afloat, however, by some of the victories in Georgia, and the fact that by moving into Tennessee many of the men were much closer to home.

Despite the doubts of his subordinates and superiors, Hood had a plan. Sherman had begun his March to the Sea, but Hood hoped that if he could destroy the Union's Tennessee formations one by one, and then take Nashville, the reversal of Union fortunes could force Sherman to make a costly about-turn and cancel his campaign. The ultimate goal – and also an unrealistic one – was for Hood to move into the North and join with the forces of General Robert E Lee (1807–70) to make a war-winning combination. Hood's first priority, however,

Sherman frequently exercised a policy of destruction towards the civilian infrastructure on his March to the Sea, wrecking telegraph lines, uprooting railroad tracks and scavenging heavily from the land. This policy subdued civilian resistance to his campaign.

Cox (1828–1900), managed to reach Columbia and set up an ad hoc defence only minutes before the Confederate cavalry arrived. The cavalry were fought off in a small engagement, and there was little they could do further to threaten Columbia, as Hood's infantry were still more than a day's march away. The bulk of Schofield's force now began to arrive in Columbia, and more substantial defensive lines were constructed.

NIGHT ESCAPE

Schofield could not keep his forces at Columbia indefinitely. He decided to pull the majority of his troops over to the north bank of the Duck River, leaving two divisions as a rearguard in the town. However, bad weather meant the operation was slowly executed, and many of the Union troops remained in Columbia through to 27 November. Once all were across the Duck River, however, the bridges were destroyed and Schofield entrenched his men on the north bank. Here was Hood's chance. He aimed to bypass Schofield's position and cross the Duck River to the north of Columbia, cutting the Union troops off from Nashville at Spring Hill. However, Hood would leave two divisions and a large artillery contingent, under the command of Lieutenant-General Stephen D Lee, around Columbia in an attempt to convince Schofield that the Confederates intended to do battle there.

Schofield initially took the bait, and stayed put. Hood's troops around Columbia even delivered an artillery barrage on 28 November to confirm the impression of an impending battle. Yet, that very morning, Schofield began to receive ominous reports from some of his advance cavalry that Confederate troops had been seen traversing the Duck at the Lewisburg crossing above them. Skirmishing between the cavalry also continued throughout the day. Critically, Schofield actually dismissed these initial reports. Only on 29 November

was to take on Schofield's two corps. Rather than let them reinforce their destination, Hood planned to cut ahead of their line of advance and crush them well before Nashville at the town of Columbia (at that point garrisoned by around 800 Union soldiers). Such an objective would require rapid movement to get ahead of Schofield, but Hood at first showed little urgency. In fact, Hood's decision to wait for Forrest's cavalry to join him (it had been out at Johnsonville on a raiding mission) resulted in a three-week delay before the Rebels finally moved out on 21 November. When they did move, however, they moved fast, and made 18km (12 miles) in the first day, the cavalry moving ahead of the three

corps-strength columns to provide reconnaissance and screening. By 23 November, the Confederates had travelled up to Mount Pleasant, just 76km (47 miles) south of Columbia.

The Union troops, stationed in Pulaski, had become aware of the potential trap they were falling into. On 22 November, Schofield gave orders for his troops to leave Pulaski and head for Columbia, where they could make an effective stand against Hood's advance. The move began the next day, but on 24 November Forrest's cavalry began fighting with Union cavalry as both raced for Columbia. A sharp, mobile battle began, in which the Union Third Division, 23rd Corps, under Major-General Jacob D

FRANKLIN
24–30 NOVEMBER 1864

1 30 November – after their tactical withdrawal at Spring Hill, Union troops move north to a defensive position at Franklin.

5 Wagner's force retreat. A hole in the Union line opens up, but is quickly plugged by Opdycke, who launches a courageous counterattack that seals the gap.

FRANKLIN

RUGER

OPDYCKE

WAGNER

CHEATHAM

HOOD

4 Wagner's division – the forwardmost in the Union line – are quickly enveloped by a Confederate attack and become embroiled in hand-to-hand fighting.

2 Hood's army moves quickly along the Columbia Pike in pursuit, reaching the outskirts of Franklin 3:00 p.m.

WOOD

3 Having destroyed his pontoons at Columbia and so unable to get his army quickly across the river, the Union commander Schofield decides to fight at Franklin.

6 Further Confederate attacks fail to break the Union lines, and by 9:00 p.m., the assault has ceased.

HARPETH RIVER

STUART

The Battle of Allatoona Pass (5 October 1864) was another defeat for Hood in Georgia. A Union brigade successfully defended the pass against a Confederate division. Both sides suffered 700–800 casualties.

General John Bell Hood (1831–79) was known for a fighting spirit that bordered on recklessness. Hood took command of the Army of Tennessee in July 1864, but his promotion brought little but defeat.

did he start to act, and then seemingly without conviction. Major-General Stanley was ordered to take two divisions – led by Brigadier-General Nathan Kimball (1822–98), and Brigadier-General George D Wagner (1829–69) – northwards. One was to secure Spring Hill, the other was to emplace itself halfway between Spring Hill and Columbia. These Union divisions would be racing against Forrest's cavalry, which was surging towards Spring Hill on the Mount Carmel Road.

It was a race only just won by the Union. Once Stanley's troops became aware of the threat running parallel to them, they drove hard up the Columbia Turnpike and, with little time to spare, lodged the First Brigade, Second Division, Fourth Corps, in Spring Hill and then fought off Forrest's cavalry, who had expected to find an undefended town. Yet although by the afternoon Stanley had his entire division in Spring Hill, it was quickly faced with a corps of Confederates numbering around 10,000 men. A Union defeat seemed inevitable. Most critically, Schofield only began withdrawing all his men from Columbia towards Spring Hill late on 29 November. Hood could still close his trap on the Union troops and prevent them from ever reaching Nashville.

It was at this point that the Confederate achievements began to unravel. Major-General Cheatham launched his corps at Spring Hill into an attack against the hastily

prepared Union defences at 4:00 p.m. on 29 November. The fading light made for a bad time to commence battle. Furthermore, the Union troops had managed to emplace good artillery positions, whereas most of the Confederate artillery was either back near Columbia or on the road. Nor did Cheatham commit his forces wisely, but instead threw them into battle in a piecemeal fashion, making it easier for the defenders to deal with each wave in turn. (Cheatham's tactical errors were in part due to a lack of knowledge of the precise layout of the Union defences.)

In a short, violent battle, the Union soldiers held on to Spring Hill, inflicting heavy casualties on their attackers with artillery and musket fire. The failed attack did allow the Confederates to gain a better sense of the location of Union defences, and they repositioned for a second attack that had a much higher likelihood of success.

The attack was not launched before nightfall, and it was during the night that Hood's battle plan truly unwound. Despite his men bivouacking close to the Columbia Turnpike, Schofield managed to sneak his entire force past them in the dark and take them north. How this was even possible is hard to imagine, as the road was literally within visual and auditory distance of the Confederate troops. Nonetheless, under Hood's very nose, Schofield made it to Spring Hill, and then led all his troops on to the town of Franklin. The Army of the Ohio had slipped through Hood's noose.

CONFEDERATE DISASTER

Hood's failure to cut off the Union forces in Tennessee had a crushing impact on Confederate campaigning in the region. Schofield heavily reinforced Franklin's defensive works, and waited for the Confederate attack. Hood, enraged by the Federal escape, ordered a frontal attack on the town – a decision that required Confederate troops to assault across 3.2km (2 miles) of open ground – despite vigorous protestations from his field commanders. Without waiting for his artillery, Hood sent the attack in at 4:00 p.m. on 30 November. The attack nearly succeeded. Confederate troops overran the Union forward lines but became locked in a horrifying close-range

battle against the main lines. The battle only stopped at 9:00 p.m. The Confederates had not taken Franklin, but had lost 6200 men, including six generals. Schofield's men had also suffered terribly, with loses of 2326 soldiers, but their resistance enabled the Army of the Ohio to move on successfully to Nashville.

The Battle of Nashville brought the final collapse of Hood's plans in Tennessee. Hood placed Nashville under a virtual siege from 2 to 15 December, keeping his army back and hoping to draw Thomas' forces out to attack the Confederate defences, whereupon they could be broken apart before a Confederate attack stormed in to take the city. The plan came apart, and over two days of fighting, in which Hood was outmanoeuvred by Thomas' troops, the Confederates took an unsustainable 13,000 casualties, against about 3000 Union dead and injured. Hood's tattered army was forced to retreat, with the Union forces now in the role of pursuers.

Hood resigned from his command on 13 January 1865. By this point the Army of Tennessee was effectively crushed, and no longer capable of having a major effect on the war's overall outcome. The actions around Columbia and Spring Hill may have been comparatively small in terms of fighting, but their implications for the war in the west were great.

A scene from the Battle of Nashville, 15 December 1864. The battle was a final, devastating defeat for the Army of Tennessee, which lost 13,000 men. Hood resigned a month later.

PETERSBURG
2 APRIL 1865

THE UNION VICTORY AT PETERSBURG IN APRIL 1865, ACCOMPLISHED AFTER THE CITY HAD ENDURED MONTHS OF SIEGE CONDITIONS, WAS ONE OF THE LAST CONFEDERATE DOMINOES TO FALL IN THE AMERICAN CIVIL WAR. ONCE THE CITY HAD FALLEN, THE CONFEDERATE CAPITAL AT RICHMOND WAS OPEN FOR THE TAKING, AND THE SOUTH BEGAN ITS FINAL POLITICAL AND MILITARY COLLAPSE.

WHY DID IT HAPPEN?

WHO Five Union corps under Lieutenant-General Ulysses S Grant (1822–85), totalling over 97,000 troops, launched a final attack against General Robert E Lee's (1807–70) thinly spread 45,000 Confederate troops around Petersburg.

WHAT The battle was the culmination of a long Union siege of Petersburg. The Union forces attacked all along the Confederate line, with Sixth Corps making the decisive break south of the city.

WHERE The battle lines ran from east of Petersburg, Virginia, then south of the city and out west to positions around Five Forks.

WHEN 2 April 1865.

WHY The battle was Grant's attempt to conclude the Petersburg siege, and to take advantage of the previous day's victory secured at Five Forks.

OUTCOME The Confederate defences around Petersburg were shattered, and Lee ordered the evacuation of the city.

By the end of March 1865, the city of Petersburg had been under siege for more than eight months. In scenes that many historians have likened to the conditions in Western Europe during World War I (1914–18), the two sides had settled into huge static trench systems, frequently probing the other's lines with raids and other minor actions. The Confederate commander in Virginia, the renowned General Robert E Lee, realized that his strategic options were contracting. The siege was steadily eating into the city's supplies. Supply lines were open, particularly the Southside Railroad running into Petersburg from the west, but it was mainly the winter weather that had prevented the Federal troops under Lieutenant-General Ulysses S Grant from

moving against these. With the improvement of weather in spring, time was running out. Furthermore, the extended length of the Confederate lines – around 60km (37 miles) from Petersburg to Richmond – meant that Lee's troops were, in many places, spread unacceptably thin, with gaps of several metres between each man enforced in places.

Lee did have something of a plan in mind, although it required a healthy dose of optimism to believe in it. If he could break his forces out of Petersburg, Lee felt that he might be able to drive to the south, resupplying on the way, and eventually join forces with the Confederate troops of General Joseph E Johnston (1807–91) in North Carolina. If this could be achieved then, maybe, the combined force could

The Battle of Five Forks was a critical defeat for the Confederates that destabilized their defence of Petersburg. Here Union cavalry charge a line of Confederate riflemen.

defeat Major-General William Tecumseh Sherman's (1820–91) units in the Carolinas, then return north to battle with Grant on a more equal footing.

As it turned out, it was Grant who took the initiative in the Virginia theatre. As spring approached, Grant diligently reinforced his positions, which snaked in a long line from east of Petersburg, ran south around the city, and then ran out well west parallel with the Hatcher's Run River. Significant additions to his aggregate strength were Major-General Philip H Sheridan's (1831–88) Army of the Shenandoah and Major-General Edward OC Ord's (1818–83) Army of the James. With a bolstered force, Grant now launched a new series of offensives aimed at breaking the Confederate hold on Petersburg.

UNION MANOEUVRES

Back in February 1864, Federal troops had carried out several assaults southwest of Petersburg around Hatcher's Run, attempting to consolidate their advantage over the Confederate supply route along the Boydton Plank Road. On 29 March, they renewed their efforts in the area, using Sheridan's cavalry units and Fifth Corps infantry under Major-General Gouverneur K Warren (1830–82) to attack towards Dinwiddie Court House.

Although the Federal troops had a numerical advantage, the Confederates were obdurate in defence. Sheridan's attempts to outflank the Confederates were stopped by defences at White Oak Road, Boydton Road, Dinwiddie Court House, Crow's House and Hatcher's Run. Even so, the Confederate commanding officer in the region – the much-criticized Major-General George Pickett (1825–75) – understood that his defences would eventually crumble, so he pulled his troops back to the Five Forks crossroads.

Pickett actually wanted to retreat further, but Lee insisted that he hold the strategically important crossroads, stating clearly: 'Hold Five Forks at all hazards. Protect road to Ford's Depot and prevent Union forces from striking the Southside Railroad. Regret exceedingly your forces' withdrawal, and your inability to hold the advantage you had gained.'

CONFEDERATE SOLDIER (LATE WAR)

This is a typical Confederate soldier of the late war period. He is already showing signs of the collapse in the Confederate supply chain and economy, indicated by the patching of his jacket and trousers. He wears the standard grey-blue Confederate uniform, with piped trousers and jacket collar and matching kepi. Around his body he has a simple bedding roll, which would also have provided additional warmth in winter. The great length of Civil War rifles is apparent here. Although some breech-loading rifles did appear during the 1860s, most remained muzzle-loaders, as indicated here by the visible ramrod. A well-trained soldier would be able to fire four to five rounds every minute from such a weapon, and the effective combat range would be in the region of 100–200m (110–220 yards).

Pickett ordered his troops to dig in and await the inevitable attack – which came on 1 April. Sheridan and Warren were once again partnered for the operation, Sheridan using cavalry to make a frontal pinning action while Warren's cavalry were sent on a flanking manoeuvre. The Union assault was poorly executed. Union intelligence had marked the Confederate defences as beginning further east than they actually did. This, combined with treacherous wooded terrain, led to slow and confused manoeuvring by the frontal divisions of Warren's Fifth Corps.

In the end, Sheridan's judicious use of Warren's reserve division permitted the

LOCATION

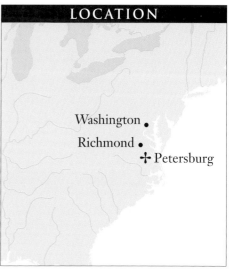

Once Petersburg was taken by the Union, the Confederate defence of Richmond was unsustainable, the city trapped between Union forces in the north and south. Richmond's evacuation was quickly ordered.

THE OPPOSED FORCES

FEDERAL
Five corps around Petersburg
Total: **90,000**

CONFEDERATE
Mixed units dug into defensive earthworks
Total: **45,000**

attack to go in, and the Confederate left flank was quickly punctured. (Pickett was actually 3.2km (2 miles) away having a meal with fellow generals, blissfully unaware that his troops were battling for their lives without central leadership.) In the end, Five Forks was abandoned, with 2950 Southern casualties against 840 Union losses, although the fight had been hard for the Union (Sheridan relieved Warren of his command), and the Confederates re-established and held a new line of defence.

The loss of Five Forks was a critical blow for Lee's defence of Petersburg, as the Federal forces had broken the main Confederate line and were moving inexorably closer to the Southside Railroad. Lee recognized that the Petersburg-Richmond line would eventually crumble, so he telegraphed Richmond advising that the city authorities make preparations to abandon the city. The defence of Petersburg was also acknowledged as unsustainable, a point that the Union forces would prove on 2 April.

ATTACK ON PETERSBURG

Grant understood that the Union victory at Five Forks presented him with the opportunity to take Petersburg with the 50,000 troops he had deployed there. Lee's line had been thinned by losses and redeployments, and the move towards retreat would leave his forces tactically vulnerable. Five corps held the Union lines around Petersburg. The eastern side of the lines was manned by Ninth Corps under Major-General John G Parke (1827–1900), while next to him was a southern front held by Sixth Corps, under the command of Major-General Horatio G Wright (1820–99). Major-General John Gibbon's (1827–96) 24th Corps, Major-General AA Humphreys' (1810–83) Second Corps and Fifth Corps, now under Major-General Charles Griffin (1825–67), ran the Union lines out to positions at Five Forks.

A typical earthwork fortification of the Civil War, such as was found around Petersburg in 1865. These defences were designed to break up the impetus and formations of enemy attacks, while providing superb protection from rifle and cannon fire.

Union Zouaves display their muskets, complete with fixed bayonets. The Zouaves' dress, with its North African origins, created a memorable sight on the battlefields of the Civil War, and sometimes included the classic tasseled fez.

Grant planned a major assault along the entire length of the line, with the heaviest weight of attack concentrated in Wright's sector. Start time for the operation was 4:00 a.m. (just before first light at 4:40 a.m.), but at 2:00 a.m., Union artillery conducted a night bombardment of Confederate lines to mask the movement of around 14,000 men into positions in no-man's-land.

At 4:00 a.m., the first Union troops surged towards the Confederate lines. Although the actions basically occurred simultaneously, it is useful to separate them out into their respective events. Looking

A dramatic bird's-eye view of the defences at Fort Steadman, 25 March 1865. A daring Confederate assault had taken the fort, but a massive Union counterattack reclaimed it the same day. The fruitless action cost the Confederate forces 5000 men.

PETERSBURG
2 APRIL 1865

PETERSBURG

5 To the west of the city, the Union Second Corps defeats six Confederate divisions. Almost all parts of the Rebel lines have now collapsed, and the evacuation of Petersburg is ordered.

1 2:00 a.m., 2 April 1865 – a bombardment of Confederate lines provides cover for Union troops to move out into no-man's-land and take up their assault start positions.

FORT STEADMAN

PARKE

GORDON

THE CRATER

WRIGHT

4 Wright's Sixth Corps punches throught the enemy defences and swings left into the Confederate rear. This is the crucial attack of the day, and throws the Rebel defence into disarray.

3 The Confederate Second Corps manages to hold off attacks in the eastern sector for the entire day, and is only forced to abandon its defences by the general evacuation order.

2 The main Union assault begins at 4.00 a..m.., with a near simultaneous attack by five corps of troops along the length of the Petersburg lines.

first to the east of Petersburg, Ninth Corps was faced by three divisions of the Confederate Second Corps, some 3600 men along approximately 6km (4 miles) of front. Second Corps' strength had been reduced by one division through Lee's redeployments, yet despite the weakening, the line still boasted some powerful defences, particularly the three-sided Fort Mahone in the far south of the sector. In fact, such was the strength of the defences that Parke had even requested his portion of the assault be cancelled. Nevertheless, at 4:30 a.m., his attack began, using three divisions. Parke initially met with success, the Union troops capturing three Confederate gun batteries and making some inroads into the Fort Mahone defences. However, the complex of Confederate trenches and defences quickly broke up the Union manoeuvres, as did a dogmatic defence by veteran troops of Lieutenant-General John B Gordon's (1832–1904) Second Corps.

By midday, Ninth Corps' position was becoming desperate, and reinforcements

Fort Steadman had an extensive complex of bunkers, as seen here. While the Confederate defences around Petersburg were undoubtedly strong, the troops were spread too thin for a focused resistance.

were requested. These helped contain a vigorous counterattack by Gordon around 3:00 p.m., but only just. In fact, only news of a Sixth Corps breakthrough to the west prevented Gordon from making another, potentially successful, attempt to eject the Union troops from the lines. The day ended with 1700 Union casualties amongst Ninth Corps, and Gordon's Confederates moving back only because of the Petersburg evacuation order.

The Sixth Corps attack was the nexus of victory at Petersburg on 2 April. Wright's front faced the critical Boydton Plank Road.

Wright had formed much of the corps into a powerful wedge formation, aiming to crack open the Confederate line with a powerful concentration of force at a single point, the positions around Fort Welch. It was a precarious formation, one that risked decimation by enemy artillery, but if it could be launched with surprise, its effect would be decisive.

The attack went in at 4:40 a.m., assaulting over a 10km (6-mile) front against six brigades of Confederate troops between Fort Howard and Peebles Farm. In only half an hour, Sixth Corps smashed open the enemy lines, the wedge formation first cutting into, then through, the North Carolina Brigade. With the line pierced, Sixth Corps then swung to the left to support the Union Second Corps attack from the south. The chaos unleashed in the Confederate rear was profound, aided by the fact that some isolated Union units even fought as far forward as the Southside Railroad. For a day's-end casualty figure of 2100, Sixth Corps had inflicted around 5000 dead and wounded. One of the Confederate dead was Major-General AP Hill (1825–65), who was ambushed and shot

This painting by Don Troiani shows Confederate forces under Major-General William Mahone counter-attacking Union troops (foreground) at the battle of the Crater, Petersburg, 1864. Union troops became trapped in the crater and were massacred in what Mahone later described as a 'turkey shoot'. The Confederates reported losses of 1,032 men in the battle, while Union losses were estimated at 5,300.

PETERSBURG

A dead Confederate soldier lies at the bottom of a ditch in the defences around Petersburg. Over 4000 Confederate troops were killed or injured during the final battle, and another 30,000 were forced into a humiliating retreat.

Were they to overrun the two forts, the Federal forces would be able to continue north to the Appomattox River and take the bridges that were vital to Petersburg's resupply and evacuation.

The Union assault swung into action at aprproximately 1:00 p.m., but met with unexpectedly fierce resistance from both garrisons (the two forts could also support one another with fire, and further fire assistance came from a battery on the Dimmock Line). Eventually, however, sheer weight of numbers and the collapse of Confederate ammunition supplies carried the day, and the Union troops managed to clamber into Fort Gregg's interior and take the surrender. Witnessing this, Fort Whitworth's garrison then evacuated their stronghold. Occupying the two forts had not been without cost for the Federals, however: 24th Corps had lost around 122 killed and 200 wounded.

Further to the southwest, fighting was also heavy along the Boydton Line, down to Hatcher's Run and beyond, down the White Oak Road Line, defended by six divisions of Confederates under Major-General Harry Heth (1825–99) against the Union Second Corps. Humphreys took this corps into the attack around 8:00 a.m., buoyed by news of Wright's breakthrough, and it only took one hour to put the Confederates into a retreat (by this stage, Heth's men also had advance units of Wright's corps pressing on their left

while riding along the lines of battle.

The Sixth Corps attack destabilized the entire Confederate line, and in the west the Rebels rushed to reinforce the last major strongpoints protecting the defences of the Boydton Plank Road – Fort Gregg and Fort Whitworth (the latter also known as Fort Baldwin). These objectives were the province of General Gibbon's 24th Corps, plus one division from 25th Corps – 5000 troops compared to the 300 defenders.

The Confederate mortar known as the 'Dictator' was used at Petersburg. It had a calibre of 33cm (13in) and could fire a 91kg (200lb) explosive shell over a distance of 4km (2.5 miles).

Union troops at Petersburg. Although the battle was a Union victory, it still cost the Federal Army about 3500 casualties. Confederate artillery fire using grape shot was particularly lethal amongst the tightly packed ranks of the attackers.

flank). Only some subsequent poor manoeuvring on the part of the Union forces allowed Heth's soldiers to escape complete destruction.

Rather than pursue the Rebel troops up the Claiborne Road, Humphreys was ordered to move to support the push on Petersburg itself, even though his forward division, led by Major-General Nelson A Miles (1839–1925), was battling the Confederates around Sutherland Station. Humphreys responded by leaving this division with its present action, and moving his other two divisions up towards the city. However, Miles actually found himself in trouble battling the veteran Confederates,

and Humphreys had to make an about-turn to come to his rescue. Only in the late afternoon did the Confederate defence finally collapse, when the shattered troops moved up to the Appomattox to begin their retreat into Petersburg itself. By this time, they were joined by men retreating back from the Five Forks area. Some uncertain decisions by Sheridan meant that Fifth Corps was deployed ineffectively, and as the Confederate cavalry of Major-General Fitzhugh Lee (1835–1905) fought several very effective delaying actions, a large number of infantry were able to make their escape along the Appomattox.

ABANDONING PETERSBURG

By the end of 2 April 1865, the Battle of Petersburg was conclusively won for the Union. Nonetheless, Grant did not make a final drive into the city itself, but essentially just placed a noose around the city's neck. There were several reasons for this policy.

First, the Union troops had suffered for victory, with around 3500 casualties against the Confederates' estimated 4250. Factor in the mental condition of men who had been in action for over 16 hours, and the Union troops were in no condition for a final epic assault. Furthermore, the Confederates had received some reinforcements in the form of a division from First Corps.

More importantly, Grant probably understood that the Confederate defence of Petersburg was, in any case, untenable. Such was indeed the case – as early as 10:00 a.m., Lee had sent a telegram to Richmond saying that he would not be able to hold the lines, and that an evacuation must take place. By 8:00 p.m., this evacuation had begun and, overnight, around 30,000 troops pulled out of the city, to endure further ordeals over the coming days. The fall of Petersburg meant, by implication, the fall of Richmond and the effective end of the Confederate war.

BIBLIOGRAPHY

Anderson, Bern. *By Sea and by River: The Naval History of the Civil War.* New York: Knopf, 1962.

Arnold, James. *Grant Wins the War: Decision at Vicksburg.* NY: Wiley, 1997.

Ballard, Michael. *Vicksburg: The Campaign that Opened the Mississippi.* Chapel Hill, NC: University of North Carolina Press, 2003.

Berringer, Richard et al. *Why the South Lost the Civil War.* Athens, GA: University of Georgia Press, 1986.

Castel, Albert. *Decision in the West: The Atlanta Campaign of 1864.* Lawrence, KS: University Press of Kansas, 1992.

Catton, Bruce. *Gettysburg: The Final Fury.* Garden City, NY: Doubleday, 1974.

Catton, Bruce. *Glory Road.* Garden City, NY: Doubleday, 1952.

Catton, Bruce. *Mr. Lincoln's Army.* Garden City, NY: Doubleday, 1962.

Catton, Bruce. *A Stillness at Appomattox.* Garden City, NY: Doubleday, 1953.

Catton, Bruce. *This Hallowed Ground.* Garden City, NY: Doubleday, 1962.

Coddington, Edwin B. *The Gettysburg Campaign: A Study in Command.* New York: Scribners, 1984.

Commager, Henry Steele, ed. *The Blue and the Gray: The Story of the Civil War as Told by Participants.* New York: *Mentor,* 1973 (paperback).

Connelly, Thomas L. *Army of the Heartland: The Army of Tennessee, 1861–1862.* Baton Rouge, LA: Louisiana State University Press, 1997.

Connelly, Thomas L. *Autumn of Glory: The Army of Tennessee, 1862–1865.* Baton Rouge, LA: Louisiana State University Press, 2001.

Cooling, Benjamin. *Forts Henry and Donelson: The Key to the Confederate Heartland.* Knoxville, TN: University of Tennessee Press, 1988.

Cozzens, Peter. *The Darkest Days of the War: The Battles of Iuka & Corinth.* Chapel Hill, NC: University of North Carolina Press, 1977.

Davis, William C. *Battle at Bull Run: A History of the First Major Campaign of the Civil War.* Mechanicsburg, PA: Stackpole Books, 1995.

Dowdey, Clifford. *Lee's Last Campaign: The Story of Lee and his Men against Grant—1864.* Boston, MA: Little, Brown and Company, 1960.

Foote, Shelby. *The Civil War: A Narrative.* Vol. 1, *Fort Sumter to Perryville.* Vol. 2, *Fredericksburg to Meridian.* Vol. 3, *Red River to Appomattox.* NY: Random House, 1986.

Frassanito, William A. *Gettysburg: A Journey in Time.* New York: Scribners, 1975.

Furguson, Ernest. *Chancellorsville, 1863: The Souls of the Brave.* NY: Alfred A. Knopf, 1992.

Gott, Kendall. *Where the South Lost the War: An Analysis of the Fort Henry–Fort Donelson Campaign, February 1862.* Mechanicsburg, PA: Stackpole Books, 2003.

Grant, Ulysses S. *Personal Memoirs of U.S. Grant.* 2 vols. New York: Webster & Co., 1885-1886.

Hattaway, Herman and Archer Jones. *How the North Won: A Military History of the Civil War.* Chicago, IL: University of Illinois Press, 1983.

Hearn, Chester. *The Capture of New Orleans, 1862.* Baton Rouge, LA: Louisiana State University Press, 1995.

Hennessy, John. *Return to Bull Run: The Campaign and Battle of Second Manassas.* NY: Simon & Schuster, 1993.

Jones, Archer. *Civil War Command & Strategy.* NY: The Free Press, 1992.

Jones, Virgil C. *The Civil War at Sea.* 3 vols. New York: Holt, 1960-62.

McDonogh, James. *War in Kentucky: From Shiloh to Perryville.* Knoxville, TN: University of Tennessee Press, 1994.

McMurry, Richard. *Atlanta 1864: Last Chance for the Confederacy.* Lincoln, NE: University of Nebraska Press, 2000.

McPherson, James. *Battle Cry of Freedom: The Civil War Era.* Oxford: Oxford University Press, 1988

Miller, Edward Stokes. *Civil War Sea Battles.* Mechanicsburg, PA: Stackpole, 1995.

Murfin, James. *The Gleam of Bayonets: The Battle of Antietam and Robert E. Lee's Maryland Campaign.* NY: Thomas Yoseloff, 1965.

Rhea, Gordon C. *The Battle of the Wilderness, May 5–6, 1864.* Baton Rouge, LA: Louisiana State University Press, 2004.

Rhea, Gordon C. *The Battles for Spotsylvania Court House and the Road to Yellow Tavern.* Baton Rouge, LA: Louisiana State University Press, 1997.

Robertson, James. *Stonewall Jackson: The Man, The Soldier, The Legend.* NY: MacMillan Publishing USA, 1997.

Sears, Stephen. *Chancellorsville.* NY: Houghton Mifflin Co, 1996.

Sears, Stephen. *Gettysburg* NY: Houghton Mifflin Co, 2003.

Sears, Stephen. *Landscape Turned Red: The Battle of Antietam.* NY: Ticknor and Fields, 1983.

Sears, Stephen. *To the Gates of Richmond.* NY: Houghton Mifflin Co, 1992.

Shea, William and Terrence Winschel. *Vicksburg is the Key: The Struggle for the Mississippi River.* Lincoln, NE: University of Nebraska Press, 2003.

Sommers, Richard. *Richmond Redeemed: The Siege at Petersburg* Garden City, NY: Doubleday, 1981.

Swanberg, W. A. *First Blood: The Story of Fort Sumter.* NY: Dorset Press, 1957.

Tanner, Robert. *Stonewall in the Valley.* Garden City, NY: Doubleday, 1976.

Tucker, Glenn. *High Tide at Gettysburg.* New York: Smithmark, 1994.

Williams, T. Harry. *Lincoln and His Generals.* New York: Alfred A. Knopf, 1952.

Woodworth, Stephen. *Nothing But Victory: The Army of the Tennessee, 1861-1865.* NY: Alfred A. Knopf, 2005.

Woodworth, Stephen. *Six Armies in Tennessee: The Chickamauga and Chattanooga Campaigns.* Lincoln, NE: University of Nebraska Press, 1998.

INDEX

Page numbers in *italics* refer to illustrations, those in **bold** type refer to information displays with illustrations and text. Abbreviations are as follows: (B) – battle; (NB) – naval battle; (S) – siege.